Carla Beaufort.

Carla Beaufort.

The Dictionary of
BRITISH WATERCOLOUR
ARTISTS
up to 1920

H. L. Mallalieu

Antique Collectors' Club

ISBN 0-902028 48 0

Front Cover
*"Queen Victoria and the King of Sardinia inspecting
troops at Woolwich."*
*Watercolour by George Bryant Campion N.W.S.
1796-1870.*

Printed in England by Baron Publishing, Church Street, Woodbridge,
Suffolk.

INTRODUCTION

The late David Jones, himself no mean painter as well as a poet, wrote that 'when the workman is dead, the work shall be remembered'. Given the sad lack of critical recognition from which he suffered for much of his life, it is not surprising that he should find comfort in such a hope. It is true that from the point of view of the pure aesthete, a work of art should be appreciated only for itself, but for the historian, or indeed anyone who is interested in the products and variety of the human mind, it needs a background setting, just as does the most perfect diamond. If the diamond be flawed, how much greater the need for the setting. The poems of Chatterton and the paintings of Haydon would mean little now if they were not set in struggle and tragedy.

Watercolour painting is one of the two branches of the arts in which the British have excelled, and it is the purpose of this book to provide as much information about its practitioners as it has been possible to find and compress into a small space. Obviously, I can say little that is new on Turner or Cox or Cotman, and I have thought it best to devote what might be considered a disproportionate amount of space to the more obscure artists, both professional and amateur. Wherever possible I have tried to provide bibliographies for further and more detailed information. I have covered some six thousand artists, and I know that there must be many more whose talents would have merited their inclusion, had I been able to discover them. Equally, I am certain that further information exists about many whom I have had to leave incomplete. I would, therefore, be grateful for any additional information either on artists who have been included, or on artists of merit whose names and details have been inevitably omitted. This information will be invaluable in the compilation of subsequent revisions.

The only possible method of determining the merit necessary for inclusion has been to use my own judgement, and I make no apology for it. Also, all comments on style, unless otherwise stated, are expressions of personal opinion, and should not be regarded as gospel. In fact I do not set out to compete with the triumvirs of the watercolour collector's world, Roget, Williams and Hardie, merely to complement their work.

One of my main problems has been to decide who is and who is not a watercolourist. Many great oil painters have made occasional watercolour sketches, but I have tried to include these only where the work is of a particularly high quality, or where it has influenced that of others. Another problem has been the final date of 1920, which I chose because after that date there are few new developments — although many able practitioners — and for the greatest artists medium has become something of an irrelevance. Here I have tried to include only artists who had produced a significant body of work by that date.

A book of this sort can never hope to be fully comprehensive. That this one is as complete as it is, is largely due to Caroline Smyth, who has worked with me at all stages of its preparation. It is her book as well as mine.

H.L.M.

ACKNOWLEDGEMENTS

To list all the collectors, dealers and directors and staffs of museums to whom I owe a debt of gratitude for assistance and information would require another volume. It is invidious to do so, but I should especially like to thank the following: the Marchioness of Aberdeen and Temair and the late Marquess of Aberdeen and Temair; Lord and Lady Clitheroe; A.M. Cotman, Esq.; D.A. Fothergill, Esq.; Mr. and Mrs. D. Francis; Thomas Girtin, Esq.; Sidney Gold, Esq.; Mr. and Mrs. Rainsford Hannay; Peter Hadley, Esq.; A.E. Haswell Miller, Esq.; Sir Oliver Millar; Dr. John Nesfield; the Earl of Oxford and Asquith; Matthew Pryor, Esq.; Mr. and Mrs. D. Scott; R.G. Searight, Esq.; Denis Thomas, Esq.; H. Cornish Torbock, Esq.; Ian Fleming Williams, Esq.; Mrs. E.M. Woodward; the Misses Yglesias; John Baskett; the Hon. C.A. Lennox-Boyd; Charles Chrestien; Michael Danny; William Drummond; Andrew Edmunds; Martyn Gregory; Richard Ivor; Beryl Kendal; Anthony Reed; John Robertson; Stanhope Shelton; Bill Thomson; Prue Heathcote-Williams; Andrew Wyld; Noel Annesley and Anthony Browne (Christie's); David Dallas and Mark Fisher (Phillips); John Newton (Sotheby's); Andrew Wilton and Reginald Williams (B.M.); John de Witt (Ashmolean); Francis Greenacre (Bristol); Denis Perriam (Carlisle); David Fraser (Derby); James Holloway (Edinburgh); Caroline Bruce (F.B.A.); Duncan Robinson (Fitzwilliam); Edward Archibald (Greenwich); A.G. Davies (Hertford); Eric J. Stanford (Reading); Dr. John Harris (R.I.B.A.); Malcolm Fry (R.W.S.); Martin Anglesea (Ulster); the Director and staff of the Mellon Centre and the Librarian and staff of the London Library.

Especial thanks are due to Jane Johnson for her researches and Sarah Danny for her typing. Also to Clive Butler for putting up with the mess with so few complaints.

THE ANTIQUE COLLECTORS' CLUB

The Antique Collectors' Club, formed in 1966, pioneered the provision of information on prices for collectors. The Club's monthly magazine *Antique Collecting* was the first to tackle the complex problems of describing to collectors the various features which can influence prices. In response to the enormous demand for this type of information the *Price Guide Series* was introduced in 1968 with **The Price Guide to Antique Furniture,** a book which broke new ground by illustrating the more common types of antique furniture, the sort that collectors could buy in shops and at auctions, rather than the rare museum pieces which had previously been used (and still to a large extent are used) to make up the limited amount of illustrations in books published by commercial publishers. Many other price guides have followed, all copiously illustrated, and greatly appreciated by collectors for the valuable information they contain, quite apart from prices.

Club membership, which is open to all collectors, costs £6.95 per annum. Members receive free of charge *Antique Collecting,* the Club's monthly magazine, which contains well-illustrated articles dealing with the practical aspects of collecting not normally dealt with by magazines. Prices, features of value, investment potential, fakes and forgeries are all given prominence in the magazine.

In addition members buy and sell among themselves; the Club charges a nominal fee for introductions but takes no commission. Since the Club started many thousands of antiques have been offered for sale privately. No other publication contains anything to match the long list of items for sale privately which appears monthly.

The presentation of useful information and the facility to buy and sell privately would alone have assured the success of the Club, but perhaps the feature most valued by members is the ability to make contact with other collectors living nearby. Not only do members learn about the other branches of collecting but they make interesting friendships. The Club organises weekend seminars and other meetings.

As its motto implies, the club is an amateur organisation designed to help collectors to get the most out of their hobby: it is informal and friendly and gives enormous enjoyment to all concerned.

For Collectors — By Collectors — About Collecting

The Antique Collectors' Club, Clopton, Woodbridge, Suffolk.

ABBREVIATIONS USED IN THE TEXT.

A.A.	Associated Artists in Watercolours (1808-1812)
A.J.	*Art Journal,* 1849-1912
A.N.W.S.	Associate of the New Society of Painters in Watercolours
A.O.W.S.	Associate of the ('Old') Society of Painters in Watercolours
A.R.A.	Associate of the Royal Academy
A.R.H.A.	Associate of the Royal Hibernian Academy
A.R.I.	Associate of the Royal Institute of Painters in Watercolours
A.R.S.A.	Associate of the Royal Scottish Academy
A.R.S.W.	Associate of the Royal Scottish Society of Painters in Watercolours
A.R.W.S.	Associate of the Royal Society of Painters in Watercolours
B.I.	British Institution, 1806-1867
B.M.	British Museum
F.R.S.	Fellow of the Royal Society
F.S.A.	Fellow of the Society of Antiquaries
G.G.	Grosvenor Gallery
Hardie	M. Hardie: *Watercolour Painting in Britain,* 3 Vols., 1967-1969
I.L.N.	*Illustrated London News*
N.G.	National Gallery
N.P.G.	National Portrait Gallery
N.W.S.	New Society of Painters in Watercolours, founded in 1831
O.W.S.	'Old' Society of Painters in Watercolours, founded in 1804
P.	President
R.A.	Royal Academy, founded in 1768
R.B.A.	Royal Society of British Artists
R.C.A.	Royal College of Art
R.D.S.	Royal Dublin Society, founded in 1731
R.H.A.	Royal Hibernian Academy
R.I.	Royal Institute of Painters in Watercolours
R.I.A.	Royal Irish Academy
Roget	J.L. Roget: *History of the Old Water Colour Society,* 1891, repr. 1972
R.S.A.	Royal Scottish Academy
R.S.W.	Royal Scottish Society of Painters in Watercolours
R.W.S.	Royal Society of Painters in Watercolours
S.B.A. ⎫ Suffolk Street ⎬	Society of British Artists, founded in 1824. The Galleries were at 6½ Suffolk Street
South Kensington	later Royal College of Art
V.A.M.	Victoria and Albert Museum
Williams	I.A. Williams: *Early English Watercolours,* 1952, repr. 1971

Note: Many of the artistic societies tended to change their names at more or less frequent intervals. In most cases I have not attempted to impose standard initials on them, preferring to use the contemporary varieties. One exception is the R.D.S. which was founded in 1731, but did not receive its Royal Charter until 1820. Owing to the complicated nature of its early history, I have held to R.D.S. throughout. For a discussion of it, and of the other Irish societies, see W.G. Strickland: *A Dictionary of Irish Artists,* 1922, repr. 1965. The O.W.S. received its Charter in 1881, as did the N.W.S., and the S.B.A. followed in 1887. The first two had in fact had previous name changes, which I have found it safest to ignore, the O.W.S. operating as the Society of Painters in Oil and Watercolours between 1813 and 1820, and the N.W.S. as the Institute of Painters in Watercolours from 1863.

ABBEY, Edwin Austin, R.A., A.R.W.S.
1852 (Philadelphia) – 1911 (London)
The son of a merchant, he took his first drawing lessons from a local landscape painter and at a writing school. He worked for a firm of wood engravers and studied at the Pennsylvania Academy before moving to New York to work for Harper's in 1871. In 1878, he was sent to England to illustrate an edition of Herrick, and after a brief visit to New York three years later, settled in London and the Cotswolds. He was a member of the R.I. from 1883 to 1893, transferring to the R.W.S. in 1895. He was elected A.R.A. and R.A. in 1901 and 1902.

He was best known as a black and white illustrator, and his full watercolours are rare. They are mostly of figure or genre subjects.

Illustrated: *The Comedies of Shakespeare*, 1904.
Examples: Ashmolean.
Bibliography: E.V. Lucas: *E.A.A.*, 1921. *A.J.*, 1911. Yale University: *The E.A.A. Collection*, 1939.

ABBOT, Henry **1768 (London) – 1840 (London)**
An artist who, in 1820, published twenty-four engravings of Roman Antiquities after his own drawings, which he had made on the spot in 1818.

ABBOTT, John White **1763 (Exeter) – 1851 (Exeter)**
A friend and pupil of F. Towne (q.v.), he was educated and spent nearly all his life in Exeter, where he practised as a surgeon. In 1791 he made his only extended journey outside the West Country, a sketching tour of Scotland, the Lake District, Lancashire, Derbyshire and Warwickshire. From 1793 to 1805 he exhibited oil paintings at the R.A. as an honorary exhibitor. In 1797 he toured Monmouthshire, and again in 1827 when he also visited Gloucestershire and Wiltshire. He exhibited again at the R.A. in 1810 and 1822. In 1825 he inherited the estate of Fordlands, near Exeter, and in 1835 he was appointed a Deputy Lieutenant for the County.

His drawing style is always very close to that of his master, with neat pen outlines and light, clear colour washes or grey wash. He rarely approaches Towne's grandeur and is often at his best dealing with the details of foliage, bank and water. His drawings are generally monogrammed and often inscribed on the reverse.

Examples: B.M.; V.A.M.; Ashmolean; Cecil Higgins A.G., Bedford; Coventry A.G.; Exeter Mus.; Fitzwilliam; Leeds City A.G.; Leicestershire A.G.; N.G., Scotland; Newport A.G.; Ulster Mus.; York A.G.
Bibliography: *Walpole Soc.* XIII, 1925. *Apollo*, March 1933.

ABNEY, Hepzibah
A landscape painter, who was working between 1790 and 1822.

ABRAHAM, Francis Xavier 'Frank' 1861 – 1932 (Hartshill)
A pottery designer, who studied at the Stoke-on-Trent Art School and at South Kensington. He then worked for a number of Staffordshire firms and occasionally painted watercolours. He exhibited at the R.I. in 1887.

ABRAHAM, Lilian
A London painter of flowers and genre subjects. She exhibited at the R.I. and the R.B.A. from 1880 to 1886.

ABSOLON, John, R.I. **1815 (Lambeth) – 1895**
A landscape and figure painter in oil and watercolour and a book illustrator, he began his career as a portraitist and scene painter at Drury Lane and Covent Garden. He first exhibited at Suffolk Street in 1832, then in 1835 went to Paris for three years. On his return he was elected to the N.W.S., from which he resigned in 1858 to concentrate on oil painting. However, he rejoined in 1861 and was Treasurer for many years. He returned to Paris for a time from 1839, working as a miniaturist, and visited Italy and Switzerland in about 1858. He also made drawings of the fields of Crecy and Agincourt which were published by Graves in 1860.

His work is very varied in quality, and his drawing is sometimes rather sloppy, but he had a good eye for colour. His beach scenes can occasionally approach Constable at his most impressionistic.

Examples: B.M.; V.A.M.; Ashmolean; Grundy A.G., Blackpool; Leeds City A.G.; Sydney A.G.; Ulster Mus.
Bibliography: *A.J.*, 1862; 1895.

ACLAND, Sir Henry Wentworth, Bt., F.R.S.
1815 (Killerton) – 1900 (Oxford)
Fourth son of Sir T.D. Acland (q.v.), he was educated at Harrow and Christ Church, and from 1838 he spent nearly two years cruising in the Mediterranean. In 1840 he was elected a Fellow of All Souls and began to study medicine. From 1843 to 1845, he lived in Edinburgh, and he later became Regius Professor at Oxford and President of the B.M.A. In 1860 he visited America with the Prince of Wales, and in 1890 he was created a baronet. He made illustrations for a number of his publications.

Published: *The Plains of Troy*, 1839. *The Oxford Museum*, 1859. Etc.
Bibliography: J.B. Atlay: *Sir.H.W.A., Bt.*, 1903.

ACLAND, Sir Thomas Dyke, 10th Bt.
1787 (London) – 1871 (Killerton)
Politician, philanthropist and amateur artist. He was educated at Christ Church and was in and out of Parliament, where he was regarded as 'the head of the religious party', from 1812 to 1857. A number of his sketches of English and Continental scenery were worked up by F. Nicholson (q.v.).

Other members of the family who were amateur artists include HUGH DYKE ACLAND (1778-1836) who painted a brown wash view in the Tyrol which passed through Sotheby's in June 1975. A CAROLINE ACLAND made rather weak brown wash drawings of Rome in about 1820.

ACOCK, Walter William **– ?1933**
A painter of still-lifes and landscapes who exhibited in 1870 and 1871, and taught drawing in Croydon. For the last thirty years of his life he was blind.

ACRAMAN, William Henry
A painter of landscapes and birds who was working in Hastings in 1851. He exhibited in London from 1856 to 1868. He was also a Professor and seller of Music, and compositions of his were published in 1886 and 1893.

ADAM, James **1730 (Kirkaldy) – 1794 (London)**
Architect and landscape draughtsman, he was the third son of William Adam and the younger brother of R. Adam (q.v.). He toured Italy from 1760 to 1763 with Clerisseau and Zucchi, returning to work in partnership with Robert in London, Edinburgh, Glasgow and elsewhere.

Examples: Soane Mus.; Register Ho., Edinburgh.
Bibliography: J. Swarbrick: *Robert Adam and his Brothers*, 1915. A.T. Bolton: *The Architecture of Robert and J.A.*, 1922. D. Yarwood: *Robert Adam*, 1970.

ADAM, Joseph Denovan, R.S.A., R.S.W.
1842 (Glasgow) – 1896 (Glasgow)
The son and pupil of a landscape painter who brought him to London at an early age. He studied at South Kensington and made

several visits to Scotland, returning to live there in 1871. He exhibited at the R.A. from 1858 to 1880, and was elected A.R.S.A. and R.S.A. in 1884 and 1890. From 1887 he ran an art school near Stirling, and he had a considerable influence on the Glasgow School. He was particularly noted for his mountain landscapes with sheep and cattle in both oil and watercolour.

Examples: Glasgow A.G.

ADAM, Robert, F.R.S., F.S.A. 1728 (Kirkaldy) – 1792 (London)
The architect, he was the second son of William Adam, the Scottish Palladian. He was educated in Edinburgh, and was a competent artist by the age of fourteen. In 1754 he set off on the Grand Tour, travelling as far as Rome with the Hon. Charles Hope. In Rome he worked with Clerisseau, and in 1757 he moved to Venice and Diocletian's Palace on the Dalmatian coast. He returned to England the following January by way of the Rhine. He was the head of the family architectural partnership, setting up the London office, and for thirty years he imposed his style on English decoration. At the time of his death he was working on eight public and twenty-five private commissions. From 1765 he was Surveyor of Chelsea Hospital and, from 1769, M.P. for Kinross.

His original drawings, as distinct from his plans and elevations, are romantic and picturesque in feeling. They are generally in ink and grey wash, and show castles and river gorges. He was much influenced by Piranesi in Rome and by his own studies at Diocletian's Palace.

Published: *Ruins of the Palace of the Emperor Diocletian at Spalatro*, 1764. *A Book of Mantels*, 1901.
Examples: B.M.; V.A.M.; Exeter Mus.; Fitzwilliam; Leeds City A.G.; N.G., Scotland; Soane Mus.
Bibliography: P. Fitzgerald: *R.A.*, 1904. J. Fleming: *R.A.*, 1962. *Burlington*, LXXX, 1942; CXI, 1969. Kenwood: *Exhibition Cat.*, 1953. *Connoisseur*, CXXXVII, 1956; CXLVI, 1960.

ADAMS, Albert George
A landscape and coastal painter in oil and watercolour, he specialised in views on the South and South Welsh coasts and visited the Channel Islands in about 1877. He exhibited in London from 1854 to 1887.

ADAMS, Caroline, Charlotte and Lucy
Three sisters who lived at Billericay, where their father was probably a doctor, and in London. Caroline exhibited from 1834 to 1837 and was teaching in London as early as 1828, and Lucy from 1815 to 1843. Both Lucy and Charlotte were candidates for the N.W.S. in 1839, Lucy trying again the following year, and one of them in 1848. In the B.M. there is a very impressive beach scene by Charlotte, rather in the earlier manner of Cox or Prout. While Caroline and Charlotte confined themselves to landscapes, Lucy also painted portraits and literary subjects. She may have been the author of *Ben Saunders, A Tale for Mothers*, 1852, and Charlotte may have produced improving literature from 1838 to 1866. They are unlikely to be the 'three Misses Adams' met by Farington in 1796.

ADAMS, Charles James 1859 (Gravesend) – 1931
A landscape painter who was a pupil of W. Pilsbury (q.v.). He lived and worked in London, Leicester and Surrey, and also studied at the Leicester School of Art. He made a number of lithographs early in his career and painted some watercolours, but the bulk of his work is in oil. He also painted animals, history and genre subjects.

Examples: Leicestershire A.G.

ADAMS, James 1785 (Plymouth) –
An architect and draughtsman, who was a pupil of John Soane from 1806 to 1809. He entered the R.A. Schools in 1808 and exhibited designs at the R.A. in 1818 and 1819. At that time he was living in Plymouth, and he designed the Freemasons' Hall there in 1827. He may have been working as late as 1845.

Published: *The Elements of the Ellipse etc.*, 1818.

ADAMS, John Clayton 1840 – 1906 (nr. Guildford)
A landscape painter who lived at Edmonton and near Guildford and exhibited at the R.A., the N.W.S. and elsewhere from 1863. The majority of his subjects were Surrey views.

Examples: V.A.M.

ADDISON, William Grylls – 1904
A painter and etcher who lived in London and Kent and occasionally exhibited watercolours at the R.I. from 1876.

Examples: V.A.M.

ADYE, General Sir John Miller
 1819 (Sevenoaks) – 1900 (Rothbury)
Soldier and sketcher, he was a member of a military family and entered Woolwich Academy in 1834. He was commissioned in the Artillery in 1836, and was posted to Malta in 1840 and Dublin in 1843. He was at the Tower of London in 1848 during the Chartist troubles and also in Gibraltar. Thereafter he served in the Crimea from 1854 to 1856, in Ireland in 1857, and in India during the suppression of the Mutiny and for nine years thereafter. He returned to the Crimea in 1872 to report on the state of the war graves, and in 1875 he was appointed Governor of Woolwich Academy. He was Chief of Staff to the expedition against Arabi Pasha in 1882, and was appointed Governor of Gibraltar at the end of that year. He was promoted General in 1884 and retired two years later.

Published: *Recollections of a Military Life*, 1895. Etc.

AFFLECK, William 1869 (Rochdale) – 1909
A genre painter who exhibited from 1890. He lived in London and also painted flowers and spring and autumn landscapes.

AGLIO, Agostino 1777 (Cremona) – 1857 (London)
An Italian who settled in England in 1803, and worked as a scene painter, decorator, lithographer and landscape painter. Before his arrival in England he had visited Greece and Egypt with William Wilkins, R.A., and he worked with Wilkins in Cambridge in 1803 and 1804. In London he worked at the Opera House in 1804, Dury Lane Theatre in 1806 and the Pantheon in 1811. He also worked at the Olympic Theatre and Buckingham Palace. He visited France, Germany and Italy in 1825.

His watercolours, especially coastal views, are often very close to those of Constable, and indeed are often attributed to the greater artist. They are usually rather free and blobby in technique, with slightly clumsy figures and a predominance of greys and blue-greens.

His son, AGOSTINO AGLIO, YR., also known as Augustine, (1816-1885) was a drawing master and married a daughter of J. Absolon (q.v.).

Published: *Twelve Pictures of Killarny. A Collection of Capitals and Friezes drawn from the Antique*, 1820. *Sketches and Decorations in Woolley Hall, Yorkshire*, 1821. *Studies of various Trees and Forest Scenery*, 1831. *Antiquities of Mexico*, 1830-48.
Examples: B.M.; V.A.M.; N.G., Scotland.
Bibliography: F. Sacchi: *Cenni sulla vita e le opere di A.A.*, 1868. *Apollo*, November 1940; November 1943.

AIKIN, Edmund 1780 (Warrington) – 1820
An architect and draughtsman who entered the R.A. Schools in 1801 and practised in London until 1814. He then moved to Liverpool, but also worked on dockyards at Sheerness, Portsmouth and elsewhere. His architecture is usually Greek in inspiration, but occasionally Gothic.

Published: *Designs for Villas and other Rural Buildings*, 1808.
Bibliography: L. Aikin: *Memoir of John Aikin, M.D.*, 1823.

AIKMAN, George, A.R.S.A. 1830 – 1905
An Edinburgh landscape painter and etcher who exhibited at the R.S.A. and elsewhere from 1850 to 1905. His watercolours often have an admixture of bodycolour.

Illustrated: J. Smart: *A Round of the Links*, 1893. T. Chapman and J. Strathesk: *The Midlothian Esks*, 1895.

AINSLEY, Colonel Henry Francis c.1805 – 1879
He joined the Army in 1824 and was posted to India in 1849, serving in Sind from 1850 to 1853.

Examples: V.A.M.; India Office Lib.

AINSLEY, Samuel James 1806 – 1874
A landscape and figure painter and print-maker, who was in Italy in 1842 and 1843 working with G. Dennis on his *Cities and Cemeteries of Etruria*. He produced both wash and full colour drawings using a wet technique reminiscent of that of de Wint.

Examples: B.M.

AITKEN, James Alfred, A.R.H.A., R.S.W.
1846 (Edinburgh) – 1897 (Glasgow)
A landscape painter in oil and watercolour who trained under H. MacCulloch (q.v.) and then went with his family to Dublin where he entered the R.D.S. Schools. He exhibited at the R.H.A. from 1865 and was elected an Associate in 1871. The following year, he married and moved to Glasgow, exhibiting at the R.S.A., the R.S.W. and the Glasgow Institute. He was a founder member of the R.S.W. as well as of the Pen and Pencil Club, and he travelled extensively in America and on the Continent.

Examples: Glasgow A.G.

ALBERT see MARKES, Albert Ernest

ALBERT Charles Augustus Emmanuel, H.R.H. Prince
1819 (Rosenau) – 1861 (Windsor)
An occasional etcher and draughtsman who took hints from many professional artists, including Sir E. Landseer (q.v.).

Examples: B.M.

ALBIN, Eleazar
A naturalist and painter of birds and flowers who changed his name from Weiss on coming to England from Germany. He worked in this country from 1713 to 1759.

Published: *Natural History of English Insects*, 1720. *Natural History of the Birds*, 1731-38. *A Natural History of Spiders*, 1736. *A Natural History of English Song-Birds*, 1737.
Bibliography: *Country Life*, December, 1963.

ALDAY, Paul
The proprietor of a Dublin music shop, he was an amateur violinist and watercolour painter. He exhibited with the Dublin Society of Artists in 1809, and at the R.H.A. in 1826 and 1827. For the most part, he painted landscapes.

ALDIN, Cecil Charles Windsor 1870 (Slough) – 1935
A sporting and humorous artist, and prolific illustrator. He studied at South Kensington under Calderon. He was a keen countryman and was Master of the South Devonshire from 1914 to 1918. His style is made up of simple washes and outlines like that of Caldecott. There is sometimes the feel of a Japanese woodcut about his work.

Bibliography: C.A.: *Time I was Dead*, 1934.

ALDRIDGE, Frederick James 1850 – 1933
A marine painter somewhat in the manner of T.B. Hardy, he lived at Worthing and painted the Channel coasts. He was a regular visitor to Cowes Week, and held exhibitions at Brighton in 1909 and Dorchester the following year. He exhibited in London from 1880 to 1901.

His work is generally rather loose in drawing and the predominant colours are a yellow-green and brown.

Examples: Preston Manor, Brighton; Dudley A.G.

ALEFOUNDER, John – 1795 (Calcutta)
The son of an architect and surveyor, he studied architecture at the R.A. Schools, winning the silver medal in three successive years from 1782. In 1784 he went to India where he painted miniatures, and oil and watercolour portraits. He exhibited at the R.A. from 1777 to 1793.

ALEXANDER, Edwin John, R.S.A., R.W.S., R.S.W.
1870 (Edinburgh) – 1926 (Musselburgh)
His boyhood interest in botany and animal life, combined with the influence of Joseph Crawhall, a friend of his father Robert Alexander, R.S.A., formed his whole artistic outlook. In 1887 the two Alexanders and Crawhall made a long visit to Tangier, and in 1891 he studied under Fremiet in Paris. He lived in Egypt from 1892 to 1896. In 1904 he married, and settled in Inveresk where he kept a large private zoo to supply himself with models. He was elected A.R.S.A. and R.S.A. in 1902 and 1913, R.W.S. in 1910 and R.S.W. in 1911.

He is best remembered for his bird and animal drawings, in which, although always accurate in detail, he avoids overloading the composition, and the effect is always rather simplified. Both in these and in his landscapes he often works on textured papers, fabrics, silks or linen. He knows exactly how best to work the defects and blemishes of his surfaces into the composition. His landscapes, which reflect the current interest in Japanese art, show the same ability to select significant detail.

Illustrated: J.H. Crawford: *The Wild Flowers*, 1909. C.W.G. St. John: *Wild Sports and Natural History of the Highlands*, 1919.
Examples: B.M.; Aberdeen A.G.; Cartwright Hall, Bradford; Dundee City A.G.; Glasgow A.G.; Kirkaldy A.G.; N.G., Scotland.
Bibliography: O.W.S. Club, IV, 1926.

ALEXANDER, Herbert, R.W.S. 1874 (London) – 1946
A traditional romantic landscape and figure painter in the line of Palmer, Foster and J.W. North. He was educated in Cranbrook, Kent, and studied under Herkomer at the Slade. During the First World War, he served in India and Mesopotamia. He was elected A.R.W.S. and R.W.S. in 1905 and 1927. He lived in Cranbrook for much of his life, and his subjects are often Kentish and show an eye for picturesque detail.

Examples: Ulster Mus.
Bibliography: *Studio*, XXXI, 1904.

ALEXANDER, John
A Scottish painter and engraver who was working in Rome in 1718. He was back in Scotland in 1720, where he painted portraits and mythological subjects. The B.M. has a drawing of Rome in pen and brown ink, blue and brown wash. It is rather untidy.

ALEXANDER, Robert Graham Dryden
1875 (London) – 1945 (London)
An amateur landscape painter, who was the son of strict Presbyterian parents. Rather grudgingly, they allowed him a year or two to study art before placing him safely in the family business in the City. He studied at the B.M., the Hornsea School of Art – where, through his future wife, he came under the influence of H.B. Brabazon (q.v.) – and later at the Slade. The majority of his views are of Essex subjects, since he lived in Brentwood and often stayed at Walton-on-the-Naze. He was a very rapid worker, which was lucky as he was only able to paint early in the morning, on Saturday afternoons (never on a Sunday) and during his two-week annual holiday.

He was most influenced by Turner, Constable, Brabazon and Wilson Steer and was a close friend of Sir George Clausen and of Mark Fisher. He was a regular exhibitor at the N.E.A.C., and, in 1922 shared an exhibition at the Grosvenor Galleries with Sir Charles Holmes and others.

Examples: B.M.; V.A.M.; Ashmolean; Fitzwilliam.

ALEXANDER, William 1767 (Maidstone) – 1816 (Maidstone)
The son of a coach builder, he was a pupil of Pars and Ibbetson, and studied at the R.A. Schools. He went to China in 1792 as a draughtsman attached to Lord Macartney's Embassy, and some of his best drawings of its progress were used to illustrate Sir George Staunton's account, published in 1797. The other official artist was T. Hickey (q.v.). In 1802 he was appointed Professor of Drawing at the Military College at Great Marlow, a post which he relinquished in 1808 on being appointed Keeper of Prints and Drawings at the B.M. He continued to re-use his Chinese material throughout his career, although later in life he also made many factual drawings of antiquities and some very charming English landscapes.

Published: *Views of the Headlands, Islands etc. . . . of China*, 1798. *The Costumes of the Russian Empire*, 1803. *The Costumes of China*, 1805. *Engravings from the Egyptian Antiquities in the B.M.*, 1805. *Picturesque Representations of the Dress and Manners of the Austrians*, 1813. *Picturesque Representations of the Dress and Manners of the Russians*, 1814. *Picturesque Representations of the Dress and Manners of the Chinese*, 1814. *Picturesque Representations of the Dress and Manners of the Turks*, 1814.
Illustrated: Sir G. Staunton: *An Authentic Account of an Embassy . . .* , 1797. Sir J. Barrow: *Travels in China*, 1804. Sir J. Barrow: *Voyage to Cochin China*. 1806. J. Britton: *Architectural Antiquities*, 1805-14.
Examples: B.M.; V.A.M.; Ashmolean; Fitzwilliam; Greenwich; India Office Lib.; Leeds City A.G.; Maidstone Mus.
Bibliography: *Gentleman's Mag.* LXXXVI, ii, p.279, 369. *Geographical Mag.*, September 5, 1947.

ALFORD, Marianne Margaret, Viscountess
'Lady Marian Alford' 1817 (Rome) – 1888 (Ashridge, Berkhamsted)
Daughter of the 2nd Marquess of Northampton, she spent her early life in Italy, coming to England in 1830. In 1841 she married Lord Alford, who died ten years later. She helped to establish the Royal School of Art-Needlework in Kensington, and was an accomplished artist in various media, as well as a generous patron.

ALICE Maud Mary, H.R.H. Princess
Grand-Duchess of Hesse 1843 (Buckingham Palace) – 1878 (Hesse)
The third child of Queen Victoria (q.v.). Like her sisters, she was taught by E.H. Corbould (q.v.). She painted rather dainty little figure studies.

Bibliography: C. Bullock: *Doubly Royal*, 1879.

ALKEN, Henry Thomas 1785 (London) – 1851 (London)
In the naming of their children, the Alken family showed a carelessness of future biographers bordering on the callous. Among the painters there are two Samuels, two Seffriens and a Seffrien John, two, if not three Georges, Henry Thomas and Henry Gordon – who is also sometimes given as Samuel Henry. Of these, the Samuels, one Seffrien and Henry Gordon are separately noticed.

Henry Thomas was the son of the elder Samuel, who gave him his first lessons. He also studied with J.T. Barker Beaumont, the miniaturist, whose influence is noticeable in Alken's figure work. In 1801 Alken exhibited miniatures at the R.A. It is possible that he spent a period in the Army, and he may have visited Persia with J.J. Morier. In 1809 he married Maria Gordon at Ipswich, and the following year they went to live in Melton Mowbray. To raise money, he schooled horses, and, between 1810 and 1816, he even tried his hand at decorating papier-mâché trays with hunting and coaching scenes. His first prints, which appeared under the pseudonym of 'Ben Tally Ho!', were published in 1813, and his best drawings and prints date from the 1820s and 1830s, after which both his health and the quality of his work declined. His popularity was also falling off, and he died an embittered and penniless man.

He was a meticulous and colourful painter, and of his hunting subjects it was said 'No fox-hunter will find matter to cavil at there.' In some ways his prints may be regarded as graphic journalism, illustrating actual events and real characters, but in the best of them there is a sense of excitement and speed which raises them above mere reporting. In many, even the overtly serious ones, there is a touch of satire. One of his trade marks is to show his characters taking their fences with the right arm raised above the head, flourishing the whip.

Examples: B.M.; V.A.M.; Fitzwilliam; Leeds City A.G.; Leicestershire A.G.; N.G., Scotland.
Bibliography: W. Shaw Sparrow: *H.A.*, 1927. F. Siltzer: *The Story of British Sporting Prints*, 1929. A. Noakes: *The World of H.A.*, 1952. *Queen*, CXVIII, 1905. *Apollo*, XXXVII, 1943. *Country Life*, October 9, 1969.

ALKEN, Samuel 1756 (London) – 1815 (London)
The eldest son of Seffrien Alken, a carver and gilder, he began his career as an architectural draughtsman and probably intended to practise architecture. However, his skill as an etcher and aquatinter turned him to art. He worked with many of the most celebrated print-makers and artists of the day, including Bartolozzi, Rowlandson and George Garrard and was the first of his family to excel in sporting subjects. He also produced a number of purely topographical drawings and prints, some from the Bristol area.

Published: *A New Book of Ornaments*, 1779.

ALKEN, Samuel, Yr. 1784 (London) – 1825 (London)
Eldest son of Samuel Alken, with whom, since he hardly ever differentiated his signature, he is often fused or confused. He was also a sporting painter, with an emphasis on fishing subjects. As with the two Henrys, perhaps the only way of telling the work of son from father is through their lesser quality.

ALKEN, (Samuel) Henry Gordon 1810 (Ipswich) – 1894 (London)
Often described as a faker of his father H.T. Alken's work, he was certainly a close disciple and was usually content to sign himself 'H. Alken' *tout court*. He worked in both oil and watercolour.

ALKEN, Seffrien, Yr. 1821 – 1873 (London)
A younger son of H.T. Alken, in whose manner he inevitably worked. He produced some racing subjects which are of a high quality. An earlier Seffrien (1754-c.1778) may well have been a sporting painter, and H.T. Alken's younger brother Seffrien John (b.1796) certainly was. He shared a studio with George Alken, who was probably another brother and died c.1835.

ALLAN, Sir Alexander 1764 – 1820
After service in the Madras Native Infantry from 1780, he resigned as a major in 1804. He became a Director of the East India Company in 1814. He made many pen and watercolour drawings of the third and fourth Mysore Wars.

Published: *Views in the Mysore Country*, 1794.
Examples: India Office Lib.

ALLAN, David 1744 (Alloa) – 1796
He was apprenticed to Robert Foulis, a Glasgow printer, and was sent to study painting in Rome in 1764. From 1777 to 1779 he was in London, and then he returned to Edinburgh, where he spent the rest of his life, becoming Master of the Trustees' Academy in 1786. He worked in a number of media, producing both Italian and Scottish landscapes, as well as studies of Edinburgh and Continental characters. He also made a number of pen and wash illustrations for Shakespeare and for a life of Mary, Queen of Scots. In his homely Scottish subjects, he was a precursor of Wilkie and his school. H.W. Williams (q.v.) was one of his pupils.

Illustrated: A. Ramsay: *The Gentle Shepherd*, 1788. A. Campbell: *An Introduction to the History of Poetry in Scotland*, 1798.
Examples: B.M.; Glasgow A.G.; N.G., Scotland.
Bibliography: T.C. Gordon: *D.A.*, 1951.

ALLAN, Robert Weir, R.W.S. 1851 (Glasgow) – 1942

A landscape and marine painter in oil and watercolour, who came to London in 1881. He was elected A.R.W.S. and R.W.S. in 1887 and 1896. Although much of his best work was painted on the coasts of Scotland, he also worked in Holland, Belgium, France and Italy. He visited India from 1890 to 1892 and Japan in 1907, and he made a world tour in 1900. His watercolours are generally rather weak in effect, and tend to be blotty in technique.

Examples: Glasgow A.G.; City A.G., Manchester.
Bibliography: *Studio*, XXIII, pp.229-237.

ALLAN, Sir William, R.A., P.R.S.A.
 1782 (Edinburgh) – 1850 (Edinburgh)

The son of a macer in the Court of Session, he studied at the Trustees' Academy and the R.A. Schools. In 1805 he went to Russia, staying there for nine years. He then returned to Edinburgh, becoming Master of the Academy in 1820. He was elected R.S.A. and P.R.S.A. in 1829 and 1837, and A.R.A. and R.A. in 1825 and 1835. In 1842 he succeeded Wilkie as Queen's Limner in Scotland, and in 1844 he revisited Russia. He painted Russian and Scottish historical subjects.

Examples: B.M.
Bibliography: *A.J.*, 1849.

ALLASON, Thomas 1790 – 1852

An architect and draughtsman, he was a pupil of W. Atkinson (q.v.) and entered the R.A. Schools in 1808. In 1814 he went to Greece as a draughtsman for Messrs. Spencer Stanhope. He later became Surveyor to the Stock Exchange and to other bodies and estates, and he also designed many villas.

Published: *Picturesque Views of the Antiquities of Pola in Istria,* 1817.
Illustrated: *The Battle of Platoea,* 1817. *The Actual State of the Plain of Olympia etc.,*1824.

ALLCHIN, William T Howell 1844 – 1883

The organist of St. John's College, Oxford, from 1876 to 1883, he copied still-lifes in oil and watercolour, and made spirited but very amateur caricatures of such incidents as Ruskin's road building venture.
Examples: Ashmolean.

ALLEN, George 1798 – 1847

An architect who entered the R.A. Schools in 1818 and exhibited at the R.A. from 1820 to 1840. He was widely employed as a surveyor and worked in Southwark.

Published: *Plans and Designs for the future Approaches to the New London Bridge,* 1827-8.

ALLEN, Isabella Anne

A number of flower studies by this artist, dated 1829, passed through Sotheby's on February 2, 1973.

ALLEN, Major John Whitacre

A landscape painter who lived in Bath and Cheltenham and who visited Italy and Greece. He exhibited in London from 1859 to 1886, mostly at Suffolk Street and the N.W.S. for which he was an unsuccessful candidate in 1864 and 1867. He was promoted captain in 1865 and major in 1870.

ALLEN, Joseph William 1803 (Lambeth) – 1852

Allen was educated at St. Paul's and worked as an usher at Taunton Academy before taking up painting. He then painted scenery with C. Stanfield (q.v.) at the Olympic Theatre and elsewhere, and exhibited rather grandiose oil paintings at the R.A. from 1826. He also exhibited at the N.W.S. and became Secretary of the S.B.A. and the first drawing master at the City of London School. His watercolours are rather in the manner of Cox.

Examples: B.M.; V.A.M.
Bibliography: *A.J.* October, 1852.

ALLEN, Thomas John 1821 – 1846

A painter of architectural subjects.

ALLEN, William Herbert 1863 (London) –

A landscape painter in oil and watercolour who studied at the R.C.A. and was made Principal of the Farnham School of Art in 1888. He worked on commission for the V.A.M. and other museums, painting in France and Italy. He was elected to the R.B.A. in 1904.

Examples: Curtis Mus., Alton.
Bibliography: Curtis Mus., Alton: *Illustrated Handbook to the W.H.A. Bequest,* 1945.

ALLERSTON, John Taylor

A draper, stationer and photographer at Bridlington, who became a professional marine artist in about 1900. He is said to have painted some two thousand local coastal scenes in oil and watercolour.

Examples: Bridlington Lib.; Ferens A.G., Hull.

ALLINGHAM, Helen, Mrs., née Paterson, R.W.S.
 1848 (near Burton-on-Trent) – 1926 (Haslemere)

The daughter of a doctor, she studied at the Birmingham School of Design and came to London and the R.A. Schools in 1867. There she was particularly influenced by the work of Birket Foster and Fred Walker. She visited Italy in the spring of 1868, and in 1874 she married the Irish poet William Allingham, author of 'Up the airy mountain'. This placed her at the centre of the Cheyne Walk set. She was elected A.R.W.S. in 1875, and when in 1890 full membership was opened to ladies, she was immediately promoted.

Her subject matter is reflected in her husband's poem:
> 'Four ducks on a pond,
> A grass-bank beyond,
> A blue sky of spring,
> White clouds on the wing:
> What a little thing
> To remember for years –
> To remember with tears!

Her colours are always fresh and bright with a predominance of yellow in the palette. Her cottages in Surrey and Berkshire are a little idealised, but less sentimental than those of Foster. Her occasional small portraits are very beautiful indeed.

Illustrated: .J.H. Ewing: *A Flat Iron for a Farthing,* 1884. S. Dick: *The Cottage Homes of England,* 1909.
Examples: B.M.; V.A.M.; City A.G., Manchester; Maidstone Mus.; Ulster Mus.
Bibliography: H.B. Huish: *Happy England as painted by H.A.,* 1903. *A.J.,* 1888.

ALLOM, Thomas 1804 (London) – 1872 (Barnes)

During a seven year apprenticeship to the architect Francis Goodwin beginning in 1819, he helped draw up the plans for the Kensal Green Cemetery. Later he was a co-founder of the R.I.B.A. and worked with Sir C. Barry (q.v.) on Highclere and the Houses of Parliament. He travelled widely in Europe, the Near and Far East, drawing houses and landscapes for publication, often by Virtue & Co. and Heath & Co.

He worked in brown wash and in full watercolour, and was essentially a topographer, working neatly, accurately, pleasingly and without great originality.

Illustrated: Fisher: *Constantinople and its Environs,* G.N. Wright: *China in a Series of Views,* 1843. G.N. Wright: *France Illustrated,* 1845. Etc.
Examples: B.M.; V.A.M.; Fitzwilliam; Glasgow A.G.; Grosvenor Mus., Chester; N.G., Scotland; Newport A.G.

ALLPORT, Henry C.

Probably the 'Cousin Allport' who gave Cox his first paint-box and helped him to his first scene-painting job in Birmingham, he lived at Aldridge between Lichfield and Birmingham and taught drawing in

the latter city from 1808. He exhibited at the R.A. in 1811 and 1812 and at the Oil and Watercolour Society from 1813, to which he was elected in place of Glover in 1818. He showed a few Italian views from 1819, and was re-elected as an Associate of the re-constituted O.W.S. in 1823, but exhibited for the last time in that year, giving a Lichfield address. Dr. Percy believed that he subsequently went into the wine trade, but this is possibly *ben trovato.*

Examples: B.M.; V.A.M.; Stafford Lib.; Ulster Mus.

ALMOND, William Douglas, R.I. 1868 (London) – 1916 (London)
An illustrator of Anglo-Scottish parentage, he was on the staff of the *I.L.N.* He also worked for the *English Illustrated Magazine* and the *Studio,* and he exhibited at the R.A., the R.I. and elsewhere from 1886. He was elected R.I. in 1897.

ALPENNY, Joseph Samuel 1787 (Ireland) – 1858
After studying in London, where he exhibited at the R.A. from 1805 to 1808 as 'J.S. Halfpenny', he moved to Ireland in 1810. From 1812 he lived in Dublin and used the name Alpenny. He was a prolific exhibitor in Dublin exhibitions, but in about 1824 he returned to London, exhibiting at the R.A. from 1825 to 1853.

His work includes portraits, figure and historical subjects and ceremonial pictures in oil and watercolour.

Published: *Alpenny's New Drawing Book of Rustic Figures,* 1825.
Examples: N.G., Ireland.

ALTHAUS, Fritz B (London) –
A landscape and coastal painter who first learnt to draw from his mother, an amateur portraitist. He studied under A.H. Haig (q.v.) as well as at St. Martin's School of Art and later Westminster School of Art and the R.I. He exhibited from 1881 and lived in London until 1893 when he moved to Exeter. He painted the moors and coasts of Devon and Cornwall and in Oxford, Cambridge and the Channel Islands. In 1908 he was living in Headingley, but disappears from the directories in 1914, perhaps because of the War.

AMHERST, Sarah Elizabeth, Countess 1762 – 1838
The daughter of Lord Archer, she married firstly Other Hickman, 5th Earl of Plymouth, and secondly in 1800, William Pitt, 2nd Lord Amherst. Amherst led a mission to China in 1816, which failed in its objectives owing to his laudable refusal to kowtow to the Emperor. He was appointed Governor-General of India in 1823, and directed the Burmese War of the following year. In 1826 he was created Earl Amherst and he retired in 1828. Lady Amherst made numerous sketches in India, which she worked up in the de Wint manner on her return to England. The Earl married the widow of the 6th Earl of Plymouth in 1839. He had been a pupil of J.B. Malchair (q.v.).

Examples: India Office Lib.

ANDERSON, John 1835 (Scotland) – 1919
A painter of Warwickshire landscapes in oil and watercolour. He lived in Coventry and exhibited in London between 1858 and 1884. He taught at the Coventry School of Art from 1880 to 1884 and also painted on the Thames, in Devon and in Venice.

Examples: Coventry A.G.

ANDERSON, Robert, A.R.S.A., R.S.W.
** 1842 (Edinburgh) – 1885 (Edinburgh)**
An engraver and watercolourist who painted landscapes, seascapes and figure subjects. He exhibited at the R.A. and R.I. from 1880 to 1884 and was elected A.R.S.A. in 1879.

ANDERSON, William 1757 (Scotland) – 1837
Originally a shipwright, he came to London and became a painter in both oil and watercolour, exhibiting at the R.A. from 1787 to 1834. He was a close friend of J.C. Ibbetson, but does not seem to have been influenced stylistically by him. His drawings 'show the formal vision of the eighteenth century without the crudeness or naivity of

many of the eighteenth century ship painters'. He specialised in river and harbour scenes, which are usually calm and luminous. His watercolours are generally signed and dated, but his rare monochromes are not. He also produced large numbers of figure sketches and occasional landscapes. In 1825 he published a pamphlet upholding the lawfulness of war.

Examples: B.M.; V.A.M.; Fitzwilliam; Greenwich; Ulster Mus.

ANDREWS, George Henry, R.W.S.
** 1816 (Lambeth) – 1898 (London)**
A professional engineer who painted marine subjects and drew for the *I.L.N.* and the *Graphic.* He exhibited from 1840 until his death, and was elected A.O.W.S. and O.W.S. in 1856 and 1878, becoming Treasurer. He is presumably the artist who accompanied Howard Vyse to Gizeh in 1836 and illustrated his *Operations at the Pyramids of Gizeh,* 1840.

Illustrated: J. Corbet Anderson: *English Landscapes and Views,* 1883.
Examples: V.A.M.; Greenwich; Nat. Mus., Wales.

ANDREWS, Henry – 1868
A genre painter, some of whose copies of Watteau subjects were sold as originals. He exhibited from 1827 to 1863, and at his death the *A.J.* remarked: 'Had he been an artist of quality rather than quantity, he might have acquired a good reputation.'

ANDREWS, James Pettit, F.S.A.
** 1737 (nr. Newbury) – 1797**
Author, antiquarian and draughtsman who painted topographical and marine subjects and was a friend of Grimm and Grose. Like the latter he was a militiaman, and he was a magistrate at Queen's Square, Westminster. He built himself a house, Donnington Grove, near Newbury, but soon sold it. His books are mainly historical. He exhibited with the Society of Artists and the Free Society.

Published: *The Savages of Europe* (trans.), 1764. Etc.

ANELAY, Henry 1817 (Hull) – 1883 (Sydenham)
A landscape and coastal painter who lived at Upper Sydenham from 1848. He exhibited in London and elsewhere from 1845 to 1875 and was an unsuccessful candidate for the N.W.S. in 1859, 1860 and 1869. He was a prolific illustrator, most notably of *Uncle Tom's Cabin,* 1852, and its first Welsh edition in 1880.

ANGAS, George French 1822 (Durham) – 1886
The son of one of the founders of South Australia, he travelled widely, in particular visiting the Mediterranean in 1841. He then spent two years in London studying drawing before going to Australia. He settled in Sydney in 1851 as director of the Museum, but returned to England in about 1873. He was the author and illustrator of numerous books.

Published: *A Ramble in Malta and Sicily,* 1842. *Savage Life and Scenes in Australia and New Zealand,* 1847. *The Kafirs illustrated . . . ,* 1849. Etc.

Examples: B.M.; Sydney A.G.

ANGELL, Helen Cordelia, Mrs., née Coleman
** 1847 (Horsham) – 1884 (London)**
A flower painter, her early training was in helping her brother, W.S. Coleman (q.v.), in his designs for Minton, and her first exhibited works were at the Dudley Gallery in 1865, again through his influence. W.H. Hunt had already declared that she was his only successor as a painter of flowers and birds. In 1875 she married T.W. Angell, exhibiting thereafter under her married name, and she succeeded Bartholomew as Flower Painter in Ordinary to the Queen. In the same year she was elected R.I., but she resigned three years later. Her later style is rather looser than in her first works, in which she had aimed at a minute perfection of finish.

Examples: V.A.M.; Exeter Mus.; Stalybridge A.G.

ANNESLEY, Rev. and Hon. Charles Francis
1787 – 1863
A landscape painter, he was the brother of the 10th Viscount Valentia and lived at Eydon Hall, Northamptonshire. His subjects are usually views in Italy, Switzerland and on the Riviera and are strongly drawn, with muted colours. Occasionally his work is a little reminiscent of that of Copley Fielding, but he tends to use strong outlines.

Examples: B.M.; Cardiff Central Lib.

ANSELL, Charles c.1752 –
An animal painter and engraver and an illustrator, he was probably studying in Paris in 1778. He exhibited at the R.A. in 1780 and 1781, and was still working in 1790. His figures are not perfectly drawn and show a distant kinship with those of Fuseli.

Examples: B.M.

ANTHONY, Henry Mark 1817 (Manchester) – 1886
A landscape painter in oil and watercolour who was the pupil of his kinsman GEORGE WILFRED ANTHONY (1800-1859), a Manchester drawing master, landscapist and art critic. He lived in Paris and Fontainebleau from 1834 to 1840, and later visited Ireland and Spain. He absorbed the influence of such French friends as Corot and was approved of by the Pre-Raphaelites.

ARBUTHNOTT, George c.1803 –
A painter of British and Swiss views, who lived in London and exhibited from 1829 to 1854. He also visited the Rhine and Northern France.

ARCHER, John Wykeham, A.N.W.S.
1808 (Newcastle-upon-Tyne) – 1864 (London)
Apprenticed to the animal engraver John Scott in London, he began his independant career as an engraver in Newcastle where he was in partnership with William Collard, and continued in Edinburgh until 1831. In that year, he returned to London where he worked for the Findens, gradually turning to watercolour painting. He was commissioned by William Twopenny, and later by the Duke of Northumberland, to draw old buildings in London and elsewhere. He also turned his hand to wood-engraving for the *I.L.N.* and to making monumental brasses. He was elected A.N.W.S. in 1842. He and G. Lance (q.v.) married two sisters.

Published: *Views of Old London . . .* , 1851. *Posthumous Poems*, 1873.
Illustrated: W. Beattie: *The Castles and Abbeys of England*, 1844.
Examples: B.M.; V.A.M.
Bibliography: *A.J.*, 1864.

ARDEN, Edward see TUCKER, Edward

ARDEN, Lieutenant George – (West Indies)
The eighth son of Rev. John Arden of Longcroft, Cumberland, he served in the Navy and painted shipping subjects in the manner of D. Serves (q.v.) or W. Anderson (q.v.). His watercolours are small and detailed, in pale colours.

ARMITAGE, Edward, R.A.
1817 (London) – 1896 (Tunbridge Wells)
An historical painter, and a favourite pupil of Paul Delaroche from 1837. He entered the various cartoon competitions for the Houses of Parliament with marked success, and after a year's study in Rome, he began to exhibit at the R.A. in 1848. He was in the Crimea during the war. He was elected A.R.A. and R.A. in 1867 and 1872. He was a champion of mural painting, and his style is severe and academic.

Illustrated: Baron Bunsen: *Lyra Germanica*, 1868.
Bibliography: J.P. Richter: *Pictures and Drawings selected from the work of E.A.*, 1897. *A.J.*, 1863.

ARMOUR, Lieutenant-Colonel George Denholm
1864 (Waterside, Lanark) – 1930
Educated at St. Andrews University, he studied at the R.A. Schools and became a *Punch* illustrator in 1894. During the First World War he commanded the depot of the Army remount service, and from 1917 to 1919 he served with the Salonica Force. He was awarded the O.B.E. in 1919. His subjects are hunting, shooting and fishing and he illustrated many sporting books. He used much body colour and sometimes worked on canvas. He lived in Wiltshire.

Examples: Glasgow A.G.

ARMSTRONG, Fanny
A landscape painter who lived in Oxford and exhibited at the R.I. and Suffolk Street from 1883 to 1890. She visited Italy and also painted in Chester, Surrey and Canterbury and produced genre subjects.

ARMSTRONG, Francis Abel William Taylor
1849 (Malmesbury) – 1920 (Bristol)
A businessman who turned to painting, and studied in Paris and Scotland. He painted landscapes and architectural subjects, and exhibited in France and Germany as well as in Britain where he became a member of the R.B.A. He provided illustrations for the *A.J., Portfolio* and other art magazines.

Illustrated: R.D. Blackmore: *Lorna Doone*, 1883.
Examples: V.A.M.

ARMSTRONG, Thomas
1832 (Fallowfield, Manchester) – 1911 (Abbots Langley)
A decorative and landscape painter who studied under a Mr. Crazier in Manchester, and in 1853 in Paris, appearing in *Trilby*. He exhibited at the R.A. from 1865 to 1877 and was Director for Art at the V.A.M. from 1881 to 1898. He was in Algeria in 1858 and 1859, and visited Düsseldorf in 1860.

ARMYTAGE, Charles 1835/6 –
A painter of figure subjects who was working between 1857 and 1874. He was the son of an artist and also painted Norman landscapes.
Examples: V.A.M.

ARMYTAGE, Mary Elizabeth, Lady – 1834
A daughter of O. Bowles (q.v.), she married Sir George Armytage, 4th Bt., in 1791. Like other members of her family, such as W. Markham (q.v.), she carried on the traditions of Malchair.

ARNALD, George, A.R.A. 1763 (Berkshire) – 1841 (London)
A topographer who was a pupil of William Pether, and who exhibited at the R.A. from 1788. He was elected A.R.A. in 1810. In 1798 and 1799, he visited North Wales with J. Varley, and in 1828 he was working in France. He also sketched in many parts of the British Isles and Ireland, and from 1825 carried out a number of commissions for the Duke of Gloucester. His work is in the tradition of Dayes and early Turner, with thin blue, grey and green washes. His son, Sebastian Wyndham Arnald, and two of his daughters were also artists.

Published: *The River Meuse*, 1828.
Illustrated: T. Wright: *History and Topography . . . of Essex*, 1836.
Examples: B.M.; Bishopsgate Inst.

ARROLL, Richard Hubbard 1853 (Helensburgh) – 1931
The son of a woodcarver, he was educated at Glasgow University. He painted genre and village scenes in oil and watercolour, and lived in Ayr.

ARUNDALE, Francis Vyvyan Jago
 1807 (London) – 1853 (Brighton)
An architect, traveller and topographer. He was a pupil of A. Pugin (q.v.) whom he accompanied to Normandy in 1826. In 1829 he entered the R.A. Schools, and in 1831 he went to Egypt. He stayed in the Near East until 1840, working on Egyptian and Palestinian antiquities and publishing several books on them. Most of his winters were spent in Rome. He married a daughter of H.W. Pickersgill, R.A. and is believed to have died of a disease acquired in a Pharoah's tomb.

Published: *Paladian Edifices in Vicenza*, 1832. *Illustrations of Jerusalem and Mount Sinai*, 1837. *Examples and Designs of Verandahs*, 1851.
Examples: B.M.; Greenwich.
Bibliography: *A.J.*, February 1854.

ASH, John Willsteed
A landscape and coastal painter working in Warwickshire and elsewhere in the 1890s. He lived in Birmingham and Dudley.

ASHBURNHAM, George Percy c.1815 – c.1886
A landscape and architectural painter, he was the grandson of Sir William Ashburnham, 5th Bt. In the 1870s and 1880s he produced very competent copies of Prout's Gothic watercolours.

ASHBY, Henry Pollard 1809 – 1892
A painter of views of Wimbledon, who lived in Mitcham and exhibited at the R.A. from 1835 to 1865. He also painted on the South Coast and was the son of Henry Ashby, a portrait and genre painter.

ASHFORD, William, P.R.H.A.
 1746 (Birmingham) – 1824 (Dublin)
A landscape painter in oil and watercolour who settled in Dublin in 1764. He worked in the Ordnance Department for a while, but soon set up as a professional artist, exhibiting with the Dublin Society of Artists from 1767 to 1780. He first exhibited landscapes in 1772 – until that time he had confined himself to still-lifes. He contributed to the R.A. exhibitions at intervals between 1775 and 1811, as well as to the Society of Artists (London) of which he was a Fellow, and the B.I. He worked in conjunction with D. Serres (q.v.) in London for a period in the 1780s, and an exhibition of their works was held in 1790. He later returned to Dublin where, in February 1819, an exhibition of his work was held in the Dublin Society's house in Hawkins Street. He was elected President of the Irish Society of Artists in 1813, and played a large part in the establishment of the R.H.A., becoming its first President in 1823.

Although he was criticised by Anthony Pasquin in 1794 for the weakness of his figure drawing and the greenish tint of his skies, he gained a reputation as the foremost landscape painter of his time in Ireland. Many of his works were engraved.

His remaining works were sold by auction in Dublin, May 18-21, 1824. His son, DANIEL ASHFORD (d.1842) also exhibited in Dublin.

Examples: N.G., Ireland.

ASHMORE, Charles 1823/4 –
A Birmingham genre painter who was working between 1849 and 1886. He exhibited in London as well as Birmingham, and also painted portraits and rustic subjects.

Illustrated: H. Armitage: *Chantrey Land*, 1910.

ASHPITEL, Arthur, F.S.A. 1807 (Hackney) – 1869
The son of W.H. Ashpitel (q.v.), he was an architect and surveyor as well as an archeologist, scholar and linguist. He exhibited views and reconstructions of old buildings at the R.A. from 1845 to 1864 and was F.R.I.B.A. In 1853 and 1854 he was in Italy with D. Roberts (q.v.) visiting Rome and Naples.

Examples: V.A.M.

ASHPITEL, William Hurst 1776 – 1852
An architect and draughtsman who was pupil and assistant to Daniel Asher Alexander and George Rennie. He worked in Bath, London and the Home Counties, but retired to his own estate in early life.

ASPINALL, J.
An artist who exhibited landscapes between 1790 and 1800. In style they are between Towne and Pars, and they are very weak.

Examples: B.M.

ASPINWALL, Reginald 1858 (Preston) – 1921 (Lancaster)
A landscape painter in oil and watercolour who exhibited at the R.A. from 1884 to 1908.

Examples: Lancaster Mus.

ASPLAND, Theophilus Lindsey 1807 (Hackney) – 1890
A pupil of the acquatinter George Cooke, he worked in Manchester and Liverpool until 1848. In that year he retired to a house on Estwaite Water, and concentrated on painting Lake District views. His work is in early landscape manner of Cox and Prout, and his washes are sometimes reminiscent of Varley.

Examples: B.M.

ASSHETON, William
 1758 (Cuerdale, Lancashire) – 1833 (Brandon, Warwickshire)
A Lancashire landowner and amateur artist who was educated at Westminster and at Brasenose and Baliol Colleges, Oxford. In 1779 he became a member of the Middle Temple, and until 1786 he lived at Over Norton, Oxfordshire. From June 1783 to November 1784 he made his Grand Tour, travelling extensively in France, Switzerland, Italy, Austria, Germany and Belgium. In Rome he met many artists including Carlo Labruzzi, from whom he took lessons, A. Kauffmann (q.v.), Captain Koehler (q.v.) and J. More (q.v.). In the autumn of 1785 he visited Lisbon. He married in 1786, but separated from his wife in 1804. He was High Sheriff of Lancashire from 1792 and spent the rest of his life on his properties at Cuerdale, Downham and Beaconsfield, travelling and sketching in many parts of England.

Through his daughters he was connected with the Armytage, Bowles, Holbech and other families of amateur artists. See Bowles Family Tree.

ASTLEY, Henry
A Liverpool topographer who was working in pen, ink and coloured washes around 1810.

ASTON, Charles Reginald, R.I. 1832 – 1908
The great-nephew of Sir T. Lawrence, he studied architecture, but became a landscape painter in oil and watercolour. He lived in Birmingham for some years around 1850, and travelled widely in Britain as well as to Italy. He exhibited at the R.I., the R.A. and elsewhere in London from 1862, and was a member of the R.I. from 1882 to 1901. He was living in Oxford in 1900.

ATHOW, T.
A landscape and portrait painter who exhibited at the R.A. from 1806 to 1822. He also made watercolour copies of Tudor portraits. They are not very good.

Examples: B.M.; Ashmolean; J. Rylands Lib., Manchester.

ATKIN, John
A Hull carrier and amateur artist who was working in the late nineteenth century.

Examples: Hull Central Lib.

ATKINS, Catherine J. 1846/7 –
A genre painter in oil and watercolour who exhibited at the R.A., the R.I. and elsewhere from 1877. She lived in London as did her sister, EMMELINE ATKINS who exhibited from 1878 to 1896.

ATKINS, Samuel
A marine painter of whom little is known. He exhibited at the R.A. between 1787 and 1808, and was at sea from 1796 to 1804, visiting the East Indies and the China Coast. He is at his best when working on a small scale, but his work lacks some of the charm of such contemporaries as W. Anderson (q.v.). He often signed with his surname on a buoy or piece of floating wood.

Examples: B.M.; V.A.M.; Ashmolean; Greenwich; Leeds City A.G.; Ulster Mus.

ATKINS, William Edward 1842/3 – 1910 (Portsmouth)
The son of GEORGE HENRY ATKINS, a marine painter, with whom he published lithographs. He worked in Portsmouth as a ship portraitist and during the 1870s was correspondent and marine artist for the *Graphic*. In 1864 he visited the Isle of Wight. He moved to Portsea in 1872 and Southsea in 1878, advertising as a marine painter. He visited America in 1885.

Examples: Greenwich.

ATKINSON, George Mounsey Wheatley
 c.1806 (Queenstown) – 1884 (Queenstown)
Of English parentage, he began his naval career as a ship's carpenter, and later became Government Surveyor of Shipping and Emigrants at Queenstown. He taught himself to draw and exhibited marine works at the R.H.A. from 1842.
 His eldest son, GEORGE MOUNSEY ATKINSON (d.1908) was art examiner at South Kensington for many years. The second son, RICHARD PETERSON ATKINSON (c.1856-1882) was a landscape and marine painter living near Cork, and the third, ROBERT ATKINSON also a marine painter. His daughter, SARAH, MRS, DOBBS, was a Dublin art teacher.

Published: *Sketches in Norway . . .* , 1852.

ATKINSON, James 1780 – 1852
Doctor, journalist and artist of the Afghan Campaign. He was a Civil Surgeon in Bengal from 1805 to 1813, and then Assay Master of the Mint until 1818 when his press career began. In 1823 he founded the *Calcutta Annual Register*. He was appointed Surgeon to the 55th Native Infantry in 1833, and from 1838 to 1841 served in Kabul. He retired to England in 1847.
 His wife JANE ATKINSON was a pupil of G. Chinnery in Calcutta, and his son GEORGE FRANKLIN ATKINSON (1822-1859) served with the Bengal Engineers from 1840 until his death, and was the author and illustrator of *Pictures from the North in Pen and Pencil*, 1848; *The Campaign in India, 1857-8,* 1859; and *Curry and Rice*, 1860.

Published: *Sketches of Afghanistan*, 1842.
Examples: India Office Lib.

ATKINSON, John 1863 (Newcastle-upon-Tyne) – 1924 (Gateshead)
A businessman until 1900 when he attended the Newcastle Art School under W. Cosens Way. He exhibited at the R.A., the R.S.A. and elsewhere and was an etcher as well as a landscape and animal painter. Many of his subjects were found near Glaisdale, Yorkshire, where he lived for a while. He also taught art at Ushaw College and Morpeth Grammar School as well as working for the *Newcastle Journal*. Late in life, he designed many signs for public houses.

Examples: Shipley A.G., Gateshead; Ulster Mus.

ATKINSON, John Augustus, O.W.S.
 c.1775 (London) – c.1833
When nine years old he went to Russia with an uncle, where he was patronised by the Empress Catherine and the Emperor Paul, returning to London after the latter's assassination in 1801. In 1803 he began work on the plates for his *Manners . . . of the Russians*, and in the same year he exhibited for the first time at the R.A. He was elected both A.O.W.S. and O.W.S. in 1808, and was probably a member of the Chalons' Sketching Club. He resigned from the O.W.S. at the reorganisation of 1812. He remained in London until at least 1818, but little is known of his later life. Apart from his

Russian scenes, he was chiefly known for spirited battle pieces, many of incidents in the Peninsular War. The Duke of Wellington bought a number of these. The figures are strongly drawn in pen, and they are always the centre of interest in his work. He also produced pleasant caricatures in a mildly Rowlandsonian manner.

Published: *A Picturesque Representation of the . . . Costumes of Great Britain*, 1807. *A Picturesque Representation of the Manners . . . of the Russians*, 1812.
Illustrated: A Russian edition of *Hudibras*, 1797. Beresford: *The Miseries of Human Life*, 1807. Etc.
Examples: B.M.; V.A.M.; Greenwich; Newport A.G.

ATKINSON, Robert 1863 (Leeds) – 1896 (Dunedin)
A landscape painter and illustrator, who was a pupil of the portraitist Richard Waller and studied in Antwerp in 1883. He suffered from chest troubles and two years later went to New Zealand for his health. He then moved to Australia where he drew for the *Sydney Bulletin*. In 1889 he returned to Leeds, working as an illustrator for Messrs. Cassells. He moved to Newlyn in 1892, spending the winters of 1892-3 and 1893-4 in Egypt. The following year he went back to New Zealand.

Examples: Leeds City A.G.

ATKINSON, Thomas Witlam
 1799 (Cawthorne, Yorkshire) – 1861 (Lower Walmer, Kent)
Architect, traveller and artist, he began work at the age of eight as a farm-hand and a bricklayer. When he was about twenty, he spent some time as a drawing master at Ashton-under-Lyne. In 1827 he set up as an architect in London and in 1835 moved to Manchester. In 1842 he set out for St. Petersburg by way of Hamburg and Berlin. He also visited Egypt and Greece before undertaking a vast journey around Russia, which lasted from 1848 to 1853. Throughout his travels he made hundreds of sketches and watercolours, some of which he used to illustrate his publications. He exhibited at the R.A. from 1830 to 1842.

Published: *Gothic Ornaments selected from the different Cathedrals*, 1829. *Oriental and Western Siberia*, 1858. *Travels in . . . Amoor*, 1860.
Bibliography: *A.J.*, October, 1861.

ATKINSON, William 1773 (Bishop Auckland) – 1839 (Cobham)
An architect who began as a carpenter, was a pupil of James Wyatt and entered the R.A. Schools in 1796. He was the proprietor of 'Atkinson's Cement' and was architect to the Ordnance Office from 1813 to 1829. He specialised in alterations to country houses, especially in the Scottish baronial style. He was also a botanist and a geologist.

Published: *Picturesque Views of Cottages*, 1805.

AUGUSTA Sophia, H.R.H. Princess
 1768 (London) – 1840 (London)
The sixth child of George III, she was, like her sisters, an occasional artist and composer. Her work is in the manner of Cipriani, and she sometimes produced portraits with thin washes of colour.

Examples: B.M.
Bibliography: D.M. Stuart: *The Daughters of George III*, 1939.

AULD, Patrick C.
A landscape painter in oil and watercolour who specialised in Scottish subjects and exhibited at the R.A. from 1850 to 1865. In 1851 he was an unsuccessful candidate for the N.W.S. and was living in London. Previously in the 1830s he had lived in Edinburgh, Ayr and Aberdeen, and in the 1860s he returned to Ayr and Aberdeen.

Examples: Aberdeen A.G.

AUMONIER, James, R.I. 1832 (Camberwell) – 1911 (London)
A landscape painter in oil and watercolour, he studied at the Birkbeck Institution, the Marlborough House and South Kensington Schools. He worked as a calico print designer at the beginning of his career, but turned to painting in about 1862. He exhibited at the R.A. from 1870 and was elected A.N.W.S. and N.W.S. in 1876 and 1879. He is known for his green meadows and sheep or cattle.

A memorial exhibition was held at the Goupil Gallery, London, in 1912.

STACY AUMONIER, who also painted late Victorian landscapes, may have been a relation. An exhibition of his work was held at the Goupil Gallery in 1911, and he was a prolific author of short stories.

Examples: B.M.; Preston Manor, Brighton; Maidstone Mus.

AUSTEN, Henry Haversham Godwin-, F.R.S.
1834 (Teignmouth) – 1923 (Godalming)
The surveyor and explorer after whom the mountain K2 is sometimes called. He was at Sandhurst where he was taught drawing by a Captain Petley, and he was commissioned in 1851. He served in the Burmese War of 1852, and from 1856 spent a number of years surveying in Kashmir and among the Karakoram glaciers. In 1863 he accompanied an expedition to Bhutan, and he retired in 1877. His drawings show artistry as well as accuracy.

AUSTEN, James 1765 –
The eldest brother of Jane Austen, he was a pupil of J.B. Malchair (q.v.).

AUSTIN, H
There is a view of Rotterdam by this artist in the V.A.M. He exhibited in 1833, and he also made figure drawings.

AUSTIN, Samuel, O.W.S. 1796 (Liverpool) – 1834 (Llanfyllin)
After a Charity School education and a period as a bank clerk, he determined to become a professional artist. He took three lessons from P. de Wint (q.v.) and exhibited a local view at the R.A. in 1820. He was a foundation member of the S.B.A. in 1824, and was elected A.O.W.S. in 1827. From 1829 he exhibited views of Holland, Belgium and the Rhine, and from 1830 of Normandy. However, the bulk of his subjects are from Lancashire and North Wales. His style is based on that of de Wint, and he is at his best in conveying atmospheric effects. He was elected to full membership of the O.W.S. on his deathbed in 1834. He had a considerable practice as a drawing master, and he left a daughter, also taught by de Wint, whose work is said to be very close to his own. Another of his pupils was Miss A. Swanwick (q.v.).

Illustrated: Elliot: *Views in the East,* 1833.
Examples: B.M.; V.A.M.; Accrington A.G.; Ashmolean; Fitzwilliam; Walker A.G., Liverpool; City A.G., Manchester; Castle Mus., Nottingham; Ulster Mus.; Warrington A.G.; Wolverhampton A.G.
Bibliography: *Connoisseur,* LXXXIV, 1929.

AUSTIN, William 1721 (London) – 1820 (Brighton)
A failed engraver who took up landscape drawing and print-selling. He also copied old masters, and may be the artist mentioned by Henry Angelo as a drawing master and political caricaturist.

AUSTIN, William Frederick 1833 (Bedford) – 1899 (Reading)
He was in business with his father in Oxford by 1866 under the name 'J. Austin & Son'. They both drew in Wallingford and Wantage. William Frederick made many drawings in Derby, Reading and Norwich, where he lived for some time.

He specialized in drawings of pubs, with which he paid the landlords' bills. His topographical work is primitive in concept, but can be extremely well drawn and shows a good eye for architectural detail. As well as his watercolours, he made a number of pencil portraits.

Examples: Derby A.G.; King's Lynn A.G.; St. Giles's Church Hall, Reading; Reading A.G.

AYLESFORD, Heneage Finch, 4th Earl of
1751 (London) – 1812
An enthusiastic amateur artist who was educated at Westminster and at Oxford where he was a pupil of J.B. Malchair (q.v.). He was M.P. for Castle Rising, was elected F.R.S. and to the Dilettanti Society, and toured Italy and Sicily before succeeding to the title in 1777. As well as producing numerous pen and wash drawings, he was a talented etcher, and he exhibited at the R.A. from 1786 to 1790. In his earlier years, he remained very much under Malchair's influence. He drew romantic landscapes with castles and other buildings, using brown wash for the foreground and grey for the background, sometimes giving the roofs a touch of pale red. His architectural studies at Packington were made under the guidance of his architect, Joseph Bonomi. It is always difficult to tell his work from that of his numerous kinsfolk and friends who took up drawing with his encouragement. His brothers Edward and Daniel Finch are separately noticed, as is his wife, Louisa, Countess of Aylesford. His third brother SEYMOUR FINCH (1758-1794) and his sisters SARAH FRANCES, COUNTESS OF DARTMOUTH (1761-1838), MARIA ELIZABETH FINCH (1766-1848) and HENRIETTA CONSTANTIA FINCH (1769-1814) were probably all artists of greater or lesser enthusiasm. The same is true of his children, HENEAGE FINCH, 5TH EARL OF AYLESFORD (1786-1859), MARY FINCH (1788-1823), DANIEL FINCH (1789-1868), ELIZABETH FINCH (1789-1879), FRANCES FINCH (1791-1886) and HENRIETTA FINCH (1798-1828). Great confusion is obviously possible between the two Daniels, the two Marys and the two Henriettas.

Examples: B.M.; V.A.M.; Ashmolean; Coventry A.G.; Leeds City A.G.
Bibliography: *Country Life,* July 15, 1971.
See Family Tree.

AYLESFORD, Louisa, Countess of – 1832
The daughter of the 1st Marquess of Bath, she married the 4th Earl of Aylesford (q.v.) in 1781. She produced a large number of very competent and attractive botanical watercolours. Many of them were in two large albums, originally from Packington, which were broken up in 1973.

AYLING, Albert William – (Deganwy)
A painter of landscapes, portraits and country girls, who was brought up in Guernsey where he was a pupil of P.J. Naftel. He exhibited from 1853 to 1905, and was an unsuccessful candidate for the N.W.S. in 1857. He lived in London and Chester before moving to Liverpool in about 1883, and to Conway in 1886. Many of his landscapes were found in North Wales, and he also painted genre subjects and still-lifes, and was a drawing teacher.

AYLMER, Thomas Brabazon
1806 (Limerick) – c.1856 (Weston-super-Mare)
The son of a general, he was a prolific topographical and landscape painter in oil and watercolour. He lived in London and Tunbridge Wells until 1849 when he moved to Weston-super-Mare, later settling in Bath. In 1853 he wrote and illustrated a series of articles for the *Art Journal.* He exhibited from 1838 to 1855 and painted in Belgium, Germany and Italy.

AYRTON, Sophia, née Nicholson
A daughter of F. Nicholson (q.v.) in whose manner she worked. She exhibited from 1800 to 1820.

AYRTON, W J
A landscape painter in oil and watercolour who was living in London when he exhibited at the O.W.S. and Suffolk Street in 1833 and 1834.

BABB, John Staines
A landscape and coastal painter who lived in London and exhibited between 1870 and 1900. Latterly he produced a number of drawings and paintings in the form of Greek friezes.
A CHARLOTTE E. BABB exhibited a Shakespearian subject with the Society of Female Artists in 1857.

BACH, Guido R., R.I.　　　　1828 (Annaberg) − 1905 (London)
A portrait, figure and genre painter who studied in Dresden and settled in England in 1862. He was elected A.N.W.S. and N.W.S. in 1865 and 1868, and he travelled extensively, visiting Cairo in 1876. His work is often stronger and less sentimental than was usual at the time.

Examples: B.M.

BACH, William Henry
A London painter of Welsh landscapes. He exhibited from 1829 to 1859, and in 1833 briefly joined the N.W.S.

BACK, Admiral Sir George
　　　　　　1796 (Stockport, Cheshire) − 1878
The Arctic explorer. He joined the Navy in 1808 and in the following year was taken prisoner. He remained in France until the beginning of 1814 and taught himself drawing during this time. In the 1820s and 1830s, he made a number of polar voyages and explorations both with Franklin and on his own. He was knighted in 1839, and promoted Admiral in 1857.
He illustrated his *Narratives* with his own dramatic sketches.

Published: *Narrative of the Arctic Land Expedition. Narrative of an Expedition in H.M.S. Terror.*
Examples: B.M.; Greenwich.

BACKHOUSE, Mrs.
A figure and genre painter who was an unsuccessful candidate for the N.W.S. in 1850 and exhibited with the Society of Female Artists in the 1860s. She lived in Islington.

BACKHOUSE, James Edward　　　1808 (Darlington) − 1879
An etcher and marine painter, many of whose subjects were found on the North East coast. He exhibited in London from 1886 to 1891 and probably lived in Sunderland for much of his life.

Examples: Sunderland A.G.

BACON, John Henry Frederick, A.R.A.
　　　　　　　　　　　　1865　　　− 1914 (London)
An illustrator and painter of portraits and historical subjects in oil and watercolour. He studied at Westminster Art School, exhibited at the R.A. from 1889, and was elected A.R.A. in 1903.

Published: *The King's Empire*, 1906.
Illustrated: C. Squire: *Celtic Myth and Legend . . .* , 1912.
Examples: B.M.

BACON, Thomas
A topographer and antiquarian who was in Bengal and the Doab, where he drew with Captain Meadows Taylor from 1831 to 1836. He was elected F.S.A. in 1838 and resigned in 1846.

Published: *First Impressions and Studies from Nature in Hindoostan*, 1837. *Oriental Annual*, 1839. *The Orientalist*, 1843.

BADESLADE, Thomas
A topographer working in London between 1720 and 1750. He made many drawings of country houses for Harris's *History of Kent* and similar publications. He was also much concerned with the draining of the Fens.

Published: *Thirty-Six Different Views of . . . Seats*, 1750. Etc.

BAGOT, Richard
The fourteenth son of the 5th Bt., he exhibited a view of Toulon harbour at the R.A. in 1796. See also Howard, Frances.

BAILEY, John　　　　　　1750 (Bowes, Yorkshire) − 1819
A topographical, agricultural and animal painter who worked at Barnard Castle before becoming land agent for Lord Tankerville at Chillingham. He engraved both his own and other people's drawings as illustrations. He was a friend of T. Bewick.

Published: *General View of the Agriculture of the County of Cumberland*, 1794. *General View of the Agriculture of the County of Northumberland*, 1794. *General View of the Agriculture of the County of Durham*, 1797.

BAILLIE, Caroline
A flower painter who lived in Brighton and who exhibited there in 1875 and in London in 1872.

BAINES, Henry　　　　　　1823 (King's Lynn) − 1894
A drawing master at King's Lynn who was a pupil of W. Etty and Sir E.H. Landseer, and studied at the R.A. Schools. He was a prolific painter of local views in oil and watercolour.
His elder brother THOMAS BAINES (1820-1875) was a painter of English and African views in oil and watercolour.

Examples: King's Lynn Mus.

BAIRD, Nathaniel John Hughes　1865 (Yetholm, Roxburgh) −
An engraver and genre and portrait painter in oil and watercolour and he exhibited at the R.A. from 1883.

Illustrated: E.W.L. Davies: *Memoir of the Rev. John Russell*, 1902.

BAKER, Alfred　　　　See BAKER, Richard

BAKER, Father Anselm
　　　1834　　　− 1885 (Mt. St. Bernard's Abbey, Leicestershire)
An heraldic painter who trained in Messrs. Hardman's studios in Birmingham. He became a Cistercian monk in 1857. He painted murals as well as illustrating a number of heraldic publications. His work is signed 'F.A.' (Father Anselm).

Published: *Hortus Animae. Horae Diurnae. Liber Vitae.*

BAKER, Blanche　　　　　　　1844　　　− 1929
A painter of landscapes and rustic scenes who lived in Bristol and exhibited at the N.W.S. and Suffolk Street from 1869.

BAKER, Harry　　　　　　1849 (Birmingham) − 1875
The eldest son and pupil of S.H. Baker (q.v.). He painted landscapes and coastal scenes, often from Devonshire or North Wales, and he exhibited in London and Birmingham from 1866 to 1875.

BAKER, Oliver　　　　　　　　1856 (Birmingham) −
The youngest son of S.H. Baker (q.v.), he painted landscapes and etched. Educated at the Bridge Trust School, he exhibited at the R.A. and R.I. as well as in Birmingham from 1874 to 1913. He was a member of the R.B.A., and he lived in Stratford-on-Avon.

Published: *Ludlow Town and Neighbourhood*, 1888. *Jacks and Leather Bottells*, 1921. *In Shakespeare's Warwickshire*, 1937.
Illustrated: A. Hayes: *The Vale of Arden*, 1897.

BAKER, Richard 1822 –
An English landscape and gamey still-life painter who worked in Dublin and exhibited at the R.H.A. from 1843 to 1851. His younger brother ALFRED BAKER (b.1825) was also an artist and exhibited there from 1851 to 1854. They were the sons of a military surveyor.

BAKER, Samuel Henry 1824 – 1909
A Birmingham landscape painter who began his career making magic lantern slides. He studied at the Birmingham School of Design and exhibited with the Birmingham Society from 1848 and at the R.A. from 1875 to 1896. He was a member of the R.B.A.

His work is often in the manner of Cox, but he uses an un-Cox-like stipple effect. He signed with initials.

His second son, ALFRED BAKER (1850-1872) studied at the Birmingham School of Art. His other sons, Henry and Oliver, are separately noticed.

Examples: Birmingham City A.G.

BAKER, Thomas, of Leamington
1809 (Birmingham) – 1869
A Midland landscape painter in oil and watercolour who exhibited at the R.A. from 1831 to 1858 and in Birmingham from 1827 to 1873. He was one of the Birmingham family of artists. He lived in Leamington from 1854 to 1862, and many of his landscapes (with cattle) are from the area.

Examples: B.M.; V.A.M.; Coventry A.G.

BALDOCK, James Walsham
c.1822 (Heeley, Sheffield) – 1898 (Nottingham)
A landscape, sporting and animal painter who was born J.W. Markham, but took the name of his grandfather who adopted him after the death of his parents. He began by working on a farm whose owner sent him to have drawing lessons, then for a Worksop painter before setting up on his own.

In turn, he brought up his own orphaned grandson CHARLES EDWIN MARKHAM BALDOCK (c.1878-1941) and he too became an animal and landscape painter.

The elder Baldock worked in oil, watercolour, bodycolour and pencil, and was noted for his forest scenes.

Examples: Bassetlaw County Lib.

BALDREY, John Kirby
1754 – 1828 (Hatfield Woodside, Hertfordshire)
An engraver and draughtsman who worked in London and Cambridge from 1780 to 1810. He produced portraits and landscapes, and exhibited at the R.A. in 1793 and 1794. On his retirement he settled in Hatfield.

Examples: V.A.M.

BALDWIN, Robert
An architectural draughtsman who was a pupil of the architect Matthew Brettingham, and exhibited designs and views with the Society of Artists and the Free Society from 1762 to 1783.

BALE, Edwin, R.I. 1838 – 1923 (London)
A figure and landscape painter who studied at South Kensington and in Florence. He was Art Director for Cassells from 1882, and the first Chairman of the Imperial Arts League. He exhibited from 1867, and was elected A.N.W.S. and N.W.S. in 1876 and 1879.

Examples: V.A.M.

BALL, Louisa, Mrs., née Noel – 1863
The daughter of A. Noel (q.v.), she married in about 1807 John Ball, a Dublin silk manufacturer, who died in 1810. She exhibited landscapes and portraits in Dublin from 1809 to 1811, and gave drawing and painting lessons. She lived in London with her mother for a time, after which she married Michael Furnell of Cahirelly Castle, Co. Limerick.

BALL, Wilfred Williams 1853 (London) – 1917 (Khartoum)
Etcher, landscape and marine painter in watercolour and oil, he lived in Putney and worked as an accountant until about 1877, painting in his spare time. He exhibited etchings and some pictures at the R.A. from 1877 to 1903. He visited Italy in 1887, Holland in 1889, Germany in 1890 and Egypt in about 1893. In 1895 he married and settled in Lymington. In 1916 he returned to accounting and was sent to Cairo, and from there to Khartoum, to work on military accounts.

His work is fresh and professional, and generally on a small scale. Exhibitions were held at the Fine Art Society in 1899, 1904 and 1912. He illustrated a number of County books.

Examples: V.A.M.; Maidstone Mus.; Newport A.G.
Bibliography: *Studio*, XVI, p. 3. *Studio*, XXXI, p. 72.

BALMER, George
1806 (North Shields) – 1846 (Ravensworth, Durham)
He began as a decorator in Edinburgh, but exhibited pictures painted in his spare time. In 1831 he contributed to an exhibition of watercolours at Newcastle and worked with J.W. Carmichael (q.v.). He then visited the Continent before he settled in London as a professional artist, exhibiting Rhineland and other scenes and making drawings for the Findens' *Ports and Harbours of Great Britain*. In 1842 he retired to Ravensworth, Durham.

In his work for engravers he owes much to Turner, in his coastal scenes to Bentley and Carmichael.

Examples: B.M.; V.A.M.; Shipley A.G., Gateshead; Leeds City A.G.; City A.G., Manchester; Laing A.G., Newcastle.

BALMFORD, Hurst 1871 (Huddersfield) –
A portrait and landscape painter in oil and watercolour. He studied at the R.C.A. and Julian's, and became Headmaster of Morecambe School of Art. Later he lived in Blackpool and kept a studio in St. Ives.

BAMPFYLDE, Coplestone Warre
1720 (Taunton, Somerset) – 1791 (Hestercombe, Somerset)
An amateur topographical draughtsman and caricaturist. In 1780 he seems to have made a tour of the Lake District. He exhibited at the R.A., the S.A. and the Free Society between 1763 and 1783. Works by him were engraved by Vivares and Benazech. He occasionally etched landscapes, and made humorous illustrations for Anstey's *Election Ball*, 1776. He was Colonel of the Somerset militia.

Examples: B.M.; Exeter Mus.
Bibliography: *Apollo*, XI, 1930.

BANCROFT, Elias Mollineaux 1846 – 1924
A Manchester landscape painter who also worked in London for a time. He exhibited at the R.A. from 1874 and painted in Wales, Germany and Switzerland. With J.H.E. Partington (q.v.) and others, he set up a Manchester Sketching Club.

His wife LOUISA MARY BANCROFT was a flower and miniature painter, and an illustrator.

Examples: Darlington A.G.; City A.G., Manchester.

BANNISTER, Edward. 1820 – 1916
Although a member of a Hull family of coal merchants, by 1846 he described himself as an artist. He travelled widely and later moved to Grimsby.

Examples: Ferens A.G., Hull.

BARBER, Charles Vincent 1784 (Birmingham) – 1854 (Liverpool)
The elder son of J. Barber (q.v.), he was a friend of Cox, accompanying him on his first trip to Wales in 1805, and was elected A.O.W.S. with him in June, 1812. He did not, however, become a Member of the Oil and Watercolour Society, although he was an Exhibitor. In 1816 he moved from Birmingham to Liverpool, where he was a teacher, and President of the Liverpool Academy of Arts from 1847 to 1853. He shared Cox's love of North Wales and they often visited Bettws together.

Examples: V.A.M.

BARBER, Christopher 1736 – 1810 (Marylebone)
A painter of miniatures and small landscapes in oil, watercolour and pastel. He was a member of the Incorporated Society and exhibited at the R.A. from 1770 to 1808.

BARBER, Joseph 1757 (Newcastle) – 1811 (Birmingham)
The son of a Newcastle bookseller, he settled as a drawing master in Birmingham where he gained a considerable reputation, and taught at the Grammar School. Much of his work consists of small, simple, picturesque landscapes, but he could occasionally be more abitious, as with some views of North Wales.

His best known pupil was David Cox.

Examples: B.M.; V.A.M.; Birmingham City A.G.; Dudley A.G.; Newport A.G.; Ulster Mus.

BARBER, Joseph Vincent 1788 (Birmingham) – 1838 (Rome)
The younger son of J. Barber (q.v.), he was a painter of landscapes with figures. He was a pupil of his father and spent most of his career in Birmingham. He exhibited in London from 1810, and was Secretary of the Birmingham Academy of Arts in 1814 and a member of the Birmingham Society.

Examples: Birmingham City A.G.

BARBER, R.
In the British Museum are illustrations for Sterne's *Sentimental Journey* bearing this signature and dating from about 1775. They are competent and are in brown wash with touches of colour.

BARBER, Reginald
A Manchester painter of portraits and genre subjects, sometimes in the manner of A. Moore (q.v.). He was active from 1882 to 1908 and exhibited at the R.A. from 1885, as well as in Paris and elsewhere.

BARCLAY, Edgar 1842 – 1913
A landscape and figure painter and an etcher, he studied in Dresden in 1861 and Rome in 1874 and 1875. He lived in Hampstead.

Published: *Notes on the Scuola di San Rocco*, 1876. *Mountain Life in Algeria*, 1882.
Illustrated: H.D. Barclay: *Orpheus and Eurydice*, 1877.

BARCLAY, Hugh 1797 (London) – 1859 (Paris)
An artist who painted miniature watercolour copies of Italian pictures, and worked in London and Paris.

BARCLAY, J Edward
A landscape painter in oil and watercolour who exhibited between 1868 and 1888.

BARCLAY, James Maclaren, R.S.A. 1811 (Perth) – 1886
A portrait painter who also sketched in watercolour. He exhibited at the R.A. from 1850 to 1875, and was elected R.S.A. in 1871.

Examples: N.G., Scotland.

BARCLAY, William 1850 (Dundee) – 1907
A businessman who took up art criticism and landscape painting in oil and watercolour. He was particularly noted for his effective skies.

BARDWELL, William
An architect and designer who exhibited at the R.A. from 1829 to 1845. He was involved in drawing up plans for the improvement of Westminster, and he also worked in Ireland. He lived at Exeter Change in the Strand.

Published: *Temples Ancient and Modern . . .*, 1837. *Westminster Improvements*, 1839. *Healthy Homes and How to Make Them*, 1854. *What a House should be, versus Death in the House*, 1873.
Examples: R.I.B.A.

BARING, Ann
A very competent landscape painter in the Wilson manner in oil, and that of White Abbott in watercolour. She was the daughter of John Baring (1730-1816), a Devonshire businessman and an ancestor of the Northbrook family. She was working in 1791 and painted in Devon and Ireland.

MARY BARING, who painted romantic landscapes in 1794, may have been a kinswoman.

BARKAS, Henry Dawson
 1858 (Gateshead-on-Tyne) – 1924
Shortly after his birth, his family moved to St. Helier. He was educated in Jersey and at Granville in France, and at the age of seventeen entered the Bath School of Art, from whence he gained a scholarship to the R.C.A. He taught at the Warrington and Bradford Schools of Art before settling in Reading, where he became Headmaster of the School of Science and Art. In about 1894 he founded another School of Art at Reading, which continued to function until his death. He spent his summer vacations in sketching and experimenting with watercolour, aiming for natural atmospheric effects. His work also included detailed architectural studies. He was a regular exhibitor at the R.A. Summer Exhibitions and, in 1912, an exhibition of his work entitled 'English Pleasure Resorts' was held at the Fine Art Society.

His brother HERBERT ATKINSON BARKAS (1870, Jersey – 1939, Reading) studied under him at the School of Science and Art, and became a Reading art master. He was for twenty years Headmaster of the Berkshire School of Art, Maidenhead, and also taught art at Eton. There are examples of his work in Reading A.G.

Published: *Art Student's Pocket Manual*, 1892.

BARKER, Benjamin 1776 – 1838 (Totnes)
A landscape painter who was the younger brother of Thomas Barker of Bath. The family settled in Bath in about 1783. He exhibited in London from 1800 until his death and was a member of the A.A. Benjamin West regarded him as a better and more poetic painter than his brother. He left Bath to live with his daughter at Totnes in 1833.

His watercolours are soft in colour, and he makes great use of umber. His pupils included H.V. Lansdown (q.v.).

Examples: V.A.M.; Victoria A.G., Bath; Grosvenor Mus., Chester; Leeds City A.G.; Newport A.G.

BARKER, Henry Aston
 c.1774 (Edinburgh) – 1856 (Bilton, near Bristol)
The younger son of R. Barker (q.v.), he came to London with his father, in 1789, from Edinburgh where he had already made the sketches for their first attempt at a panorama. He studied at the R.A. Schools and made the drawings for their London ventures, and, after his father's death in 1806, carried on the concern. He was a friend of Turner, Ker Porter, and above all, of Girtin, whose own projects in London and Paris he inspired. He sketched in Venice and Naples, showing the results in Dublin in 1823 and 1824.

Bibliography: *Gentleman's Mag.*, February, 1856.

BARKER, John Joseph
A member of the Bath family, he painted landscapes and genre subjects, and exhibited at the R.A. from 1835 to 1863. His colours are fresh and his figures quite well drawn.

Examples: V.A.M.

BARKER, Robert 1739 (Kells, County Meath) – 1806 (London)
A painter of panoramas who, after practising unsuccessfully in Dublin, moved to Edinburgh and set himself up as a portrait and miniature painter. He invented a mechanical system of perspective, which he taught, and in 1787 produced a panoramic view of Edinburgh in watercolour which was exhibited in London the following year. His next panorama, after drawings by his son H.A. Barker (q.v.), was of the Thames and was painted in distemper. All his subsequent panoramas were in oil, and were exhibited in a

building constructed by himself in Leicester Place, Cranbourne Street.

His elder son, THOMAS EDWARD BARKER, after working with him, started up a rival business in the Strand with R.R. Reinagle (q.v.).

BARKER, Thomas, of Bath
1769 (Pontypool, Monmouthshire) – 1847 (Bath)
His family moved to Bath in his youth, and at twenty-one he attracted a rich patron, who sent him to Rome from 1790 to 1793. He was chiefly an oil painter, but occasionally produced large, stiffly drawn and woolly watercolours. He experimented with various washes and generally wiped or scratched out his highlights. His pen and ink drawings are spirited and show a marked Italian influence.

Examples: B.M.; V.A.M.; Haworth A.G., Accrington; Abbot Hall A.G., Kendal; Leeds City A.G.; Ulster Mus.
Bibliography: Sir E. Harington: *A Schizzo on the Genius of Man . . .* , 1793. *Connoisseur*, X, 1904; XI, 1905.

BARKER, William Dean
A landscape painter who lived at Trefriw on the river Conway, and exhibited from 1868 to 1880. He was living at Plas Celyn in 1886.

BARLOW, Francis **c.1626 (Lincolnshire) – 1704**
The earliest British sporting painter whose name is known, he worked in oil and in pen and wash. He was apprenticed to 'one Shepherd, a Face-Painter', according to Vertue. He designed ceilings and panels with bird and animal paintings and illustrated an edition of *Aesop's Fables*. L. Binyon suggested that he probably worked in pure watercolour as well as monochrome.

Published: *Various Birds and Beasts*, 1710.
Examples: B.M.; V.A.M.; Cecil Higgins A.G., Bedford; Leeds City A.G.
Bibliography: *Connoisseur*, XCVIII, 1936. *Apollo*, XIX, 1934; XLI, 1945. *BM Quarterly* XX, 1955-6.

BARLOW, John
There is a naive and amusing grey wash drawing of a man in the stocks by this artist in the B.M. He was active between 1791 and 1804.

BARNARD, Catherine, Mrs., née Locking
(Edinburgh) –
A landscape painter who exhibited at the R.A. and R.I. She painted 74 pictures of vanishing London for the London Museum. She signed 'K.B.' or 'K. Barnard'.

Published: *In a Wynberg Garden*, 1930.
Examples: London Mus.

BARNARD, Frederick **c.1836 – 1896 (Wimbledon)**
A genre painter and illustrator from Northumberland, he studied in Paris, and worked in Cullercoats and London. As well as exhibiting at the R.A. from 1858 to 1887, he drew for *Punch* and the *I.L.N.* He painted in both oil and watercolour and was noted for his pure colours.

Examples: V.A.M.

BARNARD, George **– c.1890**
An illustrator and drawing master who was a pupil of J.D. Harding (q.v.) and exhibited at the R.A. from 1837 to 1873. He also exhibited at the B.I. and Suffolk Street, and his subjects include views in Switzerland, Wales and Devon. In 1870 he was appointed Professor of Drawing at Rugby.

Published: *The Brunnens of Nassau and the River Lahn*, 1840. *Switzerland*, 1843. *Handbook of Foliage and Foreground Drawing*, 1853. *The Theory and Practice of Landscape Painting in Water Colours*, 1855. *Drawing from Nature*, 1856. *Barnard's Trees*, 1868.

BARNARD, Rev. William Henry **1767 – 1818 (Stowe)**
Of Irish extraction, Barnard found subjects for his earliest drawings in Ireland, Wales and Oxford. He graduated Bachelor of Civil Laws from Pembroke College, Oxford, in 1797 and thereafter travelled fairly widely, visiting Italy in 1804 and again between 1815 and 1818. He became Rector of Marsh Gibbon and Water Stratford, Buckinghamshire. His drawings can be very striking, but always owe a great deal to Malchair.

His son LIEUTENANT-GENERAL HENRY WILLIAM BARNARD also painted in the same manner.

Examples: Leeds City A.G.

BARNES, Robert, A.R.W.S. **1840 – 1895**
A painter of figure and genre subjects, he exhibited at the R.A. and O.W.S. from 1873, and was elected A.O.W.S. three years later. He illustrated a number of books in the 1860s and 1880s.

BARNETT, James D.
A painter of French landscapes who lived in Liverpool in the 1840s and at Crouch End until 1892. He exhibited from 1855 to 1872, and also painted in Britain and Germany.

BARNEY, Joseph, Yr.
The son of Joseph Barney, Fruit and Flower Painter to George III. He was working in Wolverhampton in the early nineteenth century and exhibited at the O.W.S. for a few years prior to 1820. He often initialled his work.

BARNICLE, James
An amateur landscape and coastal painter who lived in London and painted all over Britain and in France and the Channel Islands between 1821 and 1845.

BARRALET, John James **1747 (Dublin) – 1815 (Philadelphia)**
A Huguenot, he was trained at the R.D.S. Schools and taught drawing in Dublin before leaving for London in about 1770. In 1773 he opened a Drawing School in James's Street, Golden Square, and in 1777 started up another in St. Alban's Street, Pall Mall. He exhibited at the R.A. from 1770 and the Society of Artists from 1773 to 1780, being elected a Fellow in 1777. He returned to Dublin in 1779 and the following year, with G. Beranger (q.v.), toured Wicklow and Wexford making antiquarian drawings. He worked as a scene painter for the Crow Street Theatre in 1782. He went to America in 1795, and lived in Philadephia, working as a book illustrator.

According to Pasquin, he 'drew landscapes in Italian chalk in which he affected to imitate Vernet'. He also worked in watercolour, and Williams states that he was 'an inept and heavy handed, if ambitious artist'.

Illustrated: F. Grose: *Antiquities of Ireland*, 1791-95.
Examples: B.M.; Ulster Mus.

BARRALET, John Melchior **c.1750 (Dublin) – c.1787**
The brother of J.J. Barralet (q.v.), he worked in Dublin before coming to London where he was a pupil of J. Laporte (q.v.). He exhibited with the Free Society in 1774 and at the R.A. between 1775 and 1787, and was a drawing master, W.F. Wells (q.v.) being among his pupils.

His landscapes, mostly tinted drawings, are taken from London and the South of England.

Examples: B.M.; V.A.M.

BARRATT, Reginald, R.W.S. **1861 (London) – 1917 (London)**
An illustrator, landscapist and painter of Oriental scenes, he studied under the architect Norman Shaw and under Bouguereau in Paris. He drew for the *Graphic* early in his career, and travelled widely in Europe, North Africa and the East. He exhibited from 1885, was elected A.R.W.S. and R.W.S. in 1901 and 1913, and was F.R.G.S.

Examples: V.A.M.

BARRAUD, William **1810 – 1850**
Of Huguenot extraction, he was the eldest son of William Francis
Barraud, Prime Clerk in the London Customs House. He was a pupil
of A. Cooper (q.v.) and exhibited at the R.A. from 1829. He often
collaborated with his brother HENRY BARRAUD (1811-1874),
who painted portraits, animals and genre and exhibited at the R.A.
and elsewhere from 1831 to 1868. These two artists worked mainly
in oil.

A younger brother, CHARLES DECIMUS BARRAUD
(1822-1897), became a chemist and emigrated to New Zealand in
1849, where he painted and sketched. In 1877 he published in
London a volume of chromo-lithographs entitled *New Zealand
Graphic and Descriptive*.
FRANCIS PHILIP BARRAUD (1824-1901), another brother,
worked almost exclusively in watercolour and was a partner of
Lavers and Barraud, stained glass artists. He produced a series of
views of colleges, and another of cathedrals.

Other painting members of the family include ALLAN
BARRAUD (1847-1913) and CHARLES JAMES BARRAUD
(1843-1894), cousins of William.

Examples: V.A.M.
Bibliography: *Country Life*, April 25, 1963 (letters); October 21,
1965.

BARRET, George, R.A. **1732 (Dublin) – 1784 (London)**
The son of a clothier, he attended the drawing school in George's
Lane, Dublin, supporting himself by colouring up prints for Thomas
Silcock. He worked as a drawing master before gaining the
patronage of Edmund Burke, who commissioned him to sketch
Powerscourt and the Dargle. He came to London in 1762, and in
1768 was a Foundation Member of the R.A. He was for a while a
very fashionable painter, but he was also an improvident man and,
towards the end of his life, when he was broken in health and
pocket, Burke again helped by obtaining for him the sinecure of
Master Painter to Greenwich Hospital.

Although primarily an oil painter, he made a number of 'stained
drawings', and had a strong influence on later watercolourists in his
romantic representation of English scenery. He gained considerable
fame by a continuous view of lakeland scenery which he painted in
distemper on the walls of a room at Norbury Park, Surrey.

Examples: B.M.; V.A.M.; Blackburn A.G.; Newport A.G.; Ulster
Mus.
Bibliography: T. Bodkin: *Four Irish Landscape Painters*, 1920.

BARRET, George, Yr. **1767 (London) – 1842 (London)**
One of the original members of the O.W.S., Barret had exhibited
little before 1805, and his professional life seems to have been a
struggle from its beginning. He always lived in the Paddington area
and never travelled very widely, finding many of his subjects in the
Thames Valley and the Home Counties, with a few in Wales.
Gradually, he gave up topographical landscapes in favour of
Claudian romantic compositions, with titles such as *Retirement of
the Weary Traveller*. A number of his works were engraved for the
Annuals of the 1820s and 1830s. Like his father before him, he left
his family destitute.

Published: *The Theory and Practice of Water-Colour Painting*, 1840.
Examples: B.M.; V.A.M.; Derby A.G.; Fitzwilliam; Glasgow A.G.,
Leeds City A.G.; Leicestershire A.G.; City A.G., Manchester;
Newport A.G.; Portsmouth City Mus.; Richmond Lib.;
Southampton A.G.; Ulster Mus.; Warrington A.G.
Bibliography: *A.J.*, 1898. *Connoisseur*, CV, 1940. O.W.S. Club,
XXVI, 1947.

BARRET, James
The elder son of G. Barret, R.A., he painted landscapes in oil and
watercolour and the manner of his father, all over Britain. He makes
a rather lurid use of white heightening but can be an effective artist.
He exhibited at the R.A. from 1785 to 1819.

Examples: B.M.; Carisbrooke Cas.

BARRET, Mary, O.W.S. **– 1836**
The daughter of G. Barret, R.A. (q.v.), she was a pupil of Romney and
Mrs. Mee (q.v.). Her professional life probably began in 1797 when
she began to send miniatures to the R.A. She was elected a Member
of the Society of Painters in Water-Colours on February 10th, 1823,
and exhibited birds, fish, fruit and other still-life subjects. Between
that year and her death she lived with her brother George (q.v.) in
Paddington.

BARRETT, Thomas **1845 (Nottingham) – 1924 (Nottingham)**
A painter of genre scenes and interiors in oil and watercolour who
taught at the Nottingham School of Art. He exhibited at the R.A.
and the B.I. from 1883 to 1888, and was an engraver.

Examples: Castle Mus., Nottingham.

BARRON, William Augustus **1750 –**
The younger brother of the portrait painter Hugh Barron, he
exhibited from 1764 to 1791 and entered the R.A. Schools in 1770.
He was also a pupil of William Tomkins and won a premium from
the Society of Arts in 1766. He painted and etched in the Home
Counties, and he was patronised by the Walpoles who found him a
post in the Treasury – on which he gave up painting. On the
evidence of the drawing in the B.M., this was no great loss.

Examples: B.M.

BARROW, Joseph Charles
A topographer who held an evening drawing class twice weekly at
12 Furnival's Inn Court. Holborn, at which Francia and J. Varley
were employed as assistants. He took Varley on a tour to
Peterborough with him in 1797 or 1798. He re-drew some of the
sketches of J. Moore (q.v.), and made a series of views of Strawberry
Hill for Horace Walpole. His style is that of a rather wooden
follower of Sandby. He exhibited at the R.A. from 1789 to 1802.

Published: *Sixteen Plates . . . of Churches and other Buildings*,
1790-93.
Examples: B.M.

BARRY, Sir Charles, R.A., F.R.S. **1795 (London) – 1860**
The architect. He was articled to a firm of surveyors, and from 1817
to 1820 travelled through France, Italy, Greece and Turkey and
visited Egypt, Syria, Cyprus, Rhodes, Malta and Sicily. On his
return, he set up in practice in London and pioneered the
adaptation of the Italian palazzo to English use. In 1836 he won the
competition for the new Houses of Parliament, for which he made
over eight thousand drawings. He was elected A.R.A. and R.A. in
1840 and 1842, and he was knighted in 1852.

His work is a little stiff with muted colours, and he probably
employed other artists to put in his foregrounds and figures.

Examples: B.M.; Hove Lib.; R.I.B.A.
Bibliography: Rev. A. Barry: *Life and Works of Sir C.B.*, 1867. *A.J.*,
July, 1860.

BARSTOW, Montague
A figure painter in the tradition of A. Moore (q.v.), he lived in
London and exhibited there from 1891 to 1900 and from 1916 to
1919. In 1923 he was living in Monte Carlo.

BARTH, J S
A painter of Swiss and London views who was working between
1797 and 1809. He aquatinted prints after his own drawings, and
also visited Kent and the South West. He usually painted in
bodycolour, but, at its best in pure watercolour, his work can be
reminiscent of that of C. Varley (q.v.).

Examples: B.M.; Leeds City A.G.

BARTHOLOMEW, Anne Charlotte, Mrs., née Fayermann
c.1800 (Lodden, Norfolk) – 1862 (London)
An authoress, previously married to Walter Turnbull the popular composer, she married V. Bartholomew (q.v.) as his second wife in 1840. As well as producing plays and poems, she was a miniaturist, exhibiting at the R.A., and, under Bartholomew's influence, became a flower painter.

Published: *Songs of Azrael*, 1840. *The Ring, or the Farmer's Daughter*, 1845. *It's only my Aunt*, 1850.
Examples: B.M.
Bibliography: *A.J.,* October, 1862.

BARTHOLOMEW, Valentine 1799 (Clerkenwell) – 1879 (London)
Although he had some professional instruction at sixteen, Bartholomew was largely self taught. From 1821 to 1827 he worked for, and lived with, Charles Hullmandel the lithographer, whose daughter, Adelaide, he married in the latter year. He executed a work on flowers for Hullmandel, and in 1826 exhibited a flower piece at the R.A. He was a Member of the N.W.S. in 1834 and 1835, and was elected A.O.W.S. in the latter year. He was appointed Flower Painter to the Duke and Duchess of Kent in 1836, and Flower Painter in Ordinary to the Queen in 1837. He lived in London and married as his second wife A.C. Bartholomew (q.v.) in 1840. They were well known for their hospitality to other artists. His models were reared in the conservatory; 'largeness of style' and 'careful execution' were the hallmarks of his style.

Examples: V.A.M.

BARTLETT, William Henry 1809 (Kentish Town) – 1854 (at sea)
A topographer and traveller who was apprenticed to J. Britton (q.v.) and worked on his publications. He also painted copies of Turner, Girtin, Cotman and others. He exhibited at the R.A. and the N.W.S. from 1831 to 1833. In about 1830 he made a Continental tour and then visited Syria, Palestine and Egypt. He went to America four times and died between Malta and Marseilles.

His remaining works were sold by Southgate & Barrett of Fleet Street, in January 1855.

He should not be confused with the genre painter WILLIAM H.BARTLETT who was active from 1874.

Published: *Walks About Jerusalem*, 1845. *Pictures from Sicily*, 1852. *The Pilgrim Fathers*, 1853.
Examples: B.M.; V.A.M.; Devizes Mus.; Fitzwilliam; Glasgow A.G.; Leeds City A.G.; City A.G., Manchester; Newport A.G.; Ulster Mus.; Worcester City A.G.
Bibliography: W. Beattie: *Brief Memoir of W.H.B.*, 1855. J. Britton: *A Brief Biography of W.H.B.*, 1855. *A.J.*, January, 1855. *Country Life*, February 15, 1968.

BARTON, Rose Maynard, R.W.S. 1856 – 1929
The daughter of an Irish solicitor, she lived in Dublin and London and painted town scenes, particularly in London. She exhibited from 1889, and was elected A.R.W.S. and R.W.S. in 1893 and 1911.

Various exhibitions of her work were held in London galleries, including the Japanese Gallery in 1893 and the Clifford Gallery in 1898.

Published: as F.A. Gerard: *Picturesque Dublin*, 1898. *Familiar London*, 1904.
Examples: Ulster Mus.

BARWELL, John 1798 (Norwich) – 1876
A drawing master who painted portraits, figure subjects, landscapes and architecture. He was a member of the Norwich Society from 1813 to 1833 and exhibited at the R.A. in 1835.

H.G. BARWELL, who was a member of the Norwich Art Circle in 1885, was presumably a relative.

BATCHELDER, S J 1849 – 1932
A painter of the Norfolk Broads. His hallmark is a wherry which almost always appears in the composition.

BATEMAN, William 1806 (Chester) – 1833 (Shrewsbury)
An engraver who specialised in views of Chester and who made occasional watercolours.

BATES, David 1840 – 1921
A landscape painter in oil and watercolour who lived in Worcester, in Birmingham from 1884 to 1899, and in Malvern. He exhibited in Birmingham from 1868 to 1907, and at the R.A. and elsewhere in London from 1872. He painted mostly in the Midlands, but also at times in both Egypt and Switzerland, and he specialized in scenes, notably winter scenes, of cattle and farmworkers.

Examples: Worcester City A.G.

BATHURST, Charles 1790 – 1863
An amateur artist and the son of the Rt. Hon. Charles Bragge who took the name of Bathurst in 1804. He was educated at Christ Church, Oxford, and lived at Lydney Park, Gloucestershire. His work shows the influence of Malchair, and he drew in London, Oxford, Lancaster, Blenheim and elsewhere.

Examples: Ashmolean.

BATLEY, Walter Daniel 1850 (Ipswich) –
A landscape painter who lived at Ipswich until 1922 when he moved to Felixstowe. He exhibited in Liverpool, Brighton, Manchester and Bristol as well as in London.

BATTY, Elizabeth Frances
The daughter of Dr. Batty (q.v.), she painted landscapes. She exhibited at the R.A. from 1809 to 1816 and visited Italy in 1817.

Published: *Views of Italian Scenery*, 1818.

BATTY, John
A landscape painter working at York. He exhibited stained drawings of Yorkshire abbeys and views of the Lake District in London from 1772 to 1788.

BATTY, Dr. Robert M.
A surgeon who lived in Hastings and painted landscapes and marine subjects. He exhibited at the R.A. from 1788 to 1797. His colours are bright and his figures animated. He was the father of E.F. Batty (q.v.) and R. Batty (q.v.).

BATTY, Lieutenant-Colonel Robert, F.R.S.
1789 (London) – 1848 (London)
The son of Dr. Batty (q.v.), he was educated at Gonville and Caius College, Cambridge. He entered the Grenadier Guards in 1813, returning to Cambridge on leave to take a degree in medicine. He served in the Peninsular war and at Waterloo, where he was wounded in the hip, and he was promoted lieutenant-colonel in 1828. He produced a series of illustrated memoirs of the campaign, and afterwards worked on a series of views of Europe. He first visited Italy at the age of fifteen, and later toured France in 1819, Germany in 1820, as well as Belgium, Holland and Wales. He retired in 1839.

Published: *A Sketch of the Late Campaign in the Netherlands*, 1815. *An Historical Sketch of the Campaign of 1815*, 1820. *French Scenery*, 1822. *Campaign of the Left Wing of the Allied Army . . .*, 1823. *Welsh Scenery*, 1823. *German Scenery*, 1823. *Scenery of the Rhine, Belgium and Holland*, 1826. *Hanoverian and Saxon Scenery*, 1829. *Six views of Brussels*. 1830. *A Family Tour through South Holland*, 1831. *Select Views of the Principal Cities of Europe*, 1832.
Illustrated: Sir J. Barrow: *The Mutiny and Piratical Seizure of H.M.S. Bounty*, 1876.
Examples: Nat. Mus., Wales; Wolverhampton A.G.
Bibliography: *A.J.*, January, 1849.

BAUER, Ferdinand Lucas
1760 (Feldsberg, Austria) − 1826 (Vienna)
In 1786 he was engaged as a draughtsman by John Sibthorn who was passing through Venice on his first journey to Greece. He illustrated Sibthorp's *Flora Graeca* and worked for him as a topographical artist both in Greece and later in England. His botanical drawings are conventional, and his sepia and indian ink views stiff and rather formal.

His brother, FRANS ANDREAS BAUER, F.R.S. (1758-1840), came to England in 1788 and was employed by Sir Joseph Banks as draughtsman to the Royal Botanic Gardens, Kew. He was also Botanic Painter to George III.

Examples: B.M.; Ashmolean; Nat. Hist. Mus.

BAXTER, Thomas 1782 (Worcester) − 1821 (London)
A porcelain painter at Worcester and Swansea, who ran an art school in London from 1814 to 1816, when he returned to Worcester. As well as studies of fruit and of decorative and mythological subjects, he painted portraits and provided drawings for Britton's *Salisbury Cathedral*. He was also an occasional engraver and exhibited at the R.A. from 1802 to 1821.

Published: *An illustration of the Egyptian, Grecian and Roman Costume*, 1810.
Examples: B.M.; V.A.M.; Worcester City A.G.

BAXTER, W G c.1855 (Ireland) − 1888
After working for an architect in Manchester, he moved to London where he became a cartoonist for *Judy*. From 1884 to 1886, he produced the drawings for *Ally Sloper's Half-Holiday*. See also De Tessier, Isabelle Emilie.

BAYES, Alfred Walter 1832 (Yorkshire) − 1909 (London)
A genre painter and etcher, he exhibited from 1858. He painted in both oil and watercolour, and his style is that of a meticulous Pre-Raphaelite follower. He illustrated a number of fairy and Biblical stories. His maidens tend to look faintly care-worn. He was killed by a motor cab.

BAYES, Walter John, R.W.S. 1869 (London) − 1956
The son of A.W. Bayes (q.v.), he was a painter, decorator and scene designer. He was Headmaster of the Westminster Art School, Art Master at Camberwell, and an art critic for the *Athenaeum*. He travelled widely throughout Europe.

Examples: Fitzwilliam; Leeds City A.G.

BAYFIELD, Fanny Jane
A drawing mistress at Norwich, she exhibited flower paintings in London from 1872 to 1889. She was a member of the Norwich Art Circle, and her best known pupil was Munnings.

BAYLISS, Sir Wyke, F.S.A.
1835 (Madeley, Shropshire) − 1906 (London)
An architect, painter in oil and watercolour and a writer, he was the son and pupil of a drawing master. He studied at the R.A. Schools, worked in an architect's office and lived in Clapham. He exhibited from 1855 and in 1864, after attempting to join the N.W.S., he was elected to the S.B.A. of which he became President in 1888. His subjects are often Gothic Church interiors. He was knighted in 1897, and was a lecturer and writer on art.

Examples: City A.G., Manchester; Castle Mus., Nottingham.
Bibliography: *A.J.*, 1906.

BAYNES, Frederick Thomas
The grandson of J. Baynes (q.v.) and probably the son of T.M. Baynes (q.v.). He lived in London and exhibited fruit and flower subjects from 1833 to 1864, and he was an unsuccessful candidate for the N.W.S. in 1863.

Examples: V.A.M.; Bethnal Green Mus.

BAYNES, James 1766 (Kirkby Lonsdale) − 1837
A 'poor nervous creature' but a successful drawing master and landscapist. He studied under Romney and at the R.A. Schools. In 1798 or 1799 he accompanied J. Varley (q.v.) on a sketching tour of Wales, and shortly afterwards he was unmasked by Varley and Nicholson as submitting his own drawings to the Society of Arts for those of his pupils. He was a member of the A.A. and exhibited with the Oil and Watercolour Society until 1820. He was fond of drawing farm-houses, sometimes rather in the manner of Girtin.

Examples: B.M.; V.A.M.; Ashmolean; York A.G.

BAYNES, Thomas Mann 1794 − 1854
Probably the son of J. Baynes (q.v.), he was a lithographer. He exhibited at the R.A. and the O.W.S. in 1820. He worked in London and Ireland.

Published: *The Parks of London*, 1825.
Examples: B.M.; City A.G., Manchester.

BAYNTON, Henry 1862 − 1926
A landscape painter who lived in Coventry and exhibited at Birmingham in 1833.

Examples: Coventry A.G.

BEACH, Ernest George 1865 (London) −
A landscape, figure and portrait painter in watercolour as well as in oil and pastel. He was educated at Mill Hill School and studied in London and Paris. He lectured on art, lived in Kent, and painted in Holland, Belgium and France. He was still active in 1934.

BEACH, Thomas 1738 (Milton Abbas) − 1806 (Dorchester)
A portrait painter who was a pupil of Reynolds and worked in Bath. He exhibited from 1772 and was a member of the Society of Artists.

BEALE, James 1798 (Cork) −
A landscape painter who travelled in Europe and North Africa.

Examples: Cork A.G.

BEAN, Ainslie H
A landscape and coastal painter who specialised in Italian subjects and exhibited from 1870 to 1886.

BEARDSLEY, Aubrey Vincent 1872 (Brighton) − 1898 (Mentone)
The black and white illustrator. For a time he worked as a city clerk, but on the advice of Burne-Jones turned to art full time. His first illustrations were for Dent's edition of the *Morte d'Arthur*, and he worked for the *Pall Mall Budget*, the *Yellow Book* and the *Savoy*.

His work has been divided into three phases: first, the romantic and Pre-Raphaelite; second, the decorative and Japanese; and third, the eighteenth century and French. At the time, it was described as 'the mere glorification of a hideous and putrescent aspect of modern life'.

Examples: B.M.; Ashmolean; Cecil Higgins A.G., Bedford; Glasgow A.G.
Bibliography: A. Symons: *A.B.*, 1898. H.C. Marillier: *The Works of A.B.*, 1899, 1901. C.H.C. MacFall: *A.B.*, 1928. A.R. Walker: *How to detect B. Forgeries*, 1950. H. Maas, J. Duncan & W. Good: *The Letters of A.B.*, 1970. Tate Gall.: *Exhibition Cat.*, 1923-4.

BEARNE, Edward H
A landscape, genre and portrait painter who exhibited from 1868 to 1895. He painted in Britain, Italy, Germany, France and Holland, and in 1892 moved from London to Dunster, Somerset. His work is of a very high quality, and an exhibition was held at MacLean's Gallery in 1893.

His wife, CATHERINE MARY, née CHARLTON, whom he married in 1889, was also a landscape painter and a Royal biographer.

Illustrated: C.M. Bearne: *Lives and Times of the Early Valois Queens*, 1899.

BEATRICE, Mary Victoria Feodore, H.R.H. Princess,
Princess Henry of Battenburg
 1857 (Windsor Castle) – 1944 (Brantridge Park, Sussex)
The fifth daughter of Queen Victoria (q.v.) and Prince Albert (q.v.), she was a pupil of A Corbould (q.v.). She painted landscapes, most notably in Egypt in 1903 and 1904, and was perhaps the best and most serious artist of her family. She was made an Honorary R.I. in 1885.

Bibliography: M.E. Sara: *The Life and Times of H.R.H. Princess B.*, 1945.

BEAUCLERK, Lady Diana **1734** **– 1808**
The eldest daughter of Charles Spencer, second Duke of Marlborough, she married the second Viscount Bolingbroke in 1757. In 1768 she was divorced and, two days later, married Topham Beauclerk. He died in 1780. Reynolds and Walpole were among her admirers, but Johnson thought little of her.

She made seven 'sut-water' designs for Walpole which he hung at Strawberry Hill; and several of her drawings, including a portrait of the Duchess of Devonshire, were engraved by Bartolozzi. She also produced mythological and rustic costume scenes in light colour washes.

Illustrated: Burger, *Leonora*, 1796. *Fables of John Dryden*, 1797.
Examples: B.M.; V.A.M.
Bibliography: B.C. Erskine: *Lady D.B.*, 1903. *Connoisseur*, VII, 1903. *Antique Collector*, August, 1958.

BEAUFORD, William H **1735** **– 1819 (Dublin)**
An amateur antiquarian draughtsman, working in Dublin. He made an antiquarian tour of the south of Ireland in 1786, and toured Carlow and Wicklow in 1787. Many of his drawings from these and other tours were engraved by James Ford for Ledwich's *Antiquities of Ireland*, 1790. Other drawings were engraved for the *Irish Bards*, and by H. Brocas (q.v.) and S. Clayton for *Anthologia Hibernica*, 1793-4. He was one of the founders of the Antiquarian Society.

Published: *The Ancient Topography of Ireland*, 1770. *Druidism Revived*, 1770. *An Essay on the Poetical Accents of the Irish*, 1786.

BEAUMONT, Sir Albinus **(Piedmont) – c.1810**
A landscape painter who became a naturalised Englishman. He produced a number of aquatint views of France, Italy and Switzerland from 1787 to 1806. These were usually based on his own rather weak drawings.

Examples: B.M.

BEAUMONT, Alfred
An architect who entered the R.A. Schools in 1831. Later he travelled in Greece, making architectural drawings which he exhibited at the R.A. He became Surveyor to the County Fire Office.

Published: *Hints for Preventing Damage by Fire*, 1835.

BEAUMONT, Sir George Howland, 6th Bt.
 1753 (Dunmow, Essex) – 1827
In 1762 he succeeded to the baronetcy, and he was brought up in Suffolk by the Rev. Charles Davy, through whom in 1771 he met T. Hearne (q.v.). Both Hearne and J. Farington (q.v.), whom he met two years later, had a considerable influence upon him and they joined him on his honeymoon in the Lake District in 1778. He also studied under Cozens at Eton, and under Malchair at New College, Oxford. He toured Switzerland and Italy with his wife in 1782 and 1783, and made a further visit, or visits, to the Continent from 1819 to 1822, touring Holland, Germany, Switzerland and Italy. He was M.P. for Beeralston from 1790 to 1796. In 1800 he left his house at Dunmow, and, with the assistance of G. Dance (q.v.), began the re-building of Coleorton Hall, Leicestershire. There he established a well merited reputation as an art patron, befriending Constable, Haydon, Alexander, Edridge, Wordsworth, Coleridge and Scott amongst many others. His house in Grosvenor Square was also a focal point for people from the worlds of art and politics. He was one of the principal founders and benefactors of the National Gallery.

In his drawings he is always old-fashioned in a romantic, eighteenth century manner which shows the influence of Claude and Wilson. His inability to understand the modernism of Constable is well-known as is his dislike of Turner's work. His style is rather woolly, but conveys a sense of the dramatic qualities of landscape. His drawings are generally in pencil and wash.

An exhibition of his work was held at the Leicester A.G. in 1938.

Examples: B.M.; Glasgow A.G.; Abbot Hall A.G., Kendal; Leeds City A.G.; Leicester A.G.; N.G., Scotland.
Bibliography: W.A. Knight: *Memorials of Coleorton*, 1887. M. Greaves: *Regency Patron, Sir G.B.*, 1966. V.A.M. MSS: *Letters to Dr. T. Monro*, 1808-21. Leicester A.G., 1938; 1953. *Country Life*, February 27, 1969.

BEAVIS, Richard, R.W.S. **1824 (Exmouth) – 1896 (London)**
A landscape and coastal painter who, despite parental opposition, entered the Government School of Design at Somerset House in 1846. Thereafter he worked as designer for Messrs. Trollope, a successful decorating firm, full-time until 1863 and thereafter part-time. He exhibited at the R.A. and elsewhere from 1851, and was elected A.N.W.S. and N.W.S. in 1867 and 1871. He later transferred to the older Society, and was elected A.R.W.S. and R.W.S. in 1882 and 1892. He lived at Boulogne in 1867-8, visiting Holland, and in 1875 he travelled to Egypt and Palestine by way of Venice and Brindisi. He was noted for his atmospheric treatment of his subjects, and he also painted animals and Eastern scenes.

His remaining works were sold at Christie's, February 17, 1897.

Examples: B.M.; V.A.M.; Gray A.G., Hartlepool; Portsmouth City Mus.
Bibliography: J.H. Hollowell: *A Critical Description . . . of the Halt of Prince Charles Edward* [by R. Beavis], 1881. *A.J.*, 1877.

BECHER, Rear Admiral Alexander Bridport
A surveyor, scientist and amateur artist who, before entering the Hydrographic Office of the Admiralty in 1823, served in the West Indies and carried out surveys of the Canadian Lakes, the Azores, a part of the African coast and some of the Cape Verde Islands. From 1820 to 1822 he was in the Pacific and in the latter year he was promoted lieutenant. He worked in the Hydrographic Office until his retirement in 1865, and edited the *Nautical Magazine* from its first issue in 1832 to 1871. He was in the North Sea in 1839 and surveyed the Orkneys in 1847-8. In 1856 he was made a retired rear-admiral. He sketched in Fareham, Wales, Rutland and Scotland.

Published: *Description of an Artificial Horizon*, 1844. *The Landfall of Columbus*, 1856. *Navigation of the Atlantic Ocean*, 1883.
Examples: Greenwich.

BECK, John W
A drawing master at Mussoorie School, India in 1861, he exhibited at the Grafton and New Galleries from 1879 and was on the Consulting Committee of the latter in 1888. He was for a time Secretary of the Grosvenor Gallery.

Examples: India Office Lib.

BECKER, Edmund
Probably an amateur pupil of R. Cooper, Yr. (q.v.), and of German extraction. He seems to have worked in Rome in about 1780, and in the Lake District and Thames Valley at the end of the 1790s. His style is close to that of T. Sunderland (q.v.), but with a weaker pen line. His drawings are often inscribed with place names and sometimes with colour notes.

He should not be confused with FERDINAND BECKER who was active from about 1793 and died at Bath in 1825.

Examples: B.M.; Leeds City A.G.

BECKER, Harry 1865 – 1928
A landscape painter who was living in Colchester in 1885, London, in 1895, and Wenhaston, Suffolk, in 1913.

Examples: B.M.; City A.G., Manchester.

BECKWITH, Thomas – 1786 (York)
A painter of the antiquities of Yorkshire. For a short time F. Nicholson (q.v.) was his pupil. He was working in York from 1765 or earlier.

BEDE, Cuthbert see BRADLEY, Rev. Edward

BEDFORD, Francis 1784 – 1858
An architectural draughtsman who was in Greece in 1812 drawing the Temple of Diana at Magnesia for the Society of Dilettanti. He later worked as a church architect in London and made topographical illustrations.
 His son FRANCIS BEDFORD, YR. exhibited similar subjects at the R.A. from 1843 to 1849.

Examples: R.I.B.A.; Soane Mus.

BEDFORD, Francis Donkin 1864 (London) –
Possibly the grandson of F. Bedford (q.v.), he lived in London, painted genre scenes, sometimes in imitation of Boucher, and exhibited at the R.A. from 1892. He also made illustrations for children's books, novels and topographical works.

BEDFORD, Admiral Sir Frederick George Denham
 1838 – 1913
An amateur artist who kept regular albums and diaries. He served as a midshipman in the Crimea, and commanded the Indian trooper *Seraphis* on its journey to take the Prince of Wales to India in 1875-6. On his return he left for the Pacific on board the H.M.S. *Shah,* where he became engaged in a battle with the *Huascar.* He was Commander-in-Chief of Capetown in 1892, and of the North American Station in 1899.

Published: *The Sailor's Handbook,* 1884. *Life on Board H.M.S. Britannia,* 1890.

BEDFORD, George 1849 – 1920 (Torquay)
After studying at Torquay School of Art and at South Kensington, he returned to Torquay as Headmaster of his old school from 1878 to 1918. He was also Headmaster of Newton Abbot Art School and examiner to the Royal Drawing Society. He lectured on etching and crafts.

Examples: V.A.M.

BEDFORD, John Bates 1823 (Yorkshire) –
A painter of historical and genre subjects and occasional landscapes or garden scenes. He worked in London and exhibited at the R.A. and elsewhere from 1848 to 1886.

BEECHEY, Captain Richard Bridges 1808 – 1895
An occasional watercolourist who entered the Navy and was posted to the West Indies. In 1825 he sailed on board H.M.S. *Blossom* to the Pacific, twice visiting the Bering Strait. In 1828 he was sent to the Mediterranean, and in 1835 he joined a survey of Ireland, where he remained for a long time. He was promoted commander in 1846 and captain in 1851.
 A watercolour of Macao, dated 1826 and taken from H.M.S. *Blossom,* was in the Chater Collection.

BEETHOLME, George Law
A solicitor who exhibited watercolours of Scottish topography from 1847 to 1878. He lived in London. His son GEORGE LAW FRANCIS BEETHOLME exhibited still-lifes of fruit from 1879 to 1904.

BEILBY, William 1740 - 1819 (Nottingham)
The son of a Durham goldsmith and brother of the engraver Ralph Beilby, he was an enamel painter, drawing master and topographer. He was taught in Birmingham and worked in Newcastle, Chelsea, where he kept a school, and the Nottingham area. In 1778 he was the only drawing master in Newcastle, and in 1785 he produced drawings of Battersea and Chelsea which were aquatinted by Jukes. His brother Thomas and his sister Mary worked as his assistants.

BELCHER, Diana, Lady, nee Joliffe
A landscape and figure painter who exhibited with the Society of Female Artists in the 1860s. She married Admiral Sir Edward Belcher in 1830 and had a difficult married life.

Published: *The Mutineers of the Bounty and their Descendants,* 1870.
Bibliography: A.G.K. L'Estrange: *Lady Belcher and her Friends,* 1891.

BELGRAVE, Major-General Dacres Thomas Charles
 1847
A landscape painter who taught drawing at the R.M.A. Woolwich in the late nineteenth century. He was commissioned in the Royal West Kent Regiment in 1866, served in the Sudan in 1885-6 and retired in that year.

BELL, Arthur George, R.I. 1849 – 1916
A landscape painter who lived in Hampstead and London. He exhibited from 1879 and was elected R.I. in 1911. He painted in France and Germany as well as on the Thames, in East Anglia, Devon and the New Forest. He illustrated a number of travel books by Nancy Meugens, whom he later married.

BELL, Sir Charles 1744 (Edinburgh) – 1842 (Worcester)
A surgeon and amateur artist. He produced sketchy wash landscape drawings, and etchings. He wrote a number of medical treatises.

Examples: B.M.

BELL, John Anderson 1809 (Glasgow) – 1865
An architect who was educated at Edinburgh University. He studied in Rome in 1829 and 1830, and practised in Birmingham, where he exhibited in 1835, and Edinburgh.
 He painted landscapes, sea pieces, Italian churches and Roman ruins, as well as still-lifes.

Examples: B.M.; N.G., Scotland.

BELL, Robert Anning, R.A. 1863 (London) – 1933
Designer of mosaics and stained glass, sculptor, illustrator and painter in several media, he was apprenticed to an architect and studied at the Westminster School of Art, the R.A. Schools and in Paris under Aimé Morot. He visited Italy and exhibited there and in France as well as London. He was elected A.R.A. and R.A. in 1914 and 1922, and A.R.W.S. and R.W.S. in 1901 and 1904. He was Professor of Design at the R.C.A. from 1918 to 1924, and taught in Glasgow and Liverpool.
 An exhibition of his work was held at the Fine Art Society in 1907.

Examples: B.M.; Cartwright Hall, Bradford; Preston Manor, Brighton; City A.G., Manchester.

BELLERS, William, Yr.
The son of an artist, he painted and etched landscapes in the Lake District, Derbyshire, Hampshire and Sussex. He was working in the second half of the eighteenth century and in the manner of G. Lambert (q.v.). He also painted coastal scenes.

BELSHAW, Frank c. 1850 (Nottingham) – c.1910
A still-life painter in oil and watercolour who exhibited at the R.A. and Suffolk Street in 1881 and 1882.

BENDIXEN, Siegfried Detlev 1786 (Kiel) – 1864 (London)
A landscape painter, portraitist and print-maker who settled in London in 1832, and exhibited at the N.W.S., the R.A. and elsewhere from 1833 until his death.

Examples: V.A.M.

BENETT, Newton 1854 (London) – 1914 (Dorchester)
A landscape painter who was the son of a Master in the High Court and a collateral descendant of Sir Isaac Newton. He was a pupil of P.J. Naftel (q.v.), and worked much in the New Forest and Dorset and at Warborough-on-Thames. He used white heightening in his watercolours.

Examples: V.A.M.

BENGER, Berenger 1868 – 1935
A painter of landscapes and town scenes in oil and watercolour. He lived in Liverpool and exhibited at the R.A., the R.I. and elsewhere from 1884. His style is atmospheric and sometimes impressionistic.
 A W. EDMUND BENGER also painted watercolours.

Illustrated: H.A. Morah: *Highways and Hedges*, 1911.
Examples: Towner Gall., Eastbourne; Glasgow A.G.; Ulster Mus.

BENNETT, Harriet M.
A painter of the highest Victorian genre subjects who exhibited at the R.A. and the R.I. from 1877. She designed Christmas cards and calendars in 1894 and 1903.
 She should not be confused with FRANK MOSS BENNETT (1874-1953) the Cardinal and landscape painter in oil and watercolour, nor with the American naval painter and writer FRANK MARION BENNETT.

BENNETT, William, N.W.S. 1811 – 1871 (Clapham Park)
A painter of castles and abbeys who may have been a pupil of Cox. He exhibited from 1848, in which year he was elected A.N.W.S., becoming a full member in 1849. He is often listed as 'Yr', and may have been the son of W.J. Bennett (q.v.).
 His work is often very close to that of Cox in his middle period. His own pupils included A. Williams (q.v.).

Examples: B.M.; V.A.M.; Maidstone Mus.; Sydney A.G.

BENNETT, William James 1787 (London) – 1844 (New York)
Little is known of this artist; even his christian names and the spelling of his surname are in dispute. He was a member of the A.A. and Treasurer during the last two years. In 1820 he was elected A.O.W.S., but resigned in 1825. He seems to have been a talented engraver, and may be identified with the brother-in-law of F. Nash (q.v.) who is said to have fled to America after a banking fraud and become President of the New York Academy. He exhibited a number of Mediterranean views and engraved several plates after his brother-in-law.

Examples: B.M.; Newport A.G.

BENNETT, William Mineard c. 1778 (Exeter) – 1858 (Exeter)
A portrait painter in oil and watercolour and a miniaturist, Bennett was a pupil of Sir T. Lawrence (q.v.). He spent some time in London before moving to Paris, where he practised until 1844, in which year he returned to Exeter. His portraits are much influenced by those of his master.

Examples: Ulster Mus.

BENSON, Charlotte E. 1846 – 1893
She attended the R.D.S. Schools, where she won a medal for a still-life drawing. She exhibited landscapes and seascapes at the R.H.A. from 1873 to 1890. She made many sketches while visiting her brother in India.
 Her sister MARY KATE BENSON was also an artist.

BENTINCK, Lady Charles, née Anne Wellesley – 1875
With her husband, she was a pupil and patron of de Wint. She was in Italy in 1827. Her husband was Lt. Col. Lord William Charles Augustus Bentinck, and they were married in 1816. Her previous marriage to Sir William Abdy, 7th Bt., had been dissolved.

BENTLEY, Charles, O.W.S. 1806 (London) – 1854 (London)
A marine artist who was apprenticed to the engraver Theodore Fielding (q.v.). His style was largely moulded by a study of Bonington's work for engravings, and later by his fellow-apprentice and life-long friend W. Callow (q.v.). He started engraving on his own behalf on the termination of his apprenticeship in 1827, and for some years combined engraving with watercolour painting. He was elected A.O.W.S. in 1834 and O.W.S. in 1843. He was a poor business man and always in financial difficulties. He died from cholera.
 He painted on almost all the British coasts as well as the Channel Islands, and in 1836, 1840 and 1841 he visited Normandy and Paris with Callow. Although he produced works of subjects which were further afield, these were probably worked up from amateur sketches.
 His watercolours are done with great verve and his colour comes directly from Bonington. There is sometimes, however, evidence of weak drawing and perspective. On occasions he makes liberal use of bodycolour. His remaining works were sold at Christie's, April 15, 1855.

Examples: B.M.; V.A.M.; Blackburn A.G.; Leeds City A.G.; Newport A.G.; Ulster Mus.
Bibliography: *Walker's Quarterly, 1, April*, 1920.

BENTLEY, Joseph Clayton 1809 (Bradford) – 1851 (Sydenham)
A pupil of R. Brandard (q.v.), he was an engraver and landscape painter who is often confused with his better-known namesake, Charles. His subject matter is similar, as is his style, although this is rather weaker. They also worked as engravers or illustrators on a number of the same publications, thus adding to the confusion. J.C. Bentley exhibited at the B.I. from 1833 and the R.A. from 1846, as well as at Suffolk Street.

Examples: V.A.M.; Cartwright Hall, Bradford.
Bibliography: *A.J.*, January, 1852.

BENWELL, John Hodges 1764 (Blenheim) – 1785 (London)
A pupil of Saunders, a portrait and genre painter, he studied at the R.A. Schools from 1779, winning a silver medal in 1782. He then became a drawing master in Bath.
 He was a competent and charming illustrator.

Examples: B.M.; V.A.M.; City A.G., Manchester.

BENWELL, Joseph Austin
A painter of Eastern scenes in oil and watercolour who spent some years in India and China up to 1856. He was in Egypt and Palestine in 1865-6. He exhibited at the R.A. and the R.I. from 1865 to 1883 and was also a wood engraver.

Illustrated: Raffer: *Our Indian Army*. Capper: *Three Presidencies of India*.

BERANGER, Gabriel 1729 (Rotterdam) – 1817 (Dublin)
A landscape draughtsman of Huguenot extraction, he came to Dublin in 1750, where he taught drawing and exhibited with the Dublin Society of Artists. In 1773 he made an antiquarian tour of Ireland, and in 1779 toured the west of Ireland with a view to making drawings for the newly formed Antiquarian Society. The next year, together with J.J. Barralet (q.v.), he toured Wicklow and Wexford, and the following year visited Dundalk. He ran a print-selling business and, from 1783 to 1789, he worked as assistant ledger keeper in the Exchequer office.
 He was an accurate, if unimaginative, draughtsman. His figures, however, are spirited, and he often included himself in red coat, yellow breeches and cocked hat, measuring-staff in hand. He kept an illustrated itinerary of his tours, which he left, in two volumes ready for publication, to two nieces of his second wife. One of these volumes is now in the R.I.A.

Bibliography: Sir W.R.W. Wilde; *Memoir of G.B.*, 1880.

BERESFORD, Cecilia Melanie
A painter of Italian, and occasional Irish, figure subjects. She lived in Tenbury before going to Rome in 1882, and in London after her return ten years later. She exhibited at Suffolk Street and the R.I. from 1865 to 1885.

Examples: V.A.M.

BESTLAND, Charles
An etcher and oil painter who occasionally produced historical and genre scenes, such as 'The Sailor's Farewell and Return', in watercolour, presumably as preparatory compositions for prints. He exhibited from 1783 to 1837.

Examples: N.G., Scotland.

BEUGO, John **1759 (Edinburgh) – 1841**
An engraver and friend of Burns. He made watercolours of subjects from Burns as well as engravings for the 1787 edition of the poems. He also painted small wash portraits.

Examples: N.G., Scotland.

BEVAN, Robert Polhill **1865 (Hove) – 1925 (London)**
An animal, portrait and landscape painter who studied in Paris. He became Treasurer of the London Group. Early in his career he specialised in scenes of horse sales, and later in Devonshire landscapes.
A memorial exhibition was held at Brighton in August 1926.

BEVAN, William **– c.1848**
A drawing master at Hull College from 1842 to 1848, he executed a number of coloured lithographs of local churches.

BEVERLEY, William Roxby
 1811 (Richmond, Surrey) – 1889 (Hampstead)
The son of a family of northern actors called Roxby who took the name of Beverley because they liked the town. He began his career as a scene painter and actor for his father in the North. In 1838 he was working in Edinburgh and in 1839 in London. After some time in Manchester, he returned to London in about 1846. In 1851 he visited Switzerland. From 1853 he was scenic director at Covent Garden, and from 1854 to 1884 did a great deal of work at Drury Lane. Between 1865 and 1880 he exhibited marine watercolours at the R.A.
In style he is a follower of Bonington, with a similar liking for beached boats and misty effects. Blues, browns and golden sunsets, usually with touches of red on the figures, are his favourite colours. He was a friend and pupil of C. Stanfield (q.v.).

Examples: B.M.; V.A.M.; Bridport A.G.; Towner Gall., Eastbourne; Fitzwilliam; Greenwich; Leeds City A.G.; Leicestershire A.G.; Newport A.G.; Portsmouth City Mus.; N.G. of Scotland; Ulster Mus.
Bibliography: *Magazine of Art*, 1889. *Walker's Quarterly* II, XXI.

BEWICK, Robert Elliot **1788 (Newcastle) – 1849 (Newcastle)**
The pupil and only son of T. Bewick (q.v.), he became his father's partner in 1812 and assisted him with the illustrations for *Aesop's Fables*, 1818, and the projected *History of British Fishes*. He took over the business shortly before his father's death. He also made small watercolours of Newcastle buildings.

Examples: B.M.; Laing A.G., Newcastle.

BEWICK, Thomas
 1753 (Cherryburn, Northumbria) – 1828 (Gateshead)
The wood engraver and naturalist. He was apprenticed to Ralph Beilby, a copper engraver in Newcastle, whose partner he later became. After a short time in London and Scotland, Bewick returned to Newcastle, where he revived the art of wood-engraving. He produced a number of extremely fine books, and instructed the foremost engravers of the next generation. His health was not good: he had a serious illness in 1812 and, shortly before his death, he passed his business to his son. His drawings are careful and often

strongly coloured, as would be expected from an engraver. A loan exhibition of his work was held at the Fine Art Society in 1880. His pupils included L. Clennell (q.v.), J. Nesbit, W. Harvey (q.v.), J. Jackson (q.v.), E. Landells (q.v.), H.F.P.W. Hole, W. Temple, and his son R.E. Bewick (q.v.).
His brother JOHN BEWICK the elder (1760-1795), his nephew JOHN BEWICK, YR. (1790-1809) and his daughter JANE BEWICK (1787-1881) were all watercolourists and engravers.

Published: *History of Quadrupeds*, 1790. *History of Birds*, 1797. *Aesop's Fables*, 1818. *Memoir*, 1862.
Illustrated: *Gay's Fables. Select Fables.* Consett: *A Tour through Sweden, Lapland . . . etc.*
Examples: B.M.; V.A.M.; Fitzwilliam.
Bibliography: F.G. Stephens: *T.B., Notes on a Collection of Drawings and Woodcuts*, 1881. D.C. Thomson: *The Life and Works of T.B.*, 1882. D.C. Thomson: *The Water-Colour Drawings of T.B.*, 1930. C.M. Weekley: *T.B.*, 1953. V.A.M. MSS: Letters and Documents. *A.J.*, 1903. *Country Life*, September 17, 1970.

BEWICK, William **1795 (Hurworth) – 1866 (Darlington, Durham)**
No relation of T. Bewick, he was a pupil of B.R. Haydon (q.v.) and produced drawings of antiquities as well as painting portraits and copying old masters in Italy, where he lived for four years in the 1820s. Soon after 1840 his health broke down and he retired to Durham, living at Haughton-le-Skerne.

Examples: B.M.
Bibliography: T. Landseer, *Life and Letters of W.B.*, 1871.

BIDLAKE, Rev. John
The Headmaster of Plymouth Grammar School, he was a poet and an amateur artist and encouraged the young S. Prout (q.v.) and B.R. Haydon (q.v.) by taking them on sketching trips. He also taught Sir C.L. Eastlake (q.v.) who painted his portrait in 1813.

BIFFIN, Sarah
 1784 (East Quantoxhead, Somerset) – 1850 (Liverpool)
A pupil of W.M. Craig (q.v.) who, being handless and footless, painted miniatures with the brushes held in her mouth. She practised at Brighton, where she lived with her guardian, Mr. Dukes, and at Liverpool, and she received Royal patronage.

Bibliography: *A.J.*, November 1850.

BIGARI, Angelo Maria **(Bologna) –**
He left Italy for Ireland, and in 1772 was working as a scene painter for the Smock Alley Theatre, Dublin. He exhibited with the Dublin Society of Artists in 1777, and in 1779 accompanied G. Beranger (q.v.) on his antiquarian tour of western Ireland.

Illustrated: F. Grose: *Antiquities of Ireland*, 1791-5.
Examples: R.I.A.

BIGLAND, M. B
A landscape painter who lived in Darlington and also painted in the Home Counties, exhibiting a Surrey view at Brighton in 1875.

BIGOT, Charles
A painter of London views in pen and watercolour, who was working between 1820 and 1850.
Examples: B.M.

BILLINGS, Robert William **1815 (London) – 1874 (London)**
A sculptor and architect as well as a landscape and topographical painter. He visited Bath between 1834 and 1837, painting churches, and he exhibited at the R.A. from 1845 to 1872.

Published: *Architectural Illustrations of Carlisle Cathedral*, 1840. *Architectural Illustrations of Durham Cathedral*, 1843. *Architectural Illustrations of Kettering Church*, 1843. *Baronial Antiquities of Scotland*, 1848-52.
Examples: Victoria A.G., Bath; N.G., Scotland.

BILSTON, S.
A prolific architectural painter in Northumbria during the middle of the nineteenth century.

BINGLEY, James George 1840 – 1920 (Norwood)
A landscape painter in oil and watercolour who lived in Godalming, Wallington and Midhurst. He also painted in the West Country and Italy and exhibited at the R.A., the R.I. and elsewhere from 1871. His watercolours are colourful and fairly freely drawn, and he uses white heightening.

Examples: B.M.

BIRCH, Samuel John Lamorna, R.A , R.W.S.
 1869 (Egremont, near Birkenhead) – 1955
Brought up in Manchester, he worked in a mill for some years, selling watercolour sketches made in his spare time. In 1892 he turned to art full time, and moved to Newlyn, Cornwall. Shortly afterwards he went to study in Paris, where he was influenced by Monet and Pissaro. He took the extra name of Lamorna (from the village in which he lived) in order to avoid confusion with Lionel 'Newlyn' Birch. In 1902 he married and settled there permanently. He was elected A.R.A. and R.A. in 1926 and 1934. He travelled widely, reaching Australia and New Zealand, but is chiefly remembered for his views of Cornish woods and streams in oil and watercolour, and for his handling of light and colour.

Examples: B.M.; Towneley Hall, Burnley; Exeter Mus.; Glasgow A.G.; Hove Lib.; Leicestershire A.G.; City A.G., Manchester; Newport A.G.; Nottingham Univ.

BIRD, Edward, R.A. 1772 (Wolverhampton) – 1819 (London)
Apprenticed to a firm of tin and japan ware manufacturers at Wolverhampton and Birmingham, he had moved to Bristol and set up a drawing school by 1797. He was self taught and painted portraits, landscapes and historical subjects in oil and watercolour. He exhibited at the R.A. from 1809 and was elected A.R.A. and R.A. in 1812 and 1815. In 1813 he was appointed Historical Painter to Princess Charlotte. He always painted from the life and often produced Wilkie-like sketches of his friends, who included many of the artists and intellectuals of Bristol. Despite his success he died poor and embittered. A memorial exhibition was held in Bristol in 1820.

Examples: B.M.; Aberdeen A.G.; City A.G., Bristol; Wolverhampton A.G.
Bibliography: *A.J.*, November 1859, 1899.

BIRD, Isaac Faulkner
A portrait and landscape painter who was working at Exeter from 1826 to 1861. His work can be free in the manner of Gainsborough, and there are sometimes echoes of J.J. Cotman.

BIRD, John, 'of Liverpool' 1768 – 1826 (Whitby)
A topographer who provided drawings for Angus: *Seats of the Nobility*, 1787. He settled in Whitby and encouraged the young G. Chambers (q.v.). His work can be reminiscent of that of R. Dixon (q.v.).

Published: with G. Young: *A Geological Survey of the Yorkshire Coast*, 1822.

BIRKETT, S.
A landscape and still-life painter, working in about 1862.

BIRLEY, Ada Kate
A flower painter who lived at Birmingham and exhibited there in 1880 and 1881.

BIRTLES, Henry 1838 (Birmingham) – 1907
A Birmingham painter of meadows, sheep and cattle who moved to London in 1864. In 1867 he settled at Arundel but kept a studio in Hampstead. He exhibited in Birmingham and London from 1855 to 1900, and was an unsuccessful candidate for the N.W.S. on four occasions from 1863 to 1874.

Examples: Birmingham City A.G.; Glasgow A.G.

BISSCHOP, Catherine Seaton Forman, Mrs., née Swift
 (London) –
A figure painter, who married a German artist in 1869, and worked in England and on the Continent. She was elected an Honorary Member of the Société des Aquarellistes Belges in 1871.

BLACKBURN, Jemima, Mrs., née Wedderburn
 1823 (Edinburgh) – 1909
The daughter of the Solicitor General for Scotland and a kinswoman of Clerk of Eldin (q.v.), she showed a precocious talent for drawing birds and animals. She was much influenced by a book of Bewick's. In about 1840 she paid her first visit to London and was encouraged by Landseer and W. Mulready. In 1849 she married Hugh Blackburn, Fellow of Trinity College, Cambridge and later Professor of Mathematics at Glasgow. Thackeray and Ruskin were among her fervent admirers, although the latter rather deplored her love of horror.

 Her work is extremely accomplished. She had a good visual memory, physical stamina in pursuing her subjects, and a dry wit.

Published: *Scenes from Animal Life and Character*, 1858. *Birds drawn from Nature*, 1862. *A Few Words about Drawing for Beginners*, 1893. *Birds from Moidart*, 1895. Etc.
Illustrated: A. White: *The Instructive Picture-Book*, 1859. W.J.M. Rankine: *Songs and Fables*, 1874.
Examples: B.M.

BLACKLOCK, William James 1816 (London) – 1858 (Dumfries)
The son of a bookseller who returned to his native Cumwhitton, Cumberland, in about 1820. He was apprenticed to a bookseller and printer, and first exhibited in London in 1836. He worked there for about fourteen years to 1850, when he again settled at Cumwhitton. However his eyes failed and he gave up painting.

 His landscapes, with their Pre-Raphaelite qualities, were admired by such artists as Turner, Roberts and W.B. Scott as well as by Gladstone. He concentrated on the effects of light and cloud and his oil paintings are perhaps better than his watercolours. His figures are generally poor.

 WILLIAM KAY BLACKLOCK (b. 1872), a Sunderland artist, was no relation.

BLAIR, John
An Edinburgh painter active between 1885 and at least 1917.

BLAKE, Fanny
An accomplished pupil of de Wint who was working between 1812 and 1850.

BLAKE, William 1757 (London) – 1827 (London)
The son of a hosier, he was apprenticed to James Basire, the engraver, and studied under H. Pars (q.v.) and at the R.A. Schools. In 1780 the R.A. accepted a watercolour by him, and he exhibited eleven more up to 1808. In 1782 he married Charlotte Boucher, who later helped him with his printing. His earliest important patron was Thomas Butts, who bought from him for about twenty years. In 1800 he attracted the notice of that somewhat trying literary patron, William Hayley, and went to live near him at Felpham, Sussex, where he stayed for three years. Thereafter he returned to London and poverty. There was a small exhibition of his work in 1809, but it was not until 1818, when he met John Linnell, that he gathered a group of friends and artistic disciples around him. These included J. Varley, S. Palmer, E. Calvert, G. Richmond, F.O. Finch and F. Tatham (all q.v.).

 Stylistically he owes much to older draughtsmen, such as

Stothard, Fuseli and Mortimer, and his effects are largely obtained by a reliance on rhythmically flowing lines. His colours seem to grow stronger throughout his career, and can at times verge on the garish. As Williams says: 'Blake is one of the masters – though perhaps rather one of the masters who worked in watercolour than one of the master watercolourists.' He generally signed his drawings either 'W. Blake' or with a monogram. There are however very good forged signatures which are occasionally found on Fuseli drawings. His youngest brother, ROBERT BLAKE, who died in 1787, produced drawings in his manner.

Published: *Songs of Innocence and Experience*, 1789. *The Book of Thel*, 1789. *There is no Natural Religion*, 1790. *Visions of the Daughters of Albion*, 1793. *America*, 1793. *The Book of Urizen*, 1794. *The Book of Los*, 1794. *Jerusalem*, 1804. Etc.

Examples: B.M.; V.A.M.; Aberdeen A.G.; Cecil Higgins A.G., Bedford; Abbot Hall A.G., Kendal; Leeds City A.G.; City A.G., Manchester; Newport A.G.; N.G., Scotland; Southampton A.G.; Tate Gall.; Walsall A.G.
Bibliography: R.L. Binyon: *The Art of W.B.*, 1906. E.L. Cary: *The Art of W.B.*, 1907. G.K. Chesterton: *W.B.*, 1920. G.L. Keynes: *A Bibliography of W.B.*, 1921. D. Figgis: *The Paintings of W.B.*, 1925. A. Gilchrist: *Life of W.B.*, 1942. Etc.
Burlington Fine Arts Club, *Exhibition Cat.*, 1876; 1927. Tate Gall., *Exhibition Cat.*, 1913. N.G., Scotland, *Exhibition Cat.*, 1914. Etc.

BLAKE, William, of Newhouse
A pupil of J.M.W. Turner (q.v.) who lived in Glamorgan and was active between 1794 and 1798. His landscapes are very green with saw-toothed foliage, and they can be slightly reminiscent of the work of Warwick Smith.

Examples: B.M.

BLAKEY, Nicholas (Ireland) – (Paris)
An Irish book illustrator, who studied and mainly lived in Paris. He illustrated an edition of Pope's works, and together with F. Hayman produced some illustrations of English history, published in 1778. He was working from about 1747.

Illustrated: J. Hanway: *Travels through Persia*, 1753.
Examples: B.M.

BLANCHARD, Beckwith
A drawing master at Hull who was active between 1829 and 1873.

BLAND, John F.
A landscape painter who was living in London in 1863 and Lympton, Devon in 1873. As well as the West Country he painted Yorkshire and Scottish subjects, and he exhibited at the R.A. and elsewhere from 1860 to 1872.

BLATCHFORD, Conway 1873 (Bristol) –
A landscape and marine painter in oil and watercolour. He studied at the Bristol School of Art and the R.C.A. and became Headmaster of the Halifax School of Art and Principal of the Newton Abbot School of Art. An exhibition of his work entitled 'Watercolours of the Sea' was held at the Brook Street Gallery in 1922.

BLATHERWICK, Dr. Charles, R.S.W.
** – c.1895 (Helensburgh)**
A doctor who lived in Helensburgh and painted landscapes and genre subjects. He exhibited from 1874.
 LILY BLATHERWICK, who also painted and lived in Helensburgh, was probably his daughter.

BLAYMIRE, Jonas – 1763 (Dublin)
A topographical draughtsman who worked as a Surveyor and Measurer in Dublin. In 1738 he was commissioned to make drawings of Irish cathedrals for Walter Harris's edition of *Ware's Works*.

Examples: St. Patrick's Cathedral, Dublin.

BLIGH, Jabez
A painter of wild flowers and, above all, mushrooms, who moved from Worcester to London in the 1860s and then to Gravesend. He was an unsuccessful candidate for the N.W.S. in 1862, and exhibited in London and elsewhere from 1863 to 1889. His name is sometimes mis-spelt Bly.

Examples: Worcester City A.G.

BLIGHT, John Thomas
An antiquarian and topographer who worked in Cornwall and the Isle of Man. He was elected F.S.A. in 1866 and resigned in 1872. By 1883 he was penurious.

Published: *Account of the Exploration of ... Treveneague ... Cornwall*, 1867.
Illustrated: J.G. Cuming: *The Great Stanley*, 1867.

BLORE, Edward, F.R.S., F.S.A. 1789 (Derby) – 1879 (London)
An architectural draughtsman and rather uninspired architect, he was the son of Thomas Blore the antiquarian. He drew for various county histories as well as for Britton's *Cathedrals* and *Architectural Antiquities*. From 1816 he worked on Scott's Gothic rebuilding of Abbotsford. He was Special Architect to William IV and for a while to Queen Victoria, and undertook the completion of Buckingham Palace. He retired as a practising architect in 1849, but continued to draw throughout his long life.

Published: *The Monumental Remains of Noble and Eminent Persons*, 1824.
Illustrated: T. Blore: *History of Rutland*, 1811. Sir J. Hall: *Essay on the Origin ... of Gothic Architecture*, 1813. W. Scott: *The Provincial Antiquities and Picturesque Scenery of Scotland*.
Examples: B.M.; R.I.B.A.; Soc. of Antiquaries.
Bibliography: *A.J.*, 1879.

BLUCK, J.
An engraver and draughtsman who worked for Ackermann and exhibited at the R.A. between 1791 and 1819. His work is in the eighteenth century topographical tradition.

Examples: Fitzwilliam.

BLUNDEN, Anna L , Mrs. Martino 1829 (London) –
A landscape painter in oil and watercolour, she was brought up in Exeter and worked as a governess in Devon before turning to art. She studied at Leigh's as well as copying at the B.M. and the N.G., and she exhibited from 1853. She was encouraged by Ruskin and the Pre-Raphaelites and soon dropped figures, which she found difficult, from her work. She was on the Continent from 1867 to 1872, when she married F.R. Martino. They settled in Birmingham and she exhibited there until 1915.

Examples: Greenock A.G.

BLUNT, Henry Bala
Probably a pupil of J.D. Harding (q.v.), he sketched in pencil or chalk and clean light washes and was active in the 1830s and 1840s.

Examples: B.M.

BLUNT, James Tillyer 1765 – 1834
An engineer, he served with the Bengal Engineers from 1783 to 1807. He surveyed the Ganges from Cawnpore to Patna, was present at Seringapatam, and thereafter surveyed the Allahabad, Delhi, Hardwar, Lucknow and other areas. He was the brother-in-law of R.H. Colebrooke (q.v.).

Examples: India Office Lib.

BLUNT, John Silvester
** 1874 (Alderton, Northamptonshire) – 1943**
A painter of landscapes and street scenes. He was educated at Denstone College, Staffordshire and lived in Middlesex. He was elected R.B.A. in 1912.

BODDINGTON, Harriet Olivia
An amateur painter of figures in landscapes who had a few lessons from W.L. Leitch (q.v.), and occasionally contributed to charity exhibitions.

Published: *Real and Unreal*, 1876.

BODDY, William James **1832 (Woolwich) – 1911 (Acomb)**
The son of an architect, he followed the same profession for a while, moving to York in 1853 as assistant to George Jones. However, he soon built up a flourishing practice as a drawing master and exhibited in York and London from 1865 to 1879. A folio of his work was presented to the Princess of Wales in 1900. For the last twenty-five years of his life he lived at Acomb, Yorkshire, and he gave up teaching in 1908.

His landscapes are taken from many parts of Great Britain as well as Switzerland and Normandy.

Published: *Manual for Invalids: Sunday by Sunday*, 1895.
Examples: York A.G.

BODEN, Samuel Standige **1826 (Retford) – 1896**
A landscape painter who worked in London. He produced drawings which are very much in the manner of M.B. Foster (q.v.) and sometimes sketched in a freer, de Wint-like style.

Published: *A Popular Introduction to the Study and Practice of Chess*, 1851.
Examples: B.M.

BODICHON, Barbara, Mme., née Leigh Smith
1827 (Wathingham, Sussex) – 1891 (Scalands Gate, Sussex)
The foundress of Girton College, and a landscapist. A pupil of W. Henry Hunt (q.v.), she was a prolific watercolourist and frequent exhibitor. She had a house in Algiers, where she met her husband, Dr. Bodichon, and another in Cornwall. She was a friend of Brabazon and often accompanied him on his sketching tours. She also visited Canada and America.

Her work is detailed and intense, with a feeling for open-air effects and the handling of flowers. These can be used in the manner of A. Nicholl (q.v.) to form a foreground through which a coastal landscape is seen. There is sometimes an attempt at the detail of the Pre-Raphaelites, who were also her friends.

Bibliography: H. Burton: *B.B.*, 1949.

BOISSEREE, Frederick
A painter of Welsh landscapes who lived at Bettws-y-Coed and was active between 1870 and 1880.

BOLINGBROKE, Minna R , Mrs. Watson
A watercolourist who was a member of the Norwich Art Circle in 1885.

BOLTON, Charles Newport **1816 – 1884**
An Irish amateur draughtsman who was educated at Oxford. In 1878 he inherited Mount Bolton, Co. Waterford. A volume of his sketches in Killarney and Glengarrif, lithographed by G. Rowe, was published in aid of the Irish Famine Fund, and a second volume containing views of the River Suir was published later. Woodcuts after his drawings appear in Hall's *Ireland, its Scenery and Character*. He exhibited at the R.H.A. in 1845 and 1846. He was particularly fond of sketching old buildings and heraldic designs.

Illustrated: Hore: *History of Wexford*.

BOLTON, James **– 1799 (Halifax)**
A naturalist who drew and etched his own illustrations. He was working from about 1775 in the Halifax area. His drawings are in the manner of G.D. Ehret (q.v.) and are sometimes on vellum.

Published: *Filices Britannicae*, 1785. *A History of Funguses growing around Halifax*, 1788-91. *Harmonia Ruralis*, 1794-6. *A History of British Proper Ferns*, 1795.
Examples: Fitzwilliam.

BOLTON, John Nunn **1869 (Dublin) – 1909 (Warwick)**
The son of HENRY E. BOLTON, an amateur landscape painter, he trained at the Metropolitan School of Art and the R.H.A., after which he left Dublin to live in Warwick. He exhibited in Dublin, Birmingham and Manchester, and taught for a short time at the Leamington School of Art.

He painted, both in oil and watercolour, landscapes, marine subjects and portraits, as well as miniatures.

BOLTON, William J **1816 – 1884**
A painter of town scenes who lived in London and was an unsuccessful candidate for the N.W.S. on four occasions from 1861 to 1872.

Examples: Victoria A.G., Bath.

BOMFORD, L G
A painter of Scottish landscapes and views near London in oil and watercolour. He lived in Kilburn and exhibited at the R.A. and Suffolk Street from 1871 to 1882.

BOND, John Linnell **1764 – 1837**
An architect who studied drawing under J. Malton (q.v.) and entered the R.A. Schools in 1783. He exhibited designs and views at the R.A. from 1782 to 1814. From 1818 to 1821 he travelled in Italy and Greece making topographical and historical, as well as architectural, drawings.

Examples: B.M.; R.I.B.A.

BOND, John Lloyd
A painter of Welsh landscapes in oil and watercolour who exhibited from 1868 to 1872. He lived in London and Bettws-y-Coed.

Examples: V.A.M.

BOND, Richard Sebastian 1808 (Liverpool) – 1886 (Bettws-y-Coed)
A kinsman of W.J.J.C. Bond (q.v.), he studied at Liverpool and lived in Birmingham and at Bettws-y-Coed. He exhibited in London and elsewhere from 1841 to 1881, and he painted Cox-like landscapes, often with rivers and mills, in oil and watercolour.

Examples: Greenwich.

BOND, William Joseph J C 'Alphabet'
1833 (Liverpool) – 1926
A landscape and marine painter in oil and watercolour, he was apprenticed to a picture restorer and dealer. He lived at Caernarvon and then at Liverpool, where he became a member of the Academy in 1859. His subjects are generally taken from Cheshire, Wales and Anglesey, although he visited Antwerp.

He painted old buildings, harbours and the sea, and was himself a keen sailor. Early in his career he was influenced by the Pre-Raphaelites; later he is closer to Turner.

BONE, Henry Pierce **1779 (Islington) – 1855 (London)**
The son and pupil of Henry Bone, R.A., a miniaturist. He was a member of the A.A. and the Langham Sketching Club, exhibiting enamel portraits and watercolour copies of old masters, usually at the R.A.

Bibliography: V.A.M. MSS.: 2 letters from J.I. Richards to H.B., 1801.

BONINGTON, Richard Parkes
1802 (Arnold, near Nottingham) – 1828 (London)
His comrade, Delacroix, said of him: 'Other artists were perhaps more powerful or more accurate than Bonington, but no one in the modern school, perhaps no earlier artist, possessed the ease of execution which makes his works in a certain sense diamonds, by which the eye is pleased and fascinated, quite independently of the subject and the particular representation of nature.'

He was the son of RICHARD BONINGTON, a drawing master and portrait painter and sometime sailor and Governor of Nottingham Gaol. His mother was a teacher, and she probably provided most of his formal schooling. At the end of 1817, or early in the following year, the family moved to Calais, where the father set up in the lace

business, and subsequently they settled in Paris. In Calais Bonington took lessons from Francia, thus absorbing the influence of Girtin, and in Paris he studied in the studio of Baron Gros and met the young Delacroix when sketching at the Louvre. He was at the centre of the nascent Romantic Movement, and his first exhibits at the Salon in 1824 caused a sensation. He revisited England in 1825, perhaps touring Scotland as well, and in the following year he exhibited in London, where his reception was rather more reserved. Also in 1826 he paid his homage to La Serenissima, travelling by way of Switzerland and returning by Florence, Turin and the Riviera. In the summer of 1828 he contracted brain fever, and in September he left Paris for the last time, in the hope that the treatment of St. John Long (q.v.) in London might cure him. He was still painting on his death bed.

Despite the shortness of his working life, Bonington is one of the very few English artists to have had a profound effect on Continental painting. The British had not suffered from the stultifying effects of Neo-Classicism to anything like the extent which their French and German contemporaries had. The style was too closely identified with the Imperial propaganda of Napoleon to appeal to his enemies. Thus Bonington was well situated to act as a catalyst to the frustrations of the younger generation of Continental artists. He was also far better placed than his teacher Francia to display the glories of the English watercolour school to an audience who knew little, or nothing of it. His work in oil, superb as it is, should always be seen as the extension of the techniques and genius of a master painter in watercolour.

His work divides into two parts, firstly that of the landscape painter working in the English conventions of the time — his first coastal scenes to be exhibited in London were rightly compared to those of W. Collins (q.v.). In his last years he also proved himself to be the greatest, as well as one of the earliest, of English nineteenth century genre painters. In this he was inspired by the French painters of the generation before last, particularly Fragonard, and by Van Dyck. His Venetian scenes and his charming figures in Valois or Bourbon costume in the parks of Fontainebleau and Versailles are not only charming, but unexpectedly full of life and immediacy.

His influence was not only felt in France during the next half century, but returned to England with the many English artists who were working in Paris, or who visited it in the ten years following his death. They include his pupil Boys, W. Callow, the Fieldings, J. Holland, D. Roberts and D. Cox.

Examples: B.M.; V.A.M.; Aberdeen A.G.; Ashmolean; Blackburn A.G.; Fitzwilliam; Glasgow A.G.; City A.G., Manchester; N.G., Scotland; Portsmouth City Mus.; Wallace Coll.
Bibliography: H. Stokes: *Girtin and B.*, 1922. A. Dubuisson and C.A. Hughes: *R.P.B. life and work*, 1924. G.S. Sandilands: *R.P.B.*, 1929. A. Dubuisson: *B*, 1927. A. Shirley: *B.*, 1940. M. Gobin: *R.P.B.*, 1955. M. Spencer: R.P.B. (unpublished). *A.J.*, May, 1858. *Gaz. des Beaux Arts*, 2nd series, xiv, 1876. *Studio*, XXXIII, 1904. *Walpole Society*, II, 1913. *Walpole Society*, III, 1914. *Connoisseur*. May 1925. *Burlington Mag.*, III, 1926. Burlington Fine Arts Club: *Exhibition Cat.*, 1937. *Burlington Mag.*, LXXXVIII, 1946. *Country Life*, March 1, 1962; April 22, 1965. King's Lynn: *Exhibition Cat.*, 1961. Agnew: *Exhibition Cat.*, 1962.

BONNAR, George Wilmot 1796 (Devizes) – 1836
A wood engraver who produced a number of wash illustrations and worked in London.
Examples: B.M.

BONNEAU, Jacob – 1786 (London)
A landscape painter who came to London in about 1741 with his father, a French engraver. He was a member of the Incorporated Society and a drawing master. He sometimes painted genre subjects.

BONNER, Thomas c.1740 (Gloucestershire) –
An engraver and illustrator who made topographical drawings as well as figure subjects for the works of such writers as Shakespeare, Richardson, Smollett and Fielding. He was working at least until 1807.

His figures are sometimes rather grotesque, and his washes reminiscent of W. Gilpin (q.v.) but with touches of colour.

Illustrated: Collinson: *History of Somersetshire*, 1791. Polwheles: *History of Devonshire*, 1797.
Examples: B.M.

BONOMI, Joseph, Yr. 1796 (Rome) – 1878 (London)
The son of the architect of the same name, and a godson of A. Kauffman (q.v.) and Maria Cosway, he was brought to England at an early age and studied at the R.A. Schools. He also studied sculpture under Nollekens. He revisited Rome in 1823 and, in the following year, went to Egypt with Robert Hay. He remained there for eight years drawing antiquities and studying the figure and hieroglyphics. In 1833 he was in Sinai and Palestine with F. Arundale (q.v.) and F. Catherwood (q.v.), and he returned to Egypt again for two years from 1842. The remainder of his life was spent in illustrating numerous works on Egypt and as Curator of Sir John Soane's Museum.

His work is in various media including watercolour, and his figure drawing is particularly impressive.

BOOT, William Henry James, R.I.
 1848 (Nottingham) – 1918 (London)
He studied at the Derby School of Art before moving to London, where he contributed to the *Graphic, I.L.N., Art Journal, Magazine of Art,* and other periodicals. He painted landscapes, including views of Italy and Spain, and exhibited at the R.A. from 1874 to 1884, the R.I. and the R.B.A. In 1884 he became a member of the R.B.A., and later Vice-President.

Published: *Trees and How to Paint Them*, 1883.
Illustrated: R.D. Blackmore: *Lorna Doone*, 1883. G.E.S. Boulger: *Familiar Trees*, 1885.
Examples: Derby A.G.

BOOTH, Rev. Richard Salvey c.1765 – 1807
A landscape painter who lived in Folkestone and exhibited at the R.A. from 1796 to 1807. He visited Wales. He died, according to Farington, from a palsy brought on by his father's unexpectedly leaving him a fortune after keeping him on short commons for years.

Examples: Newport A.G.

BOOTH, Lieutenant-Colonel William
A Royal Engineer who was a pupil of P. Sandby (q.v.) at Woolwich. He served at Gibraltar in 1780 and the Tower of London in 1817. His work is better in the earlier years when the teaching was fresh.

Illustrated: J. Heriot: *An Historical Sketch of Gibraltar*, 1792.
Examples: B.M.

BOSANQUET, Charlotte 1790 (London) – 1852
She was a member of a large Huguenot family, and her father died when she was ten years old. After the death of her mother five years later, she continued to live in London, making frequent visits to friends and relations at Vintners, near Maidstone; Broxbournbury and Meesdenbury, Hertfordshire; Strood Park, Sussex; and Gabalva, Glamorgan, among other places.

In the Ashmolean is an album of watercolours, mainly dating from the early 1840s, which faithfully portray the interiors of these houses with considerable charm and ability.

Bibliography: *Country Life*, December 4, 1975.

BOSANQUET, J E
A Cork photographer who painted local views, mainly in watercolour, and exhibited at the R.H.A. between 1854 and 1861. They are generally poor things.

His son, J. CLAUDE BOSANQUET, also painted landscapes.

BOSTOCK, John
Bostock, of Kensington, was elected an A.O.W.S. in 1851, but allowed his associateship to lapse in 1855. Between 1835 and 1849 he had produced a number of drawings for the Annuals, usually portraits or costume pieces. He exhibited in London from 1826 to 1869.

BOTHAM, William
A topographer and landscape painter who worked in London and Nottingham. He painted in the Girtin manner and exhibited from 1800 to 1830.

Examples: B.M.; Castle A.G., Nottingham; Sheffield A.G.

BOTHAMS, Walter – c.1914
A painter of rural genre subjects who was living in London in 1882, Salisbury in 1885 and Malvern in 1913.
Examples: City A.G., Manchester; Salisbury Mus.

BOUGH, Samuel, R.S.A. 1822 (Carlisle) – 1878 (Edinburgh)
A landscape painter who was briefly placed with T. Allom (q.v.) in London to learn engraving. He soon returned to Carlisle and led a wandering life until 1845 when he went to the Theatre Royal, Manchester, as a scene painter. He exhibited at the Royal Manchester Institution, and in Liverpool and Worcester. In 1848 he moved to the Princess Theatre, Glasgow, and in 1849 to the Adelphi Theatre, Edinburgh. After a quarrel with the manager, he gave up scene painting, and moved to Hamilton for a few years where he practised as a professional landscape painter. He was elected A.R.S.A. in 1856 but did not become a full member until 1875. At this time his work was increasingly sought after, and he became a well established Edinburgh character. Although he travelled widely about Great Britain, his favourite sketching areas were the coasts of the Firth of Forth and Fifeshire. His most typical work is very like that of Cox's late period, although his colours are often thinly painted in comparison. They become fuller, and later he uses bodycolour. His pictures are generally signed and often dated, but '1857' should always be treated with suspicion since he used this date twenty years later on the grounds that it was 'said to be my best period'.

Illustrated: R.L. Stevenson: *Edinburgh Picturesque Notes*, 1879.
Examples: B.M.; V.A.M.; Aberdeen A.G.; Dundee City A.G.; Fitzwilliam; Glasgow A.G.; Greenock A.G.; Kirkcaldy A.G.; City A.G., Manchester; Paisley A.G.; N.G., Scotland; Ulster Mus.
Bibliography: S. Gilpin: *S.B.*, 1905. *A.J.*, 1871.

BOUGHTON, George Henry, R.A.
 1833 (near Norwich) – 1905 (London)
The son of a farmer, his family emigrated to America in 1839. He returned to Britain for some months in 1853, visiting London, Ireland, Scotland and the Lake District. He then lived and painted landscapes in New York until 1859, when he went to Paris to study. He settled in London permanently in 1861 or 1862 and exhibited at the R.A. from the following year. He visited Norfolk in 1890, Scotland in 1892 and Paris in about 1895, and for a period of some twenty years he was a regular visitor to the Isle of Wight. He was elected A.R.A. and R.A. in 1879 and 1896, and was a member of the R.I. from 1879 to 1885. His early work shows the influence of F. Walker (q.v.), but he can be over-sugared. He was also an illustrator.
His remaining works were sold at Christie's, June 15, 1908.

Examples: V.A.M.; Ashmolean.
Bibliography: *A.J.*, 1899.

BOULGER, Thomas
He studied at the R.D.S. Schools, after which he set himself up in Dublin as a painter of portraits, flowers and miniatures, and gave drawing lessons. He exhibited with the Dublin Society of Artists in 1769. In 1788 he was teaching drawing and painting in a school at Portarlington.

BOURNE, Rev. James
 1773 (Dalby, Lincolnshire) – 1854 (Sutton Coldfield)
A drawing master who was educated in Louth and who came to London in 1789, where for eighteen months he tried to find employment before moving to Manchester. On his return to London in about 1796 he was taken on by Lord Spencer and the Duchess of Sutherland (q.v.), through whom he may have met Girtin and Turner, and also Beaumont with whom he toured Wales in 1800. He

first exhibited at the R.A. in that year, and he made regular summer tours, visiting the Lakes in 1789, the West Country in 1799, Lincolnshire in the autumn of 1803, Yorkshire, Surrey and Kent. In 1838 he gave up his profession for the Church, and he left London in 1846.

His style should be unmistakable, but often seems to be mistaken for that of better men. His work is usually in monochrome and is clumsy and without crispness of outline. His habit of using black hatching to indicate the foliage and the details of his foregrounds has a distant kinship with that of Glover. He was much imitated, not least by his three daughters, all of whose christian names began with an E.

Other artists of the name include HARRIET P. BOURNE, and JOHN COOKE BOURNE (1814-1896) who stood unsuccessfully for the N.W.S. three times between 1866 and 1877. He specialized in railways.

Published: *A Selection of Views in the County of Lincoln*, 1801.
Examples: B.M.; V.A.M.; City A.G., Birmingham; Dudley A.G.; Fitzwilliam; Hertford Co. Record Office; Hertford Mus.; Hove Lib.; Leeds City A.G.; City A.G., Manchester; Nat. Mus. Wales; Newport A.G.; Glynn-Vivian A.G., Swansea; York A.G.
Bibliography: *Connoisseur*, CLXIII, 1966.

BOURNE, Samuel c.1840 – 1920
An amateur landscape painter who painted in many parts of Britain, as well as on the Continent and in India. He lived in Wapping for a time and exhibited from 1880 to 1898.

Examples: Castle Mus., Nottingham.

BOUVIER, Agnes Rose, Mrs. Nicholl 1842 (London) – c.1892
The daughter of Jules Bouvier (q.v.), who taught her. The family spent much time in Germany, Holland and France until the death of her brother James in 1856, when they settled permanently in London. She exhibited a genre subject at Birmingham in 1860. Until the death of her father, for whom she kept house, she exhibited little, but thereafter she was very active, and in 1868 she visited Germany and Venice. In 1874 she married S.J. Nicholl, an architect. Her favourite subjects are country girls and children.

BOUVIER, Auguste Jules, N.W.S. 1827 (London) – 1881 (London)
The son of Jules Bouvier (q.v.), he studied at the R.A. Schools from 1841 and in France and Italy. He exhibited in London from 1845, and was elected A.N.W.S. and N.W.S. in 1852 and 1865. He painted portraits and genre subjects in oil and watercolour.

Examples: V.A.M.; Shipley A.G., Gateshead; Maidstone Mus.

BOUVIER, Gustavus A.
Probably a son of Jules Bouvier (q.v.), he lived in London and painted genre subjects. He exhibited from 1866 to 1884. He translated French books on pastel and enamel painting.

BOUVIER, Joseph
Possibly a brother or son of Jules Bouvier (q.v.), he was working in London from 1839 to 1888. He lived in St. John's Wood and was an unsuccessful candidate for the N.W.S. in 1868. He painted pretty children in oil and watercolour.

Published: *A Handbook for Oil-Painting*, 1885.

BOUVIER, Jules 1800 – 1867
The father of A.R. Bouvier (q.v.), A.J. Bouvier (q.v.) and probably G.A. Bouvier (q.v.). He came to England in 1818 and married a Scotswoman. Thereafter he divided his time between London and the Continent until 1856, when he settled permanently in London. He painted genre subjects and exhibited from 1845 to 1865.

Examples: V.A.M.

BOWDICH, Sarah, Mrs. 1791 – 1856
A painter of fish who used very mixed media including gold and silver. She was the wife and editor of T.E. Bowdich (1791-1824), the African traveller.

Examples: Ashmolean.

BOWEN, Owen **1873 (Leeds) – 1967**
A designer, teacher and still-life painter who studied at the Leeds School of Art in 1885 under Gilbert Foster, at whose private school he subsequently taught. As a result of a long illness he gave up teaching and turned to painting still-lifes and, later, landscapes in oil and watercolour. He exhibited at Leeds from 1890 and at the R.A. from 1892.

Examples: Leeds City A.G.

BOWERS, Georgina
A caricaturist who copied J. Leech (q.v.) and worked in his style. She exhibited with the Society of Female Artists in 1862. Between 1862 and 1889, she illustrated a number of sporting and country books.

BOWERS, Stephen J.
A landscape and figure painter who lived at Kew and exhibited at the R.I. and the R.B.A. from 1874 to 1891.

BOWLER, Henry Alexander 1824 (Kensington) – 1903 (London)
A landscape and genre painter who studied at Leigh's and the Government School of Design at Somerset House. He was Headmaster of Stourbridge School of Art in 1851, and subsequently taught at Somerset House and worked for the Science and Art Department from 1855 to 1891, from 1876 as Assistant Director. He was Teacher of Perspective at the R.A. from 1861 to 1899, and he exhibited from 1847.

Examples: V.A.M.

BOWLES, Oldfield **1739 – 1810**
'A most accomplished country Squire' and enthusiastic amateur painter. Through Thomas Price, Wilson's pupil, who stayed with him at North Aston, Oxfordshire, he became a close follower of the master. He was also an amateur actor and a leading light of the Society of St. Peter Martyr, whose other members were his son CHARLES BOWLES, A. Phipps, Sir G.H. Beaumont, B. West, J. Farington, G. Dance and T. Hearne (all q.v.). He was also a patron of J.B. Malchair and a member of his circle. Several of his descendants inherited his enthusiasms.
See Family Tree.

BOWYER, Robert **1758 – 1834 (Byfleet, Surrey)**
Possibly a pupil of John Smart, he was appointed Painter in Water Colours to George III and Miniature Painter to the Queen. He exhibited at the R.A. from 1783 to 1828.

Illustrated: D. Hume: *History of England*, 1800
Examples: B.M.

BOX, Alfred Ashdown **(Manningtree) –**
A landscape painter who was educated and worked in Birmingham. He was organist at St. Thomas's Church there. He exhibited in Birmingham and Manchester from 1879 to 1910. He signed 'A. Ashdown Box', presumably to differentiate himself from another landscape painter, ALFRED BOX, who may have been a relative and was working in Herefordshire in 1881.

BOXALL, Sir William, R.A., F.R.S.
 1800 (Oxford) – 1879 (London)
A painter of portraits and religious subjects in oil and watercolour who entered the R.A. Schools in 1819. He was in Italy for about two years from 1827 and was elected A.R.A. and R.A. in 1852 and 1863, retiring in 1877. He was appointed Director of the N.G. in 1865 and gave up his successful portrait practice. He was knighted in 1871.
 His work in watercolour can be free in the best manner of J. Absolon (q.v.). His remaining works were sold at Christie's, June 8, 1880.

Examples: Ashmolean.
Bibliography: *A.J.*, 1880.

BOYCE, George Price, R.W.S. 1826 (London) – 1897 (London)
An artist who was closely linked with the Pre-Raphaelites. He was trained as an architect, but after meeting Cox in 1849, he abandoned his career and took up painting, having independant means to support himself. He was always drawn to architectural subjects, which he executed with an exactitude which shows the influence of his Pre-Raphaelite friends. He exhibited at the R.A. between 1853 and 1861 and, in 1864, he was elected A.O.W.S., becoming a full Member in 1877. The diary which he kept between 1851 and 1875 provides many valuable insights into the workings of the Pre-Raphaelite group.
 The correctness of his style is saved from pedantry by the mellow, harmonious colours he used, of which a favourite was plummy red. He was a friend of J.W. North (q.v.), and their work is similar.

Examples: B.M.; V.A.M.; Ashmolean; Fitzwilliam; N.G., Scotland; Stalybridge A.G.
Bibliography: *Architectural Review*, 1899. O.W.S. Club, XIX, 1941 (Diary).

BOYCE, William Thomas Nicholas
 1858 (South Shields) – 1911
The son of a ship-owner, he worked as a draper before turning professional artist. Much of his life was spent in Durham and his subjects are generally marine.
 His sons, HERBERT WALTER BOYCE (1883-1946) and NORMAN SEPTIMUS BOYCE (1895-1962), were also marine watercolourists.

Examples: Laing A.G., Newcastle; South Shields Pub. Lib. and Mus.; Sunderland A.G.

BOYD, Alexander Stuart, R.S.W. 1854 (Glasgow) – 1930
An illustrator and painter of street scenes. He worked for *Punch*, the *Graphic*, and other magazines, and exhibited at the R.A. and the R.I. from 1884 to 1887. He emigrated to New Zealand in 1912. He used the pseudonym 'Twym'.

Examples: Glasgow A.G.

BOYD, Alice
A landscape and subject painter in oil and watercolour who inherited a love of sketching from her mother. For a time she lived in Newcastle where she was encouraged by W.B. Scott (q.v.), and in 1865 she retired to Penkill Castle, Ayrshire, which she decorated.
 She exhibited at the R.S.A., the R.A., the Dudley Gallery and elsewhere.

Published: *Robin's Christmas Song*.

BOYD, Dr. Michael Austin **– 1899**
A doctor who lived in Kingstown and Dublin, and painted landscapes. He was a frequent exhibitor with the Watercolour Society of Ireland.

BOYD, W S
A Birmingham artist who exhibited a view of Smethwick at the Birmingham Society in 1881.

BOYLE, Hon. Mrs. Eleanor Vere
 1825 (Auchlunies, Kincardine) – 1916 (Brighton)
The daughter of Alexander Gordon of Ellon, she married the Hon. and Rev. Richard Boyle in 1845. She was encouraged and advised by Boxall and Eastlake, and from 1851 she published a long series of children's books under the initials 'E.V.B.'.
 Her style is reminiscent of that of C. Green (q.v.) and Sir J. Gilbert (q.v.).

Published: *Child's Play*, 1851. *A Children's Summer*, 1852. Etc.

BOYNE, John c.1750 (Co. Down) – 1810 (London)
A caricaturist who was the son of a joiner and was apprenticed to William Byrne, the engraver, in London. He left to join a company of strolling players, returning in 1781. Thereafter he set up a drawing school, but he was too lazy to make a great success of it. He worked, rather weakly, in the manner of Rowlandson.

Examples: B.M.; V.A.M.; Fitzwilliam.

BOYS, Thomas Shotter, N.W.S.
 1803 (Pentonville) – 1874 (London)
In 1817 Boys was apprenticed to George Cooke, the engraver and father of E.W. Cooke (q.v.). In 1823, on the expiry of his indentures, he went to Paris where he worked, first as an engraver, then as a lithographer and watercolourist, in close contact with Bonington. His pupils in Paris included W. Callow (q.v.) and A. Poynter (q.v.). He returned to London in 1837 and continued his lithographic work, being the virtual inventor of chromolithography. He was elected A.N.W.S. and N.W.S. in 1840 and 1841, but hardly attended a meeting for the next three years 'in consequence of a domestic affliction'. In 1847 he joined W. Oliver (q.v.) in his criticism of the Society, afterwards becoming a most assiduous member. Despite the brilliance of his watercolours and the fame of his lithographs, Boys's career faded away after the early 1840s. He found new subjects in Germany, North Wales and the West Midlands, but was also scraping work for architects and tinting backgrounds for lesser men. By 1871 illness rendered him 'utterly inable' to work.

He was primarily an architectural painter, admiring only Girtin of his predecessors. The accuracy of his portraits of buildings and his skill in composition have seldom been bettered. In his French years he used all the tricks that distinguish the Bonington circle, thumb prints, scraping and so on. He also produced a group of watercolours following Bonington's costume pieces, which have Watteau-like figures at Versailles. Later he turned to landscapes without buildings, and in the striking colour and power of his studio works showed himself to be a major High Victorian watercolourist.

Published: *Picturesque Architecture in Paris, Ghent, Antwerp, Rouen*, etc., 1839. *Original Views of London as it is*, 1842.
Examples: B.M.; V.A.M.; Aberdeen A.G.; Ashmolean; Cecil Higgins A.G., Bedford; Grosvenor Mus., Chester; Fitzwilliam; Leeds City A.G.; Walker A.G., Liverpool; Laing A.G., Newcastle; Newport A.G.; Castle Mus., Nottingham; Portsmouth City Mus.; Shrewsbury Mus.; Tate Gall.; Ulster Mus.
Bibliography: E. Beresford Chancellor: *Original Views of London* etc., 1926. E. Beresford Chancellor: *Picturesque Architecture in Paris* etc., 1928. J. Roundell: *T.S.B.*, 1974. *Connoisseur* LX, 1921. *Walker's Quarterly*, XVIII, 1926. *Architectural Review*, LX, 1926.

BRABAZON, Hercules Brabazon
 1821 (Paris) – 1906 (Oaklands)
The second son of Hercules Sharpe, he was educated at Harrow, Geneva and Cambridge. On leaving Cambridge, where he read mathematics, he determined to become an artist and spent three years in Rome, studying under J. D'Egville (q.v.) in 1847 and later under A.D. Fripp (q.v.). On the death of his elder brother, he inherited the Brabazon estates (and name) in Ireland and in 1858, on the death of his father, Oaklands, Sussex, and lands in Durham. In Ireland he was an absentee, and in England a vicarious, landlord, leaving the estate management to his brother-in-law and nephew. He spent his summers in England and winters in France, Spain, Italy or Germany; after 1867 he included North Africa and the Nile on his itineraries, and in 1870 he went to India. It was not until 1891 that this consummate amateur became known to a wide public. In that year he was elected to the N.E.A.C., and in the following December he was unwillingly persuaded by Sargent and other artists to allow a Brabazon Exhibition to be mounted at the Goupil Gallery. In old age he found himself, as a result, at the forefront of the modern movement. His last three years were largely spent at Oaklands, going through his portfolios and signing his works.

He was most influenced by Turner, Cox, Muller and de Wint among his predecessors, and by Velasquez among oil painters. The essences of his style are simplicity and a mastery of colour. He is the continuer of Turner's late 'impressionist' period, concerned with the feel of a place rather than a topographical exactitude. He was a musician as well as an artist, and his career has been summed up by Sir Frederick Wedmore as 'A country gentleman who at seventy years old made his debut as a professional artist and straightway became famous.'

An exhibition of his work was held at Leighton House in 1971.

Examples: Oaklands, Sedlescombe, near Battle, Sussex; B.M.; V.A.M.; Ashmolean; Cecil Higgins A.G., Bedford; Cartwright Hall, Bradford; Towner Gall., Eastbourne; Fitzwilliam; Hove Lib.; Leeds City A.G.; Leicestershire A.G.; City A.G.. Manchester; Newport A.G.; Nottingham Univ.; N.G., Scotland.
Bibliography: Mrs. H.T. Combe: *Notes on the Life of H.B.B.*, 1910. D.S. MacColl: *The Study of B.*, 1910. Sir F. Wedmore: *H.B.B.*, 1910. C. Lewis Hind: *H.B.B.*, 1912. *Studio*, XXXV, 1905. *A.J.*, 1906. *Antique Collector*, October 1962; March 1974.

BRACEBRIDGE, Selina, Mrs., née Mills
 (Bisterne, Hampshire) –
A traveller who was S. Prout's favourite pupil. She was in Italy in 1824, and in Italy and Germany in 1825, the Near East from 1833, Sweden in 1840 and the Pyrenees in 1842. She nursed at Scutari with Florence Nightingale. Her work is sometimes reminiscent of that of E. Lear (q.v.), and at others of that of W. Page (q.v.).

Published: *Panoramic Sketch of Athens*, 1836.

BRADDON, Paul
The *nom de plume* of James Leslie Crees who spent a considerable part of his life in the neighbourhood of Hull, where he made large watercolour copies of old prints. He also made a number of drawings of cathedrals. His colour and his subject matter show the influence of Paul Marny, the French watercolourist.

Examples: V.A.M.; Birmingham Lib.; Doncaster A.G.; Ferens Gall. and Central Lib., Hull; Leeds City A.G.; Johnson Birthplace Mus., Lichfield.

BRADFORD, Louis King, A.R.H.A. 1807 (Dublin) – 1862 (Dublin)
He entered the R.D.S. Schools in 1824 and first exhibited at the R.H.A. in 1827. He exhibited at the S.B.A. in 1854, and was elected A.R.H.A. in 1855.

Until 1838 his work consisted entirely of landscapes in oil and watercolour, but after this date he also painted genre and literary subjects.

BRADLEY, Basil, R.W.S. 1842 (Hampstead) – 1904
A landscape, genre and sporting painter who studied at the Manchester School of Art. He exhibited, mostly at the O.W.S., from 1866 and was elected Associate and Member in 1867 and 1881. He visited New South Wales.

Examples: B.M.; Haworth A.G., Accrington; City A.G., Manchester; Sydney A.G.

BRADLEY, Rev. Edward
 1827 (Kidderminster) – 1889 (Lavington, near Grantham)
Humorist, author and illustrator, he was educated at University College, Durham and ordained deacon in 1850. He was Curate of Glatton, Huntingdonshire from 1850 to 1854; Leigh, Worcestershire from 1854 to 1857; Bubbington, Staffordshire from 1857 to 1859; he was Rector or Vicar of Denton, near Peterborough from 1859 to 1871; Stretton, near Oakham from 1871 to 1883, and Lavington (or Lenton) from 1883. His best known work, with his own illustrations, was *The Adventures of Mr. Verdant Green, an Oxford Freshman*, 1853-6. As well as illustrations, he painted watercolours of his churches, which can be a little dull. They are signed with his *nom de plume*, Cuthbert Bede.

Examples: B.M.

BRADLEY, Gordon
A member of the N.W.S. in 1834, he lived in London and exhibited at the R.A. and elsewhere from 1832. By 1846 he had forfeited his membership and was bankrupt.

BRADLEY, John Henry 1832 (Hagley, Worcestershire) –
A landscape and coastal painter, he was a pupil of D. Cox (q.v.) and J. Holland (q.v.). He lived in Leamington and London and, in 1869, in Florence. He exhibited in London and on the Continent from 1854, and was an unsuccessful candidate for the N.W.S. on several occasions from 1865 to 1879. He exhibited in Birmingham until 1896.

BRADLEY, Mary
A flower painter who exhibited at the R.A. in 1811.

Examples: V.A.M.

BRADLEY, Robert 1813 (Nottingham) – c.1880
He was for many years landlord of the 'Lord Belper', Nottingham. He painted local scenes in oil and watercolour until his intemperate habits brought his artistic career, and shortly afterwards his life, to an untimely end.

Examples: Derby A.G.; Castle Mus. Nottingham.

BRADLEY, William 1801 (Manchester) – 1857 (Manchester)
An errand boy who, at the age of sixteen, set up in a Manchester warehouse as a 'portrait, miniature and animal painter and teacher of drawing'. He was largely self-taught, with advice from Mather Brown. He came to London in 1823, and first exhibited in that year with the encouragement of Lawrence. In 1833 he re-visited Manchester and worked in the studio of C. Calvert (q.v.), whose daughter he married. He returned finally to Manchester in 1847, but by this time he was in poor health.

Examples: B.M.; City A.G., Manchester; Sydney A.G.
Bibliography: *A.J.*, 1857.

BRAGG, Edward 1785 – 1875
There are views of Battersea in the V.A.M. by this artist.

BRAGG, John
A Birmingham coastal and landscape painter who was active between 1880 and 1889. He was presumably related to the figure painter HENRY BRAGG who was working in Birmingham in 1814, and to the figure, portrait and genre painter CHARLES WILLIAM BRAGG who exhibited there and in London from 1852 to 1887.

BRANDARD, Edward Paxman 1819 – 1898
The brother of R. Brandard (q.v.), he was an engraver and collaborated with Queen Victoria (q.v.) on a view of Balmoral. He also painted rustic scenes and Biblical subjects.

BRANDARD, Robert 1805 (Birmingham) – 1862 (London)
He came to London in 1824 and studied engraving under Edward Goodall for a year before turning professional. Although primarily an engraver, working on such publications as Turner's *Picturesque Views in England and Wales*, 1838, he painted watercolours, and was an occasional exhibitor at the R.A., the N.W.S. and elsewhere. His drawing is good, as is to be expected, but his colour can be over-done and his compositions rather awkward.

Examples: B.M.; V.A.M.; Blackburn A.G.; Fitzwilliam.
Bibliography: *A.J.*, February 1862.

BRANDLING, Henry Charles
Elected A.O.W.S. in June 1853, he exhibited six views of Nuremberg, one of Glasgow Cathedral and an historical scene in Durham Cathedral before allowing his associateship to lapse in 1857. He may have exhibited portraits at the R.A. from 1847 to 1850. He lived in London. In 1848 he published a series of lithographic views in Northern France. The watercolours for these are close in style to S. Prout (q.v.)

Illustrated: W.W. Collins: *Rambles beyond Railways*, 1852.

BRANDOIN, Michel Vincent Charles 1733 – 1807
A Swiss artist who worked and taught in England at least from 1768 to 1772 and, like S.H. Grimm (q.v.), forms one of the links between the English and Swiss watercolour schools in the late eighteenth century.

Examples: B.M.; Aberdeen A.G.
Bibliography: *Walpole Society*, XXIII, 1935.

BRANEGAN, J F
Probably an Irishman, he was a landscape painter. He was working in Dublin in 1841, and later visited many parts of the British Isles including the Isle of Man, Rochester, Scotland in 1857 and Norfolk in 1871. He exhibited at the R.A. and Suffolk Street from 1871, and at that time lived in London. His drawing is good and his colours are effective.

BRANGWYN, Sir Frank William, R.A.
** 1867 (Bruges) – 1956**
Painter, designer, etcher, lithographer and watercolourist, in the early part of his career he worked for his friend W. Morris (q.v.) and then went to sea. He exhibited at the R.A. from 1885, and elsewhere. He was knighted in 1941. The Brangwyn Museum was opened in Bruges in 1936, and a memorial exhibition was held at the Fine Art Society in 1958.

He was much influenced by the Newlyn School in his early days, and his watercolours emerge from greyness to full colour in the course of his career.

Examples: B.M.; Aberdeen A.G.; Blackburn A.G.; Bruges; Darlington A.G.; Dundee City A.G.; Fitzwilliam; Glasgow A.G.; Harrogate Mus.; Leeds City A.G.; Maidstone Mus.; Newport A.G.; Portsmouth City Mus.
Bibliography: P Macer-Wright: *B – a Study of Genius*, V. Galloway: *Oils and Murals of B.*, W. Shaw-Sparrow: *F.B. and His Work*, 1910 H. Furst: *The Decorative Art of F.B.*, 1924. *A.J.*, 1903, *Studio*, 1924; 1928. *Apollo*, XLI, 1945. *Country Life*, October 24, 1952.

BRANWHITE, Charles, A.O.W.S.
** 1817 (Bristol) – 1880 (Westfield Park, Bristol)**
The son of N.C. Branwhite (q.v.), he began his career as a sculptor and as a painter in oil, and was a pupil of his father and of W.J. Muller (q.v.). He was elected A.O.W.S. in 1849 and was a regular exhibitor for the rest of his life. He remained in Bristol throughout his life and was a close friend of his fellow townsmen F. Danby (q.v.) and S.P. Jackson (q.v.). He sketched well in watercolour, but was so lavish in the use of bodycolour that 'many of his drawings may be regarded as works in distemper' (Roget). He was the father of C.B. Branwhite (q.v.), and his elder brother, NATHAN BRANWHITE, was a portrait painter and engraver.

His remaining works were sold at Christie's, April 15, 1882.

Examples: B.M.; V.A.M.; Bristol City A.G.
Bibliography: *A.J.*, 1880.

BRANWHITE, Charles Brook 1851 (Bristol) –
The son of C. Branwhite (q.v.) under whom he studied before going to South Kensington. He lived in Bristol and painted West Country landscapes, exhibiting in Birmingham in 1881 as well as in London.

BRANWHITE, Nathan Cooper
** 1775 (Lavenham, Suffolk) – 1857**
The father of C. Branwhite (q.v.), he painted miniatures and watercolour portraits, and he exhibited at the R.A. from 1802 to 1828.

BRAY, Captain Gabriel
An amateur topographer and marine painter who lived in Deal in the second half of the eighteenth century. A view of the Fleet at Portsmouth by him was presented to George III. His drawing is poor but pleasant.

Examples: B.M.

BREANSKI, Alfred de
A landscape painter in oil and watercolour who lived in Greenwich. He specialised in Welsh and Highland scenes and also painted on the Thames, exhibiting from 1869. He was active until at least 1890. ALFRED DE BREANSKI, YR., exhibited a view of Fiesole at the R.A. in 1904.

BREANSKI, Gustave de
Probably the brother or son of A. de Breanski, whose style and subject matter he echoed. He exhibited from 1877 to 1892, and also painted marine subjects.

BREE, Rev. William Thomas 1754 – 1822
The rector of Allesley, near Packington Park, the seat of Lord Aylesford (q.v.), by whom he was clearly influenced. His accomplished watercolours, usually in low tones of grey and green, also show slight influences of Grimm, Rooker and Nattes. He is particularly good at rendering the stonework of his buildings.

Published: *The Plain Reader's Help in the Study of the Holy Scriptures*, 1821.
Examples: B.M.; Coventry A.G.

BRENAN, John c.1796 (Fethard, Co. Tipperary) – 1865
He entered the R.D.S. Schools in 1813, after which he worked, first as an heraldic, and later as a landscape painter in Cork. He exhibited at the R.H.A. between 1826 and 1864, and his views are taken from Cork and the South. He gave D. Maclise (q.v.) some of his first lessons in drawing.

His son, JAMES BUTLER BRENAN, was a portrait painter in Cork. Another son, JOHN J. BRENAN, trained in London, after which he returned to Cork and spent his time painting in the backgrounds to his brother's portraits.

BRENNAN, Michael G. – 1871 (Algiers)
A landscape painter who studied at the R.D.S. Schools and the Hibernian Society. He worked in Italy and North Africa as well as Ireland.

BRETT, John Edward, A.R.A. 1830 – 1902 (Putney)
A landscape and coastal painter, he worked extensively in watercolour in his early years, but almost entirely in oil after 1870. He lived in London and visited Italy for the first time in 1858. On his second visit he stayed in Florence from November 1861 to March 1862, and he also spent the winters of 1862-3, 1863-4 and 1864-5 in Italy. He was much influenced by W. Henry Hunt (q.v.) and the Pre-Raphaelites, contributing to their exhibition at Russell Place in 1857. His early work is in the Pre-Raphaelite manner; later it becomes more impressionist in feeling. There is often a strong geological element. He was described by Ruskin as 'one of my keenest-minded friends,' and he was elected A.R.A. in 1886.

His sister, ROSA BRETT, exhibited fruit, flowers, animals and landscapes at the R.A. from 1858 to 1881.

Examples: Ashmolean; Birmingham City A.G.; Fitzwilliam; Maidstone Mus.; Whitworth Inst., Manchester.
Bibliography: *A.J.*, 1902. *Burlington*, CXV, February, 1973.

BRETT, Joseph William
An artist who painted views on the Thames in 1830.

Examples: B.M.

BRETT, Admiral Sir Peircy 1709 – 1781 (Beckenham)
The son of a master in the Navy, he served as volunteer and midshipman and was promoted lieutenant in 1734. He served on Anson's circumnavigation, returning as captain of the *Centurion* in 1744. In the following July, he commanded the *Lion* in the action with the French Ship *Elisabeth* which proved so damaging to the attempt of the Jacobites. He fought at Finisterre in 1747, and was knighted in 1753 as commander of the Royal yacht. He served on the commission to examine the state of the port of Harwich in 1754 and, in 1759, prepared a report on the coasts of Essex, Kent and Sussex. He was second in command in the Mediterranean in 1762 and 1763 and was promoted admiral in 1778.

Examples: Greenwich.
Bibliography: *Gentleman's Mag.* 1781.

BREWER, Henry Charles, R.I. 1866 – 1943
A landscape and architectural painter and engraver who studied at the Westminster School of Art. He exhibited at the R.A. and the R.I. as well as in Australia and New Zealand, and exhibitions of his work were held at the Fine Art Society in 1908 and 1911. He visited Tangier in 1910. He may have been the son of H.W. Brewer (q.v.).

BREWER, Henry William – 1903
A painter in the manner of S. Prout (q.v.) who was educated at Oxford and lived in London. He exhibited at the R.A. and elsewhere from 1858, and was an unsuccessful candidate for the N.W.S. in 1869.

Illustrated: H.A. Cox: *Old London Illustrated*, 1921.

BREWER, John 1764 (Madeley, Shropshire) – 1816 (Derby)
A landscape and porcelain painter. In 1795 he moved to Derby to work for Duesbury and, at the same time, gave drawing lessons and kept open studio to potential buyers. His landscapes are of good quality.

His brother, ROBERT BREWER (1775, Madeley – 1857, Birmingham), came to Derby to join him at the Porcelain works, and took over after his death. He painted landscapes in oil and watercolour, and his wife Mary was a miniature painter.

Examples: Derby A.G.

BREWTNALL, Edward Frederick, R.W.S. 1846 – 1902
A landscape painter in oil and watercolour who exhibited from 1868, and was elected A.R.W.S. and R.W.S. in 1875 and 1883. He was also a member of the S.B.A. from 1882 to 1886.

Examples: V.A.M.; City A.G., Manchester.

BRICKDALE, Eleanor FORTESCUE-, R.W.S. 1871 – 1945
An illustrator, designer and painter of genre and historical subjects in oil, chalk and watercolour. She studied at the Crystal Palace School of Art and the R.A. Schools, and exhibited at the R.A. from 1896. She was elected A.R.W.S. and R.W.S. in 1902 and 1919. Her work is a continuation of the Pre-Raphaelite tradition, with its minuteness of detail and jewel-like colours.

A loan exhibition was held at Leighton House in 1904.

Published: *E.F.B.'s Golden Book of Famous Women* 1919.
Examples: Birmingham City A.G.; Leeds City A.G.

BRIDDEN, Rev. John
Eight volumes of topographical watercolours by this artist, mostly of churches, were sold by Sotheby's in 1929. He was working in Gloucestershire, Hampshire, Herefordshire, Hertfordshire, Lancashire and Lincolnshire between 1782 and 1791.

Examples: Co. Record Office, Lincoln.

BRIDELL, Frederick Lee 1831 (Southampton) − 1863
Mainly a portraitist and copyist of old masters, he also painted landscapes, usually Continental. He exhibited at the R.A. from 1851 to 1862. His remaining works were sold at Christie's on February 26, 1864.

His wife, ELIZA FLORENCE, née FOX, exhibited portraits and genre subjects at the R.A. from 1859 to 1871. The majority of both husband and wife's work is in oil.

Examples: Shipley A.G., Gateshead.

BRIDGES, James
A landscape and portrait painter who lived in Oxford. He travelled in Italy, Sicily and Germany and exhibited at the R.A. from 1819 to 1853. He worked in oil and watercolour, and he lived with his brother JOHN BRIDGES, who painted similar subjects and was active from 1818 to 1854. James's watercolours show the influence of J. Varley (q.v.), and his figures are generally poor.

Examples: B.M.; Grundy A.G., Blackpool.

BRIDGFORD, Thomas, R.H.A. 1812 (Lancashire) − 1878
His family moved to Ireland in 1817, and in 1824 he entered the R.D.S. Schools. He first exhibited at the R.H.A. in 1827, and was elected an Associate in 1832. In 1834 he went to London where he practised as a portrait painter. He returned to Dublin in 1844 and was elected R.H.A. in 1851. He taught drawing at Alexandra College and elsewhere.

All well as painting portraits and genre in oil, he made small, rather stiff, portraits in pencil and watercolour.

Examples: N.G., Ireland; R.H.A.

BRIERLY, Sir Oswald Walters, R.W.S.
1817 (Chester) − 1894 (London)
A marine painter who was the son of a doctor and amateur artist, and who studied at Sass's School and at Plymouth. In 1841 he set out to sail round the world, but settled in Auckland. He made two surveying cruises on the Australian coast, and returned home in 1851 by way of New Zealand and the Pacific coasts of North and South America. He accompanied the British fleet to the Baltic on the outbreak of the Crimean War in 1854, and then went to the Black Sea. From this time he was a favourite of the Royal Family, accompanying the Duke of Edinburgh to Norway and the Mediterranean as well as round the world in 1867-8. He was with the Prince of Wales in Egypt, Turkey and the Crimea in 1868. He was A.N.W.S. from 1840 to 1843, and was elected A.R.W.S. in 1872 and a full member in 1890. He was appointed Marine Painter to the Queen in 1874 and was knighted in 1885.

His paintings of contemporary marine subjects can be fine and atmospheric. His later historical subjects, in particular the Armada, are less so. An exhibition of his work was held at the Pall Mall Gallery in 1887.

Published: *The English and French Fleets in the Baltic* 1858.
Examples: Greenwich; Sydney A.G.
Bibliography: *A.J.*, 1887.

BRIGGS, Ernest Edward, R.I. 1865 − 1913 (Dunkeld)
A landscape and portrait painter who trained as a mining engineer before studying at the Slade and in Italy. He exhibited at the R.A. and the R.I. from 1889, and was elected R.I. in 1906. Various exhibitions of his work were held at the Fine Art Society, including one of specifically Highland subjects in 1908.

Published: *Angling and Art in Scotland*, 1908; *The Two Rivers*, 1912.
Examples: Leeds City A.G.

BRIGHT, Harry
A rather sentimental bird painter who was active between 1867 and 1892 or later. Occasionally he produced free sketches in the manner of E. Alexander (q.v.). These are much more interesting than the general run of his robins and wrens.

Published: *Birds and Blossoms*, 1879; *A.B.C. of Pretty Birdies*, 1896, 1902. Etc.
Examples: Ashmolean.

BRIGHT, Henry 1810 (Saxmundham) − 1873 (Ipswich)
A landscape and marine painter who was the son of a clockmaker and was apprenticed to a chemist in Norwich. However, his indentures were transferred to A. Stannard (q.v.), and he also took lessons from J.B. Crome (q.v.) and J.S. Cotman (q.v.). He moved to Paddington in 1836 and lived in or near London until 1858, building up a highly successful practice as a drawing master. He exhibited in London from 1836, was a member of the N.W.S. from 1839 to 1845, and of the Graphic Society. He exhibited at Norwich from 1848. In 1858 he returned to his brother's house, Park Lodge, Saxmundham, and two years later he moved to Redhill, and he may have lived in Maidstone after 1865. For the last five years of his life he settled in Ipswich. He made regular sketching tours both in Britain and abroad, visiting Wales and Sussex before 1838, Devon, Cornwall and Monmouth before 1844, Yorkshire by 1846, Oxfordshire by 1847 and Kent in 1847, Cumberland in 1850 and Scotland and the North several times in the 1850s and 1860s. Abroad he certainly visited the Alps in 1849, the Rhine in 1851 and Paris in 1853 and 1855, and he probably travelled more widely.

His early watercolours are fine uncluttered examples of the later Norwich style, and his pencil drawings show a strong sense of line and composition. His later works, by which he is best known, are executed in a variety of media, with crayon and bodycolour coming to predominate; they are often on tinted paper and sometimes verge on the gaudy.

Published: *Drawing-Book of Landscapes*, 1843. Etc.
Examples: B.M.; V.A.M.; Bridport A.G.; Dudley A.G.; Leeds City A.G.; Newport A.G.; Castle Mus., Norwich; Portsmouth City Mus.; Glynn Vivian A.G., Swansea; Gt. Yarmouth Lib.
Bibliography: *A.J.*, November, 1873; Castle Mus., Norwich, *Exhibition Cat.*, 1973.

BRIGHTY, G M
A portrait painter who exhibited at the R.A. and the B.I. from 1809 to 1827. His drawing is good and he uses thin washes of colour.

Examples: B.M.

BRISBANE, Rear Admiral Sir Charles
c.1769 − 1829
The son of an admiral under whom he served from 1779 at Cape St. Vincent, Gibraltar and in the West Indies. In 1793 he fought at Toulon and in Corsica with Nelson, like him losing an eye. In 1796 his disregard of orders led to the capture of the Dutch fleet at Saldanha Bay, and thereafter he served on the Cape Station until 1798. He was off Brest in 1801 and then in the West Indies. In 1806 he was involved in a number of actions, some of which he sketched, off Havana, and in the following year he captured Curacoa and was knighted. He was governor of St. Vincent from 1809 until his death.

Examples: Greenwich.

BRISTOW, Edmund 1787 (Eton) − 1876 (Eton)
Predominantly a sporting and animal painter in oil, he lived at Eton and Windsor, where his patrons included William IV. His watercolours tend to be in the eighteenth century tradition.

Bibliography: *A.J.*, 1876.

BRISTOW, S
A landscape and topographical painter who was active between 1778 and 1780, and sketched in South Wales.

Examples: Newport A.G.

BRITTAN, Charles Edward **1837 – 1888**
A West Country artist who painted landscapes and cattle and exhibited at the S.B.A. in 1858.

He is easily confused with his son, CHARLES EDWARD BRITTAN, YR. (b. 1871, Plymouth), who lived near Princetown, Dartmoor, and illustrated an edition of *Lorna Doone* in 1911 and A. Vowles's *The Lorna Doone Country*, 1925. Exhibitions of his work, including views of Dartmoor in 1901 and Perthshire views in 1902, were held at the St. James's Galleries, and Ackermann's held an exhibition entitled *Arran and the Western Isles* in 1913.

Examples: Plymouth A.G.

BRITTON, John F.S.A.
 1771 (Kingston St. Michael, Wiltshire) – 1857 (London)
The topographer and antiquarian. He was the son of a shopkeeper and small farmer, and was apprenticed to the landlord of a Clerkenwell tavern. He progressed to cellarman and became a hop merchant. By this time he had met, and collaborated on a ballad with, Edward William Brayley and in 1801 their *Beauties of Wiltshire*, the first of twenty-six county volumes, appeared. By 1804 the authors had travelled some 3,500 miles in their researches. Britton gave up his full-time connection with the project after the publication of Volume VII. Subsequently he published his own *Architectural Antiquities of Great Britain*, 1805-14, and *Cathedral Antiquities of England*, 1814-35. For all these works as well as other publications such as *Specimens of Gothic Architecture*, 1823-5, *Architectural Antiquities of Norway*, 1825, *Public Buildings of London*, 1825-8, *History...of the...Palace...of Westminster*, 1834-6, (again with Brayley), and *Architectural Description of Windsor*, 1842, he commissioned drawings from the best topographical draughtsmen of the day, and himself did some of the drawings. His work is in the tradition of Dayes and the Bucklers, and is usually soft in colour and on a small scale.

Published: *Autobiography*, 1850.
Examples: B.M.; Ashmolean; Devizes Mus.
Bibliography: *R.I.B.A. Papers*, 1856-7; *A.J.*, February, 1857.

BROADBELT, W
A bird painter in water and bodycolour who was working about 1785. F. Nicholson (q.v.) had a friend of the name in Knaresborough.

BROCAS, Henry **1762 (Dublin) – 1837**
A landscape painter and engraver who worked for several Dublin periodicals. He was appointed Master of the Landscape and Ornament School of the R.D.S. in 1801, which post he held until his death.

His work includes portraits, topographical views and occasional political caricatures as well as landscapes. Occasionally he painted in oil.

BROCAS, Henry, Yr. **1798 (Dublin) – 1873**
The fourth son of H. Brocas (q.v.), he was, like his father, a landscape painter and engraver. He etched a series of twelve *Views of Dublin* after drawings by his brother S.F. Brocas (q.v.), which were published in 1820. He exhibited at the R.H.A. periodically between 1828 and 1872, and in 1838 succeeded his father as Master of the Landscape and Ornament School of the R.D.S. He drew and engraved portraits and caricatures as well as topographical works, and he retired in 1854.

Examples: B.M.

BROCAS, James Henry **c.1790 (Dublin) – 1846 (Cork)**
The eldest son of H. Brocas (q.v.), he attended the R.D.S. Schools and settled in Cork in about 1834.

He painted landscapes, portraits and animals, and made etchings.

Examples: B.M.

BROCAS, Samuel Frederick **c.1792 (Dublin) – 1847 (Dublin)**
The second son of H. Brocas (q.v.). He won three medals from the R.D.S. Schools, after which he practised in Dublin as a landscape painter in oil and watercolour. He exhibited at the R.H.A. between 1828 and 1847, and was a member of the Society of Irish Artists. Twelve of his drawings of Dublin were engraved by his brother H. Brocas, Yr. (q.v.) in 1820 as part of a projected general topography of Ireland.

Examples: B.M.; V.A.M.; N.G., Ireland.

BROCAS, William, R.H.A. **c.1794 (Dublin) – 1868 (Dublin)**
The third son of H. Brocas (q.v.), he exhibited portraits and figure subjects as well as occasional landscapes at the R.H.A. between 1828 and 1863. He was President of the Society of Irish Artists, and was elected Associate and Member of the R.H.A. in 1854 and 1860. He etched caricatures for James Sidebotham, and made etchings after Hogarth's engravings.

BROCK, Charles Edmund, R.I. **1870 (London) – 1938**
A prolific illustrator and portraitist, he was educated in Cambridge. He worked on many popular editions, such as Lamb's *Essays* and Dent's edition of Jane Austen's works. He was elected R.I. in 1909.

BROCK, Henry Matthew, R.I. **1875 (Cambridge) – 1960**
The younger brother of C.E. Brock (q.v.), he was also a prolific illustrator in black and white and colour. He was educated in Cambridge, and he worked for *Punch* as well as on Dent's *Essay Series* and other popular classics. He also made spirited landscape sketches for his own pleasure. He was elected R.I. in 1906.

BROCKEDON, William, F.R.S.
 1787 (Totnes, Devon) – 1854 (London)
After attempting his father's watchmaking trade, Brockedon moved to London and the R.A. Schools in 1809. He exhibited portraits and sculpture from 1812. In 1815 he made his first Continental visit, travelling through France and Belgium, and he was in Italy in 1821 and 1822. He became a member of the Academies of Florence and Rome. In 1830 he assisted in the founding of the R.G.S., and in 1831 founded the Graphic Society. He was also an inventor and improved steel pens.

His landscapes, often views in Italy, are sometimes brightly coloured and are usually well drawn.

Published: *Illustrations of the Passes*, 1827-9; *Journals of Excursions in the Alps*, 1833. *Road Book from London to Naples*, 1835. *Italy, Classical, Historical and Picturesque*, 1842-4.
Examples: B.M.; V.A.M.

BROCKY, Charles (Karoly), A.N.W.S.
 1807 (Temeswar, Hungary) – 1855 (London)
An Hungarian who worked as strolling player, cook, barber and painter in Vienna and Paris before being brought to London by Munro of Novar. He exhibited portraits and classical subjects at the R.A. from 1839 to 1854 and also at the N.W.S., and he built up a successful practice as a drawing master. He also made watercolour copies of old masters. In 1854 he was elected A.N.W.S.

Examples: B.M.; V.A.M.
Bibliography: N. Wilkinson: *Sketch of the Life of C.B. the Artist*, 1870. J. Szentkláray, *B.K., festömüvész élete*, 1907.

BROMLEY, John
A draughtsman who was working in London from 1784 to 1796.

BROMLEY, Valentine Walter Lewis
 1848 (London) – 1877 (Fallows Green, near Harpenden)
The son of William Bromley, a genre painter, he also painted genre and historical subjects in oil and watercolour. He worked for the *I.L.N.* and as a book-illustrator, accompanying Lord Dunraven to

America in 1875 to illustrate *The Great Divide*. He also painted views. He was elected A.N.W.S. in 1868 and lived in St. John's Wood.

His wife, ALICE LOUISA MARIA BROMLEY, née ATKINSON, was a landscape painter.

Examples: Shipley A.G., Gateshead.

BROOKE, Sir Arthur De Capel, Bt.
1791 (London) – 1858 (Oakley Hall, Northamptonshire)
The eldest son of Sir Richard de Capel Brooke, he graduated from Magdalen College, Oxford, in 1813. He travelled widely, particularly in Northern Europe. He also entered the army, and was promoted major in 1846. In 1829 he succeeded his father. He was an original member of the Travellers' Club, and in 1821 founded the Raleigh Club, which later became part of the Royal Geographical Society. In 1843 he was made Sheriff of Northamptonshire.

Published: *Travels through Sweden, Norway and Finmark to the North Pole in the Summer of 1820*, 1823. *A Winter in Lapland and Sweden...*, 1827. *Winter Sketches in Lapland...*, 1827. *Sketches in Spain and Morocco*, 1837.

BROOKE, A. Newton
A landscape and coastal painter who was working in Devon in 1883.

Examples: V.A.M.

BROOKE, Rev. John c.1802 – c.1881
A pupil of de Wint who matriculated at B.N.C., Oxford in 1821 and was ordained in 1826. From 1831 to 1847 he was Vicar of Shifnal, Shropshire, and on retirement lived at Haughton Hall, Shifnal. It is probable that he shared some of the interests of his neighbour Rev. J.L. Petit (q.v.). He sketched in North Wales.

BROOKE, Leonard Leslie 1863 – 1940
An illustrator and landscape painter who exhibited at the R.A. and the R.I. from 1887.

Published: *Johnny Crow's Garden* etc. 1903; *L.B.'s Children's Books* 1907-22.
Examples: City A.G., Manchester.

BROOKE, William Henry, A.R.H.A. 1772 – 1860
He was the grandson of ROBERT BROOKE a portrait painter in Co. Cavan, and son of HENRY BROOKE (1738-1806), an historical and biblical painter in London and Dublin and a drawing master. He trained under H. Drummond (q.v.) and established himself as a portrait painter. He was elected A.R.H.A. in 1828.

As an illustrator he was much influenced by his friend T. Stothard (q.v.). He produced both landscape and figure drawings, the former freely sketched in pen and ink with clear, fairly bright washes. His pretty figures are very close to those of Stothard. He sometimes inscribed in a characteristic, flowing hand.

Illustrated: T. Moore: *Irish Melodies*, 1822. Keightley: *Greek and Roman Mythology*, 1831.
Examples: B.M.

BROOKES, Warwick, of Manchester
1808 (Salford) – 1882 (Manchester)
He worked in a calico print works before studying at the Manchester School of Design under John Zephaniah Bell. In 1840 he became head designer to the Rossendale Printing Company and retained the position for twenty-six years.

He produced figure subjects and landscapes and became known to a wider public with the Manchester Exhibition of 1857. In 1866 he contributed illustrations to *A Round of Days* and in 1868 he became a member of the Manchester Academy.

Illustrated: J. Brown: *Marjorie Fleming*, 1884. T. Letherbrow: *W.B.'s Pencil Pictures of Child Life*, 1889.
Examples: B.M.; V.A.M.; City A.G., Manchester.

BROOKING, Charles 1723 – 1759 (London)
Brought up in the dockyard at Deptford, he died of consumption before his reputation was well established. His marine drawings, usually in monochrome, are very attractive, and many were engraved.

An exhibition of his oil paintings, drawings, and engravings was held by the Paul Mellon Foundation in 1966 in association with the Aldeburgh Festival and Bristol City A.G.

Examples: B.M.; V.A.M.

BROUGH, Robert Barnabas 1828 (Monmouthshire) – 1860
A writer and journalist who worked as a portrait painter from an early age, and, while still in his teens, started up a satirical paper in Liverpool. He and his brother William produced satires and burlesques for the London stage. He used the nom de plume Papernose Woodensconce.

BROWN, Agnes Mary
A landscape, church and flower painter who lived in Birmingham and exhibited there from 1867 to 1886.

BROWN, Alexander Kellock, R.S.A., R.I.
1849 (Edinburgh) – 1922
A landscape and flower painter in oil and watercolour who was educated at the Haldane Academy, Glasgow, and studied at Heatherley's and the Glasgow School of Art. Later he worked as a calico designer. He exhibited at the R.S.A. from 1871, and the R.A. and R.I. from 1873. He was elected A.R.S.A. and R.S.A. in 1892 and 1908, and R.I. in 1916.

Examples: Glasgow A.G.

BROWN, Alfred J WARNE- – 1915
A coastal and landscape painter who exhibited at the R.A., the R.I. and elsewhere from 1884. An exhibition of his work was held at the Fine Art Society in 1905. He lived in Ealing until 1894, when he moved to Ruan Major on the Lizard. Many of his subjects are taken from Cornwall. His name is sometimes spelt with a final 'e'.

BROWN, David
A landscape painter who began his career painting signs. At the age of thirty-five, he worked under Morland as a copyist. He later set up as a drawing master in the country. He exhibited ten landscapes at the R.A. from 1792 to 1797, and he may have been in Liverpool between 1811 and 1822. The bulk of his work was probably in oil.

BROWN, Edward Archibald 1866 – 1935
A landscape and animal painter who lived in Hertford and exhibited at the R.A. from 1900. He also painted, infrequently, in oil, and his animals are poorly drawn.

Examples: Hertford Mus.

BROWN, Ford MADOX- 1821 (Calais) – 1893 (London)
Trained in Belgium, he began his career in Antwerp and Paris. In 1845 he spent some months in Rome. In 1848 he took Rossetti as a pupil, thus coming into contact with the Brotherhood. He never formally joined them but the exchange of influence between them was marked. He was not a very popular painter, and also quarrelled with the artistic establishment. He taught at the Camden Town Working Men's College from 1854, and from 1861 to 1874 was a leading designer for Morris and Co.

Examples: B.M.; V.A.M.; Ashmolean; Cecil Higgins A.G., Bedford; Cartwright Hall, Bradford; Maidstone Mus.; City A.G., Manchester. Bibliography: F.M. Heuffer: *Memoir of M.B.*, 1896. H.M.M. Rossetti: *F.M.B.*, 1901. *A.J.*, April, 1873, 1893. Birmingham City A.G., *Exhibition Cat.*, 1939 and supp.

BROWN, Frederick 1851 (Chelmsford) – 1941
A landscape and genre painter in oil and watercolour, he studied at South Kensington, and in Paris in 1883. He taught at the

Westminster School of Art from 1877 to 1892 and was Slade Professor from 1892 to 1918.

An exhibition of his Isle of Wight views was held at the Goupil Gallery in 1920.

Bibliography: *Studio*, XXXVII, p. 29; XLIV, p. 136; *Burlington*, LXXXII, 1943.

BROWN, John **1752 (Edinburgh) – 1787 (Edinburgh)**
He studied at the Trustees' Academy, Edinburgh, and was a pupil of A. Runciman (q.v.). He went to Italy in 1771 and stayed there for ten years or more, visiting Sicily amongst other places. He was not really a watercolourist, but his drawings are very much in the manner of Fuseli, of whose circle in Rome he was a member. He did sometimes use sepia wash and may have used colour. He returned to Edinburgh in or after 1781, but died before he could establish any great reputation.

His monogram J.B. can sometimes look deceptively like Blake's. W.Y. Ottley (q.v.) was his pupil.

Examples: B.M.; N.G., Scotland; N.P.G., Scotland.
Bibliography: J.M. Grey: *J.B., the Draughtsman*, 1889. *Country Life*, August 12, 1971.

BROWN, John
An architect who was County Surveyor of Norfolk from about 1835. He exhibited at the R.A. from 1820 to 1844. As an architect he specialized in churches and as an artist in church interiors. His drawing is good, and his detail exact and pleasing.

BROWN, Major-General John
A landscape, marine and town painter who painted in monochrome and full colour, and worked in Hampshire, the Isle of Wight, Ireland and Scotland between 1792 and 1820.

Examples: Nat. Lib., Scotland.

BROWN, J. Michael
A genre painter who worked in Edinburgh and exhibited at the R.A., the R.I. and elsewhere from 1885. His watercolours would be unlikely to aid digestion.

BROWN, Lancelot, 'Capability'
 1715 (Harle-Kirk, Northumberland) – 1783
The landscape gardener and architect whose work included the re-modelling of the grounds at Kew, Blenheim and Nuneham Courtenay, and buildings at Croome. The preparatory drawings which he made, often on a large scale, are typical of the tinted manner, with careful and conventional outlines and grey, green and blue washes.

Examples: Heveningham Hall, Suffolk.
Bibliography: D. Stroud: *C.B.*, 1950.

BROWN, Oliver MADOX- **1855 (Finchley) – 1874**
The son of F. Madox-Brown (q.v.), he showed great promise and strong individuality both as an author and a watercolourist. He first exhibited at the Dudley Gallery when he was fifteen, and at the R.A. the following year. His subjects include scenes from *The Tempest* and *Silas Marner*. His first novel, *Gabriel Denver*, was published in 1873. He died of blood poisoning following gout.

Published: *Gabriel Denver*, 1873. *The Dwale Bluth*, 1876.
Examples: City A.G., Manchester.

BROWN, Peter
A flower painter in water and bodycolour who was a member of the Incorporated Society, and exhibited there and at the R.A. from 1766 to 1791. He was appointed Botanical Painter to the Prince of Wales.

Published: *Nouvelles Illustrations de Zoologie*, 1776.
Examples: B.M.

BROWN, Richard
An 'Architect and Professor of Perspective' who exhibited designs and landscapes at the R.A. from 1804 to 1828.

Published: *Principles of Practical Perspective*, 1818. *Domestic Architecture...*, 1842. *Sacred Architecture...*, 1845.

BROWN, Thomas Austen, A.R.S.A.
 1857 (Edinburgh) – 1924 (Boulogne)
The son of a drawing master, he studied at the R.S.A. Schools before coming to London. He was elected A.R.S.A. in 1889, and was a member of the R.I. from 1888 to 1899. He lived in Boulogne for many years and his paintings, which are in many styles, and coloured woodcuts won medals at several Continental exhibitions.

Published: *Bits of Chelsea*, 1921 (lithographs).
Examples: B.M.; V.A.M.; N.G., Scotland.

BROWN, Vandyke
A Shrewsbury artist who painted landscapes, street scenes and buildings and was active between 1820 and 1840. In the 1880s, someone of this name edited the periodical *The Berkshire Bell and Counties Review*.

Examples: Shrewsbury Lib.

BROWN, William
A drawing master and topographer who worked in Norfolk and Durham. A print was made from one of his drawings by Jukes and Sarjent in 1809. His style is reminiscent of that of J. Farington (q.v.), and he uses grey and brown washes.

Examples: B.M.

BROWN, William Fulton, R.S.W. 1873 (Glasgow) – 1905 (Glasgow)
A genre painter who was the nephew and pupil of the Scottish artist David Brown. He also studied at the Glasgow School of Art.

Examples: Glasgow A.G.; Paisley A.G.

BROWNE, E **F**
A North Eastern landscapist of the late nineteenth century.

BROWNE, Gordon Frederick, R.I. **1858** **– 1932**
Son of H.K. Browne (q.v.), he was an illustrator and worked on editions of Shakespeare, Scott and Defoe. He lived in Richmond, Surrey and was elected R.I. in 1896.

Examples: Doncaster A.G.; Hove Lib.

BROWNE, Hablot Knight, 'Phiz'
 1815 (Kennington) – 1882 (Brighton)
The ninth son of a merchant, he was educated in Suffolk and apprenticed to Finden the engraver. As soon as he was out of his articles, he set up as a painter and attended life classes in St. Martin's Lane. His first illustrations for Dickens appeared in 1836, with *Sunday as it is*, by Timothy Sparks and the *Pickwick Papers*. In 1837 he visited Flanders with Dickens, and the following year they went to Yorkshire. Although best known as an illustrator, he exhibited both in oil and watercolour. Apart from his work with Dickens, his most popular illustrations were for the works of Charles Lever, in which he was greatly helped by his passion for horses and hunting. In 1867 he became paralysed but continued to work at drawing and etching until his death. In 1880 he moved to Brighton.

Examples: B.M.; City A.G., Manchester.
Bibliography: F.G. Kitton: *Phiz, a Memoir*, 1882. D.C. Thompson: *Life and Labours of H.K.B.*, 1884. S.M. Ellis: *Mainly Victorian*, 1924. *Country Life*, June 10, 1965.

BROWNE, J **D** **H**
An artist who went to Mont Blanc with A.G. Goodall (q.v.) in 1852, and subsequently produced a volume of ten lithographs. For a time he lived in London.

Bibliography: *Country Life*, April 27, 1961.

BROWNE, James Loxham
A landscape painter who visited North Wales and exhibited at the R.B.A. in 1892 and 1893 and at the R.A. from 1894. He lived in Hampstead.

BROWNE, Philip
A landscape, sporting, still-life and genre painter in oil and watercolour who lived in Shrewsbury. He exhibited in London and Birmingham from 1824 to 1868, and was an unsuccessful candidate for the N.W.S. in 1841. His landscapes are sometimes Claudian or Barret like in composition, but their style and technique owe more to J. Varley (q.v.). He sketched in Wales and Holland, and in his later years he concentrated on painting fruit.

Examples: Ashmolean.

BROWNE, Thomas Arthur, R.I.
 1870 (Nottingham) − 1910 (London)
A black and white illustrator who also worked in watercolour and pastel and painted in Holland, Spain, China and Japan as well as Britain. He was apprenticed to a firm of lithographers in Nottingham, and came to London in 1895. He exhibited at the R.A. from 1898 to 1901, in which year he was elected R.I., and he was a member of the R.B.A. from 1898. He established a printing business in Nottingham under the name 'Tom Browne Ltd.'

Published: *Tom Browne's Clyde Sketch Book*, 1897; *Tom Browne's Annuals*, 1904-5. Etc.
Examples: Castle Mus., Nottingham.
Bibliography: A.E. Johnson *'T.B.'*, 1909.

BROWNSWORD, Harry A. **c.1850 (Nottingham) − c.1910**
The son of a Nottingham silk merchant, he was an amateur artist. He exhibited at the R.A. and Suffolk Street between 1889 and 1892, and painted in oil and watercolour.

BRUHL, Louis Burleigh **1862 (Baghdad) − 1942**
Educated in Vienna, he specialised in landscape painting in oil and watercolour. He was President of the British Watercolour Society, and a member of the R.B.A. He lived in Watford.

Published: *A China Dish; Landscape*, 1929.
Illustrated: A.R.H. Moncrieff: *Essex*, 1909.
Examples: Newport A.G.

BRUMMELL, George Bryan, 'Beau'
 1778 (Westminster) − 1840 (Caen)
Educated at Eton, he spent a year at Oriel College, Oxford, and held a cornetcy in the 10th Hussars from 1794 until 1798 when the regiment was ordered to Manchester. He ruled London society until his debts and his quarrel with the Prince Regent (q.v.) drove him to Calais in 1816. He was Consul at Caen from 1830 to 1832, and in 1835 he was imprisoned for debt. He died insane.
He painted landscapes which may owe a little to F.L.T. Francia (q.v.), and figures which are in the tradition of R. Westall (q.v.).

BRUNDEN, Commander Edgar Montgomery
 1776 − 1848
A marine painter, he joined the Navy as a midshipman in 1790. He served in the Mediterranean under Captain Cochrane in 1801-2, and was later wounded at the Battle of Trafalgar. In the American war of 1812, he was present, in command of a sloop, at the bombardment of Washington. Four years later, he was retired on half pay. He had hitherto produced highly competent watercolours in the style of the Joy brothers (q.v.), and, in his retirement, he also painted landscapes taken from about his home near Canterbury. These were influenced in style by J. Varley (q.v.), from whom he had some lessons.

Bibliography: P. Huth: *Memories of a Sailor and Artist*, 1892.

BRYANT, Joshua
A landscape draughtsman and engraver who was working between 1795 and 1810.

BUCK, Adam **1759 (Cork) − 1833 (London)**
A portrait and miniature painter, he was the son of a Cork silversmith and had acquired a good reputation locally before coming to London in 1795. His portraits, often of children, were popular and he was a successful teacher. Many of his works were engraved. He exhibited at the R.A., S.B.A. and the B.I.
His work is usually elaborately drawn in pencil and washed in clear, thin colours with a concentrated finish on the head of the sitter. He made occasional illustrations, as for an edition of Sterne's *Sentimental Journey*.
His son, SIDNEY BUCK, carried on his father's profession in London. His younger brother, FREDERICK BUCK (1771-1840), was a miniature painter in Cork.

Published: *Paintings on Greek Vases*, 1881.
Examples: B.M.; Ashmolean; Fitzwilliam; City A.G., Manchester; Ulster Mus.
Bibliography: *Apollo*, XXXVIII, 1943.

BUCK, Samuel **1696 − 1779**
An engraver and topographical draughtsman, he produced more than five hundred prints of the remains of abbeys, castles, etc., as well as more extensive views of towns. From 1711 to 1726 he engraved his own works, after which his brother, NATHANIEL BUCK, worked with him on both the drawing and engraving until 1753. They generally travelled around the country each summer, making drawings which they engraved during the winter. Samuel exhibited at Spring Gardens in 1768 and 1774, and at the R.A. the following year.
Their drawings are generally done in Indian ink with grey or brown wash. They have the crude and rather stiff appeal of the earlier generation of Dutch topographical artists working in this country. The styles of the brothers are much the same, although that of Nathaniel is perhaps rather looser. The drawings often bear fake signatures.

Published: The complete works were re-published as: *Buck's Antiquities...*', 1774.
Examples: B.M.; Greenwich; N.G., Scotland.

BUCK, William
An amateur artist in watercolour and pen and black ink. In 1876 he was in the Isle of Wight where he made many coastal sketches, often on tinted paper, and he was on the Thames in 1877 and 1878. He has a fine sense of space and distance and sometimes uses a pointilliste technique. His colours are clear, and the details are well drawn.

Examples: Ashmolean; Carisbrooke Castle; Reading A.G.

BUCKLE, Mary
A landscape painter working in about 1817. She may have visited North Wales or may have copied the work of others. She worked in pencil and wash.

BUCKLER, John, F.S.A.
 1770 (Calbourne, Isle of Wight) − 1851 (London)
He was articled to a Southwark architect, Charles Thomas Cracklow, and practised as an architect until 1826, when he handed over his practice to his son, J.C. Buckler (q.v.). He worked for Sir R.C. Hoare (q.v.) in Wiltshire, Lord Grenville in Buckinghamshire, Dr. Whitaker in Yorkshire, H.S. Pigott in Somerset and W. Salt in Staffordshire. He exhibited at the R.A. from 1796 to 1849. At the end of his life, he estimated that he had made more than 13,000 drawings.

Examples: B.M.; V.A.M.; Ashmolean; Bristol City A.G.; Grosvenor Mus., Chester; Coventry A.G.; Devizes Mus.; Co. Record Office, Hertford; Lambeth Lib; Newport A.G.; Cas. Mus., Norwich; William Salt Lib., Stafford; Taunton Mus.; Wakefield City A.G.; York A.G.

BUCKLER, John Chessell 1793 – 1894
The eldest son of J. Buckler (q.v.), to whose architectural practice
he succeeded in 1826. He also painted topographical subjects in a
manner so close to that of his father that only the signature
distinguishes between them. Essentially, they both belong to the
eighteenth century tradition.

In his turn, J.C. Bucker's son, CHARLES ALBAN BUCKLER
(1824-1904), joined the family business. Later he worked at the
College of Heralds.

Published: *Views of Cathedral Churches in England*, 1822.
Historical and Descriptive Account of the Royal Palace at Eltham,
1828. *Remarks upon Wayside Chapels*, 1843. *History of the
Architecture of the Abbey Church at St. Albans*, 1847. *Description
of Lincoln Cathedral*, 1866.
Examples: B.M.; Ashmolean; Bristol City A.G.; Bowes Mus.,
Durham; Fitzwilliam; Usher A.G., Lincoln; City A.G., Manchester;
Cas. Mus., Norwich; Richmond Lib.; Southwark Lib.; William Salt
Lib., Stafford; Wakefield City A.G.

BUCKLER, William 1814 (Newport, Isle of Wight) – 1884
Nephew of J. Buckler (q.v.), he studied at the R.A. Schools and
exhibited portraits at the R.A. from 1836 to 1856. In about 1848
he settled at Emsworth and took up entomology. This gradually
became his main interest, and he made at least five thousand
drawings of larvae as well as writing articles and books.

Published: *The Larvae of the British Butterflies and Moths*,
1886-1901.
Examples: B.M.

BUCKLEY, C F
A landscape painter who came to London, probably from Cork, in
about 1840. He painted in Hampshire, the Isle of Wight, the Lake
District, North Wales, Yorkshire, Derbyshire and Ireland and
exhibited at the R.A. and R.B.A. from 1841 to 1869. He was an
unsuccessful candidate for the N.W.S. in 1844. He was a prolific
painter, and his work is pleasing if of no great originality.

Examples: V.A.M.; Cape Town Mus.; Derby A.G.; Glasgow A.G.;
Leeds City A.G.

BUCKLEY, J E
Probably the brother of C.F. Buckley (q.v.), with whom he was
living in 1843. He painted landscapes and Tudor and Stuart scenes,
and exhibited at the R.B.A. from 1843 to 1861. He had been in
Bootle in 1840, perhaps on his way from Ireland, and was still active
in 1873.

Examples: V.A.M.

BUCKLEY, John
A miniaturist, portrait and landscape painter who moved from Cork
to London in about 1835. He was probably the elder brother of the
other painting Buckleys.

BUCKLEY, William
A landscape, architectural and genre painter who exhibited at the
R.B.A. from 1840 to 1845. At that time he was living in
Kensington. He painted in the Isle of Wight and on the Wye,
probably with C.F. Buckley (q.v.) and in Essex and Kent.

BUCKMAN, Edwin, A.R.W.S.
A painter of domestic and street scenes and figure subjects. He lived
in London and Birmingham, and was in Jersey in 1875. He was
elected A.R.W.S. in 1877, and a member of the Birmingham Society
in 1890.

BUCKNALL, Ernest Pile 1861 (Liverpool) –
A landscape painter who exhibited at the R.A., the R.I. and the
R.B.A. from 1885. An exhibition of his work was held at the
Burlington Gallery in 1888, and he was still painting in 1910.

BUCKNER, Richard
A very popular portrait and genre painter in oil and watercolour
who has now fallen into total obscurity. He worked in Rome from
1820 to 1840 and was active in London from 1836 to 1879,
exhibiting at the R.A. from 1842 to 1877. Sales of his work were
held at Christie's, February 22-24, 1873 and July 31, 1877. He was
still alive at that date. Du Maurier described him, deprecatingly, as
the only Victorian artist to be accepted as a gentleman.

Examples: B.M.

BUDD, George (London) –
A hosier who turned to art and painted landscapes, portraits and
still-lifes. He taught drawing for some years at Dr. Newcome's
School at Hackney. He was working in 1750. The majority of his
work is probably in oil.

BUGLER, Abel
An artist who made drawings of churches, some of which were
published as prints in about 1850.

BULLOCK, George
A painter and decorator at Bridlington, who made a number of local
views in watercolour in about 1900.

BULMAN, Job c. 1740 –
An amateur who is said to have been a friend of P. Sandby (q.v.), by
whose topographical style he was much influenced. He visited
Scotland, Cumberland, the Isle of Man, Suffolk, Sussex, Cornwall,
the Wye Valley, Yorkshire, Durham in 1774 and Northumberland in
1774 and 1779.

His work is generally rather crude and heavy in handling,
although he can rise to slightly better things.

Examples: B.M.; Leeds City A.G.

BULWER, Rev. James 1794 – 1879
An amateur landscape painter of high quality, he was educated at
Jesus College, Cambridge, from 1815 and was ordained in 1818. He
married the daughter of an Irish barrister, and from 1823 was
Perpetual Curate of Booterstown, Dublin. From 1833 to 1848 he
was Minister of York Chapel and Curate of St. James's, Westminster,
and from 1848 until his death Rector of Stody with Hunworth,
Norfolk. He was a pupil and friend of J.S. Cotman (q.v.), and his
son, J.N.BULWER, also made Cotman copies.

Published: *Views of Madeira*, 1825-26. *Views of Cintra in Portugal.
Views in the West of England.*
Examples: B.M.; N.G., Washington.

BUNBURY, Henry William 1750 (Suffolk) – 1811 (Keswick)
An amateur caricaturist, who was educated at Westminster and St.
Catherine's College, Cambridge, Bunbury studied drawing at Rome
while on the Grand Tour. He married in 1771 Catherine Horneck,
Goldsmith's 'Little Comedy', who acted with him in amateur
productions at Wynnstay. For these he designed invitation cards,
and P. Sandby the scenery. He was a friend of West, Walpole,
Goldsmith, Garrick and Reynolds, and was appointed equerry to the
Duke of York in 1787. He was colonel of the West Suffolk Militia.
He exhibited at the R.A. in an honorary capacity between 1780 and
1808. His wife died in 1798, and he then retired to Keswick.

He produced many caricature drawings which were often etched,
or otherwise reproduced, by professional artists. These include two
strip cartoons published in 1787, *A Long Minuet, as Danced at Bath*
and *The Propagation of a Lie*. His humour is social rather than
political. His Shakespearian figure subjects – perhaps inspired by
the Wynnstay productions – are like those of Lady D. Beauclerk
(q.v.).

Several members of his family, including his second son, SIR
HENRY EDWARD BUNBURY (1778-1860), the soldier and
military historian, produced drawings very much in his manner.

Published: As 'Geoffrey Gambado': *An Academy for Grown*

Horsemen, 1787.
Examples: B.M.; V.A.M.; Ashmolean; Greenwich; N.G., Scotland.
Bibliography: *Country Life,* 19 February, 1943 (letters).

BUNCE, Myra Louisa
A landscape, coastal, still-life and flower painter, she was the elder
daughter of the Editor of the *Birmingham Post.* She painted in oil
and watercolour, and in Cornwall and Wales, and exhibited in
Birmingham and London from 1873 to 1910.
 Her sister, KATE ELIZABETH BUNCE (1858-1927), studied at
the Birmingham School of Art and painted portraits, genre subjects,
flowers and church interiors and was influenced by the
Pre-Raphaelites.

BUNDY, Edgar, A.R.A., R.I. 1862 (Brighton) – 1922 (Hampstead)
A genre and historical painter in oil and watercolour who was
largely self-taught, but encouraged by A. Stevens (q.v.). He was also
a member of the Langham Sketching Club. He exhibited at the R.A.
from 1881 and was elected R.I. in 1891, becoming Vice President,
and A.R.A. in 1915.

Examples: Blackburn A.G.; Towneley Hall, Burnley; Shipley A.G.,
Gateshead.

BUNNEY, John Wharlton 1828 (London) – 1882 (Venice)
A painter of Venetian scenes in oil and watercolour who was an
unsuccessful candidate for the N.W.S. in 1862, when living in
Kentish Town. He exhibited at the R.A. from 1873 to 1881 and an
exhibition of his work was held at the Fine Art Society in 1883.

Examples: Maidstone Mus.

BUNNEY, Sydney John 1877 – 1928
A Coventry topographer who studied at the Art School and worked
as a cashier at the Auto-Machinery Co. He made more than five
hundred pencil and watercolour drawings of local buildings.

Examples: Coventry A.G.

BUNTING, Thomas 1851 (Aberdeen) – 1928
A painter of Aberdeenshire landscapes.

Examples: Aberdeen A.G.

BURBANK, J M – 1873
An animal and bird painter in oil and watercolour who was a
member of the N.W.S. in 1833. He exhibited at the R.A. and
elsewhere from 1825 to 1872. He lived in Camberwell and travelled
in America.

BURCHETT, Arthur
A genre painter in oil and watercolour who lived in Hampstead and
was working between 1874 and 1900.

Examples: Preston Manor, Brighton.

BURD, Laurence
A Shrewsbury estate agent who painted landscapes and exhibited in
Birmingham from 1848 to 1870. He painted views of Gibraltar in
1851 and 1852, on the South Coast from 1872, in Yorkshire from
1885 and in Wales from 1892 to 1898.

BURDER, William Corbett
A painter who lived in Clifton and exhibited in London in 1859. He
painted Welsh landscapes.

Published: with others: *The Architectural Antiquities of Bristol,*
1851. *The Meteorology of Clifton,* 1863.
Examples: V.A.M.

BURGESS, Adelaide
The relationships between the various members of the Burgess
family are very difficult to elucidate and the problem is further
complicated by unrelated artists of the same name. Adelaide was
probably a daughter of the elder John. She lived in Leamington and
exhibited genre subjects from 1857 to 1872.

Examples: V.A.M.

BURGESS, Henry William
The son of T. Burgess (q.v.) and the father of J.B. Burgess (q.v.), he
exhibited landscapes from 1809 to 1844 and was appointed
Landscape Painter to William IV in 1826. He was also a drawing
master at Charterhouse and lived in London.

Published: *Views of the General Character and Appearance of
Trees . . .* 1827.
Examples: B.M.; Leeds City A.G.

BURGESS, James Howard 1817 – 1890
A landscape and miniature painter who worked in Belfast,
Carrickfergus and Dublin. He exhibited at the R.H.A. from 1830,
and he was no relation to any of the English artists.

Illustrated: Hall: *Ireland, its Scenery and Character,* 1841.
Examples: Ulster Mus.

BURGESS, John, N.W.S.
Probably a son of T. Burgess (q.v.), he painted portraits and
miniatures. He exhibited from 1816 to 1840 and lived in Chelsea.

BURGESS, John, Yr., A.O.W.S. 1814 (Birmingham) – 1874
The son of J. Burgess (q.v.), he was of artistic stock on both sides of
his family, and became a painter after an early flirtation with the
sea. In about 1833 he went to Italy via Normandy and Paris, and
stayed there until 1837. At this period he was attempting to become
a figure painter, but soon turned to landscape, where his true talent
lay. On his return he made sketching tours in Devon, Surrey and the
Thames Valley, and in 1840 settled in Leamington, buying the
teaching practice of the widow of D. Dighton (q.v.). In 1851 he was
elected A.O.W.S. He is at his best when using a pencil, and his
architectural sketches made on the spot have been favourably
compared to those of S. Prout (q.v.) and H. Edridge (q.v.).
 His sister, JANE AMELIA BURGESS (b. 1819/20), worked as a
governess and exhibited flower subjects in 1843 and 1844. In the
latter year, she was an unsuccessful candidate for the N.W.S.
 FREDERICK BURGESS, who was an unsuccessful candidate for
the N.W.S. in 1869, lived in London and Leamington and exhibited
landscapes at the R.A. until 1892, was probably a son of John, Yr.

Examples: V.A.M.; Haworth A.G., Accrington; Fitzwilliam;
Nottingham Univ.
Bibliography: *Walker's Quarterly,* IV, 16, 1925.

BURGESS, John Bagnold, R.A. 1829 (Chelsea) – 1897 (London)
The son of H.W. Burgess (q.v.), he was trained by Sir W.C. Ross the
miniaturist. He went to Leigh's School and in 1850 the R.A.
Schools. He began as a portrait and genre painter, but from 1858
devoted himself to Spanish subjects, visiting Spain annually for
thirty years. He also crossed to Morocco at least once. He was
elected A.R.A. and R.A. in 1877 and 1888.
 He left a vast number of sketches and watercolours which were
usually made in preparation for his oil paintings. His remaining
works were sold at Christie's, March 25, 1898.

Examples: Worcester City A.G.
Bibliography: *A.J.,* 1880.

BURGESS, John Cart 1798 – 1863 (Leamington)
The son of W. Burgess (q.v.), he painted flowers and landscapes,
exhibiting at the R.A. from 1812. In 1825 he married and became a
drawing master, with Royal pupils.

Published: *A Practical Treatise on Flower Painting,* 1811. *Useful
Hints on Drawing and Painting,* 1818. *An Easy Introduction to
Perspective,* 1828.
Examples: B.M.; Newport A.G.
Bibliography: *A.J.,* April, 1863.

BURGESS, Thomas Yr. – 1807 (London)
Probably the brother of W. Burgess (q.v.), he exhibited historical subjects from 1778 to 1791 and landscapes from 1802 to 1806 at the R.A. He also made pencil and wash drawings of stormy beach scenes, which are slightly reminiscent of those of L. Clennell (q.v.).

An earlier THOMAS BURGESS, probably the father of this one, set up the Maiden Lane School and is said to have taught Gainsborough at the St. Martin's Lane Academy.

Published: *Principles of Design in Architecture*, 1809.
Examples: B.M.

BURGESS, William 1749 – 1812
A conventional topographical draughtsman. His drawings are outlined with a fine pen and rather timidly tinted, often in greys and blues. He visited South Wales and the Wye in 1785. He is chiefly notable as one of the first of the artistic dynasty.

Examples: B.M.; Newport A.G.

BURGESS, William, of Dover 1805 (Canterbury) – 1861 (Dover)
Unrelated to the London and Leamington Burgesses, he was a schoolfriend of T.S. Cooper (q.v.) in Canterbury, where he had drawing lessons. He was apprenticed to his uncle, a coach builder and painter, and undertook the redecoration of the local theatre. In 1827 he went to Dover with Cooper, and they pressed on to Calais and Belgium. Leaving Cooper, he went back to coach-painting. He exhibited landscapes at the R.A. and Suffolk Street from 1838 to 1856, and visited London in about 1840. He then settled in Dover as a drawing master.

Although Cooper praises his early landscape work, there is sometimes something rather awkward in the perspective of his drawings.

Published: *Dover Castle, A.D. 1642*, 1847.
Examples: B.M.; V.A.M.

BURN, Gerald Maurice 1862 (London) –
A painter and etcher of architectural subjects, he produced both oils and watercolours. He was educated at University College School, London and studied at South Kensington, in Cologne, Düsseldorf, Antwerp and Paris. He lived in Amberley, Sussex, and also painted maritime subjects.

BURN, Thomas F (Northumberland) –
A landscape and coastal painter who was living in London in 1861, and exhibited at the B.I. in 1867. He worked in Lancashire, Yorkshire, the Isle of Wight, Boulogne and Italy, and also painted on the Thames.

Examples: B.M.

BURNET, James M 1788 (Musselburgh) – 1816 (Lee, Kent)
The brother of J. Burnet (q.v.), he was apprenticed to a woodcarver and studied at 'Graham's Evening Academy'. In 1810 he joined his brother in London and fell under the influence of Wilkie and the Dutch Masters. He exhibited at the R.A. from 1812, taking his subjects from rural Battersea and Fulham. He was noted for his careful study of nature and his strong colours.

Examples: B.M.; V.A.M.

BURNET, John, F.R.S.
 1784 (Edinburgh) – 1868 (Stoke Newington)
The son of the Surveyor-General of Excise for Scotland, he was apprenticed to the engraver Robert Scott, and he studied at the Trustees' Academy at the same time as Wilkie. In 1806 he moved to London and concentrated on engraving, often after Wilkie. He exhibited genre and historical works from 1808 to 1862. Like his brother James (q.v.), he painted many landscapes with cattle. He visited Paris in 1815.

Published: *Practical Hints on Composition*, 1822. *Practical Hints on Light and Shade*, 1826. *Practical Hints on Colour*, 1827. *An Essay on the Education of the Eye*, 1837. *Hints on Portrait-Painting,*

1850. *Turner and his Works*, 1852. *Progress of a Painter in the Nineteenth Century*, 1854.
Examples: B.M.; V.A.M.; Aberdeen A.G.; N.G., Scotland; Wolverhampton A.G.
Bibliography: A.J., 1850; 1868.

BURNETT, William Hickling
An architectural and landscape painter who lived in London and visited Italy, Egypt, Spain, Tangier and Scotland. He published fourteen views of Cintra in 1836, and exhibited at the R.A. from 1844 to 1860. His colours and details are clear and precise.

BURNEY, Edward Francis 1760 (Worcester) – 1848 (London)
A cousin of Fanny Burney, for whose *Evelina* he produced an illustration. He came to London in 1776, where he lived with his uncle Dr. Burney and studied at the R.A. Schools. He exhibited at the R.A. from 1780 to 1803. In 1784 he designed large illustrations for Dr. Burney's volume for the Handel Commemoration in Westminster Abbey; these show his talent for arranging complicated figure groupings. He made a number of charming designs and vignettes, as well as his well-known large satirical watercolours. He designed scenes for the lids of snuff boxes, and for the last forty years of his life worked almost exclusively as a book illustrator, illustrating the works of such poets as Langhorne and Young. These drawings are often in grey wash, with light over-colouring. His caricatures can be splendid things, owing their composition to Hogarth and some of the figure drawing to Fuseli, as well as to Stothard's illustrations.

BURNS, Robert, A.R.S.A. 1869 (Edinburgh) – 1941 (Edinburgh)
A figure and portrait painter who studied at South Kensington and, from 1890 to 1892, in Paris. He exhibited at the R.S.A. from the latter year and was elected A.R.S.A. in 1902.

Examples: Aberdeen A.G.; N.G., Scotland.

BURR, A **Margaretta HIGFORD, née Scobell**
A traveller and amateur artist who married D. Higford Burr, M.P., in 1839. In that year they visited Spain, Portugal and Italy and in 1844 Egypt, Palestine and Constantinople. Two years later they returned to the Nile, reaching a point some two hundred miles below Khartoum.

A number of her sketches were published by the Arundel Society, others were exhibited for charity.

BURR, G **Gordon**
A painter of Aberdeen streets and houses who was working in about 1894. His watercolours are sometimes on a large scale.

Examples: Aberdeen A.G.

BURR, John R **, A.R.W.S.** 1831 (Edinburgh) – 1893 (London)
A genre and portrait painter in oil and watercolour who studied at the Trustees' Academy. He moved to London in 1861 and is said to have studied at 'Mr. Emblin's Academy' at Leytonstone, Essex. More probably he taught there. He exhibited at the R.A., the O.W.S. and elsewhere from 1862, and was elected A.R.W.S. in 1883. He was also a member of the R.B.A.

BURRARD, Admiral Sir Charles, Bt. 1793 – 1870
Burrard went to sea at twelve, served through the Napoleonic wars, and in 1808 was in the Baltic on board the *Victory*, under Vice-Admiral Sir James Saumarez. He was promoted captain in 1822, rear-admiral in 1852, vice-admiral in 1857, and admiral in 1863 while on half pay, and he retired to his seat at Lyndhurst.

His early works at sea are reminiscent of N. Pocock (q.v.). His New Forest landscapes are freer and more colourful, and were probably influenced by W.S. Gilpin (q.v.), who was for a time a neighbour.

Burrard had six daughters, and on his death the baronetcy became extinct.

Bibliography: *Country Life*, February 27, 1948; June 18, 1948; July 7, 1960.

BURT, Albin Robert **1784** **– 1842 (Reading)**
Is there a Youth who his Adora loves?
Whose every step his partial eye approves?
Till Time shall place her on the Bridal Throne
Let BURT portray the charmer – Lover's own. . .

 (Llwyd)

Burt started his career as an engraver under Robert Thew and Benjamin Smith, and later turned to portraiture, exhibiting at the R.A. in 1830. As well as young ladies, he painted Reading dignitaries, and he had a good eye for detail.

His son, HENRY W. BURT, was also a portrait painter, and opened a drawing school in Reading in about 1830. He sometimes painted small, full-length figures, using a miniaturist's technique. The work of father and son is very similar.

His daughter Emma married John White, a Reading artist.

C.T. Burt (q.v.) may have been another son.
Examples: Reading A.G.

BURT, Charles Thomas **1823 (Wolverhampton) – 1902**
A Birmingham artist who may have been the son of A.R. Burt (q.v.) and who studied under S. Lines (q.v.) and painted in Wales, the Orkney Islands, Worcestershire, Somerset, Yorkshire and Derbyshire. He exhibited at the R.A., B.I., R.B.A. and elsewhere, and was a member of the Birmingham Society of Artists from 1856.

He worked in oil and watercolour, the latter rather in the manner of D. Cox (q.v.), whose friend and pupil he was.

BURTON, Sir Frederick William, R.H.A., R.W.S., F.S.A.
 1816 (Corotin House, Co. Clare) – 1900 (London)
The son of Samuel Frederick Burton, an amateur landscape painter in oil, he trained under the Brocas brothers (q.v.) in Dublin. He first exhibited at the R.H.A. in 1837, in which year he was elected A.R.H.A., becoming a full Member two years later. He began by painting portraits in watercolour or chalk, and miniatures, but soon moved to genre pictures. He made several visits to Germany and lived in Munich for seven years from 1851. During this time he paid yearly visits to London, where he exhibited his German drawings. He was elected A.O.W.S. and O.W.S. in 1855 and 1856. In 1869 he resigned, but was made an Honorary Member in 1886. He was one of the founders of the Archaeological Society of Ireland, and was elected F.S.A. in 1863. In 1874 he was appointed Director of the N.G., and gave up painting to devote his time to improving the Gallery's collection of old masters. He was knighted on his retirement in 1894.

A memorial exhibition of his work was held at the N.G., Ireland a few months after his death. A sale of his drawings was held at Christie's on June 21, 1901.

Examples: B.M.; V.A.M.; Ashmolean; N.G., Ireland; City A.G., Manchester.

BURTON, William Paton **1828 (Madras) – 1883 (Cults, Aberdeen)**
After an education in Edinburgh, he worked for a short while for David Bryce, the architect. He then turned to landscape painting and exhibited frequently at the R.A. and Suffolk Street from 1862 to 1880. He painted views in England, Holland, France, Italy and Egypt. He was an unsuccessful candidate for the N.W.S. on several occasions from 1867, when he gave a Surrey address, to 1872.

Examples: B.M.; V.A.M.; Aberdeen A.G.; City A.G., Manchester; Newport A.G.

BURTON, William Shakespeare **1830 (London) – 1916 (Lee, Kent)**
A Pre-Raphaelite follower, best known for the *Wounded Cavalier*, which was exhibited at the R.A. in 1856. He studied at the R.A. Schools, gaining a gold medal in 1851. He hardly worked during the 1880s and 1890s, but resumed in about 1900. He was primarily an oil painter, but occasionally worked in watercolour.

Bibliography: V. Paton: *An Artist in the Great Beyond. Messages from a Father*, 1925.

BURY, Thomas Talbot **1811 (London) – 1877 (London)**
An architect and topographer who produced Parisian views. They are somewhat in the manner of W. Callow (q.v.). He also worked in London and Liverpool.

Published: *Remains of Ecclesiastical Woodwork*, 1847. *Rudimentary Architecture*, 1849.
Examples: B.M.; City A.G., Manchester.

BUSH, Flora, Mrs., née Hyland **(Bethersden, Kent) –**
Unsurprisingly a flower painter, she studied at South Kensington. She married Reginald Edgar James Bush, R.E., A.R.C.A. (b. 1869), Principal of the Bristol School of Art, and lived in Bristol from 1899 to 1929.

BUSHBY, Thomas
 1861 (Eccleshill, near Bradford) – 1918 (Carlisle)
A landscape painter who started work in a woollen mill at the age of ten. At fourteen he became a pupil teacher, and was then apprenticed to a lithographer. He also took drawing lessons at the Mechanics' Institute. After four years in London he moved to Carlisle in 1884 and worked as a designer. He was encouraged by the Earl of Carlisle (q.v.), and frequently sketched in Norway, France, Switzerland, Holland and Italy.

He was in some ways a topographer, but his work can show a Pre-Raphaelite precision of detail.

Examples: Carlisle City A.G.

BUSS, Robert William **1804 (London) – 1875 (Camden Town)**
After an apprenticeship with his father, an engraver and enameller, he studied painting under G. Clint (q.v.). For some years he painted only theatrical portraits, but later he turned to historical and conversation pieces, which he exhibited at the R.A., the B.I. and Suffolk Street from 1826 to 1859. For some time he was Editor of *The Fine Art Almanack*. He was also a successful illustrator, notably of the novels of F. Marryat (q.v.).

Examples: B.M.; Fitzwilliam; Newport A.G.
Bibliography: *A.J.*, 1875.

BUSSEY, Reuben **1818 (Nottingham) – 1893**
The son of a cork-cutter, he learned the trade in Nottingham and also studied art under Thomas Barber and John Rawson Walker before being sent to study in London, where he spent much time sketching in the Tower. His father's death caused his return to Nottingham and to cork-cutting. In middle age he retired to devote himself to painting. His subjects are chiefly taken from Bailey's *History of Nottinghamshire*, Shakespeare and the Bible.

A memorial exhibition was held at Castle Mus., Nottingham, in 1894.

Examples: Castle Mus., Nottingham.

BUTLER, Elizabeth Southerden, Lady, née Thompson, R.I.
 1846 (Lausanne) – 1933
A battle painter on an heroic scale. She was brought up abroad and studied at South Kensington, Florence and Rome. She first exhibited at the R.A. in 1873 and was elected R.I. the following year. She married Lt.-Gen. Sir W.F. Butler in 1877. As well as her battle scenes, which show a Pre-Raphaelite exactness of detail, she sketched in Palestine, Egypt, South Africa, Italy and Ireland.

Published: *Letters from the Holy Land*, 1903. *From Sketchbook and Diary*, 1909. *An Autobiography*, 1923.
Examples: B.M.; City A.G., Manchester.
Bibliography: *Country Life*, November 21, 1952.

BUTLER, Mary E
A flower painter who exhibited at the R.A., the R.I. and elsewhere from 1867. By 1909 she was living in Natal.

Examples: V.A.M.

BUTLER, Mildred Anne, R.W.S.
1858 (Kilmurry, Co. Kilkenny) – 1941
A landscape, genre and animal painter, she studied at the Westminster School of Art and under Frank Calderon. She was also a pupil of Norman Garstin at Newlyn. She was elected A.R.W.S. in 1896. Her work is in the Cox tradition.

Examples: Portsmouth City Mus.; Tate Gall.; Ulster Mus.

BUTTERSWORTH, Thomas
A marine painter who had been a sailor and who lived in London. He was active between 1798 and 1827, and was appointed Marine Painter to the East India Company. He specialised in the naval battles of the Napoleonic Wars.

Examples: B.M.; Greenwich.

BUXTON, Albert Sorby **1867 (Mansfield) – 1932**
The first head of the Mansfield Art School, he was the town's topographer, antiquarian and historian. He presented his collection of watercolours to the Mansfield A.G.

Published: *Mansfield a Hundred Years Ago. Mansfield in the Eighteenth Century.*
Examples: Mansfield A.G.

BYRNE, Anne Frances, O.W.S. **1775 (London) – 1837 (London)**
The eldest daughter of William Byrne, the engraver, and sister of J. Byrne (q.v.), she began her career as a teacher, but soon turned to a full-time practice of art. She was the first lady Associate in 1805, and Member in 1821, of the O.W.S. She retired during the 'oil invasion' of 1812 to 1819, but was a regular exhibitor both before and after until her retirement in 1834. She was the first to break the Society's initial ban on flower painters, and she remained faithful to the genre throughout her career, with an occasional bird or nest in her later years. From 1808 she lived near Fitzroy Square.

Examples: V.A.M.

BYRNE, John, A.O.W.S. **1786 (London) – 1847 (London)**
The only son of William Byrne, like his sisters Letitia and Elizabeth, he began life as an engraver, both assisting his father and on his own account by, for example, producing plates for Wilde's *Cathedrals*. He left engraving for landscape painting and was elected A.O.W.S. in 1827. After 1832, he travelled extensively in France and Italy, but largely remained faithful to the Home Counties and Wales for his subject matter. He visited the West Country in 1844 and Yorkshire in 1845, and he very occasionally attempted subjects from Roman history.

Examples: V.A.M.; Laing A.G., Newcastle; Richmond Lib.

BYRNE, Letitia
A daughter of William Byrne, the engraver, she exhibited views in Derbyshire, Wales and France from 1799 to 1848.

Illustrated: P. Amsinck: *Tunbridge Wells*, 1810.
Examples: B.M.; Doncaster A.G.

BYRON, Frederick George **1764 –**
Several members of the Byron family painted, usually caricatures, including the poet's father, **CAPTAIN JOHN BYRON**, and his nephew, F.G. Byron. He exhibited with the Society of Arts in 1791. His work is rather in the manner of H.W. Bunbury (q.v.), but his drawing is poor.

Examples: B.M.

BYRON, William, 4th Lord **1669 – 1736**
Gentleman of the Bedchamber to Prince George of Denmark, and an amateur watercolourist, he was a pupil of P. Tillemans (q.v.). He employed Tillemans to make drawings at Newstead Abbey. He inherited the title in 1695.

CADENHEAD, James, R.S.A., R.S.W.
1858 (Aberdeen) – 1927 (Edinburgh)
A landscape painter in oil and watercolour who was educated at the Dollar Institute and Aberdeen Grammar School, and who studied at the R.S.A. Schools and in Paris under Duran. He exhibited at the R.S.A. from 1880 and was elected A.R.S.A. and R.S.A. in 1902 and 1921. He was also a founder of the N.E.A.C. and a print-maker.

Examples: Aberdeen A.G.; Dundee City A.G.; City A.G., Manchester.

CAFE, James Watt **1857 (London) –**
Probably the younger son of T. Cafe, Yr. (q.v.), he painted cathedrals and other architectural subjects, such as the Radcliffe Camera, in oil and watercolour.

Examples: Salisbury Mus.

CAFE, Thomas, Yr. **1817/18 –**
The son of T.S. Cafe (q.v.), he painted topographical and landscape subjects and exhibited at the R.A. and at Suffolk Street between 1844 and 1868.

Examples: Richmond Lib.

CAFE, Thomas Smith **1793 – c.1841**
A landscape, portrait, architectural and marine painter who exhibited between 1816 and 1840. He lived in Kilburn and St. John's Wood and often worked at Hastings.

Examples: B.M.; Towner A.G., Eastbourne.

CAFE, Thomas Watt **1856 (London) – 1925**
The elder son of T. Cafe, Yr. (q.v.), he painted landscapes and genre subjects and exhibited from 1876. He lived in St. John's Wood.

CAFFIERI, Hector, R.I. **1847 (Cheltenham) – 1932**
A landscape, flower and sporting painter who studied in Paris before working in London and Boulogne. He seems to have covered the Russo-Turkish war of 1877-8 and to have lived in London from 1882 to at least 1901. In Boulogne he painted the fisherfolk. He was a member of the R.B.A. and was elected R.I. in 1885, retiring in 1920.
An exhibition of his work was held at the Continental Gallery, London, in 1902.

CAHILL, Richard S
A figure painter in oil and watercolour who exhibited from 1853 to 1887.

CAHUSAC, John Arthur, F.S.A. **c.1802 – 1866/7**
A painter of fruit, figure subjects and portraits who exhibited from 1827 to 1853. A portrait drawing by him was engraved and published in 1818, and he was a member of the N.W.S. from 1834 to 1838. At that time he lived in Pentonville and described himself as a Professor of Figure Drawing. He was elected F.S.A. in 1840.

CAIL, William **1779 (Carlisle) –**
The son of an innkeeper, he was possibly a pupil of R. Carlyle (q.v.). He toured the south of Scotland in 1792 and seems to have left Carlisle soon afterwards. He specialised in landscape and topography. A William Cail published *The Collier's Wedding* in 1829, under the *nom de plume* 'Edward Chicken'.

Examples: Carlisle City A.G.

CALDECOTT, Randolph, R.I.
1846 (Chester) – 1886 (St. Augustine, Florida)
The son of an accountant, he became head boy of King Henry VIII's School, Chester, where he won a drawing prize. Despite this early evidence of his aptitude, he was set to work as a banker, firstly in Whitchurch, Shropshire, and then in Manchester, developing his true talent by doodling. Between 1866 and 1869 drawings of his were published in local papers, and, encouraged by this success, he moved to London in 1872, determined on becoming an artist. Drawings were accepted by *London Society* and other papers, and he studied in the studio of the sculptor Dalou. His first major successes were his illustrations for Washington Irving's books, *Old Christmas* and *Bracebridge Hall* in 1875 and 1876. He was then encouraged by Edmund Evans the publisher to illustrate children's books. In 1878 his first two, *The House that Jack Built* and *John Gilpin*, were instantly popular. In all he produced sixteen books of this kind.
He exhibited finished watercolours at the R.A. from 1872 to 1885 and was elected R.I. in 1882. He also occasionally produced sculpture. In 1885 he went to America to escape the English winter, as his health had been weak for a long time. He died while engaged on a series of sketches of American life.
He was a highly original artist with a keen eye for the eccentricities of English country life. His colours are applied in flat washes, and the seeming spontaneity of his pen outline is the result of long practice and great thought. As he said, he studied 'the art of leaving out as a science,' believing that 'the fewer the lines, the less error committed.' The influence of this discipline is plain not only in his own work, but also in that of later artists such as Phil May and Cecil Aldin.

Examples: B.M.; V.A.M.; Ashmolean; Cecil Higgins A.G., Bedford; Grosvenor Mus., Chester; Fitzwilliam; Newport A.G.; Ulster Mus.; Walsall A.G.
Bibliography: H.R. Blackburn: *R.C.*, 1886. M.G. Davis: *R.C.*, 1946. *A.J.*, 1886. *Apollo*, XLIII, 1946.

CALDWELL, Commander James Thomas **– 1849**
A naval officer who served on the Far East station from 1842 to 1849, and who produced rough chunky watercolours of Eastern scenes rather in the manner of Chinnery. He was promoted commander in 1844.

CALEY, George Allison
A pupil of J. Glover (q.v.), who was working in 1837.

CALLCOTT, Sir Augustus Wall, R.A.
1779 (Kensington) – 1844 (Kensington)
He began his career as a musician, but then became a pupil of Hoppner and turned firstly to portraiture and then to landscape and seascape painting. He was a member of Girtin and Francia's Sketching Club and was elected A.R.A. and R.A. in 1806 and 1810. He visited France and Holland before 1827, and in that year he married and made his first visit to Italy. Thereafter Continental subjects form the majority of his exhibited work. From 1837, when he was knighted, he also exhibited figure subjects in oil. In 1849 he was appointed Conservator of the Royal Pictures. In his own time he was classed in the same category as his friend Turner, and although this was obviously to overestimate his abilities, he could be a very pretty and able draughtsman. He is at his best with coastal scenes, either in sepia or in full colour. His remaining works were sold at Christie's, May 8-11, 1845, and June 22, 1844.
His wife MARIA, LADY CALLCOTT (1785-1842) was the daughter of Rear Admiral Dundas, with whom she went to India in 1808. She married Captain Graham in the following year and returned to England in 1811. They went to South America in 1821, but the Captain died off Cape Horn. She married Callcott in 1827. They spent much time in Italy, and she made many competent

watercolours and drawings, some of which are in the B.M. She was the author of *Journal of a Residence in India,* 1812; *Letters on India,* 1814; and *Little Arthur's History of England.*

Examples: B.M.; V.A.M.; Cartwright Hall, Bradford; Leicestershire A.G.
Bibliography: J. Dafforne: *Pictures by Sir A.W.C.,* 1875. *A.J.* January, 1856; April, 1860; 1896. R.B. Gotch: *Maria, Lady C.,* 1937.

CALLCOTT, William James
A marine painter who lived in Regents Park and Putney and who worked from 1843 to 1896. His subjects are often on the North Sea coasts and he also visited Plymouth. He painted in oil and watercolour and was an unsuccessful candidate for the N.W.S. in 1856, 1868 and 1874.

CALLENDER, H R
A friend and follower of F. Nicholson (q.v.).

CALLOW, George D
A landscape and marine painter in oil and watercolour who worked between 1858 and 1873. His style is reminiscent of that of T.B. Hardy (q.v.). The marine painter JAMES W. CALLOW seems to have been his brother, but they do not appear to have been related to the more famous family.

CALLOW, John, O.W.S. 1822 (London) – 1878 (Lewisham)
A pupil of his brother William, who took him to Paris in 1835, where he studied and ultimately took over the drawing practice, returning to England in 1844. He was elected A.N.W.S. in 1845, but resigned in 1848 and joined the O.W.S. the following year. From 1855 to 1861 he was Professor of Drawing at the R.M.A., Addiscombe, after which he became joint Master of Landscape Drawing with A.E. Penley (q.v.) at the R.M.A., Woolwich. In 1875 he was appointed Professor at Queen's College, London; at the same time he kept up a large and profitable private practice.

His style is largely based on that of his brother, and he excelled in coastal scenes. His subjects were taken from the coasts of England, Wales, Normandy and the Channel Islands. He also painted landscapes in North Wales from 1861, Scotland from 1862 and the Lakes from 1864. He occasionally painted in oil. Like his brother, he was a firm believer in the use of pure watercolour rather than heightening with bodycolour.

His executors held sales of his drawings at Christie's, June 24 and December 18, 1878 and April 7, 1879.

Examples: B.M.; V.A.M.; Glasgow A.G.; Gray A.G., Hartlepool; Leeds City A.G.; Newport A.G.
Published: with R.P. Leitch: *Easy Studies in Water-Colour Painting,* 1881.
Illustrated: V. Foster: *Painting for Beginners,* 1884.

CALLOW, William, R.W.S. 1812 (Greenwich) – 1908 (Great Missenden)
The son of a builder, who encouraged his early artistic efforts, he was employed by Theodore Fielding in 1823 and formally articled to him two years later. A fellow apprentice was C. Bentley (q.v.) who gave him his first painting lessons. Callow worked for Thales Fielding between 1827 and 1829, when he went to Paris, where he worked for the Swiss artist Osterwald, as well as for Newton Fielding. He returned to London for six months but in 1831 was back in Paris where he shared a studio with T.S. Boys (q.v.) and thus came under the influence of Bonington. In 1834 he took over the studio from Boys and built up a large and profitable teaching practice among the French nobility, including the Duc de Nemours and the Princesse Clementine, son and daughter of King Louis Philippe. At this period he began the series of long walking and sketching tours which he made during his holidays. He visited the South of England in 1835, the South of France in 1836, Switzerland and Germany in 1838, Italy in 1840, Normandy in 1841, the Rhine and Moselle in 1844, Holland in 1845, Germany,

Switzerland and Venice in 1846, and Coburg, Potsdam and Berlin in 1862. His final visit to Italy was made in 1892. Between the earlier tours he also re-visited England. In 1838 he was elected A.O.W.S. and this encouraged him to leave Paris in 1841 and to set up as a drawing master in London. Here again he built up a large practice, and his pupils included Lady Beaujolais Berry, Lady Stratford de Redcliffe and Lord Dufferin. He continued to work as a drawing master until 1882. In 1848 he was elected O.W.S. and he served the Society well throughout his life, acting as Trustee and as Secretary from 1865 to 1870. In 1855 he moved from London to Great Missenden where he lived until his death.

Callow could be said to have started at the height of his powers and to have declined gradually throughout his very long working life. In his earlier work the influence of Boys and Bonington is very marked, and he often uses the tricks and mannerisms of the older men, even to the stopping out lights with a finger or thumb. The decline in quality becomes evident after about 1850. It is worth noting, too, that at about this date, he changed his neat and precise signature for a sloppy, backward-sloping one. He begins to grow over-ambitious and to work on too large a scale. His attitude to nature is always that of the topographer, although his marine subjects, which owe something to Bentley, show a greater freedom. Throughout his career, his draughtsmanship is exact, but his sense of composition, which was unerring at first, grows less sure. Even though he was carried away by a fussy attention to detail and over-variety of colour, he continued all his life making small, more effective drawings for his own pleasure.

Examples: B.M.; V.A.M.; Aberdeen A.G.; Ashmolean; Blackburn A.G.; Cartwright Hall, Bradford; Bridport A.G.; Grosvenor Mus., Chester; Coventry A.G.; Bowes Mus., Durham; Towner A.G., Eastbourne; Exeter Mus.,; Fitzwilliam; Glasgow A.G.; Greenwich; Inverness Lib.; City A.G., Manchester; N.G., Scotland; Newport A.G.; Portsmouth City Mus.; Beecroft A.G., Southend; Stalybridge A.G.; Ulster Mus.; Worcester City A.G.
Bibliography: H.M. Cundall: *W.C.,* 1908. *Walker's Quarterly,* XXII, 1927. O.W.S. Club, XXII.

CALVERT, Charles 1785 (Glossop Hall, Derby) – 1852 (Bowness, Westmorland)
The son of the Duke of Norfolk's agent, who was an amateur artist, he was a cotton merchant before turning to art. He taught both oil and watercolour and painted landscapes. He was a founder of the Royal Manchester Institution and father-in-law to W. Bradley (q.v.).

Examples: V.A.M.; City A.G., Manchester.
Bibliography: *A.J.,* May, 1852.

CALVERT, Edward 1799 (Appledore) – 1883 (London)
After a period in the Navy, he studied under James Ball and A.B. Johns at Plymouth. In 1824 he moved to London and entered the R.A. Schools. He became one of 'The Ancients', Blake's disciples, and was a frequent visitor to Shoreham. He exhibited at the R.A. from 1825 to 1836 as well as at the S.B.A. Thereafter he devoted most of his time to producing woodcuts. He attended the Life Academy in St. Martin's Lane, where he became a close fiend of Etty. To improve his knowledge of anatomy he sketched at St. Thomas's and St. Bartholomew's Hospitals during the cholera epidemic of 1830. He made several visits to Wales, the first in 1835, and in 1844 he toured Greece, returning by way of Venice, the Rhine and Antwerp. In 1851 he moved from Paddington to Hampton Court, and finally, in 1854, to Hackney. His woodcuts, oil paintings and watercolours alike are imbued with the arcadian spirit of Greece; the Welsh landscape also had a profound influence on him.

Examples: B.M.; Exeter Mus.
Bibliography: S. Calvert: *Memoir of E.C.,* 1893. R.L. Binyon: *The Followers of William Blake,* 1925. R. Lister: *E.C.,* 1962. *Print Collector's Quarterly,* XVII, ii. 1930.

CALVERT, Edwin Sherwood, R.S.W. 1844 – 1898
A Glasgow School follower of Corot who began by painting coasts and harbours. Later he concentrated on landscapes from Northern France and he also visited Italy in 1877. He exhibited at the R.A. from 1878 to 1896 and used a subdued palette.

CALVERT, Frederick – c.1845
Originally from Cork, he exhibited with the Dublin Society of Artists and the Hibernian Society in 1815 and left for England soon afterwards. There he exhibited between 1827 and 1844 and contributed antiquarian articles and illustrations to the *Archaeological Journal*. He also published a series of lithographs, *Studies of Foreign and English* in 1824.

Published: *The Interior of Tintern Abbey. Lessons in Landscape Colouring.* Etc.
Illustrated: W. West: *Picturesque Views in Staffordshire and Shropshire.* 1830. J. Pigot: *Pigot's Coloured Views. The Isle of Wight...,* ?1847.
Examples: V.A.M.; Ashmolean; Chelsea Lib.; Dudley A.G.; Richmond Lib.

CAMERON, Hugh, R.S.A., R.S.W.
1835 (Edinburgh) – 1918 (Edinburgh)
A portrait and genre painter who studied at the Trustees' Academy. He exhibited in Scotland from 1854 and was in London between 1876 and 1888. Thereafter he spent his summers at Largs and his winters in Edinburgh. He visited the Riviera in about 1880. He was elected A.R.S.A. and R.S.A. in 1859 and 1869 and R.S.W. in 1878. He specialised in children and crones.

Examples: Paisley A.G.

CAMPBELL, Caecilia Margaret, Mrs. Nairn
1791 (Dublin) – 1857 (Battersea)
The daughter of J.H. Campbell (q.v.) who gave her lessons, and in whose style she worked. She exhibited in Dublin from 1809, and between 1826 and 1847 sent views, particularly of Killarney and Wicklow, to the R.H.A. In 1826 she married George Nairn, A.R.H.A., an animal painter in oil. Her son, John Campbell Nairn (b. 1831) copied and restored his father's pictures. She painted in both oil and watercolour and also made wax models of flowers.

CAMPBELL, John Francis, of Islay 1822 – 1885 (Cannes)
The eldest son of W.F. Campbell of Islay, he was educated at Eton and Edinburgh University. He held a number of official posts such as Groom-in-waiting, Secretary to the Lighthouse Commission and Secretary to the Coal Commission, but his most important work was as a writer and folklorist. He travelled on the Continent in the 1840s, visiting Italy in 1841 and 1842, Spain in 1842, Germany in 1846 and France in 1848, and he went to America in 1864. Much of his time was spent in the Western Highlands and on Islay collecting traditional tales and songs. He illustrated a number of his books, as well as making landscape and topographical sketches.

Published: *Popular Tales of the West Highlands,* 1860-2. *Life in Normandy,* 1863. *Frost and Fire . . . with Sketches,* 1865. *A short American Tramp in the Fall of 1864,* 1865. *Leabhair na Fenine,* 1872 etc. *Thermography,* 1883.
Examples: N.G., Scotland.
Bibliography: *Athenaeum,* 1885, i 250; *Academy,* 1885, XXVII, 151.

CAMPBELL, John Henry 1757 (Dublin) – 1828
A landscape painter in oil and watercolour, he was trained in the R.D.S. Schools and exhibited in the opening exhibition of the R.H.A. in 1826 and again in 1828. His views appear to be taken entirely in Ireland: Dublin and Wicklow in particular. His drawing is good, if conventional, and his colour strong. He was the father of C.M. Campbell (q.v.).

Examples: B.M.; V.A.M.; Nat. Mus., Ireland; Ulster Mus.

CAMPBELL, John Hodgson 1855 – 1927
The son of an artist, he studied in Edinburgh and later worked as a portrait painter in Newcastle. He was a member of various local literary and artistic clubs and also painted large numbers of landscapes in watercolour.

Examples: B.M.; Shipley A.G., Gateshead; Laing A.G., Newcastle.

CAMPION, George Bryant, N.W.S. 1796 – 1870 (Munich)
A prolific topographical, genre and coastal painter who taught drawing at the R.M.A., Woolwich for many years. He exhibited from 1829 and joined the N.W.S. in 1834 when he was living in Pentonville. For the latter part of his life he lived in Munich. He generally worked on grey or light brown paper and often used a combination of chalk and watercolour rather in the manner of Henry Bright. Perhaps as a result of his employment, many of his drawings contain soldiers.

Published: *The Adventures of a Chamois Hunter*
Examples: B.M.; Ashmolean; Towner A.G., Eastbourne; Greenwich; Newport A.G.

CANNING, Charlotte, Viscountess 1817 – 1861 (Calcutta)
The elder daughter of Lord Stuart de Rothesay and sister of Lady Waterford (q.v.), with whom she was a pupil of W. Page (q.v.). In 1835 she married Charles, later Viscount, Canning, and she was a Lady of the Bedchamber to Queen Victoria from 1842 to 1855, accompanying her on the visit to Louis Philippe in 1843. Canning was appointed Viceroy of India in 1855, and the rest of her life was spent there, travelling widely and writing graphic accounts of the Mutiny to the Queen. Her landscapes and small flower studies were admired by Ruskin who maintained that of the two sisters 'Lady Canning was the colourist'. Her work is, however, much the less original.

Bibliography: A.J.C. Hare: *The Story of Two Noble Lives,* 1872. V. Surtees: *C.C.,* 1975. *Country Life,* April 4, 1957.

CAPELL, A
A bird painter working in 1766.

CAPON, William 1757 (Norwich) – 1827 (Westminster)
The son of an artist, who taught him portrait painting. His talent, however, was more for architecture, and he was articled to Novozielski and worked at the Italian Opera House and Ranelagh Gardens. In 1794 he built a theatre for Lord Aldborough in County Kildare. Thereafter he was chiefly connected with Kemble as a scene painter at Drury Lane. He also undertook architectural work in Bath in 1807 and was appointed architectural draughtsman to the Duke of York in 1804. He produced a number of watercolour views of London and exhibited at the R.A. and elsewhere from 1788 to 1827. He was a friend and sketching companion of J. Carter (q.v.).

Examples: B.M.; Victoria A.G., Bath; Guildhall Lib.; Westminster Lib.

CARELLI, Gabriel 1821 (Naples) – 1900
The son of Raphael Carelli, special artist to the Duke of Devonshire, Carelli settled in England, married an Englishwoman and took British nationality. He travelled widely in Europe, North Africa, Turkey and Palestine. He was an unsuccessful candidate for the N.W.S. in 1866, when he was living at Kenilworth, and he exhibited at the R.A. from 1874. He was a favourite of Queen Victoria.
 GONSALVO CARELLI, who lived with him for a time, appears to have been a brother. CONRAD H.R. CARELLI (b. 1869) was the son of Gabriel, studied at Julian's in Paris and also travelled widely. He held a number of spring exhibitions at Menton. His style is rather looser than that of his father, whose eye for colour and detail was superior.

CAREY, Peter
A landscape painter who was a pupil of J. Farington (q.v.) in 1791 and exhibited at the R.A. in 1795. J.G. Le Marchant (q.v.) was his brother-in-law.

CARFRAE, J
A landscape painter who exhibited at the R.A. in 1787 and was working in Scotland as late as 1799.

Examples: B.M.; N.G., Scotland.

CARLAW, John, R.S.W. **1850 (Glasgow) – 1934**
He was a designer at the Saracen Foundry, Glasgow, before retiring at an early age to devote himself to painting. He worked mainly in watercolour and was elected R.S.W. in 1885. Later in life he lived at Helensburgh. WILLIAM CARLAW (1847-1889) by whom there is a watercolour in Glasgow A.G., and who exhibited there in 1878, was presumably his brother, and EFFIE CARLAW who exhibited in 1886, a sister.

CARLILL, Stephen Briggs **– 1903 (South Africa)**
A master at the Hull School of Art and an examiner for the Department of Science and Art, he exhibited at the R.A. and R.I. from 1888. Later he went to farm in South Africa where he was killed by Kaffirs.

Published: With A. Woodruff: *Rural Rambles*, 1889.
Examples: V.A.M.

CARLINE, George F. **1855 (Lincoln) – 1920 (Assisi)**
A painter of landscapes, genre subjects and portraits in oil and watercolour, he was the son of a solicitor. He studied at Heatherley's, in Antwerp and in Paris, and he exhibited in London from 1886. He lived in Oxford for some years, becoming Secretary of the Oxford Art Society; later he lived in Hampstead. Fifty-nine of his pictures were shown at the Dowdeswell Galleries in 1896 and he was elected R.B.A. in 1904. In the Leicestershire A.G. is an example of the work of his son SYDNEY WILLIAM CARLINE (1888-1929), who painted landscapes and portraits.

Illustrated: A. Lang: *Oxford*, 1915
Examples: V.A.M.

CARLISLE, George Howard, 9th Earl of
1843 (London) – 1911
An amateur painter in oil and watercolour who studied at South Kensington and exhibited from 1868. His London house was decorated by Morris and Burne-Jones, and after he inherited the title in 1889, he entertained a wide circle of literary and artistic friends at Naworth Castle, Cumberland. He travelled widely in Europe and visited Africa and the West Indies. He was an Honorary R.W.S. and Chairman of the Trustees of the N.G. His watercolours are brightly coloured and not particularly detailed, in the contemporary Italian manner.

Examples: B.M.

CARLYLE, Robert **1773 (Carlisle) – 1825**
A landscape and architectural painter, he was the son of a sculptor. He won a silver medal from the Society of Arts in 1792 for drawings of Carlisle Cathedral. He supplied illustrations for Britton's *Beauties* and ran successful drawing classes. In 1808 he drew up plans for the rebuilding of the city – unexecuted – and in 1822 he was one of the founders of the Carlisle Society. At the time of his death he was working on a series of views of Dovedale, Matlock, the Scottish Lochs, Cumberland, Westmorland and North Wales. He was also a poet and published *De Vaux or the Heir of Gilsland*, 1815. He was a topographer, and his work is usually outlined in pen. His pupils included his nephews George and Robert, W. Cail (q.v.) and M.E. Nutter (q.v.). His work was much copied.

Illustrated: W. Hutchinson: *History of Cumberland*, 1794.
Examples: Carlisle City A.G.; Carlisle Lib.

CARMICHAEL, John Wilson
1800 (Newcastle) – 1868 (Scarborough)
After a period at sea and an apprenticeship to a ship builder, Carmichael became a pupil of the elder T.M. Richardson (q.v.).

From 1838 to 1862 he sent oil paintings and watercolours for exhibition at the R.A. and elsewhere in London, and in about 1845 he moved there himself. He visited Holland and Italy and went to the Baltic as a war artist for the *I.L.N.* during the Crimean War. In about 1862 he left London in poor health and settled in Scarborough.

He is a clean workman and the freedom which he sometimes attains in his finished work is based on careful observation and drawing. This is in part due to his early association with J. Dobson (q.v.) the architect of Newcastle, for whose plans he provided the figures and often the colour. He is chiefly known as a marine painter, and this tends to obscure the quality of his town scenes. His sea pieces show practical experience and a strong feeling for the elements.

He is sometimes misnamed James. His remaining works were sold at Christie's, November 24-5, 1870.

Published: *The Art of Marine Painting in Watercolours*, 1859. *The Art of Marine Painting in Oil Colours*, 1864.
Examples: B.M.; V.A.M.; Darlington A.G.; Shipley A.G., Gateshead; Greenwich; Laing A.G., Newcastle; Newport A.G.; Sunderland A.G.; Ulster Mus.
Bibliography: *A.J.*, July, 1868.

CARPENTER, A R
A landscape and coastal painter who painted in oil and watercolour and exhibited at Birmingham from 1868 to 1890.

CARPENTER, John
A painter of shipping in brown wash who was working in 1827.

Examples: V.A.M.

CARPENTER, Margaret Sarah, Mrs., née Geddes
1793 (Salisbury) – 1872 (London)
The daughter of Captain Geddes of Edinburgh, she took lessons from a Salisbury drawing master and copied paintings from Lord Radnor's collection at Longford Castle before establishing herself in London as a portraitist in 1814. In 1817 she married William Hookham Carpenter, later Keeper of Prints and Drawings at the B.M. She exhibited at the R.A. and elsewhere from 1818 to 1866. As well as portraits she made landscape studies in watercolour. She was the mother of W. Carpenter (q.v.), and her sister married W. Collins, R.A.

Examples: B.M.; V.A.M.
Bibliography: *A.J.*, January, 1873.

CARPENTER, William **1818 (London) – 1899 (Forest Hill)**
The son of M.S. Carpenter (q.v.), he spent many years in India and drew and etched Oriental ladies and landscapes. He also sketched in the Scilly Isles. His work can be reminiscent of that of J.D. Harding (q.v.). An exhibition of his Indian subjects was held at South Kensington in 1881.

Examples: B.M.; V.A.M.; Ashmolean.

CARPENTER, William John
An architectural painter who lived in London and exhibited at the R.I. and the R.B.A. from 1885 to 1895.

CARR, Frances
A pupil of Cox at Kennington, she made a sketching tour of the Rhine. She was perhaps the Frances Susanna Carr who published *Genevive: a Tale*, 1826. Her sister-in-law was Mrs. Jane Carr, the daughter of John Allnutt the collector, who herself left many watercolours to the V.A.M.

CARR, Sir John **1772 (Devonshire) – 1832 (London)**
A gossip and traveller who was called to the bar but did not practise because of poor health. The success of his first *Tour* led to a long series, and after the Irish one he was knighted by the Viceroy, the Duke of Bedford. He was satirised by Walter Scott and others, and

Byron begged to be omitted from the account of Spain. He also published poetry. His illustrations are much in the manner of the landscape and topographic work of J. Nixon (q.v.) although they are not as accomplished as Nixon's at his best.

Published: *The Stranger in France, A Tour from Devonshire to Paris*, 1803. *A Northern Summer, or Travels around the Baltic*, 1805. *The Stranger in Ireland*, 1805. *A Tour through Holland*, 1807. *Caledonian Sketches*, 1808. *Descriptive Travels in . . . Spain*, 1811.
Examples: B.M.

CARR, Rev. William Holwell 1758 (Exeter) — 1830 (London)
A landscape painter in the manner of J. Bourne (q.v.), he held the living of Menheniot, Cornwall, *in absentio* from 1792. He was the son of Edward Holwell, an apothecary, married Lady Charlotte Hay and took the additional name of Carr in 1798 in consequence of an inheritance from her uncle. He exhibited at the R.A. from 1797 to 1820, but was best known as a connoisseur and patron.

Examples: B.M.

CARRICK, Robert, R.I.
** ?1829 (Western Scotland) — 1904**
A landscape and genre painter somewhat in the manner of the Pre-Raphaelites. He had moved to London by 1848 when he was elected A.N.W.S. He was elected N.W.S. in 1850 and also exhibited at the R.A. from 1853 to 1880.

Examples: City A.G., Manchester.

CARRICK, Thomas Heathfield
** 1802 (Upperly, Carlisle) — 1875 (Newcastle)**
A chemist and self-taught miniaturist, he worked at Carlisle, Newcastle and in London. He exhibited at the R.A. from 1841 to 1866 and also produced larger portraits and hand coloured photographs.

Examples: V.A.M.; Laing A.G., Newcastle.

CARROLL, Michael William
A general artist and engraver active in Hull from 1795 to 1807. He painted portraits and landscapes in various media, and he may be identifiable with the William Carroll, an Irishman, who exhibited Irish views at the R.A. from 1790 to 1793 when living in London.

CARSE, Alexander (Edinburgh) — c.1838
After establishing a reputation in Edinburgh where he was painting views as early as 1796, he moved to London in 1812 and exhibited at the R.A. and the B.I. He returned to Edinburgh in about 1820. He was best known for his drawings and paintings of Scottish domestic life, and scenes from Burns and his own unpublished poems. In his genre subjects he forms a link between Allan and Wilkie. He was probably the father of the oil painter WILLIAM CARSE who was working between 1818 and 1845.

Examples: B.M.; Fitzwilliam; N.G., Scotland.

CARTER, Ellen, Mrs., née Vavasour
** 1762 (York) — 1815 (Lincoln)**
She was educated at a convent in Rouen and married Rev. John Carter, later Headmaster of Lincoln Grammar School. She provided illustrations for periodicals such as *Archeologia* and the *Gentleman's Magazine* and was particularly noted for her figure drawing.

CARTER, Henry Barlow 1803 (Scarborough) — 1867 (Torquay)
A marine and landscape painter who served in the Navy and lived in Plymouth, Newington and Hull before settling in Scarborough in the 1830s. He remained there teaching drawing until 1862 when he retired to Torquay. His style is derived from that of Turner, and his palette and subject matter are limited, his penchant being for a yellow-green and for wrecks and storms.
His sons J.N. Carter (q.v.) and VANDYKE CARTER were also

artists. MATILDA AUSTIN CARTER (b. 1842) who was an unsuccessful candidate for the N.W.S. on several occasions from 1868, and who lived in Torquay, was probably a daughter, and R.H. Carter (q.v.) another son.

Examples: B.M.; V.A.M.; Derby A.G.; Greenwich; Hull Mus.; Leeds City A.G.; Maidstone Mus.; Wakefield City A.G.; York A.G.

CARTER, Hugh 1837 (Birmingham) — 1903 (London)
A topographer and genre and portrait painter who studied promiscuously at Heatherley's, under Alexander Johnston, J.W. Bottomley, F.W. Topham and J. Phillip and at Düsseldorf under von Gebhardt. He exhibited in London and Birmingham from 1859 and was elected A.N.W.S. and N.W.S. in 1871 and 1875, resigning in 1899. A memorial exhibition was held at Leighton House in 1904.

Examples: V.A.M.

CARTER, John, F.S.A. 1748 (London) — 1817 (London)
An architectural draughtsman and writer, he was the son of a marble carver and was trained as a surveyor and mason. In 1774 he began to draw for the *Builder's Magazine*, and he continued to do so until 1786. In 1780 he was employed by the Society of Antiquaries as a draughtsman, and he was elected F.S.A. in 1795. Also in 1780, he began to work for Richard Gough, one of his most important patrons. Others included the Earl of Exeter, Horace Walpole, Sir H.C. Englefield (q.v.) and Sir R.C. Hoare (q.v.). Between 1798 and 1817 he published a series of papers entitled 'Pursuits of Architectural Innovation' in the *Gentleman's Magazine* which were an attack on over-zealous restoration as carried out by Wyatt and others, and they provoked stormy scenes among the Antiquaries. He had a small practice as an architect. His style is close to that of J. Varley (q.v.) in his early years, and by the 1790s he had abandoned the old topographical tradition of careful pen outlining. His foliage is rather flat with a number of sloping curved lines and much stopping out.
His collection, including his remaining works, was sold at Sotheby's, February 23-5, 1818.

Published: *Specimens of Ancient Sculpture and Painting*, 1780-94. *Views of Ancient Buildings in England*, 1786-93. *The Ancient Architecture of England*, 1795-1814. Etc.
Examples: B.M.; V.A.M.; St. Alban's Abbey; Victoria A.G., Bath; Bodleian Lib.; Exeter Mus.; Westminster Lib.
Bibliography: *Gentleman's Mag.*, 1817, ii, 363-8.

CARTER, Joseph Newington 1835 (Scarborough) — 1871
A son of H.B. Carter (q.v.) whose style and subjects he inherited. He lived at Scarborough and exhibited in London from 1857 to 1860.

Examples: B.M.; York A.G.

CARTER, Owen Browne 1806 — 1859 (Salisbury)
A Winchester architect who spent some time in Cairo in the early 1830s where he made many architectural and topographical drawings. Thereafter he worked in Hampshire both as an architect and an antiquary, illustrating his own writings. His topographical work shows a strong drawing line, and he generally uses light washes.

Published: *Picturesque Memorials of Winchester*, 1830. *Some Account of the Church at Bishopstone*, 1845.
Illustrated: R.Hay: *Illustrations of Cairo*, 1840.
Examples: B.M.

CARTER, Richard Harry 1839 (Truro) — 1911 (Sennen)
Possibly a son of H.B. Carter (q.v.), he painted Cornish landscapes. He exhibited from 1864 and turned to oil painting later in life.

Illustrated: J.T. Tregallas: *Peeps into the Haunts and Homes . . . of Cornwall*, 1879.
Examples: Maidstone Mus.

CARTER, William
A Leeds landscape and coastal painter who exhibited in London from 1836 to 1876. It is possible that he was a relative of − or perhaps even the same as − the Carter mentioned in the biography of G. Chambers (q.v.) as working in Whitby and Stockton in the early 1830s. He went to London in 1835 and was believed to have cut his throat there.

Examples: V.A.M.

CARTERET, Mary Ann, Lady, née Masters
1777 (Cirencester Abbey) −
An amateur painter in oil and watercolour, she married Lord John Thynne (1772-1849), later Lord Carteret, in 1801. She produced portraits, landscapes in the Aylesford manner and copies of old masters.

CARTWRIGHT, Frederick William
A landscape painter who lived in Brixton and Dulwich and exhibited from 1854 to 1889. He worked in both oil and watercolour and painted in North Wales, Devon, Surrey, on the South Coast and on the Continent.

Examples: Exeter Mus.

CARTWRIGHT, Joseph 1789 (Dawlish) − 1829 (London)
A marine painter who worked for the Navy as a civilian. On the British occupation of the Ionian Islands he was appointed paymaster-general at Corfu where he spent several years. On his return to England he became a professional artist, exhibiting at the R.A., the B.I. and with the S.B.A. of which he was elected a member in 1825. He was appointed Marine Painter to the Duke of Clarence in 1828. He shows a firm grasp of drawing, accuracy in nautical detail and a good sense of composition. His palette is made up of harmonious blues, greys and greens with the occasional touch of plummy red.

Published: *Views in the Ionian Islands*, 1821.
Examples: B.M.; V.A.M.; Greenwich.

CARVER, Robert (Dublin) − 1791 (London)
The son and pupil of Richard Carver, an historical and landscape painter. He began his career by exhibiting small watercolours in Dublin and painting scenery for Cork and Dublin theatres. Garrick was impressed by his work and invited him to Drury Lane where he met with considerable acclaim. He moved to Covent Garden with Springer Barry and there worked with J.I. Richards (q.v.). He exhibited landscapes in oil and watercolour with the Incorporated Society from 1765 to 1790, being elected a Fellow in 1773, Vice-President in 1777 and President in 1887. He also exhibited with the Free Society, and at the R.A. in 1789 and 1790.

The techniques of scene painting are evident in his watercolours. He shows considerable skill in conveying atmospheric effects. E. Garvey (q.v.), his pupil, thought that he painted best 'the dashing of the *sea waves* upon a flat shore, or upon rocks − the colour so true − the water so transparent.' (Farington, *Diaries*, III, p.48.) He signed his works 'R.C.' as did R. Crone (q.v.).

CASEY, William Linnaeus 1835 (Cork) − 1870 (London)
The son of a gardener, he was a portrait and genre painter who trained at the Cork School of Design and at Marlborough House. In 1854 he was appointed second master at the Limerick School of Art, and later he set up as a drawing master in London, his pupils including some of the Royal children. He was Master of the St. Martin's Lane Academy for a time.

Examples: V.A.M.

CASHIN, Edward
An Irishman who painted views of Bristol for G.W. Braikenridge. His style is inspired by the seventeenth century Dutch painters and in particular by Jan van der Heyden. He was in Bristol from 1823 to 1826.

Examples: V.A.M.; Bristol City A.G.

CASSIE, James, R.S.A.
1819 (Keith Hall, Aberdeen) − 1879 (Edinburgh)
An accident lamed him in early life and made him turn to painting as a career. He was a pupil of J.W. Giles (q.v.) and lived in Aberdeen until 1869 when he was elected A.R.S.A. and went to live in Edinburgh. He was elected R.S.A. in 1879. Early in his career he mainly painted landscapes in the manner of Giles, but gradually he found his subjects more on the coast and among the fisherfolk. He also painted portraits, animals and domestic subjects. His style is broad and he avoids over-elaboration of detail and composition.

Examples: Aberdeen A.G.
Bibliography: *A.J.*, 1879.

CATHERWOOD, Frederick 1799 (London) − 1854 (at sea)
An archaeological draughtsman and railway engineer, he was a pupil of the architect Michael Meredith. From 1821 to 1825 he toured Italy, Greece and Egypt. In 1831 he returned to the Nile with Haig's expedition. He visited Palestine and Syria with F.V.J. Arundale (q.v.). In 1836 he set up in New York as an architect and in 1839 went to Central America to record the Mayan antiquities. It was at this time that he worked on the railways. He visited England in 1853 and was drowned on the return voyage.

Published: *Views of Ancient Monuments in Central America*, 1844.
Examples: B.M.
Bibliography: V.W. von Hagen: *F.C., Architect*, 1950.

CATLOW, George Spawton
A landscape painter who lived in Leicester and exhibited at the R.A. and the R.I. from 1884 to 1916. He was painting at Runswick Bay, Yorkshire, in 1907.

CATTERMOLE, Charles, R.I. 1832 − 1900
The son of R. Cattermole (q.v.) and the nephew of G. Cattermole (q.v.), whose subject matter he adopted. He exhibited from 1858 and was elected A.N.W.S. and N.W.S. in 1863 and 1870, serving as Secretary for many years. He was also the Secretary of the Artists' Society at Langham Chambers. Although his landscape work is not as good as that of his uncle, his Civil War and Stuart hunting scenes, especially when on a small scale, are often very pretty indeed.

Illustrated: E.M.L.: *Records and Traditions of Upton-on-Severn*, 1869. E.M. Lawson: *The Nation in the Parish*, 1884.
Examples: B.M.; V.A.M.; Leicestershire A.G.; Paisley A.G.; Royal Shakespeare Theatre, Stratford; Sydney A.G.

CATTERMOLE, George
1800 (Dickleburgh, Norfolk) − 1868 (London)
The youngest brother of R. Cattermole (q.v.), his artistic career began as an architectural draughtsman for J. Britton (q.v.), with whom he was placed at the age of fourteen. He first exhibited at the R.A. in 1819 and was elected A.O.W.S. in 1822, but allowing his Associateship to lapse, had to be re-elected in 1829, becoming a full Member in 1833. During the 1820s he shifted the emphasis of his art from the architecture of old buildings to the historical figures with which he peopled them. His early reading is said to have been Scott − in 1830 he toured Scotland making illustrations for the Waverley Novels − and his works are to art what Scott's were to literature. He refused to take pupils, however eminent, and also refused a knighthood in 1839, but was an intimate of the Blessington-d'Orsay circle and a member of the Athenaeum and the Garrick. In 1852 he resigned from the O.W.S. and spent his last years in an unsuccessful attempt to establish himself as an oil painter.

Cattermole's figure subjects, despite the characteristically sketchy handling, won even Ruskin's approval, and his pure landscapes that of Cox, for whose work they are sometimes mistaken. His remaining works were sold at Christie's, March 9, 1869. His son, Leonardo Cattermole, followed him as a painter of horse and cavalier subjects.

Published: *Cattermole's Portfolio*, 1845.
Illustrated: R. Cattermole: *The Great Civil War*, 1841-5.
Examples: B.M.; V.A.M.; Haworth A.G., Accrington; Ashmolean; Blackburn A.G.; Grundy A.G., Blackpool; Cartwright Hall, Bradford; Devizes Mus.; Dudley A.G.; Exeter Mus.; Glasgow A.G.; Leeds City A.G.; Maidstone Mus.; City A.G., Manchester; N.G., Scotland; Newport A.G.; Portsmouth City Mus.
Bibliography: *A.J.*, July, 1857; September, 1868; March, 1870. O.W.S. Club, IX, 1932.

CATTERMOLE, Rev. Richard
　　　　　　　　　c.1790 (Dickleburgh) – 1860 (Boulogne)
The eldest brother of G. Cattermole (q.v.), he began his career as an architectural draughtsman, working for such publications as Pyne's *Royal Residences* and Britton's *Cathedral Antiquities of Great Britain*. He also exhibited with the Oil and Watercolour Society in 1814. His subjects were generally cathedrals, which was probably no coincidence, since he abandoned art for the Church, taking a B.D. at Cambridge in 1831. He was Minister of the South Lambeth Chapel from 1844 and Vicar of Little Marlow from 1849. He published many devotional, literary and historical works, including *The Book of the Cartoons of Raphael*, 1837. His drawing style is close to that of his brother.

Examples: B.M.

CATTON, Charles, R.A.　　　1728 (Norwich) – 1798 (London)
Apprenticed to a London coach-painter, he later set up on his own and became Coach-Painter to George III. He studied at the St. Martin's Lane Academy and was a Foundation Member of the R.A. He had previously exhibited with the Incorporated Society. In 1784 he was Master of the Painter-Stainers' Company.

Examples: V.A.M.; N.G., Scotland.

CATTON, Charles, Yr.　1756 (London) – 1819 (New Paltz, N.Y.)
The son and pupil of C. Catton (q.v.), he also studied at the R.A. Schools and became a scene painter and animal artist. He also sketched for the topographic publishers and presumably maintained some connection with his father's native Norwich, since a small watercolour of the town by him was engraved for Walker's *Copper-plate Magazine* in 1792. He exhibited at the R.A. from 1775 to 1800. In 1793 he worked with E.F. Burney (q.v.) on a series of designs for Gay's *Fables*. In 1804 he emigrated to America where he lived on a farm on the Hudson River. His style is sometimes close to that of Dayes, with careful architectural drawing and freely applied colour washes.

Published: *Animals drawn from Nature*, 1788.
Examples: B.M.; V.A.M.; Ashmolean.

CAULFIELD, Mrs.
A Dublin lady renowned for her skill with the needle. She also worked as a modeller and in oil and watercolour, and she was active in the late eighteenth century.

CAVE, Henry　　　　　　1779 (York) – 1836 (York)
A York topographer, working somewhat in the manner of the elder T.M. Richardson, he was the fourth son of William Cave, an engraver under whom he studied. In 1801 he was admitted a Freeman of York and described on the roll as an engraver. In 1821 he was elected a Chamberlain of the city. He taught drawing, and his favourite subjects were the monastic ruins and the coast of his native county. He painted in oil and watercolour, and he also made Indian ink copies of old masters in private collections for engraving. He exhibited at the R.A. and the B.I. from 1814 to 1825.

His elder brother, William Cave, Yr., and several other members of the family, were engravers.

Published: *The Antiquities of York*, 1813.
Examples: Dundee A.G.; York City A.G.

CAVE, James
An architectural and landscape painter who worked in Winchester

and exhibited from 1801 to 1817. He was unconnected with the York family of artists.

Illustrated: J. Milner: *History of Winchester*, 1801.
Examples: B.M.

CAW, Sir James Lewis　　1864 (Ayr) – 1950 (Lasswade)
An artist and connoisseur who was educated at Ayr Academy and studied at Glasgow, Edinburgh and on the Continent. From 1895 he was the Curator of the Scottish N.P.G. and from 1907 Director of the N.G., Scotland.

Published: *Sir Henry Raeburn*, 1901. *Scottish Portraits*, 1903. *Scottish Painting*, 1908. *National Gallery of Scotland*, 1911. *William McTaggart*, 1917.
Examples: N.G., Scotland.

CAWSE, John　　　　1779　　　– 1862 (London)
A portrait and history painter in oil and watercolour, he exhibited at the O.W.S., the R.A. and elsewhere from 1801 to 1845. In the B.M. there is a pen drawing in the manner of Rowlandson.

Published: *The Art of Painting in Oil . . .*, 1840.

CAZALET, Captain Charles Henry　1818 (India) – 1860 (Kamptee)
The son of Anglo-Indian parents, he was educated in Paris and Southampton, and in 1837 he was commissioned as an ensign in the 29th Madras Native Infantry. He was promoted lieutenant in 1840 and captain in 1848. His watercolour of Penang Harbour dated 1856 is illustrated in a letter to *Country Life*, February 22, 1973.

CHAIGNEAU, Henry　　　　　　c.1760　　　–
A landscape painter who entered the R.D.S. Schools in 1776. He exhibited until 1780, after which his name does not appear. There is a drawing signed 'Thes. Heny. Chaigneau' at the N.G.I. This may be by Theophilus Chaigneau, son of David Chaigneau, M.P. for Gowran, who may be identical with the above.

CHALMERS, George Paul, R.S.A., R.S.W.
　　　　　　　　　1836 (Montrose) – 1878 (Edinburgh)
A portrait and later landscape painter who moved to Edinburgh in 1853 to study under Scott Lauder at the Edinburgh School of Design. He exhibited at the R.S.A. from 1863 and was elected A.R.S.A. and R.S.A. in 1867 and 1871. Previously he had worked for a ship chandler and as a grocer. In 1862 he sketched in Brittany with J. Pettie (q.v.) and John Graham, and in 1874 he toured France, Belgium and Holland with Joseph Farquharson. He also painted genre subjects and was influenced by Rembrandt and Wilkie.

Bibliography: A. Gibson: *G.P.C.*, 1879. E. Pinnington: *G.P.C. and the art of his time*, 1896. *A.J.*, 1897.

CHALMERS, J
A scene painter working in Dublin and Cork between 1801 and 1820. In 1819 he was appointed Drawing Master at the Cork Institution, and he exhibited landscapes.

CHALMERS, W　A
A painter of architectural and theatrical subjects who lived and worked in London and appears to have died young. He exhibited at the R.A. from 1790 to 1794.

CHALON, Alfred Edward, R.A.　1780 (Geneva) – 1860 (London)
The son of a Huguenot refugee from Geneva who settled in Kensington, and the younger brother of J.J. Chalon (q.v.). The brothers, both unmarried, lived in Kensington for the rest of their lives. A.E. Chalon entered the R.A. Schools in 1797. He became a member of the A.A. in 1807, resigning in 1808 to found the Sketching Society with his brother and F. Stevens (q.v.). He exhibited at the R.A. from 1810 and was elected A.R.A. and R.A. in 1812 and 1816.

He is the better known of the two brothers and enjoyed the greater success during his lifetime. His graceful portraits, usually

about fifteen inches high, typify early Victorian art. His portrait of the young Queen was reproduced on many early issues of Colonial stamps, and he was appointed Painter in Water Colours to the Queen. He also painted many historical and literary subjects in oil, and like his brother, caricatures in brown wash.

Illustrated: L. Fairlie: *Portraits of Children of the Nobility*, 1838. M. Gardiner: *The Belle of a Season*, 1840. S. Uwins: *A Memoir of Thomas Uwins*, 1858.
Examples: B.M.; V.A.M.; Ashmolean; Blackburn A.G.; Leeds City A.G.; N.P.G.; Castle Mus., Nottingham; Ulster Mus.
Bibliography: *A.J.*, January, 1862; 1899.

CHALON, John James, R.A., O.W.S.
 1778 (Geneva) − 1854 (London)
A landscape and genre painter in oil and watercolour, and the elder brother of A.E. Chalon (q.v.), he entered the R.A. Schools in 1796 and exhibited his first picture at the R.A. in 1800. In December, 1805 he was one of the first Associates elected by the O.W.S., and he became a full Member in 1807. He was elected A.R.A. and R.A. in 1827 and 1841. In 1816 he exhibited his best known work in oil, *Napoleon on the Bellerophon*, at the R.A. In 1819 or 1820 he visited Paris and produced a set of lithographs, published in 1822, entitled *24 Subjects exhibiting the Costume of Paris*. He is said to have had an extensive practice as a drawing master.

His favourite sketching grounds were the Thames and Wye Valleys and the South Coast. Many of his drawings contain elements of caricature, and his pure caricatures are more accomplished than those of his brother. They are often executed in freely handled brown wash.

Published: *Sketches of Parisian Manners*, 1820.
Examples: B.M.; V.A.M.; Maidstone Mus.; Richmond Lib.
Bibliography: *A.J.*, January, 1855.

CHAMBERS, George, O.W.S. 1803 (Whitby) − 1840 (Brighton)
The second son of a Whitby sailor, he went to sea at the age of ten. His first artistic work was decorating the brig *Equity* on which he served a five year apprenticeship. Freed from his indentures, he spent three years with a house and ship painter at Whitby. His first important commission came from Christopher Crawford, the landlord of the Waterman's Arms, Wapping, for whom he painted a 'Prospect of Whitby', which inspired further commissions for ship portraits. Crawford also helped him to go on a number of sketching voyages around the coasts and to work on T. Horner's (q.v.) Panorama in Regent's Park. After a period as a scene painter, he set up as a marine artist and soon gained commissions from naval men and the Sailor King himself because of the accuracy of his nautical detail. His health being poor, he returned to Whitby for a while and in 1833 spent some time in Sussex. At about this time he turned from oil painting to the more subtle medium, and he was elected A.O.W.S. and O.W.S. in 1834 and 1835. In 1837 he visited Whitby and in 1838 he went to Holland with his pupil J.C. Gooden-Chisholm (q.v.). Thereafter his health collapsed entirely, and Crawford sent him to Madeira, but he died at Brighton on his return.

He can be one of the most poetic of British marine artists, and his stylistic epitaph was written by his friend Sidney Cooper: 'His painting of rough water was truly excellent, and to all water he gave a liquid transparency that I have never seen equalled . . . his ships are all in motion.'

His remaining works were sold at Christie's, February 10, 1841.

Examples: B.M.; V.A.M.; Exeter Mus.; Greenwich; Leeds City A.G.; Newport A.G.; Wakefield City A.G.
Bibliography: Anon: *Memoir of C.G.*, 1837. J. Watkins: *Life and Career of J.C.*, 1841. O.W.S. Club, XVIII, 1940.

CHAMBERS, George, Yr. c.1830 −
The elder son of G. Chambers (q.v.), he was educated at Sandgate and Christ's Hospital. He became a marine painter in his father's manner and exhibited at the R.A. from 1850 to 1861. He painted on the South and East Coasts, the Thames and in Holland. His brother, William Henry Chambers (b.1832) may also have painted.

Examples: Greenwich; Gray A.G., Hartlepool.

CHAMBERS, John 1852 (South Shields) − 1928
A landscape, architectural and portrait painter who worked for the Tyne Pilotage Service before studying in Paris. His subjects are usually found in North Shields, where he lived, and on the Tyne.

Examples: Laing A.G., Newcastle.

CHAMBERS, Thomas c.1828 − 1910
A Scarborough marine painter who had an unsuccessful career until 1879 when he gave up art for the millinary business and moved to York. He died rich.

CHAMPAIN, Colonel Sir John BATEMAN-
A Royal Engineer who served, and sketched, in India during the Mutiny. In 1862 he accompanied Colonel Patrick Stewart on a survey to trace a possible line for the first telegraph line across Persia to link India and the Home Country. An example of his work is given in a letter to *Country Life*, June 19, 1975.

CHAMPERNOWNE, Arthur
The owner of Dartington Hall, his name was originally Harrington. He was a pupil of Francis Towne (q.v.) and painted Devonshire views. Later members of the family were patrons and pupils of de Wint.

CHANDLER, Rose M
A genre painter who lived in Haslemere and exhibited at the R.I. and Suffolk Street from 1882 to 1891.

CHANTREY, Sir Francis Leggatt, R.A.
 1781 (Norton, Derbyshire) − 1842
Of the Bequest. He was a sculptor, but at the beginning of his career he took portraits in miniature and pencil, and he later became a keen landscape sketcher. He visited France, Holland and Italy. He was elected A.R.A. and R.A. in 1816 and 1818 and was knighted in 1835. His landscape drawings are often in thick pencil with thin blue, green and pink washes.

Published: *C's Peak Scenery*, 1885.
Examples: B.M.
Bibliography: G. Jones: *Sir F.C.*, 1849. J. Holland: *Memorials of Sir F.C.*, 1851. A.J. Raymond: *Life and Work of Sir F.C.*, 1904.

CHAPMAN, Abel 1851 (Sunderland) − 1929 (Northumberland)
A cousin of J. Crawhall (q.v.), and a natural history writer, who often illustrated his books with drawings and watercolours. He lived at Houxty, near Wark, from 1898 until his death. He published a number of bird books and illustrated the works of others on big game hunting and kindred subjects.

Published: *Retrospect: Reminiscences, 1851-1928*, 1928. Etc.
Examples: Hancock Mus., Newcastle.

CHAPMAN, William 1817 (Sunderland) − 1879
A successful engraver who had studied under William Miller in Edinburgh, he spent the latter part of his life in York, where he made many watercolours of both buildings and landscapes. He may be the R. William Chapman who stood for the N.W.S. in 1858.

Examples: B.M.; Leeds City A.G.; Laing A.G., Newcastle; York City A.G.

CHAPPELL, Reuben
 1870 (Hook, Yorkshire) − 1940 (Par, Cornwall)
By the age of twenty he had set himself up as a ship painter at Goole, much of his work being commissioned by the masters and crews of Danish ships. In 1904 he moved to Cornwall on account of his health, where he remained for the rest of his life. He never exhibited and supported his family entirely by commission. During the War he made watercolour plans for improvements in ship construction which were considered by the Ministry of Defence. He did little work after 1930.

His merchant coasters are usually depicted broadside and under sail. The majority of his work is in watercolour and is brightly

coloured and technically accomplished. He also painted occasional landscapes. Before about 1908 he usually signed 'R. Chappell, Goole', later he signed 'R. Chappell', 'R.C.', or, very rarely, 'R.C.G.' He kept regular diaries of his commissions. He is represented in many Continental collections, especially in Denmark, and exhibitions of his work were held at the Bristol City A.G. and at Greenwich in 1970.

Bibliography: *Sea Breezes*, February, 1948.
Examples: Kronberg Mus., Elsinore; Greenwich; Ferens A.G., Hull; Marstal Mus.; Amts Mus., Svendborg.

CHARLES, W
A marine and landscape painter who exhibited at Suffolk Street in 1870 and 1871 and was still active three years later.

CHARLTON, John 1849 (Bamburgh) — 1917
A painter of portraits, battles and landscapes and an illustrator, Charlton began his career in a Newcastle bookshop. Later he entered the School of Art under W.B. Scott (q.v.) and then South Kensington. He exhibited at the R.A. for the first time in 1870 and moved to London permanently. He worked for some years in the studio of J.D. Watson (q.v.), concentrating on figure painting. He also drew for the *Graphic* and produced grand ceremonial pictures.

Published: *Twelve Packs of Hounds*, 1891.
Illustrated: H.A. Macpherson: *Red Deer*, 1896.
Examples: Shipley A.G., Gateshead; Gray A.G., Hartlepool; Laing A.G., Newcastle.

CHARLTON, William Henry
 1846 (Newcastle-upon-Tyne) — 1918
A landscape and coastal painter in oil, watercolour and chalk, he studied under C. Richardson (q.v.) and at the Académie Julian in Paris. His watercolours are often on a small scale.

Examples: B.M.; Laing A.G., Newcastle.

CHASE, Frank M
A London landscape painter who exhibited at the R.A. from 1875. He painted in Venice and Switzerland as well as in Britain. He was presumably a son of J. Chase (q.v.).

CHASE, John, N.W.S. 1810 (London) — 1879 (London)
A pupil of Constable who also studied architecture, he exhibited landscapes and views of churches from 1826 and was a member of the N.W.S. from 1834. His first wife, MARY ANN CHASE, née RIX was elected to the N.W.S. in 1835 and exhibited until 1839.

Published: *A Practical Treatise on ... Water Colours*, 1863.
Examples: V.A.M.; Sydney A.G.
Bibliography: *A.J.*, 1879.

CHASE, Marian Emma, R.I. 1844 (London) — 1905 (London)
The second daughter of J. Chase (q.v.) by his second wife Georgiana Ann, née Harris. She was taught by her father and by M. Gillies (q.v.) and exhibited at the R.A., the N.W.S. and elsewhere from 1866. She was elected A.N.W.S. and N.W.S. in 1875 and 1879. In 1888 she was awarded the silver medal of the Royal Botanical Society. She painted genre subjects as well as flowers. Her sister JESSIE CHASE was also a watercolour painter.

Examples: V.A.M.

CHATELAIN, John Baptist Claude 1710 (London) —1771 (London)
A draughtsman and engraver of Huguenot descent whose real name was Philippe. French authorities claim that he was born and died in Paris and that he served in the French Army. He worked for Boydell and exhibited engravings at the Free Society from 1761 to 1763. He lived in Chelsea and produced views of London as well as of the Lake District and copies after Italian artists. The topographical drawings which he made for prints are usually much more free than his finished wash or chalk drawings, which tend to be formal and with a strong conventional outline. His colour washes are very limited, usually no more than browns, greys or blues. F. Vivares (q.v.) was probably his pupil.

Examples: B.M.; V.A.M.

CHATTOCK, Richard Samuel 1825 (Solihull) — 1906 (Clifton)
A landscape painter in oil and watercolour and an etcher, he was educated at Rugby, and worked in Birmingham, Solihull and the Black Country. He exhibited at the R.A. and the R.I. from 1865 and was an R.P.E. as well as a member of the Birmingham Society.

Published: *Wensleydale*, 1872. *The Black Country*, 1878. *Practical Notes on Etching*, 1883.
Illustrated: W.W. Wood: *Sketches of Eton*, 1874.

CHAWNER, Thomas 1775 — 1851
An architect and draughtsman, he was a pupil of Sir J. Soane and entered the R.A. Schools in 1797. Ultimately he became Joint Architect and Surveyor under the Commissioners of Woods and Works, retiring in 1845. His architectural work was mostly in London and Surrey.

Examples: B.M.

CHEARNLEY, Anthony
An Irish amateur draughtsman. Two views by him of his house, Burnt Court, County Tipperary, and a view of Ardfinnan Castle appear in Grose's *Antiquities of Ireland*. He also made illustrations for Smith's *History of Waterford* and *History of Cork* and for Ledwich's *Antiquities*.

CHENEY, Harriet
The daughter of de Wint's patron, Mr. Cheney of Badger Hall, Shropshire, she was a pupil of the artist, although her work is not usually in his style. She was active in about 1815 and a print dedicated to Sir Joseph Banks was published from her drawing of a bust of Euripides.

CHERON, Louis 1655 (Paris) — 1725 (London)
The son of Henri Chéron, a miniaturist, he visited Italy, returning to Paris in 1687, and left France finally in 1695 as a result of the Revocation of the Edict of Nantes. In England he worked as a painter of murals, but the competition was too great for him, and he turned to book illustration. His drawings are generally in black chalk and light brown wash with a characteristic knobbly outline, and his subjects were biblical and mythological. He also illustrated an edition of Milton in 1720. Two of his sisters, Elisabeth Sophie and Marianne, were miniaturists.

CHESHAM, Francis 1749 — 1806 (London)
An engraver who made prints after P. Sandby (q.v.), G. Robertson (q.v.) and others. His engravings are in the manner of Vivares, and his own drawings are in thin washes with the tight, spindly pen-line of an eighteenth century print maker. They are rather Dutch in feeling.

Examples: B.M.

CHILDE, Elias 1778 — 1862
Primarily a landscape and coastal painter in oil, he was also an occasional exhibitor with the O.W.S. and the N.W.S. He was active from 1798 to 1848 and painted much in Sussex, Kent and on the Thames. He became a member of the S.B.A. in 1825.

CHILDS, George
A painter of landscapes and rustic genre subjects who exhibited at the R.A. and Suffolk Street between 1826 and 1873 and stood for the N.W.S. unsuccessfully in 1839 and 1841. He was also a lithographer.

Published: *A New Drawing-Book of Figures. The Little Sketch Book. Childs' Drawing-Book of Objects. English Landscape Scenery and Woodland Sketches.*

CHINNERY, George **1774 (London) – 1852 (Macao)**
The landscape and portrait painter. He entered the R.A. Schools and first exhibited at the R.A. in 1791. In 1796 he went, by way of Bristol, to Dublin, where he had influential relatives. The following year he was appointed director of life classes at the Dublin Society, and in 1799 he married. In 1800 he re-organised the moribund Society of Artists in Ireland and became its Secretary. In 1802 he abandoned his family, returned briefly to London and sailed to Madras. In 1807 he moved to Calcutta and from 1808 to 1812 was in Dacca, where he gave lessons to his friend Sir C. D'Oyly (q.v.) and others. From 1812 to 1823 he had a studio in Calcutta, and in 1823 he was in Serampore. In 1825, to escape debts and his wife, who had re-joined him, he moved to Macao. The rest of his life was spent in Macao, Hong Kong and Canton. The ban on European women in Canton enabled him to evade his wife again when she attempted to follow him.

Throughout his career he was highly thought of as a portrait painter, in oil and miniature, but today he is most remembered for the innumerable pencil sketches, wash drawings and finished watercolours which he made on the China Coast. His subjects are old buildings, junks and crowds of coolies in the streets. There are also many drawings for his portraits of European and Chinese merchants, most notably his patrons, Messrs. Jardine and Matheson and the great Hou Qua. He had many followers, both European and Chinese, but it is usually possible to tell his work from theirs. His sketches are often annotated in shorthand, and his figures are beautifully drawn, often with large foreheads and a stocky build. His palette is muted, and his handling atmospheric.

He was not, as is often claimed, of Irish birth, nor was he a member of the R.H.A. which was founded in 1823, twenty-one years after his departure from Ireland. The persistent claim that he was elected to it in 1798 (sic) is probably due to a confusion with the Society of Artists in Ireland.

Examples: B.M.; V.A.M.; Ashmolean; Greenwich; Leeds City A.G.; N.G., Scotland.
Bibliography: J.J. Cotton: *G.C.*, 1852. H. & S. Berry-Hill: *G.C.*, 1963. *China Journal*, VIII, 1928. Tate Gall.: *Exhibition Cat.*, 1932. *Country Life*, May 30, 1936. Arts Council: *Exhibition Cat.*, 1957. *Connoisseur*, CLXXV, 1970.

CHIPP, Herbert
A landscape painter who lived in Ely and exhibited at the R.I., Suffolk Street and in Birmingham from 1877 to 1885. He sketched in the Channel Islands. He was also a devotee of lawn tennis.

Examples: Ulster Mus.

CHISHOLM, Alexander, A.O.W.S.
 c.1792 (Elgin) – 1847 (Rothesay)
He was apprenticed to a weaver at Peterhead, but taught himself to draw both there and in Aberdeen. In about 1812 he went to Edinburgh, where he won the patronage of the Earls of Buchan and Elgin and taught drawing at the R.S.A. Schools. He married one of his private pupils, SUSANNA STEWART CHISHOLM, née FRASER, and in 1818 moved to London and set up as a portrait painter. He gradually turned from portraits to subject pictures and from oil to watercolour, and he was elected A.O.W.S. in 1829. From about 1832 he concentrated largely on historical and literary subjects. He made a number of illustrations for the Annuals and for the Waverley Novels, and his work resembles that of T. Uwins (q.v.) or J.W. Wright (q.v.). He died on the Isle of Bute while making portrait studies for an ambitious picture of the Evangelical Alliance, and he left a large family of impecunious daughters. His name is sometimes spelt, wrongly, with a final 'e'.

Examples: B.M.; V.A.M.

CHISHOLM, James Chisholm GOODEN-
A pupil of G. Chambers (q.v.), whom he accompanied on a number of yachting and sketching trips on the Thames in 1837 and 1838. In the latter year they also visited Holland. In the summer of 1858 he was on the Thames again, this time with E. Duncan (q.v.). He was also a friend of W.J. Muller (q.v.), and he exhibited from 1835 to 1865.

Published: *The Thames and Medway Admiralty Surveys*, 1864.
Examples: V.A.M.; Newport A.G.

CHOWNE, Gerard **1875 (India) – 1917 (Macedonia)**
The son of Colonel W.C. Chowne, he was educated at Harrow and studied at the Slade under Professor Brown. He painted landscapes, portraits and flowers and was a member of the N.E.A.C. In the First World War he served as a captain in the East Lanarkshire Regiment, and he died of wounds. His work is free, impressionistic and pleasing.

Examples: V.A.M.; City A.G., Manchester; Ulster Mus.

CHURCH, Sir Arthur Herbert, F.R.S., F.S.A.
 1834 (London) – 1915
An occasional painter, who was educated at King's College, London, and Lincoln College, Oxford, and was Professor of Chemistry at Cirencester from 1863 to 1879 and at the R.A. from 1879 to 1911. He wrote on chemistry, precious stones, English porcelain and other subjects and exhibited infrequently between 1854 and 1870.

Examples: V.A.M.

CHURCHYARD, Thomas **1798 (Melton) – 1865 (Woodbridge)**
An enthusiastic amateur painter and a good but unenthusiastic country lawyer, Churchyard was educated at Dedham Grammar School and lived an uneventful life at Woodbridge. He visited London and Bury St. Edmunds occasionally, but for the most part painted the fields and rivers about his home. There his friends and fellow 'Wits of Woodbridge' included the poets Edward Fitzgerald and Barton. He may well have known Constable and G. Frost (q.v.). He exhibited in London from 1830 to 1833 and in Norwich in 1829 and 1852.

The quality of his work varies, but his watercolours are almost always charming. In his earlier days he based his style on that of Crome and his Norwich followers, later he was a devoted disciple of Constable. His daughters, and probably his sons, were also painters, and their work can be similar to his. They were THOMAS CHURCHYARD, YR. (b. 1825); ELLEN CHURCHYARD (1826-1909); EMMA CHURCHYARD (1828-1878); LAURA CHURCHYARD (1830-1891); ANNA CHURCHYARD (1832-1897); ELIZABETH CHURCHYARD (1834-1913); HARRIET CHURCHYARD (1836-1927); CATHERINE CHURCH-YARD (1839-1889) and CHARLES ISAAC CHURCHYARD (1841-1929).

Examples: B.M.; V.A.M.; Ashmolean; Dundee City A.G.; Fitz-william; Christchurch Mansion, Ipswich; Maidstone Mus.; Castle Mus., Norwich.
Bibliography: D. Thomas: *T.C. of Woodbridge*, 1966.

CIPRIANI, Giovanni Battista, R.A.
 1727 (Florence) – 1875 (London)
The pupil of an English painter in Florence called Hugford, Cipriani went to Rome in 1750 and came to England in 1755 on the persuasion of Sir William Chambers and Joseph Wilton. In 1758 he was appointed teacher of drawing in the short-lived school set up by the Duke of Richmond in his private gallery in Whitehall. He studied at the St. Martin's Lane Academy and was one of the Foundation Members of the R.A. in 1768. His drawings, in pencil, black or red chalk or pen and grey wash, are generally much more attractive and stronger than his pure watercolours. These represent the classical Italian tradition in its extreme decadence, but his little cherubs are sometimes pretty, according to Williams. He had a fairly wide influence, and it is often difficult to differentiate between his work and that of Hamilton, Kauffmann and Mortimer. His remaining works were sold at Christie's, March 22, 1786. His son CAPTAIN SIR HENRY CIPRIANI occasionally painted watercolours.

Examples: B.M.; V.A.M.; Fitzwilliam.

CLACK, Thomas **1830 (Coventry) – 1907 (Hindhead)**
The son of a schoolmaster in whose establishment he was educated, he lived in Coventry for much of his life. In 1884 he was a master at the National Art Training School at Marlborough House, teaching

painting and freehand drawing of ornament, the figure and anatomy. He exhibited at the R.A. from 1851 to 1891.

Examples: V.A.M.; Coventry A.G.

CLARK, Christopher, R.I. **1875 (London) – 1942**
A painter and illustrator of military and historical subjects. He was elected R.I. in 1905. He lived in London and King's Langley, Hertfordshire.

Published: *British Soldiers, 1550-1906*, 1907.
Illustrated: R.D. Blackmore: *Lorna Doone*, 1912. Sir H.J. Newbolt: *Tales of the Great War*, 1916.

CLARK, Ernest Ellis **– 1932 (Derby)**
An oil and watercolour painter who studied at the Derby School of Art and became a designer at the porcelain works. Later he taught at the School of Art and was a member of the Derby Sketching Club. He exhibited locally from 1893.

Published: *A Handbook of Plant-Form for Students of design*, 1904.
Examples: Derby A.G.

CLARK, James, R.I. **1858 (West Hartlepool) – 1943 (Reigate)**
A landscape, flower and portrait painter and Biblical illustrator, who studied locally, at South Kensington and in Paris. He worked in Chelsea and West Hartlepool and also made frescoes and stained glass designs and painted in oil and pastel.

Examples: Shipley A.G., Gateshead; Gray A.G.. Hartlepool; Laing A.G., Newcastle.

CLARK, John Heaviside 'Waterloo'
 c.1771 – 1863 (Edinburgh)
A landscape painter and book illustrator who was working in London from 1802 to 1832. Prior to this, he may well be the 'I. Clark' whose name appears on a number of excellent aquatinted views of Aberdeen and other Scottish cities. He went to the field of Waterloo immediately after the battle, and prints were published from his sketches, earning him his nickname. He also painted marine subjects.

Published: *Practical Essay on the Art of Colouring and Painting Landscapes*, 1807. *Field Sports Etc. of the Native Inhabitants of New South Wales*, 1813. *Practical Illustration of Gilpin's Day*, 1824.
Examples: Glasgow A.G.; Greenwich; Maidstone Mus.

CLARK, Joseph **1835 (Dorset) – 1926**
A still-life painter who studied at Leigh's School and exhibited at the N.W.S. and elsewhere from 1857. At one time he lived in Ramsgate. His nephew, JOSEPH BENWELL CLARK (b. 1857 London) was also a painter in oil and watercolour.

CLARK, Thomas, A.R.S.A.
 1820 (Whiteside, Stirling) – 1876 (Dunderach, Aberfoyle)
A landscape painter who injured his shoulder during his schooldays at Dollar, making him a cripple for life. He studied at Edinburgh and contributed to the first R.S.A. exhibition. He was elected A.R.S.A. in 1865. Although he often spent the winters in the South, his subjects are chiefly Scottish.

CLARKE, Rev. Edward Daniel 1769 (Willingdon) – 1822 (London)
A traveller, antiquary and mineralogist. He was educated at Tonbridge Grammar School and Jesus College, Cambridge, and worked as a tutor which gave him the opportunity to travel. In 1791 he toured Great Britain and, in 1792-3, Italy. His most ambitious journey took place from 1799 to 1802 when he visited Scandinavia, Russia, Siberia and the Caucasus, Turkey, Cyprus, Rosetta, Palestine, Greece and France. He was a keen, if envious, disciple of Elgin in the collecting of antiquities. On his return much of his time was taken up with writing and with scientific experiments. He was ordained in 1805 and held the livings of Harlton and Yeldham, Essex. His drawings were used to illustrate his *Travels* and are of a fairly high quality. His wife, ANGELICA CLARKE, née RUSH, also painted.

Published: *Travels in Various Countries . . .*, 1810-15. Etc.
Bibliography: W. Otter: *The Life and Remains of the Rev. E.D.C.*, 1824.

CLARKE, George Row
A landscape painter who stood unsuccessfully for the N.W.S. in 1871 and 1873 and exhibited there and elsewhere from 1858 to 1888. He lived in London, although many of his subjects were found in the Midlands.

CLARKE, Theophilus, A.R.A. **1776 – 1831**
A student at the R.A. Schools and under John Opie, he exhibited at the R.A. from 1795 to 1810. He was elected A.R.A. in 1803, and his name remained on the list until 1832. He exhibited portraits, landscapes, fishing and domestic subjects and painted in both oil and watercolour.

CLAUSEN, Sir George, R.A., R.W.S.
 1852 (London) – 1944 (Newbury)
The son of a Danish sculptor, he studied at South Kensington and in Paris. He visited Holland and Belgium in 1876, the year of his first R.A. exhibit, and was influenced by the Hague School as well as by his French contemporaries. He was a member of the R.I. from 1879 to 1888, transferring to the R.W.S. in the following year and becoming a full member in 1898. He was elected A.R.A. and R.A. in 1895 and 1908 and was knighted in 1927. From 1904 to 1906 he was Professor of Painting at the R.A. and later he was Director of the Schools. He was a keen exponent of *plein air* painting, and he spent much time on the farms of Essex. His work captures atmosphere rather than detail.

Published: *Six Lectures on Painting*, 1904. *Aims and Ideals in Art*, 1906.
Examples: B.M.; V.A.M.; Aberdeen A.G.; Cecil Higgins A.G., Bedford; Blackburn A.G.; Fitzwilliam; Glasgow A.G.; Leeds City A.G.; City A.G., Manchester; N.G., Scotland; Newport A.G.; Ulster Mus.
Bibliography: *A.J.*, 1890. O.W.S. Club, XXIII.

CLAXTON, Adelaide, Mrs. Turner **c.1842 (London) –**
An illustrator and humorous artist. As a child she was taken to Australia and the Far East by her father, Marshall C. Claxton, a painter who took the first exhibition of pictures to be shown in Australia. Her elder sister FLORENCE CLAXTON, later Mrs. Farrington, was also an illustrator until her marriage in 1868. Adelaide had little training and first exhibited in 1863. She made many copies of her most popular works. As well as genre subjects, she specialised in ghosts. She married G.G. Turner in 1874.

Published: *A Shillingsworth of Sugar-Plums*, 1867. *Brainy Odds and Ends*, 1900.

CLAYTON, Alfred B **1795 (London) – 1855**
An architect who visited the Mediterranean in 1820 and chiefly worked in London and Manchester. He exhibited designs for houses and churches at the R.A. from 1814 to 1837. He also painted historical subjects and made prints.

Examples: R.I.B.A.

CLAYTON, Eleanor 'Ellen' Creathorne
 c.1846 (Dublin) –
The descendant of an artistic family, she became a novelist and illustrator. She studied briefly at the N.G. and the B.M. She made a number of humorous drawings for magazines and in the early 1870s did a great deal of commercial painting, valentines, calendars and so forth.

Published: *Queens of Song*, 1863. *Cruel Fortune*, 1865. *Repenting at Leisure*, 1873. Etc.
Illustrated: F. Claxton: *Miss Milly Moss*, 1862.

CLAYTON, John 1728 (Edmonton) – 1800 (Enfield)
A still-life painter who was trained as a surgeon, but soon turned to art, painting in both oil and watercolour. He exhibited from 1761 with the Free Society and with the Incorporated Society from 1767. His studio, with many of his best works, was destroyed in the Covent Garden fire of March 1769. After this he virtually gave up painting for gardening and music, although he exhibited once more, in 1778.

CLAYTON, Joseph Hughes
A painter of beach and coastal scenes who was working about 1900.

CLENNELL, Luke
 1781 (Ulgham, Northumberland) – 1840 (Newcastle)
The coastal and landscape painter. After working for his uncle, a tanner, he was apprenticed to T. Bewick (q.v.) in 1797 and became a very talented wood engraver. In 1804 he moved to London, where he continued to work as an engraver until 1810, painting on his own account at the same time. He was a member of the A.A. from 1810 to 1812 and exhibited at the R.A. and the Oil and Watercolour Society. After completing his most ambitious work, the *Banquet of the Allied Sovereigns in the Guildhall*, he became insane in 1819, as did his wife, a daughter of Charles Warren the engraver, soon afterwards. In his more lucid moments thereafter he wrote strange poems and made weird drawings. From 1831 he was permanently in an asylum.

His earliest watercolours are in the contemporary style of S. Prout (q.v.) and J. Cristall (q.v.). Later he excelled in painting rapid action with a strong feeling for the elements. Although he sometimes painted pure landscapes and figure subjects, he is at his best with beach and coastal scenes in which the fishermen of his native north-east battle stolidly against wind and spray.

Examples: B.M.; V.A.M.; Dundee City A.G.; Greenwich; Laing A.G., Newcastle; Newport A.G.; Ulster Mus.

CLERIHEW, William
A topographer and landscape painter who worked in the Near East, India and Ceylon in the 1840s and 1850s.

CLERK, John, of Eldin 1728 (Penicuik) – 1812 (Eldin)
An amateur artist and etcher who was the seventh son of Sir John Clerk of Penicuik. After a successful business career in Edinburgh he retired in 1773 and settled at Eldin, just outside the city, where he developed his artistic and scientific interests. He is best known for an essay he wrote on naval tactics which aroused great controversy. In 1753 he had married Susannah Adam, sister of the architects, and their son became the judge, Lord Eldin. He drew for most of his career, and in about 1770, encouraged by his friend P. Sandby (q.v.), he took up etching. A collection of his prints was presented to the King by the Earl of Buchan in 1786. His etchings were published by the Bannatyne Club in 1825 (twenty-eight plates) and 1855 (eighty plates).

His drawings, which include both landscapes in the Edinburgh area and portraits, are generally in monochrome or low colour with firm pen outlines. His son JOHN, LORD ELDIN (1757-1832) was also an amateur draughtsman, as was his brother SIR GEORGE CLERK-MAXWELL OF PENICUIK (1715-1784) who etched a number of Scottish views.

Examples: B.M.; N.G., Scotland.

CLEVELEY, John, Yr. 1747 (Deptford) – 1786 (Deptford)
The twin son of JOHN CLEVELEY, (d.c.1782), a shipwright and painter of Deptford, he attracted the notice of P. Sandby (q.v.), then at Woolwich, who gave him lessons. He first exhibited in 1767, and in 1772 he was draughtsman to Sir Joseph Banks's expedition to the Hebrides, Orkneys and Iceland. In the following year he accompanied Phipps's expedition in search of a northern route to India, which got little further than Spitzbergen. He may have travelled more widely – possibly to Ireland and Portugal – but he also worked up the drawings of his brother JAMES CLEVELEY who sailed with Captain Cook. Occasionally he made topographical

drawings and painted in oil as well as in watercolour.

Examples: B.M.; V.A.M.; Greenwich.

CLEVELEY, Robert 1747 (Deptford) – 1809 (Dover)
The twin brother of John Cleveley, Yr. (q.v.) who transmitted Sandby's influence to him. He too first exhibited in 1767. He seems to have held a civilian appointment with the Navy and was Marine Draughtsman to the Duke of Clarence and Marine Painter to the Prince of Wales. He often worked on a very large scale for a watercolourist, and he produced drawings of London and elsewhere in which a topographical element is added to the nautical. The influence of E. Dayes (q.v.) as well as that of Sandby is sometimes evident.

Examples: B.M.; Greenwich; Richmond Lib.

CLIFF, William F.R.S. 1775 – 1849
A topographer who worked in the London area. When in full colour his work can be rather gaudy, and his under-drawing, sometimes in charcoal, is weak.

Examples: B.M.;

CLIFFORD, Edward 1844 (Bristol) – 1907
A painter of landscapes, portraits and historical subjects in oil and watercolour. He studied at the Bristol School of Art and at the R.A. Schools, and he exhibited in London from 1886. He visited Italy, India and the East. He was particularly noted for his portraits of the aristocracy and for his religious and philanthropic work late in life.

CLIFFORD, Edward Charles, R.I. 1858 – 1910 (London)
An illustrator and figure painter who exhibited from 1891 and was elected R.I. in 1899. He was Secretary of the Artists' Society and the Langham Sketching Club and one of the Principals of the Berry Art School. He provided illustrations and essays for the *Art Journal* and similar magazines.

Published: *Trees and Tree Drawing*, 1909.

CLINT, Alfred 1807 (London) – 1883 (London)
The younger son and pupil of G. Clint (q.v.), he was primarily an oil painter, but he also produced landscapes, port and coastal scenes and portraits in watercolour. He exhibited from 1828, was Secretary of the S.B.A. from 1858 and President from 1870. He also made a brief appearance as a member of the N.W.S. in 1833. Many of his subjects were found on the South Coast and in the Channel Islands. His remaining works were sold at Christie's, February 23, 1884.

Published: *Landscape from Nature*, 1855. *Guide to Oil Painting*, c.1885.
Illustrated: G.J. Bennett: *The Pedestrian's Guide through North Wales*, 1838.
Examples: B.M.

CLINT, George 1770 (London) – 1854 (London)
A portrait painter and engraver, he was educated in Yorkshire and apprenticed to a fishmonger. However, after a quarrel with his master, he became a decorator, working at Westminster Abbey and elsewhere in London. Later he took up miniature painting and then tried larger portraits in oil and watercolour. He made copies of prints after Morland and Teniers and painted leading actors and actresses in scenes from their plays. He was elected A.R.A. in 1821 but resigned in 1836. He produced both engravings and mezzotints. Of his five sons it is probable that GEORGE CLINT, YR. was the eldest. He drew Yorkshire coast scenes at the end of the century and is represented in the Bridlington Library.

Examples: B.M.
Bibliography: *A.J.*, July, 1854.

CLIVE, Alan Butler
 1746 (Woking) – 1810 (Plumpton Green, Sussex)
A traveller, author and drawing master who was the son of a brewer. He visited France, Germany, South America, the North American

Colonies in 1768 and the Cape. On his return from the latter, in 1784, he founded the *Blackfriars Advertiser,* which collapsed after only two issues, and wrote a picaresque novel, now rare, *The Adventures of Young Lancelot,* 1790. His later years were spent as a drawing master in Sussex, but his dissolute habits prevented him from building up any considerable practice. He died by falling down the steps of an inn cellar. His work is traditional and his drawing can be neat and accurate, but his colour is sometimes garish.

Bibliography: A. Browne: *Stews of London,* 1928.

CLOVER, Joseph 1779 (Aylsham, Norfolk) – 1853
A portrait painter in oil and watercolour who worked in Norwich and was inspired by John Opie. He exhibited at the R.A. and the B.I. from 1804 to 1836, and his works comprise a valuable catalogue of the features of the painters of the Norwich School.

Examples: Castle Mus., Norwich.

CLOWES, Harriett Mary
A painter of church interiors and exteriors and landscapes in Scotland and on the Rhine. She was working at least between 1847 and 1861 and sometimes collaborated with E. A. CLOWES.

COBBETT, Edward John 1815 (London) – 1899
A landscape and genre painter who was a pupil of J.W. Allen (q.v.). He exhibited at the R.A. from 1833 to 1880 and was a member of the R.B.A.

COCHRANE, Helen Lavinia, Mrs., née Shaw
1868 (Bath) – 1946
A painter of romantic landscapes and Venetian scenes, she was educated at Clifton High School and studied at the Liverpool and Westminster Schools of Art and in Munich. She lived in Italy and, during the First World War, was in charge of military hospitals at Menton and Sargens.

COCKBURN, Edwin
A painter of domestic genre and landscapes who was a pupil of J. Jackson (q.v.). He was working from 1835 to 1870 and painted at Whitby early in his career, becoming a friend of G. Chambers (q.v.). He lived in London.

Examples: B.M.

COCKBURN, Major-General James Pattison
c.1779 – 1849 (Woolwich)
A pupil of P. Sandby (q.v.) at Woolwich, which he entered in 1793 and left in 1795 to serve at the capture of the Cape of Good Hope. He was in India in 1798 and at Copenhagen as a captain in 1807. He also visited Canada. He was Director of the Royal Laboratory, Woolwich, from 1838 to 1846, in which year he was promoted major-general. After the peace of 1815 he was stationed for a time at Malta, from where he made a number of visits to Italy and Switzerland, which resulted in several publications. His drawings, often in greys, greens and blues, can be charming and of a high quality.

Published: *Swiss Scenery,* 1820. *Views in the Valley of Aosta,* 1822. *Views to Illustrate the Simplon Route,* 1822. *Views to Illustrate the Mont Cenis Route,* 1822.
Examples: B.M.

COCKRELL, Charles Robert, R.A. 1788 (London) – 1863
An architect and archaeologist, he was the son of Samuel Pepys Cockrell and was educated at Westminster. He worked for his father for about five years, during which time he toured Wales and the West Country. In 1810 he went to Turkey and Greece, where he was one of the discoverers of the Aegina marbles with J. Foster (q.v.) and Baron Heller. In 1811 and 1812 he toured the country of the Seven Churches and the Ionian Islands. After visiting Malta, Sicily and Albania, he returned to Greece in 1813. He wintered in Rome in 1815-16 and reached England in 1817. Thereafter he concentrated on his architectural practice. He was elected A.R.A.

and R.A. in 1829 and 1836 and was appointed Professor of Architecture in 1840, retiring in 1857. Not only was he an excellent architectural draughtsman, but his figures and landscapes are of a high order.

Published: *The Antiquities of Athens* etc., 1830. *The Temple of Jupiter Olympus at Agrigentum,* 1830. *The Iconography of the West Front of Wells Cathedral,* 1851. *The Temples of Jupiter Panhellenus* etc., 1860.
Examples: B.M.; V.A.M.; R.I.B.A.
Bibliography: *A.J.,* November, 1863. *R.I.B.A. Transactions,* 1863-4; N.S. vi, 1890. *R.I.B.A. Journal,* 3rd series, vii, 1899-1900; xviii, 1911; xxxvii, 1930.

COCKING, Thomas
The personal servant and draughtsman to F. Grose (q.v.). It is probably impossible to distinguish the work of man and master. Pierce Egan in his *Sporting Anecdotes* says: 'The Captain had a funny fellow of the name of Tom Cocking, one after his own heart, as an amanuensis, and who was also a draughtsman of considerable merit.' He accompanied Grose to Scotland and Ireland and was active between 1783 and 1791.

Examples: R.I.A.

COCKRAM, George, R.I. 1861 (Birkenhead) – 1950
A painter of mountains and coasts who studied at the Liverpool School of Art from 1884 and in Paris in 1889. He exhibited at the R.A. from 1883 and was elected R.I. in 1913. He lived in Liverpool until 1890 and thereafter in North Wales, at Conway and in Anglesey. His subjects were predominently Welsh, but in his later years he also painted in Venice.

Examples: Christchurch A.G., N.Z.; Walker A.G., Liverpool; Portsmouth City Mus.

COCKRAN, Jessie
A fruit painter who exhibited with the Society of Female Artists in 1875.

COLE, George Vicat, R.A. 1833 (Portsmouth) – 1893 (London)
The son and pupil of George Cole, a landscape painter, his first exhibited works were views in Surrey and on the Wye which were shown at the B.I. and the S.B.A. in 1852. In the following year he toured Germany with his father, and then he set himself up as a drawing master in London. From 1863 until 1867 he lived at Holmbury Hill, Surrey, and thereafter in Kensington. He was elected A.R.A. and R.A. in 1870 and 1880. At this period he also broadened his scope by painting in the Thames Valley and Sussex, and after 1888 he found many subjects in the Pool of London.

Cole was primarily an oil painter, and his best work in both oil and watercolour was done in his earlier, Surrey period, when he showed a meticulous craftsmanship and an understanding of the effects of sunlight. When there is no other clue, it is possible to give an approximate date to his works by the signature. Until 1854 he signed in full, then Vicat Cole *tout court* until 1870 after which he used a 'V.C.' monogram. His son REX VICAT COLE was also a landscape painter.

Examples: B.M.; V.A.M.; Cartwright Hall, Bradford.

COLE, Sir Henry 1808 (Bath) – 1882 (London)
The son of an army officer, he was educated at Christ's Hospital from 1817 and in 1823 entered the Record Commission under Sir Francis Palgrave. He also studied under Cox and exhibited at the R.A. On the setting up of the Record Office in 1838, he was made one of the senior assistant-keepers. Through his work he developed an interest in medieval art, and he learnt engraving and later etching. Under the name of 'Felix Summerly' he wrote illustrated guide books and books for children. He became a member of the Society of Arts in 1846 and was Chairman in 1851 and 1852. He was also on the Committee for the Great Exhibition in 1851. Until his retirement in 1873 he was much involved with the Schools of Design, of which he became Secretary, and with the formation of

the South Kensington Museums, of which he was the first Director. He also proposed the plans for the Albert Hall. For the rest of his life he continued to take an interest in projects for artistic reform. From 1876 to 1879 he lived in Birmingham and Manchester, returning to London in 1880. He was made K.C.B. in 1875. Fifty-eight volumes of his diaries, dating from 1822 to 1882, are in the V.A.M.

Examples: V.A.M.

COLEBROOKE, Lieutenant Robert Hyde
 1762 – 1808
A soldier and surveyor who served in the Mysore War and was Surveyor-General of India from 1800 until his death.

Published: *Twelve Views of Mysore,* 1794.

COLEMAN, Rebecca c.1840 (Horsham) –
The sister of W.S. Coleman (q.v.) and Mrs. Angell (q.v.). With her brother's encouragement she spent a few months at Heatherley's, but found the life of an artist too difficult. She taught English in Germany for three years, returning on the outbreak of the Austro-Prussian War in 1866. Thereafter she took to painting seriously, producing portraits, figure and genre subjects, as well as making a name for herself as a designer of heads on pottery.

COLEMAN, William Stephen 1829 (Horsham) – 1904 (London)
The brother of Mrs. Angell (q.v.) and R. Coleman (q.v.), he was trained as a surgeon before he turned to art. He exhibited between 1865 and 1879, producing landscapes with figures, rather in the manner of M.B. Foster (q.v.), classical figure subjects akin to those of A. Moore (q.v.), and pastels, oil paintings and etchings. He was a keen naturalist, making illustrations for books and for the *Illustrated London Almanack,* and designing a heading for the *Field.* Until 1881 he was on the committee of the Dudley Gallery.

Published: *Our Woodlands, Heaths and Hedges,* 1859. *British Butterflies,* 1860.
Examples: V.A.M.; Grundy A.G., Blackpool.

COLEY, Hilda
A flower painter who was working in Birmingham in about 1805.

COLKETT, Samuel David 1800 (Norwich) – 1863 (Cambridge)
A pupil of J. Stark (q.v.), he lived in London from 1828 to 1836, when he returned to Norwich and set up as a drawing master and also in business as a picture dealer and restorer. From 1843 to 1853 he lived at Great Yarmouth and, for the last ten years of his life, in Cambridge. He often produced copies of Stark's work.

Examples: B.M.; Castle Mus., Norwich.
Bibliography: W.F. Dickes: *The Norwich School,* 1905.

COLLET, John c.1725 (London) – 1780 (London)
A caricaturist, he was a pupil of G. Lambert (q.v.) and studied at the St. Martin's Lane Academy. He first exhibited with the Free Society in 1761, and last appeared there, posthumously, in 1783. He inherited a 'genteel fortune', and lived in Chelsea. A large number of prints were made from his drawings and published by such leading figures as Carington Bowles, Smith and Sawyer, and Boydell.

His caricatures owe much to Hogarth, but have not his moral force. Both they and his landscape and figure drawings are rather clumsy and generally have a thick black pen outline. His colour can be harsh, and the whole effect is rather stiff, although not devoid of charm.

Examples: B.M.; V.A.M.; Leeds City A.G.

COLLIER, Alexander
A landscape painter in oil and watercolour who worked in London and Southampton and exhibited from 1870 to 1882.

COLLIER, Thomas, R.I. 1840 (Glossop) – 1891 (Hampstead)
The landscape painter. He was the best and most important of the inheritors of the traditions of Cox and de Wint. He studied at the

Manchester School of Art, and from 1864 to 1869 he lived at Bettws-y-Coed, which remained a source of inspiration to him throughout his career. He first exhibited in London in 1863, and he moved there in the hope of election to the O.W.S. However, he was turned down twice and turned to the N.W.S., being elected Associate unanimously in 1870 and a full member two years later. In 1879 he built himself a large house and studio in Hampstead. He continued to visit many parts of the country on sketching tours, especially Wales and East Anglia. His health was always weak, and it cannot have been helped by his habit of working out of doors in all weathers. He died young and comparatively unnoticed by the artistic establishment, although in 1878 his first exhibit in Paris, a view of *Arundel Castle from the Park,* had won him the Legion of Honour.

J. Orrock (q.v.), who had first met with his work in Birmingham in 1868, called him 'a master in our English School', and 'the finest of sky painters, especially of rain and cumulus clouds, while possessing more mastery of direct modelling and pearl-grey shadows than any of our brotherhood'. Orrock, along with his other friends, E.M. Wimperis (q.v.), C. Hayes (q.v.) and R. Thorne Waite (q.v.) also paid him the flattery of imitation.

Collier's subjects, moor and downland, tend to be repetitive, but this is partly because the quality of his work is so consistent.

Examples: B.M.; V.A.M.; Aberdeen A.G.; Williamson A.G., Birkenhead; Birmingham City A.G.; Towneley Hall A.G., Burnley; Guildhall; Harrogate A.G.; Leeds City A.G.; Walker A.G., Liverpool; City A.G., Manchester; N.G., Ireland; Nat. Mus., Wales; Laing A.G., Newcastle; Castle Mus., Nottingham; Oldham A.G.; Lady Lever A.G., Port Sunlight; Salford A.G.; Sheffield A.G.; Stoke A.G.; Ulster Mus.; Wakefield City A.G.
Bibliography: A. Bury: *The Life and Art of T.C.,* 1944. G. Emslie: *A Countryman's Anthology,* 1944.

COLLIER, Thomas Frederick
A landscape painter who entered the R.D.S. Schools in 1848. He exhibited at the R.H.A. from 1850 and also at the R.A. in 1856, 1857 and 1860. From 1853 he taught at the Cork School of Design, becoming Headmaster in 1860. He became an alcoholic, and was forced to leave the School a few months after his promotion. He also left his wife and children, and may have moved to England, where he exhibited until 1874.

He painted town views and landscapes, some with rather awkward figures, and also produced still-lifes in the manner of Clare.

His son BERNARD COLLIER occasionally exhibited at the R.H.A., and taught for a time at Hereford and at the Canterbury School of Art founded by T.S. Cooper.

Examples: B.M.; V.A.M.; Ashmolean; Newport A.G.

COLLING, James Kellaway
An architectural and landscape painter who was active in Norfolk and elsewhere between 1844 and 1883.

Published: *Gothic Ornaments,* 1846-50. *Details of Gothic Architecture,* 1851-6. *Art Foliage,* 1865. *Examples of English Medieval Foliage,* 1874. *Suggestions in Design,* 1880.

COLLINGS, Charles John 1848 (Devonshire) – 1931
A landscape painter working rather in the Barbizon manner, he first exhibited in 1887. A number of one-man and other exhibitions were held in London prior to 1910 when he moved to Canada, settling in British Columbia. Thereafter he painted the Rockies.

He has a highly original broad sweeping style and a strong sense of form and design and atmospheric effect. His deep admiration for Cotman is shown in his work.

Examples: Fitzwilliam.
Bibliography: *Apollo,* LIV, 1951.

COLLINGS, Samuel
A landscape painter and caricaturist. He provided Rowlandson with

drawings for prints, including satires on Johnson's *Tour to the Hebrides* and Goethe's *Sorrows of Werter*. He also contributed humorous drawings and verses to the *Wit's Magazine*. He exhibited at the R.A. between 1784 and 1789.

Published: *Picturesque Beauties of Boswell*, 1786.
Examples: B.M.

COLLINGWOOD, William, R.W.S.
1819 (Greenwich) – 1903 (Bristol)
A landscape painter, he was the son of an architect and a pupil of J.D. Harding (q.v.) and S. Prout (q.v.) as well as of his cousin W.C. Smith (q.v.). From about 1856 he made his name as an Alpine painter. Much of his working life was spent in Liverpool, where he was a lay preacher for the Plymouth Brethren.

His son was William Gersham Collingwood, Ruskin's disciple and secretary.

Examples: V.A.M.; Ashmolean.

COLLINS, Charles **– 1744**
A painter of still-lifes and especially of birds in water and bodycolour. He was working in 1720s and 1730s and may well have been Irish. He was certainly active in Dublin, and in the catalogue of the collection of Sir Gustavus Hume, which was sold in Dublin in May 1786, there are 'two pictures, most admirably executed, one of live fowl, the other a dead hare, etc., by an Irish master, Collins'.

Examples: B.M.; Leeds City A.G.

COLLINS, Charles Allston **1828 – 1873**
The second son of W. Collins (q.v.), he studied at the R.A. Schools, sketched with Millais and joined the Pre-Raphaelites. He exhibited at the R.A. from 1847 to 1855, when he gave up painting for literature. He married Kate Perugini (q.v.), a daughter of Charles Dickens.

Examples: B.M.; Ashmolean.
Bibliography: *A.J.*, June 1873; 1904.

COLLINS, George Edward **1880 (Dorking) – 1968**
An etcher and illustrator. He was educated at Dorking High School and studied at the Epsom and Lambeth Schools of Art. He was interested in natural history and illustrated an edition of Gilbert White's *Selborne* in 1911. He was art master at his old school and later at the Royal Grammar School, Guildford, and lived at Gomshall.

COLLINS, Thomas **– c.1894**
A painter of flowers, still-lifes and landscapes who lived in Birmingham. He exhibited both there and in London from 1857 to 1893.

COLLINS, William, R.A. **1788 (London) – 1847 (London)**
The son of an Irish author who wrote a biography of Morland. Collins watched Morland painting, and his enthusiasm encouraged his father to send him to the R.A. Schools in 1807. By 1812 he had established himself as a painter of landscapes and genre scenes. In 1815 he visited the Norfolk coast, where he stayed with the family of J. Stark (q.v.); in 1817 he went to Paris and in 1828 visited Holland and Belgium. In 1836 he went to Italy, where he stayed until 1838. He visited Germany in 1840 and the Shetlands in 1842. In between these journeys he made numerous sketching tours in England and Scotland. He was elected A.R.A. in 1814 and R.A. in 1820. In 1840 he was appointed Librarian, but he resigned after two years. In 1822 he married the sister of M.S. Carpenter (q.v.), and he was a life-long friend of Linnell.

In both subject matter and style he resembles Mulready, being a careful and pretty draughtsman, if a little dull. His landscapes are generally freer and can be very attractive. Again, like Mulready, he made watercolour versions of some of his better known oil paintings.

He was the father of Wilkie Collins, who wrote his biography, and of C.A. Collins (q.v.), the painter and author.

Examples: B.M.; V.A.M.; Towner Gall., Eastbourne; N.G., Scotland; Newport A.G.; Portsmouth City Mus.
Bibliography: W.W. Collins: *Memoirs of the Life of W.C.*, 1848. *Athenaeum*, February 20, 1847. *A.J.*, May, 1855.

COLLINS, William Wiehe, R.I. **1862 (London) – 1951**
A painter of military subjects and street scenes, he was the son of an Army doctor and was educated at Epsom College. He was elected R.I. in 1898 and in the First World War saw service in the Dardanelles and in Egypt, which provided him with subjects. Later he lived in Wareham, and Bridgwater, Dorset.

Exhibitions of his work were held at the Fine Art Society in 1901 and the Abbey Gallery in 1927.

Published: *Cathedral Cities of Spain*, 1909. *Cathedral Cities of Italy*, 1911.
Illustrated: G. Gilbert: *Cathedral Cities of England*, 1905. R.H. Cox: *The Green Roads of England*, 1914.

COLLINSON, James
1825 (Mansfield, Nottingham) – 1881 (London)
An original Pre-Raphaelite Brother who studied at the R.A. Schools and was engaged to Christina Rossetti in 1849-50, when he resigned from the Brotherhood and retired to become a monk at Stonyhurst. Later he returned to London and painted pretty genre subjects in oil and occasionally watercolour. He exhibited from 1847 and his work can be like that of W. Henry Hunt (q.v.) without the high finish.

Examples: Ashmolean.
Bibliography: *Apollo*, XXXI, 1940.

COLLYER, H H
1863 (Leicestershire) – 1947 (Mapperley, Nottingham)
He moved to Nottingham at the age of thirty and became a member of the Nottingham Society of Artists. He was associated with the firm of Tom Browne Ltd., Colour Printers, founded by T.A. Browne (q.v.). He was an amateur and painted local scenes, particularly gardens.

COMBER, Mary E
A painter of mossy banks and blossoms in the manner of W. Cruickshank (q.v.). She lived in Warrington and was active in the 1880s.

COMPTON, Edward Theodore 1849 – (Bavaria)
An active climbing and painting member of the Alpine Club. During the First World War he was nominally interned, after which he attempted to work as an art correspondent near the Italian frontier, but was refused a permit. He lived for most of his life in Austria and Germany, sending contributions to London exhibitions, including the R.A. from 1879. After his seventieth birthday he climbed the Gröss Glockner. His work is generally delicate both in colour and feeling.

Illustrated: T. Compton: *A Mendip Valley*, 1892. J.F. Dickie: *Germany*, 1912. G.W. Bullett: *Germany*, 1930.

CONDER, Charles Edward 1868 (London) – 1909 (Virginia Water)
A painter of landscapes in oil and charming fan designs, often on silk, in watercolour. He was brought up in India and went to Australia in 1885. There he worked for the *Illustrated Sydney News* and studied at the Melbourne Art School. In 1890 he went to Paris and Julian's, and in 1897 he settled in London. He was elected to the N.E.A.C. in 1901, and he gave up painting because of poor health, in 1906.

Examples: B.M.; Aberdeen A.G.; Cecil Higgins A.G., Bedford; Cartwright Hall, Bradford; Fitzwilliam; Glasgow A.G.; Leeds City A.G.; City A.G., Manchester; N.G., Scotland; Ulster Mus.
Bibliography: F.G. Gibson: *C.C.*, 1914. J. Rothenstein: *The Life and Death of C.C.*, 1938. *A.J.*, 1909. Tate Gall.: *Exhibition Cat.*, 1927.

CONDY, Nicholas 1793 (Torpoint, Cornwall) – 1857 (Plymouth)
After service in the Peninsula, Condy retired as a half-pay lieutenant

in 1818 and became a professional artist in Plymouth. Between 1830 and 1845 he occasionally exhibited at the R.A., the B.I. and Suffolk Street.

His works are mainly small watercolours on tinted paper, usually about 5in. x 8in. They are executed in water and bodycolour, often with rather garish reds and greens. They are somewhat impressionistic in technique and can be very appealing.

His son, NICHOLAS MATTHEW CONDY (1818-1851) was also a marine painter and teacher in Plymouth. There are examples of his work at Exeter Mus. and Greenwich.

Published: *Cotehele . . . the seat of the Earl of Mount-Edgecumbe*, 1850.

CONEY, John 1786 (London) – 1833 (Camberwell)
A topographical draughtsman and engraver who was apprenticed to an architect but never practised. He exhibited ten works at the R.A. between 1805 and 1821. From 1815 to 1829 he drew and engraved a series of exterior and interior views of English Cathedrals and Abbeys, and from 1829 to 1832 he was engaged in similar work on Continental Cathedrals, Town Halls and the like. He also engraved for C.R. Cockerell (q.v.) and Sir John Soane.

He is best on a small scale; his larger works are poor in detail.

Published: *A Series of Views . . . of Warwick Castle*, 1815. *The Beauties of Continental Architecture*, 1843. Etc.
Illustrated: Sir W. Dugdale: *Monasticon Anglicanum*, 1846.
Examples: B.M.; V.A.M.; Ashmolean.

CONNOLLY, John
An Irish landscape painter, working in the early nineteenth century. He also produced several lithographs, both after his own drawings and those of other artists.

CONRADE, Alfred Charles 1863 (Leeds) – 1955
A very fine traditional architectural painter who studied in Düsseldorf, Paris and Madrid. He travelled widely in Europe and visited Japan. He was chief artist at the White City from 1911 to 1914, and he lived in London, Kingston-on-Thames and Manchester.

Examples: B.M.

CONSTABLE, John, R.A.
1776 (East Bergholt, Suffolk) – 1837 (Hampstead)
By the time he left Dedham Grammar School between sixteen and seventeen, Constable was already determined on becoming an artist, but at his father's insistence he worked for a while in the family watermills. He early acquired his first patron, Sir G. Beaumont (q.v.), who introduced him to the works of Claude and, later, Girtin. From 1795, when he paid a visit to London, he was also aided by J.T. Smith (q.v.), who helped him with his artistic education thereafter by letter. In 1799 he finally abandoned milling and was admitted to the R.A. Schools. In 1801 he visited Derbyshire, in 1803 he made a voyage from London to Deal and in September and October, 1806, he made a tour of the Lake District. In 1809, with the encouragement of Farington, he stood for, but failed to gain, election as A.R.A. He was finally elected in 1819 and a full member in 1829. In 1811 he first visited Salisbury, and the area became, with Sussex and Hampshire, one of his favourite sketching grounds. He stayed with Beaumont at Coleorton Hall, Leicestershire, in 1823, and visited Brighton annually between 1824 and 1828. He was at Arundel in 1834 and 1835. Otherwise his life was uneventful; despite the influence which his pictures had on the Continent from 1824, he never went abroad himself.

Even his large and formal studio drawings show an unexpected spontaneity of handling, and in the best of his pencil drawings and watercolour sketches there is a freedom that is far ahead of his time. These sketches, like his cloud studies, whilst only intended as rough notes, convey a strong atmosphere and sense of locality. Many of these characteristic and most remarkable watercolours date from the last decade of his life.

His children all drew to some degree. They were JOHN CHARLES CONSTABLE (1817-1841); MARIA LOUISA

CONSTABLE (1819-1885); CHARLES GOLDING CONSTABLE (1821-1879), who served in the Indian Navy and sketched in the East, the Mediterranean and widely in Britain; ISOBEL CONSTABLE (1822-1888), who painted studies of shells; EMILY CONSTABLE (1825-1839); ALFRED ABRAM CONSTABLE (1826-1853) and LIONEL BICKNELL CONSTABLE (1828-1887).

Published: *Various Subjects of Landscape characteristic of English Scenery*, 1830-32.
Examples: B.M.; V.A.M.; Ashmolean; Cecil Higgins A.G., Bedford; Birmingham City A.G.; Blackburn A.G.; Exeter Mus.; Leeds City A.G.; City A.G., Manchester.
Bibliography: C.R. Leslie: *Memoirs of the Life of J.C., R.A.*, 1843. S.J. Key: *J.C., his Life and Work*. J.C. Holmes: *C*, 1902. J.D. Linton: *C's Sketches*, 1905. A. Shirley: *J.C.*, 1944. A.G. Reynolds: *C., the Natural Painter*, 1965. F. Constable: *J.C.*, 1975. I. Fleming-Williams: *C – Landscape Watercolours and Drawings*, 1976. *A.J.*, January, 1855; 1903. O.W.C. Club, XII, 1935. *Country Life*, May 1, 1937; April 16, 1938; March 10, 1955. *Connoisseur*, CXXXVIII, 1956. A.G. Reynolds: *Cat., of the Constable Collection at the V.A.M.* 1960. Tate Gall.: *Exhibition Cat.*, 1976.

COOK, Charles A
A landscape painter who was active in Kent, Sussex and East Anglia in the 1890s. He visited Rome in 1891. He might perhaps be identified with Sir Charles Archer Cook, the legal writer.

COOK, Ebenezer Wake 1843 (Maldon, Essex) – 1926 (London)
A landscape painter who studied in Paris and exhibited at the R.A. from 1875 to 1910 as well as at the R.I. He took his subjects from Italy and the Lakes, Switzerland, Yorkshire and the Thames Valley. His work is pretty but over-sweet and detailed, and his colours are bright. He was a spiritualist.

Published: *Anarchism in Art and Chaos in Criticism*, 1904. *Retrogression in Art and the Suicide of the Royal Academy*, 1924.
Examples: V.A.M.; Shipley A.G., Gateshead; Melbourne A.G.; Sydney A.G.

COOK, Edward Dutton 1829 (London) – 1883 (London)
An author, playwright and dramatic critic, he studied painting under Charles Rolt and for a time worked for *Punch* as a wood engraver.

COOK, Herbert Moxon 1844 – c.1920
A landscape painter in oil and watercolour who exhibited at the R.A., the R.I. and elsewhere from 1868. He lived in London and later in his career at Prestatyn, North Wales.

Examples: Manchester A.G.

COOK, Richard, A.R.A. 1784 (London) – 1857 (London)
An historical painter who studied at the R.A. Schools. He first exhibited at the R.A. in 1808 and was elected A.R.A. in 1816. As well as his work in oil he was a book-illustrator and made many tinted pencil sketches of figures, furniture, arms and the like.

His remaining works, including sketches, were sold at Christie's, June 1, 1857.

Illustrated: Sir W. Scott; *The Lady of the Lake*, 1810.
Examples: B.M.; Swansea A.G.

COOK, Samuel, of Plymouth, N.W.S.
1806 (Camelford, Cornwall) – 1859 (Plymouth)
He received a rudimentary education, and at the age of nine was apprenticed to a local firm of woollen manufacturers. At the same time he was painting sign boards and the like. Once out of his articles he moved to Plymouth and eventually set up as a house painter. In his spare time he made sketches of the coast and quays. He was an unsuccessful candidate for the N.W.S. in 1843 but was elected Associate and Member in 1849 and 1854. In the former year he was in Ireland.

Examples: B.M.; V.A.M.; Exeter Mus.; Shipley A.G., Gateshead.

COOK, William, of Plymouth
Probably the son of S. Cook (q.v.), he painted repetitive views of the Cornish coasts. They are usually signed with initials and are painted in a very characteristic range of greens and pinks. He exhibited in London in the 1870s.

COOKE, Edward William, R.A., F.R.S.
1811 (London) — 1880 (Groombridge, Kent)
The son of the engraver George Cooke, he was already making wood engravings of plants for publication by the age of nine. Some of these were used to illustrate Loudon's *Encyclopaedia of Plants*, and others Loddidge's *Botanical Cabinet*. He married Loddidge's daughter. In about 1825 he met C. Stanfield (q.v.), and sketched boats after him. He began to study architecture under A. Pugin (q.v.), but gave this up to pursue his interest in ships. Between 1825 and 1831 he made a series of drawings of the building of the new London Bridge, and also made studies of antiquities at the B.M. In 1826 he sketched on the Norfolk coast at Cromer, in 1830 he went to Normandy and between 1832 and 1844 he visited Belgium and Holland several times, France, Scotland, Ireland and elsewhere. In 1845-6 he was in Italy and later he travelled in Spain, North Africa, Germany, Denmark and Sweden. He was elected A.R.A. in 1851 and R.A. in 1864.
His drawing is of a very high quality, and he made many careful pencil studies. His full watercolours are more rare and are also impressive. Occasionally he painted small figure studies of fisherfolk.
His remaining works were sold at Christie's, May 22, 1880.

Examples: B.M.; V.A.M.; Glasgow A.G.; Greenwich: Leeds City A.G. (with Cotman); Wakefield A.G.
Bibliography: *A.J.* 1869; 1880.

COOKE, George
1781 (London) — 1834 (Barnes)
The engraver and father of E.W. Cook (q.v.). Occasionally he painted landscapes and architectural subjects in wash.

Examples: B.M.

COOKE, Isaac
1846 (Warrington) — 1922
A landscape painter in oil and watercolour who exhibited in London and elsewhere from 1879. He was a member of the R.B.A. from 1896 to 1915 and of the Liverpool Academy and Water-Colour Society. He lived in Cheshire.

COOKE, William Cubitt
1866 (London) — 1951
A landscape and figure painter and book illustrator who was apprenticed to a chromo-lithographer. He studied at Heatherley's and the Westminster School of Art and exhibited from 1890. He worked for the *I.L.N.* and the *Graphic* and lived in London and Stroud.

COOKSEY, Mary Louise Greville 1878 (Birmingham) —
An 'ecclesiastical artist' and figure and landscape painter in watercolour and oil. She studied at the Leamington and Liverpool Art Schools and South Kensington, and she won a travelling scholarship to Italy. She lived at Freshfield, Lancashire.

COOPER, Abraham, R.A.
1787 (London) — 1868 (Greenwich)
A painter of sporting and battle pictures, he was largely self-taught except for a few lessons from Benjamin Marshall. At the age of thirteen he was working at Astley's Circus and soon afterwards for Meux the brewer. He first exhibited at the B.I. in 1814 and he was elected A.R.A. and R.A. in 1817 and 1820. Among his pupils were the elder Herring and William Barraud. He was primarily an oil painter.

Examples: B.M.
Bibliography: *A.J.*, 1863; 1869.

COOPER, Alfred Heaton
1864 — 1929 (London)
A landscape and still-life painter and illustrator who lived at Ambleside. He exhibited in London from 1885 and was the father of ALFRED EGERTON COOPER (1883-1974), who painted similar subjects and portraits.

COOPER, Edwin W
1785 (Beccles) — 1833
An animal painter who was the son of DANIEL COOPER, who taught drawing at Bury School. He worked at Norwich, Newmarket and Cambridge and specialised in horse portraits. He also painted stalking and genre subjects.

Examples: B.M.; V.A.M.; Castle Mus., Norwich.

COOPER, Emma, Mrs., née Wren
1837 (Buntingford, Hertfordshire) —
A bird and flower painter, she married C.B. Cooper on leaving school in 1858 and only took to art seriously in 1865. She was a friend of the Coleman family (q.v.), who encouraged her study at Heatherley's. During the 1870s she obtained a great reputation as a successor to 'Bird's Nest' Hunt and as an illuminator. Inevitably, wrens were a favourite subject.

Published: *Plain Words on the Art and Practice of Illumination*, 1868.

COOPER, Frederick Charles
c.1821
An artist who was sent out to Layard at Nineveh in 1849 by the B.M. The two did not get on, and Layard seems to have taken credit for some of Cooper's better work. Cooper's landscapes are effective, but his figures can be rather shaky. He may be identifiable with F.C. Cooper (q.v.).

Illustrated: H.A. Layard: *Nineveh and Babylon.*

COOPER, F C
c.1811 (Nottingham) — c.1880
After setting up as an artist in Nottingham, he moved to London, where he exhibited at the R.A., the B.I. and Suffolk Street between 1844 and 1868. He painted chiefly figure subjects and interiors, in oil and watercolour. He may be identifiable with Frederick Charles Cooper (q.v.).

COOPER, George
An architect who exhibited topographical drawings at the R.A. from 1792 to 1830.

Published: *Architectural Reliques...*, 1807. *Designs for the Decoration of Rooms*, 1807.
Examples: B.M.

COOPER, Richard, Yr.
1740 (Edinburgh) — c.1814
The son of RICHARD COOPER (d.1764), the engraver and occasional watercolourist. Cooper studied in London and Paris and went to Italy in about 1770 and he may have stayed there until at least 1776. He had certainly returned by 1778, when he exhibited Roman and Italian views at the R.A. and thereafter he shows a penchant for the Richmond and Kew area. He lived for a time in Edinburgh and in the 1780s was drawing master at Eton. He later taught the Princess Charlotte. His drawings are usually in pen or pencil and wash, often a distinctive yellow-brown wash, but he occasionally produced pure watercolours. He was fond of small, strongly contrasted areas of light and shade, outlined with pen, giving a mottled, sunlit effect, which may have been imitated from Canaletto, whose drawings and etchings he may well have seen at Windsor Castle.

Examples: B.M.; V.A.M.; Aberdeen A.G.; Fitzwilliam; Leeds City A.G.; N.G. Scotland.

COOPER, Thomas George
c.1832
A landscape and rustic genre painter, he was a son of T.S. Cooper (q.v.). He visited North Wales and Osborne, Isle of Wight, with his father in 1848, and he exhibited from 1868 to 1896. He worked in both oil and watercolour.

COOPER, Thomas Sidney, R.A.
1803 (Canterbury) — 1902 (near Canterbury)
The landscape and cattle painter. He was first encouraged and taught by Doyle, a scene painter. He studied at the B.M. with G. Richmond (q.v.) and Catterson Smith as fellow pupils, and won a place at the R.A. Schools which he was unable to take up. He then

taught at Canterbury and, in 1827, went to France with W. Burgess (q.v.) and to Brussels where he remained until the revolution of 1830. He was strongly influenced by his friend Verboeckhoven. In 1829 he toured the Meuse towns with Captain Hotham (q.v.), a pupil, and in 1830 paid a brief visit to Holland. He returned to London in 1831. He exhibited at the R.A. from 1833, was elected A.R.A. and R.A. in 1845 and 1867, and collaborated on a number of oil paintings with F.R. Lee from 1847. He visited the Isle of Wight in 1839 and again, on a commission from the Queen, in 1848. In that year he also visited North Wales. Other sketching grounds included Liverpool, Norfolk and Devon. In the 1860s he moved back to Canterbury and in about 1869 set up an Art School and Gallery. He made a visit to Switzerland in 1879 and to Skye in 1882 or 1883.

His works, which are repetitive, with their groups of cattle or sheep often set in the Canterbury marshes, have been extensively faked, both in his lifetime and later. Many of the earliest fakes were taken from the lithographs which were issued in the 1840s.

In London his pupils included the daughters of Lord Liverpool; Lady Catherine Jenkinson, daughter of Earl Fitzwilliam; Mrs. Brand, daughter of Lord Stourton; and the daughter of Dr. Stephen Lushington.

Published: *T.S.C.'s Drawing Book of Animals and Rustic Groups*, 1853. *My Life*, 1890.
Examples: B.M.; V.A.M.; Aberdeen A.G.; Haworth A.G., Accrington; Blackburn A.G.; Exeter Mus.; Leeds City A.G.; Maidstone Mus.; City A.G., Manchester; Newport A.G.
Bibliography: E.K. Chatterton: *T.S.C.*, 1902. *A.J.*, 1849; 1861; 1902.

COOPER, William Sidney
The second son of T.S. Cooper (q.v.) or perhaps his nephew, he painted landscapes and cattle, and he exhibited at the R.A. from 1871 to 1908.

Examples: Maidstone Mus.

COPE, Charles — 1827
An amateur artist who lived in Wakefield. He was a friend of West and Turner, and the father of C.W. Cope (q.v.); and his wife also painted rustic subjects.

Published: *Views of Bolton Abbey and its Environs*, 1822.
Examples: Leeds City A.G.

COPE, Charles West, R.A. 1811 (Leeds) — 1890 (Bournemouth)
An historical painter and the son of C. Cope (q.v.), he studied at Sass's School in 1827 and entered the R.A. Schools in 1828. In 1832 he visited Paris and in 1833 set out for two years in Italy. He had been a friend of the patron John Sheepshanks from childhood and was introduced by him to G. Richmond (q.v.) and R. Redgrave (q.v.), with whom he sketched. He was a founder of the Etching Club, and he was elected A.R.A. and R.A. in 1843 and 1848. He was much taken up with fresco painting for the Houses of Parliament, and he visited Italy in 1845 in order to study the art. In 1876 he represented the R.A. at the Centennial Exhibition in Philadelphia. In 1879 he settled in Maidenhead.

His work in watercolour, apart from studies and sketches, consists of Leighton Leitch-like landscapes and illustrations.

Examples: B.M.; Ashmolean; Leicestershire A.G.
Bibliography: C.H. Cope: *Reminiscences of C.W.C. A.J.*, 1869.

COPLAND, Charles
At Greenwich there are forty pencil and watercolour sketches of St. Helena, Bombay and the East by this artist. They appear to have been drawn in about 1810.

COPPIN, Daniel c.1770 — 1822
A Norwich landscape painter in oil and occasionally in watercolour. He exhibited copies of Barker of Bath at the Norwich Society from 1805 to 1816 and was President in the latter year. He visited Paris in 1814 with Crome, and his daughter became E. Stannard (q.v.).

CORBAUX, Marie Francoise Catherine Doetter, 'Fanny', N.W.S.
 1812 — 1883 (Brighton)
She studied at the N.G. and the B.I. and in 1827 and 1828 her watercolours received silver medals from the Society of Arts. In 1830 she was elected an honorary member of the S.B.A., where she exhibited small oil paintings, and in 1839 a member of the N.W.S. She was well known as a biblical critic and writer. As well as figure studies in watercolour she painted miniatures.

Her sister LOUISA CORBAUX, N.W.S. (b.1808) exhibited children and animals from 1828 to 1881 at the R.A., the S.B.A., and the N.W.S., of which she was elected a member in 1837.

Illustrated: T. Moore: *Pearls of the East*, 1837. T. Moore: *Cousin Natalia's Tales*, 1841.
Examples: B.M.

CORBET, Matthew Ridley, A.R.A.
 1850 (South Willingham, Lincolnshire) — 1902 (London)
A portrait and landscape painter in oil and watercolour who was intended for the Army, but turned to art. He was educated at Cheltenham and studied under Davis Cooper, at the Slade and the R.A. Schools. In 1880 he went to Rome for three years, studying under Giovanni Costa. He exhibited from 1875 to 1902, gradually turning from portraits to landscapes. He was elected A.R.A. in 1902.

Examples: V.A.M.

CORBOULD, Aster Chantrey — 1920
A painter of horses, portraits, rustic genre and sporting subjects who worked for *Punch* and exhibited from 1878.

Other painting members of the family include ALFRED CHANTREY CORBOULD (ex.1831-1871); ALFRED HITCHENS CORBOULD (ex.1844-1875); ANNE ROSE CORBOULD; ASTER RICHARD CHANTREY CORBOULD (ex.1842-1877) and WALTER E. CORBOULD (b.1859).

CORBOULD, Edward Henry, R.I. 1815 (London) — 1905 (London)
The son of H. Corbould (q.v.) and a pupil of H. Sass (q.v.), he also studied at the R.A. Schools. He was elected N.W.S. in 1838 and from 1851 to 1872 was Instructor of Historical Painting to the Royal Family. He also specialised in literary subjects.

Examples: B.M.; Sydney A.G.

CORBOULD, Henry, F.S.A.
 1787 (London) — 1844 (Robertsbridge, Sussex)
A figure draughtsman and ilustrator who studied at the R.A. Schools, gaining a silver medal, and first exhibited at the R.A. in 1807. A major part of his work was as a book illustrator, but he was also employed for some thirty years in drawing the marbles at the B.M.

Illustrated: W. Camden: *History of England*. A. Lefanu: *Rosara's Chain etc.*, 1815; F. Burney: *Cecilia*, ?1825; D. Defoe: *Robinson Crusoe*, 1860.
Examples: B.M.; Leeds City A.G.

CORBOULD, Richard 1757 (London) — 1831 (London)
Although chiefly a book illustrator, he painted, both in oil and watercolour, portraits, landscapes, still-life, history, copies of old masters, and miniatures on ivory, porcelain and enamel, and he exhibited from 1776 to 1817. He also etched. Much of his work was for publishers, including Cooke, whose pocket editions of *English Classics*, upon which he worked, appeared from 1795 to 1800.

Examples: B.M.; V.A.M.

CORNER, Frank W (North Shields, Northumberland) — 1928
A town and coast painter who frequently exhibited in Northumbrian exhibitions. He was also an etcher.

Examples: Laing A.G., Newcastle; Sunderland A.G.

CORNER, Sidney
A London landscape and figure painter who exhibited from 1838 to

1849. In 1847 he was an unsuccessful candidate for the N.W.S. and in 1864 for the Keepership of the Society.

Published: *Rural Churches*, 1869. *The Earl's Path*, 1875.

CORNISH, Hubert c.1770 – 1832
A painter of shipping and landscapes and an amateur musician. He went to India as a Civil Servant in 1797 and in the same year survived the massacre in Benares. Later he became a judge in Bengal. In 1830 he retired to his estate at Totnes.

COSTELLO, Dudley 1803 (Sussex) – 1865 (London)
After Sandhurst, he became an ensign in the 34th Regiment of Foot, later serving with the 90th Foot in North America and the West Indies. He retired on half-pay in 1828 and went to Paris, where he worked with his sister in copying illuminated manuscripts. On his return to London in 1833, he became a journalist and novelist.

Published: *A Tour through the Valley of the Meuse*, 1846. *Piedmont and Italy from the Alps to the Tiber*, 1859-61.

COSWAY, Richard, R.A.
1740 (Tiverton, Devon) – 1821 (Edgeware, Middlesex)
A portraitist in watercolour, oil and miniature, he showed an early inclination towards art and was sent to London, where he studied at Shipley's Academy and under Hudson. In 1755 he won his first premium from the Society of Arts. On leaving Shipley, Cosway taught at Pars' drawing school, painted ship signs and 'not always chaste' snuff box lids. He was also a picture dealer. In 1769 he entered the R.A. Schools, and he was elected A.R.A. and R.A. in 1770 and 1771. In 1781 he married Maria Hadfield, herself an artist and one of the best known faces of the period. They visited Paris and Flanders together, but later separated. Cosway enjoyed the patronage of the Prince of Wales, the Duchess of Devonshire and other leaders of fashion. Like many artists of the time, he had leanings towards mysticism.

He usually painted small, full-length figures, sketchily executed, with the exception of the head and hands, which are highly finished.

Examples: Blenheim Palace; B.M.; Ashmolean; Fitzwilliam; Exeter Mus.
Bibliography: G.C. Williamson: *R.C., his Wife and Pupils*, 1897.

COTMAN, Frederick George, R.I.
1850 (Ipswich) – 1920 (Felixstowe)
A landscape, portrait and genre painter in oil and watercolour, he was the nephew of J.S. Cotman (q.v.). He studied at the R.A. Schools from 1868 and exhibited from 1871. He assisted Leighton for a time. He went to the Mediterranean with the Duke of Westminster, who had commissioned portraits from him, and made many watercolours during the tour. He was elected R.I. in 1882 and an exhibition of his work 'around London' was held at the Dowdeswell Galleries in 1888. His watercolours vary in quality. They can be very impressive with strong drawing and bright colours.

Examples: Ashmolean; Castle Mus., Norwich.
Bibliography: *Studio*, XLVII, p.167.

COTMAN, John Joseph 1814 (Great Yarmouth) – 1878 (Norwich)
The second son of J.S. Cotman (q.v.) and the most original of his children. In 1824 the family moved to Norwich, and he was apprenticed to his uncle, a haberdasher. His first sketches were made with his friends J. Geldart (q.v.) and Arthur Dixon. In 1834 he went to London with his father, where he helped to teach at King's College and studied at the B.M. and N.G. In the summer he had a holiday at Cromer, and in 1835 he returned to Norwich, the more practical Miles Edmund taking his place with his father. From 1849 to 1851 he lectured at the Thorpe Institute and in the latter year also at Yarmouth. In about 1852 Miles Edmund came to live with him at Thorpe-by-Norwich. In 1858 he moved back to the centre of Norwich. He was always mentally unstable, alternating periods of depression and lassitude with bursts of work. His personal life was also erratic.

His work is hot and bright, in some ways a cross between the styles of his father and Samuel Palmer. He was an inveterate sketcher.

Examples: B.M.; V.A.M.; Fitzwilliam; Gt. Yarmouth; Castle Mus., Norwich.

COTMAN, John Sell 1782 (Norwich) – 1842 (London)
He was educated at Norwich Grammar School, where he was encouraged to draw by the enlightened Headmaster, Dr. Forster. After a brief period in his father's drapery business he went to London in 1789, finding employment with Ackermann and earning the patronage of Dr. Monro (q.v.). Monro's classes provided one link with Girtin, and Cotman also became a member of the Francia/Girtin sketching club, although probably not until the very end of Girtin's life. In 1800 he made a sketching tour to Bristol and Wales, again meeting Girtin, whose work at this time his closely resembles. In 1801 he visited South Devon, and in 1802 he made another Welsh tour with P.S. Munn (q.v.). His most important summer sketching tours were in 1803, 1804 and 1805, when he visited his most influential patrons Mr. and Mrs. Francis Cholmeley of Brandsby Hall, Yorkshire. These visits provided Cotman with his inspiration for the next five years at least, and resulted in the Greta drawings which are perhaps the greatest in his career. He seems to have gone home to Norwich at some point in each year, and in 1803 he had briefly attempted to set up a drawing practice there. At the end of 1806 he did indeed return to Norwich, where he joined the Norwich Society and attempted to become a portrait painter. He stayed in Norwich until 1812, when he moved to Yarmouth to take over Crome's functions as supplier of architectural drawings to Dawson Turner, and teacher to his daughters. From 1824 to 1833, having escaped from Turner's benevolent but exacting patronage, he lived in Norwich again, but in the latter year he was elected Professor of Drawing at King's College, London, where he based himself for the rest of his life.

The most important works undertaken for Turner were the result of three journeys to Normandy in 1817, 1818 and 1820. The drawings done on these trips were the finest series of architectural wash drawings ever done by an English artist. Throughout his life, with the possible exception of the Yorkshire period, Cotman was subject to violent bouts of depression, and an inability to bear opposition, which led to a suppression of the stylistic individuality of his children and his pupils. In fact, he used his children as a sort of factory to produce drawings for his Circulating Library, through which he hired out drawings to amateurs to copy, and later for his classes at King's. Often these works are indistinguishable from his own, and are even signed by him. After the Greta drawings, in which his preoccupation was with pattern, flat areas of colour and clear-cut form to build up a fresh and vital whole, he gradually fell into a hardness and stylization which can become unattractive, despite his technical brilliance. This is especially true in the 1830s, when he attempted garish blue and gold historical paintings in a search for popular success. Of his late works, only those from his last Norfolk visit in 1841 have anything of the poetry and harmony of his best period. These were done entirely for his own pleasure, and provide a fitting end to his career. In his maturity, by the boldness of his colour and the simplicity of his subject matter and composition, he was more advanced in spirit than many who came after him. In some works it seems almost as if a pointillist painting had been vastly magnified, leaving only a few large 'dots' to convey the relevant impression.

His remaining works were sold at Christie's, May 18-19, 1843.

Examples: B.M.; V.A.M.; Ashmolean; Blackburn A.G.; Dudley A.G.; Fitzwilliam; Glasgow A.G.; Inverness Lib.; Abbot Hall A.G., Kendal; Leicestershire A.G.; City A.G., Manchester; N.G., Scotland; Newport A.G.; Castle Mus., Norwich; Glynn Vivian A.G., Swansea; Wakefield A.G.; Nat. Mus., Wales; Gt. Yarmouth; York A.G.
Bibliography: W.F. Dickes: *The Norwich School*, 1905. S.D. Kitson: *Life of J.S.C.*, 1937. V.G.R. Reinacker: *J.S.C.*, 1953. H.L. Mallalieu: *The Norwich School*, 1975. Burlington Fine Arts Club: *Exhibition Cat.*, 1888. N.G.: *Exhibition Cat.*, 1922. *Connoisseur*, 1923. *Studio* special no. 1923. *Walker's Quarterly*, V, 1926. Norwich Castle: *Exhibition Cat.*, 1927. O.W.S. Club, VII, 1929. Whitworth Inst.,

Manchester: *Exhibition Cat.*, 1937. *Burlington*, LXXXI, July, 1942; LXXXVII, August, 1945; CXIV, November, 1972.

COTMAN, Miles Edmund 1810 (Norwich) – 1858 (Norwich)
He was the eldest son of J.S. Cotman (q.v.), from whose influence he never escaped. On his father's appointment as drawing master to King's College, London, in 1834, he took over the teaching practice in Norwich. However, in 1836 he changed places with his brother, John Joseph, as assistant to his father, whom he succeeded in 1843. He exhibited in London between 1835 and 1856. Towards the end of his life his health broke down and he returned to Norfolk, where he continued to teach.

Primarily a marine painter, his style is a weaker version of that of his father. His work is skilful and can be pleasing and even impressive, but it lacks originality. The effect is often hard and dry.

Examples: B.M.; V.A.M.; Ashmolean; Fitzwilliam; Greenwich; City A.G., Manchester; N.G., Scotland; Castle Mus., Norwich; Portsmouth City Mus.; Southampton A.G.; Gt. Yarmouth.
Bibliography: *Walker's Quarterly*, 1927.

COTTON, R C
An artist working in the Lake District in about 1800. He was probably an amateur, using pencil, thin washes and pen over-drawing. He also employed a convention of foliage drawing similar to that of J. Powell (q.v.). In the Richmond Lib., Surrey, there is a topographical drawing, dating from about 1812, by CHARLES COTTON.

Examples: B.M.

COTTRELL, Henry J
An architectural painter in oil and watercolour who lived in Birmingham and exhibited there between 1878 and 1884. He was probably related to the Birmingham landscape painter and engraver ARTHUR WELLESLEY COTTRELL, who exhibited there and in London from 1872 to 1913.

Examples: Birmingham City A.G.

COUSINS, Samuel, R.A. 1801 (Exeter) – 1887 (London)
A mezzotint engraver and occasional watercolourist, he was trained at the Society of Arts and apprenticed to S.W. Reynolds (q.v.), whose partner he later became. His early patrons included Captain Bagnall and Sir T. Dyke Acland (q.v.). In about 1825 he set up business on his own and in 1826 he visited Brussels. In 1825 he was also elected A.R.A., and became an 'academician-engraver' in 1855. His earliest works were pencil copies of engravings, and later he made landscape and portrait watercolours.

Examples: B.M.
Bibliography: G. Pycroft: *Memoir of S.C.*, 1887. A.C. Whitman: *S.C.* 1904.

COUTTS, Herbert, R.I. – 1921 (Windermere)
A Lake District painter who exhibited from 1874 and was elected R.I. in 1912. He changed his name from Hubert Coutts Tucker and was a brother of Arthur Tucker (q.v.).

COVENTRY, Robert McGowan, A.R.S.A., R.S.W.
1855 (Glasgow) – 1914
A marine painter in oil and watercolour who studied in Glasgow and Paris and exhibited in London from 1890. He specialised in North Sea fishing scenes and Dutch harbours, and was elected A.R.S.A. in 1906. He painted in Scotland, Holland and Belgium.

Examples: Glasgow A.G.

COWEN, William 1797 (Rotherham, Yorkshire) – 1861
A landscape painter whose early drawings gained him the patronage of Earl Fitzwilliam, who paid for him to travel through Switzerland and Italy. The sketches he made on this journey provided him with material throughout his career. He exhibited in London from 1823 until his death. In 1840 he went to Corsica, and in 1843 published a series of twelve etchings of the island. These were later used as illustrations for his book *Six Weeks in Corsica*, 1848. After his return he lived in London. He was very much a topographer.

Published: *Six Views of Woodsome Hall*, 1851.
Examples: B.M.; Kensington & Chelsea Lib.

COWHAM, Hilda, Mrs. Lander (London) – 1964
The first lady artist to work for *Punch*, she studied at the Lambeth School of Art and exhibited with the R.W.S. She was the creator of the 'Cowham Kid'. She lived in London and Guildford.

COWPER, Frank Cadogan, R.A., R.W.S.
1877 (Wicken Rectory, Northamptonshire) – 1958 (Cirencester)
A portraitist and romantic subject painter in watercolour and oil. He was educated at Cranleigh and studied at the R.A. Schools. He was elected A.R.W.S. and R.W.S. in 1904 and 1912 and A.R.A. and R.A. in 1907 and 1934. He also painted landscapes, and he lived in Guernsey and later in Gloucestershire.

COWPER, William
A landscape painter, probably amateur, who visited Switzerland in 1778 and worked up his sketches in 1793. He was perhaps a son of the 2nd Earl Cowper.

COX, Alfred Wilson c.1820 (Nottingham) – c.1888
A Nottingham artist and photographer, he painted landscapes and portraits in oil and watercolour. He exhibited at the R.A. and Suffolk Street from 1868 to 1886.

His daughter, Louisa, was a miniaturist.

Examples: Castle Mus., Nottingham.

COX, David, O.W.S.
1783 (Deritend, Birmingham) – 1859 (Birmingham)
After the briefest of educations, Cox was put to work in his father's smithy, but was encouraged to paint by his cousin Allport — probably H.C. Allport (q.v.) — and sent to J. Barber (q.v.) for drawing lessons. Thereafter he was apprenticed to a toy-maker until 1800, and then became a scene-painter under de Maria at the Birmingham Theatre. He went to London in 1804, where he continued to work in theatres as well as selling sepia drawings to dealers. In 1808 he married Mary Ragg, his landlady's daughter, who encouraged him to take pupils, and they set up house at Dulwich. Cox was always willing to take advice and instruction — as late as 1840 he took lessons in oil painting from the young W.J. Muller (q.v.) — and at this period was a pupil of Varley, whose landscape formulae influenced his work for many years. He visited Wales in 1805 and 1806 and paid regular visits to his parents in Birmingham. He was an exhibitor with the A.A. from 1809 to 1812, and President in 1810. On the collapse of the Association he was elected A.O.W.S. and he became a full member of the re-constituted O.W.S. in 1820. Whilst living in Dulwich his pupils included Lady Arden, Lady Burrell, Lady Sophia Cecil, Lady Gordon (q.v.), the Hon. Misses Eden, Miss Tylney Long and Colonel the Hon. Henry Windsor, later 8th Earl of Plymouth (q.v.). He was drawing master at the Military College at Farnham in 1814, after which he moved to Hereford and taught at a number of schools in the area. He also continued to take private pupils, among them J.M. Ince (q.v.). In 1816 he toured the valley of the Wye, in 1818 North Wales and in 1819 was in Bath and Devonshire. The first of his Continental visits was with his son to Belgium and Holland in 1826. His other two visits abroad occured in 1829, when he went to Paris, and 1832, when he was on the coast at Dieppe and Boulogne. In 1826 he returned to London, where he lived until 1841. During this time he sketched in Yorkshire in 1830, Derbyshire in 1831, 1834, 1836 and 1839, Wales in 1837, Kent in 1838 and Lancashire in 1840. In 1841 he returned to Birmingham, where he lived for the rest of his life. For the first four years of this period he usually paid a visit to his son in London each summer before sketching in Yorkshire, in 1842, or Derbyshire and North Wales. However, after staying at Bettws-y-Coed in 1844 with H.J. Johnson (q.v.), he was won over almost exclusively to North Wales.

Stylistically, his work can be divided into three major periods.

The first, which lasted until about 1820, saw him gradually introducing clean and low-toned washes of colour into his largely monochrome drawings. The influence of Varley and Barber is strong throughout, although, especially at the beginning, his works are very close to those of Cotman, Prout and Girtin at this period. During the second period (1820-1840) he fully mastered the use of colour, although he always used a limited palette with blue gradually predominating; and, in his Continental drawings, often with a splash of bright green as a highlight. During his last twenty years he achieved a freedom and a breadth in his painting which is a direct forerunner of Impressionism. These pictures are, as he said, 'the work of the mind, which I consider very far before portraits of places'. It was at this time that he was so complimented for his painting of wind and atmospheric effects. The rough paper which he preferred and had sent especially from Dundee, is still known as 'Cox Paper'.

His remaining works were sold at Christie's, May 3-5, 1873. His main professional pupils included W. Bennett (q.v.), D.H. McKewan (q.v.) and his son, D. Cox, Yr. (q.v.).

Published: *Treatise on Landscape Painting and Effect in Watercolour*, 1814. *Progressive Lessons on Landscape for Young Beginners*, 1816. *A Series of Progressive Lessons*, c.1816. *The Young Artist's Companion*, 1825.
Examples: B.M.; V.A.M.; Aberdeen A.G.: Haworth A.G., Accrington; Ashmolean; Birmingham City A.G.; Blackburn A.G.; Cartwright Hall, Bradford; Bridport A.G.; Bury A.G.; Grosvenor Mus., Chester; Coventry Mus.; Doncaster A.G.; Dudley A.G.; Exeter Mus.; Fitzwilliam; Glasgow A.G.; Greenwich; Hartlepool A.G.; Hove Lib.; Abbot Hall A.G., Kendal; Leeds City A.G.; Leicestershire A.G.; City A.G., Manchester; N.G. Scotland; Newport A.G.; Nottingham Univ.; Portsmouth City Mus.; Southampton A.G.; Ulster Mus.; Wakefield A.G.; Nat. Mus., Wales; York A.G.
Bibliography: N.N. Solly: *D.C.*, 1873. W.Hall: *D.C.*, 1881. F.G. Roe: *D.C.*, 1924. F.G. Roe: *Cox the Master*, 1946. T. Cox: *D.C.*, 1947; 1954. *A.J.*, February, 1860; 1898; 1909. Burlington Fine Arts Club: *Exhibition Cat.*, 1873. *Gentleman's Mag.*, March, 1878. Birmingham City A.G., *Exhibition Cat.*, 1890. O.W.S. Club, X, 1933. *Antique Collector*, October, 1959.

COX, David, Yr., A.R.W.S. **1809 (Dulwich) – 1885 (Streatham)**
His choice of career was largely pre-destined, although he may have spent a brief time in the Navy, and he accompanied his father on many sketching tours, including the visit to Belgium and Holland in 1826. He first exhibited at the R.A. in 1827, thereafter helping his father in the teaching practice until 1841, when he took over the business. He was briefly a member of the N.W.S. and, from 1848, A.O.W.S. Like his father, he drew much inspiration from North Wales; other subjects were taken from Scotland, the Lakes, the Home Counties and Devon, and there is evidence of a visit to Grenoble in about 1853 and Switzerland in 1869. His works are often but poor reflections of his father's genius, although at his best he is a very pretty and competent artist.

Examples: B.M.; V.A.M.; Ashmolean; Coventry Mus.; Greenwich; Hove Lib.; Portsmouth City Mus.

COX, Dorothy, Mrs. Lewis **1882**
A landscape, marine and architectural painter who exhibited widely in the early years of the twentieth century. She lived at Shoreham.

Examples: Brighton A.G.

COZENS, Alexander **c.1717 (Russia) – 1786 (London)**
The 'Blotmaster-General to the Town' or 'Sir Dirty Didgit' was the son of one of Peter the Great's ship-builders. He appears to have visited England before 1743, then returning to Russia and journeying to Rome in 1746. There he worked for a time in Joseph Vernet's studio and sketched in both City and Campagna. He was in London soon afterwards and built up a highly successful practice as a drawing master. He taught at Christ's Hospital from 1749 to 1753 and at Eton from about 1763. He may also have given lessons for a time in Bath. From 1778 to 1784 he taught Princes William and

Edward. Also in about 1778 he came into contact with his great patron and friend, William Beckford.

The great success of Cozens as a drawing master lay partly in his 'blots', which became fashionable, as did Gainsborough's 'moppings and grubbings' or, later, Payne's stylized manner. He must also have been an inspiring teacher, since Mrs. Harcourt (q.v.) wrote that she spent six hours a day following his methods. These are described in full in the *New Method* which is reprinted in Oppé.

As well as the blots, Cozens painted more conventional watercolours and wash drawings and a few oil paintings and magnificent oil sketches on paper. In all his work he shows the powerful romanticism which attracted Beckford to him.

Published: *The Shape... of Trees...*, 1771. *Principles of Beauty relative to the Human Head*, 1778. *New Methods...*, 1785.
Examples: B.M.; V.A.M.; Aberdeen A.G.; Ashmolean; Cartwright Hall, Bradford; Fitzwilliam; Leeds City A.G.; N.G. Scotland.
Bibliography: A.P. Oppé: *A. and J.R.C.*, 1952. Burlington Fine Arts Club: *Exhibition Cat.*, 1916. *Burlington*, 1919. *Print Collectors' Quarterly*, VIII, 1921. Graves A.G., Sheffield: *Exhibition Cat.*, 1946. Tate Gall.: *Exhibition Cat.*, 1946. *Connoisseur*, CXIX, 1947. Whitworth Inst., Manchester: *Exhibition Cat.*, 1956.

COZENS, John Robert **1752 (London) – 1797 (London)**
The son of A. Cozens (q.v.), and an early inspiration to Girtin and Turner, Cozens is perhaps the most poetic of English painters. Few details of his life are known. He exhibited for the first time in 1767 and helped his father in his practice. He visited Italy twice, first in 1776 with Payne Knight, from whom he parted in Rome, staying until 1779, and secondly with Beckford in 1782, returning towards the end of the following year. Despite the evidence of numerous sketches and finished drawings, Beckford regarded him as lazy. Towards the end of his life he visited the Lake District, probably with his pupil T. Sunderland (q.v.). He died mad, under the care of Dr. Monro.

Constable said of him that he was 'all poetry, the greatest genius that ever touched landscape', and this was achieved by a very limited palette, usually blues, greys and greens, the simplest of compositions and occasionally (in the earlier works) faulty drawing. There is a grandeur and simplicity about his best work which appeals directly to the heart.

Examples: B.M.; V.A.M.; Aberdeen A.G.; Ashmolean; Cecil Higgins A.G., Bedford; Birmingham City A.G.; Blackburn A.G.; Leeds City A.G.; City A.G., Manchester; Ulster Mus.
Bibliography: A.P. Oppé: *A. and J.R.C.*, 1952. *Studio*, February, 1917. Burlington Fine Art Club: *Exhibition Cat.*, 1923. *Country Life*, November 30, 1935; March 11, 1971. *Walpole Society* XXIII, 1935. Whitworth Inst., Manchester: *Exhibition Cat.*, 1937; 1956. V.A.M.: *Exhibition Cat.*, 1971.

CRACE, Frederick **1779 (London) – 1859 (London)**
Commissioner of sewers, architectural decorator and collector of maps and views of London, Crace is most remembered as a patron of such artists as T.H. Shepherd (q.v.). His ambition was to have a painting of every noteworthy building in the metropolis and he drew many himself.

Examples: B.M.

CRADOCK, Marmaduke
 c.1660 (Somerton, Somerset) – 1716 (London)
After serving an apprenticeship with a London house-painter, he turned to painting animal and bird studies and still-lifes, often on commission from dealers. Some of his groups of birds were engraved and published in 1740-3 by Josephus Sympson.

Examples: B.M.

CRAIG, William **1829 (Dublin) – 1875 (Lake George)**
A landscape painter who entered the R.D.S. Schools in 1847, and first exhibited at the R.H.A. in the same year. He continued to exhibit there until 1862, and the following year went to America, where he exhibited Irish as well as American views and became a

founder member of the American Society of Watercolour Painters.

His work deteriorated in the latter part of his career as 'he painted almost exclusively for auction-dealers'.

CRAIG, William Marshall c.1765 – c.1834
An illustrator, miniaturist, engraver and painter in oil, as well as a watercolour painter of rustic subjects in the manner of R. Westall (q.v.). He was a frequent exhibitor at the R.A. from 1788 and elsewhere, and from 1810 to 1812 he was a member of the A.A. He was obviously a favourite with the Royal Family, for he was Painter in Watercolours to Queen Charlotte, Miniaturist to the Duke and Duchess of York, and taught the Princess Charlotte. He lived in Manchester during the early part of his life and moved to London in about 1790. Many of his drawings were done for wood engravers and they are usually colourful and highly finished in a somewhat pointilliste fashion. They are also usually on a small scale.

Examples: B.M.; V.A.M.; N.G., Scotland; Newport A.G.; Castle Mus., Nottingham.
Bibliography: *The Collector*, XI, December, 1930.

CRAMPTON, Sir John Fiennes Twistleton, Bt.
1805 (Dublin) – 1886 (near Bray, Co. Wicklow)
A diplomat whose career began at Turin in 1826. He was transferred to St. Petersburg in 1828, Brussels in 1834, Vienna in 1839 and Berne in 1844. His most important post was Washington, where he served from 1845 to 1856, when he was declared persona non grata for recruiting troops for the British Army in defiance of American law. Diplomatic relations were broken off, and there was even talk of war. He was sent to Hanover in 1857 and to St. Petersburg again the following year. His last post was Madrid from 1860 to 1869, after which he retired to his seat in Ireland, Bushey Park, where he died.

He painted freely, rather in the manner of Cox, as well as producing more careful, lightly coloured, drawings, and some caricature doodles in pen and ink.

Examples: B.M.

CRANE, Walter, R.W.S. 1845 (Liverpool) – 1915 (Horsham, Sussex)
The son of THOMAS CRANE (1808-1859), a miniaturist and watercolour portraitist, and brother of LUCY CRANE (1842-1882), authoress, critic and occasional artist. There are examples of Thomas's work in the Grosvenor A.G., Chester.

Walter Crane was best known as a designer and a prolific illustrator and also as a teacher. His family moved first to Torquay, and in 1857 to London where he was apprenticed to W.J. Linton (q.v.) and studied at Heatherley's. From 1867 he worked for the Dalziels, for *Once a Week* and for *Fun*. In 1869 he sketched at Bettws-y-Coed, and in 1871 he married and went to Italy for two years. He revisited Italy in 1881 and the winter of 1883-4. He was a member of the R.I. from 1882 to 1886, but resigned to join the older Society, and was elected A.R.W.S. and R.W.S. in 1888 and 1889. In this period he became increasingly involved with W. Morris (q.v.) and socialism. He visited Greece in 1888, Bohemia and Italy in 1890 and in 1891 America. He was in Hungary in 1894 and Normandy and the Channel Islands in 1896.

His illustrations for children's books bid fair to equal the appeal of those of K. Greenaway (q.v.), but his touch is a little heavier.

His son LIONEL FRANCIS CRANE (b. 1876, London) studied architecture under Reginald Blomfield and Ernest George. He worked in America, Ireland and Italy.

An earlier W. CRANE of Chester published a series of views of Snowdonia in 1830.

Examples: B.M.; V.A.M.; Aberdeen A.G.; Ashmolean; Cecil Higgins A.G., Bedford; Dundee City A.G.; Fitzwilliam; Glasgow A.G.; City A.G., Manchester; N.G., Scotland.
Bibliography: P.G. Konody: *The Art of W.C.*, 1902. *Country Life*, May 4, 1935.

CRANSTONE, Lefevre James
A landscape and genre painter who lived in Hemel Hempstead and

exhibited in London from 1845 to 1867. He sketched in Scotland, Berkshire, Nottingham and Kent as well as in Hertfordshire, and he also lived in Birmingham. In 1859 he went to America by way or Ireland and Nova Scotia to visit relatives. He toured widely, making many sketches of Wild West towns, and returned to England the following year. Shortly afterward he emigrated to Australia. He uses pale colours, and his work is very delicate and pretty.

Published: *Fugitive Etchings*, 1849.
Examples: Boston Mus.; Indiana Univ. Lib.

CRANSTOUN, James Hall 1821 – 1907
A Perthshire landscape painter in oil and watercolour. He studied at the Slade.

Examples: Dundee City A.G.

CRAWFORD, Edmund Thornton, R.S.A.
1806 (Cowden, near Dalkeith) – 1885 (Lasswade)
A marine and landscape painter who was briefly apprenticed to a house-painter in Edinburgh before entering the Trustees' Academy where he became the friend and disciple of William Simson. Although one of the first Associates of the R.S.A., he failed to exhibit until 1831 and was not re-elected until 1839. He was elected R.S.A. in 1848. He made several visits to Holland which provided him with material which he worked up for many years afterwards. He taught painting for a while, and left Edinburgh for Lasswade in 1858.

His most typical subjects are coastal and river scenes on the Scottish and North-East coast and in Holland. The influence of the Dutch masters can be seen in his picturesque style. His watercolours are often on light brown paper and show a free use of bodycolour.

CRAWHALL, Joseph 1821 (Newcastle-upon-Tyne) – 1896
The son of an amateur artist, Crawhall worked in the family ropery business. He was a close friend of C.S. Keene (q.v.), providing him with ideas and preliminary sketches for his *Punch* cartoons. He also wrote and illustrated a number of books and was secretary of the Newcastle Arts Club.

Published: *The Compleatest Angling Booke That Ever was Writ*, 1859. Etc.
Examples: B.M.; Glasgow A.G.

CRAWHALL, Joseph, Yr., 'Creeps', R.S.W.
1861 (Morpeth) – 1913 (London)
The animal painter in oil and watercolour and son of J. Crawhall (q.v.), who gave him his earliest lessons and insisted that his work from memory without corrections. He was educated in Newcastle and at King's College, London, subsequently studying for two years in Paris. On his return he went to Scotland and became a leader of the Glasgow School. He was in Lincolnshire in the summer of 1882. Later he spent much of his time in Tangier, drew bull-fights in Spain, and finally settled in Brandsby, Yorkshire.

He was a perfectionist in his work, destroying anything which did not please him. He was a friend of E.J. Alexander (q.v.) and like him was influenced by the prevailing Japanese styles.

Examples: V.A.M.; Newport A.G.
Bibliography: A. Bury: *J.C., the Man and the Artist*, 1958. O.W.S. Club, XXIII, 1945. *Country Life*, April 2, 1948; May 1, 1969. *Apollo*, LXVI, 1957.

CREALOCK, Lieutenant-General Henry Hope
1831 – 1891
After an education at Rugby, he joined the Army in 1848, serving in the Crimea, China in 1857-8, the Indian Mutiny, St. Petersburg and Vienna, and in Zululand in 1879. He was promoted lieutenant-general in 1884. There are a number of his drawings in the B.M., and he also produced watercolours of dogs, figures and landscapes.

Illustrated: anon: *Wolf-Hunting and Wild Sport in Lower Brittany*,

1875. G.J.W. Melville: *Katerfelto,* 1875. W.D.B. Davenport: *Sport,* 1885.

CREASY, John L
A marine and landscape painter who lived and taught in Greenwich. He exhibited from 1800 to 1828 and shows a penchant for portraits of East Indiamen. He may have been connected with the architect, antiquarian and sanitary engineer, Edward Creasy of Dartford (1792-1858). His father was presumably also a painter, since he sometimes signed himself 'jun'. His work can be of a high quality.

Examples: Greenwich.

CREE, Edward Hodges **– c.1869**
A surgeon, he entered the Navy in 1837 and the following year served in the Mediterranean. In 1839 he sailed to China on board the H.M.S. *Rattleship,* in which he took part in operations connected with the first China War of 1840-42. He was involved in affrays with pirates in Borneo in 1845. After 1850 he served in the Baltic and Black Sea, and on the Home and Lisbon Stations. In 1855 he was present at the capture of Sebastopol and Kinburn. Several of his drawings of the China War were lithographed.

CREES, James Leslie **see BRADDON, Paul**

CRESWICK, Thomas, R.A. **1811 (Sheffield) – 1869 (London)**
A landscape painter in oil and watercolour and a book illustrator. He studied under J.V. Barber (q.v.) in Birmingham, and moved to London in 1828, when he first exhibited at the R.A. He was elected A.R.A. in 1842 and R.A. in 1851. In 1837 he visited Ireland, producing many charming drawings. He was one of the first members of the Etching Club.

In his larger paintings, particularly his oils, he often worked in collaboration with figure and cattle painters such as Ansdell, Cooper, Elmore and Frith. He preferred to work directly from nature, which gives his paintings freshness linked with a careful reflection of English landscape. His foliage was praised by Ruskin.

His collection of English pictures, together with one hundred of his own sketches was sold at Christie's, May 7, 1870.

Examples: B.M.; Glasgow A.G.; Leicestershire A.G.; City A.G., Manchester.
Bibliography: *A.J.,* May, 1856; February 1870; 1908.

CRIDDLE, Mary Ann, Mrs. Harry, née Alabaster, A.O.W.S.
 1805 (Holywell, Flint) – 1880 (Addlestone, near Chertsey)
The daughter of an amateur caricaturist, she was educated at Colchester. She was at first discouraged from drawing by her mother, but in 1824 she was allowed to take lessons from Hayter, which she did until 1826. Until 1846 she worked in oil, but being of poor health, she found watercolour more appealing thereafter. At this time she took some lessons from S. Setchel (q.v.), and she entered a cartoon for the Houses of Parliament competition in 1847, a literary subject, as were most of her works. In 1852 she nearly lost her sight from attempting miniature painting, and in 1861 she moved from London to Addlestone. From 1849 until just before her death she was an A.O.W.S. Although her subjects were often taken from Spenser, Milton, Thomson, Dickens, Tennyson and George Eliot or from the New Testament, she did virtually no work as an illustrator.

Illustrated: The Misses Catlow: *The Children's Garden,* 1865.

CRISTALL, Joshua, P.O.W.S.
 1767 (Camborne, Cornwall) – 1847 (London)
The son of a Scottish sea captain and merchant, he was brought up in Rotherhithe and Blackheath. His father, wishing to make a business man of him, found him various jobs in the china trade, and later as a copying clerk and a printer at Old Ford. However, being determined to become an artist, he turned down an offer of the management of a china works. He appears to have been largely self-taught, despite a period spent at the R.A. Schools, and by 1795 was trying to support himself entirely by painting. In 1802 and

1803 he was in North Wales with the Varleys, with whom in 1805 he was a founder member of the O.W.S. His life for the next twelve years, although a constant struggle against poverty, was apparently uneventful. He may have visited Paris in 1814 and Scotland in 1815 and often stayed on the Isle of Wight. He was President of the O.W.S. in 1816 and 1819 and again from 1821 to 1831. In 1823 he moved to Goodrich on the Wye, where he lived until 1841. He was driven back to London by the death of his wife and the breakdown of his own health. In his last years he was an active member of the Sketching Society, and attempted to win popularity through portrait painting.

His early style shows an affinity with those of his younger contemporaries, Prout and Cox. By 1810, however, his initial simplicity has given place to a more sentimental approach. His charming sketches of country boys and girls have been tidied up in the studio and his landscapes have acquired the romantic patina of a Barret or Finch. Occasionally though, in his last years, his landscape drawings escape from these conventions, as do his sketches and flower studies, which seem to have been done for his own gratification. Some of these, initialled J.C., are over-enthusiastically given to Constable.

Examples: B.M.; V.A.M.; Haworth A.G., Accrington; Glasgow A.G.; Gloucester City A.G.; Abbot Hall A.G., Kendal; Leeds City A.G.; Newport A.G.; Walsall A.G.; Ulster Mus.
Bibliography: W.G.S. Dyer: *J.C., Cornish Painter,* 1958. O.W.S. Club, IV, 1926.

CROCKET, Henry Edgar, R.W.S. **1870 (London) – 1926**
A landscape painter who studied at South Kensington and the Académie Julian. He exhibited from 1900 and was elected A.R.W.S. and R.W.S. in 1905 and 1913. He lived at Lewes.

CROFT, Arthur **1828 –**
A landscape and genre painter who painted in Wales, Switzerland in 1871, Algeria in 1881, the U.S.A. and New Zealand. He exhibited at the R.A. and elsewhere from 1868 and was an unsuccessful candidate for the N.W.S. on several occasions between 1862 and 1873. His work is not particularly distinguished.

Examples: V.A.M.

CROFT, John Ernest
A cattle painter in oil and watercolour who lived in Tunbridge Wells and exhibited from 1868 to 1873.
A Miss MARIAN CROFT of Bayswater exhibited landscapes from 1869 to 1882.

Examples: V.A.M.

CROME, John **1768 (Norwich) – 1821 (Norwich)**
A landscape painter and the lynch-pin of the Norwich School and Society which he helped to found in 1803. With the exceptions of a brief period in London and a visit to Paris in 1814, Crome's life was almost entirely spent in Norfolk.

Although his most important work is in oil, Crome was a drawing master for much of his career, and he left a number of impressive watercolours. They are modelled on the style of the Dutch masters but adapted to East Anglia. The composition is often flat, the colours sometimes bright and the drawing broad rather than crisp. It is difficult to be precise about his watercolours, since his work is often confused with that of his followers and vice versa. A memorial exhibition was held at Norwich Castle in October 1821.

Three of his sons, J.B. Crome (q.v.), FREDERICK JAMES CROME (1796-1831) and WILLIAM HENRY CROME (1806-1873) and one daughter, EMILY CROME (1801-1833), became artists.

Examples: B.M.; V.A.M.; Blackburn A.G.; Cartwright Hall, Bradford; Doncaster A.G.; Castle Mus., Norwich.
Bibliography: J. Wodderspoon: *J.C. and his Works,* 1876. W.F. Dickes: *The Norwich School,* 1905. R.H. Mottram: *J.C. of Norwich,* 1931. D. and T. Clifford: *J.C.,* 1968. H.L. Mallalieu: *The Norwich School,* 1975. Norwich Castle: *Exhibition Cat.,* 1927. *Country Life,* August 15, 1968.

CROME, John Berney 1794 (Norwich) – 1842 (Great Yarmouth)
The eldest son of J. Crome (q.v.), he was educated at the Norwich Grammar School, of which he became Captain. He sketched with his father as a boy and, in 1816, visited Paris with George Vincent. In 1819 he became President of the Norwich Society and helped to end the secession. He was also appointed Landscape Painter to the Duke of Sussex. He built up a good practice and reputation, but also debts, and was declared bankrupt in 1831. In 1833 he moved to Yarmouth.

He is best known for his moonlight scenes and his Cuyp-like landscapes.

Examples: B.M.; City A.G., Manchester; Castle Mus., Norwich.
Bibliography: W.F. Dickes: *The Norwich School*, 1905.

CROMEK, Thomas Hartley, A.N.W.S.
 1809 (London) – 1873 (Wakefield)
The son of R.H. Cromek, the engraver, he was a pupil of J. Hunter, a portrait painter, at Wakefield and J. Rhodes (q.v.) at Leeds. He became a landscape and topographical painter, and he lived on the Continent, primarily in Rome, from 1831 to 1849. He also painted in Belgium, Germany and Switzerland. He was elected A.N.W.S. in 1850 and was reported to be 'in a helpless condition' in 1871. His work is colourful and sometimes striking, although his drawing is not always perfect. He can convey a marvellous simplicity and grandeur of composition.

Published: *A Manual of Hebrew Verbs*, 1851.
Examples: B.M.; Fitzwilliam; Wakefield City A.G.

CROMPTON, James Shaw, R.I. 1853 (Bootle) – 1916 (Hampstead)
An illustrator who was a pupil of J. Finnie (q.v.) and studied at Heatherley's. He exhibited from 1882, was elected R.I. in 1898 and was Chairman of the Langham Sketching Club. He painted genre subjects.

Examples: V.A.M.; Maidstone Mus.

CRONE, Robert (Dublin) – 1779
A Wilson pupil who was working in Rome in 1755. His drawings are closely based on those of his master, but without their freedom and spirit.

He signed 'R.C.' as did R. Carver (q.v.).

Examples: B.M.

CRONSHAW, James Henry 1859 (Accrington) –
A landscape and flower painter who studied at South Kensington. He became an art master at Accrington and Slough, and was Headmaster of the Ashton-under-Lyne School of Art. He was still active in 1927.

CROSBY, Charles James 1809 (Nottingham) – 1890 (Ireland)
An amateur artist who worked in the Inland Revenue Office, Somerset House, for many years. He retired to paint in Ireland. His work consists of small watercolours and pencil drawings.

CROSBY, William 1830 – 1910
A Sunderland artist in oil and watercolour who exhibited landscapes, portraits, coastal, animal and genre subjects at the R.A. from 1859 to 1873.

CROSSE, Lawrence c.1650 – 1724
A miniaturist who was a pupil of Samuel Cooper. He also made watercolour copies of old masters.

CROTCH, Dr. William 1775 (Norwich) – 1847 (Taunton, Somerset)
At the age of four he was already performing in London on the organ and piano, and was famous as 'the Musical Child'. By eleven he was in Cambridge studying music and two years later he settled in Oxford, where he met J.B. Malchair (q.v.). In 1790 he was appointed organist of Christ Church, where he remained until about 1807, and in 1797 he became a Professor of Music. In about 1810 he moved to London where he continued his musical career, becoming the first Principal of the Royal Academy of Music. At the

same time he was an etcher and talented amateur watercolourist. His drawings owe a great deal to Malchair, with their underpainting of dark grey and light washes of limited colours on top. They often have notes on the reverse, giving atmospheric and other information. Many of them were done between 1832 and 1842 at Windsor and on holiday at Budleigh Salterton and Brighton.

Examples: Ashmolean; Grosvenor A.G., Chester; Fitzwilliam; N.G., Scotland.
Bibliography: *Country Life*, January 30, 1948.

CROUCH, William
An obscure but prolific watercolour painter who was active between 1817 and 1840. He painted small romantic subjects of ruins in Italianate landscapes. Stylistically, they fall between the work of F.O. Finch (q.v.) and that of W.M. Craig (q.v.).

Examples: B.M.; Ashmolean; Leeds City A.G.; Newport A.G.

CROWE, Eyre, A.R.A. 1824 (London) – 1910 (London)
The son of E.E. Crowe, historian and journalist, he studied under William Darley and in Paris under Delaroche. He was at the R.A. Schools from 1844 and was secretary to his cousin Thackeray for a time. He lived in America from 1852 to 1857. He exhibited from 1846 to 1904 and was elected A.R.A. in 1875.

His subjects are often historical, but sometimes contemporary social comment.

Published: *With Thackeray in America*, 1893.
Examples: Ashmolean.
Bibliography: *A.J.*, 1864.

CROWTHER, John
An architectural and genre painter who exhibited at the R.A. from 1876 to 1898. He also exhibited at the Royal Pavilion Gallery, Brighton, in 1875 from a London address.

Illustrated: E.B. Chancellor: *Lost London*, 1926 (painted c.1879-1887).

CROXFORD, William Edwards
A marine painter who was working between 1874 and at least 1905. He lived in Brentford, Hastings and Newquay and sometimes used the name 'William Croxford Edwards'.

CROZIER, Robert 1815 – 1891
A marine painter in oil and watercolour who exhibited from 1836 to 1848 and was living in London in 1846. Many of his subjects were taken in the Thames estuary or at Boulogne.

Examples: City A.G., Manchester.

CRUICKSHANK, Frederick 1800 – 1868
A genre and portrait painter who was a pupil of Andrew Robertson, the miniaturist. He exhibited at the R.A. and elsewhere from 1822 and worked in Scottish country houses.

Examples: V.A.M.; Greenwich; City A.G., Manchester.

CRUICKSHANK, William
A follower of W. Henry Hunt (q.v.) who lived in South London and was active from 1866 to 1879. He was a painter of still-lifes and above all of birds' nests on mossy banks.

Examples: Brighton A.G.

CRUIKSHANK, George 1792 (London) – 1878 (London)
A caricaturist, he was the second son of I. Cruikshank (q.v.) and brother of I.R. Cruikshank (q.v.). He was largely self-taught and published his first etching aged about twelve. His career began with political and social caricatures which carried on the tradition of Gillray. These included stock subjects such as the career of Napoleon and the loves of the Prince Regent, and one, 'Bank-note *not* to be Imitated', 1818, is credited with encouraging the liberalisation of the hanging laws. From 1819 he turned more and more to book illustration and by the 1830s this had become his

main business. In 1836 his connection with Harrison Ainsworth and with Dickens began, and his drawings for these two authors are among his best — although his claims to have supplied some of their better known plots cannot be taken too seriously. From 1847 he conerned himself more and more with teetotal propaganda, the most effective being *The Bottle*, 1847; and *The Drunkard's Children*, 1848. He even used fairy stories as temperance tracts. He continued both to draw and paint until the last year of his life.

As well as an etcher and a watercolourist, he was a competent oil painter, and exhibited regularly at the R.A. His lack of academic training shows in his weakly drawn horses and women. His touch is surer with men, however, and his long skeletal villains with their satanic grins are as good as a signature. His handling of crowd scenes is particularly good.

Examples: V.A.M.; Coventry Mus.; City A.G., Manchester; Newport A.G.
Bibliography: G.W. Reid: *Descriptive Cat. of the Works of G.C.*, 1871. W. Bates: *G.C.*, 1878. D. Jerrold: *Life of C.*, 1882-3. J. Grego: *C's watercolours*, 1904. A.M. Cohn: *G.C., Catalogue Raisonnē*, 1924. *A.J.*, 1878.

CRUIKSHANK, Isaac 1756 (Edinburgh) — 1811 (London)
A Lowland Scot who was not only a caricaturist but also a painter of sentimental genre scenes. His father had been a professional artist for a time and Cruikshank followed him at an early age. He exhibited at the R.A. in 1789, 1790 and 1792, and the majority of his political and social prints are dated from 1790 to 1810. He worked as an illustrator for Laurie and Whittle.

His drawings sometimes bear fake Rowlandson signatures but need cause little confusion since his line is smoother and more flowing. The predominating colours are usually blues and greys, with touches of red.

Examples: B.M.: V.A.M.; Fitzwilliam; Greenwich.
Bibliography: F. Marchmont: *The Three Cs*, 1897. E.B. Krumbhar: *I.C. Catalogue Raisonnē*, 1966. *Burlington*, April 1928.

CRUIKSHANK, Isaac Robert 1789 (London) — 1856
The elder son of I. Cruikshank (q.v.), he went to sea on an Indiaman before setting up as a miniaturist and caricaturist. Like his brother George, he turned to book illustration, and they sometimes worked in collaboration. The most successful of their books, with text by Pierce Egan, was *Life in London*, 1821, which was a best seller and was turned into a play.

His style is akin to that of his brother, by whom he is over-shadowed.

Examples: B.M.
Bibliography: F. Marchmont: *The Three Cs*, 1897. W. Bates: *G.C., the Artist, the Humorist and the Man, with some account of his brother Robert*, 1878.

CRUISE, John
A landscape and subject painter who won the first prize for drawing at the R.D.S. Schools in 1814. He exhibited at the R.H.A. from 1827 to 1830, and in 1832 he came to London where he exhibited at the R.A. and the B.I. His name does not appear after 1834.

Examples: St. Patrick's Cathedral, Dublin.

CUBLEY, W H 1816 — 1896 (Newark)
A Newark art master and landscape painter in oil and watercolour. His best known pupil was Sir William Nicholson. He exhibited at the R.A. and Suffolk Street from 1863 to 1878. He also took portraits.

Published: *A System of Elementary Drawing*, 1876.
Examples: Castle Mus., Nottingham.

CUIT, George 1743 (Moulton, Yorkshire) — 1818 (Richmond)
A landscape and portrait painter who was sent to Italy in 1769 where he remained until 1775. On his return he was in London for a while and exhibited at the R.A., but within two years he returned to Richmond. There he worked for Lord Mulgrave, for whom he produced a set of views of Yorkshire ports visited by Captain Cook.

He also made many landscape drawings in bodycolour which are bright and attractive, but a little naïve in detail.

Examples: B.M.; Newport A.G.

CUITT, George Yr. 1779 (Richmond, Yorkshire) — 1854 (Masham)
The only son of G. Cuit (q.v.), he was an etcher and painter, and taught drawing at Richmond and at Chester from about 1804 to about 1820. He then returned to the Richmond area and built a house at Masham, where he lived for the rest of his life. He may have taken the second 't' of his name to distinguish himself from his father.

Published: *Saxon Buildings of Chester*, 1810-11. *History of Chester*, 1815. *Yorkshire Abbeys*, 1822-5. *Wanderings and Pencillings among the Ruins of Olden Time*, 1848.
Examples: B.M.; Leeds City A.G.; Laing A.G., Newcastle; Newport A.G.

CUMBERLAND, George 1754 — 1848
A miniaturist, landscape and figure painter, as well as a poet and art critic, he was a friend of Blake, who engraved some of his designs, of Lawrence and of Stothard. He exhibited at the R.A. from 1773 to 1783 and settled in Bristol in about 1808. There he helped other artists and sketched with them regularly, working rather in the manner of his friend Linnell. He was also an etcher and lithographer.

Examples: B.M.; V.A.M ; City A.G., Bristol.
Bibliography: *The Book Collector*, Spring 1970.

CUMING, J B
A painter of portraits and landscapes which are in the arcadian vein of F.O. Finch (q.v.) or G. Barret, Yr. (q.v.). He was working in 1812.

RICHARD CUMING painted landscapes and topographical subjects and exhibited from 1797 to 1803. He was still active in 1806.

Examples: B.M.

CUNDELL, Henry 1810 — 1886
A landscape and marine painter who lived in London and exhibited at the R.A. from 1838 to 1858. His early work in brown wash and full colour is reminiscent of that of T.S. Boys (q.v.).

Examples: B.M.

CUNNINGHAM, Georgina, Mrs.
A genre painter who lived in Putney and exhibited from 1888.

CUNNYNGHAME, D
A topographer who was working in Edinburgh in 1782.

Examples: N.G., Scotland.

CURNOCK, James Jackson 1839 (Bristol) — 1891
The son of James Curnock (1812-1870), a portrait painter, he painted lakes and mountains, particularly in North Wales. He was a pupil of his father and lived in Bristol, exhibiting in London from 1873 to 1889. Towards the end of his life he also painted in oil.

Examples: Bristol City A.G.; Reading A.G.

CURREY, Fanny W
A landscape painter who was living at Lismore, Co. Waterford, in 1878 and visited France in the following year. She also visited North Wales and she exhibited in London from 1880.

Published: *Prince Ritto*, 1877.

CURTIS, J Digby c.1775 (Newark) — 1837
A topographer who worked in Newark in oil and watercolour.

CUSTARD, A Marsh
A landscape and figure painter who lived in Yeovil and exhibited in London from 1856 to 1860. He was an unsuccessful candidate for the N.W.S. in 1863.

DADD, Frank, R.I. **1851 (London) – 1929**
Nephew of R. Dadd (q.v.) and brother-in-law and cousin of K. Greenaway (q.v.). He is best known for his black and white illustrations, but was also a very competent painter in oil and watercolour. He studied at the R.C.A. and the R.A. Schools. He drew for the *I.L.N.* from 1878 to 1884 and thereafter for the *Graphic*. In the latter year he was elected R.I. He sometimes initialled his watercolours, which can lead to confusion with the work of F. Dillon. He exhibited at the R.A. from 1878 to 1912.

Illustrated: J.H. Newman: *Lead Kindly Light*, 1887. G.M. Fenn: *Dick O' the Fens*, 1888. G.R. Sims: *Nat Harlowe, Mountebank*, 1902.
Examples: B.M.; Exeter Mus.

DADD, Richard **1817 (Chatham) – 1886 (Broadmoor, Berkshire)**
The son of a Chatham chemist and business man. Dadd was educated at the grammar school and took drawing lessons at William Dadson's Academy. He also studied the picture collection at Cobham Park and sketched in the Kentish countryside, as well as on the Medway. In 1834 the family moved to London, where his father set up as a carver and gilder. This led to friendships with a number of artists, including D. Roberts (q.v.), and C. Stanfield (q.v.), who recommended him to the R.A. Schools, which he entered in January 1837. The visitors who taught him there included D. Maclise, W. Mulready, W. Etty and Stanfield himself. His taste for fairy painting was encouraged by Henry Howard, who was Professor of Painting at the time. His co-students and friends included W.P. Frith, J. Phillip, A. Egg, A. Elmore, E.M. Ward and H.N. O'Neil, who shared his ideals and called themselves 'The Clique'. In 1840 he won a medal for the best life drawing. He began to exhibit portraits and landscapes at the S.B.A. in 1837, and the B.I. in 1839. At about this time he was commissioned to decorate Lord Foley's house in Grosvenor Square with scenes from Tasso's *Jerusalem Delivered* and Byron's *Manfred*.

In July 1842 he left England with his patron Sir Thomas Phillips for a tour of Italy, Greece and the Middle East. They visited Venice, Bologna, Corfu, Athens, Smyrna, Constantinople, Halicarnassus, Lycia, Rhodes, the Lebanon, Damascus, Palestine and Cairo. They sailed up the Nile, and returned home by way of Malta, Naples and Rome. By this time Dadd was convinced that he was pursued by devils, one being Sir Thomas and another the Pope, whom he considered assassinating. Although he was obviously mad by his return the following May, the full danger was not realized – despite drawings of his friends with their throats cut. On August 28th he murdered his father in Cobham Park. He fled to France, and was arrested two days later after attacking a stranger in a diligence. He was extradited in 1844 and admitted to Bethlem Hospital, Southwark. There he was treated by Dr. Edward Thomas Monro, son of T. Monro (q.v.), who may have encouraged him to take up painting again. In 1853 Dr. W.C. Hood was appointed resident physician, and he became a great collector and admirer of Dadd's work. In 1864 he was moved to the new hospital at Broadmoor, where he died.

Although his style has a kinship with the pre-Raphaelites and the Fuseli/Blake tradition, it cannot be strictly classified. His watercolours are generally not as precise as his oils, although in both media, and increasingly towards the end of his life, he can work with the exactitude of the miniaturist. He has a very personal, pointilliste method of painting the sea. His colours are usually soft, clear and cold, and some of his later drawings are almost monochromes in greys and blues. Many of his asylum works, such as the series of the *Passions,* are pedantically inscribed with dates and times.

Illustrated: S.C.Hall, *Book of British Ballads,* ?1843.
Examples: B.M.; V.A.M.; Bethlem Hospital, Beckenham; Cecil Higgins A.G., Bedford; Fitzwilliam; Laing City A.G., Newcastle; Newport A.G.
Bibliography: D. Greysmith: *R.D.,* 1973. P. Allderidge: *R.D.,* 1974. Tate Gall., *Exhibition Cat.,* 1974.

DADE, Ernest **(Scarborough) –**
A genre, marine and landscape painter in oil and watercolour who exhibited from 1886. He lived in Chelsea in 1887 and 1888 and then returned to Yorkshire. He specialised in subjects on the Yorkshire and East Anglian coasts.

Published: *Sail and Oar*, 1933.
Examples: V.A.M.; Greenwich; London Mus.

DAGLEY, Richard **c.1765 – 1841**
An orphan, educated at Christ's Hospital, Dagley was apprenticed to a jeweller, for whom he painted ornaments. He was a friend of Henry Bone, the enamel painter, and designed medals as well as painting in watercolour. For a while he taught drawing in Doncaster, but returned to London in 1815 where he worked as a book reviewer and an illustrator. He exhibited at the R.A. and elsewhere from 1784 to 1833.

Published: *Gems selected from the Antique*, 1804.
Illustrated: I. D'Israeli: *Flim-flams*, 1805.

DALGLEISH, William **1860 – 1909 (Glasgow)**
A landscape painter in oil and watercolour who exhibited at the R.A. and in Glasgow.

Examples: Paisley A.G.

DALTON, Richard, F.S.A. **1720 – 1791 (London)**
Studied in Rome and travelled with Lord Charlemont from 1749 to Sicily, Greece, Constantinople and Egypt. On his return he became Librarian and Keeper of the Pictures to George III. He was sent to the Continent to buy pictures on several occasions and in 1763 persuaded Bartolozzi to come to England from Venice. He was a member of the Incorporated Society and became Antiquarian to the R.A.

His drawings are weak, although interesting as the earliest of Near Eastern antiquities.

Published: *A Selection from the Antiquities of Athens*, 1751.

DALZIEL, Edward Gurden **1849 (London) – 1889**
Son of Edward Dalziel the wood engraver, he exhibited genre subjects from 1869 to 1882. He also painted rather Pre-Raphaelite landscape studies.

DANBY, Francis, A.R.A. **1793 (Wexford) – 1861 (Exmouth)**
Danby's family moved to Dublin during the 1798 rebellion and there he studied at the R.D.S. and under J.A. O'Connor (q.v.). In 1813 he accompanied O'Connor and G. Petrie (q.v.) to London, and settled in Bristol, having run out of funds on the return journey. He visited Norway and Scotland before 1817. In 1824 he moved to London and was elected A.R.A. the following year. Domestic troubles drove him abroad in 1829 and he lived on the Continent, mostly on the Lake of Geneva, until 1841. He then took a house in Lewisham, and in 1847 settled permanently in Exmouth.

His subjects are very varied, from pure landscapes and marine paintings to visionary masterpieces reminiscent of Martin, and history and genre pictures. His watercolours and drawings are usually but smaller expressions of his painting in oil.

Examples: B.M.; V.A.M.; City A.G., Bristol; Ulster Mus.
Bibliography: E. Malins and M. Bishop; *James Smetham and F.D.,* 1974. *A.J.,* 1855; 1861. *Cornhill Mag.,* 1946.

DANBY, James Francis 1816 (Bristol) – 1875 (London)

Eldest son of F. Danby (q.v.), he shared his family's Continental travels until 1841. He first exhibited at the R.A. in 1842. His work is in the poetic manner of his father, but without great originality, and he shows a penchant for sunsets. He seems to have visited Ireland and was an occasional exhibitor at the R.H.A. from 1849 to 1871.

DANBY, Thomas, R.H.A., R.W.S. c.1818 (Bristol) – 1886 (London)

The second son of F. Danby (q.v.), he left England with his family in 1829 and during several years spent in Paris became adept at copying the old masters in the Louvre, where he also fell under the influence of Claude. Later, the family moved to Switzerland, and Swiss and Italian lake scenes appear regularly among his subjects. The family returned to England in 1841 and Danby first exhibited at the R.A. in 1843. He was elected R.H.A. in 1860. It was not until 1866 that he finally turned to watercolour as his principal medium, but he quickly adapted himself to it, and within a year was unanimously elected A.O.W.S. He became a full member in 1870. He was twice married, firstly to the daughter of the landlord of the inn at Capel Curig, which was one of his favourite sketching grounds. In his last years his subjects were drawn almost exclusively from South Wales. His style is generally unlike his father's, being closer to that of his friend P.F. Poole (q.v.). His remaining works were sold at Christie's, June 17-18, 1886.

Examples: B.M.; V.A.M.; Cartwright Hall, Bradford; Ulster Mus.

DANCE, George, Yr., R.A., F.R.S., F.S.A.
 1741 – 1825 (London)

The son of George Dance, Surveyor to the City of London, who trained him as an architect, he studied in France and Italy. He was a member of the Incorporated Society, first exhibiting in 1761, and was a Foundation Member of the R.A. He was Professor of Architecture at the R.A. from 1798 to 1805. Among his buildings as an architect – he succeeded his father in 1768 – were Newgate prison and St. Luke's Hospital.

He produced many portraits in chalk as well as in the manner of Downman, and like his elder brother, Sir N. Dance-Holland (q.v.) he was a caricaturist working in grey wash.

Published: *A Collection of Portraits sketched from the Life*, 1811.
Examples: B.M.; V.A.M.; Ashmolean; Soane Mus.

DANIELL, Rev. Edward Thomas 1804 (London) – 1842 (Adalia)

The son of a former Attorney-General of Dominica, he was born in London and brought up at the family's Norfolk home. He attended the Grammar School, where he was taught drawing by Crome. He went up to Balliol in 1823, but showed a strong interest in artistic matters during the vacations, visiting Linnell in London and frequenting Joseph Stannard's Norwich studio. In 1831 he was ordained and spent two years in a Norfolk curacy, but then moved to London and fully entered into the artistic life of the capital. In 1840, however, he was so impressed by Roberts' Egyptian drawings that he joined the Lycian expedition and died of fever in Asia Minor. He was a master of etching and dry point, and his watercolours are far from the laboured productions of so many amateurs. On the contrary, they have been well described as 'the perfection of free sketching'.

Examples: B.M.; V.A.M.; Castle Mus., Norwich.
Bibliography: R.I.A. Palgrave: *E.T.D.*, 1882. F.R. Beecheno: *E.T.D.*, 1889. W.F. Dickes: *The Norwich School*, 1905. H.L. Mallalieu: *The Norwich School*, 1975.

DANIELL, Samuel 1775 (Chertsey) – 1811 (Ceylon)

The younger brother of W. Daniell (q.v.), he was probably the most talented of the family. He was educated at the East India College, Hertford, where he was taught by T. Medland (q.v.). He was also Medland's private pupil in London. He exhibited for the first time at the R.A. in 1792. In 1799 he sailed for the Cape, where he attached himself to the Governor's suite. In October, 1801, he set out as secretary and draughtsman to an expedition to Bechuanaland, then unvisited by Europeans. After numerous hardships and adventures he was back in the colony in April 1802, and the following year he returned to England. In 1805 he left for Ceylon. There again he made a friend of the Governor, who appointed him to the entirely honorific post of 'Ranger of the Woods and Forests.' He remained in the island until his death.

In his work, both finished watercolours and sketches, he breaks away from the largely topographical tradition of his family and the eighteenth century methods which satisfied his uncle Thomas. His figure drawing is quite the best of the family. The published plates from his work were engraved by his brother.

Published: *African Scenery and Animals*, 1804. *Scenery etc. of Ceylon*, 1808.
Illustrated: Sir J. Barrow: *Account of Travels into the Interior of South Africa*, 1806. Sir J. Barrow: *A Voyage to Cochin China*, 1806.
Examples: B.M.; V.A.M.
Bibliography: T. Sutton: *The Daniells*, 1954.

DANIELL, Thomas, R.A. 1749 (Chertsey) – 1840 (London)

The son of an inn-keeper, he was apprenticed to a coach-painter and then worked for C. Catton (q.v.) in the same line. He first exhibited at the R.A. in 1772 and entered the R.A. Schools in the following year. At this time he was painting flowers, landscapes, portraits and caricatures, and he worked in Buckinghamshire, Oxfordshire, Somerset and Yorkshire. In 1785 he left for India with his sixteen-year-old nephew William (q.v.), travelling by way of Madeira, the Cape, Java and the China coast. They spent two years in Calcutta and in 1788-9 undertook the outward leg of their North Indian tour, reaching Srinagar in Garwhal, the first Europeans to do so. On the return journey they spent a year with S. Davis (q.v.) at Bhagalpur, and they reached Calcutta again in the autumn of 1791. There they held a successful lottery of the one hundred and fifty or so pictures resulting from the tour, and they sailed to Madras the following March. In April 1792 they set out on a southern tour reaching Cape Comorin and Ceylon. After a second lottery they sailed to Bombay and to Muscat. There they heard of the outbreak of war with France, and they returned to Bombay. Late in 1793 they set out for home, again travelling by the China coast, where they joined Lord Macartney's convoy. They reached Spithead in September, 1794.

Thereafter, much of Thomas's time was taken up with the publication of *Oriental Scenery*, and with the architectural projects to which it gave rise at Melchet and Sezincote. The original plans for Brighton Pavilion were also influenced by his work. He was elected A.R.A. and R.A. in 1796 and 1797, and he exhibited for the last time in 1830. He visited Devon, and Wales in 1807, with William, and lived in London.

His watercolours are those of an eighteenth century topographer, with careful drawing – sometimes done with the aid of a camera obscura – a ground of grey wash, and light local colours. His work is fresh, but careful, and as Colonel Grant said: 'A good "Thomas Daniell," is, in short, a very fine thing.'

Published: with W. Daniell: *Oriental Scenery*, 1795-1808. with W. Daniell: *A Picturesque Voyage to India by the Way of China*, 1810.
Examples: B.M.; V.A.M.; Victoria Memorial Hall, Calcutta; Fitzwilliam; India Office Lib.
Bibliography: T. Sutton: *The Daniells*, 1954. M. Shellim: *The Daniells in India*, 1970. Walpole Society, XIX, 1931. *Walker's Quarterly*, 35-6, 1932. *Country Life*, January 23, 1958. *Journal of the R.I.B.A.*, September, 1960. *Apollo*, November, 1962. *Connoisseur*, CLII, 1963. *Journal of the Royal Society of Arts*, October, 1962.

DANIELL, William, R.A. 1769 (Chertsey) – 1837 (London)

The son of the elder brother of T. Daniell (q.v.), who had inherited the family inn, 'the Swan' at Chertsey. His training was of the most practical nature, as his uncle's assistant in India from 1785 to 1794. For details of their voyaging, many of which are taken from William's journals, see the previous notice. By the time of their return to England, William was not only a proficient draughtsman, but was perfecting himself in the art of aquatinting. After the

publication of the first series of Oriental Scenery, nearly all the family plates were engraved by William, whatever the attribution on them.

From 1802 to 1813 much of his time was taken up with a series of views of London and another of the London Docks. He was elected A.R.A. and R.A. in 1807 and 1822. He refused the post of draughtsman to an Australian expedition, the job going to his brother-in-law W. Westall (q.v.), and instead made numerous tours in England and Scotland. His *Voyage Round Great Britain* occupied him from 1813 to 1823. In 1813 he went from Land's End to Holyhead and in 1814 from Holyhead to Creetown. Both of these tours were with Richard Ayton, who wrote the text for this part of the work. In 1815 he completed the Scottish coasts on his own. He did no more field-work until 1821 and may have visited the Continent in the interim. In 1821 he went from St. Andrews to Southend, in 1822 from Sheerness to Torquay, and in 1823 from Torquay to Land's End. He visited Ireland in 1828, probably with a similar project in mind, and he was in France in 1833.

He was a superb aquatinter, and his watercolours advanced in style and quality after his return to England. On tour he made small wash sketches, producing larger, coloured versions in the studio. Perhaps his best work is among the Scottish views for the *Voyage*, and the English scenes of the Windsor and Eton series. In these, his restrained colours capture the atmosphere perfectly, while his Indian works rely almost entirely on accurate draughtsmanship and the interest of the subjects. His work lacks the originality promised by that of his brother Samuel (q.v.), but it should not be dismissed in the scornful manner of many of his artistic contemporaries. It is topography at its best. His marine work, too, is excellent.

Published: with T. Daniell: *Oriental Scenery*, 1795-1808. with T. Daniell: *A Picturesque Voyage to India by the way of China*, 1810. *Interesting Selections from Animated Nature*, 1807-12. *A Familiar Treatise on Perspective*, 1810. *A Voyage Round Great Britain*, 1814-25. *Illustrations of the Island of Staffa*, 1818. after S. Daniell: *Sketches of the Native Tribes . . . of Southern Africa*, 1820. Views of *Windsor, Eton and Virginia Water*, 1827-30.
Examples: B.M.; V.A.M.; Aberdeen A.G.; Cecil Higgins A.G., Bedford; Exeter Mus.; Fitzwilliam; Glasgow A.G.; Greenwich; India Office Lib.; Leeds City A.G.
Bibliography: T. Sutton: *The Daniells*, 1954. M. Shellim: *The Daniells in India*, 1970. *Connoisseur*, CLII, 1963.

DANSON, George　　　　　1799 (Lancaster) – 1881 (London)
A scene painter, who also produced landscapes and town views in oil and watercolour, usually on a large scale. He exhibited at the R.A. and elsewhere from 1823 to 1848.

Examples: V.A.M.

DARLEY, Matthew
An engraver, artists' colourman, caricaturist and drawing master who worked in London and Bath in the 1770s. He published some of Bunbury's earliest works as well as producing some three hundred of his own caricatures and painting landscapes and marine subjects. These last may have been in bodycolour.

Published: with G. Edwards: *New Book of Chinese Designs*, 1754.

DARRELL, Sir Harry Verelst, 2nd Bt.
　　　　　　　　　　　　1768　　　　　 – 1828 (India)
A Bengal merchant. Either he or his son, SIR HARRY FRANCIS COLVILLE DARRELL (1814-1853) who lived in Richmond, Surrey, painted a number of views in Sicily.

DASHWOOD, Georgiana
An amateur artist who sketched in Scotland in 1851.

DAVENPORT, John
An artist working in the Crimea in 1855.

DAVEY, Robert　　　　　　　　　 – 1793 (London)
A drawing master who taught at a school for young ladies in Queen's Square and painted portraits. He succeeded G. Massiot

(q.v.) as assistant drawing master at Woolwich in 1780 and was killed by robbers near the Tottenham Court Road.

A WILLIAM DAVEY made a very competent topographical watercolour of Exeter Cathedral in the 1790s. Both it and a print after it are in Exeter Mus.

DAVIDSON, Alexander, R.S.W.　　　1838　　　 – 1887
A genre painter in oil and watercolour and illustrator who studied in Glasgow and exhibited in London from 1873. He illustrated an edition of Scott's *Waverley Novels*.

DAVIDSON, Caroline
A very competent artist who visited Ramsgate in 1838. Her style is close to Cox, her colours strong, and she shows a good understanding of skies and light.

Examples: Ashmolean; Blackburn A.G.

DAVIDSON, Charles, R.W.S.　　1824 (London) – 1902 (Falmouth)
A landscape painter who studied under J. Absolon (q.v.). He lived at Bletchingley and Redhill and sketched in Surrey, Kent and Yorkshire. He was elected Associate and Member of the N.W.S. in 1847 and 1849 but moved to the O.W.S. in 1855, becoming a full member in 1858. He exhibited some eight hundred watercolours in London from 1844, but, as he rarely signed, much of his work may have been re-attributed. He was a friend of Linnell, Varley and Palmer, and his daughter Annie Laura married F.M. Holl (q.v.).

His son CHARLES TOPHAM DAVIDSON (b. 1848) exhibited coastal views, often in Cornwall and Wales, from 1870 to 1902.

Examples: V.A.M.; Blackburn A.G.; Reading A.G.

DAVIDSON, George Dutch 1879 (Goole, Yorkshire) – 1901
An illustrator of Scottish extraction who was working in Dundee in 1899. In the same year he went to Italy by way of London and Antwerp, returning in 1900.

There was a memorial exhibition in Dundee in 1901 and a memorial volume was published the following year.

Bibliography: *Scottish Art Review* XIII. *Magazine of Art*, 1904.

DAVIES, Edward　　　　　　1843 (London) – 1912 (London)
A landscape painter in oil and watercolour who lived in Leicester. He also painted in Scotland, Wales and the Isle of Man. He exhibited from 1880.

It is possible that he should be identified with EDWARD DAVIES, R.I., whose dates are given as 1841 to 1920 and who was elected in 1896.

Examples: Leicestershire A.G.

DAVIES, Henry Casson (or Casom)　　1831　　　 – 1868
A drawing master at Hull College in 1851, he seems to have spent some time in Australia.

DAVIES, John
An artist who was in Italy in 1820 and 1821. He was probably a pupil of the architect George Maddox and worked in the Home Counties and London, exhibiting at the R.A. from 1819 to 1853.

DAVIES, Norman Prescott-, F.R.S.
A miniaturist, portrait and genre painter who worked in Isleworth and Central London in the 1880s and 1890s.

Illustrated: B. Davies: *The Vicar's Pups*, 1900.

DAVIES, Lieutenant-General Thomas c.1737　　　 – 1812
He served in the Royal Artillery, being promoted major in 1782, lieutenant-colonel 1783, colonel 1794, major-general 1796 and lieutenant-general 1803. He sketched in North America, the West Indies and elsewhere.

DAVIS, Edward Thompson　　　1833 (Worcester) – 1867 (Rome)
He studied at the Birmingham and Worcester Schools of Design under J. Kyd (q.v.). He exhibited at the R.A. in 1854, when living in

Worcester, and in 1856, giving a London address.

He is a pleasing and competent painter of subject pictures with titles such as *Granny's Spectacles* and *The Little Peg-top*. His people are chubby and carefully drawn with free washes.

Examples: Ashmolean.

DAVIS, Frederick William, R.I. 1862 – 1919
A Birmingham genre painter in oil and watercolour. He was elected R.I. in 1897 and was also a member of the Birmingham Society. He first exhibited there in 1887.

Examples: Preston Manor, Brighton.

DAVIS, Lieutenant-Colonel Henry Samuel
An Irish officer with the 52nd Regt., he retired as Lieutenant-Colonel in 1851. He was an honorary member of the S.I.A. with whom he exhibited West Indian sketches in 1845. He exhibited American and Irish views at the R.H.A. in 1833, 1835 and 1843. He also painted historical subjects.

DAVIS, Henry William Banks, R.A.
 1833 (Finchley) – 1914 (Rhayader, Radnor)
A sculptor, landscape and animal painter in oil and watercolour who exhibited from 1853 and was elected A.R.A. and R.A. in 1873 and 1877.

DAVIS, John Philip 'Pope' 1784 (Ashburton, Devonshire) – 1862
Primarily a portraitist and painter of large subject pictures in oil. Although he exhibited at the R.A. from 1811, like his friend Haydon he was its persistent attacker. He went to Rome in 1824, returning to London by 1826. Graves claims that he exhibited until 1875. This is unlikely since his last book gives his date of death as September 28, 1862.

Published: *Facts of Vital importance relative to the Embellishment of the House of Parliament*, 1843. *The Royal Academy and the National Gallery*, 1858. *Thoughts on Great Painters*, 1866.

DAVI(E)S, John Scarlett 1804 (Hereford) – 1844
An architectural draughtsman who studied at the R.A. Schools and at the Louvre. After 1830 he travelled in Italy, Spain, France and Holland. He exhibited in London from 1825 to 1844. He lithographed twelve heads after Rubens, and, in 1832 some views of Bolton Abbey.

His clean style is close to that of Bonington, for whom he has sometimes been mistaken.

Examples: B.M.; V.A.M.; Ashmolean; Fitzwilliam; Hereford A.G.
Bibliography: Hereford A.G.: *Exhibition Cat.*, 1937.

DAVIS, Joseph Lucien, R.I. 1860 (Liverpool) – 1951
The son of the Irish landscape painter William Davis, he was principal social artist on the *I.L.N.* for twenty years. He studied at the R.A. Schools and on retirement became art master at St. Ignatius College, North London. He exhibited abroad as well as from 1878 at the R.A. and R.I., to which he was elected in 1893.

DAVIS, Richard Barrett 1782 (Watford) – 1854
An animal painter who studied under Bourgeois and Beechey as well as at the R.A. Schools and possibly with Evans of Eton. He exhibited in 1802. He was Huntsman to the Royal Harriers and was appointed Animal Painter to the King in 1831.

DAVIS, Samuel 1757 (West Indies) – 1819
Davis went to India in 1780 and travelled fairly widely, penetrating as far as modern Bhutan. He became Accountant-General in Bengal. Between July 1790 and July 1791 he was visited by Thomas and William Daniell at Bhagalpur, and Thomas may well have given him some lessons. William later aquatinted some *Views of Bootan*, 1813, after his drawings. In 1795 he was made judge and magistrate of Benares, and in 1799 he defended his house single-handed against the followers of Wazir Ali. He was then posted to Calcutta until his return to England in 1806. Thereafter, he was a Director of the East India Company. On the whole his style is close to that of Thomas Daniell.

Illustrated: Turner: *Account of an Embassy to the Court of Teshwo Lama in Tibet*, 1800.
Examples: B.M.; V.A.M.; R.G.S.; Victoria Memorial Hall, Calcutta.
Bibliography: T. Sutton: *The Daniells*, 1954.

DAVIS, V
An architectural painter who was working in London in about 1800.

DAVISON, William
A portrait and landscape painter in oil and watercolour who exhibited at the B.I. and the R.A. from 1813 to 1843.

DAVY, C R
An artist who was working from 1856 or earlier. He painted landscapes in brown wash and pencil, reminiscent of Munn, and worked in Somerset, Cornwall, Bath, the Wye Valley, Yorkshire and around London.

Published: *Mechanical Drawing for Beginners*, 1891.

DAVY, Henry – 1832/3
An architect and landscape painter who published sets of etchings of Suffolk antiquities and seats in 1818 and 1827. He lived in Ipswich. His collection and remaining works were sold by Deck of Ipswich, April 16, 1833.

DAWS, J
An early nineteenth century marine painter.

DAWSON, Henry 1811 (Hull) – 1878 (Chiswick)
A landscape and marine painter who was put to work at an early age in a Nottingham lace factory. In 1835 he set up as a professional artist painting anything that offered and in 1838 he took twelve lessons from W.H. Pyne (q.v.). He moved to Liverpool in 1844 where he studied at the Academy and rapidly found patrons. However his income was small, and he settled in Croydon in 1850. He was encouraged by Ruskin, but regularly 'skied' at the Academy, and in the south of England his work did not find popularity until the very end of his life. He was an unsuccessful candidate for the N.W.S. in 1870.

His early work is in the tradition of Wilson. Later he was influenced by Turner. His watercolours are generally only sketches for oil paintings, but a number were engraved for Bulmer's *East Riding of Yorkshire*.

Examples: Ferens A.G., Hull; Castle Mus., Nottingham.
Bibliography: A. Dawson: *The Life of H.D.*, 1891.

DAWSON, Nelson 1859 – 1941 (London)
A marine and landscape painter who exhibited in oil and watercolour at the R.A. and R.I. from 1885. His subjects were mainly on the Cornish coasts. From 1895 both he and his wife, Edith, largely abandoned painting for metalwork.

Illustrated: E.V. Lucas: *A Wanderer in London*, 1906.
Examples: City A.G., Bristol.
Bibliography: *Studio* Special nos. 1898; 1901.

DAWSON, Robert 1776 – 1860 (Woodleigh, Devonshire)
A topographical draughtsman who joined the Ordnance Survey of Great Britain in 1794. In 1802 he transferred to the Corps of Surveyors and Draughtsmen at the Tower of London, where he acted as drawing master to officers of the R.E. and the Q.M.G.'s department. From 1810 he also taught at the R.M.A., Addiscombe.

He had a keen eye for the artistic use of light and was said to have helped to bring 'the sketching and shading of Ordnance plans to the degree of perfection afterwards attained'.

His son Lieutenant-Colonel ROBERT KEARSLEY DAWSON, R.E. (1798-1861) worked on the Scottish and Irish Surveys and superintended the government survey of cities and boroughs for the first Reform Bill.

DAWSON, William
A painter of rather primitive landscapes and town scenes who was working in Exeter from the 1830s until at least 1864. Railway bridges were a speciality.

Examples: Exeter Mus.

DAY, William 1764 (London) – 1807
An amateur landscape painter, geologist and mineralogist who worked as a linen draper in London until about 1804, when he inherited a Sussex estate. He made a number of sketching tours with his friend J. Webber (q.v.), including visits to Derbyshire in 1789 and to North Wales in 1791. He exhibited at the R.A. from 1782 to 1801. He was self-taught, and his style was greatly influenced by Webber, whose practice of making detailed pencil drawings on the spot, and colouring them later, he followed. His earlier rather dull colours became increasingly delicate and subtle. His finest works are those in which his passion for geology shows itself in craggy mountains and rocks. His latest recorded works, dated 1805, are mainly in pen or pencil and wash and taken from Hampshire, Sussex and the Isle of Wight.

Examples: B.M.; Derby A.G.
Bibliography: *Connoisseur*, CLXXIV, 1970.

DAYES, Edward 1763 (London) – 1804 (London)
Dayes studied print-making under William Pether, the mezzotinter, and produced prints, miniatures, oil paintings and book illustrations as well as his better known watercolours. He exhibited at the R.A. from 1768 until his suicide. He also exhibited at the Society of Artists, and was appointment Designer to the Duke of York. He had a number of pupils and apprentices, including Girtin, whom he is supposed to have put in prison. He was largely employed as a topographer, and travelled throughout Britain. After 1790 he visited the Northern Counties on a number of occasions, and some of his best works are of northern subjects. He was also employed in working up, or re-drawing, the sketches of lesser men and amateurs such as J. Moore (q.v.).

His style had a great influence on the young Turner and Girtin, and it is sometimes difficult to tell which of the three is the author of a particular work. He is particularly fond of producing what are, in effect, blue monochromes, in which he uses Prussian blue and brown Indian ink over light pencil. When he uses a pen, it is in the neat manner of the eighteenth century tinted drawings. Occasionally he worked on larger and more ambitious watercolours, such as his *Buckingham House, St. James's Park* in the V.A.M., in which the crowded figures are elegant, graceful and full of life. His purely topographical drawings tend to be rather more woolly in effect.

Published: *Instructions for Drawing and Colouring Landscape*, 1805. *Professional Sketches of Modern Artists*, 1805. *The Works of the late E.D.*, 1805.
Examples: B.M.; V.A.M.; Haworth A.G., Accrington; Blackburn A.G.; Cartwright Hall, Bradford; Fitzwilliam; Greenwich; Leeds City A.G.; Leicestershire A.G.; City A.G., Manchester; Whitworth Gall., Manchester; Newport A.G.; Nottingham Univ.; N.G., Scotland; Stalybridge A.G.; Ulster Mus.
Bibliography: V.A.M. MSS., documents including a work diary, 1798-1801 *O.W.S. Club*, XXXIX.

DEACON, Augustus Oakley 1819 (London) – 1899
An art teacher in Derby who helped to establish the School of Art, and taught privately. He later moved to the South Coast to devote himself to his own painting, but shortly afterwards went blind.

Published: *Elements of Perspective Drawing*, 1841.
Examples: Derby A.G.; Derby Borough Lib.

DEACON, James c.1728 – 1750
A miniature and portrait painter in colour and grey wash. He died of gaol fever while attending the Old Bailey as a witness.

Examples: B.M.

DEAKIN, Peter
A landscape painter in oil and watercolour who lived in Birmingham and Hampstead. He exhibited from 1855 to 1879 and was an unsuccessful candidate for the N.W.S. in 1868 and 1873. He was a sketching companion, and later executor, of his friend Cox, whose manner he followed. His wife JANE DEAKIN also painted.

Examples: V.A.M.

DEALY, Jane M., see LEWIS, Jane M., Lady

DEAN, Frank 1865 (Headingley) – 1947
A painter of landscape and genre subjects who studied at the Slade and from 1882 to 1886 in Paris. He returned to Leeds in 1887. He also painted in India and Ireland and visited Egypt in 1894 and Switzerland in 1912.

An exhibition of his views of Northern and Central India was held at the Fine Art Society in 1910.

DEANE, Dennis Wood c.1820 –
Elder brother of W.W. Deane (q.v.), he painted scenes from Spanish and Italian history and from Shakespeare. He exhibited at the R.A. from 1841 to 1868.

DEANE, John Wood
A merchant seaman who was present at the surrender of the Cape of Good Hope in 1803. He became a cashier in the Bank of England. A coloured etching from his sketch of the surrender was published in June 1805. He was an accomplished amateur watercolourist.

His wife was from Barnstaple, Devon, was named Glasse, and also painted. Two of their sons are separately noticed.

DEANE, William Wood, O.W.S.
 1825 (Islington) – 1873 (Hampstead)
The third son of J.W. Deane (q.v.) he was articled to Herbert Williams, architect, in 1842 and became an Associate of the R.I.B.A. in 1848. He travelled on the Continent, mostly in Italy, with his brother Dennis from 1850 to 1852 and continued to practice as an architect and architectural draughtsman until about 1856, then gradually turning to painting. He made sketching tours in Normandy in 1856, Belgium in 1857 and to Whitby in 1859 and Cumberland in 1860. He became an Associate and Member of the N.W.S. in 1862 and 1867 and transferred to the O.W.S. in June, 1870. He continued to visit the Continent, concentrating on France, Spain, which he visited in 1866 with Topham, and Italy. He married the sister of the architect George Aitchison A.R.A. He was noted for catching the atmosphere of the countries which he painted, and his Venetian scenes have been compared to those of J. Holland and even Turner. However, he could be over-lavish in the use of bodycolour.

Examples: B.M.; V.A.M.; Wakefield A.G.
Bibliography: *A.J.*, March, 1873.

DE CORT, Henry Francis (Hendrik Frans)
 1742 (Antwerp) – 1810 (London)
After studying in Antwerp under W. Herreyns and H.J. Antoniessen, he was in Paris from about 1780 to 1788 and came to England in the following year. He travelled widely in England, especially the West, and exhibited in London from 1790.

He was a landscape painter specialising in views of towns. He produced many brown wash drawings, and among his pupils was G.H. Harlow (q.v.).

Examples: Glynn Vivian A.G., Swansea.

D'EGVILLE, James T Hervé c.1806 – 1880
The son of a ballet master settled in London, he entered the R.A. Schools in 1823 and was a pupil of A. Pugin (q.v.). He exhibited English and Continental landscapes from 1826, was in Rome for some years about 1840, and was elected N.W.S. in 1848. With F.T. Rochard (q.v.) he prepared the French versions of their exhibition catalogues. He was a successful drawing master, H.B. Brabazon being among his pupils.

Examples: V.A.M.

DE LA COUR, F J
An Irish painter who was working in a sub-Nicholson manner in about 1830 in Cork. In 1822 a B. DE LA COUR was painting portraits in London in the manner of Buck.

Examples: B.M.; V.A.M.

DELACOUR, William – 1768 (Edinburgh)
A Frenchman who was appointed the first drawing master at the Board of Manufacturers' School in Edinburgh in 1760. He painted landscapes and portraits and did decorative work.

DE LACY, Charles J
A marine painter in the manner of Wyllie who was working from 1885.

Illustrated: A.O. Cooke: *A Book about Ships*, 1914. J.S. Margerison: *Our Wonderful Navy*, 1919.

DELAMOTTE, Philip Henry – 1889 (Bromley, Kent)
The son of W.A. Delamotte (q.v.) he was a photographer as well as an artist working much in his father's manner. He was Professor at King's College London from 1855 to 1879 and exhibited at the R.A. from 1861 to 1876.

Published: *The Art of Sketching from Nature*, 1871. *Drawing Copies*, 1872. Etc.
Illustrated: C.H. Hartshorne: *A Guide to Alnwick Castle*, 1865. Sir H. Lyle: *A History of Eton College*, 1875. M.O. Oliphant: *The Makers of Florence*, 1876.
Examples: B.M.

DELAMOTTE, William Alfred 1775 (Weymouth) – 1863 (Oxford)
A drawing master and landscapist, Delamotte won the patronage of George III when a boy at Weymouth and was placed under B. West in 1794 at the King's instigation.

His career was largely spent in Oxford, where he inherited Malchair's drawing practice, and in the Thames Valley. In 1803 he was appointed drawing master at the R.M.A., Great Marlow. In 1805 he was one of the first Associates elected to the O.W.S., but retired after three years. He seems to have visited Paris in 1802, and often returned to the Continent after 1819. Although his earliest works are sometimes said to be close to those of Girtin, his style shows very little change or development throughout his long life. His drawings show the conscientious handling of a drawing master, with careful outlining in soft pencil or pen, and thin, even washes of gentle colour. They are often fairly exactly inscribed and dated. His remaining works were sold at Sotheby's, May 1864. His brother GEORGE ORLEANS DE LA MOTTE was also a landscape painter who taught at Sandhurst and Reading.

Published: *Thirty etchings of rural subjects*, 1816. *Illustrations of Virginia Water*, 1828. *Original views of Oxford*, 1843. *An Historical Sketch . . . Hospital of St. Bartholomew*, 1844.
Illustrated: W.H. Ainsworth: *Windsor Castle*, 1843. G.T. Fisher: *Smokers and Smoking*, 1845.
Examples: B.M.; V.A.M.; Ashmolean; Cartwright Hall, Bradford; Canterbury Cathedral Lib.; Fitzwilliam; Greenwich; Reading A.G.; Ulster Mus.; Weymouth Lib.

DE LOUTHERBOURG, Philip James, R.A.
** 1740 (Strasburg) – 1812 (Chiswick)**
The son of a miniature painter, he studied at Strasburg and Paris under Vanloo and Casanova, being elected to the Académie Royale in 1767. He travelled in Switzerland, Germany and Italy, coming to England in 1771. He worked for Garrick at Drury Lane and Covent Garden until 1785. He exhibited at the R.A. from 1772, being elected A.R.A. in 1780 and R.A. in 1781. In 1782 he visited Switzerland and in 1793 he and Gillray accompanied the Duke of York's Netherland expedition. In his later years at Chiswick he became a mystic and faith healer.

As an oil painter, he specialised in battle pictures and many of his drawings and watercolours are sketches for these. He also made theatrical portraits, marine drawings in wash, banditti subjects,

which are reminiscent of Mortimer, and rather weak topographical watercolours. A number of drawings attributed to him are, in fact, by Gillray, dating from their joint commissions. He was the painter and proprietor of the 'Eidophusikon', a Panorama in which theatrical lighting and gauze veils gave the illusion of movement and atmospheric effects.

Examples: B.M.; V.A.M.; Fitzwilliam; Greenwich.

DENHAM, John Charles
The Treasurer of Girtin and Francia's Sketching Club, 'The Brothers', which met for the first time on May 20, 1799, and an honorary exhibitor at the R.A. from 1796 to 1858. He was a friend of Constable.

DENNING, Stephen Poyntz 1795 – 1864 (Dulwich)
A portrait painter who was a pupil of the miniaturist J. Wright. He was Curator of the Dulwich Museum and exhibited at the R.A. from 1814 to 1852.

Examples: N.P.G.; Fitzwilliam.

DENNISTOUN, William 1838 – 1884
A landscape and architectural painter in oil and watercolour who exhibited from 1880. He visited Italy and was in Capri in 1878.

Examples: Glasgow A.G.

DERBY, Alfred Thomas 1821 (London) – 1873 (London)
He studied at the R.A. Schools and began his career as a portrait painter and illustrator of Scott. Later he helped his father W. Derby (q.v.) to make watercolour copies and thereafter concentrated on portraits and figure subjects in watercolour. He exhibited from 1839 to 1872. His remaining works were sold at Christie's, February 23, 1874.

Examples: V.A.M; N.G., Scotland.

DERBY, William 1786 (Birmingham) – 1847 (London)
A copyist who learnt drawing from J. Barber (q.v.) and came to London in 1808. He worked as a portrait painter and miniaturist as well as copying pictures until 1825, when he took over the drawing for Lodge's *Portraits of Illustrious Personages of Great Britain* from W. Hilton, R.A. This was completed in 1834. He was partially paralysed in 1838 and thereafter was assisted by his son. As well as copying from Landseer and older masters he produced still-lifes and painted in oil. He exhibited from 1811 to 1842.

In his copies he catches the spirit of the original as well as providing faithful reproductions.

Examples: B.M.; V.A.M.; Greenwich.

DE TABLEY, Sir John Fleming Leicester, Bt., 1st Lord
** 1762 (Tabley House, Cheshire) – 1827 (Tabley House, Cheshire)**
A pupil of Marras, T. Vivares (q.v.) and P. Sandby (q.v.), Leicester was educated at Trinity, Cambridge. From 1784 he travelled in France and Italy, sketching with Sir R.C. Hoare (q.v.). On his return he built up a fine collection of British art, which was open to the public at his London house from 1818. In 1805-6 he helped to found the B.I. He was M.P. for Yarmouth, Isle of Wight, in 1791, for Heytesbury, Wiltshire, in 1796 and for Stockbridge, Hampshire, in 1807. He was a friend of the Prince Regent (q.v.), W.R. Fawkes and other patrons. He was created Baron de Tabley in 1826.

As well as his watercolour sketches, he made lithographs and occasionally painted in oil.

DE TESSIER, Isabelle Emilie 1851 (Paris) –
An actress and humorous illustrator who worked under a number of *noms d'artiste* including Marie Duval and the Princess of Hesse-Schartzbourg. She worked for several English magazines including *Judy* and was the artistic creator of Ally Sloper.

DETMOLD, Charles Maurice 1883 (Putney) – 1908 (Ditchling)
Twin brother of EDWARD JULIUS DETMOLD, with whom he worked closely. They studied in the Zoological Gardens and

exhibited at the R.A. from their fourteenth year. They worked together illustrating books of fish and birds and producing drawings and etchings.

A joint exhibition of their work was held at the Fine Art Society in 1900.

Illustrated: R. Kipling: *The Jungle Book,* 1903. Etc.
Examples: B.M.; V.A.M.; Fitzwilliam.

DEVIS, Anthony
1729 (Preston, Lancashire) – 1817 (Albury, nr. Guildford)

The younger half-brother of ARTHUR DEVIS, he was working in London in the early 1740s, although he later returned to Preston for a time. He exhibited at the R.A. and the Free Society between 1761 and 1781 and then retired from professional practice. From 1780 until his death he lived at Albury House near Guildford. He may have visited Italy in 1783-4 with William Assheton of Cuerdale Hall (q.v.), who seems to have been one of his pupils. He also travelled fairly extensively in Britain, probably visiting Scotland early in his career and returning often to the Lakes, Yorkshire and Glamorgan. He may have made a number of country house views in 1783 and 1784 for Wedgwood's Russian Service. His most easily recognisable mannerism is his representation of leaves by a series of banana-like loops. His sheep, of which he was fond, are also characteristic with their long, stick-like legs. He used a number of media, even bodycolour, but most frequently employed pen and grey-blue washes.

On the whole, his earlier drawings are the stronger and more imaginative; in his middle years they show Italian influence with strong shadows of Indian ink; towards the end they are pretty, but weaker and often circular in shape.

He is sometime confused with his nephew THOMAS ANTHONY DEVIS, and the work of a nephew-in-law, R. Marris (q.v.) is very close to his in style.

Examples: B.M.; V.A.M.; Aberdeen A.G.; Ashmolean; Grundy A.G., Blackpool; Dudley A.G.; Towner Gallery, Eastbourne; Fitzwilliam; Abbot Hall A.G., Kendal; Leeds City A.G.; Leicestershire A.G.; City A.G., Manchester; Newport A.G.; Castle Mus. Norwich; Ulster Mus.; York A.G.
Bibliography: S.H. Paviere: *The Devis Family of Painters,* 1950. *Walpole Society,* XXV, 1937. Harris A.G., Preston: *Exhibition Cat.,* 1937; 1956.

DEVOTO, John

A Frenchman 'of Italian parents', he was a scene painter at a number of London theatres including Lincoln's Inn Fields and Goodman's Fields from about 1719. His drawings, which are often brightly coloured and spirited, include designs for wall decorations and cartouches as well as stage settings. He was still active in 1776.

Examples: B.M.

DE WILDE, Samuel 1748 (Holland) – 1832 (London)

Brought to England as a child by his widowed mother, De Wilde was apprenticed to a Soho wood-carver. His artistic career began with a series of mezzotint portraits issued under the pseudonym of 'Paul' from about 1770. He began to exhibit at the S.A. in 1776 and the R.A. in 1782. These early works were generally portraits and 'banditti' pictures in oil. From 1795 his attention was caught by the stage and he began to produce the long series of theatrical portraits which occupied the rest of his life.

These portraits are usually in soft pencil or crayon with light washes of watercolour. They are delicate and spirited. He occasionally used a reed pen. His work is usually signed with initials 'S.D.W.' and dated.

Examples: B.M.; V.A.M.; Ashmolean: Newport A.G.

DE WINT, Peter, O.W.S.
1784 (Stone, Staffordshire) – 1849 (London)

The fourth son of a Dutch-American father and a Scottish mother, he took his first lessons from a Stafford drawing master called Rogers, and in 1802 he was apprenticed to J.R. Smith (q.v.). A fellow apprentice was his friend and future brother-in-law W.

Hilton (q.v.), who introduced him to Lincolnshire, which became his favourite sketching ground. In 1806 de Wint's indentures were cancelled and he made the acquaintance of Dr. Monro, through whom he came under the influence of the work of Girtin. He was also advised by John Varley, his near neighbour. In 1809 he became a student at the R.A. and the next year he married Harriet Hilton. He first exhibited at the R.A. in 1807, appeared briefly at the O.W.S. in 1810 and 1811, finally re-joining the reorganised society in 1825. With the sole exception of a visit to Normandy in 1828, his travels were confined to England and Wales. Each summer he would stay with one of his patrons, who included the Earl of Lonsdale, at Lowther Castle; the Earl of Powis; the Marquis of Ailesbury; the Clives of Oakley Park, Ludlow; the Heathcotes of Connington Castle; Mr. Cheney of Badger, Shropshire; Walter Ramsden Fawkes of Farnley Hall, Yorkshire; Mr. Champernowne of Dartington, Devon; Mr. Ellison of Sudbrooke Holme, Lincolnshire and Colonel Greville Howard of Castle Rising, Norfolk. He also sketched in the valleys of the Trent and the Thames, where he was probably acquainted with the Havell family of Reading. Throughout his life he had many amateur pupils, whose style is very close to his own. In particular, drawings by his daughter, Mrs. Tatlock, can be deceptively like his.

In his landscapes, chiefly of river and harvesting scenes, he is very fond of the shallow broad panorama, often enclosed by sombre masses of woodland and also uses a St. Andrews Cross composition. The trees are built up in several layers of super-imposed blues and greens becoming darker in tone. There is much brown, green and orange in his work, but this predominance may be due to fading, from which the drawings have often suffered badly. In particular, his skies are now often pink or non-existent. Although he could be rather woolly, his best is very impressive indeed. Towards the end of his life his style becomes freer, and the effect is closer to the sketchiness of his pencil drawings. He rarely, if ever, signed his works, and signatures or initials should be treated with suspicion. His remaining works were sold at Christie's, May 22-28, 1850.

Examples: B.M.; V.A.M.; Aberdeen A.G.; Ashmolean; Grundy A.G., Blackpool; Dudley A.G.; Towner Gall., Eastbourne; Fitzwilliam; Abbot Hall A.G., Kendal; Leeds City A.G.; Leicestershire A.G.; Usher A.G., Lincoln; City A.G., Manchester; Newport A.G.; Castle Mus., Norwich; Ulster Mus.; York A.G.
Bibliography: W. Armstrong: *P. de W.,* 1888. A. de Wint: *A short memoir of P. de W.,* 1900. A.P. Oppé: *The water-colours of Turner, Cox and de W.,* 1925. M. Hardie: *P. de W.,* 1929. B.S. Long: *List of Works exhibited by P. de W. A.J.,* 1898. *Studio,* 1903; 1917; 1919; 1922. O.W.S. Club I, 1923. *Connoisseur,* XCIII, 1934. Usher A.G., Lincoln: *Catalogues,* 1937; 1942; 1947. *Apollo,* XXVI, 1937. *Antique Collector,* April, 1949. *Country Life,* July 1, 1949.

DIBDIN, Charles

An amateur landscape painter who worked in the Lake District. It is possible that the artist may be the dramatist and songwriter Charles Dibdin (1745, Southampton – 1814, London). He had three illegitimate sons, one of whom may have been the father of T.C. Dibdin (q.v.). Certainly one of his grandsons, HENRY EDWARD DIBDIN (1813-1866), was not only a fine musician, but also a skilled artist and illuminator.

Examples: V.A.M.

DIBDIN, Thomas Colman
1810 (Betchworth, Surrey) – 1893 (London)

A painter of landscapes and town scenes, he may have been the grandson of C. Dibdin (q.v.) the actor and dramatist. He worked as a clerk in the G.P.O. for a time and exhibited from 1831. His subjects, which are in the middle manner of Callow, are often found in the towns of Northern France, Belgium and Germany. He also exhibited a panorama of Indian scenes, based on other people's sketches, in 1851.

Published: *A Guide to Water-Colour Painting,* 1859.
Examples: B.M.; V.A.M.; Ashmolean; Gloucester City A.G.; Hove Lib.; Leicestershire A.G.; Nottingham Univ.; Sydney A.G.

DICKINSON, A
A landscape painter working about 1880.

DICKINSON, J Reed
A London painter of landscapes, genre and Breton peasant subjects. He exhibited from 1870 to 1881, and between 1869 and 1873 he was unsuccessful several times as a candidate for the N.W.S.

DICKINSON, Lowes Cato 1819 (Kilburn) – 1908 (London)
The son of Joseph Dickinson, a London lithograph publisher, with whom he worked. With the help of Sir R.M. Laffan he spent three years in Italy and Sicily from 1850. Later he taught drawing at the Working Men's College with Rossetti and Ruskin and, in 1860, helped to found the Artists' Rifle Corps. He exhibited portraits, including one of Queen Victoria, from 1848.

Published: *Letters from Italy, 1850-1853*, 1914.
Examples: B.M.; V.A.M.; Fitzwilliam.

DICKSEE, Sir Francis Bernard, P.R.A., R.I.
 1853 (London) – 1928 (London)
The son of the genre and portrait painter THOMAS FRANCIS DICKSEE, he studied at the R.A. Schools from 1870 to 1875 where he was influenced by Leighton and Millais. He began his career as a book and periodical illustrator, but soon became a fashionable portraitist. He was elected A.R.A. in 1881, R.A. in 1891, and P.R.A. in 1924, and was knighted in the following year. He was a Trustee of the B.M. and N.P.G.

Illustrated: H. Longfellow: *Evangeline*, 1882.
Examples: B.M.; V.A.M.; City A.G., Manchester; Newport A.G.; Royal Shakespeare Theatre, Stratford.
Bibliography: E.R. Dibdin: *F.D.*, 1905.

DIGHTON, Denis 1792 (London) – 1827 (St. Servan, Brittany)
A son of Robert Dighton (q.v.), he studied at the R.A. Schools. He won the patronage of the Prince of Wales, which gained him a commission in the 90th Regiment. He resigned on his marriage, and in 1815 was appointed Military Draughtsman to the Prince, sometimes making professional tours abroad. He exhibited at the R.A. from 1811 to 1825.

He is at his best with soldiers and uniforms and is in some ways the most serious painter of his family. His handling of watercolour is delicate and his detail accurate.

His wife PHOEBE, née EARL, was a still life painter, exhibiting from 1820 to 1835. She was appointed Flower Painter to the Queen, and until about 1830 she taught drawing in Leamington. Her work is Dutch in inspiration and is rather flat.

Examples: B.M.; V.A.M.; Army Mus.; Nottingham Univ.

DIGHTON, Richard 1795 (London) – 1880 (London)
A son of Robert Dighton, he specialised in rather stilted semi-caricature portraits in profile. They are often of racing and hunting personalities.

Another brother, JOSHUA DIGHTON, also produced sporting caricatures from the 1820s to the 1840s.

Examples: B.M.; N.P.G.; Ashmolean; Greenwich.

DIGHTON, Robert 1752 – 1814 (London)
A portrait painter, caricaturist, etcher and drawing master, he began to exhibit in 1769. His working life was spent in London, although his subjects include views at Brighton and elsewhere. In 1806 he was discovered to have stolen and sold a number of prints from the B.M., leaving copies in their place.

His work includes theatrical and legal portraits as well as more elaborate social satires. His figures and faces are rather stylised. His drawing and colour have been called harsh (Williams), but are always strong and accomplished and he shows a good eye for detail. He generally signed 'R. Dighton' in contrast to his son Richard, who signed in full.

Examples: B.M.; V.A.M.; Ashmolean; Fitzwilliam; City A.G., Manchester; Newport A.G.; N.G., Scotland.

Bibliography: *Apollo*, XIV, 1931. *Print Collectors' Quarterly*, XIII, parts 1, 2.

DIGHTON, Robert, Yr. c.1786 – 1865 (Southsea)
The eldest son of R. Dighton, he joined the London Volunteers and the Norfolk Militia before fighting in the Peninsula and being wounded at Bayonne with the 38th Regiment. He retired on half-pay in 1816, but re-joined in 1829 and served with the 16th Lancers in India. A number of his Peninsula drawings were worked up by his brother Denis, but he appears not to have painted after 1815.

DIGHTON, William Edward 1822 – 1853 (Hampstead)
A landscape painter who studied under Muller and Goodall in London and exhibited from 1845. He made an extended tour of Egypt and Palestine, from which he returned in the year of his death. He was Trustee of the Clipstone Street Society.

There is a feeling of de Wint in much of his work and like E.T. Daniell (q.v.) he favoured panoramic views.

Examples: B.M.; V.A.M.

DILLON, Frank, R.I. 1823 (London) – 1909 (London)
A landscape painter and traveller who was a pupil of J. Holland (q.v.) and studied at the R.A. Schools. After some topographical work including two plates for *Apsley House and Walmer Castle*, he travelled extensively especially in Egypt, where he was sharing a studio with Lundgren and Boyce in 1861. In 1865 he was in Ravenna, again with Lundgren. He also visited Spain, Madeira and Japan. He was elected R.I. in 1882. An exhibition of his Japanese work was held by Messrs. Agnew in 1877, and his remaining works were sold at Christie's, January 21, 1911.

His early work is tight and precise in the manner of Boys. Later, via that of T.M. Richardson, Yr., his style becomes very free.

Published: *Sketches in the Island of Madeira*, 1850.
Examples: V.A.M.
Bibliography: *A.J.*, 1909.

DINGLE, Thomas, Yr.
The son of a landscape painter, he too painted landscapes with sheep and cattle, in about 1880.

DITCHFIELD, Arthur 1842 (London) – 1888
A landscape painter in oil and watercolour who studied at Leigh's and the R.A. Schools which he entered in 1861. He exhibited from 1864 to 1886 and his subjects are taken from Spain, Italy and North Africa as well as the Thames and Cornwall.

Examples: V.A.M.

DIXEY, Frederick Charles
A painter of marine and Thames subjects in oil and watercolour who was working from 1877 to 1891.

Examples: Richmond Lib.

DIXON, Charles Edward, R.I.
 1872 (Goring) – 1934 (Itchenor, Sussex)
A marine painter who first exhibited at the R.A. at the age of sixteen and in 1900 was elected R.I. He worked as an illustrator for the *Graphic* and other periodicals and was a member of the Langham Sketching Club. He was himself a keen yachtsman and generally painted contemporary shipping subjects, although occasionally he attempted vast watercolours of naval history. His style is a blend of freedom and accuracy.

Illustrated: C.N. Robinson: *Britannia's Bulwarks*, 1901.
Examples: V.A.M.; Aberdeen A.G.; Greenwich; Grundy A.G., Blackpool; Newport A.G.

DIXON, J
In the Ashmolean are landscapes with this signature, which are dramatically lit and have Rowlandsonian figures. It might be possible to identify the artist with JOHN DIXON who was clerk and

draughtsman to James Wyatt from about 1772 to 1794, or with his son Joseph.

DIXON, Percy, R.I. 1862 – 1924
A landscape painter who lived in Bournemouth. He was elected R.I. in 1915.

DIXON, Robert 1780 (Norwich) – 1815 (Norwich)
He was a scene painter at the Norwich Theatre as well as a teacher of drawing. For the first five years of the Norwich Exhibitions he was a regular contributor, and he was elected Vice-President in 1809. His watercolours vary greatly in style from weak imitations of J.S. Cotman or Girtin to far more impressive productions which are close to Crome. He is chiefly notable for his soft ground etchings, which are among the best prints produced by the Norwich School.

Published: *Norfolk Scenery,* 1810-1811.
Examples: B.M.; V.A.M.; Leeds City A.G.; Castle Mus., Norwich.

DIXON, Samuel (Dublin) – 1769 (London)
The brother of John Dixon, an engraver working in Dublin and London. Samuel produced bird and flower miniatures in bas relief which were hand-coloured in body colour. In 1757 he set up a textile printing business. He lived for a short while in London, returning to Dublin in 1768, in which year he exhibited three flower pieces in watercolour at the R.D.S.

DOBBIN, John 1815 – 1888
A landscape painter who travelled in Holland, France, Spain and Germany as well as working in Scotland, Yorkshire and the North-East. He exhibited at the R.A. and the S.B.A. from 1837 to 1884, and his works usually include well drawn ancient buildings. He also painted in oil and designed mosaics.

Examples: V.A.M.; Cartwright Hall, Bradford; Darlington A.G.; Shipley A.G., Gateshead.

DOBSON, Henry John, R.S.W. 1858 (Inverleithen) – 1928
A Scottish genre painter who worked in Edinburgh.

DOBSON, John
 1787(Chirton, North Shields) – 1865 (Newcastle-upon-Tyne)
After an apprenticeship to a leading Newcastle architect, Dobson took lessons from J. Varley (q.v.) and set up in his home town. He made sketching tours in England and France and made stage designs. To his architectural skill are due the buildings and streets which made Newcastle one of the most beautiful towns in the North. Owing to the improving zeal of the local authorities little of his work now remains. However, the Laing Art Gallery retains many of his plans (some coloured by T.M. Richardson or J.W. Carmichael) as a memorial to the past splendour of the city and the present barbarity of (some of) its inhabitants.

Examples: B.M.; Laing A.G., Newcastle.
Bibliography: M.J. Dobson: *A Memoir of J.D.,* 1885.

DOBSON, Robert
A landscape painter in oil and watercolour who lived in Birkenhead, and who painted in Lancashire and Cheshire from the 1850s to the 1880s. He also produced scenes in the Liverpool docks.

DOBSON, William Charles Thomas, R.A., R.W.S.
 1817 (Hamburg) – 1898 (Ventnor, Isle of Wight)
A pupil of Edward Opie, Dobson entered the R.A. Schools in 1836 and thereafter taught at the Government School of Design. He was Headmaster at the Birmingham School from 1843 to 1845, when he went to Italy. He then spent several years in Germany, where he came under the influence of the Nazarenes. He was elected A.R.A. and R.A. in 1860 and 1871 and Associate and Member of the O.W.S. in 1870 and 1875.

On his return from Germany he devoted himself to biblical subjects in oil and watercolour. His work is simple, if sentimental, and he strongly objected to the use of bodycolour.

Examples: V.A.M.
Bibliography: *A.J.* May, 1860.

DOCHARTY, Alexander Brownlie 1862 (Glasgow) – 1940
A landscape painter who specialised in Highland and Scottish coastal scenes in oil and watercolour. The latter can be very pretty indeed. He exhibited at the R.A. from 1882.

Examples: Glasgow A.G.

DODD, Arthur Charles
Probably a son of C.T. Dodd (q.v.), he worked in Tunbridge Wells and exhibited between 1878 and 1890. He painted landscapes and farmyard scenes.

DODD, Barrodall Robert
An engraver who signed a watercolour of Newcastle-upon-Tyne in 1825. He was also a canal and railway engineer.

DODD, Charles Tattershall
 1815 (Tonbridge) – 1878 (Tunbridge Wells)
A landscape painter who exhibited from 1832. In 1837 he was appointed drawing master at Tonbridge School and he held the post until his death. As well as views and lithographs of the area, he painted in Sussex and Wales.

His son CHARLES TATTERSHALL DODD, YR. painted landscapes and architectural subjects at the end of the nineteenth century. JOSEPH TATTERSHALL DODD, who painted in Spain was presumably another son.

Examples: V.A.M.

DODD, Daniel
A portrait painter in oil, pastel and wash and an illustrator, he was a member of the Free Society, with whom he exhibited from 1761 to 1780. He provided grey wash illustrations for the Bible, Harrison's series of Novelists, and Raymond's *History of England,* as well as making drawings of fashionable life.

Examples: B.M.

DODD, Joseph Josiah 1809 – 1880
A landscape painter and topographer who worked in Cheshire. He also produced Parisian views in about 1835. Although his work is very competent, it can have a slightly primitive air. At other times it harks back to F. Towne (q.v.).

Examples: Grosvenor A.G., Chester; City A.G., Manchester.

DODGSON, George Haydock, O.W.S.
 1811 (Liverpool) – 1880 (London)
He was intended for an engineer and apprenticed to George Stephenson between 1827 and 1835; however, a series of accidents and over-exertions turned him to painting. After a sketching tour of Wales, Cumberland and Yorkshire, he moved to London in 1836, making sketches of St. Paul's, the Abbey and other public buildings. By 1842 he had turned more to landscape and joined the N.W.S., from which he resigned in 1847, and he joined the O.W.S. the following February. He worked for the *Cambridge Almanack* and the *I.L.N.* In the 1850s and early 1860s he sketched on the Thames – in 1858 with Fripp and Field – and thereafter much in the Whitby area where he was friendly with the Weatherall family. From 1875 he also visited the Gower Peninsula. His subjects have been described as being divided between *L'Allegro* and *Il Penseroso,* at least until 1860, after which they became more directly topographical. His style was affected by a shaking hand which led to a spotting technique in powerful colours, which he often worked on very wet paper.

Published: *Illustrations of the Scenery on the Line of the Whitby and Pickering Railway,* 1836.
Examples: B.M.; V.A.M.; Leicestershire A.G.; Maidstone Mus.
Bibliography: *A.J.,* 1880.

DODWELL, Edward, F.S.A. 1767 (Dublin) – 1832 (Rome)
An archaeologist and draughtsman who was educated at Trinity College, Cambridge, and who visited Greece in 1801 and 1805-6, the second time as a French prisoner on parole. He spent most of the remainder of his life in Italy. He made some four hundred drawings in Greece and illustrated his publications.

Published: *Alcuni Bassi rilievi della Grecia*, 1812. *A Classical and Topographical Tour through Greece*, 1819. *Views in Greece*, 1821. *Views and Descriptions of Cyclonian or Pelasgic Remains* . . ., 1834.

DOLAN, P
A London artist who exhibited a view of Mapledurham at Brighton in 1875.

DOLBY, Edwin Thomas
A painter of churches who lived in London and was a candidate for the N.W.S. several times between 1850 and 1864.

Published: *A Series of . . . views . . . during the Russian War*, 1854. *D's Sketches in the Baltic*, 1854.
Illustrated: E.H. Nolan: *Great Britain as it is,* 1859.

DOLBY, J Edward A
A landscape sketcher who worked in France, Holland, Switzerland and Italy between 1837 and 1875, as well as at Eton.

DOLLMAN, John Charles, R.W.S.
1851 (Brighton) – 1934 (London)
A black and white artist who turned to colour, painting in watercolour and oil, in 1901, and at the same time moved from the R.I. to the R.W.S. He lived in London and studied at South Kensington and the R.A. Schools. He painted historical genre and animal subjects. An exhibition of his works was held at the F.A.S. in January 1906.
RUTH DOLLMAN painted weak but pretty landscapes in Sussex at the beginning of the twentieth century, and an exhibition of her works was held at the Leicester Galleries, April-May, 1904. There is a watercolour by Charles Dollman in Newport A.G.

Published: *The Legend of the Devil's Dyke*, 1868.
Illustrated: J.M. Brown: *In the days when we went Hog-Hunting,* 1891.
Examples: Glasgow A.G.; City A.G., Manchester.

DONALD, John Milne 1817 (Nairn) – 1866 (Glasgow)
A landscape painter in oil and watercolour who was apprenticed to a Glasgow house painter. He then studied in Paris in 1840 and worked for a London picture restorer before returning to Glasgow. He exhibited in London from 1844 to 1847.

DONALDSON, Andrew
1790 (Comber, nr. Belfast) – 1846 (Glasgow)
Landscape and architectural painter in oil and watercolour, who went to Glasgow and worked in a cotton mill at an early age. After an accident he turned to painting and concentrated on village scenes. He sketched in England and Ireland, and gave drawing lessons.

Examples: Glasgow A.G.

DONALDSON, Andrew Benjamin 1840 (London) – 1919
A painter of landscapes, historical and religious subjects. He studied at the R.A. Schools, visited Italy in 1864 and lived in London where he exhibited from 1861 to 1898, and later at Lyndhurst.

Examples: V.A.M.

DONALDSON, John 1737 (Edinburgh) – 1801 (Islington)
An etcher, miniaturist and figure painter. He worked as a porcelain painter at Worcester and came to London in 1762. He was a member of the Incorporated Society and exhibited from 1761 to 1791.

Published: *The Elements of Beauty,* 1780. *Poems* 1784.
Examples: B.M.

DONNE, Colonel Benjamin Donisthorpe Allsop
1856 – 1907
A professional soldier who served in Egypt and the Sudan from 1882 to 1885. He was also a landscape painter and sketched in Italy. His work is bright and freely drawn.
Published: *Colloquy and Song* 1898.
Examples: Fitzwilliam; Army Regular Commissions Board, Westbury, Wiltshire.

DONNE, Benjamin John Merifield 1831 – 1928
A painter of landscapes, coastal and occasional classical subjects. Several exhibitions of his work, which is free and atmospheric, were held at the Dowdeswell Galleries, London, in the 1880s.

Examples: B.M.; Exeter Mus.

DONOWELL, John
A topographical and architectural draughtsman in the manner of the Maltons. He proposed to issue a series of engravings of Oxford in 1754 and exhibited in London from 1761 to 1786. In the 1750s and 1760s he was probably working as an architect at West Wycombe.

Examples: B.M.
Bibliography: *Country Life,* March 5, 1948 (letters).

DORRELL, Edmund 1778 (Warwick) – 1857 (London)
He began exhibiting at the R.A. in 1807 and was elected A.O.W.S. in 1809, but resigned in 1812. He concentrated upon cottages, trees and river banks in the Home Counties, but also produced similar subjects from Monmouthshire and South Wales. From 1819 to 1836 he exhibited with the S.B.A., but throughout his career only eighty-four exhibits are recorded in all. He married a Miss Robson, possibly a relative of the artist. His style is pleasant but rather indefinite.

Examples: V.A.M.; Coventry Mus.; Fitzwilliam.

D'ORSAY, Count Alfred Guillaume Gabriel
1801 (Paris) – 1852 (Dieppe)
The son of a Napoleonic general and a Princess of Würtemburg, d'Orsay reluctantly entered the Army after the Restoration. He was in England for the Coronation of George IV. In 1823 he was persuaded by the Earl and Countess of Blessington to resign his commission and to join them on a tour of Italy. In Genoa he took a portrait of Byron. He briefly married the Blessingtons' daughter but they were almost immediately separated and in 1831 he came to England with the widowed Lady Blessington. For the next twenty years they were at the centre of a brilliant social, intellectual and artistic circle, after which he found himself deeply in debt and contantly pursued by bailiffs. In 1849 he retired to Paris, where he set up a studio and was appointed Director of Fine Arts by Louis Napoleon. He was a sculptor and a painter, but is best known for his small sketches in profile of his most distinguished contemporaries. These are excellent likenesses, usually in pen and ink or soft pencil with touches of colour, but they are a little naïve in comparison with similar works by his friends Landseer and Wilkie.

Examples: B.M.; V.A.M.
Bibliography: *A.J.,* September, 1852.

DOUGLAS, Allen Edmund
1835 (Clones, Co. Monaghan) – 1894 (Warrenpoint)
A doctor who was trained at Edinburgh and worked at Glasslough and for twenty-five years at Warrenpoint. He drew and painted as a hobby, and spent his holidays sketching in the Mourne Mountains. His other interests included carving, modelling and antiquarian studies.

DOUGLAS, Rev. James, F.S.A.
1753 (London) – 1819 (Preston, Sussex)
After an adventurous career including service in the Austrian army and the Leicester Militia, he went up to Peterhouse, Cambridge, and was ordained. He was Rector of Litchborough, Northamptonshire,

from 1787 to 1799; of Middleton, Sussex, from 1799 to 1803; and Vicar of Kenton, Suffolk thereafter. He painted portraits in oil and miniature and is said by Angelo to have been a caricaturist.

Published: *On the Urbs Rutupiae of Ptolemy*, 1780. *Travelling Anecdotes through various parts of Europe*, 1782 *A dissertation on the Antiquity of the Earth*, 1785. *Discourses on the influence of the Christian Religion*, 1792. *Nenia Britannica; or, a Sepulchral History of Great Britain*, 1793.

DOUGLAS, James R.S.W. **1858 (Dundee) — 1911**
A landscape painter who lived and studied in Edinburgh. He exhibited at the R.I. in 1885 and visited Paris in 1900.

Examples: Dundee City A.G.

DOUGLAS, John **1867 (Kilmarnock) —**
A Scottish landscape painter in oil and watercolour. He studied at the Glasgow School of Art and lived in Ayr.

DOUGLAS, Sir William Fettes, P.R.S.A.
 1822 (Edinburgh) — 1891 (Newburgh, Fife)
The son of an amateur artist, he worked in a bank until 1847 when he spent a few months at the Trustees' Academy. He exhibited at the R.S.A. from 1845, being elected A.R.S.A. and R.S.A. in 1851 and 1854. In 1859 he made his first visit to Italy; previously his sketching had been done in England and Scotland with the Faeds (q.v.) and A. Fraser (q.v.). He was curator of the N.G., Scotland from 1872 until 1882, when he was elected P.R.S.A. and was knighted.

His early work is a mixture of landscape and Pre-Raphaelite subject paintings. Later he turned almost entirely to small landscapes in watercolour.

Examples: V.A.M.; Aberdeen A.G.; Ashmolean; Dundee City A.G.; Glasgow A.G.; N.G., Scotland.
Bibliography: *A.J.*, 1869.

DOW, Alexander Warren **1873 (London) — 1948**
A painter of landscape, towns and still-lifes in watercolour, he was educated at the Leys and Clare College, Cambridge. He was a pupil of Brangwyn and Garstin and studied in Paris. He exhibited at the R.A., R.I. and elsewhere and for a time worked as art critic for *Colour*. He also etched, and painted in oil.

DOWNIE, Patrick, R.S.W. **1854 (Greenock) — 1945**
A postman turned ship painter. He studied in Paris and exhibited from 1885. He lived in turn in Greenock, Paisley, Glasgow and Skelmorlie, Argyll. He exhibited at the R.S.A. from 1885 and the R.A. from 1887. His subjects are clippers and square-riggers and his paint is mixed with nostalgia.

Examples: Paisley A.G.; Glasgow A.G.

DOWNING, H E — 1835
A painter of landscapes and town views, he was a Foundation Member and first Secretary of the N.W.S. He is presumably the 'H.E. Dowing who taught drawing in Lambeth in 1828, and he also lived in Camden Town. His first initial is sometimes wrongly given as M. His style is a rather sloppy version of that of Prout, and he exhibited from 1827 to 1833.

Examples: B.M.

DOWNMAN, John A.R.A.
 1750 (probably Ruabon, Wales) — 1824 (Wrexham)
He came to London in his youth, studying under B. West (q.v.) and at the R.A. Schools, and first exhibiting in 1768 with the Free Society and in the following year at the R.A. He was elected A.R.A. in 1795. In November 1771 he set out for Italy with Wright of Derby (q.v.), arriving in Rome in March 1774, by way of Lyons, Nice, Turin, Verona, Venice and Florence. He may have visited Naples, and he returned to England in 1775. He was in Cambridge from 1777 to 1778, and then he remained in London until 1804, when he moved to East Malling, Kent. In 1806 he was at Plymouth,

and in 1807 and 1808 at Exeter, returning to London again in 1809. In 1812 he made a tour of the Lake District, and in 1817 settled at Chester.

He is perhaps the most important watercolour portraitist of the late eighteenth century. The most characteristic of his portraits are small ovals, although he occasionally worked on a much larger scale. His works (and his sitters) are pretty and delicate, usually done in light watercolour over black chalk or charcoal. He sometimes even applied the colour for the faces to the back of the paper to give a softer effect. He often wrote comments on the sitters underneath his characteristic mounts. Downman's rare landscape drawings, so far as they are known, come from the Italian journey and the Lake District tour. Of these, the more impressive are the Italian drawings, despite a rather fussy pen line, over which are laid light washes, chiefly of pale grey and yellow green. They are not highly finished and have the vigour of on-the-spot sketches.

Examples: B.M.; V.A.M.; Cecil Higgins A.G., Bedford; Exeter Mus.; Fitzwilliam; Greenwich; City A.G., Manchester.
Bibliography: *Connoisseur, Extra Number,* 2, 1907. *B.M. Quarterly,* September, 1940.

DOYLE, Charles Altimont **1832 (London) — 1893 (Dumfries)**
Fourth son of J. Doyle (q.v.). At the age of nineteen he entered the Edinburgh Office of Works, where he remained for most of his life. He frequently exhibited watercolours and pen and ink studies at the R.S.A. and produced illustrations for the *London Society* in 1862, 1863 and 1864, as well as for humorous books.

He was the father of Sir Arthur Conan Doyle.

DOYLE, Henry Edward, R.H.A. **1827 (Dublin) — 1892 (Dublin)**
Third son of J. Doyle (q.v.). After training in Dublin, he came to London and worked as a draughtsman and wood-engraver, working for *Telemachus*, *Punch* and *Fun*. He was Commissioner for Rome in the London International Exhibition of 1862. In 1864 he decorated the chapel of the Dominican Convent at Cabra, near Dublin. From 1869 until his death he was Director of the N.G.I. and his work in improving the collection, particularly with regard to the portraits, gained him a C.B. in 1880. He was elected A.R.H.A. and R.H.A. in 1872 and 1874, and he occasionally exhibited portraits and religious subjects in oil and watercolour.

DOYLE, James William Edmund **1822 (London) — 1892 (London)**
Eldest son of J. Doyle (q.v.), he started life as a painter but soon turned to historical research. He made drawings to illustrate his publications.

Published: *A Chronicle of England*, 1864. *Historical Baronage of England*, 1886.

DOYLE, John, 'H.B.' **1797 (Dublin) — 1868**
He studied under the landscapist Gabrielli, the miniaturist Comerford, and at the R.D.S. He came to London in 1821 and exhibited portraits at the R.A., but having little success he turned to caricature lithography. His series of nine hundred and seventeen plates, which appeared from 1829 to 1851, over the signature H.B., provide a political and social history of the period.

Thackery said of him in 1840, 'You never hear any laughing at H.B., his pictures are a great deal too genteel for that'. There is none of the zestful savagery of Gillray and the drawing is closer to H. Alken than to Rowlandson. Despite its high quality, his work marks the beginning of the long decline of political caricaturing.

Examples: B.M.

DOYLE, Richard **1824 (London) — 1883 (London)**
The second son of J. Doyle (q.v.) who educated him and taught him to draw at home. By the age of fifteen he had developed a remarkable skill as a draughtsman and at nineteen he was a regular contributor to *Punch*, for which he worked from 1843 to 1850. Thereafter he concentrated on book illustration and watercolour painting.

As Dobson says: 'in Oberon's court he would at once have been appointed sergeant-painter', for the majority of his designs are of

'elves and fays and gnomes' often with backgrounds taken from the moors and woods of Devon and Wales. His *Punch* series *Manners and Customs of ye Englyshe, drawn from ye Quick* and the later *Bird's-eye Views of Society* which he contributed to the *Cornhill Magazine* are an equally charming commentary on a more substantial society.

A collection of his drawings was exhibited at the Grosvenor Gallery in 1881.

Examples: B.M.; V.A.M.; Cartwright Hall, Bradford; Fitzwilliam; N.G., Ireland; Newport A.G.; Ulster Mus.

D'OYLY, Sir Charles, 7th Bt.
 1781 (Calcutta) – 1845 (Livorno)
After an education in England, D'Oyly returned to India in the Company's Service in 1798. He was in Calcutta until 1808 when he became Collector in Dacca, where he had lessons from Chinnery. He returned to Calcutta in 1818, became opium agent at Behar in 1821, commercial agent at Patna in 1831 and senior member of the Board of Customs in 1833. In 1824 he initiated an art society, entitled 'The United Patna and Gaya Society' or 'Behar School of Athens' which local residents as well as officers posted nearby were urged to join. In 1832 and 1833 he made a tour of the Cape. He returned to England in 1838 and spent most of the remainder of his life in Italy.

His work is often on a small scale, and brightly coloured. He also made numerous pen and ink drawings. Occasionally, as at the Cape of Good Hope, he tried humorous sketches in pen and wash, but his figure drawing is poor. He published *The Feathered Game of Hindostan*, 1828, and *Oriental Ornithology*, 1829, in conjunction with Christopher Webb Smith, who drew the birds.

Published: *Antiquities of Dacca*, 1814-1815. *Tom Raw, the Griffin: a Burlesque Poem*, 1828. *Indian Sports*, 1829. *The Costumes of India*, 1830. *Sketches on the New Road in a journey from Calcutta to Gyah*, 1830.
Illustrated: Capt. T. Williamson: *The European in India . . .*, 1813.
Bibliography: *Connoisseur*, CLXXV, 1970.

D'OYLY, Elizabeth Jane, Lady, née Ross **– 1875**
The second wife of Sir C. D'Oyly (q.v.), whom she married in India in 1817, and whose manner she imitated closely. She was also a pupil of Chinnery.

Examples: B.M.

DRAKE, Nathan **c.1728 – 1778**
A drawing master and portrait painter who was the son of a minor canon of Lincoln. He settled in York in 1750 and two years later advertised as a teacher of watercolour painting. His charge was an entrance fee of 1gn., and 2gns. per quarter.

DRUMMOND, James, R.S.A.
 1816 (Edinburgh) – 1877 (Edinburgh)
He first worked as a draughtsman for Captain Brown, author of works on ornithology. He taught drawing briefly before entering the Trustees' Academy under Sir W. Allan (q.v.). He first exhibited at the R.S.A. at the age of eighteen, being elected A.R.S.A. in 1845 and R.S.A. in 1852. In 1868 he was appointed Curator of N.G., Scotland.

His main works are large scenes from Scottish history, which show great attention to antiquarian detail. He produced portraits and landscapes, and a long series of rather sickly and loosely drawn watercolours of the heads and shoulders of fishermen and peasants.

Illustrated: J. Anderson: *Ancient Scottish Weapons*, 1881.
Examples: V.A.M.; Blackburn A.G.; N.G., Scotland.
Bibliography: *A.J.*, 1877.

DRUMMOND, John Murray **1802 – 1889**
The eldest son of Admiral Sir Adam Drummond of Megginch and Lady Charlotte Murray, he was educated at Corsham, near Bath, and at Edinburgh High School. In Edinburgh he studied art under A. Nasmyth (q.v.), and on going up to Sandhurst in August 1818 he wrote home, 'I like all the studies here very much, except landscape drawing, for I think the professor does not teach so well as Mr.

Nasmyth'. In 1821 he went to Fontainebleau, and in 1822 was commissioned in the Grenadier Guards and posted to Dublin. He retired from the Army in 1838.

He was a prolific amateur artist, and he painted for Queen Victoria at Osborne. The watercolours, which form the majority of his work, are of a higher quality than the oil paintings.

DRUMMOND, Julian E
A genre and landscape painter working in London in the 1880s and 1890s.

DRUMMOND, Samuel, A.R.A. 1765 (London) – 1844 (London)
After some years at sea, he returned to England in about 1786, began drawing crayon portraits, and worked for several years for the *European Magazine*. He turned to oil painting and exhibited at the S.A. from 1790 and the R.A. from 1791, being elected A.R.A. in 1808. He later became Curator of the Painting School.

He was mainly a portrait painter, also producing landscapes in Wilson's Italian manner, naval and biblical scenes, and illustrations from poetry.

Examples: B.M.

DRUMMOND, William
A portrait painter working in 1849. Perhaps he may be identified with the student who won prizes at the R.D.S. in 1826 and 1827 and who published lithographs in Dublin.

DRURY, Susanna, Mrs. Warter
The sister of the Dublin miniature painter, Franklin Drury, she painted landscapes in England and Ireland, and occasionally made book illustrations. She made two drawings of the Giant's Causeway, which were turned into popular engravings by Vivares. The drawings were shown at the R.D.S. exhibition of 1858.

Examples: Ulster Mus.

DUCKETT, Isabella, Lady
The daughter of Lieutenant-General Sir Lionel Smith, Governor of Jamaica, she married Sir G.F. Duckett, Bt. in 1845. She was a pupil of one of the Schranzs (the Maltese family of artists) and of one of the Earps. She exhibited birds and flowers from 1867 and for a time painted in oil as well as watercolour.

DUDLEY, Robert
A marine, portrait and landscape painter in oil and watercolour and a lithographer. He worked in Spain, Tangiers and Venice as well as in England, and he exhibited at the R.A. in 1865. He illustrated popular history books, the Bible and Army and Navy Almanacks.

DUDLEY, Thomas
A Hull landscape and coastal painter who was the son of a musician and a pupil of a Mr. Dodd. He became a drawing master himself and exhibited in York and elsewhere from 1879 to 1910. He painted in Durham, the Lake District and Cornwall as well as in Yorkshire.

Examples: V.A.M.; Ferens A.G., Hull.

DUFF, John Robert Keitley, R.I. 1862 (London) – 1938 (London)
Trained as a barrister, he was educated at Bishop's Stortford and Sidney Sussex College, Cambridge, before studying at the Slade under Legros. He painted in watercolour, pastel and oil, was an R.E. and exhibited from 1891. He was elected R.I. in 1913.

DUFFIELD, Mary Elizabeth, Mrs., née Rosenberg, R.I.
 1819 (Bath) – 1914
The daughter of T.E. Rosenberg (q.v.), she married W. Duffield (q.v.) in 1850. She won a silver medal from the Society of Arts in 1834 and exhibited flower pieces of a high quality from 1848 to 1912. She was elected to the N.W.S. in 1861.

Published: *The Art of Flower Painting*, 1856.
Examples: V.A.M.

DUFFIELD, William 1816 (Bath) − 1863 (London)
A still-life painter in oil and watercolour, he studied under G. Lance (q.v.) in London and in Antwerp under Baron Wappers. He then returned to Bath. He specialised in food paintings, occasionally turning to flowers, sometimes in collaboration with his wife (q.v.). He died of an infection caught from a dead stag which he was painting in his studio.

Bibliography: *A.J.*, Nov. 1863.

DUGGAN, Patrick
An Irish landscape painter. He gained prizes at the R.D.S. Schools in 1815 and 1818. Portraits by him of Oliver J. Dowel Grace and his wife Frances, as well as Irish castles and buildings, are engraved in *Memoirs of the Family of Grace.*

Illustrated: Hardiman: *History of Galway*, 1820.

DUGMORE, John, of Swaffham 1793 − 1871
A topographer who was a protégé of the Keppel family, one of whom he accompanied on a Grand Tour of Germany and Italy.

His style is old-fashioned, harking back to the traditions of the eighteenth century.

DUGUID, Henry G
A drawing master and music teacher in Edinburgh, he painted landscapes and old buildings and was working between 1831 and 1860.

Examples: N.G. Scotland.

DU MAURIER, George Louis Palmella Busson, R.W.S.
 1834 (Paris) − 1896 (London)
The pen and ink illustrator and novelist who was the chief *Punch* caricaturist from 1864. He studied in Paris and Antwerp between 1856 and 1860 and published his best known novel, *Trilby*, in 1894. His watercolours were all produced between about 1880 and 1889, when he gave up because of eye-strain. They are almost all family portraits or copies of *Punch* drawings.

Examples: B.M.; Cartwright Hall, Bradford; City A.G., Manchester; N.G., Scotland; Ulster Mus.
Bibliography: T.Martin Wood: *G du M.*, 1913. *A.J.*, 1896.

DUNBAR, Sophia, Lady − 1909
The daughter of George Orred, she married Sir Achibald Dunbar, Bt. of Northfield, Elgin, in 1840. She took lessons from J. le Capelain (q.v.) and exhibited in London and Edinburgh from 1863. She painted landscapes in Scotland, Algeria with Mme. Bodichon (q.v.), Corsica, the Riviera, Spain and the New Forset.

DUNCAN, Edward, R.W.S. 1803 (London) − 1882 (London)
Duncan was apprenticed to the Robert Havells, elder and younger, the aquatint engravers, and his first independant practice as an artist was engraving coaching and marine prints for such publishers as Fores. He was not himself a sailor, and his introduction to marine painting was through William Huggins, whose pictures he engraved and whose daughter, Bertha, he married. He began to exhibit in 1830 and became a member of the N.W.S. in 1834. In 1847 he resigned, to become an Associate of the O.W.S., of which he was elected a member in 1849. His sketching tours were generally confined to the southern counties and the Bristol channel, although in 1840 he sailed across to Holland. In the early 1850s he went to the Channel Islands and in 1865 he visited Italy. He also made occasional visits to Scotland and Wales. His subjects are divided between the coastal scenes, for which he is best known, and landscapes, most often in the Thames Valley. In his marine painting he often depicts rough and breezy weather and is at his most successful with wrecks, rescues and lifeboats. He was also at home with beachcombers and fisherfolk. In contrast, his Thames views are peaceful in the extreme, with punts, cattle and perhaps a distant church tower as the main points of interest. He employed strong blues and greens and was not afraid of white heightening. His drawing is generally good, perhaps as a result of his training as an engraver.

His remaining works were sold at Christie's, March 11, 1885.

Published: *Advanced Studies in Marine Painting*, 1889. *British Landscape and Coast Scenery*, 1889.
Examples: B.M.; V.A.M.; Haworth A.G., Accrington; Blackburn A.G.; Cartwright Hall, Bradford; Glasgow A.G.;
Bibliography: *Walker's Quarterly*, XIII, 1923. O.W.S. Club, VI, 1928.

DUNCAN, Lawrence
A son of E. Duncan (q.v.) he lived in Long Ditton and London and exhibited genre subjects and landscapes in Britain and Brittany from 1860.

DUNCAN, Thomas, A.R.A., R.S.A.
 1807 (Kinclaven, Perthshire) − 1845 (Edinburgh)
A portrait and history painter who studied at the Trustees' Academy, of which he later became Master. He was Professor of Colour and subsequently of Drawing at the R.S.A. He painted mainly in oil and was elected R.S.A. in 1829 and A.R.A. in 1843.

DUNCAN, Walter, A.R.W.S.
A son of E. Duncan (q.v.), he lived in Hampstead in the 1880s, Central London from 1890 to 1895, and thereafter in the southern suburbs. He was working from 1869 to 1906 and was elected A.O.W.S. in 1874. He painted marine and historical subjects, some with an excess of bodycolour.

DUNDAS, Agnes
A painter of birds and dogs in oil and occasional landscapes in watercolour, she lived in London and exhibited between 1863 and 1873.

DUNDAS, James
An artist who painted landscapes and figure studies in England and on the continent between 1846 and 1868.

DUNDAS, Agnes
A painter of birds and dogs in oil and occasional landscapes in watercolour. She lived in London and exhibited between 1863 and 1873.

DUNDAS, James
An artist who painted landscapes and figure studies in England and on the Continent between 1846 and 1868.

DU NOYER, George Victor
 1817 (Dublin) − 1869 (Northumberland)
A topographical draughtsman of French parentage. He studied in Dublin under G. Petrie (q.v.), who procured for him a job on the Ordnance Survey. In about 1844-5 he was teaching drawing at St. Columba's College, Stackallan, afterwards working with the Geological Survey of Ireland. He exhibited at the R.H.A. from 1841 to 1863 and in 1859 was elected a member of the Royal Irish Academy. He was also a member of the Kilkenny Archaeological Society. He died of scarlet fever while working on a revision of the Geological Survey in the North of Ireland.

Illustrated: Hall: *Ireland, its Scenery and Character*, 1841. Portlock: *Geological Report on Londonderry, Tyrone and Fermanagh.*
Examples: R.I.A.; University Coll., Dublin.

DUNTHORNE, James, Yr. c.1758 (Colchester) − c.1793
The son of JAMES DUNTHORNE (1730-1815), a portrait and miniature painter known as 'The Colchester Hogarth'. He was a crude but amusing caricaturist working a little in the manner of Rowlandson, and he exhibited at the R.A. from 1783 to 1794. Usually he worked on a comparatively large scale, painting local social gatherings. His drawing *Ague and Fever* was etched by Rowlandson.

This family should not be confused with the John Dunthornes, father and son, who lived at East Bergholt and were plumbers, glaziers and amateur artists. The elder JOHN DUNTHORNE (1770-

1844) was a friend of Constable, and his son JOHN DUNTHORNE, YR. (1798-1832) became Constable's assistant and exhibited at the R.A. from 1827 to 1832.

A link may exist between the families, as it is possible that the elder John was a son or nephew of the elder James.

Bibliography: W. Gurney Benham: *The Ds of Colchester,* 1901.

DUTTON, Thomas Goldsworth **– 1891**
The lithographer of shipping subjects, which he also painted in oil and watercolour. He was living in Wandsworth in 1862 and 1863 when he was an unsuccessful candidate for the N.W.S. He had a feeling for the texture of water, rubbing and dragging to imitate spray.

Examples: The Old Customs House, Lymington.

DUVAL, Marie see DE TESSIER, Isabelle Emilie

DYCE, Rev. Alexander 1798 (Edinburgh) – 1869 (London)
An amateur artist and cousin of W. Dyce (q.v.), he graduated from Exeter College, Oxford, in 1819. He held two curacies between 1822 and 1825, when he came to London and devoted himself to literary studies. He edited Shakespeare and Beaumont and Fletcher. He painted flowers and butterflies.

Examples: V.A.M.; N.G.

DYCE, William, R.A., A.R.S.A.
 1806 (Aberdeen) – 1864 (Streatham)
During his education at Marischal College, Aberdeen, he taught himself to paint, selling his pictures in order to raise the money to go to London. He briefly attended the R.A. Schools before going to Rome, in the autumn of 1825, for nine months. In 1826 he re-visited Aberdeen, and returned to Rome in 1827, remaining there until late 1828. Whilst in Rome he developed the style which later became known as Pre-Raphaelitism. Although this won him a following among foreign artists, it was little appreciated at home, and he virtually gave up painting in favour of science on his return. However, in 1830 he moved to Edinburgh and was encouraged to take up portraiture. He remained in Edinburgh for about seven years, becoming Fellow of the Scottish Royal Society in 1832 and A.R.S.A. in 1835. For a time he travelled on the Continent preparing a report on Schools of Design at Somerset House. In 1843 and 1844 he was Inspector of Provincial Schools, and then became Professor of Fine Arts at King's College, London. He was elected A.R.A. in 1844 and R.A. in 1848. At this time, feeling desk-bound and in need of new inspiration, he attended life-classes at Taylor's in St. Martin's Lane.

He provided one of the most successful frescoes for the House of Lords, *The Baptism of Ethelbert,* having re-visited Italy to study the technique. He painted many other frescoes and also worked as a stained glass and coin designer and an etcher.

In watercolour, as in oil, his colour is bright and clear, and his detail essentially Pre-Raphaelite. In contrast to his scholarly oil paintings, his watercolours are often of landscapes and old buildings, and were done more for his own pleasure.

Illustrated: Sir T.T. Lauder: *The Morayshire Floods,* 1830. *Highland Rambles,* 1837.
Examples: B.M.; V.A.M.; Aberdeen A.G.; Ashmolean; Fitzwilliam; Owen's College, Manchester; N.G., Scotland.
Bibliography: *A.J.,* October 1860; April 1864. *Country Life,* August 13, 1964. *Burlington,* CV, November, 1963.

EAGLES, Lieutenant Edward Bampfylde – c.1866
A marine and shipping artist who was in the West Indies in 1805 and was promoted first lieutenant in the Royal Marine Artillery in 1807. He was placed on half-pay in 1816. He was the brother of J. Eagles (q.v.) and probably related to C.W. Bampfylde (q.v.). Many of his drawings are in pen and ink, but he also worked in full watercolour.

Examples: Greenwich.

EAGLES, Rev. John 1783 (Bristol) – 1855 (Bristol)
A Wykhamist who made a tour of Italy and then returned to Wadham and to take orders. He began as Curate of St. Nicholas, Bristol, and then became Vicar of Halberton, Devon, from 1822; of Winford, Bristol, from about 1835; and of Kinnersley, Hertford-shire, returning to Bristol in 1841. He was a member of Danby's Sketching Club and an etcher. His style is old-fashioned in the manner of Claude and the Poussins, and his drawings are mostly in monochrome. He is best remembered as an art critic, writing for *Blackwood's*. It was his attack which roused Ruskin 'to the height of black anger' in the defence of Turner. He was a candidate for the O.W.S. in 1824, but was excluded as an amateur.

Published: *The Sketcher*, 1856.
Examples: City A.G., Bristol.

EARL, William Robert
A coastal and landscape painter in oil and watercolour who exhibited from 1823 to 1867. Many of his subjects were found in, or off, Kent, Sussex and the Isle of Wight.

EARLE, Augustus 1793 – 1838
The son of an American artist, he travelled from about 1813, visiting the Mediterranean, Africa and the U.S.A. He spent six months shipwrecked on Tristan da Cunha, travelled around South America and went on to New Zealand, Australia and India, returning to England by way of France. Later he was draughtsman to H.M.S. *Beagle* for some time until 1833.
He exhibited at the R.A. from 1806 to 1815 and from 1837 to 1839. As well as topographic work, he produced caricatures, portraits and genre drawings, some of which were worked up by D. Dighton (q.v.).

Published: *A Narrative of a Nine Months' Residence in New Zealand*, 1832.
Examples: B.M.

EARLE, Charles, R.I. 1832 – 1893 (London)
A landscape painter who worked in England, Wales, Germany, Italy and France and lived in London. He exhibited at the R.A. and elsewhere from 1857 to 1893 and was elected R.I. in 1882. He had a penchant for rather violent colouring.

EARP, Henry 1831 – 1914 (Brighton)
The Earps of Brighton, like so many of the dynasties of English watercolourists, are veiled in obscurity. They were landscape and coastal painters. They were prolific, but for the most part their work is undistinguished. Henry exhibited in London from 1871 to 1884 and specialised in cattle. FREDERICK EARP (1828-1914) was presumably his elder brother. There are examples of his work at Greenwich and Hove Lib. Other painters of the name, and probably the family, include EDWIN EARP, who was active about 1900;

GEORGE EARP, who was living in Brighton in 1874, and whose work is represented in the Carlton Mus., Nottinghamshire; VERNON EARP, who lived in London and exhibited in Manchester in 1900; and WILLIAM HENRY EARP who also lived in Brighton.

Examples: Brighton A.G.

EAST, Sir Alfred, R.A., F.R.S.
1849 (Kettering) – 1913 (London)
A landscape painter in oil and watercolour, who began his working life in his brother's factory. In about 1872 he was in Glasgow on business and attended the School of Art. Thereafter he studied in Paris, and in about 1883 he settled in London. He was discovered by Leighton and was elected R.I. in 1887, resigning in 1898. He was elected A.R.A. and R.A. in 1899 and 1913. He was knighted in 1910. He travelled widely, visiting Japan in 1889 as well as Morocco, Spain, Italy and France, where he was influenced by the Barbizons. He was President of the R.B.A. and also produced etchings.

Published: *Brush and pencil notes in landscape*, 1914.
Examples: B.M.; V.A.M.; Haworth A.G., Accrington; Ashmolean; Dudley A.G.; Towner Gall., Eastbourne; A. East Gall., Kettering; Leeds City A.G.; Newport A.G.; Wakefield A.G.
Bibliography: Laing A.G., Newcastle: *Exhibition Cat.*, 1914.

EASTLAKE, Caroline H
A flower painter who lived at Plymouth and exhibited from 1868 to 1873.

Examples: V.A.M.

EASTLAKE, Charles Herbert
A landscape painter who studied in Antwerp and Paris and visited Japan. He exhibited at the R.A. and the R.I. from 1889 and was active until about 1930. Both he and Caroline H. Eastlake (q.v.) had Plymouth connections and may well have been related to Sir C.L. Eastlake (q.v.). He also lived in South London.

Examples: V.A.M.

EASTLAKE, Sir Charles Lock, P.R.A.
1793 (Plymouth) – 1865 (Pisa)
An historical, genre and portrait painter in oil and watercolour who was educated at Plympton Grammar School under T. Bidlake (q.v.) and took lessons from S. Prout. He spent a term at Charterhouse, but left in January 1809 to become a pupil of Haydon, also entering the R.A. Schools under Fuseli. In 1813 he painted several portraits in Plymouth and in the following two years visited Calais and Paris. He made several sketches of Napoleon on the *Bellerophon* and the sale of the resulting picture enabled him to go to Italy in 1816. He remained there until 1830, only re-visiting England briefly in 1820 and after his election as A.R.A. in 1828. He also visited Greece, Sicily and Malta in 1818 and toured Holland, Belgium and Germany in 1828. He visited Vienna en route for England in 1830 – in which year he was elected R.A. He was Librarian of the R.A. from 1842 to 1845 and Keeper of the National Gallery from 1843 to 1847. He was elected P.R.A. in 1850 and appointed Director of the N.G. in 1855. He made a number of journeys to buy pictures in Europe and it was on one of these that he died.
He married ELIZABETH RIGBY (1809-1893) in 1849. She was a daughter of Dr. Edward Rigby of Norwich and a pupil of J.S. Cotman. She was a noted writer of articles on artistic and literary subjects and travelled widely both before and after her marriage. Her drawing is well-disciplined and reminiscent of her master.

Examples: B.M.; Exeter Mus.; Newport A.G.
Bibliography: Lady Eastlake: *A Memoir of Sir C.L.E.*, 1869. C. Monkhouse: *Pictures by Sir C.L.E.*, 1875. *A.J.*, October 1855; February 1866.

EASTWOOD, Walter 1867 (Rochdale) – 1943
A Lancashire painter who studied at the Heywood School of Art

and lived at Lytham St. Annes, where he was first President of the Art Society.

Examples: Grundy Gall., Blackpool; Harris Gall., Preston.

EBDON, Christopher c.1745 p.1810
A pupil of James Paine, the architect, he was in Italy in 1766. He exhibited views and architectural designs at the Society of Artists from 1767 to 1783 and worked as a draughtsman for Soane in 1791 and 1792. He designed the Freemasons' Lodge, Durham in 1810.

Examples: Ashmolean.

EDDINGTON, William Clarke
A landscape painter who lived in Worcester and exhibited from 1861 to 1885. He was an unsuccessful candidate for the N.W.S. in 1862 and 1871. His work can be in the manner of M.B. Foster (q.v.), but with poor figures. He sometimes signed with initials.

Examples: V.A.M.; Reading Mus.

EDEN, Sir William, 7th and 5th Bt.
 1849 (Windlestone, Durham) – 1915
Soldier, boxer, gardener, M.F.H. and amateur artist, he succeeded to the baronetcies in 1873. He and Whistler played the title roles in the 'Bart and Butterfly' lawsuit of 1875. He visited Egypt, India, Japan and the U.S.A. and exhibited in London and Paris. His style approaches the modern tradition of Rothenstein and Muirhead Bone.

Bibliography: Sir T. Eden: *The tribulations of a Baronet,* 1933.

EDGE, John
A marine painter who exhibited with the N.W.S. and was working between 1827 and 1834.

EDGELL, Vice-Admiral Henry Edmund 1809 – 1876
A prolific sketcher who entered the Navy in 1821 and was stationed in Scotland in 1823. He then spent three years on the North American, West Indian, Home and Mediterranean stations and was promoted lieutenant in 1828. In 1831 he went to China on the *Imogene,* after which he was stationed in Spain and the Mediterranean. He was promoted captain in 1845 and was in the East again from 1855 to 1860.

Examples: Greenwich; Raffles Mus., Singapore.
Bibliography: *I.L.N.,* February 19, 1876.

EDMONSTON, Samuel 1825 (Edinburgh) –
A painter of portraits, marine and genre subjects in watercolour and chalk. He studied at the R.S.A. Schools and exhibited in London in 1856 and 1857 as well as in Edinburgh.

Examples: N.G., Scotland.

EDRIDGE, Henry, A.R.A. 1769 (Paddington) – 1821 (London)
After an apprenticeship to William Pether, he attended the R.A. Schools, where he won the approval of Reynolds. He began his career as a miniaturist, often drawing portraits of his friends and fellow artists such as Dr. Munro, Girtin, and Hearne with whom he made a number of sketching trips. He was best known as a portraitist and specialised in small full or three-quarter length drawings, usually with the sitter rather formally posed against a park or landscape. They are generally done with black-lead pencil and a little flesh colour applied to the face and hands. Charming though these can be, his landscape and architectural work is on the whole more interesting. As F.G. Stephens writes: 'Edridge's landscapes often remind us of de Wint's, and they have more colour than Girtin's, less delicate mystery and variety than Turner's, and they are only a little less masculine and studious than Hunt's.' In 1817 and 1819 he visited the North of France, and his knotty pencil drawings, sometimes with watercolour, of Gothic buildings, pre-date those of Prout's later style, which they probably inspired. He was elected A.R.A. only a few months before his death, presumably in recognition of his eminence as a portraitist.

Examples: B.M.; V.A.M.; Fitzwilliam; Greenwich; Leeds City A.G.; City A.G., Manchester; N.G., Scotland; Ulster Mus.
Bibliography: V.A.M. MSS – Letters to Dr. Monro, 1808-21. *Antique Collector,* August, 1972.

EDWARD VI, H.M. King
 1537 (Hampton Court) – 1553 (Greenwich)
The only legitimate son of Henry VIII, he reigned from 1547. His father employed various Flemish painters, such as Vincent Volpe and John Luckas, who made topographical drawings in watercolour, usually of castles and fortifications. Edward may have been taught by one of these artists, and there is a watercolour of Richmond by him in the Royal Collection.

EDWARDES, Hon. Elizabeth 1840 – 1911
The daughter of the 3rd Lord Kensington, she painted Windsor and the Thames.

EDWARDS, Edward, A.R.A. 1738 (London) – 1806 (London)
A friend and follower of Sandby, Edwards attained neither the fame nor the prosperity of the greater artist. He began by providing designs for furniture-makers, including his father. In 1759 he worked as a student at the Duke of Richmond's Gallery, and shortly afterwards he opened his own evening drawing school, while still himself studying at St. Martin's Lane. He began to work for Boydell in 1763 and first exhibited at the R.A. in 1771. He was elected A.R.A. in 1773. In 1775, with the help of Robert Udney, he went to Italy, returning in the following year. Later he worked as a decorator, as well as providing drawings for Horace Walpole up to 1784. In 1787, after failing to be elected to the Chair of Perspective at the Academy, he took a post as scene-painter at the Newcastle theatre. Many of his best topographical drawings are of Northumbrian subjects, but he regarded himself as an exile and was happy to return to London on winning the election in the following year. He retained the post until his death.

His topographical style is very close to that of Sandby, with careful and conventional outlines (sometimes etched) and even washes, often with a predominance of blue. He also did portrait drawings and pen and wash studies of classical figures for book illustrations, as well as drawings of furniture and architectural detail. He generally signed with initials, and these are almost identical with the monogram of Edward Eyre (q.v.)

Published: *A Short History of the Hurricane,* 1781. *Anecdotes of Painters . . . ,* 1808.
Examples: B.M.; V.A.M.
Bibliography: *Country Life,* June 7, 1930.

EDWARDS, Rev. Edward 1766 – 1849
A Norfolk vicar who was largely responsible for the foundation of King's Lynn Museum in 1844. The Museum now houses a collection of his local views, mostly in pen and wash.

EDWARDS, Edwin 1823 (Framlingham) – 1879 (London)
An etcher and landscape painter, who, in 1860, gave up a flourishing bar practice to become a professional artist. His earlier works were watercolours, but later, under the influence of Fantin Latour and other Frenchmen, he turned to oil painting. He was a lover of coastal scenes, especially in Cornwall and Suffolk, as well as of views on the Thames and of old towns.

Published: *Old English Inns,* 1873-81.
Examples: Castle Mus., Nottingham.

EDWARDS, George F.R.S., F.S.A.
 1694 (Stratford, Essex) – 1773 (Plaistow)
A naturalist who became librarian to the Royal College of Physicians. He served an apprenticeship in London, after which he spent a month in Holland. In 1718 he visited Norway, where he was captured as a suspected spy, and in 1719 and 1720 he travelled through France. On his return he began making wash drawings of animals. He revisited Holland in 1731. In 1750 he won the gold medal of the Royal Society and was later elected a Fellow. He was

elected F.S.A. in 1752, and in 1764 he retired to Plaistow. Shortly before his death, his collection of drawings was bought by the Marquess of Bute.

Published: *History of Birds*, 1743-51. With M. Darley: *New Book of Chinese Designs*, 1754. *Gleanings of Natural History*, 1758-64. *Essays of Natural History*, 1770. *Elements of Fossilogy*, 1776.
Examples: B.M.; V.A.M.

EDWARDS, George Henry
A genre and fairy painter in oil and watercolour who exhibited from 1883.

EDWARDS, James
A Nottingham landscape painter who exhibited at the R.A. in 1868.
Examples: V.A.M.

EDWARDS, Mary Ellen, Mrs. Staples
 1839 (Kingston-upon-Thames) – c.1908
A prolific book illustrator who specialised in the homely. She worked for the *Graphic, I.L.N., Good Words, Cornhill Magazine* etc. She exhibited at the R.A. from 1862 to 1908, using her maiden name until 1869, then Mrs. Freer until 1872, when she became Mrs. Staples.
Examples: Ulster Mus.

EDWARDS, Rev. Pryce Carter
A Welsh follower of J.S. Cotman (q.v.) who lived in Bath and was working between 1830 and 1840. His drawings are mostly in brown wash but occasionally in full watercolour, and are strongly reminiscent of Cotman's Greta period. His humans and cattle are distinctly cubist.
Examples: Nat. Mus., Wales.
Bibliography: *Apollo*, XXVII, 1938.

EDWARDS, Sydenham Teak **c.1769 (Usk) – 1819 (Brompton)**
A draughtsman of flora and fauna who exhibited at the R.A. from 1792 to 1814. He provided illustrations for Rees's *Cyclopaedia*, the *Sportsman's Magazine*, etc.

Published: *Cynographia Britannica*, 1800-5. *New Flora Britannica*, 1812.
Examples: B.M.; V.A.M.

EDWARDS, William Croxford see CROXFORD, William Edward

EGERTON, Hon. Alice Mary **c.1830 – 1868**
The daughter of the 1st Lord Egerton of Tatton, she married R. Cholmondeley of Condover Hall, Shropshire, in 1867 and died in childbirth the following year. She painted Civil War subjects and possibly portraits from at least 1849.

EGERTON, Jane Sophia see SMITH, Jane Sophia Collingwood

EGGINTON, Wycliffe, R.I. **1875 (Edgbaston) – 1951**
A landscape painter in the Collier tradition who worked in Ireland and England, and especially on Dartmoor. He exhibited from 1910 and was elected R.I. in 1912. In 1927 he was living in Teignmouth.
Examples: Aberdeen A.G.; Feaney A.G., Birmingham; Exeter Mus.; City A.G., Manchester; Plymouth A.G.

EGLEY, William **1798 (Doncaster) – 1870 (London)**
A miniaturist who occasionally painted on a larger scale. He exhibited at the R.A. from 1824 to 1870 and was noted for his portraits of children. He moved from Doncaster to Nottingham to London and was the father of W.M. Egley (q.v.).

Bibliography: *A.J.*, July, 1870.

EGLEY, William Maw **1826 – 1916**
The son of W. Egley (q.v.), he became a genre painter. He first exhibited at the R.A. in 1843 and from that year until 1855 he

concentrated on book illustrations. For the next seven years, probably under the influence of his friend W.P. Frith (q.v.) he painted scenes from contemporary life and thereafter eighteenth century costume subjects. He worked in both oil and watercolour.

Examples: B.M.; V.A.M.; Fitzwilliam.
Bibliography: V.A.M. MSS diaries.

EHRET, Georg Donysius **1708 (Erfurt) – 1770 (London)**
A natural history draughtsman and a friend of Linnaeus, Ehret first came to England in 1735, settling permanently the next year after a visit to Holland. His approach is that of a scientist rather than a decorative artist. He often worked on vellum and used bodycolour as well as watercolour.

Examples: V.A.M.; Ashmolean; Kew; Nat. Hist. Mus.
Bibliography: Linnaean Soc.: *Proceedings*, 1894-5.

ELFORD, Sir William, Bt. **1749 (Bickham, Devon) – 1837 (Totnes)**
A partner in a Plymouth bank, he was Mayor of Plymouth in 1797 and M.P. from 1796 to 1806. From 1807 to 1808 he was M.P. for Rye. He was also Lieutenant-Colonel in the South Devon Militia and served in Ireland during the 1798 rebellion. He was created a baronet in 1800 and lived the latter part of his life at the Priory, Totnes, where he took an active part in local affairs.

 A member of a wide literary and artistic circle, he was himself an artist, exhibiting at the R.A. from 1774 to 1837. He often made presents of his pictures and drawings to his friends, including the Prince Regent.

Examples: B.M.

ELGOOD, George Samuel, R.I. **1851 (Leicester) – 1943**
A landscape painter and gardener, he was educated at Bloxham and studied at South Kensington. He lived near Leicester and near Tenterden, Kent, and specialised in painting formal gardens and architecture in England, Italy and Spain. He was elected R.I. in 1882. Various exhibitions of his views of gardens were held at the Fine Art Society. THOMAS SCOTT ELGOOD, by whom there are three watercolours in the Darlington A.G., may have been a relation. He lived in Birmingham in 1879.

Published: *Some English Gardens*, 1904. *Italian Gardens*, 1907.
Examples: Preston Manor, Brighton; Maidstone Mus.; Wakefield A.G.

ELIZABETH, H.R.H. Princess, Landgravine of Hesse-Homburg
 1770 (Buckingham House) – 1840 (Frankfurt)
Seventh child of George III and Queen Charlotte, she married the Hereditary Prince of Hesse-Homburg in 1818, and remained in that state until her death in 1829, when she moved to Hanover. She revisited England in 1831 and spent many winters in Frankfurt.

 Her early enthusiasm for drawing earned her the nickname of 'The Muse'. The first series of engravings after her drawings *The Birth and Triumph of Cupid* was published in 1795. Later publications included *Cupid turned Volunteer*, 1804 and *The Power and Progress of Genius*, 1806, the profits from which provided dowries for 'virtuous girls'. She continued to produce similar subjects in Germany.

Examples: B.M.
Bibliography: Mrs. E.T. Cook: *Royal Elizabeths*, 1928. D.M. Stuart: *The Daughters of George III*, 1939.

ELLICOMBE, General Sir Charles Grene
 1783 (Alphington, Devon) – 1871 (Worthing)
A topographer who, on leaving Woolwich in 1801, was commissioned in the Royal Engineers and spent the next eighteen months in Portsmouth. He was then sent to Ceylon, where he remained until 1807. He served next at Chatham and in the North, and, from 1811 to 1814, in the Peninsula. In 1813 he was promoted lieutenant-colonel, becoming full colonel in 1830 and major-general in 1841. From 1821 to 1842 he was Inspector-General of Fortifications in London. He was appointed Colonel-Commandant of the Royal Engineers in 1856, was promoted full general in 1861

and knighted in the following year. On his retirement he settled at Worthing.

Examples: B.M.

ELLIOTT, Rev. Anthony Lewis c.1847 – 1909
An amateur artist who graduated from Trinity College, Dublin in 1869. He held various clerical appointments in Dublin, becoming a Canon of Christ Church in 1905.

ELLIOTT, Captain Robert James – 1849 (London)
A naval officer who was promoted captain in 1808 and probably rear-admiral in 1846. He may also have been the Robert Elliott who exhibited views of Canada and Jamaica at the R.A. from 1784 to 1789. At all events, his sketches of India, Canton and the Red Sea made between 1822 and 1824 were worked up for publication by S. Prout and C. Stanfield.

Illustrated: E. Roberts: *Views in the East,* 1830-33.

ELLIOTT, Robinson 1814 (South Shields) – 1894
A painter of landscapes, portraits, coastal and genre scenes in oil and watercolour. He attended Sass's Academy and on his return to the North-East, set up the first art class in South Shields. He exhibited at the R.A. from 1844 to 1881. He was also a poet.

Published: *Treasures of the Deep,* 1894.

ELLIS, Edwin John 1841 (Nottingham) – 1895
A marine and landscape painter who moved to London after working in a lace factory and studying under Henry Dawson. He exhibited from 1865 to 1891 and became a member of the S.B.A. in 1875. His favourite subjects were found on the coasts of Yorkshire, Cornwall and Wales. His work can be free in the later manner of Napier Hemy (q.v.), although his colour tends to be brighter. He was also a poet and book illustrator.

Examples: V.A.M.; Maidstone Mus.; City A.G., Manchester; Castle Mus., Nottingham.

ELLIS, Tristram James 1844 (Great Malvern) – 1922
Probably a relative of E.J. Ellis (q.v.), he worked as an engineer on the District and Metropolitan Railways before studying art in Paris. He travelled in Syria in 1880, produced a number of Norwegian views around 1893 and visited Cyprus in 1879, and Egypt, Cyprus, Turkey and Russia in 1896 and 1898. He was a book illustrator.

Published: *On a Raft, and through the Desert,* 1881.

ELLIS, William 1747 (London) – 1810
An engraver who was a pupil of W. Woollett (q.v.) and worked from his own topographical drawings as well as those of the Sandbys, Hearne and others. His work is in the manner of S.H. Grimm (q.v.).

Illustrated: D. Lyson: *Environs of London,* 1844.
Examples: B.M.

ELLIS, W
A painter who accompanied Captain Cook's last voyage to the Pacific, as surgeon on the *Resolution.* Ten of his views are at Greenwich.

ELMORE, Alfred, R.A.
 1815 (Clonakilty, Co. Cork) – 1881 (London)
An historical painter who moved to London, with his father, a retired army surgeon, at the age of twelve. There he made drawings from the antique at the B.M., entered the R.A. Schools in 1834 and first exhibited at the R.A. two years later. He travelled in France, Germany and Italy, returning to London in 1844. Pictures from this tour, which he exhibited at the B.I. and the R.A., established him as an historical painter of the first rank and won his election as A.R.A. He became a full R.A. in 1857 and was made an Honorary R.H.A. in 1878.

Examples: B.M.; V.A.M.; Ashmolean; N.G., Scotland.
Bibliography: *A.J.,* April 1857.

ELPHINSTONE, J
A topographer working in London about 1739. His style is reminiscent of that of A. Devis (q.v.), with spindly figures.

Examples: N.G., Scotland.

ELTON, Samuel Averill 1827 (Newnham) – 1886 (London)
A landscape painter in oil and watercolour who exhibited between 1860 and 1884 and became Master of the Darlington School of Art.

Examples: V.A.M.

ELWOOD, J
A draughtsman and caricaturist working in the late eighteenth and early nineteenth centuries.

EMANUEL, Frank Lewis 1865 (London) – 1948
An etcher and illustrator who was educated at University College School and University College, London, and studied at Julian's and the Slade. He travelled widely, visiting South Africa and Ceylon as well as the Continent. He worked as a town planner for a while and taught art at the Central School of Art, Forest School, Claremont and Linden House School. He was also a special artist for the *Manchester Guardian* and art critic for the *Architectural Review.* His subjects were usually landscapes and coastal scenes, and his style derived from those of de Wint and Beverley. He sometimes used tinted paper.

Examples: V.A.M.; London Mus.

EMES, John – c.1809
An etcher and engraver who may have been a pupil of W. Woollett (q.v.). There are prints by him in *Vitruvius Dorsettiensis,* 1816. He exhibited at the R.A. in 1790 and 1791 and made Hearne-like tinted drawings in the Lake District. He died before March 1810.

Examples: B.M.; V.A.M.; Abbot Hall A.G., Kendal.

EMSLIE, Alfred Edward, A.R.W.S. 1848 – 1917
A genre and portrait painter who exhibited from 1867 and was elected A.R.W.S. in 1888. An exhibition of his work was held at the Fine Art Society in 1896.

EMSLIE, John Phillipp 1839 – 1913 (London)
The son of an engraver, he followed the same profession and painted genre and topographical subjects, which he exhibited from 1869. He lived in London.

Examples: Bishopsgate Inst.

ENFIELD, Henry c.1830 (Nottingham) – c.1900
He entered the family firm of solicitors in Nottingham and was an amateur artist, painting landscapes in oil and watercolour. He exhibited at the R.A. and Suffolk Street from 1872 to 1893.

ENFIELD, Mrs. William
Wife of William Enfield, Town Clerk of Nottingham from 1845 to 1870, she was a pupil and imitator of J.B. Pyne (q.v.). Several of her views of Nottingham were lithographed.

Examples: Castle Mus., Nottingham.

ENGLAND, J
A topographer working around London in about 1800. The watercolours in the B.M. are of Clapham and Enfield.

Examples: B.M.

ENGLEFIELD, Sir Henry Charles, Bt., F.R.S., F.S.A.
 1752 – 1822 (London)
An antiquary, collector and patron, and a scientific writer, he succeeded his father in 1780 and was the last baronet. He was elected F.S.A. in 1779 and was President in 1811 and 1812. He was also a member of the Dilettanti and Linnæan Societies. He was a friend of Dr. Monro and a patron of J.S. Cotman, probably introducing him to his brother-in-law, Francis Cholmeley. Cotman

dedicated his first series of etchings to Englefield in 1811. His own drawings are rather old-fashioned.

Published: *On the Determination of the Orbits of Planets,* 1793. *A Walk through Southampton,* 1801. *Observations on . . . the Demolition of London Bridge,* 1821, etc.

ENGLEHEART, George **1752 (Kew) – 1839 (Blackheath)**
A miniaturist who was a pupil of Reynolds. Occasionally he also painted rather dull topographical watercolours. He was Miniature Painter to George III.

Examples: V.A.M.; Salisbury Mus.

ENOCK, Arthur Henry **(Glamorganshire) –**
A self-taught painter of landscapes and moorlands who began his career working for a Brazilian merchant in Birmingham. There he studied the Coxes, and during his holidays he sketched at Bettws-y-Coed and around Snowdon. He exhibited at Birmingham from 1869 to 1910 as well as in London. In about 1890 he turned to art as a profession and moved to Devon, where he was known as 'the Artist of the Dart'. He painted in both oil and watercolour, the latter particularly later in life, and he was noted for his handling of mist and sunlight.

Examples: Exeter Mus.

ESPIN, Thomas **c.1768 (Holton, Lincolnshire) – 1822 (Louth)**
An antiquarian, schoolmaster and occasional architect and artist. Most of his career was spent in Louth where he ran a 'Mathematical, Architectural, Nautical and Commercial Academy'. His architectural work was in the Gothic style.

Published: *A Short History of Louth Church,* 1807. *A Description of the Mausoleum in Brocklesby Park,* 1812.

ESSEX, Richard Hamilton **1802 – 1855 (Bow)**
An architectural and topographical draughtsman who was A.O.W.S. from 1823 until his resignation in 1837. Very occasionally he produced subject pieces, but he usually concentrated on English Cathedrals and churches, or, in 1830 and 1831, Belgian Cathedrals. He made a number of diagrams and drawings of the Temple Church for the Benchers and appears to have lived in London throughout his career.

Examples: V.A.M.

ESTALL, William Charles **1857 (London) – 1897**
A painter of landscapes, moonlight and sheep, he was brought up in Manchester and studied in London, France and Germany. He exhibited from 1874.

Examples: V.A.M.; Leeds City A.G.

ETTY, William, R.A. **1787 (York) – 1849 (York)**
He began to draw on the floor of his father's bakery, and, after serving an apprenticeship with a Hull printer, he came to London in 1805 determined to become an artist. With the support of Opie and Fuseli he attended the R.A. Schools, and he boarded with Lawrence, who gave him some tuition. In 1811 he first exhibited at the B.I. and the R.A. and by about 1820 had won a measure of success. He visited Italy briefly in 1816 and again in 1822-3, spending eighteen months in Venice. He also visited Paris several times, and later Belgium. His life was entirely devoted to painting, and towards the end of his career he achieved financial success and his work briefly became a cult. He was elected A.R.A. and R.A. in 1824 and 1828. 'Finding God's most glorious work to be woman', he set himself to extol her naked virtues. His remaining works were sold at Christie's, May 6-14, 1850.

Examples: B.M.; V.A.M.; Cartwright Hall, Bradford; Leicestershire A.G.; City A.G., Manchester; York City A.G.
Bibliography: A. Gilchrist: *Life of W.E.,* 1855. W.C. Monkhouse: *Pictures by W.E.,* 1874. W. Gaunt: *E. and the Nude,* 1943. D. Farr: *W.E.,* 1958. *A.J.,* 1849; 1858; 1859; 1903. *Country Life,* November 11, 1949. *Connoisseur,* CLIII, 1963.

EVANS, Rev. Arthur Benoni
 1781 (Compton Beauchamp) – 1854 (Market Bosworth)
A miscellaneous writer, a musician and an amateur artist, he was educated at Gloucester College School and St. John's College, Oxford. In 1805 he was appointed Professor of Classics and History at the Royal Military College, Great Marlow, which moved to Sandhurst in 1812. He resigned in 1822, and became Curate of Burnham, where he ran a crammer until 1829, when he was appointed Headmaster of Market Bosworth Grammar School. His writings are very varied, and his drawings include works in pencil, pastel and brown wash. He was particularly praised for his cattle subjects.

EVANS, Bernard Walter, R.I. 1848 (Birmingham) – 1922 (London)
The son of the designer Walter Swift Evans, and a cousin of George Eliot, he was a pupil of Samuel Lines and then settled in London exhibiting at the R.A. from 1871 to 1886. He was elected R.I. in 1888 and was a member of the R.B.A. as well as a founder of the short-lived City of London Society of Artists. He specialised in English and Continental landscapes.

Examples: V.A.M.; Blackburn A.G.; Cartwright Hall, Bradford; Laing A.G., Newcastle.

EVANS,.Frederick M
A genre painter who exhibited at the R.A. from 1891. He had a strange apocalyptic vision. He lived in London from 1888 to 1894 and from 1914 to 1928, and, in the interim, at Penzance.

Examples: Maidstone Mus.

EVANS, Richard **1784 (Birmingham) – 1871 (Southampton)**
He studied at the R.A. Schools in 1815 and began as a copyist of his friend Cox, continuing in Rome as a copyist of old masters. He was assistant to Lawrence for a time and exhibited portraits at the R.A. from 1816 to 1859.

Examples: B.M.
Bibliography: *A.J.,* March, 1872.

EVANS, Samuel Thomas George, R.W.S.1829 (Eton) – 1904 (Eton)
The son and successor of Evans of Eton, he exhibited from 1854 and produced Thames views reminiscent of those of T.M. Richardson, Yr. (q.v.). He was elected A.R.W.S. and R.W.S. in 1858 and 1897.

Published: *Learning to Draw,* 1899.
Examples: B.M.; N.G., Ireland.

EVANS, William
A draughtsman and engraver who worked for the Society of Dilettanti, Boydell and others in about 1800. He also took pencil and wash portraits.

EVANS, William, of Eton, O.W.S. **1798 (Eton) – 1877 (Eton)**
The son of SAMUEL EVANS, drawing master at Eton, whom he succeeded in 1818, and the father of S.T.G. Evans (q.v.), who in turn succeeded him in the post. He was educated at Eton and was a pupil of de Wint. He lived at Eton all his life and was house-master at the College for a while. He made regular visits to Scotland from 1833 and visited Ireland in 1836 and possibly in 1840. He does not seem to have visited the Continent until 1866 or 1867, when he went to the Riviera. He was a noted *Psychrolute.*

Examples: B.M.; V.A.M.; Haworth A.G., Accrington; Portsmouth City Mus.
Bibliography: E.G. Parm: *Annals of an Eton House,* 1907. *Connoisseur,* CXII, 1943.

EVANS, William, of Bristol, A.O.W.S.
 1809 (Bristol) – 1858 (London)
Evans seems to have spent most of his earlier life in Bristol and Wales. After 1845, when he was the elected A.O.W.S., he generally lived or stayed in London although still visiting the West. He probably made at least one Continental tour, in or after 1852, to

the Rhine and Italy, and he may have been in the Lake District with J.B. Pyne (q.v.) in 1857 or 1858. He was a teacher both of drawing and of the guitar, but was not himself a prolific artist. In style he was a great technician, soaking, pumping, scraping and scratching his paper, and using its texture to aid his compositions. His drawings are gay and rich in colouring.

Examples: B.M.; Bristol City A.G.; Newport. A.G.
Bibliography: *A.J.*, May, 1859.

EVERITT, Allen Edward 1824 (Birmingham) — 1882 (Edgbaston)
The son of an art dealer and grandson of a drawing master, Everitt took lessons from Cox. Until about the age of thirty he concentrated on drawing the old buildings of the Midlands. Between thirty and forty he made tours in Germany, Belgium and France gathering similar material. Later he painted interiors. He had a large practice as a drawing master and taught at the Birmingham Deaf and Dumb Institution. He was a member of the Royal Society of Artists of Birmingham and became its secretary.

Illustrated: Davidson: *History of the Holtes of Aston*, 1854. J.T. Bunce: *History of Old St. Martin's*, 1875.
Examples: City A.G., Birmingham; Birmingham Lib.; Grosvenor Mus., Chester; Gloucester City A.G.; Shrewsbury Lib.; Nat. Mus., Wales.

EWART, Vice-Admiral Charles Joseph Frederick
1816 — 1884
A professional sailor who accompanied the Lycian expedition of 1842 and served in the Mediterranean in 1854 and the Lebanon in 1861. He had retired by 1868. He was a competent draughtsman, working in a style based on that of E. Lear.

EWBANK, John Wilson, R.S.A.
1799 (Gateshead) — 1847 (Edinburgh)
Intended for the Catholic Church, he ran away from Ushaw College and in 1813 apprenticed himself to T. Coulson in Newcastle. He moved to Edinburgh with his master and studied under A. Nasmyth (q.v.). He became a successful drawing-master and in 1830 was a Foundation Member of the R.S.A. In 1838 he lost his membership and during his last twelve years he became an alcoholic; his pictures were painted in ale-houses or in the cellar where he lived. These were slap-dash efforts, painted on tin, and immediately sold to pay for his drinking. His best works were small pictures in oil or watercolour of rivers, coastal or marine subjects. From about 1829 he also painted large historical scenes.

Illustrated: J. Browne: *Picturesque Views of Edinburgh,* 1825.
Examples: B.M., Haworth A.G., Accrington; N.G., Scotland.

EYRE, Edward
A landscape and architectural painter who was working between about 1771 and 1792. He visited Bath each season from 1772 to 1776 and also painted in Derbyshire. His buildings are good, but his figures poor.

Examples: B.M.; V.A.M.; Victoria A.G., Bath.

EYRE, James 1807 (Ashbourne) — 1838 (Derby)
After training as a solicitor, he took up art and came to London where he studied under de Wint and Creswick, exhibiting at the B.I. and Suffolk Street. He established a class for drawing and design at the Derby Mechanics Institute. He painted a few landscapes in oil.

Examples: Derby A.G.

FAED, James 1821 (Kirkcudbright) – 1911 (Edinburgh)
Brother of J. and T. Faed (q.v.), he exhibited landscapes and genre
subjects from 1855 in London and Edinburgh. He was also a print
maker. His son JAMES FAED, YR. exhibited landscapes at the R.A.
from 1900 and died in 1920.

Examples: Aberdeen A.G.

FAED, John, R.S.A. 1819 (Kirkcudbright) – 1902 (Kirkcudbright)
He began his career as a self-taught miniaturist, achieving success
after moving to Edinburgh in 1841. During the next ten years he
turned from miniatures to larger works in oil and watercolour,
specialising in genre scenes which were greatly influenced by Wilkie.
He was a regular exhibitor at the R.S.A. and was elected A.R.S.A. in
1847 and R.S.A. in 1851. He moved to London in 1862, where he
exhibited at the R.A. until 1880. His style is close to that of his
brother Thomas, and throughout his life he remained close to
Wilkie, especially in his wash drawing.

Examples: Cartwright Hall, Bradford; Glasgow A.G.; Royal
Shakespeare Theatre, Stratford.
Bibliography: *A.J.*, October, 1871.

FAED, Thomas, R.A., A.R.S.A.
 1826 (Kirkcudbright) – 1900 (London)
The pupil of his brother, John Faed (q.v.), he studied at the
Edinburgh School of Design and was elected A.R.S.A. in 1849. He
moved to London in 1852 and was elected A.R.A. and R.A. in 1861
and 1864, retiring in 1893 because of increasing blindness. He was a
good draughtsman, and his subjects were Scottish, sentimental and
pathetic. His remaining works were sold at Christie's, February 16,
1901.
 His son JOHN FRANCIS FAED (b.c.1860) was a marine painter.

Examples: B.M.; V.A.M.; Haworth A.G., Accrington; Dundee A.G.;
Exeter Mus.; Glasgow A.G.; Paisley A.G.
Bibliography: *A.J.*, January, 1871.

FAGAN, Louis Alexander 1845 (Naples) – 1903 (Florence)
Diplomat, art critic and amateur artist. After serving in Italy,
Venezuela, Sweden and France, he retired from the foreign service
and joined the staff of the B.M. where he became Assistant Director
of Prints. He produced a number of books on old master and more
contemporary painters.

Published: *Reform Club: its founders and architect*, 1887. Etc.

FAHEY, Edward Henry, R.I. 1844 (Brompton) – 1907
The son of J. Fahey (q.v.), he studied architecture at South
Kensington and the R.A. Schools and was in Italy from 1866 to
1869. On his return he re-entered the R.A. Schools to study
painting. He exhibited from 1863 and was elected A.R.I. and R.I. in
1870 and 1876. He painted landscapes, coastal and genre scenes,
and his work can be very pretty.

Examples: V.A.M.

FAHEY, James, R.I. 1804 (Paddington) – 1885 (London)
He began by training as an engraver under his uncle, John Swaine,
after which he turned to watercolours and studied under G. Scharf
(q.v.) and in Paris. There he made anatomical drawings for
lithographs. He first exhibited in 1825 and was a founder of the
N.W.S. He was Secretary from 1838 to 1874, retiring because of
financial mismanagement. In 1856 he was appointed drawing-master
at the Merchant Taylors' School. Early in his career he painted
portraits, but by the mid-1830s he had turned almost exclusively to
landscapes.

Examples: B.M.

FAIRBAIRN, Thomas, R.S.W.1820 (Campsie, Stirling) – 1884
A pupil of Andrew Donaldson in Glasgow, he lived in Hamilton and
exhibited landscapes at Suffolk Street from 1865 to 1877. He also
made a series of drawings of old Glasgow. He was an unsuccessful
candidate for the N.W.S. in 1867.

Published: *Relics of ancient architecture . . . in Glasgow*, 1885.
Examples: Glasgow A.G.

FAIRHOLT, Frederick William 1814 (London) – 1866 (London)
The son of a German immigrant, he won a silver medal for drawing
from the Society of Arts when a boy. He worked first for a scene
painter and then, at twenty-one, became assistant to S. Sly, the
wood-engraver. He later worked for the Society of Antiquaries, of
which he was a Fellow, the British Archaeological Association, the
Numismatic Society, and on the *Art Journal*. In 1856 he visited the
South of France and Rome with Lord Londesborough, and on two
later occasions he went to Egypt with Londesborough's eldest son.
He left a number of books to the museum in Shakespeare's house at
Stratford.

Published: *Lord Mayors' Pageants*, 1841. *Costume in England*,
1846. *The Home of Shakespeare*, 1847. *Tobacco, its History and
Associations*, 1859. *Gog and Magog*, 1860. *Up the Nile*, 1862.
Illustrated: C. Roach Smith: *History of Richborough*. C. Roach
Smith: *Roman London*.
Examples: B.M.; V.A.M.
Bibliography: *A.J.*, June, 1866.

FAIRMAN, Frances C 1836 – 1923
Painter of dogs, mostly in oil, she turned to art as a profession after
a disastrous land speculation in Florida. She painted for Queens
Victoria and Alexandra, and rescued animals in London. In about
1870 she made a number of watercolours of Continental scenes.
They are sloppy and weak with no pencil underdrawing.

FALL, George c.1848 – 1925
A York topographer who studied at the York School of Drawing
and taught at Selby. In 1875 he married the daughter of an
engraver. The Minster is his favourite subject, but he drew elsewhere
in Yorkshire and also produced portraits in oil.

Examples: York City A.G.
Bibliography: *Notes and Queries*, 10th series, Vol. 15.

FALLOWES, William
A Bridlington painter and decorator. He worked in oil, watercolour
and brown wash between 1870 and 1900.

Examples: Bayle Gate Mus., Bridlington; Bridlington Lib.

FANSHAWE, Admiral Sir Edward Gennys
 1814 – 1906
An artist who joined the Navy in 1828, served in the Mediterranean
and was promoted commander in 1841. He painted in the East
Indies in 1844, the Falklands, Pitcairn, Tahiti and Borabora in 1849,
Panama in 1850, China in 1851 and in San Francisco. His ships are
well drawn, and his landscapes brightly coloured, if a little crude.

Examples: Greenwich.

FARINGTON, Joseph, R.A.
 1747 (Leigh, Lancashire) – 1821 (Didsbury, Lancashire)
A landscape painter who came to London in 1763 and spent several
years working under Richard Wilson. He was a member of the
Society of Artists from 1768 to 1773 and entered the R.A. Schools
in 1769. In the summer of 1773, he and his brother George went to

Houghton to draw the pictures which were later mezzotinted by Earlom and published by Boydell. In the late 1770s he returned to the North of England, remaining until 1781, during which time he sketched in the Lake District. In 1781 he came back to London and he lived there for the rest of his life. He was elected A.R.A. and R.A. in 1783 and 1785, and in 1793 he began to keep his diary, which is one of the most important sources of knowledge of the arts of the period.

In his finished topographical drawings he first sketches the subject lightly in pencil, then adds painstaking pen and black or brown ink outlines and finally a grey or brown wash, with occasional local colour such as blue. The whole effect is careful and self-controlled. His sketch books, however, show him in a much freer and more dashing vein.

Published: *Views of the Lakes*, 1789. *Views of Cities and Towns of England and Wales*, 1790.
Illustrated: W. Combe: *History of the River Thames*, 1794.
Examples: B.M.; V.A.M.; Ashmolean; Cartwright Hall, Bradford; Fitzwilliam; Glasgow A.G.; Leeds City A.G.; Walker A.G., Liverpool; N.G., Scotland; Laing A.G., Newcastle; Wakefield A.G.; York A.G.
Bibliography: J. Grieg: *Farington's Diaries*, 1922-28. F. Rutter: *Wilson and F.*, 1923. *Walker's Quarterly*, October, 1921.

FARMER, Emily, R.I. 1826 (London) – 1905 (Porchester)
The pupil of her brother ALEXANDER FARMER (d.1869), she was a miniaturist who later turned to genre painting. She exhibited at the R.A. and the N.W.S. from 1847 and was elected to the N.W.S. in 1854. She is best known for her groups of children.

Examples: V.A.M.

FARNBOROUGH, Amelia, Lady
 1762 – 1837 (Bromley Hill, Kent)
The daughter of Sir Abraham Hume, the connoisseur, she married Charles Long in 1793. He was knighted in 1820 and created Baron Farnborough in 1826. Like her, he was a patron of the arts – and an etcher – and he helped Girtin to make his visit to Paris in 1801. Lady Farnborough was Girtin's favourite pupil, and, in the words of the *Somerset House Gazette*, she had 'a talent for painting and drawing that might fairly rank with the professors of the living art.' She may also have been taught by J. Varley, since she produced works which are very close to his in style. She also shows the influence of Dr. Monro in some of her pencil drawings. She lived at Bromley Hill Place, Kent, and many of her subjects are taken from the area.

Examples: B.M.; Bromley Lib.; Dundee City A.G.; Glasgow A.G.; Leeds City A.G.; N.G., Scotland.

FARQUHARSON, David, A.R.A., A.R.S.A.
 1840 (Blairgowrie) – 1907 (Balmore, Perthshire)
Landscape, cattle and snow painter in oil and watercolour, he was the son of a dyke-builder and was apprenticed to a painter-decorator. He exhibited at the R.S.A. from 1868 and was elected A.R.S.A. in 1882. He was elected A.R.A. in 1905.

FARRIER, Robert 1796 (London) – 1879 (London)
After working for an engraver, he entered the R.A. Schools, supporting himself by taking portrait miniatures. He first exhibited at the R.A. in 1818. His later subjects, many of which were engraved for the Annuals, were often scenes of schoolboy life. His sister, Charlotte, frequently exhibited miniatures at the R.A.

Examples: V.A.M.

FAULKNER, John c.1830 – c.1888
An Irish landscape and marine painter in oil and watercolour who entered the R.D.S. Schools in 1848 and first exhibited at the R.H.A. in 1852. He was elected A.R.H.A. and R.H.A. in 1861. In 1870 he was expelled from the Academy and left Dublin for America. Later he came to London, where he earned his living by painting watercolours for dealers. He exhibited at the R.H.A. again from

1880 to 1887 and was living in Kenilworth in 1883.

Examples: Whitworth Inst., Manchester.

FAWKES, Francis Hawksworth 1797 – 1871
Eldest son of Walter Ramsden Fawkes of Farnley Hall, near Otley, Yorkshire, he drew wash caricatures, and was a friend and patron of Turner, as his father had been. It was he who described Turner's methods of painting *A First-Rate taking in Stores* in 1818. On his death in 1871, the estate and collection passed to his brother, the Rev. Ayscough Fawkes.

FEARNSIDE, W
A painter of landscapes, cattle and rustic genre scenes who exhibited at the R.A. from 1791 to 1801. He worked in water and bodycolour.

Examples: V.A.M.

FENNELL, John Greville 1807 (Irish Sea) – 1885 (Henley)
Angler and artist, he studied with H. Sass and with the Findens, where he was a close friend of 'Phiz' Browne. Most of his life was devoted to the theory and practice of fishing, which plays an equally large part in his painting. His work includes caricatures and pure landscapes. He was a friend of Dickens and Thackeray, and his epitaph read: 'The fishers also shall mourn, and all they that cast angle in the brooks shall lament.' Isaiah XIX, 8.

FENNELL, Louisa 1847 – 1930
There are a number of watercolours in the Wakefield A.G. by this artist.

Published: *Twelve Sketches illustrating the life of St. Paul in Rome*, 1881.

FERGUSON, J
A painter of army uniforms, primarily of Scottish regiments. He was probably the illustrator of *Army Equipment*, 1865-6 and may well be identifiable with James Ferguson who painted landscapes in London, Edinburgh and Keswick and was an unsuccessful candidate for the N.W.S. in 1850.

FERGUSON, John
An artist working in Preston in about 1830. Lithographs were published after his drawings by Day and Haghe.

FERGUSON, William J
A landscape painter who specialised in trees, buildings and views of the Italian Lakes. He was working between 1849 and 1886 and was an unsuccessful candidate for the N.W.S. in 1868 and 1869. On the latter occasion he went unballoted because he had apparently lied about his age. He lived in London and Cheltenham.

FERNYHOUGH, William
A Lichfield artist who may have been a pupil of Glover and was active between 1804 and 1815. There were a number of other painters of the name including FANNY FERNYHOUGH, JOHN ROBERT FERNYHOUGH and THOMAS FERNYHOUGH. There are examples of their work in Stafford Lib. A WILLIAM H. FERNYHOUGH, who may be identical with the above, published twelve profile portraits of Aborigines of New South Wales in 1836.

FERRIER, George STRATTON-, R.I., R.S.W.
 (Edinburgh) – 1912 (Edinburgh)
The son of James Ferrier, a landscape painter, he exhibited Scottish views and scenes at the R.A. and the R.I. to which he was elected in 1898. He was also an engraver.

FIDLER, Gideon 1857 – 1942
A painter of rustic scenes and landscapes in oil and watercolour. He lived in Wiltshire and exhibited at the R.I. from about 1887.

FIDLOR, I

A painter of landscape and shore scenes who was working in Devonshire in the 1820s. At his best he was a restrained follower of W. Payne (q.v.), otherwise he worked rather in the manner of J. Varley, with weak figures and cattle and stilted architectural drawing.

Examples: Exeter Mus.

FIDLOR, J H

A topographer who was active from 1797 to 1808 and who worked in Monmouthshire in the early style of S. Prout (q.v.).

Examples: B.M.

FIELD, Edwin Wilkins
1804 (Leam, Warwickshire) – 1871 (the Thames)

A solicitor who in 1840 began the agitation for Chancery Law reform. Another measure with which he was associated was the Act of 1862 establishing artistic copyright. Early in his career he set up a drawing class at the Harp Alley School. In his free time he sketched in the Isle of Wight and regularly on the Thames with Dodgson, George Fripp and others. He was legal adviser to the O.W.S., by whom he was presented with a portfolio of original drawings in 1863. He was drowned in a boating accident.

FIELD, John 1771 – 1841 (Molesey)

A landscape, portrait, architectural and coastal painter who exhibited at the R.A. from 1800 to 1836. He worked in Kent and Pembrokeshire as well as London. His work is predominantly in blues and greens with little drawing, and is rather flat.

Examples: B.M.

FIELD, Walter, A.R.W.S. 1837 (Hampstead) – 1901 (Hampstead)

The son of E.W. Field (q.v.), he was educated at University College School, was a pupil of J.R. Herbert and of John Pye and studied at the R.A. Schools. He exhibited landscapes, often on the Thames, genre subjects and portraits from 1856 and was elected A.R.W.S. in 1880.

Examples: V.A.M.

FIELDING, Anthony Vandyke Copley, P.O.W.S.
1787 (Halifax) – 1855 (Worthing)

The second son of N.T. Fielding (q.v.), who gave him his first lessons. The family moved to London a few months after his birth, and to the Lake District when he was fifteen. In 1807 he visited Liverpool to sell drawings and in 1808 he toured Wales and visited London, where he settled the following year. He became a pupil of J. Varley (q.v.) and was one of the Monro circle. In 1810 he made a tour of the Borders and was elected A.O.W.S. In 1811 he sketched in Wales and the next year he made a short trip to Kent and was elected O.W.S. In 1813 he was in Durham and Yorkshire, in 1814 on the Thames, in 1815 in North Wales and in 1816 he toured the Wye valley. In the same year his elder daughter fell ill, and he spent as much time as possible with his family on the coast at Sandgate. During the 1820s he painted a large number of marine subjects. In 1829 he settled in Brighton, keeping a studio in London, and in about 1847 he made a final move to Worthing.

In 1813 he became Treasurer of the O.W.S. and in 1815, Secretary. He was President from 1831 until his death.

Fielding, it has been said, was a man of 'one sea, one moor, one down, one lake, one misty gleam' and this is largely true. Early in his career, as exemplified by his Wye drawings, he works are smaller, fresher and more appealing than later. He is not only limited in his subject matter, but in his mannerisms and his palette which usually consists of blues, purples, yellows and browns. His mannerisms include the dragging of the brush to give an idea of distance and the effect of sunlight through mist, which cleverly disguises the lack of more original ideas. His stormy marine subjects catch the feeling of the British coasts, but they too are repetitive in composition and palette.

Examples: B.M.; V.A.M.; Aberdeen A.G.; Blackburn A.G.; Grundy

A.G., Blackpool; Bury A.G.; Coventry Mus.; Derby A.G.; Doncaster A.G.; Dudley A.G.; Towner Gall., Eastbourne; Exeter Mus.; Glasgow A.G.; Gloucester City A.G.; Harrogate Mus.; Abbot Hall A.G., Kendal; Leeds City A.G.; City A.G., Manchester; Newport A.G.; Castle Mus., Nottingham; Sydney A.G.

Bibliography: O.W.S. Club, III, 1925.

FIELDING, Frederick F (or R)

A son of N.T. Fielding (q.v.), he painted views of Carlisle in oil and watercolour. Given the ambitious names of his brothers, it is not impossible that he is the mysterious 'Raffael Fielding' mentioned by Thomas Dodd as working under him for a while as a clerk in the Enrolment Office of the Court of Chancery with his brother Copley.

Examples: Carlisle A.G.

Bibliography: *Memoir of Thomas Dodd,* 1879.

FIELDING, Mary Anne, Mrs., née Walton, O.W.S.

The daughter and sister of artists and the wife of T.H.A. Fielding (q.v.) with whom she worked. She painted flowers and still-lifes and was a Lady Member of the O.W.S. from 1820 to 1835.

FIELDING, Nathan Theodore

Landscape painter in oil and watercolour, he was the father and mentor of at least five painting sons. He worked in the North of England and in London, and he exhibited from 1775 to 1814.

FIELDING, Newton Smith Limbird 1799 (London) – 1856 (Paris)

Youngest son of N.T. Fielding (q.v.), he first exhibited at the Oil and Watercolour Society in 1815 and 1818. He ran the family engraving business in Paris from about 1827 to 1830 when the Revolution drove him back to England. At this time W. Callow (q.v.) was working under him. He worked with his brothers Thales and Theodore in England for a time and then returned to Paris where he remained until his death. He had an extensive teaching practice, his pupils including members of the family of Louis-Philippe. His best known works are studies of farmyards and small wild animals. They are executed in a pleasing mixture of accurate detail and impressionistic effects.

Published: *Three Hundred Lessons,* etc., 1852. *Lessons on Fortifications,* etc., 1853. *A Dictionary of Colour* etc., 1854. *What to Sketch with,* etc., 1856. *How to Sketch from Nature,* 1856 (2nd.ed.).

Examples: B.M.; V.A.M.

FIELDING, Thales, A.O.W.S. 1793 (London) – 1837 (London)

Pupil and third son of N.T. Fielding, he exhibited with the O.W.S. from 1810 and was elected Associate in 1829. Although he shared the family house in Newman Street from 1818 until the end of his life, he worked in the Paris business from about 1820 to 1827 and shared a house there with Delacroix, of whom he painted a portrait. He was for some years teacher of drawing at the R.M.A., Woolwich.

His landscapes are usually English or Welsh, and generally make a strong feature of a group of cattle. He also made figure studies of gipsies, fishermen and the like, and occasionally attempted classical or literary themes.

Examples: B.M.; V.A.M.; Gloucester City A.G.

FIELDING, Theodore Henry Adolphus
1781 (?Halifax) – 1851 (Croydon)

The eldest son of N.T. Fielding (q.v.), he was an engraver and landscape painter. He exhibited at the R.A. from 1799 and worked at the family studios in Newman Street until 1825 when he moved to Kentish Town. In 1827 he was appointed Professor of Drawing at the Military Academy, Addiscombe. From this time he lived in or around Croydon.

His engravings include plates after his brother Copley, Barker of Bath and Bonington. His watercolours are difficult to tell from those of his brother Thales. His pupils included W. Callow and C. Bentley.

Published: *Synopsis of Practical Perspective* etc., 1829. *On Painting*

in Oil and Water Colours, 1830. *Index of Colours and Mixed Tints*, 1830. *On the theory of Painting*, 1836. *The Art of Engraving*, etc., 1844. *The Knowledge and Restoration of Oil Paintings*, 1847.
Examples: B.M.; V.A.M.; Towner A.G., Eastbourne; Leeds City A.G.

FILDES, Sir Samuel Luke, R.A. 1844 (Liverpool) – 1927 (London)
Illustrator, portrait and genre painter, he studied at a Liverpool Mechanics' Institute, the Warrington School of Art and South Kensington. He worked on various magazines including the *Graphic*, and he illustrated Dickens's *Edwin Drood*. In the 1870s he turned to genre painting in oil and in the 1890s to portraits. He was elected A.R.A. and R.A. in 1879 and 1887 and knighted in 1906. His remaining works were sold at Christie's, June 24, 1927.

Examples: V.A.M.; Glasgow A.G.
Bibliography: L.V. Fildes: *L.F., R.A., a Victorian Painter*, 1968.

FILKIN, G GRIFFIN
A Birmingham painter of coastal, genre and rural subjects who exhibited there between 1873 and 1882.

FINCH, Rev. and Hon. Daniel 1757 – 1840
The sixth son of the 3rd Earl of Aylesford, he was a pupil of J.B. Malchair at Oxford. He was Rector of Cwm, Flintshire, and Harpsden, Oxfordshire, and became a Prebend of Gloucester and Senior Fellow of All Souls. He drew caricatures as well as landscapes.
He should not be confused with his nephew, Hon. Daniel Finch, for whom, and for others of the family, see Aylesford, 4th Earl of.

Examples: B.M.; Fitzwilliam.
See Family Tree.

FINCH, General Hon. Edward 1756 – 1843
The brother of H. Finch, 4th Earl of Aylesford (q.v.) and of D. Finch (q.v.), he was educated at Westminster and Cambridge and in 1778 enlisted as a Cornet in the 2nd Light Dragoons. He served through the campaigns in Flanders, Denmark and Egypt among others, and in 1796 he was promoted major-general. In 1799 he was elected M.P. for Cambridge, holding the constituency for twenty years. He retired from active service in 1808 and was promoted full general in 1819. He was a keen sketcher, although only one drawing definitely by his hand has so far been identified outside the Packington collection.

See Family Tree.

FINCH, Francis Oliver, O.W.S. 1802 (London) – 1862 (London)
An orphan, he had little formal education and was largely brought up by his grandmother near Aylesbury. In 1814 or 1815 he was apprenticed to J. Varley for three years, remaining as a pupil for two further years. He exhibited at the R.A. from 1817. In 1820 he made one of only two journeys outside the southern counties, sailing to Edinburgh and touring the Highlands. Two years later, when only nineteen, he was elected A.O.W.S., becoming a full Member in 1827. Prior to this he had studied at Sass's Life School and may have attended Fuseli's R.A. lectures. He was a great admirer of Fuseli, as of Blake, whom he had met through Varley, becoming one of the Shoreham disciples. Although he disliked teaching, he took pupils in order to raise the money to marry, which he did in 1837. He lived in London throughout his career and only once ventured abroad, in the summer of 1852 when he visited Paris. In 1857 he had a stroke which led to increasing paralysis and deafness. However he was still able to make pencil copies of his earlier works.
As well as a painter, he was a poet and a deeply religious man, being much involved with the Swedenborgian Church. As an artist he is best described as 'a poetic landscapist'. He shared the dislike of Cox, with whom he is often bracketed, for mere 'portraits of places'. In style the two were not alike, Finch working more in the quiet romantic vein of Barret.

Examples: B.M.; V.A.M.; Ashmolean; Fitzwilliam.

Bibliography: E. Finch: *Memorials of F.O.F.*, 1865. *Connoisseur*, CIII, 1939.

FINN, Herbert John 1861 (London) –
A landscape painter in oil and watercolour, and an etcher, he studied at South Kensington, where he won a scholarship. He lived in London and worked there and at Folkestone.

Illustrated: E.J. Macdonald: *Castles of England and Wales*, 1925.
Examples: Maidstone Mus.; Castle Mus., Nottingham.

FINNEMORE, Joseph, R.I. 1860 – 1939
A genre, figure and architectural painter in oil and watercolour, who studied at the Birmingham School of Art and in Antwerp. Thereafter he lived in Birmingham. He was elected R.I. in 1898 and retired in 1930.

FINNIE, John 1829 (Aberdeen) – 1907 (Bootle)
A landscape painter, illustrator and mezzotinter who studied at Newcastle under W.B. Scott (q.v.). He lived in Edinburgh, Wolverhampton and Newcastle before moving to London in 1853. Later he settled in Liverpool where he became President of the Academy and, until 1896, Head of the School of Art. He was an unsuccessful candidate for the N.W.S. in 1869.

Examples: V.A.M.; Leeds City A.G.; Walker A.G., Liverpool.

FIRMINGER, Rev. Thomas Augustus Charles
** 1812 (London) – 1884**
Educated at Pembroke College, Cambridge, Firminger lived in Edmonton for some years and visited France and the Rhine. He was elected N.W.S. in 1834 but retired ten years later 'in consequence of his having entered the Church.' In 1846 he was appointed to the honorary curacy of Sittingbourne and to a practical chaplaincy to the Bishop of Calcutta. At first he was based on Ferozepore, later at Howrah, Chinsurah and Gowhatty. In 1854 he made an extensive Indian tour and in 1864-5 served with the Bhutan expedition. He retired in 1868. Despite the abandonment of the N.W.S. for the cloth, he continued to exhibit Indian views there, at the R.A. and the B.I. until 1871.

Published: *Manual of Gardening for India*, 1863.

FISCHER, John George Paul 1786 (Hanover) - 1875
The son of an engraver, he was the pupil of the court painter J.H. Ramberg. He came to England in 1810 and was commissioned to paint miniatures of members of the Royal Family and military uniforms for the Prince Regent. He exhibited at the R.A. and elsewhere from 1817 to 1852 and occasionally painted landscapes as well as publishing a few prints.

Examples: B.M.

FISHER, Alfred Thomas 1861 (Plymouth) –
A landscape painter who was the son of a Chaplain to Seamen and was educated at St. John's, Leatherhead. He lived in Cardiff and was Secretary of the South Wales Art Society from 1913 to 1924.

FISHER, Amy E
A painter of domestic scenes and town views who exhibited at the R.A., the R.I. and elsewhere from 1866 to 1890.

Examples: V.A.M.

FISHER, Sir George Bulteel 1764 – 1834
A landscape and shipping painter who was a pupil of F. Towne (q.v.). He served in the Artillery in the Peninsula and in Canada and at the end of his life was Commandant at Woolwich. He exhibited at the R.A. from 1780 to 1808 and a number of engravings were made from his views from about 1790. Williams points out that his drawings are constructed 'in a series of a few superimposed vertical planes, like stage scenery.'

Examples: B.M.; V.A.M.; Leeds City A.G.; Laing A.G., Newcastle.

FISHER, J H Vignoles
A landscape painter who lived in London and exhibited at the R.A., the R.I. and at Suffolk Street from 1884. Various exhibitions of his work were held at the Dowdeswell Galleries in the 1890s and 1900s.

Examples: Towner Gall., Eastbourne.

FISHER, John, Bishop of Salisbury
 1748 (Hampton) — 1825 (London)
Educated at St. Paul's and Peterhouse, Cambridge, he became a Fellow of St. John's in 1774. He was private tutor to a number of distinguished pupils including Prince Edward, Duke of Kent from 1780 to 1785. He was in Italy in 1785 and 1786 and was then appointed Canon of Windsor by the King, of whom he was a favourite. In 1803 he became Bishop of Exeter and in 1807 of Salisbury. In 1818 he paid an episcopal visitation to the Channel Islands. He was a distinguished connoisseur and patron, whose protégés included Constable — although he should not be confused with his nephew and chaplain, Archdeacon John Fisher, who was Constable's close friend. His own work shows poor drawing, but a good sense of composition and pleasing light washes of colour. He drew in Italy as well as in East Anglia and the West Country.

Examples: Ashmolean; Abbot Hall A.G., Kendal.
Bibliography: R.B. Beckett: *John Constable with the Fishers*, 1952.

FISHER, Jonathan (Dublin) — 1809
A Dublin draper who became a landscape painter. He appears to have been self-taught, although he may have had some lessons when he visited England early in his career. He exhibited with the Society of Artists from their opening exhibition in 1765 until 1801. His pictures, which are rather stiff, were not popular, and in 1778 he was forced to take a position in the Stamp Office, where he remained until his death. The prints which were made after his drawings, however, were more successful. In 1770 he published six *Views of Killarney*, and in 1772 six *Views of Carlingford* were published in London. Other sets followed, including, in 1789, a folio volume *A Picturesque Tour of Killarney* which he dedicated to his friend and patron, John, Earl of Portarlington. His major work was a *Scenery of Ireland*, 1796, with sixty plates aquatinted by himself. Four of his drawings were used in Grose's *Antiquities of Ireland*. After his death, his collection of old master paintings was auctioned at 12, Bishop Street, Dublin, and he left his drawings to H. Graham (q.v.).

Examples: B.M.; V:A.M.; City A.G., Manchester.

FISHER, Joseph 1796 — 1890 (Oxford)
After serving an apprenticeship with the Oxford engraver F. Whessell, he spent some time in London before returning to Oxford in the early 1830s. He was the first Keeper of the University Galleries in 1844 and became a Freeman of the City. His work is topographical and includes copies of early works by Turner.

Examples: Fitzwilliam.

FISHER, Joshua 1859 (Liverpool) —
A landscape and figure painter who was the son of a painter-decorator. He studied at the Liverpool School of Art under J. Finnie (q.v.) and was President of the Liverpool Sketching Club in 1918.

Examples: Nat. Lib., Wales.

FISHER, Mark See FISHER, William Mark

FISHER, Richard Siddons 1864 — 1928
The son of RICHARD FISHER, manager of the Derby gas works and an amateur artist, who contributed drawings to the Anastatic Drawing Society and died at the age of ninety-six. The son worked as an accountant at the gas works and was a member of the Derby Sketching Club for many years.

Examples: Derby A.G.

FISHER, Thomas, F.S.A.
 1782 (Rochester) — 1836 (Stoke Newington)
A painter of landscapes and town scenes and an antiquarian draughtsman and engraver, he worked in the India Office. His collections and remaining works were sold by Southgate & Son, March 15 and May 30, 1837.

Examples: B.M.; Cecil Higgins Mus., Bedford.

FISHER, William Mark, R.A., R.I.
 1841 (Boston, U.S.A.) — 1923 (London)
Painter of landscapes and cattle, he studied in Boston and Paris and came to England in 1872. He was elected R.I. in 1881, A.R.A. in 1911 and R.A. in 1919, and he was also a Member of the N.E.A.C. He was strongly influenced by Corot, and his work in both oil and watercolour is full of light.
 His daughter Millicent Margaret Fisher Prout was also an artist.

Examples: V.A.M.; Blackburn A.G.; Exeter Mus.; Leeds City A.G.; Ulster Mus.
Bibliography: V. Lines: *M.F. and Margaret Fisher Prout*, 1966.

FISK, William Henry 1827 — 1884 (Hampstead)
The son and pupil of the painter William Fisk, and a student at the R.A. Schools, he was appointed anatomical draughtsman to the Royal College of Surgeons and exhibited landscapes from 1846. He taught drawing and painting at University College, London.

Examples: V.A.M.

FITCH, Walter
He made botanical illustrations for the works of Sir W.J. Hooker (q.v.), the majority after 1835.

Illustrated: W.J. Hooker: *Icones Plantarum*, 1827-54. W.J. Hooker: *The Botanical Magazine*, 1827-65. J.E. Howard: *Illustrations of the Nueva Quinologia of Pavon*, 1859. J.L. Stewart: *The Forest Flora of N.W. and Central India*, 1874.
Examples: B.M.

FITTON, Hedley 1859 (Manchester) — 1929 (Haslemere)
An etcher and occasional watercolour painter of architectural subjects. He worked in France, Italy and Scotland as well as England, and he lived in Cheshire, London and Surrey.

Examples: City A.G., Manchester.

FITZGERALD, Frederick R
A painter of coastal and marine subjects who lived in Cheltenham. He visited Norway, and he exhibited in Birmingham in 1897.

FITZJAMES, Anna Maria (Bath) —
A flower painter who took lessons from V. Bartholomew and was one of William Henry Hunt's few known pupils. She exhibited in London from 1852 to 1876 and became a highly successful teacher.

FITZPATRICK, Thomas 1860 (Cork) — 1912
A draughtsman and lithographer, he was apprenticed to a printing and publishing firm in Cork, after which he worked as a lithographer in Dublin and was cartoonist for the *Weekly Freeman* and the *Weekly National Press*. In 1905 he started the monthly *Leprechaun* in which his skill as a humorous cartoonist was amply demonstrated. As well as his illustrations, he painted in oil and watercolour.

FLACK, Thomas 1771 (Garboldisham) — 1844 (Arras)
A landscape painter in oil and watercolour who worked mainly on the Continent.

Examples: Mus. d'Arras.

FLEMING, John B , R.S.W. 1792 (Greenock) — 1845
A painter in oil and watercolour of landscapes and above all of lochs, of which he provided a series for Swan's *Scottish Lochs*, 1834. He lived in Greenock.

Examples: Glasgow A.G.; Greenock A.G.; Paisley A.G.

FLEMWELL, George Jackson 1865 (Mitcham) – 1928 (Lugano)
A painter of the Alps and their wild life who was a pupil of W.P. Frith and studied in Antwerp before settling in Switzerland. He exhibited at the R.A. from 1892 and an exhibition of his work was held at the Baillie Gallery, London, in 1910.

Published: *Alpine Flowers and Gardens*, 1910. *The Flower Fields of Alpine Switzerland*, 1911. *Beautiful Switzerland*, 1913.

FLETCHER, William Teulon Blandford
1858 – 1936
He studied at South Kensington from 1875 to 1879 and under Verlat in Antwerp until 1882. In France where he painted during his summers, he came into contact with such artists as Stanhope Forbes and Bastien-Lepage, his friendship with Forbes continuing at Newlyn. In Cornwall, and later near Dorking, where he lived after his marriage, he painted and sketched village scenes as well as landscapes, seascapes and portraits. He exhibited at the R.A. from 1879.

With the exception of his very early and very late works, which are muted in tone, his colour is rich, and he shows the influence of F. Walker (q.v.) whom he much admired, and his watercolour style is sometimes reminiscent of that of L. Rivers (q.v.).

Examples: Ashmolean; Worcester City A.G.

FLINT, Robert Purves, R.W.S., R.S.W. 1883 (Edinburgh) – 1947
Younger brother of Sir W.R. Flint (q.v.), he was educated at Daniel Stewart's College, Edinburgh, and later lived at Whitstable, Kent. He was elected R.S.W. in 1918, A.R.W.S. in 1932 and R.W.S. in 1937, and held a one-man show at the Leicester Galleries in 1926. His subjects are often views in the South of France and North Africa.

Examples: Glasgow A.G.

FLINT, Sir William Russell, R.A., P.R.W.S., R.S.W.
1880 (Edinburgh) – 1969 (London)
The son of an artist, he was educated in Edinburgh where he also worked for a lithographer before moving to London in 1900. He studied at Heatherley's, turning to pure watercolour, and produced many fine illustrations. During the First World War he was in the R.N.V.R. and the R.A.F., working on airships. He was elected A.R.A. and R.A. in 1924 and 1933 and P.R.W.S. three years later.

His early illustrative work, in the tradition of Dulac, Rackham and the young Heath Robinson, can be very beautiful. He also produced a number of landscapes whose merits are often overlooked in the contemplation of the banal if technically brilliant breastscapes which filled his later years.

Examples: B.M.; V.A.M.; Aberdeen A.G.; Blackburn A.G.; Darlington A.G.; Glasgow A.G.; Greenock A.G.; Harrogate Mus.; Leeds City A.G.; Leicestershire A.G.; Maidstone Mus.; Newport A.G.; Paisley A.G.

FLOWER, Charles Edwin 1871 (Merton) –
An architectural and garden painter who studied at the R.C.A. and became an art master. He was much patronised by the Royal Family, worked as an illustrator and lived near Wallingborough, Oxfordshire.

Illustrated: G.F. Edwards: *Old Time Paris*, 1908. C.E. Pascoe: *No. 10, Downing Street*, 1908.
Examples: London Mus.

FLOWER, John 1793 (Leicester) – 1861 (Leicester)
A topographer who spent a year in London as a pupil of de Wint. As well as working in his native county, he painted in Wales, Yorkshire, Lancashire, Derbyshire, the Isle of Man, Cheltenham, Kent, Middlesex and other parts of the British Isles. He painted in oil as well as watercolour, and his style is close to that of the master. In turn, his daughter, ELIZABETH FLOWER, painted in a manner similar to his.

Examples: B.M.; Leicestershire A.G.; Nat. Lib., Wales.

FOLEY, J B
A landscape and marine painter in oil and watercolour who exhibited at the B.I. and Suffolk Street from 1863 to 1877.

FOLINGSBY, George Frederick
1830 (County Wicklow) – 1891 (Melbourne, Australia)
An historical painter who, at the age of eighteen, left Ireland for Canada and later New York, where he was draughtsman to *Harper's Magazine* and studied drawing at the New York Academy. He then travelled through Europe, visiting Greece and Turkey, and from 1852 to 1854 studied in Munich. After six months in Paris he spent a further five years working in Munich. He visited Belfast in 1862, returned once more to Munich and settled in Australia in 1879. He was appointed Director of the National Gallery of Victoria in 1884.

Examples: Melbourne A.G.

FONNEREAU, Thomas George 1789 (Reading) – 1850 (Bushey)
An author, barrister and amateur artist who gave up his legal practice in 1834 to devote himself to writing. In about 1840 he visited Italy with C. Stanfield (q.v.) and later wrote *Memoirs of a Tour in Italy* which was privately printed and was illustrated with fifteen of his landscape sketches. He built himself a villa at Bushey.

Published: *Diary of a Dutiful Son*, 1864.

FORBES, Elizabeth Adela Stanhope, Mrs., née Armstrong, A.R.W.S.
1859 (Ottawa) – 1912 (Newlyn)
After a London upbringing and studying at South Kensington, she returned to Canada. She spent some time at the Art Students' League in New York and then, in 1882, studied and painted in Munich and Brittany. In 1883 she came back to London, and, after a stay in Holland, she settled at Newlyn, Cornwall. She married Stanhope Alexander Forbes, R.A. in 1889, and in 1898 she was elected A.R.W.S.

Published: *King Arthur's Wood*, 1904.
Examples: B.M.; V.A.M.
Bibliography: Mrs. L. Birch: *S.A. Forbes and E.F.*, 1906. *A.J.*, 1904.

FORBES, James, F.R.S., F.S.A.
1749 (London) – 1819 (Aix-la-Chapelle)
In 1765 he went to Bombay as a writer to the East India Company, and in 1775 he accompanied Colonel Keating on a Mahrattas expedition. He held posts in Goojerat and Dubhoy and returned to England in 1784. He married in 1788 and thereafter lived in London and Stanmore. He and his family later visited Switzerland and Germany, and France during the Peace of Amiens. They were detained in France until June, 1804. In 1811 he took charge of his grandson, Charles de Montalembert, and after Waterloo they went to live in France with his daughter and son-in-law. Two years later they returned to England and in 1819 set out for Stuttgart, Forbes dying en route.

In India Forbes filled one hundred and fifty folio volumes with sketches and notes on the flora, manners, religions and archaeology of the country. He also produced views in France, mainly in brown ink and brown wash.

Published: *Letters from France*, 1806. *Oriental Memoirs*, 1813-15.
Bibliography: *Country Life*, September 17, 1964.

FORD, F
A London landscape painter who exhibited at the R.A. from 1852 to 1860. He may be the F.J. Ford who was an unsuccessful candidate for the N.W.S. in 1848.

Examples: Bishopsgate Inst.

FORD, J
In the Beecroft A.G., Southend there is a watercolour of the old Pier with this signature, dated 1883.

FORD, Richard 1796 (London) – 1858 (Heavitree, Essex)
The son of Sir Richard Ford, M.P. and Lady Ford, an amateur artist,

he was educated at Winchester and Trinity College, Oxford and was called to the bar, but never practised. Between 1830 and 1834 he lived in the Alhambra and Seville, making long tours around the country and entertaining artist friends such as J.F. Lewis. On his return he built himself a house near Exeter and concentrated on writing and criticism. He spent the winter of 1839-40 in Rome.

His book, the *Handbook*, has become a classic. He was a collector and connoisseur as well as an amateur artist. His work shows the influence of Lewis, but his drawing is generally weak and his colours can be rather sickly.

His first wife, HARRIET FORD (1806-1837), the illegitimate daughter of the 5th Earl of Essex, was also a watercolourist in the Lewis manner.

Published: *Handbook for Travellers in Spain*, 1845. *Apsley House and Walmer Castle*, 1853.
Examples: Newport A.G.
Bibliography: *A.J.*, October, 1858. *Burlington*, LXXX, May, 1942. Wildenstein, *Exhibition Cat.*, 1974.

FORDE, Samuel 1805 (Cork) — 1828 (Cork)
He studied at the Cork Academy under J. Chalmers (q.v.), who also taught him scene painting. He tried mezzotint engraving, but abandoned it to become a drawing master at the Cork Mechanics' Institute and elsewhere. His pictures were ambitious and literary, including a distemper painting *The Vision of Tragedy* for which he made many sketches. He died of consumption at the age of twenty-three while engaged upon what he considered his most important painting, *The Fall of the Rebel Angels*.

Examples: V.A.M.

FORREST, Charles c.1748 —
He entered the R.D.S. Schools in 1765, and exhibited miniatures and chalk portraits in Dublin until 1780. There is a watercolour of Dunbrody Abbey, County Wexford, by him in the R.I.A.

FORREST, Thomas Theodosius 1728 (London) — 1784 (London)
The son of Ebenezer Forrest, a solicitor who wrote the account of Hogarth, Scott, Thornhill and company's *Five Days Peregrination* down the Thames in 1732. Theodosius studied under G. Lambert (q.v.) and adopted his father's profession, becoming solicitor to Covent Garden where one of his musical compositions was once performed. He was a member of the Beefsteak Club, and he exhibited at the R.A. from 1762 to 1781, after which date he suffered from the nervous illness which led to his suicide.

Examples: B.M.; V.A.M.
Bibliography: *Gentleman's Mag.*, 1784.

FORRESTER, James
A landscape painter and engraver known as the 'Irish Sandby'. He studied in the George's Lane School, Dublin, from 1747, and in 1752 he received the School's drawing prize. Soon afterwards he went to live in Rome, occasionally sending pictures for exhibition in Dublin and London. He produced a number of carefully etched Italian scenes.

Examples: V.A.M.; Ulster Mus.

FORRESTER, Joseph James, Baron de, F.S.A.
 1809 (Hull) — 1861 (River Douro)
A wine merchant in Hull and Portugal who exhibited watercolours at Hull in 1827, 1828 and 1829. He went to Oporto in 1831 to work in the family firm. Whilst there he compiled an elaborate map of the Douro which was published in 1848. He strove to raise the standards of the port trade and published many pamphlets on it.

FORSTER, J
A topographer who made pen and wash or watercolour drawings of Edinburgh and the Lowlands from 1785 to 1790.

Examples: N.G., Scotland.

FORTESCUE, Henrietta Anne, Hon. Mrs. — 1841
A landscape painter who married firstly Sir T.D. Acland, 9th Bt. and secondly, in 1795, Captain the Hon. Matthew Fortescue, R.N., brother of the first Earl Fortescue. She painted in Italy in 1817 and 1821, the Pyrenees in 1818, Scotland in 1823 and in the Lake District, Cornwall and other parts of Britain. Her work, although in no way original, would be a credit to many of the professionals of the period.

Examples: Coventry Mus.; Abbot Hall A.G., Kendal.

FOSBROOKE, Leonard
A landscape painter who lived at Ashby de la Zouche and exhibited in London from 1884.

FOSTER, John c.1787 (Liverpool) — 1846
The son of an architect and pupil of Jeffry and James Wyatt, he exhibited drawings at the R.A. from 1804. In 1809 he travelled on the Continent, and he was in Greece the following year with Haller and C.R. Cockrell (q.v.). He returned to England in 1816 and worked as a partner in the family firm until 1824. Until 1835 he was Architect and Surveyor to the Liverpool Corporation, designing many of the city's most important buildings.

His Greek and Turkish watercolours show an ability to handle both landscape and architectural detail. They are in clear brown or coloured washes, and they are often inscribed and initialled.

Examples: B.M.

FOSTER, Myles Birket, R.W.S.
 1825 (North Shields) — 1899 (Weybridge)
The course of Foster's early career may have been influenced by his parents' knowledge of Bewick. When the family moved to London in 1830, he was given a Quaker education and apprenticed to the wood-engraver Peter Landells. Until about 1850 he worked exclusively as an engraver and a black and white illustrator, making many designs for the *I.L.N.* Throughout the 1850s he was teaching himself to paint in watercolour and he turned to it seriously in about 1859. Thereafter he exhibited some four hundred works with the O.W.S., of which he was elected Associate and Member in 1860 and 1862. His house at Witley, Surrey, was partly decorated by the Pre-Raphaelites and became a centre for artists of many different types. He lived there until illness forced a move to Weybridge in 1893. He travelled widely on the Continent from his first visit to the Rhine in 1852, and he first visited Venice with F. Walker (q.v.) in 1868. He was commissioned to make a series of fifty Venetian views by Charles Seeley of Nottingham at a fee of £5,000.

Although he has been hugely faked, his genuine works are fairly easy to recognise. His early experience as a wood-engraver left its mark in his style. In finished watercolours he employs a stipple technique, especially on flesh, and his drawing is always minutely accurate. He generally worked on a comparatively small scale, but he is also one of the very few watercolourists to have made a complete success of a really large composition. To many tastes there is too much sentiment mixed with his pigments, but among artists his reputation has always been high.

Examples: B.M.; V.A.M.; Aberdeen A.G.; Haworth A.G., Accrington; Ashmolean; Blackburn A.G.; Grundy A.G., Blackpool; Exeter Mus.; Glasgow A.G.; Greenwich; Hitchin Mus.; Inverness Lib.; City A.G., Manchester; N.G., Scotland; Laing A.G., Newcastle; Newport A.G.; Paisley A.G.
Bibliography: H.M. Cundall: *B.F.*, 1906. *A.J.*, May, 1871, 1890. O.W.S. Club, XI, 1933.

FOSTER, William — 1812
A portrait and figure painter in oil and watercolour who exhibited from 1772. His figures can be reminiscent of those of Cristall.

Examples: B.M.

FOSTER, William 1853 (London) — 1899
The second son of M.B. Foster (q.v.), whose manner he followed.

He exhibited landscapes, still-lifes and genre subjects and was both a black and white and a colour illustrator, notably of bird books.

FOSTER, William Gilbert 1855 (Manchester) – 1906
The son of a portrait painter who taught him until 1876 when he first exhibited at the R.A. and moved to Leeds. He became a member of the R.B.A. in 1893. He painted in oil and watercolour and drew in charcoal, and his favourite subjects were farms and evenings.

Examples: Cartwright Hall, Bradford.

FOTHERGILL, George Algernon 1868 (Leamington) –
A doctor and sporting artist, he studied medicine at Edinburgh University and art at Uppingham. He practiced in Darlington, where he played a prominent part in sporting life and illustrated a number of books on sporting subjects. He worked in watercolour, pen and ink and pencil.

Published: *Fothergill's Sketch Books*, 1903. Etc.
Examples: Darlington A.G.
Bibliography: *A.J.*, 1902.

FOWLER, Robert, R.W.S. 1853 (Anstruther) – 1926 (Liverpool)
He studied in London and then lived in Liverpool until 1904 when he returned to the metropolis. He exhibited from 1876 and was a member of the R.I. from 1891 to 1915 when he transferred to the R.W.S. His earlier work is in the neo-classical manner of A. Moore (q.v.), sometimes with an admixed Japanese influence. Later he painted landscapes in oil and watercolour and also posters.

Examples: Exeter Mus.

FOX, Charles 1794 (Norfolk) – 1849 (Leyton)
He was brought up in the gardens of Lord Strafford at Cossey Hall, Norfolk, whence he derived his life-long interest in flowers. He took drawing lessons from C. Hodgson (q.v.) and trained as an engraver with William Camden Edwards at Bungay, Suffolk. Afterwards he came to London and assisted John Burnet on plates after Wilkie. He also worked for the Annuals. He was a judge of the Horticultural Society and superintended the illustrations of *The Florist*. As well as watercolours of plants, he took portraits of his friends.

FOX, Charles James
A London painter of landscapes in oil and watercolour who exhibited from 1883.

FOX, Edward
A London painter who exhibited landscapes in oil and watercolour at the R.A., the O.W.S. and elsewhere from 1813 to 1854. He moved to Brighton in 1829.

Examples: V.A.M.

FOX, Henry Charles 1860 –
A painter of rustic scenes who exhibited at the R.A. and Suffolk Street from 1879 to 1913, and lived for a time at Kingston-on-Thames. His backgrounds, although not his figures, are in the Birket Foster tradition. He generally uses white heightening.

Examples: Reading A.G.

FRANCIA, Louis Thomas 1772 (Calais) – 1839 (Calais)
Francia came to England in 1795, when he first exhibited at the R.A. He was a fellow student with Girtin at Dr. Monro's, and in May 1799 was Secretary and a co-founder of Girtin's Sketching Club 'The Brothers'. He worked as an assistant at J.C. Barrow's drawing school in Holborn and in 1805 he set up as a drawing master in Kensington. In 1810 he joined the A.A. and the next year became Secretary. He was also Painter in Watercolours to the Duchess of York. In 1816 he failed to gain election as A.R.A. and in 1817 he returned to Calais where he spent the rest of his life, and where he gave lessons to his most famous pupil R.P. Bonington (q.v.).

His early work is executed in deep dark tones, both of monochrome and colour washes, and shows the influence of Girtin. Later his colours became thinner, tending more to yellow-browns and greys, and the works of this period can be similar to those of J.S. Cotman. In the coastal scenes of his Calais years, which are among his best works, it is often difficult to tell which of the two, he or Bonington, influenced the other more. They are often signed 'L.F.' on a floating spar or piece of timber.

Published: *Studies of Landscapes*, 1810. *Marine Studies*, 1822.
Examples: B.M.; V.A.M.; Aberdeen A.G.; Ashmolean; Fitzwilliam; Greenwich; Leeds City A.G.; N.G., Ireland; Newport A.G.

FRANKLAND, Sir Robert (-Russell), 7th Bt.
** 1784 – 1849**
An amateur artist and M.P. for Thirsk, Yorkshire from 1815 to 1834. He lived at Thirkleby Park and took the additional name of Russell in 1837. His father, SIR THOMAS FRANKLAND (1750-1831) was a pupil of J.B. Malchair (q.v.).

FRANKLIN, John
An Irish landscape and genre painter who entered the R.D.S. Schools in 1819, after which he worked in Dublin. He exhibited at the opening exhibition of the R.H.A. in 1826 and again in 1827 and 1828. He then moved to London, where he exhibited at the B.I. and the R.A. from 1830 to 1861, specialising in scenes from Venetian history.

Illustrated: Hall: *Ireland, its Scenery and Character*, 1841. W. Harrison Ainsworth: *Old St. Paul's*. Carleton: *Traits and Stories of the Irish Peasantry*, 1852.
Examples: B.M.; V.A.M.

FRASER, Alexander, R.S.A.
** 1828 (Linlithgow) – 1899 (Musselburgh)**
The son of A.G. Fraser (q.v.), he studied at the Trustees' Academy and was elected A.R.S.A. and R.S.A. in 1858 and 1862. From 1847 to 1857 he spent the winters in London, and he also sketched in Wales. However his subjects were usually Scottish landscapes. He was partially disabled by rheumatism from 1885. As well as landscapes he painted still-lifes and interiors. His work became progressively less detailed.

Examples: V.A.M.; N.G., Scotland; Newport A.G.

FRASER, Alexander George A.R.S.A.
** 1785 (Edinburgh) – 1865 (Wood Green)**
A fellow student who became Wilkie's assistant. He exhibited his own work at the R.A. from 1810 to 1848 and was one of the first A.R.S.A.'s. His drawings are very much in the Wilkie mould of Scottish genre.

Examples: B.M.; N.G., Scotland; Paisley A.G.

FRASER, Claud Lovat 1890 (London) – 1921 (Sandgate)
An illustrator and stage designer who was educated at Charterhouse and was a pupil of Sickert. He was gassed at Loos, and he later worked in the Records Office for two years. His greatest theatrical success was *The Beggar's Opera*. His watercolours include bird studies.

Examples: B.M.; V.A.M.

FRASER, John 1858 – 1927
A marine painter in oil and watercolour who exhibited from 1879 and was a member of the R.B.A.

Examples: Greenwich; Hove Lib.

FRASER, Captain Thomas 1776 – 1823
The son of a Morpeth portrait painter, he served with the Madras Engineers from 1796 to 1819. He carried out surveys at Seringapatam in 1799 and, with J. Gantz (q.v.), in the districts of Bellary, Kurnod, Anantapur and Cuddapah in 1802. He made watercolours of ruins and waterfalls as well as plans and surveys.

Examples: India Office Lib.

FRASER, William Gardener
The Frasers of Huntingdon and Bedfordshire are yet another of the prolific but obscure families among watercolour painters. They were of Scottish origin and regarded themselves as Jacobites, regaling their neighbours with free beer on Oak Apple Day. W.G. Fraser, who also used the name W.F. Garden, settled in Hemingford Abbotts before 1890, and he was soon joined by GEORGE FRASER at Houghton and GILBERT BAIRD FRASER and ROBERT WINTER FRASER, who had been living in Highbury from at least 1881, at Holywell. W.G. Fraser and G.B. Fraser were still there in 1920. R.W. Fraser was the most talented of the family. Like the others, he painted river landscapes, often on the Bedford Ouse. He used a rather acid green and sometimes too much bodycolour, but the results can be pleasing.

There are examples of his work at Darlington A.G. and Cecil Higgins A.G., Bedford.

FREEBAIRN, Robert, A.O.W.S. 1765 — 1808 (London)
A pupil of Richard Wilson, after whose death in 1782 he went to study and work in Italy, returning in 1792. Although chiefly an oil painter, he was one of the first group of Associates elected to the O.W.S. in December 1805. In his two years he only exhibited eight drawings, all of Italian subjects. His son Alfred Robert Freebairn was an engraver.

Examples: Lancaster Mus.

FREEBORN, William
An artist who painted London views in about 1850.

FREEMAN, William Philip Barnes
1813 (Norwich) — 1897 (Norwich)
The son of William Freeman, Secretary of the Norwich Society and Crome's companion in Paris, he was a pupil of J.S. Cotman and J.B. Ladbroke and was a member of the Norwich Amateur Club. He exhibited in London in 1860 and 1862 and was three times an unsuccessful candidate for the N.W.S. between 1862 and 1865.

Examples: Castle Mus., Norwich; Gt. Yarmouth Lib.

FRENCH, William Percy 1854 (Cloonyquin) — 1920
An engineer and composer and arranger of folk songs such as 'Slattery's Mounted Foot', he was educated at Trinity College Dublin. He painted landscapes using a wet technique and specialised in mists and moors. He also produced humorous drawings.

Examples: County Mus., Armagh; Ulster Mus.

FRIPP, Alfred Downing, R.W.S. 1822 (Bristol) — 1895 (Hampstead)
The brother of G.A. Fripp (q.v.) and a grandson of N. Pocock (q.v.), he came to London in 1840 and studied at the B.M. and the R.A. Schools. He exhibited with the O.W.S. from 1842 and was elected A.O.W.S. and O.W.S. in 1844 and 1846. He was Secretary from 1870 until his death. He went to Rome in 1850, and for the next four years Italian landscapes and peasants are prominent among his subjects. Before and afterwards, despite another Italian visit in 1859, English, Irish and Welsh views form the major part of his work.

Examples: V.A.M.; City A.G., Bristol; Sydney A.G.
Bibliography: C.E.M. Roberts *A.F.*, 1932. *Walker's Quarterly*, XXV XXVI, 1928.

FRIPP, Charles Edwin, A.R.W.S.
1854 (London) — 1906 (Montreal)
The son of G.A. Fripp (q.v.) he studied in Nuremburg and Munich. From 1878 to 1900 he was a war correspondent for the *Graphic*, his extensive travels including a visit to Japan. He was elected A.R.W.S. in 1891, and he may be identifiable with the C.L. Fripp noted by the *Art Journal* as an exhibitor at the B.I. in 1873.

Illustrated: B. Field: *Fairy Tales*, 1898.
Examples: V.A.M.

FRIPP, George Arthur, R.W.S. 1813 (Bristol) — 1896 (London)
A grandson of N. Pocock (q.v.), he was taught to paint in oil and watercolour by J.B. Pyne (q.v.) and S. Jackson (q.v.). He began his career as a portrait painter in Bristol. He visited Italy in 1834 with W.J. Muller (q.v.). He began to exhibit with the O.W.S. in 1837 and moved to London in the following year. In 1841 he was elected A.O.W.S. and in 1845 O.W.S., serving as Secretary from 1848 to 1854. In 1864 he stayed at Balmoral drawing local views for the Queen. His style is varied, in his early landscapes showing an affinity to Cox, and later a rather old-fashioned effect of greens and yellows over careful pencil drawing.

Examples: B.M.; V.A.M.; Aberdeen A.G.; Ashmolean; Blackburn A.G.; Coventry A.G.; Leeds City A.G.; City A.G., Manchester; N.G. Scotland; Newport A.G.; Richmond Lib.; Beecroft A.G., Southend; Ulster Mus.
Bibliography: H.S. Thompson: *G.A.F. and A.D. Fripp*, 1928. *Walker's Quarterly*, XXV, XXVI, 1928.

FROST, George 1734 (Ipswich) — 1821 (Ipswich)
An admirer of Gainsborough and a friend of Constable, Frost was an amateur artist who, confusingly, taught other amateurs. He worked first in his father's building business and then in the office of the Blue Coach at Ipswich. His subjects are taken from Ipswich and the neighbourhood, and the black chalk and grey wash drawings which form the majority of his work can be very close to Gainsborough. He also made watercolours of boats and buildings on the Orwell, and figure studies. A characteristic touch is his use of a purplish-red.

Examples: B.M.; Glasgow A.G.
Bibliography: F. Brown: *Frost's Drawings of Ipswich*, 1895.

FROST, William Edward, R.A.
1810 (Wandsworth) — 1877 (London)
He studied at Sass's drawing school on the advice of W. Etty (q.v.), the B.M. and the R.A. Schools, and he began his career as a portrait painter. He was elected A.R.A. in 1845, R.A. in 1870 and retired in 1876. By the 1840s his naked nymphs had become so popular that he gave up portrait painting to give them his undivided attention. His subjects are usually taken from Milton, Spenser and the ancients. His ladies and their attendants are all the same, with long sensuous outlines, glowing pink complexions and discreetly placed draperies.

Examples: B.M.; Ashmolean; Fitzwilliam.
Bibliography: *A.J.*, January, 1857; 1877.

FROUDE, Rev. Robert Hurrell 1779 — 1859
Educated at Oriel College, Oxford, he became Rector of Dartington and Denbury, Devonshire, and Archdeacon of Totnes. He sketched in the West Country and in France. His subjects are village streets, ruins and landscapes, his washes of colour or monochrome soft and gentle and his pen outlines economical. He was the father of J.A. Froude, the historian.

Examples: Cathedral Lib., Exeter.

FRY, William Arthur 1865 (Otley) —
A landscape and marine painter who lived in Hollywood, Co. Down. He also painted portraits and genre pictures.

FUGE, James, N.W.S. — 1838 (London)
A landscape painter who exhibited from 1832. He appears to have been a member of the N.W.S. for a few months in 1838.

FULLEYLOVE, John, R.I. 1847 (Leicester) — 1908 (London)
A painter of towns, landscapes and genre subjects, he was apprenticed to an architect. He travelled widely in Europe and the Near East, illustrating books on the Holy Land, Greece, Oxford and elsewhere. He exhibited in London from 1871, was a member of the R.W.S. for a short time and was elected A.R.I. and R.I. in 1878 and 1879. He was a friend of T. Collier (q.v.), whose influence can occasionally be seen in his work. Although his drawing and colouring are good, the overall effect can sometimes be a little messy.

Various exhibitions of his work were held at the Fine Art Society, including *Greek views* in 1896 and *Views of the Holy Land* in 1902.

Examples: B.M.; V.A.M.; Ashmolean; Coventry Mus.; Fitzwilliam; Greenwich; Leicestershire A.G.; Maidstone Mus.; Newport A.G.; Stalybridge A.G.

Bibliography: *A.J.*, 1908.

FULLWOOD, John **(Birmingham) — 1931**
A landscape painter and etcher who was educated in Birmingham and studied in Paris. He was a member of the R.B.A. and exhibited from 1874. He was living at Twickenham in 1927, and he may have been the brother of ALBERT HENRY FULLWOOD, (b. 1864) a Birmingham landscape painter who was working from 1881 to at least 1904 and living in London in the latter year.

Published: *Remnants of Old Wolverhampton*, 1880. *Fairlight Glen*, 1892.

FULTON, David, R.S.W. **1848 (Glasgow) — 1930 (Glasgow)**
A painter of interiors and landscapes who studied at the Glasgow School of Art and exhibited in London, Venice, Prague and St. Louis as well as in Scotland. He was elected R.S.W. in 1891.

Examples: Paisley A.G.

FUSELI (FÜSSLI), John Henry, R.A.
 1741 (Zürich) — 1825 (Putney)
Fuseli came of a distinguished and artistic Swiss family, and in his early years he showed more of a leaning towards literature than painting. His friendship with the physiognomist, J.C. Lavater, had a great influence on his later style. In 1761 they were both ordained, but two years later they left Zürich for Berlin as a result of a political disturbance. Early in 1764 Fuseli came to England, where he was much encouraged by Reynolds, who inspired him to paint in oil. In 1769 he went to Rome, and he remained in Italy for eight years, studying the old masters and working under Raphael Mengs. In Rome he was the centre of a circle which included A. Runciman (q.v.) and J. Brown (q.v.). In 1788 he left Rome and in the following year returned to England by way of Switzerland. He was

elected A.R.A. and R.A. in 1788 and 1790. In 1790 he was appointed Professor of Painting at the R.A., and he held the post virtually until his death. His lectures had a wide influence on the younger generation of artists.

Fuseli was a figure draughtsman who occasionally added coloured washes to his drawings. His work is related stylistically to the wash drawings of Romney, and he is of the school of illustration which includes Stothard and Westall. He, however, takes the conventions of this school to an extreme, and his drawings are decidedly individual in a theatrical manner. It seems probable that Blake's pen work was more strongly influenced by that of Fuseli than the other way around. Fuseli's inspiration is mainly drawn from history, romance and literature — he contributed nine subjects to Boydell's Shakespeare. His women, in particular, are stately and stylised with fantastic head-dress and coiffures.

He was ambidextrous.

Published: *Lectures on Painting*, 1801.
Examples: B.M.; V.A.M.; Ashmolean; Fitzwilliam; N.G., Scotland; Ulster Mus.
Bibliography: J. Knowles: *Life and writings of H.F.*, 1831. P. Ganz: *The drawings of H.F.*, 1949. N. Powell: *The drawings of H.F.*, 1951. F. Antal: *F. studies*, 1956. P. Tomory: *The Life and Art of H.F.*, 1972. *A.J.*, May, 1859. November, 1861. Tate Gal., *Exhibition Cat.*, 1975.

FUSSELL, Joseph
 1818 (Birmingham) — 1912 (Point Loma, Canada)
A landscape painter who studied at the R.A. Schools and afterwards worked for a time as an engraver. He lived for most of his life in Nottingham, where he taught at the School of Art, of which his brother FREDERICK FUSSELL was Headmaster. In 1903 he emigrated to Canada to live with one of his sons. He also painted still-lifes.

His daughter ALICE FUSSELL (b. c.1850) gave drawing lessons and later became an art mistress at Nottingham High School for girls. She exhibited locally.

Examples: Castle Mus., Nottingham.

GADSBY, William Hippon 1844 (Derby) – 1924 (London)
The son of a Derby solicitor, in whose office he worked for two years. He was determined to study art and trained at Heatherley's and for nine years at the R.A. Schools, where Millais took an interest in him. He visited the Continent, and studied in Rome and Venice in 1870. In 1896 he worked on a commission to copy a portrait of Queen Victoria at Buckingham Palace. He exhibited at the R.A. and on his death was the oldest member of the R.B.A. He painted in oil and watercolour and was best known for his sentimental portraits of children. In 1922 he contributed a watercolour of a child's head to the Queen's Dolls' House. He also painted still-life and figure subjects, and he rarely signed his work.

Examples: Derby A.G.

GAGE, Sir Thomas, Bt. c.1780 – 1820
An amateur marine artist who was a patron of J. Bourne (q.v.). He succeeded to the title in 1798, and in 1809 he married a daughter of the Earl of Kenmare.

GAINSBOROUGH, Thomas, R.A.
 1727 (Sudbury, Suffolk) – 1788 (London)
'At ten years old Gainsborough had made some progress in sketching, and at twelve was a confirmed painter' (Cunningham). At fourteen he was sent to London and became a pupil of Gravelot, the engraver. He then attended the St. Martin's Lane Academy and spent three years as a pupil of Francis Hayman. He tried to establish himself in London, but returned to Sudbury in 1745. He married and settled in Ipswich, where he built up a successful practice. In 1760 he moved to Bath, where his portraits were highly fashionable. He was a founder member of the R.A. in 1768, and he made a final move to London in 1774. He quarrelled with the Academy twice and exhibited nothing with them from 1769 to 1772 and from 1784 to his death. He became a favourite painter at Court as well as in Society.
 He worked in a variety of media including pencil, black and white chalk, monochrome and occasionally water or bodycolour. Usually his drawings are the result of a mixture of several techniques. His Suffolk drawings show more naturalism than those of the Bath or London periods, which became more Italianate and composed as his style found favour among amateurs. Although he used watercolour, he cannot be classed as a true watercolourist, and his importance in this field lies mainly in the stylistic influence which he exerted on artists such as G. Frost (q.v.) and Dr. Monro (q.v.), and indirectly on many more.

Examples: B.M.; V.A.M.; Ashmolean; Cartwright Hall, Bradford; Fitzwilliam; Leeds City A.G.; City A.G., Manchester; N.G. Scotland; Wakefield A.G.
Bibliography: P. Thicknesse: *A Sketch of the Life and paintings of T.G.*, 1788. Lord Leveson Gower: *The Drawings of T.G.*, 1907. W.T. Whitley: *T.G.*, 1915. Sir C.J. Holmes: *Constable, G., and Lucas*, 1921. M. Woodall: *G's Landscape Drawings*, 1939. M. Woodall: *T.G.*, 1949. O. Millar: *T.G.*, 1949. B. Taylor: *G.*, 1951. E.K. Waterhouse: *G.*, 1958. J. Hayes: *The Drawings of T.G.*, 1970. *Country Life*, February 29, 1936. Victoria A.G., Bath: *Exhibition Cat.*, 1951. Arts Council: *Exhibition Cat.*, 1953; 1960. *Connoisseur:* CLXI, 1966.

GALE, Benjamin 1741 (Aislaby, Yorkshire) – 1832 (Bridlington)
He worked as a portrait painter and landscapist in the Hull area from about 1775 until 1803. In 1800 he became a friend of the young J.C. Ibbetson (q.v.), whom he helped to some of his first commissions. In 1803 he became resident drawing master at Scawby Hall, Lincolnshire, the home of the Nelthorpe family, and he also worked for other patrons in the area, including J. Uppleby (q.v.) and Sir Charles Anderson of Lea. He was still exhibiting at Hull in 1829.

Illustrated: Tickell, *History of Hull*, 1796(?).
Examples: Wilberforce House, Hull.
Bibliography: R.M. Clay: *Life of J.C. Ibbetson*, 1948.

GALE, George
An artist who painted Venetian views about 1832. An R.L. GALE was an unsuccessful candidate for the N.W.S. in 1841.

GALTON, J
An artist who sketched in Yorkshire, Devon and Provence between 1839 and 1852.

GANDON, James, R.H.A., F.S.A.
 1743 (London) – 1823 (Lucan, Co. Dublin)
An architect and artist, he studied at Shipley's Academy in St. Martin's Lane, under Sir William Chambers until 1765 and at the R.A. Schools from 1768. He exhibited drawings at the Free Society and Society of Arts from 1762 and the R.A. from 1774 to 1780. He went to Dublin in 1781 to build the new docks and Custom House. He designed a number of other important buildings in Dublin, including the Four Courts. In 1808 he retired to his estate near Lucan, where he concentrated on improvements.

Bibliography: *Country Life*, October 22, 1948.

GANDY, Joseph Michael, A.R.A. 1771 (London) – 1843
Like his brothers, J.P. Gandy-Deering and Michael Gandy, he was principally an architect, and was a pupil of James Wyatt. He studied at the R.A. Schools, and travelled on the Continent from 1793 to 1799. He was elected A.R.A. in 1803. In 1811 he returned to London from a spell in Liverpool to work for Sir John Soane as he had previously, making numerous drawings for which Soane got the credit. He seems to have died insane.
 His drawings show a strong architectural bias and a preference for neo-classicism. In his larger and more elaborate works he employs a strange blend of architecture and mysticism. His son Thomas became a portrait painter.

Published: *Designs for Cottages . . .*, 1805. *The Rural Architect . . .*, 1805.
Examples: B.M.; V.A.M.; R.I.B.A.; Soane Mus.
Bibliography: *A.J.*, 1899.

GANTZ, John 1772 – 1853 (Madras)
A draughtsman and surveyor of Austrian extraction who worked for the East India Company from about 1800 to 1803. He set up as an architect and lithographer in Madras.
 His eldest son JUSTINIAN GANTZ (1802-1862) was a partner in the business as well as painting miniatures and visiting Burma as a Company Surveyor. His work is less classical and lighter in feeling than that of his father. In 1856 he published *A Manual of Instruction . . . Architectural Drawing*.

Published: *The Indian Microcosm*, 1827.
Examples: B.M.; India Office Lib.
Bibliography: *Antique Collector*, XXXI, March 1960.

GARBUT, Joseph 'Putty'
A house painter who lived in South Shields and also painted landscapes and genre subjects in oil and watercolour. He was active from about 1870 to 1900.

GARDEN, W F see FRASER, William Gardener

GARDINER, General Sir Robert William
 1781 – 1864 (Claremont)
He entered the R.M.A., Woolwich, in 1795 and in 1797 left for
Gibraltar as a second lieutenant in the Royal Artillery. He served at
the capture of Minorca, and in 1805 in Germany. He was then
posted to Sicily, returning via Gibraltar in December 1807. He was
with Wellington in Portugal, served on the Walcheren expedition,
and thereafter fought through the Peninsular Campaign. He was
made K.C.B. in 1814 and fought at Waterloo. He was appointed
principal equerry to Prince Leopold on his marriage to Princess
Charlotte, and was Governor of Gibraltar from 1848 to 1855. In
1854 he was promoted General.

He was an amateur artist, working generally in light washes, and
he wrote several military treatises.

GARDINER, William Nelson 1766 (Dublin) – 1814 (London)
Principally an engraver and bookseller, he showed an early interest
in drawing, and was sent to the R.D.S. Schools for three years from
1781. After this he came to London but, growing tired of his
profession as an engraver, returned to Dublin and squandered all his
money. He then came back to England, and tried unsuccessfully for
a Cambridge Fellowship. For a time he was employed by Edward
Harding, for whom he had previously worked as an engraver, to
copy oil paintings in watercolour. He exhibited genre subjects at the
R.A. between 1787 and 1793. In 1801 he opened a book shop in
Pall Mall, but, although to begin with his eccentricities attracted
customers, he deteriorated in manner and appearance and business
slackened. He became ill and finally committed suicide. His
chequered career also included periods as a silhouette painter, an
actor and scene painter, and a portraitist.

Examples: B.M.; N.P.G.

GARDNER, William Biscombe 1847 – 1919 (Tunbridge Wells)
He was primarily an engraver, making prints after Alma Tadema and
Leighton as illustrations for the *Graphic* and the *I.L.N.* He also
painted landscapes in oil and watercolour and exhibited at the R.A.
from 1874. He lived in London from 1880 to 1882 and from 1897
to 1905, Surrey from 1883 to 1896 and Tunbridge Wells from
1906.

Examples: V.A.M.; Margate Mus.

GARDNOR, Rev. John 1729 – 1808 (Battersea)
A drawing master who kept a school in Kensington Square and
exhibited with the Free Society from 1763 to 1767. He entered the
Church and became Vicar of Battersea in 1778, officiating at Blake's
wedding in 1782, and remaining there until his death. He exhibited
landscapes at the R.A. from 1782 to 1796. In 1787 he toured
France, Switzerland and the Rhine with his nephew RICHARD
GARDNOR, who was also a drawing master, and who exhibited
between 1766 and 1793.

Published: *Views Taken on and near the River Rhine . . .,* 1788.
Illustrated: D. Williams: *History of Monmouthshire,* 1796.

GARRARD, George, A.R.A. 1760 – 1826 (Brompton)
A sculptor and animal painter in oil and watercolour. He studied
under S. Gilpin (q.v.) and at the R.A. Schools. He exhibited from
1781 to 1826 and was elected A.R.A. in 1802.

Published: *A description of the different varieties of oxen common
to the British Isles,* 1800.
Examples: B.M.
Bibliography: *A.J.,* 1899.

GARVEY, Edmund, R.A. (Ireland) – 1813
An Irish landscape painter in oil and watercolour. He visited Italy
and Switzerland and then settled in Bath. He exhibited with the
Free Society from 1767 and at the R.A. from 1769. He was one of
the first A.R.A.s in 1770, and was elected R.A. in 1783. In 1778 he
moved to London.

His favourite subjects are foreign views and country seats. His

pictures are rather monotonous, he being, according to Pasquin, 'a
Royal Academician whose qualifications are, if possible, more
doubtful than any of his compeers'.

GASTINEAU, Henry G , O.W.S.
 1791 – 1876 (Camberwell)
After an apprenticeship with an engraver, he entered the R.A.
Schools. He exhibited at the R.A. from 1812 and with the Oil and
Watercolour Society between 1818 and 1820. He was elected
A.O.W.S. and O.W.S. in 1821 and 1823. He travelled widely in the
British Isles, and in Switzerland and Italy from 1829. He built
himself a house in Camberwell in 1827, and lived there for the
remainder of his life. He had a very wide practice as a drawing
master.

He was an extremely prolific artist and exhibited regularly for
fifty-eight years. He loved painting the wild scenery of the coasts of
Devon and Cornwall, Wales, Yorkshire and particularly Scotland and
Antrim. Although contemporary with innovators such as Cox, his
own style remains rooted in the 1820s; at their best his works can
be marvellous examples of this period. He occasionally practised
lithography.

His remaining works were sold at Christie's, May 19, 1876.
JOHN GASTINEAU, who exhibited in 1826, was perhaps a
brother.

Published: *Wales Illustrated,* 1829.
Examples: B.M.; V.A.M.; Birmingham City A.G.; Blackburn A.G.;
Cartwright Hall, Bradford; Cardiff A.G.; Fitzwilliam; Greenwich;
N.G., Ireland; City A.G., Manchester; Newport A.G.; Ulster Mus.;
Nat. Mus. Wales; York A.G.
Bibliography: *A.J.,* 1876.

GASTINEAU, Maria G – 1890 (Llantysilio)
The daughter of H.G. Gastineau (q.v.), she exhibited landscapes
between 1855 and 1889 and was a member of the Society of
Female Artists.

GAUCI, Paul
The son and brother of lithographers working in London, he too
produced lithographs as well as landscapes in oil and watercolour,
some of near Eastern or Jamaican subjects. He exhibited at the R.A.
and elsewhere from 1834 to 1863 and in 1866 began publication of
a *Practice Drawing Book.*

Examples: V.A.M.

GAY, Susan Elizabeth (Oswestry, Shropshire) –
A figure painter and illustrator who was the daughter of WILLIAM
GAY, a Post Office official and amateur artist. She received little
instruction since the family was constantly moving about England
and Scotland. She was also a writer and a spiritualist. She lived in
Falmouth and wrote on its history.

Published: *Harry's Big Boots,* 1873. *Old Falmouth,* 1903. Etc.

GEDDES, Andrew, A.R.A. 1783 (Edinburgh) – 1844 (London)
A painter and etcher who was educated at Edinburgh High School
and University. In 1806 he went to the R.A. Schools and in 1810
set up as a portrait painter in Edinburgh. In 1814 he went to Paris.
Later he settled in London, and in 1827 married the daughter of
Nathaniel Plymer, a miniaturist. They travelled on the Continent,
mainly in Italy, in 1830-1. In 1832 he was elected A.R.A., and in
1839 he visited Holland.

His etchings are more skilful than his paintings. The latter, in oil
and occasionally watercolour, include landscapes and copies from
old masters as well as portraits.

Examples: B.M.; N.G., Scotland.

GEDDES, Ewan, R.S.W. – 1935 (Blair Gowrie)
An Edinburgh landscape painter whose work was very popular in
the U.S.A. He exhibited in Edinburgh from 1884 and London from
1891 and was elected R.S.W. in 1902.

GEE or JEE, David 1793 – 1871
An oil painter who worked at Coventry from 1815 to 1868. He painted marine and terrine battle subjects, landscapes, town views, portraits and Lady Godiva. His obituary states that he made watercolour copies of all his paintings. His style is rather naïve but charming.

Examples: Coventry A.G.

GEIKIE, Walter,·R.S.A. 1795 (Edinburgh) – 1837 (Edinburgh)
An illustrator and landscape painter who studied at the Trustees Academy. He was elected A.R.S.A. and R.S.A. in 1831 and 1834. Towards the end of his life he became a deaf-mute. His figures are good and his subjects anticipate those of E. Nicol (q.v.).

Examples: B.M.; N.G., Scotland.

GELDHART, Joseph 1808 – 1882
A friend and sketching companion of J.J. Cotman (q.v.). He abandoned a legal career for painting, and, from the late 1830s, spent much time in Italy studying Venetian colouring.

Examples: B.M.

GELL, Sir William, F.R.S., F.S.A. 1777 – 1836 (Naples)
A classical archaeologist, educated at Jesus College, Cambridge, graduating in 1798 and becoming a Fellow of Emmanuel College. He attended the R.A. Schools, and although he did not exhibit thereafter, he made many sketches of archaeological sites and discoveries, some of which he used to illustrate his books. He visited the Troad in 1801 and was knighted on his return from the Ionian Islands in 1803. He travelled to the Morea in 1804 and Ithaca in 1806. In 1814 he accompanied Princess Caroline to Italy. He returned to Italy in 1820, and lived there for the rest of his life.

The drawings, nearly eight hundred, in number, which he made on his travels through Spain, Italy, Syria, Dalmatia, the Ionian Islands, Greece and European Turkey, were left on his death to his friend Kepple Craven, by whom they were bequeathed to the B.M.

Published: *Topography of Troy*, 1804. *Geography and Antiquities of Ithaca*, 1807. *Itinerary of Greece*, 1810. *Itinerary of the Morea*, 1817. *Narrative of a Journey in the Morea*, 1823. *Pompeiana*, 1817-19, 1832. *Topography of Rome*, 1834.
Examples: B.M.; Barrow-in-Furness Mus.; N.G., Scotland.

GENDALL, John 1790 (Exe Island, Exeter) – 1865 (Exeter)
Showing early aptitude, he was sent to Sir John Soane in London, from whom he received his first commission and an introduction to Ackermann. He worked for Ackermann for several years, during which time he was sent to sketch in Normandy. He was also sent about Britain to make topographical drawings, and views he made of Edinburgh, Richmond, Kew and elsewhere were aquatinted by T. Sutherland. He exhibited at the R.A. from 1846 to 1863. In about 1830 he retired to Exeter, where he painted Devonshire views, and taught at Cole's School in the Cathedral Close.

Despite occasional weaknesses of colour, his work has an affinity to that of Turner, who was his admirer. The overall effect can be rather messy. He painted in oil, water and bodycolour.

Published: with A. Pugin: *Picturesque Views on the Seine*, 1821. with R. Westall and G. Shepherd: *Country Seats*, 1823-28.
Examples: B.M.; V.A.M.; Exeter Mus.

GENT, G **W**
An amateur topographer and landscape painter who lived at Moynes Hall, Essex, which he papered with his drawings. He exhibited at the R.A. from 1804 to 1822. His wash drawings show neat pencil work but shaky perspective.

Examples: B.M.; V.A.M.

GEORGE IV, H.M. King 1762 (London) – 1830 (Windsor Castle)
A weak but amusing draughtsman, specialising in designing costumes and uniforms.

Examples: B.M.

GEORGE, Sir Ernest, R.A. 1839 (London) – 1922 (London)
An architect who was educated at Brighton and Reading and entered the R.A. Schools in 1858. From 1861 he practised on his own. In 1908 he became P.R.I.B.A. and he was knighted in 1911. He was elected A.R.A. and R.A. in 1910 and 1917.

His watercolours were mostly the fruits of holiday tours, sometimes in Northern France as in 1875 and 1884.

Examples: V.A.M.; Doncaster A.G.; Leeds City A.G.; Maidstone Mus.; Ulster Mus.

GERARD, Ebenezar
An amateur caricaturist working between 1800 and 1810.

Examples: B.M.

GERE, Charles March, R.A., R.W.S. 1869 (Gloucester) – 1957 (Gloucester)
A landscape and decorative painter who lived in Leamington, studied and then taught at the Birmingham School of Art for many years. He also worked with Morris's Kelmscott Press as an illustrator, and exhibited from 1890. His subjects are often found in Italy and the Cotswolds. He exhibited at the R.A., R.W.S. and elsewhere and was elected A.R.A. and R.A. in 1934 and 1939.

Examples: Cartwright Hall, Bradford.

GESSNER, Johann Conrad 1764 (Zürich) – 1826 (Zürich)
A horse and military artist who studied at Dresden and worked in Italy and Switzerland before coming to England in 1796. He exhibited at the R.A. from 1799 to 1804 when he returned to Zürich.

Examples: V.A.M.

GETHIN, Percy Francis 1875 (Holywell, Co. Sligo) – 1916 (the Somme)
A teacher in London and Liverpool who had studied in Paris. He was killed in action.

Illustrated: W.M. Crowdy: *Burgundy and Morvan*, 1925.
Examples: B.M.; Cartwright Hall, Bradford.

GIBB, Robert, R.S.A. 1801 (Dundee) – 1837 (Edinburgh)
A landscape painter in oil and watercolour who was a foundation member of the R.S.A.

Examples: N.G., Scotland.

GIBB, Robert, R.S.A. 1845 (Laurieston, near Falkirk) – 1932 (Edinburgh)
Trained as a lithographer, he became a military painter and was King's Limner for Scotland from 1908 to 1932. He studied at the R.S.A. and exhibited there from 1867. He was elected A.R.S.A. and R.S.A. in 1878 and 1882. He was Keeper of the N.G., Scotland from 1895 to 1907 and is most remembered for his oil painting *The Thin Red Line*.

Bibliography: *A.J.*, 1897.

GIBB, William 1839 (Laurieston, near Falkirk) – 1929 (London)
The brother of R. Gibb (q.v.), he was a painter in various media, a lithographer, designer and book illustrator. He was working in London for some years before his death.

Illustrated: A.C. Lamb: *Dundee, its Quaint and Historic Buildings*, 1895. Etc.

GIBBONS, F.
There is a view of Cirencester in the V.A.M. signed and dated 1880 by this artist.

GIBBS, Albert and Arthur
Brothers from Coventry who moved to York in about 1897 as valets to Archbishop Maclagan and vergers in the Minster. They exhibited topographical subjects at York in 1900.

GIBBS, James
An artist painting Welsh views in 1835. He may have been working in Bath from 1819.

Examples: Leeds City A.G.

GIBSON, Edward 1787 – 1859 (Hornsea)
The son of a naval shipbuilder, he combined shipbuilding and marine painting. His earliest known watercolour is a three position view of a corvette, dated 1805. He was Sheriff of Hull in 1824 and Mayor in 1834 and 1835. He was principal Judge at the Hull Art Exhibition of 1829.

GIBSON, Joseph Vincent
A genre painter in oil and watercolour who worked in London and Manchester and who exhibited at the R.A. from 1861 to 1888, and elsewhere.

GIBSON, Patrick 1782 (Edinburgh) – 1829 (Dollar)
After a classical education, he studied art under A. Nasmyth (q.v.) and at the Trustees' Academy. He was in Lambeth from 1805 to 1808, and exhibited at the R.A. He returned to Edinburgh, and in about 1811 visited the Faroes. In 1826 he was a Foundation Member of the R.S.A. He was drawing master at the Dollar Academy from 1824 to 1829.

His topographical views of London and Scotland are delicate with low and limited colour and neat pen or pencil outline.

Published: *View of the Arts in Great Britain* (Edinburgh Annual Register, 1816)
Illustrated: *Select Views of Edinburgh with Historical and Explanatory Notes,* 1817.
Examples: B.M.; N.G., Scotland.

GIBSON, Thomas
 1810 (North Shields, Northumberland) – 1843 (London)
A landscape and portrait painter in oil and watercolour who practised in Newcastle and Carlisle. He exhibited locally and in 1841 at Suffolk Street. In 1843 he moved to London.

GIBSON, William Sidney 1814 (Fulham) – 1871 (London)
After working on a Carlisle newspaper, Gibson was called to the bar in 1843 and appointed Registrar of the Newcastle Court of Bankruptcy. After the Bankruptcy Act of 1869 had abolished the Court, he was retired on a pension and devoted himself to antiquarian studies, in the course of which he made a number of competent watercolours, which included coastal scenes and landscapes.

Published: *History of Tynemouth. Northumbrian Castles, Churches and Antiquities. Descriptive and Historical Guide to Tynemouth.* Etc.

Examples: Laing A.G., Newcastle.

GIBSONE, George c.1763 – 1846
An amateur conchologist and son of Sir George Gibsone, Bt. He ran the earliest iron furnace at Lemington, Northumberland. His watercolours of sea shells were presented to the Newcastle Central Library in 1890.

Examples: Newcastle Central Lib.

GIFFORD, Augustus Edward
The Headmaster of Coventry School of Art in about 1850, he produced local views.

Examples: Coventry A.G.

GILBERT, Annie Laurie
 c.1848 (Nottingham) – 1941 (Nottingham)
The daughter of ISAAC CHARLES GILBERT (c.1816-c.1890), a Nottingham architect and occasional landscapist. She painted topographical views in and around Nottingham, which she annotated, as well as landscapes in other parts of England, and in Wales.

GILBERT, Ellen
A painter of genre subjects who lived in Blackheath and exhibited from 1863 to 1893 and in 1903. The F. GILBERT of Blackheath who was an unsuccessful candidate for the N.W.S. in 1862 was presumably Frederick Gilbert the illustrator and a relation, and they were probably both related to Sir John Gilbert (q.v.).

In the Ashmolean there is a crude caricature dated 1851 and signed HENRY GILBERT.

GILBERT, Sir John, R.A., P.R.W.S.
 1817 (Blackheath) – 1897 (Blackheath)
The historical painter. After two years as an estate agent's clerk, he took a few lessons in colour from G. Lance (q.v.), and taught himself to engrave, etch and model as well as paint in oil and watercolour. He exhibited at Suffolk Street for the first time in 1836 and at the R.A. in 1838. His chief work in the early part of his career was black and white book illustration, culminating in Staunton's edition of Shakespeare, 1856-60. He was the main artist of the *I.L.N.* from its foundation in 1842. He was elected A.O.W.S. and O.W.S. in 1852 and 1854 and became President in 1871 when he was also knighted. He was elected A.R.A. and R.A. in 1872 and 1876. From 1885 he sold no pictures, but kept them for the nation.

His work is monumental in style and execution, and always worthy, if dull to a modern eye. His favourite colours are reds and deep black shadows.

Examples: B.M.; V.A.M.; Haworth A.G., Accrington; Ashmolean; Towneley Hall, Burnley; Harrogate Mus.; Manor House, Lewisham; City A.G., Manchester; Newport A.G.; N.G., Scotland; Ulster Mus.
Bibliography: *A.J.,* August 1857; 1908.

GILBERT, Josiah 1814 (Rotherham) – 1892 (London)
The son of the Rev. Joseph Gilbert, who moved to Nottingham in 1825 to take up an appointment. Josiah studied at the R.A. Schools and Sass's School and became a portrait painter in watercolour and pastel. He remained in London for the rest of his life and exhibited at the R.A. and elsewhere between 1837 and 1865.

Examples: Castle Mus., Nottingham.
Bibliography: O.W.S. Club X, 1932.

GILDER, Henry
An artist who exhibited views at the R.A. from 1773 and 1778. He lived with T. Sandby (q.v.) at Windsor, and was probably his architectural assistant.

Examples: V.A.M.

GILES, James William, R.S.A. 1801 (Glasgow) – 1870 (Aberdeen)
The son of P. Giles (q.v.) from whom he learnt drawing. By the age of thirteen he was painting the lids of wooden snuff boxes, and by nineteen was a drawing master himself. In 1823 he went to London to complete his studies and in the following year went to France and Italy, returning to Aberdeen in 1826. During this Continental tour he made over one thousand sketches, as well as forty copies of Old Masters. His first important patrons were Gordon of Fyvie and the 4th Earl of Aberdeen. In 1827 he was a co-founder with Archibald Simpson of the Aberdeen Artists' Society, and in 1829 was elected to the re-formed R.S.A.

Giles is best known for his watercolours of Aberdeenshire Castles, most notably the Haddo House Collection. However, he was a man of wide and varied talents, both as a painter and as a landscape gardener, advising Prince Albert on the lay-out of Balmoral. His pen drawings and panoramas are careful, but a little dull; his full watercolours show great beauty of colour and composition. They are usually traditional in conception.

Examples: B.M.; Haddo House, Aberdeen; Aberdeen A.G.; N.G., Scotland.
Bibliography: *Connoisseur,* CLXII, 1966. *Country Life,* October 1, 1970.

GILES, Peter
The father of J. W. Giles (q.v.), he worked as a pattern designer and drawing master in Aberdeen and pioneered a scheme for hiring out

his pictures. He is said to have died early in his son's childhood. However in about 1810 a drawing master and portrait painter named Peter Giles moved from Glasgow to Belfast where he worked until about 1825.

GILES, R H
A portrait and figure painter who worked in Gravesend from 1826 to 1876. He considered standing for the N.W.S. in 1855.

GILFILLAN, John Alexander (Melbourne)
A landscape painter who served as a naval lieutenant and was Professor of Painting at the Andersonian University, Glasgow, from 1830 to 1840. He emigrated to New Zealand, but his farm failed and he moved on to Australia where he worked in the Melbourne Post Office.

Examples: B.M.; V.A.M.; Glasgow A.G.

GILL, Edmund 'Waterfall'
1820 (Clerkenwell) – 1894 (Hackbridge, Carshalton)
He started his career as a portraitist like his father E.W. Gill, but in 1841, under the influence of Cox, he turned to landscapes and sketched in Wales. In 1843 he went to the R.A. Schools. For much of his career he lived in Ludlow and Hereford. He exhibited at the R.A. from 1842 to 1886, and should not be confused with EDWARD GILL who was active from 1835 to 1865 and who also painted waterfalls.

Examples: V.A.M.; Victoria A.G., Bath; Hereford Lib.

GILL, Edwyn
In the Gilbey sale of 1940 at Christie's, there were two angling caricatures by this artist dated 1812.

GILLIES, Margaret, R.W.S.
1803 (London) – 1887 (Westerham, Kent)
At three years old she visited Lisbon where her mother died. She was adopted by her uncle, Lord Gillies, an Edinburgh judge, who introduced her to Scottish literary society. At about eighteen she and her elder sister came to London to make a career as artists, and she took lessons from G. Cruickshank (q.v.) and set up as a miniaturist. Gradually she moved to subject painting and to watercolours. In 1851 she went to Paris to study with the Scheffers, and therefore made frequent Continental journeys, visiting many parts of France and Italy. She also painted Scottish and Irish peasants. Her works were often engraved. She became a Lady Member of the O.W.S. in 1852, having failed as a candidate for the N.W.S. in the previous year.

Her younger sister Mary (d. 1870), who lived with her for most of her life, became an authoress.

Examples: B.M.; V.A.M.
Bibliography: Mary Howitt: *Autobiography*, 1889, II, p. 30-31, 262-3, 311-12.

GILLRAY, James 1757 (Chelsea) – 1815 (London)
The caricaturist. He was the son of a Chelsea Pensioner and was apprenticed to a letter engraver. He ran away to join a company of strolling players before entering the R.A. Schools and studying engraving under W.W. Ryland and Bartolozzi. His political works date from 1780 and the majority were published by Miss Humphrey with whom he lived. His last print was engraved in 1811 when he went mad.

His watercolours are very rare, since most of his work was drawn directly on to the plates. Some of his more serious figure drawings, especially those made for a series of military subjects painted in conjunction with P.J. de Loutherbourg (q.v.), have been attributed to the latter.

Examples: B.M.; V.A.M.; Ashmolean.
Bibliography: T. Wright: *The Caricatures of J.G.*, 1851. T. Wright: *The Works of J.G.*, 1873. D. Hill: *Mr. G. the Caricaturist*, 1965. D. Hill: *Fashionable Contrasts: Caricatures by J.G.*, 1966. *Country Life*: December 5, 1952; January 12, 1967.

GILMAN, Harold 1876 (Road, Somerset) – 1919 (London)
A painter of landscapes, interiors and portraits in oil and occasionally watercolour, he studied at Hastings Art School and became a member of the Camden Town and London Groups.

Examples: City A.G., Manchester.
Bibliography: W. Lewis and L.F. Fergusson: *H.G.*, 1919.

GILPIN, Captain John Bernard 1701 – 1776
An amateur artist who lived at Irthington, Cumberland, and was the father of W. Gilpin (q.v.) and S. Gilpin (q.v.), and the first patron of J. 'W'. Smith (q.v.).

GILPIN, Sawrey, R.A. 1733 (Carlisle) – 1807 (Brompton)
The seventh child of Captain J.B. Gilpin (q.v.), from whom he received instruction. At the age of fourteen his father sent him to work under S. Scott (q.v.) in London with whom he remained for ten years. However, his talent was almost exclusively for animal painting, and his independent career began with a commission from the Duke of Cumberland to draw in his stud at Windsor and Newmarket. After this he lived in Knightsbridge until the death of his wife, when he spent some time in Bedfordshire with Samuel Whitbread. During his last years he lived with his daughters in Brompton. He exhibited with the Incorporated Society from 1762, becoming President in 1774. He was elected A.R.A. in 1795 and R.A. in 1797.

His drawing of animals, especially of horses, is of very high quality, but for his landscape backgrounds he often relied upon artists as G. Barret (q.v.) for whom he provided animals in return. Many of his drawings were intended as illustrations for the books of his brother, W. Gilpin (q.v.).

Examples: B.M.; V.A.M.; Fitzwilliam; Leeds City A.G.; Leicestershire A.G.; Newport A.G.; Ulster Mus.; York A.G.

GILPIN, Rev. William
1724 (Scaleby Castle, near Carlisle) – 1804 (Boldre, Hampshire)
The elder brother of S. Gilpin (q.v.), he was educated at Carlisle, St. Bees and Queens College, Oxford, before being ordained in 1746. He published his first book in 1753 in order to pay off his Oxford debts. He was a curate at Irthington, Cumberland, and in London, and then took over a boys' school at Cheam, Surrey, which he ran for some thirty years. He made sketching tours of East Anglia in 1769 and 1773, the Wye and South Wales in 1770 and 1782, the South-East Coast in 1774 and the Lake District and Highlands in 1776. In 1777 he was made vicar of Boldre in the New Forest, where he remained as a progressive parish priest until his death. He was the high priest of the 'picturesque', and was the inspiration for Combe and Rowlandson's *Doctor Syntax*.

His drawings are executed with the brush, in indian ink, sometimes on a yellow foundation – rather in the manner of A. Cozens (q.v.) – and often over a pencil outline. He used a reed pen to strengthen his outlines and compositions. His pen work and his inscriptions, once seen, are quite unmistakable. His subjects are generally imaginary and were often done to illustrate his theories of the picturesque. As he himself said, they are meant 'rather to explain the country than to give an exact portrait of it'.

Two sales of his drawings were held at Christie's, May 6, 1802 and June 6, 1804, and the proceeds were used to endow the village school at Boldre. A loan exhibition of his work was held at Kenwood in 1959.

Published: *Essays on Prints*, 1768. *Observations on the River Wye.. .,* 1782. *Observations on the Lakes of Cumberland and Westmorland*, 1786. *Picturesque Remarks on the Western Parts of England and the Isle of Wight*, 1798. *Observations on the Coasts of Hampshire, Sussex and Kent . . .,* 1804. *Two Essays . . . on the Author's mode of executing Rough Sketches*, 1804. *Observations on . . . Cambridge . . .,* 1809. Etc.
Examples: B.M.; V.A.M.; Fitzwilliam; Leeds City A.G.; Leicestershire A.G.; Newport A.G.; Ulster Mus.
Bibliography: W.D. Templeman: *The Life and Work of W.G.*, 1939. C.P. Barbier: *W.G., his Drawings, Theory and Teaching of the Picturesque*, 1963.

GILPIN, William Sawrey, P.O.W.S. 1762 – 1843 (Yorkshire)
The son of S. Gilpin (q.v.) and nephew of W. Gilpin (q.v.), he became a drawing master and the first President of the O.W.S. in 1805. He is said to have resigned the Presidency in the following year because he felt outdone by the other exhibitors. This seems unlikely, since his work is at least as competent as that of Holworthy or Nattes, for instance. He accepted the post of drawing master at the R.M.C. Great Marlow at that point, and this necessary absence from London provides a more reasonable explanation of his resignation. He later moved to Sandhurst, and continued to exhibit with the Society until 1815, after which date he gave up drawing and became a landscape gardener, working in England and Ireland. He had already visited Ireland and sketched there, and also exhibited views on the Thames and in the Southern Counties.

His earliest landscape drawings are influenced by those of his artistic family, and have an affinity with those of N. Pocock (q.v.), or even his fellow landscape gardener, H. Repton (q.v.). Later, he seems to show the influence of Girtin. His favourite and most characteristic colour is a greenish-grey, often laid over careful pencil drawing. Due to the variations of style throughout his life, it is possible that drawings attributed to more important artists are in fact by him.

Published: *Practical Hints upon Landscape Gardening*, 1832.
Examples: B.M.; Fitzwilliam.

GIRLING, Edmund 1796 (Yarmouth) – 1871 (London)
An etcher and landscape painter who was a fellow clerk with Frederick Crome at Gurney's Bank. He was a good draughtsman and engraved after Rembrandt, J. Crome (q.v.) and others.

Examples: B.M.

GIRLING, Richard 1799 (Yarmouth) – 1863 (London)
The brother of E. Girling (q.v.), he also etched after Crome and was a draughtsman.

GIRTIN, Thomas 1775 (Southwark) – 1802 (London)
The elder son of a Southwark rope maker, who died when Girtin was eight. His mother later married Mr. Vaughan, a pattern designer, who encouraged his artistic leanings. His first lessons were from a Mr. Fisher in Aldersgate Street, after which he was apprenticed to E. Dayes (q.v.). There is evidence that they quarrelled and Dayes is even said to have had him imprisoned. He attended the evening drawing classes of Dr. Monro (q.v.) and J. Henderson (q.v.), where he became a close friend of Turner. Together they copied drawings by Hearne, Malton, Morland, Wilson, Canaletto, Piranesi and Ricci. He may have gone to Scotland with J. Moore (q.v.) in 1792, and in 1794 he visited Peterborough, Lincoln, Warwick and Lichfield with him. In this year he first exhibited at the R.A. with a view of Ely Minster based on a sketch by Moore. They visited the Cinque Ports in 1795.

In 1796 he toured the North of England and the borders and in 1798 he was again in the North, staying at Harewood. Some of the sketches from these tours were worked up for J. Walker's *Itinerant*. In 1799 he and Francia founded the sketching club known as 'The Brothers', of which R. Ker Porter (q.v.) was Treasurer. In 1800 he married the daughter of the goldsmith Phineas Borrett, and they moved to St. George's Row, Hyde Park, where P. Sandby was a neighbour. In this year he seems to have made a further visit to the North. He was also working on a panorama of London from a spot at the south end of Blackfriars Bridge. His patrons included Lords Essex, Hardwicke and Mulgrave, Sir G.H. Beaumont (q.v.) and the Hon. Spencer Cowper. From 1800 his health was failing and he was in Paris on doctor's orders from November 1801 to May 1802. He died in his studio in the Strand in the following November.

The influence of Dayes appears more strongly in the early work of Turner than in that of Girtin, who was his pupil. At this stage Girtin instigated the development from the tinted drawing to the pure watercolour, and Turner quickly followed. He discarded the careful outlining and grey wash base of his predecessors. His buildings and landscapes show nothing of the 'neat precision of Malton and his school'; rather his use of a full brush, freely handled,

rougher and more absorbent cartridge paper and his concentration on atmosphere altered the artistic climate of the time. He suggests rather than paints details by the use of shorthand dots and whirls, and his effects are gained by broad massing of form and light. His composition shows great daring in its simplicity and the abandonment of the Claudean framework. What eighteenth century topographer would have imagined that an empty *Rue St. Denis* could be so much more effective than one cluttered with figures?

The original effect of his colours can rarely be judged nowadays, since his work has suffered particularly from fading. He seems to have used a preponderance of mellow browns, yellows, greens and purples. His drawings sometimes show a central fold line which is a characteristic of his cartridge paper.

His influence is seen directly in his pupils and immediate followers such as Lady Farnborough (q.v.), the Duchess of Sutherland (q.v.), W. Pearson (q.v.), F.J. Manskirsch (q.v.) and T. Worthington (q.v.), as well as in the work of such more gifted contemporaries as Francia, Cotman and even Cox.

Examples: B.M.; V.A.M.; Aberdeen A.G.; Ashmolean; Birmingham City A.G.; Blackburn A.G.; Bowes Mus., Durham; Fitzwilliam; Glasgow A.G.; N.G., Ireland; Leeds City A.G.; Leicestershire A.G.; Usher A.G., Lincoln; City A.G., Manchester; N.G., Scotland; Laing A.G., Newcastle; Newport A.G.; Portsmouth City Mus.
Bibliography: R.L. Binyon: *T.G.*, 1900. R.L. Binyon: *English Watercolours from the work of Turner, Girtin . . .*, 1939. R. Davies: *T.G.'s Watercolours*, 1924. J. Mayne: *T.G.*, 1949. T. Girtin and D. Loshak: *The Art of T.G.*, 1954. O.W.S. Club, XI, 1933. *Walpole Soc.* XXXVII, 1938.

GISBORNE, Rev. Thomas
 1758 (Yoxall, Staffordshire) – 1846 (Yoxall)
An amateur artist, he was educated at Harrow and St. John's College, Cambridge, and was a friend of Wright of Derby who painted his portrait in 1777, and with whom he sketched. He was Curate of Barton-under-Needwood, Staffordshire, from 1783. In 1792 he met W. Gilpin (q.v.) and in the following year visited the Lake District with Wright. He also knew J. 'W'. Smith (q.v.) from whom he learnt several techniques. He was an author and poet, and an amateur botanist.

Published: *Walks in a Forest,* 1794.
Examples: Derby A.G.
Bibliography: *Burlington,* CVII, February 1965.

GLASGOW, Edwin 1874 (Liverpool) – 1955
An amateur artist who was educated at Wadham College, Oxford, and became an Inspector for the Board of Education, working on the Tyneside and later in Northumberland. He exhibited local landscapes and buildings at the R.A., the R.I. and elsewhere, painting in both watercolour and oil. Later in life he became Keeper of the N.G. He was living in Birmingham in 1927.

Published: *Sketches of Magdalen College,* 1901. *Sketches of Wadham College,* 1901. *The Painter's Eye,* 1936.

GLASS, John Hamilton, A.R.S.A.
 1820 (Edinburgh) – 1885 (Australia)
A painter of portraits, horses and landscapes who was elected A.R.S.A. in 1849. He exhibited at the R.A. in 1847 and 1859. A later J. Hamilton Glass was working in the 1920s.

GLEN, John
A drawing master at the Inverness Academy in about 1850. He produced Highland landscapes in watercolour, which are rather like brown versions of those of W.L. Leitch (q.v.).

GLENDENNING, Alfred Augustus
 1861 (Greenwich) – 1907 (Southend)
The son of the oil painter Alfred Glendenning of Greenwich, he painted genre subjects in oil and watercolour and exhibited from 1881. He was a member of the R.B.A. and latterly worked as a scene painter. He visited New York in 1901.

GLENNIE, Arthur, R.W.S.
1803 (Dulwich Grove, Surrey) – 1890 (Rome)
Taught by S. Prout (q.v.) at school at Dulwich Grove, he was later advised by W. Havell (q.v.) but only turned professional artist when ill-health prevented a mercantile career. He had already visited Rome when he was elected A.O.W.S. in 1837, but for the next eighteen years he lived either in Kent or London, with about two years as a drawing master in Sidmouth, probably from 1840. In 1855 he took up permanent residence in Rome and thereafter his exhibited subjects are almost all Italian. He was elected O.W.S. in 1858, and in 1865 he married Anne Sophia Parker, daughter of the Chaplain to the Forces. They travelled much in Italy and Istria and visited the Baltic at least once, probably in 1862 or 1863, and possibly again in 1881. Glennie tried to work up his drawings as much as possible on the spot and kept to pure watercolour rather than achieving his effects with bodycolour.

Examples: V.A.M.

GLINDONI, Henry Gillard, A.R.W.S.
1852 (Kennington) – 1912 (London)
A genre and Cardinal painter who exhibited from 1872 and was elected A.R.W.S. in 1883. He lived at Chadwell Heath, Essex.

Examples: Barking Lib.; Sunderland A.G.

GLOAG, Isobel Lilian **1865 (London) – 1917 (London)**
Of Scottish parentage, she studied at St. John's Wood Art School, the Slade, Mr. Ridley's studio, South Kensington and Paris. She exhibited at the R.A., R.I., R.B.A. and elsewhere from 1889. She painted in both oil and watercolour, and produced legendary and romantic subjects, portraits, flower pieces, book illustrations, posters and designs for stained glass.

Examples: B.M.; V.A.M.

GLOVER, John, O.W.S. 1767 (Houghton-on-the-Hill, Leicestershire) – 1849 (Launceston, Tasmania)

The son of a small farmer, Glover was largely self-taught, although he had seven lessons from W. Payne (q.v.) and one from J. 'W'. Smith (q.v.). He had two club feet, but worked in the fields as a youth and was extremely agile and active throughout his life. He had a great love of birds, animals and nature in general. In 1786 he was appointed writing master at a school in Appleby, and in 1794 he set up as a drawing teacher in Lichfield. He began to exhibit at the R.A. in 1795. He was a founder member of the O.W.S. and as a result of the success of the first exhibition in 1805, he moved to London. He was a prime instigator of the change to the Oil and Watercolour Society in 1813 and became President two years later. However, he resigned at the end of 1817 in order to try for the R.A. Being unsuccessful, he held a series of one man exhibitions from 1820 and in 1824 was one of the founders of the S.B.A. Before 1820 he had bought himself a house on Ullswater to which he had intended to retire, but, reversing more recent practice, he sold it to buy a Claude. In 1831 he went to Tasmania with his family and remained there, sending pictures of local scenery to London for exhibition, until his death.

The influence of Payne is not evident so much in Glover's style as in his adoption of an easily recognisable formula. His method of work was always the same, beginning with a ground base of indigo, indian red and indian ink. He damped the paper for the soft effects, and used a few basic local colours. His hallmark is an individual use of the split-brush technique. Other artists, including 'Grecian' Williams, had experimented in a similar manner, but Glover made it the prime feature of his foliage drawing. This has become more prominent with fading – Glover's skies have almost entirely disappeared and his local colour has often turned to a rather sulpherous yellow.

His composition is largely based on Claude. His subjects are mainly landscapes, particularly of the Lake District, Wales and Dovedale. He also painted sea-pieces and life-size cattle pictures, and made many pencil sketches. His pupils included E. Price (q.v.), J. Holworthy (q.v.), H.C. Allport (q.v.) and H. Salt (q.v.) and his style

was also widely imitated amongst professionals and amateurs.

Examples: B.M.; V.A.M.; Aberdeen A.G.; Ashmolean; Cartwright Hall, Bradford; Grosvenor Mus., Chester; Fitzwilliam; Leeds City A.G.; Leicestershire A.G.; Manchester City A.G.; Newport A.G.
Bibliography: *A.J.*, 1850. *Walker's Quarterly*, XV, 1924.

GLOVER, John, Yr.
A son of J. Glover (q.v.), he exhibited at the R.A. from 1808 to 1829 and emigrated to Tasmania with his family in 1831.

GLOVER, William
A son of J. Glover (q.v.), who was probably teaching drawing in Birmingham in 1808 with H.C. Allport (q.v.). He exhibited with the Oil and Watercolour Society and in 1822 was giving lessons in both media at half a guinea an hour. In 1831 he emigrated to Tasmania with his family.

His style is close to his father's, and his drawings can be very charming.

Examples: V.A.M.

GODDARD, George Bouverie **1832 (Salisbury) – 1886 (London)**
A self-taught animal painter in oil and watercolour who was hailed as a genius at the age of ten. In 1849 he came to London and spent two years sketching at the Zoological Gardens, meanwhile drawing sporting subjects on wood for periodicals such as *Punch*. He returned to Salisbury, where to took commissions, and finally settled in London in 1857. He exhibited at the R.A. from 1856.

GOFF, Frederick E J 1855 (London) – 1931 (London)
A painter of rather lurid London views. He worked on a small scale using a magnifying glass, and he exhibited from 1890. He also painted Thames views and landscapes in Kent.

Examples: B.M.

GOFF, Colonel Robert Charles
1837 (Ireland) – 1922 (La Tour de Peitz, Vevey)
An Irishman who was commissioned in 1855 and served in the Crimea, Ceylon, Malta and China. He retired in 1878 and lived in Hove before settling in Florence and Switzerland, and he travelled widely. He sketched and etched in England, Scotland and France as he had throughout his career.

A memorial exhibition was held at the Fine Art Society in 1923.

Illustrated: C. Goff: *Florence and some Tuscan Villas*, 1905. C. Goff: *Assisi of St. Francis*, 1908.
Examples: V.A.M.; Hove Lib.

GOGIN, Charles **1844 (London) – 1931**
A Newlyn painter of portraits and genre. He studied under J.P. Laurens and occasionally exhibited works in oil, watercolour and gesso. He also made a number of illustrations.

Published: *Things are waking up at Mudham*, 1929.
Examples: Cartwright Hall, Bradford; Glasgow A.G.; Hove Lib.

GOLDICUTT, John **1793 (London) – 1842 (London)**
An architect and draughtsman, he was a pupil of Henry Hakewill and entered the R.A. Schools in 1812. In 1815 he went to study in Paris and later spent some time in Italy. In 1819 he returned and worked as an architect, both with Hakewill and independently. He worked in a strictly classical manner, reminiscent of C.R. Cockerell (q.v.), and his drawings are highly finished and show a love of strong colour.

Published: *Antiquities of Sicily*, 1819. *Specimens of Ancient Decoration from Pompeii*, 1825. *Heriot's Hospital, Edinburgh*, 1826. *Ancient Wells and Reservoirs*, 1836.
Examples: V.A.M.; R.I.B.A.
Bibliography: *Architectural Review*, XXXI, 1912.

GOLDSMITH, Walter H
A landscape painter who lived at Maidenhead and worked on the Thames. He exhibited from 1880.

Examples: Maidenhead Lib.; Reading A.G.

GONNE, Mrs. Anne **1816 (Devonshire) –**
A flower painter who in 1840 married the Irish engraver Henry
Gonne. She exhibited frequently at the R.H.A. and was a drawing
teacher. She also modelled wax flowers, examples of which were in
the Dublin exhibition of 1853.

GOOCH, John
A topographer who painted a view of Oxford in 1777 which was
etched in the following year. He is not to be confused with the artist
who exhibited landscapes from 1825 to 1831. This was JOHN or
JAMES GOOCH, a Norwich painter.

GOOD, Clements **1810** **– 1896**
The Danish Consul in Hull. He made a number of local views and
also painted shipping subjects.

GOOD, Thomas Sword
 1789 (Berwick-upon-Tweed) – 1872 (Berwick-upon-Tweed)
He began as a house painter, taking portraits on the side. He moved
on to genre painting and to London in 1822, exhibiting there
between 1820 and 1834, at which date he gave up painting and
returned to Berwick.
 His paintings, in oil and watercolour, are rather in the manner of
Wilkie. His favourite subjects were rustics and fishermen.

Bibliography: *Country Life*, January 23, 1948.

GOODALL, Edward Angelo, R.W.S. **1819** **– 1908**
The eldest son of Edward Goodall (1795-1870), the engraver. He
accompanied the Schomburgh Guiana Boundary Expedition in 1841
and was in the Crimea for the *I.L.N.* in 1854. He also travelled in
Spain, Portugal, Morocco and Italy. He exhibited from 1841 and
was elected A.R.W.S. and R.W.S. in 1858 and 1864.
 His work is neat and restrained.

Examples: B.M.; V.A.M.; Ashmolean. Greenwich; N.G., Ireland;
City A.G., Manchester; Sydney Mus.
Bibliography: *A.J.,* 1908.

GOODALL, Frederick, R.A. **1822** **– 1904 (London)**
The second son of Edward Goodall, in whose studio he was placed
to learn engraving at the age of thirteen. Frederick and his brother
Edward Angelo (q.v.) were encouraged to paint by such artists as
Ruskin, Roberts and Turner, who were frequent visitors to the
house. He drew from casts and made sketching exhibitions along the
Thames and to the Zoological Gardens. In 1837 he won a silver
medal of the Society of Arts and he visited Normandy in 1838,
1839 and 1840, Brittany in 1841, 1842 and 1845, and Ireland with
F.W. Topham (q.v.) and G. Fripp (q.v.). He exhibited at the R.A.
from the age of sixteen and was elected A.R.A. in 1852 and R.A. in
1863. In 1858-9 he spent eight months in Egypt, where he shared a
house in Cairo with C. Haag (q.v.) with whom he toured the
countryside. In 1870 he returned to Cairo with Edward Angelo. On
his return Norman Shaw built him an exotic house in Harrow Weald,
which he surrounded with weird shrubs and filled with Egyptian
sheep.
 His sons, FREDERICK TREVELYAN GOODALL (1848-1871)
and HERBERT HOWARD GOODALL (1850-1874), both exhibited
at the R.A. Frederick Trevelyan, of whose work there are examples
at the V.A.M. and the Paisley A.G., died at Capri, accidentally shot
by his brother, and Herbert Howard at Cairo.

Published: *Reminiscences of F.G.,* 1902.
Examples: B.M.; V.A.M.; City A.G., Manchester; Sydney A.G.

GOODALL, Walter, R.W.S.
 1830 (London) – 1889 (Clapham, near Bedford)
The youngest son of Edward Goodall, he was trained at the
Government School of Design at Somerset House and the R.A.
Schools, and attended the Clipstone Street 'Academy' (later the
Langham Sketching Society). He was elected A.O.W.S. in 1853 and
O.W.S. in 1861, and he confined himself entirely to watercolours.

He spent the winter of 1868-9 in Rome, and also visited Venice. In
about 1875 he became partially paralysed, and eventually totally
helpless. His works were generally small figure subjects, often of
rather idealised peasants. He also specialised in Venetian boats.
Apart from Italy he visited Holland, Brittany and the Pyrenees.
From 1865 to 1872 he lived off Oxford Street, he then moved to
Bedfordshire.

Published: *W.G.'s Rustic Sketches,* 1855-7.

GOODWIN, Albert, R.W.S. **1845 (Maidstone) – 1932 (London)**
The son of a builder and brother of H. Goodwin (q.v.), he was a
pupil of A. Hughes (q.v.) and F.M. Brown (q.v.). In 1872 he went to
Italy with Ruskin and A. Severn (q.v.). From this time he travelled
widely, sometimes with his brother, visiting India, Egypt and the
South Seas, as well as many parts of Britain and Europe. He was
elected A.R.W.S. and R.W.S. in 1871 and 1881 and held one-man
shows at Leggatt Bros. in 1912, Vicars Gallery in 1925 and
Birmingham Art Gallery in 1926. He lived for much of his life at
Arundel. His diary for the years 1883 to 1927 was printed privately
in 1934.
 His style is highly idiosyncratic and at its best very impressive. It
can be described as a reversal of the usual processes, with the
drawing coming last.
 His youngest brother FRANK GOODWIN (1848-c.1873) and his
nephew W.S. GOODWIN (d.1916) were also artists. The eldest
brother, Charles, made frames and mounts for the family. SYDNEY
GOODWIN (1867-1944), who painted English, Canadian and
Australian landscapes, was presumably another nephew.

Examples: B.M.; Aberdeen A.G.; Ashmolean; Blackburn A.G.;
Cardiff A.G.; Fitzwilliam; Leeds City A.G.; Maidstone Mus.; City
A.G., Manchester; Melbourne A.G.; Newport A.G.; Paisley A.G.;
Portsmouth City Mus.; Wakefield A.G.; Ulster Mus.
Bibliography: Birmingham City A.G. *Exhibition Cat.* 1926.

GOODWIN, Edward
A painter of landscapes and church interiors who lived in
Manchester and Liverpool. He exhibited at the R.A. and the O.W.S.
from 1801 to 1815 and was a founder of the Liverpool Academy in
1810. He painted in Wales, Scotland and the North of England. His
landscapes are good but his drawing of cattle is poor. His interiors
are in the manner of A. Pugin (q.v.) and are dramatically lit.

Examples: B.M.; V.A.M.; Ashmolean; Derby A.G.; Maidstone Mus.;
City A.G., Manchester; Ulster Mus.

GOODWIN, Francis **1784 (King's Lynn) – 1835**
An architect and engineer who was a pupil of J. Coxedge, a
Kensington architect, and who first exhibited at the R.A. in 1806.
His plans for the new House of Commons were printed in 1833. He
had a considerable practice in the North of England and visited
Ireland in 1834.
 His work is architectural in the main, but includes views as well
as designs.

Published: *Domestic Architecture . . . ,* 1833-4.
Examples: Soane Mus.

GOODWIN, Harry **– 1925**
The elder brother of Albert, with whom he visited the Italian Lakes
and Lucerne in 1887. He was also in Italy in 1892 and 1920. He
exhibited from 1867 and worked in a manner which is close of that
of his brother. He has an excellent feeling for distance.

Illustrated: W.A. Knight: *Through the Wordsworth Country,* 1887.
Examples: Ashmolean; Maidstone Mus.; City A.G., Manchester.

GOODWIN, W **Kate, Mrs., née Malleson**
Landscape painter and wife of H. Goodwin (q.v.). She exhibited at
the R.A. from 1873, and they lived in Brighton, Croydon and
Torquay.

Examples: City A.G., Manchester.

GORDON, Julia Isabella Levina, Lady, née Bennet
1772 — 1867
A pupil of Kennion, Turner in 1797, Girtin and Cox, she married JAMES WILLOUGHBY GORDON (b. 1772), himself a sketcher, in 1805. He was military secretary to the Duke of York and later quartermaster-general in the Peninsula and at the Horse Guards, and was created a baronet in 1818. They lived at Beckenham near Lady Farnborough (q.v.), in Chelsea and at Northcourt, Isle of Wight, where Turner stayed with them in 1827. She was sister-in-law of Sir John Swinburne of Capheaton, brother of E. Swinburne (q.v.).

Her work is often in direct colour and has been confused with that of her daughter, JULIA EMILY GORDON (1810-1896), another very talented amateur, who worked on the island, in various parts of England, on the Rhine and in Provence. She used a number of media, but from the 1830s preferred elaborate monochrome drawings on blue paper. She was also a fine draughtswoman and many of her coloured and monochrome works are over a careful pen outline. She published a volume of etchings in 1847.

An exhibition of the work of both ladies was held at the Brook Street Galleries, London, in 1939.

Bibliography: *Country Life,* July 8, 1939. *Burlington,* XCIX, 1957.

GORDON, Pryse Lockhart
1762 (Ardersier, Inverness) — 1834 (Brussels)
A memorialist and occasional caricaturist. He served in the Marines and the Army in Britain, Italy and Minorca, and lived in Sicily with Lord Montgomery from 1811 to 1813 and thereafter in Brussels.

In the B.M. is a drawing by him in the manner of G.M. Woodward (q.v.), but with thinner people.

Published: *A Companion to Italy,* 1823. *A Companion for the Visitor at Brussels,* 1828. *Personal Memoirs,* 1830. *Holland and Belgium,* 1834.

GORDON, Rachel Emily, Lady Hamilton-
— 1889
A talented landscape painter who was the wife of Sir Arthur Hamilton-Gordon, later created Lord Stanmore, the youngest son of the Premier Earl of Aberdeen. He was Lieutenant-Governor of New Brunswick from 1861 to 1866, Governor of Trinidad from 1866 to 1870, Fiji from 1875 to 1880 and Ceylon from 1883 to 1890. She was born Shaw Lefevre, married in 1865, and signed her work variously R.S.L., R.H.G. or Lady Gordon. Her drawings are very professional and she may well have been a pupil of W. Page, W. Collingwood Smith and P. de Wint (all q.v.).

Other members of her family who show more or less talent include her sisters, MARY JANE GEORGIANA, LADY RYAN; MADELEINE SHAW LEFEVRE; and EMILY SHAW LEFEVRE; and cousins or nieces CAROLINE, LADY GORDON; KATHLEEN ISABELLA GORDON; EMILY OCTAVIA SHAW LEFEVRE; and MARY EMMA SHAW LEFEVRE.

GORDON, Rev. William
—1853
An amateur landscape painter who was Vicar of Mundesley on the Norfolk coast. He was closely connected with the second generation of Norwich artists.

GORE, Hon. Charles
1729 (Lincolnshire) — 1807 (Weimar)
A Lincolnshire landowner, Gore was primarily a marine artist, and for a time worked at Southampton. In 1773 his wife's ill-health forced them abroad, and he went to Lisbon and on to Italy by sea. He visited Rome, Naples, Leghorn, Florence, Corsica, Nice, Marseilles and other Mediterranean towns, and in 1777 spent April and May in Sicily with R.P. Knight (q.v.) and Philipp Hackert. His drawings on this visit were later worked up by J.R. Cozens (q.v.). Gore had returned to England by 1781, when he sketched in Sussex and became a member of the Dilettanti Society. Later, he went back to Florence, and from 1791 until his death was a member of the Ducal Court at Weimar.

As well as his marine drawings, his studies of archaeological remains in Sicily are both extremely accurate and full of dramatic impact. His Sussex landscapes owe a little to P. Sandby (q.v.), and show a liking for yellowish greens, greys and pinks. Sometimes his monochrome marine drawings are reminiscent of those of W. Marlow (q.v.).

Examples: B.M.; Ashmolean; Gloucester City A.G.; Greenwich; Leeds City A.G.
Bibliography: *Walpole Society,* XXIII, 1935 (Introduction).

GORE, Spencer Frederick
1878 (Surrey) — 1914 (Richmond)
A post-Impressionist landscape painter who studied at the Slade. He was a member of the London Group and was much influenced by Sickert and Lucien Pissaro.

Examples: Cartwright Hall, Bradford.

GOSLING, William W
1824 — 1883 (Wargrave)
A landscape painter in oil and watercolour who lived at Wargrave. He exhibited from 1849 and was a member of the R.B.A. but was an unsuccessful candidate for the N.W.S. in 1869 and 1870. At his best he can be close to T. Collier (q.v.), but his work is varied.

GOSSELIN, Colonel Joshua
1739 (Guernsey) — 1813 (Bengeo Hall, Hertfordshire)
A topographer and landscape painter of an old Channel Islands family, who lived and worked in the Channel Islands, where he was a Colonel of the Second Regiment of Militia and was sworn Greffier in 1768, and Hertfordshire. He also worked in Wales, and his drawings are more polished than those of M. Griffith (q.v.), with thin Sandby-like figures.

The landscape at Hertford Mus., which is looser and rather splashy, may possibly be by his son, JOSHUA GOSSELIN, YR. (1763-1789).

GOTCH, Thomas Cooper, R.I.
1854 (Kettering) — 1931 (London)
A portrait, landscape and genre painter, he studied at Heatherley's, Antwerp, the Slade and Paris. He first visited Newlyn, Cornwall, in 1879, but lived in London until 1887, with a year in Australia in 1883. He was a founder of the Royal British Colonial Society of Artists, and, with Stanhope Forbes and W. Langley (q.v.), of the 'Newlyn School'. He was elected R.I. in 1912, and a retrospective exhibition of his work was held at the Laing A.G., Newcastle in 1910.

After a visit to Italy in 1891, his painting, in oil and watercolour, became more allegorical than plein-air.

Illustrated: A. Le Braz: *The Land of Pardons,* 1906. A.G. Bradley: *Round about Wiltshire,* 1907.
Examples: B.M.; A. East A.G., Kettering.

GOULD, Elizabeth, Mrs. née Coxon
1804 (Ramsgate) — 1841
The daughter of a sea-captain, she came to London to take a post as a governess and in 1829 married John Gould. Together with E. Lear (q.v.) she produced finished watercolours as guides for the illustrations of Gould's ornithological publications, including *A Century of Birds from the Himalayan Mountains* and the *Birds of Europe.* In 1838 she and her husband sailed to Australia to work on the *Birds of Australia,* returning in 1840. He often took the credit for her work and, indeed, for that of the young Lear.

Bibliography: *Country Life,* June 25, 1964.

GOULD, Sir Francis Carruthers
1844 (Barnstaple) — 1925
The son of an architect, he worked as a bank clerk and stockbroker before becoming the first newspaper cartoonist. He worked for *Punch,* the *Westminster Gazette* and the *Pall Mall Gazette.* The majority of his work is naturally in pen and ink.

His son ALEC CARRUTHERS GOULD (1870-1948) was an accomplished landscape painter in oil and watercolour and lived at Porlock. They were both members of the R.B.A.

Examples: B.M.; Towner Gall., Eastbourne.
Bibliography: *Country Life,* January 10, 1925.

GOULDSMITH, Harriet, Mrs. Arnold
1787 — 1863
She began to exhibit at the R.A. in 1809 and from 1813 to 1820

was a Lady Member of the Oil and Watercolour Society. She was an Honorary Member of the S.B.A. from 1824 to 1843 and continued to patronise the R.A. until 1854. She was primarily an oil painter, and was a landscapist, producing both compositions and topographical views in or near London. In 1819 she published four etched views of Charlemont and in 1824 *Four Views of Celebrated Places* lithographed by C. Hullmandel. Late in life she married Captain Arnold, R.N.

GOUPY, Joseph **(Nevers) – 1763 (London)**
A drawing master and scene painter who worked in London from 1724 or earlier. He painted miniatures, figure subjects, caricatures, landscapes, copies of old masters and wash illustrations.

Examples: N.G., Scotland.
Bibliography: *Walpole Society*, XXII, 1934.

GOW, Andrew Carrick, R.A., R.I. 1848 (London) – 1920 (London)
The son of James Gow, a genre painter, he studied at Heatherley's and painted portraits, historical, military and genre subjects and town views. He exhibited from 1866 and was elected A.R.A. and R.A. in 1880 and 1890 and was Keeper from 1911. He was elected A.N.W.S. and N.W.S. in 1868 and 1870. His style is free but accurate in drawing, and his colouring mellow.

Examples: V.A.M.; Fitzwilliam.

GOW, Mary L , Mrs. Hall, R.I.
 1851 (London) – 1929 (London)
A member of a family of artists and sister of A.C. Gow (q.v.), she studied at the Queen's Square School of Art and at Heatherley's. She exhibited from about 1869 and was elected N.W.S. in 1875, resigning in 1903, and she married S.P. Hall (q.v.). She specialised in genre and figure subjects.

Examples: V.A.M.; City A.G., Manchester.

GOWANS, George Russell, R.S.W.
 1843 (Aberdeen) – 1924 (Aberdeen)
A painter of town views and Aberdeenshire landscapes in oil and watercolour. He studied in Aberdeen, London and Paris and exhibited in London from 1877.

Examples: Aberdeen A.G.

GOWLAND, John
A Dundee whaling seaman and amateur artist, working in the first half of the nineteenth century. He mainly painted sailing ships.

Examples: Dundee City A.G.

GRACE, Alfred Fitzwalter 1844 (Dulwich) – 1903 (Steyning)
A painter of Sussex landscapes and portraits who studied at Heatherley's and the R.A. Schools. He won the Turner medal, and he exhibited from 1863. He was a friend of Whistler and lived at Steyning.

Published: *A Course of Landscape Painting in Oils*, 1881.
Examples: V.A.M.

GRACE, Harriette Edith 1860 – 1932
An artist who lived in Brighton and exhibited genre subjects at the R.A. and Suffolk Street from 1877.

Examples: Hove Lib.

GRACE, James Edward 1851 – 1908 (Bedford Park)
A book illustrator and landscape painter who studied at the Liverpool Institute and at South Kensington. He exhibited at the R.A. and elsewhere from 1871 to 1907 and was elected S.B.A. in 1879. His wife also painted landscapes.

Illustrated: Marquis of Granby: *The Trout*, 1899.
Examples: City A.G., Manchester; Montreal A.G.; Sydney A.G.; Wakefield A.G.

GRAHAM, Alexander 1858 –
An architect and painter of architecture, usually abroad, who exhibited from 1875.

Examples: V.A.M.

GRAHAM, Henry
An Irish landscape painter. He entered the R.D.S. Schools in 1768 and studied under Jonathan Fisher (q.v.), with whom he lived and worked as assistant for many years. He exhibited with the Dublin Society of Artists in 1777 and 1780. Fisher, on his death in 1809, left him his painting materials and his sketches and drawings.

GRAHAM, Lord Montagu William 1807 – 1878
A pupil of de Wint, he was the son of the 3rd Duke of Montrose. He painted landscapes, cattle and shipping studies, sometimes on tinted paper. After service in the Coldstream Guards he was M.P. for Grantham and Hereford.

GRAHAM, Peter, R.A., A.R.S.A.
 1836 (Edinburgh) – 1921 (St. Andrews)
A painter of Scottish landscapes in oil and occasionally watercolour, he was a pupil of R.S. Lauder at the Trustees' Academy. He was elected A.R.S.A. in 1860, A.R.A. in 1877 and R.A. in 1881. He was particularly good at painting mist.

Examples: Worcester City A.G.
Bibliography: *A.J.*, 1899.

GRAHAM, Major-General William Henry
 1837 – 1888
Commissioned in the Royal Artillery in 1856, he was promoted lieutenant-colonel in 1883 and major-general on his retirement in 1886. He served in Egypt in 1882 and in India. His landscapes are in pencil or pen and watercolour.

GRANT, Charles
A London portrait painter who worked there from 1825 to 1839. After that date he probably went to India, where he published books of portraits until 1845.

Examples: B.M.

GRANT, Colesworthy 1813 – 1880
An artist and journalist who went to India in 1832. In 1849 he was appointed Drawing Master at the Engineering College at Howrah and later at the Presidency College, Sibpur. In 1846 he had visited Rangoon and in 1855 he was official artist to the embassy to the King of Ava. During the Mutiny he was the Correspondent for the *Durham Advertiser* and in 1857 he settled at Malnath. He drew portraits and topographical views.

Published: *An Anglo-Indian Domestic Sketch*, 1849. *Rough Pencillings of a Rough Trip to Rangoon*, 1853. *Rural Life in Bengal*, 1860. *To the Children of Calcutta. On Cruelty*, 1872.
Bibliography: P.C. Mittra: *Life of C.G.*, 1881.
Examples: India Office Lib.

GRANT, Mary Isabella
A landscape painter who lived at Cullompton, Devon, and exhibited at the R.I. and Suffolk Street from 1870.
Examples: V.A.M.

GRANT, 'Miss'
There is a watercolour figure drawing in the N.G., Scotland which is inscribed 'By "Miss Grant", a Drawing Mistress in Edinburgh, who later turned out to be a man'.

GRAPES, Elizabeth, Mrs., née Crump
 c.1860 – c.1932 (Australia)
A Hull artist who painted landscapes in oil and watercolour. She emigrated to Australia late in life. Her sister HARRIET, MRS. ELLERKER painted a number of copies.

GRATTAN, George **1787 (Dublin) – 1819 (Cullenswood)**
He studied at the R.D.S. Schools, where he gained prizes in 1797 and in later years. He was painting miniatures at this time, and in 1801 he sent portraits and landscapes to an exhibition in Parliament House. He was brought to the attention of the Earl of Hardwicke, for whom he made portraits and views in crayon. From 1804 he was working in Dublin and exhibited until 1813, occasionally visiting London to exhibit at the R.A.

His early works were mainly landscapes in crayon and watercolour, but he later turned to historical and subject pictures in oil. A memorial exhibition was held at 15 Dame Street, Dublin.

His younger brother WILLIAM GRATTAN was a landscape and figure painter who was trained at the R.D.S. Schools. He was active from 1801 to 1821 and exhibited in Dublin between 1809 and 1815. In 1818 he produced a pamphlet entitled *Patronage Analysed*.

Examples: V.A.M.

GRAVATT, Colonel William **– c.1852**
An engineer who was probably a pupil of P. Sandby (q.v.) at Woolwich. He was commissioned in 1791 and served in the West Indies. He was promoted captain in 1799 and full colonel in 1821. He worked in water and bodycolour and his penwork is sometimes untidy.

Examples: B.M.

GRAY, Paul Mary **1842 (Dublin) – 1866 (Brighton)**
An illustrator who was educated in a convent but returned to Dublin determined to become an artist. He worked as a drawing master at Tullabeg School and for Dillon the print seller, exhibiting genre and figure subjects at the R.H.A. from 1861 to 1863, in which year he came to London. He produced illustrations for Kingsley's *Hereward*, after which he worked on *London Society*, *The Sunday Magazine*, *Fun*, *Punch* and other periodicals.

GRAY, W Hal
A sculptor, landscape and portrait painter of Ventnor, Isle of Wight, and London. He exhibited from 1835 to 1894.

GRAY, William J of Salisbury
A painter of intimate and pretty architectural watercolours between 1833 and 1840. They are not technically of a very high quality.

Examples: B.M.

GREEN, Amos 1735 (Halesowen, Birmingham) – 1807 (York)
He was apprenticed to Baskerville, a Birmingham printer, for whom he decorated trays and boxes. As an artist, he began by copying Dutch still-lifes and later turned to landscape painting, primarily in watercolour. For a time he lived with the family of his friend Anthony Deane at Bergholt, Suffolk, and at Bath. He exhibited with the Incorporated Society in 1760, 1763 and 1765. He married Harriet Lister (q.v. as Green, Harriet) in 1796 and they made many sketching tours, often in the Lake District.

His landscapes are generally of woods, waterfalls and lakes, in browns, greens and yellows. The effect is usually a little woolly.

His brothers BENJAMIN GREEN (c.1736-c.1800) and JOHN GREEN were engravers and drawing masters, Benjamin at Christ's Hospital and John at Oxford.

Illustrated: Miller: *History and Antiquities of Doncaster*, 1804.
Examples: B.M.; V.A.M.; Cartwright Hall, Bradford.
Bibliography: H. Green: *Memoir of A.G., Esq.*

GREEN, Benjamin Richard, N.W.S.
 1808 (London) – 1876 (London)
The son of James Green (q.v.), he studied at the R.A. Schools and was elected N.W.S. in 1834. He exhibited at the R.A., Suffolk Street and elsewhere from 1832, and was a drawing master and lecturer, and for many years Secretary to the Artists' Annuity Fund. In 1829 he published a numismatic atlas of ancient history.

He painted figure and architectural subjects, portraits, landscapes and interiors, predominantly in watercolour.

Published: *A Guide to Pictorial Perspective*, 1851.
Examples: B.M.; V.A.M.; Coventry Mus.; Ulster Mus.

GREEN, Charles, R.I. 1840 – 1898 (Hampstead)
An illustrator who also painted genre subjects in oil and watercolour. He exhibited from 1862 and was elected A.N.W.S. and N.W.S. in 1864 and 1867. He drew for papers such as *Once a Week* and the *Graphic* as well as producing charming book illustrations such as the drawings for *Robin Hood*. He was the brother of H.T. Green (q.v.).

Examples: B.M.; V.A.M.; Cardiff A.G.; Harrogate Mus.; Leicestershire A.G.; Maidstone Mus.

GREEN, David Gould, R.I. 1854 – 1917 (London)
The brother of N.E. Green (q.v.), he exhibited landscapes from 1873 and was elected R.I. in 1897. He lived in London. The works of the brothers are similar in style.

Published: *Marine Painting in Water-colours*.
Example: Maidstone Mus.

GREEN, Harriet, Mrs., née Lister
Possibly a relation of T. Lister of Mallam-Waterhouse, Craven, Yorkshire, the friend of Devis. She became a pupil of A. Green (q.v.) and married him in 1796. They made many tours of the Lake District, Scotland and Wales, and their drawings, when unsigned, are very difficult to tell apart. She was particularly fond of mountain scenery and soft light.

GREEN, Henry Towneley, R.I. 1836 – 1899 (London)
The brother of C. Green (q.v.), he started in banking, but soon turned to art. He exhibited from 1855 at the R.A., N.W.S. and elsewhere, and was elected A.N.W.S. and N.W.S. in 1875 and 1879. He worked as an illustrator both in black and white and full watercolour.

His remaining works were sold at Christie's, January 13, 1900.

Examples: V.A.M.

GREEN, J
A painter of birds and fish in the eighteenth century. He may be Amos Green's brother (see under A. Green) or possibly 'JOHNNY GREEN', the London dealer and draughtsman who was active between 1749 and 1763. His drawings are heightened with bodycolour.

GREEN, James 1771 (Leytonstone, Essex) – 1834 (Bath)
A portrait painter who was apprenticed to Thomas Martyn, a natural history draughtsman of Great Marlborough Street. He studied at the R.A. Schools and first exhibited at the R.A. in 1792. He was a member and Treasurer of the A.A. In 1805 he married Mary (1776-1847), daughter of William Byrne, the engraver, herself a miniaturist and a member of the A.A. Many of his portraits were engraved. They show careful draughtsmanship although no great flair. He occasionally painted literary, classical and genre scenes in oil and watercolour.

Published: *Poetical Sketches of Scarborough*, 1813.
Examples: B.M.

GREEN, Joshua
Painter of Lake District views and landscapes who exhibited in London from 1852 to 1868.

Examples: V.A.M.

GREEN, Nathaniel Everett – 1899 (St. Albans)
An astronomer and landscape painter who studied at the R.A. Schools and exhibited from 1854. He was an unsuccessful candidate for the N.W.S. in 1852 and 1858 when living in North London. He painted in Ireland and a great deal in Scotland, contributing illustrations to Queen Victoria's *More Leaves from the Journal of*

Life in the Highlands, 1884. His work is pleasant, if lacking in detail, and he is fond of greens.

He was presumably related to the formidable Mary Anne Everett Green, and her son or husband, GEORGE PYCOCK EVERETT GREEN who painted in Wales.

Published: *Hints of Sketching from Nature*, 1871. *Foliage Exercises for the Brush*, 1888. *A Guide to Landscape Animal Drawing*, 1888. *A Guide to Landscape Figure Drawing*, 1891.
Examples: Beecroft A.G., Southend.

GREEN, William 1761 (Manchester) — 1823 (Ambleside)
After briefly assisting a surveyor in Manchester and studying engraving in London, he went to the Lake District, which provided him with a home and subjects for the rest of his life. His views are generally very much the same, with dejected-looking cows in the foreground and mountains across a lake. The weather for him is always bad, with thick clouds hanging over the lake. Sometimes, though, there is a dramatic flash of steely light, as if between showers. The colours are suitable greys, browns and dull greens.

He published sets of prints in 1808, 1809, 1810 and 1814.

Published: *The Tourists' New Guide...*, 1822.
Examples: B.M.; V.A.M.; Abbot Hall A.G., Kendal; Leeds City A.G.; Wakefield City A.G.

GREENAWAY, Kate, R.I. 1846 (London) — 1901 (London)
The daughter of a wood-engraver, and a cousin of R. Dadd (q.v.), she studied at the Islington School of Art, Heatherley's and the Slade. She first exhibited in 1868 and provided illustrations for the *I.L.N.*, *Little Folks* and other papers. In 1877 she began her profitable association with Edmund Evans, the printer and publisher, producing a long series of children's books and, from 1883 to 1897, the famous Almanacks. In 1889 she was elected R.I.

Ruskin, a great admirer, thought of her work as 'a Dance of Life'. With their sweetness, apparent naïveté and simplicity of technique, her drawings created a happy world which had never existed, but which nevertheless has become part of our cultural heritage. Their strength is in perfect drawing and in the muted washes of colour, which re-interpret the methods, as well as the modes, of the late eighteenth century. At the end of her career she attempted to go beyond the perfection of her 'petit maître' art, and to paint portraits in oil.

Examples: B.M.; V.A.M.; Ashmolean; City A.G., Manchester; Lady Lever A.G., Port Sunlight; Ulster Mus.
Bibliography: M.H. Spielmann: *K.G.*, 1905. A.C. Moore: *A Century of K.G.*, 1946.

GREENBANK, Arthur
A figure and genre painter working in the 1880s and 1890s.

GREENE, Mary Charlotte c.1860 — 1951 (Harston)
She was for several years President of the Cambridge Drawing Society, and exhibited at the R.A. She ran the Harston School and took an active part in village life, and she was a keen horticulturist. One of her one-act plays, *An Afternoon with Blake*, was broadcast in 1940. She also published reminiscences and poems, and painted up to her death.

Her work is sketchy, and she uses bodycolour.

Examples: Fitzwilliam.

GREENWOOD, John
1727 (Boston, Massachusetts) — 1792 (Margate, Kent)
In 1742 he was apprenticed to Thomas Johnston, a jobbing artist, and began to paint portraits. In 1752 he went to Surinam, where he lived for over five years, taking portraits and sketching flora and fauna. In 1758 he went to Holland to learn mezzotinting and for some time dealt in pictures in Amsterdam. In 1763 he visited Paris, and London, where he settled the following year. He joined the Incorporated Society in 1765. In the 1770s he made a number of Continental journeys to buy pictures and he set himself up as an auctioneer in the Haymarket and Leicester Square.

Examples: B.M.

GREGAN, John Edgar 1813 (Dumfries) — 1865 (Manchester)
He studied architecture under Walter Newall and later at Manchester under Thomas Witlam Atkinson, and he practised in Manchester from 1840. He was an enthusiast for art education, and was a supporter of the local art school.

GREGORY, Charles, R.W.S. 1849 (Surrey) — 1920 (Milford)
A genre and history painter who exhibited from 1873. He was elected A.R.W.S. and R.W.S. in 1882 and 1883 and exhibitions of his work were held in London, Liverpool and Melbourne. He lived at Milford, Surrey.

Examples: Bristol City A.G.

GREGORY, Edward John, R.A., P.R.I.
1850 (Southampton) — 1909 (Great Marlow)
An illustrator, portrait and genre painter in oil and watercolour, he worked for P & O for a time before 1869, when he moved to London on Herkomer's advice. He studied at South Kensington and the R.A. Schools and from 1871 to 1875 worked on the decorations of the V.A.M. He also provided illustrations for the *Graphic*. He was elected A.R.I. and R.I. in 1871 and 1876, and was President from 1898. He was elected A.R.A. and R.A. in 1879 and 1898. In 1882 he visited Italy.

Examples: B.M.; Ashmolean; City A.G., Manchester.

GREGORY, George
1849 (Newport, Isle of Wight) — 1938 (Newport)
A marine painter in oil and watercolour, he was the son of CHARLES GREGORY (1810-1896) who also painted shipping subjects and occasional landscapes. At the age of seven George's eyesight was damaged in a fire, which made sustained painting difficult.

As well as the shipping about the island, which he painted with love and accuracy, he produced occasional Continental landscapes. Most of his life was spent in East Cowes.

GREIG, George M — 1867 (Edinburgh)
A painter of old Edinburgh interiors. He was a good draughtsman and exhibited at the R.A. in 1865.

GREIG, John
A landscape painter and lithographer who was working between 1807 and 1819. He produced a series of prints of Yorkshire antiquities from his own drawings.

Illustrated: D. Hughson: *Promenades across London*, 1817. J. Hakewill: *Views of London*. F.W.L. Stockdale: *Tours in Cornwall*, 1824.

GRESLEY, James Stephen 1829 (Derby) — 1908
The first of a family of Derby artists and drawing masters, he lived in Derby and then at Bolton Abbey, Yorkshire. He painted landscapes in oil and watercolour and exhibited in London from 1866 to 1883. He illustrated S.T. Hall: *Days in Derbyshire*, 1863.

His son FRANK GRESLEY (1855-1946) lived at Chellaston, near Derby, and painted landscapes, particularly on the Trent, around Barrow and Ingleby.

CUTHBERT GRESLEY (1876-1963) who worked for the Porcelain Company, and HAROLD GRESLEY (1892-1967) who taught art at Repton School, were sons of Frank.

Examples of the family's work can be seen at the Derby A.G.

GRESSE, John Alexander 1741 (London) — 1794 (London)
The son of a Genoese with property in London, 'Fat Jack Grease' began as an engraver under Gerard Scotin and Major. He later worked as an assistant to Cipriani, while taking lessons from Zuccarelli. Turning to drawing, he worked for Boydell. He became a fashionable drawing master and from 1777 taught the Princesses. R. Hills (q.v.) was also his pupil.

His style is typical of the neat eighteenth century tinted manner with the colours laid on a basis of grey wash. He also produced

miniatures and large gouache landscapes in the tradition of Zuccarelli.

Gresse Street, W.1 was the property of his family.

Examples: B.M.; V.A.M.

GREVILLE, Hon. Charles Francis 1749 – 1809
The second son of the 1st Earl of Warwick, Greville was a patron and sketching companion of P. Sandby (q.v.). He learnt aquatint engraving from Le Prince and in turn taught Sandby.

Examples: B.M.

GREVILLE, Hon. Robert Fulke 1751 – 1824
Groom of the bed-chamber to George III. Like his brother the Earl of Warwick (q.v.), he was an amateur watercolourist and a patron of J. 'W'. Smith (q.v.). In 1792 he made a tour of Wales with Smith and J.C. Ibbetson (q.v.). In 1797 he married Louisa, Countess of Mansfield.

Bibliography: R.M. Clay: *Life of J.C. Ibbetson*, 1948.

GRIBBLE, Bernard Finegan 1873 (London) – 1962
A marine and portrait painter in oil and watercolour. He was the son of Herbert Gribble, the architect of the Brompton Oratory, and after an education in Bruges he was trained as an architect. However he turned to painting and acted as an artist-correspondent during the Hispano-American War of 1898. He exhibited at the R.A. from 1891 to 1904, as well as at the R.I. and R.H.A., and in Paris in 1907. He lived in London and at Parkstone, Dorset.

GRIERSON, Charles MacIver
 1864 (Queenstown, Co. Cork) – 1939
A painter of literary and genre subjects in watercolour, pastel and black and white. He was educated in Plymouth, lived in London and was elected R.I. in 1892, but later retired.

GRIEVE, Thomas 1799 (London) – 1882 (London)
The son of John Henderson Grieve (1770-1845) and a member of a family of scene painters at Covent Garden. He became principal painter there in 1839 and later moved to Drury Lane. He worked on a number of highly successful panoramas, at first with W. Telbin (q.v.) and J. Absolon (q.v.), and later with his son THOMAS WALFORD GRIEVE. 'Grieve and Son' became a hallmark of quality. He occasionally exhibited landscapes at the R.A.

Examples: V.A.M.

GRIEVE, William 1800 (London) – 1844 (London)
The younger brother of T. Grieve (q.v.), he was first employed as a scene painter at Covent Garden Theatre, later moving to Drury Lane and the Royal Opera House. The quality of his work was such that he was once given a curtain call.

He painted small landscapes in oil and watercolour.

GRIFFITH, Moses
 1747 (Trygrainhouse, Caernarvonshire) – 1819
Of poor parents, Griffith was self-taught as an artist, and from 1769 was employed by Thomas Pennant (1726-1798) as a drawing man-servant. He accompanied his master to Scotland in 1769, Cumberland and Yorkshire in 1773, the Isle of Man in 1774, the Midlands in 1776, Yorkshire and Derbyshire in 1777, Staffordshire in about 1780 and the Severn Valley in 1783. He continued to work for Pennant's son between 1805 and 1813, and may have set himself up as an engraver near Holyhead. 'He was a real primitive, a sort of untaught rustic Sandby' (Williams), producing antiquarian and topographical drawings in the tinted manner.

Several hundred of his drawings were included in the sale of Pennant's Collection at Christie's, July 4, 1938.

Examples: B.M.; V.A.M.; Grosvenor Mus., Chester; Coventry Mus.; Hawarden Co. Record Office, Flintshire; Manx Mus.; Newport A.G.; Staffordshire County Mus.; York A.G.
Bibliography: T. Pennant: *The Life of Thomas Pennant*, 1793.

Country Life, July 2, 1938. *Walker's Monthly*, August and September, 1938.

GRIFFITHS, John 1837 – 1918 (Norton, Sherborne)
After studying at the National Art Training School and working on the decoration of the South Kensington Museums, he was appointed first Principal of the Bombay School of Art. He made many studies of Indians, and he exhibited Indian subjects in oil and watercolour at the R.A. from 1869 to 1904.

Examples: V.A.M.

GRIGGS, Frederick Landseer Maur, R.A.
 1876 (Hitchin, Hertfordshire) – 1938 (Chipping Campden)
A book illustrator and topographer with a love of medieval architecture. From 1912 he turned increasingly to aquatinting. He was elected A.R.A. and R.A. in 1922 and 1931, and lived at Chipping Campden.

Illustrated: M.P. Milne-House: *Stray Leaves from a Border Garden*, 1901. P.B. Shelley: *The Sensitive Plant*, 1902. E.V. Lucas: *Highways and Byways in Sussex*, 1904. W.F. Rawnsley: *Highways and Byways in Lincolnshire*, 1914. Etc.
Examples: B.M.; Hitchin Mus.; Cas. Mus., Nottingham.

GRIMM, Samuel Hieronymus
 1733 (Bergdorf, Switzerland) – 1794 (London)
He began as a poet and oil-painter in Switzerland, where he was a pupil of J.L. Aberli, occasionally producing watercolour views. In 1765 he moved to Paris, and stayed in France until the beginning of 1768, when he crossed the Channel and made his home in England. In 1766 he had made a sketching tour of Normandy with Philipp Hackert and Nicholas Perignon. In 1768 he contributed to the first exhibition at the R.A., and he later exhibited with the S.A. and the Free Society. In 1776 Gilbert White employed him to make drawings for the great *Natural History* at Selborne. In 1777 he toured Wales with the antiquary Henry Penruddocke Wyndham; later he worked for Cornelius Heathcote Rodes of Barlborough Hall, Derbyshire, Sir William Burrell in Sussex, the Rev. Sir Richard Kaye in Sussex, the Farne Islands and elsewhere, and Richard Gough. He was also well known for caricature drawings, and illustrations to Shakespeare.

Of his topographica work, Gilbert White wrote: 'He first of all sketches his scapes with a lead-pencil; then he pens them all over, as he calls it, with Indian ink, rubbing out the superfluous pencil-strokes; then he gives a charming shading with a brush dipped in Indian ink; and last he throws a light tinge of watercolours over the whole.'

Examples: B.M.; V.A.M.; Ashmolean; Birmingham City A.G.; Canterbury Cathedral Lib.; Derby A.G.; Fitzwilliam; Guildhall; Leeds City A.G.; Usher A.G., Lincoln; N.G., Scotland; Newport A.G.; Portsmouth City Mus.; Taunton Cas.; Ulster Mus.; Weymouth Lib.
Bibliography: R.M. Clay: *S.H.G.*, 1941.

GRIMSHAW, John Atkinson 1836 (Leeds) – 1893 (Leeds)
The painter of moonlit docks and autumn lanes. He was the son of a policeman and worked as a clerk on the G.N.R., teaching himself to paint. In 1858 he married a cousin of T.S. Cooper (q.v.), and became a professional artist. From 1870 he lived at Knostrop Hall, near Leeds, which appears in many of his works. He also lived and worked in Scarborough and Chelsea.

His early work is very much in the Pre-Raphaelite manner, and his rare, jewel-like watercolours usually date from this period. He signed J.A. Grimshaw until about 1867, and he used bodycolour lavishly.

Examples: Leeds City A.G.

GRIMSTON, Lady Katherine – 1874
A landscape painter, she was the daughter of the 1st Earl of Verulam and married J. Foster-Barham, M.P. in 1834 and the 4th Earl of Clarendon in 1839.

GRISET, Ernest Henry 1844 (France) – 1907
An animal painter and humorist, he settled in London in the 1860s. He worked for the Dalziels and for *Punch* and *Fun*. His style relies on heavy outlines and thin pale colours.

Examples: B.M.; V.A.M.

GROGAN, Nathaniel c.1740 (Cork) – 1807
A landscape and humorous painter. He worked under his father, a wood-turner, but his preference for drawing angered his father, and he was obliged to leave home. He joined the Army, and served through the American War and in the West Indies. On returning to Cork he gave drawing lessons, painted landscapes and caricatures of country life, did some house decorating and produced a number of large aquatints. He exhibited with the Free Society in 1782, and may have stayed briefly in London.

Eighteen of his pictures, including a self-portrait, were in the Cork Exhibition of 1852.

Two sons, NATHANIEL GROGAN YR and JOSEPH GROGAN (b.c. 1775), imitated his style; Nathaniel, who worked in Cork, also made copies of his father's pictures. Joesph, of whose work there is an example in the Cork A.G., left Cork after 1810 and came to London.

Examples: B.M.

GROOMBRIDGE, William
A painter of small, tinted landscapes who exhibited at the R.A. from 1770 to 1790. He moved from London to Canterbury in 1780, published a volume of sonnets in 1789 and appears to have been alive in 1816.

Examples: Peabody Inst., Baltimore
Bibliography: J.H. Pleasants: *Four Late Eighteenth Century Anglo-American Landscape Painters*, 1943.

GROSE, Daniel Charles
 c.1760 (London) – 1838 (Carrick-on-Shannon)
A topographical draughtsman, and nephew of F. Grose (q.v.), after whose death he completed the drawings for the *Antiquities of Ireland*. He was in the Invalid Artillery, and he wrote legends in verse and prose. His drawings were used to illustrate the *Irish Penny Journal* in 1841.

GROSE, Captain Francis, F.S.A.
 1731 (Greenford, Middlesex) – 1791 (Dublin)
A topographical draughtsman, he was the son of a Swiss jeweller living at Richmond, Surrey. He studied at Shipley's Drawing School, and lived at Wandsworth. From 1755 to 1763 he was Richmond Herald, and was thereafter Adjutant to the Hampshire and the Surrey Militias. He exhibited architectural views with the Incorporated Society, of which he was a member, in 1767 and 1768, and at the R.A. from 1769 to 1777. He made frequent sketching tours, often with other amateurs, such as J. Nixon (q.v.) or Thomas Pennant and M. Griffith (q.v.) with whom he visited the Isle of Man in 1774. In 1789 he toured Scotland, and he died of an apoplectic fit at Horace Hone's house in Dublin, in the middle of an Irish tour.

His drawing is very weak and conventional, but generally it has charm and pretty colouring. Some works attributed to him may in fact be by his servant, T. Cocking (q.v.). He also produced landscapes entirely in bodycolour.

Published: *Antiquities of England and Wales*, 1773-87. *The Antiquarian Repertory*, 1775. *A Treatise on Ancient Armour and Weapons*, 1786. *Military Antiquities*, 1786-88. *Antiquities of Scotland*, 1789-91. *Antiquities of Ireland*, 1791-95.

Illustrated: J.H. Grose: *Voyage to the East Indies*, 1776. Rev. W. Darrell: *History of Dover Castle*, 1786.
Examples: B.M.; Ashmolean; N.G., Scotland; Ulster Mus.

GROVES, John Thomas – 1811 (London)
An architect who exhibited views of Westminster Abbey at the R.A. in 1778 and 1780. He lived in Italy from 1780 to 1790 and exhibited Italian views on his return. He was Clerk of the Works at St. James's, Whitehall and Westminster from 1794, and architect to the G.P.O. from 1807. He had a wide practice and built the Baths at Tunbridge Wells and the Nelson monument on Portsdown Hill.

GRUBB, William Mortimer
A landscape painter who taught art at Dundee High School in the 1880s and exhibited from 1890 to 1895.

Published: with A.G. Grubb: *The First Grade Freehand Drawing Book*, 1879.
Examples: Dundee City A.G.

GRUNDY, Edwin Landseer 1837 – 1898
A Liverpool art critic. He spent a part of his early life at sea, and during the Crimean war took watercolour views of the harbours.

GRUNDY, Robert Hindmarsh 1816 – 1865
A friend and sketching companion of D. Cox (q.v.). He lived in Liverpool and was one of the founders of the Print-Sellers Association.

Examples: V.A.M.

GUEST, Thomas Douglass 1781 –
A portrait and historical painter who studied at the R.A. Schools and exhibited from 1803 to 1839.

Published: *An Inquiry into the Causes of the Decline of Historical Painting*, 1829.
Examples: B.M.

GULICH, John Percival, R.I. 1865 (Wimbledon) – 1899
A black and white illustrator, etcher and caricaturist who was educated at Charterhouse and drew for the *Graphic*. He was elected R.I. in 1897 and died of typhoid.

GUNSON, J H
A landscape painter who sketched in North Wales in 1800.

GUTHRIE, Sir James, P.R.S.A., R.H.A., R.S.W.
 1859 (Greenock) – 1930 (Row, Dumbartonshire)
A lawyer who turned to painting in 1877 and studied in London and Paris. He was the leader of the Glasgow School. He was elected A.R.S.A. and R.S.A. in 1888 and 1892 and was President from 1902, when he was knighted, until 1919.

Examples: Glasgow A.G.; N.G., Scotland.
Bibliography: Sir J.L. Caw: *Sir J.G.*, 1932.

GYFFORD, Edward 1772 - 1834
A pupil of the architect James Lewis, he entered the R.A. Schools in 1789. He practised as an architect to some extent, but is best known for his pen, brown ink and wash drawings of the London Thames.

His son EDWARD A. GYFFORD (or GIFFORD), exhibited genre subjects at the R.A. from 1833 to 1870.

Published: *Designs for Elegant Cottages and Small Villas*, 1806.
Examples: B.M.; V.A.M.

HAAG, Carl 1820 (Erlangen, Bavaria) – 1915 (Oberwesel)
Haag began his career as a miniaturist and book illustrator in Munich, but in 1846 he left Bavaria with the intention of going to Paris. At the end of a five-month stay in Brussels he decided to study English watercolour painting instead, and first visited this country in the spring of 1847. After spending the winter in Rome he returned to London the following year, and it was at this point that he studied in the R.A. Schools. In December 1848 he nearly lost his right hand in an accidental explosion, and it was saved by Sir P. Hewitt (q.v.), who became a friend and patron. In 1850 he was elected A.O.W.S., and he came a Member in 1853. He continued to travel widely, returning to Nuremburg in the winter of 1851, visiting Rome and the Tyrol in 1852 and 1853, Dalmatia, Montenegro and Venice in 1854 to 1855, Rome in 1856, Munich in 1857 to 1858, and the Near East with F. Goodall (q.v.) from the autumn of 1858 to 1860. He revisited Egypt in 1873. For a while in the 1860s he maintained studios both at Oberwesel and in London.

He was always able to attract Royal and aristocratic patrons, and spent the autumn of 1853 at Balmoral and that winter at Windsor.

His style developed from the tight precision of the miniaturist to the greater diffuseness of handling associated with his friend Goodall. His colours in this later period are often so muted that the works are almost in monochrome.

Examples: B.M.; V.A.M.; Blackburn A.G.; Leeds City A.G.; Ulster Mus.
Bibliography: *A.J.*, 1883.

HACCOU, Johannes Cornelis 1798 (Middleburg) – 1839 (London)
A marine and moonlight painter in oil and watercolour who was a pupil of J.H. Koekkoek and travelled in Switzerland, France and Germany before settling in London.

Examples: Preston Manor, Brighton.

HACKER, Arthur, R.A., R.I. 1858 (London) – 1919 (London)
A portraitist and painter of historical genre, he studied at the R.A. Schools and in Paris, and exhibited from 1878. He was elected A.R.A. and R.A. in 1894 and 1910, and R.I. in 1918.

Examples: Greenwich.

HACKERT, Johann Gottlieb 1744 (Prenzlau) – 1793 (Bath)
A landscape painter who was the son and brother of artists and studied under Le Sueur in Berlin. He visited Italy before coming to England in about 1770.

Examples: Coventry A.G.

HACKSTOUN, William 1855 – 1921
A landscape and topographical artist who trained as an architect in Glasgow. His watercolours attracted Ruskin's attention, and in 1876 he began studying under him. He worked largely in Perthshire and Edinburgh and also painted in Kent. In 1896 he was living in London and in 1916 in Glasgow.

Examples: Glasgow A.G.; N.G., Scotland.

HADEN, Sir Francis Seymour
 1818 (London) – 1910 (Woodcote Manor, near Alresford)
A surgeon who took up etching and painting as a hobby. He studied medicine in London and France and was made F.R.C.S. in 1857. He was a founder of the R.P.E. in 1880 and was knighted in 1894. His wife was Whistler's half-sister. He was an ardent campaigner against cremation.

Examples: B.M.; V.A.M.

HADLEY, J
A landscape painter, probably amateur, who was working in the southern counties from about 1730 to 1758.

Examples: V.A.M.
Bibliography: *Magazine of Art* II, 1904.

HAFFIELD, Cooper – 1821
An amateur draughtsman and painter who worked as a clerk in his father's auditing office in Dublin. He had a keen interest in natural history.

HAGARTY, Mary S –c. 1935
A painter of farms and landscapes who was active from 1882 and exhibited in London from 1885. She lived in Liverpool, Egremont, Seacombe and finally London again from 1896. She was noted for her plough horses and her shimmering light.

HAGHE, Louis, P.R.I. 1806 (Tournai, Belgium) – 1885 (London)
A sound lithographer and rather indifferent watercolourist, Haghe studied printing at Tournai under the Chevalier de la Barrière and J.P. de Jonghe, and then, moving to London in 1823, formed a partnership with William Day the publisher. His most important lithographic work was David Roberts's *Holy Land*. In 1852, however, he gave up printing and resigned from the firm. He became a member of the N.W.S. in 1835 and was its President from 1873 to 1884. He travelled much on the Continent, especially in Belgium, Germany and Northern France, and in 1853 was in Rome with Roberts. His work is much in the manner of Cattermole, but where Cattermole is happy to sketch, and hint at details, Haghe is infinitely conscientious, and this can give his work a less lively effect. Owing to a deformed right hand, he painted entirely with the left.

His brother CHARLES HAGHE (d. 1888) was also a lithographer and worked with him.

Published: *Travels through Sicily*, 1827. *Sketches in Belgium and Germany*, 1840.
Examples: B.M.; V.A.M.; Bethnal Green Mus.; Blackburn A.G.; Glasgow A.G.; Abbot Hall A.G., Kendal; Leicestershire A.G.; City A.G., Manchester; Newport A.G.; Portsmouth City Mus.; Sydney A.G.; Ulster Mus.
Bibliography: *A.J.*, January, 1859.

HAGREEN, Henry Browne c.1831 - 1912 (Putney)
An architectural draughtsman who taught at the National Art Training Schools for forty-six years and exhibited at the R.A. between 1883 and 1885.

Examples: V.A.M.

HAGUE, Joshua Anderson, R.I.
 1850 (Manchester) – 1916 (Deganwy)
A landscape painter who lived in Stockport, exhibited from 1873 and was elected R.I. in 1889.

An exhibition of his work was held at the Dowdeswell Gallery, London, in 1891.

HAIG, Axel Herman
 1835 (Katthamra, Gotland) – 1921 (Haslemere)
An architectural draughtsman and etcher, he studied naval architecture at Carlskrona and worked for a ship-builder in Glasgow before moving to London and ecclesiastical work. He painted churches in many parts of Britain and the Continent as well as making designs for interiors. For the last thirty years of his life he concentrated on etching. He re-visited Sweden each year.

Bibliography: E.A. Armstrong: *A.H.H. and his Work*, 1905. *A.J.*, 1892.

HAILEY, George
A painter who was working in London in 1851.

HAINES, William
1778 (Bedhampton, Hampshire) – 1848 (East Brixton)
A painter of miniatures and watercolour portraits who exhibited from 1808 to 1840 when he retired on an inheritance.

HAINES, William Henry 1812 (London) – 1884 (London)
A painter and copyist in oil and watercolour, who worked as a picture restorer until 1856. Thereafter he turned to painting full-time. He had a few lessons from A. Stewart, a miniaturist. He painted landscapes, London scenes and genre subjects as well as copies of Guardi and Canaletto. He sometimes used the name William Henry.

Examples: V.A.M.

HAIR, Thomas H
A painter of landscapes and street scenes in the North East in watercolour and oil. In 1839 he published a series of etchings of coal mines from his own watercolours, and he was working at least as late as 1875.

Examples: B.M.; Newcastle Univ.

HAITE, George Charles, R.A.
1855 (Bexley Heath) – 1924 (London)
The son of a designer, he was largely self-taught as a landscapist and illustrator. He designed the cover of the *Strand Magazine* and was first President of the London Sketch Club. He exhibited from 1883 and was elected R.I. in 1901. As well as producing English landscapes, he painted in Spain and Morocco.
An exhibition of his work was held at the Modern Gallery, London in 1907.

Examples: B.M.; Cartwright Hall, Bradford; Cardiff A.G.; Leeds City A.G.; City A.G., Manchester.

HAKEWILL, James 1778 – 1843 (London)
Son of JOHN HAKEWILL (1742-1791) a painter and decorator who studied under S. Wale (q.v.), James was trained as an architect and exhibited designs at the R.A. In 1816 and 1817 he was in Italy and in 1820 and 1821, in Jamaica. As an architect he worked at High Legh and Tatton in Cheshire. In 1807 he married Maria Catherine Browne (d. 1842), who exhibited portraits at the R.A. His sons Arthur William (1808-1856), Henry James (1813-1834), and Frederick Charles were respectively an architect, a sculptor and a portraitist.
His brothers Henry and George were also artists and architects.
He made many drawings for his own publications, some of which were worked up by Turner, and others.

Published: *Views in the Neighbourhood of Windsor, etc.* 1813. *A Picturesque Tour of Italy. A Picturesque Tour in the Island of Jamaica. Plans, sections and elevations of the Abattoirs in Paris,* 1828.

HALE, William Matthew, R.W.S. 1837 (Bristol) – 1929
A landscape and marine painter who was a pupil of J.D. Harding and W. Collingwood Smith. He was elected O.W.S. in 1871 and painted in England, Scotland, Norway and Spain.

Examples: Bristol City A.G.; Cardiff; Dundee City A.G.; Paisley A.G.
Bibliography: W.M. Hale: *The Family of Hale,* 1936.

HALFNIGHT, Richard William 1855 (Sunderland) – 1925
A Sunderland artist who painted local scenes and Thames views in oil and watercolour. He exhibited at the R.A. from 1884 to 1889 and later lived in Newcastle.

HALFPENNY, Joseph
1748 (Bishopsthorpe, Yorkshire) – 1811 (York)
An architectural draughtsman who was apprenticed to a house-painter and later practised in York. He also became a drawing-master and acted as Clerk of the Works during the restoration of York Minster, making many drawings of the Gothic ornaments. He made a number of topographical drawings of churches and monuments in Yorkshire.

Published: *Gothic Ornaments in the Cathedral Church of York,* 1795-1800. *Fragmenta Vetusta,* 1807.
Examples: B.M.; V.A.M.; York A.G.

HALL, Ann Ashley
A painter of Venetian and coastal scenes who lived at Bilston, Staffordshire, and exhibited in Birmingham and at the Society of Female Artists in 1873.

HALL, George Lothian 1825 – 1888 (Wales)
The son of John Hall of Liverpool and Kircudbrightshire, he was educated at Rugby and B.N.C., Oxford. He was in Brazil from 1848 to 1854 and visited Ireland in 1856. Thereafter he lived in London and took up painting, exhibiting landscapes and coastal scenes until 1878. In 1880 he retired to Wales.

Examples: B.M.; V.A.M.; Shipley A.G., Gateshead; Maidstone Mus.; Melbourne A.G.

HALL, John George 1835 – 1921
A City Councillor and painter and decorator at Hull. His watercolours of local scenes are of distinctly higher quality than his oil paintings.

Published: *Notices of Lincolnshire,* 1890. *A History of South Cave,* 1892.
Examples: Library, Guildhall; Wilberforce House, Hull.

HALL, Sydney Prior 1842 (Newmarket) – 1922
The son and pupil of Harry Hall, a sporting artist, he also studied with A. Hughes (q.v.) and at the R.A. Schools. He provided illustrations for the *Graphic,* covering the Prince of Wales's Indian tour and the Franco-Prussian War, and for a number of books, and he also painted portraits and Royal or military occasions in oil and watercolour.

HALLEWELL, Colonel Edmund Gilling
A painter of town views who was commissioned in 1839, was promoted colonel in 1860 and retired from active service in 1864. He was Commandant of Sandhurst in 1869. His home was in Stroud, and he was an unsuccessful candidate for the N.W.S. in 1850 when a captain in the XXth Regiment. He exhibited at the R.A. in 1865. For some reason the V.A.M. catalogue (1927) and Graves give his Christian name as Benjamin.

Examples: V.A.M.

HALLYAR, James 1829 (Chichester) – 1920
An architectural and genre painter who lived in Surrey until 1898 and thereafter at Bournemouth. He was active from about 1850 until 1902, when he retired.

HALSWELLE, Keeley, A.R.S.A., R.I.
1832 (Richmond, Surrey) – 1891 (Paris)
Illustrator and landscape painter. His career began with drawings for the *I.L.N.* and continued with book illustration. He exhibited at the R.S.A. from 1856 and was elected A.R.S.A. in 1865, and R.I. in 1882. From 1869 he spent some years in Italy. At the end of his life he lived near Petersfield and was the moving spirit of the Primrose League.
His work for much of his career is either literary illustration or life drawing. Later he turned to landscapes in the splashy style of the time.

Published: *The Princess Florella and the Knight of the Silver Shield,* 1860. *Six Years in a House-boat.*
Examples: N.G., Ireland; N.G., Scotland.
Bibliography: *A.J.,* 1879.

HAMERTON, Robert Jacob
An Irish book illustrator who taught drawing at the age of fourteen at a school in Longford. He came to London where he worked as a lithographer for Hullmandel, and exhibited portraits and figure studies in oil and watercolour between 1831 and 1858 at the R.A., the B.I., and the S.B.A., of which he was a member. He worked for *Punch* until 1848. Towards the end of his career he was mainly involved in lithography.

Illustrated: G. à Beckett: *Comic Blackstone.* Forster: *Life of Goldsmith.*
Examples: B.M.

HAMILTON, James Whitelaw, R.S.A.
1860 (Glasgow) – 1932 (Glasgow)
A landscape and marine painter in oil and watercolour who was educated in Glasgow and at Helensburgh where he later lived. He was more widely appreciated on the Continent and in America than at home and studied in Paris. He was a member of the 'Munich Secession'. He was elected A.R.S.A. and R.S.A. in 1911 and 1922.

HAMILTON, John (Dublin) – (London)
An amateur Irish draughtsman and etcher who came to England while young. He exhibited landscapes with the Incorporated Society from 1767 to 1777 and was elected a Fellow in 1772, and later Vice-President. He was a close friend of F. Grose (q.v.) and etched most of the plates for his *Ancient Armour and Weapons,* 1786.

Examples: B.M.

HAMILTON, William, R.A. 1751 (Chelsea) – 1801 (London)
His father was an assistant to Robert Adam, who sent William to Rome, where he studied under Zucchi. He returned in 1769 and entered the R.A. Schools. He began to exhibit at the R.A. in 1774. In 1784 he was elected A.R.A., and in 1789 R.A. Until 1789 he concentrated on portraits and afterwards turned to biblical, historical, Shakespearean and poetical subjects. He painted a number of large pictures of this nature for places such as Fonthill Abbey but was more successful with his small watercolour illustrations of poets such as Gray, Milton and Thomson. He worked in a number of different styles but was mostly influenced by Cipriani and Kauffmann. His colour can be rather harsh.

Examples: B.M.; V.A.M.; Cecil Higgins A.G., Bedford; Fitzwilliam; Leicestershire A.G.

HAMMERSLEY, James Astbury
1815 (Burslem, Staffordshire) – 1869 (Manchester)
He studied under J.B. Pyne (q.v.). From 1849 until 1862 he was Headmaster of the Manchester School of Design, and he was President of the Manchester Academy of Fine Arts from its foundation in 1857 until 1861. In about 1848 he was commissioned by Prince Albert to paint Rosenau castle, and also produced other German views in watercolour.

Illustrated: G.R. Dartnell: *The Shipwreck of the . . . 'Premier',* 1845.

HAMMOND, Gertrude E. Demain, R.I.
1862 (London) – 1953
An historical and genre painter who exhibited from 1886 and was elected R.I. in 1896. She illustrated Shakespearean and similar editions.

Examples: Shipley A.G., Gateshead; Sydney A.G.

HANCOCK, Charles – a.1868
A drawing master who moved from Marlborough to Reading in the 1820s and set himself up as a teacher in both oil and watercolour. In 1826 he advertised his own scentless colours. He later moved to London and painted portraits, miniatures, landscapes and animal studies. He illustrated the writings of Nimrod and others.

HANKEY, William LEE- 1869 (Chester) – 1952 (London)
One of the best of the English Impressionists, he was primarily an oil painter. He was a member of the R.I. from 1898 to 1906 and 1918 to 1924. He painted both landscapes and genre subjects.

Examples: V.A.M.; Grosvenor Mus., Chester; Dundee City A.G.; Glasgow A.G.; City A.G., Manchester; Newport A.G.; Ulster Mus.

HANLON, Daniel
1819 (Cabinteely, Co. Dublin) – 1901 (Stoke Row, Oxfordshire)
An amateur flower and landscape painter who worked in an architect's office in Dublin before coming to London in 1850. He then worked for the Cities of London and Westminster in the provision of public lavatories for the metropolis, and his activities in this field won him immortality as the eponymous hero of a bawdy popular ballad. He retired to Stoke Row, near Henley, in 1886. His watercolours, which were painted in England, Ireland and on holidays in Aberdeenshire, are very sensitive productions and owe much to his friendship with W. Callow (q.v.), although he does not seem to have been a pupil.

Bibliography: A.D. Gordon: *D.H., his Life and Work,* 1903.

HANNAFORD, Charles E 1865 (Liverpool) – 1955
A landscape and marine painter who studied in London and Paris. At the age of seventeen he was articled to Henry Alty, Borough Engineer of Plymouth, and his work brought him to the notice of W. Cook (q.v.). In 1888 he was elected to the Institute of Civil Engineers, after which he turned to architecture, practising in South Wales. He made frequent sketching tours of Devon and Cornwall, and in 1897 he gave up his career and settled in Plymouth. In 1899 he studied with Stanhope Forbes. He held one-man exhibitions at the Walker Gallery in 1910 and 1912 and was much patronised by the Royal Family. A miniature painting by him is in the Queen's Doll's House. He lived later in London and Norfolk, and he signed with the surname only.

Examples: Exeter Mus.

HANNAN, William (Scotland) – 1775 (West Wycombe)
A draughtsman and decorator who worked for Sir Francis Dashwood at West Wycombe. He exhibited views of the Lake District and Cumberland at the Incorporated Society from 1769 to 1772.

Examples: B.M.

HARCOURT, George Simon, 2nd Earl of, F.R.S.
1736 – 1809
M.P. for St. Albans from 1761 to 1768 and Master of the Horse to Queen Charlotte from 1790, he was a pupil, friend and patron of P. Sandby, some of whose drawings he etched.

Published: *Ruins of Stanton-Harcourt,* 1763. *An account of the Church . . . at Stanton Harcourt,* 1808.

HARCOURT, Mary, Countess of – 1833
The daughter of the Rev. W. Danby of Swinton, Yorks, she married firstly Thomas Lockhart and secondly, in 1778, General William Harcourt, later Field Marshal and 3rd Earl of Harcourt. She was a pupil of A. Cozens (q.v.) and her drawings were praised by Horace Walpole. She and Lord Harcourt were close friends of the Royal Family, and she accompanied Queen Caroline, wife of George IV, on her wedding journey to England. She exhibited at the B.I.

Examples: Leeds City A.G.

HARDEN, John
1772 (Borrisoleigh, Co. Tipperary) – 1847 (Miller Bridge, Ambleside)
An amateur landscapist and painter of conversation pieces, who, according to Hartley Coleridge, 'had he not been too happy to wish for greatness would himself have been a great painter'. He paid his first visit to England and Wales in 1795 and two years later toured South West Ireland with G. Holmes (q.v.). In 1798 he visited the Lake District for the first time, with D.B. Murphy (q.v.) and in 1799, the South of England and the Isle of Wight with William Cuming, P.R.H.A. In 1801 he was again in England, and met his

future second wife on the return boat from Holyhead. In 1802 he went to Edinburgh to marry her, and in the following year they revisited the Lakes, where they settled in 1804. At Brathay Hall and later at other nearby houses they were at the centre of an artistic and literary circle and were visited by such men as Constable, Farington and W. Havell. Harden revisited Ireland at intervals throughout his life, and from 1809 to 1811 he was in Edinburgh assisting his father-in-law, the proprietor of the *Caledonian Mercury*. In 1829 he and his family made a Grand Tour of the Low Countries, Germany, Switzerland, Italy and France, returning by way of Ireland. The last few years of Harden's life were spent living with his children in Edinburgh and the Lakes. He revisited Ireland for the last time in 1844.

Harden was a very good amateur indeed, and although apparently self-taught, he knew how to learn from his professional friends. His earliest known works date from 1797, although it is possible that earlier drawings have been given to other amateurs working in Ireland such as J. Nixon (q.v.). His work is often on a small scale and he drew in pencil, pen and ink, pen and wash and full watercolour, sometimes using white heightening and buff or grey paper. His figure drawing is surprisingly good and his sketches from nature have spontaneity, freshness and strong colouring. He often painted into the light, rather in the manner of Wright of Derby.

His family, especially his daughter JESSIE, MRS. CLAY, (1814-1908), were all keen sketchers.

A loan exhibition of a hundred of his drawings was held at the N.G., Scotland in the summer of 1939. Another exhibition was held at South London A.G., in January 1952.

Examples: B.M.; Armitt Lib., Ambleside; Burton-on-Trent Gall.; Tullie Ho. Mus., Carlisle; R.I.A.; Abbot Hall A.G., Kendal; N.G., Scotland; Nat. Lib., Scotland.
Bibliography: D. Foskett: *J.H. of Brathay Hall*, 1974. *Cork Historical and Archaeological Society*, LX, 1955.

HARDIE, Charles Martin, R.S.A. 1858 (East Linton) – 1917
Although almost entirely an oil painter, in his early days he produced a number of landscapes in watercolour. He studied at the R.S.A. Schools, and he was elected A.R.S.A. in 1886 and R.S.A. in 1895.

His nephew was Martin Hardie, R.I., the writer on watercolours.

Illustrated: D.M. Moir: *The Life of Mansie Wauch*, 1911.

HARDING, Edward J 1804 (Cork) – 1870
A portrait painter in oil, watercolour and pen and ink who worked in Cork. He was highly thought of as a miniaturist. Pictures by him were in the Cork Exhibition of 1852.

HARDING, George Perfect – 1853 (Lambeth)
Son of S. Harding (q.v.), he was a miniaturist and portrait copyist. He exhibited at the R.A. from 1802 to 1840. He published a series of portraits of the Deans of Westminster, 1822-1823, and later worked on a similar series of the Princes of Wales. Between 1840 and 1843 he was involved in the Granger Society, which intended to publish hitherto unengraved historical portraits, and after the Society's collapse published fifteen of them on his own account. He was F.S.A. from 1839 to 1847, when he resigned.

Illustrated: T. Moule: *Ancient Oil Paintings and Sepulchral Brasses in the Abbey Church of St. Peter, Westminster*, 1825. J.H. Jesse: *Memoirs of the Court of England during the Reign of the Stuarts*, 1840.
Examples: B.M.; Victoria A.G., Bath; City A.G., Manchester; Newport A.G.

HARDING, James Duffield, O.W.S.
** 1797 (Deptford) – 1863 (Barnes, Surrey)**
He received a good artistic education from his father J. Harding (q.v.), who sent him to Prout for further lessons and apprenticed him to Charles Pye, the engraver. However, disliking engraving, he left after one year and from the age of thirteen exhibited landscapes at the R.A. He was elected A.O.W.S. in 1820 and a full Member in 1821. He first visited Italy in 1824 and was there again in 1831,

1834 and 1845. He also visited the Rhine in 1834 and 1837 and Normandy in 1842. He was throughout his life an ardent teacher and a most popular drawing master, J. Ruskin (q.v.) being a pupil.

His pencil and wash drawings are intended for copying and also for the production of lithographs with which he was most at home. He worked for Hullmandel and other publishers, making prints from drawings by Lewis, Bonington, Roberts and Stanfield, as well as from his own works. Harding's pure watercolours tend to show the faults of works produced for engravers. The effects and contrasts are overplayed; there is too much fussy detail and a weakness of composition. Perhaps because of his early difficulty in drawing trees, he was determined to master the technique, and did so successfully that Ruskin called him 'after Turner, unquestionably the greatest master of foliage in Europe'.

His remaining works were sold at Christie's, May 19-20, 1864.

Published: *Lithographic Drawing Book*, 1832. *Art, or the Use of the Lead Pencil*, 1834. *Principles and Practice of Art*, 1845. *Lessons on Trees*, 1852. Etc.
Examples: B.M.; V.A.M.; Ashmolean; Cartwright Hall, Bradford; Fitzwilliam; Glasgow A.G.; Leeds City A.G.; City A.G.. Manchester; Laing A.G., Newcastle; Newport A.G.; Nottingham Univ.; Portsmouth City Mus.; Ulster Mus.
Bibliography: *A.J.*, 1850; September 1856; February 1864. O.W.S. Club XXXVIII, 1963.

HARDING, John
An engraver and drawing master in Deptford, he was a pupil of Sandby (q.v.) and an imitator of Morland. He exhibited at the R.A. between 1800 and 1807, and was the father of J.D. Harding (q.v.).

Examples: B.M.

HARDING, Patty, Mrs., née ROLLS
A pupil of W. Callow (q.v.) and W. Collingwood Smith (q.v.), she married Rev. J.T. Harding, Vicar of Rochfield, Monmouth. In Britain she sketched on the Wye, the Thames and the Welsh and Cornish coasts. She also visited Italy and Norway, and she exhibited with the Society of Female Artists.

HARDING, Sylvester
** 1745 (Newcastle-under-Lyme) – 1809 (London)**
At the age of fourteen he ran away from his uncle's house in London and joined a company of actors. In 1775 he returned to London, and he began to exhibit miniatures at the R.A. the next year. From 1786 to about 1797 he and his brother Edward ran a publishing business in Fleet Street and Pall Mall, and issued many prints after his drawings by Bartolozzi, Delatre, Gardiner and others. Thereafter they carried on separately. Like his son G.P. Harding (q.v.), he is best known for his copies of portraits and old masters.

Examples: B.M.; Victoria A.G., Bath; Fitzwilliam.

HARDING, W.
An illustrator who worked between 1787 and 1792. The B.M. has drawings for Sterne's *Sentimental Journey* and Thomas Hull's *Sir William Harrington*. They are large and circular with good figures, poor perspective and light washes of colour.

Examples: B.M.

HARDINGE OF LAHORE, Henry, Field Marshal, 1st Viscount
** 1785 (Wrotham, Kent) – 1856 (South Park, Tunbridge Wells)**
An amateur artist who succeeded the Duke of Wellington as General Commanding in Chief of the forces in 1851. He was commissioned as an ensign in 1798, was at the R.M.C., High Wycombe in 1805 and 1806, and served throughout the Peninsular Campaign from 1807, much of it on the staff of the Portuguese Army. He was British military commissioner at Blücher's headquarters in 1815 and lost his left hand when sketching at Quatre Bras. He was an M.P. from 1820 to 1844 and served two terms each as Secretary of War and Irish Secretary in Wellington and Peel's administrations. In 1844 he was appointed Governor General of India, and he travelled out by way of Egypt. He was created Viscount in 1846 as a result of his

successes in the Sikh War and retired from India at the beginning of 1848. As Commander-in-Chief he was blamed for the lack of preparedness at the outbreak of the Crimean War.

He drew landscapes in India, France, Belgium, Switzerland, Italy, Spain and Germany as well as in England, Wales and Scotland. An exhibition of his work was held at 23 Park Lane, June 23-24, 1892.

HARDWICK, John Jessop, A.R.W.S.
1831 (Beverley, Yorkshire) – 1917 (Thames Ditton)
Apprenticed to Henry Vizetelly, the engraver and founder of *I.L.N.*, he joined the staff of the *I.L.N.* in 1858 as an illustrator and only as a side-line continued to work in full colour. He exhibited fruit and flower subjects in the manner of Hunt at the R.A. from 1861 to 1915 and also produced landscape drawings. He was elected A.R.W.S. in 1882.

Examples: Reading A.G.

HARDWICK, Philip, R.A., F.S.A.
1792 (London) – 1870 (Wimbledon)
The son of the architect Thomas Hardwick, he was educated at Dr. Barrow's School, Soho, and trained at the R.A. Schools and in his father's office. He exhibited architectural drawings at the R.A. from 1807 to 1814. In 1815 he went to Paris and was in Italy in 1818 and 1819. After his return he set up as an independent architect and exhibited Italian views at the R.A. as well as architectural designs. He was elected A.R.A. in 1840 and R.A. the following year. His most important buildings included Euston and Victoria stations and the City Club. His son Philip Charles (b. 1822) succeeded to his business.

Examples: Ulster Mus.

HARDWICK, William Noble, N.W.S. 1805 – 1865
A landscape painter who was a pupil of J.M.W. Turner. He was a member of the N.W.S. in 1834 and settled in Bath in 1838. He exhibited from 1829 and worked in the West country and on the Continent.

Examples: B.M.; V.A.M.; Bath Lib.; Victoria A.G., Bath; City A.G., Manchester; Nat. Mus., Wales.

HARDY, David
A painter of genre subjects in oil and watercolour. He lived in Bath and exhibited from 1835 to 1870.

HARDY, Dudley, R.I. 1867 (Sheffield) – 1922 (London)
The son and pupil of T.B. Hardy (q.v.), he also studied in Düsseldorf, Antwerp and Paris. He exhibited at the R.A. from 1884, and was elected R.I. in 1897, and was best known as an illustrator and cartoonist. He also produced fashion drawings, theatre posters, landscapes, seascapes, biblical and genre scenes and North African and Oriental views in the manner of N.H. Leaver (q.v.).

An exhibition of views taken in Northern France was held at the Continental Gallery, London, in 1902.

Examples: Leeds City A.G.; Leicestershire A.G.; Newport A.G.
Bibliography: P.V. Bradshaw: *The Art of the Illustrator*, 1918. *A.J.*, 1897.

HARDY, Frederick Daniel
1826 (Windsor) – 1911 (Cranbrook, Kent)
A genre painter who began as a musician and was a pupil of T. Webster (q.v.). He lived at Cranbrook from about 1854 as a member of the 'Colony' and was noted for his luminous colours.

Bibliography: *A.J.*, 1875.

HARDY, James 1801 – 1879
A painter of landscapes and old buildings in oil and watercolour who worked in London and, from about 1845, in Bath. His daughter, a still-life painter, married H. Hobson, Yr. (q.v.).

Examples: Victoria A.G.. Bath; Blackburn A.G.

HARDY, James, Yr., R.I. 1832 – 1889
The son of J. Hardy, he worked in Bristol painting moors and sporting scenes in oil and watercolour. He was elected A.N.W.S. and N.W.S. in 1874 and 1877 and studio sales of his work were held by Christie's, March 9, 1878 and April 4, 1889.

Examples: V.A.M.; Williamson A.G., Birkenhead; Portsmouth City Mus.

HARDY, Thomas Bush 1842 (Sheffield) – 1897 (London)
A marine painter who spent some time in France and Holland before exhibiting for the first time in 1871. He was an unsuccessful candidate for the N.W.S. on several occasions in the 1870s, but was elected to the R.B.A. in 1884.

His best work is usually on a small scale, sketches of Venice, the Broads or Dutch beaches. Once he had found his well-known formula of sickly yellow-green seas heightened with a knife, and brown knotted ships and rigging, his finished pieces became facile and repetitive.

Examples: B.M.; V.A.M.; Haworth A.G., Accrington; Cartwright Hall, Bradford; Dundee City A.G.; Towner Gall., Eastbourne; Greenwich; Gray A.G., Hartlepool; Leeds City A.G.; Leicestershire A.G.; City A.G., Manchester; Newport A.G.; Nottingham Univ.; Sydney A.G.

HARDY, William Wells
A London flower painter who exhibited from 1818 to 1856.

HARE, Augustus John Cuthbert
1834 (Rome) – 1903 (St. Leonards)
Author of guide books and biographies, illustrator and topographer, he was a kinsman of Sir J. Dean Paul (q.v.) and was educated at Harrow, privately and University College, Oxford. He spent a year in Italy from 1857 to 1858 and wrote his first guide book on his return. He was abroad again for most of the time between 1863 and 1870. Thereafter he lived in St. Leonards, visited country houses and won a reputation as a writer of ghost stories.

His watercolours are often very competent, and are usually in a free and wet manner.

Published: *Berks, Bucks and Oxfordshire*, 1860. *Handbook to Durham*, 1863. *Walks in Rome*, 1871. *Cities of Northern and Central Italy*, 1876. *Walks in London*, 1878. Etc.
Examples: Dundee City A.G.; Leeds City A.G.

HARE, St. George, R.I. 1857 (Limerick) – 1933 (London)
A painter of historical genre subjects, portraits, and above all, of nudes. He studied with N.A. Brophy before going to South Kensington in 1875. His first notable nudes date from 1890, and he was elected R.I. two years later. He also painted in oil and pastel.

HARFORD, John Scandrett 1785 – 1866
A writer, collector, banker and improving landlord, Harford inherited property near Bristol and in Wales. He made something of a grand tour from 1815 to 1817 during which he bought many old masters. He also visited Italy in 1846 and 1852. He was a deputy-lieutenant for Gloucestershire and Cardiganshire and twice stood for Parliament at Cardigan. He went blind in 1862.

Published: *Life of Michael Angelo Buonarotti*, 1857. *Illustrations of the Genius of M.A. Buonarotti*, 1857.
Examples: V.A.M.

HARGITT, Edward, R.I. 1835 (Edinburgh) – 1895 (London)
A Highland landscape painter, he was a pupil of H. MacCulloch (q.v.). He was elected A.N.W.S. and N.W.S. in 1867 and 1871, by which dates he had moved to London. He visited Ireland, was a keen ornithologist and a good painter of cattle.

Examples: V.A.M.; Glasgow A.G.; City A.G., Manchester; Paisley A.G.; Sydney A.G.

HARLE
A drawing master in Durham in about 1803 who gave G.F. Robson (q.v.) his first lessons.

HARLEY, George **1791** **– 1871 (London)**
A drawing master who worked in many parts of the country and exhibited in London from 1817 to 1865. He painted landscapes and topographical subjects.

Published: *Lessons in Landscape,*1820-2. *Guide to Pencil and Chalk Drawing from Landscape,* 1848.
Examples: B.M.; V.A.M.; Newport A.G.

HARLING, William O
A portrait painter who lived in Chester and London and exhibited in London from 1849 to 1878. In the latter year he showed Italian views.

HARLOW, George Henry **1787 (London) – 1819 (London)**
The son of a china merchant, Harlow was educated at Dr. Barrow's, Mr. Roy's in Burlington Street, and Westminster. He was a pupil of H. De Cort (q.v.) and Samuel Drummond, A.R.A., before spending a year with Sir T. Lawrence (q.v.). He combined a wild social life with hard work and, despite a dislike of the R.A., exhibited there from 1804. He went to Italy in 1818 to study old masters and made a stir both as an artist and as a social lion. He died within a month of his return to England.
 Harlow is best known for his portraits in the manner of Lawrence, with an emphasis on eyes and red lips. They are often of actors and were said to be very good likenesses. His history and literary subjects are generally less successful, showing poor composition and draughtsmanship.
 His remaining works were sold at Foster's, London, June 21, 1819 and June 3, 1820.

Examples: B.M.; V.A.M.; Ashmolean.

HARPER, Edward
A barrister who lived in Brighton and York and was a collector and amateur watercolourist. He was working from 1836 to 1879 and should not be confused with EDWARD SAMUEL HARPER, a Birmingham man born in 1854, nor he in turn with EDWARD STEEL HARPER (b. 1878).

Examples: Hove Lib.; Nat. Mus., Wales; York A.G.

HARPER, Henry Andrew
1835 (Burnham, Bedfordshire) – 1900 (Westerham Hill, Kent)
An author and painter of the Holy Land who exhibited from 1858 and accompanied the Earl of Dudley to the Near East. Agnews held an exhibition of Palestine, Egypt and Nubia in 1872, but this did not impress the N.W.S. who rejected his candidacy two years later. Various exhibitions of his work were also held at the Fine Art Society.

Examples: Bridport A.G.; Wallace Coll.

HARPER, John **1809 (nr. Blackburn, Lancashire) – 1842 (Naples)**
An architect and brother of E. Harper (q.v.), he studied under Benjamin and Philip Wyatt, helping them with plans for Apsley and York Houses. He practised at York. He had many artist friends including Etty, Roberts and Stanfield. He died during a tour of Italy to study art.
 He was a prolific sketcher of landscape and architecture, and was praised by Etty for his 'elegant execution and correct detail'.

Examples: B.M.; Laing A.G., Newcastle; York A.G.

HARPER, Thomas
A marine painter who lived in Newcastle, where he was taught by one or more of the Richardsons. He was an unsuccessful candidate for the N.W.S. in 1850 and exhibited in 1875. His subjects are mostly, but not exclusively, Northern.

Examples: Shipley A.G., Gateshead; Laing A.G., Newcastle.

HARRADEN, Richard **1756 (London) – 1838 (Cambridge)**
An engraver and topographical artist, he worked in Paris for some years before 1789. He then returned to London and, in 1798, he moved to Cambridge. He is best known for his various prints of Cambridge. He was the father of R.B. Harraden (q.v.).

Published: *Six Large Views of Cambridge,* 1797-8. *Costume of the Various Orders in the University of Cambridge,* 1803. With R.B. Harraden; *Cantabrigia Depicta,* 1811.

Examples: B.M.

HARRADEN, Richard Bankes **1778 (Paris?) – 1862 (Cambridge)**
The son of R. Harraden (q.v.), he worked in conjunction with his father at Cambridge. He was a member of the S.B.A. from 1824 to 1849. With his father he made a number of prints after Girtin's Parisian views.

Published: With R. Harraden: *Cantabrigia Depicta,* 1811. *Illustrations of the University of Cambridge,* 1830.
Illustrated: Gosham: *The Antiquarian Itinerary,* 1818.

HARRINGTON, Charles **1865 (Brighton) – 1943**
A Sussex landscape painter who was a late exponent of the Cox-Collier tradition. He was educated in Brighton and lived in Lewes. He was killed in an air raid.

Examples: V.A.M.; Aberdeen A.G.; Darlington A.G.; Fitzwilliam; Towner Gall., Eastbourne; Gloucester City A.G.; Hove Lib.; Portsmouth City Mus.; Newport A.G.; Rochdale A.G.; Sargent Gall., Wanganui, N.Z.

HARRINGTON, Jane, Countess of, née Fleming
 – 1824
The wife of the 3rd Earl. The B.M. has a drawing of a romantic river landscape by her. It is a little in the manner of 'Grecian' Williams, but there is chalk on top and the figures are out of proportion.

HARRIOTT, William Henry **– 1839 (London)**
A War Office clerk who spent several months each year sketching on the Continent. He exhibited from 1811 to 1837 and worked in a number of styles from that of Devis to those of Francia, Cotman and Gothic Prout. This was not a one-way traffic, however, since Cotman, who was a friend, took tracings of many of his compositions and later worked them up for exhibition.

Examples: B.M.; Bridport A.G.

HARRIS, Daniel
Architect, builder, draughtsman and Keeper of the Oxford County Gaol. He supervised the building of a number of Thames Locks using convict labour. He exhibited at the R.A. in 1799 and produced a number of Oxford drawings in the 1780s and 1790s, including illustrations for the *Oxford Almanack.* He was still working as an architect in 1820.
 He was a competent if traditional artist. His figures are elongated and romanticised, his detail unfussy, and there is not too much ruler-work on the architecture. Greys and blues predominate.

Examples: V.A.M.; Ashmolean.

HARRIS, Henry Hotham **1805 (Birmingham) – 1865**
He studied art under W. Rider (q.v.) in Leamington, and his early work attracted the attention of the Duchess of St. Albans. He studied for a time in London, where he exhibited from 1826.
 He was one of the founders of the Birmingham Society of Artists, and acted as Secretary from 1852 to 1859.

Examples: City A.G., Birmingham; Portsmouth City Mus.

HARRIS, James
A marine painter working in Swansea between 1846 and 1876.
 J.C. HARRIS, living in Nice, was an unsuccessful candidate for the N.W.S. in 1869, and SIR JAMES C. HARRIS (1831-1904), perhaps the same, was elected Hon. R.I. in 1888.

Examples: Castle Mus., Norwich.

HARRIS, John **– 1834**
An illustrator and lithographer who exhibited watercolours at the R.A. from 1802 to 1815. He lithographed a number of Masonic plates in 1825. His son, JOHN HARRIS, YR. (1791-1873), followed

his business. Together they published illuminated versions of early Statutes and Magna Carta in 1816.

Examples: B.M.; Exeter Mus.

HARRIS, Moses 1731 (London) – c. 1785
An entomologist and botanical artist who drew for private patrons, as well as for his book on butterflies and moths. Although the arrangement of the drawings for his plates is rather stilted and naïve, his drawing and colouring is of high quality. He was Secretary of the second Aurelian ('Chrysalis') Society.

Published: *The Aurelian*, 1766. *An Essay preceding a supplement to the Aurelian . . . 1767. Natural System of Colours*, 1811.
Examples: B.M.

HARRIS, R P
An artist who between 1868 and 1892 sketched in Skye, Corsica, Italy, the Tyrol, the Rhine, the Pyrenees, the Riviera and at Reigate.

HARRIS, William E
A Birmingham landscape and coastal painter who exhibited there and in London from 1879 to 1900. He painted in Wales, Devon and the Pool of London.

Examples: Birmingham City A.G.

HARRISON, Charles Harmony
 1842 (Yarmouth, Norfolk) – 1902
A Norfolk artist who was apprenticed to a sign-writer and, in 1859, enlisted in the Yarmouth Volunteers. He later joined the Rifle Volunteers, painting in his spare time. His early works were in oil but, on being presented with a box of watercolours in 1870, he turned exclusively to this medium, and soon afterwards made painting his profession, being helped by the commissions he received through Lady Crossley, of Somerleyton. In 1878 he moved to London, where he ran into financial difficulty, and he returned to Norfolk in 1880, making a tour of the Broads with S. Batchelder (q.v.). He exhibited in East Anglia and at the R.I.

He drew his inspiration from the Norfolk landscape, which he loved, and from the great Norwich artists on whom he based his style, and his pictures attained considerable local popularity. Towards the end of his life rheumatism, combined with the increasing financial necessity to sell pictures, lowered the standard of his work.

Examples: Great Yarmouth Lib.
Bibliography: A.H. Patterson and C.H. Smith: *C.H.H.*, 1903. *Country Life*, CLVII, March, 1975.

HARRISON, George Henry, A.O.W.S.
 1816 (Liverpool) – 1846 (Paris)
The son of a failed merchant and land-owner and of Mary Harrison (q.v.), he came to London when about fourteen and studied anatomy at the Hunterian School. He was advised and encouraged by Constable, and he began to exhibit at the R.A. in 1840 and was elected A.O.W.S. in 1845. He taught both in London and in Paris, where he lived during his last years, mainly through open air sketching classes. His style and subject matter are those of Boys and Bonington in their Watteauesque moments.

Examples: V.A.M.; Williamson A.G., Birkenhead.

HARRISON, Harriet
A sister of G.H. Harrison (q.v.), she was a flower painter like her mother and sister. She was an Hon. Member of the Society of Female Artists.

HARRISON, James
Possibly another son of Mary Harrison (q.v.), he exhibited landscapes and architectural subjects at the R.A. from 1827 to 1846. He lived in London until 1881.

Examples: V.A.M.; Bristol City A.G.

HARRISON, Dr. John 1810 – 1896
Doctor to W.J. Müller (q.v.) with whom he often sketched in Leigh Woods, Coombe Valley, on the banks of the Frome, Chew and Avon and other places in the neighbourhood of Bristol from 1837. He attended Müller in his last illness and contributed a memoir of him to Solly's *Life*, 1875.

Examples: Bristol City A.G.

HARRISON, Maria
A sister of G.H. Harrison (q.v.), she studied under her mother and in Paris, and became a drawing mistress and flower painter. In February 1847 she was elected a Lady Member of the O.W.S., filling the place of her late brother.

HARRISON, Mary P , Mrs., née Rossiter, N.W.S.
 c.1788 (Liverpool) – 1875 (Hampstead)
The daughter of a Stockport hat-maker, she was known as 'the Rose and Primrose painter'. She began painting regularly in France on her honeymoon in 1814, and was the first English lady to be given permission to copy in the Louvre. In about 1830 her husband's business and health collapsed, and they moved from Liverpool to London. She turned to art to support her family, and in 1834 was a founder of the N.W.S., with whom she exhibited flowers, fruit and birds' nests for some forty years, gradually progressing from cut to growing flowers.

Several of her children are separately noticed.

Examples: *A.J.*, 1876.

HARRISON, William Frederick
 1814 (Amiens) – 1880 (Goodwick, nr. Fishguard)
The eldest son of Mary Harrison (q.v.) and brother of G.H. Harrison (q.v.), he showed an early aptitude for painting, although he was never a full-time professional. He worked at the Bank of England for more than forty years, and also exhibited marine subjects at the R.A., the Dudley Gallery and elsewhere.

HART, E M M
A landscape painter working in Kent in the 1830s.

HART, J Laurence – 1907 (Morfa Nevin, Caernarvon)
A Birmingham landscape painter who worked in Worcestershire and the Isle of Man from 1870 to 1890. He then became a hermit at Morfa Nevin. A book of his poems was published in 1912.

HART, James Turpin 1835 (Nottingham) – 1899 (Nottingham)
He studied at the Nottingham School of Design and at the R.A. Schools from 1860 to 1867, where he was awarded a silver medal and a life studentship. Afterwards he returned to Nottingham, where he built up a portrait practice and taught at the School of Art. He also had a large number of private pupils. He painted many landscapes of rustic scenery in watercolour.

Examples: Castle Mus., Nottingham.

HART, Solomon Alexander, R.A.
 1806 (Plymouth) – 1881 (London)
The son of a goldsmith, he was apprenticed to Samuel Warren the engraver and entered the R.A. Schools in 1823. He exhibited from 1826, and was elected A.R.A. and R.A. in 1835 and 1840. He visited Italy in 1841 and 1842 and was Professor of Painting at the R.A. from 1854 to 1863. He painted landscapes, portraits and historical scenes in oil and watercolour.

Examples: B.M.; V.A.M.
Bibliography: A. Brodie: *Reminiscences of S.A.H.*, 1882.

HART, Thomas, F.S.A. – 1886
A coastal painter who lived in Plymouth and Falmouth. He stood unsuccessfully for the N.W.S. in 1862, 1863 and 1864, and exhibited in London from the following year to 1880. He is at his best with wide views of the Cornish coasts and estuaries, but is weak when he includes ships or figures. He was elected F.S.A. in 1856 and

served on the council in 1861 and 1862.

There is a watercolour by PERCIVAL HART in the Newport A.G. He painted in Cornwall and the London docks in the 1890s.

Examples: B.M.; V.A.M.

HART, Thomas Gray 1797 (Fareham, Hampshire) – 1875
An amateur landscape and coastal painter who settled in Southampton in 1825. He was also strongly interested in music and cricket.

HARTLAND, Henry Albert
1840 (Mallow, Co. Cork) – 1893 (Liverpool)
The son of a landscape gardener, he was trained in the Cork School of Art. He made drawings for a bookseller, and was a scene painter at the Cork Theatre and the Theatre Royal. He first exhibited at the R.H.A. in 1865, and sent landscapes to the Society of Artists in 1868 and the R.A. in 1869. In 1870 he toured Ireland and Wales, and settled in Liverpool, where his landscapes met with considerable success, and where he remained, except for a period in London from 1887 to 1890, a brief stay in Huddersfield and occasional visits to Ireland, for the rest of his life. He was elected to the Liverpool Academy.

Examples: V.A.M.; Williamson A.G., Birkenhead; Blackburn A.G.; Cork A.G.; Greenwich; Reading A.G.; Ulster Mus.

HARTRICK, Archibald Standish, R.W.S.
1865 (Bangalore) – 1950
An illustrator and genre painter who studied at the Slade and in Paris. He was himself a successful teacher and also produced lithographs. He was a fine draughtsman, and he was elected A.R.W.S. and R.W.S. in 1910 and 1920.

Examples: Glasgow A.G.
Bibliography: Apollo, XXIV, 1936.

HARTSHORNE, Rev. Charles Henry 1802 – 1865
An antiquarian author and topographical artist, he was educated at Shrewsbury and St. John's College, Cambridge. He took his B.A. in 1827 and was ordained in the same year. From 1850 until his death he was Rector of Holdenby, Northamptonshire, and he was also Domestic Chaplain to the Duke of Bedford and Rural Dean of East Haddon. Among his publications was A Guide to Alnwick Castle, 1865, illustrated by P.H. Delamotte (q.v.). He is said to have been 'a very fine watercolour artist. He painted hundreds of sketches of churches and castles.'

HARVEY, Sir George, P.R.S.A.
1806 (St. Ninian's, Perthshire) – 1876 (Edinburgh)
Apprenticed to a Stirling bookseller, Harvey entered the Trustees' Academy in about 1824. He was one of the first A.R.S.A.s in 1826 and became R.S.A. in 1829. He was elected P.R.S.A. in 1864 and knighted in 1867. He painted both figure subjects, notably Covenanting pictures, and landscapes in oil and watercolour.

Published: Notes on the Early History of the R.S.A., 1870.
Illustrated: J.Brown: Rab and his Friends, 1876.
Examples: B.M.; N.G., Scotland.
Bibliography: Recollections of Sir G.H., 1880. A.J., 1876.

HARVEY, William
1796 (Newcastle-upon-Tyne) – 1866 (Richmond)
Apprenticed to T. Bewick (q.v.), he went to London in 1817 and became a pupil of B.R. Haydon (q.v.). He worked first as a wood-engraver and then as a designer. His style is florid and becomes mannered. His original works in oil and watercolour, which were sometimes engraved by others, are rare and generally on a small scale.

Illustrated: Northcote: Fables, 1828-1833. Lane: 1001 Nights, 1838-1840. Etc.
Examples: B.M.; Fitzwilliam.

HASELER, Henry
A topographical and landscape painter who exhibited from 1814 to 1817 and published a series of views of Sidmouth in 1825. He was in Devon in 1817. His work is pretty but weak and can have a feeling of Girtin about it.

Published: Sidmouth Scenery.
Examples: V.A.M.; Exeter Mus.

HASLEHURST, Ernest William, R.I.
1866 (Walthamstow, Essex) – 1949 (London)
A landscape painter and illustrator who was educated in Hastings, at Felstead and at University College, London. He lived in South London, and painted in England and Holland. He was elected R.B.A. in 1911 and R.I. in 1924.

Examples: V.A.M.

HASLEM, John 1808 (Carrington, Cheshire) – 1884 (Derby)
At the age of fourteen he entered Derby Porcelain Works. In 1835 he moved to London, returning to Derby in 1851, after which date his output was small. He exhibited watercolour portraits at the R.A., R.B.A. and elsewhere, and painted enamel portraits for the Royal Family. He also painted in oil.

Published: Old Derby China Factory; the Workmen and their Productions, 1876. Catalogue of China . . . the property of Mr. John Haslem of Derby, 1879.
Examples: Derby A.G.

HASSAM, Alfred
A painter and designer who was working in the middle of the nineteenth century. He produced portraits and visited the Near East. He also wrote Arabic Self-Taught, 1897.

HASSELL, Edward – 1852 (Lancaster)
The son of J. Hassell (q.v.), he was a member of the R.B.A. from 1841 and became its Secretary. He also exhibited at the R.A. and the B.I. As well as for his landscapes and topographical views, he was noted for his Gothic interiors.

Examples: B.M.; V.A.M.; Guildford Mus.; N.G., Ireland; Lambeth Lib.; Merton Lib.; Wandsworth Lib.

HASSELL, John 1767 – 1825
An engraver and drawing master, he was also a prolific author. He produced a biography of his friend George Morland, as well as treatises on watercolour painting and a series of elaborate guide books illustrated by aquatints from his own drawings. He exhibited at the R.A. from 1789.

Published: Tour of the Isle of Wight, 1790. Picturesque Guide to Bath, 1793. Life of George Morland, 1806. Speculum: or the art of Drawing in Watercolours, 1808. Aqua Pictura, 1813. Picturesque Rides and Walks, 1817. The Tour of the Grand Junction Canal, 1819. Camera: or Art of Drawing in Watercolours, 1823. Excursions of Pleasure and Sports on the Thames, 1823.
Examples: B.M.; Guildford Mus.; Lambeth Lib.; City A.G., Manchester; Merton Lib.

HASTIE, Grace H 1855 – 1930
A landscape, fruit and flower painter who exhibited from 1874 and was a member of the Society of Female Artists. She visited the Channel Islands. Her flower studies are generally more impressive than her landscapes.

Examples: B.M.

HASTINGS, Edmund
A portrait and landscape painter who was working in Durham from 1804 to 1861. He exhibited at the R.A. from 1804 to 1827, and his landscape work can be in the manner of J.S. Cotman (q.v.).

HASTINGS, Captain Thomas
An amateur etcher and artist who was Collector of Customs at

Liverpool, where he was an Associate of the Academy. He was active between 1804 and 1831.

Published: *Vestiges of Antiquity, or a Series of Etchings of Canterbury*, 1813. *Etchings from the Works of Richard Wilson*, 1825. *The British Archer, or Tracts on Archery*, 1831.
Illustrated: Woolnoth: *Canterbury Cathedral*, 1816.

HATHERELL, William, R.I. **1855 – 1928 (London)**
A painter of Biblical subjects who lived in London and was elected R.I. in 1888.

Illustrated: E.J. Bradley: *Annals of Westminster Abbey*, 1895. E.R. Pennell: *Tantallon Castle*, 1895. S.L. Clemens: *The Prince and the Pauper*, 1923.
Bibliography: P.V. Bradshaw: *The Art of the Illustrator*, 1918.

HATTON, Brian 1887 (Hereford) – 1916 (Oghratina, Egypt)
A child prodigy who by the age of twelve had attracted the attention of Princess Louise and G.F. Watts. He was put through a well-planned course of training, including one year at Oxford and a period at George Harcourt's painting school in Arbroath. He learnt modelling under Professor Lanteri. From 1908 to 1909 he was in Egypt and, in 1910, spent a short time at the Académie Julian in Paris. In 1912 he set himself up in London and began to receive important commissions. However, he joined up on the outbreak of war and was killed in 1916. He was concerned mainly with country figures and horses, and he also executed some portraits in oil.

Examples: B.M.; Brian Hatton Gall., Churchill Mus., Hereford.
Bibliography: Hereford Mus.: *Exhibition Cat.*, 1925. *Walker's Quarterly*, 1926.

HATTON, Richard George
 1865 (Birmingham) – 1926 (Newcastle-upon-Tyne)
A painter of landscapes, portraits and genre subjects in oil and watercolour, he studied at the Birmingham School of Art. In 1890 he became assistant art master at Armstrong College, Newcastle, and in 1895, Headmaster. In 1912 he was appointed Director of the King Edward VII School of Art, and in 1917 Professor of Fine Art. The Hatton Gallery at Newcastle University was named after him.

Published: *Perspective for Art Students*, 1901. *Figure Drawing*, 1905. *The Craftsman's Plant-Book*, 1909. *Principles of Decoration*, 1925.

HAUGHTON, Moses, Yr. 1772 (Wednesbury) – 1848
The son of MOSES HAUGHTON (1734-1804), an enamel and still-life painter, he was a pupil of G. Stubbs and studied at the R.S.A. Schools. He was a friend of Fuseli and is best known as a miniaturist and engraver. He exhibited at the R.A. from 1808 to 1848.

Examples: B.M.

HAVELL, William 1782 (Reading) – 1857 (London)
A landscape painter who, despite his large artistic family, was almost entirely self-taught. He made his first sketching tours to Wales and the Wye Valley in 1802 and 1803, meeting the Varleys and Cristall, who became his close friends. In 1805 he was a founder member of the O.W.S. with them. In 1807 he went to the Lake District and lived at Ambleside for more than a year. In 1812 and 1813 he visited Hastings and, between 1813 and 1816, he worked on a large number of small sepia landscapes for various annuals, such as Peacock's *Polite Repository*. In 1816 he sailed for China as artist to Lord Amherst's Embassy, visiting Madeira, Rio de Janeiro, the Cape and Java. It is not certain whether he accompanied Amherst to Peking or remained with the ships. It is also uncertain at which point he left the Embassy, and whether he was on board H.M.S. *Alceste* when she was wrecked. However, he next went to Calcutta and stayed in India for eight years, working as a watercolour portrait painter. He returned to England in 1827, but, in the following year, went to Italy where he remained, staying with his friend T. Uwins (q.v.) until the spring of 1829. Although he had re-joined the O.W.S. on his first return to England, he finally retired

on his second, and thereafter he tried to establish himself as an oil-painter.

Havell's best landscapes are of his native Reading and the Thames Valley. They begin much in the manner of Girtin and later can come very close to De Wint, especially in the massed forms of the trees. During his Italian stay, he broadened his subject matter to include such themes as peasants bringing in the grape harvest — subjects more usually associated with Uwins.

Examples: V.A.M.; Newport A.G.; Nottingham Univ.; Reading A.G.; Richmond Lib.; Warrington A.G.
Bibliography: O.W.S. Club, XXVI, 1948. *Connoisseur*, Dec. 1949. Reading Mus. Cat., 1970.

HAVELL FAMILY
The Havells were primarily printmakers, but several of them were also drawing masters and occasional watercolour painters. They include CHARLES RICHARD HAVELL (1827-1892); EDMUND HAVELL (1785-1864), younger brother of W. Havell (q.v.); and EDMUND HAVELL, YR. (1819-1894). See Family Tree.

HAVERS, Alice Mary, Mrs. Morgan
 1850 (Norfolk) – 1890 (London)
Daughter of the manager of the Falkland Islands, she was brought up there and in Montevideo. She returned to England in 1870 and studied at South Kensington. In 1872 she married Frederick Morgan, an artist, but continued to use her maiden name. She exhibited at the S.B.A. and, from 1873, at the R.A. In 1888-1889 she was in Paris.

She was an illustrator and painter of biblical and genre subjects.

HAWES, Captain Arthur Briscoe 1832 – 1897
The youngest son of Sir Benjamin Hawes, K.C.B., M.P., Permanent Under-Secretary for War. He was educated at Westminster from 1846 to 1849, in which year he was commissioned as a cadet in the Bengal Native Infantry. He retired as a captain in 1858. He produced Indian views in pen and wash.

Published: *Rifle Ammunition*, 1859.
Examples: India Office Lib.

HAWKER, J
A landscape painter who exhibited at the R.A. from 1804 to 1809.
 A GEORGE HAWKER was painting in Corfu in 1835; and JOSEPH HAWKER exhibited a landscape at the S.B.A. in 1833.

HAWKINS, George, Yr. 1809 – 1852 (Camden Town)
An architectural draughtsman and lithographer. He worked for Messrs. Day, and often coloured architects' designs for exhibition at the R.A. His own work is said to be particularly 'correct and delicate'.

HAWKSWORTH, William Thomas Martin, R.I.
 1853 – 1935 (Herne Bay)
A landscape and marine painter who was educated at King's School, Canterbury, apprenticed to E.W. Pugin, the architect, and a pupil of Henry Tonks. He worked on the Sussex coast with L. Hadham (q.v.), and in the West Country, Norfolk and Holland. He was elected R.I. in 1934.

Examples: B.M.; V.A.M.; Glasgow A.G.

HAY, James Hamilton 1874 (Liverpool) – 1916
The son of a Scottish architect, he himself was trained as an architect before studying painting with J. Finnie (q.v.). He painted at St. Ives with Julius Olsson, R.A., and exhibited at the N.E.A.C. and elsewhere. He painted in oil and watercolour, and was an etcher.

HAY, Thomas Marjoribanks, R.S.W.
 1862 – 1921 (Edinburgh)
Landscape painter in oil and watercolour, he studied at Edinburgh and exhibited in London from 1885. He designed stained glass early in his career.

Examples: Dundee City A.G.; City A.G., Manchester; N.G., Scotland.

HAYDON, Benjamin Robert 1786 (Plymouth) − 1846 (London)
The son of a Plymouth bookseller and school-friend of Prout, Haydon is best known as an heroically unsuccessful historical painter in oil. He occasionally made very effective coloured wash drawings as preparatory sketches and memoranda.

His style is neo-classical in the manner of West or a narrower Fuseli. His many pupils included W. Bewick, Sir C. Eastlake, W. Harvey, G. Lance, C., E. and T. Landseer.

Examples: B.M.; Ashmolean; City A.G., Manchester.
Bibliography: T. Taylor: *Life of H.*, 1853. F.W. Haydon: *B.R.H., his Correspondence and Table Talk*, 1876. E. George: *The Life and Death of B.R.H.*, 1948. *A.J.*, Sept. 1853, June 1856.

HAYES, Claude, R.I.
1852 (Dublin) − 1922 (Brockenhurst, Hampshire)
His father, Edwin Hayes (q.v.), being determined to turn him into a businessman, Hayes ran away to sea. In 1867-1868 he served with the Abyssinian Expedition and then went to the U.S.A. for a year. On his return he became a student at the R.A. Schools, and later studied at Antwerp. He was elected R.I. in 1886.

He belongs to a group of landscape artists, including his brother-in-law W.C. Estall (q.v.), J. Aumonier (q.v.) and E.M. Wimperis (q.v.), whose artistic descent is from Cox and Collier. Like Collier, Hayes was particularly fond of wide stretches of moorland dominated by the sky. He was a very rapid worker but this, combined with ill-health and loss of money towards the end of his career, led to slipshod productions.

Examples: V.A.M.; Brighton A.G.; Towner Gall., Eastbourne; Leeds City A.G.; Newport A.G.; Ulster Mus.; Wakefield A.G.
Bibliography: *Studio*, XXXIII. *Walker's Quarterly*, 7.

HAYES, Edward, R.H.A. 1797 (Co. Tipperary) − 1864 (Bath)
A portrait painter in watercolour and miniature who studied under J.S. Alpenny (q.v.), and at the R.D.S. Schools. He practised as a miniaturist and taught drawing at Clonmel, Kilkenny and Waterford, before returning to Dublin in 1831 to build up a practice and exhibit at the R.H.A. until 1863. He was elected A.R.H.A. and R.H.A. in 1856 and 1861.

As well as portraits, he painted occasional landscapes in oil and watercolour.

He was the father of M.A. Hayes (q.v.).

Examples: N.G., Ireland.

HAYES, Edwin, R.H.A., R.I. 1820 (Bristol) − 1904 (London)
A marine painter who came to Dublin at an early age and studied at the R.D.S. Schools. His love of the sea drove him to serve on the crew of a ship bound for America, and on his return he worked for ten years in Dublin, exhibiting at the R.H.A. from 1842. He came to London in 1852 where he painted scenery at the Adelphi and elsewhere, and exhibited at the B.I., R.A., S.B.A. and the N.W.S., of which he was elected Associate and Member in 1860 and 1863. He continued to exhibit at the R.H.A., and was elected Associate in 1853 and Member in 1871. He visited France, Spain and Italy, but the majority of his subjects were taken from the South coast of England. He has an accurate eye for detail, and is traditional in manner.

He was the father of C. Hayes (q.v.).

Examples: V.A.M.; Bowes Mus., Durham; Cardiff A.G.; Greenwich; Leeds City A.G.; Leicestershire A.G.

HAYES, Frederick William
1848 (New Ferry, Cheshire) − 1918 (London)
A landscape painter, he was the son of a glass-maker and trained as an architect in Ipswich. However, he then studied painting in Liverpool and, in 1870, came to London as a pupil of H. Dawson (q.v.). He returned to Liverpool after eighteen months, and was a founder of the local Watercolour Society. He was also a musician, a song-writer and an historical and economic author. From 1872 he exhibited at the R.A. and from 1880 lived in London.

Examples: B.M.; V.A.M.; Glasgow A.G.; Newport A.G.
Bibliography: C.R. Grundy: *F.W.H.*, 1922.

HAYES, George
A Manchester painter in oil and watercolour who exhibited from 1851 to 1875. He began by painting historical genre subjects and turned to landscapes in the Cox tradition.

HAYES, Michael Angelo, R.H.A., A.N.W.S.
1820 (Waterford) − 1877 (Dublin)
Best known for his racing and military subjects, he was the son and pupil of Edward Hayes (q.v.). He first exhibited at the R.H.A. in 1837, and in 1842 was appointed Military Painter-in-Ordinary to the Lord Lieutenant. He came to London and exhibited at the R.A. in 1848, in which year he was elected A.N.W.S. On returning to Dublin he became A.R.H.A. and R.H.A. in 1853 and 1854. He was elected Secretary in 1856 and served through a difficult time of schism, being expelled the following year. He was reinstated in 1861, and retired in 1870. He also served as Dublin City Marshal.

His work, in oil and watercolour, includes miniatures, portraits, landscapes and ceremonial pictures.

Published: *The Delineation of Animals in rapid Motion*, 1876.
Illustrated: A.G. Stark: *The South of Ireland*, 1850.
Examples: B.M.

HAYES, William
An ornithological artist working in the second half of the eighteenth century, mainly in the Menagerie at Osterley. In 1794 he was living at Southall, Middlesex in poor circumstances, having ten surviving children − of twenty-one − of whom seven helped with his work.

The plates in his books are etched and carefully coloured by hand, with the subjects sometimes chosen rather for the effects of brilliant plumage than scientific interest.

Published: *A Natural History of British Birds etc.*, 1775. *Portraits of Rare and Curious Birds, from the Menagery of Osterly Park*, 1794.
Examples: Ashmolean.

HAYGARTH, Miss
An artist who was working in Italy in 1837.

HAYWARD, John Samuel 1778 − 1822
The son of a floor cloth manufacturer to whose business he succeeded, he was a friend of J. Cristall (q.v.), from the calico printing works at Old Ford. He helped Cristall to paint a panorama of Constantinople when he first arrived in London, and later worked on panoramas with James de Maria. Although an amateur he was a good watercolourist, exhibiting both figures and landscapes at the R.A. from 1798 to 1816, and acting as Secretary of the Sketching Society, to which he was elected in 1803. His style, after 1800 was closely modelled on that of Cristall in his looser manner, and was influenced by Cotman. Previously it had been more old fashioned, possibly based on that of Grimm. He met Girtin in North Wales with Sir G. Beaumont in 1800 and again in Paris the following year. In 1802 he visited Italy, and in 1803 he made a tour to Liverpool, the Lakes, Loch Lomond and Edinburgh. In 1804 he went to Paris from Southampton, returning by way of the Isle of Wight, which he had previously visited in 1799. In August 1805 he went to Dublin and Leillip, returning by Liverpool, and in 1807 he was in the West Country and Cornwall where he went down a tin mine. In 1810 he revisited North Wales, and in 1811 he was at Stonehouse. He was in France and Italy again in 1816. He also produced Indian subjects, presumably worked up from the sketches of others.

There were sales of his collection and library at Christie's, June 27, 1822 and February 26-28, 1823, on the last day of which his own remaining works were sold.

Examples: B.M.
Bibliography: see V.A.M. MSS. P.S. Munn: *Letter to J.H.*, 1803. J.H. Barnes: *The Artistic Life of J.S.H.*, 1922.

HEAD, Major Charles Franklin — 1850
Commissioned in 1811, he was promoted captain in 1825 and major in 1833 six years later. He served with the Queen's Royal Regiment in Egypt where he produced good brown wash drawings in the Roberts manner. His *Eastern Scenery* had a serious purpose. It was to 'shew the advantage and practicality of steam navigation from England to India'.

Published: *Eastern Scenery and Ruins etc.*, 1833. *Defence of British India from Russian invasion*, 1839.

HEAD, Guy 1753 (Carlisle) — 1800 (London)
A pupil of J.B. Gilpin (q.v.), he studied at the R.A. Schools and first exhibited at the R.A. in 1799. He went to Italy in about 1782 and based himself on Rome, working as a copyist. In 1798 he returned to England with a large collection of drawings and copies, but died before he could put them on exhibition. He was a friend and protégé of Lord Nelson.

HEADLEY, Lorenzo Headley 1860 (Harborne) —
A landscape and flower painter who was educated and lived in Birmingham and at Stoke Prior, Shropshire. He exhibited in Birmingham and London from 1888, and he visited the Channel Islands.

HEALD, H **Benjamin** 1819 (Nottingham) — 1888 (Nottingham)
A Nottingham lace designer and watercolour painter. Later in life he was connected with Heald and Naylor, Nottingham engravers.

Examples: Castle Mus., Nottingham; Mechanics Institute, Nottingham.

HEAPHY, Thomas 1775 (London) — 1835 (London)
A descendent of Huguenot silk-weavers and noble bastards, he was apprenticed to a dyer but soon transferred to R.M. Meadows the engraver. He spent his evenings at an art school in Finsbury, run by one Simpson, and at another, run by J. Boyne (q.v.) near Queen Square. His earliest exhibited works are portraits, but, to earn more money, he also copied popular prints. At the end of his apprenticeship he became a student at the R.A., but did not take kindly to academic teaching. In 1803 he was appointed portrait painter to the Princess of Wales and in 1806 elected A.O.W.S. He resigned from the Society in 1812. By this time he had largely turned from portraits to subject paintings, and it was with these that he attained his greatest popularity. However, he went to Spain in order to take portraits of the chief officers in the British Army during the Peninsular War. The chalk studies for these are strong and well characterised. Later, he almost abandoned painting for some years and became a property speculator in St. John's Wood. He was among the founders of the S.B.A. and its first President in 1823. He was in Italy in 1831 and 1832.
His early genre scenes were praised for their high finish and the brilliancy and harmony of their colour. On his return to painting he discovered that he had lost much of his former facility.
For his daughter, see Murray, Elizabeth, Mrs.

Examples: B.M.; V.A.M.; Ashmolean; N.G., Scotland.
Bibliography: *Antique Collector*, April 1958.

HEAPHY, Thomas 'Frank' 1813 (London) — 1873 (London)
A portraitist who also painted genre scenes in oil. His portraits can be very close to those of G. Richmond (q.v.). He spent many years trying to establish the traditional likeness of Christ. He was in Italy with his father in 1831 and 1832, and first exhibited at the R.A. in 1831. His researches, as well as commissions, led to much Continental travel, his last visit to Rome being in 1860. His middle name of 'Frank' was adopted to distinguish his work from that of his father, but was abandoned before 1850.
His brother, CHARLES HEAPHY (1821 — 1881), worked as a draughtsman, surveyor and administrator in New Zealand.

Examples: B.M.
Bibliography: *A.J.*, Oct. 1873. O.W.S. Club, XXVI, 1948.

HEARNE, Thomas, F.S.A.
1744 (Brinkworth, nr. Malmesbury) — 1817 (London)
A topographical artist who was apprenticed to W. Woollett (q.v.), the engraver. In 1771 he went to the Leeward Islands with the Govenor-General Sir Ralph Payne, and stayed there for three-and-a-half years. He occasionally made drawings of West Indian subjects after his return, but his Continental scenes appear to be after sketches by other people. His most important work was in conjunction with the engraver William Burne, with whom he produced *The Antiquities of Great Britain* between 1777 and 1781, and many of the plates for *Britannia Depicta* between 1806 and 1818.
His early works show the influence of P. Sandby (q.v.) and, in his turn, through Dr. Munro, who owned many of his drawings, he influenced the early style of Girtin and Turner. He is one of the most successful, and can be one of the most charming, of the eighteenth century topographers. His drawings are frequently in grey wash, and when he uses colour it is never very strong. Often it is merely a warm base of orange or pale coffee. He is very good at suggesting the texture of his surfaces with slight touches. Although he used pencil for his basic outline — and occasionally drew in pencil only — in his finished works he goes over these outlines with the brush.

Published: *The Works of T.H.*, 1810.
Examples: B.M.; V.A.M.; Aberdeen A.G.; Ashmolean; Cecil Higgins A.G., Bedford; Coventry A.G.; Bowes Mus., Durham; Fitzwilliam; Greenwich; Leeds City A.G.; Leicestershire A.G.; City A.G., Manchester; Newport A.G.; Portsmouth City Mus.; N.G., Scotland; Ulster Mus.
Bibliography: *A.J.*, 1907.

HEARSEY, Major Hyder Young 1782 (India) — 1840 (Kareli)
A topographer who accompanied Webb to the source of the Ganges in 1808 and Moorcroft to Tibet in 1812. His work is accurate but rather crude and flat in execution. His career in various armies, including two periods when he was virtually an independent raja, was a most romantic one. He was a son-in-law of the Emperor Akbar Shah.

Examples: India Office Lib.
Bibliography: H.W. Pearse: *The Hearseys: five generations of an Anglo-Indian family*, 1905.

HEATH, Charles 1785 — 1848 (London)
An engraver and illustrator, he was the illegitimate son and the pupil of the engraver James Heath. For a time he was a member of the S.B.A., and later he was best known as the promoter of the Annuals. His own work is colourful and in the manner of R. Corbould (q.v.). There are examples of the work of JAMES HEATH (1757-1834), who was an occasional watercolourist, in Newport A.G.

Examples: B.M.; Castle Mus., Nottingham.

HEATH, William 1795 — 1840 (Hampstead)
A portrait, genre and military painter and an engraver. He provided illustrations for Jenks's *The Military Achievements of Great Britain and her Allies*, and E. Orme's *Historical, Military and Naval Anecdotes*. His work is in the tradition of R. Westall (q.v.), and his figures are drawn with a splendid exaggeration of emotion.

Published: *Life of a Soldier*, 1823. *A collection of Prints . . . after . . . Paul Potter*.
Illustrated: Sir John Bowring: *Minor Morals*, 1834.
Examples: B.M.; V.A.M.; N.G., Scotland.

HEATHCOTE, John Moyer 1800 1890
He was educated at Eton and St. John's College, Cambridge, and lived at Connington Castle. He was a patron and pupil of de Wint (q.v.), whose manner he weakly imitated. His sons JOHN MOYER HEATHCOTE, YR. (1834 — 1912) and CHARLES GILBERT HEATHCOTE (b. 1841) worked in the same manner.

Examples: B.M.

HEATHER, F T
A still-life painter working in the 1870s.

HEATON, E
A portrait painter working in about 1836. He also copied old masters in watercolour.

Examples: V.A.M.

HEITLAND, Ivy 1875 – 1895
A designer who was the daughter and pupil of H.E. Heitland, an artist. She painted from the age of six and later took lessons from Sir J.D. Linton (q.v.). She painted landscapes and illustrations.

Examples: V.A.M.

HEMSLEY, William 1819 (London) –
An architect who became a self-taught genre and view painter. He visited Germany and Holland, exhibited from 1848, and became Vice-President of the R.B.A.

Examples: Ashmolean.

HEMY, Bernard Benedict c.1855 (Newcastle) – 1913
The younger brother of C.N. and T.M.M. Henry (q.v.), he lived at North Shields until 1898 and thereafter at South Shields. He was primarily a marine painter.

Examples: Bootle; Gray A.G., Hartlepool.

HEMY, Charles Napier, R.A., R.W.S.
1841 (Newcastle) – 1917 (Falmouth)
The eldest son of a composer, he studied under W.B. Scott (q.v.). In 1852 the family moved to Australia where he worked briefly as a gold miner. On his return to England in the mid-1850s he entered Ushaw College, Co. Durham, intending to become a priest. After a period working as an apprentice on a collier, he did in fact become a monk, serving for three years in monasteries in Newcastle and Lyons. He left before final vows and took up painting professionally, studying in Antwerp. In 1870 he settled in London, moving to Falmouth some twelve years later. He was elected A.R.W.S. and R.W.S. in 1890 and 1897, A.R.A. and R.A. in 1898 and 1910.

He put all his practical experience into his marine painting, and while his style became broader and more impressionist in the latter part of his career, he never lost his accuracy of detail or his feeling for the wind and sea.

Examples: B.M.; Grundy A.G., Blackpool; Dudley A.G.; Greenwich; City A.G., Manchester; Laing A.G., Newcastle.
Bibliography: A.J., 1881.

HEMY, Thomas Marie Madawaska
1852 (at sea) – 1937 (St. Helens, Isle of Wight)
The younger brother of C.N. Hemy (q.v.), he was born aboard the 'Marie Madawaska' off the Brazilian coast on the way to Australia. On his parents' return to England he was educated at Newcastle and spent much of his youth at sea. At the age of twenty-one he attended the Newcastle Art School under W. Cosens Way, and then studied in Antwerp for two years. He worked as a marine painter in Sunderland, later moving to London.

Published: Deep Sea Days, 1926.

HENDERSON, Charles Cooper
1803 (Chertsey) – 1877 (Lower Halliford-on-Thames)
The second son of J. Henderson (q.v.) and a pupil of S. Prout, he was educated at Winchester, and he read for the Bar, but never practised as a lawyer, becoming a prolific sporting and coaching painter. He visited Italy in his youth and etched some landscapes.

He was a skilful painter of horses, and his drawing is generally good. His colours are usually rather thin.

Examples: B.M.; V.A.M.

HENDERSON, John 1764 – 1843
A neighbour of Dr. Monro in Adelphi Terrace, he also allowed young artists, including Girtin and Turner, to copy older masters at his house. Later he collected works by de Wint, Cattermole and others and his collection was left to the nation. He was himself an amateur draughtsman, often working in grey or blue monochrome and the usual 'Monro school' format.

His elder son, JOHN HENDERSON, YR. (1797 - 1878), was also a notable collector, patron and amateur artist.

Examples: B.M.; Fitzwilliam.

HENDERSON, Joseph, R.S.W.
1832 (Stanley, Perthshire) – 1908 (Ballantrae, Ayrshire)
A landscape, portrait, genre and coastal painter who studied at the Trustees' Academy from 1849 to 1853. He then settled in Glasgow, where he was influenced by McTaggart. He exhibited in London from 1871 to 1892. His work was mainly in oil.

HENNING, Archibald Samuel
A painter of literary subjects and portraits who was active between 1825 and 1835. An Archibald Henning was making medical and natural history drawings for illustrations in the 1850s.

Examples: B.M.

HENRY, George, R.A., R.S.A., R.S.W.
1858 (Ayrshire) – 1943
Together with James Guthrie and E.A. Hornel he was a founder of the Glasgow School. He studied at the Glasgow School of Art and later worked with Crawhall, Walton and Guthrie at Brig o' Turk, Roseneath and Eyemouth. He shared a studio with Hornel and they visited Japan in 1892. He was elected A.R.S.A. and R.S.A. in 1892 and 1902, and A.R.A. and R.A. in 1907 and 1920.

Examples: Glasgow A.G.

HENRY, James Levin 1855 (London) –
A London landscape painter who was educated at University College School and exhibited at the R.A., R.I. and elsewhere from 1877.

HENRY, William see HAINES, William Henry

HENSHALL, John Henry, R.W.S.
1856 (Manchester) – 1928 (Pinner)
A genre and history painter in watercolour and oil. He studied at South Kensington and the R.A. Schools and exhibited from 1879, winning several international medals. He was elected A.R.W.S. in 1883 and R.W.S. in 1897. He lived in Pinner and Bosham, Sussex. His work is often on a very large scale.

Examples: V.A.M.; Cardiff.

HENSHAW, Frederick Henry 1807 (Birmingham) – 1891
He was articled to J.V. Barber (q.v.) at the age of fourteen. In 1826 he became a member of the Birmingham Society of Artists and in the same year he went to London and studied the works of the major English landscape painters, especially Turner. In 1837 he visited the Continent, where he remained for three years, sketching in France, Germany, Switzerland and Italy. In 1841 he returned to Birmingham, where he remained for the rest of his life, making annual sketching tours.

He painted mainly landscapes and occasional portraits and genre scenes in oil and watercolour; he exhibited in London and Birmingham from 1829 to 1864.

A loan exhibition of his works was held at Birmingham City A.G. in 1886.

Examples: Birmingham City A.G.

HENTON, George Moore c. 1859 – 1924
A Leicester painter who worked at Eton and in Scotland as well as in his own county. He exhibited church interiors and landscapes at the R.I. from 1884.

Examples: Leicestershire A.G.

HERALD, James Watterson 1859 (Forfar) – 1914 (Arbroath)
A landscape, figure and, above all, harbour painter, who was strongly influenced by A. Melville (q.v.). He studied at Dundee and Edinburgh and under Herkomer, and lived in Croydon and London until 1901, when he returned north to Arbroath. His style is close to Melville and the Glasgow School as is his preoccupation with light and form. Some of his best works are impressions of the harbour and fishing boats at Arbroath.

Examples: B.M.; V.A.M.; Dundee City A.G.; Glasgow A.G.; Greenock A.G.; Paisley A.G.

HERBERT, Alfred c. 1820 (Southend) – 1861 (Southend)
The son of a Thames waterman, who apprenticed him to a boat builder. He exhibited coastal and fishing scenes and Thames views at the S.B.A. from 1844 and the R.A. from 1847 to 1860.

His style is unoriginal, and he won little popularity during his lifetime.

Examples: V.A.M.; Blackburn A.G.; Grundy A.G., Blackpool; Beecroft A.G., Southend.

HERBERT, Arthur John 1834 – 1856 (Muriac, Auvergne)
The son and pupil of J.R. Herbert (q.v.), he also studied at the R.A. Schools. He exhibited historical genre subjects at the R.A. in 1855 and 1856, but died of fever before he could make his name.

Examples: V.A.M.

HERBERT, John Rogers, R.A.
 1810 (Maldon, Essex) – 1890 (Kilburn)
He studied at the R.A. Schools from 1826 and became one of the first masters at the Government School of Design at Somerset House. He exhibited from 1830 to 1889 and was elected A.R.A. and R.A. in 1841 and 1846, retiring in 1886. He was also an Hon. R.I. He began as a portrait and romantic painter, later producing Italian views and still later – after conversion to Roman Catholicism – religious subjects.

His son CYRIL WISEMAN ROGERS HERBERT (1847 – 1882) travelled and drew in Iraq and was appointed curator of the Antique School at the R.A. just before his death.

Examples: B.M.; V.A.M.

HERDMAN, Robert, R.S.A., R.S.W.
 1829 (Rattray, Perthshire) – 1888 (Edinburgh)
The youngest son of the Minister of Rattray, he went to St. Andrews University, sometimes giving drawing lessons in the vacations. In 1847 he entered the Trustees' Academy, where he gained awards for both drawing and painting. During 1855 and 1856 he spent nearly a year in Italy, which he revisited in 1868 and 1869. He began to exhibit at the R.S.A. in 1850 and at the R.A. in 1861. He was elected A.R.S.A. and R.S.A. in 1858 and 1863.

He had a flourishing practice as a portrait painter, as well as painting literary and historical subjects. His landscapes and flower paintings are for the most part in watercolour. He made a large collection of artists' portraits which is now in Aberdeen A.G.

Illustrated: T. Roscoe: *Legends of Venice*, 1841.

HERDMAN, William Gawin 1805 (Liverpool) – 1882 (Liverpool)
An art master at Liverpool, he exhibited at the R.A. and Suffolk Street from 1834 to 1861. He was an active member of the Liverpool Academy until about 1857, when he broke with them in protest again Pre-Raphaelitism, and founded his own Academy.

His works are primarily of local topography and sometimes show a not unpleasing naivety in the handling.

His sons WILLIAM HERDMAN, W. PATRICK HERDMAN and J. INNES HERDMAN all became artists. There was also STANLEY HERDMAN, who seems to have been a relative.

Published: *Views of Fleetwood-on-Wye*, 1838. *Studies from the Folio of W.H.*, 1838.

Examples: Birkenhead A.G.; Bootle; Liverpool Lib.; Stalybridge A.G.

Bibliography: Trans Lancs. & Chesh. Hist. Soc. 63, 1912.

HERING, George Edwards 1805 (London) – 1879 (London)
The son of a London bookbinder of noble German extraction, he was sent to study in Munich in 1829, after working for some time in a bank. Subsequently he spent two years in Venice and travelled throughout Italy and to Turkey, before returning to Rome. He then journeyed through Hungary and Transylvania. After seven years abroad he settled in London, returning to Italy to sketch. In 1858 he was in Northern Italy with F.J. Wyburd (q.v.). He exhibited at the R.A. from 1836.

He specialised in paintings of Danube scenery and very occasionally took English and Scottish views.

His wife exhibited at the R.A. in 1853 and 1858.

Published: *Sketches on the Danube, in Hungary and Transylvania . . .* 1838. *The Mountains and Lakes in Switzerland, the Tyrol, and Italy*, 1847.
Examples: V.A.M.
Bibliography: *A.J.*, 1880.

HERIOT, George 1766 (Haddington, East Lothian) – 1844
Educated at Edinburgh High School and University, he was a cadet at Woolwich while P. Sandby (q.v.) was drawing master there. Later he became a civil servant, and from 1799 to 1816 he was deputy Postmaster General of Canada. He travelled through much of Quebec and Ontario. After his return to England in 1816 he travelled fairly widely on the Continent, visiting Salzburg, Spain, France and the Channel Islands.

His early drawings can be very Sandby-like and are characterised by neat penwork, but later his handling is less sure.

Published: *Travels Through the Canadas*, 1807. *A Picturesque Tour*, 1824.
Examples: B.M.; Ashmolean; Williamson A.G., Birkenhead; Coventry A.G.; Glasgow A.G.; Newport A.G.
Bibliography: J.C.A. Heriot: *Americana*, V, 1910, pp 888-892.

HERKOMER, Sir Hubert von, R.A., R.W.S.
 1849 (Waal, Bavaria) – 1914 (Budleigh Salterton)
The son of a German who settled at Southampton in 1857. He studied at South Kensington from 1866 and began working for the *Graphic* three years later. He was the founder of Bushey School of Art and its Director from 1883 to 1904. From 1885 to 1894 he was also Slade Professor. He was a member of the R.I. from 1873 to 1890 when he moved to the R.W.S. He was elected A.R.A. and R.A. in 1879 and 1890. In 1899 he was ennobled by the German Emperor and added 'von' to his name, and in 1904 he was knighted.

His works include figure, genre and historical subjects, large group portraits and theatre designs. He also composed operas.

Published: *Autobiography*, 1890.
Examples: B.M.; Leeds City A.G.; City A.G. Manchester; Ulster Mus.
Bibliography: W.L. Courtney: *Professor H.H.*, 1892. A.L. Baldry: *H.v.H.*, 1901. J.S. Mills: *Life and Letters of Sir H.H.*, 1923. *A.J.*, 1880.

HERNE, Charles Edward 1848 (Australia) – 1894
A marine painter who taught members of the Royal Family including the Princess Royal. He exhibited from 1884 and also painted Venetian subjects. His name is sometimes given without the final 'e'.

HERRING, E L
A very awful artist who painted coastal scenes and landscapes in the 1880s.

HERRING, John Frederick 1795 (Surrey) – 1865 (Tunbridge Wells)
The son of an American fringe-maker in London, he was in Doncaster in 1814 when the Duke of Hamilton's 'William' won the St. Leger. This is said to have inspired him to take up animal and coach painting. For a while he was also a coach driver working on

the 'Nelson' from Wakefield to Halifax, Doncaster and Lincoln and the 'Highflyer' from London to York. He retired to Doncaster and, after working briefly with A. Cooper (q.v.), made a good living from horse portraiture. In 1830 he moved to Newmarket and later to London and Tunbridge Wells. He was a member of the S.B.A. from 1841.

His drawings of horses and farmyards are usually in muted colours with thick brown ink outlines and shading.

Examples: B.M.; Williamson A.G., Birkenhead; Fitzwilliam; Newport A.G.
Bibliography: Anon: *J.F.H.*, 1870. *A.J.*, Nov. 1865.

HERRING, John Frederick, Yr. 1815 – 1907 (Cambridge)
The eldest son of J.F. Herring, his work is very close to that of his father. He specialised in farmyard scenes using the same quiet colours and brown ink, often heightened with white. His drawing is more crude that his father's and he used an oval signature to distinguish his work. He exhibited at the R.A. from 1863 to 1873. His brothers Charles (d.1856) and Benjamin (d.1871) were also painters.

HEWERDINE, Matthew Bede c.1871 (Hull) – 1909
An artist, cartoonist and book illustrator living in Hull and later Oxford.

Illustrated: Lady Glover: *Lest we forget them,*1900. C. Reade: *Cloister and the Hearth*, 1904.

HEWETT, Sir Prescott Gardiner, 1st Bt.
1812 (Doncaster) – 1891
An eminent surgeon and patron, and an accomplished amateur watercolourist, he was one of the first Honorary Members of the O.W.S. in 1873. He was the surgeon who saved the young Carl Haag's hand, and he later introduced him to his first patron, Lord Penrhyn. He had himself studied painting, as well as surgery, in Paris. He became P.R.C.S. in 1876 and was created a baronet in 1883. On his retirement to Horsham in 1883 he devoted himself to painting.

Examples: V.A.M.

HEWETT, Sarah F
A Leamington painter of rustic genre subjects. She was an unsuccessful candidate for the N.W.S. in 1851 and exhibited in London, Birmingham and Glasgow from 1851 to 1885. In 1878 she was living in Kent. Her work is in the tradition of F.W. Topham (q.v.) or P.F. Poole (q.v.).

Published: *The Peasant Speech of Devon*, 1892. *Nummits and Crummits*, 1900.
Examples: Leamington A.G.

HEWLETT, James 1789 – 1836 (Isleworth)
A flower painter, practising mainly in Bath, whose works are in the ornate Dutch tradition, with accurate botanical drawing. He occasionally painted gipsy, and similar, themes, and exhibited at the R.A. and elsewhere.

Another JAMES HEWLETT, possibly father to the above, was working in a similar manner in Bath at an earlier date. He died in London in 1829. The sister of one married B. Barker (q.v.).

Examples: V.A.M.

HICKEY, Thomas c. 1745 (Dublin) –
After attending the Dublin Academy, he spent some years studying in Rome, returning to Dublin in 1767. He went to London in about 1771 where he exhibited at the R.A. and practised as a portrait painter. He worked for a time in Bath, and visited India, where he may have been the author of *The History of Painting and Sculpture from the Earliest Accounts*, 1788. He was portrait painter to Lord Macartney's expedition to China in 1792.

Whilst in India he made a large series of striking pencil, chalk and wash portraits of soldiers and East India Company officials.

His brother John Hickey (1756 – 1795) was a sculptor.

Examples: B.M.; Stratfield Saye.
Bibliography: *Memoirs of William Hickey*, 1923 – 1925. Sir H.E.A. Cotton: *T.H., Portrait Painter*, 1924.

HICKIN, George Arthur
A still-life and farmyard painter in oil and watercolour who lived in Greenwich and Birmingham. He exhibited in London, Brighton and Birmingham from 1839 to 1881.

Examples: V.A.M.

HICKS, George Elgar1824 (Lymington, Hampshire) – 1914 (London)
A genre and portrait painter in oil and watercolour who had lessons from a marine painter when very young, but was trained as a doctor. He then studied at the Bloomsbury School of Art and the R.A. Schools and exhibited from 1848. His pictures are often of contemporary life and he used mixed media.

Examples: Ulster Mus.
Bibliography: *A.J.*, April, 1872.

HICKS, Lillburne, N.W.S. – 1861
A genre painter who lived in Sloane Square and exhibited from 1830. He was elected N.W.S. in 1836.

HIGHMORE, Anthony 1719 – 1799
The only son of Joseph Highmore the artist. He lived the greater part of his life in Canterbury, where he studied theology. He drew five views of Hampton Court, which were engraved by J. Tinney.

HIGNETT, George
A landscape painter in oil and watercolour who lived and exhibited in Birmingham from 1879 to 1887.

HILES, Frederick John, 'Bartram' 1872 (Bristol) – 1927 (Clifton)
He lost both arms in a road accident during his childhood, and learnt to write and draw holding the pencil and brushes in his mouth. He studied at the Bristol School of Art and won a Scholarship to South Kensington. He exhibited at the R.B.A. in 1893, and later at the R.I. and R.A. His subjects are generally landscapes and shipping subjects around Bristol.

HILL, Arthur c. 1829 (Nottingham) –
A painter of genre and figure subjects in oil and watercolour. He exhibited at the R.A. and Suffolk Street between 1858 and 1893. An ARTHUR HILL, A.R.I.B.A., published a number of illustrated works on Irish architecture in the 1870s.

HILL, David Octavius, R.S.A. 1802 (Perth) – 1870 (Edinburgh)
A landscape painter and photographer, he studied in Edinburgh. He was one of the first A.R.S.A.s in 1826 and, after a contretemps, was elected R.S.A. in 1829. He was Secretary from 1830 to 1869. from about 1843 he concentrated on photography.

Examples: Williamson A.G., Birkenhead; N.G., Scotland.
Bibliography: *A.J.*, 1850; 1869; 1870.

HILL, 'Jockey' (Warwickshire) – c.1827 (London)
He moved from Derby to London before 1800 where he took a post as a dealer in government stores. He painted in subdued washes and some of his works were engraved. His nickname was due to his love of riding, and he was also a horse-dealer. He died at an advanced age.

He may be identifiable with Thomas Hill who exhibited views of Derbyshire at the R.A. in around 1820.

Examples: Derby A.G.

HILLS, Robert, O.W.S. 1769 (Islington) – 1844 (London)
A founder member of the O.W.S., Hills was best known for his paintings of animals, and in this field he was largely self-taught, working from nature. He was the Society's first Secretary and later served as Treasurer, although he retired during the period of the Oil and Watercolour Society, from 1813 to 1820. In 1815 he made his

only foreign journey, visiting Waterloo a month after the Battle, and touring in Holland and Flanders. He also made many tours in Britain, staying with such patrons as Fawkes of Farnley Hall, Yorkshire.

His earliest watercolours are executed in a limited range of low washes and are outlined in a rather eighteenth century manner. They have a simplicity which is lacking in his work from about 1810 onwards. By this date he is working very much more in the manner of his friends Barret, Cristall and Robson – with whom he often actually collaborated. He employs an almost pointillist technique which at its best is very effective but can become rather muzzy and mechanical. His snow scenes are experimental in that he would leave large areas of his off-white paper totally bare to represent a snow-laden sky, and would vigorously scrape out snowflakes. This can be very effective but, equally, can decline into a mere formula. Throughout his life he made small and free sketches. A development of this practice was to make elaborately finished miniatures from which he would work up his compositions. These he called his 'models' and they can have a greater charm than his finished versions, which can appear overworked.

His sketches often bear shorthand notes both on the front and the reverse. Many are also stamped with the initial J.G. in a horizontal oval and come from the sale of his Trustee, John Gaile, F.S.A. at Christie's, April 27, 1874.

Examples: B.M.; V.A.M.; Ashmolean; Blackburn A.G.; Fitzwilliam; Leeds City A.G.; Newport A.G.; Ulster Mus.; Warrington A.G.
Bibliography: *Walker's Quarterly* III, 1923. *Burlington* LXXXVI, February 1945. O.W.S. Club, XXV, 1947. *Connoisseur,* CL, 1962. *Country Life,* July 25, 1968.

HILTON, William, R.A. **1786 (Lincoln) – 1839**
The son of a portrait painter, he studied under J.R. Smith (q.v.) from 1800, with P. de Wint (q.v.) as a fellow pupil. They made sketching tours together, and in 1828 de Wint married his sister. He entered the R.A. Schools in 1806 and was elected A.R.A. and R.A. in 1813 and 1819. He was keeper from 1827. In 1818 he was in Rome with Thomas Phillips, R.A. In 1827 he became Keeper of the R.A. He painted landscapes and battle scenes, but was largely ignored by the patrons and never met with great success.

Examples: B.M.; Fitzwilliam; Newport A.G.; N.G., Scotland.
Bibliography: *A.J.,* Sept. 1885, 1899.

HINDE, Mrs. B **L**
A fruit and flower painter who exhibited with the Society of Female Artists in 1875.

HINE, Harry T **, R.I.**
 1845 (London) – 1941 (Botteslade, Suffolk)
The son of H.G. Hine (q.v.) and husband of V. Hine (q.v.), he was educated at the North London Collegiate and Philological School. He served for a while as a mate in the Merchant Service and later lived in Suffolk. His style is a continuation of that of his father.

Illustrated: C.W.D. Fife: *Square Rigger Days,* 1938.

HINE, Henry George, R.I. **1811 (Brighton) – 1895 (London)**
The son of a coachman, he was self-taught and began by copying the Vicar's Copley Fieldings. He spent some years painting Sussex coastal scenes before being apprenticed to the engraver Henry Meyer in London. Thereafter he spent two years in Rouen and in 1841 became a wood engraver for Landells. From 1841 to 1844 he drew for *Punch* and afterwards for rival publications. He had begun to exhibit landscapes in 1830 and in 1863 was elected A.N.W.S. He became a full Member the following year and was Vice-President from 1888 to 1895. From 1840 he lived mostly in London.

His style remained based upon Fielding and his subjects, chiefly in Sussex. He was also a friend of T. Collier (q.v.), whose influence can be seen in his work.

Illustrated: H. Mayhew: *Change for a shilling* 1848.
Examples: B.M.; V.A.M.; Williamson A.G., Birkenhead; Towner Gall., Eastbourne; Fitzwilliam; Hitchin Mus.; Hove Lib.; Leeds City A.G.;

Leicestershire A.G.; Maidstone Mus.; City A.G., Manchester; Beecroft A.G., Southend; Sydney A.G.

HINE, Victoria Susanna, Mrs., née Colkett
The daughter of S.D. Colkett (q.v.) and wife of H.T. Hine (q.v.), she painted views of Oxford and Cambridge Colleges which are very much in the manner of G. Pyne (q.v.).

Examples: Fitzwilliam.

HINE, William Egerton **– 1926 (Haslemere)**
A son of H.G. Hine, he studied in London and Paris. He was Art Master at Harrow from 1892 and exhibited landscapes in oil and watercolour from 1873 to 1920.

HINES, Frederick
A landscape painter in oil and watercolour who lived in London and exhibited at the R.I. and elsewhere from 1875 to 1897. He wrote and illustrated a number of religious books. He may have been working in Essex as early as 1842. His brother Theodore was also an artist.

HIXON, James Thompson, A.N.W.S. **1836** **– 1868 (Capri)**
A painter of North African and Eastern scenes who exhibited from 1856. He died of consumption shortly after his election as A.N.W.S.

HOARE, Prince **1755 (Bath) – 1834 (Brighton)**
The son and pupil of William Hoare, R.A., he was educated at Bath Grammar School. He entered the R.A. Schools in 1772, visited Rome in 1776 and was for a time a pupil of Mengs. He exhibited portraits and historical subjects at the R.A. in 1781 and 1782 and became Hon. Foreign Secretary to the Academy. He was also a dramatic author. His compositions and figures can be reminiscent of those of Fuseli, but his colours tend to be rather messy.

Examples: B.M.; V.A.M.

HOARE, Sir Richard Colt, 2nd Bt., F.R.S., F.S.A.
 1758 (Barn Elms, Surrey) – 1838 (Stourhead)
A patron of the arts and an amateur watercolourist, he was educated at schools run by Devis at Wandsworth, and Dr. Samuel Glasse at Greenford. He worked briefly in the family bank. On the death of his wife in 1785 he began a tour of France, Italy, Switzerland and Spain, returning in July 1787, in which year he succeeded to the baronetcy. From 1788 to 1791 he travelled in Holland, Germany, Bohemia, Austria, Italy and the islands, and in the Tyrol. Later he toured Wales, Monmouth, and Ireland in 1807.

His later years were primarily taken up with antiquarian and archaeological pursuits, and he published numerous books and pamphlets. In the course of his tours he made large numbers of pen and sepia wash drawings.

His younger half-brother, PETER RICHARD HOARE (1772-1849), produced a number of drawings of the West Country, which are much in the manner of J.B. Knight (q.v.) although with less detailed outlining.

Examples: B.M.; Nat. Mus., Wales.

HOARE, Sarah **1777** **– 1856**
The daughter of Samuel Hoare and Sarah Gurney. She was a flower painter of merit and probably studied under W. Henry Hunt (q.v.).

Published: *The Pleasures of Botanical Pursuits,* 1823. *Poems on Conchology and Botany,* 1831.

HOBDAY, William Armfield **1771 (Birmingham) – 1831 (London)**
A portrait painter in watercolour and miniature who was apprenticed to an engraver and studied at the R.A. Schools. He exhibited at the R.A. from 1794 and lived in Bristol from 1804 to 1817 when he returned to London. In 1829 he became bankrupt through a gallery speculation.

Examples: B.M.; Leicestershire A.G.

HOBDEN, Frank
A genre painter who lived in Islington from 1882 to 1892, Chiswick until 1906, and South Benfleet, Essex, until 1915. He was a member of the R.B.A.

HOBSON, Alice Mary, R.I. 1860
A peripatetic landscape painter who lived at various times in Leicester, Bedford, London, Doncaster, Midhurst, Chichester and Marazion. She was elected R.I. in 1888 and resigned in 1931.

HOBSON, Cecil James, R.I. 1874 – 1915
A landscape painter and illustrator who was elected R.I. in 1901.

HOBSON, Henry E
The son of HENRY HOBSON a Bath engraver, watercolourist and musician, and an artist mother, he married the daughter of J. Hardy (q.v.). He exhibited genre and rustic subjects from 1857 to 1866.

Examples: V.A.M.; Wakefield A.G.

HODGE, Ann
A figure and landscape painter who was working in the 1840s.

HODGES, Walter Parry
A sporting artist working in the 1830s. He signed with initials.

HODGES, William, R.A.
 1744 (London) – 1797 (Brixham, Devonshire)
He picked up the rudiments of drawing whilst employed as an errand boy at Shipley's. He became a pupil of Richard Wilson and later worked in London and Derby, partly as a scene painter. He exhibited at the S.A. from 1766. In 1772 he was appointed draughtsman to Captain Cook's second voyage to the South Seas, returning in 1775, when he superintended the engraving of his drawings for the official account. In 1778 he left for India, where he remained until 1783, travelling extensively and even visiting Nepal. In 1784 he settled in London, and was elected A.R.A. in 1786 and R.A. in 1789. In about 1790 he travelled widely on the Continent, visiting St. Petersburg. His landscapes in the Wilson manner and large, allegorical pictures had little appeal and in 1795 he retired to Dartmouth where he unsuccessfully tried to run a bank.

Published: *Select Views in India*, 1786-8.
Examples: B.M.: V.A.M.; Admiralty; India Office Lib.; R.G.S.; Soane Mus.
Bibliography: Sir W. Foster: *W.H. in India*, 1925. *Geographical Magazine* XIX, 1947. *Burlington*, CXV, Oct. 1973.

HODGSON, Charles c. 1770 – 1825
An architectural painter in oil and watercolour. In 1802 he was running a school in Norwich and teaching mathematics. Drawing and painting were at first his hobby, but they gradually took precedence. He visited North Wales in 1805. He became maths master at the Norwich Free School, but also had a reputation as a private drawing master and helped to found the Norwich Society in 1803. He was President in 1813 and in 1825 was appointed Architectural Draughtsman to the Duke of Sussex. He appears to have died in the same year.
His views are generally in Norwich, but he also exhibited copies of Swiss landscapes.

Examples: Castle Mus., Norwich.
Bibliography: W.F. Dickes: *The Norwich School*, 1905.

HODGSON, David 1798 (Norwich) – 1864 (Norwich)
A pupil of J. Crome (q.v.) and his father C. Hodgson (q.v.) whom he accompanied on sketching tours. He built up a teaching practice and became drawing master at Norwich Grammar School. He exhibited not only at Norwich from 1813 to 1833 but also at Liverpool, Manchester and Newcastle.
His subjects, both in oil and watercolour, are generally old houses and lively street scenes in Norwich and Norfolk.

Examples: Castle Mus., Norwich.
Bibliography: W.F. Dickes: *The Norwich School*, 1905.

HODGSON, Edward 1719 (Dublin) – 1794 (London)
An Irish drawing master who practised in London and exhibited with the Free Society from 1763 to 1783 and at the R.A. in 1781, 1782 and 1788. He became Treasurer of the A.A. of Great Britain.
He painted fruit and flower pieces and occasionally made academic drawings.
His daughter exhibited flower pieces with the Free Society from 1770 to 1775.

HODGSON, George 1847 – 1921 (Ruddington, Nottingham)
The son of a Nottingham braid-manufacturer, he became a member of the Nottingham Society of Artists. He painted mainly in watercolour.

Examples: Castle Mus., Nottingham.

HODGSON, William J
An illustrator from Gateshead who worked in London from 1878. His style is reminiscent of that of Caldecott. He also painted in Devon, Scotland and on the Yorkshire coast.

Examples: B.M.

HODSON, Edward
A Birmingham landscape and coastal painter in oil and watercolour who exhibited there from 1849 to 1881.

HODSON, Sir George Frederick, 3rd Bt. 1806 – 1888
The second son of Sir Robert Hodson of Hollybrook, Bray, he was in Italy in 1830 and succeeded his brother as third baronet in 1831. He exhibited landscapes and figure subjects at the R.H.A. from 1827, and in 1871 was made an Honorary Member.

Examples: Ulster Mus.

HODSON, Samuel John, R.W.S. 1836 (London) – 1908
A lithographer and illustrator who studied at Leigh's and the R.A. Schools and exhibited from 1858 to 1906. He worked for the *Graphic* and was a member of the R.B.A. He was elected A.R.W.S. in 1880 and R.W.S. in 1891. He specialised in architectural subjects and romantic Continental views.

Illustrated: P. Slater: *History of the Parish of Guiseley*, 1880.
Examples: B.M.; Haworth A.G., Accrington.

HOFLAND, Thomas Christopher
 1777 (Worksop, Nottinghamshire) – 1843 (Leamington)
The son of a wealthy manufacturer of cotton-mill machinery, he painted occasional landscapes until the family moved to London in 1790, and, being reduced to poverty, Hofland made painting his profession. He studied briefly under J. Rathbone and exhibited at the R.A. between 1799 and 1805. At this time the King employed him in making botanical drawings. From 1805 to 1808 he taught at Derby. He lived briefly in Doncaster and Knaresborough before returning to London in 1811, where he continued to teach and exhibited at the S.B.A., of which he was a founder member, the B.I. and the R.A. He held a one-man exhibition in New Bond Street in 1821. In 1840 he spent nine months in Italy, making sketches which he later worked up for his patron, Lord Egremont.
His son, T.R. Hofland, is separately noticed.

Published: *The British Angler's Manual*, 1839.
Illustrated: B. Hoole: *A descriptive account ... of White Knights*, 1819. E. Rhodes: *Yorkshire Scenery*, 1826.
Examples: V.A.M.

HOFLAND, Thomas Richard 1816 – 1876 (Durham)
The son of T.C. Hofland (q.v.), he was permanently ill, and lame, from youth. He was a drawing master and landscape painter, and he travelled in America and elsewhere.

Bibliography: *A.J.*, 1876.

HOLDING, Henry James G H c. 1833 – 1872 (Paris)
A painter of Tudor scenes and landscapes in oil and watercolour

who lived and worked in Manchester. In the Manchester City Art Gallery there is a Shakespearian scene by his brother FREDERICK HOLDING (1817-1874) who also illustrated Southey's *Battle of Blenheim*, 1864.

Examples: Williamson A.G., Birkenhead.
Bibliography: *A.J.,* Oct. 1872.

HOLIDAY, Henry James 1839 (London) – 1927 (London)
An illustrator, historical genre painter, sculptor and stained glass designer. He studied at Leigh's School and the R.A. Schools and worked with Burne-Jones before starting his own glass works in 1890 in Hampstead. He exhibited from 1858 and his early work shows a strong Pre-Raphaelite influence.

Published: *Reminiscences*, 1914.
Illustrated: L. Carroll: *The Hunting of the Snark*.
Examples: B.M.

HOLL, Francis Montague 'Frank', R.A., A.R.W.S.
1845 (London) – 1888 (London)
The son of Francis Holl, A.R.A., the engraver, he was mainly a portrait painter in oil, but also made chalk drawings and occasional watercolours. He entered the R.A. Schools in 1861 and gained two silver medals for drawings and a gold medal for an historical painting. He exhibited at the R.A. from 1864 until his death. In 1866 he visited Bettws-y-Coed where he met and later married Annie Laura, daughter of C. Davidson (q.v.). He worked for the *Graphic* from 1874 to 1876, and was elected A.R.A. in 1878, after which time he became inundated with commissions for portraits. He was elected A.R.W.S. and R.A. in 1883.

Illustrated: A. Trollope: *Phineas Redux*, 1874.
Examples: B.M.; N.G., Scotland.
Bibliography: A.M. Reynolds: *Life and Work of F.H.*, 1912. *A.J.,* 1876, 1889.

HOLLAND, James, O.W.S.
1800 (Burslem, Staffordshire) – 1870 (London)
His family were designers and painters of pottery, and his own earliest drawings were flower pieces. He came to London in 1819 and gave drawing lessons while teaching himself mastery of landscape and architecture. In 1831 he paid his first visit to France, and came under the influence of Bonington who had died only two years previously. This influence is very strong in his works during the next decade. In 1835 he was elected A.O.W.S. for the first time and he made his first visit to Venice. In 1837 he went to Portugal, in 1841 he visited Paris, and in 1844 Verona, 1845 Holland, 1850 Normandy and North Wales, 1851 Genoa, and in 1857, Innsbruck. In 1842 he resigned from the O.W.S. in order to attempt to enter the R.A. as an oil painter. The failure of his ambitions led him back to the O.W.S. in 1856 and he became a full Member in 1857.

Early flower pieces attributed to him should be approached with some caution, as many of these comparatively crude drawings are in fact by an elder brother, THOMAS HOLLAND. To modern tastes his best work was produced before 1845, when the influence of Bonington was still comparatively strong, and before he became over-elaborate in his colour. At the time there were two opinions about him; Ruskin refers to his irrevocable fall from a peak of perfection in about 1837. Roget, on the other hand, praises his 'poetry of the palette in the late Venetian drawings'. Amongst the most attractive of his works are the sketches which were never meant for general circulation. Many of them taken at various places on the Kent coast, are mere memoranda for his future use, but their freedom and verve are extremely appealing. His remaining works were sold at Christie's, May 26, 1870.

Illustrated: W.H. Harrison: *The Tourist in Portugal*, 1830.
Examples: B.M.; V.A.M.; Ashmolean; Blackburn A.G.; Greenwich; Newport A.G.; City A.G., Manchester; Reading A.G.; Ulster Mus.
Bibliography: *A.J.,* April, 1870. *Studio,* Special no., 1915. *Walker's Quarterly,* XXIII, 1927. O.W.S. Club, VII, 1930. O.W.S. Club, XLII, 1967.

HOLLAND, John
A Nottingham landscape and coastal painter who exhibited at the B.I. and Suffolk Street between 1831 and 1879. He sometimes worked in charcoal like G. Sheffield (q.v.).

His son, JOHN HOLLAND YR. (1830-1886) painted landscapes in watercolour and, towards the end of his life, portraits in oil. He signed 'jnr'.

SAMUEL HOLLAND (c. 1807, Nottingham – 1887), a Nottingham picture dealer and painter of landscapes and seascapes was probably a brother of John Holland, elder.

His son, SAMUEL HOLLAND YR. (c.1835, Nottingham – c. 1895) exhibited at the R.A. and Suffolk Street from 1877 to 1890.

HOLLAND, Sir Nathaniel DANCE-, Bt., R.A.
1735 (London) – 1811 (Cranborough House, nr. Winchester)
The third son of George Dance, the elder, and elder brother of G. Dance, Yr. (q.v.). He attended Merchant Taylor's School, and studied art under Francis Hayman and in Italy. In 1761 he was elected to the Incorporated Society, and he was a Foundation Member of the R.A., exhibiting portraits and historical and classical subjects in oil until 1776. In 1790 he retired from painting as a profession, and, taking the name Holland, entered Parliament as the member for East Grinstead, which seat he held for many years. He was created baronet in 1800, but died without issue.

Like his brother, his work in watercolour and wash consists primarily of spirited caricatures and grotesques.

Examples: B.M.; Towneley Hall, Burnley; Fitzwilliam; N.G., Scotland.

HOLLAND, Peter
A landscape and miniature painter who exhibited from 1781 to 1793. C. Rosenberg aquatinted a set of Lake District views after his drawings in 1792.

HOLLAR, Wenceslaus 1607 (Prague) – 1677 (London)
He came to London from Cologne and Antwerp in 1637 with the Earl of Arundel, for whom he acted as draughtsman. In 1639 or 1640 he was appointed Teacher of Drawing to the Prince of Wales, later Charles II. With the exception of the years 1644 to 1652, when he fled to Holland as a Royalist, and a visit to Tangier in 1669 with Lord Henry Howard, he remained in England for the rest of his life. Many of his most important English engravings were produced during the exile in Amsterdam.

He is one of the most important artists to have worked in England at this period, and he gives us the best idea of the scenery and buildings of the time. He was one of the first people to use watercolour in this country, and although in his drawing he is very much the print-colourer, the use of tinted washes adds a new dimension to the development of the art. He sometimes worked from sketches by native artists such as D. King (q.v.) and T. Johnson (q.v.) and his influence was spread by his friend and disciple, F. Place (q.v.).

His son who, Aubrey says, was 'an ingeniose youth' and 'drew delicately', died of the plague.

Examples: B.M.; J. Rylands Lib., Manchester; N.G., Scotland.
Bibliography: F. Sprinzels: *H. Handzeichnungen*, 1938. J. Urzidel: *H.,* 1942. *Country Life,* April 25, 1928, Sept. 26, 1963. *Burlington,* CVI, Feb., 1964.

HOLLINS, John, A.R.A. 1798 (Birmingham) – 1855 (London)
The son of William Hollins, a Birmingham painter and architect, he showed early enthusiasm for art. He sent portraits to the R.A. in 1819 and 1821. In 1822 he came to London and was in Italy from 1825 to 1827. He returned to London and exhibited at the R.A., being elected Associate in 1842, and at the B.I. As well as portraits he painted historical subjects, and, later, landscapes and figure subjects.

Examples: V.A.M.; Fitzwilliam.

HOLLIS, George 1793 (Oxford) – 1842 (Walworth)
An etcher who was a pupil of George Cooke. He also produced

watercolour studies of monuments, portraits and views of colleges.

Published: with T. Hollis: *The Monumental Effigies of Great Britain*, 1840.
Examples: B.M.; Ashmolean.

HOLLIS, Thomas 1818 – 1843 (Walworth)
The son and collaborator of G. Hollis (q.v.), he studied with H.W. Pickersgill (q.v.) and at the R.A. Schools. His landscapes, often around Dulwich, are a little Constable-like and full of greens and blues.

Examples: B.M.

HOLLOWAY, Charles Edward, R.I.
 1838 (Christchurch, Hampshire) – 1897 (London)
A fellow pupil at Leigh's School with F. Walker (q.v.), Sir J.D. Linton (q.v.) and C. Green (q.v.), Holloway worked with William Morris, producing stained glass, until 1866. After that date he began to exhibit marine subjects and drawings of the Fens and the Thames Valley at the R.A. and elsewhere. He was elected A.N.W.S. in 1875 and a Member in 1879. He visited Venice in 1875 and 1895. His watercolours, especially the sea pieces, are generally impressionistic and show the influence of Whistler in their colouring.

An exhibition of his work was held at the Goupil Gallery, London, in 1897.

Examples: V.A.M.; Cartwright Hall, Bradford; Leeds City A.G.

HOLMES, Sir Charles John, A.R.W.S., F.S.A.
 1868 (Preston) – 1936 (London)
Nephew of Sir R.R. Holmes (q.v.) and a landscape painter in watercolour and oil. He was educated at Eton and Brasenose College, Oxford. From 1903 to 1909 he edited the *Burlington Magazine* and from 1904 to 1910 he was Slade Professor of Fine Art at Oxford. In 1916 he was appointed Director of the National Gallery. He signed his work, either with his full names, or with initials and date.

Published: *Constable*, 1902. *Notes on the Science of Picture Making*, 1909. *The National Gallery*, 1923, 1925.
Examples: B.M.; V.A.M.; Aberdeen A.G.; Blackburn A.G.; Dundee City A.G.; Fitzwilliam; Leeds City A.G.; Leicestershire A.G.; Maidstone Mus.; City A.G., Manchester; Stalybridge A.G.; Ulster Mus.; Wakefield A.G.
Bibliography: *Burlington*, LXXVII, August 1940.

HOLMES, George
An Irish illustrator and landscape draughtsman who studied at the R.D.S. Schools, winning a medal for a landscape in 1789. He worked on the *Sentimental and Masonic Magazine* and the *Copper Plate Magazine* and drew for Ledwich's *Antiquities of Ireland* and Brewer's *Beauties of Ireland*, 1825-1826. In 1797 he toured South West Ireland with J. Harden (q.v.). He came to London in 1799, where he exhibited at the R.A. until 1802. He may be the George Holmes of Plymouth who exhibited English and Irish views at the R.H.A. in 1841 and 1843.

Published: *Sketches of some of the Southern Counties of Ireland collected during a Tour in the autumn, 1797, in a series of Letters*, 1801.
Examples: B.M.; Ashmolean.

HOLMES, James 1777 (Burslem) – 1860
A figure and portrait painter who was apprenticed to Meadows the engraver, but turned to watercolour painting as soon as his articles were out. He was a member of the A.A. from 1809 to 1812 and the Oil and Watercolour Society from 1812 to 1821. In 1824 he was a founder of the S.B.A. G.B. Brummel (q.v.) was an early friend and patron, and Byron wrote that one of his portraits by Holmes was 'the very best of me'. His figure and genre subjects have titles like *The Doubtful Shilling* and *Hot Porridge*. He painted three portraits of George IV of whom he was a favourite – so much so that he was dubbed 'the King's hobby' in Court circles. After 1821 he devoted

himself chiefly to oil painting, and his later years were spent in Shropshire. A number of his drawings were engraved for the Annuals.

Bibliography: A.T. Storey: *J.H. and John Varley*, 1894.

HOLMES, Sir Richard Rivington 1835 – 1911
The son of an assistant keeper of manuscripts at the B.M., he was educated at Highgate, and succeeded his father in 1854. In 1860 he worked with Henry le Strange and T.G. Parry in decorating Ely Cathedral, and he produced stained glass designs. In 1868 he went with the Abyssinian expedition as archaeologist. In 1870 he was appointed Librarian at Windsor.

He worked in a number of media including full watercolour. His Abyssinian landscapes are in brown wash.

Examples: B.M.

HOLMES, R Sheriton
A Newcastle shipping and landscape painter who worked in the 1870s and 1880s.

Examples: Laing A.G., Newcastle.

HOLROYD, Sir Charles 1861 (Leeds) – 1917
An etcher and painter who was educated at Leeds Grammar School and the Yorkshire College of Science. He studied at the Slade, winning a two-year travelling scholarship to Italy, and later becoming Legros's assistant. He exhibited at the R.A. from 1883 and was Director of the N.G. from 1906 to 1916.

Examples: B.M.; V.A.M.; Haworth A.G., Accrington.

HOLST, Theodore M, Von 1810 (London) – 1844 (London)
A genre painter who was the son of a music teacher and of Livonian descent. He studied at the B.M. and at the R.A. Schools under Fuseli, in whose manner he worked. His drawings are generally rather more colourful.

Examples: B.M. V.A.M.

HOLWORTHY, James, O.W.S.
 1781 (Bosworth, Leicestershire) – 1841 (London)
A pupil of J. Glover in the 1790s, Holworthy exhibited three Welsh views at the R.A. in 1803 and 1804. He was at this time living in Mount Street, and he was a founder member of the O.W.S. He retired in 1814 but continued to practise in London until after his marriage to a niece of J. Wright of Derby (q.v.) in 1821. Thereafter he bought a property in Derbyshire where he lived until his death. His subjects are picturesque views in England and Wales, with a bias towards ruined castles, and his style closely modelled on that of his master.

Examples: V.A.M.

HOME, Robert 1752 (Hull) – 1834 (Cawnpore)
A portrait painter and brother of Sir Everard Home, the anatomist. At an early age he voyaged to Newfoundland on board a whaler. He helped his brother-in-law, Dr. John Hunter, with anatomical diagrams, and had lessons from A. Kauffman (q.v.). He exhibited at the R.A. in 1770 and 1771 and was in Rome from 1773 to 1778. He returned to London, and the following year went to Dublin, where for ten years he had a successful practice. He returned to London in 1789 and in 1790 left for India. His sketches of the Mysore war were published as engravings in 1794. In 1795 he went to Calcutta, and in 1802 was appointed Secretary to the Asiatic Society, whose rooms he decorated with portraits. In 1814 he became Court Painter to the King of Oudh. He is said to have made a fortune, chiefly out of military and ceremonial subjects. In 1825 he retired to Cawnpore.

Published: *Select Views in Mysore*, 1794.
Examples: V.A.M.; Asiatic Soc., Calcutta; N.G., Ireland; N.P.G.; N.G., Scotland.
Bibliography: Sir H.E.A. Cotton: *R.H.*, 1928.

HOOD, George Percy JACOMB- 1857 (Redhill, Surrey) – 1929
Illustrator, etcher and portrait painter, he studied at the Slade and under J.P. Laurens in Paris. He exhibited at the R.A. from 1878 and, for most of his career, kept a Chelsea studio. For a time he worked for the *Graphic* and he was on the King's staff during the Delhi Durbar. In his early days he was influenced by the Pre-Raphaelites. He was also a friend of H.S. Tuke and visited the nascent Newlyn School in Cornwall in the 1890s.

Published: *With Brush and Pencil,* 1925.
Examples: Hove Lib.

HOOD, John
A Limehouse shipwright who exhibited stiff and crude Indian ink drawings of shipping from 1762 to 1771.

Examples: B.M.; Greenwich.

HOOK, James Clarke, R.A.
 1819 (Clerkenwell) – 1907 (Churt, Surrey)
A pupil of J. Jackson (q.v.), he entered the R.A. Schools in 1836. Between 1845 and 1848 he travelled in France and Italy on a scholarship. From 1864 to 1867 much of his work was done in Cornwall and the Scilly Islands. He was elected A.R.A. and R.A. in 1850 and 1860, retiring a few months before his death.

Until about 1859 he specialised in genre and historical subjects, thereafter turning to landscapes and coastal scenes. He was noted for his vivid colouring.

Bibliography: A.J. Hook: *Life of J.C.H.,* 1929. *A.J.,* 1888, 1907.

HOOD, Thomas 1799 (London) – 1845 (London)
The poet and humorist. Between 1815 and 1818 he lived in Dundee for the sake of his health. There he sketched and wrote for local newspapers. On his return to London he was apprenticed to his uncle, an engraver, and to Le Keux, before turning to full time writing as a career. His son THOMAS HOOD, YR. was also a humorist and a caricaturist.

In the B.M. are several small and colourful landscapes by Hood, in which the drawing is poor, also a Blake-like figure in a landscape.

Examples: B.M.

HOOK, James Clarke, R.A.
 1819 (Clerkenwell) – 1907 (Churt, Surrey)
A pupil of J. Jackson (q.v.), he entered the R.A. Schools in 1836. Between 1845 and 1848 he travelled in France and Italy on a scholarship. From 1864 to 1867 much of his work was done in Cornwall and the Scilly Islands. He was elected A.R.A. and R.A. in 1850 and 1860, retiring a few months before his death.

Until about 1859 he specialised in genre and historical subjects, thereafter turning to landscapes and coastal scenes. He was noted for his vivid colouring.

Bibliography: *A.J.,* 1888; 1907.

HOOKER, Sir William Jackson, F.R.S.
 1785 (Norwich) – 1865 (Kew)
A botanist and son-in-law of D. Turner (q.v.) with whom he botanised in Scotland in 1806. He visited Iceland in 1809 and France, Switzerland and North Italy in 1814. After his marriage the following year he lived in Suffolk, and in 1820 took the post of Professor of Botany at Glasgow University. In 1841 he was appointed Director of Kew Gardens. He was elected to the Linnean Society in 1806 and the Royal Society in 1812.

Until 1835 he himself drew the majority of the illustrations for his books – after this date they were executed by W. Fitch (q.v.).

Published: *Musci Exotici,* 1818-1820. *Flora Scotica,* 1821. *Exotic Flora,* 1823-1827. *Catalogue of the Plants in the Glasgow Botanical Garden,* 1825. *British Flora,* 1830-1831. *The Journal of Botany,* 1834-1842. *Companion to the Botanical Magazine,* 1835-1836. *Guide to Kew Gardens,* 1847-1865.

HOPKINS, Arthur, R.W.S. 1848 – 1930 (London)
A brother of Gerard Manley Hopkins the poet – himself a fine draughtsman – and of Edward Hopkins, a black and white illustrator. He was educated at Lancing College and for twenty-five years he worked for the *Graphic* and for *Punch.* He also painted country genre scenes in the manner of H. Allingham (q.v.) and strong landscapes and coastal views which are very effective in their clear colours and discipline of detail.

Published: *Sketches and Skits,* 1900.
Examples: B.M.; Ashmolean; Exeter Mus.
Bibliography: *A.J.,* 1899.

HOPKINSON, Anne E
A flower painter who was awarded a gold medal by the Society of Female Artists in 1879. She exhibited at the S.B.A. from 1877 to 1884.

HOPLEY, Edward William John
A painter of literary and genre subjects who lived in Islington. He was an unsuccessful candidate for the N.W.S. in 1844 and exhibited at Suffolk Street from that year until 1851.

HOPPNER, John, R.A. 1758 (London) – 1810 (London)
The portrait painter. Like his friend Dr. Monro (q.v.) he produced a number of Gainsborough-like chalk drawings, usually on bluish paper. He also made similar drawings in brown wash. He was elected A.R.A. and R.A. in 1793 and 1795.

Examples: B.M.; V.A.M.
Bibliography: H.P.K. Skipton: *J.H.,* 1905.

HOPWOOD, Henry Silkstone, R.W.S.
 1860 (Markfield, Leicestershire) – 1914 (Edinburgh)
A genre and landscape painter in oil and watercolour who was a Manchester and Belfast businessman before studying in Manchester, Antwerp and Paris. He visited North Africa, and Australia and Japan between 1888 and 1890. He exhibited from 1884 and was elected A.R.W.S. and R.W.S. in 1896 and 1908. Many of his landscapes are of the area around Montreuil.

Examples: V.A.M.; Leicestershire A.G.
Bibliography: *Connoisseur,* XL, 1914.

HORNBROOK, Captain A.
A Plymouth marine painter who visited Spain in 1837. He was presumbly related to T.L. Hornbrook (1780-1850), also of Plymouth, who was Marine Painter to the Duchess of Kent and Queen Victoria.

HORNE, Herbert Percy 1864
A landscape painter who visited Italy with F.G. Shields in 1889. He wrote a number of biographies of Italian painters and was a collector of the works of A. Cozens (q.v.)

Examples: B.M.; Birmingham City A.G.

HORNER, Thomas (Hull) –
A topographer who was working between 1800 and 1844 and was in South Wales from 1816 to 1820. He also painted rather Grimm-like Swiss views, perhaps copied from prints. He was the proprietor of the Regents Park Colosseum and employed E.T. Parris (q.v.) and G. Chambers (q.v.) on a huge Panorama from the top of St. Pauls. This enterprise broke him.

Examples: B.M.; Cardiff Co. Record Office; Swansea Lib.; Nat. Lib., Wales; Nat. Mus., Wales.

HORNSEY, J
A topographer and cattle painter who worked in Yorkshire for the *Copper Plate Magazine* between 1795 and 1800. His cows, in slightly tinted grey wash, are unusually lifelike.

Examples: B.M.

HORTON, George 1859 (North Shields) – 1950
A self-taught artist who specialised in Dutch townscapes. He was particularly fond of sketching in Rotterdam and Dordrecht. He

exhibited in France and Holland as well as at the R.A. He moved to London in 1918.

Examples: Shipley A.G., Gateshead; Laing A.G., Newcastle.

HORTON, Wartley
An animal and rustic painter who was active at the end of the nineteenth century. In mood he is akin to M.B. Foster (q.v.) and H. Allingham (q.v.) although in subject matter he is closer to E. Alexander (q.v.). His Christian name may be a catalogue mistake for Westley. There was a landscape painter of this name working in Birmingham in 1874 and 1875.

HOTHAM, Hon. Amelia, Mrs. Woodcock – 1812
The daughter of the 2nd Lord Hotham, she married J. Woodcock in 1798. She painted landscapes.

Examples: B.M.

HOTHAM, Sir Charles
 1800 (Dennington, Suffolk) – 1855 (Melbourne, Australia)
A naval commander, colonial governor and a pupil of T.S. Cooper (q.v.). He entered the Navy in 1818 and was promoted lieutenant, commander and captain in 1825, 1828 and 1833. In 1845 he took part in the Para expedition and was the hero of the first Battle of the River Plate. He was knighted the following year. He was appointed Lieutenant-Governor of Victoria in 1854 and Governor in 1855.

By her previous and subsequent marriages, his wife, Hon. Jane Sarah Hook, was connected to the family of Oldfield Bowles.
See Family Tree.

HOUGH, William B
An imitator of W.Henry Hunt (q.v.) painting meticulous still-lifes of fruit, flowers and birds. He exhibited at the N.W.S. and elsewhere from 1857 to 1894, and also painted competent and attractive landscapes. He lived in Coventry and London.

Examples: V.A.M.; Glasgow A.G.; Newport A.G.

HOUGHTON, Arthur Boyd, A.O.W.S.1836 – 1875 (London)
He was a pupil at Leigh's Art School. Early in his career he concentrated on providing illustrations for periodicals, such as the *Graphic,* for whom he visited India and America, and books such as Dalziel's edition of the *Arabian Nights,* 1865. After returning with his father from India he attempted oil painting and wood engraving – in which he was hampered by the loss of an eye. He turned to watercolours and was elected A.O.W.S. in 1871, exhibiting with them in 1871, 1872 and 1874.

He is best known as an illustrator of the Walker/Pinwell group. His colours are rich and powerful, and his black and white effects striking. Many of his subjects are Oriental in inspiration. His remaining works were sold at Christie's, March 17, 1876.

Examples: B.M.; V.A.M.; Cecil Higgins A.G., Bedford.
Bibliography: L. Housman: *A.B.H.: Selection of Work,* 1896. *A.J.,* 1876.

HOUGHTON, Georgiana
An exhibition of her 'Spirit Drawings in Watercolour' was held at the New British Gallery, London, on May 22, 1871. These were done under the guidance of her sister Zilla (d. 1851) who had been 'an accomplished artist while upon earth'; her brother Cecil Angelo; Henry Lenny who had been a deaf and dumb artist; and other spirits including those of H.R.H. the late Prince Albert (q.v.), W. Blake (q.v.) and W. Shakespeare.

Published: *Evenings at Home in Spiritual Seance,* 1881. *Chronicles of the Photographs of Spiritual Beings,* 1882.

HOUSTON, George, R.S.A., R.I., R.S.W.
 1869 (Dalry, Ayrshire) –
A painter of Ayrshire and Argyllshire landscapes. He lived in Glasgow and was elected R.S.W. in 1908, A.R.S.A. in 1909, R.I. in 1920 and R.S.A. in 1924.

Examples: Glasgow A.G.

HOUSTON, John Adam P , R.S.A., R.I.
 1802 (Gwydyr Castle, Wales) – 1884 (London)
A landscape painter who studied in Edinburgh, Paris and Germany and settled in London in 1858. He exhibited at the R.S.A. from 1833 and was elected A.R.S.A. and R.S.A. in 1842 and 1845. After an unsuccessful attempt in 1868 he was elected A.N.W.S. and N.W.S. in 1874 and 1879. As well as landscapes he painted Cattermole-like Civil War and genre subjects.

Examples: Ashmolean; Maidstone Mus.; N.G., Scotland.

HOWARD, E Stirling
A Sheffield artist who exhibited landscapes and rustic subjects on infrequent occasions from 1834 to 1870. He was an unsuccessful candidate for the N.W.S. in 1867 and 1868, in which latter year he sketched in North Wales.

Examples: V.A.M.

HOWARD, Hon. Frances
The youngest daughter of MARY, VISCOUNTESS ANDOVER, (1716-1803) who was a daughter of the 2nd Earl of Aylesford. Both mother and daughter were artists in pen and grey wash. Frances married Richard Bagot, fifth son of Sir W.W. Bagot, Bt., in 1783, and he took her maiden name. She was the heiress of her nephew, the 13th Earl of Suffolk and 6th Earl of Berkshire. THOMAS HOWARD, 14TH EARL OF SUFFOLK AND 6TH EARL OF BERKSHIRE (1721-1783) was also a draughtsman. In style the family owed much to their double-cousin, the 4th Earl of Aylesford (q.v.) and to his connection with J.B. Malchair (q.v.).

Examples: B.M.; Ashmolean.
See Family Tree.

HOWARD, Vernon 1840 – 1902
A drawing master who worked at Boston and Sutton, Lincolnshire, at Kidderminster and Grantham. He exhibited at the R.I. and elsewhere from 1864 to 1899.

Examples: V.A.M.; Castle Mus., Nottingham.

HOWITT, Samuel 1756 – 1822 (London)
A country gentleman from Chigwell in Essex, Howitt became a professional artist only because of his financial troubles. He first exhibited in 1783 and his subjects are always drawn from country and sporting life. His style is very clearly influenced by Rowlandson, whose sister he married. His drawing, which is fairly crude at the beginning of his career, improves until it is very skilful indeed. One hallmark of his style is a fretted outline for foliage. His animal sketches, often done from life at such places as the Menagerie at the Tower of London, are very lifelike indeed. He illustrated a book of Oriental Sports, but never went East himself.

Illustrated: T. Williamson: *Oriental Field Sports,* 1807. Etc.
Examples: B.M.; V.A.M.; Fitzwilliam; City A.G., Manchester; Newport A.G.
Bibliography: Hewitt Family: *The Pedigree of Hewitt or Howitt of London,* 1959.

HOWLETT, Bartholomew
 1767 (Louth, Lincolnshire) – 1827 (Newington)
An engraver and draughtsman who was apprenticed to James Heath. His work was mainly antiquarian and topographical. In 1817 he made several drawings for a projected History of Clapham. He also drew about a thousand seals of English religious houses for John Caley.

Published: *A Selection of views in the County of Lincoln,* 1801.

HOWLEY, Harriet Elizabeth, Mrs. Wright – 1860
The youngest daughter of William Howley (1766-1848) Archbishop of Canterbury, she married J.A. Wright, Rector of Merstham, Surrey, in 1832. She may have been a pupil of Cox and produced pencil and brown wash drawings of North Wales.

HOWSE, George, N.W.S. — 1860
A painter of landscape, architecture, town and coastal scenes who lived in London. He exhibited from 1830 and was elected N.W.S. in 1834. He painted in France, Holland and Wales and on the South Coast.

Examples: V.A.M.; N.G., Ireland.

HUDSON, William, N.W.S. — 1847
A portrait painter who lived in Croydon and exhibited from 1803. He was elected N.W.S. in 1834.

HUEFFER, Catherine, Mrs. née Madox Brown
1850 — 1927 (London)
The younger daughter and a pupil of F.M. Brown (q.v.) she was a follower of the Pre-Raphaelites and exhibited from 1869 to 1872. She married Francis Hueffer.

HUGGINS, William
1820 (Liverpool) — 1884 (Christleton, nr. Chester)
An animal painter who studied at the Mechanics' Institute, the Liverpool Academy and from the life in the zoo. In 1861 he moved to Chester and in 1876 and 1877 lived in Bettws-y-Coed. He exhibited at the R.A. from 1846.

As well as his best known animal subjects in oil and watercolour or chalk, he painted portraits, landscapes and themes from Milton and the Bible. His drawing is good and his colour brilliant. Few artists have better painted the eye of a lion.

Examples: Williamson A.G., Birkenhead; Warrington A.G.
Bibliography: *A.J.*, 1904.

HUGGINS, William John 1781 — 1845 (London)
A marine painter whose early life was spent as a sailor on East Indiamen, visiting China and the Far East. He exhibited at the R.A. from 1817, having settled in Leadenhall Street. He retained links with the East India Company and was regularly employed to paint pictures of their ships. He was marine painter to George IV and William IV. There are many aquatints after his works.

Although primarily an oil painter he made occasional watercolours. His drawing is good and accurate, but his colour and composition are weak.

His daughter BERTHA HUGGINS produced grey wash drawings and married E. Duncan (q.v.). There is an example of her work at Greenwich.

Examples: Greenwich.

HUGHES, Arthur 1832 (London) — 1915 (London)
Illustrator, genre and historical painter, he entered the R.A. Schools in 1847 and first exhibited two years later. In 1858 he moved out of London to Kew and the quality of his work in oil and watercolour declined. His remaining works were sold at Christie's, November 21, 1921.

Illustrated: T. Hughes: *Tom Brown's Schooldays*, 1869. Etc.
Examples: B.M.; Ashmolean; City A.G., Manchester.

HUGHES, Arthur Foord 1856 —
A London landscape and genre painter.

Illustrated: G.M. Fowell: *Windmills in Sussex*, 1930.
Examples: Haworth A.G., Accrington; Hove Lib.; Maidstone Mus.

HUGHES, Edward c. 1825 —
An antiquary and topographer who prepared two volumes of *Kent Sketches and Annotation* which were presented to the Maidstone Mus. in 1905. As well as original drawings these contain copies of works by his cousin W. Alexander (q.v.).

Examples: Maidstone Mus.

HUGHES, Edward Robert, R.W.S.
1851 (London) — 1914 (St. Albans)
A painter of romantic genre subjects who studied at the R.A.

Schools and with his uncle A. Hughes (q.v.) and Holman Hunt (q.v.). He exhibited from 1870 and was elected A.R.W.S. and R.W.S. in 1891 and 1895.

Examples: Ashmolean; Maidstone Mus.; Melbourne A.G.; Sydney A.G.

HUGHES, John 1790 (Uffington) - 1857 (London)
An author, he was educated at Westminster and Oriel. He lived at Uffington, where his father was Vicar, from about 1820 to 1833 when he moved to Donnington Priory, Berkshire. He was an etcher and sculptor as well as an accomplished draughtsman. His sketches were worked up by P. de Wint (q.v.) and engraved by William Bernard Cooke for *Views in the South of France*, 1825.

Published: *An Itinerary of Provence and the Rhone etc.*, 1822.

HUGHES, John Joseph — c.1909
A Birmingham landscape painter who worked extensively in Wales and the Lake District. He exhibited in London from 1838 to 1867 and in Birmingham from 1862 to 1908. He also painted coastal and town subjects, churches and still-lifes and worked in oil and watercolour.

HULK, Abraham 1813 (Amsterdam) - 1897 (London)
A marine and landscape painter, primarily in oil. He studied under the portraitist J.W. Daiwaille and at the Amsterdam Academy from 1828 to 1834. He then visited America and worked in Holland before settling in London in 1870. He specialised in Dutch barges.

The son ABRAHAM HULK, YR. painted landscape and coastal watercolours, in a manner even less distinguished than the father, between 1876 and 1898. He lived in Dorking. WILLIAM F. HULK, who exhibited animal subjects at the N.W.S. and elsewhere from 1875, may have been another son.

HULL, Edward
A lithographer and topographical draughtsman working between 1820 and 1834. He may be the 'Dealer in Curiosities' in London whose stock was sold up in 1845 and 1846. He painted in France and was an acquaintance of T.S. Boys.

Examples: B.M.

HULL, Edward
Perhaps a son of his namesake, he painted genre subjects, landscape and illustrations and exhibited from 1860 to 1877. He was presumably related to W. Hull (q.v.) who used his address in 1867.

Illustrated: A.J. Buckland: *The Little Warringtons*, 1861. Sir S. Lee: *Stratford on Avon*, 1885. A.J. Church: *The Laureate's Country*, 1891.
Examples: Coventry A.G.

HULL, George
A Leicester artist who exhibited at the R.I. from 1875 to 1900.

HULL, William 1820 (Graffham, Huntingdonshire) - 1880 (Rydal)
The son of a farmer, Hull was intended for a minister of the Moravian Church at Ockbrook, Derbyshire, where he trained for three years and took drawing lessons from the Germans, Petersen and Hassé. He spent a year as assistant at the settlement at Wellhouse, Yorkshire and two or three years from 1838 at Grace Hill, Ballymena. He gave up his appointment in 1840 and worked as a printers' clerk in Manchester where he also studied at the school of design. He travelled on the Continent as a tutor from 1841 to 1844, thereafter returning to Manchester where he lived until 1870 when he moved to Rydal. He was left lame and deaf by a stroke in 1850.

His best known works are fruit and flower pieces closely modelled on those of W. Henry Hunt (q.v.), but he also produced landscapes in wash and book illustrations. His colour is weak in his earlier work, as Ruskin told him, but it improves.

Examples: V.A.M.; Abbot Hall A.G.; Kendal.
Bibliography: Manchester Literary Club: *In Memoriam, W.H.*, 1880.

HULLMANDEL, Charles Joseph 1789 (London) - 1850 (London)
One of the foremost lithographers of his time, he travelled on the Continent, studying and sketching before turning to print-making in 1818. His first publication, produced in that year, was *Twenty-Four views of Italy* from his own drawings. He later reproduced the drawings of artists such as C. Stanfield (q.v.), D. Roberts (q.v.), L. Haghe (q.v.) and G. Cattermole (q.v.).

HULME, Frederick William
 1816 (Swinton, Yorkshire) - 1884 (London)
The son of an artist, he produced figure studies before turning to landscape. He first exhibited at Birmingham in 1841 and later at the B.I., the Royal Manchester Institution and the R.A. He came to London in 1844 and worked for the *Art Journal* and other publications. He taught drawing and painting.
 His watercolours, which are often views in Bettws-y-Coed, are very much in the manner of T. Creswick (q.v.).

Published: *A graduated Series of Drawing copies on Landscape subjects for use of Schools,* 1850.
Bibliography: *A.J.,* April, 1858.

HUMPHREYS, Captain Henry 1773/4 (America)
He entered the Navy as a midshipman in 1792 and was Master of the *Chatham* two years later on Vancouver's circumnavigation. Two plates were taken from his drawings for the account: *Voyage round the World,* 1789.

Examples: Greenwich.

HUNN, Thomas H.
A landscape and Thames painter who lived in Hackney and exhibited at the R.A. and Suffolk Street from 1878 to 1910. Sometimes his work can be Allingham-like and is brightly coloured.

HUNSLEY, William
A topographer and military artist who also worked as a draughtsman for the East India Company in Madras. He was active between 1837 and 1843.

Examples: India Office Lib.

HUNT, Alfred William, R.W.S. 1830 (Liverpool) - 1896 (London)
The son of ANDREW HUNT (1796-1861), a landscape painter and friend of Cox, he was educated at Corpus Christi, Oxford, of which he became a Fellow in 1853. Although he first exhibited at the age of twelve, he was destined for an academic career. It was only on his marriage to the novelist Margaret Raine in 1861, which meant automatic resignation of his Fellowship, that he turned to art full-time. He had already become a member of the Liverpool Academy in 1856, and was exhibiting Pre-Raphaelite works at the R.A. He had visited Scotland, Cumberland, Devonshire and Wales in his youth, the Rhine in 1850, and Wales again in 1854. In 1862 he moved to London and was elected A.O.W.S. He became a full Member in 1864 and Vice-President in 1888. He and his wife were at the centre of an artistic and literary circle.
 Hunt's main sketching grounds were Scotland, the Lakes, the Thames Valley and Whitby, but his first love was always North Wales. He also visited Mont St. Michel and Oberwesel, the Rhine and Moselle, and in 1869-70 made a nine-month tour of Italy, Sicily and Greece. At some point he visited America. Although influenced by Turner's middle period, he always works with a Pre-Raphaelite minuteness of detail. Having achieved this he sometimes works backwards again so as to reduce the finish and secure atmospheric effect. Some of his Welsh sketches are reminiscent of Linnell.
 A memorial exhibition was held at the Burlington Fine Arts Club in 1897.

Examples: B.M.; V.A.M.; Ashmolean; Leeds City A.G.
Bibliography: O.W.S. Club, II, 1925.

HUNT, Arthur Acland
A landscape painter who lived in London and exhibited from 1863 to 1887. He painted in Cornwall and also produced still-lifes and literary subjects.

HUNT, Cecil Arthur, R.W.S. 1873 (Torquay) – 1965 (Burnham)
A landscape painter in watercolour, oil and tempera. He was educated at Winchester and Trinity College, Cambridge. He was elected A.R.W.S. and R.W.S. in 1918 and 1925, and was a member of the R.B.A. from 1914 to 1921. He lived in London and South Devon.

Examples: B.M.; V.A.M.; Blackburn A.G.; Cartwright Hall, Bradford; Exeter Mus.; Fitzwilliam; Glasgow A.G.; India Office Lib.; Leeds City A.G.; City A.G., Manchester; Newport A.G.; Portsmouth City Mus.
Bibliography: O.W.S. Club XXXVIII, 1963.

HUNT, Thomas, A.R.S.A., R.S.W. 1854 (Skipton) - 1929
A painter of Scottish landscapes and characters in watercolour and oil. He studied at the Glasgow School of Art and in Paris and lived in Glasgow. He served as Vice-President of the R.S.W. and was elected A.R.S.A. in 1914.

Examples: Glasgow A.G.; Leeds City A.G.; Wakefield A.G.

HUNT, William Henry, O.W.S. 1790 (London) - 1864 (London)
Since he had deformed legs he was thought incapable of anything better than art. He was apprenticed to J. Varley (q.v.) in about 1804 and one of his fellow pupils was J. Linnell (q.v.). The two aspiring artists seem to have had a good influence on each other's work, and they made a number of sketching tours together, including a visit to Hastings in 1809. In 1808 he entered the R.A. Schools, but probably he did not stay there very long. He was, however, one of the group of students who were selected to help re-decorate Drury Lane Theatre after the fire of 1809. His earliest important private patrons were the Duke of Devonshire and the Earl of Essex, who commissioned drawings of the state rooms at Chatsworth and Cassiobury. At the latter place he met Dr. Monro (q.v.) who also employed him. By 1815 he had set up on his own as an architectural and rustic painter. He exhibited with the Oil and Watercolour Society, but failed to gain election to the O.W.S. in 1823. He was elected, however, in the following year, and became a full member in 1826. By this time he was turning from pure landscapes and buildings to studies of rustics and to still-lifes.
 Throughout his life Hunt visited Hastings and the South Coast and he rarely seems to have left the Southern Counties. His work can be divided into two periods; in the first, up to about 1825, he was in some ways a traditional topographical draughtsman, working carefully with the pen and using thin washes of pale colour. In the second period his work is marked by a massing and building up of colour by a technique of hatching with a number of different tints to obtain a life-like texture. His colours in this period are generally laid over a ground of white bodycolour to give them luminosity. He had a keen sense of humour, not without its malicious edge, and enjoyed poking fun at the foibles of his rustics. Unfortunately the popularity of these works and of the still-lifes which earned him the nickname of 'Bird's nest Hunt' caused him to neglect his great talent for landscape.
 His remaining works were sold at Christie's, May 16-17, 1864. His few pupils included A.M. Fitzjames (q.v.) and J. Sherrin (q.v.).

Examples: B.M.; V.A.M.; Aberdeen A.G.; Haworth A.G., Accrington; Ashmolean; Williamson A.G., Birkenhead; Blackburn A.G.; Blackpool A.G.; Grundy A.G., Blackpool; Cartwright Hall, Bradford; Derby A.G.; Dudley A.G.; Glasgow A.G.; Leeds City A.G.; Leicestershire A.G.; Newport A.G.; Portsmouth City Mus.; Reading A.G.; N.G., Scotland; Ulster Mus.

Bibliography: J. Ruskin: *Notes on S. Prout and W.H.H.,* 1879; *A.J.,* April, 1864; *Fraser's Magazine,* October, 1865; *O.W.S. Club* XII, 1936; *Country Life,* April 27, 1972.

HUNT, William Holman, A.R.S.A., R.S.W.
1827 (London) - 1910 (London)
The Pre-Raphaelite Brother. He worked for an estate agent before studying with H. Rogers, the portrait painter, and at the B.M., N.G. and the R.A. Schools from 1844. He exhibited from 1846. 1848-9 was the great year of the Brotherhood, and in 1849 Hunt visited the Continent with Rossetti. He first visited Egypt and Syria in 1854. He was in Italy from 1865 to 1867 and the Holy Land from 1869 to 1871. He was again in Palestine from 1875 to 1878 and in 1892. He was elected A.O.W.S. and O.W.S. in 1869 and 1887, but retired in 1893. His watercolours, often studies for, or derived from, his oil paintings, show the meticulous handling that one would expect. They can be very fine indeed.

Examples: B.M.; V.A.M.; Ashmolean; Coventry A.G.; City A.G., Manchester.
Bibliography: *A Memoir of W.H.H.'s Life*, 1860; F.W. Farrar: *W.H.H.*, 1893; H.W. Shrewsbury: *Brothers in Art*, 1920; A.C. Gissing: *W.H.H.*, 1936; *A.J.*, 1910; *O.W.S. Club* XIII, 1935-6; *Country Life*, April 3, 1969.

HUNT, William Howes **1806** **– 1879**
A painter of beaches and fishing boats who lived at Great Yarmouth. His work is good enough to make one wish that it were better.

Examples: B.M.; Castle Mus., Norwich; Gt. Yarmouth Lib.

HUNTER, Colin, A.R.A., R.I., R.S.W.
1841 (Glasgow) - 1904 (London)
Best known for his seascapes in oil, for which he was elected A.R.A. in 1884, he also painted marine watercolours and was elected R.I. in 1882. In his youth he lived in the Western Highlands, and the pictures he painted there best show his particular skill at rendering the changing effects of water.
His remaining works were sold at Christie's, April 8, 1905.

Bibliography: *A.J.*, 1884.

HUNTER, Lieutenant James **- 1792 (India)**
An artilleryman who served under Cornwallis against Tippoo Sultan.

Illustrated: Blagdon: *A Brief History of Ancient and Modern India. Pictorial Scenery in the Kingdom of Mysore*, 1804-5.

HUNTER, Mason, A.R.S.A., R.S.W.
1854 (Broxburn) - 1921 (Edinburgh)
A landscape and marine painter in oil and watercolour. He studied in Edinburgh and Paris, exhibited from 1881, and was elected R.S.W. in 1896 and A.R.S.A. in 1913.

HURDIS, James Henry 1800 (Southampton) - 1857 (Southampton)
After an education at Southampton and in France he was articled to C. Heath (q.v.), who taught him drawing and engraving. He was never a professional artist, but drew and etched many caricatures in the style of G. Cruikshank (q.v.). He lived mostly at Newick, Sussex, but returned to Southampton towards the end of his life. He also dabbled in architecture.

HURLSTONE, Frederick Yeates **1800 (London) - 1869 (London)**
Great-nephew of Richard Hurlstone, the portraitist and friend of Wright of Derby, he was a pupil of Beechey and Lawrence, and possibly Haydon. He entered the R.A. Schools in 1820 and first exhibited at the R.A. in the following year. In 1831 he was elected to the S.B.A. and became President in 1835. He paid a number of visits to Italy, Spain and Morocco between 1835 and 1854.

He was a portrait and historical painter and, in his later years, produced many rather weak studies of Continental and Arab peasants.

His wife JANE HURLSTONE, née CORAL (d.1858) exhibited watercolours and portraits at the R.A. and S.B.A. from 1846 to 1850.

Examples: B.M.

HUSON, Thomas, R.I. **1844 (Liverpool) - 1920 (Bala)**
A landscape painter in oil and watercolour and an etcher, he worked as a chemist before taking up painting as a profession. He was elected R.I. in 1883, and he lived in Liverpool until about 1907 when he moved to Bala.
His wife was also an artist.

Published: *Round about Snowdon*, 1894; *Round about Helvellyn*, 1895.

HUSSEY, Henrietta, Mrs., née Grove 1819 (Salisbury) – 1899
An amateur landscape painter in watercolour and oil, she was a pupil of D.C. Read (q.v.) in Salisbury, where she lived after her marriage in 1839. She visited the Continent and North Wales as well as making sketches on the South Coast. Her watercolours show a freedom possibly influenced by Whistler, but they can be over-splashy.

HUTCHINSON, Samuel
A marine painter who lived in London and exhibited at the R.A. and elsewhere from 1770 to 1802.

HUTCHISON, Robert Gemmell, R.S.A., R.S.W.
1860 (Edinburgh) - 1936 (Edinburgh)
A genre, portrait and landscape painter who was much influenced by Josef Israels both in style and subject. He studied at the Board of Manufacturers' School of Art, Edinburgh, and lived in Edinburgh and Musselburgh. He exhibited from 1878 and was elected R.S.W. in 1895 and A.R.S.A. and R.S.A. in 1901 and 1911.

Illustrated: T.R. Barnett: *Reminiscences of Old Scots Folk*, 1913.
Bibliography: *A.J.*, 1900.

HUTTULA, Richard C
A genre painter who exhibited at Suffolk Street and in Brighton from 1866 to 1887. He lived in London.

Published: *The Young Dragoon*, 1874.
Illustrated: W.H.G. Kingston: *Hurricane Harry*, 1874.

HYDE, Henry James
A London painter of genre subjects who exhibited at the R.I. from 1883.

IBBETSON, Sir John Thomas Selwin, 6th Bt.
 1789 –
An amateur landscape painter who lived at Down Hall, Essex, and
Denton Park, Otley, Yorkshire. In 1825, he assumed the additional
surname of Selwin on receiving an inheritance from his mother's
family, and he sometimes used this name alone as a signature. He
exhibited drawings at the R.A. in 1811 and 1812 as well as in his
friend Walter Fawkes's exhibition of 1817. In that year he toured
Italy and Sicily, and he also sketched in Devon and Cornwall. His
son was created Lord Rookwood.
 DENZIL O. IBBETSON (1775-1857) who fought in the
Peninsula and sketched Napoleon and his companions on St. Helena,
seems to have been a member of the same family.

IBBETSON, Julius Caesar
 1759 (Farnley Moor, Leeds) – 1817 (Masham)
The 'English Berghem' was apprenticed to a ship painter in Hull in
1772. He remained there for five years, also painting scenery for
Tate Wilkinson, before running away to London. There he worked
for a picture restorer until 1784, studying techniques and gradually
making himself a name, and he exhibited at the R.A. for the first
time in 1785. In 1787 and 1788 he sailed as draughtsman to the
Chinese Embassy of the Hon. Charles Cathcart, visiting Madeira, the
Cape, and Java, where the Ambassador died. On Ibbetson's return,
he painted in South Wales, staying at Cardiff Castle with Lord Bute,
in 1789, and on the Isle of Wight in 1791. He also moved out of
London to Kilburn and later to Paddington. In 1792, he made an
extensive tour of North Wales with the Hon. R.F. Greville (q.v.).
From the death of his first wife in 1794 he went through a period of
great personal and professional difficulties culminating in a
disastrous contract to work for the dealer Warren in Liverpool in
1798. In 1800 he was in Edinburgh and Roslin during tne summer
and he won the friendship and patronage of Lady Crawford. He
then settled at Ambleside and remarried in 1801. He moved to
Troutbeck in 1803 and, following commissions at Swinton and
crippling rheumatism brought on by the climate of the Lake
District, to Masham in the North Riding.
 His work, both in oil and watercolour, is based on the Dutch
landscape tradition, but he has an elegance and wit which are
entirely his own. His figures have a superficial resemblance to those
of Wheatley or La Cave, but he is by far the greater artist, for his
are no pretty stereotypes, but real people. His comparatively rare
portraits are fine studies in character.
 His eldest son, JULIUS CAESAR IBBETSON, YR. (1783-1825),
followed him to Liverpool and the Lake District. In 1805 he set up
as a drawing master at Richmond in place of G. Cuitt (q.v.), and he
died there, a respected councilman as well as artist and landlord of
the Fleece Inn.

Published: *An Accidence or Gamut of Painters in Oil and
Watercolours*, 1803. *Process of Tinted Drawing*, 1805.
Illustrated: J. Trusler: *Modern Times*, 1785. J. Hassell: *A
Picturesque Guide to Bath*, 1793. Church: *Cabinet of Quadrupeds*,
1796.
Examples: B.M.; V.A.M.; Aberdeen A.G.; City Mus. Bristol;
Darlington A.G.; Fitzwilliam; Greenwich; Leeds City A.G.;
Leicestershire A.G.; N.G., Ireland; Newport A.G.
Bibliography: B.L.K. Henderson: *Morland and Ibbetson*, 1923. R.M.
Clay: *J.C.I.*, 1948. *Gentleman's Mag.* 1817, p. 637.

IKEN, Jonathan Alfred
An artist who visited Brazil and the Cape Verde Islands in 1858-9.
He painted panoramic views of the towns in which he stayed; they
are poorly drawn but well coloured.

INCE, Joseph Murray
 1806 (Presteign, Radnor) – 1859 (Presteign)
A pupil of Cox at Hereford from 1823 to 1826, when he came to
London and began to exhibit at the R.A. and the S.B.A. By 1832,
he had moved to Cambridge, where he worked as an architectural
draughtsman, and he returned to Presteign about three years later,
remaining there for the rest of his life.
 He was best known for his small landscapes and coastal subjects.
He was particularly adept at handling the texture of brick and stone.

Published: *Views illustrating the County of Radnor*, 1832.
Examples: B.M.; V.A.M.; Haworth A.G., Accrington; Coventry A.G.;
Fitzwilliam; Maidstone Mus.; Newport A.G.; Ulster Mus.

INCHBOLD, John William **1830 (Leeds) – 1888 (Headingley)**
A landscape painter who was the son of the owner and editor of the
Leeds Intelligencer. He began his career as a draughtsman for Day
and Haghe, taking lessons from L. Haghe (q.v.). He entered the R.A.
Schools in 1847 and exhibited from 1849. He travelled widely in
Germany, Austria and Switzerland and visited Algeria a year or two
before his death.
 He enjoyed little popular or Academic success although he had
many literary admirers and supporters. His style is hard and
over-faithful with rather lurid effects that are reminiscent of
MacWhirter. He also uses thick splashes of bodycolour on occasion.
His poetry is probably more attractive than his painting.

Published: *Annus Amoris*, 1877.
Examples: V.A.M.; Ashmolean; Leeds City A.G.

INCHBOLD, Stanley
An artist who lived in Bushey, and who exhibited North African
scenes at the R.I. and elsewhere from 1884.

Illustrated: A.C. Inchbold: *Under the Syrian Sun*, 1906; A.C.
Inchbold: *Lisbon and Cintra*, 1907; A. Beckett: *The Spirit of the
Downs*, 1909; G.N. Whittingham: *The Home of Fadeless Splendour
(Palestine)*, 1921.

INGLEFIELD, Admiral Sir Edward Augustus, F.R.S.
 1820 (Cheltenham) – 1894 (London)
The son of a rear-admiral, his own distinguished naval career
included the Arctic Expedition of 1853 in search of Franklin, and a
period as C.-in-C., North American Station.
 He was Chairman of the Arts Section of the Chelsea Naval
Exhibition of 1891, at which he also exhibited. He also showed
both oil and watercolour paintings at the R.A. He was best known
as a practical and scientific man, and the inventor of the Inglefield
Anchor. His watercolours are extremely professional, somewhat in
the manner of Edward Duncan.

Examples: Greenwich.

INGLIS, Jane **– 1916**
A fruit and flower painter in oil and watercolour who exhibited at
the R.A., the N.W.S. and elsewhere from 1859 to 1905. She should
not be confused with Jean Winifred Inglis (b. 1884), an art mistress
and painter in various media.

INGRAM, William Ayerst, R.I.
 1855 (Glasgow) – 1913 (Falmouth)
Primarily an oil painter, he also made a number of watercolours of
coastal and marine subjects, and was a pupil of J. Steeple (q.v.). He
exhibited at the R.A. from 1880 and was elected R.I. in 1907. He
travelled widely, becoming President of the Royal British Colonial
Society of Artists in 1888. From the 1880s he spent much of his
time in St. Ives and Falmouth, and he opened a gallery there in
about 1894 with H.S. Tuke (q.v.).

His brother, R.S. INGRAM, exhibited a watercolour in Glasgow in 1877.

Examples: V.A.M.; Greenwich; Sydney A.G.

INNES, James Dickson
1887 (Llanelly) – 1914 (Swanley, Kent)
A figure and landscape painter in oil and watercolour, who studied at the Slade and was influenced by Augustus John. He painted in Wales, France and Spain, and from 1908 he spent some time in North Africa and Teneriffe because of poor health.

A memorial exhibition was held at the Chenil Gallery, London, in 1923.

Examples: B.M.; V.A.M.; Cartwright Hall, Bradford; Cecil Higgins A.G., Bedford; Fitzwilliam; Leeds City A.G.; Newport A.G.
Bibliography: J. Fothergill and L. Browse: *J.D.I.*, 1946.

INSKIPP, James
1790 – 1860 (Godalming)
A business man who turned professional artist in 1820. He exhibited portraits and figure subjects in oil and watercolour at the R.A. and elsewhere from 1816 to 1864. He made illustrations for an edition of *The Compleat Angler* which was published in 1875.

IRELAND, Samuel
– 1800 (London)
Primarily an author, collector and engraver, he made some slightly amateurish architectural and landscape drawings in watercolour. He lived for the most part in London and became deeply involved in the unravelling of the Shakespeare forgeries of his son William Henry. This affair cast a blight over the latter part of his career.

His daughter, Jane, exhibited miniatures at the R.A. in 1792 and 1793.

Published: *A Picturesque Tour through France, Holland etc. . . . made in the Autumn of 1789*, 1790. Etc.
Examples: B.M.

IRTON, Lieutenant-Colonel Richard
– 1847
An amateur landscape painter who was commissioned in the Rifle Brigade in 1815. He was promoted captain in 1826 and lieutenant-colonel in 1841.

Illustrated: G.N. Wright: *The Rhine, Italy and Greece*, 1840. G.N. Wright: *The Shores and Islands of the Mediterranean*, 1840.

IRWIN, Clara
A painter of Armagh street scenes who was working between 1891 and 1916 and lived in Dublin and Carnagh, Ireland.

JACKSON, Frederick Hamilton 1848 - 1923
An illustrator and designer who trained at the R.A. Schools, was Master of the Antique School at the Slade, and, in 1880, co-founder of the Chiswick School of Art. He was a member of the R.B.A. and the Langham Sketching Club.

Published: *Sicily*, 1904; *The Shores of the Adriatic*, 1906. Etc.

JACKSON, Frederick William 1859 (Oldham) - 1918
Marine and landscape painter in oil and watercolour, and a ceramic designer, he studied at the Oldham School of Art, the Manchester Academy and in Paris. He visited Italy and Morocco and mostly lived at Hinderwell, Yorkshire. He exhibited from 1880 and is particularly noted for his broad and atmospheric sketches.

JACKSON, John, R.A.
 1778 (Lastingham, Yorkshire) - 1831 (London)
A portrait painter, he was the son of a tailor who discouraged his artistic tendencies. However, he won the patronage of Lord Mulgrave at Whitby, who in turn introduced him to the Earl of Carlisle and Sir G. Beaumont (q.v.). The latter sent him to the R.A. Schools in 1804, where he became a close friend of Wilkie and Haydon. He also copied at the B.M. He was elected A.R.A. in 1815 and in 1816 toured the Netherlands with General Phipps, Lord Mulgrave's brother. In 1817 he was elected R.A. and two years later travelled through Switzerland to Rome with Sir F. Chantrey (q.v.).
 Although he exhibited regularly, and had an extensive practice, producing very sensitive likenesses, he never achieved the popularity of Lawrence.

Examples: B.M.; V.A.M.; Greenwich; N.P.G.; Newport A.G.; Portsmouth City Mus.
Bibliography: *A.J.*, 1899.

JACKSON, Samuel, A.O.W.S. 1794 (Bristol) - 1869 (Clifton)
The son of a merchant for whom he worked until 1820, when the end of the business and sketching holidays in Scotland and Ireland turned him to art. He was strongly influenced by F. Danby, but unlike his mentor, he remained in Bristol and became the father figure and mainstay of the Bristol School. He built up a successful practice as a drawing master and developed a complex and highly sophisticated technique of painting, with much sponging, stopping, scratching and glazing with thin bodycolour. The majority of his subjects are British landscapes, particularly from Wales and Devon, but he seems to have visited the West Indies, perhaps for his health, in 1827, and he toured Switzerland in 1854 and 1858. He was elected A.O.W.S. in 1822 and retired in 1848.

Examples: B.M.; V.A.M.; Preston Manor, Brighton; City A.G., Bristol; Fitzwilliam; Glasgow A.G.; Newport A.G.
Bibliography: *A.J.*, February, 1870.

JACKSON, Samuel Phillips, R.W.S. 1830 (Clifton) - 1904
The son and pupil of S. Jackson (q.v.), he began by exhibiting oil paintings in London from about 1850. However, after his election as A.O.W.S. in 1853, he turned almost entirely to watercolour painting. He became a full member of the Society in 1876. He moved from Clifton to Streatley-on-Thames in 1870 and in 1876 to Henley. Later, however, he returned to Clifton.

His earlier coastal subjects were mostly found in Cornwall and Devon, with a few in the Channel Islands and Wales. He also made a single Continental tour, to Switzerland with his father in 1858. After 1870 his subjects are largely taken from the Thames Valley. He uses sober colours, greys, greens and browns which, with his clean handling, were praised by Copley Fielding. He has a talent for conveying moist and hazy atmosphere. Sometimes he over-uses bodycolour.

Examples: B.M.; V.A.M.; City A.G., Bristol.

JACKSON, Sir Thomas Graham, Bt., R.A., F.S.A.
 1835 - 1924
An architect who was educated at Oxford, where he later became a Fellow of Wadham. While in Oxford he took lessons from W. Turner (q.v.). He was elected A.R.A. and R.A. in 1892 and 1896, and was created a baronet in 1913. He lived in Surrey. In the Fitzwilliam there are a number of pretty wash drawings of Cambridge by him.

JAMES, Edith Augusta 1857 (Eton) - 1898 (Tunbridge Wells)
Painter of flowers, portraits and St. Paul's Cathedral. She studied in Paris and exhibited in London from 1884. Her St. Paul's interiors date from the last three years of her life.
 Other painting James ladies include CHARLOTTE J. JAMES, who exhibited flower pieces in the 1860s and 1870s, and SARAH JAMES who was living in Essex in 1900.

Examples: V.A.M.

JAMES, Francis Edward, R.W.S.
 1849 (Willingdon, Sussex) - 1920 (Gt. Torrington, Devon)
A painter of landscapes, flowers and church interiors, he was the son of the Vicar of Willingdon and was a friend of H.B. Brabazon (q.v.). He was a member of the N.E.A.C. and was elected A.R.W.S. and R.W.S. in 1916 and 1920.

Examples: B.M.; V.A.M.; Aberdeen A.G.; Leeds City A.G.; Leicestershire A.G.

JAMES, William
Canaletto's assistant during his London visit, James exhibited rather Bellotto-like views of London from 1761 to 1771 and became a member of the Society of Artists in 1766.

Examples: V.A.M.

JAMESON, T (Ambleside) –
A landscape painter who was living at Ambleside in the early nineteenth century. He became a protégé of J. Harden (q.v.), who introduced him to Farington and Constable and brought him to London. He probably knew W. Havell (q.v.) while living in the Lake District, as the influence of the latter is shown strongly in his work.

Examples: B.M.

JEAKES, Joseph – c. 1829
An engraver who made prints after D. Serres (q.v.), and an occasional draughtsman. He exhibited at the R.A. between 1796 and 1809. There was a 'small rather formal monochrome landscape' in I.A. Williams's collection which is now in the B.M.

JEE, David see GEE, David

JEFFERSON, Charles George
 1831 (South Shields) - 1902 (South Shields)
An accomplished amateur painter of river and marine subjects. He exhibited at the R.S.A. and in Glasgow as well as locally and worked in oil and watercolour.

JEFFERSON, John
A topographer who provided illustrations for J. Britton (q.v.). His style is rather woolly.

Examples: B.M.

JEFFERY, Emmanuel 1806 – 1874
An Exeter artist who painted views of the city and local landscapes from about 1821. His perspective is not perfect and his colour can be rough, but generally his drawing is good. He preferred views with streams in them.

Examples: Exeter Mus.

JEFFREY, J
A drawing master at Portsmouth Naval Academy from 1774 to 1794.

JENKINS, John c.1798
A student at the R.A. Schools from 1821, he was in Italy in 1824 and exhibited views and drawings of temples at the R.A. from 1825 to 1832. He was probably a son of W. Jenkins, a builder and architect of Red Lion Square. His brother WILLIAM JENKINS, YR. travelled in Greece in 1820 and exhibited Greek views from 1822 to 1827. They may have been practising architects.

Published: with W. Hosking: *A Selection . . . of Ornament . . . drawn from . . . museums . . . in Italy*, 1827.

JENKINS, Joseph John, O.W.S., F.S.A.
 1811 (London) – 1885 (London)
The son of an engraver, he began drawing and engraving early and seems to have exhibited when only fourteen. In his younger days he travelled much about the Continent and the British Isles, visiting Belgium – which he disliked – and Brittany in 1846. He was a member of the N.W.S. but seceded in 1847 and became an Associate and Member of the O.W.S. in 1849 and 1850. From this time until his death he was engaged in the research for a history of watercolour painting, his notes and papers forming the basis for Roget's *History of the O.W.S.* He was a very active Secretary of the Society from 1854-64 and was well known for his benefactions to and encouragement of his fellow artists. He was a figure draughtsman of the genre school, but latterly turned more to pure landscape. There are many engravings after his works. His own collection and remaining works were sold at Christie's, March 1, 1886.

Examples: V.A.M.; Blackburn A.G.; Reading A.G.

JENKYNS, Caroline
The sister of R. Jenkyns (q.v.) and also a pupil of Turner of Oxford. Her copies of his drawings in pencil and wash are almost indistinguishable from the originals. She married the Dean of Christ Church.

JENKYNS, Rev. Richard 1782 (Evercreech, Somerset) – 1854
Master of Balliol College and Dean of Wells. He went up to Balliol in 1800 and was elected Master in 1819, serving as Vice-Chancellor from 1824 to 1828 and holding the Deanery of Wells from 1845. He was a reformer in College affairs and a strong anti-tractarian. He was a pupil of Turner of Oxford, but may only have done pencil drawings.

JEWITT, Arthur
 1772 (Sheffield) – 1852 (Headington, nr. Oxford)
A schoolmaster and topographical writer who painted landscapes in watercolour, he served an apprenticeship under his father, a cutler, after which he opened a private school. Among the towns in which he later taught were Chesterfield, and Kimberworth from 1814 to 1818, in which year he retired. He moved to Duffield, near Derby. In 1838 he joined some of his family at Headington. He contributed to various periodicals and in 1817 started up *The Northern Star,* or *Yorkshire Magazine,* which only appeared for three volumes. The following year he brought out *The Sylph,* or *Lady's Magazine for Yorkshire, Derbyshire and the adjoining Counties.*

Published: *The History of Lincolnshire,* 1810. *The History of Buxton,* 1811. *Matlock Companion,* 1835. *Handbook of Practical Perspective,* 1840. *Handbook of Geometry,* 1842.

JOBBINS, William H
After teaching at the Nottingham School of Art, he went to Venice in about 1880, and later to India on Government service. He painted landscapes both in oil and watercolour, and he exhibited at the R.A. and Suffolk Street from 1872 to 1886.

Examples: Castle Mus. Nottingham.

JOBLING, Robert
 1841 (Newcastle-upon-Tyne) – 1923 (Whitley Bay)
Until he was sixteen Jobling worked as a glass-maker, but spent his free time sketching and attending Cosens-Way's evening classes. Thereafter he was a foreman painter in a shipyard, only devoting himself entirely to art in 1899. His subjects are mostly river and coastal scenes. He occasionally exhibited at the R.A. and, in 1910, was elected President of the Bewick Club.
 His wife Isa, née Thompson, was also a painter.

Illustrated: Wilson: *Tales of the Borders.*
Examples: Laing A.G., Newcastle

JOEL, H B
A landscape and marine painter in oil and watercolour who worked in a rather Dutch manner. He is sometimes mis-catalogued as A.J. Boel because of the complexities of his signature. He was working between 1880 and 1905.

JOHNSON, Alfred George c.1820
An Irishman who was trained at the R.D.S. Schools. He exhibited oil and watercolour paintings at the R.H.A. between 1846 and 1850, and later worked as a draughtsman at the Ordnance Survey
 His elder brother BLUCHER JOHNSON (1816-1872) was a sculptor and draughtsman. He studied at the R.D.S. and later worked as a designer and modeller for Dublin Silversmiths.

JOHNSON, Charles Edward, R.I.
 1832 (Stockport) – 1913 (Richmond)
A landscape, marine and historical painter who studied at the R.A. Schools and began his career in Edinburgh. He moved south in 1864 and opened an art school in Richmond, Surrey. He exhibited Scottish and West of England subjects from 1855 and was elected R.I. in 1882.

JOHNSON, Cyrus, R.I. 1848 (Cambridge) – 1925 (London)
A genre and landscape painter who studed at the Perse School, Cambridge, and worked in London. He exhibited from 1871 and was elected R.I. in 1887. Later in life he also painted portraits.

JOHNSON, Edward Killingworth, R.W.S.
 1825 (Stratford-le-Bow) – 1896
A self-taught painter of contemporary genre scenes, he attended a few classes at the Langham Life School and took up painting full time in 1863, although he had exhibited from 1846. He was elected A.O.W.S. and O.W.S. in 1866 and 1876 and in 1871 moved from Wembley to a family property near Halstead in Essex.
 His work is often intensely detailed and highly finished, but somehow lacks true depth of feeling.

JOHNSON, Harry John, R.I.
 1826 (Birmingham) – 1884 (London)
A pupil of Muller, whom he accompanied on Sir Charles Fellowes's expedition to Lycia in 1840. On his return he took lessons from S.R. Lines (q.v.) and settled in London in 1843. He was a founder member of the Clipstone Street Academy. He accompanied Cox on his first visit to Bettws-y-Coed in 1844 and on other sketching tours in North Wales. He was unanimously elected an Associate of the R.I. in 1868 and a member in 1870.
 In style he remained a disciple of Muller and, to a lesser extent, of Cox, using fluent washes and careful draughtsmanship. This care is especially noticeable in his studies of boats.

Examples: B.M.; V.A.M.; Fitzwilliam; Abbot Hall A.G., Kendal.

JOHNSON, Isaac 1754 – 1835
An antiquary and surveyor who worked in the Woodbridge area of Suffolk. He painted landscapes and tree studies.

Examples: Ipswich Lib.

JOHNSON, James 1803 (Bristol) – 1834
The son of a Bristol innkeeper, he was probably a pupil of H. O'Neill (q.v.) and of F. Danby (q.v.) who certainly influenced him greatly. His earliest dated drawing is of 1819, and he was one of the organisers of the first Bristol exhibition. He moved to London soon afterwards, returning in 1826. The following year he was teaching in Bath, and by 1829 he suffered a first bout of mental illness. He planned a visit to Jamaica for his health, but it is unlikely that he actually went there.

He painted poetic landscapes in oil that are very close to those of Danby in inspiration and execution. As a watercolourist his forte was for very detailed architectural work, especially church interiors. These, and his more extensive topographical works, are among the most impressive products of the Bristol School.

Published: *Bristol Scenery*, 1862.
Examples: City A.G., Bristol.

JOHNSON, Lieutenant-Colonel John c.1769 – 1846
A surveyor in the Bombay Engineers from 1785. He worked in many parts of India, and in 1817 he returned to England by way of Persia, Russia and Georgia. He retired in 1819.

His landscapes and topographical subjects are in a traditional, rather stilted style and his figures are weak.

Published: *A Journey from India to England*, 1818.
Examples: India Office Lib.

JOHNSON, Robert
 1770 (Shotley, Northumberland) – 1796 (Kenmore, Perthshire)
In 1788 he was apprenticed to Bewick and Beilby in Newcastle, at the same time making sketches from nature in watercolour. He turned from copper-plate engraving to painting, and at the time of his death was copying the portraits at Taymouth Castle. These copies were later reproduced in Pinkerton's *Iconographia Scotica*. The engraving from his drawing of St. Nicholas's Church, Newcastle, by his friend C. Nesbit, was claimed to be 'the largest engraving on wood ever attempted in the present mode'.

His drawings are delicate and detailed.

Illustrated: T. Bewick: *Fables*. Goldsmith and Parnell: *Poems*, 1795. J. Pinkerton: *Iconographia Scotica*, 1797.
Examples: Laing A.G., Newcastle.

JOHNSON, Thomas
A topographer who made drawings of Canterbury and Bath churches in about 1675. He worked in the style of W. Hollar (q.v.)

Examples: B.M.

JOHNSTON, Rev. George Liddell
 1817 (Sunderland) – 1902 (London)
He was educated at University College, Durham, and began his clerical career near Exeter becoming, in 1856, Chaplain to the British Embassy in Vienna. Although he retired in 1885, he returned to Austria regularly thereafter. He left sketchbooks of grotesque studies which, en masse, have the impact of a danse macabre. He may well have met Freud and seems to have been influenced by his writings. The drawings are, in fact, a splendid example of the decadence of the later Habsburg Empire. They are mostly done in pen with light washes.

JOHNSTON, Henry, N.W.S.
A landscape painter who exhibited from 1834 to 1858. He was elected to the N.W.S. in 1838, but was thrown out again in 1842.

A Miss M.H. JOHNSTON, who lived in the Strand, was an unsuccessful candidate for the N.W.S. between 1843 and 1847. She exhibited at the S.B.A., where she is spelt without a 'T', from 1842 to 1852.

JOHNSTONE, George Whitton, R.S.A., R.W.S.
 1849 (Glamis) – 1901 (Edinburgh)
A landscape painter who began as a cabinet maker in Edinburgh and then studied at the R.S.A. Life School. As a painter he started with portraits and genre subjects, later specialising in Scottish glens, rivers and coasts. He also painted at Fontainebleau. He exhibited at the R.S.A. from 1872 and was elected A.R.S.A. and R.S.A. in 1883 and 1895. In 1892 he moved to Largs.

As his work developed it became more mannered under the influence of Corot.

Bibliography: *A.J.*, 1899.

JOHNSTONE, William Borthwick, R.S.A.
 1804 (Edinburgh) – 1868 (Edinburgh)
He abandoned a career as a lawyer and began to exhibit at the R.S.A. in 1836. From 1840 to 1842 he attended Sir William Allen's evening classes at the Trustees' Academy. He was elected A.R.S.A. and R.S.A. in 1840 and 1848. In 1850 he was appointed Treasurer, and he exhibited at the Academy until his death. In 1842, with C. Vacher (q.v.), he visited Venice and Rome, returning to Scotland in 1844. He was well known as a collector and connoisseur and in 1858 was appointed first Principal Curator of the newly formed N.G., Scotland. He compiled a catalogue of the Gallery.

He had studied miniature painting under Robert Thorburn, and he painted figure subjects.

Examples: V.A.M.; Abbot Hall A.G., Kendal.
Bibliography: *A.J.*, August, 1868.

JOLLY, Fanny C , Mrs.
A painter of landscapes and still-lifes who was working from about 1856 to 1875. She exhibited in London and Brighton and lived in Bath.

JONES, Anna M
A landscape and portrait painter who lived in Guernsey and exhibited in London from 1868. As well as local scenes, she painted on the Thames.

JONES, Rev. Calvert Richard 1804 (Swansea) – 1877 (Bath)
The son of a Swansea dignitary, whose estate he inherited in 1847. After Oriel College, Oxford, he was ordained and in 1829 was appointed Rector of Loughor, near Swansea. He is said to have worked in the studio of G. Chambers (q.v.) and for the most part he painted shipping subjects. He travelled extensively in Europe and lived in Colchester and Bath. He was also an able mathematician and musician.

JONES, Charles, A.R.S.A. 1836 (Barnham) – 1892
An animal painter in oil and watercolour who exhibited in London from 1860. He worked in Scotland and the South of England.

JONES, Sir Edwin Coley Burne, BURNE-, A.R.A., R.W.S.
 1833 (Birmingham) – 1898
He was educated at King Edward's School, Birmingham and Exeter College, Oxford, where he and W. Morris (q.v.) formed the nucleus of the romantic 'Brotherhood'. Encouraged by Rossetti and the Pre-Raphaelites they became artists and designers. He was elected A.O.W.S. in 1863, but until 1877 his work was virtually submerged in that of Morris & Co. After that date his independent reputation grew apace, culminating in his creation as a baronet in 1894. He was elected R.W.S. in 1886 and A.R.A. in 1885. Many of his drawings are designs and cartoons rather than finished works, and pure watercolours are rare.

Examples: B.M.; V.A.M.; Ashmolean; Cecil Higgins A.G., Bedford; Fitzwilliam; City A.G., Manchester.
Bibliography: M. Bell: *Sir E.B.J.*, 1898. A.L. Baldry: *B.J.*, 1909. M. Harrison & B. Waters: *B.J.*, 1973. P. Fitzgerald: *B.J.*, 1975. *A.J.*, 1898. O.W.S. Club, IX, 1932. *Burlington*, CVX, February 1973.

JONES, George, R.A. 1786 (London) – 1869 (London)
The son of an engraver, he entered the R.A. Schools in 1801 and exhibited portraits, landscapes and genre from 1803 to 1811. He then joined the Army and served in the Peninsula and in Paris after the Occupation. Thereafter he painted military subjects. In 1822 he was elected A.R.A., and R.A. in 1824. He was Librarian from 1834 to 1840, Keeper from 1840 to 1850, and acting President from 1845 to 1850. He was 'a genial, well-bred man, strongly resembling the Duke of Wellington'. His watercolours are usually in blue, grey or brown wash and he painted landscapes in France, Belgium, Germany and Ireland as well as in many parts of Britain.

Published: *Waterloo*, 1817; 1852. *Sir Francis Chantrey*, 1849.
Examples: B.M.; Fitzwilliam; Newport A.G.

JONES, Inigo 1573 (London) – 1652 (London)
In his youth Inigo Jones was sent to Italy by Lord Pembroke to study architecture. He returned by way of Denmark in 1604, and he visited Italy again in 1613-14. Although his greatest importance is as an architect, for a major part of his career, between 1605 and 1640, he produced designs for the scenery and costumes for a series of court masques. His splendidly baroque costume designs are usually in pen and ink with a brown or grey wash. However, nine coloured drawings survive. His imaginative landscape designs for stage settings are also in pen and black ink, with grey wash, and in them can be seen the influence of the great Italians as well as that of Rubens. There is also an affinity with Claude's broadest drawings.

Examples: B.M.; Chatsworth; R.I.B.A.
Bibliography: J.P. Collier: *I.J., remarks on his sketches for masques etc.*, 1848. S.C. Ramsay: *I.J.*, 1924. J.A. Gotch: *I.J.*, 1928. *Festival Designs by I.J.*, 1967. *Walpole Society*, XII, 1924. *Apollo*, LXXXVI, Aug. 1967. *Burlington*, CXV, June 1973. Fraser and Harris: *Cat. of Drawings by I.J.* (typescript in V.A.M.)

JONES, Josiah Clinton
 1848 (Wednesbury, Staffordshire) – 1936
A landscape and marine painter in watercolour and oil who exhibited North Welsh subjects from 1885 and lived at Conway.

Examples: Blackburn A.G.

JONES, Owen Carter 1809 (London) – 1874 (London)
A designer and architect who was a pupil of Louis Vulliamy for six years before entering the R.A. Schools in 1830. He then travelled in France, Italy, Egypt and Spain, returning in 1836. He was a member of the circle about Henry Cole which aimed at higher standards in 'art manufactures', and whose ideas later influenced William Morris. He produced designs and illustrations for Cole's *Journal of Design and Manufactures*, founded in 1849. In 1851 he supervised the decoration of the building for the Great Exhibition and again in the following year on its re-erection as the Crystal Palace. He exhibited at the R.A. from 1831 to 1861.

Apart from his designs for wall-papers, textiles and the like, Jones also produced topographical drawings, most notably a series of Cairene views which were lithographed.

Published: *The Grammar of Ornament*, 1856. Etc.
Examples: B.M.
Bibliography: *A.J.*, 1874.

JONES, Sir Philip BURNE-, 2nd Bt. 1861 – 1926
The son of Sir E. Burne-Jones (q.v.), he painted genre and decorative subjects in oil and watercolour.

Published: *Dollars and Democracy*, 1904. *With Amy in Brittany*, 1904.
Examples: B.M.

JONES, Reginald T 1857 (Old Charlton, Kent) –
A landscape painter in oil and watercolour who exhibited at the R.A. and the R.I. from 1880. He visited Italy, Switzerland, Corsica and France – particularly Brittany and Pont Aven – and had an especial love of the Essex countryside. In England he also sketched on the Dorset and Devon coasts.

Examples: Wakefield A.G.

JONES, R
A painter of portraits, landscapes and architectural subjects in the manner of J. Bourne (q.v.). He was an Honorary exhibitor at the R.A. from 1780 to 1812.

Examples: V.A.M.

JONES, S J E
A landscape and sporting painter who was active between 1820 and 1846.

Examples: V.A.M.

JONES, Thomas
 1742 (Aberedw, Radnorshire) – 1803 (Aberedw, Radnorshire)
In 1759 he went to Oxford and in 1762 came to London where he studied under Richard Wilson from 1763 to 1765. He first exhibited with the Society of Artists in 1765, later becoming a member. He spent the winter of 1773-4 with O. Bowles (q.v.) at North Aston. From 1776 to 1783 he lived in Rome and Naples, and after his return exhibited Italian scenes at the R.A. On his brother's death he inherited the family estate at Pencerrig and became High Sheriff of Radnorshire.

He painted Welsh scenery in the manner of Wilson. Occasionally J.H. Mortimer (q.v.) would add figures to his landscapes. His small works in oil are often painted on paper.

His diaries were published by the Walpole Society in 1951. Exhibitions of his work were held at Marble Hill, Twickenham, and Nat. Mus., Wales, in 1970.

Examples: B.M.; Fitzwilliam; Nat. Mus., Wales.
Bibliography: *Walpole Soc.* XXXII. *Country Life*, November 16 and 23, 1945; July 9, 1970. *Connoisseur*, CLXVIII, 1968; CLXXIV, 1970.

JONES, Thomas Howell
An artist working between 1836 and 1848. In the former year he produced a crude series of London characters. Their poses are awkardly forced into profile like an Egyptian frieze.

Examples: B.M.

JOPLING, Joseph Middleton, A.N.W.S.
 1831 (London) – 1884 (London)
He worked for a few years as a clerk in the War Office, meanwhile teaching himself to paint. In 1859 he was elected Associate of the N.W.S. He joined the 3rd Middlesex Volunteers and was officially commissioned to make drawings of the Queen inspecting the Troops. He was a member of the Arts Club, Hanover Square.

He exhibited still-lifes and historical and genre subjects at the R.A. and elsewhere from 1848. In 1874 he married Louise Goode, formerly Mrs. Romer, herself an artist. She published *Hints to Amateurs*, 1891.

Examples: B.M.; V.A.M.; Williamson A.G., Birkenhead.

JOY, Arthur, R.H.A. c.1808 (Dublin) – 1838 (London)
An historical, landscape and subject painter in oil and watercolour who studied under Robert Lucius West, R.H.A., a portraitist, in Dublin, and afterwards in Paris and Holland. He was elected A.R.H.A. and R.H.A. in 1836 and 1837, in which year he came to London. He exhibited at the B.I. in 1838, the year of his death.

JOY, William 1803 (Great Yarmouth) – 1867
JOY, John Cantiloe 1806 (Great Yarmouth) – 1866 (London)
Marine painters who generally collaborated. They were educated at Wright's Academy, Yarmouth, of which they made sketches which were engraved. They were given the use of a room in the Royal Hospital, from which they taught themselves to paint the sea. In about 1832 they moved to Portsmouth, where they worked as government draughtsmen. They later lived in London, Chichester, Putney, and London again, where John died in 1866. William moved to the country, where he died the next year.

Their work shows careful observation in the detail of ships and

rigging. However, John's figure drawing tends to be weak and William over-uses a lurid green in his seas.

Examples: B.M.; V.A.M.; Greenwich; Gt. Yarmouth.

JUDKIN, Rev. Thomas James 1788 – 1871
Private Chaplain of Somers College, Somers Town, from 1828 to 1868. He exhibited landscapes at the R.A. and elsewhere from 1823 to 1849. His watercolour work is full of techniques such as scraping and white heightening. He was a friend of Constable, whose funeral service he conducted in 1837. He published several religious works.

JUKES, Francis 1745 (Martley, Worcestershire) – 1812 (London)
An engraver who coloured his works by hand. He made topographical views and shipping scenes, and most of his later printed work is done in aquatint. His watercolours are muddy and traditional and lack the discipline of line necessary to a print.

JULIAN, Lieutenant Humphrey John – 1850
He entered the Navy in 1824 and was promoted lieutenant in 1840 and sent to Africa, where he was involved in the destruction of a slave-factory at Corisco. In 1841 he sailed to the East Indies, from which he visited China. Later he was in the Mediterranean. He painted shipping subjects.

Examples: Greenwich.
Bibliography: *Gentleman's Mag.*, November, 1850.

JUSTYNE, Percy William 1812 (Rochester) – 1883 (London)
A landscape painter and book illustrator who worked for, among others, the *I.L.N.*, the *Graphic* and the *Floral World*. He exhibited landscapes at the R.A. and Suffolk Street. From 1841 to 1848 he was in Grenada.

Illustrated: Dr. Smith: *History of Greece*. Dr. Smith: *Biblical Dictionary*. Fergusson: *Handbook of Architecture*. C. Kingsley: *Christmas in the Tropics*. Etc.
Examples: Castle Mus., Nottingham.

JUTSUM, Henry 1816 (London) – 1869 (London)
After an education in Devonshire, where he drew landscapes, he returned to London, and drew frequently in Kensington Gardens. He exhibited at the R.A. and elsewhere from 1836. In 1839 he became a pupil of J. Stark (q.v.) and in 1843 was elected A.N.W.S. He resigned in 1847, after which date he painted chiefly in oil.

His remaining works and collection were sold at Christie's, April 17, 1882.

Examples: Blackburn A.G.; Cartwright Hall, Bradford; Coventry A.G.; Leeds City A.G.; Maidstone Mus.; Newport A.G.
Bibliography: *A.J.*, 1859; 1863; 1869.

KAUFFMANN, Maria Anna Angelica Catharina, R.A.
1741 (Coire, Switzerland) – 1807 (Rome)
The daughter of Johann Josef Kauffmann, a minor Swiss painter who encouraged her early artistic leanings. The family travelled widely in Italy, and Angelica studied art and music in Milan, Florence and Rome. They came to London in 1766. She received commissions for portraits from the Royal Family and nobility, including the Princess of Brunswick, Queen Charlotte, and Christian III of Denmark. Her effect on literary and artistic circles was dramatic, both Reynolds and Nathaniel Dance falling for her. She was a Foundation Member of the R.A., exhibiting there between 1769 and 1797. She visited Ireland in 1771. In 1781 she married A. Zucchi (q.v.). They immediately left for Italy where Angelica lived, mainly in Rome, for the rest of her life. Among her circle of admirers in Rome was Goethe, whose portrait she painted.

She painted mainly in oil, but some of her portraits are in pastel. She also painted fans and allegorical compositions in watercolour. Her works are in the neoclassical tradition. She was employed by the Adam brothers, and greatly contributed to the concept of the 'Adam style'. Her figure drawing is weak and her colour can be overdone.

Examples: B.M.; V.A.M.; Fitzwilliam; N.G., Scotland.
Bibliography: G.G. de Rossi: *A.K.*, 1810. Lady V. Manners: *A.K.*, 1924. A. Hartcup: *Angelica: portrait of an 18th century artist*, 1954. Kenwood: *Exhibition Cat.*, 1955.

KAY, A
A series of aquatints of Edinburgh were made from his drawings in about 1814.

Examples: V.A.M.

KAY, Archibald, A.R.S.A. 1860 – 1935
A landscape painter in oil and watercolour who lived in Glasgow. He studied in France in about 1886 and exhibited at the R.A. from 1890 to 1921. He also lived in Edinburgh.

Examples: Glasgow A.G.

KAY, James, R.S.A., R.S.W. 1858 (Lamlash, Isle of Arran) – 1942 (Whistlefield, Dumbartonshire)
A painter of landscapes, street scenes, marine and Continental subjects who threw up a career in insurance for art. He studied at the Glasgow School of Art and was elected R.S.W. in 1896 and A.R.S.A. and R.S.A. in 1893 and 1938. He lived in Dumbartonshire. His subjects were found above all on the Clyde, and on Dutch rivers and the French coast. He specialised in the less romantic aspects of ships and shipping, and his style can be a little monotonous and overworked.

KAY, John 1742 (Dalkeith) – 1830 (Edinburgh)
A caricaturist and miniature painter, he was apprenticed to a barber – often synonymous with print-seller. A grateful customer gave him a pension in 1782 and he set up as an artist, publishing his first caricatures two years later. He was sued several times.

His drawing is a little crude, but his likenesses were thought good. The satire seems good-humoured to a modern eye and it covers a wider social spectrum than was usual, from senators to sweeps.

Published: *Kay's Edinburgh Portraits*, 1784 – 1813.

KAY, Joseph
A painter who was working between 1793 and 1813 and who visited Italy, probably in 1802. His style is a mixture of precision and sketchiness. He uses clear colour washes and much blue and brown.

KEARNAN, Thomas, N.W.S.
A landscape painter who was working in London from 1821. He was elected N.W.S. in 1837 and resigned in 1851, when he seems to have given up painting.

KEARNEY, William Henry, N.W.S. 1800 – 1858 (London)
A landscape and genre painter who joined the N.W.S. in 1833 and later became Vice-President. He exhibited at the R.A. from 1823. On his death his widow was left in poor circumstances. He painted in London and in Wales and his work can be rather charming and old-fashioned in the manner of P. Sandby.

Published: *Illustrations of the Surrey Zoological Gardens*, 1832.
Examples: B.M.; V.A.M.; Guildford Mus.; N.G., Ireland.

KEARSLEY, Harriet – 1881
A copyist of old masters in watercolour and a figure painter in oil and watercolour. She lived in London and exhibited from 1824 to 1858.

Examples: V.A.M.

KEATE, George, F.R.S., F.S.A.
1729 (Trowbridge, Wiltshire) – 1797 (London)
An antiquary, naturalist and poet as well as a prolific amateur artist. After an apprenticeship as clerk to the steward to the Duke of Bedford, he entered the Inner Temple in 1751. He was called to the bar in 1753, but never practised. He lived abroad for some years, in Geneva, where he became a friend of Voltaire, and in Rome in 1755. He then returned to England and exhibited at the R.A. in an honorary capacity between 1766 and 1789.

He generally painted views of English and Continental towns, and the major part of his work is in bodycolour.

Published: *Sketches from Nature in a Journey to Margate*, 1779. *An Account of the Pelew Islands*, 1788. Etc.
Examples: B.M.; V.A.M.
Bibliography: C.E. Engel: *G.K. et la Suisse*, 1948.

KEATS, C J
An artist who sketched in France, Holland and on the Rhine in 1885. He also worked in the Lake District and on the Severn.

KEELEY, John 1849 – 1930 (Birmingham)
A Birmingham landscape painter. He exhibited from 1872 and became a member of the Royal Birmingham Society in 1902.

KEELING, William Knight, R.I.
1807 (Manchester) – 1886 (Barton-upon-Irwell)
After an early apprenticeship to a Manchester wood-engraver, he came to London to work under W. Bradley (q.v.). Returning to Manchester in about 1835, he set himself up as a painter of portraits and genre, as well as giving drawing lessons. He exhibited at the Royal Manchester Institution, once each at the B.I. and the R.A., and was a member of the original Manchester Academy. He helped found the Manchester Academy of Fine Arts, of which he was President from 1864 to 1877, and exhibited with them until 1883. He was elected Associate and Member of the N.W.S. in 1840 and 1841.

The style of many of his earlier works, in particular his illustrations to Sir Walter Scott and other authors, owed much to his friend H. Liverseege (q.v.).

Examples: V.A.M.

KEENE, Alfred John 'Jack' 1864 – 1930
Son of a Derby art dealer and photographer, his family had been known as Midlands artists for nearly a century. He was a co-founder of the Derby Sketching Club and at the time of his death was President.

He specialised in landscapes and old Derbyshire buildings, the latter done with extreme accuracy, often in pale colours and vignette form. His later work became more atmospheric and colourful. His figure-drawing is good.

His wife, Mrs. A. Keene, née Brailsford, was also an artist.

A brother WILLIAM CAXTON KEENE (1855-1910) studied under· Sir E.J. Poynter (q.v.) and became an illustrator, working for, amongst others, the *Magazine of Art* and *Picturesque London*. Examples of his watercolour landscapes are in the Derby A.G.

Examples: Derby A.G.

KEENE, Charles Samuel
1823 (Hornsea, North London) — 1891 (Hammersmith)
Keene's family moved from London to Ipswich during his childhood, but returned after the death of his father, a solicitor, in 1838. He was briefly articled to a solicitor and then to an architect, but as soon as his apprenticeship was over he was re-articled to Charles Whymper and then set up as a professional artist. The first book with his illustrations appeared in 1842 and thereafter he worked on many books and periodicals, including *I.L.N.* His drawings for *Punch* which made his name, began in 1851. From about 1848 he was a regular attender at the Clipstone Street Academy, where he not only sketched, but also produced a number of very striking etchings. Early in his career he made short trips to Brittany and the Rhine but on the whole he preferred the scenery of the Suffolk coast and Scotland.

Whistler decribed him as 'the greatest English artist since Hogarth', and he is certainly the best pen and ink draughtsman that this country has produced. His drawings are generally social rather than political, and it is through his eyes that we see the late Victorian era. In his economy of line he comes close to Impressionism. His watercolours are rare, mostly dating from early in his career, and are very competent wash drawings, with a preference for light greys, browns and pinks. Generally, his pure watercolours, as distinct from his coloured pen drawings, do not have the clarity of line which one would expect. He did occasional landscape sketches as well as figures.

Eamples: B.M.; Ashmolean; Fitzwilliam; N.G., Scotland; Tate Gall.
Bibliography: G.S. Layard: *The Life and Letters of C.S.K.*, 1892. G.S. Layard: *The Work of C.K.*, 1897. Sir L. Lindsay: *C.K.*, 1934. F.L. Emanuel: *C.K.*, 1935. D. Hudson: *C.K.*, 1947.

KELLY, Robert George Talbot, R.I.
1861 (Birkenhead) — 1934
The son of Robert George Kelly a portrait, figure and landscape painter, he was a painter of Eastern scenes, especially in Egypt, which he visited on several occasions, and Burma. He also painted in Iceland. He was a member of the R.B.A. and was elected R.I. in 1907. He lived in Liverpool and London, and he also painted genre subjects.

An exhibition of his Egyptian views was held at the Fine Art Society in 1902.

His son RICHARD BARRETT TALBOT KELLY (b. 1896) painted birds and historical subjects, and was elected R.I. in 1925.

Published: *Egypt*, 1902. *Burma*, 1905.
Illustrated: Sir R.C. Slatin: *Fire and Sword in the Sudan*, 1896.

KEMP, John
A portrait painter and drawing master. He studied at the Cork School of Art and taught at the Gloucester School of Art. He exhibited from 1868 to 1876 and may have emigrated to Australia the following year.

Examples: V.A.M.

KEMPE, Harriet
A London genre painter who exhibited from 1867 to 1892 at the R.A. as well as at Brighton and Birmingham.

KENDRICK, Emma Eleonora **1788 — 1871**
The daughter of a sculptor, she was a miniaturist and occasional subject painter. She exhibited at the R.A., O.W.S., N.W.S. and S.B.A. from 1811 to 1840 and was appointed Miniature Painter to William IV in 1830.

KENDRICK, Matthew, R.H.A. **c.1797 (Dublin) — 1874 (London)**
A marine painter who began as a sailor and entered the R.D.S. Schools in 1825. He exhibited at the R.H.A. between 1827 and 1872 and was elected A.R.H.A. and R.H.A. in 1832 and 1850, and served as Keeper from 1850 to 1866. He lived in London from 1840 until 1848, exhibiting at the R.A., the B.I. and the S.B.A. He then went back to Dublin where he practised until 1872 when, his right hand having become paralysed, he retired to London.

KENNEDY, Charles Napier, A.R.H.A.
1852 (London) — 1898 (St. Ives, Cornwall)
A portrait and figure painter in oil and watercolour who studied at the Slade and in Paris. He exhibited at the R.A. from 1872 to 1894, the S.B.A., and the R.H.A. from 1886, and was elected A.R.H.A. in 1896.

KENNEDY, Edward Sherard
A London genre painter in oil and watercolour who was working between 1863 and 1890.

KENNEDY, John
A Scottish landscape painter who was working about 1855. He was Master of the Dundee School of Art for a time.

Published: *The first grade Freehand Drawing Book*, 1863. *The first grade Practical Geometry*, 1863.
Examples: V.A.M.; N.G., Scotland.

KENNEDY, William Denholm 1813 (Dumfries) — 1865 (London)
After being educated in Edinburgh, he came to London, and in 1833 entered the R.A. Schools. He exhibited at the R.A. almost every year from 1833 until his death. In 1835 he won a gold medal for an historical painting, and from 1840 to 1842 he was sketching and studying in Rome. He frequently made designs for stained glass for Thomas Willemont.

He painted a variety of subjects, including portraits. His style was marked by his friendship with W. Etty (q.v.); and, after his stay in Rome, Italian influence is felt in his work.

Examples: B.M.

KENNEDY, Admiral William Robert — 1916
The artist of a folio of watercolours and plans relating to the China War of 1857 to 1860. He was promoted lieutenant in 1857, captain in 1874, rear-admiral in 1889, vice-admiral in 1896 and admiral in 1901.

Examples: Greenwich.

KENNION, Edward, F.S.A. 1744 (Liverpool) — 1809 (London)
Educated in Liverpool and London, he sailed for Jamaica in 1762 and accompanied the Cuban expedition. He returned to England after the capture of Havana but was in Jamaica again from 1765 to 1769 as manager of a cousin's estates and aide-de-camp to the Commander-in-Chief. From 1769 to 1782 he was in trade in London. He lived near Malvern for the next few years and was back in London as a drawing master during the winters of 1787 and 1788 and permanently from the following year. He became a member of the S.A. and exhibited at the R.A. from 1790 to 1807. From about 1782 he was working on a book on landscape painting, which he never finished. He made frequent visits to Liverpool and the Lakes sometimes with G. Barret (q.v.).

His earlier drawings are in ink or pencil, later tints are added and finally full colour. His drawing is accurate and he manages to differentiate between different types of foliage.

His son CHARLES JOHN KENNION (1789-1853) exhibited at the R.A. and Suffolk Street from 1804 to 1853 when he died in London. His work is similar to that of his father.

Published: *Elements of Landscape and Picturesque Beauty*. 1790. *An Essay on Trees in Landscape*, 1815.

KERR, Frederick James 1853 (Neath, Glamorgan) –
A landscape painter who began by working in oil but turned to
watercolour. He studied at the Swansea School of Art and at South
Kensington. He lived at Barry, S. Wales, and was for a time Chairman
of the South Wales Art Society.

KERR, Henry Wright, R.S.A., R.S.W.
 1857 (Edinburgh) – 1936 (Edinburgh)
A genre and landscape painter who studied in Dundee and at the
R.S.A. Schools. He visited Connemara in 1888 and exhibited in
London from 1890. He was elected A.R.S.A. and R.S.A. in 1893
and 1909.

Illustrated: E.B. Ramsay: *Scottish Life and Character,* 1909. J. Galt:
Annals of the Parish, 1910. G.A. Birmingham: *The Lighter Side of
Irish Life,* 1911. J. Galt: *The Last of the Lairds,* 1926.
Examples: Dundee City A.G.; N.G., Scotland.

KETTLE, Sir Rupert Alfred
 1817 (Birmingham) – 1894 (Wolverhampton)
Barrister, industrial arbitrator and amateur artist, he practised at
Oxford and in 1859 was appointed judge of the Worcestershire
County Courts. He established a system of arbitration in
Wolverhampton which was followed in other towns. In 1880 he was
knighted, and in 1882 elected a bencher of the Middle Temple.
 Several of his pictures were exhibited.

Examples: V.A.M.

KEYS, John 1798 (Derby) – 1825 (Derby)
Son of Samuel Keys, a decorator at the Derby Porcelain works. He
painted on china and on being discharged in 1821, taught flower
painting in Derby. His watercolours are very neat.

Published: *Sketches of Old Derby,* 1895.

KIDD, J
A topographer who visited Orkney in 1805.

Examples: N.G., Scotland.

KIDD, Joseph Bartholomew
 1808 (Edinburgh) – 1889 (Greenwich)
A pupil of Thomson of Duddingston (q.v.), Kidd was one of the
original A.R.S.A.s, becoming R.S.A. in 1829. In 1836 he moved
from Edinburgh to London and resigned from the Academy two
years later. He became a drawing master at Greenwich.
 His subjects are generally Highland or Lake District views. He
also painted portraits.

Illustrated: Sir T.D. Lauder: *The Miscellany of Natural History,*
1833.

KILBURNE, George Goodwin, R.I.
 1839 (Norfolk) – 1924
A genre painter who worked for the Dalziels for five years and
exhibited at the R.A. from 1863. He was elected N.W.S. in 1866.
Many prints were made from his work, which is almost entirely set
in the eighteenth century.

Examples: Haworth A.G., Accrington.

KINDON, Mary Evelina
A portrait, genre and landscape painter in oil and watercolour. She
exhibited from 1874 to 1919 at the R.A., the R.I. and elsewhere,
and lived in Chelsea, Croydon, Chalk Hill, Bushey and Watford.

KING, Daniel c.1622 (Chester) – c.1664 (London)
An engraver who was apprenticed to Randle Holme, the elder, for
ten years from 1630. He moved from Chester to London where he
produced drawings and engravings in the manner of Hollar. He was
said to be ' a most ignorant, silly fellow', and he made a bad
marriage.

Published: *The Vale Royall of England,* 1656. *The Cathedrall and
Conventuall Churches of England and Wales,* 1656. *Universal Way of*

Dyaling by G. de Desargues (trans.), 1659. *An Orthographical
Design of Severall Views upon ye Road in England and Wales,*
c.1660.
Examples: B.M.

KING, Haynes 1831 (Barbados) – 1904 (London)
A landscape and genre painter who came to England in 1854 and
studied at Leigh's Academy. He exhibited from 1855 and became a
member of the S.B.A. in 1864. For a time he shared a house with
his namesake H.J.Y. King, and he was killed by a train. He
specialised in cottage interiors.

Examples: V.A.M.; Derby A.G.

KING, Henry John Yeend, R.I. 1855 (London) – 1924 (London)
A landscape painter who began his career in a glassworks. He
became a pupil of William Bromley, an historical painter, and
studied in Paris, and he exhibited in London from 1874. He was
elected R.I. in 1887 and became Vice-President in 1901. His work is
very typical of his period with bright colours and a slight crudeness
of handling, and he sometimes shows the influence of Brabazon.

Examples: Reading A.G.

KING, Jessie Marion, Mrs. Taylor 1875 – 1949
An illustrator who exhibited from 1901 to 1940. She lived in
Glasgow from 1901 to 1908. Manchester from 1909 to 1910 and in
1912, Paris in 1911 and from 1913 to 1915, and thereafter at
Kirkcudbright. She married E.A. Taylor, an artist. She illustrated
Kipling and Milton and produced many lightly-coloured pen and ink
drawings of fairy-tale princesses in a style that is very much her
own, if influenced by the great late nineteenth century illustrators.

KING, Captain John Duncan 1789 – 1863 (Windsor Castle)
King entered the Army in 1806, served in the Walcheren expedition
and the Peninsular War and he was present at the Occupation of
Paris in 1815. He was promoted captain in 1830, in which year he
retired. He was made a military Knight of Windsor in 1852.
 He often exhibited his views of Spain, Portugal, Killarney,
Boulogne, and elsewhere at the R.A. and B.I.

KINNAIRD, Henry J
A landscape and cattle painter who exhibited in London from 1880
to 1908. He lived in London until 1886 and thereafter at Chingford,
Arundel and Lewes.

KINSLEY, Albert, R.I. 1852 (Hull) – 1945
A painter of woods, moors and rivers in oil and watercolour who
was brought up in Leeds and moved to London in 1879. He was a
drawing master and exhibited from 1881, being elected R.I. in
1896.

KIPLING, John Lockwood 1837 – 1911
An architect, sculptor and illustrator who was educated at
Woodhouse Grove and studied at South Kensington, taught at the
Bombay School of Art and was Principal of the Mayo School of Art,
Lahore, from 1865 to 1875. He was Curator of the Central Museum
at Lahore from 1875 until his retirement in 1893.
 He provided illustrations in a number of media for his son
Rudyard's Indian books and also produced wash drawings of
Indians.
 His wife was sister-in-law of Sir E.J. Poynter and Sir E.C.B.
Burne-Jones.

Published: *Beast and Man in India,* 1891.
Examples: India Office Lib.

KIRBY, John Joshua, F.R.S., F.S.A.
 1716 (Wickham Market) – 1774 (Kew)
A friend of Gainsborough who began his career in Ipswich as a
coach and house painter. In 1745 Gainsborough came to live in the
town and encouraged Kirby to try landscape painting. He began
with a series of drawings of the monuments of Suffolk and later
worked for Boydell and others. He gave three lectures on

perspective at the St. Martin's Lane Academy in 1764 and taught George III architectural drawing. The King appointed him Clerk of the Works at Kew Palace. He was briefly President of the Incorporated Society of Artists in 1768.

He is a neat and pleasant, if unadventurous, artist, working in the topographical tradition which continued down to the Bucklers.

His son WILLIAM KIRBY who died at Kew in 1771 was a member of the Incorporated Society from 1766.

Published: *Monasteries, Castles, Ancient Churches and Monuments in the County of Suffolk*, 1748. *Dr. Brook Taylor's Method of Perspective made Easy*, 1754.
Examples: B.M.

KIRCHHOFFER, Henry, R.H.A. 1781 – 1860 (London)
The son of Francis Kirchhoffer, a cabinet-maker working in Dublin, he entered the R.D.S. Schools in 1797, after which he practised as a miniature painter in Cork. He returned to Dublin in 1816, where he was a frequent exhibitor, and he became an original A.R.H.A., being elected R.H.A. in 1826. He exhibited there from 1826 to 1834, and acted as Secretary for a period up to 1830. He moved to London in 1835 and exhibited at the R.A. and elsewhere between 1837 and 1843. He lived for some years in Brighton.

He painted landscapes, portraits and figure subjects in watercolour and occasionally in oil.

Examples: N.G., Ireland.

KIRKPATRICK, Joseph
A painter of landscapes and rustic scenes rather in the manner of M.B. Foster (q.v.) or W.S. Coleman (q.v.). He worked in the Liverpool area and may have visited Jamaica in about 1903. He also lived at Curdridge, Hampshire for a time.

Examples: Haworth A.G., Accrington; Newport A.G.

KIRKUP, Seymour Stocker 1788 (London) – 1880 (London)
The son of a London diamond merchant, he entered the R.A. Schools in 1809. He became a friend of Blake and Haydon. In 1816 he paid his first visit to Italy and subsequently settled in Rome and Forence. In 1840 he was one of the discoverers of Giotto's missing portrait of Dante, for which he was later made a Cavaliere di SS Maurizio e Lazzaro. Owing to a misunderstanding he referred to himself as 'Baron' thereafter. In 1872 he moved to Leghorn and in 1875 married a twenty-two year old Italian.

He was a dilettante in his approach to painting and is best known for his chalk and watercolour portraits in the manner of Lawrence.

Examples: Ashmolean.

KIRWAN, William Bourke c. 1814 (Dublin) -
A landscape painter in the Morland tradition who exhibited in Dublin and London from 1836 to 1846. His work can be weak. In about 1850 he was involved in a celebrated criminal case.

Examples: B.M.

KITCHEN, T S
A landscape painter who lived in Peckham and exhibited from 1833 to 1852. He produced excellent studies of trees in pen and wash which are reminiscent of those of D.S. McColl (q.v.).

A MISS E.M. KITCHEN of Windsor was an unsuccessful candidate for the N.W.S. in 1856 and 1857. She exhibited fruit and flower subjects at the S.B.A. from 1850 to 1852.

KITTON, Frederick George
A painter of London views who exhibited with the Norwich Art Circle in 1886 and 1887. He was a prolific illustrator of, and commentator on, the works of Dickens.

Bibliography: Anon. *F.K., a Memoir*, 1895.

KNELL, William Adolphus c. 1805 - 1875
The best-known and best of a family of marine painters. He lived in London and perhaps Bristol, and exhibited in London from 1825 to

1866. He painted in oil and watercolour on the southern coasts of England and off France, Belgium and Holland. He used a distinctive dark green and rubbing for his seas.

WILLIAM CALLCOTT KNELL who worked between 1848 and 1871 and ADOLPHUS KNELL were probably his sons, and J. H. KNELL, working in 1833 and 1834, perhaps a brother.

Examples: Greenwich; N.G., Scotland.

KNEWSTUB, Walter John 1831 - 1906
A caricaturist and genre painter who was D.G. Rossetti's assistant in the 1860s and F.M. Brown's at Manchester Town Hall from 1878 to 1893. His caricatures belong to the early part of his career, and he exhibited from 1865 to 1881.

KNIGHT, Henry Gally 1786 - 1846 (London)
An architectural writer, playwright and polemicist, educated at Eton and Trinity College, Cambridge. In 1810 and 1811 he travelled in Spain, Sicily, Greece, Egypt and Palestine, producing publications in verse to illustrate these journeys. He studied architecture in Normandy in 1831 and Sicily in 1836. Whilst in England he managed his estate, Langold Hall, Yorkshire, and served in Parliament intermittently between 1824 and 1837, and from 1837 until his death as member for North Nottinghamshire. He was a friend of J.M.W. Turner (q.v.).

The drawings he made to illustrate his travels are in pencil with light washes.

Published: *An Architectural Tour of Normandy*, 1836. *The Normans in Sicily*, 1838. *Saracenic and Norman Remains to illustrate the 'Normans in Sicily'*, 1840. *The Ecclesiastical Architecture of Italy from . . . Constantine to the 15th Century*, 1842-4.

KNIGHT, John Baverstock 1788 (Langton, near Blandford, Dorset)
 – 1859 (Piddle Hinton, Dorset)
The son of a land agent and connoisseur who encouraged his many talents. He was educated at home and at Child Okeford. Later he assisted his father and toured Britain, Ireland and the Continent painting in oil and watercolour and sketching in chalk and pen and ink. He also made etchings and miniatures. He is said to have painted between five and six in the morning leaving the rest of the day for agriculture, sport and his other love, poetry.

His style is rather stilted and old-fashioned and his drawings have some affinity with the Towne school.

An exhibition of his work was held at the Goupil Gallery, London, in 1908.

Examples: B.M.; V.A.M.; Victoria A.G., Bath; Williamson A.G. Birkenhead; Blackburn A.G.; Brighton A.G.: Wiltshire Mus., Devizes; Co. Mus., Dorchester; Exeter Mus.; Fitzwilliam; Glasgow A.G.; Leeds City A.G.; Leicestershire A.G.
Bibliography: Rev. F. Knight: *J.B.K.*, 1908; D.S. MacColl: *Burlington*, May, 1919; *Dorset Year Book*, XXI, 1925.

KNIGHT, John Prescott, R.A. 1803 (Stafford) - 1881 (London)
A genre and portrait painter in oil and watercolour, he was the son of a comedian and came to London as a boy. He worked as a junior clerk to a West India merchant before studying at Sass's and with G. Clint (q.v.). As a portraitist he was largely unsuccessful so he turned to rustic genre, exhibited from 1824 and was elected A.R.A. and R.A. in 1836 and 1844. He was Professor of Perspective in 1839 and Secretary in 1848.

Examples: B.M.; V.A.M.
Bibliography: *A.J.*, 1849.

KNIGHT, John William Buxton 1843 (Sevenoaks) - 1908 (Dover)
Although the son of a landscape painter, he was self-taught to begin with. He worked for a while at Knole Park with J. Holland (q.v.) and was advised to enter the R.A. Schools by Landseer, which he did in 1860. He exhibited from 1863 and won a gold medal at Paris in 1889.

His subjects are often views in Kent and are a fusion of the English and French traditions of landscape. He painted in oil and watercolour and was an etcher and engraver.

An exhibition of his work was held at the Goupil Gallery in 1897, and a memorial exhibition was held at the British Galleries, Bradford, in 1908.

Examples: B.M.; V.A.M.; Williamson A.G., Birkenhead; Cartwright Hall, Bradford; Derby A.G.; Fitzwilliam; Leeds City A.G.
Bibliography: *A.J.*, 1908.

KNIGHT, Joseph, R.I. 1837 (London) - 1909 (Bryn Glas, Conway)
A landscape painter in oil and watercolour, he taught himself to paint while working for a photographer. He then attended the Manchester Academy and exhibited in London from 1861. He moved to London in 1871 and to North Wales in 1875. He was elected R.I. in 1882. He lost his left arm in early life.

Sometimes his Welsh landscapes are in the Birket Foster manner. He also etched.

Examples: V.A.M.; Tate Gall.
Bibliography: Manchester Brazenose Club: *Exhibition Cat.*, 1878.

KNIGHT, Joseph, of Bury 1870 (Bolton) - 1950
A landscape painter and etcher who studied in Paris and became Headmaster of Bury Art School.

Published: with H.B. Carpenter: *Introduction to the History of Architecture*, 1929.

KNIGHT, Richard Payne 1750 - 1824 (London)
A collector and amateur artist, Knight was the son of the Rev. Thomas and a member of the Shropshire ironworks family. He spent several years in Italy from 1767 and returned there in 1777, visiting Sicily with Philipp Hackert and C. Gore (q.v.). He was a prolific writer, usually on artistic subjects, and his collections of bronzes, statues, pictures and coins in London and at Downton, Herefordshire were justly famous. He was M.P. for Leominster from 1780 and Ludlow from 1784 to 1806. He was Townley trustee of the B.M. from 1814.

Examples: Townley Hall, Burnley.

KNIVETON, William
A Dublin landscape painter who exhibited at Parliament House in 1802 and Dame Street in 1804. Two aquatints after his drawings were published by del Vecchio in Dublin.

KNOWLES, George Sheridan, R.I. 1863 - 1931
A medieval and Imperial genre painter who lived in London. He exhibited from 1885 and was elected R.I. in 1892, later serving as Treasurer. He was also a member of the R.B.A.

KNOX, Archibald 1864 - 1933
A landscape painter who sketched and taught in many parts of the country. He was the founder of the Knox Guild of Design and Crafts and lived in Douglas, Isle of Man, from 1895.

Examples: Manx Mus.

KNOX, George James 1810 - 1897
This artist is probably to be identified with the grandson of the 1st Earl of Ranfurly. His watercolours, which are fairly common, show a decided penchant for sunsets and snow-covered landscapes, usually in combination. He also painted beach scenes. He exhibited at the R.A. and Suffolk Street from 1839 to 1859.

Examples: Cape Town A.G.

KOEHLER, George Frederic, Brigadier-General

- 1800 (Jaffa)
A pupil of Sandby at Woolwich, he made reconnaissances in Corsica with Sir John Moore in 1794. His drawings of enemy positions, which Moore praised highly, were included in his official report. He was of German origin and was commissioned 2nd lieutenant in the Royal Artillery during the siege of Gibraltar in 1780. He distinguished himself and became a favourite aide-de-camp of Lord Heathfield, with whom he later travelled and who recommended him to the Belgian rebels against the Austrians in 1790. Thereafter he served in Gibraltar, Toulon in 1793, Corsica and Newcastle-upon-Tyne, and headed a mission to Constantinople in 1799. He died while visiting the Syrian front. The cannon in the background of the famous portrait of Heathfield was designed by Koehler.

Examples: Greenwich.

KYD, James
A genre painter who lived in Worcester. He exhibited from 1855 to 1875.

'KYD'
The nom d'artiste of Joseph Clayton Clarke who made a series of spirited watercolour sketches of Dickens's characters. They were published in 1889.

LA CAVE, Peter
A painter of rustic figures and landscapes in the Bergham tradition, who was probably a member of a family of French artists working in Holland. He was in England from at least 1789 to 1816 and painted in Worcestershire, Berkshire, Devonshire and Wilton, where he was in prison in 1811. He was a friend of Ibbetson and probably an assistant to Morland.

His finished watercolours are pretty, conventional and rather weak. His pencil drawings are much stronger and were admired by Cotman. He had a number of pupils, some of whom seem to have added their signatures to his works. Among them were J.R. Morris (q.v.) and John Thomas Gower.

Examples: B.M.; V.A.M.; Derby A.G.; Fitzwilliam; Leeds City A.G.; London Mus.; Newport A.G.
Bibliography: *The Examiner*, August 4, 1811. *Walker's Quarterly*, July, 1922. *Walker's Monthly*, August, 1929. *Apollo*, December, 1947.

LADBROOKE, Henry 1800 (Norwich) – 1870 (Norwich)
Second son of R. Ladbrooke (q.v.), he was a landscape painter and drawing master at North Walsham and King's Lynn. He exhibited at Norwich and in London from 1818 to 1865.

LADBROOKE, John Berney 1803 (Norwich) – 1879 (Norwich)
A pupil of his uncle John Crome, he was primarily an oil painter. He exhibited at Norwich from 1816 to 1833 and in London from 1822 to 1859. Although almost all of his life was spent in Norfolk, he seems to have visited the Lakes in the 1850s.

His younger brother Frederick was a portrait painter at Bury St. Edmunds.

Published: *Select Views of Norfolk and its Environs*, 1820.
Examples: Castle Mus., Norwich.
Bibliography: W.F. Dickes: *The Norwich School*, 1905.

LADBROOKE, Robert 1770 (Norwich) – 1842 (Norwich)
A landscape painter in oil and watercolour who was apprenticed to an engraver and shared a boyhood studio with his friend J. Crome (q.v.). In 1793 he married Crome's sister-in-law. He set up as a teacher and picture dealer. In 1803 he helped to found the Norwich Society and was a keen supporter of the exhibitions from 1805. He seems to have visited Wales at about this time. He was Vice President of the Society in 1808 and President for the following year. In 1816 he quarrelled with Crome and led the secession from the Society. His rival exhibition collapsed after 1818, and by 1824 he had returned to the fold. By this time he had given up teaching in order to concentrate on his *Norfolk Churches*.

His work is generally disappointing, especially the churches, which are very ordinary. His colour is generally muddy and his drawing indistinct. However, he could sometimes rise to higher things, and then his work is a little reminiscent of Varley.

Published: *Views of the Churches of Norfolk*, 1843.
Examples: B.M.; Castle Mus., Norwich.
Bibliography: W.F. Dickes: *The Norwich School*, 1905.

LAING, James Garden 1852 (Aberdeen) – 1915
He trained and worked as an architect in Aberdeen before he began painting watercolours. Although he produced landscapes, he was best known for his church interiors, which are influenced by Bosboom and other Dutch contemporaries whom he met on sketching tours of Holland.

Examples: Glasgow A.G.; Paisley A.G.

LAIRD, Alicia H.
A painter of Scottish genre scenes who exhibited at the Society of Female Artists and elsewhere from 1846 to 1865.

Examples: Hove Lib.

LAIT, Edward Beecham
A painter of landscapes with figures who was living in Brighton in 1874. His work seems to be influenced by his neighbours, the Earps.

LAMB, S
An artist who visited Iona in 1838. His work is light and pleasing.

LAMBERT, Clement 1855 – 1925 (Brighton)
A landscape, coastal and genre painter who lived in Brighton and exhibited from 1880. He was a member of the Brighton Fine Art Committee.

Examples: Hove Lib.

LAMBERT, George 1710 (Kent) – 1765
A landscape and scene painter who studied under Warner Hassells and John Wootton. He worked for John Rich at Lincolns Inn Fields theatre and at Covent Garden. The Beefsteak Club is sometimes said to have originated in his suppers in the painting loft. He was a friend of Hogarth and sometimes collaborated with S. Scott (q.v.). He was a member of the Society of Artists with whom he exhibited from 1761 to 1764 and a founder and first President of the Incorporated Society. T.T. Forrest (q.v.) was a pupil.

Although his oil paintings were painted in the manner of Poussin and Rosa, his watercolours belong to the typically English group embracing Taverner and Skelton, and independent of the Sandby tradition. As opposed to Sandby's method of careful outlining with the pen, the watercolour is applied loosely with a characteristic dappled effect, especially in the foliage, over a soft pencil basis.

He also produced Italian landscapes in pen and brown wash, sometimes in collaboration with Zuccarelli.

A loan exhibition of his work was held at Kenwood in 1970.

Examples: B.M.; N.G., Scotland.
Bibliography: *Country Life*, July 23, 1970.

LAMBERT, James 1725 (Jevington, Sussex) – 1788 (Lewes)
A self-taught landscape painter, Lambert began his career in Lewes producing inn signs. He exhibited at the S.A., the R.A. and elsewhere from 1761. Sir William Burrell commissioned several hundred watercolours of Sussex antiquities. Lambert was also a musician and was organist of St. Thomas-at-Cliffe.

His colour is said to have been good, but his drawings have usually faded badly. They are a little primitive in style. His son JAMES LAMBERT, YR (c.1760-c.1834) worked in a similar manner.

Illustrated: Watson: *History of the Earls of Warren*.
Examples: B.M.; V.A.M.; Leeds City A.G.
Bibliography: W.H. Challen: *Baldy's Garden, the Painters Lambert*, etc. 1952.

LAMBERT, John c.1640 (Calton, Yorkshire) – 1701 (York)
Son of General John Lambert, he was an amateur artist and friend of F. Place (q.v.). On the death of his father – who had painted flowers and Oliver Cromwell – in 1683, he inherited the family's Yorkshire estates, which had been held in trust since the Restoration. He was said by Thoresby to be 'a most exact limner'.

LAMBORNE, Peter Spendelowe 1722 (London) – 1774 (Cambridge)
An engraver, miniaturist and architectural draughtsman, he studied in London under Isaac Basire, but practised in Cambridge. He exhibited with the Incorporated Society from 1764 to 1774.

LAMONT, Thomas Reynolds, A.R.W.S. 1826 – 1898
A Scot who studied in Paris – he was 'the Laird' of du Maurier's
Trilby – and in Spain. He painted landscapes and figures and was
elected A.O.W.S. in 1866, having stood unsuccessfully for the
N.W.S. in the previous year. After about 1880 he painted little. He
lived in St. John's Wood and on an estate near Greenock.

Examples: V.A.M.; Glasgow A.G.

LAMPLOUGH, Augustus Osborne
 1877 (Manchester) – 1930 (Abergele)
A North African and Venetian architectural painter who studied at
Chester School of Art. Later he lectured at Leeds School of Art. His
architectural and Venetian subjects generally occur early in his
career. From about 1902 he concentrated on North Africa, and in
particular, Egypt. He lived in North Wales.
 Various exhibitions of his work were held in London, including
Egyptian views at the Fine Art Society in 1917.

Published: *Cairo and its Environs*, 1909. *Winter in Egypt. Egypt and
How to see it. The Flight of the Turkish Invaders.*
Illustrated: P. Loti: *La Mort de Philae.* P. Loti: *Egypt*, 1909.
Examples: Grosvenor Mus., Chester; Newport A.G.

LANCASTER, Percy, R.I. 1878 (Manchester) – 1951
A landscape painter in the tradition of Cox and Collier. He studied
at the Manchester School of Art and lived at Southport. He was
elected R.I. in 1921.

Examples: Towner Gall., Eastbourne; Leicestershire A.G.; Newport
A.G.; Portsmouth City Mus.; Preston A.G.

LANCE, George
 1802 (Dunmow, Essex) – 1864 (Sunnyside, near Birkenhead)
Primarily an oil painter of fruit and flower still-lifes, Lance studied
under B.R. Haydon (q.v.), and at the R.A. Schools. He was
encouraged by Beaumont to paint still-lifes, and exhibited at the
B.I. from 1824 and the R.A. from 1828. He also exhibited historical
and genre subjects in oil. He was brother-in-law of J.W. Archer
(q.v.).
 His watercolours are merely versions of his oils. Sir J. Gilbert
(q.v.) and W. Duffield (q.v.) were pupils.

Examples: B.M.
Bibliography: *A.J.*, October, 1857. August, 1864.

LANDELLS, Ebenezer
 1808 (Newcastle-upon-Tyne) – 1860 (London)
A wood-engraver, illustrator and founder of *Punch*, he was
apprenticed to Bewick and then worked for John Jackson and
William Harvey in London. He also worked for the *I.L.N.*, the
Lady's Newspaper and the *Queen*, and had numerous pupils and
assistants including M.B. Foster (q.v.), the Dalziels and Edmund
Evans. He was artist-correspondent for the *I.L.N.* and specialised in
sketching Royal tours.
 His eldest son ROBERT THOMAS LANDELLS (1833-1877) was
also an artist and war correspondent for the *I.L.N.*, covering the
Crimean, Prusso-Danish and Franco-Prussian wars. He also painted
in oil.

LANDSEER, Charles, R.A. 1799 (London) – 1878 (London)
The second son of John Landseer A.R.A., the engraver, he was a
pupil of B.R. Haydon (q.v.) and entered the R.A. Schools in 1816.
He went to Portugal with Lord Stuart de Rothesay's mission and on
to Rio de Janeiro. The sketches and drawings which resulted were
exhibited at the B.I. in 1828. In the same year he began to exhibit
literary and costume pictures at the R.A. He was elected A.R.A. and
R.A. in 1837 and 1845 and was Keeper from 1851 to 1873.

Illustrated: W. Scrope: *Days of Deerstalking*, 1883. W. Scrope: *Days
and Nights of Salmon Fishing*, 1898.
Examples: B.M.; V.A.M.; Ashmolean.
Bibliography: *A.J.*, 1879.

LANDSEER, Sir Edwin Henry, R.A.
 1802 (London) – 1873 (London)
The youngest son of John Landseer A.R.A., he was one of the most
fashionable painters of the nineteenth century. He can hardly be
called a watercolourist, but his drawings are very fine and he made
brown wash studies and caricatures which are very close to those of
his friend Wilkie.

Examples: B.M.; V.A.M.; Fitzwilliam; Maidstone Mus.; Nottingham
Univ.; N.G., Scotland.
Bibliography: S. Maun: *The Works of Sir E.L.*, 1843. A. Chester:
The Art of Sir E.L., 1920. V.A.M. M S S., c.1820-1919; *Fraser's
Mag.*, July 1856. *A.J.*, 1873. *Apollo* XLIX, 1949. *Country Life*, Feb.
24, 1972. R.A. *Exhibition Cat.*

LANDSEER, George c.1834 – 1878 (London)
Son of T. Landseer (q.v.), he exhibited from 1850 to 1858 and went
to India. There he painted landscapes and portraits of prominent
Indians in oil and watercolour. He returned to England in about
1870 and gave up painting because of poor health.

Examples: V.A.M.

LANDSEER, Thomas, A.R.A. 1795 (London) – 1880 (London)
The eldest son of John Landseer A.R.A. whose assistant he became.
Like his brothers he was a pupil of Haydon. Most of his life was
spent in engraving his brother's pictures. He also made occasional
designs of his own, notably the series *Monkeyana*, 1827. He was
elected A.R.A. in 1868.

Published: *The Life and Letters of W. Bewick*, 1871.
Examples: B.M.

LANE, Rev. Charlton George c.1840 – c.1892
Educated at Christ Church, Oxford, he was first curate of Great
Witley, Worcestershire, from 1866 to 1868, then of Eddlesborough
from 1868 to 1870. In that year he was presented with the living of
Little Gaddesden and became librarian to Earl Brownlow at
Ashridge, Hertfordshire. He visited Venice early in his career and
most of his exhibited works are of Venetian scenes. He often
worked on a small scale and his style is a mixture of that of W.
Callow (q.v.) and the best of T.B. Hardy (q.v.).

LANE, Theodore 1800 (Isleworth) – 1828 (London)
The son of a drawing master from Worcester, he was apprenticed to
J.C. Barrow (q.v.). He exhibited watercolour portraits and
miniatures at the R.A. in 1819, 1820 and 1826. He also produced a
number of humorous prints including *A Trip to Ascot Races*, 1827.
He took up oil painting in about 1825 with the encouragement of
Alexander Fraser R.S.A. He fell through a skylight in the Grays Inn
Road before his promise could be realized. He was left-handed.

Published: *The Life of an Actor*, 1825.
Illustrated: P. Egan: *Anecdotes of the Turf*, 1827.
Examples: B.M.

LANGLEY, Walter, R.I. 1852 (Birmingham) – 1922 (London)
Apprenticed to a Birmingham lithographer, he became a partner in
the business after studying at South Kensington. However, in 1880
he went to Newlyn, Cornwall, for a holiday and in 1881 to Brittany.
The following year he settled in Newlyn and took up painting full
time. He was elected R.I. in 1883 and exhibited in London from
1880 to 1919. He was in Holland in 1905-1906. He was one of the
founders of the Newlyn colony, and H.S. Tuke (q.v.) described him
as: 'I should think the strongest water-colour man in England'. His
work is truthful and traditional in technique, and his favourite
subjects, Cornish and Breton fisherfolk.

Examples: Leicestershire A.G.

LANSDOWN, Henry Venn 1806 – 1860
A landscape painter and topographer who settled in Bath in 1830 and
was a pupil of B. Barker of Bath (q.v.). He produced both
watercolours and brown wash drawings. Some of the latter were

used to illustrate Meehan's *Famous Houses of Bath*.

Examples: Victoria A.G., Bath.

LAPORTE, George Henry, N.W.S.1799 (Hanover) − 1873 (London)
The son of J. Laporte (q.v.), he exhibited sporting subjects at the R.A. and elsewhere from 1818. He was a member of the N.W.S. from 1834 and was Animal Painter to the King of Hanover. Some of his works were engraved for the *New Sporting Magazine*.

LAPORTE, John 1761 − 1839 (London)
A pupil of J.M. Barralet, he became drawing master at Addiscombe Military Academy as well as taking many private pupils including Dr. Monro (q.v.). He exhibited at the R.A. and B.I. from 1785 and was a founder of the short-lived A.A. He and W.F. Wells (q.v.) produced a series of soft-ground etchings after Gainsborough.

Laporte worked in both water and bodycolour, occasionally combining them with soft-ground etching. Much of his topographical work is influenced by Sandby, but occasionally there are hints of early Turner. He frequently uses the compositional device of a strong line - of a wood or cliff - at a diagonal to the horizon.

His daughter MARY ANNE LAPORTE exhibited portraits and fancy subjects at the R.A. and B.I. from 1813 to 1822. She was a member of the N.W.S. from 1835 to her retirement, because of illness, in 1846.

Published: *Characters of Trees*, 1798-1801. *Progressive Lessons Sketched from Nature*, 1804. *The Progress of a Water-Colour Drawing*, 1812.
Examples: B.M.; V.A.M.; Aberdeen A.G.; Haworth A.G., Accrington; Leeds City A.G.; Leicestershire A.G.; Newport A.G.
Bibliography: *Walker's Quarterly*, July, 1922.

LATHAM, Oliver Matthew c.1828 −
An Irish soldier and amateur artist who entered the R.D.S. Schools in 1844. He enrolled as an ensign in the 48th Regiment in 1847 and was promoted captain in 1852. He exhibited at the R.H.A. in 1849 and the R.I.A. in 1859, and he retired from the Army in 1860.

Apart from some drawings of the Crimean War which he worked up from sketches, he painted mainly landscapes.

LATHAM, Captain William
A captain in the Royal Lancashire Militia who toured the Isle of Man with S.D. Schwarbreck (q.v.) in 1815 - they brought the news of Napoleon's abdication to the island. He also sketched in Wales, the Lake District, Yorkshire, Lancashire, Cheshire, Buckinghamshire, Sussex, the Isle of Wight, Somerset and the Hebrides. He may have been the editor of a projected history of Cheshire in 1800.

Examples: Manx Mus.; Co. Record Office, Preston; N. Lib., Wales.

LAUDER, Charles James, R.S.W. 1841 − 1920 (Glasgow)
The son of a portrait painter, he studied in Glasgow and painted landscapes. Many of his subjects were found in Venice and on the Thames.

Examples: Dundee City A.G.; Paisley A.G.

LAW, David 1831 (Edinburgh) − 1901 (Worthing)
A landscape painter and etcher who was apprenticed to an engraver and studied at the Trustees' Academy from 1845 to 1850. Thereafter he worked for twenty years as an engraver in the Ordnance Office in Southampton before resigning to concentrate on his watercolours. He painted Scottish, Welsh and Southern landscapes and often made etchings from his own watercolours.

Illustrated: O.J. Dullea: *The Thames*, 1882.
Examples: Dundee City A.G.; Sydney A.G.
Bibliography: *A.J.*, 1902.

LAWLESS, Matthew James 1837 (Dublin) − 1864 (London)
Chiefly known for his book illustrations, he also drew and painted genre subjects and exhibited at the R.A. from 1858. On leaving

Dublin for London he studied at the Langham School and under H. O'Neill (q.v.). His numerous illustrations for books and periodicals met with great success. He was a member of the Junior Sketching Club.

Examples: B.M.

LAWRENCE, Mary, Mrs. Kearse
She exhibited flower pieces at the R.A. between 1794 and 1830, and in 1799 published a monograph on roses. In 1804, when she was living in Queen Anne Street, London, and giving lessons in botanical drawing, she attempted to use the patronage of Charles Greville (q.v.) and the influence of Farington to promote her pictures at the Academy. Farington declined to help. She married Mr. Kearse in 1813.

Her works were said to be 'more remarkable for the beauty of their execution than for their botanical accuracy'.

Published: *The Various Kinds of Roses cultivated in England*, 1799.
Bibliography: *Farington Diary*, April 9, 1804.

LAWRENSON, Edward Louis 1868 (Dublin) −
A landscape painter who was active between 1908 and 1934 and lived in London and at Hadlow Down, Sussex.

Examples: Hove Lib.

LAWSON, Cecil Gordon
** 1851 (Wellington, Shropshire) − 1882 (London)**
His father, William Lawson, was a Scottish portrait painter who brought Lawson to London with him in 1861. He was self-taught, making fruit studies in the meticulous manner of W.H. Hunt. Most of his brief career was taken up with large scale oil paintings, but he also made small preliminary studies and vigorous landscapes in watercolour. His form of impressionism was well fitted to catch the atmosphere and to hint at the detail of his subjects, which were taken from many different parts of the country, including Kent, Yorkshire and Scotland. In the winter of 1881 he went to the Riviera for his health. He shares something of the inspiration of Cox and Cotman in their last years, and has a kinship with A.W. Rich (q.v.), although he does not employ Rich's technical formulae.

His wife CONSTANCE LAWSON, daughter of John Birnie Philip, the sculptor, exhibited watercolours of flowers at the R.A. and elsewhere. They were married in 1879.

Examples: B.M.; V.A.M.; Ashmolean; Cecil Higgins A.G., Bedford; Cartwright Hall, Bradford; Glasgow A.G.; Leeds City A.G.; N.G., Scotland.
Bibliography: Sir E.W. Gosse: *C.L. Memoir*, 1883. *A.J.*, 1882. *Connoisseur*, CXIV, 1944.

LAWSON, Brigadier-General Robert
** c 1742 − 1816 (Woolwich)**
A pupil of Sandby at Woolwich who made good use of his talent in his military career. He entered the Academy in 1758 and was commissioned at the end of the following year. He served at the siege of Belle Isle and at Gibraltar and in America from 1776 to 1783. He then commanded the artillery in Jamaica for three years. In 1799 he was in command at Newcastle-upon-Tyne and subsequently throughout the Egyptian campaign. He was in charge of the anti-invasion fortifications of London and Chatham from 1803. His son Lieutenant-Colonel Robert Lawson (d. 1819) served in the Peninsula.

Lawson was the author of several military memoranda which he illustrated with exquisite fully coloured drawings in the Sandby manner.

LEAR, Edward 1812 (Highgate, London) − 1888 (San Remo)
With childhood lessons and encouragement from his sister Ann, by the age of fifteen Lear was already showing a talent - and even finding a market − for natural history drawings. He produced bird drawings for the publisher Gould, who claimed authorship of some of them, and took a number of lessons from T.H. Cromek (q.v.). In 1831 he was working at the Zoological Gardens as a draughtsman, and

in the following year published his first book. He attracted the notice of Lord Derby, and spent four years at Knowsley, working on the bird illustrations for Derby's privately printed *Knowsley Menagerie*, 1856. Through Derby he built up a good practice as a drawing master, and in 1846 gave lessons to the Queen.

Lear's extensive travels began in 1831 or 1832 with a visit to Holland, Switzerland and Germany. He was in Ireland in the summer of 1835 and went to Rome, by way of Belgium, Germany and Switzerland, in 1837. He based himself there until 1848, making a visit to England in 1845 and his first tour of Greece, Albania and Malta in 1848. In 1849 he was in Egypt and again in Greece, and then returned to England to enter the R.A. Schools. At this point he came under the influence of Holman Hunt, with whom he worked near Hastings. In December 1853 he went to Egypt again and from 1855 to 1857 based himself in Corfu for the winters, visiting Greece, the Holy Land and London in the summers. The winters of 1858 and 1859 were spent in Rome, those of 1860 and 1861 in Corfu, 1864 in Nice, 1865 in Malta, 1866 in Egypt and thereafter generally at Cannes where he settled, passing many of his later summers at Monte Generoso, Switzerland. He re-visited Athens in 1864, Rome in 1871, set out for India, reaching Suez, in 1872 and actually went to India in the following October, leaving Ceylon in December 1874. His last visit to England was in 1880. In 1881 he made his last move from Cannes to San Remo.

At his death he left more than ten thousand cardboard sheets of sketches. They vary from the merest pen and ink jottings to elaborate and even highly-coloured pieces. Almost all are well annotated with times, dates, colour hints, reference numbers and so forth. He was, in fact, a watercolour draughtsman in the school of Towne rather than a typical Victorian watercolour painter. Even in his finished works, in which he employs brilliant colours, it is almost always the drawing in brown ink which takes first place. The colours in both sketches and finished works are generally laid on in a very smooth and characteristic manner. He never achieved the success and popularity which he sought as a painter - he was perhaps saddened that his fame as a nonsense writer should overshadow what he considered his real achievements as an artist. He tried to achieve academic recognition by painting in oil, but he rarely matched up to his skill with watercolour.

Published: *Journal of a landscape painter in Albania, S. Calabria, Corsica*, 1870. Etc.
Examples: B.M.; V.A.M.; Ashmolean; Cartwright Hall, Bradford; Glasgow A.G.; Greenwich; Harvard Lib.; India Office Lib.; Leeds City A.G.; Newport A.G.; N.G., Scotland; Southampton A.G.; Ulster Mus.
Bibliography: A Davidson: *E.L.*, 1938. P. Hofer: *E.L. as a Landscape Draughtsman*, 1967. Vivien Noakes: *E.L.: the Life of a Wanderer*, 1968. *Antique Collector*, August, 1963. *Country Life*, November 9, 1929; October 8, 1964. *Connoisseur*, CLXIV, 1967.

LEAVER, Noel Harry 1889 (Austwick, Yorkshire) - 1951
A painter of North African street scenes. He studied at the Burnley Art School and at South Kensington, where he won a travelling studentship, and the R.I.B.A. For a time he taught at the Halifax Art School, before returning to live at Burnley.

His work is notable for the hot blue skies which often contrast with shadowed buildings.

LE CAPELAIN, John 1814 (Jersey) - 1848 (Jersey)
A marine painter who worked in London from 1832. After Queen Victoria's visit to Jersey a volume of his drawings of the island scenery was presented to her, and she commissioned him to paint the Isle of Wight.

He specialized in coast scenes and a misty or foggy effect.

Examples: B.M.; Jersey Mus.

LEE, Lady Elizabeth, née Harcourt 1739 - 1811
Sister of the 2nd Earl Harcourt, she was train-bearer to Queen Charlotte at her marriage. In 1763 she married Sir William Lee, Bt. Like her brothers (q.v.) she was a pupil and friend of Sandby, and

she made small monochrome landscapes in his manner. She may also have attempted Cozens's blot method.

Examples: B.M.

LEE, Frederick Richard, R.A.
1794 (Barnstaple) - 1879 (Vleesch Bank, Malmsay, Sth. Africa)
After a period in the Army serving in the Netherlands, Lee entered the R.A. Schools in 1818. He exhibited at the B.I. from 1822 and the R.A. from 1824. He lived mainly in Devon but visited the coasts of France, Spain and Italy in his yacht. He was elected A.R.A. in 1834 and R.A. in 1838. He retired in 1870 and died on a visit to some of his family in South Africa.

His subjects were usually coast scenes or river and woodland landscapes, but he also produced still-lifes. Figures were often added to his work by T.S. Cooper, Landseer and others. He was primarily an oil painter but left many sketches as well as finished watercolours.

His brother JOHN LEE was an architect and occasional exhibitor of drawings.

Examples: B.M.; V.A.M.
Bibliography: *A.J.*, 1879.

LEE, John
A genre painter in oil and watercolour who exhibited from 1889 to 1900. He lived in London, Middleton-in-Teesdale and Darlington.

Examples: Bowes Mus., Durham.

LEE, William, N.W.S. 1810 - 1865 (London)
A member and secretary of the Langham Sketching Club, he was elected A.N.W.S. in 1845 and N.W.S. in 1848, occasionally exhibiting there as well as at the R.A. and S.B.A. He was best known for rustic subjects and French coastal scenes.

Published: *Classes of the Capital*, 1841.
Examples: V.A.M.; N.G., Ireland.
Bibliography: *A.J.*, May, 1865.

LEECH, John 1817 (London) - 1864 (London)
The son of John Leech, proprietor of the London Coffee House and an amateur artist, he was educated at Charterhouse and trained to be a surgeon. He even worked as a doctor for a while but had turned professional artist by 1885. From this time he became one of the most prolific and successful illustrators. He was a keen huntsman and many of his most successful drawings and etchings are of the hunting field. Millais taught him to paint in oil, and he held an exhibition of his oil paintings in the Egyptian Hall, Piccadilly, in 1862. This proved such a success that he was inundated with orders for copies of his pictures, which he produced with the aid of a rubber stamp, and sold for a hundred guineas each.

Examples: B.M.; Fitzwilliam; Leicestershire A.G.; Ulster Mus.
Bibliography: F.G. Kitton: *J.L.*, 1883. W.P. Frith: *J.L.*, 1891. *A.J.*, December, 1864. *Country Life*, October, 13, 1934. January-March, 1943; November 15, 1946; October 29, 1964.

LEFEVRE, Rachel Emily, SHAW
See GORDON, Rachel Emily, Lady Hamilton

LEGGE, Lady Barbara Maria - 1840
The youngest daughter of the 3rd Earl of Dartmouth, her drawings show the influence of her kinsman Lord Aylesford (q.v.). She married Francis Newdegate in 1820.

LEGGE, Lady Charlotte - 1877
The second daughter of the 3rd Earl of Dartmouth, in 1816 she married the very Rev. and Hon. George Neville Grenville, Master of Magdalene, and Dean of Windsor. She, together with her sister Barbara Maria (q.v.), was influenced by Lord Aylesford (q.v.), their first cousin. Their father GEORGE LEGGE, EARL OF DARTMOUTH was a pupil of J.B. Malchair (q.v.) and produced drawings in the same tradition.

LEGGE, Charlotte Anne, Hon. Mrs. Perceval
The daughter of Augustus George, fifth son of William, 2nd Earl of Dartmouth, she married in 1825 the Hon. and Rev. Arthur Philip Perceval. She was perhaps the best of her family as a landscape painter, and her work has sometimes been mistaken for that of Lear.

LEICESTER, Sir John Fleming See DE TABLEY, Lord.

LEIGH, James Mathews 1808 1860 (London)
The founder of the Newman Street drawing school, rival to that of Sass. He studied under W. Etty (q.v.) and first exhibited at the R.A. in 1830. He made two Continental visits.
 He painted historical and religious subjects. His remaining works were sold at Christie's, June 25, 1860.

Published: *Cromwell*, 1838, *The Rhenish Album*.

LEIGHTON, Frederic, Lord, P.R.A., R.W.S.
1830 (Scarborough) - 1896 (London)
The son of a doctor who travelled widely, Leighton was determined to become an artist after a visit to G. Lance's (q.v.) studio in Paris in 1839. He was educated in London, Rome, Dresden, Berlin, Frankfurt and Florence. In 1848 he spent a year studying in Brussels, and he was in Paris in 1849. Thereafter he returned to Frankfurt for a three year study under Johann Eduard Steinle. He finally settled in London only in 1860, moving to Leighton House six years later. In 1868 he went up the Nile with de Lesseps. He was elected A.R.A. and R.A. in 1864 and 1868, becoming President in 1878. In 1873 he re-visited Egypt. He was created a baronet in 1886 and a peer on the day before his death.
 He was primarily an oil painter in the classical mould of Burne-Jones and Poynter. His drawings and watercolours are usually preliminary studies for oil paintings.
 His remaining works were sold at Christie's, July 11 and 13, 1896.

Examples: B.M.; V.A.M.; Ashmolean; Fitzwilliam; Reading A.G.
Bibliography: Mrs. A. Lang: *Sir F.L. Life and Works*, 1884. G.C. Williamson: *Frederic, Lord L.*, 1902. E. Staley:: *Lord L.*, 1906. Mrs. R. Barrington: *The Life, Letters and Work of F.L.*, 1906. L. & R. Ormond: *Lord L.*, 1975. *A.J.*, 1896.

LEIGHTON, Mary, Lady, née Parker
(Sweeney Hall, Oswestry) – 1864
In 1830, two years before her marriage to Sir Baldwin Leighton, Bt., of Loton Hall, Shropshire, she accompanied her brother Rev. John Parker (q.v.) to Palestine, where they both sketched. Some of his work is in the National Library of Wales. Her second son STANLEY LEIGHTON, M.P. (1837-1901) was the author and illustrator of *Salop Houses Past and Present*, 1902.

LEITCH, Richard Principal
The brother of W.L. Leitch (q.v.), he was a successful drawing master, writing several instructional books, and he exhibited from 1840. He also painted landscapes in a formalized manner, using a characteristic grey for all shadows. He was active as late as 1875.

Published: with J. Callow: *Easy Studies in Water-Colour Painting*, 1881. Etc.
Examples: B.M.; V.A.M.; Maidstone Mus.; Newport A.G.

LEITCH, William Leighton, R.I. 1804 (Glasgow) - 1883 (London)
A landscape painter who was apprenticed in Glasgow to a lawyer and to a weaver, meanwhile practising drawing at night with David Macnee, later P.R.S.A. He next worked under Mr. Harbut, a decorator and sign-painter. In 1824 he was painting scenery at the Glasgow Theatre Royal, and, on the theatre's collapse, spent two years in Mauchline, painting snuff box lids. He then moved to London, worked for the Pavilion Theatre, and took lessons from Copley Fielding. He exhibited at the S.B.A. in 1832. He also drew for Mr. Anderden, a stockbroker, who in 1833 gave him the money to visit Italy, where he remained until July 1837, having journeyed through Holland, Germany and Switzerland. He travelled widely in Italy and Sicily, sketching and teaching. On his return he built up a successful practice as a landscape drawing master, his pupils including Queen Victoria, and he exhibited at the R.A. and elsewhere. In 1862 he was elected to the N.W.S., serving as Vice-President for twenty years.
 His work is pleasant and competent, but in no way original. Despite the idyllic haze in which his landscapes bask, they seldom portray any true depth of feeling. This is especially true of his later paintings, when he has found his own formula. The drawings of his earlier years, particularly those inspired by Italy, show more freedom and imagination. His colours are warm, and he is fond of a misty purple for distant hills. His recipe for landscape became the over-romanticised 'trees - lake - mountain' formula employed by many Victorian artists.
 His remaining works were sold at Christie's, March 13-17 and April 17, 1884, and drawings from the sale bear a studio stamp.
 His son ROBERT LEITCH (d. 1882) was also a watercolour painter.

Examples: B.M.; V.A.M.; Williamson A.G., Birkenhead; Cartwright Hall, Bradford; Dundee City A.G.; Glasgow A.G.; N.G. Scotland.
Bibliography: A. MacGeorge: *Memoir of W.L.*, 1884.

LE JEUNE, Henry L , A.R.A. 1820 (London) - 1904
Of a musical family, he showed an early inclination towards art, and was sent to study in the B.M. In 1834 entered the R.A. Schools, and from 1845 to 1848 taught at the Government School of Design, leaving this post to become curator of the R.A. He first exhibited at the R.A. in 1840 and was elected A.R.A. in 1863. He painted historical and rustic genre subjects and children.

Bibliography: *A.J.*, September, 1858.

LEMAN, Robert 1799 1863
A talented amateur landscape painter who was a pupil of J.S. Cotman at Norwich. He was a member of the Norwich Amateur Club in the 1830s and exhibited at the Norwich Society. He was a friend and patron of many of the later Norfolk painters.

Examples: B.M.; V.A.M.

LE MARCHANT, Major-General John Gaspard
1766 (Channel Islands) - 1812 (Salamanca)
Commissioned in the Inniskilling Dragoons, he was stationed in Dublin and Gibraltar. Having incurred heavy gambling debts, he turned to sketching and music to keep himself from further temptation. On returning to England he commanded the King's Escort from Dorchester to Weymouth, and his drawings of Gibraltar were shown to the King, and won him Royal patronage. He was promoted rapidly and fought through the Flanders Campaign of 1793. In 1802 he was the co-founder of the Military College at High Wycombe and Marlow, and was engaged in a complicated dispute with General and Mrs. Harcourt (later Countess of Harcourt, q.v.), over the appointment of the first drawing master, although both parties eventually settled upon W. Alexander (q.v.). He fought in the Peninsula and was sketching up to the morning of his death, which occurred whilst leading a charge at the Battle of Salamanca.
 His earlier landscapes are in the manner of Farington – who had taught his brother-in-law P. Carey (q.v.) in 1791. Le Marchant later took lessons from W. Payne (q.v.), from whom he learnt to make watercolours rather than tinted drawings. Alexander, at Marlow, completed his artistic education, and his later drawings show a distinct professionalism.

Bibliography: Sir D. Le Marchant: *Memoirs of the late Major General Le M.*, 1841.

LE MOYNE DE MOROGUES, Jacques (Dieppe) - 1588 (London)
A Huguenot who was cartographer and artist on de Laudonnière's expedition to Florida in 1564. He escaped to London after St. Bartholomew and became a friend of Sir Philip Sidney, Hakluyt and Sir Walter Raleigh, who commissioned him to make new versions of his American maps and drawings.

Published: *La clef des champs . . .*, 1586.
Illustrated: T. de Bry: *America*, 1591.

Examples: B.M.
Bibliography: S. Lorant: *The New World*, 1946. *B.M. Quarterly*, XXVI.

LENS, Bernard, III 1682 (London) - 1740 (Knightsbridge)
The son and pupil of Bernard Lens, II, who had made many topographical drawings in England, he was a miniaturist and drawing master. He studied at the Academy of Painting in Great Queen Street. He became Limner to George I and George II, taught at Christ's Hospital, and his private pupils included the Duke of Cumberland, the Princesses Mary and Louisa, and Horace Walpole.

His work includes grey wash topographical views of London, Herefordshire, Shropshire, Bristol and Somerset, Portsmouth and elsewhere, as well as watercolour copies of Rubens, Vandyck and others, and *trompe l'oeils*.

Unfortunately, although all officially miniaturists, any of the members of this dynasty may have made wash and watercolour landscapes which can be confused with those of Bernard III. They are his grandfather BERNARD I (1631-1708), his father BERNARD II (1659-1725) and his three sons BERNARD IV, PETER PAUL and ANDREW BENJAMIN, all of whose dates are unknown.

Examples: B.M.

LEONARD, John Henry 1834 (Patrington) - 1904 (London)
Between 1849 and 1860, he worked as an architectural draughtsman and lithographer and was a pupil of W. Moore (q.v.). He was then in Newcastle for two years before settling in London in 1862. From this time he concentrated on landscapes, occasionally reverting to architectural subjects. He painted in France, Belgium and Holland, and from 1886 until his death he was Professor of Landscape Painting at Queen's College, London. He remains always a precise and often rather old-fashioned draughtsman, but at his best his landscapes are Mole-like and his sheep in the manner of T.S. Cooper.

Examples: B.M.
Bibliography: *A.J.*, 1909.

LESLIE, Charles Robert, R.A. 1794 (Clerkenwell) - 1859 (London)
A literary and historical painter in oil and watercolour, whose family emigrated to Philadelphia in 1800. There he studied with George Sully and was apprenticed to a New York bookseller before returning to England and Benjamin West in 1811. He entered the R.A. Schools in 1813 and first exhibited at the R.A. in the following year. He was elected A.R.A. and R.A. in 1821 and 1826. He visited Brussels and Paris in 1817, and in 1833 he went back to America as drawing master at West Point, but returned the following spring. From 1847 to 1852 he was Professor of Painting at the R.A. He was a close friend of Constable, and a perceptive critic.

His drawings are often in brown wash and of humorous subjects, in the vein and manner of J.J. Chalon (q.v.).

Published: *Life of Constable*, 1845. *Handbook for Young Painters*, 1854. *Life of Sir Joshua Reynolds. Autobiographical Recollections*, 1860.
Examples: B.M.; V.A.M.; Williamson A.G., Birkenhead; Derby A.G.; Hove Lib.; Castle Mus., Nottingham.
Bibliography: J. Dafforne: *Pictures by C.R.L.*, 1875. J. Constable: *The Letters of J.C. and C.R.L.*, 1931. *A.J.*, March-April, 1856, 1902, 1911.

LESLIE, George Dunlop, R.A.
** 1835 (London) - 1921 (Lindfield, Sussex)**
The younger son of C.R. Leslie (q.v.) and brother of Robert Charles Leslie, the marine painter. He studied at the R.A. Schools, exhibited from 1857 and was elected A.R.A. and R.A. in 1868 and 1875. He painted figures in gardens or interiors as well as landscapes, usually in the Thames Valley, and occasional historical scenes. He was mainly an oil painter but produced watercolours in a similar vein. He was a member of the St. John's Wood Clique and later lived at Wallingford.

Bibliography: *Portfolio*, 1894. *Studio*, XXI, 1921. *Connoisseur*, LIX, 1921.

LESLIE, Sir John, 1st Bt. 1822 (London) - 1916 (London)
An amateur artist who lived at Glaslough, Co. Monaghan and was M.P. for the county. He was educated at Christ Church, Oxford, served as a captain in the Life Guards and was created baronet in 1876. He painted hunting subjects and portraits and was a pupil of K.F. Sohn in Düsseldorf.

Examples: County Mus., Armagh.

LESSORE, Jules, R.I. 1849 (Paris) - 1892
The son and pupil of a French painter and engraver, he worked for the most part in England painting landscapes and genre subjects. He exhibited from 1879 and was elected R.I. in 1888.

Examples: V.A.M.; Glasgow A.G.

LETHABY, William Richard 1857 - 1931
An architect and draughtsman who was appointed Architect to Westminster Abbey in 1906. He lived in London and was F.R.I.B.A. He wrote copiously on architectural and artistic subjects.

Examples: B.M.; City A.G., Manchester; R.I.B.A.
Bibliography: Sir R.T. Blomfield: *W.R.L.*, 1932; Tate Gall: *Exhibition Cat.*, 1932.

LETHERBROW, John Henry 1836 - 1883
A Manchester landscape painter who was the brother of T. Letherbrow (q.v.), and whose work was influenced by the Pre-Raphaelites.

LETHERBROW, Thomas 1825
Elder brother of J.H. Letherbrow (q.v.), he worked in a similar, if softer style. He was also a book illustrator.

LEVINGE, Sir Richard George Augustus, Bt.
** 1811 - 1884**
An amateur artist who was in North Wales in 1844 and toured France, Italy and Switzerland in the following year. His drawings are in rather old-fashioned brown wash.

Published: *Echoes from the Backwoods*, 1846. *A Day with the Brookside Harriers at Brighton*, 1858. *Historical Records of the 43rd Regiment*, 1867. *Jottings for Early History of the Levinge Family*, 1873.

LEWIN, John William
The brother of W. Lewin (q.v.), he was also a naturalist who spent nine years, about 1805, in Paramatta, New South Wales, drawing the Aborigines, fauna and insects.

Published: *Prodromus Entomology*, 1805. *The Birds of New Holland*, 1808-22.
Examples: B.M.
Bibliography: P.M. Jones: *J.W.L.*, 1953.

LEWIN, William - 1795
A naturalist who was elected a fellow of the Linnaean Society in 1791, he lived in Kent in 1792 and Hoxton in 1794. The first edition of *The Birds of Great Britain Accurately Figured* was published in seven volumes, 1789-95, and was engraved and coloured by Lewin. His sons helped with the descriptions. The second edition was published in eight volumes, 1795-1801. He also engraved the plates for *The Insects of Great Britain systematically Arranged, Accurately Engraved, and Painted from Nature*, 1795, but unfortunately delegated the colouring to assistants.

His work is lively although the colouring can be crude and the birds badly proportioned.

His brother J.W. Lewin is separately noticed.

LEWIS, Charles James, R.I. 1830 (London) - 1892 (London)
He exhibited at the R.A. from the age of seventeen, and at the S.B.A. and the B.I. In 1882 he was elected R.I. He lived for many years in Chelsea.

He painted small genre scenes and, later in his career, landscapes.

Examples: Newport A.G.

LEWIS, Frederick Christian 1779 (London) - 1856 (Enfield)
The elder brother of G.R. Lewis (q.v.), he was an engraver and landscape artist. He studied under J.C. Stadler and at the R.A. Schools. He met Girtin, whose Paris etchings he aquatinted (published 1803). He worked under John Chamberlain, aquatinted pl. 43 of Turner's *Liber Studiorum,* and between 1808 and 1812 was engaged on Ottley's *Italian School of Design.* He also worked for Sir Thomas Lawrence and for members of the Royal Family. He exhibited landscapes in oil and watercolour at the R.A., the B.I. and the O.W.S. His early views are taken from Enfield, where he lived for some years, and later from Devonshire, which he visited frequently, and where his patrons included the Duke of Bedford, Lord Mount-Edgecumbe, and Sir J. Dyke Acland.

Published: *Scenery of the Devonshire Rivers,* 1821-7.
Examples: B.M.; V.A.M.; Fitzwilliam; Newport A.G.
Bibliography: *Walker's Monthly,* May, 1929; *A.J.,* February, 1857.

LEWIS, George Lennard 1826 (London) - 1913 (London)
A cousin of J.F. Lewis (q.v.), he exhibited landscapes from 1848 including French and Portuguese views. He was an unsuccessful candidate for the N.W.S. in 1857 and 1861 and is perhaps the least talented of the family. His wife painted views in Brittany.

Examples: B.M.; V.A.M.; Sydney A.G.

LEWIS, George Robert 1782 (London) - 1871 (Hampstead)
Younger brother of F.C. Lewis (q.v.), with whom he lived at Enfield. He studied at the R.A. Schools under Fuseli, exhibiting landscapes there from 1805 to 1807. He worked with his brother for John Chamberlaine and Ottley. In 1818 he was draughtsman to Dr. Dibden on his Continental tour. He exhibited at the R.A., B.I., Suffolk Street and the Oil and Watercolour Society between 1820 and 1859.

He painted landscapes, figure subjects and portraits, several of the latter being engraved.

Published: *Views of the Muscles of the Human Body,* 1820. *Banks of the Loire illustrated - Tours; The Ancient Font of Little Walsingham Church,* 1843. Etc.
Illustrated: Dibden: *Bibliographical and Picturesque Tour through France and Germany,* 1821.
Examples: B.M.; Leeds City A.G.

LEWIS, Jane M., Lady, née Dealy, R.I.
 - 1939
A genre painter and illustrator of children's books who exhibited from 1879. She was elected R.I. in 1887 and married Sir Walter Lewis in 1887. She lived in Blackheath.

Examples: Sunderland A.G.; Ulster Mus.

LEWIS, John Frederick, R.A., P.O.W.S.
 1805 (London) - 1876 (Walton-on-Thames)
His father F.C. Lewis (q.v.) and uncle being distinguished engravers, Lewis learnt to etch and draw almost as soon as he could read. He was a childhood friend of Edwin Landseer, and shared his practice of sketching the animals in the menagerie at Exeter Change. Since he was more interested in drawing then engraving, his father agreed that he could become a painter if he could sell a picture at a London Exhibition. This he did at the age of fourteen. Sir Thomas Lawrence was impressed by his talent and employed him for a year as an assistant to work on the backgrounds of his portraits. In 1822 he began to exhibit at the R.A. and in 1824 and 1825 he published six mezzotints after his own drawings of lions and tigers. George IV then employed him to paint sporting subjects at Windsor. In 1827 he was elected A.O.W.S. and made his first foreign journey to Germany, the Tyrol and Northern Italy. In 1829 he became a full member of the Society and in 1830 sketched in the Highlands. At this point he was still primarily an animal painter, but his rare landscapes, with their use of Chinese white and their attention to minute detail, point the way to his later development. In 1832 he went to Spain, and returned to England in 1834. This led not only to a change in his subject matter but also to a change in style. His

colour becomes more striking and his handling is looser. His work is in some ways reminiscent of that of Cotman at the same time. He left England again in 1837 and went to Rome by way of Paris and Florence. He remained there for two years, leaving for the East in 1840. He went first to Constantinople, passing through Albania and Athens. In November 1840 he moved on to Egypt and based himself on Cairo for ten years. Although he painted profusely whilst there, he sent nothing to London for exhibition between 1841 and 1850, and was asked to resign from the O.W.S. Consequently he sent to London a picture entitled *Hhareemm* which caused a sensation by its technical brilliance and won Ruskin's unqualified praise. He returned home in 1851, having accumulated enough material to last the rest of his career. He was elected P.O.W.S. in 1855 but in 1858 resigned both Presidency and membership to become an oil painter, both because this was more lucrative and because he wished to gain membership of the Academy. He was elected A.R.A. in 1859 and R.A. in 1865.

Although never one of the Pre-Raphaelite brethren, his style and technique in many ways anticipated theirs. He was a craftsman of brilliance, using bright, gem-like colours and showing a fascination for the effects of light in all its aspects, which won the admiration of Holman Hunt and Millais as well as of Ruskin. He is perhaps the most accomplished user of bodycolour in English painting. His career can be clearly divided into three phases, the early animal drawings and studies from Italy and the Highlands; the Spanish subjects; and the full maturity of his Eastern works.

On July 5, 1855 he sold 140 of his sketches, including studies, in Spain, Belgium, Italy, Greece and the East, at Christie's. His remaining works were also sold at Christie's, May 4-7, 1877.

Examples: B.M.; V.A.M.; Aberdeen A.G.; Ashmolean; Blackburn A.G.; Cartwright Hall, Bradford; Fitzwilliam; Leeds City A.G.; Leicestershire A.G.; City A.G., Manchester; Portsmouth City A.G.; N.G., Scotland.
Bibliography: H. Stokes: *J.F.L.,* 1929. *A.J.,* February, 1858, 1876. O.W.S. Club, III, 1926. *Walker's Quarterly* XXVIII, 1929, *Burlington,* LXXX, May, 1942.

LEWIS, John Hardwicke
 1842 (Hyderabad) - 1927 (Veylaux, Switzerland)
The nephew of J.F. Lewis (q.v.), he painted portraits, genre subjects and landscapes in oil and watercolour. He was a pupil of his father Frederick Christian 'Indian' Lewis, Yr. and of Couture in Paris. From 1875 to 1885 he was in California drawing for newspapers, and thereafter he settled in Switzerland, where he illustrated a number of books. His work is thin and accurate.

Examples: V.A.M.; Worcester City A.G.

LEWIS, Shelton
A landscape painter who lived in Wiltshire, Henley and London and exhibited a North Welsh view at Glasgow in 1878. He also exhibited at the S.B.A. in 1877 and 1880.

LEWIS, William
An uncle of J.F. Lewis (q.v.), he was an amateur landscape painter in oil and watercolour, exhibiting at the R.A., the N.W.S. and elsewhere from 1804 to 1838.

Examples: V.A.M.; Newport A.G.

LEYDE, Otto Theordore, R.S.A., R.S.W.
 1835 (Wehlau, Prussia) - 1897 (Edinburgh)
A lithographer and genre painter in oil and watercolour who settled in Edinburgh in 1854. He was elected A.R.S.A. and R.S.A. in 1870 and 1880 and served as Librarian. At the end of his career he turned to etching.

Examples: Williamson A.G., Birkenhead.

LIDDELL, T Hodgson 1860 (Edinburgh) - 1925 (London)
A writer and topographer who was educated at the Royal High School, Edinburgh, and travelled in China. He later worked at Worcester and became a member of the R.B.A.

A W.F. LIDDELL painted London views from about 1900 to 1927.

Published: *China: its Marvel and Mystery*, 1909.

LIDDERDALE, Charles Sillem 1813 – 1895
A rustic figure and landscape painter who exhibited from 1851 and lived in London. He generally painted on a small scale in both oil and watercolour and occasionally produced metropolitan genre subjects. He was a member of the R.B.A.

LIGHT, Colonel William
A lieutenant in the 4th Dragoons from 1807, he was promoted major in the 13th Fusiliers in 1817. He provided de Wint with the sketches which he worked up for *Sicilian Scenery*, 1823.

Bibliography: A.F. Stewart: *A Short Sketch of the Lives of Fancis and W.L.*, 1901.

LILLIE, Denis Gascoigne
An amateur caricaturist who served as Marine Biologist aboard H.M.S. *Terra Nova* on Scott's last expedition, 1910-1913. He produced caricatures while living in Cambridge in 1908 and 1909, and may have done others while at Westward Ho and Birmingham University. In 1919 he suffered a breakdown from which he never fully recovered, and although he survived for several years after, it put an end to his drawing. An example of his work in pencil and watercolour is illustrated in a letter to *Country Life*, September 12, 1968.

Examples: Scott Institute for Polar Research, Cambridge.

LINDNER, Moffatt Peter, R.W.S. 1852 (Birmingham) - 1949
A landscape and marine painter in oil and watercolour who studied at the Slade and Heatherleys. He was a member of the N.E.A.C. and of the R.I. from 1906 to 1916, transferring to the R.W.S. in the following year. He worked in London and St. Ives and was noted for Venetian views, some of which were exhibited, together with views of Holland, at the Fine Art Society in 1913.

LINDSAY, Sir Coutts, Bt., R.I. 1824 - 1913 (London)
A soldier and playwright who painted portraits and genre subjects in watercolour, exhibiting from 1862. He founded the Grosvenor Gallery in 1878 with his wife, Blanche Fitzroy, a still-life painter. Until their separation and its closure in 1890 the Gallery provided a centre for the aesthetic movement. Lindsay was elected R.I. in 1879.

LINDSAY, Robert - 1836
The second son of the 5th Earl of Balcarres, he was a rather weak topographer working in the 1780s.

Examples: B.M.

LINDSAY, Thomas, N.W.S. 1793 (London) - 1861 (Hay-on-Wye)
A landscape painter who was elected to the N.W.S. in 1833. He lived in London and Greenwich drawing Thames views and later retired to Hay-on-Wye and Welsh scenery. His drawing and colouring are generally weak.

Examples: B.M.; V.A.M.

LINDSAY, Thomas M.
A painter of coastal and genre subjects and landscapes. He lived at Rugby and exhibited with the Birmingham Society from 1881 to 1898 and at the R.I. in 1893.

LINES, Henry Harris 1800 (Birmingham) - 1889 (Worcester)
The elder brother of S.R. Lines (q.v.), he painted landscapes in Warwickshire and on the Welsh borders. He exhibited in London from 1818 to 1846 and may have stayed there for a while towards the end of his life. In about 1830 he settled in Worcester as a drawing master and a sale of his remaining works was held there in 1889.

Examples: V.A.M.; City A.G., Birmingham; Grosvenor Mus., Chester; Maidstone Mus.; Worcester City A.G.

LINES, Samuel Restell 1804 (Birmingham) - 1833 (Birmingham)
The son of SAMUEL LINES (1778-1863), a Birmingham drawing master who was a co-founder of a life academy in Peck Lane, New Street, and of the Birmingham School of Art and later treasurer of the Birmingham Society of Artists. Samuel Restell was taught by his father, showed a talent for sketching trees, and was employed in making drawings for lithographs in exercise books. He exhibited at the N.W.S. and elsewhere in 1832 and 1833. He also specialized in views of picturesque buildings, such as Haddon Hall.

Examples: V.A.M.; City A.G., Birmingham; Maidstone Mus.

LINNELL, John 1792 (Bloomsbury) - 1882 (Redhill)
A landscape painter in oil and watercolour, he was the son of a wood-carver and picture dealer and was copying pictures and drawings by the age of ten. He entered the R.A. Schools in 1805 and was a pupil of B. West (q.v.) and J. Varley. At Varley's house he met W. Henry Hunt (q.v.) and W. Mulready (q.v.), with whom he sketched and shared rooms. He was also a member of the Monro circle. He sketched on the Thames between 1805 and 1809 and in the latter year visited Hastings with Hunt. From 1811 to 1815 he made many sketches in the London Parks as well as at Windsor, in Wales and the Isle of Wight, and he was employed by A. Pugin (q.v.). He was a member of the Oil and Watercolour Society from 1813 to 1820 and was Treasurer in 1817. He painted portraits at this time and built up a teaching practice. In 1818 he met Blake and he introduced him to Varley. He toured Wales with G.R. Lewis (q.v.) in 1812 or 1813 and visited Derbyshire in 1814. He moved to Hampstead in 1824, and to Bayswater in 1829. In 1852 he built himself a house at Redhill. He abandoned portrait painting in 1847, having amassed a considerable fortune, and concentrated on landscape. His watercolours are really adjuncts to his oil paintings, but he was a brilliant sketcher and he is seen to the best advantage in the scraps and memoranda which he made in the sandpits at Hampstead or Paddington. His finished watercolours tend to be rather laboured.

He was the father-in-law of S. Palmer (q.v.), whose art he is traditionally, and unjustly, held to have ruined, and his sons JAMES THOMAS LINNELL (1820-1905), WILLIAM LINNELL (1826-1906) and JOHN LINNELL YR. all became painters, for the most part in oil. John, Yr. was also a naturalist.

Examples: B.M.; V.A.M.; Aberdeen A.G.; Ashmolean; Cartwright Hall, Bradford; Fitzwilliam; Leeds City A.G.; Newport A.G.; Ulster Mus.; Walsall A.G.
Bibliography: A.T. Story: *Life of J.L.*, 1892. *A.J.*, 1859, 1872, 1883.

LINTON, Sir James Dromgole, P.R.I.
1840 (London) - 1916 (London)
An historical, figure and portrait painter who studied at Leigh's School and began his career as a black and white illustrator for the *Graphic*. He exhibited from 1863 and was elected A.N.W.S. and N.W.S. in 1867 and 1870, twice serving as President, from 1884 to 1898 and from 1909 until his death. He was knighted in 1885. His work is in the medieval and Stuart tradition of G. and C. Cattermole (q.v.), but lacks their conviction.

Examples: V.A.M.; Ashmolean; Cartwright Hall, Bradford; Dundee City A.G.
Bibliography: *A.J.*, 1891.

LINTON, William 1791 (Liverpool) – 1876 (London)
At about sixteen he was apprenticed to a Liverpool merchant, meanwhile taking any opportunity to escape to North Wales and the

Lakes to sketch. He also copied the Richard Wilsons at Ince Blundell Hall, Lancashire. He came to London, and first exhibited at the R.A. and B.I. in 1817. He helped found the S.B.A. He left for Italy in 1828, where he remained for fifteen months. In 1840 he travelled through Italy, Sicily, Calabria and Greece. The drawings from this tour were exhibited at the N.W.S. In 1842 he resigned his membership of the S.B.A., but continued to exhibit with them until 1871, and in 1869 was made an honorary member.

He painted landscapes, classical and religious compositions and worked up his Italian and Greek sketches for many years after his visits.

His remaining works were sold at Christie's, February 15, 1877.

Published: *Ancient and Modern Colours ...*, 1852. *The Scenery of Greece and its Islands*, 1856. *Colossal Vestiges of the Older Nations*, 1862.
Examples: B.M.; V.A.M.
Bibliography: *A.J.*, 1850, January, 1858.

LINTON, William James 1812 (London) - 1898 (New Haven, Conn.)
An engraver, poet and political reformer. He was apprenticed to the wood engraver George Wilmot Bonner and later did much important work, particularly for the *I.L.N.* He also ran a succession of libertarian and republican papers. He lived for a time in Northumberland and at Brantwood, later Ruskin's Lake District home, returning to London in 1855 and emigrating to the U.S.A. in 1866. There he had a profound influence on wood engraving and illustration.

Published: *The Masters of Wood Engraving*, 1890. Etc.

LINTOTT, Edward Barnard 1875 (London) -
A landscape and portrait painter in oil and watercolour, he studied in Paris with brilliant academic success. In 1915 he was acting Librarian at the R.A. He was also art editor of the Woman's supplement of *The Times* in 1918 and 1919 and art adviser to *The Times* in the following year. Thereafter he worked as an examiner for the Board of Education. He visited America and Russia during the Revolution.

Published: *The Art of Watercolour Painting*, 1926.
Illustrated: W.G. King: *The Philharmonic-Symphony Orchestra of New York*, 1940.
Examples: V.A.M.

LISTER, Harriet, see GREEN, Harriet, Mrs.

LITTLE, Robert W , R.W.S., R.S.W.
1854 (Greenock, Glasgow) — 1944 (Tunbridge Wells)
The son of a ship-owner, he sailed to France, Spain and the Mediterranean as a youth. After studying at the R.S.A. Schools from 1876 to 1881 he went to Rome, where he worked at the British Academy, and to Paris, where he studied under Dagan-Bouveret. In 1886 he was elected R.S.W. and in 1892 A.R.W.S., becoming a full Member in 1899. He was Vice-President of the R.W.S. from 1913 to 1916. He painted not only landscapes, often Italian views, but also domestic genre subjects. His work is perhaps too soft in technique and in sentiment.

An exhibition of his Italian landscapes was held at the Fine Art Society in 1907.

Examples: Derby A.G.; Dundee City A.G.; Greenock A.G.; Portsmouth City Mus.

LITTLETON, Lucy Ann
A painter who lived in Bridport, Dorset, she exhibited a Lake District view in Glasgow in 1878.

LIVERSEEGE, Henry 1803 (Manchester) — 1832 (Manchester)
In 1827 he came to London to study at the B.M., and to copy the old masters at the B.I. He failed to gain admission to the R.A. Schools, and returned to Manchester in 1828. He re-visited London in 1829, returning to Manchester the following year. He made only one further visit to London.

He painted historical and romantic compositions and portraits. He was the brother-in-law of A.G. Vickers (q.v.).

Examples: B.M.; V.A.M.
Bibliography: C. Swaine: *Memoirs and engravings from the works of H.L.*, 1835. G. Richardson: *The works of H.L.*, 1875.

LIVESAY, Richard c. 1750 - 1826 (Portsmouth)
A pupil and assistant to Benjamin West P.R.A., he began to exhibit at the R.A. in 1776. In the 1790s he lived at Windsor, working as a portrait painter, and giving drawing lessons to the Royal children. In about 1797 he was appointed drawing master to the Portsmouth Naval Academy and described himself as a 'portrait, landscape and marine painter'. At some point in his career he lived in Bath.

JOHN LIVESAY, who was a writing master at Portsmouth Dockyard from about 1799 to 1832, painted watercolours of ships. There is an example of his work at Greenwich. A later F. LIVESAY of Portsmouth exhibited at the S.B.A. from 1869 to 1877.

Examples: Greenwich.

LLOYD, Robert Malcolm
A marine, coastal and landscape painter who was working in London, Kent, Sussex and Northern France between 1879 and 1900. He lived at Catford Bridge, Kent, and in Central London.

LLOYD, Thomas James, R.W.S. 1849 - 1910
A landscape, genre and marine painter who exhibited from 1870 and was elected A.R.W.S. and R.W.S. in 1878 and 1886. He lived in London and then at Walmer Beach and Yapton, Sussex. He was generally known as Tom Lloyd.

Examples: Cardiff A.G.; Shipley A.G., Gateshead; Glasgow A.G.

LLOYD, W Stuart
A painter of landscape and marine watercolours which are at worst ghastly and at best sub-T.B. Hardy. He lived in Brighton, worked between 1875 and 1913 and was a member of the R.B.A.

LOAT, Samuel c. 1802
An architect who entered the R.A. Schools in 1823 and gained the Gold Medal in 1827. In 1828 he was awarded a Travelling Studentship and went to Italy. He exhibited an architectural view at the R.A. in 1832.

LOBLEY, James 1829 (Hull) - 1888 (Bradford)
He studied at the Leeds School of Art and taught at the Mechanics Institute, Bradford, before resigning to devote himself to painting. He lived in Bradford and Brighouse and exhibited at the R.A. from 1865 to 1887. He painted church interiors in the manner of Webster, and portraits. He was to a certain extent influenced by the Pre-Raphaelites, particularly by Holman Hunt.

Examples: Cartwright Hall, Bradford.

LOCK, William, of Norbury 1732 - 1810 (Norbury)
A collector and amateur artist who purchased the estate of Norbury, near Mickleham, Surrey, in 1774. His circle included Fanny Burney, Mme. de Staël and the French refugees. His work is Italianate, in pen and wash.

Bibliography: Duchess of Sermoneta: *The Locks of Norbury*, 1940.

LOCK, William, of Norbury, Yr. 1767 — 1847
A friend and pupil of Fuseli who drew landscape in various media as well as figure compositions and caricatures in Fuseli's manner. These can be very free in a rather modern way with light blue and brown washes. He sold Norbury in 1819 and thereafter lived in Rome and Paris.

His son WILLIAM LOCK III was a captain in the Life Guards and also an amateur artist. He was drowned in Lake Como in 1832.

Examples: B.M.; V.A.M.; Ashmolean; Leicestershire A.G.
Bibliography: Duchess of Sermoneta: *The Locks of Norbury*, 1940.

LOCKER, Edward Hawke, F.R.S.
1777 (East Malling, Kent) — 1849 (Uxbridge)
A competent topographical watercolourist, he was educated at Eton and in 1795 entered the Navy Pay Office. In 1804 he became Civil Secretary to Lord Exmouth, serving with him in the East Indies from 1804 to 1809, the North Sea in 1810 and the Mediterranean from 1811 to 1814. He lived at Windsor from 1815 to 1819, when he became secretary of Greenwich Hospital. He was civil commissioner there from 1824 to 1844. He was co-editor of the magazine *The Plain Englishman,* 1820-23. In 1823 he contributed works from his collection to the first loan exhibition at the O.W.S. and organised the establishment of the gallery of naval pictures at Greenwich. He was the father of F. Locker Lampson.

His watercolours are generally charming if a little unsure in handling.

Published: *Views in Spain,* 1824. *Memoirs of Celebrated Naval Commanders . . . ,* 1832.
Examples: B.M.; V.A.M.; Greenwich; Victoria A.G., Bath.

LOCKHART, William Ewart, R.S.A., A.R.W.S., R.S.W.
1846 (Annan, Dumfriesshire) — 1900 (London)
A painter best known for his large oil paintings of Victorian ceremonies and Spanish landscapes. He was elected R.S.A. and A.R.W.S. in 1878. In 1863 he went to Australia for health reasons and in 1867 made the first of several visits to Spain. His watercolours, both landscapes and figures, are quieter and less studied and sometimes show a kinship with Bough's informality.

Examples: Dundee City A.G.; Glasgow A.G.; Paisley A.G.; N.G., Scotland.

LOFTHOUSE, Mary, Mrs., née Forster, A.R.W.S.
1853 (Wiltshire) — 1885 (Lower Halliford-on-Thames)
The daughter of T.B.W. Forster, a Wiltshire landscape painter, she exhibited at the R.A. in 1876 and 1878 beginning with French subjects, and sent a number of drawings to the Dudley Gallery. In 1884 she was elected A.R.W.S. and married S.H.S. Lofthouse, a barrister, but died shortly afterwards. Many of her views are in Normandy, others are in Wales, Norwich and Richmond, Yorkshire.

LONG, John O , R.S.W.
A Scot who lived in London and painted coastal subjects in oil and watercolour. He exhibited from 1868 to 1882 and found subjects in Scotland and the West Country.

LONG, John St. John
1789 (Newcastle, Co. Limerick) — 1834 (London)
A painter, drawing master and engraver who studied at the R.D.S. Schools. In 1822 he came to London and studied under J. Martin (q.v.). He worked briefly as an engraver under W.J. Ottley, afterwards taking up painting full-time. He exhibited at the S.B.A. and B.I. In 1827 he turned to medicine, advocating a cure for rheumatism, but one of his patients died under his treatment and he was charged with manslaughter. He was later acquitted, and continued to live in Harley Street. Bonington was brought to him from Paris, but got no benefit from the experience, dying within days.

LONG, M E
A member of the Gurney family who married a Mr. Long. She painted small and pretty rural scenes in the manner of Birket Foster.

LONGCROFT, Thomas
A topographer working in London from about 1786 to 1811. He painted Indian views in watercolour and wash.

Examples: B.M.; V.A.M.

LONGMIRE, W T
An artist who lived at West Bromwich and painted Lake District views in the 1870s and 1880s.

LONSDALE, James 1777 (Lancaster) — 1839 (London)
A portrait painter in oil who studied under Romney and at the R.A. Schools. He had an extensive and fashionable practice and produced occasional watercolours. His son, R.T. Lonsdale, was also an artist.

Examples: B.M.

LORIMER, John Henry, R.S.A., R.W.S., R.S.W.
1856 (Edinburgh) — 1936 (Edinburgh)
He was primarily a portrait and subject painter in oil. In 1882 he was elected A.R.S.A. and for two years went to study in Paris. In 1900 he was elected R.S.A. as a result of his paintings of Scottish country life. He became an Associate and Member of the R.W.S. in 1908 and 1932. His watercolours are generally in a low key and show a feeling for the effects of light.

LOUISE, Caroline Alberta, H.R.H. Princess, Duchess of Argyll
1848 (Windsor Castle) — 1939 (Kensington Palace)
The fourth daughter of Queen Victoria (q.v.) and Prince Albert (q.v.), she married the Duke of Argyll in 1871. She painted views in Canada and elsewhere.

Examples: B.M.; Dundee City A.G.; Maidstone Mus.

LOUND, Thomas 1802 — 1861 (Norwich)
A brewer and amateur landscape painter, he was a pupil of J.S. Cotman (q.v.), whose work he began by copying, as well as that of J. Crome, J. Stannard and Cox. He joined the Norwich Society in 1820 and exhibited with them until 1833. He entertained and sketched with all the leading Norwich artists and collected their work. He exhibited in London from 1845 to 1857, and in 1856 he was an unsuccessful candidate for the N.W.S.

His subjects are almost all in Norfolk, although he exhibited a view of Windermere in 1825 and one of Richmond, Yorkshire, in 1854. He also visited Wales. He had a strong colour sense and a dashing sketchy style. Sometimes the detail is a little clumsy, but generally his watercolours are rich and impressive.

A sale of his 'artistic effects' was held on March 6, 1861 at the Bazaar Room, Norwich.

Examples: B.M.; V.A.M.; Leeds City A.G.; Castle Mus., Norwich; Gt. Yarmouth Lib.
Bibliography: W.F. Dickes: *The Norwich School,* 1905.

LOVE, Horace Beever 1780 (Norwich) — 1838
A portraitist who exhibited at the R.A. from 1833 to 1836. He was working in Norwich earlier than this and in 1830 he drew a portrait of Cotman which is typical of the formal, lithographic style of the time. In the same year he joined Cotman in founding the Norwich Artists' Conversaziones.

Examples: B.M.; V.A.M.

LOVER, Samuel, R.H.A. 1797 (Dublin) — 1868 (Jersey)
A miniaturist, painter, illustrator, songwriter and novelist, he was intended for a stockbroker. He gave drawing lessons from the age of seventeen, teaching himself at the same time. He exhibited with the R.D.S. in 1817 and 1819, and from 1826 exhibited landscapes and miniatures at the R.H.A. He was elected A.R.H.A. and R.H.A. in 1828 and 1829. In 1831 he illustrated the *Parson's Horn-Book,* which caricatured the established Church. These illustrations were badly received and lost him many of his customers and may partly account for his move to London in 1835. Before moving, he helped to start up the *Dublin University Magazine* in 1833, which he illustrated. In London he had a successful practice as a miniaturist, and in 1836 started to write novels and plays. His sight deteriorated, and from 1844 he ceased to paint miniatures. From 1846 to 1848 he toured America and Canada with his one-man entertainment of songs and stories. He returned to London, and exhibited landscapes at the R.A. between 1851 to 1862, as well as at the R.H.A. He retired to Jersey for the last four years of his life.

Published: *Legends and Stories of Ireland,* 1831. *Rory O'More, a National Romance,* 1837. *Handy Andy,* 1842. Etc.

Examples: B.M.; Ulster Mus.
Bibliography: B. Bernard: *The Life of S.L., R.H.A., with Selections from his Papers*, 1874.

LOVERING, Ida R
The niece of A. and H. Tidey (q.v.), she painted domestic scenes and landscapes in oil and watercolour. She entered the R.A. Schools in 1878 and exhibited from 1881.

Illustrated: A.A. Procter: *Legends and Lyrics*, 1895. D. Wyllarde: *A Lovely Little Lady*, 1897.
Examples: Brighton A.G.

LOWRY, Matilda, Mrs. Heming
The daughter of Wilson Lowry (1762-1824), the engraver, and sister of Joseph Wilson Lowry (1803-1879), she won a gold medal from the Society of Arts in 1804 and exhibited landscapes, miniatures and portraits from 1808 to 1855. She may have been an engraver herself, and she visited the West Country. Her watercolour style is pretty and close to that of J. Cristall (q.v.) or J.S. Hayward (q.v.).

Examples: B.M.; V.A.M.

LUARD, Lieutenant-Colonel John 1790 – 1875
He was commissioned in the 4th Regiment of Dragoons in 1809 as second lieutenant, and promoted lieutenant in 1811, captain in the 30th Regiment of Foot in 1821, and major in 1834. In 1838 he became a lieutenant-colonel in the 21st Fusiliers, and he was retired on half-pay in 1845. He was commissioned by Mrs., later Lady, Parkes, wife of Sir Harry Parkes, to make sixty watercolour sketches of India. These were exhibited, under the title *A Grand Moving Diorama of Hindustan* in the Asiatic Gallery, Portman Square, in 1851, and were later taken to America.

Published: *History of the Dress of the British Soldier*, 1852.
Examples: B.M.

LUARD, John Dalbiac
** 1830 (Blyborough) – 1860 (Winterslow, nr. Salisbury)**
Son of J. Luard (q.v.). He served in the Army from 1848 to 1853. Thereafter he studied with J. Phillip (q.v.), and visited the Crimea. He exhibited military subjects at the R.A. from 1855.

LUCAN, Margaret, Countess of – 1815
A miniaturist and illustrator. She was the daughter of James Smith and married the Earl of Lucan in 1769. Walpole was very flattering about her talents. Between the ages of fifty and sixty-five she filled five folio volumes with illustrations to the historical plays of Shakespeare.

Examples: Althorpe.

LUCAS, John Seymour, R.A., R.I.
** 1849 (London) – 1923 (Southwold)**
Figure, historical and portrait painter in oil and watercolour, he was the nephew of John Lucas, a portraitist. He studied at St. Martin's School of Art and the R.A. Schools and exhibited from 1872. He was elected A.N.W.S. and N.W.S. in 1876 and 1877 and A.R.A. and R.A. in 1886 and 1898. His wife Marie (d. 1921) also painted portraits.

Illustrated: S.R. Crockett: *The Grey Man*, 1896.
Examples: B.M.

LUCAS, Ralph W 1796 – 1874
A landscape, portrait and genre painter who lived in Greenwich and Blackheath and exhibited at the N.W.S. and elsewhere from 1821 to 1852.

LUCAS, Samuel
** 1805 (Hitchin, Hertfordshire) – 1870 (Hitchin)**
Educated at a Quaker school in Bristol, he was apprenticed to a ship-owner at Shoreham. His religion only allowed him to paint as an amateur and he very rarely exhibited his works. After his marriage in 1838 he returned to Hitchin. He was paralysed in 1865.

He painted landscapes around Hitchin, portraits, birds, animals and flowers, some of the latter being engraved in the *Florist*.
Many members of his family painted, including his son SAMUEL LUCAS, YR. (1840-1919), his wife MATILDA LUCAS, née HOLMES, and his daughters and grand-daughters, ALICE MARY LUCAS (1844-1939), FLORENCE LUCAS, MATILDA LUCAS (1849-1943), ROSA LUCAS, ANN RACHEL LUCAS (d. 1971) and CONSTANCE LUCAS.

Examples: B.M.; Hitchin Mus.; Glynn Vivian A.G., Swansea.
Bibliography: Walker's Quarterly, 27.

LUCAS, William 1840 (London) – 1895 (London)
The brother of J.S. Lucas (q.v.), he exhibited portraits and figure subjects from 1856 to 1880. He was A.N.W.S. from 1864 to 1882 but then his health broke down and he gave up painting for lithography. He lived in St. John's Wood.

LUDBY, Max, R.I. 1858 (London) – 1943
A landscape painter who lived and worked at Cookham. He exhibited from 1886, was elected R.I. in 1891 and was a member of the R.B.A.

Examples: Melbourne A.G.

LUDOVICI, Albert 1820 – 1894
A genre painter in oil and watercolour who worked in Paris and London where he exhibited at the R.A. and the R.I. from 1854 to 1889. He was elected to the S.B.A. in 1867.

LUDOVICI, Albert, Yr. 1852 (Prague) – 1932
Son of A. Ludovici (q.v.), he too painted genre subjects and lived much in Paris. He exhibited there, in Geneva and in London where he was a member of the R.B.A. He was influenced by Whistler.

Published: *An Artist's Life in London and Paris*, 1926.

LUND, Neils Moeller, R.A.
** 1863 (Faaborg, Denmark) – 1916 (London)**
A landscape and portrait painter who studied at the R.A. Schools and at Julian's in Paris. He was chiefly noted for his large oil paintings but also worked in watercolour, often in Scotland and Northumbria.

LUNDGREN, Egron Sellif, O.W.S.
** 1815 (Stockholm) – 1875 (Stockholm)**
He studied in Paris for four years, and went to Italy in 1841, where he remained for eight years. He served under Garibaldi at the siege of Rome in 1849. After this he left for Spain, where he lived for ten years. He met F.W. Topham (q.v.) and J. Phillip (q.v.) in Seville in about 1852, and they encouraged him to come to London in 1853. He seems to have worked in London for some time as an illustrator before going to India, where he was on Lord Clyde's staff during the campaigns of 1857. He made a large number of drawings in 1857 and 1858, including Indian landscapes and portraits. A collection of 271 of these was sold at Christie's on April 16, 1875 for 3,050 guineas. He visited England again on his return, and undertook several commissions for the Queen. He then re-visited Scandinavia and by 1861 had gone to Cairo. In 1862 he visited Spain once more and in 1865, Italy. His last years were divided between London and Stockholm. In 1864 he was elected A.O.W.S. and in the following year a full Member.
The majority of his subjects are taken from Spain, Italy and Egypt. Although he often produced single figure studies of peasants, he is happiest with small group subjects such as fiesta or bull-fighting scenes. His colours are generally pale and fairly limited, laid on in thin washes, but with a dashing style of execution which can be most attractive. His portrait drawings, although rather conventional in the manner of A.E. Chalon (q.v.), can also be very pretty.

Published: *Old Swedish Fairy Tales*, 1875. *Letters from Spain*, pub. in Stockholm. *Letters from India*, pub. in Stockholm.
Illustrated G.O. Hyltén-Cavallius: *Old Norse fairy tales*, 1882.

Examples: B.M.; V.A.M.; Fitzwilliam; Maidstone Mus.

Bibliography: *A.J.,* 1876.

LUNY, Thomas 1759 (London) – 1837 (Teignmouth)

A marine artist who served in the Navy and was a pupil of Francis Holman. He exhibited at the S.A. in 1777 and 1778 and at the R.A. from 1780. He probably spent most of his time at sea until 1810 when he was paralysed and settled at Teignmouth, where he managed to paint. One hundred and thirty of his pictures were exhibited in Bond Street three months before his death.

Examples: Exeter Mus.; Greenwich.

LUSCOMBE, Henry A 1820 (Plymouth) –

A marine and town painter who lived in Plymouth. He worked in oil and watercolour until at least 1865 specialising in pictures of the modern Navy and Rayner-like street scenes.

Examples: Exeter Mus.; Greenwich.

LUSHINGTON, Maria 1800 (London) – 1855 (London)

The eldest daughter of Sir Henry Lushington, Bt., British Consul-General in Naples from 1815 to 1832. Her reconstructions of Pompeii are probably based on the original sketches for Sir W. Gell (q.v.): *Pompeiana,* 1832, to which they show a striking similarity. The fact that she knew Gell may be deduced from his inclusion in one of her drawings. Her landscapes and interiors are accomplished although the overall effect is rendered rather charmingly naïve by her fanciful colours and uncertain drawing of fixtures and fittings. She signed 'Maria' *tout court.*

LUTTERELL, A F

A pupil of W. Callow (q.v.), who was working in Somerset in 1846.

LUXMORE, Myra E 1851 – 1919

An historical and portrait painter who exhibited from 1887. She lived in Somerford, near Newton Abbot, Devon, and in London.

LYNDON, Herbert

A landscape painter in oil and watercolour who exhibited from 1879 to 1898, when he went to India. He also lived in London and continued to exhibit until 1921.

Examples: India Office Lib.

LYNN, William Henry 1829 – 1915

Probably a Belfast architect, he painted views in Ireland and Wales.

Examples: Ulster Mus.

McALLISTER, John A **1896** **– 1925**
An Irish painter of landscapes and coastal subjects.

Examples: Ulster Mus.

MACALLUM, John Thomas Hamilton, R.I., R.S.W.
 1841 (Kames, Argyllshire) – 1896 (Beer, South Devon)
A landscape painter in oil and watercolour, he was intended for a
merchant, but rebelled in 1864 and entered the R.A. Schools. He
kept studios successively in Hampstead, Piccadilly and Beer, Devon
and spent much time sketching on his yacht. His favourite areas
were Heligoland, Holland, Southern Italy and the Devonshire coast.
He exhibited at the R.A. between 1869 and 1896, the S.B.A.,
N.W.S. and elsewhere, and was elected R.I. in 1882.

 He caused a great stir by his highly individual colouring and
technique, especially in painting sunlight, his favourite subject.

Examples: Tate Gall.

McARTHUR, A **c.1795 (Nottingham) –c.1860**
A Nottingham topographer working in oil and watercolour.

MacARTHUR, Blanche
A painter of figure and genre subjects, flowers and landscapes often
on the South Coast. She also painted in Brittany and perhaps Italy,
and she exhibited at the R.B.A. and elsewhere from 1870 to 1889.
She lived in Hampstead and Bedford Row with her sister MARY
MacARTHUR, who painted similar subjects in oil and watercolour
and exhibited from 1873 to 1882.

Published: with J. Moore: *Lessons in Figure-painting in
water-colours*, 1881.

MacARTHUR, Charles M
A landscape painter who lived in London and worked in Yorkshire,
Derbyshire, Nottinghamshire, Cornwall and Chamonix. He was
active at least from 1860 to 1880.

Examples: Haworth A.G., Accrington; Castle Mus., Nottingham.

MacARTHUR, John **1755** **– 1840 (Hayfield, Hampshire)**
The author of *Army and Navy Gentlemen's Companion*, 1780, for
which he made pleasing and rather Sandby-like figure illustrations.
He was a clerk and purser in the Navy, serving on the North
American station and as Lord Howe's secretary on the *Victory* in
the Mediterranean. He was the inventor of a new code of signals. He
returned to England in 1796 and concentrated on a literary career,
the most important fruit of which was the *Naval Chronicle* which
ran for twenty years from 1799.

Bibliography: *Connoisseur*, March, 1948.

MACAULAY, Kate
A landscape painter who lived in Ealing and exhibited at the R.A.,
the R.B.A. and the Society of Female Artists from 1874 to 1883.
She worked in North Wales, on the West Coast of Scotland and in
Cornwall.

Examples: Dundee City A.G.

MACBETH, Robert Walker, R.A.
 1848 (Glasgow) – 1910 (London)
The son of Norman Macbeth, portrait painter, he came to London

in 1870 and worked as an illustrator for the *Graphic*. He was a
member of the R.I. from 1882 to 1891, and was elected A.R.A. in
1883 and R.A. in 1903. He is best known as an etcher, producing a
long series after Velasquez and other masters as well as by
contemporaries. He was also a watercolourist, specializing in rural
subjects, often in the Fens.

Illustrated: F.G. Jackson: *A Thousand Days in the Arctic,* 1899.
Examples: Aberdeen A.G.

MacBRIDE, Alexander, R.I., R.S.W. 1859 (Cathcart) – 1955
A landscape painter who was educated in Glasgow and Edinburgh
and studied at Julian's Academy in Paris. He was elected R.S.W. in
1890 and R.I. in 1899. He produced many Berkshire subjects.

Examples: Glasgow A.G.

MACBRIDE, John
An artist who produced rather weak landscapes in the manner of F.
Towne (q.v.) in about 1794.

Examples: B.M.

MacCALLUM, Andrew **1821 (Nottingham) – 1902 (London)**
A landscape painter in oil and watercolour who was apprenticed in
his father's hosiery business. At twenty-one he studied at the
Nottingham School of Art and later at the Government School of
Design at Somerset House. He taught at the Manchester School of
Art from 1850 to 1852, and was Head of the Stourbridge School of
Art until 1854, when he went to Italy. On his return in 1857 he
helped in the decoration of South Kensington.

Examples: V.A.M.

McCLEAN, Captain John **– 1768**
Commissioned in the Madras Engineers in 1762, he was promoted
captain in 1766 and killed at the battle of Tingricottah in 1768. In
the India Office Library there is a pen and wash drawing of the
ruined citadel of Pondicherry. It is amateurish but pleasing.

McCLOY, Samuel **1831 (Lisburn) – 1904 (Balham)**
A figure, flower and genre painter who was apprenticed to J. and T.
Smyth, the Belfast engravers, and studied at the School of Design.
He came to London, where he studied at the Central School at
Somerset House, and in about 1853 he became Master of the
Waterford School of Art. He was again in Belfast from 1875 until
1881, when he returned to London. He exhibited at the R.H.A.
from 1862 to 1882, and in London from 1859 to 1891.

 His wife E.L. McCLOY, née HARRIS, painted childrens' heads
in his manner. She was still alive in 1913.

Examples: V.A.M.; Haworth A.G., Accrington; Ulster Mus.

McCOLL, Dugald Sutherland **1859 (Glasgow) – 1948 (London)**
An art critic and landscape, town and figure painter who was
educated in Glasgow and at University College, London, and
Lincoln College, Oxford, and who studied at the Westminster
School of Art and the Slade. He wrote for the *Spectator* and the
Saturday Review, and edited the *Architectural Review.* He lectured
at University College, was a founder of the National Art-Collections
Fund, and was Keeper of the National Gallery from 1906 to 1911
and of the Wallace Collection from 1911 to 1924. He usually signed
'D.S.M.'.

Published: *Greek Vase Paintings,* 1894. *Nineteenth Century Art,*
1902. *The Administration of the Chantrey Bequest,* 1904. Etc.
Examples: B.M.; V.A.M.; Towner A.G., Eastbourne; Glasgow A.G.;
Leeds City A.G.; Leicestershire A.G.; Kirkcaldy A.G.; Ulster Mus.

McCORMICK, Arthur David, R.I.
 1860 (Coleraine) – 1943 (London)
A genre painter and engraver, he exhibited from 1889. He was an
F.R.G.S. and accompanied Sir Martin Conway on his Himalayan
expedition in 1892. He also painted in the Caucasus, and many
other parts of the world. An exhibition of his Alpine views was held

at the Alpine Club Gallery in 1904, and he was elected R.I. in 1906.

Published: *An Artist in the Himalayas*, 1895.
Illustrated: Sir W.M. Conway: *Climbing and Exploration in the Himalayas*, 1894. R.W. Frazer: *Silent Gods and Sun-Steeped Lands*, 1895. E.A. Fitzgerald: *Climbs in the New Zealand Alps*, 1896. Sir G.S. Robertson: *The Kahirs of the Hindu-Kush*, 1896. E.C. Openheim: *New Climbs in Norway*, 1898. A. Graves: *Prince Patrick*, 1898. E.S. Grogan: *From the Cape to Cairo*, 1900. Sir R.F. Burton: *Wanderings in Three Continents*, 1901. Sir W.M. Conway: *The Alps*, 1904. M. Macgregor: *The Netherlands*, 1907. R. Horsley: *New Zealand*, 1908. V. Surridge: *India*, 1909. Etc.

McCULLOCH, Horatio, R.S.A.
1805 (Glasgow) – 1867 (Edinburgh)
The son of a weaver, he was apprenticed to a house-painter and then studied under John Knox, with W.L. Leitch (q.v.) and Daniel Macnee. He and Macnee went to Cumnock in about 1824, where they painted snuff boxes, and then to Edinburgh where they worked for W.H. Lizars, the engraver. McCulloch later returned to Glasgow. In 1829 he began to exhibit at the R.S.A. He was elected A.R.S.A. in 1834 and R.S.A. in 1838, when he moved back to Edinburgh. He sketched throughout the Highlands, often spending months at a time in Oban. His work had a wide influence not only on pupils such as E. Hargitt (q.v.), but on many of the succeeding generation of Scottish painters. However, it has been justly remarked that his technique and use of colour fall short of the grandeur of his subjects.

Examples: Glasgow A.G.; Paisley A.G.; N.G., Scotland.
Bibliography: A. Fraser: *H. McC.*, 1872. *A.J.*, August, 1867.

MACCULLOCH, James, R.S.W.
–1915 (London)
A painter of Scottish subjects who lived in London and exhibited there from 1872. He was a member of the S.B.A. from 1884, and he also worked on the Suffolk coast, in Yorkshire, Surrey and Sussex.

Examples: Glasgow A.G.; Sydney A.G.

MACDONALD, Miss A
A landscape painter who lived in London and exhibited at the S.B.A. from 1870 to 1878. She worked on the Thames and the Wye, in Ireland, Sussex and Devon.

MACDONALD, John Blake, R.S.A.
1829 (Boharm, Morayshire) – 1901 (Edinburgh)
A painter of historical subjects, often from the Jacobite period. He studied under Lauder at the Trustees' Academy, and was elected A.R.S.A. and R.S.A. in 1862 and 1877. Later in life he painted landscapes and Venetian subjects in both oil and watercolour.

Examples: Dundee City A.G.

MACDONALD, Murray
An Edinburgh landscape painter who exhibited at the R.S.A. between 1889 and 1910.

McEVOY, Arthur Ambrose, A.R.A., A.R.W.S.
1878 (Crudwell, Wiltshire) – 1927 (London)
A portrait painter who studied at the Slade and in the N.G. He was influenced by his father's friend, Whistler, as well as by the Impressionists, Rembrandt, Titian and Gainsborough. During the war he was commissioned to take the portraits of naval V.C.s. He was elected A.R.A. in 1924 and A.R.W.S. in 1926. An exhibition of his watercolours was held at the Leicester Galleries in 1927, and memorial exhibitions at the R.A. in the winter of 1928 and at Manchester in 1933.

His preoccupation is with the character of his sitters and his style a blend of fine drawing and seemingly arbitrary washes.

Examples: Cartwright Hall, Bradford; Leeds City A.G.; Ulster Mus.; Walsall A.G.
Bibliography: C. Johnson: *The Works of A.M. from 1900 to May 1919*, 1919. R.M.Y. Gleadowe: *A.M.*, 1924. O.W.S. Club, VII, 1931.

McEWAN, T(h)om, R.S.W.
1861 – 1914
A genre painter in oil and watercolour. He lived in Glasgow.

Examples: Glasgow A.G.

MACFARREN, J J
A landscape painter who lived in London and exhibited at the S.B.A. and R.A. from 1839 to 1846. Many of his subjects are in and around London, but he also visited the Isle of Man, France, Geneva and Northern Italy.

MACGREGOR, William York, R.S.A., R.S.W.
1855 (Finnart, Argyll) – 1923 (Bridge of Allan)
The son of a shipbuilder, he has been dubbed 'the father of the Glasgow School'. He studied under James Docharty at the Slade and Glasgow School of Art. His landscapes in oil and watercolour were conventional at first but, under the Parisian influence of his friend J. Paterson (q.v.), his style became broader. After a visit to South Africa in 1889-1890 for his health, his colours became darker, and he placed greater emphasis on form. He was elected R.S.W. in 1885, A.R.S.A. in 1898 and R.S.A. in 1921. He was also a member of the N.E.A.C. from 1892.

Examples: Dundee City A.G.; Glasgow A.G.; N.G., Scotland.

MACHELL, Major Christopher
1747 (Asby, Westmorland) – 1827
A friend and patron of F. Nicholson (q.v.), he served in the American war, losing his left arm, and settled at Beverley. He was a Deputy Lieutenant for the East Riding. He drew pen and wash landscapes and was a skilful musican and botanist.

The family seat, Crackenthorpe, Westmorland, was sold by his brother.

Examples: Wakefield A.G.
Bibliography: See E. Bellasis: *The Machells of Crackenthorpe*, 1886.

MacINTOSH, John MacIntosh 1847 (Inverness) – 1913 (Shanklin)
A landscape painter who specialized in Berkshire views. He studied at Heatherley's, the West London School of Art and at Versailles. He exhibited from 1880 to 1901, mainly at the R.B.A., of which he was a member from 1889 to 1904. He was also a member of the Dudley Gallery and the Ridley Art Club, and Secretary of the Newbury Art Society. His studio was at Woolhampton, near Reading.

Illustrated: E.G. Hayden: *Islands of the Vale*, 1908.
Examples: V.A.M.; Reading A.G.

MACIRONE, Emily
An historical genre, figure and architectural painter who lived in London. She exhibited at the S.B.A. from 1846 to 1879 and was an unsuccessful candidate for the N.W.S. on numerous occasions between 1852 and 1866, often proposed by H. Warren (q.v.), whose pupil she may have been. From 1860 she exhibited Breton and Norman historical and architectural subjects, from 1870 views of the Hotel de Ville, Brussels and, in 1878, a Genoese church interior.

Miss Cecilia Macirone, who exhibited an oil painting of the Crimean War at the S.B.A. in 1855, may have been her sister.

MacKAY, T
A landscape and figure painter active at least between 1899 and 1905. He may have lived in Warwickshire.

McKECHNIE, Alexander Balfour, R.S.W.
1860 (Paisley) – 1930 (Miliken Park, Renfrewshire)
A painter of landscapes and Egyptian subjects, he was educated at St. Andrews University and studied at the Glasgow School of Art. He was elected R.S.W. in 1900 and later served as Deputy President. He was also a President of the Glasgow Art Club.

Examples: Glasgow A.G.

MacKELLAR, Duncan 1849 (Inveraray) – 1908 (Lochgoilhead)
A figure and eighteenth century painter in oil and watercolour. He studied in Glasgow and London.

Examples: Glasgow A.G.

MACKENZIE, Frederick, O.W.S. 1787 – 1854 (London)
A pupil of J.A. Repton (q.v.), he became an architectural and topographical draughtsman, working for many of the foremost publishers and engravers of the day, including Britton, Ackermann, the Havells, and J. and H. Le Keux. He was briefly a member of the Oil and Watercolour Society and joined the reconstituted O.W.S. as an Associate in 1822 and a Member in 1823. He was Treasurer of the Society from 1831 until his death.

Although he drew a number of Continental subjects after other artists, he seldom, if ever, left England. In the 1830s and 1840s he worked on a number of important publications, including *Memorials of Oxford*, 1837 and *Memorials of Cambridge,* 1841-1842. In his later years his skills in drawing for engravers were less in demand, owing to the introduction of photography. His style, which is neat, accurate and attractive, is close to that of the elder Pugin (q.v.) with whom he sometimes worked — they both owe much to the teachings and inspiration of the architect John Nash. He sometimes painted landscapes in a looser manner, reminiscent of Cox.

His remaining works were sold at Sothebys, March 24-30, 1855.

Published: *Etchings of landscapes for the use of students,* 1812. *Illustrations of the Principal Antiquities of Oxfordshire,* 1823. Etc.
Examples: B.M.; V.A.M.; Ashmolean; Victoria A.G., Bath; Fitzwilliam; Usher A.G., Lincoln; City A.G., Manchester; Laing A.G., Newcastle; Castle Mus., Nottingham; Stafford Lib.

MACKENZIE, James Hamilton, A.R.S.A., R.S.W.
 1875 (Glasgow) – 1926
A landscape painter in oil and watercolour and an etcher, he studied in Glasgow and Florence. He was elected R.S.W. in 1910 and A.R.S.A. in 1924. He was President of the Glasgow Arts Club from 1923 to 1925.

Examples: Glasgow A.G.

McKENZIE, J
A topographer who was working in the Lowlands in the 1830s. He was drowned on a voyage to New Zealand.

McKEWAN, David Hall, N.W.S. 1817 (London) – 1873
A pupil of D. Cox (q.v.), he exhibited at the R.A. and elsewhere from 1836. He was elected A.N.W.S. and N.W.S. in 1848 and 1850. He lived in South London and painted primarily in Kent, Wales, Scotland and Ireland. As well as working in full colour, he produced many pleasing brown wash studies of trees and woods.

Published: *Lessons on Trees in Watercolours,* 1859.
Examples: B.M.; V.A.M.; Leicestershire A.G.; Nat. Mus., Wales; Wakefield City A.G.

McKEWAN, M W
A genre and landscape painter who lived in London and often worked around Tichborne, Hampshire. He exhibited at the S.B.A. from 1872 to 1875.

MACKIE, Charles Hodge, R.S.A., R.S.W.
 1862 (Aldershot) – 1920 (Edinburgh)
A landscape and figure painter in oil and watercolour who also produced murals and etchings. He was educated at Edinburgh University and studied at the R.S.A. Schools, before working for some years in France, Spain and Italy. In France he was acquainted with Gauguin and Vuillard. He exhibited at the R.A. from 1889, as well as on the Continent. He was elected A.R.S.A. and R.S.A. in 1902 and 1917.

Examples: B.M.; V.A.M.; Dundee City A.G.

MacKINNON, W
A pupil of Towne who was painting in Switzerland in 1798.

Examples: B.M.; V.A.M.

MACKLIN, Thomas Eyre 1867 (Newcastle) – 1943
A landscape and portrait painter who lived in Newcastle and worked in France, Italy and the North East. He studied at the R.A. Schools and in Paris, and he exhibited at the R.A. from 1897.

Examples: Shipley A.G., Gateshead.

McLACHLAN, Thomas Hope
 1845 (Darlington) – 1897 (Weybridge)
A painter of landscapes with figures in oil and watercolour, he was educated at Trinity College, Cambridge, and was called to the Bar. He exhibited from 1875 and turned professional artist three years later, studying in Paris, where he was influenced by Millet. He was a member of the N.E.A.C. and also etched.

Illustrated: B. Hall: *Fish-Tails and some true ones,* 1897.

McLAURIN, Duncan, R.S.W. 1848 (Glasgow) – 1921 (Helensburgh)
A painter of landscapes with cattle and coastal scenes. He studied at the Glasgow School of Design and Heatherley's, and was an Honorary Member of the Glasgow Arts Club.

MacLEAN, Sara
A painter of coastal scenes in Cornwall and still-lifes who was active in the 1880s.

Examples: Portsmouth City Mus.

MACLEAY, Kenneth, A.R.S.A. 1802 (Oban) – 1878 (Edinburgh)
The son of an antiquary, he was brought up at Crieff and entered the Trustees' Academy in 1822. He was an original Associate of the R.S.A. in 1826, resigning and being re-elected in 1829.

He began as a miniaturist on ivory and gradually moved to small full length portraits on paper. He produced a number of figure drawings for the Queen to illustrate Highland costume. Later in life he turned to oil painting because of the competition from photography.

Published: *Highlanders of Scotland,* 1870.

McLELLAN, Alexander Matheson, R.S.W.
 1872 (Greenock) – 1957
A portrait and history painter and a designer. He studied at the R.A. Schools and the Ecole des Beaux Arts. He lived in Glasgow and was elected R.B.A. in 1909 and R.S.W. in 1911. He also worked in Paris, London, Manchester and New York.

Examples: Glasgow A.G.

MACLISE, Daniel, R.A. 1806 (Cork) – 1870 (London)
Mainly known for his romantic scenes in oil, he made, while in Cork, some portraits in a style which he adopted from A. Buck (q.v.).

He also made freer watercolours as studies for his oil pictures. He made early studies from the casts in the Cork Institute, and was briefly put to work in a bank, which he left to open his own studio. In 1825 he toured Wicklow, and in 1827 he came to London, entering the R.A. Schools the following year. In 1829 he first exhibited at the R.A., and returned briefly to Ireland. In around 1830 he started producing illustrations for books and periodicals, including a series of portraits of literary figures for *Fraser's Magazine*. He became popular in artistic circles, and was elected R.A. in 1840. His work for the re-decoration of the Houses of Parliament damaged his health, and this, together with the death of his sister Isabella in 1865, caused him to withdraw from society. He refused both a knighthood and the proffered post of P.R.A.

Illustrated: J. Barrow: *Tour round Ireland,* 1836. Hall: *Ireland, its Scenery and Character,* 1841. C. Croker: *Fairy Legends and Traditions of the South of Ireland,* 1882. Etc.
Examples: B.M.; V.A.M.; Ashmolean; N.G., Ireland; Newport A.G.;

N.P.G.; Royal Shakespeare Theatre, Stratford; Ulster Mus.
Bibliography: J. Dafforne: *Pictures by D.M.*, 1873. *A.J.*, June, 1870. N.P.G.: *Exhibition Cat.*, 1972.

McMANUS, Henry, R.H.A. 1810 – 1878 (Dalkey)
An historical and portrait painter who exhibited at the R.H.A. from 1835, while living in Co. Monaghan, until his death. He was elected A.R.H.A. and R.H.A. in 1838 and 1858, and was Professor of Painting for the last five years of his life. He lived in London from 1837 to 1844, exhibiting at the R.A., the B.I. and the O.W.S. From 1845 to 1849 he was Headmaster of the Glasgow School of Design, and, from 1849 until his retirement in 1863, Headmaster of the R.D.S. School of Design.

As well as his typical subjects he painted landscapes in oil and watercolour and was a prolific book illustrator. His work 'in his latter years became puerile, and even ludicrous' (Strickland).

Illustrated: Hall: *Ireland, its Scenery and Character*, 1841. Carleton: *Traits and Stories of the Irish Peasantry . . .* Etc.
Examples: County Mus., Armagh.

McMASTER, James, R.S.W. 1856 – 1913
A painter of Highland views and Scottish and Dutch coastal scenes in oil and watercolour. He exhibited widely in Edinburgh and London, and lived in Glasgow.

Examples: Glasgow A.G.; Dick Inst., Kilmarnock; Paisley A.G.

McNAB, Robert Allan 1865 (Preston) –
A barrister and painter in both watercolour and oil, he was educated at Preston, where he lived for much of his career. He was a yachtsman, and during the First World War he served in the Naval Deputy Coast Watch.

His subjects were generally found in Lancashire and the Lake District.

McNALLY, Irvine
A painter of military subjects working in the 1870s and 1880s.

McNIVEN, Lieutenant-Colonel Thomas William Ogilvie
 – c. 1870
A topographical and biblical artist who was commissioned in the 42nd Royal Highland Regiment in 1812. He was at Gibraltar in 1814 and at Toulouse where 'only 18 men of all ranks escaped without a wound'. He subsequently served with the Cameronians and the Surreys, and was promoted lieutenant-colonel in 1841.

His drawing of Gibraltar in 1814 is a good example of the Serres tradition of marine painting. He exhibited views of Elba and Paestum at the S.B.A. in 1846. He also provided sketches to be worked up by artists such as H. Martens (q.v.).

Illustrated: *The Life of Christ*, 1862.

MacPHERSON, John
A landscape and river painter who lived in London and exhibited from 1865 to 1884. He painted in Scotland, on the Thames, in Essex and in Northern France.

Examples: V.A.M.; Dundee City A.G.

MACPHERSON, M , N.W.S.
A portrait painter who exhibited from 1828 to 1834. He was a Member of the N.W.S. in 1833.

MACQUIN, Abbé Ange Denis 'Meldensis'
 1756 (Meaux) – 1823 (London)
Of Scottish descent, he became Professor of Rhetoric at Meaux. He was an ardent Royalist and escaped to England in 1792. He lived in Hastings for a while, teaching himself English and sketching local scenery. In 1793 he was appointed heraldic draughtsman to the College of Arms. He designed Nelson's funeral car and contributed to a number of magazines and journals. His topographical work is in the manner of Hearne. In 1814 he revisited France.

Published: *A Description of more than Three Hundred Animals*, 1812. *A Description of the picture . . . by Benjamin West*, 1814. *Tabella Cibaria*, 1820.
Examples: Ashmolean.

MacQUOID, Percy Thomas, R.A. 1852 – 1925 (London)
The son of T.R. MacQuoid (q.v.), he studied at Heatherley's, the R.A. Schools and in France, and he painted genre scenes in oil and watercolour. He exhibited at the R.A. from 1875 to 1887, the R.B.A., N.W.S. and elsewhere and was elected R.I. in 1882, the same year as his father. He did much work as a decorator and furniture designer, and was working on a Dictionary of English Furniture at the time of his death.

Published: *History of Furniture.*
Examples: Preston Manor, Brighton; Hove Lib.
Bibliography: *Country Life*, March 28, 1925.

McQUOID, Thomas Robert, R.I. 1820 (London) – 1912 (London)
An architectural painter in oil and watercolour who worked in Spain, where he produced occasional genre subjects, and in France and England. He exhibited at the R.A. between 1838 and 1894, the R.B.A., N.W.S. and elsewhere; and worked for the *I.L.N.* and the *Graphic*. He was a candidate for the N.W.S. in 1858 and was elected R.I. in 1882.

A memorial exhibition was held at the New Dudley Gallery, London, in 1912.

Illustrated: M.B. Edwards: *Little Bird Red and Little Bird Blue*, 1861. M.B. Edwards: *The Primrose Pilgrimage*, 1865. K.S. Macquoid: *Through Normandy*, 1874. K.S. Macquoid: *Pictures in Umbria*, 1905. Etc.

McTAGGART, William, R.S.A., R.S.W.
 1835 (Aros, near Campbeltown) – 1910 (Broomieknowe)
He began to paint portraits of Campbeltown characters whilst working as an apprentice apothecary. In 1852 he went to Edinburgh and studied at the Trustees' Academy for seven years. During the holidays he went to Glasgow and Dublin, where he obtained many small commissions. He first exhibited at the R.S.A. in 1855 and was elected Associate and Member in 1859 and 1870. He was Vice-President of the R.S.W. from its foundation in 1878. The majority of his watercolours were done before 1889 and in that year about a hundred and twenty dating from 1857 to 1888 were sold at Dowell's of Edinburgh, realising over £4,000.

Quite independently of the French he evolved a form of impressionism, first in his watercolours and later in his oil paintings. He was fascinated by light, movement and the immediate impact of nature. He used small sheets of rough paper so that his brush strokes could sweep right across. His colours are bright and sparkling and usually applied with a full brush to damp paper. Although in his early works he makes frequent use of white heightening, the glitter of the later watercolours is due to cunning use of untouched areas of paper.

The love of the sea and shore, which was native to him, remained the main inspiration of his career. Children play a large part in his compositions.

Exhibitions of his works were held at the Tate in 1935, the N.G., Scotland in 1935 and Manchester in 1937.

Examples: Aberdeen A.G.; Ashmolean; Glasgow A.G.; Kirkcaldy A.G.; N.G., Scotland.
Bibliography: J.L. Caw: *W. McT.*, 1917. D. Fincham: *W. McT.*, 1935. Tate Gall.: *Exhibition Cat.*, 1935.

MacWHIRTER, Agnes E 1837 (Colinton, Edinburgh) –
The daughter of a paper-maker and the sister of J. MacWhirter (q.v.), she was a self-taught landscapist in oil and a flower painter in watercolour. In early life illness forced her to give up outdoor work and thus oil painting. She moved to London in about 1870.

Her still-lifes and flower pieces are generally on a small scale and are very delicately painted.

Examples: Ashmolean.

MacWHIRTER, John, R.A., A.R.S.A.,
1839 (Slateford, Edinburgh) – 1911 (London)
After a brief apprenticeship to an Edinburgh bookseller he studied at the Trustees' Academy. He was elected A.R.S.A. in 1867, and two years later moved to London, where he was elected A.R.A. in 1879 and R.A. in 1893. He was a Member of the R.I. from 1882 to 1888. During his early days in London he won the favour and encouragement of Ruskin, and the watercolours of this period are among his best. He made extensive tours abroad, visiting France, Switzerland, Italy and Sicily, Austria, Turkey, Norway and the U.S.A., and he illustrated a number of books.

There is a sameness and over-sweetness about his mature watercolours which won him popularity at the time, but which now seems rather sickly. The purple of heather contrasted with groups of silver birch constantly appears in the landscapes, which form the majority of his work. At his best, however, he can achieve an effect not unlike Whistler. His signature is generally a neat 'MacW'.

Published: *Landscape Painting in Watercolours*, 1901. *The MacWhirter Sketch Book*, 1906. *Sketches from Nature*, 1913.
Examples: B.M.; V.A.M.; Derby A.G.; Dundee City A.G.; Glasgow A.G.; City A.G., Manchester; N.G., Scotland; Newport A.G.; Ulster Mus.
Bibliography: M.H. Spielmann: *The Art of J. McW.*, 1904. *A.J.*, 1879, 1903.

MADDOX, George **1760 (Monmouth) – 1843**
An architect and drawing master, he was apprenticed to his father, a builder, before moving to London, where he worked briefly as an assistant to Soane. He specialized in designing theatres and shop fronts. He ran a drawing school for young architects, among them Gilbert Scott, and exhibited Gandy-like oil paintings at the S.B.A. from 1824.

Examples: R.I.B.A.

MAGUIRE, Adelaide Agnes **1852 (London) – 1876**
The eldest daughter of Thomas Herbert Maguire, an oil painter and lithographer. Her genre subjects generally include children, and she exhibited at the R.A., the Incorporated Society and the Society of Female Artists, of which she was a member, from 1868 to 1876. She also painted flower pieces.

She was a close follower of W. Henry Hunt (q.v.), and was also influenced by the Pre-Raphaelites.

Published: *Lizzie's Secret*, 1872.

MAGUIRE, Helena J **1860 (London) – 1909**
The second daughter of T.H. Maguire. Like her sister Adelaide Agnes, she was strongly influenced by Hunt, Foster and the Pre-Raphaelites. She exhibited at the R.A. between 1881 and 1902. Her work can be very attractive and shows a good sense of colour and line.

A third sister, BERTHA MAGUIRE, exhibited flower pieces at the R.A. from 1896 to 1904, and a brother, Sidney Calton Maguire, was an enamel painter and publisher.

Published: *Blue Eyes and Cherry Pies*, 1895.

MAHONEY, James, A.R.H.A., A.N.W.S.
c. 1810 (Cork) – 1879 (London)
A landscape painter and illustrator. He made a Continental tour, after which he practised in Cork. He exhibited at the R.H.A. from 1842, and in about 1846 he went to Spain, where he travelled for several years. Drawings by him were in the Cork exhibition in 1852. In 1856 he was elected A.R.H.A., and in 1859 moved to London, where he exhibited at the R.A. between 1866 and 1877 and with the N.W.S., of which he was elected Associate in 1867. Among the periodicals which he illustrated are the *I.L.N.*, *Sunday at Home*, *Leisure Hour*, the *Sunday Magazine*, *Good Words*, *Cassell's Magazine* and *National Nursery Rhymes*. His most important work was on the Household Edition of Dickens's novels.

As well as illustrations and topographical views he produced genre subjects in the later manner of W. Henry Hunt (q.v.).

Examples: B.M.; V.A.M.; N.G., Ireland.

MAINGY, Miss
A pupil of Francis Towne, from whom she began to take lessons in August 1790. She made feeble copies of his drawings.

MAISEY, General Frederick Charles **1825 -1892**
A painter of Indian relics, antiquities and occasional landscapes. He joined the Bengal Native Infantry as an ensign in 1842, served in the Burma Campaign of 1852-1854 and the Mutiny, was Assistant Commissioner in the Punjab, from 1854 to 1856, and held various posts in the Advocate General's Office. He was promoted general in 1888. Some of his drawings were reproduced in J. Fergusson's *Tree and Serpent Worship*, 1868.

Published: *Description of the Antiquities of Kalinjar*, 1848; *Military Law*, 1872; with Sir A. Cunningham: *Sanchi and its Remains*, 1892.
Examples: V.A.M.; India Office Lib.

MAISEY, Thomas, P.N.W.S.
1787 (Beckford, Gloucestershire) - 1840 (London)
A drawing master who taught at Dr. Mayo's Preparatory School, Cheam, and the Misses Shepheard's School, Kensington. He exhibited from 1818 until his death and was a Founder member of the N.W.S. He became its second President in 1833.

Examples: B.M.; Ashmolean.

MALAN, Rev. Solomon Caeser
1812 (Geneva) - 1894 (Bournemouth)
The son of a Huguenot pastor, his love of the literature of the Orient made itself felt at an early age and culminated in a severance of family ties when he was eighteen. He entered St. Edmund Hall, Oxford, in 1833 and won the Boden Sanscrit Scholarship and married in the following year. He contributed a drawing to the famous *Tract 90*.

In 1837 he left for India to take up the post of Classical Professor at Bishop's College, Calcutta, but returned, via the Cape, in 1839, on account of his wife's illness. He held the livings of Alverstoke, Hampshire, from 1843 to 1844, Crowcombe, Somerset, from 1844 to 1845, and Broadwindsor, Dorset, from 1845 to 1885, after which he moved to Bournemouth. In 1880 he was made a Doctor of Divinity of Edinburgh. Throughout his life he travelled extensively in pursuit of his philological and theological studies, visiting the Holy Land in 1842, Central Asia in 1850, the Far East, Armenia and Nineveh, and Italy and Greece. During these journeys he painted many watercolours in a variety of styles, which show a marked talent. His bird and fish studies are a result of his deep interest in natural history. He does not appear to have painted English scenery, although he taught drawing to the parish children.

Published: *A Systematic Catalogue of the Eggs of British Birds*, 1848; *List of British Birds*, 1849; *Aphorisms on Drawing*, 1856; *The Coast of Tyre and Sidon*, 1858. *Letters to a Young Missionary*, 1858. Etc.
Illustrated: A.H. Layard: *Nineveh and Babylon*.
Bibliography: A.N. Malan: *S.C.M.*, 1897; *Connoisseur*, CLXIX, 1968.

MALCHAIR, John Baptiste **1731 (Cologne) - 1812 (Oxford)**
The son of a watch-maker, he is said to have made his first drawing from nature at Nancy and to have come to England in 1754. He taught drawing and the violin in London and Lewes and at Bristol in 1758-9. In the latter year he was appointed leader of the band in the Music Room at Oxford, holding the post until 1792. He was widely influential among undergraduates as a drawing master, his pupils including the Earl of Aylesford and his brothers, W.H. Barnard, Sir G.H. Beaumont, O. Bowles, W. Crotch, and J. Skippe (all q.v.). He exhibited at the R.A. in 1773. By 1798 he was going blind and he handed over his practice to W.A. Delamotte (q.v.).

His Oxford drawings are topography tempered by the picturesque. They are always inscribed and precisely dated, and his favourite colours are primrose yellow and a pink-brown with which he highlights his grey wash. In 1789, 1791 and 1795 he visited Wales, and these journeys inspired him to a more grandiose manner

and a true appreciation of imaginative landscape. His figure drawing is generally weak.

He was a man of great kindliness and charm, and his former pupils provided him with an annuity of £150 on his retirement from the band. The work of many of them is deceptively similar to his own.

Examples: B.M.; V.A.M.; Ashmolean; Leeds City A.G.; Nat. Mus., Wales..
Bibliography: *Oxoniensia*, VIII, 1943; X, 1944; *Burlington*, LXXXIII, August, 1943.

MALCOLM, James Peller, F.S.A.
 1767 (Philadelphia) - 1815 (London)
A topographer and engraver, he was brought up and educated in Philadelphia and Pottstown. Soon after 1784 he came to London and spent two years at the R.A. Schools. Thereafter he turned to engraving, specialising in topographic and history subjects.

Published: *Twenty Views within Ten Miles of London*, 1800. *Londinium Redivivum etc.*, 1802-1807. *Excursions in the County of Kent*, 1802. Etc.
Illustrated: Lyson: *Environs of London*, 1797-1800.

MALIPHANT, George
An architectural and topographical draughtsman. He was active from 1806 and was a member of the S.B.A., exhibiting with them from 1824 to 1833. His pencil drawing can be fussy and his washes untidily applied.

Examples: B.M.

MALIPHANT, H
A painter of views on the Scotch Borders who was active in about 1811.

Examples: N.G., Scotland.

MALIPHANT, William 1862 (Brynmaur, S. Wales) -
A landscape painter who emigrated to America with his family at the age of two. He was brought up in Pennsylvania but returned to London when he was thirteen to serve an apprenticeship with a wood draughtsman. He then studied at the Westminster School of Art. His subjects, in oil and watercolour, are often taken from the Usk Valley.

MALKIN, S
A landscape painter who lived in Islington and was active between 1821 and 1832. He painted in oil and watercolour and exhibited at the S.B.A. and elsewhere.

Examples: B.M.

MALTESE, Fanny Jane, Signora, née Fayrer
 1849 (London) - 1926 (Il Torrione, Forio)
The daughter of Rev. Robert Fayrer, she married Giovanni Maltese, a sculptor from Ischia, in 1901. Thereafter she lived in Ischia and painted local views and peasants.

Examples: V.A.M.

MALTON, James c. 1766 - 1803 (London)
An architectural draughtsman, he accompanied his father, T. Malton (q.v.), to Dublin where he worked for three years for the architect J. Gandon (q.v.). He exhibited with the Incorporated Society in 1790, and in 1791 completed a series of drawings of Dublin buildings which he etched and started to publish in London the following year. He exhibited at the R.A. from 1792 until his death, and like his brother, T. Malton, Yr., (q.v.), produced careful architectural views of London.

In his etchings he was often assisted by other artists, including F. Wheatley (q.v.), Robert Smirke and J.J. Barralet (q.v.). He made watercolour copies after the prints, and the hand-coloured prints can sometimes be mistaken for original drawings.

Published: *Views of Dublin*, 1792. *Essay on British Cottage Architecture*, 1795. *A Descriptive view of Dublin*, 1797. *The Young Painter's Mahlstick*, 1800. *A Collection of Designs for Rural Retreats or Villas*, 1802.
Examples: B.M.; V.A.M.; Fitzwilliam; N.G., Ireland; York A.G.

MALTON, Thomas 1726 (London) - 1808 (Dublin)
As well as being an architectural artist and a lecturer on perspective, he was an upholsterer with a shop in the Strand. He occasionally exhibited in London from 1772, but on the failure of the shop in 1785 he moved to Dublin where he made topographical drawings and continued to teach.

Published: *The Royal Road to Geometry*, 1774. *A Treatise on Perspective on the Principles of Dr. Taylor*, 1775.
Examples: V.A.M.; Aberdeen A.G.; Fitzwilliam; India Office Lib.; Newport A.G.

MALTON, Thomas, Yr. 1748 (London) - 1804
He first exhibited in London in 1768. He was in Bath in 1780 and accompanied his father, the elder T. Malton (q.v.), to Dublin in 1785. He studied architecture under J. Gandon (q.v.) for three years and in 1773 entered the R.A. Schools. He worked as a scene painter as well as running evening drawing classes, at which Turner took lessons in perspective. From 1796 until 1804 he lived in Long Acre and he is best known for his careful drawings of London buildings. At the time of his death he was working on a series of views of Oxford.

He worked in the traditional tinted manner with light colours laid over a grey foundation. His watercolours are sometimes painted over an etched outline; his figures are lively.

Published: *A Picturesque Tour through the Cities of London and Westminster*, 1792. *Picturesque Views in the City of Oxford*, 1802.
Examples: B.M.; V.A.M.; Fitzwilliam; Williamson A.G., Birkenhead.

MANBY, Thomas - 1695 (London)
A landscape painter who worked in Italy and produced a number of pen and grey wash drawings, some of which were in the P.A. Fraser sale of 17th Century English Drawings at Sotheby's in 1931. They are chiefly of romantic ruins. According to Vertue he was in England in 1672, 1676, 1677 and 1681 and was employed to paint in the landscape backgrounds to Mary Beale's portraits. He was probably also a dealing partner of Edward Pierce. Their collection of books, prints and drawings was sold by John Cocks, February 4, 1695.

Bibliography: *Apollo*, XXIII, May, 1936.

MANLY, Alice Elfrida 1846 (London) - c. 1923
A landscape, portrait and flower painter who lived in London and worked in Wales, the Isle of Wight, Devon, Yorkshire, Kent and at Boulogne. She exhibited from 1868 to 1897 and was an unsuccessful candidate for the N.W.S. in the former year.

Her sister ELEANOR E. MANLY lived with her and exhibited similar subjects, at least from 1875 to 1894.

MANN, James Scrimgeour, R.I. 1883 (Dundee) - 1946
A marine painter in watercolour and oil who was educated in Scotland and on the Continent, and studied at the Liverpool School of Art. He was later Secretary of the Liverpool Academy of Arts. During the First World War he served in the Scottish Horse and the King's Regiment. Later he lived at Caldy, Cheshire. He was elected R.I. in 1932.

Examples: Bootle A.G.

MANN, Robert
A Birmingham landscape painter in oil and watercolour who exhibited there from 1869 to 1892.

MANNERS, William
A Yorkshire landscape painter in oil and watercolour who was active from 1885 to 1910. He was elected R.B.A. in 1893. He lived in Bradford, Otley, Shipley, Crosshills and at Sutton Coldfield.

Examples: Abbot Hall A.G., Kendal.

MANNIN, James (France) - 1779
A landscape and flower painter of French birth, he settled in Dublin, and in 1746 was engaged as drawing master at the R.D.S. Schools. He exhibited with the Dublin Society of Artists from their first exhibition in 1765 until 1777. In 1779 he handed over his position as drawing master to a former pupil, J.J. Barralet (q.v.). Other pupils included G. Barret (q.v.) and T. Roberts (q.v.).

MANNING, William Westley 1868 (London) - 1954
A landscape painter in oil and watercolour and a print-maker. He was educated at University College School and studied at Julian's. His subjects are often landscapes and coastal scenes in the South of England, Scotland, France and Italy. He lived in London.

Examples: V.A.M.

MANSKIRCH, Franz Joseph 1770 - 1827 (Danzig)
A German landscape and figure painter who worked in England between about 1796 and 1805. His landscapes are strongly influenced by Girtin, although more woolly in the handling. He occasionally painted scenes of rustic life.

Examples: B.M.; Ashmolean; Whitworth A.G., Manchester.

MANSON, George
1850 (Edinburgh) - 1876 (Lympstone, Devonshire)
In 1871, after a five-year apprenticeship to the wood engravers W. and R. Chambers, he entered the Edinburgh School of Art. In 1873 he visited France, Belgium and Holland, and in 1874, for health reasons, he spent some months in Sark. He returned briefly to Scotland, and in January 1875 went to Paris to study etching under M. Cadart. From September 1875 until his death in February of the next year he lived in Devonshire.
His watercolours are rather in the manner of F. Walker (q.v.). He generally painted children.

Examples: N.G., Scotland.
Bibliography: J.M. Gray: *G.M. and his Works*, 1880.

MAPLESTONE, Henry, N.W.S. 1819 - 1884 (London)
A landscape and genre painter who lived in Birmingham and London. He exhibited in London from 1841 and in Birmingham from 1845, and he was elected A.N.W.S. and N.W.S. in 1841 and 1848. In 1870 he suffered severe lung trouble.
FLORENCE E. MAPLESTONE, who painted historical genre and flower subjects in oil and watercolour and who also lived in London and Birmingham, was possibly his daughter. She exhibited from 1868 to 1886, and she illustrated C.M. Yonge's *Nurse's Memories*, 1888.

MAPPING, Helen
A fruit and flower painter who exhibited with the Society of Female Artists in 1875.

MARGETSON, William Henry, R.I. 1861 (London) - 1940
A genre and landscape painter in watercolour and oil and a book illustrator. He was educated at Dulwich College, and studied at South Kensington and the R.A. Schools. He lived at Wallingford, Berkshire. He was elected R.I. in 1909. His wife HELEN HOWARD MARGETSON, née HATTON (b. 1860) was a figure painter in pastel and watercolour, and a Member of the Berkshire Art Society.

Published: *Pictures of Jesus*, 1942.
Illustrated: B. Hatton: *The Village of Youth*, 1895. H. Strang: *Humphrey Bold*, 1909.

MARGETTS, Mary, Mrs., N.W.S. - 1886
A London flower painter who was active from 1841 to 1877. She was elected N.W.S. in 1842.

MARIA See LUSHINGTON, Maria.

MARKES, Albert Ernest 1865 - 1901
The son of Richmond Markes, a marine artist, Albert, as he signed himself, began life as a shop assistant in Newquay, Cornwall. Later he moved to London, where he painted coastal scenes with fishing boats. He found a ready market for his watercolours, and he was sent by dealers to paint at Leigh-on-Sea and Southend as well as in Belgium and Holland. He drank a great deal and was colour-blind, and both handicaps are evident in his work, which is dominated by grey greens and highlights slashed into the paper with a knife.

Examples: B.M.; V.A.M.

MARKHAM, Colonel William
1796 (Becca, near Leeds) - 1852 (Becca)
The grandson of the Archbishop of York and of O. Bowles (q.v.), he married Lucy Anne Holbeach, who was also a grand-daughter of Bowles and a niece of Lady Mordaunt (q.v.). Their son married the daughter of Sir F. Grant (q.v.). Markham was educated in Chiswick, at Westminster and Christ Church, Oxford. He visited Sweden in 1818, the Rhine, Switzerland and Italy in 1819 and Russia in 1823. He was a keen yachtsman and cricketer. In 1834 he was appointed colonel of the 2nd West Yorkshire Militia. A Russian view by him was sold at Sotheby's, November 5, 1970.
See Bowles Family Tree.

MARKS, Henry Stacy, R.A., R.W.S.
1829 (London) - 1898 (London)
The son of a coach-builder, he studied heraldry painting as well as at Leigh's school. In 1851 he entered the R.A. Schools. In 1852 he spent five months in Paris with Calderon and in the following year exhibited at the R.A. He visited Belgium in 1860 and 1863. As well as painting, both in oil and watercolour, Marks was a stage and stained-glass designer and a wood-engraver. He painted a massive frieze of the Canterbury Pilgrims for the Duke of Westminster at Eaton Hall. He was elected A.R.A. and R.A. in 1871 and 1878, and A.R.W.S. and R.W.S. in 1871 and 1883.
Although he is now best known for his brilliant paintings of birds, Marks was thought of as a genre painter with a natural history slant. The humour of his work has survived rather better than might be expected. He was also a good landscapist, particularly favouring the Suffolk coast at Walberswick, where his friend C.S. Keene (q.v.) was a frequent visitor.
His remaining works were sold at Christie's, March 25-26, 1898.

Published: *Pen and Pencil Sketches*, 1894.
Illustrated: T.J. Ellis: *Sketching from Nature*, 1876. E. Stuart: *The Good Old Days*, 1876. Etc.
Examples: V.A.M.; Ashmolean; Exeter Mus.; Portsmouth City Mus.
Bibliography: *A.J.*, December, 1870. *Apollo*, June 1964 (The St. John's Wood Clique).

MARLBOROUGH, George, 5th Duke of 1766 – 1840
A friend, but not a pupil, of J.B. Malchair (q.v.), in whose manner he worked.

Examples: Ashmolean.

MARLOW, William 1740 (Southwark) - 1813 (Twickenham)
A pupil of S. Scott (q.v.) and at St. Martin's Lane Academy, Marlow began exhibiting with the S.A. in 1762, painting topographical views of country seats. In 1765 he went to the Continent and travelled in France and Italy until 1768. After his return, he worked in many parts of Britain, but he was particularly drawn to the Thames and to Twickenham, where he lived from 1778. He exhibited at the R.A. from 1788 until 1796, and again in 1807.
He used a wide range of media, including watercolour, body-colour and wash. His full watercolours can be rather garish in

colour - mainly blues and greens - but they are well and strongly drawn. His monochrome drawings vary widely in style from a tight, precise pen line with neat wash shadows to almost impressionistic sketches which combine an Italianate feeling with the execution of a Gainsborough. It is for his shipping pictures that he is best known.

Examples: B.M.; Cecil Higgins A.G., Bedford; Fitzwilliam; N.G., Ireland; Leeds City A.G.; Worcester City A.G.

MARNY, Paul 1829 (Paris) - 1914 (Scarborough)
A landscape and architectural painter who probably worked as a scene painter and a decorator for Sèvres before joining a French architect in Belfast. He was persuaded to move to Scarborough in 1860 by Oliver Sarony, the photographic pioneer. He revisited France occasionally, but for the most part he remained in Scarborough, and from 1878 he sold almost all his work to John Linn, a local dealer. He went to Birmingham to live with a cousin a few months before his death, but could not stand it and returned to Scarborough to die. It is possible that his real name was Paul François Goddard or Charles Paul Goddard, but he always seems to have used Paul Marny in artistic life.

Occasionally his work can be very impressive, but on the whole his brown buildings, from Scarborough and Northern France, have a depressing effect.

Examples: Williamson A.G., Birkenhead; Doncaster A.G.; Usher A.G., Lincoln; Scarborough A.G.; Sheffield City A.G.; Pannett A.G., Whitby; Ulster Mus.

MARRABLE, Madeline Frances, Mrs., née COCKBURN
(London) - 1916 (London)
The daughter of a soldier turned merchant and the niece of R. Cockburn (q.v.), she was a pupil of H. Warren (q.v.) and studied at Queen's College. She married an architect who died in 1872. She travelled much in Italy, Switzerland and Austria and exhibited from 1864. She became President of the Society of Female Artists and also worked in oil. Her daughter, EDITH MARRABLE, also painted in watercolour.

MARRIS, Robert 1750 - 1827
Marris married the niece of A. Devis (q.v.), whose style he closely imitated. His drawings are rather stiffer than those of his master. A watercolour in the Exeter Mus. seems to be by him, and if so, it provides a link between Devis and F. Towne, (q.v.), for elements of their styles are combined in it. Marris was the grandfather of the abominable Martin Farquhar Tupper.

Examples: B.M.; Derby A.G.

MARRYAT, Captain Frederick, F.R.S.
1792 (London) - 1848
A sailor and the author of *Peter Simple, Mr. Midshipman Easy, The Children of the New Forest*, etc. A number of his caricature drawings were printed and published. They are a long way after Gillray. He also copied old master portraits in pen and pencil.

Examples: B.M.; Greenwich.

MARSH, Arthur Hardwick, A.R.W.S.
1842 (Fairfield, Lancashire) - 1909
Family pressure at first prevented him from following his artistic bent, but in 1860 he was articled to an architect. He then went to London where he studied at the B.M., the N.G., and the Langham Sketching Club. His early subjects were scenes from Shakespeare. After a time in Wales, he settled at Cullercoats, Northumberland. In 1870 he was elected A.O.W.S., and he was a Member of the R.B.A. from 1882. His later works are peasant and coastal subjects.

Published: *Scenery of London. Cathedral Cities of France.*
Examples: Laing A.G., Newcastle.

MARSHAL, Alexander
A botanical painter who was active between 1656 and 1690.

Illustrated: J. Tradescant: *Museum Tradescantianum*, 1656.
Examples: B.M.

MARSHALL, Charles 1806 (London) - 1890 (London)
A scene painter who worked at Drury Lane and Covent Garden. He painted landscapes, possibly as studies for later use in his sets, and exhibited at the R.A., B.I., R.I., and Suffolk Street from 1828 to 1884. He also produced panoramas and the like, and was the first to use limelight on stage.

His sons, CHARLES MARSHALL, Yr. and R.A.K. Marshall (q.v.), were landscape painters. Charles exhibited at the R.A., B.I. and R.B.A. from 1864 to 1886.

Illustrated: W.E. Trotter: *Select Illustrated Topography . . . round London*, 1839.
Examples: V.A.M.; Portsmouth City Mus.

MARSHALL, Herbert Menzies, R.W.S.
1841 (Leeds) - 1913 (London)
A topographical and architectural painter who was educated at Westminster and Trinity College, Cambridge. He studied at the R.A. Schools, winning a travelling scholarship in 1868, and in Paris. He exhibited from 1871 to 1893 and was elected A.R.W.S. and R.W.S. in 1879 and 1883. In 1886 the Fine Art Society held an exhibition of his work, and another was held at the Abbey Gallery in 1935. In 1904 he was appointed Professor of Landscape Painting at Queen's College, London.

He produced many topographical watercolours of French Cathedral cities and Continental rivers as well as of English scenes. His work is fairly free and usually on a small scale, with a preponderance of blues and russets.

Illustrated: E.W. Howson & G.T. Warner: *Harrow School*, 1898. Etc.
Examples: V.A.M.; Brighton A.G.; City A.G., Manchester; Stalybridge A.G.

MARSHALL, Robert Angelo Kittermaster 1849 - c.1923
A landscape painter and son of C. Marshall (q.v.), he lived in London and Sussex. He exhibited at the R.A. from 1867 to 1902 and at the R.I., R.B.A. and elsewhere. In 1922 he was living at Herstmonceux, Sussex. He painted in the Midlands and the Southern and Western counties. His figures are sometimes a little awkward, but his landscape drawing is excellent.

MARSHALL, Thomas Falcon 1818 (Liverpool) - 1878 (London)
He first worked in Manchester and Liverpool, continuing to exhibit at these towns throughout his life. In 1846 he was elected a Member of the Liverpool Academy. He first exhibited at the R.A. in 1839, and in 1847 moved to London permanently. He also exhibited at the B.I. and Suffolk Street.

He painted portraits, landscapes, and historical and conversation pieces.

WILLIAM E. MARSHALL, who lived with him until 1870, and who exhibited similar subjects at the R.B.A. from 1859 to 1882, was probably his son.

Examples: V.A.M.

MARTEN, John, of Canterbury
A landscape painter who was working in Canterbury between 1782 and 1808 and exhibited at the R.A. from 1793 to 1802. His watercolours and wash drawings are rather in the manner of Barker of Bath.

His son, JOHN MARTEN, YR., lived and worked in Canterbury and Hastings. He exhibited from 1822 to 1834 and there are examples of his work in the V.A.M.

ELLIOT H. MARTEN, who worked on the South Downs and in Scotland, may have been a member of this family.

Examples: B.M.; V.A.M.; Laing A.G., Newcastle; Newport A.G.

MARTENS, Henry **- 1860**
A military painter in oil and watercolour who lived in London and
exhibited at the B.I. and Suffolk Street from 1828 to 1854. He
worked up drawings by soldiers such as T.W.O. McNiven (q.v.) as
well as producing original work and historical battle subjects.

Illustrated: Ackermann: *Costumes of the Indian Army*, 1846.
Ackermann: *Costumes of the British Army in 1855*, 1858.

MARTIN, Ambrose
A landscape and marine painter in oil and watercolour. He lived in
London, exhibited from 1830 to 1844 and was a Member of the
N.W.S. in 1833-40.

MARTIN, Elias, A.R.A. **1739 (Stockholm) — 1818 (Stockholm)**
Martin came to England in 1768 and became one of the first students
of the R.A. Schools, exhibiting at the second exhibition in 1769. He
was elected A.R.A. in 1771, and continued to exhibit sporadically
at the R.A. He also exhibited with the Free Society in 1776. In
1780 he returned to Sweden and became Court Painter to the King.
He lived in England again from 1788 to 1791, continuing to exhibit
at the R.A.
 He produced landscapes, portraits and figure drawings as well as
classical and ceremonial subjects. He occasionally engraved genre
scenes from his own designs. His earlier works show greater talent
than the later ones.
 He had two sons, Carolus, a cabinet-maker, and John, an artist.
His brother JOHN FREDERICK MARTIN (1745-1808) lived in
England with him, making engravings from his drawings, and
returning with him to Sweden.

Illustrated: C.M. Bellman: *Bacchi tempel*, 1783.
Examples: B.M.; V.A.M.
Bibliography: H. Frolich: *Broderner E. and J.F. Martins*, 1939.
Stockholm Nat. Mus.: *Akvareller och teckningar ar E.M.*, 1943. Arts
Council: *Exhibition Cat.*, 1963. *Country Life*, July 18, 1963.

MARTIN, Henry
A painter of the Cornish and Kentish coasts and Venetian views in
oil and watercolour. He exhibited from 1870 to 1894 and lived in
Penzance, Plymouth and Sidcup.

MARTIN, John, N.W.S.
1789 (Haydon Bridge, near Hexham) - 1854 (Douglas, Isle of Man)
The son of a fencing master, tanner and coach builder, he was
apprenticed to a coach-painter in Newcastle. However, he ran away
and was placed with Boniface Musso, a china-painter and the father
of Charles Muss, the miniaturist, and went to London with him in
1806. There he worked as a glass and china-painter and studied
architecture and perspective. He exhibited for the first time in 1812,
at the R.A., with which he began to quarrel two years later. By the
early 1820s he could be described by Lawrence as 'the most popular
painter of the day' - although Constable called *Balshazzar's Feast*
'Martin's pantomine'. As well as his vast historical and biblical
canvases, he made many small engravings and illustrations, most
notably for *Paradise Lost,* with R. Westall (q.v.) for which he was
paid £2,000. Gradually watercolour landscapes began to
predominate among his works, probably because they could be
executed on his wanderings about the Home Counties and environs
of London with a view to improving the water supply of the capital.
He was also much involved with schemes for the docks, sewers and
the embanking of the Thames. He exhibited at the S.B.A. from
1824, was briefly a Member of the N.W.S. in 1836, and was
Historical Painter to Princess Charlotte and Prince Leopold.
 His work is grandiose in conception but often weak in execution.
In contrast with his large oil paintings, which are usually composed
on a vertical plan, his watercolours are generally horizontal in
composition, giving a feeling of space. His colours are often more
effective in this medium.
 He was probably the sanest of his family. His brother
WILLIAM MARTIN (1772-1851), the 'Natural Philosopher',
produced engravings and probably watercolours.

Examples: B.M.; V.A.M.; Aberdeen A.G.; Bridport A.G.; Towner
A.G., Eastbourne; Fitzwilliam; Leeds City A.G.; Manx Mus.;
Newport A.G.; Ulster Mus.
Bibliography: W. Martin: *A Short Outline of the Philosopher's
Life. . . and an Account of Four Brothers and a Sister,* 1833. W.
Feaver: *The Art of J.M.. A.J.*, April, 1858.

MARTIN, Jonathan, 'Mad' 1782 (Hexham, Northumberland) -
 1838 (St. Luke's Hospital, London)
A brother of John Martin (q.v.), he was a religious fanatic whose
most notable act was setting fire to York Minster in 1829. He was
tried, found not guilty because insane, and confined in St. Luke's
Hospital, London, where he produced numerous bizarre caricature
drawings.

Bibliography: W. Martin: *An Account of the Philosopher's Life,*
1833.

MARTIN, Sylvester
A sporting painter who lived at Handsworth and exhibited in
Birmingham from 1870 to 1899.

MARTINEAU, Edith, A.R.W.S. 1842 (Liverpool) - 1909 (London)
The youngest daughter of Dr. James Martineau, and the niece of
Harriet, she was a landscape, portrait, figure and genre painter. She
studied in Liverpool and at Leigh's and the R.A. Schools. She
exhibited from 1862 and was elected A.R.W.S. in 1888. Her work
can be very attractive indeed.
 An elder sister, GERTRUDE MARTINEAU, also exhibited from
1862 and was an unsuccessful candidate for the N.W.S. in 1863 and
1864. She painted animals, flowers and genre subjects. Exhibitions
of the work of the two sisters were held at the Modern Gallery in
1906 and the New Dudley Gallery in 1910.

Examples: V.A.M.; City A.G., Manchester.
Bibliography: *A.J.*, 1909.

MARTINEAU, Robert Braithwaite 1826 (London) - 1869
After University College, London, and a short apprenticeship to a
solicitor, Martineau attended Sass's School in Bloomsbury, then
under the mastership of F.S. Cary. In 1848 he entered the R.A.
Schools, after which he studied under Holman Hunt. They shared a
studio in Pimlico until 1865, when Martineau married. He first
exhibited at the R.A. in 1852. A memorial exhibition of his work
was held at the Cosmopolitan Club, Charles Street, Berkeley Square,
in June 1869.
 He made liberal use of body-colour, and also produced
distinguished pencil portraits.

Examples: B.M.; Ashmolean; City A.G., Manchester.
Bibliography: *A.J.*, 1869.

MASON, Frank Henry, R.I.
 1876 (Ebberston Hall, Yorkshire) - 1965
After beginning his career at sea, he worked in engineering and
shipbuilding. During the First World War he served in the North Sea
and Egypt. He made extensive sketching tours, illustrated many
books and designed posters for railway companies. He exhibited
from 1900 at the R.A., and was a Member of the R.B.A. He was
elected R.I. in 1929. In 1973 an exhibition of his work was held at
Greenwich.

Examples: Cartwright Hall, Bradford; Dundee City A.G.; Gray A.G.,
Hartlepool.

MASON, George Finch **1850 - 1915**
A painter of hunting scenes and sporting subjects. He was at Eton,
where his father, Rev. John Finch Mason, was a master, from 1860
to 1864, and shortly after he left, he painted a set of ten
watercolour caricatures of Eton life, which he entitled 'Eton in the
Sixties'. He was a prolific book illustrator.

Published: *The Run of the Season*, 1902. *Sporting Nonsense
Rhymes*, 1906. Etc.

MASON, George Hemming, A.R.A.
1818 (Stoke-on-Trent) - 1872 (London)
After a brief apprenticeship to a Birmingham surgeon and a period as art critic on a local newspaper, Mason, with his brother, left England in 1843 for France, Switzerland and Italy. They reached Rome in the autumn of 1845, and there he took portraits of the English and their animals. During the siege of Rome he was arrested as a suspected spy, narrowly escaping death. From 1851 he painted the cattle and scenery of the Campagna. In 1858 he returned to England, married, and lived in the family home, Wetley Abbey, Stoke, although he spent much time in London. He was elected A.R.A. in 1869, and exhibited at the R.A. and the Dudley Gallery. He is best known for his landscapes and animal compositions.

A memorial exhibition of his work was held at the Burlington Fine Arts Club in 1873. His remaining works were sold at Christie's, February 15, 1873.

Examples: B.M.
Bibliography: Burlington F.A. Club, 1873. Birmingham Royal Soc. of Artists, 1895. *A.J.*, 1872, 1883.

MASON, W. c. 1769 — c.1822
A Cambridge topographer who published a number of views of the Colleges, probably engraved from his own drawings.

Examples: Fitzwilliam.

MASSIOT, Gamaliel — c. 1781
The second drawing master at Woolwich Academy, he was appointed in 1744 and held the post until 1780. He also took private pupils.

MASTERS, Captain William Godfrey Rayson
A captain in the Royal Marine Light Infantry who served on the Chinese Expedition in 1859-60. He was seriously wounded in the attempt to storm the forts at the mouth of the Pei Ho River. A number of lithographs were made from his drawings by T.G. Dutton (q.v.).

An exhibition of his work was held by F.T. Sabin in 1972.

Published: *The Chinese Expedition*, 1859-60, 1861.

MATHER, John Robert 1845 (Scotland) — (Australia)
A landscape painter who worked in Northumbria and Norway in the 1860s and 1870s, and emigrated to Australia in 1878. He was Curator of the Melbourne Museum from 1893.

Examples: Shipley A.G., Gateshead.

MATKIN, Sarah
A follower and perhaps pupil of J. Stannard (q.v.) who was working in about 1870.

MATTHEWS, Henry — 1830
A portrait painter and miniaturist who worked for the East India Company from 1801 to 1827.

MATTHEWS, James
A painter working in Sussex at the end of the nineteenth century. His work is in the manner of H. Allingham (q.v.), but it is less accomplished.

MATTHISON, William
A landscape and coastal painter in oil and watercolour who exhibited in Birmingham from 1874 to 1910, and at the R.B.A. from 1885 to 1894. He lived in Oxford and Banbury and also painted in Scotland, Yorkshire and Hampshire.

MAUGHAN, James Humphrey Morland
1817 (Northumberland) — 1853 (London)
An amateur artist who lived in Northumberland until 1844 when he moved to Maidstone, Kent. At this point he was a schoolmaster. In 1847 he joined H.M. Customs and Excise in Newcastle-upon-Tyne, and in 1853 he was transferred to the London office. An example of his work is illustrated in a letter to *Country Life,* May 22, 1969.

MAUND, George C.
A painter of Hampstead and Hendon views who was an unsuccessful candidate for the N.W.S. in 1852 and exhibited at the S.B.A. from 1853 to 1864. He lived in St. John's Wood and Kilburn, and also visited Bath.

MAWLEY, George 1838 (London) — 1873 (London)
A landscape painter in oil and watercolour. He exhibited at the R.A., Suffolk Street and elsewhere from 1858 to 1872, and his views are chiefly taken from the Thames Valley and Yorkshire. He was living in Gower Street in 1860 and 1863, when he was an unsuccessful candidate for the N.W.S.

MAXWELL, Hamilton, R.S.W. 1830 (Glasgow) — 1923 (Glasgow)
A businessman and landscape painter. He lived in Australia from about 1852 to 1881, and on his return, settled at Luss, Loch Lomond, and studied in Glasgow and Paris. He painted many Continental town scenes and was President of the Glasgow Arts Club in 1909.

Examples: Glasgow A.G.

MAXWELL, Sir John Stirling, 10th Bt., of Pollock
1866 — 1956
A traveller and able amateur watercolour painter, he made many topographical drawings on the Continent. He was internationally reputed an expert on rhododendrons, and his estate, gardens and collections were left to the City of Glasgow by his widow in 1966.

Examples: Paisley A.G.
Bibliography: W. Fraser: *The Cartulary of Maxwell Pollock*, 1875.

MAY, Arthur Powell
A landscape painter in oil and watercolour who exhibited at the R.A., R.I. and Suffolk Street from 1875. He lived at Lee, Bexley Heath and Littlehampton and painted on the South Coast and in Suffolk.

Examples: Towner Gall., Eastbourne.

MAY, George H.
A painter of Exeter and Devonshire views who was working in the 1820s.

Examples: Exeter Mus.

MAY, Philip William, 'Phil', R.I.
1864 (Wortley, near Leeds) — 1903 (London)
The caricaturist. He was the son of a brass-founder and was educated at a Board School. At the age of twelve he became a scene painter at Leeds and, two years later, joined a company of strolling players. In 1882 he was back in Leeds designing pantomime costumes. He then moved to London, where he worked as a newspaper illustrator. From 1885 to 1888 he was in Australia working for the *Sydney Bulletin,* and on his return to Europe he studied in Paris. He published his *Winter Annuals* from 1892, joined *Punch* in 1895 and was elected R.I. in 1897.

His work has a greater element of caricature than that of C.S. Keene (q.v.) and his draughtsmanship is not in the same class, but his drawings are highly accomplished and have great verve. Sometimes he coloured his portraits using thin washes, and he often introduced self-portraits into his work - he is instantly recognisable with his severe fringe, cigar and canary-coloured waistcoat.

His remaining drawings were exhibited at the Leicester Galleries in 1903.

Illustrated: H.H.S. Pearse: *The Comet Coach,* 1895. Etc.
Examples: B.M.; V.A.M.; Cartwright Hall, Bradford; Glasgow A.G.; Leeds City A.G.; Newport A.G.; N.G., Scotland.
Bibliography: J. Thorpe: *P.M.,* 1932. *A.J.,* 1903. *Apollo,* LXXVI, December, 1962.

MAY, Captain Walter William, R.I. 1831 — 1896
A marine painter in oil and watercolour who served in the Navy from 1850 to 1870, retiring as captain. He exhibited from 1859 and

was an unsuccessful candidate for the N.W.S. on several occasions from 1861. He was finally elected A.N.W.S. and N.W.S. in 1871 and 1874. He painted coastal and shipping subjects in England, France, Holland and Norway. His work is in the tradition of E.W. Cooke (q.v.) and C. Stanfield (q.v.) and, although not particularly original, is always competent and pleasing.

Published: *A Series of Fourteen Sketches . . . in search of Sir J. Franklin*, 1855. *Marine Painting*, 1888.
Illustrated: W.H.G. Kingston: *Will Weatherhelm*, 1879. J. Bickerdyke: *Sea Fishing*, 1895. C.N. Robinson & J. Leyland: *In the Queen's Navee*, 1902.
Examples: Greenwich.

MAY, W Holmes
A Surrey painter who was working in the early 1880s.

MAYNARD, Charles, 2nd Viscount – 1824
The son of Sir William Maynard, Bt., he succeeded a kinsman in the Viscountcy in 1775. He was a pupil of A. Cozens (q.v.) at Eton and of P. Sandby (q.v.). His wife was painted by Gainsborough, and he lived in Essex.

MAYOR, William Frederick, 'Fred'
** 1866 (Winksley, Yorkshire) – 1916 (London)**
A landscape painter, he was the son of Rev. William Mayor. He was educated at St. Edmund's, Canterbury, and studied at South Kensington and Julian's in Paris. He shared a studio with F. Brangwyn (q.v.) early in his career and was a friend of Edward Stott. He exhibited from 1888, and he visited Morocco in 1900.
He was essentially an impressionist, and among his most effective works are his beach scenes, which lent themselves to rapid execution. He was prodigal in his use of white heightening, which has often oxidised.

Examples: V.A.M.; Blackburn A.G.; Leeds City A.G.

MEADE, Lieutenant The Hon. Herbert George Philip
** 1842 – 1868 (Portsmouth)**
A son of the 3rd Earl Clanwilliam, he joined the Navy as a sub-lieutenant in 1861, being promoted two years later. He served on the Australian Station from 1864 to 1867, and was killed by an accidental shellburst.
He painted Eastern and Pacific scenes in a competent amateur manner.

Published: *A Ride through the disturbed districts of New Zealand*, 1870.

MEADE, Lucy Emma, Hon. Mrs., née Jacob – 1918
The wife of Canon Sidney Meade, elder brother of H.G.P. Meade (q.v.). She travelled and painted with her brother-in-law.

MEADOWS, Arthur Joseph 1843 – 1907
The son and brother of marine painters, he lived in London and Dover and painted coastal subjects in England, Holland, France and the Mediterranean in oil and watercolour. He exhibited from 1862 to 1885.

MEADOWS, Joseph Kenny 1790 (Cardigan) – 1874 (London)
An illustrator and wood-engraver, he first achieved popularity in 1823 with his designs and lithographs for Planche's *Costume of Shakespeare's Historical Tragedy of King John*. He produced his own illustrated edition of Shakespeare between 1839 and 1842. He was a prolific illustrator of children's books and worked on the Christmas numbers of the *I.L.N.* He was one of the first to champion wood-engraving for popular publishing. He occasionally painted in oil.

Examples: V.A.M.

MEASHAM, Henry 1844 (Manchester) – 1922
A portrait and landscape painter who lived in Manchester, Conway and Liverpool. Many of his subjects were taken from North Wales. He exhibited at the R.A. from 1867.

MEDLAND, Thomas
An engraver and draughtsman who worked on many plates of topographical subjects. He exhibited his own watercolours at the R.A. from 1777 to 1822. He was the first drawing master appointed at the East India College, Hertford, later moving with the College to Haileybury. One of his pupils in Hertford and London was S. Daniell (q.v.).

MEDLEY, Samuel 1769 (Watford) – 1857 (Chatham)
A painter and educationalist, he was the son of a Baptist minister. He exhibited at the R.A. in 1792, and painted religious, historical landscape subjects and latterly portraits until 1805, when he abandoned art for health reasons. He then went on to the Stock Exchange and was one of the founders of University College, London. He lived at Chatham for the later part of his life.

MEDLYCOTT, Rev. Sir Hubert James, 6th Bt.
** 1841 – 1920**
An amateur artist who was educated at Harrow and Trinity College, Cambridge, and was ordained after a period in the Diplomatic Service. He was Vicar of Milborne Port, Somerset, from 1870 to 1883, and of Hill, Gloucestershire, from 1883 to 1886. He exhibited at the R.I. and the S.B.A.

Examples: Towner A.G., Eastbourne; Gloucester City A.G.

MEEN, Margaret, Mrs.
A painter of flowers, portraits and landscapes who was active from 1775 to at least 1818. She often painted on vellum and in a Dutch manner.

Examples: V.A.M.; Fitzwilliam; Ulster Mus.

MEGSON, Arthur
A flower and bird's-nest painter who kept an art shop in Bradford in about 1880. His drawings are often circular and are in the manner of W. Henry Hunt (q.v.), but without his use of stippling.

Examples: Cartwright Hall, Bradford.

MELVILLE, Arthur, A.R.S.A., R.W.S.
** 1858 (Loanhead of Guthrie, Forfarshire) – 1904 (Witley, Surrey)**
He entered the R.S.A. Schools in 1875, exhibiting his first picture in that year. In 1878 he went to study in Paris, where he remained for some three years and then made his way East. He went first to Egypt and then down the Red Sea and to Karachi, then up the Persian Gulf to Baghdad. From there he travelled by land and sea to Constantinople. In 1884 he returned to Scotland, where he was immediately recognised as a leader by the Glasgow School. He was elected A.R.S.A. in 1886 and, moving to London, in 1888, A.R.W.S. He was elected R.W.S. in 1899. His subjects were drawn from the East or from Spain, Morocco and sometimes Italy. In his use of colour he is close to Brabazon, using it often to convey atmosphere rather than form. He worked on a primed white paper, and often on a wet surface. His wild blots and splashes are in fact carefully thought out and composed, and his methods were well suited to the brightness and gaudiness of his subjects.
In 1892 he was accompanied on one of his visits to Spain by F. Brangwyn (q.v.), whose later work owes much to Melville's influence. He was also the inspiration of many of his Scottish contemporaries.

Examples: B.M.; V.A.M.; Aberdeen A.G.; Dundee City A.G.; Fitzwilliam; Glasgow A.G.; Kirkcaldy A.G.; Leeds City A.G.; Walker A.G., Liverpool; N.G., Scotland.
Bibliography: O.W.S. Club, I, 1923. A.E. Mackay: *A.M.*, 1951.

MELVILLE, Harden Sidney
A genre, landscape and architectural painter in oil and watercolour who lived in London and was active from 1847 to 1881.

Published: *The Adventures of a Griffin*, 1867.
Illustrated: W. Dalton: *The War Tiger*, 1859. J. Greenwood: *Curiosities of Savage Life*, 1864. Etc.
Examples: B.M.; Maidstone Mus.

MELVILLE, Henry
An artist who painted miniature watercolour copies of contemporary pictures for engraving in the *London Art Union Annual*. He often used red outlining, which gives his work a slight similarity to that of J.J. Cotman (q.v.).

Published: *Illustrated Guide to the Botanical Gardens at Rosherville*, 1843.
Examples: B.M.

MENDS, Captain George Pechell – ? 1872
A Naval officer and amateur artist who entered the Navy in 1824 and was promoted lieutenant in 1841, while serving in the Mediterranean. From September, 1841 to 1843 he was stationed in South America, after which he served in the Cape until 1849, when he returned to the Mediterranean. He was promoted commander in 1854 and captain in 1858. He served at the Naval Prison from 1867 and in 1870 was made paymaster. His watercolours are built up from flat, colourful washes and are very effective.

Examples: Greenwich.

MEREDYTH, William 1851 (Manchester) –
A landscape painter who studied at the Manchester School of Art.

MERIVALE, John Herman 1799 (Exeter) – 1844 (London)
A scholar, lawyer and minor poet. He was educated at St. John's College, Cambridge, and entered Lincoln's Inn in 1798. He practised in Chancery and Bankruptcy and was appointed Commissioner of Bankruptcy in 1831. He was a friend and pupil of F. Towne (q.v.), and painted romantic peasant scenes and copies of Claude. He published a number of poems and translations.

Published: *Leaves from the Diary of a Literary Amateur*, 1911.
Examples: Exeter Mus.; Leeds City A.G.

MERRITT, Thomas Light (Chatham) – 1870 (Rochester)
A Kent painter of still-lifes. He was also a poet.

Published: *The Castle of Chinon*, 1837.
Examples: V.A.M.; Maidstone Mus.

METEYARD, Sidney Harold 1868 (Birmingham) – 1947
He studied at the Birmingham School of Art under Edward R. Taylor, and worked in Birmingham, exhibiting at the R.A. and at provincial exhibitions.

His glass-staining, as well as his work in oil, watercolour and tempera, is greatly influenced by Burne-Jones.

Illustrated: H.W. Longfellow: *Golden Legend*, 1910.

METZ, Conrad Martin 1755 (Bonn) – 1827 (Rome)
A mythological figure draughtsman who spent some years in London, at first as a pupil of Bartolozzi and later as a teacher. F. Nicholson (q.v.) took lessons from him, although they had little effect on his style. In 1802 Metz left for Rome.

Examples: B.M.; W. Richartz Mus., Cologne.
Bibliography: M.A. Buonarroti: *Contorni delle figure del Giudizio Universale*, 1808.

MEYER, Henry c. 1782 (London) – 1847
A portrait painter and engraver, he was a nephew of Hoppner and a pupil of Bartolozzi. He exhibited both oil and watercolour portraits at the R.A. from 1821 to 1826, and at the S.B.A. from 1824 to 1833. He was P.S.B.A. in 1828-9. He was successful in mezzotint as well as line and stipple engraving.

HENDRICK MEYER YR. a Dutchman who died in London in 1793, painted landscapes in oil and watercolour.

MIDDIMAN, Samuel 1750 – 1831 (London)
The engraver. He exhibited landscape drawings at the Incorporated Society and the R.A. from 1772. He studied engraving under Byrne and Woollett and later worked for Boydell.

Published: *Select Views in Great Britain*, 1784 – 92.

MIDDLETON, Fanny
The daughter of the Rector of Brampton, Yorkshire, she exhibited landscapes, sometimes in the Thames Valley, in London and Leeds from 1881. In 1884 she was living in York.

MIDDLETON, John 1827 (Norwich) – 1856 (Norwich)
A pupil of J.B. Ladbroke (q.v.), J. Stannard (q.v.) and H. Bright (q.v.), he was also influenced by his friend T. Lound (q.v.). In 1847 he went to London, and began to exhibit, but returned to Norwich two years later. He visited the coast, Tunbridge Wells, Devon and, in 1853, Scotland. His health was never good, and he died of consumption.

He specialised in wooded landscapes and rocky streams, with timber fellers and sometimes cattle. His style is free and vigorous and shows the Norwich preoccupation with light. He sometimes uses a monogram. He painted in both oil and watercolour, and his studies of plants and grasses can be very attractive indeed.

Examples: B.M.; Castle Mus., Norwich.
Bibliography: W.F. Dickes: *The Norwich School*, 1905. *A.J.*, February, 1857.

MILES, Helen Jane Arundel c.1840 –
The daughter of COMMANDER ALFRED MILES (d.1851), an amateur artist, she studied at South Kensington and the Lambeth School of Art and exhibited designs and illustrations at the Dudley Gallery and elsewhere. She lived in South London and also painted Cornish and Italian subjects. She was a prolific book illustrator.

MILLAIS, Sir John Everett, Bt., P.R.A.
 1829 (Southampton) – 1896 (London)
Millais was brought up in Jersey and studied at Sass's Academy and the R.A. Schools. He exhibited at the R.A. from 1846. His splendid drawings and few watercolours are really only interpretations of his oil paintings in different media, and follow the same stylistic path from Pre-Raphaelite minuteness, through comparative freedom to conventionality. He was created a baronet in 1885 and unanimously elected P.R.A. just before his death from cancer of the throat.

Examples: B.M.; V.A.M.; Ashmolean; Cecil Higgins A.G., Bedford; Glasgow A.G.; City A.G., Manchester.
Bibliography: W. Armstrong: *Sir J.E.M.*, 1885. M.H. Spielman: *M. and his Works*, 1898. A.L. Baldrey: *Sir J.E.M.*, 1899. J.G. Millais: *Life and Letters of J.E.M.*, 1899. J.E. Reid: *Sir J.E.M.*, 1909. A. Fish: *J.E.M.*, 1923. M. Lutyens: *M. and the Ruskins*, 1967. *A.J.*, 1884, 1896, 1898.

MILLAIS, John Guille 1865 (London) – 1931
The youngest son of J.E. Millais (q.v.), he was educated at Marlborough and Trinity College, Cambridge and became a lieutenant in the Seaforth Highlanders and a lieutenant commander R.N.V.R., as well as a painter. Millais specialised in monochrome wash drawings of birds and animals. They are usually carefully and somewhat stiffly outlined. He lived much of his life at Horsham, but travelled widely, visiting Iceland, North America and the Arctic, the Carpathians and South Africa.

Published: *A Breath of the Veldt*, 1895. *British Deer and their Horns*, 1897. *Life and Letters of J.E. Millais*, 1899. *The Wildfowler in Scotland*, 1901. *American Big Game*, 1915. *Rhododendrons and Hybrids*, 1917.

MILLAIS, William Henry 1828 –1899 (Farnham)
The brother of Sir J.E. Millais (q.v.), he painted landscapes in oil and watercolour. In the 1850s he worked and sketched with his brother. He exhibited from 1853 to 1892, and his work can show the stippled intensity of a Grimshaw watercolour. His son married JUDITH AGNES BOOTHBY in 1860. She painted coastal scenes with figures and died in 1862.

Published: *The Princess of Parmesan*, 1897.
Examples: B.M.; Ashmolean.

MILLARD, Caroline, Mrs.
The aunt of E.C. Clayton (q.v.), she was a wood-engraver and flower painter in watercolour. She lived in Dublin.

MILLARD, Charles S
A landscape painter who lived in London, painted in North Wales and Galloway, and exhibited from 1866 to 1889.

Examples: V.A.M.

MILLER, George B
A landscape painter who studied under B. Barker (q.v.), and was living in Kilkenny in 1815 and Dublin from 1817. In 1818 he was advertising himself as 'Professor of landscape painting in oil and water-colour'. He exhibited at the R.H.A. in 1815, 1817 and 1819. He may have returned to Bath after this date.

Examples: N.G., Ireland.

MILLER, James
Probably the younger son of J. Miller (q.v.). His large views of London have charm and topographical value, although his figures are usually rather out of scale and badly drawn. He is perhaps more akin to Sandby than to the true topographers. He was active between 1773 and 1791.

Examples: B.M.; V.A.M.; Newport A.G.

MILLER, John (Johann Sebastian Müller)
 c.1715 (Nuremberg) – c.1790
A flower painter and engraver who studied under J.C. Weigel and M. Tyrott. He came to England in 1744. He published a number of botanical books often from his own drawings, most notably the *Illustrations of the sexual system of Linnaeus*. He also drew and engraved domestic, topographic and history subjects. He almost certainly produced a number of fake old master paintings. He exhibited landscapes at the Society of Artists and the R.A. from 1762 to 1788. In his early days he signed J.S. Müller or J.S. Miller, but after 1760, John Miller.

Examples: Nat. Hist. Mus.

MILLER, John Frederick
The elder son of J. Miller (q.v.), he was draughtsman to Banks's Iceland expedition in 1772. He was a frequent exhibitor of topographical views at the Society of Artists.

Published: *Various subjects of National History . . .*, 1785.
Examples: B.M.

MILLER, Captain Ralph Willett
 1762 (New York) – 1799 (St. Jean d'Acre)
A rather crude amateur artist, he came to England at an early age, entered the Navy, and served on the *Ardent* in 1788, in which year he also left for the West Indies. He returned to England late in 1792. He took part in the French wars and in August 1796 was appointed flag-captain to Nelson, with whom he served through the attack on Santa Cruz and the battle of the Nile. He was killed on board ship while defending St. Jean d'Acre under Sir Sidney Smith. There is a monument by Flaxman, donated by his fellow officers, in St. Paul's.

Examples: Greenwich.

MILLER, William 1796 (Edinburgh) – 1882 (Sheffield)
An engraver and watercolourist who was a pupil of George Cooke in London, but lived much of his life at Millerfield, near Edinburgh. He was an Honorary Member of the R.S.A.

Examples: Glasgow A.G.

MILLER, W H
A coastal and town painter in oil and watercolour, who lived in Lambeth. He exhibited oil paintings at the S.B.A. from 1836 to 1851. His watercolours are of no great quality.

Examples: B.M.

MILLIKEN, Richard Alfred
 1767 (Castle Martyr, Co. Cork) – 1815 (Cork)
A lawyer and amateur artist who worked in Cork and served through the 1798 rebellion in the Royal Cork Volunteers. He made political illustrations for the *Monthly Miscellany* and, in 1797, founded, with his sister, *The Casket or Hesperian Magazine,* which came out monthly until February, 1798. He also founded the Society for the Promotion of the Fine Arts in Cork, and occasionally exhibited pictures and drawings.
 A memorial exhibition was held in Cork in 1816.

MILLS, Charles S 1859 (Dundee) – 1901
A businessman and amateur landscape painter. He was an original member of the Tayport Art Circle.

Examples: Dundee City A.G.

MILLS, S F
A landscape, architectural and genre painter who lived in London and exhibited from 1858 to 1882. He was a master at the Metropolitan School of Art, and he painted in Surrey, Suffolk and Brittany.

Examples: V.A.M.

MILNE, Ada Frances
A landscape painter working in the 1870s and 1880s. She exhibited a Thames view at the S.B.A. in 1880 and sometimes signed with initials.

MITCHELL, Elizabeth Harcourt, Mrs., née Rolls
 1833 (London) –
The daughter of JOHN E.W. ROLLS and ELIZABETH MARY ROLLS, née LONG, both amateur artists, she was a landscape and architectural painter. She was brought up at Hendre, Monmouthshire, spending the summers on the family yacht and visiting France, Spain, Portugal, Holland, Norway and the Scilly and Channel Islands. In 1860 she married F.J. Mitchell of Llanfrechfa Grange, Mon., with whom she toured the galleries of Italy. She lithographed a number of her drawings and wrote poems and novels. She was an unsuccessful candidate for the N.W.S. in 1865, and exhibited a view of Avignon with the Society of Female Artists in the following year.

Published: *The Ballad of Sir Rupert,* 1855. *Golden Horseshoes,* 1884. *Forty Days in the Holy Land,* 1890. *Harriet's Treasure,* 1910.

MITCHELL, J Edgar 1871 – 1922
A painter of landscapes, figures and portraits in oil and watercolour who lived in Newcastle.

Examples: Shipley A.G., Gateshead; Laing A.G., Newcastle.

MITCHELL, John 1838 (Aberdeen) – 1926
An Aberdeenshire landscape painter.

Examples: Aberdeen A.G.

MITCHELL, Philip, R.I. 1814 (Devonport) – 1896
A landscape and coastal painter who served in the Navy and later lived in Plymouth. He was an unsuccessful candidate for the N.W.S. in 1853 and was elected Associate in the following year and Member in 1879. He was a good sketcher and a skilful manipulator of atmospheric effects and skies. Much of his work is from the Cornish coasts, but he also ventured further afield, to Derbyshire and elsewhere.

Examples: Exeter Mus.; Plymouth City Lib.

MITCHELL, Thomas
A shipwright who painted marine subjects. He exhibited with the Free Society from 1763 and at the R.A. from 1774 to 1789. He worked at Chatham and Deptford dockyards, and rose to become Assistant Surveyor of the Navy.

He specialised in views of ports, and some of his drawings were engraved.

Examples: B.M.

MITCHELL, William Frederick
c.1845 (Calshot Castle, Hampshire) – 1914 (Ryde, Isle of Wight)
A painter of competent ship portraits who can occasionally be very good indeed. He worked for some years as an amateur in Portsmouth before acquiring an agent, Griffith, after which he worked continuously on commissions from naval officers. For many years he 'illustrated Brassey's *Naval Annual.* The majority of his work is in watercolour, and he sometimes made postcard-sized watercolours of ships. He numbered all his works up to at least 3,500; thus his signature might read 'W. Fred Mitchell 1891 – 1,405'. He was dumb.

Published: with W.C. Symons: *The British Navy, Past and Present,* 1905.
Examples: Greenwich.

MITFORD, Bertram Osbaldeston 1777 – 1842
The owner of Mitford Castle, Northumberland. He took the name of Osbaldeston in 1835 and was High Sheriff of the county for that year. He produced crude but amusing caricatures in the manner of Woodward, and he sometimes copied Rowlandson.

Examples: B.M.

MOFFAT, James 1775 – 1815
A caricaturist, topographer and engraver who lived in Calcutta from 1789.

Examples: India Office Lib.

MOGFORD, John, R.I. 1821 (London) – 1885
Mogford was of Devonshire descent and married the daughter of F. Danby (q.v.). His subjects were mainly taken from the coasts of the West Country. He studied at the Government School of Design, and was elected A.N.W.S. in 1866 and N.W.S. in 1867, exhibiting nearly three hundred drawings with them. He also exhibited at the R.A., B.I. and Suffolk Street.

His brother, HENRY MOGFORD (fl.1837-1846) was a very competent watercolourist in the Bonington manner. He published a *Handbook for the Preservation of Pictures,* in 1845. There is an example of his work in the Williamson A.G., Birkenhead.

Examples: V.A.M.; Castle Mus., Nottingham; Sydney A.G.

MOGFORD, Thomas 1809 (Exeter) – 1868 (Guernsey)
A landscape and genre painter, he was articled to John Gendall and Mr. Cole in Exeter, after which he married Cole's eldest daughter, settling in Exeter. He sent pictures to the R.A. in 1838 and 1839, and in 1843 moved to London, where he continued to exhibit portraits and religious compositions at the R.A. Later he moved to Guernsey where he mainly painted landscapes and gave lessons, occasionally re-visiting Exeter to take portraits. His earlier work shows a Pre-Raphaelite influence.

Examples: B.M.; Exeter Mus.; Castle Mus., Nottingham.

MOIRA, Gerald Edward, R.W.S.
1867 (London) – 1959 (Northwood, Middlesex)
Originally Giraldo Eduardo Lobo de Moura, he was the son of a Portuguese miniaturist who settled in London. He was a pupil of J.W. Waterhouse, and is best known as a decorative painter. He also painted landscapes and flower studies in water and bodycolour. He was elected A.R.W.S. and R.W.S. in 1917 and 1932, and was Vice-President from 1953.

Illustrated J. Walter: *Shakespeare's True Life,* 1890.
Examples: V.A.M.
Bibliography: J.H. Watkins: *The Art of G.E.M.,* 1922.

MOLE, John Henry, R.I.
1814 (Alnwick, Northumberland) – 1886 (London)
After an apprenticeship to a solicitor in Newcastle-upon-Tyne, he took up miniature and watercolour painting, first exhibiting miniatures at the R.A. in 1845. He was elected A.N.W.S. in 1847, and a member the following year, after which he gave up miniature painting. He exhibited watercolours at the N.W.S., and an oil painting at the R.A. in 1879. In 1884 he was elected Vice-President of the R.I.

Although he is best known as a painter of children in landscapes, it should really be the other way round, since his children, although often charming, are generally the weakest points of the composition. His backgrounds are extremely well painted, often with a preponderance of rich greens.

Examples: V.A.M.; Haworth A.G., Accrington; Ashmolean; Williamson A.G., Birkenhead; Cartwright Hall, Bradford; Gray A.G., Hartlepool; Maidstone Mus.; Newport A.G.

MOLLOY, Joseph 1798 – 1877
A landscape painter who taught drawing at the Belfast Academical Institution, and was a member of the Belfast Association of Artists. His thirty views of *Belfast Scenery* were published in London and Belfast in 1832. The original drawings are in the Ulster Mus.

MONAMY, Peter c.1670 (Jersey) – 1749 (London)
The marine painter, he came to London at an early age and was apprenticed to a house painter on London Bridge. His paintings and wash drawings are much in the style of the Van de Veldes. He is said to have died poor as the bulk of his work was bought by dealers.

Examples: B.M.; V.A.M.
Bibliography: *Walker's Monthly,* February, 1936.

MONRO, Dr. Thomas
1759 (London) – 1833 (Bushey, Hertfordshire)
The third of a line of at least five doctors who specialised in insanity and followed each other as Physicians to Bethlem Hospital. He was educated at Harrow and Oriel College, Oxford, and was a pupil of J. Laporte (q.v.). He became Principal Physician at Bethlem in 1792, and in 1811 and 1812 he was called in consultation to George III at Windsor.

From 1793 or 1794 to 1820 he lived at 8, Adelphi Terrace, as well as at Fetcham Cottage, near Leatherhead, and later at Bushey. He became one of the most notable patrons of the day, and at all these places he ran his 'Academy', inviting young artists to study and copy his collection of paintings and drawings. In this he presumably collaborated with his neighbour J. Henderson (q.v.), who kept a similarly open house. The collection included many works by Hearne, Cozens, whom he treated in his madness, Canaletto, Wilson and Gainsborough, and among those who benefited were Girtin, Turner, Francia, Underwood, Munn, George Shepherd, Cristall, J.S. Cotman, J. and C. Varley, de Wint, Linnell, Alexander and W. Henry Hunt (all q.v.).

His own drawings – 'my imaginings' as he called them – are very much in the Gainsborough manner. He used wet paper, drawing the outlines with a stick of Indian ink and finishing with the brush. Occasionally there are touches of colour, but these may have been added by members of his family.

All his children doubtless drew to some extent. They were DR. EDWARD THOMAS MONRO (b.1789), who succeeded to his practice, HENRY MONRO (1791-1814), SARAH MONRO (1794-1880), ROBERT MONRO (b.1799), JOHN MONRO (1801-1880) and ALEXANDER MONRO (1802-1844). Of them Henry, John and Alexander were to some degree professionals. Alexander was a particularly competent watercolourist working at Bushey, Oxford, Albury, Brighton, Malvern and in Guernsey, Germany and the Isle of Wight. There are examples of Henry's works in the Ashmolean and the Fitzwilliam.

Examples: B.M.; V.A.M.; Aberdeen A.G.; Ashmolean; Exeter Mus.; Fitzwilliam; Abbot Hall A.G., Kendal; N.G., Scotland; Leeds City

A.G.; Newport A.G.; Ulster Mus.
Bibliography: *A.J.,* 1901. V.A.M.: *Exhibition Cats.,* 1917, 1976.
Connoisseur, XLIX, 1917. O.W.S. Club, II, 1924. Walpole Soc., V;
XXIII; XXVII.

MONTAGUE, Clifford
A Birmingham landscape and coastal painter who was active at least
between 1883 and 1900. He exhibited in Birmingham from 1887
and painted in Britain and France.

MONTALBA, Clara, A.R.W.S. 1842 (Cheltenham) — 1929 (Venice)
The daughter of a genre painter of Spanish descent, she studied
under Isabey in Paris. She exhibited marine subjects and landscapes
in London from 1873, and was elected A.R.W.S. in the following
year. She and her artist sisters, ELLEN MONTALBA (ex.
1868-1902), HENRIETTA, MRS. SKERRET and HILDA
MONTALBA (d.1919), spent much of their time in Venice, which
provided the majority of their subjects.

Examples: Leeds City A.G.; Castle Mus., Norwich.

MONTGOMERY, Miss V A
A landscape painter who was a pupil of J.W. Ferguson and N.E.
Green (q.v.). She exhibited for many years in the late nineteenth
century at the Royal Amateurs Art Exhibition in London as well as
in Edinburgh and Perth.

MOORE, Albert Joseph 1841 (York) — 1893 (London)
The thirteenth son of W. Moore (q.v.), and the brother of H. Moore
(q.v.), and of J.A. Moore (q.v.) by whom he was taught after the
death of his father. After attending schools in York, he came to
London in 1855, continuing his education at Kensington Grammar
School. In 1858 he entered the R.A. Schools, having exhibited bird
studies at the R.A. in the previous year. For the following two years
he continued to exhibit natural history studies, after which he
turned to biblical scenes and, after visiting Rome for the winter of
1862-63, to classical compositions. From this point he concentrated
on the Hellenic themes for which he is best known, and which
anticipate the excesses and successes of Alma Tadema.
 He frequently exhibited at the R.A., and stood for many years as
a candidate, but was refused admission in view of his outspoken
judgements on artistic and other matters. A memorial exhibition
was held at the Grafton Gallery in 1894.
 He always kept to the detailed brushwork of his early days, but
his figures, even when depicted in motion, lack movement.

Examples: B.M.; V.A.M.; Ashmolean; Williamson A.G., Birkenhead;
City A.G., Birmingham; Liverpool A.G.; City A.G., Manchester.
Bibliography: *A.J.,* 1881; 1893; 1903.

MOORE, Anthony John
1852 (Monkwearmouth, Co. Durham) — 1915
A violin maker who also painted marine subjects in watercolour and
etched. Many of his works were sold in local pubs.

Examples: Sunderland A.G.

MOORE, Barlow
A marine painter in oil and watercolour who worked rather in the
manner of T.B. Hardy (q.v.). He was active between 1863 and 1891,
and was painter to the Royal Thames Yacht Club. He lived in
London and Erith.

Illustrated: R.T. MacMullen: *Down the Channel,* 1869.
Examples: Greenwich.

MOORE, Charles 1800 — 1833
An architectural painter who worked for Ackermann and Britton
producing subjects such as the Brighton Pavilion and Exeter
Cathedral. He was elected A.O.W.S. in 1822 and exhibited until
1828. He lived in London.

Examples: B.M.

MOORE, Edwin 1813 (Birmingham) — 1893 (York)
The eldest son of W. Moore (q.v.), he studied under Cox and Prout.
He was a drawing master at York and worked for the Quakers for
fifty-seven years. He exhibited at the R.A., the R.I. and elsewhere.

Examples: Walker A.G., Liverpool.

MOORE, George Belton 1806 — 1875
A landscape, architectural and topographical draughtsman who was
a pupil of A. Pugin (q.v.). He taught drawing at the R.M.A.,
Woolwich, and University College, London. He exhibited, often
Italian subjects, in London from 1830.

Published: *Perspective, its Principles and Practice,* 1850-59. *The
Principles of Colour applied to Decorative Art,* 1851. *London
Promenades,* 1856.
Bibliography: *A.J.,* 1876.

MOORE, Henry 1776 (Derby) — 1848 (Derby)
A Derby drawing master who taught himself to engrave. Whilst
working for the Derby Marble Works he introduced the art of
etching on marble, for which the Society of Arts awarded him a
silver medal. He painted rather primitive landscapes.

Published: *Picturesque Excursions from Derby to Matlock, Bath and
its Vicinity,* 1818.
Examples: Derby A.G.

MOORE, Henry, R.A., R.W.S. 1831 (York) — 1895 (Margate)
The ninth son of W. Moore (q.v.), he became a marine painter,
although up to about 1857 he painted landscapes which show a
Pre-Raphaelite influence. He was elected A.O.W.S. and O.W.S. in
1876 and 1880, A.R.A. in 1885, and R.A. in 1893. He was trained
by his father, at the York School of Design, and at the R.A. Schools
from 1853. His landscapes were taken from many parts of England
and from Switzerland which he visited in about 1856. He lived
mostly at Hampstead.
 His marine work, for all its apparent looseness of style, is the
result of careful observation and painstaking pencil studies of the
movement of waves and ships. His use of colour developed from
cold greys to rich deep blues and greens, and always in his work the
sea is of greater importance than the boats upon it.

Examples: B.M.; V.A.M.; Portsmouth City A.G.
Bibliography: F. Maclean: *H.M.,* 1905. *A.J.,* 1881.

MOORE, James F.S.A. 1762 — 1799 (London)
A linen draper in Cheapside, Moore's interest in drawing was mainly
antiquarian. Perhaps on the excuse of poor health — he died of
tuberculosis — he was able to make frequent tours to record the
appearance of old buildings, the most important being to Scotland
and the North in 1785; the Welsh border in 1787; South-West Wales
in 1788; Yorkshire in 1789; East Anglia in 1790; the West and
North Wales in 1791; Scotland, with Girtin, in 1792; the Midlands,
also with Girtin, in 1794; the Kent Coast, possibly again with Girtin,
in 1795. He was a weak draughtsman, using light tints over
uncertain outlines, and his drawings were often worked up or
redrawn by better artists including Dayes, Girtin, Hearne, J.C.
Barrow and G. Robertson (all q.v.).

Published: *A List of the Abbeys, Priories and other Religious
Houses, Castles . . . ,* 1786. *Monastic Remains,* 1792-1816. *Twenty-
Five Views of the Southern Part of Scotland,* (one part only), 1794.
Examples: B.M.; Ashmolean; Fitzwilliam.
Bibliography: H. Stokes: *Girtin and Bonington,* 1922. Walpole Soc.,
V, 1917.

MOORE, Dr. James 1819 — 1883 (Belfast)
A Belfast surgeon who studied medicine in Edinburgh, where he met
many local artists who encouraged him to paint landscapes. He was
a frequent exhibitor at the R.H.A., of which he was made an
Honorary Member in 1868.
 His landscapes, mainly done on the spot, are bold and free.

Illustrated: Syme: *Surgery.*

Examples: Belfast A.G.; Portsmouth City Mus.; Ulster Mus.
Bibliography: Ulster Mus. *Exhibition Cat.*, 1973.

MOORE, John Collingham 1829 (Gainsborough) – 1880 (London)
The eldest son of W. Moore (q.v.) by his second wife, Sarah
Collingham. He learnt painting under his father, and in 1851 entered
the R.A. Schools. He exhibited at the R.A., the B.I. and elsewhere
from 1853 until his death. He worked as a portraitist until 1857,
and in 1858 went to Rome where he made many views, chiefly in
watercolour, of the Campagna. Several of these were exhibited at
the Dudley Gallery. After 1872 he was mainly engaged in child
portraiture.

Examples: V.A.M.; Fitzwilliam.

MOORE, J Marchmont
A London genre painter who was active in the 1830s. His work is in
the manner of Landseer at his most sentimental.

Examples: Ashmolean.

MOORE, Thomas Cooper 1827 (Nottingham) – 1901
A self-taught landscape painter in oil and watercolour. His three
sons became artists. Of them, his eldest son, CLAUDE T.S. MOORE
(1853-1901), is the most proficient. He was apprenticed to a
Nottingham firm of printers, and later moved to London, where he
painted many scenes on the Thames, and exhibited at the R.A.,
before returning to Nottingham.

Examples: Castle Mus., Nottingham.

MOORE, William 1790 (Birmingham) – 1851 (York)
A portrait painter in watercolour, oil, and pastel. He studied design
under Richard Mills in Birmingham, after which he turned to
portraits, working in Birmingham and London before making his
career in York.
 His thirteen sons included A.J. Moore (q.v.), E. Moore (q.v.), H.
Moore (q.v.), J.C. Moore (q.v.) and WILLIAM MOORE, YR.
(1817-1909), who was an unsuccessful candidate for the N.W.S. in
1858. He lived mainly in Yorkshire and painted there, in Scotland
and in Devon. A sale of his work was held by Mills of York on July
17, 1894, and there are examples in the York A.G.

MORDAUNT, Sir Charles, 8th Bt. – 1823
An occasional amateur painter of 'blotesque' landscapes, he was the
son of Sir John Mordaunt of Massingham, Norfolk, whom he
succeeded in 1806. He was educated at Christ Church, Oxford, and
was M.P. for Warwickshire from 1804 to 1820. He married Lady
Mordaunt (q.v.) in 1807.

Examples: B.M.

MORDAUNT, Marianne, Lady c.1778 – 1842
The eldest daughter of William Holbech of Farnborough, Co.
Warwick, she married Sir Charles (q.v.) in 1807. She painted
Scottish views and other landscapes, usually in grey wash.

Examples: Coventry A.G.
Bibliography: P. Oppé: *Early English Drawings at Windsor*, 1951.
See Bowles Family Tree

MORE, Jacob 1740 (Edinburgh) – 1793 (Rome)
He served apprenticeships to a goldsmith and to the house painter
Robert Norie, attended Runciman's School of Design, and from
1773 lived in Rome. He exhibited with the Incorporated Society in
1771 and sent pictures to their exhibitions in 1775 and 1777, and
to the R.A. from 1783. In Rome he acquired a reputation as a
Claudian landscapist. He decorated a room in the Villa Borghese
with landscape panels, and re-designed the gardens in the English
manner.
 Perhaps his best drawings are those of his Scottish years. They
show a more professional touch than his better known Italian works.
His colours are muted, generally limited to greys and greens, and his

pen outlining, which is more noticeable in the later period, is rather
clumsy and stylized.

Examples: B.M.; N.G., Scotland.
Bibliography: *Burlington*, CXIV, November, 1972.

MORGAN, Alfred Kedington, F.S.A. 1868 (London) – 1928
A landscape and portrait painter in oil and watercolour, he studied
at the R.C.A., and became art master at Rugby School and Curator
of the local museum. Previously he had taught at Aske's School,
Hatcham. He was also an etcher.

MORGAN, Henry
A Cork amateur landscapist who made a series of views of the
Harbour and River of Cork, which were published in 1849.

MORICE, Miss A A
A landscape and occasional genre painter who lived in Kent. She
exhibited with the Society of Female Artists in 1871 and with the
S.B.A. from that year until 1885. She painted in Devon, Kent and
the Isle of Wight.

MORISON, Douglas, A.O.W.S. 1814 (Tottenham) – 1847 (Datchet)
The son of a doctor, he was a pupil of J.F. Tayler (q.v.) with whom
he visited Scotland. He became a topographer and lithographer and
briefly joined the N.W.S. in 1836-37, and he exhibited at the R.A.
from 1836 to 1841, before his election as A.O.W.S. in 1844. His
rather unoriginal works found patrons including the Prince Consort,
who commissioned views of the Ducal Palaces of Saxe-Coburg, and
the Queen, for whom he sketched at Windsor.

Published: *Twenty-Five Views of Haddon Hall*, 1842. *Views of the
Ducal Palaces and Hunting Seats of Saxe-Coburg and Gotha*, 1846.
Examples: B.M.

MORLAND, George Charles 1763 (London) – 1804 (London)
The son and grandson of artists, he is chiefly known as an oil painter
who specialized in scenes of rustic life. Morland first exhibited at
the R.A. at the age of ten. Although always a Londoner, he visited
Kent, the Southern Counties, the Isle of Wight, and went once to
France. His career was divided fairly equally between hard work and
hard drinking, although his dissolute way of life may well have been
exaggerated by his upright Victorian biographers. Certainly he often
paid for his food and drink by dashing off drawings and sketches.
His fame and popularity were helped by his friendship and double
relationship with the Ward family – he and William married each
other's sister. William Ward's sensitive engravings after his pictures
made Morland perhaps the most generally known name in British
painting. Copies of these prints were made both in Germany and in
England throughout the nineteenth and early twentieth centuries.
Although at times he received comparatively large amounts from
engravers and from private sales, he was arrested for debt in 1799
and ultimately died in a sponging house.
 Although his drawings in pencil or chalk are common, true
watercolours are rare, and the thin colour is usually added only as a
guide-line for a final oil painting. Soft-ground etchings were
published after many of his drawings and were very widely copied.
However, not all weak drawings should be dismissed as copies since
his own vary greatly in quality. He was at his best with animals and
small groups of peasants in wooded landscapes.

Examples: B.M.; V.A.M.; Glasgow A.G.; Leicestershire A.G.;
Newport A.G.
Bibliography: J. Hassell: *Memoirs of the Life of G.M.*, 1806. G.
Dawe: *Life of G.M.*, 1807, 1904. G.C. Williamson: *G.M.*, 1904,
1907. Sir W. Gilbey: *G.M.*, 1907. F. Buckley: *G.M.'s Sketchbooks*,
1931. W.S. Sparrow: *A Book of Sporting Painters*, 1931. G.E.
Ayres: *G.M., Isle of Wight Associations*, 1954. *Connoisseur*, IX,
1904. *Connoisseur Extra no.*, 1906. *A.J.*, 1904. Arts Council:
Exhibition Cat., 1954.

MORRIS, Charlotte, Mrs See SHARPE, Charlotte

MORRIS, J R
Probably a pupil of La Cave, as there is a drawing in the V.A.M. which would appear to be by La Cave, but which is signed 'J.R. Morris'.

MORRIS, Oliver
A landscape painter who lived in London and exhibited from 1866 to 1892. He was working in Edinburgh in 1895.

Examples: V.A.M.

MORRIS, William 1834 (Walthamstow) – 1896 (Hammersmith)
Poet, artist, designer, socialist and manufacturer, he made watercolours and bodycolour drawings only as an adjunct to his other activities. After 1862 he produced no finished 'pictures' in any medium, but his designs for glass and tapestries are often finely drawn.

Examples: B.M.; N.G., Scotland.
Bibliography: A. Vallance: *W.M....*, 1897. W. Mackail: *Life of W.M.,* 1899. *A.J.,* 1896.

MORRIS, William Bright 1844 (Salford) – 1896
He studied under W.J. Muckley (q.v.) in Manchester, and exhibited at the R.A. and elsewhere from 1869. He toured Italy and Spain, painting genre scenes in oil and watercolour, and lived for a time in the 1870s in Capri and Granada.

MORRISH, W S 1844 (Chagford, Devon) – 1917
The son of the painter Sidney S. Morrish who worked in London and Devonshire. He studied under his father and at the Exeter School of Art and Heatherley's. In 1866 he was an unsuccessful candidate for the N.W.S. He painted landscapes in Devon, where he lived throughout his life, and Switzerland.

Examples: Exeter Mus.

MORRISON, William
A naval painter working in the 1820s. He used white heightening.

MORROW, Albert George
 1863 (Comber, Co. Down) – 1927 (W. Hoathly, Sussex)
The son of a decorator, he studied at South Kensington and worked as a book and magazine illustrator from 1884. He exhibited at the R.A. from 1890, and he lived at West Hoathly, Sussex.

MORSE, Captain John
A caricaturist and portraitist who served in the 1st Horse Guards from 1776 to about 1783. He exhibited from 1779 to 1804.

MORTIMER, F. See MORTIMER, Thomas

MORTIMER, John Hamilton, A.R.A.
 1741 (Eastbourne) – 1779 (near Aylesbury, Buckinghamshire)
Primarily a pen and ink draughtsman, he studied under several masters but was mainly influenced by Cipriani. His pen drawings are common and are far too fussy, but his much rarer pen and wash or watercolour illustrations are more attractive. Among the best of these, in which the details and hatched shading are not overdone, are his illustrations to Chaucer.

 After a wild youth he married a farmer's daughter, and moved to Aylesbury in 1775. Sober living seems to have been too much for his constitution, for he died within four years.

Examples: B.M.; V.A.M.; N.G., Ireland; N.G., Scotland.

MORTIMER, Thomas
A close imitator of T.B. Hardy (q.v.), he also painted on the North Sea and Channel coasts. He is sometimes mis-catalogued as 'F. Mortimer' owing to a large full stop between initial and surname.

MORTON, Andrew 1803 (Newcastle-upon-Tyne) – 1845 (London)
A portrait painter, he studied at the R.A. Schools, exhibiting for the first time in 1821. He worked in the manner of Lawrence. He also produced scenes of Newcastle life.

Examples: Laing A.G., Newcastle.

MORTON, William
A Manchester painter of portraits and landscapes. He was active from 1862 to 1889, and exhibited in London from 1869

Examples: City A.G., Manchester.

MOSER, Mary, R.A. 1744 (London) – 1819 (London)
The daughter of GEORGE MICHAEL MOSER, R.A. (1704–1783), who was primarily a gold-chaser and enamellist, but also drawing master to George III. She was a flower painter in both oil and watercolour. She exhibited at the Society of Artists from 1760 to 1768 and, like her father, was a Foundation Member of the R.A. She was appointed Flower Painter to Queen Charlotte for whom she decorated a room at Frogmore. In 1793 she married Captain Hugh Lloyd.

Examples: B.M.; V.A.M.; Leicestershire A.G.; Ulster Mus.

MOSES, Henry 1782 (London) – 1870 (Cowley, Middlesex)
An engraver of antiquities, usually in outline. He also produced a number of more general works after his own drawings, often with a marine interest.

Published: *Picturesque Views of Ramsgate,* 1817. *Sketches of Shipping,* 1824. *Marine Sketchbook,* 1824.

MOSSMAN, David 1825 (Newcastle-upon-Tyne) – 1901
A miniaturist, genre and landscape painter who exhibited at the R.A. from 1853 to 1888, and with the N.W.S. and the S.B.A. from 1857 to 1890.

Examples: Laing A.G., Newcastle.

MOTE, George William c. 1832 – 1909 (Ewhurst)
An artist who taught himself to paint while working as gardener and caretaker to Sir Thomas Phillipps at Middle Hill, Worcestershire. His early works are primitive views in the area. Later he moved to Ewhurst, where he lived, with the exception of two years in London, for the rest of his life. He exhibited from 1857 to 1887, painting landscapes in Surrey, Sussex, Kent and Wales. At its best, his work can be reminiscent of that of J.W. North (q.v.), but after 1887 its quality declined.

MOTTRAM, Charles Sim
A coastal and landscape painter who exhibited from 1876 to 1903. He lived in London from 1879 to 1906 with periods at Villandreath, Lands End, in 1886, Weymouth in 1891 and St. Ives from 1900 to 1903. He also painted genre and figure subjects and was a member of the R.B.A. from 1890.

Examples: Greenwich; Portsmouth City Mus.

MOULE, Henry 1825 – 1904
A watercolour of Cambridge by this artist was illustrated in *Country Life,* March 18, 1971. He may be identifiable with HENRY JOSEPH MOULE who was working in Dorset, Somerset and France in the 1850s. There are examples of the latter's work in the Dorchester County Mus., and he published papers on Dorset history as late as 1901.

MOULE, Thomas 1785 (London) – 1851 (London)
A writer on heraldry and antiquities, he was a bookseller from about 1816 to about 1823 and later a Post Office clerk. He was also Chamber Keeper in the Lord Chamberlain's Office, thus living in St. James's Palace. His rather amateurish pen and wash drawings were probably made in connection with his topographical and antiquarian researches, which took him to every county in England except Devon and Cornwall. The drawings are sometimes signed with initials. His daughter, also an amateur artist, helped in his work.

MOXON, John
A figure and landscape painter who lived in Edinburgh. He exhibited

at Glasgow in 1878 and at the S.B.A., with Yorkshire and French scenes, in 1880.

Other painters of this name include ELIZABETH MOXON, who painted landscapes in the 1820s, and JENNER MOXON, who lived in London and stood unsuccessfully for the N.W.S. in 1871.

MUCKLEY, William Jabez
1837 (Audnam, Worcestershire) – 1905
A flower and still-life painter in oil and watercolour who studied in London, Birmingham and Paris. He exhibited at the R.A. B.I., R.I., Suffolk Street and elsewhere between 1858 and 1904. He was a Member of the S.B.A. from 1876, and taught at the Government Schools in Manchester and Wolverhampton.

As well as ornate flower pictures, he occasionally painted literary genre subjects.

Published: *The Student's Manual of Artistic Anatomy*, 1878. *A Handbook for Painters and Students*, 1880. *A Manual on Flower Painting*, 1885. *A Manual on Fruit and Still-Life Painting*, 1886.

MUIRHEAD, David Thomson, A.R.A., A.R.W.S.
1867 (Edinburgh) – 1930 (London)
After training as an architect he turned to painting, and in 1894 moved to London where he studied at the Westminster School of Art and the R.A. Schools. He was a Member of the N.E.A.C., and was elected A.R.W.S. in 1924 and A.R.A. in 1928. His favourite sketching grounds were on the Thames, the Wye and the Medway, and in the marshes and estuaries of Essex. His work is similar to that of his friends A.A. McEvoy (q.v.) and P.W. Steer (q.v.), and has links with that of A.W. Rich (q.v.).

Examples: B.M.; V.A.M.; Aberdeen A.G.; Cartwright Hall, Bradford; Bootle; Dundee City A.G.; Fitzwilliam; Glasgow A.G.; Harrogate Mus.; Kirkcaldy A.G.; Leeds City A.G.; Leicestershire A.G.; City A.G., Manchester; N.G., Scotland; Paisley A.G.

MUIRHEAD, John, R.S.W.
1863 (Edinburgh) – 1927 (Upper Norwood)
The son of an architect, he was educated in Edinburgh and became an etcher and a landscape painter in watercolour and oil. He exhibited from 1881 and was elected R.S.W. in 1893. He was also a Member of the R.B.A. He painted in Belgium, Holland and France and lived at Houghton, Huntingdonshire.

Illustrated: J.H.P. Belloc: *The River of London*, 1912.

MULCAHY, Jeremiah Hodges, A.R.H.A.
(Co. Limerick) – 1889 (Dublin)
A landscape painter who practised, and in 1842 started up a painting school, in Limerick. In 1862 he moved to Dublin. He exhibited at the R.H.A. from 1843 to 1878, and was elected A.R.H.A. in 1875. He also exhibited views of Limerick at the S.B.A. in 1852.

Illustrated: Hall: *Ireland, its Scenery and Character*, 1841.

MULGRAVE, Earl of See PHIPPS, Hon. Augustus

MULLER, Edmund Gustavus
The younger brother of W.J. Muller (q.v.), he was trained as a doctor. He often worked in a manner very close to that of his brother and copied some of his works. He was active from at least 1837 and exhibited Bristol, North Welsh and Venetian views at the S.B.A. from 1850 to 1871.

Examples: City A.G., Bristol.

MULLER, Johann Sebastian See MILLER, John

MULLER, Rosa
The daughter of N.C. Branwhite (q.v.), she married E.G. Muller (q.v.). She had a greater artistic success than her husband. She exhibited landscapes from Devon and Wales at the S.B.A. in 1861 and 1867.

MULLER, William James 1812 (Bristol) – 1845 (Bristol)
The second son of a German immigrant who became Curator of the Bristol Museum, Muller was entirely educated by his English mother. He took to sketching from nature at an early age, and for a short time was apprenticed to J.B. Pyne (q.v.). In 1831, as a result of seeing Bulwer's collection of Cotman drawings, he made a sketching tour of Norfolk and Suffolk. He was one of the founders of the Bristol sketching club early in 1833, in which year he also made two visits to Wales. In 1834 he and G.A. Fripp (q.v.) travelled to Holland, the Rhine and Venice. He then remained in Bristol until 1838, producing both oil paintings and watercolours, largely based on his Continental sketches. He spent October 1838 in Athens and then sailed to Egypt, returning to London the following March. He soon settled in London and attempted to join the Academy, without success. Once again, however, he was a member of a sketching society, this time the Clipstone Street Academy. In 1840, as a result of a commission, he toured northern and central France, and in the following years he made many expeditions on the Thames and to Wales. In the autumn of 1843 he went East again, this time as a member of the Lycian expedition, and the following May, made a brief tour of North Devon, but died of a heart attack the next year. He was painting to the end.

He was a constant sketcher, preferring rapid to highly finished effects. As he himself wrote, he often used bodycolour and tinted paper to achieve depth and to counteract the natural transparency of watercolour. However, this was by no means always the case, and many of his works are in pure watercolour. Among the most brilliant and successful of his drawings are those made on the Lycian expedition, when he had run out of many of his usual colours and his white had become unusable. He generally worked in a range of earthy colours, in particular deep greens and dark reds and oranges. His works are often inscribed in a neat, backward-sloping hand. He was one of the few artists who was ambidextrous.

His remaining works were sold at Christie's, April 1-3, 1846.

Published: *Sketches Illustrative of the Age of Francis I*, 1841.
Examples: B.M.; V.A.M.; Haworth A.G., Accrington; Birmingham A.G.; Cartwright Hall, Bradford; City A.G., Bristol; Dudley A.G.; Exeter Mus.; Fitzwilliam; Kirkcaldy A.G.; Leeds City A.G.; Leicestershire A.G.; Newport A.G.; Portsmouth City Mus.; Stalybridge A.G.; Tate Gall.; Ulster Mus.; Wakefield A.G.; Warrington A.G.
Bibliography: N.N. Solley: *Memoir of W.J.M.*, 1875. C.G.E. Bunt: *Life & Work of W.J.M. of Bristol*, 1948. *A.J.*, 1850, 1864. City A.G., Birmingham: *Exhibition Cat.*, 1896. *Antique Collector*, June, 1972.

MULREADY, Augustus Edward – 1886
A genre painter in oil and watercolour. With F.D. Hardy (q.v.), George Bernard O'Neill and T. Webster (q.v.), he was a member of the 'Cranbrook Colony'. He exhibited from 1863 to 1880, and his work is refreshingly unsentimental.

MULREADY, Elizabeth, Mrs., née Varley
1785 (London) –
The sister of John Varley, she married W. Mulready (q.v.) in 1803, but they separated in 1809. She exhibited landscapes with the Oil and Watercolour Society from 1813 to 1817, and worked in the manner of her brother.

MULREADY, William, R.A.
1786 (Ennis, Co. Clare) – 1863 (London)
A genre painter, he was brought to London by his father in about 1790 and taught himself to draw at an early age. He received encouragement and some instruction from Thomas Banks, the sculptor, and entered the R.A. Schools in 1800. Afterwards he spent some time as a pupil-teacher with J. Varley (q.v.) whose sister Elizabeth he married. The marriage collapsed completely after a few years. He tried many forms of painting at this time including topography, panoramas, miniatures and illustrations. In 1815 he was elected A.R.A., and R.A. in the following year. From this time he left the rather Wilkie-like subjects for which he had become known and concentrated on humorous themes. He continued to

illustrate. He lived at Kensington Gravel Pits from 1811 to 1827 and Bayswater for the rest of his life.

He was a very conscientious draughtsman and a master of brilliant colouring.

Examples: B.M.; V.A.M.; Towneley Hall, Burnley; Glasgow A.G.; Gloucester City A.G.; City A.G., Manchester; Ulster Mus.
Bibliography: T. Marcliffe: *The Looking Glass*, 1805. F.G. Stephens: *Memorials of W.M.*, 1867. J. Dafforne: *Pictures and biographical sketch of W.M.*, 1872. *A.J.*, 1899. V.A.M., *Exhibition Cat.*, 1972.

MUMMERY, Horace A 1867 – 1951
A friend of H.B. Brabazon (q.v.) and R.G.D. Alexander (q.v.), he lived at Wood Green and painted landscapes. He exhibited at the R.B.A. and elsewhere from 1888. He was an admirer and follower of Turner.

MUNN, Paul Sandby 1773 (Greenwich) – 1845 (Margate)
The son of a carriage decorator and landscape painter, he is said to have been a godson and pupil of P. Sandby (q.v.). Munn's earlier works are certainly in Sandby's manner. He was also influenced by his friend Cotman, with whom he visited Wales in 1802 and Yorkshire in 1803. He was one of the first Associates of the O.W.S., elected in December, 1805, but ceased to exhibit after 1815. His subjects are mostly topographical and often in pencil and monochrome wash. At his best he can be very pretty, at his worst flat and woolly. After 1832 he largely gave up painting for music. F. Stevens (q.v.) was one of his pupils.

Examples: B.M.; V.A.M.; Ashmolean; Williamson A.G., Birkenhead; Cartwright Hall, Bradford; Coventry A.G.; Fitzwilliam; Leeds City A.G.; Leicestershire A.G.; Newport A.G.; Ulster Mus.

MUNNS, Henry Turner 1832 – 1898
A Birmingham portrait painter who exhibited there and in London from 1860 to 1897, and was a member of the Birmingham Society from 1868. He also painted landscapes, sometimes in watercolour.

His son, JOHN BERNARD MUNNS (1869–1942), followed in his footsteps.

MUNRO, Hugh 1873 (Glasgow) – 1928
A flower and landscape painter in oil and watercolour, he was a Member of the Glasgow Institute. His wife, MABEL VICTORIA MUNRO née ELLIOT, R.S.W. (1884-1960), was a descendant of Lady Farnborough (q.v.) and married, secondly, William Stewart MacGeorge, R.S.A. (1861–1931).

Examples: Dundee City A.G.

MUNTZ, John Henry 1727 (Mulhouse) – 1798 (Cassel)
A Swiss artist who served in the French army and came to England from Jersey in 1755. He produced classical landscapes in watercolour for Horace Walpole and also worked for William Chute at The Vyne, Basingstoke. On leaving England in 1775, he is said to have joined the Polish army, and he visited Holland and Italy before settling at Cassel.

Published: *Encaustic, or Count Caylus's Method of Painting in the Manner of the Ancients*, 1760.
Examples: B.M.; Richmond Lib.

MURPHY, Dennis Brownell c. 1755 (Dublin) – 1842
A miniaturist who studied at the R.D.S. Schools, he moved to England in 1798, living first near Lancaster, and then in Newcastle-upon-Tyne and London. He was appointed Painter in Ordinary to Princess Charlotte in 1810, and occasionally exhibited at the R.A. from 1800 to 1826.

Although only miniatures seem to have survived, he is known to have been a competent landscape sketcher from the journals kept by J. Harden (q.v.) on his tour of the Lake District in 1798.

MURPHY, James Cavanagh
 1760 (Blackrock, Co. Cork) – 1814 (London)
An architect and antiquary who studied at the R.D.S. Schools in

about 1775. He practised in Dublin, visited Portugal in 1788 to draw the church of Batalha, studied Moorish architecture in Spain from 1802 to 1809 and then settled in London.

The majority of his drawings are of architectural details and ornaments, but in the B.M. there is a view of Tynemouth in the style of J. Farington (q.v.).

Published: *Travels in Portugal*, 1795. *Plans . . . of the Church at Batalha*, 1795. *A General view of the State of Portugal*, 1798. *The Arabian Antiquities of Spain*, 1815.
Examples: B.M.; R.I.B.A.

MURPHY, John Ross 1827 – 1892
A marine and coastal painter whose career at sea ended with the command of an Indiaman. On retiring, he took lessons from C. Stanfield (q.v.) and E. Gill (q.v.). He worked in Dublin and exhibited in Liverpool as well as at the R.A. from 1877 to 1884.

MURRAY, Hon. Amelia Matilda
 1795 – 1884 (Glenberrow, Herefordshire)
The daughter of Lord George Murray, Bishop of St. Davids, she was a friend of the Royal Family and a Founder of the Children's Friend Society. She was appointed Maid of Honour to Queen Victoria, but resigned in 1856 after a tour of the U.S.A., Cuba and Canada, because she was not allowed to publish her opinions on slavery. She was a keen botanist and flower painter, and also made landscape and topographical sketches to illustrate her writings.

Published: *Remarks on Education*, 1847. *Letters from the U.S. etc.*, 1856. *Recollections from 1803 to 1837*, 1868. *Pictorial and Descriptive Sketches of the Odenwald*, 1869.

MURRAY, Charles Fairfax 1849 – 1919 (London)
A follower of the Pre-Raphaelites who worked for Morris & Co. before visiting Italy at Ruskin's suggestion. He was an eminent collector, and his own work is influenced by the old masters as well as by Burne-Jones and Rossetti.

Examples: B.M.; Ashmolean; Fitzwilliam.

MURRAY, Sir David, R.A., A.R.S.A., P.R.I., R.S.W.
 1849 (Glasgow) – 1933
After working for a Glasgow merchant and studying at the Art School, Murray moved to London in 1883. There he had a career of unflawed success – perhaps more than in fact he merited. He was elected A.R.S.A. in 1881, A.R.A. and R.A. in 1891 and 1905, and R.I. and P.R.I. in 1916 and 1917. He was primarily an oil painter, but his watercolours, too, show a good sense of colour, form and composition. He was a landscape painter and to some extent based his style on that of Constable. Towards the end of his career he often worked in bodycolour and on a rather too large scale.

Examples: Williamson A.G., Birkenhead; Glasgow A.G.
Bibliography: *A.J.*, 1892.

MURRAY, Elizabeth, Mrs., née Heaphy
 1815 (London) – 1882 (San Remo)
The daughter of T. Heaphy the elder (q.v.), who took her to Rome where she drew from the antique. In about 1835 she was commissioned by Queen Adelaide to make some drawings in Malta. From there she went to Gibraltar, where she married H.J. Murray of the Consular Service, then to Tangiers and Constantinople, and from about 1864 she lived in America. She revisited Rome in 1875. She was elected N.W.S. in 1861, and sent pictures to their exhibitions from abroad.

She specialized in Mediterranean and other street and figure subjects.

Published:: *Sixteen Years of an Artist's Life*, 1859.
Examples: B.M.

MURRAY, Emily, Lady Oswald 1800 – 1896
The sixth child of Lord Henry Murray, fifth son of the 3rd Duke of Atholl, she married Sir John Oswald of Dunniker in 1829. She painted fairy subjects in an eighteenth-century style.

NAFTEL, Isobel, Mrs., née Oakley
A landscape painter, she was the daughter of O. Oakley (q.v.), the second wife of P.J. Naftel (q.v.) and the mother of M. Naftel (q.v.). She exhibited from 1857 to 1891. As well as views of the Channel Islands and South Coast, she produced portraits, genre subjects and flower pieces.

NAFTEL, Maud, A.R.W.S. **1856 (Guernsey) – 1890 (Chelsea)**
The daughter of P.J. Naftel (q.v.), she studied at the Slade and under Carolus Duran in Paris. She began to exhibit at the Dudley Gallery in 1877 and was elected A.R.W.S. ten years later. She also exhibited at the R.A., the R.I. and elsewhere. She was a charming flower painter and a very competent landscapist.

Published: *Flowers and how to paint them*, 1886.
Examples: Walker A.G., Liverpool.

NAFTEL, Paul Jacob, R.W.S.
 1817 (Guernsey) – 1891 (Twickenham)
He was a successful drawing master in Guernsey, teaching at Elizabeth College and taking private pupils. He married, secondly, Isobel (q.v.), daughter of O. Oakley (q.v.) and was the father of Maud (q.v.). He was elected A.O.W.S. and O.W.S. in 1850 and 1859 and moved to London late in 1870. He travelled widely in Britain, visiting Scotland several times and Ireland at least once. He also visited Italy and Spain.

An exhibition of his work was held at the F.A.S. in 1889 and his remaining works were sold at Christie's, April 6, 1892.

Published: *Catalogue of Drawings illustrating Sark, Wales etc.*, 1889.
Illustrated: Anstead and Latham: *Channel Islands*, 1862.
Examples: B.M.; V.A.M.; Reading A.G.; Sydney A.G.

NAISH, William **(Axbridge, Somerset) – 1800 (London)**
A miniaturist who also painted bird subjects and exhibited at the R.A. from 1783. He was noted for theatrical portraits. JOHN NAISH, who made animal studies, may have been a brother or son.

NAPIER, Lieutenant-General, Sir Charles James
 1782 – 1853 (Oaklands, near Portsmouth)
Best known for his conquest of Sind in north-west India, he also played a most important part in circumventing the Chartist uprising in 1839. He entered the 33rd Regiment of Foot in 1794 and from 1799 served nine years with various regiments in England and Ireland before being posted to Lisbon, from where he was ordered to Spain, taking part in the retreat of Sir John Moore to Corunna. He was severely wounded in the battle and taken prisoner, but in January, 1810 he was exchanged and posted to Portugal.

He served in America during the war of 1812–14. In 1819 he was appointed Inspecting Field Officer in the Ionian Islands and in February, 1821 made a reconnaissance tour of Greece. In March, 1822 he was appointed Resident of Cefalonia in the Ionian Islands, where he remained until 1830. He went to England on leave early in 1824 and on the return journey in 1825 visited several places on the Continent, including the Tyrol. In 1830, he settled in Bath but after the death of his first wife in 1833 moved to Caen. He lived in Bath again from 1836 to 1838 when he moved to Pembroke Dock, where he remained until his appointment as General Officer Commanding, Northern District, in April, 1839. In October 1841 he left for India

where he remained for nearly ten years. On his return to England he retired to the Hampshire Downs.

He made caricatures and sketches of peasants, but he is at his best in his studies of buildings which reflect his classical leanings. He was particularly fond of drawing the castles and fortifications of Normandy. His figure drawing is poor, and he worked mainly in blue or brown wash, although he occasionally used pure watercolour.

Bibliography: W.N. Bruce: *Life of General Sir C.N.*, 1885. R. Napier: *C.N., Friend and Fighter*, 1952.

NAPIER, Mary Margaret, Lady
The daughter of Lieutenant-General Sir John Clavering and the wife of Francis, 7th Lord Napier (1758–1823), whom she married in about 1785. Their married life was mostly spent in Scotland. She painted landscapes there and in Kent.

NARES, Rev. Edward **c. 1762 – 1841**
A pupil of J.B. Malchair (q.v.) who was educated at Westminster and became Professor of History and a Fellow of Merton. He published histories, sermons and novels.

Bibliography: G.C. White: *A Versatile Professor*, 1903.

NASH, Edward **1778 – 1821 (London)**
A miniaturist and watercolour portrait painter who was a pupil of S. Shelley (q.v.). He exhibited at the R.A. from 1811 to 1820 and worked in India during the latter years of his life.

Examples: B.M.

NASH, Frederick, O.W.S. **1782 (Lambeth) – 1856 (Brighton)**
The son of a builder, he learned architectural drawing under T. Malton, Yr. (q.v.), and attended the R.A. Schools, where he was encouraged by West. He began his career as an architectural draughtsman, working for engravers. He exhibited for the first time at the R.A. in 1800. In 1807 he was appointed architectural draughtsman to the Society of Antiquaries for whom he worked for many years. In 1809 he joined the A.A. and in 1811 was elected a member of the O.W.S. In 1816 he visited Switzerland, and in 1819 he began a series of drawings of Paris, which were ultimately bought by Sir T. Lawrence. He was elected a Member of the reconstituted O.WS. in 1824 and shortly afterwards married the sister of W.J. Bennett (q.v.). In the same year he made a set of drawings of places around Paris. He was in Paris again the following year as an assistant to Lawrence. In 1827 he went to Durham where the town and Cathedral provided him with many subjects in the following years. In 1830 he was in Normandy, and in 1831 in Normandy and on the Loire. In 1834 he moved from London to Brighton, which remained his home for the rest of his life. After this date Sussex and Windsor Castle are the most common of his English subjects, although he continued to travel and in 1838 visited the Rhine and Moselle, and, in 1841, the Lake District. Throughout most of his career he was a successful drawing master, and he often worked up his pupils' sketches.

Nash generally made three drawings of a subject on the spot, in the early morning, at mid-day and in the evening, so as to catch the most effective time for a finished work. His early works are straightforward topographical views in low colours. Later he became more concerned with the atmosphere of a place, although he still painted elaborate Cathedral interiors in the studio. In some of his later works he tended to over-use white heightening.

Published:: *The Collegiate Chapel of St. George at Windsor*, 1805. *Twelve views of the Antiquities of London*, 1805-10. *Picturesque views of the City of Paris and its Environs*, 1819-23.

Examples: V.A.M.; Bishopsgate Inst.; Blackburn A.G.; Cartwright Hall, Bradford; Towner Gall., Eastbourne; Newport A.G.; Castle Mus., Nottingham.
Bibliography: *A.J.*, February, 1857.

NASH, Joseph, O.W.S. 1809 (Great Marlow) – 1878 (London)
In 1829 his master, A. Pugin (q.v.). took him to Paris to make
drawings for his *Paris and its Environs*, 1830, and in the same year
he began to practise lithography. In the early part of his career he
concentrated on illustrative work and genre scenes, as well as the
picturesque architectural subjects for which he is best known. He
was elected A.O.W.S. in 1834 and a Member in 1842. His success
was largely due to the large sets of lithographs which combine
architectural fidelity with the historical romanticism of Cattermole
and the skill of Boys. Most of his time was occupied in searching out
subjects and preparing these plates. He also lithographed Wilkie's
'Oriental Sketches' in 1846, and worked on a set of views of the
Great Exhibition of 1851. His talents seem to have declined during
his later years, and he engaged in a number of disputes with other
members of the O.W.S., possibly exacerbated by an attack of brain
fever in 1854.

His works are typical lithographer's drawings of a high standard,
marred only, perhaps, by too much bodycolour. Southgate and
Barratt of 22 Fleet Street held a sale of his drawings as well as
studio properties on December 19, 1854.

His son JOSEPH NASH, YR., R.I. (d. 1922) was a marine
painter who worked from 1859. He also produced landscapes,
historical subjects and interiors, and he was elected R.I. in 1886.

Examples: V.A.M.; Williamson A.G., Birkenhead; Blackburn A.G.;
Fitzwilliam; Glasgow A.G.; Greenwich; Maidstone Mus.; N.G.,
Scotland; Gt. Yarmouth Lib.

NASMYTH, Alexander 1758 (Edinburgh) – 1840 (Edinburgh)
A portrait and landscape painter. He studied at the Trustees'
Academy and was apprenticed to Allan Ramsay in London. He
returned to Edinburgh in 1778 and was in Italy from 1782 to 1784.
He was a friend of Burns and was an architect, also running art
classes in his house. In these he was aided by his daughters JANE
NASMYTH (b. 1778), BARBARA NASMYTH (b. 1790),
MARGARET NASMYTH (b. 1791), ELIZABETH NASMYTH
(b. 1793), ANNE NASMYTH (b. 1798) and CHARLOTTE
NASMYTH (b. 1804) all of whom were professional artists. He and
they exhibited in London as well as in Edinburgh. His occasional
watercolours are free renderings of the Girtin theme.

Examples: B.M.; Glasgow A.G.; N.G., Scotland; Nat. Lib., Scotland.
Bibliography: *Connoisseur*, CLXIII, 1970.

NASMYTH, Patrick 1787 (Edinburgh) – 1831 (London)
The eldest son of A. Nasmyth (q.v.), he exhibited in Edinburgh
from 1808 to 1814, although he had moved to London in the earlier
year. He first exhibited at the R.A. in 1811. He was a Founder
Member of the S.B.A. in 1824. He was very much a country painter
and was known as 'the English Hobbema'. His few watercolours are
less Dutch than his oil paintings and are freely handled. His first
name was in fact Peter, but he did not use it.

Examples: B.M.; V.A.M.; Williamson A.G., Birkenhead; Fitzwilliam;
N.G., Scotland; Newport A.G.

NATTES, John Claude c. 1765 – 1822 (London)
Either English or French, Nattes spent some time in Ireland and
exhibited at the R.A. from 1782. He was a pupil of Hugh Primrose
Dean and a Founder Member of the O.W.S., but he was expelled
after two years for showing other people's drawings under his own
name. He continued to exhibit at the R.A. until 1814. He was a
dealer as well as a draughtsman and drawing master. In his coloured
drawings the bodycolour has usually faded unevenly. He also made
many pen and ink drawings with or without wash.

Published: *Scotia Depicta*, 1801-4. *Hibernia Depicta*, 1802. *Bath
and its Environs Illustrated*, 1804-5. *Versailles, Paris et St. Denis*,
1804-9. *Select Views of Bath, Bristol*... 1805.
Examples: B.M.; V.A.M.; Canon Hall Mus., Barnsley; Victoria A.G.,
Bath; Chelsea Lib.; Lambeth Lib.; Leeds City A.G.; Lincoln City
Lib.; Nat. Lib., Scotland; Newport A.G.; Richmond Lib.

NAYLOR, Thomas
A rather heavy-handed marine painter working in the manner of W.
Atkins (q.v.) and about 1795.

NEALE, John Preston
1780 – 1847 (Tattingstone, Near Ipswich)
A Post Office clerk who turned professional artist, painting insects and
topography. He was a lifelong friend of J. Varley (q.v.) who
influenced this decision. He exhibited at the R.A. from 1804 to
1844 and with the Oil and Watercolour Society in 1817 and 1818.
He worked for Britton's *Beauties of England and Wales*, and
sketched with J.C. Barrow (q.v.) and Dr. Monro (q.v.) as well as
Varley.

His topographical work is carefully outlined and pleasantly
coloured, but it is rarely particularly original.

Published: *History and Antiquities of the Abbey Church of St.
Peter, Westminster*, 1816-23. *Views of the Seats*... 1818-29. Etc.
Examples: B.M.; V.A.M.; Ashmolean; Castle Mus., Nottingham;
Beecroft A.G., Southend; Gt. Yarmouth Lib.

NEALE, Samuel 1758 – 1824
A landscape and topographic painter. There is a view of Abingdon
by him in the V.A.M.

NEED, Rear-Admiral Henry c. 1816 – 1875
He entered the Navy in 1833 and served in the East Indies. He was
promoted lieutenant for the part he played in the operations of
1841 against Canton. From 1843 to 1845 he was again in the East
Indies. He was promoted commander in 1848, retired from active
service as captain in 1867 and was promoted rear-admiral in 1875.
He served on the West coast of Africa from 1852 to 1856 on H.M.
Sloop *Linnet*, and a volume of watercolour views which he made
during this time is at Greenwich.

Bibliography: *I.L.N.*, April 10, 1875.

NEEDHAM, Joseph
A landscape painter who was active between at least 1848 and 1874.
In 1862 he was living in London and was an unsuccessful candidate
for the N.W.S.

NEIL, H
There is a topographical view of Reading in the Reading A.G. which
is signed and dated 1808 by this artist. He is certainly to be
identified with Hugh O'Neill (q.v.).

NESBITT, John 1831 (Edinburgh) – 1904
A landscape and marine painter in oil and watercolour. He lived in
Edinburgh and exhibited at the R.A. from 1870 to 1888.

NESBITT, Sidney
A landscape painter who lived in London and exhibited at the R.A.
and at Suffolk Street from 1872 to 1878. He taught at the
Blackheath School of Art.

Published: with G. Brown: *Handbook of model and object drawing*,
1884.
Examples: V.A.M.

NESFIELD, William Andrews, O.W.S.
1793 (Chester-le-Street, Durham) – 1881 (London)
The son of the Vicar of Brancepeth, he made many views of the
Castle and Park at the beginning of his career. In 1809 he entered
the R.M.A., Woolwich, as a cadet, and was commissioned in the
95th (the Rifle Brigade). He served through the Peninsular War and
then transferred to the 89th Regiment which was stationed in
Canada. He retired on half-pay in 1816 and devoted himself to
landscape painting. He was elected A.O.W.S. in February, 1823 and
a Member in the following June. His exhibited subjects indicate
visits to the Alps in 1822 or 1823, to Scotland, Wales and Yorkshire
as well as his native Northumbria, and to Ireland in 1841. He was in
Wales with Cox in 1844. He lived for a period in Windsor and Eton.
For a time he combined his work as a painter with landscape

gardening. However, in 1852, he resigned from the O.W.S. in order to concentrate entirely on the latter practice. He was involved in the laying out of several of the London parks and the Botanical Gardens at Kew.

Examples: B.M.; V.A.M.
Bibliography: O.W.S. Club, XXVII.

NETTLESHIP, John Trivett 1841 (Kettering) – 1902 (London)
An illustrator, animal painter and author, he was the son of Henry John Nettleship, a Kettering solicitor in whose office he worked for a time. He studied at Heatherley's and the Slade. He worked as an illustrator in pen and ink before turning to animal painting, for which he studied at the Zoological Gardens. In 1880 he visited India. He exhibited at the R.A., the R.I., Suffolk Street and elsewhere between 1871 and 1901.

An exhibition of his works was held at the Rembrandt Gallery, London, in 1890.

Published: *George Morland*, 1898.
Illustrated: A.W.E. O'Shaughnessy: *An Epic of Women*, 1870. Mrs. A. Cholmondeley: *Emblems*, 1875. A Nichols: *Natural History sketches among the Carnivora*, 1885. A.B.R. Battye: *Ice-Bound on Kolguev*, 1895.
Examples: Ashmolean.

NEW, Edmund Hart 1871 (Evesham) – 1931 (Oxford)
An architect, illustrator and painter of landscapes, coastal and genre subjects and portraits. He studied under E.R. Taylor and A.L. Gaskin at the Birmingham School of Art and exhibited at Birmingham from 1890 to 1923. For much of his life he lived in Oxford.

Published: *Evesham*, 1904. *The College Monographs*, 1906. *The New Loggan Guides to Oxford Colleges*, 1932.

NEWBERRY, Francis H
1855 (Membury, Devonshire) – 1946 (Corfe Castle)
A painter of genre subjects and Continental and British views, he studied at the Bridport School of Art and at South Kensington. He taught at various London schools before going to Glasgow, where he was appointed Director of the Art School in about 1890. He lived at Corfe Castle from 1919.

NEWBERRY, William
A pupil of J.B. Malchair (q.v.) and friend of W. Crotch (q.v.), he lived at Heathfield, Sussex. He also knew Constable and the earlier James Roberts (q.v.).

NEWBERRY, William
Possibly the father of F.H. Newbery (q.v.), he ran a sketching club at Bridport, Dorset, in the late nineteenth century.

NEWCOMBE, Frederick Clive 1847 – 1894 (Coniston)
A landscape painter, he was the son of the artist John Suker and first cousin of W. Crane (q.v.). He changed his name from Frederick Harrison Suker to avoid confusion with his father and his brother A. Suker (q.v.). He studied at the Mount Street School of Art and exhibited at the R.A. between 1875 and 1887. Among his sketching grounds were Bettws-y-Coed, Scotland and the Lakes. In 1880 he moved to Keswick.

A SAMUEL PROUT NEWCOMBE was painting on Lake Thun in 1876. He published religious and other books and tracts between 1850 and 1870.

Examples: Blackburn A.G.

NEWELL, Rev. Robert Hassell
1778 (Essex) – 1852 (Little Hormead, Hertfordshire)
Educated at Colchester and St. John's College, Cambridge, where he was admitted Fellow in 1800. He was Dean from 1809 to 1813 when he became Rector of Little Hormead, Hertfordshire. He studied under W.H. Pyne (q.v.) and illustrated his own publications.

His son, CHARLESS A. NEWELL, was also an amateur artist. In Hertford Mus. there are views by him, taken in 1870s, of Cornwall and the Liffey.

Published: *Goldsmith's 'Poetical Works'*, 1811 and 1820. *Letters on the Scenery of North Wales*, 1821. *The Zoology of the English Poets . . .* 1845.
Examples: B.M.

NEWENHAM, Robert O'Callaghan 1770 – 1849
An Irish landscape and topographical draughtsman who drew the scenery and buildings while travelling round Ireland as Superintendent General of Barracks, a post he held for twenty-five years. These drawings were later lithographed and published, first in 1826 and subsequently in 1830 in two volumes entitled *Picturesque Views of the Antiquities of Ireland, drawn on stone by J.D. Harding from the sketches of R.O'C. Newenham.* He was for a time President of the Cork Society of Artists.

NEWEY, Harry Foster 1858 (Birmingham) – 1933
A landscape and genre painter who studied at the Birmingham School of Art and exhibited from 1882. For a time he lived at Sutton Coldfield.

Published: *Elementary Drawing*, 1894.

NEWHOUSE, Charles B
A painter of coaching subjects in oil and watercolour who was active in the 1830s and 1840s. His watercolours are often a little clumsy, and they are outlined in pen and brown ink.

NEWMAN, J E
An Irish draughtsman working in Dublin in the early nineteenth century. His work shows great exactitude of detail.

NEWNHAM, Viscount, See HARCOURT, Earl of

NEWTON, Alfred Pizzey, R.W.S.
1830 (Rayleigh, Essex) – 1883 (Rock Ferry, Cheshire)
Newton was best known for his Scottish landscapes which brought him court patronage. He was elected A.O.W.S. and O.W.S. in 1858 and 1879. His few English landscapes come from his home area, around Southend, or that of his wife, in Cheshire. He visited Italy from 1861, and a year before his death he went to Athens by way of Gibraltar and Capri. He achieved his effects rather by indications of light, mist and shadow, than by an exact representation of texture. His remaining works were sold at Christie's, April 29, 1884.

Examples: V.A.M.; Stalybridge A.G.

NEWTON, Henry – c. 1854
A landscape painter who settled in Dublin where he exhibited at the R.H.A. from 1847 to 1853.

Examples: N.G., Ireland.

NEWTON, John Edward 1834 –
A landscape and still-life painter in oil and watercolour who exhibited in London from 1862 to 1881. He lived in Liverpool until 1866, when he moved to London. He was a member of the Liverpool Academy and was an unsuccessful candidate for the N.W.S. in 1870. To begin with he painted in a Pre-Raphaelite manner, but in London he adopted a freer style.

An earlier J. NEWTON was a member of the N.W.S. from 1836, but by 1840 he had 'gone away, not known where' and was struck off the list.

NEWTON, Richard 1777 – 1798 (London)
A caricaturist and miniaturist. He worked rather in the manner of J. Gillray (q.v.), but his youth and lack of training show in weaknesses of drawing and rather stark colouring.

Examples: B.M.

NIBBS, Richard Henry 1816 (London) – 1893 (Brighton)
A musician who turned to painting after an inheritance. From 1836 he published shipping and architectural prints and from 1841 to 1889 he exhibited marine, landscape, genre and battle subjects. He lived in London with a Brighton studio until 1841 and then settled permanently in Brighton. His landscapes and coastal subjects are taken from France, Germany and Holland as well as Sussex and the South Coast.

Published: *Marine Sketch book of Shipping Craft and Coast Scenes*, 1850. *The Churches of Sussex*, 1851. *Antiquities of Sussex*, 1874.
Examples: B.M.; V.A.M.; Brighton A.G.; Cape Town Mus.; Towner Gall., Eastbourne; Greenwich; Hove Lib.

NICHOLL, Andrew, R.H.A. 1804 (Belfast) – 1886 (London)
A landscape painter who was apprenticed to the Belfast printer F.D. Finlay, the founder of the *Northern Whig* on which Nicholl worked for some years. His landscapes had already gained local recognition before he came to London, where he taught himself by copying pictures. He left for Dublin, and first exhibited at the R.H.A. in 1832, being elected A.R.H.A. and R.H.A. in 1837 and 1860. By 1840 he was back in London, and he exhibited at the R.A. from 1832 to 1854, and elsewhere. In 1846 he was sent to Ceylon to be drawing master at the Colombo Academy. On his return he lived in London, Dublin, and Belfast, where he gave drawing lessons.

His earliest drawings are charming if naive views on the Antrim coast dating from about 1828. Later, in Dublin he turned to antiquarian subjects as well as landscapes and many prints were made from his drawings. In Ceylon he again combined the two, often using his favourite sketching medium of pencil and white heightening on buff paper. His views of Irish coastal towns seen through a fringe of wild flowers are strikingly original and probably date from the 1830s; later a characteristic was to paint extensive landscapes from a high point, and in the 1860s, storms on the rocky Antrim coast.

His daughter Mary Anne Nicholl worked in pen and ink and exhibited at the R.H.A. In 1889 she presented a collection of her father's Ceylon drawings to the R.H.A.

Illustrated: Hall: *Ireland, its Scenery and Character*, 1841.
Examples: B.M.; V.A.M.; India Office Lib.; R.H.A.; Ulster Mus.
Bibliography: Ulster Mus. *Exhibition Cat.*, 1973.

NICHOLL, William 1794 (Belfast) – 1840 (Belfast)
The elder brother of A. Nicholl (q.v.), he was a Belfast businessman and amateur landscape painter. He exhibited at the R.H.A. in 1832, and was an early Member of the Belfast A.A. which was founded in 1836.

His work is pretty but rather indefinite. He used scratching for his highlights.

Examples: B.M.; V.A.M.; Ulster Mus.

NICHOLS, Alfred
A drawing master who exhibited English landscapes and architectural subjects from 1866 to 1878. He taught for a time at the Bristol School of Art.

Examples: V.A.M.

NICHOLS, Catherine Maude c. 1848 (Norwich) – 1923
A landscape and architectural painter in oil and watercolour and an etcher, she lived at Norwich where she was a member of the Art Circle from 1885. She exhibited at the S.B.A., in Birmingham and elsewhere from 1877. Her subjects were taken from Norfolk, Cornwall, France, Germany and Switzerland.

NICHOLS, Mary Anne
A portrait, genre and landscape painter who lived in Islington and Pimlico. She exhibited at the S.B.A. from 1839 to 1865 and was an unsuccessful candidate for the N.W.S. in 1848. She worked in Leicestershire, Sussex and Kent. She should not be confused with the daughter of A. Nicholl (q.v.).

CATHERINE or KATE EDITH NICHOLS, who exhibited a landscape with the Society of Female Artists in 1875, was probably her sister.

There is a topographical example of the work of WILLIAM ALFRED NICHOLS (b. 1815) in the Richmond Lib. He was an unsuccessful candidate for the N.W.S. on several occasions from 1863 to 1869 and lived in Putney.

NICHOLSON, Alfred 1788 (Whitby) – 1833 (London)
The son of F. Nicholson (q.v.), whose style he imitated. After a period in the Navy, he lived and painted in Ireland from 1813 to 1816, when he came to London and worked as an artist and drawing master. In 1821 he toured North Wales and Ireland, and the following summer sketched in Yorkshire, Jersey and Guernsey.

Examples: B.M.; V.A.M.

NICHOLSON, Alice M
A Newcastle still-life painter who exhibited at the R.A. and with the N.W.S. from 1884 to 1888. She also painted landscapes, some from the West Country.

NICHOLSON, Emily
A landscape painter who lived in London and exhibited at the S.B.A. from 1842 to 1857. In the two subsequent years she was an unsuccessful candidate for the N.W.S. She painted in Leicestershire, Kent, Sussex, Surrey, Yorkshire and Cumberland.

NICHOLSON, Francis, O.W.S.
1753 (Pickering, Yorkshire) – 1844 (London)
A landscape painter and drawing master who for the first thirty years of his life lived in a number of Yorkshire towns, learning what little was possible from the local teachers, and painting portraits and animals, largely in oil. He made two visits to London, during one of which he took lessons from C.M. Metz (q.v.) and in 1783 settled in Whitby for nine years. Here he finally took up landscape painting in watercolour, and in 1789 he first exhibited at the R.A. and began to draw for Walker's *Copper Plate Magazine*. Between 1792 and 1803, when he settled in London, Nicholson continued to move about Yorkshire and made a visit to the Island of Bute with his patron the Marquess of Bute. They toured the other islands and lochs of the Clyde, and Nicholson made many sketches which provided him with subjects for some years. He was in Scotland again in 1812, touring the Lowlands. In 1804 he was one of the Founder Members of the O.W.S. He resigned from the Society in 1813, partly in order to concentrate on his flourishing practice as a drawing master. In fact, he had made so much money from the sale of his pictures and from lessons that he was virtually able to retire for his last years and to concentrate on experimenting with techniques and pigments. Despite the care he took in the composition of his colours, many of his watercolours have faded very badly, especially in the skies, which have become a hot pink. His earliest landscapes are in the traditional tinted manner over a basis of grey wash but, by 1795, he was producing Malton-like drawings of London bridges and later experimented with the direct laying on of colour, although he never really mastered it. He was also influenced by the techniques of W. Payne (q.v.). His lighting tends to be highly stressed and his colour, where it has survived, is over-dependent on a yellowish green. This, together with his method of rendering trees and foliage, tends to give his pictures a woolly effect.

After his early period as a portrait painter he concentrated on conventional landscapes and coastal scenes, with waterfalls as a favourite feature. Very occasionally, as with the series painted for Sir Richard Colt Hoare at Stourhead, he paints an excellent interior.

His daughters SOPHIA, who married William Ayrton, and MARIANNE (1792–1854), who married Thomas Crofton Croker, and also his nephew GEORGE NICHOLSON (1787–1878) were all watercolourists and worked very much in his manner. George published two series of lithographs, *Six Views of Picturesque Scenery in Goathland*, 1821, and *Six Views of Picturesque Scenery in Yorkshire*, 1822, and there are examples of his work at York A.G. He was probably the son of Nicholson's elder brother who was a house painter in Yorkshire.

Published: *The Practice of Drawing and Painting Landscapes from*

Nature, in Watercolours... 1820. *Sketches of British Scenery,* 1821. *Six Views of Scarborough,* 1822.
Examples: B.M.; V.A.M.; Cartwright Hall, Bradford; Grosvenor Mus., Chester; Coventry A.G.; Dudley A.G.; Leeds City A.G.; Newport A.G.; Nottingham Univ.; Portsmouth City Mus.; Richmond Lib.; Southampton A.G.; York A.G.
Bibliography: *Walker's Quarterly* XIV, 1924. O.W.S. Club, VIII, 1931.

NICHOLSON, George c. 1795 – c. 1839
The younger son of Mrs. Isabella Nicholson, known for her samplers. He exhibited landscapes at the Liverpool Academy between 1827 and 1838.
 An elder brother SAMUEL NICHOLSON (d.c. 1825), a drawing master, worked with George on his publications.
 A sister ISABELLA NICHOLSON exhibited natural history studies and landscapes at the Liverpool Academy between 1829 and 1845.

Published: with S. Nicholson: *Twenty-six Lithographic Drawings in the Vicinity of Liverpool,* 1821. *Plas Newydd and Vale Crucis Abbey,* 1824.

NICHOLSON, William, R.S.A.
 1781 (Ovingham-on-Tyne) – 1844 (Edinburgh)
A portrait painter and etcher who first exhibited at the R.A. in 1808 and moved from Newcastle to Edinburgh in about 1814. He was a Founder Member of the R.S.A. and Secretary from 1826 to 1830. He contributed to every exhibition from the first until his death. His pencil and watercolour portraits were very popular.

Published: *Portraits of Distinguished Living Characters of Scotland....,* 1818.
Examples: N.G., Scotland; Laing A.G., Newcastle.

NICOL, Erskine, A.R.A., R.S.A.
 1825 (Leith) – 1904 (Feltham, Middlesex)
A painter of humorous genre subjects. He was apprenticed to a house-painter and entered the Trustees' Academy at the age of twelve. He worked as a drawing master in Leith, and from 1846 he spent four years in Dublin with the Science and Art Department. For a time thereafter he made annual visits to Ireland. He was elected A.R.S.A. and R.S.A. in 1855 and 1859, and A.R.A. in 1868, having moved to London in 1862. Towards the end of his life he retired to Scotland and then to Feltham.
 For many years his most popular subjects were scenes of Irish peasant life, in watercolour or brown wash as well as in oil. Later he transferred his affections to the Scottish peasantry. His sketching style is free, perhaps owing something to Wilkie.
 His sons ERSKINE E. NICOL (d. 1926) and JOHN WATSON NICOL (d. 1926) were both landscape painters working in Scotland, London and France.

Illustrated: A.M. Hall: *Tales of Irish Life and Character,* 1909. W. Harvey: *Irish Life and Humour,* 1909.
Examples: B.M.; V.A.M.; Aberdeen A.G.; Dundee City A.G.; Harrogate Mus.; N.G., Scotland; Ulster Mus.
Bibliography: *A.J.,* March, 1870.

NIEMANN, Edmund John
 1813 (London) – 1876 (Brixton Hill, Surrey)
At the age of thirteen he became a clerk at Lloyd's, but gave this up for art in 1839, and moved to the High Wycombe area. In 1848 he returned to London to become Secretary of the Free Exhibition. He exhibited at the R.A. from 1844 until 1872, the B.I., S.B.A., Manchester, Liverpool and elsewhere. Some of his works were exhibited at the opening of the Nottingham A.G. in 1878.
 His watercolour landscapes are similar in style to the oil paintings which form the majority of his work. He also painted occasional sea-pieces.
 His son Edward H. Niemann painted landscapes in oil and a similar style to his own.

Published: with W. Fletcher: *A Tour round Reading,* 1840.
Examples: B.M.; V.A.M.
Bibliography: *Critical Catalogue,* 1876. *A.J.,* 1877.

NIGHTINGALE, Frederick C
An amateur painter who lived in Wimbledon and exhibited from 1865 to 1885. Many of his subjects were Venetian and Italian views.
 Other artists of the name include LEONARD CHARLES NIGHTINGALE, active between 1878 and 1886, his wife AGNES NIGHTINGALE, and ROBERT NIGHTINGALE, a painter of animal and human portraits in oil and watercolour and of still-lifes. He lived in Maldon, Essex, and exhibited with the S.B.A. from 1847 to 1866.

Examples: V.A.M.

NINHAM, Henry 1793 (Norwich) – 1874 (Norwich)
The son of John Ninham, an heraldic painter and engraver whose business he inherited. He exhibited at Norwich from 1816 to 1831 and specialised in architectural and street views of the city in watercolour. He also produced prints and some oil paintings. His work is thoroughly competent, if rather unimaginative. He was a friend of J.S. Cotman (q.v.) and E.T. Daniell (q.v.).

Published: *8 Original Etchings of Picturesque Antiquities of Norwich,* 1842. *Views of the Gates of Norwich made in 1792-3 by the late John Ninham,* 1861. *23 Views of the Ancient City Gates of Norwich,* 1864. *Remnants of Antiquity in Norwich. Views of Norwich and Norfolk,* 1875. *Norwich Corporation Pageantry.*
Illustrated: Blome: *Castle Acre.* Grigor: *Eastern Arboretum,* 1841.
Examples: B.M.; V.A.M.; Castle Mus., Norwich.
Bibliography: W.F. Dickes: *The Norwich School,* 1905.

NISBET, Margaret D 1863 – 1935
Perhaps a sister of R.B. Nisbet (q.v.), she studied in Edinburgh, Dresden and Paris. She painted portraits, miniatures and some landscapes.
 There is an example of the work of ETHEL NISBET in the Richmond Lib. She lived in London, painted architectural subjects and floral still-lifes and exhibited at the R.B.A. from 1884 to 1891. She published *Flower Painting for beginners,* 1884.

NISBET, Robert Buchan, R.S.A., R.S.W.
 1857 (Edinburgh) – 1942
A landscape painter who was elected A.R.S.A. in 1893 and R.S.A. in 1902. The son of a house painter, he worked in a shipping office until 1880. He then joined his brother POLLOCK SINCLAIR NISBETT, A.R.S.A. (1848–1922) in Venice and afterwards studied in Edinburgh and Paris. He exhibited at the R.S.A. from 1880 and in London from 1888. He was a Founder and the second President of the Society of Scottish Artists. He was also a Member of the R.I. from 1892 to 1907 and of the R.B.A. from 1891.
 His work is traditional in style, being based on that of Cox and de Wint. He strove after effect by constantly rubbing, damping and working up in the contemporary Dutch manner, which results in a loss of spontaneity and an overall indistinctness.

Examples: V.A.M.; Derby A.G.; Dundee City A.G.; Kirkcaldy A.G.; Leeds City A.G.; Paisley A.G.

NIXON, Rev. Francis Russell, Bishop of Tasmania
 1803 (Foots Cray) – 1879 (Lago Maggiore)
The son of R. Nixon (q.v.), he was educated at the Merchant Taylors' School and St. John's College, Oxford. He was Chaplain to the Embassy at Naples before being made Vicar of Sandgate, Kent, in 1836 and Ash next Wingham in 1838. In 1842 he was consecrated as the first Bishop of Tasmania. He returned to England in 1863 and retired after two years as Rector of Bolton-Percy, Yorkshire. Thereafter he lived in a house he had built on the Italian lakes.
 In some ways he is the most professional artist in the family, but his work has none of the spark and charm of that of his uncle. His sketching is very good, a little in the manner of W.E. Daniell (q.v.).

Published: *The History of Merchant Taylors' School,* 1823. *The Cruise of the Beacon,* 1857.

Bibliography: N. Nixon: *The Pioneer Bishop in Van Diemen's Land*, 1954.

NIXON, John c. 1750 – 1818 (Ryde, Isle of Wight)
An amateur landscape painter and caricaturist who was in business with his brother Richard in London as an Irish merchant. He may have been a son of Robert Nixon of Uphall, near Linlithgow, and Tokenhouse Yard. Nixon visited Ireland on numerous occasions in the 1780s and 1790s, in 1791 accompanying F. Grose (q.v.). He contributed drawings to William Watts's series of engravings of English and Irish seats. He visited Scotland in 1790 and perhaps again in the following year. In 1783 he made a short trip to St. Omer and in 1784 a tour of the Netherlands. He was in Paris in 1802 and 1804. Each summer he made extensive sketching tours, usually in Southern England. He sometimes travelled with other artists such as Grose and Rowlandson, with whom he visited Bath in 1792. In London he was a special juryman at the Guildhall and a captain in the Guildhall Volunters. He was also at the centre of a convivial circle of actors and wits who dined with him at his house in Basinghall Street, Secretary of the Sublime Society of Beefsteaks and a member of the Margravine of Anspach's set at Brandenburg House, Hammersmith, and Benham Park, Newbury. He often acted in the Margravine's plays.

He provided drawings for Thomas Pennant's *Journey from London to the Isle of Wight*, 1801, and for the *European Magazine*, and he etched a number of his caricatures, others being worked up and engraved by Rowlandson. His early work, in which the caricature element is usually marked, is always charming, but not always technically accomplished. However, from about 1800, under the influence of Rowlandson, he becomes a very professional amateur indeed. Of his 'characteristics' Angelo says: 'He could sketch a portrait, with a few scratches of his pencil, of a party whom he had not seen for twenty years, and with such marked traits of resemblance, as to be known at a glance.'

Examples: B.M.; V.A.M.; Carisbrooke Castle.
Bibliography: see H. Angelo: *Reminiscences*, 1830.

NIXON, Rev. Robert
1759 (Foots Cray, Kent) – 1837 (Kenmure Castle, Galloway)
A brother of J. Nixon (q.v.) and father of F.R. Nixon (q.v.), he was educated at Christ Church, Oxford, graduating in 1780. He was Curate and Rector of Foots Cray, Kent, from 1784 to 1804 and thereafter ran a school in Burr Street, Smithfield. He was an Honorary Exhibitor at the R.A. from 1790 to 1818, produced a most impressive watercolour for the Oxford Almanack and contributed to William Watts's series of views of English and Irish seats. He was also an accomplished etcher. Turner is said to have painted his first oil painting at his house in 1793 and certainly accompanied him and F.S.D. Rigaud (q.v.) on a sketching tour of Kent in 1798.

Examples: Ashmolean.

NOBLE, R P
Perhaps a son or brother of Robert Heysham Noble, who was a landscape painter in oil, he was a Member of the S.B.A. from 1829 to 1835 and active until 1861. He was painting landscapes from about 1830 and exhibited from 1836 to 1861. He lived in London and was an unsuccessful candidate for the N.W.S. in 1844 and 1845. Many of his views are taken from North Wales and others from Sussex, Surrey and Kent.

Published: *A Guide to Water Colour Painting*, 1850. *Progressive Lessons in Water Colour Painting*, 1861.
Examples: Birmingham City A.G.; Coventry A.G.; Maidstone Mus.; N.G., Ireland; N.G., Scotland.

NOBLE, William Bonneau 1780 (London) – 1831 (London)
The youngest son of Edward Noble, author of *Elements of Linear Perspective*, and brother of Samuel and George Noble, engravers. He was a drawing master. He twice visited Wales, and sent pictures worked up from the sketches to the R.A. from 1809. The following year his works were rejected, and he took a downhill path leading to attempted suicide in 1825.

NOBLETT, Henry John 1812 (Cork) –
A landscape painter in oil and watercolour who practised in Cork before coming to London in 1831. He exhibited at the B.I., the R.A. from 1832 to 1835, the S.B.A., and the N.W.S. to which he was elected in 1833. In 1835 he resigned and returned to Cork, exhibiting at the R.H.A. in 1844. He contributed three drawings to Hall's *Ireland, its Scenery and Character*, 1841.

NODDER, Frederick Polydore – c. 1800
Described as Botanical Painter to Queen Charlotte in 1788, he exhibited flower pieces between 1773 and 1788. He was the son of an artist in silk and human hair. His son RICHARD POLYDORE NODDER, who exhibited animal subjects at the R.A., produced the later plates for his *Vivarium Naturae*.

Published: *Vivarium Naturae*, 1789–1813.
Illustrated: T. Martyn: *Plates . . . to Illustrate Linnaeus's System of Vegetables*, 1788. T. Martyn: *Flora Rustica*, 1792-4.
Examples: B.M.

NOEL, Amelia, Mrs.
A drawing mistress who exhibited landscapes between 1795 and 1804. She and her daughter who taught with her, called on Farington in 1804 in order to solicit support for their offerings to the R.A. that year. She claimed to be a friend of West and Cosway and that her husband, a solicitor, had left her penniless, with four children to support including L. Ball (q.v.) with whom she stayed in Dublin in 1810. She drew in the Lake District, Kent, Ireland and elsewhere.

Published: *Select Views of the Isle of Thanet*, 1797.
Examples: B.M.

NORDEN, John 1548 (Hendon) – 1625
In 1593 John Norden, gent. was 'authorised and appointed by her Majesty to travel through England and Wales to make more perfect descriptions, charts and maps'. He was the first Englishman to design a complete set of County histories. He lived at Fulham in the 1590s and at Hendon from 1607 to 1610. In 1600 he was Surveyor of the Woods and Forests of Berkshire, Devonshire, Surrey and elsewhere. He published a number of surveys and religious tracts.

His drawings are small and charmingly naive, many of them appearing on his maps.

Published: *A Chorographical Discription of the Severall Shires and Islands . . . 1595. Preparative to his Speculum Britanniae*, 1596. *England, An intended Guyde for English Travailers*, 1625.

NORIE, Frank V
Possibly a relative of O. Norie (q.v.), he painted romantic scenes, sometimes in North Africa and the Mediterranean. He worked in the contemporary French manner.

NORIE, G W see NORRIE, G.W.

NORIE, Orlando 1832 – 1901
A member of an Edinburgh family of painters and decorators and the great-great-grandson of the artist James Norrie, he was a prolific and popular painter of military subjects. He kept a studio at Aldershot from about 1870 so as to study his material at first hand, and he exhibited at the R.A. from 1876 to 1889. His work is usually strictly factual, but occasionally he can rise to more impressive and poetic levels.

Illustrated: R.S. Liddell: *The Memoirs of the 10th Royal Hussars*, 1891.
Examples: V.A.M.; India Office Lib.; Nat. Army Mus.

NORMAN, Philip, F.S.A. c. 1843 (Bromley Common) – 1931
The son of a Director of the Bank of England, he was educated at Eton. He exhibited landscapes and drawings of old London from 1876, and he lived in London.

Published: with W. Rendle: *The Inns of Old Southwark*, 1888. *Cromwell House, Highgate*, 1917. Etc.

Illustrated: C. Welch: *Modern History of the City of London*, 1903
Etc.
Examples: V.A.M.

NORRIE, G W
Probably another member of the Edinburgh family of decorators – the name is variously spelled with one or two rs – he painted figure subjects in the 1830s.

Examples: N.G., Scotland.

NORRIS, Charles 1779 (Marylebone) – 1858 (Tenby)
An architectural draughtsman, he was educated at Eton and Christ Church, Oxford, and served briefly in the Army. He lived at Milford, Pembrokeshire for about ten years and at Tenby from 1810. His projected publications were extremely ambitious and he taught himself to engrave to cut down the expense.

Published: *The Architectural Antiquities of Wales*, 1810. *Etchings of Tenby*, 1812. *An Historical Account of Tenby*, 1818.
Bibliography: A.L. Leach: *C.N.*, 1949.

NORTH, Brownlow 1778 – 1829
The son of Brownlow North, Bishop of Winchester, and younger brother of the 6th Earl of Guildford. He was an amateur artist who supplied Gillray with subjects for his prints.

NORTH, Lady Georgina 1798 – 1835
The daughter of the 3rd Earl of Guildford and his second wife, Susannah Coutts. She painted literary subjects.

NORTH, John William, A.R.A., R.W.S.
** 1842 (Walham Green) – 1924 (Washford, Somerset)**
North was apprenticed in J.W. Whymper's wood engraving business, where he worked with F. Walker, G.J. Pinwell and C. Green (all q.v.). From 1862 to 1866 he was employed by the Dalziel brothers and provided illustrations for publications such as *Wayside Posies*, 1867. From 1868 until the end of his life he lived in Somerset, first at Halsway Farm, then at Withycombe and elsewhere. Fred Walker stayed with him in 1868 and the two went to Algiers together in the winter of 1873-4. North was elected A.O.W.S. in 1871, R.W.S. in 1883 and A.R.A. in 1893. From about 1895 until the First World War most of his time was taken up with the manufacture and marketing of a perfect watercolour paper. This impoverished him and left him little time for painting.

His style could be called a mixture between those of Corot and the Pre-Raphaelites. His foregrounds in particular, with their massed vegetation, are full of detail while the backgrounds are often hazy and atmospheric. Foliage and vegetation were in fact his forte, and both skies and figures gave him trouble. His colour is generally subdued, but on occasion it can be very bright and very successfully so.

Examples: B.M.; V.A.M.; Ashmolean; Bristol City A.G.; Southampton A.G.; Ulster Mus.
Bibliography: O.W.S. Club, V, 1927.

NORTHEY, Lieutenant-Colonel William Brooke
** – ? 1897**
Commissioned in the 1st Royal Regiment in 1822, he was promoted captain in 1826 and lieutenant-colonel in 1851. He painted views of Hastings in a rather weak Callow-like manner.

NOTTINGHAM, Robert A , Yr.
A landscape painter who lived in south London and, at the end of his career, at Bowness on Lake Windermere. He exhibited at the S.B.A. and elsewhere from 1856 to 1875 and was four times unsuccessful for the N.W.S. between 1856 and 1860. His subjects were generally found in Kent and Surrey until his move to the Lakes.

NOWELL, Commander William Calmady – 1883
He entered the Navy in 1813 and from 1831 to 1834 served in the West Indies. He was in the Mediterranean for several years from 1836, and he retired in 1860. There are watercolours and sepia drawings by him at Greenwich.

NOWLAN, Frank c. 1835 (Co. Dublin) – 1919
A genre and portrait painter in oil and watercolour who moved to London in 1857 and attended Leigh's School, where he became a friend of F. Walker (q.v.), and the Langham School of Art. He gained Court patronage and exhibited at the R.A., Suffolk Street and elsewhere between 1866 and 1918. He painted occasional miniatures.

Examples: V.A.M.

NOYCE, E
A pupil of J.B. Malchair (q.v.) who produced views of Windsor in the 1820s.

NOYES, Robert c. 1780 – 1843
A descendant of an ancient Wiltshire and Sussex family. He gave up a career in banking for art, and is said to have painted mainly in Wales, Shropshire and Staffordshire, between 1815 and 1840. Williams, in his essay in *Country Life*, gives details of some of Noyes's movements, from a portfolio of sketches in his possession. These are mainly in pencil, a few with monochrome wash. Noyes's full watercolours he describes as having 'a bold style of drawing, and a rich colouring, inclined to hardness at times, but undeniably striking and effective'. Williams suggests that, due to similarities in style and subject matter, his work may occasionally have been taken for that of F. Nicholson (q.v.). He was drawing master at Wolverhampton School between 1822 and 1831, teaching figure, landscape, flower and architectural drawing, as well as perspective. He also worked as a lithographer.

A portrait of his wife, Anne Giddings, was painted by their son, HENRY NOYES, an art master at Shrewsbury.

Examples: Stafford Lib.
Bibliography: G. Mander: *History of Wolverhampton School*, 1913. *Country Life*, June 30, 1950.

NURSEY, Perry
There appear to have been three, if not four, individuals of this name, at least two of them clergymen, and at least two amateur artists. One painted London views and was active between 1799 and 1801; a second, or perhaps the same one, painted landscapes, animals and battle subjects between 1815 and 1829 and was a friend of Constable. He published *An Essay on Picturesque Gardening*, 1814 and *Poems*, 1829. A Rev. Perry Nursey (d. 1867) was Curate of Burlingham, Norfolk, from 1844 and later Rector of Crostwick, Norfolk. Rev. Perry Fairfax Nursey (c. 1843–c. 1910), probably the son of the last, graduated B.A. from Wadham College, Oxford in 1865 and held livings in Reading, Bristol, London, Islip, Rome, Tonbridge, Radnorshire and the Isle of Wight, before retiring to London and Bridgwater. He was a newspaper critic.

NUTTER, Matthew Ellis 1795 (Carlisle) – 1862 (Skinburness)
The son of a house painter and a descendant of carvers and cabinet makers, he became a portrait, landscape and architectural painter in oil and watercolour and a print-maker. He was a pupil of R. Carlyle (q.v.), but had to join the family business at an early age. From about 1821 he worked as a drawing master and professional artist. He was the first Secretary of the Carlisle Society, founded in 1822, and taught there and at the Green Row Academy.

He specialised in recording the disappearing features of his native city, although his last works were views on the Solway coast.

Published: *Carlisle in the Olden Time*, 1835.
Examples: Carlisle City A.G.

NUTTER, William Henry 1821 (Carlisle) – 1872 (Malaga)
A landscape painter, he was the son of M.E. Nutter (q.v.), who taught him drawing. By 1833 he was able to exhibit watercolours at the Carlisle Academy of Arts. A number of his drawings were used

for illustrations and engravings, and he worked with his father as a drawing master. In 1871 he toured Belgium and France, and he spent the winter at Malaga for his health, but died there the following summer.

His work is largely topographical and influenced by his father. He had a sound knowledge of architecture, but his later pure landscape work in the Borders and Lake District is perhaps his most original.

Illustrated: Jefferson: *History and Antiquities of Carlisle.*
Examples: Carlisle City A.G.

OAKES, John Wright, A.R.A.
1820 (Middlewich, Cheshire) – 1887 (London)
A landscape painter, he was educated in Liverpool, studying at the Mechanics Institute under John Bishop. He exhibited at the Liverpool Academy, of which he was later Secretary, from 1839. He exhibited in London from 1847, and he moved there in 1856. In 1874 he was elected A.N.W.S., but he resigned in the following year. He became A.R.A. in 1876. For the last six years of his life poor health interfered with his painting.

He began as a fruit painter, but turned to landscapes in about 1843. His work is naturalistic and he enjoyed atmospheric effects. His favourite sketching grounds were Wales, Scotland and Devon and he also visited Switzerland.

Examples: V.A.M.; Williamson A.G., Birkenhead.
Bibliography: *A.J.*, 1879.

OAKLEY, Agnes **(Derby) – 1866**
A painter of still-lifes who lived in London and was active from about 1854. Her sister, MARIA L. OAKLEY, painted similar subjects between 1854 and 1865. They were daughters of O. Oakley (q.v.) and sisters of I. Naftel (q.v.).

OAKLEY, Octavius, O.W.S. 1800 (Bermondsey) – 1867 (London)
Intended first as a surgeon, and then as a wool-merchant, Oakley was sent to a cloth manufacturer near Leeds, but instead of learning the business, concentrated on building up a practice as a watercolour portraitist. In about 1825 he moved to Derby and painted portraits at Chatsworth and other country houses and began to exhibit at the R.A. On the death of his wife he moved to London, and then, in 1836, to Leamington. There, as in Derby, he continued to study gipsies and their ways, thus providing material for his best known group of subjects. About 1841 he returned to London and became an Associate and Member of the O.W.S. in 1842 and 1844, thereafter living in the metropolis until his death. He visited the Channel Islands, where his daughter Isobel (q.v.) married P. Naftel (q.v.). Gipsies remained favourite subjects, and in his later years were joined by Italian organ grinders and other London figures. His remaining works were sold at Christie's, March 11-12, 1869.

Examples: B.M.; V.A.M.; Blackburn A.G.; Grundy A.G., Blackpool; Hove Lib.; Newport A.G.

OAKLEY, Philip
A landscape painter in the manner of S. Howitt (q.v.). He was active in about 1800.

OBEN (O'BRIEN), James George
a. 1779 (Dublin) – p. 1819 (London)
A landscape painter who had changed his name from Brien or O'Brien to Oben by 1801, when he exhibited at Parliament House. He studied at the R.D.S. Schools, and came to London in 1798, soon returning to Dublin, where he exhibited views of Ireland, Wales and the North of England. After an exhibition of his works which he held at 49, Marlborough Street in 1809, he returned to London, where he exhibited at the R.A. from 1810 to 1816. He provided drawings for Grose's *Antiquities of Ireland*, 1791-5.

Examples: B.M.; Ulster Mus.

O'CONNOR, James Arthur 1791 (Dublin) – 1841 (London)
Mainly known for his landscapes in oil, he also made occasional watercolours. He was the son of the Dublin engraver William O'Connor. Apart from some lessons from William Sadler, Yr., a landscape painter in oil, he was self-taught. His first sketches were made on the Dargle, and he exhibited with the R.D.S. from 1809 to 1821. By 1812 he was taking pupils, including F. Danby (q.v.), with whom he visited London and Bristol the following year. In 1818 and 1819 he toured the West of Ireland, where he painted for Lords Sligo and Clanricarde. In 1822 he finally left Dublin for London, exhibiting at the R.A. from that year, as well as at the B.I. and the S.B.A. In 1826 he went to Brussels for a year, and he toured Paris, Belgium and Germany from 1832 to 1833. 'Like his friend Danby, he was a poet of the brush'.

Examples: B.M.; N.G., Ireland.
Bibliography: T. Bodkin: *Four Irish Landscape Painters*, 1920.

O'CONNOR, John, A.R.H.A., R.I.
1830 (Co. Londonderry) – 1889 (Yately, Hampshire)
Scene painter, architectural and ceremonial draughtsman and a landscape painter in oil and watercolour, he was orphaned in Dublin at the age of twelve and had to support both himself and his grandfather. He worked in Belfast and Dublin theatres, and joined a travelling company. In 1848 he moved to London and worked at Drury Lane and the Haymarket, where from 1863 to 1878 he was principal scene painter. In 1849 he revisited Ireland to paint a diorama of the Queen's visit. He exhibited at the S.B.A. from 1853, the R.A. from 1857 to 1888, and the R.I., becoming a Member in 1887. He was elected A.R.H.A. in 1883, having exhibited there from 1875. He made his first Continental tour in 1855, and visited Sedan and Paris during the Franco-Prussian war, together with Lord Ronald Gower, with whom in 1872 he took a studio in Reynolds's former home in Great Newport Street. He was appointed drawing master at the London and South-Western Literary and Scientific Institution. In 1888 he moved to Hampshire, and made a journey to India for health reasons and to see his two younger sons, but died on his return.

His work shows a mastery of architectural detail. He was a favourite at Court and painted many ceremonial occasions in oil and watercolour.

Examples: B.M.; Cartwright Hall, Bradford; N.G., Ireland.

O'DONOHOE, Francis Joseph, A.R.H.A.
1878 (Dublin) – 1911 (Dublin)
An ecclesiastical and landscape painter who studied at the Metropolitan School of Art, Dublin, the R.H.A., and South Kensington, to which he was sent in 1896. He was also a pupil at the Académie Julian in Paris. On his return to Dublin he became a drawing master in the Technical Schools, and exhibited at the R.H.A. from 1899, being elected A.R.H.A. shortly before his death.

A memorial exhibition of his works was held at 28 Clare Street, Dublin, in February, 1912.

OFFLEY, John – 1883
Probably an amateur artist. There are views of Hastings, dated 1832 and Switzerland, dated 1833, by him in the B.M. They are pretty and some are well drawn. There are also Lakeland subjects which may be copies of compositions by A.V.C. Fielding (q.v.).

OGG, Henry Alexander
A portrait and landscape painter in oil and watercolour, and an engraver. He lived in London and was active from 1840 to 1870.

OGILVIE, Frank S
A landscape and genre painter in oil and watercolour who lived in North Shields, Bushey and London. He exhibited at Birmingham in 1881 and at the R.B.A. from 1888 to 1894.

OGLANDER, Jane Mary, Mrs., née Rayne
The daughter of the Provost of Oriel College, Oxford, she married

Dr. John Oglander, a member of an old Isle of Wight family, of Nunwell, near Brading, who became Warden of New College. She was a pupil of J.B. Malchair (q.v.), and she made sketching tours of Scotland and Wales with her niece, FRANCES DOROTHEA OGLANDER (d. 1852), younger daughter of Sir William Oglander, 5th Bt.

Examples: Nunwell Lib.
Bibliography: C.F.A. Oglander: *Nunwell Symphony*, 1945.

OGLE, John Connel
A marine and coastal painter who was active from 1844 to 1864. He was an unsuccessful candidate for the N.W.S. on several occasions from 1848 and lived in London except for a period from 1850 when he held a post at the University of Corfu.

O'KEEFFE, John 1747 (Dublin) – 1833 (Southampton)
A landscape painter and an actor and playwright, he studied at the R.D.S. Schools and exhibited bird and flower studies with the Dublin Society of Artists in 1767, in which year he began his career as an actor. He appeared on stage in many Irish towns, and always made drawings of local subjects. In about 1779, his sight failing, he went to London, where he wrote farces and comic operas. He became totally blind in 1797 and was looked after by his daughter, Adelaide O'Keeffe, a poet and novelist.
His brother Daniel O'Keeffe (1740-1787) was a miniature painter and worked in Dublin and London.

Published: *Recollections*, 1826.

OLDFIELD, John Edwin
A painter of architectural and topographic subjects in England and on the Continent. He exhibited at the R.A. in 1826 and 1854 and at Suffolk Street in 1825 when he was living in London. His style is rather indefinite.

Examples: B.M.; V.A.M.; Laing A.G., Newcastle.

OLDHAM, G R
A landscape, still-life, genre and portrait painter who lived in Chipping Norton and London. He exhibited at Suffolk Street from 1854 to 1857.

OLDMEADOW, J C
A landscape and architectural painter who was working in Bushey, Hertfordshire, between 1841 and 1849. His drawings are rather old-fashioned with poorly drawn figures and surer trees and buildings.

Examples: B.M.

OLIVER, Emma Sophia, Mrs., née Eburne, R.I.
 1819 (London) – 1885 (Great Berkhamsted)
The daughter of a coachbuilder, she married W. Oliver (q.v.) in 1840. In 1849 she was elected to the N.W.S., and in 1856 she married a solicitor named Sedgwick, but continued to use her first husband's name.
She painted landscapes in both oil and watercolour. They are reminiscent of the middle manner of Cox. She exhibited at the R.A., Suffolk Street and the B.I. as well as with the N.W.S.

Examples: V.A.M.

OLIVER, William, N.W.S.
 c. 1804 – 1853 (Halstead, Essex)
A landscape painter who first exhibited at the S.B.A. in 1829. He was a founder of the N.W.S. in 1834 and remained a member of the Society despite making criticisms of it, and arriving at the 1844 exhibition so drunk that he thought he would escape detection by signing in with a false name. His favourite sketching grounds were France and the Pyrenees, and he also visited Italy. He exhibited oil paintings at the R.A. and B.I. from 1835 to 1853. He was the husband of E.S. Oliver (q.v.).

Published: *Scenery of the Pyrenees*, 1842.
Examples: B.M.; Cartwright Hall, Bradford.

O'MEARA, Frank 1853 (Carlow) – 1888
A figure and landscape painter who studied in Paris and at Barbizon, which formed his style.

Bibliography: T.M.: *F. O'M; or the Artist of Collingwood*, 1876.

OMER, Rowland
An architectural draughtsman of Irish birth, he worked as an engineer for the Inland Navigation Board. His five drawings of Parliament House were published as engravings by B. Scalé (q.v.) in 1767.

O'NEILL, Henry 1798 (Clonmel) – 1880 (Dublin)
An antiquarian and landscape draughtsman and a nationalist who was orphaned young and brought up by his aunt, a Dublin haberdasher, for whom he designed patterns. In 1815 he entered the R.D.S. Schools and also worked for a print seller. He first exhibited at the R.H.A. in 1835 and was elected A.R.H.A. in 1837, but resigned in 1844. He worked as an illustrator before going to London in 1847, where he met with little success, and soon returned to Dublin, continuing to exhibit at the R.H.A. until 1879.
He lithographed the illustrations for several of his books. He also produced portraits, in oil and watercolour, which he lithographed.

Published: with G. Petrie and A. Nicholl: *Picturesque sketches of some of the finest Landscapes and Coast Scenery of Ireland*, 1835. With A. Nicholl: *Fourteen views in the County of Wicklow*, 1835. *Descriptive catalogue of Illustrations of the Fine Arts of Ancient Ireland*, 1855. *Illustrations of the most interesting of the Sculptured Crosses of Ancient Ireland*, 1857. *Fine Arts and Civilization of Ancient Ireland*, 1863. *The Round Towers of Ireland, Part One*, 1877.
Illustrated: Hall: *Ireland, its Scenery and Character*, 1841.
Examples: Ulster Mus.

O'NEILL, Henry Nelson, A.R.A.
 1817 (St. Petersburg) – 1880 (London)
An historical and genre painter who came to England at the age of six. In 1836 he entered the R.A. Schools, where he was a friend of A. Elmore (q.v.), with whom he visited Italy, and of R. Dadd (q.v.). They all became members of the 'Clique' – a breakaway group of young artists in the late 1830s. He exhibited at the R.A. from 1838 and also painted portraits and landscapes. He was heartily disliked by T.S. Cooper (q.v.), who called him 'the Great Unwashed'. He was elected A.R.A. in 1860.
His remaining works were sold at Christie's, June 18, 1880.

Published: *Lectures on Painting delivered at the R.A.*, 1866. *Modern Art in England and France*, 1869.

O'NEILL, Hugh 1784 (Bloomsbury) – 1824 (Bristol)
The son of an architect, he specialized in architectural drawing. He won a silver palette from the S.A. in 1803 and exhibited at the R.A. from 1800 to 1804. He worked as drawing master in Oxford, Edinburgh, Bath from 1813 to 1821 and Bristol from 1821 to 1824. He signed his works in a variety of ways, known examples being Neil, Neill, O'Neil and O'Neill.

Published: *Six etchings by W. Crotch from Sketches by H. O'N. . . . at Christ Church*, 1809.
Examples: B.M.; V.A.M.; Victoria A.G., Bath; Williamson A.G., Birkenhead; Whitworth A.G., Manchester; Reading A.G.

ORAM, Edward – 1810
The son of W. Oram (q.v.). He exhibited landscapes at the R.A. from 1775 to 1799 and was an assistant scene-painter to P.J. de Loutherburg (q.v.). Like Blake and Flaxman, he was patronized by the Rev. Henry and Mrs. Mathew. In 1799 he was living at Gresse St. His work is romantic, like that of R. Adam (q.v.).

Examples: B.M.; V.A.M.

ORAM, William – 1777 (Hampstead)
A landscape painter and house decorator who produced a number of drawings in the manner of Wilson. He may well have worked in

other styles including that of Wootton. He was Master Carpenter in the Office of Works from 1748 until his death. Walpole says that he 'was bred an architect, but taking to landscape painting arrived at great merit in that branch'.

Published: *Precepts and Observations on the art of colouring*, 1810.

O'REILLY, Rear-Admiral Montague Frederick
 – 1888
A naval officer and amateur artist who served in North Australia and Hong-Kong, taking part in the Chinese war of 1841. In 1845 he was on the West coast of Africa and later in the Mediterranean, and he served on the South African coast from 1851 to 1852. He next joined H.M.S. *Retribution* at Sebastopol, of which he made useful plans and diagrams. In 1856 he was promoted commander, and he spent the next four years in the West Indies and the Mediterranean. He was promoted rear-admiral in 1878. Twelve lithographs of his views of the Bosphorus and the Black Sea were published in 1856. His drawings there were also used by the *I.L.N.*

Examples: Greenwich.
Bibliography: *I.L.N.*, June 7, 1888.

ORME, Daniel c.1766 (Manchester) – c.1832 (Buxton)
A portrait painter, engraver and miniaturist, Orme was also a good draughtsman and produced excellent washed sketches. He studied at the R.A. Schools and practised in London until 1814, when he returned to Manchester. There he taught painting, drawing and etching.

Published: *The New Buxton Guide*, 1830.
Examples: V.A.M.

ORME, Edward 1774 –
A brother of D. and W. Orme (q.v.), he was a publisher and engraver and also produced architectural drawings and portraits. He entered the R.A. Schools in 1793 and was active until about 1820.

Published: *A Brief History of Ancient and Modern India*, 1805. *Orme's Graphic History of... Horatio Nelson*, 1806. *Essay on Transparent Prints*, 1807. *An Historical Memento*, 1814. *Historic, Military and Naval Anecdotes*, 1819. Etc.
Examples: V.A.M.

ORME, William (Manchester) –
A brother of D. Orme (q.v.), he worked as a drawing master and landscape painter in Manchester from at least 1794 to 1797, when he moved to London. From 1797 to 1819 he exhibited at the R.A.

Illustrated: *The Old Man, his Son and the Ass*, c.1800. E. Orme: *Twenty-four Views of Hindostan*, 1805.
Examples: V.A.M.; Greenwich.

ORROCK, James, R.I. 1829 (Edinburgh) – 1919 (Shepperton)
A landscape painter, collector and patron, Orrock was educated at the Irvine Academy, where he copied engravings and was taught by a drawing master called White. At Edinburgh University he studied medicine, surgery and dentistry. He studied under James Ferguson (see Ferguson, J.) and J. Burgess (q.v.) in Leicester, where he worked for a time. He also visited Wales and other parts of England and Scotland with Burgess. After university he practised in Nottingham and studied with Stewart Smith and at the School of Design under the Fussells (q.v.) until 1866, when he moved to London and set up as a professional artist, writer and lecturer. There he took further lessons from W.L. Leitch (q.v.). He was elected A.N.W.S. and N.W.S. in 1871 and 1875.

His style is derived from those of Constable, de Wint and Cox, and his work can be similar to that of his friends, T. Collier (q.v.) and E.M. Wimperis (q.v.). He was a sound draughtsman, and there is often much pencil underdrawing in his watercolours.

Illustrated: W.S. Crockett: *In the Border Country*, 1906. W. Wood: *Mary Queen of Scots*, 1906. W.S. Sparrow: *Old England*, 1908.
Examples: V.A.M.; Cartwright Hall, Bradford; Maidstone

Mus.; Newport A.G.; Castle Mus., Nottingham; Portsmouth City Mus.; Ulster Mus.
Bibliography: B. Webber: *J.O.*, 1903.

OSBORNE, Walter Frederick, R.H.A.
 1859 (Dublin) – 1903 (London)
A portrait painter, he was the son of William Osborne, R.H.A., an animal painter. He entered the R.D.S. Schools in 1876, first exhibiting at the R.H.A. in the following year. From 1881 to 1883 he studied in Antwerp, and he exhibited his sketches of Antwerp and Bruges on his return. He spent several summers painting in England and Brittany and visited Spain in 1895 and Holland in 1896. He was elected A.R.H.A. and R.H.A. in 1883 and 1886 and exhibited at the R.A. from 1886 to 1903. From 1891 he practised, very successfully, as a portrait painter. He declined a Knighthood in 1900.

In addition to portraits and landscapes he painted scenes of town and country life, and animal studies. He worked in oil, watercolour, pastel and pencil. Up to 1884 he signed himself Frederick Osborne, or Frederick W. Osborne.

Examples: B.M.; N.G. Ireland.
Bibliography: T. Bodkin: *Four Irish Landscape Painters*, 1920. J. Sheehy: *W.O.*, 1974.

OSCROFT, Samuel William 1834 (Nottingham) – 1924
A landscape painter in oil and watercolour who worked as an industrial designer in Nottingham. He exhibited in London from 1866.

Examples: Castle Mus., Nottingham.

OSPOVAT, Henry 1877 (Russia) – 1909
A Russian whose family settled in Manchester. He illustrated Matthew Arnold's *Poems* in 1899 and Shakespeare's *Songs* in 1901. His style was influenced by the Pre-Raphaelites and C. de S. Ricketts (q.v.).

A memorial exhibition was held at the Baillie Gallery in 1909.

OSWALD, John H
A painter of town scenes who was active in Edinburgh from 1874 to 1899.

OTLEY, Rev. Charles Bethell 1792 – 1867
Educated at Wadham, Otley was Vicar of Tortington, Sussex, from 1817, Rector of Welby, Lincolnshire from 1833 and also of Long Leadenham, Lincolnshire from 1836. He was a very competent landscape watercolour painter and exhibited from 1808 to 1821, continuing to paint for much of his life.

OTTEWELL, Benjamin John – 1937
A landscape and coastal painter who studied at South Kensington and exhibited in London from 1885. He was elected an Honorary R.I. in 1895. He lived in Wimbledon and Bath and painted in Scotland. His work can be woolly and clumsy.

Published: *Some Trivial Recollections of an Old Landscape Painter, Loiterers All*, 1926.

OTTLEY, Emily
Possibly a pupil of G. Pyne (q.v.), in whose manner she painted between 1856 and 1860. She worked in Wales, London and Paris.

OTTLEY, William Young
 1771 (Thatcham, Berkshire) – 1836 (London)
Writer on art, collector and amateur artist, he was a pupil of the elder G. Cuit (q.v.) and J. Brown (q.v.) and studied at the R.A. Schools. On Brown's death in 1787, he bought up the contents of his studio, which formed the basis of his collection. He was in Italy from 1791 to 1801. On his return he became a leading critic and authority on painting and engraving. He exhibited a drawing at the R.A. in 1833, and became Keeper of Prints at the B.M. in the same year.

Published: *The Italian School of Design*, 1805-23. *Inquiry into the Origin and Early History of Engraving . . .* , 1816. *A Series of Plates after the Early Florentine Artists*, 1826. *Notices of Engravers and their Works*, 1831. *An Inquiry into the Invention of Printing*, 1863.
Examples: B.M.
Bibliography: *B.M. Quarterly*, XVIII, 1953.

OUSELEY, Sir William Gore 1797 (London) — 1866 (London)
A diplomat and amateur artist. He served at the Embassy at Stockholm from 1817 and at other European Courts before becoming attaché at Washington in 1825. In 1832 he went to Brazil and in 1844, Buenos Aires. He returned to England in 1850 and was created K.C.B. two years later. In 1857 he undertook a mission to Central America and then travelled in America until 1860. He was Chairman of the Falkland Islands Company.

He made drawings of the scenery of the various countries which he visited, as well as studies of military costumes.

Published: *A Description of Views in South America*, 1852.

OVEREND, William Heysham
 1851 (Coatham, Yorkshire) — 1898 (U.S.A.)
A marine military and coastal painter in oil and watercolour, he was educated at Charterhouse and exhibited at the R.A. from 1872. He also made book illustrations and drew for the *I.L.N.* and other magazines.

Illustrated: F.F. Moore: *The Fate of the Black Swan*, 1865. J.C. Hutcheson: *On board the Esmeralda*, 1885. R.H.S. Bacon: *Benin, the City of Blood*, 1897. Etc.

OWEN, Rev. Edward Pryce 1788 — 1863 (Cheltenham)
Educated at St. John's College, Cambridge, he officiated at the Park St. Chapel, Grosvenor Square, before becoming Vicar of Wellington and Rector of Eyton-upon-the-Wildmoors, Shropshire, in 1823. He held the livings until 1840. He travelled widely to France, Belgium, Italy in 1840, the Levant, Germany and Switzerland, making drawings which he later worked up into pictures and etchings. He exhibited at the S.B.A. from 1837 to 1840. Towards the end of his life he lived at Bettws Hall, Montgomeryshire.

Published: *Etchings of Ancient Buildings in Shrewsbury*, 1820-1. *Etchings*, 1826. *The Book of Etchings*, 1842-55.
Examples: Shrewsbury Lib.
Bibliography: *A.J.*, March, 1865.

OWEN, Samuel 1768 — 1857 (Sunbury)
The marine painter. He exhibited at the R.A. from 1794 to 1807 and with the A.A. from 1808 to 1810, when he resigned his membership. He gave up painting many years before his death.

Owen's attitude to marine painting is more that of a landscape artist such as Cotman or Francia than that of the faithful ship portraitists of the eighteenth century. He is concerned with composition, atmosphere and movement rather than with fidelity of detail. His colours are generally in a low key, and his handling fairly broad. In his early days he was ahead of his time.

Published: with W. Westall: *Picturesque Tour of the River Thames*, 1828.
Illustrated: W.B. Cooke: *The Thames*, 1811.
Examples: B.M.; V.A.M.; Fitzwilliam; Greenwich; Leicestershire A.G.; Nat. Mus., Wales.

PACK, Faithful Christopher 1750 (Norwich) – 1840 (London)
A portrait and landscape painter in oil and watercolour. He came to London in 1781 and spent a year in Reynolds's studio. Between 1783 and 1787 he practised as a portraitist in Liverpool, after which he worked in Dublin and Cork. He returned to London in 1796, after which he worked as a drawing master in Bath, and in Dublin, where he became President of the Dublin Society of Artists in 1812 and Vice-President of the Hibernian Society in 1814. On March 21, 1821, at 33 Dawson Street, his collection of pictures, including some of his own works, was sold, and he then moved to London where he exhibited at the R.A. in 1822 and 1840 and the B.I. between 1825 and 1839.

He spent many years in copying the works of old masters to discover their methods. He also produced pastels in the manner of John Russell.

PADDEY, R
An artist who drew, engraved and published an aquatint of Buildwas Abbey, in Wolverhampton in 1796.

PADGETT, John
A landscape painter who lived in London and was active at least from 1826 to 1839. Some of his subjects were taken from Wales.

PAE, William
A late nineteenth century landscape and marine painter working in Gateshead. His watercolours are usually on a small scale.

Examples: Shipley A.G., Gateshead.

PAGE, Wilkes
There is a grey wash view of Gibraltar with an elaborate border by this artist at Greenwich. It is signed and dated 1718.

PAGE, William 1794 – 1872
A landscape painter, he attended the R.A. Schools in 1812 and 1813, and his first exhibits at the R.A. in 1816 were of North Wales. He probably visited Greece and Turkey in about 1818, and also went to Rome. He specialized in architectural drawings, landscapes and figure subjects and was a successful drawing master. A watercolour of Buyuk-Dere, near Constantinople, is illustrated in a letter to *Country Life*, September 26, 1968.

Examples: B.M.; Coventry A.G.

PAGET, Richard
A pupil of J.B. Malchair (q.v.), he was 'well skilled in antiquities and a great admirer of Bishop Laud and all Church ceremonial'.

Bibliography: Warburg, Inst., *Journal*, XVIII, 1955.

PAILLOU, Peter
A bird painter who also produced portraits and miniatures. He lived in Islington, worked for Thomas Pennant, and was active at least from 1745 to 1780.

Examples: B.M.

PAIN, Robert Tucker
A landscape painter in oil and watercolour who lived in Surrey and London. He exhibited from 1863 to 1876 and painted many Welsh subjects. He also visited Cornwall, Scotland and Switzerland.

PAINE, James, Yr.
 1745 (Pontefract) – 1829 (Sunninghill, Berkshire)
The son of James Paine (c.1716-1789), an architect and President of the Society of Artists. He studied at the St. Martin's Lane Academy and exhibited from 1761. In the 1770s he travelled in Italy. He exhibited architectural drawings at the R.A. in 1781, 1783 and 1788. His surviving drawings are mostly designs.

Examples: B.M.; V.A.M.

PALMER, Edith 1770 – 1834
A landscape painter in oil and watercolour who lived in Bath, where she was a pupil of B. Barker (q.v.). She exhibited at the B.I. from 1813 to 1815 and worked in Barker's manner. Her oil paintings are generally better than her watercolours.

Examples: V.A.M.; Victoria A.G., Bath.

PALMER, Hannah, Mrs., née Linnell 1818 (London) –
The daughter of J. Linnell (q.v.), she married S. Palmer (q.v.) in 1837. During their honeymoon in Italy she executed various commissions for her father which included making small coloured copies of Raphael's Loggia, and she copied pictures by Michelangelo, Titian and Andrea del Sarto. She was represented in the Rome exhibition of 1838, although none of her works sold. She also painted very competent landscapes and views in Palmer's Italian manner, using much bodycolour. Later she was plagued by ill-health and miscarriages and painted less.

Examples: Reading A.G.
Bibliography: E. Malins: *S. Palmer's Italian Honeymoon*, 1968.

PALMER, Harry Sutton, R.I. 1854 (Plymouth) – 1933
A landscape painter, he studied at South Kensington and exhibited at the R.A. and elsewhere from 1870. He turned from still-lifes to landscapes at about the age of twenty. He was a member of the R.B.A. from 1892 and was elected R.I. in 1920. From 1880 he held a number of one-man shows in London and New York. He lived in London and worked in Surrey, Berkshire, the Lake District and many parts of Scotland. His style is traditional and technically very accomplished.

Examples: V.A.M.; Towner Gall., Eastbourne; Exeter Mus.; Maidstone Mus.; City A.G., Manchester; Newport A.G.; Portsmouth City Mus.; Reading A.G.; Sydney A.G.

PALMER, Samuel, R.W.S. 1805 (Newington) – 1881 (Redhill)
One of the most original landscape painters of the British School, Palmer was the son of a bookseller and first exhibited at the R.A. in 1819. The most important early influences on his life were Stothard, Varley, Linnell, Mulready and, above all, Blake, whom he met in 1824. In that year he and his father were living in Shoreham, Kent, the inspiration for his most perfect primitive and visionary work. For a time he formed one of the 'Ancients' who gathered there around Blake. In 1837 he married Linnell's daughter Hannah (q.v.) and they went to Italy, returning in 1839. Thereafter he attempted to make a living by teaching and exhibiting, and made sketching tours throughout Britain, particularly in Devon, Cornwall and North Wales. He attempted to simplify his work, taking de Wint as a model, and worked up many of the careful drawings made in Italy. He was elected A.O.W.S. in 1845 and O.W.S. eleven years later. In 1861 his life and style underwent another change following the death of his eldest son, More, and something of the early inspiration returned, showing itself particularly in his etchings.

It has long been the fashion to decry Palmer's post-Italian work and to claim that his individual vision was destroyed by Linnell. This is hardly true. Linnell had a bad influence on his personal life, but generally a good one on his work. The Shoreham period with its hot and even garish colours, its great balloons of blossom and sense of the summer of youth, could not last beyond youth.

Palmer, like Blake, was a lover of gold, and often tried to work it in to his sunsets. He also felt that a landscape was nothing without figures, and generally introduced them if only in a subordinate role. Like Turner, he was concerned with light, like Cotman with

essential form. It is in the refining of the diverse influences upon him that his originality lies.

Examples: B.M.; V.A.M.; Aberdeen A.G.; Ashmolean; Williamson A.G., Birkenhead; Birmingham City A.G.; Blackburn A.G.; Cartwright Hall, Bradford; City A.G., Manchester; N.G., Scotland; Ulster Mus.
Bibliography: A.H. Palmer: *S.P.; A Memoir*, 1882. A.H. Palmer: *Life and Letters of S.P.*, 1892. R.L. Binyon: *The Followers of W. Blake*, 1925. G. Grigson: *The Visionary Years*, 1947. *The Grigson 1962 book*. C. Peacock: *S.P., Shoreham and After*, 1968. E. Malins: *S.P.'s Italian Honeymoon*, 1968. *R. Lister: S.P.*, 1974. J. Sellers: *S.P.*, 1974. V.A.M.: *Exhibition Cat.*, 1926. O.W.S. Club, IV, 1927. *Apollo*, XXIV, 1936 *Country Life*, March 7, 1957. Ashmolean Mus.: *Exhibition Cat.*, 1960.

PALMER, William James
A landscape painter and engraver who lived in London and exhibited at the S.B.A. and elsewhere from 1858 to 1875. He painted in Surrey, North Wales. Northumberland and Scotland. His wife was a painter of floral still-lifes and was active between 1872 and 1879.
Published: *Views in Wimbledon*, 1863. *The Tyne and its tributaries*, 1881.

PAPWORTH, John Buonarotti
1775 (London) – 1847 (Little Paxton, Huntingdonshire)
An architect and topographical draughtsman, he studied architecture under his father and John Plaw. He also studied the figure under the sculptor John Deare before serving an apprenticeship to a builder. At eighteen he was clerk of the works to Sir James Wright at Woodford, Essex. He sent designs to the R.A. from 1794 to 1799, when he went to the R.A. Schools. He continued to exhibit until 1841. As an architect he worked at Fonthill, Orleans House and elsewhere, becoming Architect to the King of Württemberg in 1820. He was an original designer, and many of his exhibits were designs for furniture, glass and plate. He was an original member of the A.A. and Secretary in 1809, and he was also a founder of the Graphic Society in 1833. He drew for Ackermann as well as for his own publications. The name Buonarotti was adopted in 1815 as a result of his Waterloo 'Trophaeum' design.
 His sons John Woody Papworth (1820-1870) and Wyatt Angelicus Van Sandau Papworth (1822-1894) followed his profession.
Published: *Poetical Sketches of Scarborough*, 1813. *Select Views of London*, 1816. *Rural Residences*, 1818. *Hints on Ornamental Gardening*, 1823.
Examples: V.M.; R.I.B.A.
Bibliography: W.A. Papworth: *J.B.P.*, 1879.

PARIS, Walter
A topographer in oil and watercolour who lived in London and exhibited from 1849 to 1891. He painted in Brittany and Normandy, Jersey, Germany, Venice and India as well as in England.
 He should not be confused with his namesake WALTER PARIS (1842-1906), an architect and watercolour painter who studied in London and emigrated to America, dying in Washington.
Examples: V.A.M.

PARK, James Chalmers 1858 (Wetherby, Yorkshire) –
A painter and etcher of British game-birds, he studied at the Leeds School of Art. He lived in Leeds and exhibited widely in the North as well as in London.

PARKE, Henry c.1792 (London) – 1835 (London)
An architect, he was a pupil of, and amanuensis to, Sir John Soane. He toured in Italy, Greece and Egypt from 1820 to 1824 and made many topographical drawings both then and after his return. His remaining works were sold at Sotheby's, May 20, 1836.
Examples: B.M.; V.A.M.; R.I.B.A.; Soane Mus.

PARKER, Henry H 1858 – 1930
A traditional landscape painter in oil and watercolour, who lived in the Midlands. He painted on the Thames and also in Surrey, Kent and Wales. His work can be reminiscent of that of T. Collier (q.v.).

PARKER, Henry Perlee, 'Smuggler'
1795 (Devonport) – 1873 (London)
The son of R. Parker (q.v.), and originally intended for a doctor, Parker set up as a portrait painter. However he met with little success in Plymouth and moved to Tyneside before he was twenty, painting portraits in oil and watercolour as well as large pictures of local events and scenes. With other artists he inaugurated the first Fine Art Exhibition in the North of England in 1822, which led to the founding of the Northern Academy of Artists and the North of England Society for the Promotion of Fine Arts. In 1842 he became drawing master at Wesley's College, Sheffield. He exhibited in London from 1817 and moved there in 1844.
Published: *Critiques on Painting*, 1835.
Examples: V.A.M.; Laing A.G., Newcastle.

PARKER, Rev. John
1798 (Sweeney Hall, Oswestry) – 1860 (Llan-y-Blodwell)
An amateur architect and artist, he was educated at Eton and Oriel College, Oxford, graduating in 1820. In 1830 he visited Palestine with his sister Lady Leighton (q.v.). He was Rector of Llanmarewic, Montgomeryshire, from 1827 to 1844, and added a tower and porch to his church. He was the architect of Trinity Church, Oswestry, in 1835. In 1844 he became Vicar of Llan-y-Blodwell, Shropshire, where he rebuilt the church and designed several other buildings in the Early English style. He was a keen botanist and drew flowers as well as landscapes and architectural subjects.
Published: *The Passengers*, 1831.
Examples: Nat. Lib., Wales.

PARKER, John, R.W.S. 1839 (Birmingham) – 1915 (London)
A landscape and genre painter who studied in Birmingham before settling in St. John's Wood. He exhibited from 1867 and was elected A.R.W.S. and R.W.S. in 1876 and 1881. He also painted portraits and flowers in oil and watercolour, and many of his subjects were found in the southern counties.
Examples: Walker A.G., Liverpool; Melbourne A.G.; Castle Mus., Norwich.

PARKER, Mary, see LEIGHTON, Mary, Lady

PARKER, Robert
A teacher of marine and 'mechanical' drawing at Plymouth Dockyard – now Devonport – he was the father of H.P. Parker (q.v.).

PARKES, David
1763 (Cakemore, Shropshire) – 1833 (Shrewsbury)
A schoolmaster, antiquary and artist, he ran schools in Shrewsbury and elsewhere and made many drawings of the antiquities of Shropshire.
 His sons JAMES PARKES (1794-1828) and JOHN PARKES (1804-1832) were both drawing masters and worked with him.

PARKES, William Theodore – c.1908
Son of Isaac Parkes, the Dublin medallist, he was himself a medallist and draughtsman. He worked with his father until the latter's death in 1870, when he started up on his own. He exhibited landscape and genre subjects at the R.H.A. from 1875 to 1883, and in 1872 he published a series of Irish coats of arms and crests. He also wrote for Dublin periodicals. In about 1883 he moved to London, where he worked as an artist and journalist.
Published: *The Spook Ballads*, 1895. *God Save the King*, 1902. *Comic Snap Shots from Early English history*, 1904.

PARKINSON, Sydney c.1745 (Edinburgh) – 1771 (at sea)
A Scottish artist who made large watercolours of plants and animals on Captain Cook's first voyage, 1768-71. After an apprenticeship to a wool-draper he had come to London in about 1767. He died at sea between Prince's Island and the Cape. His valuable journals and drawings were the subject of much dispute on the expedition's return.

Published: *A Journal of a Voyage to the South Seas*, 1773.
Examples: B.M.

PARKMAN, Alfred Edward 1852 –
The son of Henry Spurrier Parkman (1814-1864), a Bristol portrait painter, and brother of ERNEST PARKMAN (1856-1921), who painted town scenes in the West of England in oil and watercolour. A.E. Parkman painted Bristol views in oil and watercolour and was still active in 1930. At that time he lived at Mumbles, Swansea.

PARKYNS, George Isham
 c.1749 (Nottingham) – c.1820 (Cambridge)
An antiquary and amateur artist and architect, he was the grandson of the 2nd baronet and lived in Nottingham. He travelled in France, Belgium and North America as well as widely in Britain. He exhibited at the R.A. and the Society of Artists from 1772 to 1813. In 1793 he published a series of aquatints of the Seine which are reminiscent of the work of W. Payne (q.v.). Other drawings are like the blue works of E. Dayes (q.v.), although they are cruder, and there is sometimes no penwork.
 Two of his sons became artists.

Published: *Six Designs for improving Grounds*, 1793. *Monastic and Baronial Remains*, 1816.
Examples: Ashmolean.

PARLBY, James
A landscape and genre painter who exhibited at Suffolk Street from 1870 to 1873. He lived near Hastings and in London and painted Sussex and Scottish views.
 He may have been a relative of MAJOR S. PARLBY, a Londoner who exhibited a biblical subject at Suffolk Street in 1845.

Examples: V.A.M.

PARRIS, Edmund Thomas 1793 (London) – 1873 (London)
Principally a portrait painter, he worked in many media but always in a weak and sentimental style. He is most remembered for his ruinous restorations of Thornhill's paintings in the Cupola of St. Paul's. He exhibited at the R.A., the N.W.S. and elsewhere, from 1816 to 1873, having entered the R.A. Schools in 1816. He worked at Horner's Colosseum in Regents Park from 1824 to 1829 and was appointed Historical Painter to Queen Adelaide in 1838.

Illustrated: Lady Blessington: *Flowers of Lovliness*, 1836. Lady Blessington: *Confessions of an Elderly Gentleman*, 1836. Lady Blessington: *Confessions of an Elderly Lady*, 1838.
Examples: B.M.; V.A.M.; Doncaster A.G.
Bibliography: *A.J.*, 1874.

PARROTT, Samuel 1797 (Nottingham) – 1876 (Nottingham)
After serving an apprenticeship to a house-painter and decorator, he became a pupil of H. Dawson (q.v.). Later he and Dawson shared a studio in Nottingham and they made many sketching tours together. He exhibited at the R.A. and Suffolk Street between 1841 and 1853, and painted landscapes in oil and watercolour.

Examples: Castle Mus., Nottingham.

PARROTT, William 1813 (Overley) – 1869
A topographer and figure painter in oil and watercolour who was a pupil of Pye, the engraver. He exhibited from 1835 to 1869. He was in Paris in 1842-43 and in Rome in 1844-45. He published twelve Parisian lithographs in 1843. In 1851 he made a tour in Germany, and he paid frequent visits to Brittany and Normandy. His architectural drawing is very delicate.

Examples: B.M.

PARRY, James 1805 (? Liverpool) – 1871 (Manchester)
The son of Joseph Parry (1744-1826), a Manchester artist, he exhibited portraits, landscapes and figure drawings at the Royal Manchester Institution from 1827 to 1856. He drew and engraved a number of illustrations for Corry's *History of Lancashire*.
 His elder brother DAVID HENRY PARRY (1793-1826), his nephew CARLES JAMES PARRY (1824-1894) and his great-nephews CHARLES JAMES PARRY, YR., and DAVID HENRY PARRY, YR. were all amateur or professional artists.

Examples: City A.G., Manchester.

PARRY, Thomas Gambier 1816 – 1888 (Higham, Gloucester)
The inventor of the 'spirit fresco' process used by Leighton and Madox Brown as well as himself. He painted frescoes at Ely, Gloucester and Tewkesbury. He was the father of Sir Hubert Parry, the composer.

Published: *Spirit Fresco Painting*, 1880. *The Ministry of Fine Art to the happiness of life*, 1886.

PARS, Henry 1734 – 1806 (London)
The elder brother of W. Pars (q.v.), he was brought up in his father's profession as a gold-chaser. He became a drawing master, and in about 1763 he took over Shipley's School in the Strand. There his pupils included W. Blake (q.v.) and W.H. Pyne (q.v.). Another brother, Albert Pars, was a wax-modeller.

PARS, William, A.R.A. 1742 (London) – 1782 (Rome)
The landscape painter. He studied under his brother, H. Pars (q.v.), in the Duke of Richmond's Gallery, and at the St. Martin's Lane Academy. He exhibited at the R.A., the Incorporated Society and Free Society in the 1760s and worked as a portrait painter. Between 1764 and 1766 he was in Greece with Dr. Richard Chandler and N. Revett (q.v.) for the Society of Dilettanti. His drawings of this journey, during which he also visited Asia Minor, were used for the second and third volumes of Stuart and Revett's *Antiquities of Athens*, 1789 and 1795, as well as for the first and second volumes of the Society's *Ionian Antiquities*, 1769 and 1797. Some of these drawings were aquatinted by Sandby and some engraved by Byrne. In about 1770, the year in which he was elected A.R.A., he went to Switzerland and Austria with Lord Palmerston. He also visited Wales and Ireland. In 1775 he went to Rome, again for the Society of Dilettanti. He died there as a result of a chill caught while sketching.
 His Greek drawings are more carefully drawn and highly coloured than his Italian or British ones. In the former the figures, especially the larger ones, are not always well integrated into the composition. These early drawings are more stylized than his later works and he uses much pen-work for the outlines and details. Later his colours become paler and his handling is looser and rather haphazard. His figures, on which he prided himself, are much more successful.

Examples: B.M.; V.A.M.; Aberdeen A.G.; Ashmolean; Birmingham City A.G.; Cartwright Hall, Bradford; Fitzwilliam; Leeds City A.G.; N.G. Ireland; N.G., Scotland.

PARSONS, Alfred William, R.A., P.R.W.S.
 1847 (Beckingham, Somerset) – 1920 (Broadway, Worcestershire)
A painter of landscapes, pastoral scenes, gardens and plants in oil and watercolour, and a book illustrator. He began as a Post Office clerk, but then studied at South Kensington – where he was later Professor. He exhibited from 1871 and was elected A.R.A. and R.A. in 1897 and 1911. He was elected A.R.W.S. and R.W.S. in 1899 and 1905 and President in 1913. Previously, from 1882 to 1898, he had been a member of the R.I.

PARSONS, Arthur Wilde 1854 (Bristol) – 1931
A marine and landscape painter in oil and watercolour, he was the son of a doctor in Bristol, and he studied locally. He exhibited in London infrequently from 1867. His earliest subjects were the shores of the Bristol Channel, followed by Cornish scenes painted on summer visits to his brother, the Vicar of Crantock. He visited Holland and, in about 1911, Italy, which had a great influence on

his work, producing a Pre-Raphaelite clarity of colour and detail. Throughout his life he painted ships and scenes at Bristol and after this tour he produced many Venetian vignettes.

Examples: Bristol City A.G.

PARTINGTON, John H E
1843 (Manchester) – 1899 (Oakfield, California)
He was brought up in Stockport, where his father worked as a cabinet maker. He went to America in his youth and on his return worked as a mechanical draughtsman for Professor Scott Burn before turning to art. After studying at the Manchester School of Art he was employed by a firm of stained glass engravers at Saddleworth. He later studied at the Manchester Academy. Together with some friends, including E.M. Bancroft (q.v.), he formed a sketching group from which the 'Manchester School' can be said to have evolved. He painted in oil and watercolour and exhibited marine views, landscapes, genre and portraits at the R.A., N.W.S. and G.G. between 1873 and 1888.

PARTRIDGE, John 1790 (Glasgow) – 1872 (London)
A portrait painter who was a pupil of Thomas Phillips, R.A. He was in France and Italy from 1823 to 1827 and thereafter established a fashionable practice, becoming Portrait-painter Extraordinary to the Queen in 1842. He painted occasional subject pictures.

Published: *On the constitution and management of the R.A.,* 1864.
Examples: B.M.; Castle Mus., Nottingham.

PARTRIDGE, Sir John Bernard 1861 (London) – 1945
The nephew of J. Partridge (q.v.), he was a *Punch* cartoonist and a book illustrator. After an education at Stoneyhurst, he became an actor for a time and, between 1880 and 1884, worked as a stained-glass and decorative painter. In 1891 he joined *Punch*. He was a member of the R.I. from 1896 to 1906.

Examples: Dundee City A.G.; City A.G., Manchester; Newport A.G.

PASQUIER, E J , N.W.S.
Possibly a French refugee, he was a landscape painter and lived in Chichester. He exhibited in Paris in 1822 and 1833 and at Suffolk Street from 1828 to 1832. In 1833-4 he was a member of the N.W.S. He painted in North Wales and Scotland as well as on the South Coast.
 The genre painter J. ABBOTT PASQUIER, who lived in London and was active from 1851 to 1868, may have been a relation.

PATERSON, Emily Murray, R.S.W.1855 (Edinburgh) – 1934
A landscape, coastal and river painter, she studied in Edinburgh and Paris. She painted in Holland, Venice, Austria, Switzerland, Norway, Brittany and Belgium, and exhibited at the R.A., R.S.A. and R.I. as well as abroad.
 She was a follower of the Glasgow School with their preoccupation with colour, light and atmosphere. Like them, she used all manner of tricks to obtain her effects. She also painted flower pieces.

Examples: V.A.M.; Aberdeen A.G.; Blackburn A.G.; Dundee City A.G.; Gray A.G., Hartlepool; Leicestershire A.G.; Paisley A.G.
Bibliography: *Walker's Monthly,* November, 1930; 1935.

PATERSON, James, R.S.A., R.W.S., P.R.S.W.
1854 (Glasgow) – 1932 (Edinburgh)
A landscape painter who studied at the Glasgow School of Art and under J.P. Laurens in Paris, returning in 1882 to Glasgow, where he became a member of the Glasgow School. In 1884 he married and moved to Moniaive, Dumfriesshire, and he drew much inspiration from this area. He also painted in Edinburgh and on the West Coast and visited England, France, Italy and Corsica. He was elected A.R.W.S. in 1898 and R.W.S. in 1908. He was elected A.R.S.A. in 1896 and R.S.A. in 1910, in which year he also became Librarian. In 1923 he became President of the R.S.W. He was influenced by the Barbizons and like his Glasgow colleagues Guthrie, Henry and Macgregor he preferred the blurred edge to the clear outline. He

used a still wetter and more blurred technique in his later years and tended to overwork his drawings in search of decorative effect.
 His brother ALEXANDER NISBET PATERSON, A.R.S.A., R.S.W. (1862–1947) was an architect and architectural draughtsman. He lived at Helensburgh.

Examples: B.M.; Aberdeen A.G.; Dundee City A.G.; Glasgow A.G.
Bibliography: O.W.S. Club, X, 1933.

PATON, Frank 1856 – 1909
A genre, figure and animal painter in oil and watercolour. He was also an illustrator, and he lived in London and Gravesend, exhibiting from 1872.

Examples: B.M.

PATON, Sir Joseph Noel, R.S.A.
1821 (Dunfermline) – 1901 (Edinburgh)
Primarily a fairy and religious genre painter in oil, and an illustrator, he entered the R.A. Schools in 1843, was linked to the Pre-Raphaelites, although not a Brother, and was elected A.R.S.A. and R.S.A. in 1847 and 1850. He was appointed Queen's Limner for Scotland and knighted in 1866.
 His work was immensely popular with the laity, less so among artists.
 His sons Frederick Noel Paton (1861–1914) and Ronald Noel Paton were also artists.

Examples: B.M.; Glasgow A.G.; Royal Shakespeare Theatre, Stratford.
Bibliography: *A.J.,* 1869; 1881; 1895; 1902.

PATON, Waller Hugh, R.S.A., R.S.W.
1828 (Dunfermline) – 1895 (Edinburgh)
The brother of Sir J.N. Paton (q.v.) and of Mrs. D.O. Hill, he worked as an assistant to his father, a damask designer, until 1848, when he became a pupil of J.A. Houston (q.v.). He exhibited at the R.S.A. from 1851, and was elected A.R.S.A. and R.S.A. in 1857 and 1865. He became a Member of the R.S.W. in 1878. In 1860 he spent some time in London copying Turners, and he visited the Continent in 1861 and 1868.
 He produced landscapes, both in oil and watercolour, always making watercolour sketches of his oil paintings. He liked to work entirely in the open air. His favourite sketching grounds were Perthshire, Aberdeenshire and Arran. His work is detailed and pleasing without great originality, and earlier he showed a Pre-Raphaelite attention to detail. 'To say that he lived in a land where it was always evening would be exaggeration, but his most characteristic pictures deal with the close of day and the up-coming of the moon' (Caw).

Illustrated: with Sir J.N. Paton; W.E. Ayton: *Lays of the Scottish Cavaliers,* 1863.
Examples: Dundee City A.G.; Glasgow A.G.; Greenock A.G.
Bibliography: *A.J.,* 1895.

PATTEN, George, A.R.A.
1801 – 1865 (Winchmore Hill, Middlesex)
A portrait painter in oil and miniature, he was the son of a miniaturist under whom he studied. He entered the R.A. Schools in 1816 and again to learn oil painting in 1828. In 1837 he went to Italy, and in the same year he was elected A.R.A. He also travelled in Germany, and he was appointed Portrait Painter to the Prince Consort.

Examples: V.A.M.
Bibliography: *A J.,* May, 1865.

PAUL, Sir John Dean, 2nd Bt. **1802 — 1868 (St. Albans)**
Educated at Westminster and Eton, he worked in the family bank, Snow, Paul and Paul, from 1828. In 1852 he succeeded to the baronetcy. In 1855 the firm suspended payment and the partners were tried for fraud and sentenced to fourteen years transportation. His topographical and sporting drawings are rather old-fashioned.

Published: *A.B.C. of Foxhunting*, 1871.
Illustrated: Sir J.D. Paul (his father): *The Country Doctor's Horse*, 1847.
Bibliography: F. Higginson: *Dangerous Consequences of employing Bankers*, 1856.

PAYNE, Rev. John **1700 (Dublin) — 1771 (Dublin)**
The son of William Payne, a Dublin portrait painter, he entered Trinity College, Dublin, in 1715, graduating in 1720. He was then ordained, and held the living of Castlerickard, Co. Meath. He painted, particularly flowers, in oil and watercolour, and worked at engraving. He was also a poet and musician.

Published: *Twelve Designs of Country Houses of two, three and four Rooms*, 1757.

PAYNE, William **c. 1760 — c. 1830 (London)**
Payne was brought up in Plymouth and began his career as an engineer in the naval dockyard. He began to send local views, which are amongst his best works, to London in 1776 and to the R.A. in 1786. In 1790 he moved as a professional artist, to London, where he became one of the most fashionable and successful drawing masters of the day. He was A.O.W.S. from 1809 to 1812 and exhibited at the British Institution and elsewhere from 1809 to 1830. His popularity was partly owing to the fact that he had developed a very distinctive style which was easily taught to others. In essentials this consisted of a number of technical tricks such as dragging the brush to obtain the texture of gravel or stone and building up layers of grey, in particular a pigment of his own invention which became known as 'Payne's Grey'. A network of near-parallel strokes of Indian ink in his foregrounds and a standardized scallop-shaped method of rendering branches and foliage are other hallmarks of his style. In his later years he fell from popularity because these conventions had developed into mere mannerism. J. Glover (q.v.) was one of his pupils.

Examples: B.M.; V.A.M.; Cartwright Hall, Bradford; Co. Lib., Exeter; Exeter Mus.; Fitzwilliam; Leeds City A.G.; Leicestershire A.G.; Whitworth A.G., Manchester; Nat. Lib., Wales; Newport A.G.; Plymouth A.G.; Richmond Lib.; Ulster Mus.

Bibliography: *Walker's Quarterly*, VI, 1921. Plymouth A.G.: *Exhibition Cat.*, 1937. *Apollo*, XXXIX, 1939. *Country Life*, October 18, 1946. *Connoisseur*, CLXVIII, 1968.

PEACE, James **c. 1781 — 1827 (Dublin)**
A linen draper and landscape painter who worked in Dublin. He exhibited at Parliament House in 1802, 1812 and 1814, and was a Member of the Hibernian Society. He sometimes worked in a mixture of pastel and watercolour which is rather unsuccessful.

Examples: B.M.

PEAK, James **c. 1730 — c. 1782**
A landscape engraver and draughtsman in the manner of Vivarès. He worked in London and also produced animal etchings. His drawing of Waltham Holy Cross, engraved by himself, was published by Boydell in 1763.

Examples: Richmond Lib.

PEARSON, Cornelius **1809 (Boston, Lincolnshire) — 1891**
A landscape and topographical painter and an engraver. He was apprenticed to a London engraver and lived in London throughout his career. He was a member of the Langham Sketching Club and an unsuccessful candidate for the N.W.S. on numerous occasions from 1845 to 1865. He exhibited from 1842 until the year of his death.

He painted in many parts of the country including Wales, the Lake District, Scotland, on the Thames and in Devon. His figure drawing was poor, and, especially in the 1870s, he often collaborated with other artists such as H. Tidey (q.v.) who supplied figures, and T.F. Wainwright (q.v.) who supplied sheep and cattle.

Examples: V.A.M.; Abbot Hall A.G., Kendal; City A.G., Manchester; Newport A.G.

PEARSON, James **(Dublin) — 1805**
A stained glass designer who trained in Bristol and worked at Brazenose College, Oxford, and at Salisbury Cathedral, and he exhibited at the S.A. from 1775 to 1777. His wife EGLINTON MARGARET PEARSON, née PATTERSON (d. 1823), the daughter of Samuel Patterson the auctioneer, was also an artist and helped him in his designs.

PEARSON, John **1777 (Ripon) — 1813**
A landscape painter who may have been a pupil of F. Nicholson (q.v.) at Ripon. In 1804 he was working for Lord Hill at Hawkstone Park, Shropshire. He aquatinted a number of his drawings, and his treatment of foliage is similar to that of Nicholson.
A later J. PEARSON was working at Durham in 1830.

Examples: V.A.M.

PEARSON, William
A landscape painter who exhibited at the R.A. and the A.A. from 1798 to 1809, and who was a close imitator of Girtin. He was also a friend of Francia, and may be the author of a series of drawings of London churches dated 1810–13, and of *Select Views of the Antiquities of Shropshire*, 1807.
He is much weaker than Girtin. He tends to use rather harsh colours and to over-stress a patch of light in the middle distance.

Examples: B.M.; V.A.M.; Hove Lib.; Leeds City A.G.; City A.G., Manchester; Ulster Mus.

PEARSON, W H
A painter of river landscapes and shipping subjects somewhat in the manner of T.B. Hardy (q.v.) or C.E. Dixon (q.v.). He was working in the early years of the twentieth century. His landscapes are usually large and are often taken from Surrey.

PECKHAM, T
A drawing master at the Addiscombe Military College in the 1790s. Apparently he had a son of the same name, who was also an artist.

PEDDER, John, R.I. **1850 (Liverpool) — 1929 (Maidenhead)**
A landscape, figure and animal painter in oil and watercolour, he was educated in Liverpool and in 1886 went to Maidenhead. In the early 1890s he moved to Cookham Dene, retiring back to Maidenhead before 1900. He exhibited at the R.A. from 1875 to 1912, and elsewhere until 1928. In 1898 he was elected R.I.

PEEL, Eliza **— 1883**
The second daughter of Sir Robert, she was a pupil of H. Bright (q.v.). She married the Hon. Francis Stonor in 1855.

PEEL, Florence, Mrs. Hewitt
A painter of flowers and birds' nests who lived in Kensington. She exhibited at the S.B.A. from 1858 to 1868, was an unsuccessful candidate for the N.W.S. on several occasions between 1867 and 1879 and exhibited genre subjects with the Society of Female Artists in 1868.

PEEL, James **1811 (Newcastle-upon-Tyne) — 1906 (Reading)**
A landscape painter in oil and watercolour, he moved to London in 1840. He studied drawing under Alexander Dalziel, father of the Dalziel brothers, and exhibited at the R.A. and elsewhere from 1842 to 1894. He lived at Darlington from 1848 to 1857, when he returned to London, and he was a member of the R.B.A.

Examples: V.A.M.
Bibliography: Laing A.G., Newcastle: *Exhibition Cat.*, 1907.

PEEL, Julia – 1893
The elder daughter of Sir Robert, she married in 1841 the 6th Earl of Jersey, who died in 1859. In 1865 she married Charles Brandling of Middleton Hall, Yorkshire. She was a pupil of H. Bright (q.v.).

PEGG, William 1795 – 1867
He was brought up in Derby, and in about 1819 moved to Lancashire, where he became a pattern designer at Hoyle's Print Works. In about 1840 he moved to Heaton Norris, near Manchester, as a partner in the same trade. He was a neat flower painter in watercolour.

PEILE, Sir James Braithwaite 1833 (Liverpool) – 1906 (London)
An Indian administrator and amateur artist, he was educated at Repton and Oriel College, Oxford. In 1856 he joined the Bombay service, and he held various posts in the Bombay Government. He was on furlough in England from September, 1867 to April, 1869. He served on the famine commission and in 1879 returned to London to write his famine report. He was on the Bombay Council from 1883 to 1886 and was involved in the improvement of education – he was elected Vice-Chancellor of the University in 1884 – and agriculture. He left India in 1877 on his nomination to the India Council at Whitehall, on which he served until his retirement in 1902.

He made many atmospheric brown wash – and occasionally watercolour – drawings of India, and he also worked in black and white. After his return he sketched widely throughout Britain, especially in seaside towns and Cathedral cities. In the last years of his life he visited the Mediterranean, and Venetian drawings date from a fortnight before his death. His British drawings are meticulously numbered and dated. An exhibition of his Indian work was held at the Alpine Gallery, March, 1976.

Bibliography: *The Times*, April 27, 1906.

PELEGRIN, Manuel Jose
A landscape and marine painter who was living in Hexham in 1887. His subjects are generally North-Eastern.

PELHAM, James, III 1840 (Saffron Walden) – 1906 (Liverpool)
A landscape and genre painter, son of James Pelham, Yr., a miniaturist and genre painter. He lived in Liverpool and exhibited at the Liverpool Academy from 1858, becoming Secretary in 1867, and at the R.A. and elsewhere between 1865 and 1881.

PELLEGRINI, Carlo 'Ape' 1839 (Capua) – 1889 (London)
The caricaturist. A descendant of the Medici, he fought for Garibaldi and came to England in 1864. His first drawing for *Vanity Fair* appeared in 1869. He painted a few oil portraits. His work is similar in style and manner to that of Sir. L. Ward (q.v.). He wrote a number of historical and art books.

Examples: V.A.M.; B.M.

PEMELL, J
A portrait, genre, animal and landscape painter in oil and watercolour. He lived in Canterbury and London and exhibited from 1838 to 1851.

Examples: V.A.M.

PENLEY, Aaron Edwin, A.N.W.S. 1807 – 1870 (Lewisham)
In 1834 he was working as a miniaturist in Manchester, and in the following year he exhibited for the first time at the R.A. He was elected N.W.S. in 1838 but resigned in 1856 over the hanging of his works. He was re-elected Associate in 1859. He was Assistant, and from 1851, Professor of Drawing at the Addiscombe Military College, subsequently moving to Woolwich, and also Water-Colour Painter to William IV and Queen Adelaide, and taught Prince Arthur. He lived in London for the most part, but also stayed in Bristol, Southampton and Plymouth. In his early days he produced portraits, later the landscapes for which he is better known. Armstrong says: 'his art was of the showy, artificial kind, which was encouraged by the early popularity of chromolithography, and may

be said to have become quite obsolete before his death.' He painted in many parts of the country, especially in Scotland.

His remaining works were sold at Christie's, April 23, 1870. His son CLAUDE PENLEY painted river landscapes in the 1870s.

Published: *A System of Watercolour Painting*, 1850. *Elements of Perspective*, 1851. *English School of Painting in Watercolours*, 1861. *Sketching from Nature in Watercolours*, 1869.
Examples: B.M.; V.A.M.; Grundy A.G., Blackpool; Fitzwilliam; Hove Lib.; Leeds City A.G.; Maidstone Mus.; City C.A., Manchester; N.G., Scotland; Paisley A.G.; Ulster Mus.
Bibliography: *A.J.*, March, 1870.

PENLEY, Edwin Aaron
Probably a son of A.E. Penley (q.v.), whose manner he closely imitated, but possibly of WILLIAM HENRY SAWLEY PENLEY (b. 1794) who was working as a drawing master and miniature painter in Reading at least from 1844 to 1851. The family came from Marylebone. He was active from 1853 to 1890 and lived in London, Cheltenham and Bognor. He was an unsuccessful candidate for the N.W.S. in 1861.

PENN, Stephen
An amateur artist who made topographical pen and wash drawings of the Lake District in 1732. They are laid out like rather old-fashioned engravings, with a key to the various hills and points of interest. The pen work is weak and the washes are unadventurous.

PENROSE, Rev. Thomas c. 1743 – 1779 (Bath)
The son of the Vicar of Newbury, he was educated at Christ Church, Oxford, and, although intended for the Church, joined the Navy in 1762. After receiving severe wounds he returned to his vocation, and, on completing his religious training at Hertford College, Oxford, he inherited his father's living. He later became Vicar of Standerwick, Somerset.

He was the brother-in-law of J.P. Andrews (q.v.), and several wash caricature drawings by him appear in a scrap book of Andrews' which is described in *Country Life*, December 31, 1959.

PENSON, James 1814 (Devonport) – 1907
A Devonshire landscape painter in oil and watercolour. He was the son of a doctor and was a drawing master.

In the V.A.M. is a watercolour of snow on bracken by FREDERICK T. PENSON dating from about 1902.

Examples: Exeter Mus.

PENSON, Richard Kyrke, R.I., F.S.A. 1805 – 1886
An architect and painter of old buildings and coastal scenes. He lived in London and worked at Ferryside and Kidwelly, Carmarthen. He exhibited from 1836 to 1872 and was elected N.W.S. in 1836.

PENSTONE, Edward
A genre and landscape painter who exhibited at the S.B.A. and elsewhere from 1871 to 1889.

PEPPERCORN, Alfred Douglas
 1847 (London) – 1924 (Ashtead, Surrey)
A landscape painter in oil and watercolour who studied at the Ecole des Beaux Arts in Paris, where he was greatly influenced by Corot and the Barbizon School. He exhibited at the R.A., Suffolk Street and elsewhere from 1869. All in all, he is a very dull artist.

Examples: V.A.M.; Towner Gall., Eastbourne; Leeds City A.G.; Stalybridge A.G.

PERCIVAL, H
A marine painter working in the 1880s.

Examples: Greenwich.

PERCY, Lady Agnes – 1856

A flower painter, she was the third daughter of the 2nd Duke of Northumberland. She married Major-General F.T. Buller of Pelynt and Lantreath in 1821.

PERCY, Lady Elizabeth Susan – 1847

The second daughter of the 1st Earl of Beverley and niece of the 4th Duke of Northumberland, she was a cousin of Julia Gordon (q.v.). She was a mirror of the topographical fashions of her time, beginning as an imitator of Hearne, and ending, by way of Girtín and Sir G. Beaumont, as an imitator of Leitch and Lear. She was in Rome from 1834 to 1838.

Bibliography: *Country Life,* July 8, 1939.

PERCY, Emily

An historical genre painter who lived in Notting Hill Gate and exhibited at the S.B.A. in 1868 and 1869. She should not be confused with Lady Emily Drummond, née Percy, who was a sister of Lady E.S. Percy (q.v.), and may well have painted.

PERIGAL, Arthur, Yr., R.S.A., R.S.W.

 1816 (London) – 1884 (Edinburgh)

The son of Arthur Perigal, an historical and portrait painter. He exhibited landscapes in both watercolour and oil from 1837 and was elected A.R.S.A. and R.S.A. in 1841 and 1868. From 1880 he served as Treasurer.

Although he also painted in Italy and Norway, he is best known for what Caw calls his 'harsh and unsympathetic Highland panoramas'. This judgement itself seems a little harsh.

Examples: Dundee City A.G.; Paisley A.G.

PERRIN, Ida Southwell, Mrs., née Robins

 1860 (London) –

Potter and landscape painter in watercolour and oil, she was educated at Bedford College and studied at South Kensington She became manager of the De Morgan Pottery Works at Bushey Heath. She exhibited at the R.A., the R.I. and in Paris.

Illustrated: G.E.S. Boulger: *British Flowering Plants,* 1914.

PERRY, Alfred

A painter of landscapes, animals and genre subjects. He lived in London and exhibited from 1847 to 1881. He was an unsuccessful candidate for the N.W.S. in 1862, 1863 and 1873, and he seems to have visited Italy in about 1870. Many of his subjects were taken from Sussex and Kent.

Examples: V.A.M.

PERRY, J M

A pupil of W. Payne (q.v.). A drawing in the Payne manner dated 1807 is in the Ashmolean, another was in Williams's collection. A JOHN PERRY exhibited figures at the R.A. in 1791 and 1809.

PERUGINI, Katherine Elizabeth Macready, Mrs., née Dickens

 1838 – 1929

The daughter of Charles Dickens, she married, firstly, C.A. Collins (q.v.) in 1860 and, secondly, Charles Edward Perugini, a Neapolitan figure painter (d. 1919). She exhibited portraits and genre subjects at the R.A., R.I., Suffolk Street and elsewhere.

Examples: Hertford Mus.

PETIT, Rev. John Louis

 1801 (Ashton-under-Lyne) – 1868 (Lichfield)

Educated at Trinity College Cambridge from 1823, he was Curate of Bradfield, near Manningtree, retiring soon after 1846 to Shifnal, Shropshire. For a year or so before his death he lived in Lichfield. He was a member of the Archaeological Institute and produced papers on architectural and antiquarian subjects. His watercolours and etchings are usually of architecture.

Published: *Remarks on Church Architecture,* 1841. *The Abbey Church of Tewkesbury,* 1848. *Architectural Studies in France,* 1854 etc.

Examples: V.A.M.; Johnson Birthplace Mus., Lichfield.

PETER, Edward **1780 (Cheshire) – 1862 (London)**

A painter of apocalyptic visions who worked for a time as an assistant to Mr. Christie, the auctioneer. In about 1815 he went to Italy, where he lived, mainly in Cortona and Venice, for some fifteen years. On his return he settled in Clapham as a market gardener. There, his eccentric habits earned him the title of 'the Clapham Hermit'. His work, in pen and ink or watercolour, usually seems to have been inspired by Hieronymus Bosch, but he is also said to have produced fakes of contemporary artists.

PETRIE, George, P.R.H.A. **1790 (Dublin) – 1866 (Dublin)**

A landscape painter and the only child of James Petrie, a Dublin miniaturist. He studied at the R.D.S. Schools, and worked with his father before turning entirely to landscape painting. He toured County Wicklow in 1808 and Wales in 1810, and in 1813, together with F. Danby (q.v.) and J.A. O'Connor (q.v.), he went to London. He returned alone to Ireland and toured Wicklow, Kerry and King's County, exhibiting drawings from these tours in Dublin from 1809 to 1819. In 1816 he exhibited at the R.A., and he exhibited at the R.H.A. from the first exhibition in 1826 until 1858, being elected A.R.H.A. and R.H.A. in 1826 and 1828, and Librarian in 1829. In 1828 he also became a Member of the R.I.A., and was elected to the Council in 1830. He contributed many articles to its *Transactions,* and worked for the improvement of the library. He also wrote antiquarian articles for the *Dublin Penny Journal* in 1832–3, and in 1842 was editor of the short-lived *Irish Penny Journal.* From 1833 he worked on the Ordnance Survey of Ireland. Despite considerable opposition, he was elected P.R.H.A. in 1856, but he resigned in 1859, and was made an Honorary Member.

His pencil sketches and Indian ink or brown wash drawings are more appealing than his watercolours which, although much admired in his day, are rather stiffly executed, with severely contrasting foreground and background.

His daughter MARY ANNE PETRIE painted landscapes in his style, and was an occasional exhibitor at the R.H.A.

Illustrated: Cromwell: *Excursions through Ireland,* 1819. J.J. McGregor: *New Picture of Dublin,* 1821. C.N. Wright: *Historical Guide to Ancient and Modern Dublin,* 1821. Brewer: *Beauties of Ireland,* 1825. Etc.

Examples: B.M.; V.A.M.; N.G., Ireland; Ulster Mus.

PETRIE, Graham, R.I. **1859 (London) – 1940 (London)**

A landscape and architectural painter in oil and watercolour and a poster designer for railway companies. He was educated at Mill Hill and lived in London. He was best known for his Venetian, Italian Lake and North African subjects.

Published: *Tunis, Kairwan and Carthage,* 1908.
Examples: V.A.M.

PETRIE, Henry, F.S.A. **1768 (Stockwell, Surrey) – 1842 (Stockwell)**

An antiquary, he was the son of a dancing master and intended for the same profession. He won the patronage of Thomas Frognall Dibdin and Earl Spencer, who encouraged him in bibliographic research. In 1819 he was appointed Keeper of the Records at the Tower of London. From about 1818 he was chiefly occupied with the editorship of the projected *Monumenta Historica Britannica* of which one volume was finally published by Sir. T.D. Hardy in 1848. Petrie also made a Survey of Southern English Churches in 1800, for which he produced drawings in pencil and watercolour.

PETTIE, John, R.A.

 1839 (East Linton, Haddington) – 1893 (Hastings)

A friend and fellow student at the Trustees' Academy of McTaggart, MacWhirter and Orchardson, he made a few watercolours, generally sketches for his oil paintings. They show, however, a talent which he himself never recognized. He first exhibited at the R.S.A. in 1859

and at the R.A. in 1860, and in 1862 he moved to London and lived with Orchardson. In 1865 he married Elizabeth Ann Bossom, sister-in-law of C.E. Johnson (q.v.). He was elected A.R.A. in 1866 and R.A. in 1873.

His colours are notably bright and, especially in his later and rather cruder works, strongly contrasting. A memorial exhibition was held at the R.A. in 1894.

Illustrated: J. de Wefde: *The Postman's Bag*, 1862. C. Camden: *The Boys of Axleford*, 1869. L.G. Seguin: *Rural England*, 1881.
Examples: Glasgow A.G.
Bibliography: M. Hardie: *J.P.*, 1908. *A.J.*, 1869; 1907.

PETTINGELL, Frank Noble 1848 (Hull) – 1883
An architect and watercolourist living at 55 Whitefriargate, Hull. He made a number of competent topographical views.

PETTIT, Edwin Alfred 1840 (Birmingham) – 1912 (London)
Presumably a member of the Birmingham family of artists, he was a landscape painter. He was brought up and lived in London, although from about 1864 he spent much of his time in Switzerland and Italy. He also painted in the Lake District, Wales and Devonshire. He exhibited from 1858 to 1880 and worked in oil and watercolour.

His wife **PATTIE PETTIT**, née **MELVILLE** was also a landscape and genre painter.

PHELPS, Dr. Robert 1806 – 1890
The Master of Sidney Sussex College, Cambridge, he painted cottages and landscapes which are freely drawn in the late manner of D. Cox (q.v.).

Examples: Fitzwilliam.

PHILIPS, Nathaniel George 1795 (Manchester) – 1831 (Liverpool)
The son of an eminent collector of books and pictures, he was educated at Manchester Grammar School and Edinburgh University, where he read medicine. He visited Ireland, the Isle of Man and the Lake District, and in 1824 went to Rome by way of Switzerland. On his return he set up as a landscape painter in Liverpool. Between 1822 and 1824 he had published a series of views of old halls in Lancashire and Cheshire, from his own drawings.

His sketches are sometimes in brown wash and on tinted paper. His collection and remaining works were sold by Wales & Baines, Liverpool, 1831.

PHILLIP, Colin Bent, R.W.S. 1855 (London) – 1932
A landscape painter and the son of J. Phillip, (q.v.). He was educated in London and Germany and at St. Andrews University, and he studied at the Lambeth School of Art and in Edinburgh under D. Farquharson (q.v.). He was elected A.R.W.S. in 1886 and R.W.S. in 1898. His subjects were often Scottish or Italian.

Examples: Aberdeen A.G.; Exeter Mus.

PHILLIP, John 'Spanish', R.A. 1817 (Aberdeen) – 1867 (London)
The son of an old soldier, he was apprenticed to a house painter and glazier. He ran away to see the Academy in 1834, and two years later was sent to the R.A. Schools. He also studied with T.M. Joy. He returned to Aberdeen for a while, but settled in London in 1846. In 1851 he went to Spain for his health, paying a second visit with Richard Ansdell in 1856 and a third in 1860. In 1866 he visited Florence and Rome. He was elected A.R.A. and R.A. in 1857 and 1859.

He began as a rather weak imitator of Wilkie, producing Scottish genre subjects. The Spanish tours brought out his true talent and made his reputation as 'Spanish Phillip' or 'Phillip of Spain'. He is one of the best of the Victorian genre painters, although he is interested only in the exteriors of his Spaniards and gipsies.

His remaining works were sold at Christie's, May 31, 1867.

Examples: B.M.; Glasgow A.G.
Bibliography: *A.J.*, May, 1867. J. Dafforne: *Pictures by J.P.*, 1877. *Country Life*, April 13, 1967. Aberdeen A.G.; *Exhibition Cat.*, 1967.

PHILLIPS, Charles Gustav Louis 1863 (Montevideo) – 1944
Of Scottish parentage, he studied under W.M. Grubb in Dundee. He painted views of Dundee in oil and watercolour.

Examples: Dundee City A.G.

PHILLIPS, Elizabeth, Mrs., née Rous
The daughter of J. Rous (q.v.), she married Philip Phillips, a panorama and architectural painter who encouraged her to paint. She went on sketching tours with her husband, and worked on his panoramas. She exhibited at the R.A., the B.I., Suffolk Street and elsewhere between 1832 and 1878. She painted landscapes, particularly of the Rhine, views of churches, and still-lifes.

PHILLIPS, Giles Firman 1780 – 1867
A landscape painter who exhibited at the R.A., the B.I., N.W.S., Suffolk Street and elsewhere from 1830 until 1866. He was a founder of the N.W.S. in 1831 but resigned a few years later. His subjects were often Thames views. He lived in London and at Greenwich.

Published: *Principles of Effect and Colour, as applicable to Landscape Painting*, 1838. *Theory and Practice of Painting in Water Colours*, 1838. *Practical Treatise on Drawing and Painting in Water-colours*, 1839.
Examples: V.A.M.

PHILLIPS, Lawrence Barnett, F.S.A.
** 1842 (London) – 1922 (London)**
After a private education and studying mechanics and watchmaking, he became a watch and chronometer manufacturer. He first exhibited in 1874 and on his retirement in 1882 he devoted himself to landscape painting, etching and writing.

Published: *The Autographic Album*, 1866. *The Dictionary of Biographical Reference*, 1871.
Examples: V.A.M.

PHILLIPS, Thomas c. 1635 – 1693 (at sea)
A military engineer who was draughtsman to George Legge's survey of the Channel Islands in 1680. He surveyed the Isle of Wight and went to Tangier with Pepys in 1683, and he was in Ireland two years later.

His work is formal and competent in the manner of contemporary topographical engravings.

Examples: B.M.; Greenwich; City A.G., Manchester.

PHILLOTT, Constance, A.R.W.S. 1842 – 1931
A landscape and genre painter who studied at the R.A. Schools and exhibited from 1864. She lived in Hampstead and was elected A.R.W.S. in 1882. She produced a number of classical heads in ovals.

Examples: City A.G., Manchester.

PHILP, James George, R.I. 1816 (Falmouth) – 1885
A landscape and coastal painter, most of whose subjects were found in Devon and Cornwall. He exhibited from 1848 to 1885 and was elected A.N.W.S. in 1856, and N.W.S. in 1863, having been unsuccessful in 1843 and 1848. In all these years he was living in Falmouth.

Examples: Brighton A.G.; Maidstone Mus.; Ulster Mus.

PHIPPS, Hon. Augustus, F.R.S. 1762 – 1826
A younger brother of the 1st Earl of Mulgrave, he was one of the eight members of the Society of St. Peter Martyr in London. The others were Sir G. Beaumont, O. and C. Bowles, B. West, J. Farington, G. Dance and T. Hearne (all q.v.). With his brothers, **HENRY**, the Earl (1755–1831) and **GENERAL** the **HON. EDMUND PHIPPS** (1760–1837), he was a patron of Girtin, Jackson and Nicholson.

PHIPSON, Edward Arthur 'Evacustes' 1854 – 1931
A very prolific topographer who worked in Normandy and Brittany as well as throughout Britain. In the 1890s he lived in Birmingham.

Published: *Art under Socialism*, 1895.
Examples: V.A.M.; Croydon Lib.; Derby A.G.; Gloucester City Lib.; Hastings A.G.; Christchurch Mansion, Ipswich; Lambeth Lib.; Lewisham Lib.; Maidstone Mus.; City Lib., Manchester; Richmond Lib.; City Mus., St. Albans; Salisbury Lib.; Shakespeare Centre, Stratford-on-Avon; Castle Mus., Tamworth; Taunton Castle.

PHYSICK, William
A member of a large family of artists and sculptors. He was painting in Sussex in 1840 and exhibited landscapes at the Carlisle Anthenaeum in 1848 when living in Manchester. He may be identifiable with the sculptor who exhibited at Suffolk Street between 1867 and 1890 from various London addresses. Sometimes he signed with initials.

PICKEN, Andrew 1815 – 1845 (London)
The second son of Andrew Picken the author, he studied under L. Haghe (q.v.). He became a lithographer and first exhibited at the R.A. in 1835. From 1837, for health reasons, he lived in Madeira for two years, which he later revisited before settling finally in London.
His youngest brother THOMAS PICKEN worked on Robert's *Holy Land*, 1855; Payne's *English Lake Scenery*, 1856, etc., and he exhibited a view of Reigate at the Royal Pavilion Gallery, Brighton in 1875. He also exhibited landscapes and figure subjects at the S.B.A. from 1846 to 1875.

Published: *Madeira Illustrated*, 1840. Etc.

PICKERING, Ferdinand
An historical genre and figure painter in oil and watercolour. He exhibited from 1831 to 1882 and lived in London.

PICKERING, George 1794 (Yorkshire) – 1857 (Birkenhead)
A pupil and close imitator of J. Glover (q.v.), he took over G. Cuitt's teaching practice in Chester. He exhibited at the Liverpool Academy, procuring a studio in Liverpool in 1836. Later he taught drawing in Birkenhead. He also exhibited in London from 1815 to 1828. T. Allom (q.v.) worked up some of his drawings for exhibition.

Illustrated: G. Ormerod: *History of Cheshire*, 1819. E. Baines: *History of the County Palatine of Lancaster*. J. Roby: *Traditions of Lancashire*, 1928.
Examples: V.A.M.; Grosvenor Mus., Chester; Derby A.G.

PICKERING, J **L**
1845 (Walton, Nr. Wakefield) – 1912 (London)
A landscape painter in oil and watercolour, who worked as a civil engineer before turning to art in 1869. He studied in Italy, France and Scotland and was elected R.B.A. in 1890. He lived in Surrey and Kent.

PICKERSGILL, Frederick Richard, R.A.
1820 (London) – 1900 (Isle of Wight)
An historical and literary painter. He was the son of Richard Pickersgill, a painter, and the nephew of Henry William Pickersgill, R.A., and W.F. Witherington (q.v.), under whom he studied. He was elected A.R.A. and R.A. in 1857 and 1867. He was primarily an oil painter and his work in watercolour consists of sketches and studies and a few book illustrations.
His son Henry Hall Pickersgill painted portraits and subject pictures in oil.

Illustrated: P. Massinger: *Virgin Martyr*, 1844. J. Milton: *Comus*, 1858. E.A. Poe: *Poetical Works*, 1858.
Examples: V.A.M.
Bibliography: *A.J.*, August, 1855.

PIDGEON, Henry Clarke, N.W.S. 1807 – 1880 (London)
Intended for the church, he became instead a watercolourist, etcher and antiquarian, specialising in landscapes, portraits and architecture. Until 1847 he taught drawing in London. He then moved to Liverpool as Professor of Drawing at the Institute and became a Member and, from 1850, Secretary of the Liverpool Academy. He was also a Founder and Secretary of the Historic Society of Lancashire and Cheshire. In 1851 he returned to London and continued to take private pupils. He was elected A.N.W.S. and N.W.S. in 1846 and 1861.
His colour, whether in landscape or antiquarian details, is good and strong, and some of his work shows the influence of J. Varley.

PIERREPONT, C **Constance**
A painter of heads, fruit and flowers who exhibited with the Society of Female Artists in 1875 and at Suffolk Street in 1877. She lived in London.

PIGOTT, Charles
A landscape and coastal painter in oil and watercolour who lived in Sheffield and exhibited at the R.B.A. in 1888. He was still active in 1906.

PIGOTT, W **H** c. 1810 (Nottingham) – 1901
A landscape and genre painter who lived in Sheffield and exhibited at the R.A. and Suffolk Street from 1869. The majority of his work is in oil.

Examples: Sheffield Mus.

PIKE, Sidney
A painter of landscapes and rural genre subjects who exhibited from 1880 to 1901. He lived in London, at Taplow, Buckinghamshire, and Christchurch.

PIKE, William Henry 1846 (Plymouth) – 1908
A landscape and genre painter in oil and watercolour who exhibited from 1874. Until 1881, when he moved from Plymouth to London, his subjects were generally found in Cornwall and Devon. Thereafter there are many Venetian scenes. He was a member of the R.B.A. from 1889.

Examples: B.M.; Exeter Mus.

PILKINGTON, Major-General Robert W
1765 (Chelsfield, Kent) – 1834 (London)
He attended the R.M.A., Woolwich, after which he served with the Royal Engineers in Canada and North America before returning to the South of England in 1803. He accompanied the expedition to Walcheren in 1809, and served at Flushing, where he stayed to command the defensive operations. He returned to England in 1810 and was stationed at Woolwich and Weedon. From 1818 to 1830 he was in Gibraltar. He was promoted captain in 1801, lieutenant-colonel in 1809, major-general in 1825, and he became Inspector-General of Fortifications in 1832. He painted landscapes.

PILKINTON, Thomas 1862 (Gravesend) –
A painter of country and woodland scenes in oil and watercolour who was the son of a Gravesend writer and painter. He studied at the Gravesend School of Art and exhibited at South Kensington and elsewhere.

PILLEAU, Henry, R.I. 1813 – 1899 (Brighton)
After an education at Westminster, he joined the Army Medical Corps, ending as Deputy Inspector-General of Hospitals. From 1850 he devoted himself to travelling and painting. He worked in many parts of Britain including Ireland and Scotland, and he visited Egypt in 1845 and 1868-9, and India in 1859. Venice provided him with many subjects. He lived in London and Leicester and was elected R.I. in 1882. His work is often pleasing, but it is worthy rather than inspired.

Published: *Sketches in Egypt*, 1845.
Examples: B.M.; V.A.M.

PILSBURY, Harry Clifford 1870 (London) –
A portrait and landscape painter in watercolour and oil, he was the son of W. Pilsbury (q.v.). He was educated in Leicester and taught art at Oundle and Wiggeston School, Leicester, before becoming Headmaster of the Whittlesey School of Art, Cambridgeshire.

PILSBURY, Wilmot, R.W.S.
 1840 (Cannock Chase) – 1908 (London)
A painter of cottage gardens and landscapes in the manner of H. Allingham (q.v.), he studied at the Birmingham School of Art, under J.W. Walker (q.v.) and at South Kensington and later became Headmaster of the Leicester School of Art. He exhibited in London and Birmingham from 1866, and a memorial exhibition was held at the Fine Art Society in 1908.

Examples: Leicestershire Mus.; Maidstone Mus.; Castle Mus., Norwich.

PINWELL, George John, O.W.S.
 1842 (High Wycombe) – 1875 (London)
After a short training at the St. Martin's Lane Academy and Heatherley's, Pinwell began to work for the Dalziel brothers in 1864. He also worked, sometimes in collaboration with F. Walker (q.v.), on illustrations for a number of magazines and periodicals. He began to exhibit watercolours at the Dudley Gallery in its first year, 1865. He was elected A.O.W.S. in 1869 and a full Member the following year. He spent several winters in Tangiers most notably that of 1874-5, when he was there for eight months.

His style and illustrations closely follow those of Walker. His career began with wood engraving, and his later watercolours show this influence, especially in their rather simplified composition. As Roget says, 'In his paintings definition of detail is introduced capriciously, without due regard to the relative distance of objects from the eye; and this produces a patchy effect'. In his best works his colour is very brilliant.

Many of his subjects are taken from the fringes of literature. They consist of incidents from comparatively obscure myths and legends, and are usually connected with his later oil paintings. He also drew inspiration from contemporary poets such as Browning and Jean Ingelow.

An important memorial exhibition was held at Deschamps' Gallery, Bond Street, in February, 1876. His remaining works were sold at Christie's, March 16, 1876.

Illustrated: *Goldsmith's works*, 1864. H. Lushington: *The Happy Home*, 1864. H. Lushington: *Hacco, the Dwarf*, 1865. R.W. Buchanan: *Ballad Stones of the Affections*, 1866. R.W. Buchanan: *Wayside Posies*, 1867. J. Ingelow: *Poems*, 1867.
Examples: B.M.; V.A.M.; Aberdeen A.G.; Cecil Higgins A.G., Bedford; Cartwright Hall, Bradford; Maidstone Mus.; Nottingham Univ.; Ulster Mus.
Bibliography: G.J. Williamson: *G.J.P.*, 1900. *A.J.*, 1875.

PITCHER, William John Charles, R.I.
 1858 (Northfleet) – 1925 (London)
The son of a shipbuilder, he became a theatrical designer, an art writer and a landscape painter. He was elected R.I. in 1920. Sometimes he used the name 'C. Wilhelm'.

PITMAN, Janetta c. 1850 (Nottingham) – c. 1910
The daughter of the Rev. H.R. Pitman, Vicar of Old Basford Church, Nottingham, she studied art in London and exhibited at the R.A. and elsewhere from 1880 to 1890. She painted still-life and genre subjects in oil and watercolour.

PITT, Douglas FOX- 1864 (London) – 1922 (Chertsey)
The fifth son of General Fox-Pitt-Rivers, he studied at the Slade and became a member of the London Group and a friend of Sickert. He visited Canada, Poland, Greece and the Ionian Islands, Ceylon and, in 1905-6, Morocco. From 1911 to 1918 he lived at Brighton. He painted landscapes, architectural subjects and illustrations and there is sometimes a late Glasgow School feel to his work.

Illustrated: Count Sternberg: *The Berbers of Morocco*, 1908.
Examples: B.M.; Preston Manor, Brighton; Fitzwilliam; Imp. War Mus.

PITT, William
A landscape painter in oil and watercolour who lived in London and Birmingham. He exhibited from 1849 to 1890 and his subjects were taken from many parts of Britain, especially from Devon and Cornwall, and from Northern France.

Examples: V.A.M.

PITTAR, J F Barry 1880 (Kent) – 1948 (Dunstable)
A decorator, etcher, landscape and architectural painter who was the son of the Chairman of the Board of Trade. He studied at the St. John's Wood School of Art, South Kensington and in Paris. He worked for the *I.L.N.* and the *Graphic* and was an architectural artist at the Doulton Potteries.

Examples: V.A.M.

PIXELL, Maria
A landscape painter in oil and watercolour who was active between 1793 and 1811. She may have been a pupil of S. Gilpin (q.v.), and one of her drawings was worked up by J.P. Neale (q.v.) for Britton's *Beauties*.

PLACE, Francis 1647 (Dinsdale, Durham) – 1728 (York)
He came to London to study law, but on the outbreak of the plague in 1665 settled in York, where he was the centre of a circle of artists and antiquaries. He made a number of sketching and fishing tours with his friend William Lodge, including visits to the Isle of Wight, in 1677; Wales and the South West in 1678; London in 1683; Chester in 1689; Ireland in 1698; Chester, North Wales and Ireland again in the following year and Scotland in 1701. He was a friend, though probably not a pupil, of W. Hollar (q.v.). Many of his drawings are much influenced by Hollar, although there is generally rather less neatness and more freedom. On occasions Place anticipated much later practice in drawing with the brush alone; sometimes his work can look a little like that of F. Towne (q.v.). He worked in various media, including pencil, pen and brown or grey wash, and pen and watercolour. He was also an etcher and pioneer mezzotinter, and drew crayon portraits.

A loan exhibition of his work was held at Kenwood and York A.G. in 1971.

Examples: B.M.; Glasgow A.G.; N.G., Ireland; Leeds City A.G.; N.G., Scotland; York A.G.
Bibliography: Walpole Soc., X, 1922.

PLAYFAIR, William Henry 1780 (London) – 1857 (Edinburgh)
An architect and draughtsman. He built the R.S.A. and the N.G., Scotland and was a member of the R.S.A. from 1829 to 1845.

Examples: N.G., Scotland.

PLOWDEN, Trevor Chichele
A pupil and follower of G. Chinnery (q.v.). He painted Indian subjects in oil and watercolour. He published translations of Persian works in the 1870s and 1880s as well as an edition of his brother's *Travels in Abyssinia*.

PLYMOUTH, Colonel Henry Windsor, 8th Earl of
 1768 – 1843
A pupil and patron of D. Cox (q.v.) in Dulwich in about 1810. He served in the Coldstream Guards from 1788 to about 1795 and succeeded to the title in 1837. The earldom became extinct on his death.

POCOCK, Henry Childe 1854 (East Grinstead) – 1934 (London)
A genre and historical painter who was a pupil of J.J. Jenkins (q.v.). He came to London in 1873 and studied at the St. Martin's Lane Academy and Heatherley's, exhibiting from 1880. Gradually he moved from eighteenth century to contemporary subjects.

POCOCK, Isaac 1782 (Bristol) – 1835 (Maidenhead)

A figure painter and dramatist, he painted a fine portrait of his father N. Pocock (q.v.) and was the author of *The Miller and his Men*. He was a pupil of Romney and Beechey and exhibited portraits and genre paintings in oil and watercolour at the R.A. and elsewhere from 1800. In 1818 he inherited property at Maidenhead and from that time concentrated on play writing.

His brother WILLIAM INNES POCOCK (1783–1836) was a Naval lieutenant serving in the East and West Indies. He published a number of prints after his drawings, most notably of St. Helena. He also made copies of his father's work, and at Greenwich there is a sketchbook by him including views of Cintra, Sardinia, Istria, Corfu, Albania, Sicily and Parma.

Examples: B.M.; V.A.M.

POCOCK, Julia

The sister of L.L. Pocock (q.v.), she was an illustrator, miniaturist, sculptress and painter of genre and figure subjects. She exhibited in London and elsewhere from 1870.

POCOCK, Lexden Lewis 1850 (London) – 1919

The son of Lewis Pocock, F.S.A., he studied at the Slade under Sir E.J. Poynter (q.v.) and at the R.A. Schools. He spent two years in Rome after which he joined the council of the newly founded Dudley Gallery, and exhibited at the R.A., N.W.S., Suffolk Street and elsewhere from 1872. He painted landscapes, often river landscapes, coastal scenes and figure subjects.

Examples: V.A.M.

POCOCK, Nicholas, O.W.S. 1740 (Bristol) – 1821 (Maidenhead)

A marine artist whose watercolours were the result of practical experience. During the early years of his career he commanded several ships belonging to Richard Champion, who was afterwards the first producer of Bristol porcelain. In these years drawing was very much a side-line for Pocock and his talents were mainly shown by the series of illustrated logs which he produced. Before 1780, however, he decided to become a professional artist and he began to exhibit both marine paintings and landscapes at the R.A. in 1782. In 1789 he moved to London where he quickly won popularity as a painter of the naval battles of the French war. He was one of the Founder members of the O.W.S. in 1804 but resigned with the reconstitution of 1812. In 1780 Reynolds had advised him to 'unite landscape to ship painting' and this he did most successfully. Typical are his views of shipping on the Avon at Bristol. His pure landscapes, which tend to rely too much on a rather sulphureous green, are often a little dull in comparison with his marine paintings. It is, however, difficult to do him justice since the vast majority of his work has faded very badly.

Two sales of his works were held at Hodgson's Rooms in 1913.

Examples: B.M.; V.A.M.; Haworth A.G., Accrington; Exeter Mus.; Greenwich; Leeds City A.G.; City A.G., Manchester; Whitworth A.G., Manchester; Newport A.G.
Bibliography: O.W.S. Club, V, 1927.

POCOCK, William Fuller 1779 (London) – 1849 (London)

An architect and designer, he exhibited designs at the R.A. from 1799 to 1827. As an architect he worked in London, Ireland, Canada and elsewhere.

Published: *Architectural Designs for Rustic Cottages*, 1807. *Modern Furnishings for Rooms*, 1811. *Designs for Churches and Chapels*, 1819.

POCOCKE, E

A topographer who worked in Norwich and Ipswich in the second half of the nineteenth century. He painted many small watercolours of the old gates and buildings of Norwich. His work is not particularly accomplished.

Examples: Christchurch Mansion, Ipswich; Castle Mus., Norwich.

POLLARD, Robert 1755 (Newcastle-upon-Tyne) – 1838 (London)

A landscape and marine painter and an engraver. He was elected a Fellow of the Incorporated Society in 1788 and was its last surviving member. A number of his mixed method prints are after his own drawings. He was the father of JAMES POLLARD (1792–1867), the coaching painter. There are examples of the watercolours of the latter in the B.M. and the N.G., Scotland.

POLLEN, John Hungerford, F.S.A. 1820 (London) – 1902 (London)

A son of Sir J.W.H. Pollen, Bt. and nephew of C.R. Cockrell (q.v.), he graduated from Christ Church, Oxford, in 1842 and became a Fellow of Merton, where he painted the roof of the Chapel. He also helped Rossetti and Burne-Jones in the Oxford Union decorations. Later he became Professor of Fine Arts at Dublin University, and editor of catalogues at the South Kensington Museum.

Examples: V.A.M.

POLLITT, Albert

An artist working in the Midlands and Wales from about 1889 to about 1920. He was a landscape painter in the Cox tradition.

Examples: City A.G., Manchester.

POLLOCK, Sir Frederick MONTAGUE-, 2nd Bt. 1815 – 1874

The son of Sir George Pollock, 1st Bt., he took the additional name of Montagu in 1873 after his marriage to Laura Montagu. He served in the Royal Engineers and sketched in many parts of the world including India in 1841-2, St. Helena in 1842, Aden in 1844, Germany in 1843 and 1846, Scotland and elsewhere in Britain. His work, at its best, is on a small scale and in the tradition of W. Callow (q.v.).

His son, SIR MONTAGUE FREDERICK MONTAGU-POLLOCK (1864-1938), was educated at Harrow and Trinity College, Cambridge, and took up landscape painting in about 1904.

POOLE, Paul Falconer, R.A., N.W.S.
 1807 (Bristol) – 1879 (Hampstead)

A self-taught history and genre painter, he came to London before 1830. From 1833 to 1835 he lived in Southampton. He was elected A.R.A. and R.A. in 1846 and 1861 and a member of the N.W.S. in 1878. He married the widow of his friend F. Danby (q.v.).

His watercolours are generally less grand than his pictures, and are often of peasants and girls in country dress. The prevailing tone is a tawny gold.

His remaining works were sold at Christie's, May 8, 1880, and a memorial exhibition was held at the R.A. in 1884.

Examples: B.M.; V.A.M.; Haworth A.G., Accrington; City A.G., Manchester; Newport A.G.
Bibliography: *A.J.*, February, 1859; 1879.

POPE, Clara Maria, Mrs., née Leigh
 c. 1768 – 1838 (London)

The daughter of JARED LEIGH, (1724–1769) an amateur artist who exhibited with the Free Society from 1761 to 1767. She married F. Wheatley (q.v.) before 1788, and was forced through his extravagance to become a drawing teacher. She turned to Farington to help, and in 1798 took a post at a school in Salisbury. She returned to London the following year. Wheatley died in 1801, leaving her with two children to support. She continued to give drawing lessons, and among her pupils was Princess Sophia of Gloucester. In 1807 she married Alexander Pope, an actor and miniature painter. She exhibited at the R.A. from 1796, her earliest exhibits being miniatures. She turned to rustic scenes and later to still-lifes. She worked for some time for Samuel Curtis, the botanical publisher. Among the admirers of her flower paintings was Sir John Soane, who helped her throughout her difficult life.

Illustrated: S. Curtis: *A Monograph on the Genus Camellia*, 1819.
Examples: V.A.M.
Bibliography: *Country Life*, May 18, 1967.

POPE, Henry Martin 1843 (Birmingham) – 1908
A landscape painter in oil and watercolour who trained under a lithographer before studying with S. and H.H. Lines (q.v.). He began his career as a printmaker but turned to painting, concentrating on Welsh landscapes and Dudley Castle. He taught and exhibited in Birmingham as well as occasionally exhibiting in London.

Examples: Birmingham City A.G.
Bibliography: G.L. Leigh: *The Life and Work of H.P.*, 1917.

PORTER, Sir Robert Ker 1777 (Durham) – 1842 (St. Petersburg)
The son of an Army surgeon, he was brought up in Edinburgh. In 1790 B. West (q.v.) had him entered at the R.A. Schools and in 1792 he was awarded a silver palette by the Society of Arts, for an historical drawing. In 1799 he was a member of Girtin's sketching club 'The Brothers', and at about this time his sister Jane wrote her *Thaddeus of Warsaw*, 1803, based on the adventures of their friend J.S. Cotman. In 1800 Porter was painting scenery at the Lyceum and producing panoramas and large battle pieces. After a brief spell in the Army, he went to Russia in 1804 as Historical Painter to the Czar. Thereafter he visited Finland, Sweden, the Peninsula with Sir John Moore, Persia, and Venezuela as Consul from 1826 to 1841. He collected various foreign knighthoods and in 1813 an English one. He worked in a large variety of styles, but military subjects predominate. His collections were sold at Christie's, March 30, 1843.

Published: *Travelling Sketches in Russia and Sweden*, 1809. *Letters from Portugal and Spain*, 1809. *Narrative of the Campaign in Russia during 1812*, 1813. *Travels in Georgia . . .*, 1820.
Examples: B.M.; V.A.M.; N.G., Scotland.

PORTER, Rev. William Warren
The Chaplain to the Earl of Warwick (q.v.) in about 1780. He made drawings in a similar style to those of his patron.

POTTER, Helen Beatrix, Mrs. Heelis
** 1866 (London) – 1946 (Sawrey)**
Beatrix Potter was the daughter of a wealthy amateur photographer. Her childhood, which, as far as her parents were concerned, lasted until she was at least forty, was repressed and lonely. She was self-taught, sketching fungi, fossils and fabrics in the South Kensington Museums and animals, both furtively in her London home, and in Scotland during the family's summer holidays. Her books had their origin in illustrated letters to children. *Peter Rabbit* was privately printed in 1900, and then accepted by Frederick Warne & Co., who had previously rejected the manuscript. At least one publication followed each year until 1913. After a fierce battle with her parents, she became engaged to Norman Warne, but he died two months later. In 1905 she bought Hill Top Farm, Sawrey, and thus gained a measure of independence, although it was run by a manager. She added Castle Farm to the property in 1909 and real freedom came in 1913 with her marriage to William Heelis, her solicitor in the Lake District. From that time she concentrated on the life of a working farmer and her books fell off, both in quantity and quality.

She had little patience with those who thought of her as a major figure in the English watercolour school. She would, indeed, resent inclusion in this book. She admitted to being influenced by the Pre-Raphaelites, F Walker (q.v.) and William Henry Hunt (q.v.). In her early days she also copied R. Caldecott (q.v.). However her work is of the highest quality, especially in such miniature details as appear in *The Tailor of Gloucester*, 1903. The illustrations should never really be separated from the texts, and the two are blended from the original letter format. It should be noted, too, that her animals never lose their essential natures, despite their human clothes and trappings.

Published: *The Tale of Peter Rabbit*, 1902. Etc.
Illustrated: F.E. Weatherly: *A Happy Pair*, (n.d.)
Examples: B.M.; Nat. Book League; Tate Gall.
Bibliography: M. Lane: *The Tale of B.P.* 1947. A.C. Moore: *The Art of B.P.*, 1955.

POTTS, John Joseph 1844 (Newcastle-upon-Tyne) – 1933
A landscape painter who exhibited at the R.I. and was a founder of the Bewick Club. He specialized in Welsh scenes.

Examples: Laing A.G., Newcastle.

POUNCEY, Benjamin Thomas – 1799 (Lambeth)
He studied engraving under his father Edward Pouncey, and his brother-in-law W. Woollett (q.v.). He exhibited landscape and topographical watercolours between 1772 and 1789. From about 1780 he was Deputy Librarian at Lambeth Palace. He was a fellow of the Incorporated Society.

His subjects are often taken from Kent and his best work in full colour shows him to have been an extremely capable artist. As is to be expected of an engraver, his pen work is neat and accurate. His figures are reminiscent of those of his younger contemporary, E. Dayes (q.v.). J. Powell (q.v.) was probably one of his pupils.

Examples: V.A.M.; Whitworth A.G., Manchester.

POWELL, Alfred H
A landscape and architectural painter as well as an architect and pottery designer. He exhibited at the R A. from 1890, lived in Guildford and was active at least until 1922. An exhibition of his work was held at the Fine Art Society in 1903.

POWELL, C M – 1824
A sailor and self-taught marine painter in oil and watercolour. He exhibited at the R.A. and the B.I. from 1807 to 1821 and four of his works were exhibited at Carlisle, after his death, in 1824. He died penurious because most of his work was for dealers and engravers.

Examples: B.M.; V.A.M.

POWELL, Lieutenant-Colonel Eric W
** 1886 – 1933 (Alps)**
A landscape painter who was Art Master at Eton from 1909 until his death, except for a period of service in the R.F.C. in Egypt. He was a member of the Reading Guild of Artists from 1930, and he died in a climbing accident. He used pale colour washes and a broad handling.

Examples: Reading A.G.

POWELL, Sir Francis, R.W.S., P.R.S.W.
** 1833 (Pendleton, Manchester) – 1914 (Dunoon)**
A marine and landscape painter who studied at Manchester School of Art and was elected A.O.W.S. in 1867 and O.W.S. in 1876. In 1878 he was the first President of the R.S.W. He was knighted in 1893. Later in his career he turned from marine subjects to mountain landscapes and lakes.

Examples: V.A.M.; Dundee City A.G.; Glasgow A.G.; City A.G., Manchester; Portsmouth City Mus.

POWELL, Joseph, P.N.W.S. 1780 – 1834
A landscape and topographical painter who may have been a pupil of B.T. Pouncey (q.v.) or of M.'A'. Rooker (q.v.). He exhibited at the R.A. from 1796, failed to win election to the O.W.S., and he was the first President of the N.W.S. in 1832. He was a popular drawing master and painted on the South Coast, the Welsh Marshes, the Lake District and elsewhere. He made a number of etchings and lithographs and filled many sketch books with figures and animals.

Examples: B.M.; V.A.M.; Grosvenor Mus., Chester; City A.G., Manchester.
Bibliography: *Burlington*, XC, September, 1948.

POWER, A W
A flower and topographic painter who was working in Maidstone in about 1789. He exhibited at the R.A. in 1800 and was probably active in 1830. His drawing is weak.

Examples: B.M.; V.A.M.

POWIS, Henrietta Antonia, Countess of
She was the heiress of the last Herbert Earl Powis and married
Edward Clive, Earl of Powis in the new creation, in 1784. She may
have been a pupil of J.B. Malchair (q.v.), who stayed with them.

POWLE, George
An etcher and miniaturist who exhibited from 1764 to 1770. He
was a pupil of Thomas Worlidge and made views of Hereford which
were engraved.

POWLES, Lewis Charles **1860 – 1942**
A landscape painter in oil and watercolour, he was educated at
Haileybury and Christ Church, Oxford. He lived in Rye, Sussex, and
was elected R.B.A. in 1898.

Examples: V.A.M.

POYNTER, Ambrose **1796 (London) – 1886 (Dover)**
An architect, still-life, landscape and town painter. He was a pupil of
T.S. Boys (q.v.) and, architecturally, of John Nash. From 1819 to
1821 he was in Italy and the Ionian Islands, then he set himself up
in Westminster. In 1832 he was in Paris with Bonington. He was one
of the founders of the R.I.B.A. in 1834, and also of the Graphic
Society. From about 1860 his eyesight failed. His work is well
drawn, and his still-lifes are rather like those of de Wint.

Published: *An essay on the history and antiquities of Windsor
Castle*, 1841.
Illustrated: Sandford: *Genealogical History of England*
Examples: B.M.; V.A.M.; Fitzwilliam.
Bibliography: H.M. Poynter: *The drawings of A.P., 1836*, 1931.

POYNTER, Sir Edward John, P.R.A., R.W.S.
 1836 (Paris) – 1919 (London)
The son of A. Poynter (q.v.), he visited Italy in 1853 and then
studied at Leigh's, the R.A. Schools and in Paris from 1856 to 1859.
He exhibited at the R.A. from 1861, being elected A.R.A. and R.A.
in 1869 and 1876. He was Slade Professor from 1870 to 1875,
Director of South Kensington, and, from 1894 to 1905, of the
National Gallery. He was elected both A.R.W.S. and R.W.S. in 1883.
He was P.R.A. from 1896 to 1918 and in the former year he was
knighted. In 1902 he was created baronet.
 His work in oil and watercolour is of classical, biblical or
legendary inspiration. He also painted landscapes for his own
pleasure.

Examples: B.M.; V.A.M.; Cartwright Hall, Bradford; City A.G.,
Manchester.
Bibliography: W.C. Monkhouse: *Sir E.J.P.*, 1897. A. Margaux: *The
Art of E.J.P.*, 1905. M. Bell: *Drawings of E.J.P.*, 1906. *A.J.*, 1903.

PRATT, Claude **1860 (Leicester) – c. 1935**
A genre and portrait painter in oil and watercolour, he was the son
of Jonathan Pratt, a Birmingham artist. He studied at the
Birmingham School of Art and in Antwerp and Paris. He exhibited
frequently in Birmingham and occasionally in London, and he was
an illustrator.

PRATT, William **1855 (Glasgow) –**
A painter of figures in landscapes in oil and watercolour, he was the
son of a housepainter and studied at the Glasgow School of Art and
at Julian's. He lived in Glasgow.

PRATTENT, Thomas
An engraver and topographer who provided drawings for the
Gentleman's Magazine and similar publications in the 1790s.

Published: with M. Denton: *The Virtuoso's Companion and Coin
Collector's Guide*, 1795-7.
Examples: V.A.M.

PRAVAL, Charles **– 1789 (Dublin)**
A French landscape draughtsman who settled in Dublin in 1773, in
which year he exhibited with the Dublin Society of Artists. He ran a

school in which he taught drawing and French, and also kept a
boarding school for girls.

Published: *The Syntax of the French Tongue*, 1779. *The Idioms of
the French Language*, 1783.

PRENTICE, Kate **1845 (Stowmarket) – 1911**
Brought up at Headingley, Leeds, she lived in London for most of
her life. She was largely self-taught, but took a few lessons from P.J.
Naftel (q.v.). Her health was poor but she became a successful
teacher. Her subjects are often in Kew and Kensington Gardens, the
South of England and Yorkshire.

Examples: V.A.M.

PRETTY, Edward, F.S.A.
 1792 (Hollingbourne, Kent) – 1865 (Maidstone)
A drawing master who taught at Rugby School from the age of
seventeen. He left Rugby in 1855 and returned to Kent, where he
made many drawings.

Examples: Maidstone Mus.
Bibliography: *Gentleman's Mag.*, October, 1865.

PRICE, Edward
The son of the Vicar of Needwood, he became a pupil of J. Glover
in about 1820 and accompanied him on tours of North Wales and
Dovedale. Later he came to London, where he helped Glover to
prepare the exhibitions of his own works from 1820 to 1824 and
himself exhibited two pictures. In 1856 he was living at
Nottingham.

Published: *Norway Views of wild scenery*, 1834. *Dovedale. 12
Views in Dovedale and Ilam*, 1845. *Views in Dovedale*, 1868.

PRICE, James
A landscape painter who lived in Kent and at Thorpe, near
Ashbourne, Derbyshire. He exhibited from 1842 to 1876. His
figures are sometimes very poor but his free landscape sketches are
pretty.

Examples: B.M.

PRICE, Robert **1717 – 1761**
The son of an amateur artist and a considerable landowner, Price
was a Wykhamist and made his Grand Tour in the late 1730s, partly
in company of Wyndham of Felbrigg and his tutor Benjamin
Stillingfleet. In Rome he had drawing lessons from Busiri. In 1741
he was in Switzerland, and he returned to England by way of Paris.
After his marriage in 1746 he settled at the family home, Foxley,
Herefordshire, where he lived as a true dilettante and an improving
landlord. He brought Stillingfleet to live on the estate and they
produced books on agriculture and music which Price illustrated.
They made sketching tours of Wales and antedated Gilpin in his
appreciation of the picturesque. Price was a patron of J.B. Malchair
(q.v.) and his own drawings are rather weaker foretastes of the
younger artist's style.
 He uses low colours with an effect that is almost monochrome
and works within the conventions of the early eighteeth century. He
was the father of Sir Uvedale Price, the writer on the picturesque.

PRICE, William Lake **1810 – 1891**
He was intended for an architect and articled to A. Pugin (q.v.), but
turned to watercolour painting with a bias to architectural subjects.
He travelled much on the Continent visiting Italy, Malta, Spain,
Portugal, France, Holland, Belgium, Germany, Switzerland and the
Tyrol. He occasionally painted in oils and etched, but was best
known as a lithographer of his own works. In his lithographs as well
as his early watercolours, he was much influenced by Bonington. He
also took lessons from de Wint. He was a keen and accomplished
photographer. With Millais, he was a founder of the Volunteer
Movement in 1859, and he designed the uniform. For some years he
lived at Ramsgate, then moved to Blackheath. He was an A.O.W.S.
from 1837 to 1852 with a break in 1847. He was a prolific
illustrator.

Published: *Interiors and Exteriors of Venice*, 1843. *Interiors of Osborne*, 1858. *Manual of Photographic Manipulation*, 1858. Etc.
Examples: B.M.; N.G., Ireland.

PRIEST, Alfred 1810 (Norwich) – 1850 (Norwich)
The son of a chemist, he spent some time at sea and was apprenticed to a surgeon at Downham Market. He was a pupil of H. Ninham (q.v.) who taught him etching, and of J. Stark (q.v.) both in Norwich and London. He first exhibited at the R.A. in 1833. In 1848 he returned to Norwich in ill-health and spent much of his last year on the coast.

He often sketched on the Thames and also visited Derbyshire in 1841 or 1842. His work is often close to that of Stark with massed foliage and strong highlights.

Published: *The Hare and Three Leverets*, 1848.
Examples: Castle Mus., Norwich.
Bibliography: W.F. Dickes: *The Norwich School*, 1905.

PRINGLE, Agnes
The daughter of a Tyneside businessman, she studied under W.C. Way (q.v.) and R. Elliott (q.v.), and at the R.A. Schools from 1882. She exhibited portraits and figure subjects, showing at the R.I. in 1884 and 1893, and at the R.B.A. from 1890 to 1894.

PRIOR, W R
There was a view at Sadlers Wells by this artist in the Gilbey sale at Christie's, Arpil 25-6, 1940. It was in a Rowlandsonian style.
WILLIAM HENRY PRIOR (1812–1882) was a landscape and coastal painter who exhibited at the N.W.S., the S.B.A. and elsewhere. He lived in London and painted in the South of England and on the Rhine.

Illustrated: S. Smith: *Lyrics of a Life-Time*, 1873.

PRITCHETT, Edward
A painter of Venetian and other town scenes in oil and watercolour. He lived in London and exhibited from 1828 to 1864, but little is known of his life. Some of his works have probably been mistaken for those of Bonington. A characteristic habit is to give his figures disproportionately short thighs.

Examples: V.A.M.; Newport A.G.

PRITCHETT, Robert Taylor
 1828 – 1907 (Burghfield, Berkshire)
The son of a gunmaker and amateur draughtsman, he was educated at King's College School and went into the family business, inventing the 'Pritchett Bullet'. He visited Switzerland in 1859, Norway in 1874, and accompanied Lord and Lady Brassey on their world tours in *The Sunbeam* in 1883 and 1885. He exhibited from 1851, was a black and white illustrator for *Punch*, and became Private Painter in Watercolours to Queen Victoria. He was a friend of such artists as Birket Foster, Leech and Keene.

Published: *Brush Notes in Holland*, 1871. *Gamle Norge*, 1878. *Pen and Pencil Sketches of Shipping . . .*, 1899.
Examples: V.A.M.; Glasgow A.G.

PROCTOR, Adam Edwin, R.I. 1864 (Camberwell) – 1913 (Guildford)
A landscape and genre painter in oil and watercolour who studied at the Lambeth and Westminster Schools of Art and at the Langham Life Classes. He exhibited from 1882 and was a member of the R.B.A. from 1891. He was Secretary from 1895 to 1899. In 1909 he was elected R.I. He lived in Brixton and at Albury, Surrey, and he painted in Cornwall, Holland, Algeria and elsewhere. He wrote a number of religious pamphlets.

PROSSER, George Frederick
An artist who painted views of Winchester in 1858 and Eton in 1863 and 1868. There are architectural drawings by H. PROSSER in the Guildford Lib.

Published: *Select Illustrations of the County of Surrey*, 1828. *Select*

Illustrations of Hampshire, 1833. *Scenic and antiquarian features . . . of Guildford*, 1840. *The Antiquities of Hampshire*, 1842.

PROUDFOOT, William 1822 (Perth) – 1901
Educated at the Perth Academy, he spent some time in Italy in his twenties. Until the age of seventy he painted mainly in oil, then he took up watercolours, which he called 'diluted art'.

Examples: Dundee City A.G.

PROUT, Edith Mary 1862 – 1927
A marine painter in watercolour and oil, she was the daughter of Henry Ebenezer Prout, the Professor of Music. She lived in Plymouth and Newquay, Cornwall, and many of her subjects are on the Cornish coasts.

PROUT, John Skinner, N.W.S. 1806 (Plymouth) – 1876 (London)
Although his subject matter and style are very close to those of his uncle, S. Prout (q.v.), he was largely self-taught. He became a member of the N.W.S. in 1838, but lost his membership since he failed to exhibit during a lengthy visit to Australia. He was re-elected to the Society as an Associate in 1849 and became a full Member again in 1862. He lived and worked mainly in Bristol where he was a friend of W.S. Muller (q.v.) and with him a founder of the Bristol Sketching Club.

His style and composition are weaker than his uncle's, although the two can occasionally be confused.

Published: *Antiquities of Chester*, 1838. *Castles and Abbeys of Monmouthshire*, 1838.
Examples: B.M.; V.A.M.; Grosvenor Mus., Chester; Exeter Mus.; Fitzwilliam; Leeds City A.G.; Leicestershire A.G.; Newport A.G.; Reading A.G.
Bibliography: *A.J.*, 1876.

PROUT, Samuel, O.W.S. 1783 (Diss, Norfolk) – 1852 (London)
His early interest in painting was encouraged by J. Bidlake (q.v.), Headmaster of the Plymouth Grammar School, and by his friendship with B.R. Haydon, as well as life-long ill-health which prevented him from taking up a more active career. He made many sketching expeditions with Haydon around Plymouth. In 1796 they were present at the wreck of the East Indiaman *Dutton*, of which Prout made many drawings in later years. When he was eighteen he made an abortive tour of Cornwall, working for J. Britton (q.v.) and although his drawings were disappointing on this occasion, he worked hard to improve himself during the next year, and in 1802 he moved to London to live and work with Britton. In 1803 and 1804 he was sketching for Britton in Cambridge, Essex and Wiltshire, and in 1805 in Devon and Cornwall, having been driven home by ill-health. During this time in London he exhibited at the R.A. and made many useful contacts with dealers. He returned to London in 1808, became a Member of the A.A., and set up as a drawing master.

In 1819 he made his first visit to France: this had a decisive effect on both his style and subject matter. In the same year he joined the Oil and Watercolour Society. In the following years he made constant visits to France, Belgium, the Rhine and Bavaria, and in 1824 he made his first tour of Italy. By 1835 he found that he was not strong enough to continue living in London and he moved to Hastings where he lived in what he regarded as exile for five years. In 1846 he made his last tour of Normandy, and from then until his death he was able to do less and less work.

Until 1819 Prout's work is very much in the tradition of Girtin and Varley. Some of his studies of beached fishing boats and nets are very close to the free work of Cristall at the same period and use the same limited palette. They are often over a grey base, washed with orange and finished with a little local colour, with dark touches to heighten the main features. In his monochrome work he can be deceptively close to Cox and Cotman. After 1819 he rapidly formed the style for which he is best known. His colour is still limited although there are vivid touches on the costumes of the stylized figures which throng the foregrounds of his Gothic compositions.

The predominant effect is the deep ochre of crumbling masonry. His characteristic knotted line was anticipated by H. Edridge (q.v.) in the similar subjects which he produced during the last three years of his life. With Prout, though, it is emphasised even more strongly. His handling of the reed pen over careful pencil drawing becomes almost a signature. In this practice he had many imitators, but few were successful. Towards the end of his life, encouraged by Ruskin, he tended to overcrowd his pictures with detail. In his architectural pictures the detail becomes more precise when outlined against the sky.

This style of drawing was particularly suited to lithographic reproduction and Prout's publications were highly successful. One trick which he adopted from the engravers was that of using brown ink for the outlines of the foreground and blue for objects and buildings further away. This, too, was much imitated by such people as A. Poynter (q.v.), and by closer followers such as W.H. Harriott, J.S. and S.G. Prout and, later, G.P. Ashburnham (all q.v.). His remaining sketches were sold at Sotheby's, May 19-22, 1852.

Published: *Rudiments of Landscape in Progressive Studies*, 1813. *Illustrations of the Rhine*, 1824. *Facsimilies of Sketches made in Flanders and Germany*, 1833. *Sketches in France, Switzerland and Italy*, 1939. Etc.
Examples: B.M.; V.A.M.; Aberdeen A.G.; Haworth A.G., Accrington; Williamson A.G., Birkenhead; Blackburn A.G.; Bridport A.G.; Derby A.G.; Doncaster Mus.; Dudley A.G.; Towner Gall., Eastbourne; Exeter Mus.; Fitzwilliam; Inverness Lib.; Leeds City A.G.; Leicestershire A.G.; Usher A.G., Lincoln; City A.G., Manchester; Whitworth A.G., Manchester; N.G., Scotland; Newport A.G.; Portsmouth City Mus.; Southampton Mus.; Stalybridge A.G.; Ulster Mus.; Wakefield A.G.; York A.G.
Bibliography: J. Britton: *Recollections of the late S.P.*, 1852. J. Ruskin: *Notes on S.P. and W.H. Hunt*, 1879. J. Quigley: *P. and Roberts*, 1926. A. Neumeyer: *An Unknown Collection of English Watercolours at Mills College*, 1941. *A.J.*, 1849; November, 1857. *Studio*, special no. 1914. O.W.S. Club, VI. O.W.S. Club, XXIV.

PROUT, Samuel Gillespie 1822 (Brixton) – 1911 (Braunton, Devon)
Primarily a philanthropist, he was also an artist in the manner of his father, S. Prout (q.v.). He organized food supplies to Paris after the siege of 1871, to Spain during the Civil War of 1874, and to Egypt during the famine of 1884. As an artist he was like his father not only in style but also in his willingness to sell his work for any price offered. He lived in Devon for much of his life, first at Ilfracombe and then at Braunton.

Published: *Never Say Die*, 1879. *Whose Luck?* 1880. *Hurrah!* 1881. *You're Me, and I'm You*, 1884.
Examples: V.A.M.

PUGH, Charles J – 1815
A landscape painter who exhibited views in the Isle of Wight and Wales at the R.A. from 1797 to 1803.

PUGH, Edward – 1813 (Ruthin)
A miniature, landscape and architectural painter who exhibited from 1793 to 1808.

Published: *Cambria Depicta*, 1816.

PUGH, Herbert (Ireland) – 1788
A landscape painter of Irish birth, who settled in England in 1758. He was a member of the Incorporated Society, where he exhibited between 1760 and 1776. There were two views of London Bridge by him in the Century of British Art exhibition at the Grosvenor Gallery in 1888. He also produced occasional pictures in the manner of Hogarth, some of which were engraved.

Examples: City A.G., Manchester.

PUGIN, Augustus Charles de, O.W.S.
1762 (France) – 1832 (London)
An architectural draughtsman, who came from an old French family, Pugin fled to England in the 1790s either because of his

Royalism or on account of a duel. He seems to have landed in Wales where he became a friend of John Nash the architect. He worked as a general artist, providing designs for Nash and painting scenery. He then moved to London where he studied at the R.A. Schools and had lessons in aquatinting from Merigot. Previously in France he had been taught by his brother-in-law, Lafitte, who later worked on the Arc de Triomphe. He first exhibited architectural designs at the R.A. in 1799, and in 1807 he began to exhibit at the O.W.S. He became a Member in 1812, and was re-elected in 1820. Pugin did much work for Ackermann, including the *Microcosm of London*, 1808, and plates for *The Abbey Church of Westminster*, 1812, *History of the University of Oxford*, 1814, and *Cambridge*, 1815. During this period, with encouragement from Nash, he had set up what amounted to a school of architectural drawing, and he began to publish his own works. In 1825 he visited Normandy with some of his pupils, and in 1830, Paris. He also practised occasionally as an architect, his most important building being the Diorama in Regents Park.

In style he is a traditional and competent topographical draughtsman, with a strong feeling for architectural form. The figures in his finished drawings were often added by such artists as Rowlandson and James Stephanoff. His pupils included his son, T. Talbot Bury, J.H. D'Egville, G.B. Moore, Joseph Nash and W.L. Price (all q.v.).

Examples: B.M.; V.A.M.; Usher A.G., Lincoln; N.G., Scotland; Newport A.G.; R.I.B.A.
Bibliography: B. Ferrey: *Recollections of Welby and his father A.C.P.*, 1861. O.W.S. Club, XXXI.

PUGIN, Augustus Northmore Welby
1812 (London) – 1852 (Ramsgate)
The son of A.C. de Pugin (q.v.), he became an architect and is best remembered for his decorations for the Houses of Parliament. He exhibited at the R.A. from 1849 and went mad in 1851.

Examples: B.M.; V.A.M.; Maidstone Mus.; R.I.B.A.
Bibliography: B. Ferrey: *Recollections of Welby and his father A.C.P.*, 1861. P. Waterhouse: *Life and works of A.W.P.*, 1898. *A.J.*, November, 1852.

PURCELL, Edward
An Irish miniature painter and a drawing master who exhibited with the Dublin Society of Artists in 1812 and 1815, and worked for a time in Waterford. He spent some years in England before returning to Dublin where he was active until at least 1831.

Illustrated: Wills: *Lives of Illustrious Irishmen*, III.

PURSER, William c. 1790 – c. 1852
The son of William Purser, an architect who lived at Christ Church, Surrey, he entered the R.A. Schools in 1807. From 1817 to 1820 he was in Italy and Greece as draughtsman to John Sanders. He exhibited both views and architectural designs at the R.A. from 1820 to 1834.

Illustrated: J. Carne: *Syria*, 1836.
Examples: B.M.; V.A.M.

PYE, William
A coastal and marine painter in oil and watercolour, he exhibited at the R.B.A. from 1883 to 1891. In 1881 he was living at Hadleigh, Essex, and from 1882 to 1908 at Weymouth.

Examples: V.A.M.

PYNE, Charles 1842 –
A landscape painter who exhibited from 1861 to 1880. He lived in London and painted in many parts of England and Wales as well as in Holland, Belgium, Germany and Jersey. He was an unsuccessful candidate for the N.W.S. in 1870.

Illustrated: J.J. Mercier: *Mountains and Lakes of Switzerland and Italy*, 1871.
Examples: V.A.M.

PYNE, Charles Claude 1802 – 1878 (Guildford)
The second son of W.H. Pyne (q.v.), he was a painter of landscapes, genre and architectural subjects. He exhibited occasionally from 1836 and was an unsuccessful candidate for the N.W.S. in 1839. He visited the Continent on several occasions, and many of his subjects were Continental. He also taught drawing in Guildford, and he collaborated with his father and brother on architectural publications.

Examples: V.A.M.; Castle Mus., Nottingham.

PYNE, George 1800 – 1884
The elder son of W.H. Pyne (q.v.), he was elected A.O.W.S. in 1827, perhaps owing to his position as son and son-in-law of two Founder Members, but he retired in 1843. His drawings are weaker versions of his father's topographical works. He also imitated his father-in-law, J. Varley (q.v.). This latter relationship ended in 1842 when his wife made immediate use of the Matrimonial Causes Act to obtain a divorce. From 1837–9 he lived in Tavistock, and West Country views varied his usual Kentish output. He also made a speciality of drawing Oxford Colleges and, to a lesser extent, Cambridge and Eton. His characteristic figures have elongated, tubular legs, and he is particularly good at handling the texture of old stone buildings.

Published: *A Rudimentary and Practical Treatise on Perspective for Beginners,* 1848. *Practical Rules on Drawing for the Operative Builder, and Young Student in Architecture,* 1854.
Examples: B.M.; V.A.M.; Coventry A.G.; York A.G.

PYNE, James Baker 1800 (Bristol) – 1870 (London)
Pyne was self-taught, his family having intended him for the law. In 1835 he came to London, where he exhibited landscapes at the R.A. until 1839, when he turned exclusively to the S.B.A. with whom he had exhibited since 1833. He was made a member in 1842, and served for some years as Vice-President. In 1846 he travelled through Switzerland and Germany to Italy, and for three years from 1851, on a commission from Mr. Agnew of Manchester, he toured Southern Europe, re-visiting Italy. He frequently contributed to the *A.J.*

His style is conventional, but his works both in oil and watercolour can be very fine things. They are often infused with the spirit of Turner in his later phases. Pyne was particularly good at painting lakes.

His remaining works were sold at Christie's, February 25-7, 1871.

Published: *Windsor and its Surrounding Scenery,* 1840. *The English Lake District,* 1853. *Lake Scenery of England,* 1859.

Examples: B.M.; V.A.M.; Aberdeen A.G.; Blackburn A.G.; Cartwright Hall, Bradford; Bristol City A.G.; Inverness Lib.; Leeds City A.G.; Leicestershire A.G.; Maidstone Mus.; City A.G., Manchester; N.G., Scotland; Newport A.G.
Bibliography: *A.J.,* 1849; July, 1856; September, 1870.

PYNE, Thomas, R.I. 1843 (London) – 1935
The son and pupil of J.B. Pyne (q.v.), he painted landscapes in oil and watercolour. He exhibited from 1863 and was elected R.I. in 1885, retiring as an Honorary Member in 1916. He painted in many parts of England and Wales, and in Italy, but his most typical views are quiet stretches of the Thames.

Examples: Leeds City A.G.

PYNE, William Henry 1769 (London) – 1843 (London)
A landscape painter and writer on the arts, Pyne studied with H. Pars (q.v.) and first exhibited at the R.A. in 1790. Even at the beginning of his career he was much interested in publishing ventures, and between 1802 and 1807 he was working on his *Microcosm* which contained more than one thousand groups of figures and details for the use of landscapists. He was one of the most active of the Founder Members of the O.W.S. although he retired in 1809. After that date his main concern was with his critical writings rather than painting. Of these, the most important were his essays in the *Literary Gazette* under the name of Ephraim Hardcastle, which were re-published in 1823 as *Wine and Walnuts,* and he worked for other periodicals and attempted various other publishing schemes which usually ended badly. The best part of his last eight years was spent in the King's Bench Debtors' Prison. He was an accomplished etcher and often made prints from his own drawings. His landscape painting is pleasant without being dramatic, with well-drawn figures, as one would expect, playing an important role in the composition. In his style, as in his life, he is always ready to try the latest ideas, his first drawings being typical of the eighteenth-century tinted manner and his later ones taking due account of the advances made by his colleagues of the O.W.S. and by Girtin. His criticism is often pure journalism but is none the less a useful source of intelligent contemporary comment.

Published: *Views of Cottages, Farmhouses in England and Wales,* 1815. *History of the Royal Residences of Windsor Castle, etc.,* 1819. *Etchings of Rustic Figures,* 1819. *Lancashire Illustrated,* 1829-31. Etc.
Examples: B.M.; V.A.M.; Grosvenor Mus., Chester; Leeds City A.G.; Maidstone Mus.; Newport A.G.
Bibliography: O.W.S. Club, XXVIII, 1950.

QUATREMAIN, G William 1858 – 1930
A bird painter who lived in Stratford-on-Avon and was active at least from 1881.

Examples: Coventry A.G.

QUINTON, Alfred Robert 1853 (London) –
A landscape painter who worked in the Southern counties and exhibited from 1877. He was living in Finchley in 1929.

Illustrated: C.L. Freeston: *Cycling in the Alps,* 1900. J.H.P. Belloc: *The Historic Thames,* 1907. A.G. Bradley: *The Avon and Shakespeare's Country,* 1910. E. Hutton: *A Book of the Wye,* 1911. P.H. Ditchfield: *The Cottages . . . of Rural England,* 1912.

RACKETT, Thomas 1757 − 1841
An amateur pupil of P. Sandby (q.v.) and T.T. Forrest (q.v.) who specialized in drawing antiquities. He was also a member of the circle which centred on J.B. Malchair (q.v.).

RACKHAM, Arthur, R.W.S. 1867 (London) − 1939
One of the greatest of the late nineteenth-century school of illustrators. He studied at the Lambeth School of Art where he was influenced by his friend and fellow student C. de S. Ricketts (q.v.). He exhibited from 1888, and in 1892 he joined *The Westminster Budget*. From about 1893 he concentrated more and more on illustrations for books such as *The Ingoldsby Legends*, 1898, and *Grimm's Fairy Tales*, 1900. He also painted straightforward landscapes, and he was elected A.R.W.S. and R.W.S. in 1902 and 1908. His work is splendidly memorable with its menacing, twisted trees and long-shanked figures.
His wife, EDITH RACKHAM, was a flower painter.

Bibliography: D. Hudson: *A.R., Life and Work*, 1960. F. Gettings: *A.R.*, 1975. O.W.S. Club XVIII, 1940.

RADCLYFFE, Charles Walter 1817 (Birmingham) − 1903
A son of the engraver William Radclyffe and the brother of Edward and William Radclyffe, Yr., engravers and painters. He worked in Birmingham as a landscape painter, engraver and lithographer. He exhibited there from 1846 and in London from 1849. He painted in many parts of England, Wales and Scotland.

Published: *The Palace of Blenheim*, 1842. *Memorials of Shrewsbury School*, 1843. *Memorials of Charterhouse*, 1844. *Memorials of Eton College*, 1844. *Memorials of Westminster School*, 1845. *Memorials of Winchester College*, 1847.
Examples: V.A.M.; Birmingham City A.G.

RADFORD, Edward, A.R.W.S.
 1831 (Plymouth) − 1920 (Southwick, Brighton)
A genre painter who worked as a civil engineer to begin with, and then as an architect in Canada and the U.S.A. During the Civil War he served as a lieutenant in an Ohio battery. He took up painting on his return to England and exhibited from 1865. He was elected A.O.W.S. in 1875 and lived in London until almost the end of his life when he moved to Sussex. He painted classical figures in the manner of A. Moore (q.v.), and military subjects.

Examples: Exeter Mus.

RAEBURN, Agnes Middleton, R.S.W.
 (Glasgow) − 1955
A landscape and flower painter in watercolour and oil. She studied at the Glasgow School of Art and was elected R.S.W. in 1904.

Examples: Dundee City A.G.

RAIMBACH, David Wilkie 1820 (London) − 1895
A godson of Wilkie, with whom his father, Abraham Raimbach, worked as an engraver. He studied under his father and at the R.A. Schools, and exhibited portraits at the R.A. from 1843 to 1855. He worked at the Belfast School of Art and in 1852 became Headmaster of the Limerick School. He moved to Cork in 1856 and taught at the Art School, but resigned in 1857, and in the following year he was appointed Headmaster of the Birmingham School of

Art, which post he held for twenty years. He was also an examiner in the Science and Art Department.

Examples: V.A.M.; Birmingham City A.G.

RAINEY, H William, R.I. 1852 (London) − 1936
A landscape and genre painter. He studied at South Kensington and the R.A. Schools and began his career as a book-illustrator. He exhibited at the R.A., the R.I., Suffolk Street and elsewhere from 1878. He was elected R.I. in 1891 and, later in his career, lived in Eastbourne.

Published: *All the Fun of the Fair*, 1888. *Abdulla*, 1928. *The Last Voyage of the "Jane Ann"*, 1929. *Admiral Rodney's Bantam Cock*, 1938. *Who's on my side*, 1938.

RAMPLING, Reginald − 1909
A Lancaster painter who, from the 1870s, produced local views which were reproduced as postcards.

RAMSAY, David 1869 (Ayr) −
A landscape painter who studied at the Glasgow School of Art. He became art master at Greenock Academy.

RANDAL, Frank
A landscape and architectural painter who lived in London and was active from 1887 to 1901.

Examples: V.A.M.

RANDALL, James 1782 −
An architect who exhibited at the R.A. from 1798 to 1814. He worked in the Home Counties and Dorset.

Published: *Designs for Mansions, Casinos, Villas . . .*, 1806. *A Philosophical Enquiry on the Cause . . . of Dry Rot*, 1807. *A Collection of Architectural Designs*.

RANDLE, Charles
An amateur artist who was in Wales and the Marches in 1813 and 1814 and at Gorey in 1815. His work is rather crude and old-fashioned.

RASELL, Robert
A painter of rustic genre, landscapes and river scenes who lived in Chichester. He was active at least from 1868 to 1876.

RASHLEIGH, Rev. Peter 1746 − 1836
The fourth son of Jonathan Rashleigh, M.P., of Menabilly, Cornwall, he was a landscape painter and topographer. He was educated at Eton and University College, Oxford, becoming a Fellow of All Souls and a pupil of J.B. Malchair (q.v.). He visited Wales in 1772, 1775 and 1777 and the Lake District in 1780. In the following year he was appointed to the livings of New Romney and Barking and from 1788 he was Vicar of Southfleet.

Bibliography: *Gentleman's Mag.*, 1836 i, 560a.

RATHBONE, John c.1750 (Cheshire) − 1807 (London)
A self-taught landscape painter who worked in London, Manchester − where he was known as the 'Manchester Wilson' − and Preston. He exhibited at the R.A. and elsewhere between 1785 and 1806, and he was a friend of Morland and Ibbetson, who sometimes painted the figures in his compositions.
His watercolours tend to be more effective than his oil paintings and are well drawn.

Examples: B.M.; V.A.M.

RATTRAY, Alexander Wellwood, A.R.S.A., R.S.W.
 1849 (St. Andrews) − 1902
A landscape painter in oil and watercolour who attended Glasgow University and studied in Glasgow and Paris. He exhibited at the R.S.A. from 1876 and was elected A.R.S.A. in 1896. He lived in Glasgow and painted in many parts of Scotland.

RAVEN, Rev. Thomas
c.1795 (Wiggenhall, near King's Lynn) – 1868 (Teignmouth)
He was educated at Cambridge and became Minister of Holy Trinity,
Preston, Lancashire. He dabbled in journalism until his second
marriage, when he gave up work except for sketching and occasional
English Literature lessons. In 1865 he was living at Budleigh
Salterton. He produced dramatic Welsh and Devonian landscapes.
His daughter married H. Holliday (q.v.).

His son, JOHN SAMUEL RAVEN (1829-1877), taught himself
by studying the works of Constable and Crome. He moved to St.
Leonards, Sussex, and exhibited at the R.A. and B.I. from 1849. He
painted mainly in oil, but also produced watercolours and pen
studies. He came under the influence of the Pre-Raphaelites, his
later works becoming elaborate and highly coloured. He visited
Switzerland. He was drowned at Harlech, North Wales, and a
memorial exhibition was held at the Burlington Fine Arts Club in
1878.

Examples: V.A.M.

RAWLE, John Samuel
A landscape painter in oil and watercolour who exhibited at the
R.A. and elsewhere from 1870 to 1887. He taught at the
Nottingham School of Art and also lived in London.

Published: *Rawle's School of Art Series*, 1872. Etc.

RAWLE, Samuel **1771 – 1860 (London)**
An engraver and landscape and architectural draughtsman. He
produced drawings and plates for many publications including those
of Britton and the *Gentleman's Magazine*. He also engraved prints
after Turner, and he exhibited views of seats at the R.A. in 1801
and 1806.

Illustrated: Murphy: *Arabian Antiquities of Spain*.
Examples: V.A.M.

RAWLINGS, Alfred **1855 (London) – 1939**
A landscape and flower painter in watercolour, chalk and
occasionally oil. He was art master at Leighton Park School,
Reading, and was also a dealer in artists' materials. He was a member
of the Berkshire Art Society, and he exhibited infrequently at the
R.A. and elsewhere from 1900 to 1929.

Published: *Anthology of Sea and Flowers*, 1910, 1913. *Book of Old
Sundials*, 1915.
Illustrated: M. R. Mitford: *Our Village*, 1910.
Examples: City A.G., Manchester; Northampton A.G.; Reading A.G.

RAWLINS, Thomas J
In the B.M. there is an Indian drawing by this artist dated 1837. The
figures are still drawn in the convention of the Daniells. T.J. or J.T.
Rawlins was one of the illustrators used by 'Nimrod', Charles James
Apperley, along with H.T. Alken (q.v.).

Published: *Elementary Drawing as taught at St. Mark's College,
Chelsea*, 1848.

RAWLINSON, James **1769 (Derby) – 1848 (Matlock, Derbyshire)**
A pupil of Romney who painted portraits and landscapes. In 1822
he published an album of Derbyshire views. He produced
lithographs after drawings by his daughter ELIZA RAWLINSON, with
whom he visited Italy in 1829. His work is atmospheric but
technically unaccomplished.

Examples: Derby A.G.

RAYNER, Louise J
1832 (Matlock, Derbyshire) – 1924 (St. Leonards-on-Sea)
The best known of S. Rayner's daughters, she was largely brought
up in London, and she took up drawing during a long stay at Herne
Bay when she was fifteen. As well as her father, E.J. Niemann (q.v.),
D. Roberts (q.v.) and F. Stone (q.v.) instructed and advised her. She
began exhibiting oil paintings in 1852, but soon changed to
watercolours. Like her sisters, she often produced old interiors, but
her speciality was in the old streets and alleys of Edinburgh,
Hastings, London, Chester and elsewhere.

Her style closely resembles that of her father, but is less gloomy.

Examples: V.A.M.; Williamson A.G., Birkenhead; Coventry A.G.;
Derby A.G.; N.G., Ireland; Newport A.G.; Reading A.G.

RAYNER, Margaret
A daughter of S. Rayner (q.v.) whose manner she closely imitated.
Her subjects are generally church interiors which she was said to
paint 'with truth and force beyond those of David Roberts, hence
she is more pathetic'. She was a member of the Society of Female
Artists. She exhibited from 1866 to 1890 and lived at St. Leonards.

RAYNER, Nancy, A.O.W.S. **1827 (London) – 1855**
A pupil of her father, with advice from G. Cattermole, O. Oakley,
D. Cox, S. Prout, F. Stone and particularly D. Roberts (all q.v.), she
was elected a Lady Member of the O.W.S. in February 1850. Nancy
Rayner worked very much in the style of Cattermole and her father,
using his thick admixture of bodycolour. She painted rustic figures
and historic interiors.

RAYNER, Samuel A **– 1874 (Brighton)**
An architectural and historical genre painter, he first exhibited in
London in 1821. He was elected A.O.W.S. in February, 1845, but
was expelled in 1851 after conviction on a serious charge of fraud.
He continued to exhibit elsewhere. A few prints were made after his
drawings in the 1820s. His style is very close to that of G.
Cattermole (q.v.), although he tends to use much more bodycolour.
His wife and five daughters were all artists, and, at least until his
disgrace, he seems to have had a wide circle of artist friends.

Two of the daughters, ROSE RAYNER and FRANCES, MRS.
COPPINGER, gave up painting comparatively early. The others are
separately noticed. His son, RICHARD M. RAYNER, exhibited
landscapes in London and Derby from 1861 to 1869.

Published: *Sketches of Derbyshire Scenery*, 1830. *The History and
Antiquities of Haddon Hall*, 1836. *The History . . . of Derby*, 1838.
Examples: B.M.; Williamson A.G., Birkenhead; Coventry A.G.;
Derby A.G.; Ulster Mus.

READ, David Charles 1790 (Boldre, Hampshire) – 1851 (London)
He was apprenticed to J. Scott the engraver, and lived at Salisbury
from 1820 until 1845, working as a drawing master and sketching in
watercolour, pencil and oil. From 1826 he made landscape and
portrait etchings. He exhibited at the R.A., B.I. and Suffolk Street
between 1823 and 1840. He left for Italy in 1845, and after his
return the following year painted almost exclusively in oil.

Examples: B.M.
Bibliography: R.W. Read: *MS. Catalogue and Memoir*, 1871-4 (B.M.
print room).

READ, Samuel, R.W.S. 1815 (Needham Market) – 1883 (Sidmouth)
First intended for a lawyer, then an architect, neither career
satisfied him, and in 1841 he came to London to learn wood
engraving under J.W. Whymper (q.v.). He also studied with W.C.
Smith (q.v.), and in 1843 he began to send architectural drawings to
the R.A. and in 1844 to draw for the *I.L.N.* In 1857 he was elected
A.O.W.S., becoming a full Member in 1880. He was the first artist
special correspondent and was sent to Constantinople in 1853 just
before the Crimean War. He also travelled on the Continent,
primarily in Germany and North Italy. In 1862 he was at Toledo
and in the 1860s and 1870s visited Scotland and Northern Ireland.
He began as an architectural draughtsman and even in his late
coastal scenes 'it is too much with the builder's eye that he erects
these vast sea walls' (Roget). He narrowly escaped death in the
Staplehurst railway disaster of June, 1865, in which Dickens was
also involved.

His remaining works were sold at Christie's, February 29, 1884.

Published: *Leaves from a Sketch-Book*, 1875.
Illustrated: S.P.C.K.: *Zoological Sketches*, 1844.
Examples: V.A.M.; Reading A.G.

READY, William James Durant 1823 (London) – 1873 (Brighton)
A marine painter in oil and watercolour, he was self-taught, and painted mainly on the South Coast. He lived for five years in America and exhibited at the R.A., the B.I. and Suffolk Street in the 1860s. His works are signed W.F.R. or W.F. Durant.

REASON, Florence
A flower and genre painter who studied at the Queen's Square School of Art, winning a National Silver Medal and the Gilchrist Scholarship. She exhibited from 1883 and lived in London until 1914.

REDFARN, William Beales
An animal, landscape and town painter in oil and watercolour. He exhibited at Suffolk Street in 1870, and in 1916 he presented his drawings for *Old Cambridge* to the Fitzwilliam. They are pretty and pleasantly free for architectural work. Sometimes, however, this becomes sloppiness.

Published: *Old Cambridge*, 1876.
Illustrated: J.W. Clark: *Ancient Wood and Iron Work in Cambridge*, 1881.
Examples: Fitzwilliam.

REDGRAVE, Richard, R.A. 1804 (London) – 1888 (London)
The younger brother of Samuel Redgrave, whom he assisted with his publications. In 1826 he entered the R.A. Schools, at the same time working for his father, a manufacturer of wire fencing. In 1830 he left his father's employment and became a drawing master. He exhibited at the R.A., the B.I. and the S.B.A. from 1825 and he was elected A.R.A. in 1840 and R.A. in 1851. From 1847 he was deeply engaged in the establishment and running of the Government School of Design, and in 1855 he was on the British Committee of the Paris Exhibition. He was the first Keeper of Paintings at the V.A.M. and was Surveyor of the Queen's Pictures between 1857 and 1880, during which time he compiled a catalogue of the pictures at Windsor Castle, Buckingham Palace, Hampton Court, etc., in thrity-four manuscript volumes. In 1869 he declined a knighthood and in 1880 was created C.B.

His early pictures were mainly historical, he later turned to moralizing genre and landscape. He painted in oil and watercolour.

His son, GILBERT RICHARD REDGRAVE, was an architect and inspector of the National Art Training School. He made a number of sketches in watercolour, chalk and pencil of which there are examples in the V.A.M. They show a Pre-Raphaelite influence.

His daughter, EVELYN LESLIE REDGRAVE, exhibited landscapes in oil and watercolour at the R.A. from 1876 to 1887 and elsewhere. Another daughter, Frances M. Redgrave, painted genre scenes in oil.

Published: *An Elementary Manual of Colour*, 1853. With S. Redgrave: *A Century of Painters of the British School*, 1866. Etc.
Examples: B.M.
Bibliography: F.M. Redgrave: *R.R. a Memoir*, 1891. *A.J.*, February, 1850; July, 1859. *Connoisseur*, LXXXVIII, 1931.

REED, Joseph Charles, N.W.S. 1822 – 1877 (London)
A landscape painter who was elected A.N.W.S. in 1861 and a Member in 1866. He exhibited with the N.W.S. from 1860 until his death, and also at the R.A. and Suffolk Street. His landscapes are taken from all over the British Isles. They are often large and showy.

Examples: Shipley A.G., Gateshead; Wakefield A.G.

REID, Andrew 1831 – 1902
An illustrator and decorative designer, producing book-plates and the like. He also painted occasional historical and architectural watercolours.

Illustrated: R.N. Wornum: *Life of Hans Holbein*, 1867.
Examples: V.A.M.

**REID, Archibald David, A.R.S.A., R.S.W.
1844 – 1908**
The brother of Sir George Reid, P.R.S.A., he was a landscape painter in oil and watercolour. He was educated in Aberdeen and worked in an office before studying at the R.S.A. Schools and, later, Julian's. He exhibited at the R.S.A. and at the R.A. from 1872 and also painted in Holland and Spain. He lived in Aberdeen.

REID, John Robertson, R.I. 1851 (Edinburgh) – 1926
Primarily an oil painter, he studied under McTaggert and Chalmers at the R.S.A. Schools. His watercolours are often of Cornish coastal subjects, since he visited Cornwall regularly for twenty years from 1881. He was elected R.I. in 1897 and was a Member of the R.B.A.

His work suffers from over-contrasted lights and shadows, but his colours and effects are strong and his drawing good.

His sister and pupil, FLORA MACDONALD REID, painted genre subjects in watercolour and oil.

Examples: V.A.M.; Portsmouth City Mus.
Bibliography: *A.J.*, 1884.

REID, Major L F
An officer who was Assistant Quartermaster-General at Plymouth, and who painted landscapes and views in wash at least from 1818 to 1822.

REINAGLE, George Philip 1802 (London) – 1835 (London)
A marine painter and the youngest son of R.R. Reinagle (q.v.), whose pupil he was. He began by copying Dutch masters and exhibited at the R.A. from 1822. He was present at the battle of Navarino in 1827 and with the Fleet off Portugal in 1833, producing a number of lithographs of the engagements.

Published: *Illustrations of the Battle of Navarin*, 1828. *Illustrations of the Occurences at the Entrance of the Bay of Patras . . .*, 1828.
Examples: B.M.

REINAGLE, Philip, R.A. 1749 (Scotland) – 1833 (London)
An animal and landscape painter, he entered the R.A. Schools in 1769 and afterwards studied under Allan Ramsay. He exhibited at the R.A. from 1773, beginning with portraits. He was elected A.R.A. and R.A. in 1787 and 1812. He copied Dutch masters and also made a number of book illustrations, including botanical drawings which were used for Thornton's *Sexual System of Linnaeus*, 1799-1807, and *Philosophy of Botany*, 1809-10. His best drawings were of sporting subjects.

Illustrated: Taplin: *Sportsman's Cabinet*, 1803.
Examples: B.M.; V.A.M.
Bibliography: *A.J.*, 1898.

**REINAGLE, Ramsay Richard, P.O.W.S.
1775 – 1862**
The son of P. Reinagle (q.v.), he first exhibited at the R.A. at the age of thirteen. He visited Italy and Holland, and the Lake District was a favourite sketching ground. He worked for Barker's Panorama as well as painting in both oil and watercolour. He was one of the first Associates of the O.W.S. in 1805 and had become President by the time of the dissolution in 1812, when he resigned. After that date he concentrated on oil painting, becoming A.R.A. in 1814 and R.A. in 1823. He was forced to resign in 1848 after exhibiting another artist's work as his own. For the latter part of his career he was mainly engaged in copying and restoring old masters.

His watercolours are conventional landscapes in which browns and greens predominate. They have often faded.

Examples: B.M.; V.A.M.; Williamson A.G., Birkenhead; Maidstone Mus.; Castle Mus., Nottingham; Wakefield A.G.
Bibliography: *Collector*, X, 1930.

RENTON, John 1774 – c.1841
A figure and landscape painter who exhibited at the R.A. and elsewhere from 1799. He lived in London and painted in the Thames Valley and the Lake District. His figures are reminiscent of those of J. Cristall (q.v.) and his landscapes are rather in the manner of J. Varley (q.v.).

Examples: B.M.

REPTON, Humphrey
 1752 (Bury St. Edmunds) – 1818 (Romford, Essex)
Educated at Bury, Norwich, Helvoetsluys and Rotterdam, he failed in his first career as a merchant. In about 1780 he began to teach himself botany and landscape design and in 1783 he accompanied his earliest patron, Secretary Windham, to Ireland. On his return he settled in Romford. His first landscape work was at Cobham, Kent. In 1811 a spine injury forced him to give up work.

His drawings, whether pure landscapes or topographic views allied to his designs, are in the tinted manner. His colours are muted blues and greens. He published a number of treatises. While in Ireland he also took portraits and painted humorous subjects.

Published: *Sketches and Hints on Landscape Gardening*, 1794. *Odd Whims and Miscellanies*, 1804. Etc.
Examples: B.M.; V.A.M.
Bibliography: J.C. Loudon: *The Landscape Gardening . . . of H.R.*, 1840.

REPTON, John Adey, F.S.A.
 1775 (Norwich) – 1860 (Springfield, Essex)
An architect and writer, he was the eldest son of H. Repton (q.v.). He worked for John Nash and in Holland and Germany as well as with his father. He made a number of drawings of Norwich for Britton's *Cathedral Antiquities*, 1816.

His brother, GEORGE STANLEY REPTON (d.1858), was a pupil of A.C. Pugin and worked for Nash.

Published: *A trewe . . . Hystorie of the . . . Prince Radapanthus*, 1820. *Some account of the Beard and Moustachio*, 1839.
Examples: Soc. of Antiquaries.

REVELEY, Willey 1760 – 1799 (London)
An architect who studied at the R.A. Schools from 1777 and under Chambers, and from 1784 to 1789 was in Italy, Greece and Egypt as 'architect and draughtsman' to Sir Richard Worsley. On his return he set up as an architect, artist and pundit on matters Greek. He edited the third volume of Stuart and Revett's *Antiquities of Athens*, 1792.

Examples: B.M.; V.A.M.; R.I.B.A.; Soane Mus.

REVETT, Nicholas 1720 (Framlingham) – 1804 (London)
An architect and draughtsman. He went to Rome in 1742 to study painting. He then travelled to Venice, Dalmatia and Athens with J. Stuart (q.v.), returning to England early in 1755. He went to Turkey with Richard Chandler and W. Pars (q.v.) for the Society of Dilettanti in 1764, returning in 1766. He designed a number of buildings in the Greek taste.

Published: with J. Stuart: *Antiquities of Athens*, I, 1762. *The Antiquities of Ionia*, 1769-97.
Examples: Bodleian Lib.; West Wycombe Park.

REYNOLDS, Frank 1876 (London) – 1953
An illustrator and press artist. He worked for the *I.L.N.* and the *Sketch* before becoming art editor of *Punch*. He was elected R.I. in 1903 but resigned in 1933. He lived in London and Thames Ditton.

Published: *The F.R. Golf Book*, 1932. *Hamish McDuff*, 1937. *Off to the Pictures*, 1937. *Humorous Drawings for the Press*, 1947.
Examples: Fitzwilliam.

REYNOLDS, Frederick George 1828 – 1921
A landscape painter who was probably self-taught. He lived in London, exhibited from 1859 and was an unsuccessful candidate for

the N.W.S. in that year. As with so many others, North Wales was a favourite sketching ground. He also painted in Scotland and on the Rhine.

Examples: V.A.M.
Bibliography: E.A. Vidler: *F.G.R.*, 1923.

REYNOLDS, Samuel William 1773 (West Indies) – 1835 (Bayswater)
An engraver and landscape painter. He studied at the R.A. Schools and under W. Hodges (q.v.) and J.R. Smith (q.v.). He became drawing master to the Princesses, and Engraver to the King. He exhibited landscapes in oil and watercolour at the R.A. and the B.I. from 1797. In 1809 he visited Paris for the first time, and there he built up an enthusiastic following. Most of his paintings were, in fact, sold on the Continent. He occasionally produced drawings in the manner of A. Cozens (q.v.). His son, SAMUEL WILLIAM REYNOLDS, YR., was also a mezzotinter.

Examples: B.M.; Ashmolean.

REYNOLDS, Warwick
Probably the brother of F.G. Reynolds (q.v.), he lived in London and was an unsuccessful candidate for the N.W.S. in 1859. He was Keeper of the N.W.S. in 1864 and 1865 but was not re-elected in the following year. He exhibited from 1859 to 1885. His name is sometimes given as Walter, and he painted landscapes and genre subjects. He may have been a novelist.

He was also presumably the father of WARWICK REYNOLDS, YR., R.S.W. (1880-1926) who studied at the Grosvenor Studio, St. John's Wood School of Art and in Paris. He was an animal illustrator, mostly in black and white, and he exhibited from 1904. He died in Glasgow, and there are examples of his work in Glasgow A.G.

Examples: V.A.M.

RHEAM, Henry Meynell 1859 (Birkenhead) – 1920
A portrait, genre and landscape painter in oil and watercolour. He exhibited at the R.I., the R.B.A. and in Liverpool, and in 1890 he was living at Newlyn, Cornwall.

RHODES, John Nicholas 1809 (London) – 1842 (Leeds)
An animal painter in oil and watercolour who was the son and pupil of JOSEPH RHODES of Leeds (1782-1854). He was brought up in that town but worked in London, exhibiting from 1839 to 1842.

Examples: City A.G., Leeds; Wakefield City A.G.
Bibliography: W.H. Thorp: *J.N.R.*, 1904.

RICH, Alfred William 1856 (Gravely, Sussex) – 1921 (Tewkesbury)
A landscape painter and disciple of P. de Wint (q.v.). He was brought to London in 1860 and began his career as an heraldic painter in 1871. He studied at the Westminster School of Art and at the Slade and became a successful teacher. He was a Member of the N.E.A.C. from 1898. He painted in many parts of Britain, but especially in Sussex, and he died when taking pupils on a sketching tour to Tewkesbury.

His work owes a great deal to de Wint, especially in the colouring. He has a trick of outlining clouds with blue – which has sometimes faded to pink.

Published: *Water-Colour Painting*, 1918.
Examples: B.M.; V.A.M.; Blackburn A.G.; Cartwright Hall, Bradford; Preston Manor, Brighton; Darlington A.G.; Dudley A.G.; Towner Gall., Eastbourne; Hove Lib.; Walker A.G., Liverpool; City A.G., Manchester; Nat. Mus., Wales; Newport A.G.; Oldham A.G.; Musée d'Art Mod., Paris; Tate Gall.; Ulster Mus.
Bibliography: *A.J.*, 1907. *Walker's Quarterly*, IX, 1922.

RICHARDS, Frederick Charles
 1878 (Newport, Monmouth) – 1932 (London)
Primarily an etcher and lecturer at South Kensington, he was a talented sketcher. He worked in the Near and Middle East, Belgium, France, Italy and Holland as well as in the South and West of

England, gathering material for use as prints. His sketches include birds and dogs and stained glass designs as well as landscapes and architectural details.

Published: *A Persian Journey*, 1931. Etc.
Examples: Newport A.G.
Bibliography: W.J.T. Collins: *Artist–Venturer*, 1948.

RICHARDS, John Inigo, R.A. c. 1720 – 1810 (London)
A landscape painter in oil and watercolour who was a Foundation Member of the R.A., and its Secretary from 1788 until his death. He had been a scene painter and did some repair and restoration work. In 1791 he carried out repairs to the Academy's Leonardo Cartoon. He often drew castles and buildings in the grounds of country houses. His drawings are almost always inscribed on the reverse. His colour is usually rather intense, and his trees with their thick outlines are like those of W. Marlow (q.v.). There are a number of bodycolour landscapes in the manner of J. Laporte (q.v.) which are traditionally attributed to him, but it seems likely that they are by a different J. Richards.

Examples: B.M.; V.A.M.; Ashmolean; Abbot Hall A.G., Kendal.

RICHARDS, Richard Peter 1840 (Liverpool) – 1877 (Pisa)
A marine and landscape painter. He exhibited from 1860 and was an unsuccessful candidate for the N.W.S. in 1867 when living at Waventree. One suspects that a number of his detailed rustic scenes with their poor figures may now bear Birket Foster's monogram.

Examples: Castle Mus., Norwich.

RICHARDS, W
A painter of birds and coastal scenes, he lived in Newington and Camberwell and was active from 1836 to 1841.

RICHARDS, William Trost
A marine painter who lived in Notting Hill and exhibited a Cornish coastal subject at Suffolk Street in 1879.

Bibliography: H.S. Morris: *Masterpieces of the Sea*, 1912.

RICHARDSON, Arthur 1865 (Newcastle) – 1928
A painter of North-Eastern river and coastal subjects. He may have been a grandson of T.M. Richardson (q.v.).

Examples: Laing A.G., Newcastle.

RICHARDSON, Charles 1829 – 1908
A son of T.M. Richardson (q.v.) by his second marriage, he painted landscapes, coastal and marine subjects and still-lifes. He helped his brother H.B. Richardson (q.v.) with the Roman Wall series and exhibited from 1855. He moved to London in 1873 and later settled in Hampshire. His wife was also a watercolour painter.

Illustrated: Sir W. Lawson: *The Conquest of Camborne*, 1903.

RICHARDSON, Charles James 1806 – 1871 (London)
A designer and architectural draughtsman, he was a pupil of Sir John Soane. As well as illustrating his own publications, he worked for the *A.J.*

Published: *Studies from Old English Mansions, their furniture, gold and silver plate*, 1841. *Studies of Ornamental Design*, 1848. *Picturesque designs for Mansions, Villas, Lodges*, 1870. Etc.

RICHARDSON, Edward M , A.N.W.S. 1810 – 1874
The second son of T.M. Richardson (q.v.), he exhibited in London from 1846 and was elected A.N.W.S. in 1859. His style is close to that of his brother T.M. Richardson, Yr. (q.v.). He painted in England, Scotland and Europe.

A sale of his watercolours was held at Christie's, February 19, 1864, and his remaining works were sold, also at Christie's, May 25, 1875.

Examples: V.A.M.; Williamson A.G., Birkenhead; City A.G., Manchester; Laing A.G., Newcastle; Newport A.G.

RICHARDSON, Frederick Stuart, R.I., R.S.W.
 1855 (Clifton, Bristol) – 1934
A painter of landscapes with figures, he was educated at Repton and studied with Duran in Paris. He was elected R.S.W. in 1887 and R.I. in 1897. He lived in Bristol and at Abinger, Surrey.

RICHARDSON, George c. 1740 – c. 1813 (London)
An architectural draughtsman who travelled in France, Italy and Dalmatia from 1760 to 1763. He exhibited in London from 1766 and was elected a Fellow of the Society of Artists in 1771. He worked as a drawing master and as a draughtsman for the Adam brothers. With his son William, he aquatinted almost all the illustrations for his books from his own drawings. His remaining works and collections were sold at Stewart's Rooms, November 29 – December 2, 1813.

Published: *Treatise on the Five Orders*, 1760-63, 1787. *Aedes Pembrochianae*, 1774. *A book of Ornamental Ceilings . . .*, 1776. *Iconography*, 1779-90. *A New Collection of Chimney Pieces*, 1781. *New Designs in Architecture*, 1792. *Capitals and Columns . . .*, 1793. *New Designs of Vases*, 1793. *Original Designs for Country Seats or Villas*, 1795. *The New Vitruvius Britannicus*, 1802-8, 1808-10. *Ornaments in the Grecian, Roman and Etruscan Tastes*, 1816.

RICHARDSON, George 1808 – 1840
The eldest son of T.M. Richardson (q.v.), he set up as a drawing master when only eighteen and was later joined in the practice by T.M. Richardson, Yr. He offered a wide variety of classes during the day and evening and also gave private lessons and encouraged sketching from nature. He exhibited at the B.I. from 1828 to 1833 and at the N.W.S. He died of consumption at an age when his abilities were beginning to attract favourable attention. His unsold pictures were disposed of by lottery for the benefit of his widow.

Examples: V.A.M.

RICHARDSON, Henry Burdon
 c. 1811 (Warkworth, Northumberland) – 1874 (Newcastle)
A son of T.M. Richardson (q.v.), he travelled widely and exhibited in London from 1828. He taught in Newcastle and in 1848, helped by his brother Charles, he painted a large and impressive series of views of the Roman Wall for Dr. J.C. Bruce. He was an excellent topographer. He often signed his work with initials.

Examples: Shipley A.G., Gateshead; Laing A.G., Newcastle.

RICHARDSON, J
A painter of London views who was active between 1810 and 1834.

RICHARDSON, John Isaac, R.I.
 1836 (Newcastle-upon-Tyne) – 1913 (Co. Durham)
The youngest son of T.M. Richardson (q.v.), he exhibited landscapes in London from the age of ten, according to Graves. He was elected R.I. in 1882. His middle initial is often mistakenly given as 'J'.

Examples: Laing A.G., Newcastle.

RICHARDSON, Thomas Miles
 1784 (Newcastle-upon-Tyne) – 1848 (Newcastle-upon-Tyne)
The son of a schoolmaster, he was apprenticed to an engraver and a cabinet maker. He was a teacher himself from 1806 to 1813 and then set up as a professional artist. He exhibited in London from 1818. His favourite sketching grounds were Scotland, the Borders and Northumbria, and in his later years he visited Italy, Switzerland and France. He worked on two unfinished publications as well as a book on the Armorial Bearings in St. Andrew's Chapel, Newcastle. He was elected A.N.W.S. in 1840 but was expelled three years later.

He was an admirer of Cox and worked in the same traditions.

Examples: B.M.; V.A.M.; Cartwright Hall, Bradford; Grosvenor Mus., Chester; Derby A.G.; City A.G., Leeds; Walker A.G., Liverpool; City A.G., Manchester; N.G., Ireland; Laing A.G., Newcastle; Portsmouth City Mus.; Reading A.G.

Bibliography: *Memorials of old Newcastle on Tyne . . . with a sketch of the artist's life*, 1880. R. Welford: *Art and Archaeology: The Three Richardsons*, 1906. *Studio*, LXVII, 1916.

RICHARDSON, Thomas Miles, Yr., R.W.S.
1813 (Newcastle) — 1890 (Newcastle)
A son of T.M. Richardson (q.v.), from whom he received his training. He began his career in Newcastle, sending works to London for exhibition from 1832. He moved to London in 1846, having been elected A.O.W.S. in 1843. He was elected a Member in 1851. He made extensive tours of Scotland and the North of England and from 1843 travelled widely on the Continent. Highland scenes and views in the Swiss and Italian Alps were amongst his favourite subjects. He was a skilful draughtsman and had a good eye for composition. He was fond of bright colours and used a quantity of white heightening. He tends to become rather repetitive in his Scottish and Italian show pieces and is seen to better advantage in smaller and less pretentious views such as a series he made on the Thames.

His remaining works were sold at Christie's, June 16–18, 1890.

Examples: B.M.; Blackburn A.G.; Darlington A.G.; Derby A.G.; Shipley A.G., Gateshead; Glasgow A.G.; Abbot Hall A.G., Kendal; Maidstone Mus.; Laing A.G., Newcastle; Portsmouth City Mus.; Sunderland A.G.; Warrington A.G.

RICHARDSON, William
The son of a cabinet maker in York, he became an architect and specialized in drawings of abbeys and ruins. His style is a little reminiscent of Cotman. He exhibited at the R.A. and elsewhere from 1842 to 1877 and was an unsuccessful candidate for the N.W.S. in 1870 and 1872.

Published: *Monastic Ruins of Yorkshire*, 1843.
Examples: V.A.M.; Leeds City A.G.; York A.G.

RICHBELL, Captain Thomas
A naval officer who painted marine subjects in a rather crude Sandby manner. He was active from 1791 to 1825 and lived in Chatham. In 1792 he was a lieutenant on H.M.S. *Alfred*, and he was promoted captain in 1802.

Examples: Greenwich.

RICHMOND, George, R.A.
1809 (Brompton, London) — 1896 (London)
The son and brother of miniature painters, he entered the R.A. Schools under Fuseli at the age of fifteen. His friends there included S. Palmer, T.S. Cooper, E. Calvert and F. Tatham (all q.v.), whose sister he married. The following year he met Blake and in 1827 was by his death-bed at Shoreham. In 1828 he studied in Paris. At this time he was a miniaturist, but after his elopement and marriage in 1831, he turned to larger portraits, more suitable for engraving. In 1837 he went to Rome with the Palmers, staying for two years. He re-visited Italy in 1840, soon afterwards travelling in Germany. After about 1846 he worked in oil as well as crayon and watercolour. He was elected A.R.A. and R.A. in 1857 and 1866.

His best known works are either small three-quarter length portraits in watercolour of a particular delicacy and brilliance, or life-sized head and shoulder studies in chalk on brown tinted paper. The former are quite the best portraits of the time in watercolour, showing rapidity and sureness of handling and a strong sense of the character of the sitter as well as his likeness. Even the late landscapes can still show the influence of his Shoreham period.

He was the father of Sir William Blake Richmond, R.A. (1842–1921).

Examples: B.M.; V.A.M.; City A.G., Manchester; N.G., Scotland; N.P.G.; Newport A.G.
Bibliography: R.L. Binyon: *The Followers of William Blake*, 1925. A.M.W. Stirling: *The Richmond Papers*, 1926.

RICHMOND, Thomas, Yr. 1802 — 1874
A portrait and genre painter, he was the son of Thomas Richmond,

a miniaturist, and the brother of G. Richmond (q.v.). He studied at the R.A. Schools and exhibited from 1822. He lived in London and visited Rome in 1841.

Examples: Derby A.G.

RICHTER, Henry James, O.W.S. 1772 (Soho) — 1857 (London)
The son of John Augustus Richter, an artist and engraver, he was educated at Dr. Barrow's School and studied under T. Stothard (q.v.) and at the R.A. Schools from 1790. Although he began by exhibiting two landscapes at the R.A. in 1788, and later sketched in Wales, he was best known as a figure painter, having laid the groundwork by three years' study of anatomy. In 1810 he joined the A.A. and was President for the two following years. With the collapse of the A.A. he moved to the Oil and Watercolour Society in 1813. In 1814 he made the almost obligatory journey to Paris. He took the majority of his subjects thereafter from literary sources. He was also much interested in Kantian philosophy, sharing many ideas with Blake, whose colouring he is said to have influenced.

Published: *The Nature and Use of Daylight*, 1816. *German Transcendentalism*, 1855.
Examples: B.M.

RICHTER, Herbert Davis, R.I., R.S.W.
1874 (Brighton) — 1955
A designer and decorative artist. He was a pupil of J.M. Swan (q.v.) and Sir F. Brangwyn (q.v.) and was elected R.B.A. in 1910, R.I. in 1920 and R.S.W. in 1937. He was a director of Bath Cabinet Makers Co. and Bath Artifacts Ltd. and was also a lecturer. One-man shows of his work were held at the St. George's Gallery in 1923 and the Leicester Gallery in 1925.

Published: *Flower Painting in Oil and Watercolours*, 1929. *Floral Art*, 1932.
Examples: V.A.M.
Bibliography: H.G. Fell: *The Art of H.D.R.*, 1935.

RICKETTS, Charles de Sousy, R.A.
1866 (Geneva) — 1931 (London)
A still-life, architectural and figure painter, he was the son of the marine painter Charles Robert Ricketts. He was brought up in France and Italy and studied at the Lambeth School of Art from 1882. He and his fellow student, C.H. Shannon (q.v.), edited *The Dial* from 1889 to 1897 and ran the Vale Press from 1896 to 1904. Thereafter he concentrated on painting and sculpture. He was elected A.R.A. and R.A. in 1922 and 1928.

Published: *The Prado*, 1903. *Titian*, 1906 Etc.
Examples: B.M.; Blackburn A.G.; Cartwright Hall, Bradford; Doncaster A.G.; Exeter Mus.; Fitzwilliam; Hove Lib; Leeds City A.G.; City A.G., Manchester; Reading A.G.; Ulster Mus.
Bibliography: T.S. Moore: *C.R.*, 1933.

RICKMAN, Thomas, F.S.A.
1776 (Maidenhead) — 1841 (Birmingham)
An architect and draughtsman who worked in his father's grocery shop until 1797 when he went to London. There he studied medicine, and he practised at Lewes from 1801 to 1803. Then he returned to London as a corn factor and in 1808 moved to Liverpool as an insurance broker's clerk. By 1813 he had turned to architecture by way of drawing, and in 1817 he set up his own office. He was a Gothic enthusiast and the first to use the terms 'Norman', 'Early English', 'Decorated' and 'Perpendicular'. In 1832 he visited France.

He was a self-taught artist, beginning with cut-out figures in army uniforms in the 1790s. When in Liverpool he drew the local churches, and from 1811 he toured the North visiting some three thousand churches, monasteries and abbeys.

Published: *A Tour in Normandy and Picardy in 1832*, 1833. Etc.
Examples: Ashmolean; R.I.B.A.

RIDDEL, John
A draughtsman who specialized in British shipping subjects and was active between 1760 and 1770.

RIDDELL, Robert Andrew
A landscape painter who was working in Cheshire and on the Scottish Borders in the 1790s. His work is a little like that of W. Payne (q.v.).

Illustrated: J. Wilson: *A History of Mountains*, 1807.

RIDER, John
A landscape painter who lived in London and Uxbridge. He exhibited at the S.B.A. from 1842 to 1845 and was an unsuccessful candidate for the N.W.S. in 1844 and 1847. His subjects were from around London or from North Wales.

RIDER, William
A landscape painter, lithographer and drawing master who worked in Leamington from 1818 to 1842. H.H. Harris (q.v.) was one of his pupils.

Published: *Views in Stratford-upon-Avon*, 1828. *The Principles of Perspective*, 1836.
Illustrated: T. Bradshaw: *Views in Mauritius*, 1832.

RIGAUD, Stephen Francis Dutilh 1777 (London) – 1861 (London)
The son of John Francis Rigaud R.A., he entered the R.A. Schools in 1792. In 1798 he made a sketching tour of Kent with R. Nixon (q.v.) and J.M.W. Turner (q.v.). He was a Founder Member of the O.W.S., and he exhibited portraits and figure subjects at the R.A. from 1797, gaining a gold medal in 1801 for *Clytemnestra exulting over Agamemnon.* He retired from the O.W.S. in 1812, and thereafter exhibited with the B.I. and the S.B.A. until 1852. In 1849, however, he did show interest in rejoining his old colleagues. He lived in Pembrokeshire for a time from 1817.

Examples: B.M.; V.A.M.; Nat. Mus., Wales.

RIGBY, Cuthbert, A.R.W.S. 1850 (Liverpool) – 1935
A Lake District landscape painter, he was educated at the Liverpool Collegiate Institute and was a pupil of W.J. Bishop. He exhibited at the R.A. and the O.W.S. from 1874 and was elected A.O.W.S. in 1877. He lived at Ambleside.

Published: *From Midsummer to Martinmas, a West Cumberland Idyll*, 1891.
Illustrated: W.G. Collingwood: *The Lake Counties*, 1902.
Examples: V.A.M.; Abbot Hall A.G., Kendal; Maidstone Mus.

RIMINGTON, Alexander Wallace
 1854 (London) – 1918 (Selsey, Gloucestershire)
An etcher and landscape painter who was educated at Clifton and studied in London and Paris. He exhibited from 1880 and visited Spain and Switzerland. He tried to work out a relationship between colour and music. He lived in Weston-super-Mare and London. An exhibition of French and Pyrenean watercolours was held at the Fine Art Society in 1912.

His wife, EVELYN JANE RIMINGTON, née WHYLEY, was also a watercolourist and illustrator.

Published: *Colour-Music*, 1912. *The Conscience of Europe*, 1917.
Examples: V.A.M
Bibliography: *A.J.*, 1902.

RINTOUL, William
A marine and landscape painter who appears to have been active between 1791 and 1826.

RIPLEY, R R
A landscape painter in oil and watercolour who lived in London and Kent. He exhibited at the S.B.A. and in Birmingham from 1862 to 1881, and painted in Sussex and the Lake District, sometimes in conjunction with Benjamin Herring.

RIPPINGILLE, Edward Villiers
 1798 (King's Lynn) – 1859 (Swan Village, Staffordshire)
A self-taught genre painter in oil and watercolour, he exhibited from 1813 to 1857. He went to Rome in 1837 and remained in Italy until 1846.

His importance is more as a critic than as an artist. From 1843 he edited a short-lived periodical, *The Artist's and Amateur's Magazine*, and he also wrote for the *A.J.* and *Bentley's Magazine*. He is best remembered for his description of Turner on Varnishing Day.

Examples: V.A.M.; Bristol City A.G.

RITSO, Captain John
Of Polish descent, he became a lieutenant in the 76th Regiment in 1793 in India. From 1798 to 1805 he was A.D.C. to Lord Wellesley at Fort William, and in 1803 he was promoted captain. He sold his commission in 1807.

A drawing by him in the India Office Library is in Chinnery's Indian manner.

RIVERS, Leopold 1850 (London) – 1905 (London)
A landscape painter who was the son and pupil of a marine painter, William Joseph Rivers. He lived in Islington and was a prolific exhibitor of subjects from the Southern counties from 1873. He also exhibited Swiss views in 1891 and 1892. His technique is usually rather damp, a little like that of the Glasgow School.

RIVIERE, Briton, R.A. 1840 (London) – 1920 (London)
The son of W. Riviere (q.v.) and nephew of H.P. Riviere (q.v.), he was a genre, landscape and animal painter in oil and watercolour. He studied with his father, J. Pettie (q.v.) and Sir William Quiller Orchardson. He was also a frequent visitor to the London Zoo. He was elected A.R.A. and R.A. in 1878 and 1881. Much of his work is highly sentimental.

His wife, MARY ALICE RIVIERE, née DOBELL (1844–1923), sister of the poet Sydney Dobell, also painted in watercolour.

Examples: B.M.; V.A.M.; Blackburn A.G.; City A.G., Manchester.
Bibliography: *A.J.*, 1878; 1891. *Art Annual*, 1891.

RIVIERE, Henry Parsons, A.R.W.S.
 1811 (London) – 1888 (London)
A son of DANIEL VALENTINE RIVIERE, a drawing master, miniaturist and medallist, he studied at Clipstone Street and the R.A. Schools. He began to exhibit Rubens copies in 1832, joined the N.W.S. in 1834, but seceded in 1850 and joined the O.W.S. in 1852. He specialized in Irish joke pictures until 1865 when he gave up a considerable teaching practice and moved to Rome. His subjects were then nearly all views of the city or characteristic figures. He returned in 1884.

Examples: V.A.M.; Williamson A.G., Birkenhead.

RIVIERE, William 1806 (London) – 1876 (Oxford)
A landscape painter in oil and watercolour, he was the eldest son of D.V. Riviere and brother of H.P. Riviere (q.v.). He attended the R.A. Schools and exhibited at the R.A. from 1826. In 1849 he became drawing master at Cheltenham College where he was highly successful. Ten years later he moved to Oxford. He was the father of B. Riviere (q.v.).

Bibliography: *A.J.*, 1877.

RIX, Mary Ann See CHASE, Mary Ann, Mrs.

ROBB, William George 1872 (Ilfracombe) – 1940
A landscape and figure painter in oil and watercolour who studied at the Aberdeen School of Art and in Paris, and who lived in London. He signed with the surname only in block capitals.

Examples: V.A.M.

ROBERTS, Colonel Charles J CRAMER-
1834 – 1895
A landscape painter who joined the Army in 1853, serving in the Crimea and in India from 1875 until his retirement in 1887. He visited Greece in 1862. His work is accomplished if a little splashy in style. He hyphenated his name in 1885.

Examples: India Office Lib.

ROBERTS, David, R.A. 1796 (Edinburgh) – 1864 (London)
After an apprenticeship to an Edinburgh decorator, Roberts became a scene-painter in about 1817, working with 'Gentleman Jack' Bannister in the North of England. Later he worked at the Edinburgh Pantheon, the Theatre Royal, Glasgow, and the Theatre Royal, Edinburgh, before moving south to Drury Lane in 1822. There he worked with his friend C. Stanfield (q.v.), and he continued to paint scenery up to 1830. He was the first Vice-President of the S.B.A. in 1823 and its President in 1830, and he was elected A.R.A. in 1838 and R.A. in 1841. He was a commissioner for the Great Exhibition of 1851.

In the 1820s he made several visits to Normandy and in 1832-3, on Wilkie's advice, he worked in Spain and Tangier. This journey, together with his stay in Egypt and Palestine in 1838, and his tours of Italy in 1851 and 1853, provided him with subjects for much of the rest of his life. The volumes of lithographs resulting from these tours won him wide popularity, as well as a considerable fortune. At the time of his death he was working on a series of views of London from the Thames.

Much of the Near Eastern work, for which he is best known, was obviously executed with the lithographer in mind, with a limited palette of grey, dusky red, brown and yellow, with careful pencil drawing and white heightening. He was concerned with architectural accuracy even to the point of using mathematical instruments, which leads to a loss of liveliness in some of his finished works, both in watercolour and oil. At his best this architectural precision is combined with the scene-painter's freedom and illusionary techniques.

His remaining works were sold at Christie's, May 13-20, 1865.

Published: *Picturesque Sketches in Spain during the years 1832 and 1833. Views in the Holy Land . . .,* 1842-9.
Examples: B.M.; V.A.M.; Aberdeen A.G.; Williamson A.G., Birkenhead; Blackburn A.G.; Bury A.G.; Doncaster A.G.; Dudley A.G.; Fitzwilliam; Glasgow A.G.; Leeds City A.G.; Leicestershire A.G.; City A.G., Manchester; N.G., Scotland; Newport A.G.; Portsmouth City Mus.; Ulster Mus.
Bibliography: J. Ballantine: *The Life of D.R.,* 1866. J. Quigley: *Prout and Roberts,* 1926. *A.J.,* July 1858; February 1865. *Walker's Quarterly,* X, 1922. O.W.S. Club, 1947. *Geographical Mag.,* XXI, 1949.

ROBERTS, Henry Benjamin
1832 (Liverpool) – 1915 (Leyton, Essex)
The son of a landscape painter and decorator, and a follower of W. Henry Hunt (q.v.), he began his career as a decorator in his father's business. In 1859 he began to exhibit at the R.A. and was elected to the Liverpool Academy. He was unanimously elected A.N.W.S. in 1867, giving a Hampstead address, becoming a full Member three years later and resigning in 1884. His works are almost indistinguishable from those of his master.

Examples: V.A.M.; Williamson A.G., Birkenhead.

ROBERTS, Henry Larpent c.1830 (Nottingham) – c.1890
A rustic genre and landscape painter who exhibited at the R.A. and elsewhere from 1863 to 1873. He lived in North London.

ROBERTS, James – c.1810
The son of an engraver, he became a drawing master at Oxford where he was influenced by J.B. Malchair (q.v.). He was working from 1766 to 1800. Between 1775 and 1778 he produced a long series of small portraits of actors on vellum for Bell's *British Theatre.* In about 1795 he was appointed Portrait Painter to the Duke of Clarence. He also painted landscapes. His figure drawing is neat, if a little naïve, and would appear to be derived from Sandby, although he himself discouraged the use of ink outlines.

Published: *Introductory Lessons with Familiar Examples in Landscapes,* 1809.
Examples: B.M.

ROBERTS, Thomas Edward 1820 – 1901
A genre painter in oil and watercolour and an engraver, who specialized in historical and literary subjects. He lived in London and exhibited from 1850 to 1904. He also painted contemporary subjects, such as his well-known *Opinion of the Press.*

ROBERTS, Thomas Sautelle c.1760 (Waterford) – 1826 (London)
The son of John Roberts, a Waterford architect, and younger brother of Thomas Roberts, a landscape painter in oil, he himself painted landscapes in oil and watercolour, as well as small studies of horses. He entered the R.D.S. Schools in 1777, after which he was apprenticed to the Dublin architect Thomas Ivory. He soon abandoned architecture and went to London, returning to Dublin in 1799. He continued to make visits to London, and exhibited Irish and English views at the R.A. from 1789 to 1811 and in 1818, and at the B.I. from 1807 to 1818. He exhibited with the Dublin Society of Artists from 1800 to 1821. Some views of County Wicklow, painted for the Lord-Lieutenant, Lord Hardwicke, were specially exhibited in 1802. He was one of the three artists chosen to select the first members of the R.H.A., and he contributed to the opening exhibition in 1826. The effects of a fall, which rendered his right hand useless, caused him increasing misery, and led to his suicide.

His sister was a landscapist and painted scenery for the Waterford Theatre.

Examples: V.A.M.; R.H.A.

ROBERTSON, Lieutenant-General Archibald
c.1745 (Scotland) – 1813 (Lawers, near Cromie)
Of an old Scottish family, he was related by marriage to Robert and William Adam. In 1759 he joined the Royal Engineers as 'practitioner engineer and ensign', and early in 1762 he left for America under the Earl of Albemarle and Admiral Pocock to take part in the capture of Havana. For most of the following five years he was in the Floridas and Louisiana. From 1767 until his return to America in 1775 he was in England. He was promoted engineer ordinary and captain in 1777, and he served through most of the land operations from the siege of Boston until the surrender of Cornwallis. In 1780 he returned to England. Shortly after peace was declared in 1783, he retired from active service and bought an estate, Lawers, near Cromie, Perthshire. He was promoted lieutenant-colonel in 1790, colonel in 1795, major-general in 1798 and lieutenant-general in 1805. In 1807 Viscount Melville sought his advice on the line of attack should war break out between Britain and the United States.

He worked in monochrome and a style reminiscent of that of A. Devis (q.v.). His figures are conventional.

Examples: Nat. Mus., Wales; New York Lib.
Bibliography: A.M. Lydenberg: *A.R. . . .His Diaries and Sketches in America.* 1762-80, 1930.

ROBERTSON, Charles 1760 (Dublin) – 1821 (Dublin)
A miniature painter who practised in Dublin before moving to London in 1785. He returned to Dublin in 1793, where he lived for the rest of his life, re-visiting London in 1806. He was Secretary and in 1814 Vice-President of the Hibernian Society. He exhibited miniatures, flower pieces and watercolour portraits.

His daughter Clementina Robertson and his brother Walter Robertson were both miniature painters.

Examples: B.M.; N.G., Ireland; Newport A.G.

ROBERTSON, Charles, R.W.S.
1844 – 1891 (Walton-on-Thames)
A landscape and genre painter and engraver who exhibited at the R.A. and elsewhere from 1863. He lived at Aix-en-Provence for a number of years and at Godalming and Walton-on-Thames. He travelled in the Near East and painted many Cairene and Palestinian subjects. He was elected A.R.W.S. and R.W.S. in 1885 and 1891. His landscape work is in the tradition of J.F. Lewis (q.v.), and F. Dillon (q.v.) in his earlier manner.

Examples: B.M.; Maidstone Mus.; Sydney A.G.

ROBERTSON, George 1748 (London) – 1788 (London)
A student at Shipley's Drawing School and in Rome, he accompanied William Beckford of Somerley Hall, Suffolk, to Jamaica, producing a number of drawings which were later engraved. He was Vice-President of the Incorporated Society for several years and was a successful drawing master in London.

As well as rather theatrical landscapes which are in the manner of Morland, but often without bodycolour, he painted topographical views and Downman-like portraits.

Examples: B.M.; V.A.M.; Ashmolean; Cecil Higgins A.G., Bedford.
Bibliography: Walpole Soc., V, 1915-17. *Country Life*, October 22, 1953.

ROBERTSON, George 1776 (London) – 1833
(Nottingham County Lunatic Asylum, Sneiton)
Robertson moved to Derby in 1795 and was employed as a landscape decorator in the porcelain factory. In about 1820 he left and thereafter practised as a drawing master in Derby.

Examples: Derby A.G.
Bibliography: *Connoisseur*, XCVI, 1935.

ROBERTSON, Henry Robert 1839 (Windsor) – 1921 (London)
A landscape, genre, portrait and coastal painter, and a print-maker. He studied at the R.A. Schools and exhibited from 1861. He was an unsuccessful candidate for the N.W.S. in 1871, and he lived in London.

Published: *Life on the Upper Thames*, 1875. *The Art of Etching Explained and Illustrated*, 1883. *The Art of Painting on China*, 1884. *The Art of Pen and Ink Drawing*, 1886. *Plants we Play with*, 1915. *More Plants we Play with*, 1920.

ROBERTSON, James, 'Drunken'
A drawing master whose works are often attributed to Glover or even Cox, whose signature they sometimes bear. They are generally in brown wash with heavy pen or black chalk outline, and there are several rather sickly and unlikely patches of vivid light where the paper has been left bare. The attribution to Glover is based on a rudimentary split brush technique for rendering foliage, but in fact Robertson's work is much closer in feeling to that of J. Bourne (q.v.).

He seems to have been employed at one time at the Derby china works, which may account for his simplified outlines. Dr. Percy described him a 'a drunken fellow, frequently an inmate of the workhouse'. He was active from 1815 to 1836.

Examples: B.M.

ROBERTSON, Percy 1869 (Bellagio, Italy) – 1934
A landscape painter and etcher, he was the son of the later C. Robertson (q.v.), and was educated at Charterhouse. He exhibited from 1887, lived in London and often painted in the Thames Valley. He sometimes signed with initials.

ROBERTSON, William, N.W.S. – 1856
A marine and landscape painter in oil and watercolour who lived in London. He exhibited at Suffolk Street from 1829 and 1835 and was elected N.W.S. in the following year.

ROBINS, Thomas, Yr. 1745 (Bath) – 1806 (Bath)
A flower painter and the son of a landscape painter and gardener, Robins worked in Bath in the 1780s. His work is carefully drawn and outlined and often contains touches of bodycolour. His plants are crowded with insect life. He was the son of Thomas Robins (1715-1770), who painted country houses and topographical subjects, often with floral borders.

Bibliography: *Country Life*, December 25, 1975.

ROBINS, Thomas Sewell 1814 – 1880
A coastal and marine painter, he lived in London and exhibited from 1829 to 1879. He was elected N.W.S. in 1839 and resigned in 1866. His work is often of a high quality in the tradition of G. Chambers (q.v.) or the best of C. Bentley (q.v.) and he shows a fine sense of atmospheric effect. He also produced a number of inland views, notably of French and German river towns, which are very attractive and display an unexpected informality of handling.

Sales of his work were held at Christie's, February 19, 1859 and April 17, 1866, and his remaining works were sold in the same rooms, February 25, 1881 and February 23, 1882.

Examples: B.M.; V.A.M.; Haworth A.G., Accrington; Bethnal Green Mus.; Williamson A.G., Birkenhead; Cartwright Hall, Bradford; Preston Manor, Brighton; Greenwich; Newport A.G.; Portsmouth City Mus.

ROBINSON, Anne Marjorie 1858 – 1924
A Belfast painter of local views.

Examples: Ulster Mus.

ROBINSON, Charles F
A landscape painter in oil and watercolour and an etcher, he was active between 1874 and 1915. He painted in Surrey, Sussex, Essex, Devon and Ireland and lived in London, Romford and Rainham, Essex. He was a prolific illustrator.

Examples: V.A.M.

ROBINSON, Edward W 1824 – 1883
A landscape painter who lived in London and exhibited from 1859 to 1876. He worked in Wiltshire, Yorkshire, Sussex, Wales, Durham, Brittany, Devon, Switzerland and Northern Italy and in the Midlands.

Examples: V.A.M.

ROBINSON, Frederick Cayley, A.R.A., R.W.S.
1862 (Brentford, Middlesex) – 1927 (London)
An illustrator, decorator and designer who studied at the St. John's Wood School of Art and the R.A. Schools. From 1888 to 1890 he spent much of his time on a yacht, and at Newlyn, painting marine and coastal subjects. He then spent two years at Julian's, and in 1898 he visited Florence and fell under the spell of Fra Angelico. He exhibited from 1887 and was elected A.R.W.S. and R.W.S. in 1911 and 1918. He was elected A.R.A. in 1921 and was also a Member of the R.B.A., the N.E.A.C. and the Tempera Society. He designed the costumes for Maeterlinck's *Blue Bird* at the Haymarket in 1909 and taught figure composition and decoration at the Glasgow School of Art from 1914 to 1924. His style was also derived from Puvis de Chavannes and Burne-Jones.

Illustrated: *The Book of Genesis*, 1914.
Examples: B.M.; Fitzwilliam; City A.G., Manchester; Wakefield A.G.
Bibliography: F.A.S.: *Exhibition Cat.*, 1969.

ROBINSON, George Finlay
(Wickham, Co. Durham) – c.1900 (?Gosforth)
An engraver and landscape painter who was apprenticed to William Collard in Newcastle and worked for Mark Lambert from 1841. He was an admirer of J.H. Mole (q.v.) and T. Harper (q.v.) and produced local landscapes in their manner for his own pleasure.

ROBINSON, Peter Frederick, F.S.A.
1776 — 1858 (Boulogne)
An architect and topographer. He was a pupil of Henry Holland and apprenticed to William Porden, with whom he worked on the Brighton Pavilion. Among other buildings he designed the Egyptian Hall, Piccadilly. He employed J.D. Harding to draw for his books which included a continuation of *Vitruvius Britannicus*. In 1816 he visited Rome. Much of his practice was in making alterations to country houses. From 1835 to 1839 he was one of the first Vice-Presidents of the R.I.B.A. In 1840 he went to live in Boulogne because of financial difficulties.

Published: *Rural Architecture*, 1823. *Ornamental Villas*, 1825-7. *Farm Buildings*, 1830. *Village Architecture*, 1830. *Gate Cottages, Lodges...*, 1833. *Domestic Architecture in the Tudor Style*, 1837. *New Series of Ornamental Cottages and Villas*, 1838. Etc.

ROBINSON, Thomas
In Leeds City A.G. there is an album of sketches dating from 1810 to 1820 by this artist. They include landscapes in the North of England and on the Continent and studies in light and atmosphere. There was an engraver of the name working in Liverpool in about 1821.

ROBINSON, William A
A landscape, figure and portrait painter in oil and watercolour who lived in London. He exhibited at Suffolk Street from 1845 to 1863 and also at the R.H.A. from 1844 to 1853.

Another WILLIAM ROBINSON exhibited portraits and landscapes from 1828 to 1853. He worked in North Wales, Holland and Yorkshire, and he lived in London.

ROBINSON, William R
A landscape and genre painter who painted in Northamptonshire and at Dunstafnage in about 1831 and exhibited at the Carlisle Athenaeum in 1846. He sometimes signed with initials.

Examples: B.M.

ROBSON, George Fennel, P.O.W.S.
1788 (Durham) — 1833 (Stockton-on-Tees)
A landscape painter who was encouraged to become an artist by his family. Having learnt all he could from the one drawing master in Durham, Mr. Harle, he moved to London in about 1804. He first exhibited at the R.A. in 1807 and in 1808 he published a print of Durham which paid for a long trip to Scotland and the Grampians. In 1813 he became a Member of the Oil and Watercolour Society and was its President in 1819-20. He made repeated visits to Scotland and the North of England and also visited the South Coast and North Wales. In about 1827 he went to the Lake District and also to Ireland, and the Lakes of Killarney remained favourite subjects for him. Some of his landscape work was done in collaboration with R. Hills (q.v.), who provided the figures and livestock. Very occasionally he drew subjects from Shakespeare. He was an enthusiastic and energetic worker for the O.W.S. In the summer of 1833 he visited Jersey with Hills and in August sailed to Stockton to visit his family. He contracted food poisoning on the boat and died a week later.

His most typical works are large renderings of mountain scenery with lightning flashes or lurid effects of sunlight or storm. His work is typical of the slightly stylized romantic landscape which was practised before the innovations of Cox's last period.

Published: *Scenery of the Grampian Mountains*, 1814. *Picturesque Views of the English Cities*, 1828.
Examples: B.M.; V.A.M.; Williamson A.G., Birkenhead; Blackburn A.G.; Cartwright Hall, Bradford; Bowes Mus., Durham; City A.G., Manchester; N.G., Scotland; Newport A.G.; Portsmouth City Mus.; Ulster Mus.; Warrington A.G.
Bibliography: O.W.S. Club, XVI.

ROCHARD, François Théodore, N.W.S.
1798 (France) — 1858 (London)
A miniaturist who studied in Paris, settled in London and exhibited at the R.A. and elsewhere from 1820 to 1857. He was elected to the N.W.S. in 1835 and in 1847 he was one of the Society's critics with J.J. Jenkins (q.v.), but unlike the others did not secede. With J.H. D'Egville (q.v.) he prepared the French versions of the exhibition catalogues.

Examples: Victoria A.G., Bath.

RODEN, W Frederick
A portrait and figure painter who was presumably a member of the Birmingham family of artists, and who was active there from 1876 to 1889.
MARY RODEN, a flower painter working between 1881 and 1897, may have been a sister.

ROE, Frederick, R.I. 1864 — 1947
The son of the Highland landscape painter ROBERT HENRY ROE (1793-1880) and brother of the marine painter ROBERT ERNEST ROE, he exhibited genre and historical scenes at the R.A. and elsewhere from 1887. He painted in oil and watercolour, and also illustrated books on antique furniture. He was elected R.I. in 1909. His son was F.G. Roe, the critic.

Examples: V.A.M.; Greenwich.

ROE, John, of Warwick
He exhibited views of old buildings and ruins in the Midlands from 1771 to 1790, Warwick Castle being a favourite subject. His work can sometimes look a little like that of J. Varley (q.v.) and is indeed sometimes signed 'Varley'. Some of the least inspired productions attributed to him may well be the work of pupils. He was still alive in 1812.

Illustrated: *Warwick Castle, a Poem,* 1812.
Examples: B.M.; V.A.M.; Coventry A.G.; Wakefield A.G.

ROE, William
An Irish landscape and genre painter and occasional portraitist who studied at the R.D.S. Schools, where he won prizes between 1822 and 1827, after which he lived for a short time in London. He exhibited at the R.H.A. between 1826 and 1847. He practised in Cork for some years from 1835, and works by him were in the Cork Exhibition of 1852. He made many neat pencil drawings as well as watercolours.

ROGERS, B
A landscape and architectural painter who exhibited at the R.A. from 1800 to 1803. He was a drawing master in Stafford and gave P. de Wint (q.v.) lessons.

Published: *Views in Westmoreland and Cumberland*, 1796.

ROGERS, George
A landscape painter in oil and watercolour who exhibited with the Incorporated Society and at the R.A. from 1761 to 1793.
A later GEORGE ROGERS was an amateur watercolourist working in the Isle of Wight from 1860 to about 1893.

ROGERS, James Edward, A.R.H.A.
1838 (Dublin) — 1896
A Dublin architect who painted, mainly architectural and marine subjects, in watercolour. He exhibited at the R.H.A. from 1870, and was elected A.R.H.A. in 1871. In 1876 he moved to London, where he exhibited at the R.A.

Examples: N.G., Ireland.

ROGERS, William P
An Irish landscape and coastal painter who studied at the R.D.S. Schools, gaining prizes in 1850 and 1852. He exhibited at the R.H.A. from 1848 to 1872 and at Suffolk Street from London addresses in 1853 and 1865.

ROLFE, Alexander F

A landscape painter in oil and watercolour who exhibited from 1839 to 1871. He worked in Wales and the Southern counties, especially Surrey, and he produced many piscean subjects, both still-life and sporting, and sometimes collaborated with J.F. Herring.

Examples: Castle Mus., Nottingham.

ROLT, Vivian 1874 (Stow-on-the-Wold) – 1933

A landscape painter, he was educated at Cheltenham and in Switzerland, and studied at the Slade, St. John's Wood, Bushey and Heatherley's Schools of Art. He lived near Pulborough and most of his subjects are Sussex views. He was the founder of the New Society of Watercolour Painters (1909 to 1922) – not to be confused with the old N.W.S. – and a Member of the R.B.A. from 1913.

ROOKE, John c.1806 – 1872 (St. Bees)

A collection of studies of fish and shells by this artist, dated from 1853 to 1870, was sold at Christie's, February 4, 1975. He was the art master at St. Bees School, Cumberland from about 1854 to his death. He also lived in Whitehaven and probably took private pupils.

ROOKE, Thomas Matthew, R.W.S.
1842 (Marylebone) – 1942

After working in an Army Agent's Office, he studied at the National School of Design and at the R.A. Schools. He became a designer for Morris and Co. under Burne-Jones, who greatly admired his work. From 1878 to 1893 he worked for Ruskin, making drawings of old Continental buildings, and until about 1908 he was employed in a similar manner by other patrons. He was elected A.R.W.S. in 1891 and R.W.S. in 1903. He continued to paint until he was almost ninety-eight.

His work is pleasant and strictly accurate in architectural detail, and his figures are in the manner of Burne-Jones. Early in his career he painted biblical scenes which strongly show the Pre-Raphaelite influence. His studies of trees and plants are especially charming.

Examples: B.M.; Fitzwilliam; City A.G., Manchester.

ROOKER, Edward c.1712 (London) – 1774

A pupil of Henry Roberts, the landscape engraver, he became known for his architectural plates. He was a good topographical engraver, and sometimes worked from his own drawings. He was a founder member of the Incorporated Society, exhibiting with them from 1760 to 1768. Together with his son, M. 'A.' Rooker (q.v.), he designed the headings of the Oxford Almanacks from 1769 until 1775.

Examples: B.M.; Fitzwilliam.

ROOKER, Michael 'Angelo', A.R.A.
1743 (London) – 1801 (London)

He was taught engraving by his father, E. Rooker (q.v.), and drawing by P. Sandby (q.v.), at St. Martin's Lane and the R.A. Schools. He worked on book illustrations, both drawing and engraving, and was for many years chief scene painter at the Haymarket. In 1770 he was elected A.R.A. In 1788 he began extensive tours of the country, including Essex, Norfolk, Suffolk, Somerset, Warwickshire, Worcestershire, Monmouthshire, Wales and Kent.

Rooker is one of the most pleasing of the earlier watercolourists. He has a good eye for the picturesque in his topographical subjects. His colours are delicate, and his drawing, especially of figures, is good. His lighting is generally soft and well-controlled, indeed 'control' is perhaps the key to his work.

The name 'Angelo' is said to have been given him by Sandby.

Examples: B.M.; V.A.M.; Aberdeen A.G.; Haworth A.G., Accrington; Ashmolean; Williamson A.G., Birkenhead; Coventry A.G.; Fitzwilliam; Leeds City A.G.; N.G., Ireland; Nat. Mus., Wales; Newport A.G.; Reading A.G.; Southampton A.G.; Ulster Mus.

ROPE, George Thomas
1845 (Blaxhall, Suffolk) – 1929 (Langham, Suffolk)

A landscape and animal painter in oil and watercolour who was the son of a ship-owner. He was a pupil of the landscape painter William J. Webbe in London and visited the Continent in 1882. Otherwise he remained in East Anglia for the most part, living at Wickham Market.

Published: *Sketches of Farm Favourites*, 1881. *Country Sights and Sounds*, 1915.

ROSCOE, S G Williams
1852 (Topsham, Devon) –

Born Roscoe S.G. Williams, he was the son of W. Williams (q.v.). He studied under his father and at the Exeter and West London Schools of Art and became a member of the Langham Sketching Club. He exhibited from 1874 to 1888 at the R.A., R.I., Suffolk Street and provincially using his Christian name, his subjects including views in Devon, North Wales, Yorkshire, Surrey and Scotland, which he had probably visited in about 1871. He lived in London and at Topsham, and was an enthusiastic sailor. His work is rather like that of C. Lord (q.v.).

Examples: Exeter Mus.

ROSE, H Ethel

H. Ethel Rose, who was active between 1877 and 1890, H. RANDOLPH ROSE, active from 1880 to 1901 and RICHARD H. ROSE, active from 1870 to 1885, all lived in London and painted genre and figure subjects. H.E. Rose also painted floral still-lifes and H.R. Rose, landscapes, especially in Brittany. They were most probably related.

ROSENBERG, Charles

A brother of G.F. Rosenberg (q.v.), he also painted flowers in watercolour, and exhibited at the R.A., B.I. and Suffolk Street from 1844 to 1848. At that time he was living in London.

Published: *A Critical Guide to the Exhibition of the Royal Academy*, 1847. *A Guide to the Exhibition of the Royal Academy and Institution for the Free Exhibition of Modern Art*, 1848.
Examples: V.A.M.

ROSENBERG, Frances Elizabeth Louisa, Mrs. Harris, N.W.S.
1822 – 1873

A flower painter like her brothers G.F. and C. Rosenberg (q.v.), she married a Bath jeweller named John Dafter Harris. She exhibited from 1845 to 1872.

Examples: V.A.M.

ROSENBERG, George Frederick, A.O.W.S.
1825 (Bath) – 1869 (Bath)

Beginning with flowers and ending with mountains, he was a constant exhibitor with the O.W.S., of which he was elected Associate in 1847. Until 1855 he concentrated exclusively on still-lifes. From then on, however, the mountain scenery of Scotland, Switzerland and above all Norway takes precedence – but treated with the perhaps excessive attention to detail of the flower painter. He had a wide practice as a drawing master in Bath and was an active promoter of the Bath Fine Arts Society. His remaining works were sold at Christie's, February 12 and 14, 1870. His first name is sometimes given as William.

His elder daughter ETHEL JENNER ROSENBERG painted miniatures and landscapes.

Published: *The Guide to Flower Painting in Water-Colours*, 1853.
Examples: V.A.M.; Victoria A.G., Bath.

ROSENBERG, Mary Ann see DUFFIELD, Mary Ann, Mrs.

ROSENBERG, Thomas Elliot 1790 (Bath) – 1835
A landscape painter, miniaturist and silhouettist with a considerable teaching practice in Bath. His landscapes have been compared favourably to those of Cox and de Wint. He was the father of the other painting Rosenbergs.

Examples: Victoria A.G., Bath

ROSENBERG, William Frederick
see ROSENBERG, George Frederick

ROSS, Christina Paterson, R.S.W. 1843 – 1906 (Edinburgh)
The daughter of R.T. Ross (q.v.), she was a figure, genre and landscape painter. She lived in Edinburgh and exhibited in London from 1875.

ROSS, F W L 1792 – 1860 (Topsham)
An amateur bird painter who was working in about 1835. His drawings are very pretty.

Published: *The Fall of Sebastopol: a poem,* 1856.

ROSS, James 1745 – 1821 (Worcester)
An engraver who was a pupil of R. Hancock and produced wash drawings in the manner of J.B. Malchair (q.v.).

Examples: B.M.; Worcester City A.G.

ROSS, Rear-Admiral Sir John
1777 (Inch, Wigtonshire) – 1856 (London)
The arctic explorer. He served in the West Indies and the Baltic before making his expeditions in search of the North-West Passage in 1819 and 1829, and in search of Franklin in 1849. He was Consul in Stockholm from 1839 to 1846. He painted the Arctic in watercolour.

Examples: B.M.; Greenwich.

ROSS, Robert Thorburn, R.S.A.
1816 (Edinburgh) – 1876 (Edinburgh)
A genre painter in oil and watercolour, he studied under George Simson and Sir W. Allen (q.v.) at the Trustees' Academy. He began his career in Glasgow, moving to Berwick in 1842 and Edinburgh in 1852. He was elected A.R.S.A. and R.S.A. in 1852 and 1869.

His work is close to that of Nicol and the Faeds in subject and manner. He is at his best in his watercolour landscape sketches, rather than in the laboured genre pieces which made his reputation.

He was the father of C.P. Ross (q.v.) and of JOSEPH THORBURN ROSS, A.R.S.A. (1849-1903), an artist whose watercolour sketches and studies, especially his unambitious coast scenes, are likewise far more satisfying than his oil paintings.

Illustrated: *The History of a Pin,* 1861.
Bibliography: *A.J.,* December 1871; 1876.

ROSS, Thomas
A drawing master at St. Leonards who published several lithographs of Sussex ports and cliffs between about 1840 and 1862. He was Mayor of Hastings at one time.

Published: *Ross's Hastings and St. Leonard's Guide,* 1840. *Notices of Hastings,* 1862.

ROSSETTI, Gabriel Charles Dante, 'Dante Gabriel'
1828 (London) – 1882 (Birchington, Kent)
The poet and painter who was the mainspring of the Pre-Raphaelite Brotherhood. He was the son of a Neapolitan rebel who had become Professor of Italian at King's College, London, and he was accordingly educated there, taking lessons from J.S. Cotman (q.v.). He spent four years at Cary's Bloomsbury Street School and entered the R.A. Schools in 1846. He also studied with F.M. Brown (q.v.) in 1848, but learnt little from him, and later with Holman Hunt. The Brotherhood, which he formed with Hunt, Millais, Collinson, Stephens, Woolmer and W.M. Rossetti, lasted in strength from 1848 to 1853. Critical hostility to the movement led to Rossetti's

abandonment of exhibitions and reliance on dealers and direct sales to collectors, most importantly to Ruskin. He visited France twice, the second time on honeymoon in 1860, but surprisingly never ventured to Italy. From the 1850s he was much involved with the second generation of Pre-Raphaelite painters, notably Morris and Burne-Jones. The latter part of his life was dominated by drug-addiction and near madness which had little effect on his poetry but greatly lessened his artistic inspiration.

He painted in watercolour for much of his career, and almost exclusively from 1849 to 1864. As in all his painting, he concentrated on single figures which helped to disguise his 'inability to perfectly acquire even the grammar of painting'. As his brother says, he could never be brought to care much whether his pictures were in perspective or not. However, his rich colour, mysticism and sultry sensuous female figures – his favourite models being his wife and Jane Morris – influenced painting and decoration for many decades after his death.

In 1860 he married his model and mistress ELIZABETH ELEANOR SIDDAL (1834-1862), who had previously worked in a milliner's shop. As well as inspiring Rossetti and the other members of the Brotherhood, she produced a number of watercolours and drawings in their manner, which were much admired by Ruskin. Examples are in the Ashmolean, the Fitzwilliam and the Tate Gallery.

Examples: B.M.; V.A.M.; Williamson A.G., Birkenhead; Walker A.G., Liverpool; City A.G., Manchester.
Bibliography: W.M. Rossetti: *D.G.R., his Family Letters.* 1895. F.M. Hueffer: *R., A Critical Essay,* 1902. H.C. Marillier: *R.,* 1904. P.J. Toynbee: *Chronological List . . . of Paintings and Drawings from Dante by D.G.R.,* 1912. Sir M. Beerbohm: *R. and his Circle,* 1922. E. Waugh: *R., his Life and Work,* 1928. H.M.R. Angelli: *D.G.R.,* 1949. W. Fredeman: *Pre-Raphaelitism: a Bibliocritical Study,* 1965. O. Doughty and J.R. Wahl: *Letters of D.G.R.,* 1965-7. G.H. Fleming: *R. and the P.R.B.,* 1967. V. Surtees: *D.G.R.,* 1971. *J. Nichol: R.,* 1975. *A.J.,* 1883; 1902. R.A.: *Exhibition Cat.,* 1973.

ROSSETTI, Lucy Madox, Mrs., née Madox Brown
1843 (Paris) - 1894 (San Remo)
The only daughter of F.M. Brown (q.v.) by his first marriage, and the half sister of O.M. Brown (q.v.). On her mother's death in 1846 her father brought her to England. She took up painting in 1868 and thereafter had lessons from her father, and exhibited at the Dudley Gallery from 1870. In 1874 she married William Rossetti, younger brother of D.G. Rossetti (q.v.). From this date she concentrated on literature, frequently writing for periodicals.

ROSSITER, Frances Fripp, Mrs., née Sears c. 1840
A painter of sentimental genre in oil and watercolour, she married her teacher, Charles Rossiter, in 1860. She studied at Leigh's and exhibited first in Liverpool in 1862. Later she exhibited frequently in London. In 1864, after an illness, she took up watercolour, and from 1866 she made a speciality of bird subjects. She was still living in 1876.

ROUNDELL, Mary Anne
A pupil of P. de Wint (q.v.) who was active in Yorkshire and elsewhere in the 1830s.

ROUS, Lieutenant James
An amateur artist who sketched the field of Waterloo on the day after the battle. He lived in Fulham and was active at least until 1824, sometimes collaborating with I. Cruikshank (q.v.). He was the father of Mrs. E. Phillips (q.v.).

ROUSSE, Frank
A landscape and coastal painter in oil and watercolour who exhibited at the R.A. and the R.I. from 1897 to 1917. He lived at Ilford and Hadley, Hertfordshire, and painted in Yorkshire and elsewhere.

ROUSSEL, Theodore Casimir 1847 (Lorient) – 1926 (St. Leonards)
A painter and etcher who came to England after fighting in the Franco-Prussian War. He exhibited from 1872 and was a Member of the R.B.A. in 1887-8. He was influenced by Whistler.

Examples: V.A.M.

ROWBOTHAM, Charles
The eldest son of T.C.L. Rowbotham (q.v.), he began his career by painting the figures in his father's landscapes. He exhibited from 1877 and lived in Shepherd's Bush and Acton until 1888 when he moved to Steyning, Sussex. From 1899 he lived in Brighton and from 1913 in Croydon. He painted landscapes and in particular views on the Riviera and Italian Lakes. He used a great deal of white heightening and vivid blues.
CLAUDE ROWBOTHAM, a landscape painter working in the early years of the twentieth century, was probably a brother or son.

Examples: Nat. Mus., Wales; Portsmouth City Mus.

ROWBOTHAM, Thomas Charles Leeson, N.W.S.
1823 (Dublin) – 1875 (London)
The son of T.L.S. Rowbotham (q.v.), from whom he received lessons, he moved to England while young. In 1847 he toured Wales, and in the later years Scotland, Germany and Normandy. He was elected A.N.W.S. in 1848, and a Member in 1851. He succeeded his father as drawing master at the Royal Naval School, Greenwich.
In his earlier years he chiefly painted romantic landscapes and also marine subjects a little in the style of C. Bentley (q.v.). Later he painted Italian Lake views, although he had never been there. He published a number of chromolithographs. His son, C. Rowbotham (q.v.), often painted the figures in his compositions.

Published: *English Lake Scenery*, 1875. *Picturesque Scottish Scenery*, 1875.
Illustrated: T.L.S. Rowbotham: *The Art of Sketching from Nature*.
Examples: B.M.; V.A.M.; Haworth A.G., Accrington; Blackburn A.G.; Glasgow A.G.; Gloucester City A.G.; Greenwich; Portsmouth City Mus.; Ulster Mus.

ROWBOTHAM, Thomas Leeson Scarse 1783 – 1853
A landscape and marine painter who began his career in Bristol from about 1803, and in Dublin, where he exhibited from 1815 to 1819. Later he returned to Bristol, where he was a co-founder of the Bristol Sketching Club in 1833, then moving to Bath and in about 1835 to London. He was appointed drawing master at the Royal Naval School, Greenwich.
Some of his oil paintings indicate a flirtation with the Wilson tradition, but his watercolours are more akin to the early works of S. Prout (q.v.).

Published: with T.C.L. Rowbotham: *The Art of Painting in Water-Colours*.
Examples: V.A.M.; City A.G., Bristol; Newport A.G.

ROWDEN, Thomas 1842 (Exeter) – 1926
A self-taught landscape painter who exhibited from 1884. His favourite sketching grounds were Dartmoor, the Cornish coast and the Highlands. His landscapes invariably contain animals.

Examples: Exeter Mus.

ROWE, E Arthur – 1922 (Tunbridge Wells)
A painter of landscapes and gardens who exhibited from 1885. He lived in London, Tunbridge Wells and Manchester and many of his subjects were found in Italy. His work is sometimes over-detailed.
Numerous exhibitions of his views of gardens were held at the Dowdeswell Galleries, and the Greatorex Galleries, London.

Examples: Birmingham City A.G.
Bibliography: *Connoisseur*, LIX, 1921.

ROWE, George 1797 (Dartmouth) – 1864 (Exeter)
A painter and lithographer who worked in Exeter, Sussex, Cheltenham and, from 1852 to 1859, Australia. He painted landscapes, coastal and topographical subjects.

Published: *Cheltenham and its Vicinity*, ?1840. *Rowe's Illustrated Cheltenham*, ?1850.
Examples: Exeter Mus.

ROWE, George James – 1883
A landscape painter who lived in London and Woodbridge. He exhibited from 1830 to 1862 and painted in Suffolk and Dorset.

ROWLAND, W see WINTER, Holmes Edwin Cornelius

ROWLANDSON, Thomas 1756 (London) – 1827 (London)
The son of a bankrupt wool and silk merchant, Rowlandson was educated at Dr. Barrow's School and entered the R.A. Schools in 1772. He made his first visit to Paris, where he had relatives, probably in 1774, and in 1777 he won a silver medal at the Academy. During the next two decades he made several Continental tours, visiting France, Italy, Germany and Holland, as well as travelling extensively in England and Wales. Sometimes he was accompanied by friends and fellow caricaturists such as H. Wigstead (q.v.) and J. Nixon (q.v.). He exhibited from 1775 to 1787, and in 1789 he received a comfortable legacy from an aunt, which he is traditionally said to have gambled away. From 1798 much of his work was for Ackermann, most notably for *The Tours of Dr. Syntax*, *The Microcosm of London*, *The Poetical Magazine* and *Johnny Quae Genus*. He revisited France in 1814 and Italy in about 1820, and he was working until almost the end of his life.
Much of his best work, including the large, complex scenes of London life, dates from the eighteenth century. However, his talents were more varied than is sometimes realized, and he produced many types of drawing, including Mortimer-like pen studies, both large and small caricature groups, sheets of classical figure studies, portraits – not necessarily caricatures – marine subjects and pure landscapes. His most recognisable work has knotty drawing with a reed pen and thin, but sometimes bright washes of colour. He probably never drew a beautiful human, and he very rarely used long lines in his figure drawing. There are many fake Rowlandsons and Rowlandson signatures, but in the genuine works there is always a facility and nervousness of line which sets them apart.

Examples: B.M.; V.A.M.; Aberdeen A.G.; Ashmolean; Birmingham City A.G.; Doncaster A.G.; Dudley A.G.; Exeter Mus., Fitzwilliam; Greenwich; Hertford Mus.; Abbot Hall A.G., Kendal; Leeds City A.G.; Leicestershire A.G.; City A.G., Manchester; N.G. Ireland; N.G., Scotland; Newport A.G.; Nottingham Univ.; Portsmouth City Mus.; Richmond Lib.; Ulster Mus.; Wakefield A.G.; Gt. Yarmouth Lib.; York A.G.
Bibliography: J. Grego: *R. The caricaturist*, 1880. A.P. Oppé: *T.R., drawings and watercolours*, 1923. O. Sitwell: *T.R.*, 1929. F.G. Roe: *R.*, 1947. A.W. Heintzelman: *Watercolour drawings of T.R.*, 1947. A. Bury: *R. Drawings*, 1949. B. Falk: *T.R., Life and Art*, 1949. J. Hayes: *R.*, 1972. *Burlington* XIV, October 1908. *Apollo* X, 1929; XXIII, 1936; XXXVI, 1943; LXXXVI, 1967. *Connoisseur* CXVIII, 1946. *Country Life*, October 27, 1950. *Antique Collector*, April 1956; April 1962.

ROYAL, Elizabeth, Mrs. Surtees
A landscape painter who exhibited under her maiden name from 1865 to 1870 and under her married name from 1873 to 1888. She painted in North Wales, Northumberland and Sussex. She married J. Surtees (q.v.).

RUDD, Agnes J
A painter of landscapes and rivers who exhibited from 1888 to 1926. She lived in Bournemouth.

RUDGE, Bradford 1805 — 1885 (Bedford)
A landscape painter in oil and watercolour, he was probably the son of EDWARD RUDGE, a Birmingham and Coventry artist who taught at Rugby School. He was an unsuccessful candidate for the N.W.S. in 1837 and again in 1863 and 1865. Also in 1837 he settled in Bedford where he was the first drawing master on the staff of the Harpur Schools. He exhibited in London from 1840 to 1883, as well as at the annual exhibition at the Bedford Rooms. He retired in about 1875, although he still taught some private pupils. Many of his summer holidays were spent in North Wales. Otherwise his subjects were generally taken from Bedford and Surrey.

Illustrated: *A short account of Buckden Palace*, 1839.
Examples: Cecil Higgins A.G., Bedford; Co. Record Office, Bedford; Bedford Mus.; Coventry A.G.

RUNCIMAN, Alexander 1736 (Edinburgh) — 1785 (Edinburgh)
Primarily a landscape painter in oil, he also made drawings, sometimes coloured, in the manner of Fuseli. He studied under John Norie and in 1766, with his brother John Runciman, himself an artist, left for Rome, where he met Fuseli. He returned to Edinburgh in 1771, and took a post as drawing master at the R.S.A. He received several commissions from Edinburgh patrons, among them Sir James Clerk of Penicuik, for whom he painted two ceilings. He made some etched adaptations of his works.

Examples: N.G., Scotland.

RUNDLE, Captain Joseph Sparkhall 1815 (Norfolk) — 1880
He joined the Navy as a midshipman in 1829 and was promoted lieutenant in 1839 after the taking of Aden. In 1840 he was present at the taking of Kowloon. From 1850 to 1854 he was at Malta, and he was appointed second-in-command of transports at the outbreak of the Crimean War, where he took part in the Battle of Balaklava. Shortly afterwards ruined health forced him to give up the sea, but he joined the Coastguard Service until 1865.

He spent some of his leaves in Norwich and studied under J.S. Cotman. His drawings from many parts of the world are predominantly of ships and harbours, and although attractive are a little lacking in strength.

RUSHOUT, Hon. Anne c. 1768 — 1849
The eldest daughter of the first Lord Northwick, she painted competent and pleasing views of Northwick Park. She was unmarried.

RUSKIN, John 1819 (London) — 1900 (Coniston)
The poet, painter, critic and social reformer. His artistic inclinations were fostered by his father, who had been a pupil of A. Nasmyth (q.v.). He also travelled widely with his parents in the British Isles and, from 1833, in Europe. His own drawing masters were A.V.C. Fielding (q.v.) and J.D. Harding (q.v.). As a critic Ruskin's greatest importance was in his championship of Turner and later the Pre-Raphaelites. Until 1888 he made frequent visits to the Continent, especially to France, Switzerland and Italy. He exhibited with the O.W.S. from 1873 to 1884 and was elected an Honorary Member.

His style is often very free and pleasing, and is greatly influenced by Turner.

Published: *Modern Painters*, 1843, 1860. *Stones of Venice*, 1851-3 Etc.
Examples: B.M.; V.A.M.; Haworth A.G., Accrington; Ruskin Galls., Bembridge; Williamson A.G., Birkenhead; Birmingham City A.G.; Fitzwilliam; Glasgow A.G.; Abbot Hall A.G., Kendal; City A.G., Manchester; Newport A.G.; Ruskin Mus., Sheffield; Ulster Mus.
Bibliography: R.H. Shepherd: *The Bibliography of R.*, 1879. W.G. Collingwood: *The art teaching of J.R.*, 1891. R.A. Wilenski: *J.R.*, 1933. J.H. Whitehouse: *R. the painter and his works at Bembridge*, 1938. P. Quennell: *J.R.*, 1949. J. Evans: *J.R.*, 1954. M. Lutyens: *Millais and the Ruskins*, 1967. A. Severn: *The Professor: A.S.'s Memoir of J.R.*, 1967. P.H. Walton: *The Drawings of J.R.*, 1972. Goodspeed & Co.: *Exhibition Cat.*, 1931. *Apollo*, LXVI, 1957, LXXVIII, August 1963; *Burlington*, CIV, 1962. *Country Life*, January 23, 1964. Abbott Hall A.G., Kendal: *Exhibition Cat.*, 1969.

RUSSEL, James — 1763 (Rome)
The son of a Westminster clergyman, he lived for more than twenty years in Rome, where he acted as a guide to English visitors.

Williams describes four landscapes in his collection as 'a little reminiscent of Taverner', and the B.M. have a view of Castle Campbell.

Published: *Letters from a Young Painter Abroad to his Friends in England*, 1748.

RUSSELL, Charles, R.H.A. 1852 (Dumbarton) — 1910 (Dublin)
A portrait painter in oil and watercolour, he was the second son of John Russell, a Scottish artist. He moved to Dublin in 1874 and worked for ten years painting portraits from photographs for Chancellor of Dublin. Afterwards he practised as a portrait painter proper. He exhibited at the R.H.A. from 1878, his first exhibits being landscapes. He was elected A.R.H.A. and R.H.A. in 1891 and 1893.

Examples: Aberdeen A.G.

RUSSELL, Janette Catherine
A figure, genre and flower painter who exhibited from 1868 to 1894 and lived in Surbiton.

Examples: V.A.M.

RUSSELL, Sir Robert FRANKLAND-
 See FRANKLAND, Sir Robert (-RUSSELL)

RUTHVEN, Mary, Lady 1789 — 1885
The daughter of Walter Campbell of Shawfield, she married James, Lord Ruthven in 1813. She painted a number of Greek views after Lusieri.

Examples: N.G., Scotland.

RYAN, Charles J
A flower and landscape painter who was Master of the Leeds School of Art. He exhibited from 1885 and also lived at Bushey and Ventnor, Isle of Wight.

Published: *Systematic Drawing and Shading*, 1868. *How to draw elementary forms*, 1882. *How to draw floral and ornamental designs*, 1882. *Egyptian Art*, 1893.
Examples: V.A.M.

RYDER, Emily
A figure and genre painter who exhibited with the Society of Female Artists, and at Suffolk Street from 1866 to 1874. She lived in London.

RYLAND, Henry, R.I. 1856 (Biggleswade) — 1924 (London)
A figure and genre painter, illustrator and stained glass designer, he studied at Heatherley's, South Kensington and Julian's. He exhibited at the Grosvenor Gallery, and at the R.A. and elsewhere from 1890. He worked for the *English Illustrated Magazine* and was elected R.I. in 1898. He lived in London. His work is in the manner of Alma-Tadema and A. Moore (q.v.).

Examples: City A.G., Manchester.
Bibliography: *Cassells Mag.*, CXCIV.

RYLAND, William Wynne 1732 (Wales) — 1783 (Tyburn)
An engraver and occasional draughtsman who was apprenticed to Francois Ravenet in London, studied in France and Italy, became a favourite of George III, made a fortune as a print-seller, lost it and was hanged for forgery.

He exhibited drawings with the Society of Artists in 1769 and a few at the R.A. In the B.M. there is a circular illustration for *Tom Jones* in pen and grey wash, with figures in the manner of Dayes.

Bibliography: *Authentic Memoirs of W.W. Ryland*, 1784.

RYLEY, Charles Reuben c. 1752 (London) – 1798 (London)

After studying engraving, he became a pupil of J.H. Mortimer (q.v.) and at the R.A. Schools. He became a drawing master and decorative painter and worked as an illustrator.

Examples: B.M.

RYMSDYK, Andrew 1786 (Bath)

A painter and engraver of Dutch descent who came to London in about 1767 and a few years later settled in Bath, where he remained, taking portraits and producing classical illustrations. A charming watercolour of children playing in a park is illustrated in a letter to *Country Life,* April 18, 1963.

He assisted his father, Jan van Rymsdyk, – who lived in Bristol from 1760 to 1770 – with the plates for various works, including *Museum Britannicum,* 1778.

SADLER, Kate
A flower painter in watercolour and occasionally oil. She lived in Horsham and was active between 1878 and 1894.

ST. AUBYN, Catherine, Mrs. Molesworth
1760 (London) – 1836 (Truro)
An amateur artist who made etchings after Reynolds and Opie. She also made drawings of Cornish scenery. She was the daughter of Sir John St. Aubyn, Bt., (1758–1839) and married her cousin, Rev. John Molesworth.

ST. JOHN, Edwin (or Edwina)
A prolific painter working in the 1880s and 1890s. He, or she, painted in Germany and Spain, but above all on the Italian Lakes.
An R. ST. JOHN, of Christ Church, Oxford, exhibited Scotch and Swiss views at Suffolk Street in 1855 and 1856, and GEORGINA ST. JOHN exhibited a view on the Devon coast there in 1873.

SALMON, John Cuthbert **1844 (Colchester) – 1917 (London)**
A landscape painter who worked in London, Southampton and Liverpool and exhibited from 1865. He painted in both oil and watercolour and his subjects were taken from North Wales, Scotland, Lancashire and on the Thames.

Examples: V.A.M.

SALMON, John Francis **c. 1814 – c. 1875**
A painter of coastal scenes, mainly in watercolour. He lived at Gravesend and exhibited at the R.A. in 1849 and 1853. His work, both in watercolour and oil, is competent and pleasing.

Examples: Greenwich.

SALT, Henry **1780 (Lichfield) – 1827 (Alexandria)**
Intended for a portrait painter, he took lessons from J. Glover (q.v.) and in 1797 went to London, where he became a pupil of J. Farington (q.v.) and Hoppner. In 1802 he set out for India and Ceylon with Lord Mountnorris, as secretary and draughtsman. They returned by Ethiopia and Egypt and arrived in England in 1806. In 1809 he was sent on an Embassy to Ethiopia, returning in 1811. He was appointed Consul-General in Egypt in 1815, going by way of Italy. There he sketched and excavated antiquities and haggled with the B.M.

Published: *Twenty-Four Views in St. Helena*, 1809. *A Voyage to Abyssinia*, 1814.
Illustrated: Lord Valentia: *Voyages and Travels to India*, 1809.
Examples: B.M.; India Office Lib.
Bibliography: J.J. Halls: *Life of S.*, 1834. *Country Life*, November 19, 1959.

SALTER, Anne G
A painter of still-lifes and animals who lived in Leamington and exhibited in London and Birmingham from 1869 to 1885.
EMILY K. SALTER, who exhibited in Birmingham in 1879 and 1881, was presumably her sister.

SALTER, John William
A landscape and coastal painter who lived in Torquay and was active from at least 1860. He exhibited local subjects, and one from

Scotland, at the S.B.A. from 1868 to 1875. An album of his sketches dating from about 1871 was sold at Sotheby's, January 31, 1974. It evidences visits to Portsmouth, the Isle of Wight, Brighton, Hastings, London, Yarmouth, Yorkshire, Northumberland, Ireland, Wales and Italy. It is probable that he should be identified with John William Salter, F.G.S., who worked on the Geological Survey of the United Kingdom and of Canada from the 1840s to the 1860s.

SAMUEL, George **– 1823**
He exhibited landscape watercolours at the R.A. from 1786 to 1823, scoring a great success with a view of the frozen Thames in 1789. He was a member of Girtin and Francia's Sketching Society in 1799, and was one of the first lithographers. He was killed by a collapsing wall.
He painted in both oil and watercolour. The watercolours owe much to P. Sandby (q.v.), but they are rather coarse, and the figure drawing is poor. He sketched in Cornwall, Westmorland and elsewhere.

Illustrated: Maurice: *Grove Hill*, 1799.
Examples: B.M.; V.A.M.; Fitzwilliam; City A.G., Manchester; Castle Mus., Nottingham.

SAMWORTH, Joanna **c. 1830 (Hastings) –**
The daughter of a Civil Servant and amateur artist who had been a pupil of H. Gastineau (q.v.). She took lessons from W.C. Smith (q.v.), spent six months in 1851-2 in the Paris studio of Henri Scheffer and was taught by J.S. Prout (q.v.), exhibiting for the first time – a pen drawing – at the R.A. in 1867.
As well as pen drawings she produced landscapes and flower studies in watercolour.

SANDBY, Paul, R.A. **1725 (Nottingham) – 1809 (London)**
Often misleadingly called 'the Father of English Watercolour', Sandby probably began his career as a drawing master in Nottingham in collaboration with his brother, T. Sandby (q.v.). In about 1742 they came to London and worked in the drawing room at the Tower, making military maps and plans. Paul was appointed draughtsman to the survey of the Highlands in 1746, and he worked in Scotland until 1751. Then he re-joined his brother at Windsor, helping with the landscaping of the Park as well as beginning his series of drawings and prints of the town and Castle. From 1768 to 1796 he was drawing master at the R.M.A., Woolwich, and in 1769 he was a Foundation Member of the R.A. He was a popular drawing master, and his pupils were mainly influential amateurs. They included Lord Harcourt, Lord de Tabley, Lord Maynard and Lady Elizabeth Lee (all q.v.). With some of them he travelled about the country. He went to Wales for the first time in about 1770 with Sir Watkin Williams Wynn, and later toured Wales again with Sir Joseph Banks. His few professional pupils included his son, M. 'A'. Rooker, P.S. Munn, J.C. Schnebbelie, J. Harding and J. Cleveley (all q.v.).
Early in his career, Sandby's drawing expresses the neatness and accuracy required of him in his military work. However, some of his Scottish drawings, notably sketches of views and characters in Edinburgh, show more imagination as well as careful observation. His figure drawing – which is never very good – is distinctly poor in these drawings. Later he developed the mannerism of over-elongating the body.
Sandby's importance lies in his landscapes, which had considerable influence on topographical painting in the second half of the century. His work is always neatly executed, as if for the engraver. He painted in both clear watercolour and in bodycolour, and sometimes mixed the two. In watercolour, a good Sandby shows the eighteenth century tinted style at its best. His pen and ink outlines are neat and not over-obtrusive. His colours are laid in layers over a base of grey. He drew foliage as a series of short curves either darker or lighter than the underlying colour. This mannerism was widely imitated. His favourite range of colour is blue-green and grey, set off by a touch of red, usually for a figure. Many of his paintings, especially in bodycolour, are on a large scale, the better to show up at Academy exhibitions. He should not be thought of as a mere topographer. He generally shows a real feeling for and understanding of the English countryside. He also produced a

number of purely imaginary drawings in the Italian romantic manner, in which he was probably influenced by the Canaletto sketches at Windsor Castle.

Sandby was the first professional in England, to use aquantint which had been brought over from France by the Hon. C. Greville (q.v.), one of his pupils.

Published: *A Collection of Etchings*, 1763. *The Virtuosi's Museum*, 1778.
Examples: B.M.; V.A.M.; Aberdeen A.G.; Haworth A.G., Accrington; Ashmolean; Birmingham City A.G.; Cartwright Hall, Bradford; Bridport A.G.; Coventry A.G.; Derby A.G.; Dundee City A.G.; Bowes Mus., Durham; Fitzwilliam; Glasgow A.G.; Greenwich; Inverness Lib.; Leeds City A.G.; Leicestershire A.G.; City A.G., Manchester; N.G., Ireland; N.G., Scotland; Newport A.G.; Castle Mus., Nottingham; Portsmouth City Mus.; Reading A.G.; Ulster Mus.; York A.G.
Bibliography: W. Sandby: *P. and T.S.*, 1892. A.P. Oppé: *The Drawings of P. and T.S. at Windsor*, 1947. *Gentleman's Mag.*, December, 1869. *Burlington*, LXXXVIII, June, 1946 (reprint of *Monthly Magazine*, June 1, 1811); CXIV, July, 1972.

SANDBY, Thomas, R.A. 1721 (Nottingham) − 1798 (Windsor)
After a brief period as a drawing master in Nottingham he moved to London with his younger brother, P. Sandby (q.v.), and was appointed a draughtsman at the Tower, and in 1743 to the Duke of Cumberland. He served in the Flanders campaigns of 1743 and 1745, was in Scotland during the '45 Rebellion, and in the Low Countries again from November 1746 to October 1748. On his return to England he was appointed Deputy Ranger of Windsor Great Park under the Duke, in which capacity he worked as an architect and landscape gardener as well as a topographical artist. He was a Foundation Member of the R.A. and its first Professor of Architecture. At Windsor he re-built Cumberland Lodge and was responsible for the development of Virginia Water. In London he designed Freemason's Hall, Lincoln's Inn Fields. He made many drawings of London architecture, the best known being views of the Covent Garden arcades.

In style he is confusingly close to his brother, but his convention of foliage drawing is even more stylized, consisting of tiny pen and ink double or triple loops drawn over his colour washes. His architectural drawing is naturally neat and accurate but it is sometimes a little lifeless. The figures in some foregrounds may have been contributed by his brother.

Examples: B.M.; V.A.M.; Ashmolean; Leeds City A.G.; N.G., Scotland; Castle Mus., Nottingham.
Bibliography: W. Sandby: *P. and T.S.*, 1892. A.P. Oppé: *The Drawings of P. and T.S. at Windsor*, 1947.

SANDBY, Thomas Paul − 1832
The second son and biographer of P. Sandby (q.v.), he claimed to be the only 'repository of his discoveries and peculiar methods of working in his art'. In 1797 he succeeded his father as drawing master at Woolwich. His biographical notice of Paul Sandby was published in the *Monthly Magazine* for June 1, 1811.

Examples: B.M.

SANDERS or SAUNDERS, John 1750 (London) − 1825 (Clifton)
The son of John Saunders, a pastellist, he studied at the R.A. Schools in 1769 and exhibited from 1771. In 1778 he moved to Norwich and in 1790 to Bath.

He worked in oil, pastel and watercolour and painted portraits, biblical subjects and landscapes. His watercolour landscapes are rather in the Sandby tradition.

His son JOHN ARNOLD SANDERS was born at Bath in about 1801, worked in London as a landscape painter and drawing master, and emigrated to Canada in 1832.

Examples: B.M.

SANDERS, T Hale
A painter of the London Thames and docks in oil and watercolour.

He lived in Balham and was active at least from 1874 to 1898, also painting in Holland and Scotland.

SANDERS, W
A genre and still-life painter, primarily in watercolour. He lived in London and exhibited at the S.B.A. from 1826 to 1838.

SANDYS, Anthony Frederick Augustus
 1829 (Norwich) − 1904 (London)
A follower of the Pre-Raphaelites, he was the son of ANTHONY SANDYS (1806−1883), a Norwich portrait painter. He studied at the R.A. Schools under G. Richmond (q.v.) and exhibited at the R.A. from 1851. In 1860 he was living with Rossetti, and he illustrated poems by Swinburne and Christina Rossetti, as well as working for *Once a Week, Good Words*, the *Cornhill Magazine* and other publications. He is best known for his female portraits, often in chalk, and his woodcuts, but among his watercolours perhaps the best are the landscapes and architectural subjects which he painted at the beginning of his career, in Norfolk. These are clean and assured and reminiscent of the best work of W. Callow (q.v.). In the bulk of his work he is a link between Pre-Raphaelitism and Art Nouveau.

Examples: B.M.; V.A.M.; Cartwright Hall, Bradford; Fitzwilliam; Leeds City A.G.; Ulster Mus..
Bibliography: *A.J.*, 1884; 1904.

SANT, James, R.A. 1820 (Croydon) − 1916 (London)
A portrait, figure and genre painter who was a pupil of J. Varley (q.v.) and A.W. Callcott (q.v.) and studied at the R.A. Schools. He exhibited at the R.A. from 1840 and was elected A.R.A. and R.A. in 1861 and 1870, retiring in 1914. He was appointed Painter in Ordinary to the Queen in 1871.

SARGENT, Frederick − 1899
A painter of genre subjects, miniatures and Venetian scenes. A series of his drawings of members of the House of Lords, c. 1880 to 1885, was exhibited at Tooth's Galleries in 1951.

SARGENT, G F
A painter of Warwickshire views in brown or coloured washes who was regarded as too bad to be put to the ballot for the N.W.S. in 1854. He lived in London.

Published: *Shakespeare Illustrated*, 1842.
Illustrated: T.L. Peacock: *Polite Repository*.
Examples: Castle Mus., Nottingham.

SARGENT, John Singer, R.A., R.W.S.
 1856 (Florence) − 1925 (London)
The son of an American doctor, he travelled widely in Europe and studied in Rome, Florence and Paris before settling in London in 1886. He became the most fashionable portrait painter of the age in both Britain and the United States, which he visited regularly. However he was also an enthusiastic landscape and architectural painter, and for this side of his work he turned increasingly to watercolour. He was elected A.R.A. and R.A. in 1849 and 1897 and R.W.S. in 1904.

His watercolours are dashing things, rapidly executed on damp paper with a mixture of clear colours and Chinese white. They are concerned with facts rather than impressions − he called them 'mere snapshots' − but they convey atmosphere brilliantly.

His remaining works were sold at Christie's, July 24 and 27, 1925.

Examples: B.M.; Cartwright Hall, Bradford; Fitzwilliam; Imp. War Mus.; City A.G., Manchester; N.G., Ireland; Tate Gall.
Bibliography: Mrs. Meynell: *The Work of J.S.S.*, 1925. W.H. Downes: *J.S.S.*, 1925. E. Charteris: *J.S.S.*, 1927. M. Hardie: *J.S.S.*, 1930. C.M. Mount: *J.S.S.*, 1957. R. Ormond: *S.*, 1970. *A.J.*, 1888. O.W.S. Club, III, 1925.

SARJENT, Francis James c. 1780 – 1812
He was awarded the Greater Silver Palette of the Society of Arts in 1800 for a drawing of a landscape near Reading. He exhibited at the R.A. in 1802 and entered the R.A. Schools in 1805. From 1810 to 1812 he made aquatints after J. Sillet (q.v.) for *The History of Lynn* by W. Richards. In 1811 he made prints of the Lake District from his own drawings.

Examples: V.A.M.; Reading A.G.

SARJENT, G R
A painter of churches and interiors who lived in London and exhibited at the R.A., B.I., N.W.S. and Suffolk Street from 1811 to 1849.

SASS(E), Richard 1774 – 1849 (Paris)
A landscape painter, Sass was descended from a Baltic family, his father having settled in London. He exhibited at the R.A. from 1791 to 1813 and was teacher of drawing to Princess Charlotte. He was appointed landscape painter to the Prince Regent. He worked for a time in Ireland, and in 1810 published a series of etchings of views in Ireland, Scotland and elsewhere. In 1825 he moved to Paris and altered his name to Sasse.

His work has usually suffered badly from fading, the predominant colours which remain being pink and ochre. His handling is rather woolly, but his drawings are often competent and pleasing.

His younger half-brother, HENRY SASS (1788–1844), was a landscape and portrait painter and the founder of the famous drawing school in Bloomsbury. He was in Italy from 1815 to 1817. He retired from the school in 1842. He published *A Journey to Rome and Naples,* 1818.

Examples: B.M.; V.A.M.; Hove Lib.; Newport A.G.; Beecroft A.G., Southend.

SAUNDERS, Charles L – 1915
A landscape painter who was working in Conway in the 1880s. Thereafter he lived a peripatetic life, moving to Liverpool, Chester, Tranmere, Oxton, Castle Douglas, Kirkcudbright, and finally to Birkenhead.

Examples: Bootle A.G.

SAUNDERS, John See SANDERS, John

SAYERS, James 1748 (Yarmouth) – 1823 (London)
A caricaturist. He worked as a lawyer's clerk in Yarmouth until he inherited a small fortune from his father. He came to London in about 1780 and drew large numbers of caricatures in favour of Pitt against Fox. They were published by the Brethertons, and are powerful but crude.

Published: *The Foundling Chapel Brawl,* 1804. *Elijah's Mantle,* 1806. *All the Talent's Garland,* 1807. *The Uti Possidetis,* 1807. *Hints to J. Nollekens, Esq.,* 1808.

SCALÉ Bernard
A Dublin surveyor and topographical draughtsman of Hugnenot descent, he assisted his brother-in-law John Rocque in preparing the Maps of Dublin City published in 1756. He also produced many maps of his own. He exhibited with the Dublin Society of Artists in 1766, 1767 and 1770. In 1767 Scalé published a series of five engravings of Parliament House after R. Omer (q.v.). In about 1770 he moved to London where he exhibited with the Incorporated Society in 1772, the Free Society in 1775 and the Exhibition of Arts and Sciences at the Royal Exchange in 1777.

Published: *Tables for the easy Valuing of Estates,* 1771.

SCANDRETT, Thomas 1797 (Worcester) – 1870
An architectural painter rather in the manner of D. Roberts (q.v.), he began as a portraitist. He exhibited from 1824, for the most part at Suffolk Street, where he described himself as a 'Teacher of Architecture and Perspective'. He painted in France and Belgium as

well as Britain, and he designed Eayri, the seat of E. Jones in Merionethshire. He lived in London.

Examples: B.M.; Coventry A.G.

SCANLAN, Robert Richard
A painter of figures and portraits of dogs and humans. He was probably Irish and was working in Plymouth in 1832 and London in 1842 and 1847, when he was an unsuccessful candidate for the N.W.S. He exhibited at the R.A. from 1839 to 1857.

SCAPPA, G A
A landscape and coastal painter who exhibited in London and Brighton from 1867 to 1886. He lived in London and worked in Yorkshire, Dorset, the Thames Valley, Sussex, Surrey, Derbyshire and Holland.

SCARTH, Dr. John
A Scottish doctor who was in China from 1847 to 1859. He made pencil and watercolour sketches of the Chinese people and landscapes.

Published: *British Policy in China,* 1860. *Twelve Years in China,* 1860. Etc.

SCHARF, George 1788 (Mainburg, Bavaria) – 1860 (London)
After studying in Munich and working as a miniaturist and drawing master, he left Germany in 1810. He escaped from Antwerp during the siege of 1814 and joined the British Army, with which he served at Waterloo, and in Paris after the occupation. He made many miniatures of his fellow officers. In 1816 he settled in London, and he became an acute observer of London life. He worked as a lithographer and exhibited watercolours at the R.A., Suffolk Street and elsewhere. He was a member of the N.W.S. from 1833 to 1836.

As well as topographical scenes and large watercolours of ceremonial occasions, he made thousands of sketches of incidents and figures in London streets. In his more finished work he is close to F. Mackenzie (q.v.). He sometimes inscribed both in English and German. He was the father of Sir G. Scharf (q.v.).

Examples: B.M.; V.A.M.

SCHARF, Sir George 1820 (London) – 1895 (London)
A draughtsman and Director of the N.P.G., he was the elder son of G. Scharf (q.v.). He was educated at University College School and studied at the R.A. Schools from 1838. In 1840 he went to Asia Minor with Sir Charles Fellows, also visiting Italy, and in 1843 he was a draughtsman to the government Asia Minor expedition. He was a prolific book illustrator. He taught at Queen's College, Harley Street, and became Secretary to the N.P.G. in 1857. In 1882 he was made Director. He was knighted a few months before his death.

Published: *Recollections of Scenic Effects,* 1839.
Examples: B.M.

SCHARTZBOURG, Princess of HESSE-
 See De TESSIER, Isabelle Emilie

SCHETKY, John Alexander
 1785 (Edinburgh) – 1824 (Cape Coast Castle)
An army surgeon, brother of J.C. Schetky (q.v.) and amateur artist. He was appointed assistant-surgeon in the 3rd Dragoon Guards with whom he served in the Peninsula. He was a member of the A.A. and entered the Trustees' Academy at the end of the war. He also exhibited at the R.A. and the O.W.S. He worked in the hospital at Fort Pitt, Chatham, and in 1823 was appointed deputy inspector of hospitals in West Africa. He died on arrival.

Examples: B.M.
Bibliography: *Biographical Sketch of the late J.A.S.,* ?1825.

SCHETKY, John Christian 1778 (Edinburgh) – 1874 (London)
The son of a Hungarian composor living in Edinburgh, and of Maria Reinagle, herself an artist. He took lessons from A. Nasmyth (q.v.) and by the age of fifteen was helping his mother to run a drawing

class for young ladies. After her death in 1795 he worked as a scene painter to support his family. In 1801 he walked to Rome where he met Henry IX. He returned through France. Thereafter he spent six years teaching undergraduates at Oxford, and in 1808 was appointed third drawing master at Marlow Military College. He began to exhibit with the A.A. in the same year. He visited his brother J.A. Schetky (q.v.) in Portugal in the winter of 1810. Soon afterwards he was appointed drawing master at Portsmouth Naval Academy, where he remained until 1836, when he was appointed assistant to T. Fielding (q.v.) at Addiscombe. He became Master of Civil Drawing on Fielding's retirement in 1850. He was Painter in Water-Colour to the Duke of Clarence and Marine Painter in Ordinary to George IV and Queen Victoria. He also painted in oil.

Published: *Reminiscences of the Veterans of the Sea*, 1867.
Illustrated: Duke of Rutland: *Sketches and notes of a cruise in South Waters*, 1850.
Examples: B.M.; Greenwich.
Bibliography: S.F.L. Schetky: *Ninety Years of Work and Play, a Life of J.C.S.*, 1877. *A.J.*, 1874.

SCHNEBBELIE, Jacob Christopher
1760 (London) — 1792 (London)
A pupil of P. Sandby (q.v.) and the son of a Swiss confectioner, in whose business he worked in Canterbury and Hammersmith, until he was appointed drawing master at Westminster. He also taught at other schools, after which Lord Leicester procured him the post of Draughtsman to the Society of Antiquaries. He made many drawings for *Vetusta Monumenta* and worked with J. Moore (q.v.) and G.I. Parkyns (q.v.) on *Monastic Remains and Ancient Castles in England and Wales*, 1791-2.
Like his son, R.B. Schnebbelie (q.v.), he was primarily a London topographer. He was a careful but uninspired draughtsman.

Published: *The Antiquarie's Museum*, 1791.
Bibliography: *Gentleman's Mag.*, 1792.

SCHNEBBELIE, Robert Blemmel — 1849
A son of J.C. Schnebbelie (q.v.), whose manner and subject matter he adopted. He exhibited at the R.A. from 1803 to 1821 and provided drawings for the *Gentleman's Magazine* and Wilkinson's *Londonia Illustrata*, 1808. He is said to have died of starvation.

Examples: B.M.; V.A.M.; Bishopsgate Inst.

SCHWARBRECK, Samuel Dukinfield
See SWARBRECK, Samuel Dukinfield
SCOTT, Amy
A painter of fruit, figures, landscapes and town scenes who lived in London and Brighton. She exhibited from 1860 and was still active in 1905. She painted in Normandy as well as in Britain.

Examples: Brighton A.G.; Hove Lib.

SCOTT, The Hon. Caroline Lucy, Lady
1784 — 1857 (Petersham, Surrey)
A novelist and landscape painter, she was the second daughter of the first Lord Douglas, and she married Admiral Sir George Scott in 1810. She was a pupil of J.S. Cotman (q.v.).

Published: *A Marriage in High Life*, 1828.
Examples: Glasgow A.G.

SCOTT, David, R.S.A. 1806 (Edinburgh) — 1849 (Nr. Edinburgh)
A son of the engraver Robert Scott, he studied at the Trustees' Academy and first exhibited at the R.S.A. in 1828, being elected R.S.A. in the following year. He was in Italy from 1832 to 1834. where he made anatomical studies in the Hospital for Incurables. His oil paintings and his illustrations are academic, and heroic in conception, if not in execution.
He was the elder brother of W.B. Scott (q.v.).

Illustrated: S.T. Coleridge: *The Ancient Mariner*, 1837. Prof. Nichol: *Architecture of the Heavens*, 1851. Etc.
Bibliography: W.B. Scott: *Memoir of D.S.*, 1850. J.M. Gray: *D.S. and his Works*, 1884. *A.J.*, 1849.

SCOTT, G.G., Lady See STUART, G.G. Villiers-

SCOTT, John, R.I. 1850 — 1918
A figure and genre painter who lived in London. He exhibited from 1860 and was elected R.B.A. in 1882 and R.I. in 1885.

SCOTT, John Henderson 1829 (Brighton) — 1886 (Brighton)
A landscape painter, he was the son of W.H.S. Scott (q.v.). He exhibited infrequently in London from 1849 and painted in Gloucestershire, on the Thames, in Normandy and Switzerland.

Examples: V.A.M.; Brighton A.G.

SCOTT, Mary, Mrs. Brookbank
The daughter of W.H.S. Scott (q.v.) and sister of J.H. Scott (q.v.), she lived in Brighton until her marriage in 1833. She was elected A.O.W.S. in 1823 and she specialised in flower pieces and occasional portraits of children. She exhibited at the O.W.S. only three times after her marriage and resigned in 1837. However she is said to have exhibited elsewhere until 1859.

SCOTT, Samuel c. 1702 (London) — 1772 (Bath)
An oil painter who also produced topographical and marine watercolours. He lived at Twickenham from 1749 to 1765 and many of his subjects are views on the Thames. In 1732 he was one of Hogarth's companions on the *Five Days' Perigrination* down the Thames, and he contributed two drawings to the manuscript illustrating the trip, which is in the B.M. In April, 1765 his collection of prints was sold by Langford, and according to his pupil S. Gilpin (q.v.), he moved to Ludlow where his married daughter was living, before retiring to Bath.
His figure studies are charming and fairly freely drawn. His topographical drawing shows neat penwork and often a characteristic reddish-pink for brickwork. Walpole calls him 'the father of marine watercolour painting'. W. Marlow (q.v.) was a pupil.
His remaining drawings and prints were sold by Langford in January, 1773.

Examples: B.M.; Greenwich; Whitworth A.G., Manchester.
Bibliography: A. Dobson: *Eighteenth Century Vignettes*, 1896. *Apollo*, XV, 1932. *Burlington*, LXXXI, August, 1942. *Country Life*, April 20, 1951.

SCOTT, Thomas, R.S.A., R.S.W. 1854 (Selkirk) — 1927 (Selkirk)
After working with his father as a tailor, he entered the R.S.A. Schools in 1877. He was elected A.R.S.A. in 1888 and R.S.A. in 1902.
He is noted for his workmanlike Border landscapes. He also painted figure subjects, and he worked only in watercolour.

Examples: Dundee City A.G.

SCOTT, Thomas John (Norwich) — (Norwich)
A landscape painter working at the end of the nineteenth and the beginning of the twentieth centuries. He worked for Messrs. J.J. King, artists and decorators of St. Andrews, for a while, and was Vice-President of the Norwich Art Circle.

SCOTT, Walter 1851 (Coventry) — 1925 (Coventry)
A landscape painter who studied and taught at the Coventry Art School before becoming Headmaster of the Norwich Art School. He painted in Gloucestershire, Wales and the Lake District as well as in Warwickshire and Norfolk and copied other artists such as Cotman. In his early days he also designed watch cases.

Examples: Coventry A.G.

SCOTT, William Bell
1811 (Edinburgh) — 1890 (Penkill Castle, Ayrshire)
A son of Robert Scott the engraver and younger brother of D. Scott (q.v.), he is best known for his poetry and writings on art, and for the large historical pictures with which he decorated such houses as Wallington Hall, home of Sir Walter Trevelyan, and Penkill Castle.

He received his first lessons in art from his father, after which he entered the Trustees' Academy. In 1831 he spent some months in London sketching in the B.M. He returned to Edinburgh and assisted his father in the engraving business. In 1837 he came to live in London, and he first exhibited at the B.I. in 1838 and the R.A. in 1842. In 1843 he was made Master of the Newcastle School of Design, which post he held for twenty years. From his return to London in 1864 until 1885 he was a decorator for the South Kensington Museums and an examiner in the Art Schools. He was a close friend of Rossetti.

His watercolours are merely an extension of his work in oil. They are thick and a little crude.

Published: *Antiquarian Gleanings in the North of England*, 1851. *Half-hour Lectures of the Fine and Ornamental Arts*, 1861. *Our British Landscape Painters*, 1872. *William Blake*, 1878. Etc.
Examples: B.M.; V.A.M.
Bibliography: *Autobiographical Notes of the Life of W.B.S.*, 1892.

SCOTT, William Henry Stothard, of Brighton, A.O.W.S.
1783 – 1850
Elected A.O.W.S. in 1810, Scott remained with the Society through all its changes of composition. He lived in Brighton and the majority of his subjects are Sussex views, with a few from Edinburgh and, between 1821 and 1831, from the North of France. From 1839 to 1850 he ventured more widely abroad, visiting the Meuse, the Moselle and the Pyrenees.

He was the father of M. Scott (q.v.) and J.H. Scott (q.v.).

Examples: B.M.; V.A.M.; Hove Lib.; City A.G., Manchester.

SCRUTON, Victor
A Birmingham painter of landscapes and buildings, sometimes in Northern France. He exhibited at Birmingham from 1880 to 1884.

SEABY, Allen William 1867 (London) – 1953 (Reading)
The son of a carpenter and cabinet-maker who settled in Godalming in the early 1870s. He studied at Isleworth and from 1887 lived in Reading. In 1910 he was appointed Headmaster of the School of Art, inaugurated with University College, of which he became a member of the Senate in 1926. He retired in 1933.

A keen naturalist, he made numerous highly accomplished watercolours and woodcuts of birds and animals. He frequently worked in bodycolour on fine stretched brown linen or thick toned paper.

Published: *Drawing for Art Students*, 1921. *Art in Ancient Times*, 1928. *Birds of the Air*, 1931. *British Ponies*, 1936. Etc.
Illustrated: F.B.B. Kirkman: *British Birds*, 1910-13.
Examples: Reading A.G.

SEATON, R
A topographer and aquatinter who was working in Aberdeen and the Lake District in 1805 and 1806. His work is solid and of good quality, although strictly conventional in the tinted manner. He used strong greens.

Examples: Aberdeen A.G.

SEDDON, Thomas 1821 (London) – 1856 (Cairo)
The son of Thomas Seddon, in whose furniture business he briefly worked. In 1841 he was sent to Paris to study design, and afterwards he made designs for furniture, one of which, in 1848, gained him a silver medal from the Society of Arts. In 1849 he visited Bettws-y-Coed, where he drew his first landscapes, and in the following year he sketched in the forest of Fontainebleau. In 1850 he helped establish a school of drawing for workmen, in Camden Town. He first exhibited at the R.A. in 1852. In 1853 he travelled to Dinan, and from there to Egypt to join Holman Hunt. He returned to England in 1855 but soon re-visited Egypt, and died of dysentery at Cairo. His work is highly detailed.

Bibliography: J.P. Seddon: *Memoirs and Letters of T.S., Artist*, 1858. J. Ruskin: *Speech on T.S. (Journal of the Society of Arts*, V, May, 1857). *A.J.*, 1857.

SELBY, Prideaux John
1788 (Alnwick, Northumberland) – 1867 (Twizell, Northumberland)
A naturalist who made 'coloured drawings remarkable for the delicacy of their execution and their truthfulness to nature'. After University College, Oxford, he lived in Northumberland, devoting himself to County duties and ornithology. In 1833 and 1834 he toured the North of Scotland. He was elected a Fellow of the Royal Society of Edinburgh and of the Linnaean Society, and he exhibited at the R.S.A. He sometimes engraved his own works.

Published: *Illustrations of British Ornithology*, 1821-34. with Sir W. Jardine: *Illustrations of Ornithology*, 1825-43. *British Forest Trees*, 1842. Etc.

SELLAR, Charles A , R.S.W. –1926
A portrait painter in oil and watercolour who was working from 1888. He lived in Perth.

Examples: Dundee City A.G.

SELOUS or SLOUS, Henry Courtney
1803 (Deptford) – 1890 (Beaworthy, Devon)
A genre, portrait and landscape painter, he was the son of an artist. He was a pupil of John Martin (q.v.), studied at the R.A. Schools and lived in London. He altered the spelling of his name from Slous to Selous in 1837. He exhibited from 1818 to 1885 and painted in many parts of Britain, including Wales, on the Rhine and in Switzerland. He also made illustrations, especially to Shakespeare, and was a printmaker and author, using the *noms de plume* 'Aunt Cae' and 'Kay Spen' for his children's books.

Examples: B.M.; Fitzwilliam.

SELWIN See IBBETSON, Sir John Thomas Selwin

SELWYN, George Augustus 1719 – 1791 (London)
Wit, politician, necrophiliac and occasional amateur artist.

Bibliography: *G.S.: his letters and his life*, 1899.

SERRES, Dominic, R.A. 1722 (Gascony) – 1793 (London)
A marine painter who ran away to sea and was captured by the British in about 1758, when serving on a Spanish ship. He was brought to England where he spent the remainder of his life. On his release from captivity he opened a shop to sell his own paintings, which included a few landscapes as well as marine subjects. He first exhibited at the S.A. in 1761 and was a Member of the Incorporated Society. He was a Foundation Member of the R.A. in 1768 and Librarian from 1792. He was a friend and neighbour of Paul Sandby, and he became Marine Painter to the King.

He produced both monochrome drawings in the manner of Van de Velde and watercolours in which a soft blue predominates. His drawings of both sorts are usually heavily outlined.

Examples: B.M.; V.A.M.; Fitzwilliam; Greenwich; City A.G., Manchester; N.G., Ireland.

SERRES, Dominic M
The second son of D. Serres (q.v.), he was a drawing master, and exhibited nine landscapes at the R.A. between 1778 and 1804. His handling is thick and his trees are stylized.

Published: with J.T. Serres: *Liber Nauticum*, 1805.
Examples: B.M.; V.A.M.; Ashmolean.

SERRES, John Thomas 1759 (London) – 1825 (London)
A marine painter and the eldest child of D. Serres (q.v.). He first exhibited at the R.A. in 1780, and in 1790 travelled through Paris, Lyons, Marseilles, Genoa, Pisa, Florence and Rome to Naples. He returned after a year to marry his former pupil, Olivia Wilmot, the self-styled Princess Olive of Cumberland (1772–1834), a novel writer and painter, from whom he obtained a divorce in 1804. In 1793 he succeeded his father as Marine Painter to George III, and was appointed Marine Draughtsman to the Admiralty. In 1818, hounded by his wife's creditors, he fled to Edinburgh, where he was

imprisoned, and attempted suicide. He gave drawing lessons from the prison until he was moved back to London shortly before his death.

His landscapes have the same overall blue-grey effect, with touches of yellow and pink, as his seascapes. His penwork is neat and traditional.

For some time after his return from Italy he signed himself Giovanni T. Serres.

Published: *The Little Sea-torch*, 1804 (a translation). With D.M. Serres: *Liber Nauticum*, 1805.
Examples: B.M.; V.A.M.; Williamson A.G., Birkenhead; Coventry A.G.; Fitzwilliam; Greenwich; N.G., Scotland.
Bibliography: *Memoirs of J.T.S.*, 1826.

SETCHEL, Sarah, R.I. 1803 (London) – 1894 (Sudbury, Middlesex)
A literary genre painter, she took lessons in miniature painting from L. Sharpe (q.v.) and drew in the B.M. and N.G. She first exhibited at the R.A. in 1831 and continued to exhibit there and at the S.B.A. until 1840. In 1841 she was elected to the N.W.S., exhibiting with them spasmodically until 1867 and resigning in 1886. She gave lessons to Mrs. Criddle (q.v.). Poor sight meant that she painted virtually nothing after the 1860s.

Examples: V.A.M.

SETTLE, William Frederick 1821 (Hull) – 1897
A pupil and cousin of John Ward, the marine painter, he became drawing master at the Mechanics Institute, Hull. On his marriage in 1863 he moved to London where his patrons included Queen Victoria, for whom he designed Christmas cards.

At his best his marine work can be confused with that of Ward, but his numerous watercolour views have been described as 'precious and exquisite' but 'slight and vacuous and little more than charming trifles'.

Examples: V.A.M.; Ferens A.G., Hull.

SEVERN, Ann Mary, Lady Newton 1832 (Rome) – 1866 (London)
The daughter of J. Severn (q.v.), who gave her early lessons, as did G. Richmond (q.v.). She studied in Paris under Ary Scheffer and became a popular portrait painter in oil and watercolour. In 1861 she married the Keeper of Classical Antiquities at the B.M. and thereafter spent much time copying the marbles. They travelled to Greece and Turkey where she also sketched.

Examples: B.M.

SEVERN, Joseph 1793 (Hoxton) – 1879 (Rome)
He served an apprenticeship to an engraver, meanwhile attending the R.A. Schools from 1815, where he gained a gold medal for an historical painting and later a travelling scholarship. In 1820 he accompanied his dying friend Keats to Rome, where, in 1828, he married the daughter of Lord Montgomerie. They returned to England in 1841. He exhibited at the R.A., the B.I. and the N.W.S. from 1817 to 1868. He had little success either as a painter or as an author, and he returned to Rome in 1861, succeeding his son-in-law, Charles Newton, as Consul. He retired in 1872, but remained in Rome.

His watercolours, taken in Rome and the Campagna, are much more pleasing and interesting than the grand historical and literary paintings with which he tried to make his name.

Examples: V.A.M.; Walsall A.G.
Bibliography: W. Sharp: *Life and Letters of J.S.*, 1892. Lady Birkenhead: *Against Oblivion: the Life of J.S.*, 1943. H.E. Rollins: *The Keats Circle*, 1948. *A.J.*, 1879.

SEVERN, Joseph Arthur Palliser, R.I.
** 1842 (Rome) – 1931 (London)**
The younger son of J. Severn (q.v.), he studied in Rome from 1862 to 1864 and in Paris in 1868. He exhibited at the R.A. from 1863, was an unsuccessful candidate for the N.W.S. in that year and was elected R.I. in 1882. In 1872 he went to Italy with J. Ruskin (q.v.) and A. Goodwin (q.v.), and nine years later he married Ruskin's

niece. Later he lived at Brantwood, Coniston, Ruskin's old house. Many of his landscapes were painted in the Lake District.

Illustrated: M. Corelli: *The Devil's Motor*, 1910.
Examples: B.M.

SEVERN, Walter 1830 (Rome) – 1904 (London)
The elder son of J. Severn (q.v.), he was educated at Westminster and spent a period in the Civil Service. He then became a designer and landscape painter, collaborating with Sir. C.L. Eastlake (q.v.) and exhibiting from 1853. He was a founder of the Dudley Gallery in 1865 and later its President. An exhibition of his work was held at Agnew's in 1874.

Illustrated: Lord Houghton: *Good Night and Good Morning*, 1859.
Examples: V.A.M.

SEWELL, Ellen Mary
** 1813 (Newport, Isle of Wight) – 1905 (Isle of Wight)**
Educated at Miss Crook's School in Newport and Miss Aldridge's in Bath, she moved to Pidford, Isle of Wight, on the death of her father in 1842. There she and her sister Elizabeth ran a school for their numerous young relations and others from 1851 to 1891. Ellen taught music, singing and drawing. She also wrote novels and produced many watercolour and pencil views of the island, and may be taken as the archetypal Victorian spinster amateur artist.

Published: *Sailors' Hymns*, 1883 (3rd Ed.)
Illustrated: W. Sewell: *Sacred Thoughts in Verse*, 1885.

SEYFFARTH, Louisa, Mrs. See SHARPE, Louisa

SEYMOUR, Hariette Anne
** 1830 (Marksbury Rectory, Somerset) –**
A coastal and moorland painter in watercolour and oil who was advised by Dr. J. Harrison (q.v.) and in 1863 studied under Verveis in Brussels. Her career was constantly interrupted by ill health which prevented her from completing her courses at the R.A. Schools. Many of her subjects were found on Dartmoor and in Cornwall, where she had a cottage at Porthleven. Her sketches were often done in crayons.

SEYMOUR, Robert George 1836 (Dublin) – 1885 (Clifton)
A clerk in the office of the Church Temporalities Commission, Dublin, he exhibited, mainly coastal scenes, at the R.H.A. On his retirement he moved to England.

His sister KATE SEYMOUR was a modeller and painted in oil and watercolour.

Examples: N.G., Ireland.

SHACKLETON, William
** 1872 (Bradford, Yorkshire) – 1933 (London)**
A landscape, figure and portrait painter in oil and watercolour who studied at South Kensington, and in Paris and Italy on a travelling scholarship in 1896. From 1905 he worked mainly in London, making frequent sketching tours around Amberley with his friend W.E. Stott (q.v.). On the outbreak of war he took a cottage at Malham, Yorkshire.

His paintings are the products of a powerful, romantic imagination. His main inspiration was Turner, and this can be seen particularly in his later works, in which he became obsessed with colour. One-man shows were held at the Goupil Gallery in 1910 and the Leicester Gallery in 1922.

Examples: Cartwright Hall, Bradford; City A.G., Manchester.

SHALDERS, George, N.W.S. 1826 (Portsmouth) – 1873 (London)
A landscape painter who first exhibited at the R.A. and Suffolk Street in 1848. He was elected A.N.W.S. in 1863, and a member in the following year, and he exhibited exclusively with the N.W.S. thereafter.

His views are generally taken from Hampshire, Surrey, Yorkshire, Ireland and Wales. They often contain sheep or cattle.

Examples: V.A.M.; Blackburn A.G.; City A.G., Manchester; Portsmouth City Mus.

SHANNON, Charles Hazelwood, R.A.
1863 (Sleaford, Lincolnshire) – 1937
A painter of subject pictures and portraits, who rarely ventured to try watercolour except as an aid for preparatory drawings and occasional Conder-like fan designs. He did however exhibit two figure subjects at Suffolk Street in 1887. In his earlier days he signed with full initials, later with 'C.S.' only.

Examples: B.M.; Leicestershire A.G.
Bibliography: E.B. George: *C.S.*, 1924. *A.J.*, 1902.

SHARP, Michael William **(London) – 1804 (Boulogne)**
A painter of portraits and humorous genre, he studied under Sir William Beechey and at the R.A. Schools. He was a member of the Sketching Society in 1808. By 1813 he was living with, and taking lessons from, J. Crome (q.v.) at Norwich, where he remained until about 1820. He also painted theatrical groups. He worked in oil and occasionally watercolour.

SHARPE, Charles Kirkpatrick
1781 (Hoddam Castle) – 1851 (Edinburgh)
The son of CHARLES SHARPE of HODDAM, an occasional amateur artist. He was destined for the Church, but after Christ Church – where he spent his time in antiquarian research – he lived in Edinburgh, devoting himself to drawing and writing, mainly ballads. He drew caricatures, vignettes and grotesques and was an etcher.

Published: *The Etchings of C.K.S.*, 1869. Etc.
Examples: B.M.; N.G., Scotland.
Bibliography: A. Allardyce: *C.K.S.'s Letters*, 1868.

SHARPE, Charlotte, Mrs. Morris c. 1794 (London) – 1849
The eldest child of William Sharpe, a Birmingham engraver, she exhibited portraits in the Lawrence chalk and watercolour manner from 1817. She married Captain Morris in 1821.

SHARPE, Eliza, O.W.S.
c. 1795 (Birmingham) – 1874 (Burnham Beeches)
The second daughter of William Sharpe, like her sister L. Sharpe (q.v.) she began as a miniaturist, and, turning to a larger form of watercolour painting, was elected a Lady Member of the O.W.S. in 1829. They both began to exhibit portraits at the R.A. in 1817 and lived together until 1834. In her last years she made watercolour copies of pictures in the V.A.M., her last productions being Raphael's cartoons. She retired from the O.W.S. in 1872.

She was a woman of forceful character despite her works, which bear titles like 'The New Mamma', 'The Dying Sister' and 'The Little Dunce'.

Examples: B.M.

SHARPE, John
A pupil of J. Varley (q.v.) in about 1814, and a friend of his fellow pupil F.O. Finch. He may be identifiable with J.F. SHARPE, a painter of watercolour portraits who worked in London and Southampton and exhibited from 1826 to 1838.

SHARPE, Louisa, Mrs. Seyffarth, O.W.S.
1798 (Birmingham) – 1843 (Dresden)
The third daughter of William Sharpe. The family moved to London in about 1816, and she began to paint miniatures. She exhibited at the R.A. from 1817 to 1829, when she was elected a Lady Member of the O.W.S. In 1834 she married Professor Seyffarth of Dresden, where she lived for the rest of her life, continuing to send contributions to the O.W.S. exhibitions.

After her election to the O.W.S. she turned from miniatures to sentimental and literary illustrations, many of which were used in the Annuals. She was the most proficient of the family.

Her daughter AGNES SEYFFARTH occasionally exhibited drawings at the R.A. and Suffolk Street between 1850 and 1859.

SHARPE, Mary Anne **1802 (Birmingham) – 1867**
The youngest daughter of William Sharpe, she exhibited portraits and genre scenes at the R.A. and later the S.B.A., of which she was made an Honorary Member in 1830. She lived in London.

SHARPLES, James 1825 (Wakefield, Yorkshire) – 1893
A portrait painter, he was put to work, while young, in his father's foundry at Bury, where he practised drawing by making copies of engravings, and, at the age of sixteen, attending drawing classes at the Bury Mechanics' Institute. He gave up work at the foundry to devote himself to art, but, unable to sustain himself by painting, was forced to return to it.

Bibliography: J. Baron: *J.S., blacksmith and artist,* (n.d.)

SHAW, Henry, F.S.A.
1800 (London) – 1873 (Broxbourne, Hertfordshire)
An architectural draughtsman, engraver, illuminator and antiquary, he made drawings of Wells and Gloucester for Britton's *Cathedral Antiquities*. He was elected F.S.A. in 1833.

For most of his life he was engaged upon drawing and engraving the plates for his numerous works.

Published: *The History and Antiquities of the Chapel at Luton Park*, 1829. *Examples of Ornamental Metal Work*, 1836. *The Encyclopaedia of Ornament*, 1842. *Dresses and Decorations of the Middle Ages*, 1843. *The Arms of the Colleges of Oxford*, 1855. *Handbook of the Art of Illumination as practised during the Middle Ages*, 1866. Etc.
Illustrated: Longman: *New Testament*, 1864.

SHAW, John Byam Liston, R.I. 1872 (Madras) – 1919 (London)
A Pre-Raphaelite follower, designer and illustrator, he came to England in 1878. He studied at the St. John's Wood School of Art and the R.A. Schools. He painted genre subjects in oil, previously, like Burne-Jones, producing meticulous figure studies in pencil or watercolour. His pure watercolours and illustrations sometimes show a Japanese, as well as an Art Nouveau, influence. He was elected R.I. in 1898.

Illustrated: R. Browning: *Poems*, 1898. J. Bunyan: *Pilgrim's Progress*, 1904. Etc.

SHEFFIELD, George, Yr.
1839 (Wigton, Cumberland) – 1892 (Manchester)
A nephew of the portrait painter George Sheffield, who gave him his first lessons. His family moved first to Warrington, where he was taught by Sir S.L. Fildes (q.v.), and later to Manchester, where he was apprenticed to a firm of calico printers and studied at the School of Art. He went to sea for some years, sailing several times across the Atlantic and to Holland, before settling in Bettws-y-Coed in 1861 as a landscape and marine painter. He was elected a member of the Manchester Academy in 1871 and exhibited at the R.A. from 1873 to 1878.

He worked in both oil and watercolour and is best remembered for his monochrome coast scenes, which were well thought of in their day.

Examples: B.M.; Carlisle City A.G.; City A.G., Manchester; Warrington A.G.

SHELLEY, Arthur 1841 (Great Yarmouth) – 1902 (Torquay)
The brother of J.W. Shelley (q.v.), he produced sentimental, high-Victorian landscapes. He exhibited at the R.A. and elsewhere from 1875 to 1888 and lived in Plymouth and London before settling in Torquay.

SHELLEY, John William 1838 (Great Yarmouth) – 1870
A good amateur watercolourist who travelled fairly widely in England in the 1860s. He was in London in 1862, the Isle of Man in 1863, Cornwall in 1864, the Lake District in 1865, Norfolk and Devon in 1866, Kent in 1867, Windsor and the London area in 1868-9 and Plymouth in 1870. He was the brother of A. Shelley (q.v.).

SHELLEY, Samuel, O.W.S. 1750 (London) – ?1808 (London)
He began as a miniaturist and portraitist, but gradually developed into a subject and figure painter as well, often working on large sheets of ivory. He was a Founder Member of the O.W.S., but probably died in 1808 (some authorities say 1810) so that this contribution was not great. He made a number of drawings for book illustrations and prints, and may have been his own engraver on occasions.

Examples: B.M.; V.A.M.
Bibliography: O.W.S. Club, XI, 1934.

SHEPHARD, Henry Dunkin
A genre, architectural and landscape painter in oil and watercolour who lived in London and was active between 1885 and 1899.

SHEPHEARD, George 1770 (Herefordshire) – 1842
A landscape and rustic painter, he studied at the R.A. Schools and exhibited at the R.A. and elsewhere from 1811 to 1842. He was also a mixed medium engraver. His favourite counties were Surrey and Sussex. He may also have visited Ireland in 1807 and Wales in 1825, and he was in France in 1816. He was a good caricaturist in a free linear style.

Published: *Vignette Designs*, 1814-15.
Examples: B.M.; Leeds City A.G.

SHEPHEARD, George Wallwyn 1804 – 1852 (Brighton)
The elder son of G. Shepheard (q.v.), he travelled widely on the Continent and in 1838 married an Italian at Florence. He exhibited French and Italian views and free studies at the R.A. from 1837 to 1851.

SHEPHEARD, Lewis Henry
The younger son of G. Shepheard (q.v.), he painted landscapes in Britain and on the Rhine. Windsor Park provided him with many subjects. He exhibited from 1841 to 1875.

SHEPHERD, George c. 1782 – c. 1830
He won the silver palette of the Society of Arts in 1803 and 1804, and is best known for his topographical and architectural drawings of London. He drew for Wilkinson's *Londina Illustrata*, 1808, W.H. Ireland's *History of the County of Kent*, 1829-30, Britton's *Beauties of England and Wales*, etc. Occasionally he painted pure landscapes.

Examples: B.M.; V.A.M.; Carisbrooke Cas. Mus.; Grosvenor Mus., Chester; Greenwich; Islington Lib.; City A.G., Manchester; Newport A.G.; Castle Mus., Nottingham; Reading A.G.; Richmond Lib.

SHEPHERD, George Sidney, N.W.S. – 1861
A son of G. Shepherd (q.v.), in whose style he worked. He shows, however, greater breadth and variety of subject matter. He exhibited at the R.A., Suffolk Street and elsewhere from 1830 to 1858 and was a Founder Member of the N.W.S. in 1831. There was a move to expel him in 1850 for non-payment of dues, but he was found to be in dire poverty and made an Honorary Member. He was granted a pension in 1860, when he was bedridden. He drew for C. Clarke's *Architectura Ecclesiastica Londini* and W.H. Ireland's *England's Topographer*.

Examples: B.M.; V.A.M.; Banbury Lib.; Islington Lib.; Maidstone Mus.; Newport A.G.; Castle Mus., Nottingham; Gt. Yarmouth Lib.

SHEPHERD, Thomas Hosmer – 1840
A son of G. Shepherd (q.v.) and possibly the most talented of the family. He worked for F. Crace (q.v.), taking views of London buildings under threat of demolition. He provided illustrations for Britton's *Bath and Bristol*, 1829–31, among other works.

His sons VALENTINE CLAUDE SHEPHERD and FREDERICK SHEPHERD both carried on the family tradition in an undistinguished fashion.

Illustrated: J. Elmes: *Metropolitan Improvements*, 1827. J. Elmes: *London and its Environs in the Nineteenth Century*, 1829. J.

Britton: *Modern Athens Displayed, or Edinburgh in the Nineteenth Century*, 1829. J. Britton: *Bath and Bristol*, 1829–31.
Examples: B.M.; V.A.M.; Victoria A.G., Bath; Bishopsgate Inst.; Chelsea Lib.; Towner Gall, Eastbourne; Fitzwilliam; Greenwich; India Office Lib.; Islington Lib.; Kensington & Chelsea Lib.; Newport A.G.; Shoreditch Lib.

SHEPPARD, Philip 1838 – 1895
The son of Philip Sheppard of Bathampton Manor, near Bath, he exhibited landscapes, some from Cornwall, at the R.A., Suffolk Street and elsewhere from 1861 to 1866. He went blind at the age of thirty.

Examples: V.A.M.; Blackburn Mus.; Maidstone Mus.

SHEPPERSON, Claude Allin, A.R.A., A.R.W.S.
 1867 (Beckenham) – 1921 (London)
A landscape and figure painter, illustrator and etcher, he was educated privately and turned from the law to art. He studied in Paris and London and worked for *Punch* as a theatrical designer. He was a Member of the R.I. from 1900 to 1905 and was elected A.R.A. in 1919 and A.R.W.S. in 1920. His landscapes, which are mostly from early in his career, are often of mountains and moors.

Examples: V.A.M.; Leeds City A.G.
Bibliography: *A.J.*, 1898.

SHERINGHAM, George 1884 (London) – 1937
A decorative painter and theatrical designer who painted fan designs in the manner of C. Conder (q.v.). He studied at the Slade and in Paris and also produced book illustrations.
 An exhibition of his watercolours of Devon, Sussex and Bruges was held at the Brook Street Art Gallery in 1908.

Illustrated: Sir M. Beerbohm: *The Happy Hypocrite*, 1918. R.B. Sheridan: *The Duenna*, 1925. Etc.
Examples: B.M.; Fitzwilliam; City A.G., Manchester.

SHERLOCK, William P c. 1780 – c. 1821
The son of William Sherlock, a portrait painter and engraver. He exhibited portraits and Wilson-like landscapes in watercolour at the R.A. from 1800 to 1820. He produced many London views and published a series of soft ground etchings from his own drawings and those of Cox, Prout, Girtin and others from 1811.

Illustrated: Dickinson: *Antiquities of Nottinghamshire*, 1801–6.
Examples: B.M.; V.A.M.; Williamson A.G., Birkenhead; Leeds City A.G.

SHERRIN, John, R.I. 1819 (London) – 1896 (Ramsgate)
A fruit and flower painter who was one of William Henry Hunt's few known pupils. He was apprenticed to Samuel Smith, a jeweller, and later worked for the designers Howell & James and the diamond merchants Matthews & Peake. He was left a considerable fortune by Matthews. He exhibited from 1859 until his death and was elected A.N.W.S. and N.W.S. in 1866 and 1879. A number of chromo-lithographs were made from his works.
 DANIEL SHERRIN, the landscape and shipping painter in oil and watercolour, who lived near Whitstable and was active between 1890 and 1912, may have been a relative.

Examples: V.A.M.; Aberdeen A.G.; Blackburn A.G.; Cartwright Hall, Bradford; City A.G., Manchester; Ulster Mus.

SHERWIN, John Keyse
 c. 1751 (East Dean, Sussex) – 1790 (London)
A wood-cutter on the Mitford estate near Petworth. The family encouraged him to draw, and sent his first effort to the Society of Arts, who awarded it a silver palette. He studied painting under John Astley and engraving under Bartolozzi until 1774 and also attended the R.A. Schools. He exhibited chalk drawings and other rather weak offerings at the R.A. from 1774 to 1784. He became a successful engraver, indeed Engraver to the King, but died in poverty.

Examples: B.M.

SHIELDS, Frederick James, A.R.W.S.
1833 (Hartlepool) – 1911 (Merton, Surrey)
A Pre-Raphaelite follower who in 1847 started working for a commerical lithographer. He became a book illustrator, making drawings for *Pilgrim's Progress* and other works. In 1865 he was elected A.O.W.S. He decorated many churches and chapels in fresco, and in 1889 went to Italy to gather material for his frescoes in the Chapel of the Ascension, Shields. His landscape watercolours are often taken from Devonshire.

Examples: B.M.; Dudley A.G.; Fitzwilliam; Gray A.G., Hartlepool; City A.G., Manchester
Bibliography: E. Mills: *The Life and Letters of F.S.,* 1912. *A.J.,* 1902.

SHIPLEY, William **1714 (Maidstone) – 1803 (Maidstone)**
The founder of the Society of Arts and a celebrated drawing master. He taught drawing in Northampton for some years before coming to London in about 1750 and setting up his Academy. Among his pupils were Cosway, Pars and Wheatley. From 1754 to 1760 he was deeply involved in the establishment of the Society of Arts, and from 1768 with a similar Society in Maidstone.

SHOOSMITH, Thurston Laidlaw
1865 (Northampton) – 1933 (Northampton)
A solicitor turned landscape painter in oil and watercolour. He was a member of the R.B.A. and lived in Northamptonshire.

Examples: V.A.M.; Leeds City A.G.

SHORE, Commander, The Hon. Henry Noel
See TEIGNMOUTH, 5th Baron

SHORT, Obediah **1803 (Norwich) – 1886 (Norwich)**
Primarily an oil painter in the Crome manner, he also produced watercolours which are typical of the second generation of Norwich painters. However, they are not of the quality of those of J. Stark (q.v.) or J. Middleton (q.v.).

Examples: Castle Mus., Norwich.

SIBSON, Thomas
1817 (Cross Canonby, Cumberland) – 1844 (Malta)
He came to London in 1838, after a brief flirtation with business in Edinburgh, and established himself as an illustrator of Dickens and Scott. In 1842 he went to Munich to study under Kaulbach, but, being consumptive, returned home in 1844. He died at Malta when trying to recover his health.

Examples: B.M.; V.A.M.

SIDDAL, Elizabeth Eleanor
See under ROSSETTI, Gabriel Charles Dante

SIGMUND, Benjamin D
A landscape and figure painter who exhibited from 1879 to 1903. He lived at Burnham and in London and painted in Devon, Cornwall and Wales as well as in Berkshire and Buckinghamshire.

Published: *Among the Reeds and Grasses,* 1888. *By the Sea Shore,* 1888.

SILLETT, Emma
The daughter of J. Sillett (q.v.), she exhibited still-lifes of fruit, flowers, shells, butterflies and the like at Norwich from 1813 to 1833.

Examples: Castle Mus., Norwich.

SILLETT, James **1764 (Norwich) – 1840 (Norwich)**
After working as a heraldry painter in Norwich, he enrolled at the R.A. Schools and then worked as a scene painter at Drury Lane. He moved to King's Lynn in 1801, and returned to Norwich in 1810. He was President of the Norwich Society in 1816 and was one of the leaders of the secession in that year. He stands apart from the main body of Norwich artists since he was primarily an academic flower painter. He did, however, produce a few landscapes.

Examples: B.M.; V.A.M.; King's Lynn A.G.; Castle Mus., Norwich.

SIMKIN, Richard **1840 – 1926 (Herne Bay)**
A prolific military painter who worked in Aldershot. As well as many watercolours of uniforms and military occasions, he painted recruiting posters and illustrations for the *Army and Navy Gazette.* In style he stands between H.T. Alken (q.v.) and O. Norie (q.v.)

Published: *The Boy's Book of British Battles,* 1889. *Our Armies,* 1891. *Where Glory Calls,* 1893. Etc.
Examples: India Office Lib.; Nat. Army Mus.

SIMMS, G
A landscape painter working in London, Kent and Italy in the 1870s. His work is a little like that of A.J.C. Hare (q.v.). He may be identifiable with G. H. SIMMS of Bath who exhibited a hurdle-making scene at Suffolk Street in 1864.

Examples: V.A.M.

SIMPSON, Francis **1796 – 1865 (Stamford)**
An antiquarian and amateur draughtsman who painted studies of church architecture.
O. N. SIMPSON, who painted flower studies and landscapes in Rutland, and who exhibited at Suffolk Street in 1829, was a relation.

Published: *A series of ancient Baptismal Fonts,* 1828.

SIMPSON, Henry **1853 (Nacton, Suffolk) – 1921 (London)**
A genre, landscape and coastal painter who lived in London and exhibited from 1875. He also lived in Suffolk and painted in Holland and Normandy. An exhibition of his work, including architectural and oriental subjects, was held at the Leicester Galleries in April, 1910.

Examples: Brighton A.G.

SIMPSON, William, R.I. **1823 (Glasgow) – 1899 (London)**
After working in an architect's office, he was apprenticed to a Glasgow firm of lithographers. He moved to London in 1851 and worked for Day & Son. He was sent to the Baltic by Colnaghi to record the naval battles at the beginning of the Crimean War, and in 1854 was sent to the Crimea itself. He also toured Circassia with the Duke of Newcastle. He was sent next to India, where he spent three years and even penetrated Tibet. In 1866 Day & Son went bankrupt and his drawings were taken as assets of the firm. This led to his employment by the *I.L.N.,* who sent him to Russia, which he also toured with the Prince of Wales. On his return journey he went to Jerusalem. In 1868 he was with Napier's Abyssinia expedition, and he was at the opening of the Suez Canal in 1869. In 1870 he covered the Franco-Prussian War and the following year the Commune. In 1872 he went to China for the wedding of the Emperor, subsequently visiting Japan and returning across America. He was in India with the Prince of Wales in 1875, Asia Minor in 1877 and Afghanistan in 1878-9 and 1884-5. He then settled at Willesden and devoted himself to writing. He was elected A.N.W.S. and N.W.S. in 1874 and 1879 and was instrumental in the Society's gaining the Royal Charter in 1884.

Although chiefly thought of as a black and white artist in his own day, Simpson was a fine colourist, using clear washes of watercolour and well-balanced body-colour. His draughtsmanship is excellent, if a little old-fashioned with its stress on outlining. He also painted occasionally in oil.

Published: *Illustrations of the War in the East,* 1855-6. *Meeting the Sun,* 1873. *Picturesque People,* 1876. *Shikar and Tamasha,* 1876. *The Buddhist Praying Wheel,* 1896. *The Jonah Legend,* 1899. *Glasgow in the Forties,* 1899. *Autobiography,* 1903.
Examples: B.M.; V.A.M.; Glasgow A.G.; Greenwich; Paisley A.G.

SIMS, Charles, R.A., R.W.S.
1873 (London) – 1928 (St. Boswells, Roxburghshire)
A landscape and genre painter and an illustrator who studied at South Kensington, in Paris and at the R.A. Schools. He exhibited at the R.A. from 1894, was elected A.R.A. and R.A. in 1908 and 1915 and was Keeper from 1920. He was elected A.R.W.S. and R.W.S. in 1911 and 1914. He revisited Paris in 1903 and worked elsewhere on the Continent and in Britain. In about 1926 he went mad, and he committed suicide two years later.

Examples: B.M.; Cartwright Hall, Bradford; Leeds City A.G.; City A.G., Manchester.
Bibliography: A. Sims: *Picture Making*, 1934.

SIMS, G , N.W.S. **–1840**
A painter of landscapes and London views who exhibited from 1829 to 1840 and was a member of the N.W.S. in 1835. He lived in London and worked in the Home Counties, the Isle of Wight and Flanders.

SIMSON, William, R.S.A. 1800 (Dundee) – 1847 (London)
A portrait and coastal painter who studied at the Trustees' Academy and exhibited for the first time in 1826. He visited the Low Countries in 1827 and was elected R.S.A. in 1830. In the 1830s he spent three or four years studying in Italy, and on his return he settled in London.
His small coastal scenes for the most part date from early in his career.

Examples: V.A.M.; Williamson A.G., Birkenhead.

SINCLAIR, John
A landscape, architectural and genre painter who lived in Liverpool and worked in oil and watercolour. He exhibited in London and Bootle from 1872 to 1890.

SINGLETON, Henry 1766 (London) – 1839 (London)
Brought up by his uncle, the miniaturist William Singleton, he entered the R.A. Schools and first exhibited at the R.A. in 1784. He became a successful portrait and historical painter, but failed to be elected R.A. He did many book illustrations, and numerous engravings were made of his work, especially of his later sentimental pictures.
His sisters, SARAH MACKLARINAN SINGLETON and MARIA M. SINGLETON, were both portrait painters.

Examples: B.M.; V.A.M.; Ulster Mus.

SKEAF, D
A painter who was working in Scotland in 1803 and 1806 and who exhibited London views and landscapes from 1807 to 1819. His style is sometimes reminiscent of that of F. Nicholson (q.v.).

Examples: B.M.

SKELTON, John c. 1735 – 1759
A landscape painter who worked at Croydon in 1754, London and Rochester in 1757, and was in Rome in 1758. He is said to have been a footman to the Archbishop of Canterbury.
His palette is limited to pale blues, browns and greens, and his handling is close to that of W. Taverner (q.v.), but with a looser treatment of the foliage and sometimes a jagged pen outline to the palest areas. He is sometimes called 'Jonathan'.

Examples: B.M.; V.A.M.; Aberdeen A.G.; Fitzwilliam; Leeds City A.G.; Whitworth A.G., Manchester.
Bibliography: S. Rowland Pierce: *Jonathan S. and his Watercolours*, Walpole Soc., XXXVI, 1960.

SKELTON, Percival
A relation of JOSEPH SKELTON, F.S.A., (b. c.1781), the engraver and topographer, he lived in Dover, Bath and London and painted landscapes and coastal scenes. He was an unsuccessful candidate for the N.W.S. on several occasions from 1852 to 1861, exhibited a French view at Suffolk Street in 1860 and was active at least until 1887.

Illustrated: T. Jeans: *The Tommiebeg Shootings*, 1860. S.E. Gay: *Harry's Big Boots*, 1873. Etc.

SKENE, James, of Rubislaw 1775 (Aberdeen) – 1864 (Oxford)
According to Sir Walter Scott, Skene was 'for a gentleman, the best draughtsman I ever saw'. He was educated in Edinburgh and Germany and admitted to the Scottish Bar in 1797. From 1802 he was on the Continent again for several years, only returning to Edinburgh in 1816. In 1838 he went to Greece, where he lived in a villa of his own design near Athens. He returned in 1844, settling in Leamington and Oxford. He was a prolific painter of both landscape and antiquities.

Examples: B.M.; Aberdeen A.G.; Edinburgh Central Lib.

SKILL, Frederick John, R.I. 1824 – 1881 (London)
A landscape and portrait painter and an illustrator. He was trained as a steel engraver and worked for the *London Journal* and *Cassell's Family Paper*. He exhibited from 1858 and was elected A.N.W.S. and N.W.S. in 1871 and 1876. He lived in London and worked in Brittany, Venice and Paris. Although his work was delicate and his feeling for colour good, he was never particularly successful.

Illustrated: M.B. Edwards: *Holidays among the Mountains*, 1861.
Examples: B.M.; V.A.M.; Swansea A.G.
Bibliography: *A.J.*, 1881.

SKIPPE, John 1741 (Ledbury, Herefordshire) – 1811 (Overbury)
An amateur draughtsman and connoisseur who went up to Merton College, Oxford, in 1760 and became one of the first pupils of J.B. Malchair (q.v.). He travelled in Italy, the Mediterranean and the Near East between 1766 and 1777, making two brief returns to England. After this he settled at Overbury, Worcestershire, where he made chiaroscuro woodcuts from his collection of old master drawings. He also made a vast number of drawings in the Italianate manner which he had learned from Malchair.
His drawings are always in pen or pencil and monochrome and remain much the same throughout his career, except for the topographical sketches made on his travels which are often highly spirited and professional.

Examples: B.M.; V.A.M.

SLATER, Josiah – 1847
A portrait painter who was working between 1800 and 1833. He was a fashionable artist with a wide practice, and may have been a pupil of Sir T. Lawrence, in whose manner he worked.

Examples: B.M.; Fitzwilliam.

SLEAP, Joseph Axe 1808 (London) – 1859 (London)
A painter of rivers and lakes who is said to have lived in poverty and died just as he was beginning to win recognition.

Examples: V.A.M.

SLOCOMBE, Frederick Albert 1847 – c. 1920
A painter of portraits, figure and animal subjects and landscapes who exhibited from 1866 to 1916. He lived in Islington and Hendon and painted in many parts of England and Wales. Both he and his brother CHARLES PHILIP SLOCOMBE (1832-1895) were etchers as well as watercolour painters, as were two other members of the family, ALFRED SLOCOMBE and EDWARD C. SLOCOMBE, both working in the 1860s. C.P. Slocombe exhibited from 1850 to 1882 and taught at the National Art Training Schools. There is an example of his work in the V.A.M.

SLOUS, Henry Courtney See SELOUS, Henry Courtney

SMALL, David 1846 – 1927
A painter of vignettes of old Glasgow buildings who was a member of the Glasgow Art Club and worked as a photographer in Dundee. He illustrated the time-tables of the Caledonian Railway in 1889 and contributed drawings to several books.

Examples: Dundee City A.G. ; Glasgow A.G. ; Paisley A.G.

SMALL, Florence, Mrs. Hardy
c. 1860 (Nottingham) – 1933 (London)
A painter of domestic and flower subjects in watercolour and pastel. She exhibited at the R.A. and elsewhere between 1881 and 1901. In 1894 she married Deric Hardy and moved from Nottingham to London.

SMALL, William, R.I. **1843 (Edinburgh) – 1929**
An illustrator and painter in oil and watercolour. He studied at the R.S.A. Schools and moved to London in 1865. He exhibited at the R.A. from 1869 to 1900 as well as at the R.I., and he was an Honorary R.S.A. He also worked for periodicals such as *Once a Week, Good Words* and the *Graphic*. Towards the end of his life he lived in Worcester.

Examples: St. George's Soc., Birmingham.

SMALLFIELD, Frederick, A.R.W.S.1829 (Homerton) – 1915
A genre, figure and portrait painter in oil and watercolour. He studied at the R.A. Schools, exhibited from 1849 and was elected A.O.W.S. in 1860. He lived in London.

Examples: B.M.

SMALLWOOD, William Frome **1806 (London) – 1834 (London)**
He trained as an architect under D.N. Cottingham and spent much of his brief career on the Continent, making drawings of old churches, many of them for the *Penny Magazine*. He exhibited at the R.A. from 1826 to 1834.

His style never had time to mature, and his effects are borrowed from established masters such as Cotman, Prout and Edridge. Many of his best drawings are on a small scale.

Examples: B.M.; V.A.M.

SMART, John, R.S.A., R.S.W. **1838 (Leith) – 1899 (Leith)**
A painter of landscapes, genre and literary subjects and portraits in oil and watercolour, as well as an etcher and essayist. He was the son and apprentice of an engraver and a pupil of H. McCulloch (q.v.). He exhibited from 1860, was elected A.R.S.A. and R.S.A. in 1871 and 1877 and was a Founder Member of the R.S.W. His subjects are usually Highland, but he also painted in Wales.

Published: *A Round of the Links*, 1893.
Illustrated: F. Crucelli: *Misturat Curiosa*, 1869. J. A. Sidey: *Remollescences of a Medical Student*, 1886.

SMETHAM, James
1821 (Pateley Bridge, Yorkshire) – 1889 (London)
Apprenticed for a time to an artistic architect in Lincoln, Smetham spent much of his time sketching in the Cathedral. He then painted portraits in Shropshire for a while and came to London in 1843 to study at the R.A. Schools. He had little popular success although Rossetti thought his work 'the very flower of modern art', and in 1851 he became drawing master at the Wesleyan Normal College, Westminster. He also tried book illustration. He was virtually insane from 1877.

His work in both watercolour and oil is intense in the Pre-Raphaelite manner. Sometimes his figures are well constructed from a few broad lines.

Published: *The Literary Works of J.S.*, 1893.
Examples: B.M.; Fitzwilliam; Castle Mus., Nottingham.
Bibliography: W. Beardmore: *J.S., Painter, Poet and Essayist*, 1906. E. Malins and M. Bishop: *J.S. and Francis Danby*, 1974. *A.J.*, 1904. *Cornhill Mag.*, CMLXXVI, Autumn, 1948.

SMIRKE, Mary **1779 (London) – 1853**
The daughter of Robert Smirke, R.A., the architect and occasional draughtsman, she had a classical education, but her leaning was towards art, and after leaving school she accompanied her father and J. Farington (q.v.) on a sketching tour of Kent. She also sketched in Wales and with her family at Richmond and Hampstead during the summers. She copied manuscripts in the B.M., and her skill as a copyist earned her commissions from G. Dance and Sir Thomas Lawrence, among others. She gave drawing lessons, some of her pupils being passed on to her by Farington. In 1810 she started on a translation of Don Quixote, which was published, with illustrations by her father, in 1818. She exhibited at the R.A. from 1809 to 1814, after which date her time was increasingly taken up with household duties.

Her watercolours are small and show a good eye for detail.

Examples: V.A.M.
Bibliography: *Country Life*, November 20, 1969.

SMITH, Alexander C **1875** **– 1922**
A Perth business man and keen amateur naturalist. He painted birds in oil and watercolour.

SMITH, Arthur Reginald, R.W.S., R.S.W.
1872 (Skipton-in-Craven) – 1934 (near Bolton Abbey)
A landscape and figure painter who studied and taught at the Keighley School of Art before going to South Kensington in 1901. He went to Italy in 1906, and exhibitions of his Italian views were held at Leighton House in 1907-8 and at the New Dudley Gallery in 1910. He was elected A.R.W.S. and R.W.S. in 1917 and 1925 and R.S.W. in 1925. He lived at Grassington, Yorkshire and drowned in the River Wharfe.

Illustrated: W.G. Collingwood: *The Lake Counties*, 1932.
Examples: V.A.M.; Cartwright Hall, Bradford; Bristol City A.G.; Leeds City A.G.; Sydney A.G.; Wakefield A.G.

SMITH, Barbara Leigh **See BODICHON, Mme.**

SMITH, Carlton Alfred, R.I. **1853 (London) – 1946**
A genre painter in oil and watercolour, he was the son of a steel engraver and was educated in France. He studied at the Slade and began his career as a lithographer before taking up painting full time. He exhibited from 1879, when he was elected to the S.B.A. He was elected R.I. in 1889 and retired as an Honorary Member in 1939. His wife painted coastal scenes and exhibited from 1883.

Examples: V.A.M.; Haworth A.G., Accrington.

SMITH, Lieutenant-Colonel Charles Hamilton
1776 (Vrommen-hofen, East Flanders) – 1859 (Plymouth)
A prolific topographer and an authority on natural history and historical costume, he was a descendant of a Flemish Protestant family called Smet. He was educated at Richmond, Surrey, and trained at the Austrian artillery academy at Malines and Louvain. He joined the British army as a volunteer and in 1797 went to the West Indies for ten years. He then served at Coventry and in Holland, being engaged as deputy quartermaster-general in the Walcheren expedition, and he was promoted major in 1813. In 1816 he was sent on a mission to the United States and Canada, and his scheme for the defence of Canada was published by the government. He retired from active service in 1820 and settled in Plymouth, where he founded a club called The Artists and Amateurs. He continued to travel, visiting the Near East, North Africa and South America. He wrote the military section of W. Coxe's *Memoirs of John, Duke of Marlborough*, 1818, 1819, and supervised the designing of the plans of the campaigns. He left volumes of manuscript notes, many of which are in the library of the Plymouth Institution, and thousands of watercolours which he had made since the age of fifteen. Many of them were used to illustrate his natural history writings.

His animals and his figures, on which he occasionally uses touches of bright red, are generally the strongest points of his compositions.

Published: *Selections of Ancient Costume of Great Britain and Ireland, 7th to 16th Century*, 1814. With S.R. Meyrick: *Costume of the Original Inhabitants of the British Isles to the 6th Century*, 1815. *Natural History of the Human Species*, 1848. Etc.
Examples: B.M.; Greenwich.

SMITH, Charles John, F.S.A. 1803 (London) – 1838 (London)
An antiquary and engraver who was a pupil of John Pye. He painted views of London buildings which are very competent, although the figures are rather stiff.

Published: *Historical and Literary Curiosities,* 1840.
Examples: B.M.

SMITH, Charles Loraine 1751 – 1835
M.P., huntsman, amateur painter and poet. He rode with the Pytchley and Quorn, and sets of prints were made from his drawings of them. The earliest of these are dated 1790 and the latest 1834. He was drawing earlier than this since the B.M. has a grey wash study of George III at Cheltenham, dated 1788. In it he uses a thin pen outline and curious loopy hatching for foliage.

Examples: B.M.
Bibliography: See F. Siltzer: *The Story of British Sporting Prints,* 1929.

SMITH, Daniel Newland c.1791 (Farnham) – 1839 (Cheltenham)
A drawing master who was living in London in 1812-13, was in Stroud, Gloucestershire, by 1816 and moved between 1820 and 1832 to Gloucester. In about 1838 he moved to Cheltenham. He exhibited at the R.A. in 1813.

His son, ALFRED NEWLAND SMITH (1812-1876), studied under him and became a portrait painter. From 1855 to his death he lived in Cheltenham. Another son, EDWARD SMITH (1820-1893), specialised in topographical views. He lived for a time at Ross-on-Wye, listed himself as a 'drawing master and photographer' in the Gloucester Directory from 1863 to 1872, and in 1873 opened the 'Park Photographic and Art Studio', his address until his death. Examples of the work of the family, including OLIVER CLAUDE SMITH, FREDERICK HENRY SMITH and CATHERINE WILHELMINA MATTHEW-CLARKE, née SMITH are in Gloucester Lib.

SMITH, Emma 1783 (London) –
The daughter of J.R. Smith (q.v.), she painted miniatures and landscapes, exhibiting at the R.A. from 1799 to 1803. She was a member of the A.A.

SMITH, E Cleave
A Sheffield painter who exhibited an Isle of Man view at Birmingham in 1881.

SMITH, Francis 1705? (Naples) – c. 1779
He travelled to the East with Lord Baltimore in 1763, drawing oriental costumes and views of Constantinople. He exhibited at the Incorporated Society in 1768 and at the R.A. in 1770, 1772 and 1773.

SMITH, Garden Grant 1860 (Aberdeen) – 1913
A painter of portraits and Spanish scenes in oil and watercolour. He studied in Edinburgh and Paris and worked in Scotland. He published a number of books on golf.

Examples: Aberdeen A.G.

SMITH, George, of Chichester
 1714 (Chichester) – 1776 (Chichester)
A landscape painter and the most talented of the three brothers Smith of Chichester. He was primarily an oil painter, but occasionally produced wash drawings. He used a saw-tooth hatching to denote foliage.

His brother JOHN SMITH produced similar drawings. They published a series of etchings and engravings in 1770.

SMITH, George Fearn
 1840 (Derby) – 1926 (Quarndon, near Derby)
An amateur artist who studied at the R.A. Schools, where he gained a silver medal in 1863, and exhibited at the R.A. and in Derby. He visited Italy in 1870, Norway in 1885 and North Africa. He became a director, and later Chairman, of the family firm of clothing contractors in Derby. His early subjects were often portraits and still-lifes, but in the 1870s he turned increasingly to landscapes, the majority being taken from Derby. He also painted in Somerset, and he worked in both watercolour and oil.

SMITH, Hannah 1797 (Great Yarmouth) – 1867 (Norwich)
A flower and portrait painter in oil and watercolour, she worked in Norwich and was probably a pupil of J. Sillett (q.v.).

SMITH, Hely Augustus Morton
 1862 (Wambrook, Dorset) – 1941
A painter of seascapes, portraits and flower subjects. He was educated at Loretto, where he won drawing prizes, and he studied at the Lincoln School of Art and in Antwerp. He first exhibited in 1890, was elected to the R.B.A. in 1900 and was a member of the Langham Sketching Club. He travelled extensively, especially in North Africa.

His work is sometimes impressionist in feeling.

Examples: V.A.M.

SMITH, Herbert Luther 1809 (London) – 1869 (London)
The son of Anker Smith, an engraver and miniaturist. He was a successful portrait painter, and was employed by Queen Victoria to copy State portraits. An example of his work is illustrated in a letter to *Country Life,* November 23, 1945.

Examples: B.M.

SMITH, Hugh Bellingham 1866 (London) – 1922
A landscape and figure painter who studied at the Slade and in Paris. He was a member of the N.E.A.C. from 1894 and an exhibition of his work was held at Walker's Galleries in October, 1922.

Examples: B.M.; V.A.M.; Aberdeen A.G.; Fitzwilliam; Leeds City A.G.; City A.G., Manchester.

SMITH, Jacob
A drawing master and engraver of portraits. In 1748 he was a candidate for the post of drawing master at Christ's Hospital which was won by A. Cozens (q.v.).

SMITH, James Burrell 1822 – 1897 (London)
The painter of waterfalls in oil and watercolour, he was born in the South of England and lived in Alnwick, Northumberland, from 1843 to 1854. Until 1848 he was a pupil of T.M. Richardson (q.v.). In 1854 he moved to London as a drawing master with Dickenson of Bond Street. Thereafter he built up an extensive teaching practice and concentrated on watercolour painting.

His style is based on that of Richardson, and he shows a preference for greens in his landscape work. He painted in Scotland, Northumbria, the Lake District, Wales, Germany and elsewhere, and he had a liking for small waterfalls.

Examples: V.A.M.; Alnwick Castle; Fitzwilliam; County Record Office, Gloucester; Nat. Mus. Wales; Laing A.G., Newcastle.

SMITH, Jane Sophia Collingwood see EGERTON, Jane Sophia

SMITH, Jane Stewart, Mrs.
A painter of Scottish landscapes in the late nineteenth century.

Published: *The Grange of St. Giles. . .,* 1898.
Examples: Dundee City A.G.

SMITH, John Raphael 1752 (Derby) – 1812 (Doncaster)
The son of T. Smith (q.v.), he became a portrait painter, miniaturist and engraver. He came to London in 1767 and taught himself while working as a linen draper. He was a highly successful mezzotint engraver, but gradually turned to chalk portraits. He also painted in the manner of Morland and Wheatley. He spent the last three years of his life in Doncaster.

His son, JOHN RUBENS SMITH (1775-1849), painted portraits in his style. He went to Philadelphia, where he founded an Art School, in 1809.

Examples: B.M.; V.A.M.; City A.G., Manchester.
Bibliography: J. Frankau: *J.R.S.*, 1902. *J.R.S. ... a complete catalogue of plates*, 1914.

SMITH, John Thomas 1766 (London) – 1833 (London)
The son of NATHANIEL SMITH, a sculptor, print-seller and topographical artist, he studied under Nollekens and J.K. Sherwin (q.v.). By 1784 he had turned from engraving to topographical drawing, and in 1788 he became a drawing master at Edmonton. In 1795 he returned to London and worked as a portraitist. He was appointed Keeper of Prints and Drawings at the B.M. in 1816. He encouraged Constable.

His penwork is fine, with sharp twists and angles, a description also applicable to his biography of Nollekens.

Published: *Remarks on Rural Scenery*, 1797. *Antiquities of London*, 1800. *Antiquities of Westminster*, 1807. *The Ancient Topography of London*, 1815. *Vagabondiana*, 1817. *Nollekens and his Times*, 1828. *A Book for a Rainy Day*, 1845. Etc.
Examples: B.M.; Fitzwilliam.

SMITH, John 'Warwick'
 1749 (Irthington, Cumberland) – 1831 (London)
The son of a gardener to the sister of J.B. Gilpin (q.v.), Smith was given lessons and set up as a drawing master near Whitehaven by the Captain. Later he was sent to S. Gilpin (q.v.) for further lessons. In about 1775 Smith gained the patronage of Lord Warwick (q.v.) who paid for his stay in Italy from 1776 to 1781. He lived in Warwick for a time after his return. He had moved to London by 1797 and was elected A.O.W.S. and O.W.S. in 1805 and 1806. He became Secretary and Treasurer of the Society, was a promoter of the Oil and Watercolour Society, and finally resigned in 1823. In Britain he sketched in Devonshire and Derbyshire as well as visiting Wales every year from 1784 to 1788, in 1790, 1792, 1793, 1795, 1797, 1798, 1801 and 1806.

Among his most interesting drawings are those done on the spot in Italy. These are much more freely executed than his finished studio pieces, and owe much to his companion F. Towne (q.v.), who travelled in Italy with him in 1780, returning home with him by way of Switzerland in 1781. These drawings are often extensively annotated. Towne's influence is seen in Smith's strongly contrasted lights and shadows, although Smith's work is softer and more natural in approach.

After his return to England his work is less interesting, although always distinguished. He was one of the first artists who began to escape from the tinted tradition of grey underpainting, and his colouring shows a preponderance of blues and greens. He also occasionally worked in pen, pencil or monochrome. He sometimes used a monogram I over S.

The G. or G.W.SMITH who exhibited with the Oil and Watercolour Society in 1816, 1819 and 1820 gave Smith's Bryanston Street address and was probably his son. He also produced Italian scenes and exhibited at Suffolk Street from Lichfield in 1825.

Examples: B.M.; V.A.M.; Aberdeen A.G.; Ashmolean; Williamson A.G., Birkenhead; Cartwright Hall, Bradford; Grosvenor Mus., Chester; Exeter Mus.; Fitzwilliam; Leicestershire A.G.; City A.G., Manchester; Newport A.G.; Ulster Mus.
Bibliography: *Walker's Quarterly*, XXIV, 1927. O.W.S. Club, XXIV, 1946. B.M. Quarterly, XI.

SMITH, Joseph Clarendon 1778 (London) – 1810 (at sea)
Trained as an engraver, Smith became a neat and pleasing topographical draughtsman. He worked mostly in the Thames Valley and Home Counties but visited Warwickshire and Devon in 1805 and Cornwall in 1806. He went to Madeira in 1810 in an attempt to stave off tuberculosis but died on the return voyage.

In style his work is very like that of W. Delamotte (q.v.) or P.S. Munn (q.v.). Generally he worked with monochrome washes over careful and elegant pencil drawing, occasionally adding touches of colour. He employed the engraver's careful hatching for some shadows.

Examples: B.M.; V.A.M.; Williamson A.G., Birkenhead; Leicestershire A.G.

SMITH, N
A topographical painter working in Middlesex in 1781. He was perhaps a brother of J.T. Smith (q.v.), whose father was the sculptor Nathaniel Smith, (c.1741-p. 1800) or indeed Nathaniel himself.

Examples: B.M.

SMITH, Captain Robert 1792 (Dublin) – 1882 (Rathgar)
An army officer and amateur draughtsman who joined the 44th Regiment in 1809 and was promoted captain in 1825. In 1832, the year of his retirement, he visited Delhi, where he expressed criticism in his journal of some of the repairs to the Qutb Minar carried out by his namesake (q.v.). In about 1823 he made a folio of pencil drawings of nude female figures from gems. In 1840 he was appointed a Pursuivant in the Office of Arms, Dublin Castle, and in 1865 Athlone Pursuivant.

Examples: V.A.M.

SMITH, Colonel Robert 1787 – 1873
An East India Company engineer who was stationed in India with the Bengal Engineers from 1805 to 1830. From 1812 to 1813 he was A.D.C. to the Commander-in-Chief, Sir George Nugent, whom he accompanied on a long tour of Upper India. In 1813 he was assigned to a survey of the Frontier between Bihar and Central India, and in the following year was posted to Prince of Wales Island, later Penang. During the war with Nepal he acted as field engineer and made drawings of the battles among the foothills of the Himalayas. In 1818 he returned to Prince of Wales Island. He was in England on furlough from 1819 to 1822, and after his return was stationed in Delhi. He retired to Paignton, Devon, where he built himself a house, 'Redclyffe Towers', known locally as 'Smith's Folly', as well as another at Nice.

He was a skilful artist in pencil, watercolour, and, from 1822, oil; his oil paintings resulting from his contact in England with the Daniells. He was also keenly interested in architecture, being responsible for the repair of the Qutb Minar, Delhi. Ten aquatints from his watercolours of Prince of Wales Island were engraved by W. Daniell (q.v.) and published in 1821.

Bibliography: *Connoisseur*, CLXXIX, 1972.

SMITH, Thomas, of Derby – 1767
A landscape painter who was working in Derby from at least 1743 when a group of engravings after him by Vivares were published. He was himself an engraver and a collector and his paintings and drawings of Derbyshire and the Lake District often show Dutch and Italian influence.

He was the father of J.R. Smith (q.v.).

Published: *Book of Landskips*, 1751. *Forty Picturesque Views in Derbyshire*, 1760.
Examples: Derby A.G.

SMITH, Thomas
A topographical artist who was working at least from 1780 to 1822. An album of accomplished Italian and Swiss sketches was recently discovered by the Albany and Manning Galleries, the date 1795 on the title page possibly indicating the year of his return to England. It includes a view from the island of Procida dated 1780, which shows him to have been in Italy at the same time as T. Jones, J. 'W'. Smith, W. Pars and F. Towne (all q.v.). Some of his work, especially his views of Rome and the Campagna, shows Towne's influence. The other dated drawing is inscribed 'Caen – July '86'.

He is probably not identifiable with the THOMAS SMITH recorded in Nagler's *Kunsterlexicon* as a distinguished London watercolourist working in the first half of the nineteenth century, who was the author of various treatises published between 1824 and 1835, including *The Young Artist's Assistant in the Art of Drawing in Watercolours*, in which he acknowledges that the teaching methods of J. Varley (q.v.), had given him 'his first *systematic* ideas of effect'.

Examples: B.M.
Bibliography: Albany & Manning Galls.: *Exhibition Cat.*, 1973.

SMITH, William Collingwood
1815 (Greenwich) – 1887 (Brixton Hill)
The son of an amateur artist and musician, Smith was always
intended for an artist and was exhibiting at the R.A. by the time he
was twenty-one. He had occasional lessons from J.D. Harding (q.v.).
Although some of his earliest pictures were in oil, he soon turned
exclusively to watercolour. In the same way he turned from marine
painting to landscape, travelling widely in Britain and, after 1852,
on the Continent. At one time he had the largest teaching practice
in London, instructing both amateurs and future professionals as
well as many military and naval officers. He was elected A.O.W.S.
and O.W.S. in 1843 and 1849, and was very active in the Society's
affairs, serving as Treasurer and Trustee and promoting the
formation of the R.W.S. Art Club of which he was also Treasurer.

His drawings are 'marked by breadth of effect, firmness of
drawing, and precision of touch, if they sometimes lack qualities of
colour and intricacy of form of a more subtle kind' (*The Times*,
March 21, 1887). They show the influence of W. Callow (q.v.). His
remaining works were sold at Christie's, March 3 and 5, 1888. He
was the husband of J.S. Egerton (q.v.).

Examples: B.M.; Towner Gall., Eastbourne; Nottingham Univ.;
Stalybridge A.G.

SMITH, William Harding Collingwood 1848 – 1922
A landscape and genre painter, he was a pupil of his father W.C.
Smith (q.v.). He exhibited from 1870 and was a member of the
R.B.A. from 1890. He was a collector of Japanese and Eastern art.
Many of his subjects were found near Chichester.

Bibliography: *Connoisseur*, LXII, 1922.

SMITH, W Prior
A landscape painter who lived in London and painted on the
Thames, in Kent and in Devon. He exhibited at Suffolk Street from
1844 to 1858, and he was an unsuccessful candidate for the N.W.S.
in 1849.

SMYTH, Frederick COKE- c.1800 –
A traveller and painter who visited Turkey, Venice, Dresden, Canada
and elsewhere. He was in Turkey in 1835-6 and later he lived in
London and Brighton. He exhibited from 1842 to 1867.

Examples: N.G., Scotland.

SMYTH, W – 1837
A skilful ship portraitist of whose work there are examples at
Greenwich. He may be the W. Smyth who exhibited a picture of
partridges at Suffolk Street in 1825 from a London address.

SMYTH, Admiral William – 1877
A talented amateur artist, he entered the Navy in 1813 and was
promoted lieutenant in 1827. He served on H.M.S. *Samarang* and
was in South America from June 1831 to the beginning of 1835.
The following year he joined the expedition to the Arctic led by
Admiral Back (q.v.), on the bomb vessel H.M.S. *Terror*. He was
promoted commander in 1837 and was in South America and the
Cape of Good Hope from September, 1838 to 1843. He was
promoted captain in 1843, rear-admiral in 1863, vice-admiral in
1869 and admiral in 1875. His drawing of figures and of ships'
rigging is particularly good.

Examples: Greenwich.

SMYTHE, Lionel Percy, R.A., R.W.S.
1839 (London) – 1918 (Wimereux, France)
A friend of J.W. North (q.v.), in whose manner he worked. He was
educated at King's College School and studied at Heatherley's. He
exhibited from 1860 and was a member of the R.I. from 1880 to
1890. In 1892 he was elected A.R.W.S., and in 1894 R.W.S. He was
elected A.R.A. and R.A. in 1898 and 1911. For the latter part of his

life he lived at the Château de Honvault, near Wimereux, where he
painted the local landscape and peasants. He and his half-brother
W.L. Wyllie (q.v.) sat to each for their figures.

Examples: V.A.M.; Greenwich.
Bibliography: R.M. Whitlaw and W.L. Wyllie: *L.P.S.*, 1923. *A.J.*,
1904. O.W.S. Club, I, 1923.

SNOW, J **W**
An animal and sporting painter who lived in London and was active
at least from 1832 to 1837. His colours can be rather muddy.

Examples: B.M.

SNOW, William R
In the V.A.M. there is a watercolour of a lady in a Chinese
palanquin, dated 1870, by this artist. It is presumably connected
with the *Sketches of Chinese Life and Character* which he had
begun to publish in 1860. He also published a number of satires,
plays and charades between 1872 and 1905.

SODEN, John Edward
A genre painter in oil and watercolour who lived in London and
exhibited there from 1861 to 1887. He also exhibited at the R.S.A.
and in Birmingham.

Published: *Policeman Y, his Ballads on War, and the Military*, 1871.

SODEN, Susannah (Broenston, Northamptonshire) –
The daughter of a journalist and amateur artist (d. 1859), she
studied at South Kensington and became a flower and fruit painter.
She exhibited from 1866.

SOMERS, Charles, Earl 1819 – 1899
A competent watercolourist who, as Viscount Eastnor, was M.P. for
Reigate from 1841 to 1847. He succeeded to the Earldom in 1852.
He was appointed a Trustee of the N.P.G. in 1860 and of the B.M.
in 1874. Many of his drawings are the fruits of Mediterranean
cruises on his yacht.

SOMERSCALES, Thomas Jacques 1842 (Hull) – 1927 (Hull)
A naval painter in oil and watercolour, he was the son of a sailor. He
was educated in Hull and at Cheltenham and served as a Naval
Schoolmaster before turning to painting. He lived in Chile from
1865 to 1892 and then returned to Hull.

His style is a forerunner of that of Montague Dawson.
ANNIE ESTHER SOMERSCALES, who painted Yorkshire
landscapes, was presumably a relation.

SOPER, Thomas James
A landscape painter who exhibited from 1836 to 1889 in London,
as well as at Brighton and Birmingham. He was an unsuccessful
candidate for the N.W.S. four times between 1863 and 1873 and
lived in London. He painted in Devon, on the Thames, in Sussex,
Surrey, Yorkshire and elsewhere.

Examples: Reading A.G.

SOUTHALL, Joseph Edward, R.W.S. 1861 (Nottingham) – 1944
He was apprenticed to a firm of architects in 1878 but left to work
under Sir William Blake Richmond. In 1895 he exhibited at the
R.A., and at the New Gallery from 1897. He was elected A.R.W.S.
in 1925 and R.W.S. in 1931, and was an examiner at the
Birmingham School of Art.

Much of his work was in tempera, and in 1900 he was a
co-founder of the Society of Painters in Tempera. He was a keen
advocate of natural paints, and painted on both paper and silk. He
often prepared his paper with a yellow wash, and laid his colours on
in layers, finishing with stippling. He painted mythological and
shipping subjects, and both are stilted and lacking in movement. The
latter are often taken from Fowey, Cornwall, and Southwold,
Suffolk.

A memorial exhibition was held at the Birmingham City A.G. in
1945.

Illustrated: C. Perrault: *The Story of Blue Beard,* 1895.
Examples: Birmingham City A.G.
Bibliography: *A Testimony to the Life of J.E.S.,* 1946. O.W.S. Club, XXIV, 1946.

SOUTHGATE, Frank **1872 (Hunstanton) — 1916 (France)**
A bird painter who worked mainly in his native Norfolk. He was a member of the R.B.A., and he was particularly good at depicting flight and movement. He illustrated a number of books on Norfolk birds and Broads.

SOWDEN, John **1838 (Bradford) — 1926**
A painter of Bradford worthies, he trained at the Mechanics Institute, Bradford, where he later taught art for many years. He made sketching tours abroad, and also painted local views, as well as fruit, flowers and birds, in watercolour. He was an unsuccessful candidate for the N.W.S. in 1865 and 1867. Three hundred and fifty of his portraits were presented to the City and are now at Bolling Hall.

SOWERBY, James **1757 (London) — 1822 (London)**
The founder of a dynasty of botanical illustrators, he was best known for his work on the thirty-six volumes of Smith's *English Botany,* 1790-1814. He studied at the R.A. Schools, after which he took portraits as well as teaching flower painting.

His drawings are generally in neat pencil with touches of colour to act as hints to the engraver.

Published: *An Easy Introduction to drawing Flowers according to Nature,* 1778.
Examples: B.M.; Nat. Hist. Mus.
See Family Tree.

SPACKMAN, Isaac **— 1771 (Islington)**
A mid-eighteenth century bird painter. He painted traditional, rather crude but charming studies on vellum in water and bodycolour.

SPALDING, C B
A sporting and animal painter working in the 1840s. He painted in Scotland and elsewhere and lived in Reading, Brighton and London.

SPARKES, Catherine Adelaide, Mrs., née Edwards
1842 (London) —
A genre and flower painter and illustrator who studied at the Lambeth School of Art, at the R.A. Schools and under J. O'Connor (q.v.). She exhibited at the R.A. from 1866 to 1890 as well as with the N.W.S. and at the Grosvenor and Dudley Galleries. In 1868 she married J.C.L. Sparkes (q.v.), a director of the Lambeth Pottery, and thereafter did much work as a tile painter and designer.

Examples: Castle Mus., Nottingham.

SPARKES, John Charles Lewis **— 1907**
The husband of C.A. Sparkes (q.v.), he was a director of the Lambeth Pottery and largely responsible for its success. In the V.A.M. there is a watercolour by him of the interior of Marlborough House dated 1856. He had studied under P.J. Naftel (q.v.) in Guernsey and at Leigh's and the R.A. Schools, and he taught at Marlborough House and South Kensington until 1898. His pupils included N. Dawson (q.v.) and Alexander Stanhope Forbes. He compiled the catalogue of the Dulwich Picture Gallery.

Bibliography: *A.J.,* 1908.

SPEARE, R
A landscape painter who exhibited at the R.A. from 1799 to 1812. He worked rather in the manner of F. Nicholson (q.v.). G. SPEARE exhibited landscapes and architectural subjects from 1810 to 1826.

Examples: B.M.

SPEED, Lancelot **1860 — 1931**
A coastal painter and black and white illustrator who was educated at Rugby and Clare College, Cambridge. He worked for the *I.L.N.,* the *Graphic, Sphere, Punch* and *Sporting and Dramatic* and on many books. He lived at Barnet and Southend.

SPENCE, Charles James **1848 (North Shields) — 1905**
A banker and amateur landscape painter and etcher. He was a member of a number of learned and artistic bodies and committees in Newcastle. He specialized in views of the Northumbrian rivers and coasts. A memorial exhibition was held at the Newcastle Academy of Arts in 1906.

His son ROBERT SPENCE (b. 1871) worked as an artist and etcher in London.

SPENCELAYH, Charles
 1865 (Rochester, Kent) — 1958 (Northampton)
A figure and portrait painter in oil, watercolour and miniature. He studied at South Kensington and in Paris and lived in Chatham and Manchester. His work is intensely realistic.

SPENLOVE, John Francis SPENLOVE-, R.I.
 1866 (Bridge of Allan, Stirling) — 1933 (London)
A figure and landscape painter in oil and watercolour who ran an art school in Victoria Street, London. He studied in London and Antwerp and exhibited widely in England and on the Continent. He was elected R.I. in 1907. Later he lived at Pangbourne.

SPIERS, Benjamin Walter
A still-life and genre painter in oil and watercolour who lived in London and exhibited from 1875.

CHARLOTTE H. SPIERS and BESSIE J. SPIERS exhibited landscapes from the 1870s. They also lived in London.

SPIERS, Richard Phené, P.R.I.B.A., F.S.A.
 1838 (Oxford) — 1916 (London)
An architect who studied at King's College and in Paris, and who won a travelling scholarship from the R.I.B.A. He worked under Sir Digby Wyatt and William Burges before setting up in his own practice. He was Master of Architecture at the R.A. His architectural drawing is good, but when his work is unconnected with architecture it can be poor.

Published: with W.J. Anderson: *The Architecture of Ancient Greece,* 1902. Etc.
Examples: B.M.; V.A.M.; Fitzwilliam.

SPILLMAN, William
A genre painter who lived in London. He exhibited at Suffolk Street from 1858 to 1861 and was an unsuccessful candidate for the N.W.S. on several occasions from 1853 to 1861.

SPILSBURY, Francis B
A relation of M. Spilsbury (q.v.), he was surgeon on H.M.S. *Le Tigre* in 1799 and 1800. His sketches in the Near East were worked up and engraved by Daniel Orme for *Picturesque Scenery in the Holy Land and Syria,* 1803. He was working at least from 1796 to 1805, and he may be the author of *Advice to those who are afflicted with the venereal disease,* 1789.

SPILSBURY, Maria, Mrs. Taylor
 1777 (London) — 1823 (Ireland)
The daughter of Jonathan Spilsbury, an engraver, and niece of JOHN 'INIGO' SPILSBURY (1730-c.1795), an engraver and drawing master at Harrow School. She exhibited landscapes, portraits and genre scenes in oil and watercolour at the R.A. from 1792 to 1808 and the B.I. from 1806 to 1813. After her marriage in about 1809 she settled in Ireland, where she exhibited at the R.H.A. in 1814 and 1815.

Several of her works were engraved, and she herself made some etchings.

Examples: B.M.
Bibliography: R. Young: *Father and Daughter, J. and M.S.,* 1952. *Country Life,* May 28, 1938.

SPREAT, William
A landscape painter in oil and watercolour who was working in Exeter from the 1820s to the 1850s. He exhibited in London from 1841 to 1848.

Published: *Picturesque sketches of the Churches of Devon,* 1842.
Examples: Exeter Mus.

SPRY, William
A still-life and animal painter who lived in London and exhibited at the R.A., the N.W.S. and Suffolk Street from 1832 to 1847.

SQUIRE, Alice, R.I. 1840 – 1935
A landscape and figure painter who lived in London and exhibited from 1864. She was elected R.I. in 1888. Her sister Emma was also a painter.

SQUIRE, John
A landscape and coastal painter who exhibited from 1867 to 1896. He lived in Ross-on-Wye, Swansea, London, Kingsbridge, Devon, and Exeter. His subjects were found particularly in Devon and Cornwall, Wales and Normandy. He was an unsuccessful candidate for the N.W.S. in 1873.

STACEY, Walter S 1846 (London) – 1929
A landscape and genre painter in oil and watercolour and an illustrator. He studied at the R.A. Schools and exhibited at the R.A. from 1872. He was elected to the S.B.A. in 1881, but later resigned and became Vice-President of the Old Dudley Art Society. He lived in Hampstead and Newton Abbot.

Published: with W.J. Morgan: *Bible Pictures,* 1890. *The Child "Wonderful",* 1903.
Illustrated: L.L. Weedon: *Bible Stories,* 1911.

STAMP, Ernest 1869 (Sowerby, Yorkshire) – 1942
Primarily a portrait painter in oil and a mezzotint engraver, he was a pupil of H. von Herkomer (q.v.), and occasionally produced drawings and watercolours. He exhibited at the R.A. from 1892.

Examples: City A.G., Manchester.

STANDLY, Persis
Two volumes of flower and insect studies from China and the Indian Ocean by this artist were sold by Sotheby's, February 12, 1970. They dated from about 1800. He may be the H.P. Standly whose collection of prints and drawings was sold at Christie's, April 14, 1845.

STANESBY, A
A still-life painter working in the 1880s. He may perhaps be identifiable with, or a relative of, Alexander Stanesby who exhibited miniatures from Camberwell between 1848 and 1854.

STANFIELD, Clarkson, R.A.
 1793 (Sunderland) – 1867 (London)
The son of the actor and anti-slavery writer James Field Stanfield. He was apprenticed to an heraldic painter in Edinburgh, but went to sea in 1808. He was pressed into the Navy in 1812, and in 1814 he painted the scenery for theatricals on board H.M.S. *Namur.* Later he went to China on an East Indiaman. In 1818 he left the sea and painted scenery in London and Edinburgh, where he worked with A. Nasmyth (q.v.) and D. Roberts (q.v.), the latter returning to London with him. He exhibited from 1820 and gave up scene-painting in 1834. He was one of the founders of the S.B.A. in 1823. He was elected A.R.A. and R.A. in 1832 and 1835. He made regular visits to Italy, France and Holland, Venetian subjects predominating in the 1830s and Dutch in the 1840s. From 1840 he took a cottage at Northaw, Hertfordshire, and in 1847 settled in Hampstead. In 1858 he re-visited Scotland with Roberts.

Although primarily an oil painter, Stanfield made many watercolours in the Bonington manner, especially on his Continental tours. He also worked for the Annuals, contributing landscapes as well as marine subjects. To Ruskin he was 'the leader of the English Realists'. He is sometimes wrongly given the additional name of William.

His remaining works were sold at Christie's, May 8-14, 1868.

Published: *Coast Scenery,* 1847.
Examples: B.M.; V.A.M.; Aberdeen A.G.; Haworth A.G., Accrington; Williamson A.G., Birkenhead; Blackburn A.G.; Cartwright Hall, Bradford; Gloucester City A.G.; Greenwich; Hove Lib.; Leeds City A.G.; City A.G., Manchester; Newport A.G.; Portsmouth City Mus.; Stalybridge A.G.; Ulster Mus.
Bibliography: J. Dafforne: *C.S.: Short Biographical Sketch,* 1873. C. Dickens (letters): *The story of a great friendship,* 1918.

STANFIELD, George Clarkson 1828 (London) – 1878 (London)
The son and pupil of C. Stanfield (q.v.). He studied at the R.A. Schools and exhibited marine subjects from 1844 to 1876 at the R.A., B.I. and elsewhere.

Examples: B.M.; V.A.M.; Cartwright Hall, Bradford.

STANILAND, Charles Joseph, R.I.
 1838 (Kingston-upon-Hull) – 1916
A genre painter in watercolour and occasionally oil and an illustrator, he studied at the Birmingham School of Art, Heatherley's, South Kensington and the R.A. Schools. He exhibited from 1862 and was elected A.N.W.S. and N.W.S. in 1875 and 1879, resigning in 1907. He provided drawings for the *I.L.N.* and the *Graphic.*

Illustrated: A.W. Drayson: *The Gentleman Cadet,* 1875. M.C. Rowsell: *Traitor or Patriot,* 1900. C.N. Robinson: *Britannia's Bulwarks,* 1901.
Examples: V.A.M.; Greenwich; Sunderland A.G.

STANLEY, Archer c.1826
The son of C.R. Stanley (q.v.), he was a landscape and architectural painter and exhibited from 1847. He was an unsuccessful candidate for the N.W.S. on several occasions from 1855 to 1870. He lived in London, and many of his subjects were taken from the West of Scotland.

STANLEY, Caleb Robert 1795 – 1868 (London)
A landscape painter who studied in Italy and exhibited from 1812. He lived in London and painted in many parts of England as well as in Ireland, Wales, France, Holland and Germany. He frequently used white heightening and his work can look rather like that of J.D. Harding (q.v.), with a dash of oddity.

Examples: V.A.M.; N.G., Ireland.

STANLEY, Captain Owen, F.R.S.
 1811 (Alderley, Cheshire) – 1850 (Sydney)
The eldest son of the Bishop of Norwich, he entered the Royal Naval College in 1824. In 1826 he embarked for South America and in 1830 was engaged in a survey of the Magellan Straits. He then served for some years in the Mediterranean. He was in charge of the Astronomical and Magnetic Observations during the Polar Expedition of 1836-7, and was promoted commander in 1839. He helped form the colony of Port Essington, near Darwin, and made a track survey of the Arafura Sea and surveyed various harbours in New Zealand and the Tenasserian province. In 1844 he was promoted captain and from 1846 commanded H.M.S. *Rattlesnake* around the East Indies and Australia and undertook a hazardous survey of the southern coast of New Guinea and the Louisiade islands. He died of an epileptic fit on board his ship.

His watercolours illustrating his journeys are crude things, showing a humorous eye for incident.

Examples: Greenwich; Nat. Lib., Australia.
Bibliography: J.L. Stokes: *Narrative of O.S.'s Visits to the Islands in the Arafura Sea...,* 1846. J. MacGillivray: *Narrative of the Voyage of H.M.S. Rattlesnake...,* 1852. A. Lubbock: *O.S., Captain of the 'Rattlesnake',* 1968.

STANMORE, Lady
 See GORDON, Rachel Emily, Lady HAMILTON-

STANNARD, Alfred 1806 (Norwich) — 1889 (Norwich)
The younger brother and disciple of J. Stannard (q.v.), he specialized in landscapes, mostly in oil. He exhibited at Norwich from 1820 to 1832 and in London from 1825 to 1860. Sometime before 1830 he was commissioned by Sir R.J. Harvey to make up an illustrated Estate Book of his Norfolk properties.
 His son, ALFRED GEORGE STANNARD (1828–1895), boasted the ability to imitate all the other artists of the Norwich School. This can lead to difficulties. He exhibited at Suffolk Street from 1854 to 1857.

Examples: Castle Mus., Norwich.
Bibliography: W.F. Dickes: *The Norwich School*, 1905.

STANNARD, Eloise Harriet (Norwich) —
The eldest daughter of A. Stannard (q.v.), she became a very proficient fruit and flower painter. She was greatly admired by G. Lance (q.v.), in whose manner she worked. She exhibited in London from 1852 to 1873.

STANNARD, Emily, Mrs., née Coppin
 1803 — 1885
The daughter of D. Coppin (q.v.), whom she accompanied to Holland in 1820, copying old masters, especially Van Huysum. In both 1820 and 1821 she won a gold medal for flower painting from the Society of Arts. Shortly afterwards she married J. Stannard (q.v.). She exhibited at Norwich from 1816 to 1832 as well as in London.
 Her daughter, EMILY STANNARD, YR., was also a painter of fruit, flowers and game. They worked in both oil and watercolour.

Examples: Castle Mus., Norwich.

STANNARD, Henry John Sylvester
 1870 (London) — 1951 (Bedford)
The son of Henry Stannard, a sporting painter and a member of the R.B.A., he claimed descent, possibly optimistically, from the Norwich Stannards. He was educated at the Bedford Modern School and studied at South Kensington, where he won his art teacher's diploma at the age of sixteen. He was a member of many art societies and was elected R.B.A. in 1896. He was also the founder of the Harpur Art Society, Bedford, in 1895, and the inventor of the 'Sylvester Stannard Straining-board' for watercolour paper. In 1922 he and his daughter THERESA STANNARD held an exhibition at the Brook Street Galleries.
 His work is loosely in the Birket Foster manner, and he sometimes used a Glover-like split-brush technique for foliage. He painted rustic and garden subjects.
 His brother ALEXANDER MOLYNEAUX STANNARD (1878-1975, Buckinghamshire) and two of his sisters, L. Stannard (q.v.) and EMILY STANNARD III (1875-1907), also painted landscapes and gardens.

Examples: Dudley A.G.; Johannesburg A.G.; A. East A.G., Kettering; Luton Mus.; Wolverhampton A.G.
Bibliography: *Antique Collecting*, September 1976.

STANNARD, Joseph 1797 — 1830 (Norwich)
A marine painter who was apprenticed to R. Ladbrooke (q.v.) and first exhibited with the Norwich Society in 1811. In 1816 he seceded from the Society in the wake of Ladbrooke, and in 1821 he went to Holland to study the landscapists. He was a keen sailor, his own boat featuring in several of his paintings, and his work had a ready sale.
 He was primarily an oil painter, but his watercolours have the same effect of movement as his oil paintings. He sometimes used a monogram.

Examples: B.M.; V.A.M.; Leeds City A.G.; Castle Mus., Norwich; Gt. Yarmouth Lib.
Bibliography: W.F. Dickes: *The Norwich School*, 1905.

STANNARD, Lilian, Mrs. Silas
 1884 (Woburn) — 1944 (Blackheath)
The daughter of Henry Stannard (d. 1920), a sporting painter, and the sister of H.J.S. Stannard (q.v.), she painted gardens and flowers and lived in Blackheath. Exhibitions of her work were held at the Mendoza Gallery in 1906, 1907 and 1927.

Illustrated: W.P. Wright: *Popular Garden Flowers*, 1912.
Examples: Newport A.G.

STANNUS, Anthony Carey
Possibly the brother of H.H. Stannus (q.v.) and trained as an architect, he lived in London and exhibited from 1862 to 1909. He painted landscapes and marine subjects, often from the Cornish coasts, as well as architectural, figure and genre subjects. He also painted in Ireland and Belgium.

Published: *The King of the Cats*, 1903.
Examples: V.A.M.; Ulster Mus.

STANNUS, Hugh Hutton 1840 (Sheffield) — 1908 (Hindhead)
An architect, author, lecturer and occasional watercolourist. He studied at the Sheffield School of Art and was apprenticed to an iron founder, where he worked from the designs of A.G. Stevens (q.v.), whose pupil and assistant he later became. In 1872 he studied architecture at the R.A. Schools. He was elected F.R.I.B.A. in 1887. He taught at the R.A., South Kensington, University College, London, and the Manchester School of Art. He wrote a number of books on architecture and design, and a biography of Stevens.

STANTON, G Clark, R.S.A.
 1822 (Birmingham) — 1894 (Edinburgh)
A sculptor and painter of rustic and eighteenth century genre subjects who studied at the Birmingham School of Art and in Italy before settling in Edinburgh in 1855. He was elected A.R.S.A. and R.S.A. in 1862 and 1885. He also painted portraits and book illustrations.

Examples: Dundee City A.G.; Glasgow A.G.

STANTON, Sir Herbert Edwin Pelham HUGHES-, R.A., P.R.W.S.
 1870 (London) — 1937
A self-taught landscape painter, he was the son of William Hughes, an artist. He exhibited widely both at home and abroad. He was elected A.R.A. in 1913, R.A. in 1919, R.W.S. in 1915 and President five years later.

Examples: Aberdeen A.G.; Cartwright Hall, Bradford; Grosvenor Mus., Chester; Fitzwilliam; City A.G., Manchester.

STAPLES, Mary Ellen, Mrs., née Edwards 1839 —
A painter of romantic genre subjects and book illustrations, she worked for many periodicals including the *I.L.N.*, the *Graphic* and *Good Words*. She exhibited at the R.A. and elsewhere from 1862 to 1908. In 1866 she married John Freer (d. 1869) and in 1872 John Staples. Her work was influenced by that of F. Walker (q.v.).

STARK, Arthur James 1831 (London) — 1902 (Nutfield, Surrey)
The son and pupil of J. Stark (q.v.), he also studied with Edmund Bristow, at the R.A. Schools and, in 1874, with the animal painter F.W. Keyl. He exhibited landscapes and animal subjects, much in the manner of his father, from 1848, and he worked as a drawing master from 1859, living in London and Windsor. He retired to Nutfield in 1886.

Examples: B.M.; V.A.M.; Castle Mus., Norwich.

STARK, James 1794 (Norwich) — 1859 (London)
He was educated at the Norwich Grammar School where he became a friend of J.B. Crome (q.v.), who weaned him from a wish to farm to a love of painting. He became an apprentice of J. Crome (q.v.) in 1811. He had already exhibited drawings with the Norwich Society in the preceding two years; and he was elected a member in 1812. In 1814 he went to London where he became a friend of W. Collins (q.v.). In 1816 he paid a visit to Westmorland and in 1817 entered

the R.A. Schools. He also studied at the B.I. with George Vincent who shared his house. Ill-health sent him back to Norwich in 1819, where he remained until 1830. He then returned to London for ten years. In 1834, after the death of his wife, he visited Hampshire and the Isle of Wight. In 1840 he moved to Windsor and concentrated on painting the Thames and the New Forest. In 1850, in order to further his son's art education, he returned to London.

His style is largely derived from Crome, especially in oil painting. His watercolours show more originality, but are always of the Norwich School. His favourite and characteristic colours are orange-reds and greens. He never signed or initialled his work. In his later years he recognised his weakness in figure drawing and used his son to put figures and cattle into his compositions.

Published: *Scenery of the Rivers of Norfolk,* 1834.
Examples: B.M.; V.A.M.; Williamson A.G., Birkenhead; Cartwright Hall, Bradford; Inverness Lib.; Leeds City A.G.; N.G., Scotland; Castle Mus., Norwich.
Bibliography: W.F. Dickes: *The Norwich School,* 1905. *A.J.,* 1850.

STEAVENSON, C H
A landscape painter who worked in Gateshead, County Durham, in the late nineteenth and early twentieth centuries. He was still alive in 1917.

Published: *Colliary Workmen sketched at work,* 1912.

STEELE, Jane
A landscape and architectural painter who lived in London. She was a member of the A.A. and exhibited with them from 1810 to 1812.

STEEPLE, John –1887
A landscape and coastal painter who lived in Birmingham and London. He exhibited in Birmingham from 1846 and in London from 1852, finding his subjects in Wales, the Midlands and Sussex. He was an unsuccessful candidate for the N.W.S. on several occasions from 1868. His work is usually in the tradition of Cox, but it can sometimes show affinities with the Glasgow School.

Examples: V.A.M.; Birmingham City A.G.; City A.G., Manchester.

STEER, Henry Reynolds, R.I. 1858 (London) – 1928 (Leicester)
A painter of portraits, historical and literary subjects in oil and watercolour, and a miniaturist. From 1876 to 1881 he worked as a lithographer, and from 1879 to 1886 he studied at Heatherley's. He was elected R.I. in 1884 and lived in Leicester.

Examples: Leicestershire A.G.

STEER, Philip Wilson 1860 (Birkenhead) – 1942 (London)
A painter of landscapes, portraits, marine and genre subjects in oil and watercolour. He studied at the Gloucester School of Art and at Julian's in Paris. On his return to London in 1884 he concentrated on coastal subjects, often from France and Suffolk, and for these he made many studies and sketches from nature. He was a member of the N.E.A.C. and taught at the Slade. From about 1900 he generally painted English landscapes.

His style is varied, from a splendid impressionism in his earlier days, to the traditions of Constable later in his career.

Examples: B.M.; V.A.M.; Aberdeen A.G.; Cecil Higgins A.G., Bedford; Cartwright Hall, Bradford; Exeter Mus.; Fitzwilliam; Gloucester City A.G.; Harrogate Mus.; Leeds City A.G.; Leicestershire A.G.; City A.G., Manchester; Newport A.G.; Portsmouth City Mus.; Ulster Mus.
Bibliography: R. Ironside: *P.W.S.,* 1943. D.S. MacColl: *Life, Work, P.W.S.,* 1945.

STEERS, Fanny, N.W.S. – 1861
A landscape painter who exhibited at Suffolk Street from 1833 to 1842 and thereafter with the N.W.S., to which she was elected in 1846. Her earliest subjects are from the Malvern area, and she probably lived there before moving to London in about 1839. She also exhibited views of Brussels and the Niagara Falls, but these may have been copies.

Published: *The Ant-Prince, a rhyme,* 1847.

STEPHANOFF, Fileter N (Russia) – c. 1790
A Russian who settled in London in the 1770s. He designed scenery at the Haymarket, decorated ceilings, took portraits and made tinted landscape drawings.

His wife GERTRUDE STEPHANOFF and his daughter M. G. STEPHANOFF were both flower painters. The former exhibited at the R.A. from 1783 to 1808. He was also the father of J. and F.P. Stephanoff (q.v.).

STEPHANOFF, Francis Philip
** 1788 (London) – 1860 (West Hanham, Nr. Bristol)**
The younger brother of J. Stephanoff (q.v.), he too began to exhibit with the A.A. in 1809, becoming a member in 1811, and exhibiting with the O.W.S. from 1813. His style and subject matter are very similar to those of his brother and the two are often confused. The results of a fall on the head when a boy often prevented him from working consistently, as did the early deaths of his wife and son.

Examples: B.M.; V.A.M.; Exeter Mus.; Castle Mus., Nottingham.

STEPHANOFF, James, O.W.S.
** c.1786 (London) – 1874 (Clifton, Bristol)**
The elder son of F.N. Stephanoff (q.v.), he exhibited with the A.A. in 1809 and 1810, and became a member in 1811. He first exhibited at the R.A. in 1810 and with the O.W.S. in 1813. He became a member of the latter in 1819. In 1820 he collaborated with A. Pugin (q.v.) on a large picture of George IV's Coronation. He also worked on Pyne's *Royal Palaces.* He was a member of the Sketching Society and in the 1820s drew portraits as well as historical subjects. He was appointed Historical Painter to the King in 1831. He also drew incidents in the lives of painters such as Rubens, Rembrandt, Titian, Rosa and Van Dyck. Later in his career he made drawings of museum antiquities. In 1850 he moved to live with his brother in Bristol, where he remained for the rest of his life.

He was among the first to paint historical scenes as pictures rather than as engravers' material – although many prints were in fact made after his work. His paintings show a good eye for costume and ceremonial detail, and are elegant and highly finished. He uses fairly subdued colours and shows a preference for plummy tints.

Examples: B.M.; V.A.M.; Cartwright Hall, Bradford; N.G., Scotland; Royal Shakespeare Theatre, Stratford.

STEPHENSON, Willie – 1938
A landscape painter in oil and watercolour who exhibited from 1893. He was educated in Huddersfield and studied at South Kensington. Later he lived at Conway, Huddersfield, Rhos on Sea, with a studio in Llandudno, and in Shropshire.

STEUART, See STEWART, Sir John James
STEVENS, Albert
A landscape painter in oil and watercolour who exhibited from 1872 to 1902. He lived in London and near Keswick and painted in the Home Counties, North Wales, Devon, the Lake District, Scotland and Italy. His wife MARY STEVENS was also a painter.

STEVENS, Alfred George
** 1817 (Blandford, Dorset) – 1875 (London)**
Sculptor, craftsman and painter, Stevens was the son of a decorator whom he assisted from 1828 to 1833. He was then sent to Italy where he remained, studying and working for Thorwaldsen, until 1842. He spent two years at Blandford and two more teaching at the London School of Design. From 1850 to 1852 he worked as a designer to a Sheffield bronze manufacturer. Much of his later life was taken up with the memorial to the Duke of Wellington in St. Paul's.

He painted few pictures and is best known for his chalk drawings and for his studies and designs.

Examples: B.M.; V.A.M.; Fitzwilliam; N.G., Scotland; Portsmouth City Mus.
Bibliography: H.H. Stannus: *The Drawings of A.S.,* 1908. R. Southern: *A.S.,* 1925. K.R. Towndrow: *A.S.,* 1939, 1951. Tate Gall.: *Exhibition Cat.,* 1951.

STEVENS, Francis, O.W.S. 1781 (?Exeter) – 1823 (Exeter)
A landscape painter, he was a pupil of P.S. Munn (q.v.). He first
exhibited at the R.A. in 1804 and was one of the first Associates of
the O.W.S. elected in December 1805. He became a full Member in
1809, but did not join the Oil and Watercolour Society in 1813. He
rejoined the Society in 1821. He was a member of the Norwich
Society of Artists from 1810 and was also among the founders of
the Chalon Sketching Society. In 1816 he was a drawing master at
Sandhurst. His preferred subjects were rustic cottages and the like,
but his figures are sometimes too small for the buildings. He painted
in Yorkshire, Nottinghamshire and Devonshire.

Published: *Views of Cottages and Farmhouses in England and Wales*,
1808.
Examples: V.A.M.

STEVENSON, Robert Macauley, R.S.W.1860 (Glasgow) – 1952
A landscape painter who studied at the Glasgow School of Art and
exhibited at the R.A. from 1884 as well as in Scotland. He lived in
Glasgow, near Milngavie and at Kirkcudbright. He specialized in
moonlight scenes and was influenced by Corot and the Glasgow
School.

STEWART, James Lawson
A painter of old buildings, docks and boats who exhibited at
Suffolk Street in 1885 and 1889. He was a prolific artist, and his
work sometimes seems rather impressive at a glance, although less so
on close inspection. He signed with an involved monogram.

Examples: Bishopsgate Inst.; Maidstone Mus.

STEWART (or STEUART), Sir John James, 5th Bt. of Allanbank
1779 (Rome) – 1849 (Edinburgh)
A painter of battle and historical subjects in the manner of
Borgognone. He inherited the title in 1817, and in 1821 he
published the first of several sets of etchings. These include subjects
from Scott and Byron, 'The Visions of an Amateur' and 'Gleanings
from the Portfolio of an Amateur'. He also painted landscapes in
England and Scotland, particularly on Rothesay and the islands of
the Clyde. These tend to be more colourful than his figure drawings,
which are usually in monochrome washes heightened with white.
Much of his work is on blue or grey paper.

Examples: B.M.; Glasgow A.G.; N.G., Scotland; Ulster Mus.
Bibliography: *Print Collectors' Quarterly*, April, 1942.

STICKNEY, Sarah, Mrs. Ellis – 1872
The daughter of William Stickney of Ridgmont in Holderness, she
was a pioneer of female education and founded a school for girls at
Rawdon House, Hoddesdon. She wrote a large number of uplifting
books with titles such as *Sons of the Soil*. She painted views of Hull
between 1827 and 1829 and was a great-aunt of H.S. Tuke (q.v.).
She married William Ellis the missionary in 1837.

Bibliography: *The Home Life and Letters of Mrs. Ellis. Compiled by
her nieces*, 1893.

STICKS, George Blackie
1843 (Newcastle-upon-Tyne) – 1938
The son of an Edinburgh artist, James Sticks, he began as a glass
painter and studied under W.B. Scott (q.v.). He became a successful
landscape painter in oil and watercolour, specializing in Scottish and
North Eastern views.
 His brothers Henry J. and William Sticks were both glass
painters.

STICKS, Harry – 1938
The son of G.B. Sticks (q.v.), he was a landscape painter in oil and
watercolour. His style is free and his works are generally on a small
scale. His elder brother George Edward Sticks was also an artist.

Examples: Shipley A.G., Gateshead.

STIGAND, Helen M
A landscape painter who exhibited from 1868 to at least 1881. She

worked in England, Scotland and Italy, where she probably lived for
some time. Her work is 'artificial and sparkling' (*A.J.*).

STILLMAN, Maria, Mrs. née Spartali 1844 (London) –
The daughter of a Greek merchant based in London, she was a
pupil of F.M. Brown (q.v.) and was used as a model by Rossetti.
Her own work in both oil and watercolour shows a strong
Pre-Raphaelite influence in subject and handling. She married
William J. Stillman, an American journalist, in 1872.

STOCK, Henry John, R.I. 1853 (London) – 1930
A genre and landscape painter in watercolour and oil, and a
miniaturist. He studied at the R.A. Schools and exhibited from
1874. In 1880 he was elected R.I., and he lived near Bognor, Sussex.

Examples: City A.G., Manchester.

STOCKDALE, Frederick Wilton Litchfield
A topographic and antiquarian draughtsman who was assistant to
the Military Secretary of the East India Company until forced to
resign by ill-health. He exhibited at the R.A. from 1808 to 1821,
drew for Britton's *Beauties* and is said to have been alive in 1848.
His work can show the influence of Girtin, but can be rather hard in
touch.

Published: *Etchings... of Antiquities in... Kent*, 1810. *A
Concise... Sketch of Hastings, Winchelsea and Rye*, 1817.
Excursions in... Cornwall, 1824. *The Cornish Tourist*, 1834.
Examples: B.M.; V.A.M.; Fitzwilliam; Nat. Mus., Wales.

STOCKS, Arthur, R.I. 1846 (London) – 1889 (London)
The third son of Lumb Stocks, the line engraver, whose pupil he
was. He soon gave up engraving and entered the R.A. Schools. He
first exhibited with the S.B.A. in 1866, and subsequently at the
R.A., the Dudley Gallery, and the R.I., of which he was elected a
Member in 1882. Some of his paintings, in oil and watercolour,
usually of genre subjects, were engraved by his eldest brother
Bernard O. Stocks.

STOCKS, Katherine M – c.1891
A daughter of Lumb Stocks and sister of A. and W.F. Stocks (q.v.),
she painted flowers and exhibited in London and elsewhere from
1877 to 1889.

Examples: V.A.M.

STOCKS, Walter Fryer c.1842 –
A landscape painter and the second son of Lumb Stocks, he
exhibited at the R.A. and elsewhere from 1862. He lived in London,
Leamington and Hampstead and painted in Staffordshire, the
North-East of Scotland, Devon and Lancashire as well as in the
Home Counties. He was working until at least 1903.

Examples: V.A.M.

STOKES, Adrian Scott, R.A., R.W.S.
1854 (Southport) – 1935 (London)
A landscape painter in oil, watercolour and tempera, he studied at
the R.A. Schools and in Paris and exhibited at the R.A. from 1876.
He was elected A.R.A. and R.A. in 1910 and 1919, and A.R.W.S.
and R.W.S. in 1920 and 1926, serving as Vice-President from 1932.
He was also a member of the N.E.A.C. He painted in many parts of
Britain and Europe.
 His wife, MARIANNE STOKES, née PREINDLSBERGER
(1855–1927), an Austrian, was also a painter.

Published: *Pansy's Flour-Bin*, 1880. *Hungary*, 1909.
Illustrated: C. Holland: *Tyrol and its People*, 1909.

STONE, Frank, A.R.A. 1800 (Manchester) – 1859 (London)
Until the age of twenty-four he was a cotton spinner like his father,
but, following his artistic inclinations, he then set up as an oil
painter in Manchester. He seems to have been entirely self-taught. In
1831 he migrated to London where he made drawings for Heath's
Book of Beauty and watercolours for the dealer, Roberts. He was

elected A.O.W.S. and O.W.S. in 1833 and 1842, but retired in 1846 in order to seek admission to the R.A. as an oil painter. He was a figure painter, and he also visited Boulogne in 1853 and produced a few studies of fisherfolk. He was a friend of Dickens and a member of his troupe of amateur actors, and in 1848 he illustrated Dickens's Christmas Book *The Haunted Man*.

He was the father of M. Stone (q.v.), and his daughter ELLEN STONE was a genre painter in oil and watercolour.

Examples: V.A.M.; City A.G., Manchester.
Bibliography: *A.J.*, November, 1856. *Connoisseur*, LXII, 1922.

STONE, Marcus, R.A. 1840 (London) – 1921 (London))
The son of F. Stone (q.v.), he was a genre painter in oil and watercolour and an illustrator. He was a pupil of his father and exhibited at the R.A. from 1858. He was elected A.R.A. and R.A. in 1877 and 1887. He worked for *Cornhill Magazine* and illustrated Dickens's *Our Mutual Friend, Great Expectations* and other works.

Examples: B.M.
Bibliography: *A.J.*, 1869. *Art Annual*, 1896.

STOPFORD, Robert Lowe
 1813 (Dublin) – 1898 (Monkstown, Co. Cork)
A landscape and marine painter who practised, and gave drawing lessons, in Cork, and exhibited at the R.H.A. from 1858 to 1884. He worked for many years for the *I.L.N.* as art correspondent for the South of Ireland. Many of his views of Cork were lithographed.

STOPFORD, William Henry
 1842 (Cork) – 1890 (Halifax, Yorkshire)
A landscape and marine painter who studied under his father, R.L. Stopford (q.v.), at the Cork School of Art, and at South Kensington, where he later became a drawing master. He also taught at the St. Martin's Lane School of Art, and afterwards became Headmaster of the Halifax School of Art. He exhibited in the north of England, and at the R.A. in 1880. His watercolours are mostly of coastal scenes and seascapes.

Examples: V.A.M.

STORER, James Sargant 1771 (Cambridge) – 1853 (London)
A topographical draughtsman and engraver, he published a number of works, some in collaboration with his son HENRY SARGANT STORER (1797–1837). Their most important work was *Cathedrals of Great Britain*, 1814–19. The son exhibited at the R.A. from 1814 to 1836.

STOREY, George Adolphus, R.A. 1834 (London) – 1919 (London)
A painter of portraits and genre subjects in oil and watercolour who studied mathematics and paintings in Paris for two years from 1848. On his return, he spent a few weeks with an architect before entering Leigh's Academy. He exhibited at the R.A. from 1852 and entered the R.A. Schools two years later. He was elected A.R.A. and R.A. in 1876 and 1914. He lived in St. John's Wood, where he was a member of the 'Clique', and in Hampstead. His early work shows the influence of the Pre-Raphaelites.

Published: *Homely Ballads and old-fashioned poems*, 1880. *Sketches from Memory*, 1899.
Bibliography: *A.J.*, 1875. *Apollo*, June, 1964.

STOREY, John 1828 (Newcastle-upon-Tyne) – 1888 (Harrogate)
A Northumbrian artist, painting landscapes and old buildings in both oil and watercolour. He was a pupil of the elder T.M. Richardson (q.v.), and was an exhibitor at Suffolk Street in 1849 and 1851.

Examples: Laing A.G., Newcastle.

STORMONT, Howard Gull
A landscape and figure painter who was active between 1884 and 1923. He lived in Brighton, Hampstead, Richmond and Rye and also painted in South Wales.

STOTHARD, Charles Alfred, F.S.A.
 1786 (London) – 1821 (Beerferris, Devonshire)
The son of T. Stothard (q.v.), he entered the R.A. Schools in 1807. In 1815 he made a tour of northern England, making drawings for Lyson's *Magna Britannia*. On his return he was made Draughtsman to the Society of Antiquaries, and in 1816 he was sent to Bayeux to draw the tapestry. He married Anna Eliza Bray, the novelist, who wrote his biography as well as that of his father.

Published: *Monumental Effigies of Great Britain*, 1817.
Illustrated: A.E. Bray: *Letters written during a Tour through Normandy*, 1820.
Examples: B.M.
Bibliography: A.E. Bray: *Memoirs of C.A.S.*, 1823. A.E. Bray: *Autobiography*, 1889.

STOTHARD, Thomas, R.A. 1755 (London) – 1834 (London)
Largely brought up in Yorkshire, he began his career as a silk pattern designer. He first drew book illustrations in 1779, two years after entering the R.A. Schools. At this period he also painted small family portraits. In fact he took on all kinds of work from large subject paintings for the engravers to shop-cards and frontispieces. He was elected A.R.A. and R.A. in 1791 and 1794. In 1799 he began work on a series of staircase decorations for Burghley House and in 1806 on his most famous painting, *The Canterbury Pilgrims*. In 1812 he was appointed R.A. Librarian. He visited Paris in 1815 with Chantrey. In 1822 he decorated the Cupola of the Advocates' Library, Edinburgh, and later he produced designs for the Drawing Room and Throne Room at Buckingham Palace.

He was the most prolific and distinguished illustrator of his day, working initially in monochrome and later in full watercolour. His early work is romantic in the manner of J.H. Mortimer (q.v.), his later entirely his own. He was a compulsive sketcher of figures and groups of figures. In 1809 he produced a number of landscapes on a tour of the Lakes and Scotland. His colour is pretty and his drawing exact. The signature found on many of his drawings is a forgery.

Examples: B.M.; V.A.M.; Ashmolean; Williamson A.G., Birkenhead; Cartwright Hall, Bradford; Fitzwilliam; City A.G., Manchester; N.G., Scotland; Newport A.G.; Castle Mus., Nottingham; Ulster Mus.
Bibliography: A.E. Bray: *Life of T.S.*, 1851. *Memorial to T.S. 1867-8* (V.A.M. MS). A. Dobson: *Eighteenth Century Vignettes*, 1897. A.C. Coxhead: *T.S.*, 1906. *Connoisseur*, XXXI, 1911.

STOWERS, Thomas,
An illustrator, he exhibited at the R.A., the B.I. and the O.W.S. from 1778 to 1814. He has been claimed as a pupil or friend of Rowlandson and a pupil of Wilson, but in style his work is closest to that of J.H. Mortimer (q.v.), who, like him, was connected with the High Wycombe area. His figure illustrations in particular are like Mortimer in feeling, but they have a fussy pen line to indicate drapery. He also painted landscapes.

Examples: B.M.

STRACHAN, Arthur Claude 1865 (Edinburgh) –
A painter of landscapes and cottages who studied in Liverpool and exhibited in London from 1885 to 1929. He lived in Warwick, Evesham, New Brighton and Glasgow and painted in both watercolour and oil.

Examples: B.M.

STRACHAN, G
A copyist of Sandby, Pinelli and others, who was active in the early nineteenth century. He often worked on a large scale.

Examples: B.M.

STRANGE, Albert c. 1855 (Gravesend) –
A landscape and coastal painter who was appointed drawing master at the Maidstone School of Art in 1884 and Headmaster in 1886. He exhibited at the R.A. from 1882 to 1897, as well as with the N.W.S. and Suffolk Street, and later in life he lived in Liverpool and Scarborough.

STRATTON, Frederick
A landscape and figure painter who was active between 1898 and 1927, and who lived in London and at Amberley, Sussex.

Examples: V.A.M.

STREATFIELD, Robert 1786 – 1852
A painter of French and Belgian views. His work can be fascinatingly eccentric.

STREATFIELD, Rev. Thomas, F.S.A.
 1777 (London) – 1848 (Westerham, Kent)
A topographic and heraldic artist, he was educated at Oriel College, Oxford, and became Curate of Long Ditton and Tatsfield, Surrey, and Chaplain to the Duke of Kent. From 1822 he lived at Westerham, where he wrote tragedies and collected materials for a massive history of Kent. He retired from his curacy in 1842. There is a sketchbook of his at Greenwich which contains several shipping scenes.

Published: *The Bridal of Armagnac*, 1823. *Excerpta Cantiana*, 1836. *Lympsfield and its Environs*, 1839. *Hasted's History of Kent, corrected and enlarged*, 1886.
Examples: B.M.

STRETTON, Philip Eustace – c.1919
A landscape, animal and genre painter who exhibited from 1884. He lived in London, Wellington, Cranbrook and Surrey.

STRUTT, Arthur Edward 1862 (Gravesend) –
A painter of woodland scenes, who studied at the Gravesend School of Art and exhibited at the R.I. from 1886 to 1889, and the R.A. in 1899 and 1900.

STRUTT, Jacob George 1790 – 1864 (Rome)
An etcher and painter of portraits and forest scenery. He exhibited both oil paintings and watercolours at the R.A. and the B.I. from 1819 to 1858 and was best known for the etchings of trees and forests which he published in 1822 and 1828. In about 1831 he moved to Lausanne and then to Rome, returning in 1851.

His son, ARTHUR JOHN STRUTT (1819–1888), was a landscape painter.

Published: *Bury St. Edmunds illustrated*, 1821. *Sylva Britannica*, 1822. *Deliciae Sylvarum*, 1828.

STRUTT, Joseph 1749 (Chelmsford) – 1802 (London)
After an apprenticeship to the engraver Ryland, he entered the R.A. Schools. He exhibited classical subjects at the R.A. from 1778, and most of his best engravings were done at this time. In 1790 he moved to Bramfield, Hertfordshire, returning to London in 1795.

His life was devoted to antiquarian and literary pursuits, of which his drawings are illustrations.

Published: *The Regal and Ecclesiastical Antiquities of England*, 1773. *Manners, Customs, Arms, Habits . . . of the People of England*, 1774-6. *Chronicle of England*, 1777-8. *Biographical Dictionary of Engravers*, 1785-6. *Dresses and Habits of the English People*, 1796-9. *Sports and Pastimes of the People of England*, 1801.
Illustrated: J. Bunyan: *Pilgrim's Progress*, 1792.
Examples: B.M.
Bibliography: W. Strutt: *A Memoir of the Life of J.S.*, 1896.

STRUTT, William
 1827 (Teignmouth, Devon) – 1915 (Wadhurst, Sussex)
The grandson and biographer of J. Strutt (q.v.) and the son of William Thomas Strutt (1777-1850), a banker and miniature painter, he studied in Paris and became an animal, genre and portrait painter. In 1850 he went to Australia, where he produced the *Australian Journal* and the *Illustrated Australian Magazine*. He moved to New Zealand in 1856 and returned to England in 1862. He exhibited at the R.A. and elsewhere from 1865, was elected R.B.A. in 1891 and lived at Writtle, Essex, and Wadhurst. He was a Fellow of the Zoological Society.

His daughter ROSA STRUTT was also an animal and flower painter.

Examples: B.M.

STUART, Augustus BURNETT- 1850 – 1898
A banker who travelled widely, painting landscapes in China, India, the Near East, West Africa and many parts of Europe, as well as in England and his native North-East Scotland. He was a good pencil sketcher, and his watercolours are best when small. On a larger scale they can be rather woolly. There is a predominance of green in his work.

STUART, Gertrude Gwendoline VILLIERS-, Lady Scott
 1878 (Dromana, Cappoquin) – 1961 (London)
The second daughter of H.W. Villiers-Stuart of Dromana, she was in impressive amateur landscape painter. She studied in Italy under Nardi and Carlandi, and visited Egypt in about 1904 and India in 1908. After her marriage in 1914 to Sir Basil Scott (d. 1926), Chief Justice of the High Court of Bombay, she lived on Mull – where her wet painting technique was ill-suited to the climate – and at Tangier.

She was particularly good at depicting atmospheric effects and was at her best in views of the Kashmiri Lakes.

STUART, James 'Athenian', F.R.S., F.S.A.
 1713 (London) – 1788 (London)
Antiquary, architect and draughtsman, he was the son of a Scottish sailor and began his career with the fan painter Lewis Goupy. At the same time he not only taught himself to paint in water and bodycolour, but also learnt mathematics, anatomy, Greek and Latin. In 1742 he set out for Rome on foot. There he acted as a cicerone and picture expert. In 1748 he went to Naples with Gavin Hamilton, Matthew Brettingham and N. Revett (q.v.), and the idea of the *Antiquities of Athens* was born. He and Revett left Rome for Athens by way of Venice in 1750, arriving the following March. They returned to England in 1755. Stuart bought out Revett, who had been the real originator of the project, and it was Stuart who was made famous by the *Antiquities*. He exhibited Athenian drawings with the Free Society for a number of years thereafter.

Stuart was primarily a landscapist, Revett providing careful architectural drawings. Stuart also made a number of decorative classical designs after his return.

Published: *The Antiquities of Athens*, 1762, 1787, 1816, 1830.
Examples: B.M.; R.I.B.A.
Bibliography: Warburg Inst., *Journal*, ii, 1938-9.

STUART, John, 'Il Cavaliere Milanese'
 1739 (Edinburgh) – 1800 (Tyburn)
A painter of romantic landscapes in the tradition of Claude, he left Edinburgh under a cloud when he was about twenty. He next appears in Milan in 1765, teaching English and drawing to the daughters of the aristocracy. He was forced to leave the city after a tempestuous affair with one of his pupils, and in 1775 he was in Florence, where Horace Mann hints that he was employed as a British spy at the Court of the Jacobite Charles III. With the outbreak of the French Revolution, he returned to Scotland, where he began to compile a Gaelic dictionary. However, he failed to gain financial backing for this project and moved to London, where he engaged in various dubious speculations and was ultimately hanged for coining. It is almost certain that he awarded himself the title of 'Cavaliere' by which he was known.

Some of his drawings could be mistaken for those of R. Adam (q.v.), but he tends to use more colour.

Bibliography: C.R.V. More: *Bucks and Rakes*, 1927.

STUBBS, George, R.A. 1724 (Liverpool) – 1806 (London)
The animal painter. The sale of his remaining works at Coxe's, London, May 26-7, 1807, contained several lots of watercolours. These were presumably studies and sketches for oil paintings.

Examples: B.M.

STUMP, Samuel John c. 1783 − 1863
A miniaturist and landscape painter and a member of the Sketching Society. He studied at the R.A. Schools, and exhibited miniatures and oil paintings at the R.A. from 1802 to 1845. He also exhibited miniatures with the Oil and Watercolour Society, and English, Italian and Swiss views at the B.I. and Suffolk Street until 1849.

He took many portraits of stage personalities, some in watercolour.

Examples: B.M.; Newport A.G.

STURGE, F **William**
A coastal and landscape painter who lived in Gloucester and exhibited in Birmingham from 1878 to 1881. Many of his subjects were taken from Cornwall and the Channel Islands, but he also showed Egyptian views at the Modern Gallery in 1908.

SUKER, Arthur 1857 (Cheshire) −
The brother of F.C. Newcombe (q.v.) and first cousin of W. Crane (q.v.), he studied for about two years at the Birkenhead School of Art and painted landscapes and coastal scenes in oil and watercolour. He lived in Liverpool and Devonshire and also painted in Wales, the Lake District, the Channel Islands and the Isle of Man.

Examples: Sydney A.G.

SULLIVAN, Edmund Joseph, R.W.S.
 1869 (London) − 1933 (London)
An illustrator in black and white and watercolour and a printmaker, he was the son and pupil of an artist working in Hastings. He worked for the *Graphic* in 1889, the *Daily Graphic* from 1890 to 1892 and thereafter for the *Pall Mall Budget*. He also illustrated many books. He was elected A.R.W.S. and R.W.S. in 1913 and 1929.

Examples: B.M.; Cartwright Hall, Bradford.

SUNDERLAND, Thomas
1744 (Whittington Hall, near Kirkby Lonsdale) − 1828 (Littlecroft)
An owner of ironworks and an amateur artist, Sunderland sold his family home and built Littlecroft, Ulverston, in 1782. He was a Deputy Lieutenant for Lancashire and in 1803 formed the Ulverston Volunteers. He visited Scotland, Wales, Ireland, Italy, Spain, Switzerland, Austria and Germany, as well as many parts of England.

He was a pupil of J.R. Cozens (q.v.) and perhaps of J. Farington (q.v.), and Cozens almost certainly stayed with him on his visit to the Lake District. He generally worked in grey-blue washes with pen or pencil outlines, but he also produced black or brown wash drawings and full watercolours. Many of his drawings now bear faked Sandby signatures.

Examples: B.M.; V.A.M.; Williamson A.G., Birkenhead; Coventry A.G.; Abbot Hall A.G., Kendal; Leeds City A.G.; Leicestershire A.G.; Newport A.G.; Ulster Mus.
Bibliography: O.W.S. Club XX, 1942.

SURTEES, Elizabeth **See ROYAL, Elizabeth**

SURTEES, John 1819 (Ebchester) − 1915 (Ashover, Derbyshire)
Apprenticed to a Newcastle firm of engineers, he attended evening art classes. After a holiday tour of the Lake District with T.M. Richardson, Yr. (q.v.), he became a full time artist specializing in landscape. He exhibited at the R.A. from 1849 to 1889. Later he lived in London and Cannes. He also worked in Scotland and North Wales.

He married E. Royal (q.v.).

Examples: Shipley A.G., Gateshead; Laing A.G., Newcastle.

SUTCLIFFE, Thomas, A.N.W.S.
 1828 (Leeds) − 1871 (Ewcote, near Whitby)
A landscape, marine and allegorical painter who studied at the B.M. and the R.A. Schools. He exhibited in London from 1856 and was elected A.N.W.S. in the following year. For the last six years of his

life he suffered from a weak heart. His landscapes are sometimes in a splashy Müller-like style, and his allegories are poetic, if strange. Three hundred of his sketches were sold in Leeds, April 4, 1872.

LESTER SUTCLIFFE, also of Leeds, who exhibited coastal subjects and landscapes at Suffolk Street from 1880 to 1885, and was active until about 1930, may have been a relation.

Examples: V.A.M.; Ferens A.G., Hull; Leeds City A.G.
Bibliography: *A.J.*, 1872.

SUTHERLAND, Elizabeth, Duchess of 1765 − 1839
Elizabeth, Countess of Sutherland in her own right, was the daughter of the 18th Earl of Sutherland and married George Granville, later 1st Duke of Sutherland, in 1785. Her right to the succession was allowed after a dispute by the House of Lords in 1771. She was a favourite pupil of Girtin and a frequent visitor to his studio.

Published: *Views on the Northern and Western Coasts of Sutherland*, 1807.

SUTTON, W **J**
A ship portraitist working in the late nineteenth and early twentieth century. He painted ships for Rear-Admiral Sir George Baird. His colouring is rather lurid.

Examples: Greenwich.

SWAINE, Francis c. 1740 − 1782 (Chelsea)
A marine painter in oil and wash, he exhibited with the Incorporated and Free Societies from 1762. He became a member of the Free Society in the following year. He lived in Westminster and later Chelsea, and much of his work, including many small wash drawings in the manner of the younger Van de Velde, was sold directly to dealers.

Examples: B.M.; Greenwich: City A.G., Manchester.

SWAINSON, William
 1789 (Liverpool) − 1855 (Hutt Valley, New Zealand)
A naturalist and zoological draughtsman. He worked for the customs and commissariat in Malta and Sicily from 1807 to 1815. He also visited Italy and Greece and formed a large natural history collection. From 1816 to 1818 he was in Brazil. He lived in London until 1825 and then in Warwick until 1837 when he emigrated to New Zealand by way of Rio. In 1853 he undertook a survey of the timber in Tasmania and Victoria. He was the author of numerous books, often illustrated by himself.

Published: *Zoological Illustrations*, 1820-23. *Ornithological Drawings: Birds of Brazil*, 1834-5. Etc.
Illustrated: Sir J. Richardson: *Birds of Western Africa*, 1837.

SWAN, Alice Macallan, R.W.S. 1864 (Worcester) − 1939
The sister and pupil of J.M. Swan (q.v.), she painted flowers, landscapes and genre subjects. She exhibited from 1882 and was elected A.R.W.S. and R.W.S. in 1908 and 1929. She lived in London. Her work is sometimes reminiscent of that of Whistler.

SWAN, John Macallan, R.A., R.W.S.
 1847 (Old Brentford) − 1910
An animal painter and sculptor who studied at Worcester, the Lambeth School of Art, the R.A. Schools and in Paris. He exhibited at the R.A. from 1878 and was elected A.R.A. and R.A. in 1894 and 1905 and A.R.W.S. and R.W.S. in 1896 and 1899. He lived in London and at Niton, Isle of Wight. As well as oil paintings and watercolours, often of lions and leopards, he produced many pastels.

Examples: B.M.; Cartwright Hall, Bradford; Glasgow A.G.; Leeds City A.G.
Bibliography: A.L. Baldry: *Drawings of J.M.S.*, 1904.

SWANWICK, Anna 1813 (Liverpool) − 1899 (Tunbridge Wells)
A novelist, translator of Goethe, and the last pupil of S. Austin (q.v.), she was in Germany from 1839 to 1843. She later helped to

found Girton and Somerville Colleges, and was a friend of Browning, Gladstone and Tennyson.

Bibliography: M.L. Bruce: *A.S.*, 1903.

SWANWICK, Joseph Harold, R.I. 1866 (Middlewich) — 1929
A painter of landscapes, figures and animals in watercolour and oil. He studied in Liverpool and at the Slade and exhibited at the R.A. from 1889. He was elected R.I. in 1897 and lived in Sussex.

Examples: B.M.

SWARBRECK or SCHWARBRECK, Samuel Dukinfield
An architectural, topographical and genre painter who was active from 1815, when he visited the Isle of Man with W. Latham (q.v.), to 1863. He made a number of prints of Edinburgh and may well have lived there and in Dublin before moving to London, where he exhibited from 1852. He also painted in Durham, Chester and Wales. He was an unsuccessful candidate for the N.W.S. in 1861 and 1862. His wife Delia Caroline Swarbreck published a tragedy in 1830.

Published: *Sketches in Scotland*, 1839.
Examples: Fitzwilliam; Manx Mus.

SWETE, Rev. John c. 1752 — 1821
A topographer and antiquarian, he was the son of Nicholas Tripe of Ashburton, Devon, and changed his name in consequence of an inheritance from an aunt. He matriculated from University College, Oxford, in 1770. He was a prebendary of Exeter from 1781 and his writings and drawings were usually concerned with the county. He also sketched in Yorkshire in 1795, Scotland in 1814, Switzerland and Italy in 1816, Cumberland, Northumberland and the Midlands. In later life he lived at Oxton House, near Exeter.

Examples: City Lib., Exeter; County Record Office, Exeter; Exeter Mus.
Bibliography: *Gentleman's Mag.*, 1796, ii. *Torquay Directory*, 1871.

SWINBURNE, Edward 1765 —
The brother of Sir John Swinburne, 7th Bt., of Capheaton, near Newcastle, where he lived from 1829. He had visited Italy and, with his brother, was a patron of Turner. Views by him were engraved in Surtees' *History of Durham,* IV, 1840.

At his best, in his elaborate rustic scenes, he falls between Hills and Cristall, and his smaller coast views are highly coloured and professional.

His niece JULIA SWINBURNE and her sisters were competent amateurs in oil and watercolour.

Examples: B.M.; V.A.M.
Bibliography: *Country Life*, July 8, 1939.

SWINDELL, William — 1929 (Derby)
A Derby architect and amateur watercolour artist. He helped to found the Derby Sketching Club, of which he was Secretary for some years.

SWINDEN, Elsie C
A Birmingham fruit, flower and landscape painter who exhibited with the Birmingham Society from 1879 to 1899. She painted in the Midlands and in France and Italy.

Her sister SELINA ANNIE SWINDEN painted flowers and occasional landscapes and exhibited from 1881 to 1886.

SYER, John, R.I. 1815 (Atherstone) — 1885 (Exeter)
A landscape painter in oil and watercolour, he was a pupil of the Bristol miniaturist John Fisher. He lived in Bristol, often working in Bath during the season, until 1872 when he moved to London. He exhibited in London from 1832, was a member of the S.B.A. from 1856 to 1875 and was elected A.N.W.S. and N.W.S. in 1874 and 1875. He worked in the Cox tradition.

He had at least two painter sons. JOHN C. SYER (c. 1846-1913) served in the Navy until 1870 when he settled in Whitby. He was a

pupil of his father and a friend of B.W. Leader, and he exhibited marine subjects in York and Bristol.

JAMES SYER, who remained in Bristol, exhibited marine subjects and Welsh, Scottish and Irish views at Suffolk Street and the R.A. from 1867 to 1878.

There was also an H.R. SYER who shared John Syer's London addresses and who exhibited coastal scenes and Welsh landscapes at Suffolk Street from 1874 to 1880.

Examples: Victoria A.G., Bath; Williamson A.G., Birkenhead; Leicestershire A.G.; City A.G., Manchester; Newport A.G.

SYKES, Godfrey 1824 (Malton) — 1866 (London)
A painter of landscapes and the interiors of rustic buildings and a designer, he was apprenticed to an engraver and studied at the Government School of Design at Sheffield. He was much influenced by A.G. Stevens (q.v.) and came to London where he was involved in the plans and decorations of the buildings in the Horticultural Gardens at South Kensington. He also copied old masters.

A memorial exhibition was held at South Kensington in the summer of 1866.

Examples: V.A.M.; City A.G., Manchester.
Bibliography: *A.J.,* May, 1866.

SYKES, Peace
A Huddersfield landscape painter who exhibited at the R.A., N.W.S. and Suffolk Street from 1872 to 1900.

His son, GEORGE SYKES (b. 1863), was also a landscape painter in oil and watercolour. He was active until at least 1927.

HENRY SYKES, a landscape and genre painter who exhibited from 1874 to 1895, was probably a brother of Peace Sykes, whose Huddersfield address he shared before moving to London. He was elected R.B.A. in 1889.

SYME, Patrick, R.S.A.
1774 (Edinburgh) — 1845 (Dollar, Clackmannanshire)
An Edinburgh flower painter who occasionally took portraits. In 1803 he took over his brother's practice as a drawing master, and later taught at the Dollar Academy. He was a Founder Member of the R.S.A. and helped to run its affairs.

His nephew, JOHN SYME (1795-1861), was a portrait painter and also a Founder Member of the R.S.A.

Published: *Practical Directions for Learning Flower Drawing*, 1810. *Treatise on British Song Birds*, 1823.

SYMONS, William Christian 1845 (London) — 1911 (London)
A portrait, genre, landscape and still-life painter in oil and watercolour and a designer, he studied at the Lambeth School of Art and the R.A. Schools. He worked as a stained glass designer and later provided the much criticised mosaics for Westminster Cathedral. He was elected to the S.B.A., but resigned with Whistler in 1888. Thereafter he lived at Newlyn and in Sussex. He was much influenced by J.S. Sargent (q.v.) and H.B. Brabazon (q.v.).

A memorial exhibition was held at the Goupil Gallery in 1912.

Examples: B.M.

SYNGE, Edward Millington 1860 (Great Malvern) — 1913
An etcher who painted occasional landscapes. Of Irish extraction, he was educated at Norwich Grammar School and Trinity College, Cambridge, after which he became a land agent. In 1898 he was elected an Associate of the Royal Society of Painter-Etchers and Engravers, and he exhibited at the R.A. and elsewhere from the following year. In 1901 he retired from business to devote himself to art, and worked in Paris, Italy and Spain. In 1908 he married Miss F. Molony, herself an artist.

Illustrated: A.M. Caird: *Romantic Cities of Provence*, 1906.

TADEMA, Sir Lawrence ALMA-, R.A., R.W.S.
1836 (Dronryp, Holland) – 1912
An archaeological genre painter in oil and sometimes watercolour, he studied at the Antwerp Academy and worked as assistant to Baron Leys before settling in London in 1870. He was elected A.R.A. and R.A. in 1873 and 1879 and A.O.W.S. and O.W.S. in 1873 and 1875. Despite his living in a Pompeian villa in St. John's Wood and his stage designs for Irving and Beerbohm Tree, his work lacks life. It is, however, always technically brilliant. His finished paintings are signed L. Alma-Tadema followed by an opus number in Roman numerals. He illustrated a number of books and wrote plays, poems and novels of his own.

His wife, LAURA THERESA, LADY ALMA-TADEMA,, née EPPS (1852-1909), was his pupil before their marriage in 1871 and worked very much in his manner. She signed L. Alma-Tadema without the opus number. A memorial exhibiton was held at the Fine Art Society in 1910.

Their daughter, ANNA ALMA-TADEMA (d.1943), who exhibited from 1885, followed in their tradition.

Examples: B.M.; V.A.M.; Aberdeen A.G.; City A.G., Manchester.
Bibliography: G.E. Lorenz: *A. T.*, 1886. P.C. Standing: *Sir L. A.-T.*, 1905. W. Gaunt; *Victorian Olympus*, 1952. *A.J.*, 1875; 1883. *Apollo*, LXXVII, December, 1962. C. Spencer: *A-T.*, 1977.

TALBOT, George Quartus Pine
1853 (Bridgwater) – 1888 (Grasmere)
A landscape painter who exhibited at the R.A. from 1881 to 1885.

Examples: Walker A.G., Liverpool.

TALBOT, William Henry Fox, F.R.S.
1800 (Lacock Abbey, Chippenham) – 1877 (Lacock Abbey)
A mathematician, photographic pioneer and occasional artist. He was educated at Harrow and Trinity College, Cambridge, and was led to his experiments in photography by his failures with the camera obscura and the camera lucida. His book, *The Pencil of Nature*, 1844-6, was the first to be illustrated with photographs. He was also an antiquarian and from 1833 to 1834 M.P. for Chippenham.

TANDY, Commander Daniel
c.1770 – 1848 (Topsham, Devon)
He joined the Navy in 1782 and served on the Atrican, Jamaican and Channel stations before his promotion to lieutenant in 1790. He later served in the Mediterranean and the West Indies, and he retired in 1825.

There is a sketchbook of his at Greenwich containing crude shipping scenes and numerous ship portraits, dating from 1798 to about 1815.

TARRANT, Charles
In the B.M. there is a view of Charles Fort, near Kinsale, dated 1756, by this artist. It has neat outlines and fresh colourful washes.

TASKER, William
1808 (London) – 1852 (Chester)
A sporting painter who trained and lived at Chester. He and his brother EDWARD TASKER both drew Chester views.

Examples: Grosvenor Mus., Chester.

TATE, Thomas Moss **– 1825**
The son of Richard Tate (d.1787), a Liverpool merchant, patron and copier of Wright of Derby, and nephew of William Tate (d.1806), a portrait painter, friend and pupil of Wright. He was himself a patron and close friend of Wright. He produced landscapes and occasional heads in chalk and exhibited in Liverpool in 1784 and 1787. In the summer of 1793 he and Wright spent a week in the Lakes with T. Gisborne (q.v.). He was engaged in trading to Africa after the abolition of the slave trade.

His watercolours mainly date from the mid 1790s. Wright did not approve of his use of this medium, commenting that 'Paper and camel hair pencils are better adapted to the amusement of ladies than the pursuit of an artist'. The V.A.M. has a Roman view by him.

TATHAM, Frederick **1805 (London) – 1878**
A painter of miniatures, portraits and figure subjects and a sculptor, he was the son of CHARLES HEATHCOTE TATHAM (1772-1842), an architect and draughtsman. He was a friend, disciple and biographer of W. Blake (q.v.) and the brother-in-law of G. Richmond (q.v.), who eloped to Gretna Green with his sister. He exhibited from 1825 to 1854.

Examples: B.M.
Bibliography: L. Binyon: *Followers of William Blake*, 1926.

TATLOCK, Mrs., née de Wint
The daughter of P. de Wint (q.v.) and an imitator of his style.

TAUNTON, William
A landscape painter who lived in Worcester and London and was active from 1840 to 1875. He painted in many parts of the country, including Yorkshire, Buckinghamshire, Conway, Devon, Kelso and Hampshire. He was an unsuccessful candidate for the N.W.S. in 1854 and exhibited in London and Birmingham.

His drawing, in pencil or chalk, often on tinted paper, is good, but his full watercolours can be rather untidy. They are in the late manner of Cox or of Muller.

Examples: B.M.

TAVERNER, William **1703 – 1772**
The son of William Taverner (d.1731), a playwright and occasional painter, and the grandson of the portrait painter Jeremiah Taverner, he was described by a contemporary as 'one of the best landscape-painters England ever produced'. Like his father, he held the post of Procurator General of the Court of Arches. His romantic and poetical landscapes founded one of the two streams of eighteenth century watercolour painting, the other being exemplified by Sandby's perfect tinted topographical work. He worked in body-colour and free washes, but his most typical products are carefully drawn groups of trees, ruins and figures, with a soft light and a characteristic dappled technique for foliage. His pure figure drawing is sometimes, but by no means always, rather weak. He was much influenced by the Italians, in particular perhaps by Marco Ricci, who worked in England.

Examples: B.M.; V.A.M.; Ashmolean; Fitzwilliam; Walker A.G., Liverpool; City A.G., Manchester; Castle Mus., Nottingham.
Bibliography: *Gentleman's Mag.*, 1772, ii.

TAYLER, Edward **1828 (Orbe) – 1906 (London)**
A portrait, figure and miniature painter who exhibited at the R.A. and elsewhere from 1849. He was a Founder Member and Treasurer of the Royal Society of Miniature Painters and 'has been called the father of present-day miniature painters' (*A.J.*, 1906). His portraits are sweet and truthful, if rather insipid.

Examples: B.M.

TAYLER, John Frederick, P.R.W.S.
1802 (Boreham Wood, Hertfordshire) – 1889 (London)
Among the youngest of the seventeen children of a distressed country gentleman, Tayler was educated at both Eton and Harrow. He refused to go into the Church as his family wished, and studied

art at Sass's, the R.A. Schools, and in Paris under Horace Vernet, living with R.P. Bonington (q.v.). He also sketched with S.Prout (q.v.) on the French coast. Afterwards he spent some time in Rome. He first exhibited at the R.A. in 1830, and he was elected A.O.W.S. in 1831 and O.W.S. in 1834. He became President on the retirement of J.F. Lewis (q.v.) in 1858, and himself retired in 1871. He continued to exhibit until the year of his death. During the Paris Exhibition of 1855, he received the Cross of the Legion of Honour. He was a member of numerous societies and academies throughout Europe and America, and of the the Garrick and the Athenaeum.

His favourite subjects were hunting and hawking scenes, often in a light historical guise. He frequently stayed with his aristocratic friends and patrons in Scotland, sometimes working them into his compositions. He illustrated a number of books on country themes and was himself a keen etcher. His drawing is generally free and colourful, and he signed with the initials F.T.

A loan exhibition of his work was held by Vokins in 1880, and his remaining works were sold at Christie's, February 17, 1890. He was the father of N.E. Tayler (q.v.).

Examples: B.M.; V.A.M.; Haworth A.G., Accrington; Towneley Hall, Burnley; Maidstone Mus.; City A.G., Manchester; Portsmouth City Mus.; Reading A.G.; Glynn Vivian A G., Swansea; Ulster Mus.
Bibliography: *A.J.*, November, 1858.

TAYLER, Norman E , A.R.W.S.
 1843 (London) – 1915
A genre and landscape painter, he was the second son of J.F. Tayler (q.v.) and studied at the R.A. Schools and in Rome. He exhibited from 1863 and was elected A.O.W.S. in 1878. He lived in London.

Examples: V.A.M.; Dundee City A.G.

TAYLER, William 1808 (Boreham Wood) – 1892 (St. Leonards)
A brother of J.F. Tayler (q.v.), he went to India in 1829 as a Writer and became a national hero for his conduct as Commissioner of Patna during the Mutiny of 1857. As an artist he was primarily a caricaturist, but his drawing of the triumphal entry of Sir Herbert Maddock into Calcutta was engraved by F.C. Lewis. He illustrated his autobiography with drawings in the manner of Thackeray.

Published: *Thirty-Eight Years in India*, 1881. Etc.

TAYLEUR, William
A musician in a company of strolling players in about 1800, Tayleur met F. Nicholson (q.v.) in Ripon and took lessons from him. He then set up as a drawing master in Beverley, and for a year or two produced a number of fake Nicholsons which he sold in Yorkshire. He claimed that Nicholson had taken to drink, thus explaining the poor quality of the works. He was exposed by Nicholson and their mutual patron, Major Machell (q.v.). He is said to have died of drink himself shortly afterwards. On the other hand an actor of the same name was appearing at the Haymarket in the 1820s.

TAYLOR, Alfred Henry – 1868
A portrait and genre painter who lived in London and exhibited from 1832. He was elected N.W.S. in 1839 but resigned in 1850 'to devote nearly all my spare time to Oil and Crayon Painting'. However, this does not seem to have been a success since he tried to rejoin the Society in 1861, and he continued to exhibit watercolours in the interim.

TAYLOR, Charles, Yr.
The son of Charles Taylor, a painter of storms, coasts and historical subjects, for the most part in oil. He painted marine subjects in watercolour and generally on a large scale, and he exhibited from 1841 to 1883. He lived in London and Hastings. He sometimes signed in red.

Examples: Greenwich.

TAYLOR, Edwin
A Birmingham landscape painter in oil and watercolour who exhibited there and in London from 1858 to 1884.

Published: *Pictures of English Lakes and Mountains*, 1874.

TAYLOR, Ernest Archibald 1874 (Greenock) – 1952
Furniture and glass designer, interior decorator, etcher and painter in oil and watercolour. He was educated in Norfolk and Greenock and exhibited widely at home and abroad. He married J.M. King (q.v.).

Examples: Glasgow A.G.

TAYLOR, George Ledwell, F.S.A.
 1780 (London) – 1873 (Broadstairs, Kent)
An architect who studied at Rawse's Academy and was apprenticed to J.T. Parkinson. In 1816 he toured England with E. Cresy (q.v.) and from 1817 to 1819 they walked through France, Italy, Greece, Malta and Sicily. They were with John Sanders and W. Purser (q.v.) in 1818 when they discovered the Theban lion at Chaeronaea. From 1824 to 1837 he was Civil Architect to the Naval Department and thereafter worked in general practice. From 1856 to 1868 he spent much time in Italy.

Published: with E. Cresy: *The Architectural Antiquities of Rome*, 1821-2. With E. Cresy: *The Architecture of the Middle Ages*, 1829. *Stones of Etruria and Marbles of Ancient Rome*, 1859. *Autobiography of an Octogenarian*, 1870-2. Etc.

Examples: V.A M.

TAYLOR, Isaac 1730 (Worcester) – 1807 (Edmonton)
An engraver, portrait painter and occasional illustrator. In the B.M. are grey wash portraits of Garrick and others. They are a little crude. His son (1759-1829) and grandson (1787-1865), both Isaac, were also artists.

TAYLOR, John 1739 (London) – 1838
A pupil of Francis Hayman and at St. Martin's Lane Academy, he occasionally took small watercolour portraits which are rather stiff, but charming. His most usual works are highly finished pencil portraits. In 1766 he was a Founder Member of the Incorporated Society, and he exhibited spasmodically at the R.A. from 1779.

He should not be confused with JOHN TAYLOR (c.1755-1806) of Bath, who was a landscape painter and etcher.

TAYLOR, Joshua
A landscape, marine, portrait and genre painter in oil and watercolour who exhibited at the B.I. and Suffolk Street from 1840 to 1877. He lived at Woolwich and Islington.

TAYLOR, J W
A painter living in Ryde, Isle of Wight. He was elected N.W.S. in 1834, but was dropped from the Society in 1837 because a rheumatic fever had rendered his right hand useless.

TAYLOR, Simon – 1772
A botanical painter who studied at Shipley's drawing school. In about 1760 he was commissioned by Lord Bute to paint the plants at Kew on vellum. Many of these studies were sold at auction in 1794. The paintings he made for John Fothergill, physician and botanist, were sold to Catherine the Great in 1780.

TAYLOR, Thomas c.1770 –?1826 (Liversedge)
A topographical draughtsman who was a pupil of James Wyatt and entered the R.A. Schools in 1791. He exhibited at the R.A. from 1792 to 1809. He may well be the architect and topographer who had been an assistant of Wyatt and a Mr. Andrews and who established himself in Yorkshire in about 1805, illustrated Whitaker's *Loidis and Elmete*, 1816, and Thoresby's *Ducatus Leodiensis*, 1816, and built a number of churches and public buildings in Leeds and the West Riding.

Examples: B.M.

TAYLOR, Thomas
 (East Indies) – 1848 (Dunkerron, Co. Kerry)
Professor of botany at the Royal Cork Scientific Institution, he was elected to the Linnaean Society in 1814 and contributed articles to

the Linnaean Society and the Botanical Society of Edinburgh. His drawings were bought on his death by J.A. Lowell of Boston, Massachusetts, and presented to the Boston Society of Natural History.

Published: with Sir W.J. Hooker: *Muscologia Britannica*, 1818.

TAYLOR, Thomas
A London genre painter in watercolour and oil, he exhibited at the R.A., N.W.S. and Suffolk Street from 1883 to 1893. He signed Tom Taylor.

There was also an earlier T. TAYLOR, a drawing master working in about 1760.

TAYLOR, Walter 1860 (Leeds) – 1943 (London)
An architectural and landscape painter who trained as an architect before turning to painting. He was a friend of W.R. Sickert (q.v.) and worked with him in France and Italy. His first one-man show was held at the Grafton Gallery in 1911.

He should not be confused with his namesake, the flower painter WALTER TAYLOR, who was born in London in 1875, studied under W. Crane (q.v.) and worked for Morris & Co. He exhibited until 1940.

TAYLOR, William 1800 (London) – 1861
A schoolmaster who in 1844 became Secretary of the King's Lynn Museum. His drawings show a hard and unoriginal style. Between 1833 and 1862 he published or illustrated a number of books, for the most part on local antiquities.

TAYLOR, William Benjamin Sarsfield
1781 (Dublin) – 1850
Son of John McKinley Taylor, a Dublin map engraver, he entered the R.D.S. Schools in 1800 and became a drawing master. He served in the Peninsular War, after which he returned to Dublin to paint and work as an art critic. He played a part in the foundation of the R.H.A., after which he moved to London, where he exhibited land and seascapes and military scenes at the N.W.S., of which he was a member from 1831 to 1833, the B.I., Suffolk Street and the R.A. He also contributed to the R.H.A. from their opening exhibition in 1826 until 1829. Late in life he was Curator of the St. Martin's Lane Academy.

Published: P. Merimée: *Art of Painting in Oil and Frescoe*, 1839 (translation). *The Origin, Progress and Present Condition of the Fine Arts in Great Britain and Ireland*, 1841. *A Manual of Frescoe and Encaustic Painting*, 1843. *History of the University of Dublin*, 1845.

Examples: Williamson A.G., Birkenhead.

TEASDALE, John 1848 (Newcastle) – 1926
He studied under W.B. Scott (q.v.) at the Newcastle School of Art, and won a National Scholarship to South Kensington. Later he taught at Sherborne, Belfast, and the Doncaster School of Art. Thereafter he returned to the North East as Curator of the Shipley Collection in Gateshead.

His watercolours, often of architecture, are usually on a small scale, and he frequently uses bodycolour.

Examples: Shipley A.G., Gateshead; Laing A.G., Newcastle.

TEIGNMOUTH, Commander Henry Noel Shore, 5th Baron
1847 – 1926
A painter of Egyptian and oriental subjects who joined the Navy in 1868. He was promoted lieutenant in 1872 and commander on retiring from active service in 1891. He exhibited at the R.I. in 1883 and 1884.

Published: *The Flight of the Lapwing*, 1881. *Smuggling Days and Smuggling Ways*, 1892. *Three Pleasant Springs in Portugal*, 1899. *The Diary of a Girl in France in 1821*, 1905. With C.G. Harper: *The Smugglers*, 1923.

TELBIN, William, N.W.S. 1813 – 1873 (London)
A landscape painter and topographer who exhibited from 1839 and was elected N.W.S. in that year. He succeeded C. Stanfield (q.v.) as scene painter at Drury Lane and lived in London. He produced Italian, Portugese and other Continental subjects as well as views in Britain.

He had at least two sons, WILLIAM TELBIN, YR. who exhibited British, Irish and Tyrolean subjects from the 1860s to the 1880s, and another who was killed in an avalanche in about 1867. He never recovered from the shock.

Examples: B.M.

TENNANT, John F 1796 (Camberwell) – 1873
A marine and landscape painter who was put to work in a merchant's office, but showed no aptitude and was allowed to take lessons from W. Anderson (q.v.). He exhibited from 1829, mostly with the S.B.A., of which he was elected a member in 1842 and later Secretary. He lived in London, Kent, Wales, Surrey, Devon and again London, and also painted in Yorkshire, Dovedale, Northern France, the Channel Islands and elsewhere. His work in both oil and watercolour is usually brilliantly coloured and well drawn.

Bibliography: *A.J.*, May, 1873.

TENNANT, W
The B.M. has a marine watercolour by this artist, dated 1799. The drawing of the ship is good but the background is weak.

TENNIEL, Sir John, R.I. 1820 (London) – 1914 (London)
The cartoonist and illustrator, he was virtually self-taught. He was also a serious painter of genre and literary subjects in oil and watercolour and he exhibited at the R.A. and elsewhere from 1835. He won a premium in the Westminster Hall Competition in 1845. From 1851 to 1901 he worked for *Punch*, producing many of the leading political cartoons. He was elected A.N.W.S. and N.W.S. in 1874, and he was knighted in 1893.

Illustrated: L. Carroll: *Alice in Wonderland*, 1865. L. Carroll: *Alice through the Looking Glass*, 1872. Etc.
Examples: B.M.; V.A.M.
Bibliography: *A.J.*, 1882. *Art Annual*, Easter 1901. *Connoisseur*, XXXVIII, 1914. *Burlington*, XXX, 1917.

TERRIS, John, R.I., R.S.W. 1865 (Glasgow) – 1914 (Glasgow)
A landscape painter who studied at Birmingham School of Art and first exhibited there at the age of fifteen. He also exhibited in London, Liverpool and Glasgow from 1890. He lived in Glasgow for much of his life and was elected R.I. in 1912. His work is in the tradition of Cox.

Examples: Leeds City A.G.

TERROT, Rev. Charles Pratt c. 1805 – c. 1886
Educated at Trinity College, Cambridge, from 1823, he was ordained in 1827. In 1838 he was appointed Vicar of Wispington, Lincolnshire. He was a pupil of de Wint and painted interiors in the manner of G. Cattermole (q.v.) as well as landscapes.

TERRY, Henry John 1810 (Marlow) – 1880 (Lausanne)
A lithographer who studied under Calame in Switzerland and exhibited there as well as in England. Later in his career he turned to landscape painting in watercolour.

He was presumably not related to HENRY M. TERRY, a genre painter in oil and watercolour who exhibited from 1879 to 1920. He lived at Brixton and Tetsworth.

Examples: V.A.M.; Lausanne.

TESSON, L
A London painter of Greek and Algerian subjects who exhibited at Suffolk Street in 1866.

Examples: Mappin A.G., Sheffield.

THACKERAY, William Makepeace
1811 (Calcutta) – 1863 (London)
The novelist and editor. He was an able, if rather unprofessional, caricaturist and often illustrated his own articles and books. He contributed three hundred and eighty drawings to *Punch* alone. The sketches are often spirited, sometimes with touches of wash.

Examples: B.M.; V.A.M.; Fitzwilliam.
Bibliography: M.H. Spielmann: *W.M.T.,* 1899.

THEOBALD, Henry, A.N.W.S.
A genre painter who was elected A.N.W.S. in 1847. He lived in Camden Town.

THIRTLE, John　　　　　　**1777 (Norwich) – 1839 (Norwich)**
With the exception of his brother-in-law, J.S. Cotman, Thirtle was by far the best watercolourist among the Norwich artists. As a boy he was apprenticed to a London frame-maker, and from his return to Norwich, in about 1800, until his death, he ran a business as framer, carver and gilder, as well as painting and taking pupils. He was a founder of the Norwich Society in 1803 and exhibited with it from 1805 until the secession of 1816, when he joined the rebels. He returned to the fold in 1827, but from 1830 a lung infection prevented him from sketching, and he ceased to exhibit.

He was particularly fond of riverside subjects, combining water, countryside and old buildings. His work shows the influence of Cotman and perhaps also of Varley. At the beginning of his career he painted portraits and miniatures, since this seemed the only way to financial success. There are many copies of his drawings both by his pupils and other people's, since he also seems to have been influenced by Cotman in his methods of teaching. His own hand is described as 'free but precise' by Dickes, and he has a complete command of natural phenomena and atmospheric effects.

A loan exhibition of his work was held by the Norwich Art Circle in 1886.

Examples: B.M.; V.A.M.; Fitzwilliam; Leeds City A.G.; Newport A.G.; Castle Mus., Norwich; Ulster Mus.
Bibliography: W.F. Dickes: *The Norwich School,* 1905.

THOMAS, Mrs. F
A Sheffield painter who made a series of watercolours during three months spent in Sherwood Forest in the autumn of 1876. She exhibited in London and elsewhere, and was perhaps the wife of F. Thomas, a Birmingham portrait painter.

THOMAS, George Housman　　**1824 (London) – 1868 (Boulogne)**
The brother of W.L. Thomas (q.v.), with whom he went to America and Rome after studying wood-engraving in London and Paris. They were present during the French siege of Rome. He joined the staff of the I.L.N. on his return, and he exhibited in London from 1851. He illustrated a number of books including *Uncle Tom's Cabin.* His work is well drawn but shows no great feeling.

A memorial exhibition was held at the German Gallery, Bond Street, in 1869 after the N.W.S. had refused the use of their Gallery.

Examples: V.A.M.; Fitzwilliam.

THOMAS, Sidney
A landscape painter who was an unsuccessful candidate for the N.W.S. in 1866 and exhibited for the next two years. He lived in London and painted in the Isle of Wight.

Examples: V.A.M.

THOMAS, William Cave　　　**1820 (London) – c. 1884**
A genre painter, etcher and author who entered the R.A. Schools in 1838 and spent two years at the Munich Academy from 1840. He exhibited from 1843 and in that year won a premium in the Westminster Hall competition. He was a friend of the Pre-Raphaelites, especially of F.M. Brown (q.v.). He painted in both oil and watercolour.

Published: *Pre-Raphaelitism Tested by the Principles of Christianity,* 1860. Etc.
Examples: V.A.M.

THOMAS, William Luson, R.I.　　**1830**　　**– 1900 (Chertsey)**
The founder of the *Graphic* and the *Daily Graphic.* In 1846, together with his brother G.H. Thomas (q.v.), he went to America on an unsuccessful promotion campaign for two journals, *The Republic* and *The Picture Gallery.* They returned to England by way of Rome, where they lived for two years. In 1855 William married Annie, daughter of J.W. Carmichael (q.v.). His early experience on the *I.L.N.* enabled him to set up the *Graphic,* the first edition of which appeared in December 1869. It was so successful that in 1890 he was able to produce the *Daily Graphic.* He exhibited at Suffolk Street, and was elected A.N.W.S. in 1864 and N.W.S. in 1875, and played a considerable part in the history of the Institute. A selection of his work, entitled 'Ten Years' Holiday in Switzerland', was exhibited in 1882.

His eldest son, Carmichael Thomas, succeeded him as managing director of the *Graphic.*

THOMPSON, Frank　　　　　　　　**– 1926**
A Durham artist who painted local river views. He exhibited four times in London between 1875 and 1899.

Examples: Bowes Mus., Durham; Sunderland A.G.

THOMPSON, Gilbert G　　　**1860 (Derby) – 1921**
A civil engineer in the Hull area. He was an amateur artist and made many studies of birds, flowers and geological features, as well as sepia landscapes.

THOMPSON, James Robert　　　　**c.1799**　　　**–**
A pupil and assistant to J. Britton (q.v.), he entered the R.A. Schools in 1818. He painted elephant hunts as well as architecture and exhibited at the R.A. from 1828 to 1843. Latterly he probably worked in conjunction with Louis Vulliamy, the architect.

Examples: B.M.; V.A.M.

THOMPSON, Margaret　　　　**1843**　　　**– 1928**
A niece of S. Lucas, Yr. (q.v.), she painted genre scenes, gardens, churches and old buildings. She exhibited at Suffolk Street from 1878 and lived in London and Hitchin, Hertfordshire.

Examples: Hitchin Mus.

THOMPSON, Captain Thomas Pickering
An amateur artist who entered the Navy in 1823 and visited the Mediterranean in 1834. In 1835 he accompanied the Euphrates Expedition from Malta to the mouth of the River Orontes, after which he served on the Home, North American and West Indian stations until 1840, when he was engaged in operations on the coast of Syria. He was promoted commander in 1841. He later served in the East Indies and was promoted captain in 1847.

THOMPSON, William　　　　　　　**– 1785**
A landscape painter who worked in Britain and Italy, and often on a small scale. His remaining works were sold at Ansell's, February 4-5, 1786.

THOMSON, George
1860 (Towie, Aberdeenshire) – 1939 (Boulogne)
A painter of architecture and town scenes who studied at the R.A. Schools and exhibited at the R.A. and elsewhere from 1886. He was a member of the N.E.A.C. and lectured at the Slade from 1895 to 1914, when he settled at Samer, Pas-de-Calais. An exhibition of his work, including views of Tangier, Gibraltar, Italy, France and Wales, was held at the Goupil Gallery in 1909.

Examples: V.A.M.

THOMSON, Henry, R.A.　　　**1773 (Portsea) – 1843 (Portsea)**
A mythological and genre painter. He travelled in France with his father from 1787 to 1789 and on his return studied under Opie and at the R.A. Schools. From 1793 to 1798 he was in Italy, Austria and Germany. He was elected A.R.A. and R.A. in 1801 and 1804. His chief work was for the engravers, and the majority of his

drawings and watercolours for book illustration. He worked on Sharpe's *Poets* and *British Classics*. For his last two years he was unable to work through illness.

THOMSON, Hugh
1860 (Coleraine, Co. Londonderry) – 1920 (London)

An illustrator who worked in London for much of his career. He illustrated Jane Austen, Mrs. Gaskell and others, as well as contemporary authors. He was elected R.I. in 1897, but retired ten years later. His work is traditional and has less of the fantastic than that of Rackham or his school.

Examples: B.M.; V.A.M.; Ulster Mus.

THOMSON, Rev. John, of Duddingston
1778 (Dailly, Ayrshire) – 1840 (Duddingston)

The romantic landscape painter. He succeeded his father as Minister of Dailly, and in 1805 Sir Walter Scott arranged for his transfer to Duddingston, near Edinburgh. He was a friend of many artists, including A. Nasmyth (q.v.), from whom he received advice, Wilkie, Raeburn, Watson, and Turner, who stayed with him in 1822. He exhibited at the R.S.A. from 1829, and was elected an Honorary Member in 1830.

In many ways he is the first Scottish romantic painter, and Sir J. Caw has called him 'the greatest Scottish landscape-painter of his time'. Although technically an amateur, his works are as professional as those of his friends. The majority of his pictures are in oil and are based on the Italians and Wilson, but he also produced watercolours which are free and surprisingly impressionistic in handling.

Examples: V.A.M.
Bibliography: W. Baird: *J.T.*, 1895. R.W. Napier: *J.T.*, 1919. *A.J.*, 1883. *Connoisseur*, XLVII, 1917.

THOMSON, John Leslie, R.W.S.
1851 (Aberdeen) – 1929 (London)

A landscape and coastal painter who studied at the Slade and was much influenced by the Barbizons. He exhibited from 1873, was a member of the N.E.A.C. from 1886 and of the R.I. from 1893 to 1909. He was elected A.R.W.S. and R.W.S. in 1910 and 1912. Much of his work was done on the South and East Coasts and in Brittany and Normandy.

THORBURN, Archibald
1860 – 1935 (Godalming)

The bird painter, he was the son of Robert Thorburn, A.R.A., a miniaturist. He was educated in Dalkeith and Edinburgh and exhibited at the R.A. from 1880. He lived in London and Surrey. His work can be technically very fine, especially when it is on a small scale, but artistically there is something lacking. He illustrated the books of others as well as his own.

Published: *British Birds*, 1915-18. *A Naturalists' Sketch-Book*, 1919. *British Mammals*, 1920. *Game Birds and Wild Fowl of Great Britain and Ireland*, 1923.
Examples: B.M.; V.A.M.
Bibliography: *Studio*, XCI, 1926.

THORNEYCROFT, Helen
c.1840 – c.1913

The second daughter of the sculptors Thomas (1815-1885) and Mary Thorneycroft (1814–1895), grand-daughter of the sculptor John Francis (1780–1861) and brother of Sir W. Hamo Thorneycroft, R.A. (1850–1925). She painted biblical subjects and landscapes and exhibited from 1864 to 1912. She was a member of the Society of Female Artists and an unsuccessful candidate for the N.W.S. in 1870 and 1873.

Her sister ALYCE M. THORNEYCROFT was also a painter and sculptress.

THORNHILL, Sir James
1675 (Melcombe Regis, Dorset) – 1734 (Thornhill, Dorset)

A pupil of Highmore, whom he ultimately succeeded as Sergeant-painter to the King, he travelled in Italy in his youth and became the foremost decorative painter in England. He attempted to found a Royal Academy, and for a time ran his own, where he taught his future son-in-law, Hogarth.

His drawings are usually of mythological subjects and done in pen or pencil and grey or brown wash. They usually have a strong architectural element. Very occasionally he used full colour, and equally occasionally he produced formal landscape sketches. A common mannerism is the suggestion of features in full face by the use of a cross in an oval.

Examples: B.M.; V.A.M.; Ashmolean; Fitzwilliam; Greenwich; Leeds City A.G.
Bibliography: W.R. Osman: *Study of the Work of Sir J.T.*, 1950. *Country Life*, June 19, 1958.

THORNTON, Alfred Henry Robinson
1863 (Delhi) – 1939 (Painswick)

A landscape painter in oil and watercolour and an art critic. He was educated at Harrow and Trinity College, Cambridge. He studied at the Slade, University College, London, and the Westminster School of Art and exhibited at home and abroad. He was a member of the N.E.A.C. and lived at Painswick, Gloucestershire. He signed his work with surname and date.

Published: *Fifty Years of the N.E.A.C.*, 1935. *The Diary of an Art Student of the Nineties*, 1938.
Examples: B.M.

THORNTON, John

An amateur artist who supplied F. Nicholson (q.v.) with drawings of foreign subjects.

THORP(E), George
1847 (London) – 1939 (Hull)

A Hull architect who painted local scenes.

Examples: Central Lib., Hull.

THORPE, Thomas

A painter of Scottish and Northern landscapes in the mid-nineteenth century. He exhibited at Newcastle in 1835 and Carlisle in 1850.

THROSBY, John
1740 (Leicester) – 1803 (Leicester)

An antiquary and the parish clerk to St. Martin's, Leicester. He published a series of works on the locality, which he illustrated himself.

Published: *Memoirs of the Town and County of Leicester*, 1777. *Select Views in Leicestershire*, 1789. *The History and Antiquities... of Leicester*, 1791. *The History and Antiquities of the Town and County of Nottingham*, 1795.
Examples: V.A.M.

THRUPP, Frederick
1812 (London) – 1895 (Torquay)

A sculptor who studied at Sass's Academy and worked in Rome and London. He left a great many drawings, but, having little colour sense, worked in monochrome.

Examples: B.M.; Thrupp Gall., Winchester.

THURSTON, John
1774 (Scarborough) – 1822 (Holloway)

A copper-plate and wood engraver for book illustrations, he was elected A.O.W.S. in December, 1805, but only exhibited once, in the following summer. He also exhibited at the R.A. His drawings are rather stiff affairs, outlined in pencil or pen and tinted with Indian ink.

Illustrated: R. Bloomfield: *Rural Tales*, 1802. Etc.
Examples: B.M.; Greenwich; N.G., Scotland; Castle Mus., Nottingham.

TIDD, Julius

A 'merchant of the parish of St. Andrew, Holborn', he produced a number of drawings, perhaps as illustrations, between 1773 and 1779. The pen drawing is strong with slight washes of colour, and the style is reminiscent of that of P.J. de Loutherbourg (q.v.).

He was the father of William Tidd (b. 1760), the legal writer.

Examples: B.M.

TIDEY, Alfred 1806 (Worthing, Sussex) – 1892 (Acton, Middlesex)
The son of JOHN TIDEY, poet, schoolmaster and amateur artist, who gave him his first lessons. For most of his working life he was a miniaturist in London, but he also worked on the Continent between 1857 and 1867 and painted larger portraits and genre subjects. He exhibited at the R.A. from 1831, and he was a member of the Dudley Gallery Art Society.

TIDEY, Henry F , N.W.S. 1814 (Sussex) – 1872 (? Bedford)
The younger brother of A. Tidey (q.v.), he was also taught by his father and established a reputation as a portrait painter in oil and watercolour. He exhibited at the R.A. from 1839 and from 1855 showed mainly historical and poetical subjects. He was elected A.N.W.S. in 1858 and a Member in the following year.

His work is rather weak and sometimes in the manner of Watteau. Occasionally he and his brother collaborated on portraits. A memorial exhibition was held at the Society for the Encouragement of the Fine Arts in January, 1873, and his remaining works were sold at Christie's, March 28, 1873.

Bibliography: *A.J.*, 1869; 1872.

TILLEMANS, Peter 1684 (Antwerp) – 1734 (Norton, Suffolk)
The son of an Antwerp diamond cutter, he studied landscape and was brought to England in 1708. He became known as a painter of country houses and their owners. In 1711 he studied at Kneller's Academy and he worked as a scene painter at the Haymarket. He lived in Richmond, and his collection, with his remaining works, was sold at Cock's, London, April 19-20, 1733. William, Lord Byron, was a pupil as well as a patron.

As well as topographical and hunting watercolours he made costume studies for his pictures. He also painted in free brown wash.

Illustrated: Bridges: *History of Northamptonshire*, 1791.
Examples: V.A.M.; Ashmolean; Fitzwilliam.
Bibliography: Sir R. Cotton: *Cat. Coll. Paintings . . . P.T.*, 1733.

TIREMAN, Major Henry Stephen
An officer in the Royal Artillery who painted Medway hulks and similar subjects. He was commissioned in 1828, promoted captain in 1841, and retired in 1847. After his retirement he became a lay preacher in Bristol.

Bibliography: R. Morris: *In Memoriam of three Bristol Worthies*, 1873.

TOBIN, Rear-Admiral George
1768 (Salisbury) – 1838 (Teignmouth)
An amateur artist, he entered the Navy in 1780 and visited Nova Scotia in 1785 and Madras and China between the autumn of 1788 and the summer of 1790. In 1790 he was promoted lieutenant and from 1791 to 1793 he was engaged in taking bread-fruit to the West Indies. He next served on the Halifax station and the American coast. He returned home in 1806 and, after a spell on the Irish station, escorted a fleet of merchantmen to Barbados and Jamaica in 1809, returning home via St. Helena. During the remainder of the French war he served on the Irish and Channel stations and the Bay of Biscay. His last service at sea was in 1814 and he was promoted commander in 1798, captain in 1802 and rear-admiral in 1837.

His work varies in quality from rather clumsy productions to very competent portraits of ships. He uses rather comical dots for facial features.

Examples: Greenwich.

TOD, Colonel James 1782 (Islington) – 1835 (London)
After attending Woolwich in 1798 and 1799, Tod was posted to Bengal, arriving the following year. He carried out a number of important diplomatic commissions as well as surveying much of Central India. From 1805 to 1817 he was attached to the Envoy's

escort at Sindhia's court. In 1818 he was made political agent in the western Rajput states, remaining until 1822. He returned to England in 1823 and from 1825 lived mainly on the Continent. He illustrated his own publications.

Published: *Annals and Antiquities of Rajasthan*, 1829–32. *Travels in Western India*, 1839.
Bibliography: Royal Asiatic Soc., *Journal*, iii, 1836.

TODD, Ralph
A landscape and genre painter in oil and watercolour who exhibited from 1880. He lived in Tooting, Newlyn, Birmingham, London and Helston and painted Cornish and Breton subjects. He was alive in 1929.

He was the father of Arthur Ralph Middleton Todd, R.A., R.W.S.

TODDY Benjamin
A Greenwich pensioner who, despite having no right hand and only a thumb on his left hand, managed to produce ship portraits, albeit understandably very crude. There are five examples of his work at Greenwich, one showing the Eddystone Lighthouse. One of them is dated 1789.

TOFT, Peter Peterson 1825 (Kolding, Denmark) – 1901 (London)
An architectural and landscape painter who exhibited with the N.W.S. and at the R.A. and Suffolk Street from 1872 to 1885. His subjects include views in Cornwall, Yorkshire and Scotland as well as Newcastle and Northumbria, where he worked for some years. He also visited the Channel Islands, Spain, Egypt and the Holy Land.

Examples: B.M.

TOLLEMACHE, Hon. Duff 1859 – 1936
A marine and portrait painter in oil and watercolour, he was the seventh son of John, 1st Lord Tollemache. He studied at the R.A. Schools and at Julian's, later working in the studios of Musin in Brussels, Bonnat and A. Stevens. He lived in London and exhibited from 1883.

Published: *The Chords of Creation*, 1922.

TOMBLESON, William c. 1795 –
A landscape painter and engraver who published English, German and Austrian views from his own drawings. He sometimes worked in brown wash and was active in about 1830.

Published: With W.G. Fearnside: *Tombleson's Views on the Rhine*, 1832, with W.G. Fearnside: *Tombleson's Thames*, ?1834.

TOMKINS, Charles 1757 (London) – 1823
The elder brother of P.W. Tomkins (q.v.) and son of William Tomkins, an artist who painted in the manner of Claude. He worked as an engraver and a topographical and antiquarian draughtsman, and exhibited at the R.A. from 1773 to 1779. In 1805 he produced a set of illustrations to Petrarch's sonnets.

Published: *Eight Views of Reading Abbey*, 1791. *Tour to the Isle of Wight*, 1796.
Examples: B.M.

TOMKINS, Charles F 1798 – 1844
A caricaturist, landscape and scene painter who worked with D. Roberts (q.v.) and C. Stanfield (q.v.). He exhibited from 1825 and was elected to the S.B.A. in 1838. He painted the temporary buildings erected for the Coronation of Queen Victoria, and he drew for the early numbers of *Punch*. His work is precise and simple in the manner of the Bonington schools, and he painted in France, Belgium, Holland, Germany and Italy as well as in England.

Examples: B.M.; V.A.M.

TOMKINS, Peltro William 1759 (London) – 1840 (London)
The younger brother of C. Tomkins (q.v.), he learned engraving under Bartolozzi and worked on Sharpe's *British Poets, British*

Classics and *British Theatre*. He also engraved from his own portraits. He became drawing master to the Princess of Württemberg and Historical Engraver to the Queen. For some time he ran a business as a print publisher in Bond Street; two works which he was illustrating at the time, Tresham and Ottley's *The British Gallery of Art* and Ottley's *The Gallery of the Marquess of Stafford*, caused him severe financial loss, and he was obliged to sell all the drawings and engravings for the plates.

His daughter EMMA TOMKINS, herself a flower painter, married Samuel Smith the engraver.

Examples: B.M.; City A.G., Manchester.

TOMLINSON, Vice-Admiral Nicholas
1765 — 1847 (Near Lewes, Sussex)
There are sketch books containing unnamed landscapes by this naval officer at Greenwich. He was in the East Indies from 1783 to 1785. From 1786 to 1789 he served on the coast of Scotland, after which he is said to have spent a few years in the Russian Navy before becoming involved in the French war. His last appointment was as commander of the Sea Fencibles off the coast of Essex from 1803 to 1810. He was promoted vice-admiral in 1841.

Bibliography: R. Tomlinson: *Papers and Correspondence of N.T.*, 1935.

TONGE, Robert 1823 (Longton, near Preston) — 1856 (Luxor)
A painter of cornfields and skies who had wanted to be a soldier, but, unusually, family pressure turned him to art. He was a pupil of a portrait painter in Liverpool and exhibited there from 1843. He was elected to the Liverpool Academy just before his death. In 1853 he went to Egypt because of heart trouble, and he painted some Eastern scenes. His work, both in oil and watercolour, is usually in sombre colours.

Examples: Williamson A.G., Birkenhead.

TOOTALL, James Batty
In the Wakefield A.G. there are two landscapes, dated 1858 and 1859, by this engagingly-named artist. He exhibited at Suffolk Street from a Wakefield address in 1846.

TOOVEY, Edwin c. 1835 — c.1900
A landscape and coastal painter who was an unsuccessful candidate for the N.W.S. in 1860 and 1867. On the first occasion he was living in Brussels. He was in Leamington Spa by 1865, when he first exhibited in London, and he lived there until at least 1900. He was a drawing master.

His son, RICHARD GIBBS HENRY TOOVEY (1861–1927), was an etcher and painter in oil and occasionally watercolour. He lived in London until 1886 and then returned to Leamington. He exhibited from 1879 but gave up work ten years before his death as the result of a nervous breakdown and loss of sight.

Examples: V.A.M.

TOPHAM, Francis William, O.W.S. 1808 (Leeds) — 1877 (Cordova)
He began as an apprentice to his uncle, an engraver. He came to London in about 1830 and engraved coats-of-arms, business cards, and eventually illustrations. He joined the Clipstone Street Society, and, turning entirely to watercolours, was elected A.N.W.S. and N.W.S. in 1842 and 1843. Seceding in 1847, he was elected O.W.S. in the following year. He visited Ireland in 1844, 1860 and 1862, and was in Spain in 1852–3. He also visited Italy. He returned to Spain in the winter of 1876 and died there.

His most typical subjects are Irish and Spanish peasants and gipsies. His method of work — or lack of method — is described by J.J. Jenkins: 'He put on colour and took off colour, rubbed and scrubbed, sponged out, repainted, washed, plastered and spluttered his drawings about in a sort of frenzied way'.

He was the father of F.W.W. Topham (q.v.).

Examples: B.M.; V.A.M.; Williamson A.G., Birkenhead; Bury A.G.; Reading A.G.; Ulster Mus.

Bibliography: F.G. Kitton: *Dickens and his Illustrators*, 1899. *A.J.*, 1877; 1880.

TOPHAM, Frank William Warwick, R.I.
1838 (London) — 1924 (London)
The son and pupil of F.W. Topham (q.v.), he studied at the R.A. Schools and in Paris. He visited Ireland with his father in 1860, Italy in 1863 and in 1865, when he was in Ravenna with E.S. Lundgren (q.v.) and F. Dillon (q.v.). He painted genre subjects, in oil as well as watercolour, and he exhibited from 1860. He was elected to the N.W.S. in 1879, despite his father's secession.

TOWER, Captain Arthur 1816 — 1877
A Naval officer and a painter of large and detailed panoramas. He served in the Mediterranean, was promoted lieutenant in 1842, and in 1845 sailed to the East Indies, where he served for several years. He was promoted commander in 1853 and captain in 1869 after retiring from active service in 1865.

Examples: Greenwich.

TOWER, Sir Francis
A pupil of J. Glover (q.v.) who was working in about 1811. His work is very similar to that of his master.

TOWERS, G A 1802 — 1882
An amateur artist who came to Hertford in 1816, and in 1828 became Dispenser to the Hertford Dispensary. From 1838 until his death he served as resident medical officer at the Hertford Infirmary. He painted local views with accomplished figures in the manner of R. Westall (q.v.).

Examples: Hertford Mus.

TOWERS, James 1853 (Liverpool) —
A landscape painter who studied at the Liverpool College School of Art and the Liverpool Academy. He exhibited from 1878 at the R.A., R.I., Suffolk Street and Grosvenor Gallery and in Liverpool. Later in life he lived at Gerrards Cross, Buckinghamshire and at Purley, Surrey. He was still alive in 1934. Early in his career he painted still-lifes.

TOWERS, Samuel 1862 (Bolton) — 1943
A landscape and view painter in oil and watercolour, he exhibited at the R.A. from 1884 as well as at the R.I., in Liverpool and Manchester. For some time he lived near Evesham, Worcestershire.

Examples: Bolton A.G.

TOWNE, Charles 1763 (Upholland, Wigan) — 1840 (London)
The son of Richard Town, a portrait painter in Liverpool, where he started work as an heraldic painter. He exhibited at the R.A. and B.I. from 1799 — in which year he added an 'e' to his name — until 1823. From 1800 to 1805 he lived in Manchester, then returning to London, and he stood for admission to the O.W.S. in 1809. He moved back to Liverpool in 1810, contributing to the first exhibition of the Liverpool Academy in 1810, and becoming Vice-President in 1813. From 1824 until his death he lived in London.

He painted landscapes, and animal portraits, for which he became particularly well-known in Lancashire and Cheshire. His pictures, in oil or watercolour, are generally small and well-drawn, although landscapes with cattle can be larger.

Bibliography: *A.J.*, 1904.

TOWNE, Francis 1740 (Exeter) — 1816 (London)
The landscape painter, he studied at Shipley's in the Strand, where he was a friend of W. Pars (q.v.), Cosway and Humphrey. In 1759 he won a First Premium at the Society of Arts, and he exhibited in London from 1762, although mainly living and teaching in Exeter until 1780. In 1777 he toured Wales with his friend and pupil James White (q.v.), and in 1780-81 he was in Italy with T. Jones (q.v.) and J. 'W.' Smith (q.v.). From this date until 1807 he lived partly in Exeter and partly in London, but on his marriage to a French

dancer he settled in the capital. His wife died within a year and thereafter he made numerous sketching tours in Southern England including visits to Wales, Cornwall, Oxford and Warwickshire.

His style is idiosyncratic, and it is one that has been popular with twentieth century painters. He relies on economic and careful pen outlines and flat, muted washes of colour. At times his work seems to be composed of interlocking geometric planes, rather as if Grimm or Warwick Smith had been crossed with Euclid.

He had many pupils including J.W. Abbott (q.v.) and J.H. Merrivale (q.v.).

Examples: B.M.; V.A.M.; Aberdeen A.G.; Ashmolean; Birmingham City A.G.; Exeter Mus.; Fitzwilliam; Leeds City A.G.; Leicestershire A.G.; N.G., Scotland; Newport A.G.; Southampton A.G.; Ulster Mus.
Bibliography: A. Bury: *F.T.*, 1962. Walpole Soc., VIII, 1920. Burlington F.A.C., 1929-30. *Collector*, XI, 1930. O.W.S. Club, XXXVI, 1961.

TOWNLEY, Annie B
A painter of buildings and coastal subjects who lived in Birmingham and exhibited there and occasionally in London between 1868 and 1897.

Her sisters, ELIZABETH TOWNLEY (ex. 1868–9) and MINNIE TOWNLEY (ex. 1866–1899), were also painters, the former of interiors, the latter of landscapes and coastal subjects. Minnie, at least, visited France, Italy and Holland.

An earlier M. TOWNLEY was painting in Ramsgate in 1811.

TOWNSEND, Frederick Henry Linton Jehne
 1868 (London) – 1920 (London)
An illustrator and etcher who studied at the Lambeth School of Art. He exhibited from 1888 and worked for the *I.L.N.*, the *Graphic* and other periodicals as well as making book illustrations. He was Art Editor of *Punch* from 1905. His subjects are often military.

Examples: B.M.
Bibliography: P.V. Bradshaw: *The Art of the Illustrator*, 1918.

TOWNSEND, Henry James 1810 (Taunton) – 1890
A surgeon who turned to painting, wood-engraving and etching. He exhibited at the R.A. from 1839 to 1866, taught at the Government School of Design at Somerset House and illustrated a number of books such as Grey's *Elegy* and Milton's *L'Allegro*.

Illustrated: Mrs. S.C. Hall: *Book of Ballads,* 1847. Etc.
Examples: V.A.M.

TOWNSEND, J S A
An amateur artist who painted and etched a few British landscapes in about 1881. He did not exhibit.

TOWNSEND, John
An amateur artist who painted Canadian and British views in the 1840s. He used blue or brown washes and much scraping for the highlights.

Examples: B.M.

TOWNSEND, Patty, Mrs. Johnson
A landscape and figure painter who lived at Nuneaton and was working from 1877 to 1904. She painted in England and Scotland.

TOWNSHEND, George, 1st Marquess 1724 – 1807 (Rainham)
A field-marshal and colonel of the 2nd Dragoon Guards, he was appointed Lord Lieutenant of Ireland in 1767 and served under George II at Dettingen and Fontenoy, and at Culloden and Lafeldt. He was created Marquess in 1787. Although not strictly a watercolourist, he was a vigorous and highly talented amateur caricaturist in pen and Indian ink.

Examples: B.M.
Bibliography: *Connoisseur*, XCIV, 1934. *Country Life,* January 30, 1964.

TOWNSHEND, James – 1949
A landscape, figure and portrait painter in oil and watercolour who studied in London and Paris and exhibited from 1883. He was elected R.B.A. in 1903 and lived in London.

Examples: Exeter Mus..

TOZER, Henry Spernon
A marine and coastal painter who was active from about 1892.

Examples: Cape Town A.G.

TRAIES, Francis D 1826 – 1857
A genre and landscape painter in oil and watercolour, he was the son of WILLIAM TRAIES (1789–1872), a topographer known as 'The Devonshire Claude'. He was a pupil of T.S. Cooper (q.v.), lived in London and exhibited from 1849 to 1854.

Examples: Exeter Mus.

TRESHAM, Henry, R.A. c. 1751 (Ireland) – 1814 (London)
An historical painter, poet and collector, he attended the R.D.S. Schools and exhibited with the Dublin Society of Artists. He moved to England in 1775, earning a living by drawing portraits. Within a year he left England to accompany J.C. Cawdor, later first Baron Cawdor, through Italy. He stayed on the Continent for fourteen years, living mainly in Rome, and became a member of the Academies of Rome and Bologna. He exhibited at the R.A. from his return to London in 1789 until 1806, and was elected A.R.A. in 1791 and R.A. in 1799. In 1807 he became Professor of Painting, resigning in 1809 for health reasons.

His subjects are taken from Biblical, Roman and English history. They were often used to illustrate such works as Bowyer's *Historic Gallery*, Hume's *History of England*, Boydell's *Shakespeare* and Sharpe's *British Classics*. His drawing sometimes suffers from over-exaggeration, but can be pretty. His colour sense is weak.

Published: *Le Avventure di Saffo,* 1784. Etc.
Examples: B.M.; V.A.M.

TREVELYAN, Paulina, Lady, née Jermyn
 1816 (Suffolk) – 1866 (Neuchatel)
The eldest daughter of the Rev. Dr. Jermyn, she married Sir Walter Claverley Trevelyan, a land-owner of Somerset and Northumberland and an artist and naturalist, in 1835. She was a flower and insect painter and a friend of Ruskin.

Sir Walter's second wife, LAURA CAPEL, LADY TREVELYAN, née LLOFT, was also a flower painter.

Examples: B.M.; Wallington Hall, Northumberland.
Bibliography: R. Trevelyan: *P., Lady T. and her Circle,* 1976.

TREVENON, Rev. John
A landscape painter and topographer who worked in the earlier traditions of P.S. Munn (q.v.). He was educated at Hertford College, Oxford, and was ordained in 1858. He was Curate of St. Mary Church, Exeter, from 1858 to 1860, St. Barnabas, Pimlico, from 1860 to 1871, and Dalton in Topcliffe, Yorkshire, from 1871 to 1877, when he returned to Exeter.

TROBRIDGE, George F 1857 (Exeter) – 1909 (Gloucester)
A landscape painter in oil and watercolour who studied at the National Art Training School in London from 1875 to 1880. He was Headmaster of the Belfast School of Art from 1880 to 1901, after which he taught in the north of Ireland before leaving for England in 1908. He wrote a biography of Emanuel Swedenborg, and a book entitled *The Foundations of Philosophy*.

Published: *The Principles of Perspective as applied to Model Drawing and Sketching from Pictures,* 1884.
Examples: Ulster Mus.

TROTMAN, Samuel H
A landscape and coastal painter who lived in London and was active at least from 1862. He exhibited at Suffolk Street and the Dudley Gallery from 1866 to 1870.

LILLIE TROTMAN, who appropriately enough lived in Lillie Road, and who exhibited landscapes and cottages at the R.A., N.W.S. and Suffolk Street from 1883 to 1893, may have been a daughter.

TROUGHTON, Thomas −1797
A sailor who was shipwrecked with the privateer *Inspector* and spent thirteen years as a slave in Morocco. On his return in 1751 he published an illustrated account of his adventures.

TROWER, Walter John, Bishop of Gibraltar − 1877
An amateur landscape painter who was educated at Oriel College, Oxford, ordained in 1829 and consecrated Bishop of Glasgow and Galloway in 1848. In 1860 he was appointed sub-Dean and Prebendary of Exeter, and from 1863 to 1868 was Bishop of Gibraltar. From 1871 he was Rector of Ashington, Duncton and Washington, near Chichester.

His subjects are usually Continental, and his style is a little old-fashioned, with reed-pen outlines and thin, though fresh, washes of colour. It echoes the eighteenth century in much the same way as that of E. Lear (q.v.). The JOHN TROWER, who provided W. Payne (q.v.) with Continental subjects may well have been his father. He may also have been the 'sketching stockbroker' who encouraged the young J. Varley.

TUCKER, Ada Elizabeth
The daughter of Robert Tucker (q.v.) of Bristol. She was a painter of animal genre subjects and exhibited in London from 1879 to 1884.

TUCKER, Alfred Robert, Bishop of Uganda
 c. 1860 − 1914
There appear to have been at least three families of painting Tuckers. The Bishop was probably related to Robert Tucker (q.v.) of Bristol. He was educated at Oxford and was a curate in Bristol from 1882 to 1885, in Durham from 1885 to 1890 and Bishop of Eastern Equatorial Africa and of Uganda from 1890 to 1911, when he was appointed a Canon of Durham. He also painted in Austria and Sicily.

Published: *African Sketches*, 1892. *Toro*, 1899. *Eighteen Years in Uganda*, 1908. *Is the Gospel Effete?* 1914.
Bibliography: J. Silvester: *A.R.T.*, 1926. A.P. Shepherd: *Tucker of Uganda*, 1929.

TUCKER, Arthur 1864 (Bristol) − 1929
A son of E. Tucker (q.v.), he exhibited landscapes, often in the Lake District and Scotland, from 1883. He was elected R.B.A. in 1898 and was a Founder of the Lake Artists' Society in 1904. He lived at Windermere, and he was also an etcher.

Illustrated: E.S. Robertson: *Wordsworthshire*, 1911.

TUCKER, Edward c. 1830 − 1909
Probably a native of Bristol, he was a landscape and coastal painter and lived in London, Brighton and at Ambleside from about 1867. He exhibited in London from 1849 to 1873, and he also painted in Austria, Northern Italy and France. He was the father of A. Tucker (q.v.), EDWARD TUCKER, YR., who exhibited in 1871, FREDERICK TUCKER, who exhibited in 1880, and H. Coutts (q.v.). He may have used the pseudonym 'Edward Arden'.

Examples: V.A.M.; Williamson A.G., Birkenhead; Grosvenor Mus., Chester; Sydney A.G.

TUCKER, Raymond
Probably a son of R. Tucker (q.v.) of Bristol, he was a landscape, genre and portrait painter, and he exhibited from 1852 to 1903. He lived in Bristol, London and Sandhurst, Kent.

TUCKER, Robert 1807 (Bristol) − 1891 (Cheddar)
A co-founder of the Bristol sketching club in 1833, he was trained as a doctor but turned to art and teaching. He painted landscapes in Britain and on the Continent, where he travelled extensively. He was

Secretary of the Bristol Fine Arts Academy. His work is often on a small scale, and his earlier drawings are virtually in monochrome. He was a skilful draughtsman and a popular teacher.

Further confusion among the bearers of this name is added by the existence of ROBERT TUCKER of Exeter, a drawing master active at about the same time.

Examples: Bristol City A.G.

TUDOR, Thomas 1785 − 1855
A landscape painter who was working in monochrome in about 1800. He was a clever sketcher.

Examples: Newport A.G.

TUKE, Henry Scott, R.A., R.W.S.
 1858 (York) − 1929 (Swanpool, near Falmouth)
The painter of boys and boats, he was the son of a Quaker doctor and was brought up in Falmouth and London. He entered the Slade in 1875. In the same year he made his first trips abroad, to Belgium and France. He spent the winter of 1880-81 in Florence, and then moved to Paris where he studied under J.P. Laurens. From 1883 he spent much of his time in the neighbourhood of Newlyn, Cornwall. In 1892 he spent six months in Italy and Corfu. In 1896 and 1899 he revisited Venice. He was elected A.R.A. in 1900, A.R.W.S. in 1904, R.W.S. in 1911 and R.A. in 1914. In 1904 he was again on the Riviera and in Italy, and also in 1912. He spent the winter of 1923-4 in the Carribean, and the early part of 1925 in France and North Africa. His last visits to the Riviera were in 1926 and 1927.

Although much of his time was spent in oil painting, Tuke was primarily a watercolourist. His impressions of boats, with shimmering light and even the streaks of rust on the hulls used in the composition, can be very impressive. His naked boys, on the other hand, which caused something of a scandal, and were recognized for what they were by no less a connoisseur than J.A. Symonds, often seem contrived and become repetitive.

Examples: Fitzwilliam; Greenwich.
Bibliography: M. Tuke Sainsbury: *H.S.T., a Memoir*, 1933.

TUKE, Maria, Mrs. Sainsbury 1861 (Falmouth) −
The sister of H.S. Tuke (q.v.), whose biography she wrote. She produced watercolours which can be very close in style to her brother's shipping subjects. She married Dr. Harrington Sainsbury in 1889.

TULL, Nicholas − 1762
A portrait, landscape and animal painter, from whose work many engravings were made. He exhibited with the Society of Artists in 1761.

There was a later N. Tull who was also a landscape painter. He lived in London and exhibited at Suffolk Street from 1829 to 1852. The bulk of his work was probably in oil.

TUPPER, Colonel Gaspard Le Marchant
 1826 (Guernsey) − 1906 (London)
A fine amateur artist who entered the R.M.A., Woolwich, in 1841. He was commissioned in the Royal Artillery in 1845 and served at Gibraltar and in Jamaica before being posted to the Crimea in 1854. He fought at Sebastopol, Balaclava and Inkerman, where he was wounded. At the end of 1856 he was posted to Bermuda, where he remained until 1858. From 1865 to 1867 he was in India and in 1887-8 commandant of Woolwich. He was colonel commandant of the Royal Horse Artillery from 1896.

He was one of the best of the military artists of the time, and his style may have owed something to the work of E. Lear (q.v.). An exhibition of his Crimean drawings was held at the Albany Gallery in March 1972.

TURCK, Eliza 1832 (London) −
The daughter of a naturalized German banker, she was educated in Germany and became a painter of literary genre, coastal, landscape and architectural subjects and miniatures in oil and watercolour. She studied at Cary's School of Art and in 1852 at the Female School of

Art, where she tried 'to satisfy a wholesome appetite for study with dry bones' (Clayton). She exhibited in London from 1851 to 1886, and studied in Antwerp in 1859 and 1860, and an exhibition of her watercolours of Brittany was held at the Rogers Gallery in Maddox Street in 1879.

Published: *A Practical Handbook to Marquetrie Wood-Staining*, 1899.

TURNBULL, W
A landscape painter who was active from about 1790 to 1827. His work can be reminiscent of that of G.F. Robson (q.v.).

Examples: V.A.M.

TURNER, B W
A topographer who was active in the 1790s.

TURNER, Charles 1774 (Woodstock) – 1857 (London)
An engraver, he worked for Boydell and studied at the R.A. Schools before setting up on his own. He was a friend and trustee, although not a kinsman, of J.M.W. Turner, and worked a number of plates for the *Liber Studiorum*. In the B.M. there is a watercolour by him, which is a little crude and in the manner of F. Wheatley (q.v.).

Bibliography: A.C. Whitman: *C.T.*, 1907.

TURNER, Daniel
An engraver and painter of architecture, portraits, landscapes and, above all, of the London River and bridges. He was a pupil of John Jones, was active from 1790 to 1801, and sometimes worked in brown wash.

TURNER, Dawson, F.R.S., F.S.A.
 1775 (Great Yarmouth) – 1858 (London)
Botanist, antiquary and patron of J.S. Cotman (q.v.), he entered Pembroke College, Cambridge, in 1793 and in 1796 started work at the Yarmouth bank. In 1812 he persuaded Cotman to live near him and to take over from Crome the teaching of him, his wife, MARY TURNER, née PALGRAVE (1774–1850), and four of his daughters, as well as supplying him with illustrations for the works on architecture which he wrote from 1820. Among the many Societies to which he was elected were the Linnaean Society in 1797, the Royal Society in 1802 and the Society of Antiquaries in 1803. He wrote articles for *English Botany*, the *Transactions* of the Linnaean Society, etc. His library of nearly eight thousand volumes, many containing drawings by his wife and daughters, was sold by auction, the majority in 1853 and the remainder in 1859.

TURNER, George
A painter of portraits and historical genre subjects, he exhibited at the R.A. and the B.I. from 1782 to 1820.

Examples: V.A.M.

TURNER, George
 1843 (Cromford, Derby) – 1910 (Idringehay, Derby)
A drawing master who lived in Birmingham and Barrow-on-Trent and exhibited oil paintings and watercolours in London and provincially. Towards the end of his life he moved to Idringehay.

His son, WILLIAM LAKIN TURNER (1867–1936), painted landscapes and moved from Barrow-on-Trent to the Lake District in 1900.

TURNER, Joseph Mallord William, R.A.
 1775 (London) – 1851 (London)
Turner was the son of a barber and printseller in Covent Garden. In 1786 he went to live with his uncle at Brentford, and his earliest dated drawings are from this time. In 1789 he entered the R.A. Schools and probably became a pupil of the elder T. Malton (q.v.). He sketched in the Bristol area in 1791 and in Wales for the first time in the following year. In 1794 he toured the Midlands and joined Girtin in Dr. Monro's evening 'Classes'. In 1795 he was again in Wales, in 1797 in the Lake District and in 1798 in Wales, and in

Kent with F.S.D. Rigaud (q.v.) and R. Nixon (q.v.). In 1799 he worked for Beckford at Fonthill, toured Wales again and was elected A.R.A. In 1801 he made his first visit to Scotland, and in 1802, after his election as R.A., his first to the Continent, visiting France and Switzerland. In 1807 the first volume of the *Liber Studiorum* was published, and he was elected Professor of Perspective at the R.A. The next three years included visits to three important patrons, Sir J. Leicester (Lord de Tabley) (q.v.), the Earl of Egremont at Petworth and Walter Fawkes at Farnley Hall. This latter visit, in 1810, was repeated annually until 1824. In 1811 he toured the West, returning to Devon in 1813. 1817 brought the first visit to Belgium and the Rhine and 1818 a second to Edinburgh. In 1819, having copied Italian subjects for some years, he toured Italy itself. He was in Paris and Normandy in 1821, Edinburgh for the State Visit of 1822 and South East England in 1823 and 1824. In 1825 he toured Holland, Belgium and the Rhine, in 1826 the French rivers, in 1827 the Isle of Wight, in 1828 France and Italy, in 1829 Northern France and in 1830 the Midlands.

He was in Scotland again in 1831, staying at Abbotsford, and in 1833 not only visited Paris, but also Venice, travelling by the Baltic, Germany and Austria. In 1834 he was again in France and Germany and in 1836, France, Switzerland and the Val d'Aosta. He resigned the Professorship in 1837, and the following years saw tours of Holland, the Rhine, Venice and Germany in 1840, Switzerland in 1841 and 1842, Northern Italy in 1843, Switzerland and the Rhine in 1844, and Normandy and Picardy in 1845. He also acted as P.R.A. during Shee's illness that summer. His last watercolour that can be dated with certainty belongs to 1846.

In style Turner was absorbing the achievements of others until about 1800. In the 1790s his work moved from over-formal and harshly coloured compositions through the topographic and picturesque traditions of Dayes and Hearne to the poetry of J.R. Cozens, which both he and Girtin re-interpreted. During the first decade or so of the nineteenth century he produced romantic landscape works that were well in advance of their time, and by the 1820s his fascination with light had become predominant, forerunner as it was of Impressionism. Many of the works of the middle and late periods show in the words of Williams 'a streak of showiness and stridency' – a failing which he shared with Cotman – but this does not detract from the genius behind them or the mass of his overall achievement.

Examples: B.M.; V.A.M.; Aberdeen A.G.; Ashmolean; Williamson A.G., Birkenhead; Cartwright Hall, Bradford; Bridport A.G.; Bury A.G.; Derby A.G.; Doncaster A.G.; Dudley A.G.; Exeter Mus.; Fitzwilliam; Glasgow A.G.; Abbot Hall A.G., Kendal; Leeds City A.G.; Leicestershire A.G.; Usher A.G., Lincoln; City A.G., Manchester; N.G., Ireland; N.G., Scotland; Newport A.G.; Nottingham Univ.; Portsmouth City Mus.; Stalybridge A.G.; Sydney A.G.; Tate Gall.; Ulster Mus.; Walsall A.G.

Bibliography: J. Burnet: *T. and his Works*, 1852. T. Miller: *T. and Girtin's Picturesque Views, Sixty Years Since*, 1854. W. Thornbury: *Life of J.M.W.T.*, 1862. Sir W. Armstrong: *T.*, 1902. A.J. Finberg: *T's Sketches and Drawings*, 1910. A.J. Finberg: *T's Watercolours at Farnley Hall*, 1912. A.P. Oppé: *Watercolours of T.*, 1925. A.J. Finberg: *In Venice with T.*, 1930. B. Falk: *T. the Painter*, 1938. A.J. Finberg: *Life of J.M.W.T.*, 1939. C. Clare: *J.M.W.T., His Life and Work*, 1951. Sir J. Rothenstein: *T.*, 1962. M.R.F. Butlin: *T: Watercolours*, 1962. L. Herrmann: *J.M.W.T.*, 1963. Sir J. Rothenstein and M. Butlin: *T.*, 1964. L. Gowing: *T: Imagination and Reality*, 1966. J. Lindsay: *J.M.W.T., His Life and Work*, 1966. L. Herrmann: *Ruskin and T.*, 1968. J. Gage: *Colour in T.*, 1969, G. Reynolds: *T.*, 1969. G. Wilkinson: *T.'s Early Sketchbooks*, 1972. A.G.H. Backrach: *T. and Rotterdam*, 1974. G. Wilkinson: *The Sketches of T., R.A.*, 1974. For further bibliography and articles see R.A.: *Exhibition Cat.*, 1974 and B.M.: *Exhibition Cat.*, 1975.

TURNER, W Eddowes c. 1820 (Nottingham) – c. 1885
A self-taught artist who lived in Nottingham and exhibited locally, as well as at the B.I. and Suffolk Street from 1858 to 1862. He painted animals, particularly cattle, in oil and watercolour, and spent some time painting race-horses at Newmarket.

TURNER, William, of Oxford, O.W.S.
 1789 (Blackbourton, Oxfordshire) – 1862 (Oxford)
As Martin Hardie wrote in the O.W.S. Club, after his 'magnificent beginning William Turner left a great future behind him'. He was partly brought up by an uncle at the manor-house of Shipton-on-Cherwell, and he was placed with J. Varley (q.v.) in about 1804. In 1808 he was elected A.O.W.S. and O.W.S., and he was a faithful and prolific exhibitor until the year of his death. Until 1815 he worked in the southern counties, often sketching in Bristol and Leigh Woods - anticipating the artists of the Bristol School. Thereafter he visited the Lakes, North Wales, Derbyshire, Devon, the New Forest, the Isle of Wight and, from 1838, the West Coast of Scotland. From about 1833 he was living in Oxford, and he built up a highly successful practice among the cultured amateurs of the University, his pupils including R. and C. Jenkyns (q.v.) and possibly Mrs. Oglander (q.v.). His method was to take a watercolour through all its stages, giving it to the pupil to copy after each lesson. Some of their work is of a very high quality and deceptively close to his.

His earliest exhibited watercolours show a remarkable power and vision, sometimes anticipating those of J.S. Cotman (q.v.). However, he soon lost his inspiration, although he always retained his technical ability, and his work is almost always pleasing.

Examples: B.M.; V.A.M.; Ashmolean; Williamson A.G., Birkenhead; Coventry A.G.; Exeter Mus.; Fitzwilliam; Leeds City A.G.; N.G., Scotland; Nat. Lib., Wales; Newport A.G.; Ulster Mus.
Bibliography: University Galls., Oxford: *Exhibition Cat.,* 1895. *Walker's Quarterly,* XI, 1923. O.W.S. Club, IX, 1932. *Oxoniensia,* XXVI, XXVII, 1961-2. *Connoisseur,* CLXII, 1966.

TURNER, Rev. William Hamilton c. 1802 – c. 1879
Educated at Pembroke College, Cambridge, from 1821, he was ordained in 1826. He was Vicar of Delham and Honing, Norfolk, and Rector of Barley, Hampshire, before being appointed Vicar of Banwell, near Weston-super-Mare, in 1839, where he remained until his death. He painted architectural and topographical subjects.

Examples: B.M.; V.A.M.

TURPIN, Samuel Hart 1837 (Nottingham) – 1899
A cousin of J.T. Hart (q.v.), and a friend of H. Dawson (q.v.), he was for many years a scene-painter at Nottingham Theatre Royal. He was a co-founder of the Nottingham Society of Artists, and he painted local views in oil and watercolour. He was an Anti-Tractarian and a teetotaler.

TYNDALE, Walter Frederick Roofe, R.I.1856 (Bruges) – 1943
A painter of architectural, topographical and genre subjects and portraits, he came to England at the age of sixteen and later studied in Antwerp and Paris. He painted in oil to begin with, but then moved to Haslemere and, under the influence of C. Hayes (q.v.) and H. Allingham (q.v.), turned exclusively to watercolour. He travelled in Morocco, Egypt, Lebanon, Syria, Italy and Japan and later lived in Venice. During the First World War he was Head Censor at Boulogne.

One-man shows of his work were held at the Leicester Gallery in 1910 and 1912, Waring and Gillow's in 1913 and the Fine Art Society in 1920 and 1924.

Published: *The New Forest,* 1904. *Below the Cataracts,* 1907. *Japan and the Japanese,* 1910. *Japanese Gardens,* 1912. *An Artist in*

Egypt, 1912. *An Artist in Italy,* 1913. *An Artist on the Riviera,* 1916. *The Dalmatian Coast,* 1925. *Somerset,* 1927.
Examples: B.M.; V.A.M.; Cartwright Hall, Bradford; Leicestershire A.G.
Bibliography: *Connoisseur,* XXXII, 1912.

TYRWHITT, Rev. Richard St. John – 1895
He graduated from Christ Church, Oxford, in 1849, where he later acted as Tutor and Rhetoric Reader. From 1858 to 1872 he was Vicar of St. Mary Magdalen, Oxford. In 1865 he was an unsuccessful candidate for the N.W.S., and he was once considered for the Slade Professorship. He exhibited landscapes, some of them from the Holy Land, from 1864 to 1887.

Published: *Hand-book of Pictorial Art,* 1868. *Lectures on Christian Art,* 1870. *Art Teaching of the Primitive Church,* 1873. *Our Sketching Club,* 1874. *Christ Church, an Oxford Novel,* 1880. *Greek and Gothic, Historical Essays on the three Arts,* 1880.

TYRWHITT, Walter Spencer-Stanhope
 1859 (Oxford) – 1932
The son of R. St. J. Tyrwhitt (q.v.), he was educated at Radley and Christ Church, Oxford. He spent a number of years in the Australian outback, returning in 1886. He then trained as an architect, but turned to architectural painting rather than practice. He exhibited from 1894, was elected R.B.A. ten years later and was President of the Oxford Art Society. An exhibition of his work entitled 'Architecture of the East and West' was held at the Baillie Gallery in 1910 and included views of Tunis, Cairo, Jerusalem, Athens, Capri and Oxford.

His wife, URSULA TYRWHITT, née TYRWHITT (1878-1966), painted watercolour portraits, landscapes and flowers and was a member of the N.E.A.C.

Published: *The New Chum in the Queensland Bush,* 1887. Illustrated: D.S. Margoliouth: *Cairo, Jerusalem and Damascus,* 1907.

TYSON, Rev. Michael, F.R.S., F.S.A.
 1740 (Stamford) – 1780 (Lambourne)
The son of the Dean of Stamford, he was a topographer and antiquarian, whose drawings are sometimes attributed to better artists. He was educated at the local Grammar School and St. Benet's (Corpus Christi) College, Cambridge, and he became a Fellow of the College and researched the illuminated manuscripts in the Library. In 1766 he toured the North and Scotland with Mr. Gough, a pupil, making an illustrated journal. He was elected F.S.A. in 1767 and F.R.S. in 1769, and in 1776 he was appointed to the living of Lambourne, although not without controversy.

His work is weakly in the Sandby tradition, rather like that of F. Grose (q.v.). He also etched a portrait of Jane Shore.

TYTLER, George 1798 – 1859 (London)
A lithographer, portrait painter and caricaturist. He was in Rome in about 1820 and, while there, produced an amusing pictorial alphabet. He was in Genoa in 1829. He exhibited at the R.A. and the O.W.S. from 1819 to 1829 and was Lithographic Draughtsman to the Duke of Gloucester.

Examples: B.M.

UBSDELL, Richard Henry Clements
A miniaturist, illustrator and photographer who worked in Portsmouth. He painted a series of watercolours of Hampshire churches between 1828 and 1847 and exhibited at the R.A. from 1833 to 1849.

Examples: Portsmouth City Mus.; Guildhall Picture Gall., Winchester.

UNDERHILL, Frederick Thomas
A fruit, landscape and portrait painter who lived in London and exhibited from 1868 to 1896. He was presumably a son of Frederick Charles Underhill (ex. 1851-1875) or of his brother William Underhill (ex. 1848-1896), who were born in Birmingham, lived in London and painted landscapes, coastal scenes, mythological and biblical subjects, for the most part in oil.

UNDERWOOD, Thomas Richard
1772 – 1836 (Auteil, France)
A chemist, geologist and draughtsman who was one of the Monro School and a member of Girtin's sketching club 'The Brothers'. He provided a Cornish subject for Britton's *Beauties* and was draughtsman to the Society of Antiquaries. He visited France and Italy in 1802-3 and was imprisoned on his return journey. Much of the latter part of his life was spent in France, where he lived on a private income. In style he could be close to the Maltons (q.v.).

Published: *A Narrative of memorable events in Paris,* 1828.
Examples: V.A.M.; Devizes Mus.; Towner Gall., Eastbourne; Fitzwilliam; Hertford Mus.

UNWIN, Francis Sydney
1885 (Stalbridge, Dorset) – 1925 (Mundesley, Norfolk)
An architectural and landscape painter and a lithographer and etcher, he studied at the Winchester School of Art and the Slade. He settled in London in 1909, and he visited Holland, France, Italy, Egypt in 1908 and Switzerland in 1920-1. He was a member of the N.E.A.C. from 1913.

Published: *The Decorative Arts in the Service of the Church,* 1908.
Examples: B.M.; Hove Lib.; Leeds City A.G.; City A.G., Manchester.
Bibliography: J. Nash: *F.U.,* 1928.

UPHAM, John William
1772 (Offwell, near Honiton) – 1828 (Weymouth)
Probably the son of Charles Upham, Mayor of Exeter, he was a pupil of F. Towne (q.v.). He became a drawing master in Weymouth and specialized in Dorset and Devon landscapes. He also painted in the London area, North Wales and Switzerland. A number of prints were made from his drawings.
In the V.A.M. there is a bird subject, dated 1814, by M. UPHAM.

Examples: B.M.; V.A.M.; Exeter Mus.; Newport A.G.; Weymouth Lib.

UPPLEBY, Charles
1779 (Barrow Hall, Lincolnshire) – 1853 (Barrow Hall)
A hunting squire and an amateur musician, both interests being reflected in his works. He inherited Barrow Hall and Bardney Hall when he was thirty-seven and lived a happy and improvident life, collecting Ibbetsons and visiting his friend George Osbaldeston.

His style is entirely his own, perhaps best described as a mixture of Fuseli, Douanier Rousseau and Max Beerbohm. He has a charming naivety and a total disregard for artistic convention. His watercolours are virtually all in the possession of his family. An exhibition of some of them was held at Normanby Hall, near Scunthorpe, in 1970. Apart from the Lincolnshire subjects and characters, they included a number from summer holidays in North Wales between 1811 and 1821.

UREN, John Clarkson
A marine and coastal painter who was working in Penzance and Plymouth in the 1880s and 1890s.

UTTERSON, Edward Vernon, F.S.A.
c.1776 (Fareham, Hampshire) – 1852 (Brighton)
Educated at Eton and Trinity Hall, Cambridge, he was called to the bar in 1802. He was appointed a Clerk in Chancery in 1815. From about 1835 he lived at Newport, and then at Ryde, Isle of Wight. He was a collector and editor of early English texts. He visited Ireland, Scotland, Normandy, Sicily and Holland.
His work is often in thin washes of colour over shaky pencil drawing. His drawing in pen is rather more assured.

Examples: B.M.; N.G., Scotland; Nat. Lib., Wales.

UWINS, Thomas, R.A.
1782 (Pentonville) – 1857 (Staines)
The son of a Bank of England clerk, Uwins's talent for drawing was encouraged by his family, and he was given lessons as well as a general education. He was articled to Benjamin Smith, the engraver, in 1797, but left after a year to study at Simpson's drawing school, Finsbury, and the R.A. Schools. He began to exhibit illustrations and country figure subjects with the O.W.S. in 1809, becoming a member in 1810. He made topographical drawings for Ackermann and Britton, and he visited the Lakes in 1815. In 1817 he visited France and was especially inspired by the vintage in Médoc. He resigned from the O.W.S. in 1818 and in 1819 his eyesight was damaged by too much work on miniature copies of portraits and pictures. In 1821 he settled in Edinburgh as a result of a commission to illustrate Scott's works. He returned to London in the winter of 1823 and went to Italy the following summer, remaining until 1831. He was elected A.R.A. in 1833 and R.A. in 1838. In 1846 he was appointed Surveyor of the Queen's Pictures and in 1847 Keeper of the National Gallery. Although much of his later work was in oil, he was an enthusiastic member of the Sketching Society from 1824.
In style he is close to R. Westall (q.v.) in his less Fuseli-like moments.

Examples: B.M.; V.A.M.; Williamson A.G., Birkenhead; Fitzwilliam; Leeds City A.G.; Castle Mus., Nottingham.
Bibliography: Mrs. T. Uwins: *Memoir,* 1858. *A.J.,* October, 1857. *Connoisseur,* LII, 1928.

VACHER, Charles, N.W.S. 1818 (Westminster) – 1883 (London)
A landscape painter who studied at the R.A. Schools and in Rome from 1839. He visited Sicily, France, Germany, Algeria and Egypt. He exhibited in London from 1838 and was elected A.N.W.S. in 1846 when he was once again in Rome. He became a full Member in 1850.

He was a rapid and detailed worker, leaving over two thousand sketches at his death. His finished work is well composed and coloured. His remaining works were sold at Christie's, February 21, 1884.

Examples: B.M.; V.A.M.; Grundy A.G., Blackpool; Glasgow A.G.; Portsmouth City Mus.

VACHER, Thomas Brittain 1805 – 1880
A brother of C. Vacher (q.v.), he was in business as a publisher of Parliamentary Companions in Parliament Street with his brother George. Together they set up a charitable trust known as the Vacher Endowments. He was a keen amateur artist and sketched in Britain and Ireland, Belgium, Germany, Italy and Switzerland.

Examples: V.A.M.

VALLANCE, William Fleming, R.S.A.
 1827 (Paisley) – 1904 (Edinburgh)
A landscape painter in oil and watercolour who also painted portraits, marine and literary genre subjects. He was apprenticed to a carver and gilder in 1841 and studied at the Trustees' Academy. Although he exhibited at the R.S.A. from 1849, he took up painting full time only in 1857. He was elected A.R.S.A. and R.S.A. in 1875 and 1881. After 1870, he painted mainly in Connemara and County Wicklow, producing many atmospheric sketches of sea and sky.

VANTRIGHT, John – c.1892 (British Columbia)
A landscape painter in oil and watercolour who studied at the R.D.S. Schools and exhibited at the R.H.A. from 1861 to 1871. He worked as a clerk in the General Valuation Office in Dublin from 1856 until 1882, when he emigrated to British Columbia.

VARLEY, Albert Fleetwood 1804 – 1876 (London)
The elder son of J. Varley (q.v.) and the father of J. Varley, Yr. (q.v.), he worked as a drawing master. His remaining works were sold at Christie's, January 26, 1877.

Examples: V.A.M.

VARLEY, Charles Smith 1811 – 1888
The younger son of J. Varley (q.v.), he exhibited from 1838 to 1869. He was the father of E.J. Varley (q.v.).

VARLEY, Cornelius 1781 (Hackney) – 1873 (London)
A scientist and landscape painter, he was the brother of J. Varley (q.v.) and W.F. Varley (q.v.). He was largely brought up by his uncle Samuel, an instrument maker. In 1802 and 1803 he visited North Wales, firstly with John and then with W. Havell (q.v.), and in the latter year he exhibited for the first time at the R.A. He was a Founder Member of the O.W.S. but resigned in 1820 after the second reorganisation. After this date scientific interests took up most of his time – he was the inventor of a 'graphic telescope' – but he still exhibited at the R.A. on occasions. In 1844, rather surprisingly, he was a candidate for the N.W.S., but was rejected unanimously.

While there is a kinship between his work and that of his brother, his is at once more traditional and more modern. His main interest seems to be in the building of his compositions from contrasting masses painted in even, unemphatic, washes.

For his sons, see Varley, S.

Published: *Etchings of Shipping*, 1809. *A Treatise on Optical Drawing Instruments*, 1845.
Examples: B.M.; V.A.M.; Aberdeen A.G.; County Mus., Armagh; Coventry A.G.; Abbot Hall A.G., Kendal; Leeds City A.G.; Leicestershire A.G.; Castle Mus., Nottingham.; Portsmouth City Mus.; Stafford Lib.; Wakefield A.G.; Ulster Mus.

VARLEY, Edgar John – 1888
The son of C.S. Varley (q.v.), he exhibited in London and elsewhere from 1861. He was Curator of the Archaeological Museum in Westminster.

Examples: V.A.M.; Portsmouth City Mus.

VARLEY, John, O.W.S. 1778 (Hackney) – 1842 (London)
Drawing master and astrologer, who, in the words of Randall Davies, did for watercolour painting 'what St. Paul did for Christianity'. The nearest he came to taking professional instruction was working for a while as a general assistant in the school run by J.C. Barrow (q.v.). Barrow also took him to Peterborough, which provided the subject of his first R.A. exhibit in 1798. In that year he toured Wales with G. Arnald (q.v.), and by 1800 he was a member of the Monro circle, briefly falling under the influence of Girtin. He revisited Wales with Cornelius in 1802 and was in Northumberland in 1803. He was a founder of the O.W.S. in 1804 and was already recognised as a successful drawing master. During his career he must have had more pupils than any other artist, ranging from Cox, Dobson, Linnell, Mulready and Turner of Oxford (all q.v.) to a footman he employed during a period of unusual prosperity. Despite his success he was constantly in financial difficulties, since he was a hopeless business man and by temperament something of a Micawber.

Throughout his career his work, although often based on scenes in Wales, the North, Killarney or the London Thames, or on foreign sketches by amateurs, becomes less and less topographical and more and more compositional. Indeed, in the last years of his life, the majority of his exhibits are merely titled 'Landscape' or 'Composition'. He stands apart from the tradition of watercolour painting in that his constant experiments were designed to make the medium rival oil painting on its own terms; this, despite the fact that he could 'lay a wash' with the greatest. As a teacher he was particularly gifted since, unlike Cotman, he never sought to suppress the natural talents of his pupils.

Published: *A Treatise on the Principles of Landscape Drawing*, 1816-21. *A Pictorial Treatise on the Art of Drawing in Perspective*, 1821. *A Treatise on Zodiacal Physiognomy*, 1828.
Examples: B.M.; V.A.M.; Aberdeen A.G.; Accrington A.G.; Ashmolean; Grundy A.G., Blackpool; Bridport A.G.; Derby A.G.; Exeter Mus.; Fitzwilliam; Glasgow A.G.; Gloucester City A.G.; Harrogate A.G.; Haworth A.G.; Inverness Lib.; Abbot Hall A.G., Kendal; Leeds City A.G.; Leicestershire A.G.; City A.G., Manchester; N.G., Scotland; Newport A.G.; Portsmouth City Mus.; Southampton A.G.; Wakefield A.G.; York A.G.
Bibliography: A.T. Storey: *James Holmes and J.V.*, 1894. A. Bury: *J.V. of the 'Old Society'*, 1946. O.W.S. Club, II, 1925. Connoisseur CXII, 1943.

VARLEY, John, Yr.
The son of A.F. Varley (q.v.), he specialized in Egyptian and Japanese scenes which he exhibited from 1870. His work is competent, but shows no great originality. Various exhibitions were held of his Egyptian, Indian and Ceylonese subjects.

Examples: V.A.M.; Cape Town A.G.; City A.G., Manchester.

VARLEY, S
A watercolour view in Ceylon with this signature passed through Christie's on November 11, 1969. It was dated 1838, which seems

too early for it to be by Cornelius's son, Samuel Alfred Varley. His two other sons were Frederick Henry Varley and Cromwell Fleetwood Varley (1828-1883).

VARLEY, William Fleetwood 1785 (Hackney) – 1856 (Ramsgate)
Youngest of the Varley brothers, and pupil of the other two, he exhibited at the R.A. from 1804. He was teaching in Cornwall in 1810 and later moved to Bath and Oxford. In about 1818 he was almost burnt to death by some undergraduates and the shock made him give up working. His drawings, especially of the Thames, are often very pleasing, but have none of the originality one might have expected.

Published: *Observations on Colouring and Sketching from Nature*, 1820.
Examples: B.M.; V.A.M.; Abbot Hall A.G., Kendal; Leeds City A.G.; Reading A.G.
Bibliography: *A.J.,* May 1856.

VAWSER, George Richard 1800 – 1888
A pupil of J. Varley (q.v.) under whom he studied for three years at a premium of £200. He was a topographical and landscape painter and worked in Yorkshire, Derby and London. His son, GEORGE RICHARD VAWSER, YR. painted similar subjects between 1836 and 1875.

Examples: Derby A.G.; Richmond Lib.

VEREKER, Captain, The Hon. Foley Charles Prendergast
** 1850 – 1900 (Isleworth)**
The second son of the 4th Viscount Gort, he was a captain in the Navy and became Admiralty Surveyor and an adviser to the Board of Trade. He was F.R.G.S. He painted Irish landscapes as well as making drawings connected with his surveying work, which took him to South China and the Australian coast, among other places.

VERNON, William H 1820 –
A landscape, marine, coastal and town painter in oil and watercolour who was working in Birmingham between 1854 and 1908. His daughters ELLEN VERNON, FLORENCE VERNON, MARY VERNON, MRS. MORGAN and NORAH VERNON were all painters of flowers and landscapes.

VICKERS, Alfred 1786 (Newington, Surrey) – 1868 (London)
A self-taught landscape painter in oil and watercolour about whom surprisingly little is known. He was a popular teacher, and he exhibited from 1828. His best works, which are usually English river landscapes, are painted in a spirited and free style with a predominance of pale greens. He was the father of A.G. Vickers (q.v.).

Examples: V.A.M.

VICKERS, Alfred Gomersal 1810 (Lambeth) – 1837 (Pentonville)
The son and pupil of A. Vickers (q.v.), he was a follower of Francia and Bonington. He exhibited from 1827, and in 1833 he was sent to Russia by Charles Heath to make drawings for the Annuals. These were engraved in 1836. His remaining works were sold at Christie's, February 16, 1837.

Examples: B.M.; V.A.M.; Williamson A.G., Birkenhead; Birmingham City A.G.; Fitzwilliam; Newport A.G.; York City A.G.

VICTORIA, H.M. Queen
** 1819 (Kensington) – 1901 (Osborne, I.o.W.)**
An etcher and sketcher of portraits and animals who took lessons from R. Westall (q.v.) and Sir E. Landseer (q.v.).

Bibliography: *A.J.,* 1901.

VIDAL, Emeric Essex 1791 (Bradford) – 1861 (Brighton)
A landscape and topographical painter who entered the Navy in 1806 and spent a great part of his life in South America and Canada, where he was Secretary to Sir Edward W.C. Owen, Commander-in-Chief of the Canadian Lakes. He was an unsuccessful candidate for the N.W.S. in 1843.

Examples: R.M.C., Canada; Greenwich.
Bibliography: R.M.C., Canada, *Review,* XXXIX, 1958.

VILLIERS, Jean Francois Marie HUET-
** 1772 (Paris) – 1813 (London)**
The son of Jean Baptiste Huet under whom he studied. He settled in London in about 1801 and was appointed Miniature Painter to the Duke and Duchess of York. He exhibited at the R.A. from 1803, was a member of the A.A. and the Sketching Society, and exhibited at the O.W.S. in 1813. He also provided drawings for Ackermann's *Westminster Abbey.*

He painted portraits in oil and watercolour and also landscapes, animals and architecture, and he was best known for his series of actresses and other ladies in mythological character.

Published: *Rudiments of Cattle,* 1805. *Rudiments and Characters of Trees,* 1806.
Examples: B.M.

VINCENT, Spencer – 1910
An amateur painter of Scottish landscapes who exhibited from 1865 and was an Honorary R.I. in 1882 and 1883.

VINE, John c.1809 (Colchester) – 1867 (Colchester)
An animal painter who was malformed to such an extent that his hands virtually grew out of his shoulders. As a child, however, he showed a marked talent for drawing and was exhibited as a prodigy. From 1831 he painted the horses, cattle and dogs of the Essex gentry and farmers. His primitive, childlike vision is reminiscent of Grandma Moses or le Douanier Rousseau.

Bibliography: W.G. Benham: *J.V. of Colchester,* 1932.

VIOLET, Pierre Noel 1749 (France) – 1819 (London)
Miniaturist to Louis XVI and Marie Antoinette, he fled to England during the Revolution. He exhibited miniatures at the R.A. from 1790 and domestic subjects from 1798. Several of his drawings were engraved by Bartolozzi, and he also worked as a drawing master.

VIVARES, Francois 1709 (Montpellier) – 1780 (London)
An engraver and occasional watercolourist who settled in London in about 1727. He is thought to have taken lessons from J.B.C. Chatelain (q.v.). Most of his prints were published by Boydell. His drawings are in light washes of grey, brown and blue with a nervous, prickly brown ink pen line.

Examples: B.M.; V.A.M.

VIVARES, Thomas c.1735 (London) –
The son and pupil of F. Vivares (q.v.). His style is very similar to, but harder than, that of his father. He engraved plates for R. and J. Adam and for Orme.

Examples: B.M.

VIVIAN, George 1798 – 1873
A traveller and amateur artist, he was educated at Eton and Christ Church, Oxford. He was in Vienna in 1818, Albania in 1819, the Near East in 1824, on which journey he met Byron, and Spain and Portugal in 1833 and 1837. Before his marriage in 1841 he had also visited Russia, Scandinavia and Germany. From 1844 to 1846 he lived in Italy, where he contracted malaria while sketching in the Campagna. He returned to England, but he never completely regained his health and was soon forced to give up drawing.

His delicate landscapes are mainly in pencil and wash, and in their skilful draughtsmanship show the influence of his friend J.D. Harding (q.v.).

His love of architecture derived from his determination to preserve and restore some of the features of the family home, Claverton Manor, near Bath, after his father had commissioned Sir J. Wyatville (q.v.) to design a new house on a different site. In 1837 he published a series of lithographs of the old house, mainly after drawings by the architect C.J. Richardson.

Published: *Spanish Scenery,* 1838. *Scenery of Portugal and Spain. The Gardens of Rome,* 1848.
Bibliography: *Connoisseur,* XCV, 1935.

WADE, J.
A landscape painter who exhibited in Dublin between 1801 and 1817.

WADE, Thomas 1828 (Wharton) – 1891 (London)
A landscape and genre painter who was influenced by the Pre-Raphaelites, but essentially self-taught. He exhibited from 1867 to 1890 and lived at Preston and, from 1879, at Windermere.

Examples: City A.G., Manchester; Tate Gall.

WADHAM, B B
A Liverpool landscape painter in oil and watercolour who exhibited at Suffolk Street, in Brighton and elsewhere in the 1870s. He painted in North Wales and Kent.

WAGEMAN, Thomas Charles, N.W.S. c.1787 – 1863
A portrait and landscape painter and an illustrator who exhibited from 1816. He was a Founder Member of the N.W.S. in 1831, and he was appointed Portrait Painter to the King of Holland. Many of his sitters were eminent actors and actresses.
 He was the father of MICHAEL ANGELO WAGEMAN (ex. 1837-1879), a painter of portraits and historical genre subjects. Both lived in London.

Examples: B.M.; V.A.M.

WAGSTAFF, S
A landscape painter who lived in Leeds. He exhibited at Suffolk Street in 1876.

Examples: Leeds City A.G.

WAINEWRIGHT, Thomas Francis
A cattle and landscape painter who lived in London and exhibited from 1831 to 1883, mostly with the S.B.A., to which he was elected in 1852. He painted in the Southern counties, Scotland, Cornwall and North Wales, and he visited Normandy early in his career. He often painted cattle into the landscapes of other artists such as C. Pearson (q.v.) and T.C. Dibdin (q.v.). He is said to have emigrated to Boston.

Examples: B.M.; V.A.M.

WAINEWRIGHT, Thomas Griffiths
 1794 (Chiswick) – 1852 (Hobart, Tasmania)
Art critic, portraitist and poisoner. He was educated at Charles Burney's school, where he showed promise as a draughtsman, and he was apprenticed to Thomas Phillips, R.A. for a short while in 1814, then spending a period in the Army. From 1820 to 1823 he wrote for the *London Magazine* and from 1821 he exhibited genre watercolours at the R.A. Between 1828 and 1830 his uncle, mother-in-law and sister-in-law died in suspicious circumstances and in 1831 he fled to France. In 1837 he returned and was sentenced to transportation for forging a cheque. While in Tasmania he took a number of portraits in pastel and watercolour.

Examples: B.M.

WAINWRIGHT, William John, R.W.S.
 1855 (Birmingham) – 1931 (Birmingham)
A portrait, still-life and genre painter and a stained-glass designer, he was educated at Sedgley Park College, Wolverhampton, and

apprenticed to Messrs. Hardman, the glass designers. He studied at Antwerp and worked in Paris, London and Newlyn before returning to Birmingham in 1886. He was a founder of the Birmingham Art Circle and was elected to the Birmingham Society in 1884 and A.R.W.S. and R.W.S. in 1883 and 1905.

Bibliography: W. Turner: *W.J.W.,* 1935. *Connoisseur,* LXXII, 1925.

WAITE, Robert Thorne, R.W.S.
 1842 (Cheltenham) – 1935 (Bournemouth)
A landscape painter who was educated at Cheltenham Grammar School and studied at South Kensington. He lived in London, Bettws-y-Coed, Cheltenham and latterly Bournemouth, and he also painted in Yorkshire and on the South Downs. He was elected A.R.W.S. and R.W.S. in 1876 and 1884. His style is derived from that of A.V.C. Fielding (q.v.). An exhibition of works from his studio was held at the Bourne Gallery, Reigate, March, 1976.

Examples: V.A.M.; Haworth A.G., Accrington; Bethnal Green Mus.; Birmingham City A.G.; Exeter Mus.; Hampshire Mus.; City A.G., Manchester; Nat. Lib., Wales; Newport A.G.; Portsmouth City Mus.; Sydney A.G.; Worthing A.G.
Bibliography: *Connoisseur,* XXVIII, 1910.

WAKEMAN, William Frederick 1822 (Dublin) – 1900 (Coleraine)
A landscape painter and antiquarian draughtsman who became attached to the Ordnance Survey through the influence of G. Petrie (q.v.), from whom he took lessons. He exhibited Irish views at the R.H.A. from 1843 to 1863. When the topographical department was closed, he left the Survey and worked as a drawing master in Dublin before briefly living in London. Later he taught for four years at St. Columba's College, Stackallan, and for nineteen years at Portora Royal School. During this time he wrote many articles for the *Royal Archaeological Society of Ireland* and other periodicals. On his return to Dublin in 1884 he worked as an archaeological writer and illustrator, providing illustrations for, among others, Petrie's *Ecclesiastical Antiquities,* Hall's *Ireland, its Scenery and Character,* Wilde's *Catalogue of Antiquities in the Royal Irish Academy,* Canon O'Hanlon's *Lives of the Irish Saints,* the *Irish Penny Journal,* the *Dublin Saturday Magazine* and the *Hibernian Magazine.*

Published: *Handbook of Irish Antiquities,* 1848. *Three Days on the Shannon,* 1852. *A Guide to Lough Erne,* 1870., *Graves and Monuments of Illustrious Irishmen,* 1887. *Account of the Island of Inishmurray,* 1893. *Illustrated Railway Chart to the North, South and West of Ireland.* Etc.

Examples: R.I.A.

WAKLEY, Archibald c.1875 – 1906 (London)
A Pre-Raphaelite follower who painted in oil and watercolour. He was influenced by Burne-Jones and T.M. Rooke (q.v.), showing great promise and exhibiting at the R.A. in 1906. However he was murdered in his water closet.

Bibliography: *The Times,* May 25, 1906.

WALE, John Porter 1860 (Worcester) – 1920 (Derby)
He studied at Worcester, where he worked for the China manufactory, and the Derby School of Art. He became head of the painting room at the Derby Porcelain works. He painted flowers, particularly wallflowers, and exhibited with the R.W.S. and provincially.

Examples: Derby A.G.

WALE, Samuel, R.A. c.1720 (Great Yarmouth) – 1786 (London)
An illustrator, he trained as a silver engraver and under Hayman at St. Martin's Lane Academy, and then assisted John Gwynn in making architectural drawings of St. Paul's and elsewhere. He was a prolific book illustrator and exhibited stained drawings with the Society of Artists from 1760 to 1767. He was a Foundation Member of the R.A. and its first Professor of Perspective, and served as Librarian from 1782. He exhibited historical and biblical subjects at the R.A. from 1769 to 1778.

His drawing is weak, but his work is always charming. It is usually in pen and ink and grey wash.

Examples: B.M.; India Office Lib.

WALES, James
1748 (Peterhead, Aberdeenshire) – 1796 (Thânâ, India)
A self-taught architectural draughtsman and portrait painter. He exhibited portraits at the R.A. from 1783 to 1791, when he went to India. There he took many portraits of Indian Princes and made drawings of the temples and architecture. He worked with T. Daniell (q.v.) and provided twenty-four drawings for *Oriental Scenery*, and twenty-four for *Hindoo Excavations in the Mountain of Ellora*, 1803.

WALKER, Anthony 1726 (Thirsk, Yorkshire) – 1765 (Kensington)
A book-illustrator and engraver. After studying at the St. Martin's Lane Academy, he worked for Boydell, mainly engraving after old masters. His brother, WILLIAM WALKER (1729-1793), was also an illustrator and engraver and worked on Sandby's *Views in England and Wales*. His son, John Walker (fl. 1800), was a landscape engraver.

WALKER, Claude Alfred Pennington
1862 (Cheltenham) –
A landscape, architectural and flower painter in oil and watercolour who lived in London and exhibited at the R.A., the R.I. and provincially.

Examples: V.A.M.

WALKER, Dougald 1865 –
He was for many years Headmaster of the Northern District School, Perth. He became Secretary of the local Art Association and exhibited landscapes at the R.S.A. and elsewhere.

WALKER, Frederick, A.R.A., O.W.S.
1840 (London) – 1875 (St. Fillan's, Perthshire)
The son and grandson of amateur artists, his artistic leanings were encouraged by his parents, but he was first put to work with an architect. He spent his spare time sketching Greek statues in the B.M., which he continued to do afterwards while attending Leigh's Life School in Newman Street. In 1858 he entered the R.A. Schools. He was also a member of the Langham Sketching Club. At this time he worked for three years for Thomas Wood Whymper, the wood engraver. During 1860 he made twenty-four illustrations for *Once a Week* and in the following year he began to illustrate Thackeray's works in the *Cornhill Magazine*. At this point he began to paint in both oil and watercolour, first exhibiting at the R.A. in 1863 and the O.W.S. in 1864, in which year he was elected Associate. He became a full Member in 1866, and was elected A.R.A. in 1871. He visited Paris in 1867 and Venice in 1868, also sketching with J.W. North (q.v.) in Somerset in that year. He returned to Venice in 1870 and spent the winter of 1873-4 in Algiers for his health. He made a number of visits to the Highlands, where he stayed with Richard Ansdell, R.A., both painting and fishing. Another favourite sketching ground was Cookham-on-Thames, where he is buried.

He was a very slow and careful worker, producing a Pre-Raphaelite finish and detail. He scraped highlights and used bodycolour lavishly. Ruskin's criticism of his art and methods is largely just: 'A semi-miniature fresco, quarter wash manner of his own – exquisitely clever, and reaching under such clever management delightfullest results here and there, but which betrays his genius unto perpetual experiment instead of achievement . . .'. He sometimes signed with initials, but see also Wyburd, Francis John.

His remaining works were sold at Christie's, July 17, 1875.

Examples: B.M.; V.A.M.; Ashmolean; Towneley Hall, Burnley; Fitzwilliam; City A.G., Manchester.
Bibliography: J.C. Carr: *F.W.: an Essay*, 1885. Sir C. Phillips: *F.W.*, 1894. J.G. Marks: *Life and Letters of F.W.*, 1896. C. Black: *F.W.*, 1902. Deschamps Gall.: *Exhibition Cat.*, January, 1876. O.W.S. Club, XIV, 1937.

WALKER, George – ?1795
A landscape painter who exhibited at the R.A. from 1792 to 1795. Many of his works were engraved by William Byrne.

Examples: V.A.M.

WALKER, James William
1831 (Norwich) – 1898 (Brockdish, Norfolk)
A landscape painter who was apprenticed to a decorative painter and studied at the Norwich School of Design. Thereafter he taught with the Department of Science and Art in London, at the Bolton School of Art and privately in Southport. During the holidays he made sketching tours of the Lakes, Wales, Brittany and, in 1881, Italy. He exhibited from 1861 to 1893. His wife PAULINE WALKER was a still-life painter.

Examples: B.M.; V.A.M.; Castle Mus., Norwich.
Bibliography: W.F. Dickes: *The Norwich School*, 1905.

WALKER, John Hanson c.1844 – 1933
A landscape, figure and portrait painter who lived in London and exhibited from 1869, mainly at the R.A. and Suffolk Street. Some of his subjects are from Normandy.

WALKER, John Rawson 1796 (Nottingham) – 1873 (Birmingham)
A landscape and portrait painter in oil and watercolour who served an apprenticeship to a lace-maker before setting himself up as an artist in Nottingham. He also worked in London, and exhibited at the R.A. and elsewhere, between 1817 and 1865. Towards the end of his life he moved to Birmingham, where he exhibited with the Birmingham Society from 1863 to 1867.

WALKER, Leonard, R.I. 1877 (Ealing) – 1964
A figure and subject painter and a stained-glass designer, he was educated at King Edward's School, Bromsgrove. He became a teacher and lecturer and was Principal of St. John's Wood School of Art, where he had previously studied. He was elected R.I. in 1915.

WALKER, William (1729-1793) see under WALKER, Anthony

WALKER, William 1780 (Hackney) – 1868 (Sawbridgeworth)
A landscape and architectural painter in watercolour and occasionally oil, he was a pupil of Robert Smirke. He went to Greece in 1803, returning about two years later. He was a Member of the O.W.S. from 1808 to 1812, exhibited with the Oil and Watercolour Society, and was an Associate of the reconstituted Society until 1849. He visited Greece again in 1815 and thereafter travelled widely on the Continent. He may also have visited Rio de Janeiro.

Examples: B.M.; V.A.M.; Stalybridge A.G.

WALKER, William Eyre, R.W.S.
1847 (Manchester) – 1930 (Wimbledon)
A landscape painter who exhibited at the R.A. from 1885 to 1898, and more frequently with the R.W.S., of which he was elected Associate in 1880 and Member in 1896. He lived at Stow-on-the-Wold and Blandford, Dorset, and he painted in many parts of Britain and Ireland.

Examples: Grundy A.G., Blackpool; City A.G., Manchester; Portsmouth City Mus.; Stafford Lib.; Mus. of Staffordshire Life, Shugborough; Stalybridge A.G.

WALL, William G 1792 (Dublin) –
A landscape painter in oil and watercolour who went to America in 1818 and in 1826 became a Founder Member of the National Academy of Design, New York. A series of aquatints of the Hudson River were published in 1820 after his drawings. In about 1832 he returned to Dublin, and exhibited at the R.H.A., the Society of Irish Artists, of which he was a member, and in 1853 at the R.A. Not meeting with great success in Dublin, he went back to America in about 1856, but returned to Dublin again in 1862.

His son, WILLIAM ARCHIBALD WALL (b.1828, New York),

exhibited landscapes at the R.H.A., R.A., B.I., and at the National Academy, New York, in 1861. In 1875 he was living at Norbiton.

WALLACE, Sir Richard, Bt. 1818 (London) – 1890 (Paris)
The connoisseur and collector. He was elected an Honorary Member of the O.W.S. in 1873.

WALLER, Annie E
A genre and landscape painter who lived in Gloucester and exhibited at the Dudley Gallery from 1876 to 1878.

WALLER, Colonel Charles D
An artillery officer and amateur topographer. He was promoted captain in 1795 and full colonel in 1819. From 1818 to 1826 he commanded Charlemont Fort, County Armagh.

Examples: County Mus., Armagh.

WALLER, Richard, F.R.S. c.1650 – 1715
A painter of flowers, reptiles and animals. He was Secretary of the Royal Society in 1687.

Examples: Royal Society.

WALLIS, George, F.S.A.
 1811 (Wolverhampton) – 1891 (Wimbledon)
A designer who worked as an artist in Manchester from 1832 to 1837. In 1841 he joined the Government Schools of Design at Somerset House and was successively head of the Schools at Spitalfields, Manchester and Birmingham. He had much to do with the organising of the Great, and subsequent, Exhibitions. He was Senior Keeper of the art collection at South Kensington from 1858.

Published: *British Art, 1832-1882*, 1882. Etc.
Examples: B.M.; V.A.M.; Nat. Lib., Wales.

WALLIS, Henry, R.W.S. 1830 (London) – 1916 (Sutton, Surrey)
An historical genre painter in oil and watercolour who studied at Cary's Academy, in Paris and at the R.A. Schools. He exhibited from 1854 and was elected A.R.W.S. and R.W.S. in 1878 and 1880. Early in his career he was much influenced by the Pre-Raphaelites, but after the 1850s the quality of his work declined. He was also a writer on ceramics.

WALLIS, Joshua 1798 – 1862 (Walworth)
A painter of landscapes and snow scenes, he was a cousin of B. West (q.v.), and lived in London. He exhibited from 1809, and although praised by Ruskin his work was never very popular. He sometimes varnished his drawings, and he used only the four primary colours.

Examples: V.A.M.

WALLIS, Rosa 1857 (Stretton) –
A landscape and flower painter in oil and watercolour, an etcher and an enameller, she studied in Manchester and Berlin. She exhibited from 1878 to 1934. An exhibition of her Italian views was held at the Rembrandt Galleries in 1897, and one of Tyrolean and other European views and gardens at Walker's Galleries in 1924. She lived in London.

Examples: Richmond Lib.
Bibliography: *Connoisseur*, LXVIII, 1924.

WALLIS, William R.S.A., R.S.W.
 1860 (Dunfermline) – 1942
An animal painter in oil and watercolour, he studied at the R.S.A. Schools and in Antwerp. He worked in the zoos there and in London, as well as in the Fens and Highlands. He taught at the Edinburgh College of Art, lived at Corstorphine and was elected A.R.S.A. and R.S.A. in 1901 and 1914 and R.S.W. in 1906.

His drawings are free and rather sketchy, in the manner of E.J. Alexander (q.v.). They are often on tinted paper.

Examples: V.A.M.; Dundee City A.G.

WALMSLEY, Thomas 1763 (Dublin) – 1806 (Bath)
A landscape painter who, after a quarrel with his family, came to London and worked as a scene-painter at the Opera House. In 1788 he became a scene-painter at the Crow Street Theatre, Dublin, returning to England after two years. He exhibited Welsh and Irish views at the R.A. from 1790 to 1796. He also sketched in Scotland and the Isle of Wight, occasionally revisiting Ireland, and many of his views were aquatinted and published. He retired to Bath for the last ten years of his life.

His work, usually in bodycolour, betrays its theatrical origins. His colours, especially purples and orange reds, and his compositions are over-dramatic.

Examples: B.M.; V.A.M.; Ashmolean; Nat. Lib., Wales; Nottingham Univ.

WALROND, Sir John Walrond
A painter of birds whose original name was John Walrond Dickinson. He exhibited from 1779 to 1788, and his birds are in the manner of C. Collins (q.v.). The branches on which they perch are in the knotty style of Rowlandson.

WALSH, J R
A landscape painter who worked in a style close to that of P.S. Munn (q.v.), but with much more colour. He may be identifiable with the J.B. WALSH who exhibited literary and historical subjects at the R.A. and Suffolk Street from a London address from 1838 to 1841.

WALSH, Nicholas 1839 (Dublin) – 1877 (Italy)
A landscape painter who studied at the R.D.S. and R.H.A. Schools, where he exhibited until 1863. He spent some years in Paris and Italy from 1864. He exhibited Paris street scenes at the Crystal Palace in 1871, and the following year was in London where he exhibited at the R.A., after which he again went abroad.

WALTER, Emma
A flower and birds' nest painter who was largely self-taught except for a few lessons from J. Holland (q.v.) and three months in Calais studying perspective and chalk drawing. She exhibited from 1855 to 1891 and in 1872 was elected as Associate of the Liverpool Society of Painters in Water Colours. She lived in Dalston, Kilburn and Hampstead.

WALTER, Henry 1786 (London) – 1849 (Torquay)
A landscape, animal and portrait painter who exhibited from 1820 to 1846. He lived in London and was with S. Palmer (q.v.) at Shoreham. His work is usually in pencil and grey wash.

Examples: B.M.; N.G., Scotland.

WALTERS, George Stanfield 1838 (Liverpool) – 1924 (London)
A marine and coastal painter, he was the son and pupil of SAMUEL WALTERS (1811-1882) who had served in the Navy and was a marine painter living in Liverpool and Bootle. He moved to London in about 1864, was elected to the S.B.A. in 1867 and from that year until 1876 was an unsuccessful candidate for the N.W.S. on six occasions. He was a prolific exhibitor, and he painted on the Channel coasts, as well as landscapes in the Lake District, the Thames and Wales and scenes on the Venetian Lagoon. His work is sometimes on a very large scale, and he had a penchant for pinks, russets and sunsets.

Examples: B.M.; V.A.M.; Bootle A.G.; Greenwich.

WALTON, Edward Arthur, R.S.A., P.R.S.W.
 1860 (Glanderstone, Renfrewshire) – 1922 (Edinburgh)
A landscape painter who studied at the Glasgow School of Art and in Dusseldorf. He lived in London from 1894 and Edinburgh from 1904. He was elected A.R.S.A. and R.S.A. in 1889 and 1905 and was President of the R.S.W. from 1915.

In his early days he was much influenced by the Glasgow School. He used many prepared papers and other experimental grounds. His

landscapes are romantic, often with female accompaniment.

Examples: Dundee City A.G.; Glasgow A.G.; Leeds City A.G.; Paisley Art Inst.

WALTON, Elijah
1833 (Birmingham) – 1880 (Bromsgrove Lickey, Worcestershire)
A landscape and genre painter who studied at the Birmingham Academy and the R.A. Schools. In 1860 he went to Switzerland and Egypt on honeymoon, and, his wife dying on the Nile, he remained in the Near East until 1862. For the next five years he spent much of his time in Egypt and the Alps. Thereafter he lived at Staines and Bromsgrove and visited Greece and Norway.

His best work in watercolour is usually small and of mountain scenery. He particularly enjoyed atmospheric effects.

Published: *The Camel, its Anatomy, Proportions and Paces*, 1865. *Clouds and their Combinations*, 1869. *Peaks in Pen and Pencil*, 1872.
Illustrated: T.G. Bonney: *The Peaks and Valleys of the Alps*, 1867. T.G. Bonney: *Flowers from the Upper Alps*, 1869. T.G. Bonney: *The Coast of Norway*, 1871. Etc.
Examples: B.M.; V.A.M.; Birmingham City A.G.

WALTON, Frank, R.I.
1840 (London) – 1928 (Holmbury St. Mary, Surrey)
A landscape and coastal painter who exhibited from 1862 and was elected R.I. in 1882. He was also a member of the R.B.A. and President of the Institute of Oil Painters. He occasionally collaborated with Heywood Hardy. He lived in Harrow and Surrey. His work is meticulous, but his composition can be weak.

Examples: B.M.

WALTON, W L
A landscape painter who lived in London and worked in Northern Italy, Germany, Ireland and Yorkshire. He exhibited at Suffolk Street and elsewhere from 1834 to 1855.

WALTON, William
A landscape painter who lived in Bath. He exhibited at the R.A., Suffolk Street and elsewhere from 1841 to 1866.

Examples: V.A.M.

WANE, Richard 1852 (Manchester) – 1904 (Egremont)
A landscape and genre painter who was orphaned and brought up by his photographer brother on the Isle of Man, and who studied under F. Shields (q.v.) and at the Manchester Academy. He lived in London, Egremont, Cheshire, and at Conway and was President of the Liverpool Sketching Club. He exhibited in London from 1885. His colours are often strong, and his drawing of sheep can be a little naïve.

He was the father of HAROLD WANE (1879–1900) and ETHEL WANE, both artists.

Bibliography: *A.J.*, 1904.

WARBURTON, Egerton
Probably one of the Warburtons of Arley – perhaps Rowland Eyles Egerton-Warburton (1804-1891) – he was a very competent producer of Gothic Prouts working in about 1864.

WARD, Charles
A landscape and occasional still-life painter who lived in London, Manchester and Cambridge. He exhibited from 1826 to 1869 and painted in many parts of England and Wales.

Examples: Portsmouth City Mus.

WARD, Cyril 1863 (Oakamoor, Staffordshire) – 1935
A landscape and garden painter who was educated at Denstone College and Selwyn College, Cambridge. From 1885 to 1888 he taught at his old school. He was a professional artist from 1888 to 1924 when he took an hotel at Holybourne, Hampshire. In 1934 he was living at Exton, Southampton.

His work is often rather woolly, but sometimes shows a crisper treatment of rocks and water and a feeling for atmosphere.

Published: *Royal Gardens*, 1912.
Examples: B.M.; Lord Mayor's Parlour, Manchester.

WARD, Edward Matthew, R.A. 1816 (Pimlico) – 1879 (Slough)
An historical painter who studied at the R.A. Schools and in Rome. He is best known for his decorations in the Houses of Parliament. He often made watercolour copies and studies of his works. He was elected A.R.A. and R.A. in 1847 and 1855. He was the father of Sir L. Ward (q.v.).

His wife. HENRIETTA MARY ADA WARD (1832-1924), was the daughter of George Raphael Ward and the grand-daughter of James Ward (q.v.). She painted genre and literary subjects.

Examples: B.M.; N.G., Scotland; Newport A.G.
Bibliography: J. Dafforne: *The Life and Works of E.M.W.*, 1879. *A.J.*, February 1855; 1879.

WARD, Flora E S
The sister of Mrs. E.M. Ward (q.v.), she was also a genre painter, as was the third sister EVA WARD. Flora exhibited with the Society of Female Artists in 1875.

WARD, Lieutenant-Colonel Francis Swain
c.1734 (London) – 1805 (Negapatam)
After training as an artist, Ward went to India in about 1760 as an ensign in the Madras Army. He resigned in 1764 and returned to England where he worked as a professional artist until 1773. Then he re-joined the Madras Army as a captain. He retired as a lieutenant-colonel in 1787. He provided drawings for W. Orme's *Twenty-Four Views in Hindustan*, 1805.

Examples: India Office Lib.

WARD, Harry 1844 – 1873
A painter of boats, buildings and landscapes who worked, among other places, in Edinburgh, Kenilworth, Hemel Hempstead, Windsor, on the Thames and the Teign and in Belgium.

Examples: Leicestershire A.G.

WARD, James, R.A. 1769 (London) – 1859 (Cheshunt)
The animal painter and engraver, he was the brother of W. Ward, A.R.A. (q.v.) and the brother-in-law of G. Morland (q.v.). He was apprenticed first to J.R. Smith (q.v.) and then to his brother. His early paintings, both in oil and watercolour, are very much in the manner of Morland. Later he wasted much time and temper on huge allegorical pictures. He was elected A.R.A. and R.A. in 1807 and 1811. His watercolours are often the by-products of his many commissions to paint portraits of cattle and other animals. However, these studies, and those of birds and more exotic creatures done for his own instruction, are among the most lifelike and impressive of all British watercolours of animals. His landscapes, for which he sometimes modelled his style on that of Rubens, are also full of observation, and they are sometimes surprisingly modern in feeling. In this context it should be noted that in one or two of his pictures he anticipates the discoveries of the camera as to the correct movement of horses. He worked in many parts of Britain and was an inveterate sketcher. He often signed with a monogram made up of 'J. Ward R.A.'.

Examples: B.M.; V.A.M.; Ashmolean; Williamson A.G., Birkenhead; Cartwright Hall, Bradford; Fitzwilliam; Abbot Hall A.G., Kendal; Leeds City A.G.; Maidstone Mus.; Whitworth A.G., Manchester.
Bibliography: J. Frankau: *William Ward and J.W.*, 1904. C.R. Grundy: *J.W., His Life and Works*, 1909. G.E. Fussell: *J.W.* 1974. *A.J.*, 1849; 1860; 1862; 1897. *Connoisseur*, Extra no., 1909. *Country Life*, January 4, 1936. *Apollo*, LX, 1954. *British Racehorse*, XIV, 1958. *Arte Figuritiva*, VIII, ii, 1960.

WARD, John 1798 (Derbyshire) – 1849 (Hull)
A marine painter in oil and watercolour who was apprenticed to a house and ship painter. Most of his ship portraits and shipping

scenes were done on the Humber, but he also visited the Arctic with the whaling fleet and painted on the South coast. He was influenced by W. Anderson (q.v.) who visited Hull. He exhibited locally from 1822 and at Suffolk Street from 1841 to 1845.

Examples: Ferens A.G., Hull.
Bibliography: *Burlington*, LXXIX, October, 1941. Ferens A.G.: *Exhibition Cat.*, 1951.

WARD, Sir Leslie Matthew, 'Spy'

<div style="text-align:right">1851 (London) – 1922 (London)</div>

Caricaturist, portrait and architectural painter, he was the son of E.M. Ward (q.v.). He was apprenticed to an architect and studied architecture at the R.A. Schools. He exhibited from 1868. He provided portrait caricatures for the *Graphic* and most notably, from 1873 to 1909, for *Vanity Fair*. He was knighted in 1918. He was probably the best, and certainly the most celebrated, caricaturist of the time.

Examples: B.M.; V.A.M.; Walker A.G., Liverpool; N.G., Ireland; N.P.G.; Ulster Mus.
Bibliography: Sir L.W.: *Forty Years of Spy*, 1915. *Country Life*, October 21, 1922.

WARD, William 1761 – 1802
The owner of a whaling fleet, he painted marine subjects in both oil and watercolour.

Examples: Ferens A.G., Hull.

WARD, William, A.R.A. 1766 (London) – 1826 (London)
The engraver, and the elder brother of James Ward (q.v.). He was one of the best English mezzotinters and made occasional drawings in the manner of his brother-in-law, G. Morland (q.v.).

Examples: Fitzwilliam; City A.G., Manchester.
Bibliography: J. Frankau: *W.W., A.R.A. and J.W.*, 1904. *A.J.*, 1899.

WARING, Francis
An architectural and landscape painter who was painting at Plymouth in 1824, and who exhibited a design for a mausoleum at the R.A. in 1826.

WARING, John Burley 1823 (Lyme Regis) – 1875 (Hastings)
The son of a Naval captain, he was a pupil of S. Jackson (q.v.), the apprentice of an architect and studied at the R.A. Schools. He spent two years in Italy and became a professional architect. However, he exhibited flower subjects and landscapes at the R.A. from 1846 to 1859.

Examples: V.A.M.

WARMAN, John
A drawing master who stood against A. Cozens and others for the post at Christ's Hospital in 1748.

WARNER, Lee
A landscape and flower painter who worked at Aldershot and exhibited in 1878. There is a flower subject at the V.A.M.

COMPTON WARNER exhibited Lake District and Scottish subjects at Suffolk Street from 1873 to 1881 from a Woodford address.

WARREN, Albert Henry 1830 – 1911 (London)
A son of H. Warren (q.v.), he was apprenticed to Owen Jones, whom he assisted on the Great Exhibition. He exhibited from 1860 and taught members of the Royal Family as well as being Professor of Landscape at Queen's College, London. He also worked on panoramas with his father and painted genre and flower subjects.

WARREN, Charles Turner 1767 (London) – 1823 (Wandsworth)
An engraver of book illustrations and occasional draughtsman.

Examples: Exeter Mus.

WARREN, Edmund George, R.I. 1834 – 1909
A landscape painter, he was a son of H. Warren (q.v.). He exhibited from 1852 and was elected A.N.W.S. in that year and N.W.S. in 1856. The realistic detail and finish of his work comes close to Pre-Raphaelitism, but Ruskin found it 'mechanical', if 'careful and ingenious'.

Examples: V.A.M.

WARREN, Henry, P.N.W.S. 1794 (London) – 1879 (London)
A genre, landscape and Arabian painter, who was a pupil of Nollekens, drew at the B.M. and entered the R.A. Schools in 1818. He exhibited from 1823 to 1872. At first he produced a few oil paintings, but confined himself to watercolour after his election to the N.W.S. in 1835. He was President from 1839 until 1873, when he resigned because of blindness. Many of his drawings were used as illustrations for the Annuals and for topographical works. Despite his many Arab subjects, he never visited the Near East. He was a Knight of the Order of Leopold.

Two of his sons are separately noticed. A third, HENRY CLIFFORD WARREN (b.1843), was an unsuccessful candidate for the N.W.S. in 1868 and 1871. He exhibited landscapes at Suffolk Street, the N.W.S. and elsewhere from 1860 to 1885 and lived in London.

Published: *Hints upon Tints*, 1833. *On the Fine Arts*, 1849. *Artistic Anatomy*, 1852. *Painting in Water Colours*, 1856. *Warren's Drawing Book*, 1867. *A Text-Book of Art Studies*, 1870. *A Treatise on Figure Drawing*, 1871 *Half-hour Lectures on Drawing and Painting*, 1874.
Examples: B.M.; V.A.M.; India Office Lib.
Bibliography: *A.J.*, September, 1861.

WARREN, John
A landscape and portrait painter in watercolour and pastel. He entered the R.D.S. Schools in 1764 and exhibited with the Dublin Society of Artists from 1768. In about 1776 he moved to Bath, and he sent portraits to the Artists' Exhibition in Dublin and to the R.A. in 1777.

Examples: R.I.A.

WARREN, Sophy S (Fairford) –
A landscape painter who was the daughter of a doctor and sister of an artist. She exhibited from 1864 to 1878 and her subjects were often found in the Thames Valley. She lived in London and at Sutton, Surrey.

Examples: V.A.M.; N.G., Ireland.

WARREN, William White c.1832 – c.1912 (Bath)
A landscape and occasional portrait painter who was working in London and Bath from 1865 to 1888. He painted in Cornwall.

Examples: V.A.M.

WARWICK, George Greville, 2nd Earl of

<div style="text-align:right">1746 – 1816</div>

A patron and amateur artist, he was the elder brother of C. Greville (q.v.) and of R.F. Greville (q.v.). He was a patron of P. Sandby (q.v.), F. Nicholson (q.v.) and most notably of 'Warwick' Smith (q.v.). He met Smith in 1775 and sent him to Italy in the following year. He himself was a prolific painter of romantic Alpine landscapes. He succeeded to the title in 1773.

His illegitimate son, J.W. Chandler (d.c.1805), was a portrait painter, and his eldest legitimate son, the 3rd Earl, married a daughter of Lord Aylesford (q.v.).

WATERFORD, Louisa Ann, Marchioness of

<div style="text-align:right">1818 (Paris) – 1891</div>

The second daughter of Lord Stuart de Rothesay, from whom she inherited Highcliffe, Hampshire, she married the 3rd Marquess of Waterford in 1841. Their married life was largely spent at Curraghmore in Ireland and at Ford Castle, Northumberland, where

she continued to live after his death in 1859. She was a pupil of Ruskin and a friend of Watts and Burne-Jones. At Ford she was a model chatelaine and among her improvements was the building of a new village school which she decorated with watercolour murals of biblical childhood scenes.

She exhibited her watercolours at the Grosvenor and Dudley Galleries, and was said by a critic to be 'reviving the glories of the Venetian School'. Her drawing is sometimes weak, but she had a fine sense of colour and composition. An exhibition of her work was held at 8 Carlton House Terrace, London, in 1910.

Her elder sister was Lady Canning (q.v.).

Examples: B.M.; Fitzwilliam; N.G., Scotland; Richmond Lib.
Bibliography: C. Stuart: *Short Sketch of the Life of L.W.*, 1892. A.J.C. Hare: *The Story of Two Noble Lives*, 1892. H.M. Neville: *Under a Border Tower*, 1896. *Country Life,* April 4, 1957.

WATERLOW, Sir Ernest Albert, R.A., P.R.W.S.
1850 (London) – 1919 (London)
A landscape and animal painter in oil and watercolour who was educated at Eltham Collegiate School, studied in Heidelberg, Lausanne and at Cary's Art School, and who entered the R.A. Schools in 1872. He won the Turner Gold Medal in the following year. He was elected A.R.W.S., R.W.S. and P.R.W.S. in 1880, 1894 and 1897 and A.R.A. and R.A. in 1890 and 1903. In 1902 he was knighted. He painted in Ireland, France, Germany and Switzerland as well as in many parts of England.

His remaining works were sold at Christie's, January 6, 1920.

Examples: V.A.M.; Nat. Lib., Wales.
Bibliography: *A.J.*, 1890; 1903; Christmas no., 1906.

WATERS, Ralph, Yr. 1759 (Newcastle-upon-Tyne) – 1785
A landscape painter who exhibited four Northumbrian views at the R.A. in 1784 and three in 1785, with a drawing entitled 'A Gothic Elevation'. He was the son of Ralph Waters, a Newcastle painter.

Examples: Laing A.G., Newcastle.

WATHEN, James c.1751 (Hereford) – 1828 (Hereford)
A traveller and indefatigable sketcher. When he retired from business as a glover he began to make walking tours around the British Isles, earning the name of 'Jemmy Sketch', In 1811 he went to India, China and the Cape, and in 1816 he made an extensive tour of the Continent. In 1827 he visited Heligoland.

Published: *Journal of a Voyage to India and China,* 1814.

WATKINS, Bartholomew Colles, R.H.A.
1833 (Dublin) – 1891 (Upper Lauragh, Co. Kerry)
A landscape painter in oil and occasionally in watercolour. He entered the R.D.S. Schools in 1847 and exhibited at the R.H.A. from 1860 and at the R.A. and elsewhere in London from 1857 to 1875. He was elected A.R.H.A. and R.H.A. in 1861 and 1864, and for a time served as Secretary. He was a popular artist, and his patrons included Sir Edward Hudson Kinahan.

Most of his landscapes, which tend to be rather elaborate, are taken from County Kerry and Connemara.

His uncle, Bartholomew Watkins (b.1794, Wexford), studied at the R.D.S. Schools and practised briefly as an artist before setting up as a picture cleaner and dealer. He was assisted by his nephew, Bartholomew Watkins, Yr. who also painted, but died young.

Another uncle, George Watkins (d.1840, Dublin), was also an artist.

WATSON, Alfred Sale
A painter of views in the Richmond and Sunbury-on-Thames area who was working in the early years of the twentieth century.

WATSON, Charles John 1846 (Norwich) – 1927 (London)
A landscape, coastal and architectural painter and an etcher. He lived in London, exhibited from 1872 and worked in Norfolk, France, Holland and Italy. His wife, Minna Watson, née Bolingbroke, was also an artist.

Examples: V.A.M.; Aberdeen A.G.; City A.G., Manchester; Castle Mus., Norwich.
Bibliography: M. Watson: *Catalogue of the Etched and Engraved Work of C.J.W.,* 1931.

WATSON, Edward Facon
A painter of portraits, landscapes and architectural subjects who painted in Worcestershire, Surrey and elsewhere. He exhibited at Suffolk Street from 1839 to 1864, giving a London address, but he may be identifiable with the Birmingham artist EDWARD WATSON (1814-1887). The latter was a pupil of J. Barber (q.v.), collaborated with D. Cox (q.v.) in illustrating Radclyffe's *Wanderings in Wales* and exhibited in Birmingham from 1830 to 1852. In the 1840s he was an unsuccessful candidate for the N.W.S. on three occasions.

WATSON, Harry, R.W.S. 1871 (Scarborough) – 1936 (London)
A landscape and figure painter in watercolour and oil who studied at the Scarborough School of Art, South Kensington and the Lambeth School of Art. He was Life Master at the Regent Street Polytechnic Art School. He was elected A.R.W.S. and R.W.S. in 1915 and 1920.

Published: *Figure Drawing,* 1930.
Examples: Maidstone Mus.; Tate Gall.

WATSON, Henry 1822 (Cork) – 1911
He worked as a coach painter in Cork, where he also painted local views and portraits, until his father died in 1836 and he moved to Dublin and studied at the R.H.A. Schools. He practised as a portraitist and landscapist, as well as painting animals and still-lifes, and his patrons included Sir Charles Domvile of Santry Court. Towards the end of his life he painted heraldic signs for coaches.

WATSON, John Dawson, R.W.S.
1832 (Sedbergh, Yorkshire) – 1892 (Conway, North Wales)
In 1847 he entered the Manchester School of Art, and in 1851 the R.A. Schools, returning to Manchester the following year. He first exhibited at the Manchester R.I. in 1851. In 1856 Ford Madox Brown invited him to exhibit in his house in London. He settled in London in 1860 and was elected A.O.W.S. in 1864 and O.W.S. in 1869. In 1865 he moved to Milford, where he made designs for the furniture of the house of M.B. Foster (q.v.), his brother-in-law. In 1872 he designed the costumes for Charles Calvert's *Henry V* at the Prince's Theatre, Manchester. He illustrated a number of books from the 1860s.

Examples: V.A.M.; City A.G., Manchester; Worcester City A.G.

WATSON, Dr. Thomas Boswell
1815 (Haddington) – 1860 (Edinburgh)
A pupil of G. Chinnery (q.v.) in Macao. His work is similar to that of the master, but less assured. He trained as a doctor in Edinburgh, graduating M.D. in 1835, and he practised in Melrose. In 1845 he left for China, where he lived in Macao and, later, Hong-Kong. He returned to Scotland in 1858.

WATSON, Thomas J , A.R.W.S.
1847 (Sedbergh, Yorkshire) – 1912 (Ombersley)
The brother of J.D. Watson (q.v.), he was a landscape and marine painter who worked in Northumberland as well as in the South of England. He exhibited at the R.A. from 1871 to 1903 as well as with the R.W.S. He was elected A.R.W.S. in 1880.

Examples: Williamson A.G., Birkenhead; Melbourne A.G.

WATSON, William Smellie, R.S.A.
1796 (Edinburgh) – 1874 (Edinburgh)
A portrait painter who studied at the R.A. Schools and was advised by Wilkie. He was a Founder member of the R.S.A. and also painted occasional landscapes in oil and watercolour.

Examples: B.M.

WATTS, Frederick William 1800 – 1870
A follower of Constable who painted landscapes in oil and

watercolour. He exhibited from 1823 to 1862 and lived in Lambeth and Hampstead, painting in Surrey, Devon and elsewhere in Southern England.

Examples: B.M.

WATTS, James Thomas 1853 (Birmingham) — 1930
A landscape painter in watercolour and oil who studied in Birmingham. He exhibited at the R.A., R.I. and elsewhere from 1873. Later he lived in Liverpool.

Early in his career he was influenced by Ruskin and the Pre-Raphaelites, later by Corot and the French luminists. His wife, LOUISA MARGARET WATTS, née HUGHES, (d.1914), was also a landscape painter.

Examples: Walker A.G., Liverpool.

WATTS, John 1770 —
A landscape painter who lived in London and painted in Scotland and Wales.

WATTS, Walter Henry 1776 (East Indies) — 1842 (London)
The son of a Naval captain, he was educated in England. He became a Member of the A.A. in 1808 and from 1808 to 1830 exhibited miniatures at the R.A. He was appointed Miniature Painter to Princess Charlotte in 1816. He was also a journalist, and contributed to the *Literary Gazette*.

WATTS, William 1752 (London) — 1851 (Cobham)
An engraver who was taught by P. Sandby (q.v.) and E. Rooker (q.v.). In 1786 he toured Italy, returning the following year. From 1789 to 1791 he lived in Wales and Bristol, and from 1791 to 1793 in Bath, after which he left for Paris. From 1814 he lived in Cobham. He published several series of engraved and etched views of seats after the drawings of other artists including J. and R. Nixon (q.v.).

Examples: B.M.; Victoria A.G., Bath.

WAY, Charles Jones 1834 (Dartmouth) —
A landscape and marine painter who studied at South Kensington and exhibited from 1865 to 1888. He painted a great deal in Switzerland and was in Canada in the 1850s, where he was President of the Montreal Art Association. He also worked in many parts of England, in Scotland, Wales and Corfu.

Examples: Montreal Mus.

WAY, William Cosens 1833 (Torquay) — 1905 (Newcastle)
A landscape and marine painter who studied at South Kensington and became a Master of the Newcastle School of Art in 1862. He held the post for forty years and had a wide influence. He exhibited with the N.W.S. and at the R.A. and Suffolk Street from 1867 to 1901. He also painted flower studies.

Examples: B.M.; V.A.M.; Shipley A.G., Gateshead; Laing A.G., Newcastle.

WEATHERHEAD, William Harris, R.I.
** 1843 (London) — c.1903**
A genre and figure painter in oil and watercolour who exhibited at the R.A., R.I., Suffolk Street and elsewhere from 1862. He was elected R.I. in 1885, resigning in 1903.

Examples: V.A.M.; Dundee City A.G.; Sydney A.G.

WEATHERILL George
** 1810 (Staithes, Yorkshire) — 1890 (Whitby)**
Born into a family of farmers, he became clerk to a solicitor at Guisborough before moving to Whitby in 1830. He worked in a bank until 1860 when ill-health forced him to retire. As an artist and an engraver he was largely self-taught, and he painted throughout his life and after his retirement relied on his art for a living. He exhibited at Suffolk Street and the Dudley Gallery from 1858 to 1873, painting coastal and marine subjects, usually from

the Yorkshire coast. He also copied Turner very effectively, and he was a patron of G. Chambers (q.v.) and other local artists.

His eldest daughter MARY WEATHERILL exhibited landscapes and coastal subjects from 1858 to 1880. She made many sketching tours to France, Italy, Germany, Switzerland and Norway, and she was fond of strong effects of sunlight. There is an example of her work in Wakefield A.G. His second daughter SARAH ELLEN WEATHERILL exhibited landscapes and figure subjects from 1858 to 1868, and his youngest daughter ELIZABETH WEATHERILL also painted. His son RICHARD WEATHERILL (1844-1913) painted marine subjects, mainly in oil, and was the author of *Whitby and its Shipping*, 1908.

Examples: B.M.; Cardiff A.G.

WEBB, Archibald
A coastal painter in oil and watercolour who was probably the father of the artists Byron Webb and J. Webb (q.v.). He exhibited from 1825 to 1866 and lived in Chelsea. He worked on the Channel coasts of England and France.

Another son, ARCHIBALD WEBB, YR., also painted coastal scenes and landscapes. He exhibited from 1886 to 1892 and was elected to the R.B.A. in 1890. He painted a good deal in Holland.

WEBB, Edward 1805 (London) — 1854 (Malvern)
He left Westminster School at the age of fourteen to serve an apprenticeship under the engraver John Pye, for whom, on completion of the seven years, he continued to work for a further year. Turning to watercolour, he studied under Copley Fielding, and later Cox. With D. Cox, Yr. (q.v.) he toured Scotland in 1834, Wales in 1837 and 1840 and Sevenoaks in 1841. He also visited Paris with Pye, and Brittany, as well as making other English tours. In 1850 he moved with his family to Versailles; three months later his wife died, leaving him with three young children.

He is a competent and pleasing follower of Cox, and his work is often close to that of Cox, Yr. The fact that he copied the work of Cox, Copley Fielding and other artists is known from the diaries which he wrote regularly.

He was the father of the architect Sir Aston Webb.

Examples: V.A.M.
Bibliography: *Connoisseur*, CLXXXII, 1973.

WEBB, James 1825 — 1895 (London)
The marine and landscape painter, he was probably a son of the elder A. Webb (q.v.). He exhibited from 1853, when he was also an unsuccessful candidate for the N.W.S., and he worked in England, Wales, Scotland, Holland, France and on the Rhine. His colours are generally rather pale, but his drawing is strong.

Some of his works and his own collections were sold at Christie's March 3, June 13 and July 13, 1868.

Examples: Hove Lib.
Bibliography: *Burlington*, VII, 1905; X, 1906-7.

WEBBER, John, R.A. c.1750 (London) — 1793 (London)
The son of the Swiss sculptor Abraham Weber, he studied in Berne and Paris and entered the R.A. Schools in 1775. In the following year he sailed on Captain Cook's third and last voyage to the South Seas, returning in 1780. He worked up his sketches for the Admiralty's account of the expedition, published in 1784. He visited Switzerland and Northern Italy in 1787. From this date 1792 he etched and coloured a series of views of places visited by Captain Cook and himself. He exhibited at the R.A. from 1784 and was elected A.R.A. in 1785 and R.A. in 1791.

The drawing of his South Sea pictures is often weak, and they are not as successful as his English landscapes. These are usually washed in greys, blues and yellows over careful and detailed pencil work. He was a friend of W. Day (q.v.), with whom he painted in Derbyshire.

His brother Henry Webber was the sculptor of the bust of Garrick in Westminster Abbey.

Examples: B.M.; V.A.M.; Williamson A.G., Birkenhead; Derby A.G.; Greenwich; N.G., Ireland.

Bibliography: D.J. Bushnell: *Drawings by J.W.*, 1928. *Geographical Mag.*, XIX, X, 1947. *Apollo*, LVI, 1952.

WEBER, Otto, R.H.A., A.R.W.S. **1832 (Berlin) – 1882 (London)**
After an early training in Berlin, Weber moved to Paris where his landscapes and cattle pictures, mainly in oil, enjoyed great popularity. In 1870, on the outbreak of the Franco-Prussian War, he went to Rome, and two years later settled in London. He was elected A.O.W.S. in 1876, and he exhibited English views, with some from Scotland in 1876-77 and a few from France and Italy in 1877-78.

His remaining works were sold at Christie's, May 20, 1889.

Examples: V.A.M.

WEBSTER, George
A painter of landscapes and marine subjects who visited Holland, Tripoli and the Gold Coast. He exhibited at the R.A., the B.I., Suffolk Street and elsewhere from 1797 to 1832. His manner of painting water is sometimes close to that of the Cleveleys (q.v.), and his figure drawing can be poor. It has been said that he visited Wales with J. Varley in 1802, but this seems due to a confusion with the earlier T. Webster (q.v.).

Published: *Views of various Sea-Ports*, 1831.
Examples: B.M.; V.A.M.; Cartwright Hall, Bradford.

WEBSTER, Moses **1792 (Derby) – 1870 (Derby)**
A still-life and landscape painter who was an apprentice at the Derby porcelain works. He then worked at Worcester for four years and moved to London, later returning to teach at Derby. He died in an almshouse. His work is varied in its quality.

Examples: B.M.; V.A.M.; Derby A.G.

WEBSTER, Thomas **c.1772 (Orkneys) – 1844 (London)**
An architect, artist, geologist and natural philosopher who entered the R.A. Schools in 1793. He was a member of Girtin and Francia's Sketching Club, 'The Brothers', in 1799. He assisted the architect Count Rumford with the designs for the Royal Institution in 1800. In 1802 he toured North Wales with C. and J. Varley (q.v.).

Examples: B.M.

WEBSTER, Thomas, R.A. **1800 (London) – 1886 (Cranbrook)**
His father held a post in George III's household, and Thomas lived at Windsor until the King's death, and belonged to the choir of St. George's Chapel. In 1820 he entered the R.A. Schools, exhibiting from 1823. He was elected A.R.A. in 1840 and R.A. in 1846, retiring in 1876. In 1856 he moved to Cranbrook where he became a member of the 'Colony'. He painted portraits and genre subjects, and occasionally etched his works.

His remaining works were sold at Christie's, May 21, 1887.

Examples: V.A.M.; Towner A.G., Eastbourne.
Bibliography: *A.J.*, November 1855; 1886.

WEEDON, Augustus Walford, R.I. **1838 – 1908**
A landscape painter who lived in London and painted in England, Scotland and Holland. He exhibited from 1859 and was elected to the S.B.A. in 1883 and R.I. in 1887.

Examples: Melbourne A.G.; Sydney A.G.

WEGUELIN, John Reinhard, R.W.S.
1849 (South Stoke, Sussex) – 1927 (Hastings)
The son of a Vicar of South Stoke, who had presumably turned Roman Catholic, he was educated at Cardinal Newman's Oratory School in Edgbaston. He began working as a Lloyds underwriter but then studied at the Slade under E.J. Poynter (q.v.) and Legros. He exhibited landscapes and biblical and classical subjects in the manner of Sir L. Alma-Tadema (q.v.) from 1877. From 1893 he worked exclusively in watercolour, and he was elected A.R.W.S. and R.W.S. in 1894 and 1898. He illustrated several volumes of poems, translations and stories.

Bibliography: *Connoisseur*, LXXVIII, 1927.

WEHNERT, Edward Henry, N.W.S.
1813 (London) – 1868 (London)
Of German extraction and education, he studied in Paris and worked in Jersey for a while. He returned to London in 1837, having joined the N.W.S. in the previous year. He painted historical scenes and designed book illustrations.

A memorial exhibition was held at the N.W.S. in 1869.

Illustrated: Grimm: *Household Stories*, 1853. J. Keats: *Eve of St. Agnes*, 1856. S.T. Coleridge: *Ancient Mariner*, 1857. J. Bunyan: *Pilgrim's Progress*, 1858. H. Andersen: *Fairy Tales*, 1861. D. Defoe: *Robinson Crusoe*, 1862. E.A. Poe: *Poetical Works*, 1865.
Examples: V.A.M.

WEIGALL, Charles Harvey, N.W.S. **1794 – 1877**
A landscape, genre and portrait painter and an illustrator, he exhibited from 1810. He was elected to the N.W.S. in 1834 and served as Treasurer from 1839 to 1841. He also modelled in wax and made intaglio gems

He should not be confused with Henry Weigall, the sculptor, nor with Henry Weigall, Yr., a portrait and genre painter.

His son ARTHUR HOWES WEIGALL (ex. 1856-1892) and his daughter JULIA WEIGALL were both genre and portrait painters in oil and watercolour. The former was an unsuccessful candidate for the N.W.S. on several occasions in the 1860s.

Published: *The Art of Figure Drawing*, 1852. *A Manual of the First Principles of Drawing, with the Rudiments of Perspective*, 1853. *The Projection of Shadows*, 1856. *Guide to Animal Drawing*, 1862.
Examples: B.M.; V.A.M.; N.G., Ireland; N.G., Scotland; Nat. Lib., Wales.

WEIR, Harrison William **1824 (Lewes) – 1906 (Appledore, Kent)**
An animal painter and a prolific illustrator who trained as a colour printer with G. Baxter (q.v.) but soon turned to painting. He exhibited from 1843 and was elected A.N.W.S. and N.W.S. in 1849 and 1851. However, he disliked the exhibition system, preferring to work on commission, and he retired in 1870. He worked for the *I.L.N.*, the *Graphic,Black and White* and other publications. He was himself a keen naturalist and pigeon fancier and a friend of Darwin.

Published: *Animals and Birds*, 1868. *Our Cats, and All About Them*, 1889. *Poultry and All About Them*, 1903. Etc.
Illustrated: *The Tiny Natural History Series*, 1880. Etc.
Examples: V.A.M.
Bibliography: *A.J.*, 1906.

WEIR, Walter **– 1816**
A Scottish genre painter and illustrator. He studied in Italy and worked rather in the manner of D. Allan (q.v.).

Examples: N.G., Scotland.

WELFARE, Sir Piers **1742 (Ipswich) – 1784 (the Thames)**
An amateur topographical painter and a writer of controversial pamphlets. He was educated at Harrow and Magdalen College, Oxford, and he made the acquaintance of David Garrick in Paris in 1763 while on the Grand Tour. He was one of those who pressed Garrick to return to the stage in 1765. He inherited a small property in Yorkshire and spent most of his life there, drawing local subjects and producing scientific squibs under the name 'Anti-Linnaeus'. These aroused much interest at the time, but his theories were soon exploded by more professional scientists. He was drowned when his boat overturned near Abingdon.

His drawings are rather weakly in the manner of W. Taverner (q.v.), with muted colours and little use of outline.

WELLINGS, William
A painter of miniatures and silhouettes who was active from 1793 to 1801. He also produced theatrical drawings and portraits which are naive but charming.

Examples: B.M.; V.A.M.; Greenwich.

WELLS, Joseph Roberts
A painter of marine subjects, coasts and rivers, who lived in London. He exhibited at the N.W.S., Suffolk Street and elsewhere from 1872.

WELLS, William Frederick, P.O.W.S.
1762 (London) – 1836 (Mitcham, Surrey)
A landscape painter, and the real originator of the O.W.S., of which he was President in 1806-7. He studied under J.J. Barralet (q.v.) and exhibited at the R.A. from 1795 to 1804, and then with the O.W.S. until the re-organisation of 1813, when he resigned. Between 1802 and 1805, in conjunction with J. Laporte (q.v.), he made seventy-two soft-ground etchings after Gainsborough, which were published in 1819. He suggested the idea of the *Liber Studiorum* to his friend Turner. In 1809 he was appointed the first Professor of Drawing at Addiscombe College. He held this post for twenty years, after which he retired to Mitcham.

His views are generally taken from Norway and Sweden, which he visited in early life, and Kent, where he had a house. Williams notes his individual way of rendering foliage 'with a peculiar long, dark, narrow brush stroke'.

His daughter, Clara, Mrs. Wheeler, wrote a short account of the foundation of the O.W.S. This was privately printed in 1872.

Published: *Treatise of Anatomy*, 1796.
Examples: B.M.; V.A.M.; Cartwright Hall, Bradford; Castle Mus., Nottingham.
Bibliography: O.W.S. Club, XIII, 1936.

WENLOCK, Constance, Lady c.1853 – 1932
The daughter of the 4th Earl of Harewood, she became a remarkably enthusiastic amateur watercolourist. She was self-taught, although she received encouragement and advice from G.F. Watts, to whom she sat, E.J. Poynter, Burne-Jones and Leighton. In 1872 she married the 3rd Baron Wenlock of Escrick Park, Yorkshire, and they travelled, via Egypt, to India where he served as Governor of Madras from 1891 to 1896. She worked up her Egyptian and Indian sketches for the rest of her life, and exhibited them each year in London, Paris or Florence. She also painted in Florence, where she stayed with her niece at the Villa Medici, Fiesole.

Her watercolours are generally large, and hazy with the effects of dawn or dusk. Their luminous quality is due to her mastery of the technique of applying washes. She painted a few pictures in oil, and late in life she campaigned against the use of white mounts in exhibitions.

Bibliography: *Country Life*, March 24, 1955.

WERNER, Carl Friedrich Heinrich 1808 (Weimar) – 1894 (Leipzig)
A German architectural and landscape painter who studied in Leipzig and Munich. He travelled widely, in Europe, the Near East and Britain, and exhibited in London from 1860. He was elected A.N.W.S. and N.W.S. in that year but resigned in 1883. He was also a member of the Venetian Academy.

His son, RINALDO WERNER (b.1842), worked in Russia, Germany and Italy. He was an unsuccessful candidate for the N.W.S. in 1874 and exhibited occasionally in London, where he was living in 1920.

Examples: V.A.M.; Maidstone Mus.

WEST, Benjamin, P.R.A.
1738 (Springfield, Pennsylvania) – 1820 (London)
An American who, at the age of eighteen, set himself up as a portrait painter in Philadelphia and New York. He left for Italy in 1760, where he gained a good reputation as a portraitist, and in 1763 he came to London. Reynolds encouraged him to exhibit, which he first did with the Society of Artists in 1764, and the following year he became a Member of the Incorporated Society. His historical pictures won the admiration of George III, from whom he received many commissions for historical and religious subjects and Royal portraits. In 1772 he was appointed Historical Painter to the King, and in 1790 Surveyor of the Royal collection.

In 1782 he succeeded Reynolds as P.R.A. He was one of the two P.R.A.s who were not knighted, the other being James Wyatt, whose tenure of office in 1805-6 interrupted West's.

His watercolours are usually studies for his oil paintings, but he also produced a number of landscapes in bodycolour in the manner of P. Sandby (q.v.) and wash drawings of rustics.

Examples: B.M.; V.A.M.; Greenwich.
Bibliography: J. Galt: *Life, Studies and Works of B.W.*, 1820. G. Evans: *B.W. and the Taste of his Time*, 1959. *A.J.*, 1863.

WEST, David, R.S.W. (Lossiemouth) – 1936
A landscape and marine painter who exhibited at the R.A. from 1890 and was elected R.S.W. in 1908. He visited Alaska in 1898, served in France in 1915 and lived in Lossiemouth for much of his life.

WEST, Edgar E
A landscape and coastal painter who lived in London and was active from 1857 to 1881. He painted, among other places, in Devon, Cornwall, Normandy and Norway.

An earlier E. WEST exhibited views in Yorkshire, Wales and the Channel Islands in the 1830s.

Examples: V.A.M.

WEST, H T
A landscape and topographical painter who lived in Hornsey and exhibited from 1831 to 1836. His sister or daughter M.P. WEST exhibited portraits at Suffolk Street in 1838 and 1839.

WEST, John
A landscape painter working in Bath from about 1800 to 1830. He painted in the West Country and Wales. Williams describes his work as 'rather Japanesy . . . relying on a few simplified outlines, sharply silhouetted forms, and a strong contrast between Indian ink shadows and areas of pale primrose yellow or blue.' He had a son of the same name.

Examples: B.M.

WEST, Joseph Walter, R.W.S.
1860 (Hull) – 1933 (Northwood, Middlesex)
He studied at the R.A. Schools under E. Moore (q.v.), at Paris and in Italy and worked in many media, producing delicate landscapes and genre pictures of Quaker subjects. He was elected A.R.W.S. and R.W.S. in 1901 and 1904.

Examples: Doncaster A.G.; Ferens A.G., Hull; N.G. Scotland; Tate Gall.; Wakefield City A.G.
Bibliography: *Studio*, March, 1907; April 1913. *Pearson's Mag.*, 1907. *The Times*, June 29, 1933.

WEST, Maud Astley
A flower painter who studied at the Bloomsbury School of Art and exhibited from 1880 to 1890. She lived in London.

Published: with M. Low: *Through Woodland and Meadow*, 1891.

WEST, Samuel c.1810 (Cork) –
Principally a portrait and historical painter in oil, towards the end of his life he spent his time in making watercolour copies of old masters. After studying in Rome he came to London, where he exhibited at the R.A., the B.I. and Suffolk Street from 1840 to 1867. He specialised in portrait groups of children.

Examples: B.M.

WEST, William, 'Waterfall'
1801 – 1861 (London)
A landscape and imaginative painter in oil and watercolour in what time was left from engineering and archaeological projects and running a camera obscura and observatory. He is usually said to have been born in Bristol, but the correspondence of other Bristol artists indicates that he only arrived in the area in about 1823. He was a

member of the drawing parties in Leigh Woods and of the Sketching Club. He exhibited in London from 1824, and from about 1847 the majority of his subjects come from Norway, earning him the additional soubriquet of 'Norway' West. From 1848 he exhibited, particularly with the S.B.A., to which he was elected in 1850. He moved to London in about 1857.

His work is not particularly impressive, and he is perhaps at his best with the brown wash drawings of the Sketching Club.

Examples: V.A.M.

WESTALL, Richard, R.A. 1765 (Hertford) — 1836 (London)
An historical and figure painter and a very prolific book illustrator who, in 1779, was apprenticed to a silver engraver. He first exhibited at the R.A. in 1784 and entered the R.A. Schools in the following year. On the completion of his apprenticeship in 1786 he became a professional artist, and he was elected A.R.A. and R.A. in 1792 and 1794. At this time he began his career as an illustrator, working for Boydell, Macklin and, later, Sharpe. He illustrated most of the standard works and was second only to Stothard in prolificity. Late in life he became drawing master to Princess Victoria.

As Williams says, 'A good deal of Westall's work has, indeed, a strong element of the ludicrous in it'. In style he stands between Blake and Kauffmann with the exaggerated limbs and strong outlines of the one and the straight noses and foreheads of the other. He is at his best in his landscape backgrounds which lack the sentimentality and high, stippled finish of his figures.

Published: *A Day in Spring*, 1808.
Examples: B.M.; V.A.M.; Ashmolean; Coventry A.G.; Fitzwilliam; Hertford Mus.; Leeds City A.G.; Leicestershire A.G.; City A.G., Manchester; N.G. Scotland; Castle Mus., Nottingham; Ulster Mus.

WESTALL, William, A.R.A. 1781 (Hertford) — 1850 (London)
The younger brother and pupil of R. Westall (q.v.). At the age of eighteen, while studying at the R.A. Schools, he was chosen by B. West (q.v.) as draughtsman to Flinders's Australian expedition. During the voyage he nearly drowned at Madeira and was shipwrecked on a coral reef in the Pacific. He returned by way of China in 1803 and India in 1804. After a few months in England he left for Madeira, where he spent a year, and Jamaica. In 1808 he held a one-man exhibition and joined the A.A. In 1810 he was elected A.O.W.S. He resigned in 1812 and was elected A.R.A. Except for a visit to Paris in 1847, the rest of his life was spent in England, making topographical drawings in various parts of the country.

His best work is on a small scale and is in the eighteenth century topographical tradition. A light green predominates. His architecture is neat without being pedantic. He contributed illustrations to many books as well as to the Annuals.

Published: *Britannia Delineata*, 1822. *Picturesque Tour of the River Thames*, 1828.
Examples: B.M.; V.A.M.; Ashmolean; Fitzwilliam; Glasgow A.G.; Greenwich; Leeds City A.G.; Maidstone Mus.; City A.G., Manchester; Castle Mus., Nottingham.
Bibliography: *A.J.*, April, 1850.

WESTBROOK, Miss E T
A painter of figure subjects, portraits, flowers and occasional landscapes. She lived in London and exhibited from 1861 to 1876.

WESTON, Rev. George Frederick
 1819 — 1887
A painter of landscapes and architectural subjects who was educated at Christ's College, Cambridge, graduating in 1844. He was appointed Vicar of Crosby-Ravensworth in 1848 and thereafter Rural Dean of Lowther. He became an Honarary Canon of Carlisle in 1879. He painted in Greece, Egypt, Gibraltar and Spain as well as in England and signed his work with a G.F.W. monogram — not to be confused with the initials of G.F. Watts. He exhibited at Suffolk Street in 1840.

WHAITE, Henry Clarence, R.W.S.
 1828 (Manchester) — 1912 (Conway)
A landscape painter who studied in Manchester and at Somerset House and the R.A. Schools. He exhibited from 1851 and was elected A.R.W.S. and R.W.S. in 1872 and 1882. He was also President of the Manchester Academy and first President of the Royal Cambrian Academy. He visited Italy, but for the most part painted around his home in North Wales.

Published: *St. Christopher in English Mediaeval Wallpainting*, 1929.
Examples: Haworth A.G., Accrington; City A.G., Manchester; Nat. Lib., Wales; Portsmouth City Mus.

WHAITE, James
A landscape painter in oil and watercolour who exhibited from 1879 to 1916. He lived in Manchester, Burton Joyce, Seacombe and Liscard and painted much in North Wales.

Examples: V.A.M.

WHATLEY, Henry 1842 (Bristol) — 1901 (Clifton)
A landscape, genre and portrait painter in oil and watercolour. He had an extensive practice as a drawing master in Bristol, teaching at the Clergy Daughters' School, Clifton College and elsewhere. He travelled extensively and provided illustrations for the *I.L.N.* and other publications. His work can sometimes resemble that of P. de Wint (q.v.).

Illustrated: J. Baker: *Quiet War Scenes*, 1879. J. Baker: *Pictures of Bohemia*, 1894.
Examples: Bristol City A.G.

WHEATLEY, Francis, R.A. 1747 (London) — 1801
The figure, portrait and landscape painter. After studying at Shipley's and the Incorporated Society, with whom he first exhibited in 1765 and of which he became a Director in 1772, he entered the R.A. Schools in 1769. At this time he was a friend of J.H. Mortimer (q.v.) and often copied his work. In 1779 he eloped to Dublin with the wife of J.A. Gresse (q.v.), but was discovered and forced to return to England late in 1783 or early in 1784. He exhibited regularly at the R.A. from 1784 until his death and was elected A.R.A. and R.A. in 1790 and 1791. Many of his works were engraved, most notably the *Cries of London*. He married Clara Maria Leigh, later Mrs. Pope (q.v.), whom he often used as a model.

The chief ingredient of Wheatley's work is sugar. Except in a few comparatively realistic studies of tinkers and fair-ground characters, an insipid prettiness is his hallmark. His drawing, both of figures and animals, is generally good, and his colouring a gentle range of blues, yellowy-browns and greys. A number of his views of Irish country seats were engraved for the *Copper-Plate Magazine*.

Illustrated: F. Grose: *Antiquities of Ireland*, 1791-95. T. Milton: *Views of Seats in Ireland*, ?1794.
Examples: B.M.; V.A.M.; Aberdeen A.G.; Ashmolean; Cartwright Hall, Bradford; Fitzwilliam; Leeds City A.G.; N.G., Scotland; Newport A.G.
Bibliography: W. Roberts: *The Cries of London*, 1924. F.G. Roe: *Sketch Portrait of F.W.*, 1938. M. Webster: *F.W.*, 1970.

WHEATLEY, William Walter 1811 (Bristol) — 1885 (Bath)
A prolific topographer and a drawing master who lived in Frome, Rode and, from at least 1852, Bath. He painted in Somerset for the most part and produced a series of 1,500 views of Somerset churches for the Rev. J.S.H. Horner of Mells, as well as a considerable body of work for the Bristol patron G.W. Braikenridge. He is said to have died in reduced circumstances. He was a conscientious draughtsman — although his accuracy has been impugned — and a pleasing one. He generally signed with joined initials or initials and surname.

Examples: Victoria A.G., Bath; Bath Lib.; Bristol City A.G.; Frome Mus.; Soc. of Antiquaries; Taunton Castle.

WHICHELO, C John M , A.O.W.S.
1784 − 1865
A pupil of J. Varley (q.v.) and J. Cristall (q.v.), he was working at least as early as 1806 and first exhibited at the R.A. in 1810. He was chiefly a marine painter with views on the Channel coasts, but he was also a London topographer and a landscapist. By 1812 he is described as 'Marine and Landscape Painter to H.R.H. the Prince Regent'. He was elected A.O.W.S. in 1823. His inland British subjects are usually confined to Surrey and the New Forest, with a visit to Yorkshire in 1857. Abroad he visited the Low Countries, the Rhine, Switzerland, and just possibly Sicily. His remaining drawings were sold at Christie's, April 10, 1866.

His son, J. WHICHELO (d.1867), was a drawing master.

Examples: B.M.; V.A.M.; Fitzwilliam; Greenwich; Maidstone Mus.; Newport A.G.; Richmond Lib.

WHICHELO, Henry Mayle
Despite the confusion of initials which plagues this name, he was probably the son of C.J.M. Whichelo (q.v.) and an exhibitor of landscapes and buildings at the R.A. and elsewhere from 1818 to 1848. In 1818 he was living at his father's house off Blackfriars Road. Later he became a drawing master in Clapham and at the Stepney and Stockwell Grammar Schools.

WILLIAM J. WHICHELO, a landscape painter working in the 1860s, and 1870s was presumably a member of the same family. He lived in Brixton.

Published: *Hints to Amateurs: or, Rules for the Use of the Black Lead Pencil*, 1849.
Examples: B.M.

WHISTLER, James Abbot McNeill, R.A.
1834 (Lowell, Massachusetts) − 1903 (London)
Etcher, lithographer, portrait and landscape painter in oil and watercolour and controversialist, he was brought up in Russia and England before returning to America to join the Army. After West Point he transferred to the Navy as a cartographer, learning etching. In 1855 he went to study in Paris where he was strongly influenced by Manet and Courbet and became a leading figure of the 'Salon des Refusés'. He settled in London in 1859, paying a mysterious visit to Valparaiso in 1866. His position as one of the leading avant-garde painters and decorators was undermined by the Ruskin libel action which led to his bankruptcy in 1879. He spent the next eighteen months in Venice, producing splendid etchings as well as pastels and watercolours − almost the first since his Parisian days. He was President of the S.B.A. from 1886 to 1888, winning them the Royal Charter, but resigned amid inevitable controversy. From about 1892 he was based both in London and Paris.

His watercolours, like many of the portraits and nocturnes, are tone poems. They are usually very simple in technique, and they are often upright − which was felt to be eccentric for landscapes or beach scenes − perhaps in conscious homage to the Japanese artists who had influenced him.

Examples: Fitzwilliam; Hunterian Mus., Glasgow; City A.G., Manchester.
Bibliography: *H.W. Singer: J.A.McN.W.*, 1904. E.R. and J. Pennell: *The Life of J.A.McN.W.*, 1908. B. Sickert: *W.*, 1908. E.R. and J. Pennell: *The W. Journal*, 1921. J. Laver: *W.*, 1930. J. Laver: *W.*, 1942. H. Gregory: *The World of J. McN.W.*, 1961. D. Sutton: *Nocturne*, 1963. D. Sutton: *J.McN.W.*, 1966. R. McMullen: *Victorian Outsider*, 1973. *A.J.*, 1903.

WHITAKER, George 1834 (Exeter) − 1874 (Dartmouth)
A landscape, coastal and marine painter who lived in Exeter and Dartmouth. He studied engineering, but soon turned to art and became a pupil of Charles Frederick Williams, a landscape painter. He was an unsuccessful candidate for the N.W.S. on several occasions from 1865 to 1871. He painted in Cornwall, Devonshire, Wales and Switzerland and worked in full watercolour and brown washes.

Examples: V.A.M.; Exeter Mus.

WHITE, Alice
A landscape painter who lived in London and exhibited at the R.A., N.W.S., Suffolk Street and in Birmingham from 1873 to 1886. She painted in the Isle of Wight.

WHITE, Charles
An architect and topographical artist who worked for the Board of Ordnance in the Naval dockyards. He was Master of the Works at Portsmouth in 1792. He exhibited with the Society of Artists and the Free Society from 1765 to 1783.

WHITE, Cheverton 1830
A Brighton painter who was a civil engineer until 1867, when he turned to painting. He was an unsuccessful candidate for the N.W.S. in 1870. He may well have had an earlier painting namesake.

WHITE, Colonel George Francis 1808 (Chatham) − 1898 (Durham)
A soldier who lived in Durham and was an enthusiastic watercolour painter. He saw service in India in 1846 and his sketches of the Himalayas were utilized by Turner and Prout. From 1848 to 1892 he was Second Chief Constable of Durham and from 1880 to 1892 a Deputy Lieutenant of the County.

His wife ANN WHITE and his daughter ELLA WHITE also produced watercolours.

Published: *Views in India*, 1838.

WHITE, Henry Hopley
A barrister and landscape, genre and portrait painter. He was a Q.C., published several legal works, lived in Clapham, and was active in the 1850s and 1860s. He painted in Kent, Dorset and Somerset.

WHITE, James 1744 − 1825
A friend and pupil of F. Towne (q.v.) and uncle of J.W. Abbott (q.v.). He toured Wales with Towne in 1777 and introduced his nephew to London and to such artists as Reynolds, West and Beaumont.

WHITE, John
The illustrator of de Bry's *America*, 1590. In 1585 he accompanied the second expedition sent by Raleigh to America under Sir Richard Grenville, returning the following year. He was in command of the next expedition sent out in 1587. In 1590 he was on the last voyage to Roanoke, which found that the colony had been overrun. He was living in Ireland in 1593.

His drawings of Red Indians and American fauna were the pattern for similar illustrations for the next two hundred years. They are vigorously drawn with neat but heavy outlines and washes of colour which can be very bright. He also drew members of other races, including the imaginary portraits of ancient Britons.

Published: *The pictures of sondry things collected . . .*1585.
Examples: B.M.
Bibliography: Walpole Soc., XIII, 1925. *Connoisseur*, CLVI, 1964. *Country Life*, April 2, 1964.

WHITE, John, R.I. 1851 (Edinburgh) − 1933
A painter of landscapes, seascapes, portraits and rustic genre subjects in oil and watercolour. His family emigrated to Australia in 1856 and he was educated in Melbourne. He returned to study at the R.S.A. Schools from 1873 to 1879. He was elected R.I. in 1882, retiring in 1931, and he lived at Beer, Devon.

An exhibiton of his Devonshire views was held at the Fine Art Society in 1899.

Examples: Exeter Mus.

WHITE, Thomas
A topographer who was working in York in about 1802.

Examples: York A.G.

WHITE, William, of Swansea
A portrait painter who was active from about 1824 to 1838. He

lived in London as well as Swansea. His style is a mixture of those of W. Henry Hunt (q.v.) and G. Richmond (q.v.).

Examples: B.M.

WHITE, William Johnstone
An illustrator working rather in the manner of R. Westall (q.v.). He was active between about 1804 and 1810. He may have published a Shakespearian commentary in 1820.

Examples: B.M.; Castle Mus., Nottingham.

WHITEFORD, Sidney Trefusis 1837 – 1915
A still-life and genre painter who lived in Plymouth and London. He exhibited in London from 1860.

Published: *A Guide to Figure-Painting in Watercolours,* 1870. *A Guide to Porcelain Painting,* 1877.
Examples: Exeter Mus.

WHITEHEAD, Harold – c.1910
A ship portraitist, by whom there are rather lurid watercolours at Greenwich of the ships in which Rear-Admiral Garforth served. One of them depicts H.M.S. *Renown* on her voyage to India with the Prince of Wales in 1906.

WHITEHOUSE, Sarah E
A landscape and rustic genre painter who lived in Leamington. She exhibited in Birmingham and London and was active from 1874 to 1895.

WHITELEY, John William
A landscape painter who lived in Leeds and was active from 1882 to 1916.

Examples: Leeds City A.G.

WHITLEY, Charles 1824 – 1893
A landscape painter, writer and antiquarian, he worked as a tax collector and property developer and was clerk of Hoddesdon Town Council.

Examples: Hertford Mus.

WHITELY, Kate Mary, R.I. (London) – 1920
The daughter of a Leicester vicar, she was educated in Manchester and painted still-lifes. She exhibited in London from 1884 and was elected R.I. in 1889.

WHITTAKER, George 1834 (Exeter) – 1874 (Devonport)
A West Country landscape and coastal painter. He was a pupil of Charles Williams.

Examples: Exeter Mus.

WHITTAKER, James William, O.W.S.
1828 (Manchester) – 1876 (near Bettws-y-Coed)
A Manchester man, he began his career as an engraver, but soon turned to drawing. He moved to North Wales, where, with the possible exception of a trip to Switzerland and Italy in about 1864, and a Northern journey in the late 1860s, he remained for the rest of his life. He was elected A.O.W.S. and O.W.S. in 1862 and 1864. He died from a fall into the Llugwy when collecting his painting gear. His subjects are almost all North Welsh views, and his skill seems to have decreased towards the end of his life.

Examples: V.A.M.: City A.G., Manchester.

WHITTOCK, Nathaniel
A draughtsman and lithographer working in London and Oxford between about 1824 and 1860. He published several drawing books, and illustrated topographical and other publications including his own *Microcosm of Oxford,* 1830.

WHYMPER, Charles, R.I. 1853 (London) – 1941
A painter of landscapes, animal genre and angling subjects and

illustrations, he was a son of J.W. Whymper (q.v.). He exhibited from 1876 and travelled extensively. In 1923 an exhibition of his Egyptian work was held at the Walker Galleries. He was elected R.I. in 1909. He lived in London and at Houghton, Huntingdonshire.

Published:*Egyptian Birds,* 1909.

WHYMPER, Emily, Mrs., née Hepburn – 1886
A painter of landscapes and flowers, she married J.W. Whymper (q.v.) as his second wife in 1866. She exhibited from 1870 to 1885 and her subjects include views in Durham, Cornwall and on the Thames.

Published: *Beauty in Common Things,* 1874.

WHYMPER, Josiah Wood, R.I.
1813 (Ipswich) – 1903 (Haslemere)
The son of a brewer, he was apprenticed to a stone-mason and was largely self-taught as a landscape painter and engraver. He settled in London in 1829 and took a few lessons from W.C. Smith (q.v.) as well as making many illustrations. He exhibited from 1844 and was elected A.N.W.S. and N.W.S. in 1854 and 1857. He was a successful teacher, his pupils including C. Green, J.W. North, G.J. Pinwell and F. Walker (all q.v.). For much of his later life he lived at Haslemere.

Illustrated: C.R. Conder: *The Child's History of Jerusalem,* 1874. L.J. Jennings: *Field Paths and Green Lanes,* 1877. C.R. Conder: *Tent Work in Palestine,* 1878.
Examples: V.A.M.; Sydney A.G.

WIDGERY, Frederick John 1861 – 1942
The younger son of W. Widgery (q.v.), he was educated at the Cathedral School, Exeter, and studied at the Exeter School of Art, South Kensington and in Antwerp. He was extremely active in municipal affairs and was Lord Mayor of Exeter in 1903-4 as well as chairman or member of many committees and a captain in the Volunteers. His style and subject matter are continuations of those of his father, and his work, often in bodycolour, is repetitive, although it was very popular in his lifetime.

Illustrated: S. Rowe: *A Perambulation of Dartmour,* 1896. S. Rowe: *Fair Devon Album,* 1902. Lady R. Northcote: *Devon,* 1914. J. Presland: *Torquay,* 1920.
Examples: Exeter Mus.

WIDGERY, Julia C
A daughter of W. Widgery (q.v.), she exhibited Devonshire landscapes at Suffolk Street from 1872 to 1880.

WIDGERY, William
1826 (Uppercot, North Molton) – 1893 (Exeter)
A landscape, marine and animal painter who began his working life as a stone-mason and plasterer. He moved to Exeter and painted copies of engravings by Landseer and others before turning to original painting. He visited Italy and Switzerland at least once, but was best known for his Devon and Dartmoor landscapes. He was a prolific painter in both oil and watercolour, and his colour sense is better than that of his son, F.J. Widgery (q.v.), although the work of both can be rather garish.

Examples: Exeter Mus.
Bibliography: see G. Pycroft: *Art in Devonshire,* 1833. Exeter Mus.: *Exhibition Cat.,* 1972.

WIGHTWICK, George
1802 (Alyn Bank, Mold, Flint) – 1872 (Portishead)
An architect who was educated at Wolverhampton Grammar School and privately at Tooting. In 1825-6 he toured Italy, and on his return worked for Soane. In 1829 he opened a practice in Plymouth and thereafter designed a number of buildings in the South West. In 1851 he retired to Clifton and later to Portishead. In 1868 he married, as his second wife, Isabella, daughter of S. Jackson (q.v.).

He published many papers and two plays, as well as his architectural writings, some of which he illustrated himself. His work is competent, if a little dull and old-fashioned. The figures are

sometimes slightly too large for the background buildings.

Published: *Select Views of Roman Antiquities*, 1827. *Remarks on Theatres*, 1832. *Sketches of a Practising Architect*, 1837. *The Palace of Architecture*, 1840. *Hints to Young Architects*, 1846.

WIGRAM, Sir Edgar Thomas Ainger, Bt. 1864 – 1934
An amateur artist who was the son of the Rector of St. Andrew's Church, Hertford and succeeded his cousin in the baronetcy in 1920. He was educated at Trinity Hall, Cambridge, and was elected Mayor of St. Albans in 1926.

Published: *Northern Spain*, 1906. With W.A. Wigram: *The Cradle of Mankind*, 1914.
Illustrated: J. Lomas: *Spain*, 1925.
Examples: Hertford Mus.

WIGSTEAD, Henry c.1745 (London) – 1800 (Margate)
A caricaturist and genre painter who was active from 1784. Several of 'his' works exhibited at the R.A. were in fact by Rowlandson. He wrote the letterpress for Rowlandson's Tours, and his own unpolished drawings are weak imitations of the work of his friend and teacher. He lived in London and was a J.P. from 1798.

Published: with T. Rowlandson: *An Excursion to Brighthelmstone*, 1790. *Remarks on a Tour to North and South Wales*, 1800.

WILCOX, James 1778 – 1865
A London business man and an amateur artist of Welsh extraction who studied the work of S. Prout (q.v.) and took every opportunity to sketch. A journey to Lancashire in 1804 served as an excuse to visit the Lakes and Scotland. Other sketching tours included Canterbury in 1796, Bromley and London in 1816-17, Kent in 1818 and 1834, Dover in 1820, the Isle of Wight *via* Arundel in 1821, Greenwich in 1824 and Kenilworth in 1826. After his retirement in 1827, when he moved to Much Hormead, Hertfordshire, he made a series of tours around the Hertfordshire/Essex border. He visited Yorkshire and Colchester in 1831, Wales in 1831 and 1834, and Ely in 1835 and 1860. In 1837 he made his only trip abroad to France, and in 1847 he sketched in Shropshire and Herefordshire. In 1855-6 he visited the Isle of Dogs to see the great Eastern. He exhibited with the N.W.S. in 1834, and he was a skilful landscape gardener.

His children studied under him and were friends and sketching companions of C.A. Newell (q.v.). They were: OWEN JAMES (b.1808), ELIZA REBECCA (1809-1881), JOHN (1811-1891), JAMES (1814-1835), AMELIA (1820-1843), MATILDA ELIZABETH (1823-1902), JULIA THERESA (1826-1913) and SARAH (1829-1911). There are examples of the family's work in Hertford Mus.

WILD, Charles, O.W.S. 1781 (London) – 1835 (London)
Articled to T. Malton, Yr., Wild was best known as an architectural draughtsman, although he occasionally extended to historical subjects. He was elected A.O.W.S. and O.W.S. in 1809 and 1812. His favourite subjects were cathedrals and colleges, and his drawings were nearly always done for the engraver. In the 1820s he travelled on the Continent in search of similar subject matter. His sight, however, became progressively worse from 1827, and he resigned from the O.W.S., of which he had been Treasurer and Secretary, in 1833. His work is well drawn and pleasantly coloured.

Published: *Twelve Views of Canterbury*, 1807. *Twelve Views of York*, 1809. *An Illustration of Chester*, 1813. *An Illustration of Lichfield*, 1813. *An Illustration of Lincoln*, 1819. *An Illustration of Worcester*, 1823. *Select Examples . . .of Architecture . . .In France*, 1826. *Select Examples . . . of Architecture . . .in England*, 1832. *Twelve Outlines . . .* 1833. *Selected Examples of Architectural Grandeur . . .*, 1837.
Illustrated: W.H. Pyne: *Royal Residences*, 1819. Rev. J. Dallaway: *History of the Western Division of the County of Sussex*, 1815-30.
Examples: B.M.; V.A.M.; Williamson A.G., Birkenhead; Grosvenor Mus., Chester.

WILDE, William 1826 (Nottingham) – 1901
A Nottinghamshire landscape painter who exhibited local subjects, as well as views of Hastings and North Wales, at Suffolk Street and elsewhere from 1864 to 1880.

Examples: V.A.M.; Castle Mus., Nottingham.

WILHELM, C see PITCHER, William John Charles

**WILKIE, Sir David, R.A.
1785 (Cult, Fifeshire) – 1841 (at sea, off Gibraltar)**
The historical genre and portrait painter. Wilkie studied at the Trustees' Academy and the R.A. Schools and was elected A.R.A. and R.A. in 1809 and 1811. He was appointed King's Limner for Scotland in 1823 and Painter in Ordinary to the King in 1830. He visited Italy, Germany and Spain from 1825 to 1828, and Egypt and Palestine in 1840.

His drawings are wash drawings rather than watercolours. They are usually executed with the brush and are free and sketchy. His caricatures, like those of Landseer, which they influenced, can be most attractive.

Examples: B.M.; V.A.M.; Aberdeen A.G.; Cecil Higgins A.G., Bedford; Cartwright Hall, Bradford; Fitzwilliam; Greenwich; Leicestershire A.G.; N.G., Scotland; Newport A.G.; Castle Mus., Nottingham.
Bibliography: A. Cunningham: *Life of D.W.*, 1843. A. Raimbach: *Memoirs and Recollections*, 1843. Mrs. C. Heaton: *The Great Works of Sir D. W.* 1868. A.L. Simpson: *The Story of Sir D.W.*, 1879. J.W. Mollett: *Sir D. W.*, 1881. Lord Gower: *Sir D.W.*, 1902. W. Bayne: *Sir D.W.*, 1903. *A.J.*, 1858; 1859; 1890; 1896.

WILKINS, J F c.1795 (Nottingham) –
A portrait painter who worked mainly in watercolour. In 1833 he was elected a Burgess of Nottingham. Shortly afterwards he moved to London, where he exhibited at the R.A. in 1835 and 1836. In about 1850 he went to live in Illinois, America, where he ran a large estate.

WILKINS, William, F.S.A. 1751 (Norwich) – 1815
An architect, theatre manager and antiquarian draughtsman. He lived in Norwich until 1780, when he moved to Cambridge. He exhibited views of Norwich buildings at the R.A. from 1780 to 1787. J.A. Repton (q.v.) was a pupil and his son, WILLIAM WILKINS, YR. (1778-1839), became a successful architect and was a member of the Norwich Society of Artists, exhibiting architectural subjects from 1817 to 1828.

**WILKINSON, Colonel Henry John
1829 – 1911**
There are over one hundred drawings and watercolours, chiefly of the Crimean campaign, by this Army officer at Greenwich. He entered the 9th Regiment of Foot in 1848 and was promoted lieutenant in 1851 and captain in 1855. He served through the Crimea and later became a member of the Commissariat in Egypt and Gibraltar. He retired in 1887 and was given the honorary rank of colonel.

WILKINSON, James
The son of a Dublin print-seller and publisher. He exhibited landscapes with the Dublin Society of Artists in 1773, and a drawing of fruit in 1801.

WILKINSON, Rev. Joseph 1764 (Carlisle) – 1831 (Thetford)
An enthusiastic amateur landscape painter who was educated at Corpus Christi College, Cambridge, graduating as Fourth Wrangler in 1794. He became a Fellow of the College and was appointed Rector of the Wrethams, Norfolk, in 1803. He was also Perpetual Curate of Beccles and Domestic Chaplain to the Marquess of Huntly. Previously he had been a minor canon of Carlisle and had lived at Ormathwaite. His *Select Views* were published with the letterpress by Wordsworth, but the latter was not an admirer of Wilkinson's art. In May, 1810, he wrote to Lady Beaumont: 'The drawings, or

Etchings, or whatever they may be called, are, I know, such as to you and Sir George must be intolerable. You will receive from them that sort of disgust which can never be felt in its full strength, but by those who are practised in an art, as well as Amateurs of it . . . They will please many who in all the arts are most taken with what is most worthless.'

Published: *Select Views in Cumberland, Westmoreland and Lancashire;* 1810. *The Architectural Remains . . .of Thetford,* 1822.
Examples: V.A.M.; Carlisle A.G.; Abbot Hall A.G., Kendal.

WILKINSON, Mary Arabella 1839 – 1910
The daughter of a Derby clergyman, she was an amateur artist, and was connected with many charitable institutions including the Society for Help and Protection of Girls.

Examples: Derby A.G.

WILLATS, Mrs. J K
A lady who painted miniature views of Amsterdam and Venice when on honeymoon. She exhibited at Suffolk Street in 1881 and lived in London. She was perhaps co-authoress, with Lady M. Clay, of *Failure and fortune in farming,* 1883.

WILLCOCK, George Barrell 1811 (Exeter) – 1852
A landscape painter in oil and watercolour who began as a coach painter but then became a pupil of his friend J. Stark (q.v.). He exhibited at Suffolk Street from 1839 to 1852, as well as at the R.A. and elsewhere. He painted in many parts of southern England, but particularly in Devon. Some of his works are signed with initials.

Examples: Reading A.G.

WILLES, William (Cork) – 1851 (Cork)
A landscape and subject painter who trained to be a doctor. He had some lessons from N. Grogan (q.v.) and at the R.A. Schools, having come to London after 1815. He exhibited at the R.A. and the B.I. from 1820 and in 1823 returned to Cork. In 1829 he came back to London. He exhibited at the R.H.A. between 1843 and 1849, in which year he became Headmaster of the newly-founded Cork School of Design, which post he held until his death. He contributed drawings to Hall's *Ireland,* 1841.

WILLETT, Arthur 1868 –
A landscape painter who lived in Brighton and exhibited from 1883, usually Sussex subjects. He visited New York, where he painted frescos. His style is similar to that of J. MacWhirter.

WILLIAMS, Alexander, R.H.A.
** 1846 (County Monaghan) – 1930**
An Irish landscape and coastal painter in oil and watercolour, he was educated at Drogheda Grammar School and began his career as a musician. He then turned to painting and studied at the R.D.S. Schools. He was elected A.R.H.A. and R.H.A. in 1883 and 1891. He provided illustrations for S. Gwynn's *Beautiful Ireland,* 1911, and he lived in Dublin and on Achill Island.

WILLIAMS, Alfred 1832 – 1905 (Ste Maxime-sur-Mer)
A landscape painter who was a pupil of W. Bennett (q.v.), he began by drawing on wood for booksellers. From 1860 to 1886 he was in business, touring and sketching during his summer holidays, particularly in Scotland, Northern Italy and Switzerland. He exhibited from 1878. He visited India in 1900. An exhibition of his work was held at the Alpine Club in 1902.

Examples: V.A.M.

WILLIAMS, Alfred Walter 1824 – 1905
A son of E. Williams (q.v.) and brother of S.R. Percy (q.v.), he was a landscape painter in oil and watercolour. He exhibited from 1843 and painted in the southern counties, Wales, the Lake District, Scotland, France and Italy. He lived in London and Surrey. His colours tend to be harsh.

Examples: Nat. Lib., Wales.
Bibliography: J. Reynolds: *The Williams Family of Painters,* 1975.

WILLIAMS, Benjamin
** 1868 (Langley Green, Worcestershire) – 1920 (Wolverhampton)**
A landscape, genre and flower painter who should not be confused with B.W. Leader (né Williams). He studied at the Birmingham School of Art and later taught at a number of local art schools. He was also an authority on musical instruments.

Examples: V.A.M.; Birmingham City A.G.

WILLIAMS, Edward 1782 (London) – 1855 (London)
The son of an engraver and a nephew and pupil of James Ward (q.v.), he was the father of the Williams family of painters, some of his six sons changing their name to Boddington, Percy or Gilbert. He was apprenticed to a goldsmith and exhibited from 1811 to 1855, specializing in moonlight scenes and Thames views in oil and watercolour.

Examples: B.M.
Bibliography: J. Reynolds: *The Williams Family of Painters,* 1975.

WILLIAMS, Captain Edward Elliker
** 1793 – 1822 (off Lerici)**
A sailor, soldier and draughtsman. He was educated at Eton, joined the Navy and then, in about 1811, the Cavalry of the East India Company. In 1820 he returned to Europe and settled in Geneva, moving in the following year to Pisa to be near the Shelleys. A number of Shelley's poems are dedicated to Williams's wife Jane. Williams was Shelley's adviser and partner in the building of the *Don Juan,* in which they were both drowned.

In India Williams drew both landscapes and architecture. In the B.M. there is an accomplished self-portrait seated in the cabin of the *Don Juan.*

WILLIAMS, Hugh William, 'Grecian'
** 1773 (at sea) – 1829 (Edinburgh)**
The orphaned son of a sea captain, he was brought up in Edinburgh. He became a talented landscape painter, was a Founder Member of the A.A. in 1808, and in 1811-12 published six large engravings of Highland scenes. He made an extended tour of Italy and Greece, returning in 1818, and this established his reputation. He exhibited the watercolours from the journey in 1822.

He is always a sound workman, but in his early work he sometimes promised more. In his greys, greens and browns and his atmospheric treatment of romantic themes, he can, in his early years, approach J.R. Cozens (q.v.). He also made early attempts at using a 'split-brush' technique. Williams also notes drawings that are reminiscent of Farington and de Wint. Usually, and certainly later in his career, he is a conventional topographer and landscape painter.

Published: *Travels in Italy, Greece and the Ionian Islands,* 1820. *Select Views in Greece,* 1827-29.
Examples: B.M.; V.A.M.; Aberdeen A.G.; Williamson A.G., Birkenhead; Fitzwilliam; Glasgow A.G.; N.G., Scotland; Nat. Lib., Wales; Newport A.G.; Ulster Mus.

WILLIAMS, J
A pupil of W. Payne (q.v.). Williams records a signed drawing dated 1798. It is just possible that he should be identified with John Williams, 'Anthony Pasquin', who is said to have painted watercolours.

WILLIAMS, Joseph Lionel c.1815 – 1877 (London)
A genre and historical painter in oil and watercolour who lived in London, he was the son of S. Williams (q.v.). He was also a wood-engraver and worked for the *I.L.N.* and the *A.J.* He exhibited at Suffolk Street and elsewhere from 1834 to 1874 and in the 1860s was an unsuccessful candidate for the N.W.S. on frequent occasons.

Examples: Mappin A.G., Sheffield.

WILLIAMS, Penry 1798 (Merthyr Tydfil) – 1885 (Rome)
The son of a house painter, he studied at the R.A. Schools under Fuseli and was awarded a silver medal by the Society of Arts in 1821. He was an A.O.W.S. from 1828 to 1833. In 1826 he went to

Rome, where he lived for almost sixty years, occasionally visiting England and Wales, and producing large numbers of rather conventional views of Rome, Naples and the Campagna. He was a popular and hospitable figure, and his studio a must for sightseers.

His remaining works were sold at Christie's, May 19 and June 21, 1886.

Published: *Recollections of Malta, Sicily and the Continent,* 1847.
Examples: B.M.; V.A.M.; Fitzwilliam.
Bibliography: *A.J.,* 1864. Connoisseur, LVI, 1920.

WILLIAMS, Pownoll Toker

A landscape and genre painter in oil and watercolour who exhibited from 1872 to 1897. A number of exhibitions of his work, including Italian subjects, were held at MacLean's Gallery in the 1880s. He lived in London.

Published: *Pictoris Otia,* 1889.

WILLIAMS, S

A Plymouth drawing master working in about 1800, he was a friend of Haydon's father and may have given S.Prout (q.v.) a few lessons.

WILLIAMS, Samuel 1788 (Colchester) – 1853 (London)

A draughtsman and wood-engraver who was apprenticed to a Colchester printer and house painter. He settled in London in 1819 and gained a high reputation as an illustrator, engraving both from his own and other people's drawings.

Illustrated: D. Defoe: *Robinson Crusoe,* 1882. Mrs. Trimmer: *Natural History,* 1823-4. Selby: *British Forest Trees,* 1842. Miller: *Pictures of Country Life,* 1847. Etc.
Examples: B.M.

WILLIAMS, Terrick John, R.A., P.R.I.
 1860 (Liverpool) – 1936 (Plymouth)

A painter of shipping and coastal subjects who was educated at King's College School and studied in Antwerp and Paris. He exhibited from 1888 and painted in France, Holland, North Africa and the Mediterranean. He was elected R.I. in 1904, President in 1934, and A.R.A. and R.A. in 1924 and 1933. His work is fresh and colourful.

Published: *Landscape Painting in Oil Colour,* 1929. *The Art of Pastel,* 1937.
Examples: V.A.M.; Aberdeen A.G.; Leeds City A.G.

WILLIAMS, Thomas H

An author, illustrator and engraver who lived in Exeter and Plymouth. He also painted landscapes, some from the Isle of Wight, and marine subjects in oil and watercolour and exhibited at the R.A., N.W.S. and Suffolk Street from 1801 to 1830.

Published: *Picturesque Excursions in Devon and Cornwall,* 1801. *The Environs of Exeter,* 1815. *A Tour in the Isle of Wight,* (n.d.). *A Walk on the Coast of Devonshire,* 1828.
Examples: Fitzwilliam.

WILLIAMS, William 1808 – 1895

A Plymouth landscape and coastal painter in the manner of the Cooks of Plymouth (q.v.). He painted in oil and watercolour and exhibited from 1841 to 1876. He also lived in Bath, Torquay and Topsham.

He was the father of S.G.W. Roscoe (q.v.).

Examples: Exeter Mus.

WILLIAMSON, Daniel Alexander
 1823 (Liverpool) – 1903 (Broughton-in-Furness)

A landscape and genre painter who was the son of the artist Daniel Williamson (1783-1843). He came to London in about 1847. returning to settle near Carnforth, Lancashire, in 1860. He exhibited in London from 1849 to 1871 as well as in Liverpool. At the beginning of his career, when he painted in oil as well as watercolour, he was influenced by the Pre-Raphaelites, later he

based his style on those of Cox and Turner.

Examples: Williamson A.G., Birkenhead; Walker A.G., Liverpool.

WILLIAMSON, Frederick – 1900 (London)

A landscape and cattle painter in oil and watercolour. He lived in London and Godalming and exhibited from 1856. His early work in detailed in a Pre-Raphaelite manner.

Examples: V.A.M.; Williamson A.G., Birkenhead; Sydney A.G.

WILLIAMSON, J B

An artist who exhibited between 1868 and 1871. He was Headmaster of the Taunton School of Art and then taught at the Gower School of Art.

Examples: V.A.M.

WILLIAMSON, John Smith

A genre and coastal painter who lived in London and exhibited at the R.A. and Suffolk Street from 1866 to 1880. In 1864 he was an unsuccessful candidate for the N.W.S.

WILLIAMSON, Samuel 1792 (Liverpool) – 1840 (Liverpool)

A landscape and marine painter, he was the son of John Williamson (1751-1818), a Ripon artist who had served an apprenticeship to an ornamental painter in Birmingham and settled in Liverpool in 1783. Samuel was an original member of the Liverpool Academy in 1811. He was a prolific exhibitor there, and at the Manchester Institution from 1827.

WILLIAMSON, W M

A painter of castles, coasts and landscapes in southern England, particularly in Kent. He lived in London and was active from 1868 to 1873. His work can be of a high quality.

Examples: V.A.M.

WILLIS, Henry Brittan, R.W.S.
 1810 (Bristol) – 1884 (London)

The son of a Bristol artist and drawing master. Having had little success at home, where he was a member of the Sketching Club, Willis emigrated to the United States in about 1841. However, as a result of ill-health he was back in London by 1843, and he promptly began to exhibit the cattle pictures and drawings for which he became renowned. He studied at Clipstone Street and sketched with the Langham Club. He was elected A.O.W.S. and O.W.S. in 1862 and 1863. He appears to have visited the Rhineland in 1865, and Killarney in 1881, otherwise never again leaving Great Britain. In later life his drawings become more 'Landscapes' than 'cattle in landscapes'.

His remaining works were sold at Christie's, May 16, 1884.

Published: *Studies of Cattle and Rustic Figures,* 1849. *Studies from the Portfolios of Various Artists,* 1850.
Examples: B.M.; V.A.M.; Haworth A.G., Accrington; Sydney A.G.
Bibliography: *A.J.,* 1879.

WILLIS, Richard Henry Albert
 1853 (Dingle, County Kerry) – 1905 (Ballinskelligs, County Kerry)

A landscape painter in oil, watercolour and pastel, a sculptor and a drawing master, he was educated in Cork and apprenticed to a Cork architect. He studied drawing at the Cork School of Art and South Kensington, and in 1882 he was appointed Headmaster of the Manchester School of Art. He resigned in 1892 and worked as a drawing master and an art examiner at South Kensington. he exhibited at the R.A. from 1882 to 1899. In 1904 he was appointed Headmaster of the Dublin Metropolitan School of Art. In addition to sculpting and painting, he worked at enamelling, wood-carving and glass-staining.

WILLSON, Harry

A painter of Continental town scenes and a lithographer. He was active from about 1813 to 1852 and was a copyist of S. Prout (q.v.).

Published: *H.W.'s Fugitive Sketches in Rome, Venice, etc.*, 1838.
The Use of a Box of Colours, 1842.
Examples: B.M.

WILLSON, Captain James Kennett –? 1881
An officer who was trained at Sandhurst and was promoted first
lieutenant in 1832 and captain in 1842. He retired in 1864. There
are examples of his work at Greenwich, including an album of
watercolour views, mainly of Greece, and ship portraits in brown
ink, dating from the 1830s; and two watercolours of the battle of
St. Jean d'Acre, 1840.

Also at Greenwich there are albums by CAPTAIN RICHARD
KENNETT WILLSON (d.1877). One contains views of North and
South America, mainly in brown wash and bearing dates in the
1850s, another contains grey wash views of Corfu taken from on
board H.M.S. *Agamemnon* in 1861. He became a second lieutenant
in the Royal Marines in 1846, was promoted first lieutenant in 1850
and captain in 1857.

There is also an album containing pencil drawings by RICHARD
WILLSON who was at Sandhurst in 1822, became an ensign in the
30th Regiment and died in about 1824 at Poona.

WILLYAMS, Rev. Cooper 1762 (Essex) – 1816 (London)
A topographical draughtsman who entered Emmanuel College,
Cambridge, in 1780 and was ordained in 1784, after visiting France
that Spring. He served as a curate near Gloucester, near Newmarket
and at West Lynn before sailing for the West Indies in 1793 under
Admiral Jervis. In 1797 he became Chaplain to Jervis, by now Earl
St. Vincent, and from 1798 to 1800 served on one of Nelson's
vessels, being present at the Battle of the Nile, which he illustrated
in his *A Voyage up the Mediterranean in the Swiftsure*, 1802. In
1800 he returned to England and in 1806 was given the living of
Kingston, near Canterbury, shortly followed by that of Stourmouth.
He occasionally contributed illustrations to such periodicals as *The
Topographer*.

Published: *A History of Sudeley Castle*, 1791. *An Account of the
Campaign in the West Indies in 1794*, 1796. *A Selection of Views in
Egypt, Palastine, Rhodes, Italy, Minorca and Gibraltar . . .*, 1822.

WILSON, Alexander 1819 (Kilmarnock) – 1890 (Glasgow)
A landscape painter and textile designer who became a drawing
master at Anderson's Academy, Glasgow. He was also Registrar of
Symington, Ayrshire. He painted in Ayrshire and Renfrewshire and
sometimes signed with initials or a monogram.

WILSON, Andrew 1780 (Edinburgh) – 1848 (Edinburgh)
A landscape painter and collector who studied under A. Nasmyth
(q.v.) and at the R.A. Schools. He then toured Italy, where he made
architectural sketches in Rome and Naples. He returned to London
in 1803 and immediately set out again for Italy, with the intention
of bringing back old masters. Circumstances forced him to stay in
Genoa, but in 1805 he returned to London, via Germany, with fifty
pictures which included Rubens's *Brazen Serpent* – now in the N.G.
He was a Founder Member of the A.A. in 1808 and Professor of
drawing at the R.M.A., Sandhurst, until 1818, when he was
appointed Master of the Trustees' Academy. He returned to Italy in
1826, living for twenty years in Rome, Florence and Genoa. He
painted in oil and watercolour, his pictures being pleasant and
muted.

He was the father of C.H. Wilson (q.v.), and his pupils included
W. Simson (q.v.), R.S. Lauder (q.v.) and D.O. Hill (q.v.).

Examples: B.M.; V.A.M.
Bibliography: *Country Life*, August 15, 1968.

WILSON, Charles Edward
 (Whitwell, Nottingham) – c.1936
A genre and rustic painter who lived in Sheffield and Surrey. He
exhibited from 1891, particularly at the R.I.

Examples: V.A.M.

WILSON, Charles Heath 1809 (London) – 1882 (Florence)
A landscape painter and book illustrator, he was the eldest son of A.
Wilson (q.v.), with whom he travelled to Italy in 1826. He returned
to Edinburgh seven years later, and was elected A.R.S.A. in 1835,
resigning in 1858. He bceame Master of the Trustees' Academy in
1843, but resigned in 1848 and was appointed Master of the
Glasgow School of Design. In 1840 he visited the Continent, and in
1869 he settled in Florence.

Published: *Life of Michaelangelo*, 1876. Etc.
Illustrated: P. Pifferi: *Viaggio Antiquario*, 1832. J. Wilson: *Voyage
round the Coasts of Scotland*, 1842.
Examples: N.G. Scotland.

WILSON, Dr. Edward Adrian 1872 –
He was educated at Cheltenham College and Caius College,
Cambridge. After studying at St. George's Hospital he practised as a
surgeon in Cheltenham. He accompanied Captain Scott on his
Antarctic Expedition of 1901-4 as surgeon and vertebrate zoologist.
During the expedition he made hundreds of watercolours and pencil
drawings of the landscape and bird life, a number of which were
shown at the Bruton Gallery in 1904, in an exhibition entitled
Discovery. He illustrated a number of books on Antarctic and other
natural history subjects.

Bibliography: G. Seaver: *E.W.*, 1937.

WILSON, George
 1848 (Cullen, Banffshire) – 1890 (Huntly, Aberdeenshire)
The son of the Earl of Seafield's factor, he was educated in
Aberdeen and at Edinburgh University. At the age of about nineteen
he came to London and studied at Heatherley's and briefly at the
R.A. Schools, which he left to study figure drawing under Sir E.J.
Poynter (q.v.) at the Slade. There his friends included J.T. Nettleship
(q.v.). He remained based in London but he visited Scotland for
some months nearly each year. He made several visits to Italy, and
one to Algiers. His landscapes and figure studies show a good
understanding of colour and draughtsmanship.

Examples: B.M.; Aberdeen A.G.

WILSON, John H , 'Jock' 1774 (Ayr) – 1855 (Folkestone)
A marine painter who was apprenticed to the house painter John
Norie of Edinburgh, after which he had lessons from A. Nasmyth
(q.v.). He taught drawing in Montrose for two years, and then
became a scene painter at Astley's. He was elected an Honorary
Member of the S.A. in 1827, and exhibited with them, as well as at
the R.A., the B.I. and the S.B.A. He visited France and Holland, and
in later life he lived in Folkestone.

His son, JOHN JAMES WILSON (1818-1875) painted
landscapes, seascapes and farmyards. He exhibited prolifically at
Suffolk Street and elsewhere from 1845. He should not be confused
with his namesake (q.v.).

WILSON, John James, of Leeds 1836 (Leeds) – 1903
A landscape painter who studied for a time in Leeds and under E.
Moore (q.v.) in York, but was mainly self-taught. He was a founder
of the Leeds Fine Art Club in 1873 and President until his death. He
should not be confused with his namesake, the son of 'Jock' Wilson
(q.v.).

Examples: Leeds City A.G.

WILSON, J **T**
A painter of Surrey and Sussex views who exhibited from 1833 to
1882 and lived in London, Godalming and Hastings.

Examples: V.A.M.; Bethnal Green Mus.

WILSON, Oscar 1867 (London) – 1930
A painter of portraits, illustrations, genre and Cairene subjects. He
studied at South Kensington and Antwerp and exhibited from 1888.
He lived in London.

Examples: Leeds City A.G.

WILSON, Richard, R.A. 1714 (Penegoes, Montgomeryshire) –
 1782 (Colomondie, near Llanberis)
The landscape painter. Wilson came to London in 1729 and worked
under Thomas Wright, the portrait painter, his own portraits gaining
early recognition. In 1749 he left for Italy, where he lived, mainly in
Rome, for six years, painting landscapes and giving lessons. Among
his admirers there were Zuccarelli, H. Vernet and R. Mengs. He
returned to England in 1756 and exhibited at the S.B.A. between
1760 and 1768, when he became a Foundation member of the R.A.,
and he exhibited there until 1780. He became Librarian in 1776.
Unable to obtain the necessary commissions, he lived in increasingly
reduced circumstances until he inherited an estate at Llanberis, to
which he moved in 1781.

Although not himself a watercolourist, his chalk drawings are
very beautiful, and his style influenced many artists of his own and
the following generation. His pupils included J. Farington (q.v.) and
W. Hodges (q.v.).

Bibliography: T. Wright: *Some Account of the Life of R.W.,* 1824.
A. Bury: *R.W., R.A. The grand classic,* 1947. W.G. Constable: *R.W.,*
1953. *Country Life,* November 16 and 23, 1945; November 19,
1948. *Connoisseur,* CXVIII, 1946. *Burlington,* XCIII, May, 1951;
XCIV, November, 1952; CIV, April, 1962.

WILSON, Thomas Walter, R.I. 1851 (London) – 1912
A landscape, architectural and genre painter in oil and watercolour,
he was the son of Thomas Harrington Wilson, an illustrator. He
studied at South Kensington from 1868 and exhibited from 1870.
He was elected A.N.W.S. and N.W.S. in 1877 and 1879. He painted
in France, Belgium and Holland and drew for the *I.L.N.,* the
Graphic and other publications.

Examples: Sydney A.G.

WILTON, Kate
A Birmingham flower painter who exhibited there from 1880 to
1884.

WIMBUSH, Henry B
A landscape, coastal and town painter who lived in London and was
active from 1881 to 1908. He painted in Scotland, Wales and the
Channel Islands.

Illustrated: E.F. Carey: *The Channel Islands,* 1904.

WIMPERIS, Edmund Morison, R.I. 1835 (Chester) – 1900
The son of a cashier at Chester and of Mary Morison – the
misnomer 'Monson' is due entirely to a misprint in Graves. He began
as a wood-engraver and studied under M.B. Foster (q.v.), working
for the *I.L.N.* However his figure drawing was poor and he soon
turned to pure landscape painting. He was a member of the S.B.A.
from 1870 to 1874 and was elected A.N.W.S. and N.W.S. in 1873
and 1875. He became Vice-President in 1895.

His early work shows the painstaking influence of Foster and the
wood-engravers. Later, under the influence of T. Collier (q.v.), with
whom he sketched in Suffolk, Sussex, Wales and the Home
Counties, it becomes more expansive and less clogged with detail.
His best work, with its fine treatment of sky and shadow, was done
directly, out of doors.

One of his sons, EDMUND WIMPERIS, F.R.I.B.A., was also a
keen watercolourist.

Examples: B.M.; V.A.M.; Williamson A.G., Birkenhead; Cartwright
Hall, Bradford; Grosvenor Mus., Chester; City A.G., Manchester;
Newport A.G.; Portsmouth City Mus.
Bibliography: *Walker's Quarterly,* IV, 1921. *Connoisseur,* LIX,
1921.

WINDHAM, Joseph, F.R.S., F.S.A.
 1739 (Twickenham) – 1810
An amateur antiquarian draughtsman who was educated at Eton and
Christ's College, Cambridge. He made a long tour of France, Italy,
Austria and Switzerland, returning in 1769. He was elected to the
Society of Antiquaries in 1775, the Dilettanti Society in 1779 and
the Royal Society in 1781. He also made natural history drawings.

Published: *Some Account of the Cathedral Church of Exeter,* 1797.
Illustrated: C. Cameron: *Baths of the Romans,* 1772. Dilettanti
Soc.: *Antiquities of Ionia,* II, 1797.

WINDUS, William Lindsay 1823 (Liverpool) – 1907 (London)
An historical and genre painter who studied under William Daniels
and at the Liverpool Academy, of which he was elected Associate
and Member in 1847 and 1848. In 1850 he moved to London where
he was strongly influenced by Millais's *Christ in the House of his
Parents.* As a Member of the Liverpool Academy Council he
campaigned for the Pre-Raphaelites, and he was largely responsible
for the success of Hunt's *Valentine rescuing Sylvia from Proteus* in
Liverpool in 1851. He exhibited paintings at the R.A. in 1856 and
1859, but Ruskin's criticisms discouraged him from anything else of
an ambitious nature, and thereafter he concentrated on sketching
and drawing.

Bibliography: *A.J.,* 1859; 1905; 1907. *Liverpool Bulletin* VII, iii.

WINSTANLEY, Hamlet 1698 (Warrington) – 1756 (Warrington)
A painter and engraver who studied under Kneller and was in Italy
from 1723 to 1725. While in Rome he made pen and wash drawings
of the architecture and from the antique. He painted portraits and
landscapes in oil and made etchings from old masters. In about 1740
he was copying pictures for Lord Derby at Knowsley, and took on
Stubbs as an apprentice. Stubbs, however, on being refused
permission to copy the pictures he wished, immediately terminated
his articles.

Examples: B.M.
Bibliography: W. Beaumont: *Memoir of H.W.,* 1883.

WINSTON, J.
A painter of London buildings who was active from 1790 to 1803.

WINTER, Holmes Edwin Cornelius
 1851 (Great Yarmouth) – 1935
A landscape and topographical painter, he was the son of
CORNELIUS JASON WALTER WINTER (1820-1891), some of
whose work he appears to have signed. He lived in Norfolk and St.
Albans, and went mad. He sometimes used the pseudonym 'W.
Rowland'. His work can be pretty, but is generally rather
undistinguished.

His daughter, ROSE WINTER, MRS. MACARTHUR, worked in
his manner.

Examples: Castle Mus., Norwich; Gt. Yarmouth Lib.

WINTER, William Tatton
 1855 (Ashton-under-Lyne) – 1928 (Reigate, Surrey)
A landscape painter who began as a business man in Manchester,
attending evening classes at the Board School and Manchester
Academy. He then toured Holland and Belgium and studied in
Antwerp. He exhibited in London and abroad from 1884 and was a
member of the R.B.A. and the London Sketch Club. He painted
primarily in Surrey and Kent and lived at Reigate. An exhibition of
his work was held at the Museum Galleries in 1923.

Examples: Cartwright Hall, Bradford; Carshalton Lib.; City A.G.,
Manchester.
Bibliography: *Studio,* XXX, 1904; LXIII, 1915. *Connoisseur,*
XVIII, 1910. *Athenaeum,* II, 1919.

WINTOUR, John Crawford, A.R.S.A.
 1825 (Edinburgh) – 1882 (Edinburgh)
He studied at the Trustees' Academy and was elected A.R.S.A. in
1859. Until about 1850 he painted portraits and genre subjects;
thereafter he concentrated on romantic landscapes in the manner of
H. McCulloch (q.v.) in both oil and watercolour. His way of life was
not approved of by Victorian Edinburgh.

Examples: Glasgow A.G.; N.G., Scotland.

WIRGMAN, Charles 1832 – 1891
The brother of T. B. Wirgman (q.v.), he was a caricaturist and figure

painter. He worked in England and on the Continent before settling in Yokohama in 1860.

Examples: B.M.

WIRGMAN, Theodore Blake 1848 (Louvain) – 1925 (London)
A portrait, ceremonial and genre painter in oil and watercolour who studied at the R.A. Schools and in Paris. He exhibited from 1867 and had an extensive and fashionable portrait practice.

Examples: Cartwright Hall, Bradford.

WITHERBY, Kirsten, Mrs., née Lilja
1848 (Sala, Sweden) – 1932 (Bundoran, County Donegal)
A landscape and flower painter who studied in Paris, where she met her future husband, Arthur Witherby, a wealthy solicitor and occasional amateur oil painter. They lived in London, where she exhibited from 1879, until 1893, when he retired through ill-health. They then settled at Bundoran and travelled extensively in the British Isles, Europe, Africa and India. In style she was influenced by H.B. Brabazon (q.v.).

Published: *Sixty Years of a Wandering Life*, 1928.

WITHERINGTON, William Frederick, R.A.
1785 (London) – 1865 (London)
A landscape painter who entered the R.A. Schools in 1805 and first exhibited at the B.I. in 1808 and the R.A. in 1811, continuing to contribute until his death. He was elected A.R.A. and R.A. in 1830 and 1840.

He painted principally in Buckinghamshire, Devonshire, the Lakes, Wales and Kent. He occasionally varied his landscapes with literary subjects.

Examples: V.A.M.; Newport A.G.
Bibliography: *A.J.*, March, 1859; June, 1865. *Connoisseur*, LXIX, 1924.

WODDERSPOON, John c.1812 – 1862
An amateur landscape painter who lived in Norwich and Ipswich. He was a sub-editor on the Norwich Mercury.

Published: *Historic Sites of Suffolk*, 1841. *A New Guide to Ipswich*, 1842. *Picturesque Antiquities of Ipswich*, 1845. *Notes on the Grey and White Friars, Ipswich*, 1848. *Memorials of the Ancient Town of Ipswich*, 1850. *John Crome and his Works*, 1876.
Examples: Castle Mus., Norwich.

WOLEDGE, Frederick William
A landscape and topographical painter who was active from 1840 to 1895. He published some sketches of Brighton, where he lived, in 1842-3 and exhibited a Welsh view at the R.A. in 1846.

Examples: V.A.M.

WOLF, Joseph, R.I. 1820 (Mörz, Prussia) – 1899 (London)
An animal painter and a prolific illustrator who studied for three years under G. Becker, a Coblenz lithographer, and subsequently at Darmstadt. He came to England from Antwerp in 1848 and began working at the B.M. on Gray's *The Genera of Birds*. He contributed to the Zoological Society's publications for thirty years from his arrival in England. He exhibited at the R.A., the B.I. and the R.I. from 1849 to 1881 and in 1856 he visited Norway with John Gould. He was in contact with the Pre-Raphaelites and contributed to their exhibition in Fitzroy Square in 1857.

Examples: B.M.; V.A.M.
Bibliography: A.H. Palmer: *Life of J.W.*, 1895. *Artist*, XXV, i, 1899. *Country Life*, April 20, 1967.

WOLFE, George 1834 (Bristol) – 1890 (Clifton)
A landscape, coastal and marine painter in oil and watercolour who lived in Clifton, where he shared a studio with S. Jackson (q.v.), and near Alton, Hampshire. He exhibited in London from 1855 to 1873, and he was an unsuccessful candidate for the N.W.S. in 1867. Many of his subjects were taken from Devon, Cornwall and South Wales.

He also painted in Yorkshire, the Channel Islands, Germany and Belgium. He was very fond of wind and storm effects.

Published: *Wolfe's Book of Barges*, 1859.
Examples: V.A.M.; City A.G., Bristol; Greenwich; Nat. Lib., Wales.

WOOD, Abraham
A topographer who was working in Yorkshire in about 1808. His work is a little like that of P.S. Munn (q.v.).

Examples: B.M.; Leeds City A.G.

WOOD, Francis Derwent, R.A. 1871 (Keswick) – 1926 (London)
A portrait painter, sculptor and engraver who was educated in Switzerland and Germany and studied at South Kensington on his return in 1889. He then worked with Legros at the Slade, won a gold medal and travelling scholarship at the R.A. Schools, and assisted Thomas Brock, R.A. He was Modelling Master at the Glagow School of Art from 1897 to 1901. In 1915 he enlisted in the R.A.M.C. and after the War he remodelled the faces of wounded men. He was elected A.R.A. and R.A. in 1910 and 1920 and was Professor of Sculpture at South Kensington from 1918 to 1923.

Examples: B.M.; V.A.M.; Cartwright Hall, Bradford; City A.G., Manchester.

WOOD, Frank Watson
1862 (Berwick-on-Tweed) – 1953 (Strathyre, Perth)
A painter of shipping scenes who studied at the Berwick School of Art and in 1886 was appointed Second Master at Newcastle School of Art. From 1889 to 1899 he was Headmaster at the White School of Art, and in 1900 he took up an appointment at Portsmouth, from which time he painted naval subjects. He exhibited at the R.A. and the R.S.A., and lived for many years in Edinburgh. With W.L. Wyllie (q.v.) he was a guest of Admiral Sir Charles Madden on board H.M.S. *Queen Elizabeth* at the time of the surrender of the German fleet in 1918, and he later made several sketches of German ships before the scuttling. He accompanied George VI and Queen Elizabeth on their Canadian tour of 1938, which he illustrated.

He occasionally painted in oil, but the majority of his work is in watercolour. It includes light, colourful views of the mouth of the Tweed and the Berwick bridges. His colouring can be rather crude.

Examples; Greenwich.

WOOD, Lewis John 1813 (London) – 1901
A landscape and architectural painter and a lithographer. He exhibited from 1831 and after 1836 the majority of his subjects were found in Northern France and Belgium. He was elected A.N.W.S. and N.W.S. in 1866 and 1871, resigning in 1888. His work, especially in his earlier years, can be close to that of T.S. Boys (q.v.).

His son LEWIS PINHORN WOOD exhibited similar subjects from 1870 to 1891. There is an example of his work in the V.A.M.

Examples: B.M.; Williamson A.G., Birkenhead; Coventry A.G.; Stafford Lib.

WOOD, Robert
A Newcastle landscape painter who exhibited at the R.I. and elsewhere from 1886 to 1889.

WOOD, Samuel Peploe
1827 (Little Haywood, Stafford) – 1873 (Lichfield)
The brother of T.P. Wood, he was a sculptor and occasional draughtsman. He came to London in 1846 and then studied under Monti in Milan, where he was involved in the 1848 Revolution. On his return he concentrated on sculpture, mainly in Midland churches.

Examples: Mus. of Staffordshire Life, Shugborough.

WOOD, Thomas 1800 (London) – 1878 (Conisborough)
The second son of JOHN GEORGE WOOD, F.S.A., a landscape painter and etcher, he was largely self-taught and painted landscapes and marine subjects. He was a candidate for the N.W.S. in 1833 and

1835 and was Drawing Master at Harrow from 1835 to 1871. Towards the end of his life he went blind. His views in Wales, Devon, the Isle of Wight, the Channel Islands and around Harrow can be very good indeed and can be reminiscent of those of W. Callow or even J.S. Cotman.

Examples: B.M.; V.A.M.

WOOD, Thomas Peploe
1817 (Little Haywood, Stafford) – 1845 (Little Haywood)
The son of a toll-gate keeper and the elder brother of the sculptor S.P. Wood (q.v.), he was self-taught, collecting and copying engravings. He was taken to London by an architect in 1836 and there sold drawings to Colnaghi. He revisited London in 1839, 1840 and 1843, and he exhibited at the R.A., the B.I. and the S.B.A. from 1829 to 1844. His subjects are cattle and landscapes.

Examples: B.M.; V.A.M.; Stafford A.G.; Stafford Lib.; Mus. of Staffordshire Life, Shugborough.

WOOD, William, of Calcutta 1774 (Kendal) – 1857 (Ruislip)
A doctor who practised in Calcutta, where he painted local views. His architectural drawing is good, but his figures and trees are less assured.

Published: *A Series of twenty-eight Panoramic Views of Calcutta*, 1833.
Examples: B.M.

WOOD, William Thomas, R.W.S. 1877 (Ipswich) – 1958 (London)
The son of an artist, he was a landscape and flower painter. He was elected A.R.W.S. in 1913 and R.W.S. in 1918 and served as Vice-President from 1923 to 1926. During the First World War he was an official war artist in the Balkans. He lived in London.

Illustrated: A.J. Mann: *The Salonika Front*, 1920.
Examples: V.A.M.

WOODFORDE, Samuel, R.A.
1763 (Castle Cary, Somerset) – 1817 (Ferrara)
He entered the R.A. Schools in 1782, having already won the patronage of Henry Hoare of Stourhead, which enabled him to leave for Italy in 1786. He returned to London in 1791 and was elected A.R.A. and R.A. in 1800 and 1807. He exhibited at the R.A. from 1792 until 1815, from which date he lived in Italy. He painted historical and mythological subjects.

Examples: B.M.; V.A.M.

WOODHOUSE, William
1857 (Poulton-le-Sands) – 1939 (Morecambe)
An animal painter who lived in Heysham, Lancashire, and studied at the Lancaster School of Art. He worked in both oil and watercolour and also painted Mediterranean and Egyptian scenes.

WOODLOCK, David
1842 (near Golden, County Tipperary) – 1929
A painter of gardens, cottages, portraits and genre subjects, he stuided in Liverpool, where he became a member of the Academy and was a founder of the Liverpool Sketching Club. He exhibited in London from 1880.

WOODMAN, Charles Horwell 1823 – 1888
The son, grandson and brother of artists named Richard Woodman, he was a landscape and figure painter. He exhibited from 1842 to 1845, and he lived in London.

Examples: B.M.; V.A.M.; Cartwright Hall, Bradford.

WOODWARD, George Moutard
c.1760 (Derbyshire) – 1809 (London)
A caricaturist in the manner of H.W. Bunbury (q.v.), he came to London where he achieved popularity with his social satires. He lived a dissolute life and died, a broken man in body and estate, in a public house.

His drawing, which was much influenced by Rowlandson, relies on heavy black outlining, but it is full of life and imagination. His work was often etched by Rowlandson, and by I. Cruikshank (q.v.).

Published: *Elements of Bacchus*, 1792. *Familiar verses from the Ghost of Willy Shakspeare to Sammy Ireland*, 1795. *The Olio of Good Breeding . . .*, 1801. *The Musical Mania for 1802. The Bettyad . . .*, 1805. *The Fugitive*, 1805. *Caricature Magazine . . .*, 1807. *Eccentric Excursions*, 1807. *Chesterfield Travestie . . .*, 1808. *The Comic works, in prose and poetry*, 1808.
Examples: B.M.; Fitzwilliam; Leeds City A.G.; Newport A.G.

WOODWARD, Thomas 1801 (Pershore) – 1852 (Worcestershire)
An animal and landscape painter who showed an early talent for sketching farm animals, and studied under A. Cooper (q.v.) for a year. He worked for a time in London, but ill-health forced him to return to Worcestershire. He exhibited at the R.A., the B.I. and the R.B.A. Landseer admired his horse painting, and he was once asked to paint Queen Victoria and Prince Albert's horses at Windsor.

Examples: Worcester City A.G.

WOOLLATT, Edgar 1871 (Nottingham) – 1931 (Nottingham)
A Nottingham artist who exhibited at the R.A. and locally. Many of his landscapes are taken from Scotland.

WOOLLETT, William 1735 (Maidstone) – 1785 (London)
The engraver, topographical draughtsman and occasional watercolour painter. He studied under John Tinney and at the St. Martin's Lane Academy. His first prints were published in 1755, and he became one of the most successful engravers of the day.

Examples: Maidstone Mus.

WOOLNOTH, Alfred
A landscape painter who lived in Edinburgh and Hampstead. He was active at least from 1870 to 1896 and was an unsuccessful candidate for the N.W.S. in 1871. He painted in the Bournemouth area as well as in Scotland.

WOOLNOTH, Charles N , R.S.W.
1815 (London) – 1906 (Glasgow)
A landscape painter who exhibited in London from 1833 to 1875. He was an unsuccessful candidate for the N.W.S. in 1851 and 1853, by which time he had settled in Glasgow.

Examples: V.A.M.; Aberdeen A.G.; Glasgow A.G.; Nat. Lib., Wales.

WORSLEY, Charles Nathan
A landscape painter who exhibited from 1886 and was active until at least 1922. He lived in London, Bridgnorth and Sidmouth, and painted in Switzerland, Portugal, Spain and New Zealand. An exhibition of his New Zealand views was held at the Modern Gallery, London, in 1909.

WORSLEY, Henry F
A landscape and figure painter who worked in Bath from 1833 to 1838 and was Secretary of the Bath Society of Arts. He also lived in London, where he exhibited from 1828 to 1843, and in Caerleon and Rugby. From 1851 to 1855 he was Drawing Master at King's College in succession to M.E. Cotman.

Examples: Victoria A.G., Bath.

WORTHINGTON, Thomas Giles
A landscape painter who was a member of the Monro circle and of Girtin's Sketching Club in 1799. He had a number of lessons from Girtin and sketched, for the most part in pencil, in many parts of the country. He lived at Halliford, Middlesex.

Examples: Fitzwilliam.

WRIGHT, Henry
An amateur artist who exhibited as an Honorary Exhibitor at the R.A. between 1819 and 1821. His interest in classical ruins took

him abroad, and his talent may be seen from a watercolour of the Erechtheon on the Acropolis illustrated in a letter to *Country Life*, December 31, 1964.

WRIGHT, John 1857 (Harrogate) – 1933 (Brasted, Kent)
An etcher and landscape painter who studied in Antwerp. He visited Venice and the East Indies. His work is in the tradition of de Wint and A.W. Hunt (q.v.). His wife, Louise Wright, was also an etcher.

Examples: V.A.M.; Leeds City A.G.

WRIGHT, John Masey, O.W.S.
 1777 (Pentonville) – 1866 (London)
The son of an organ-builder, he was trained in the same business and worked as a piano-tuner for Broadwood. During his boyhood he met T. Stothard (q.v.), who gave him the run of his studio. At the age of thirty-three he married and moved to Lambeth, where he shared a house with Jock Wilson (q.v.), who introduced him to a number of artists and to the Barkers. He soon began to paint for T.E. Barker's panorama in the Strand. He also worked as a scene painter at Covent Garden and elsewhere for a number of years. He exhibited at the R.A. from 1812 to 1818 and was elected A.O.W.S. and O.W.S. in 1824. He made a number of drawings for the Annuals, and ran a teaching practice, his pupils including Lady Craven, the Marquis of Lansdowne and the daughters of Earl de Grey. He was a prolific exhibitor with the O.W.S., but was never financially successful, and had to move house frequently.
 His style is based on Stothard but generally lacks his delicacy. His figures, which are outlined with the brush, are stilted. However, his drawings, especially the Shakespearean subjects which form the majority of his work, never lack charm. Other sources of inspiration were Milton, Burns and Cervantes.

Examples: B.M.; V.A.M.; Williamson A.G., Birkenhead; City A.G., Manchester; Newport A.G.; Castle Mus., Nottingham; Reading A.G.
Bibliography: *A.J.*, February, 1867. *Burlington*, LXXII, 1938.

WRIGHT, John William, O.W.S.
 1802 (London) – 1848 (London)
A figure painter sometimes confused with J.M. Wright (q.v.), he was the son of John Wright, the miniaturist, and was apprenticed to Thomas Phillips, R.A. Previous to his election as A.O.W.S. in 1831, he had supported himself by portrait painting, but thereafter he turned more to subject and historical painting, providing a stream of illustrations for the Annuals. He became a full member of the O.W.S. in 1841, and was its amiable, if haphazard, Secretary from 1844 until his death. Although an artist of charm and acknowledged ability, he was never very successful, and left his family in poor circumstances.
 His remaining works were sold at Christie's, March 30-31, 1848.

Examples: B.M.

WRIGHT, Joseph, of Derby 1734 (Derby) – 1797 (Derby)
The landscape and portrait painter, he made a few watercolour landscapes while travelling in Italy with J. Downman (q.v.) from 1773 to 1775. He disliked the medium.

Examples: B.M.; Derby A.G.
Bibliography: W. Bemrose: *Life and Works of J.W.*, 1885. S.C.K. Smith: *W. of D.*, 1922. B. Nicolson: *J.W. of D.*, 1968. *A.J.*, 1883. *Burlington*, CVII, February, 1965.

WRIGHT, Richard Henry 1857 – 1930
A landscape and architectural painter in oil and watercolour who exhibited from 1885. He painted in Egypt, Italy, Switzerland and Greece as well as in Britain. He used a broad, splashy style.

Examples: B.M.; V.A.M.; Reading A.G.

WRIGHT, Thomas, of Newark
A landscape and topographical painter who lived at Upton Hall, near Newark. He painted a number of views of Cheltenham from 1793 to 1799, and of the Lake District from 1812 to 1815, and he exhibited at the R.A. from 1801 to 1837.

Examples: Newark Mus.

WRIGHT, Thomas 1792 (Birmingham) – 1849 (London)
An engraver and portrait painter, he was apprenticed to H. Meyer (q.v.), after which he worked for four years under W.T. Fry. In about 1817 he set up as an engraver, also taking pencil and miniature portraits rather in the manner of H. Edridge (q.v.). In 1822 he went to St. Petersburg to engrave his brother-in-law George Dawe's portraits of Russian generals. He returned to England in 1826, leaving again for Russia in 1830, where he lived for fifteen years.

Published: *Les Contemporains Russes*.
Examples: B.M.

WYATT, Henry
 1794 (Thickbroom, near Lichfield) –
 1840 (Prestwich, near Manchester)
He was brought up by his guardian, Francis Eginton the glass painter, and in 1812 he entered the R.A. Schools. In 1815 he started to work for Sir Thomas Lawrence, after which he set up as a portrait painter, practising in Birmingham, Liverpool and Manchester before settling in London in 1825. In 1834, for health reasons, he moved to Leamington. He exhibited at the R.A. and elsewhere between 1817 and 1838.
 As well as portraits, he painted a wide range of subjects, including landscapes, shipping scenes, flowers and animals, in both oil and watercolour.
 His younger brother, Thomas Wyatt (c.1799-1859), was a portrait painter in oil who studied at the R.A. Schools and worked with Henry in Birmingham, Liverpool and Manchester. He never achieved much success and eventually settled in Lichfield.

Examples: V.A.M.

WYATVILLE, Sir Jeffry, R.A.
 1766 (Burton-on-Trent) – 1840 (London)
An architect and the nephew of James Wyatt. He became the favourite architect of George IV and is best remembered for his remodelling of Windsor Castle. He was elected A.R.A. and R.A. in 1823 and 1826. He changed his name to Wyatville by Royal Licence in 1824 and was knighted in 1828.

Examples: B.M.; V.A.M.
Bibliography: H. Ashton: *Illustrations of Windsor Castle*, 1841.

WYBURD, Francis John 1826 (London) –
A genre painter who was educated in Lille and studied under Thomas Fairland, the lithographer. He exhibited from 1846 to at least 1893, and he entered the R.A. Schools in 1848. Ten years later he visited Northern Italy with G.E. Hering (q.v.). He specialized in single figures out of doors and his work was described by the *A.J.* as 'a perfect realization of female beauty'. He sometimes signed with the initials 'F.W.' which has led to hopeful attributions to F. Walker.
 LEONARD WYBURD, who lived with him in London and exhibited similar subjects at Suffolk Street from 1879, was presumably his son.

Bibliography: *A.J.*, 1877.

WYLD, William, R.I. 1806 (London) – 1889 (Paris)
A landscape painter who began his career as Secretary to the British Consul in Calais, where he took lessons from F.L.T. Francia (q.v.). He was also a friend and admirer of R.P. Bonington (q.v.), and he travelled extensively with Horace Vernet, visiting Italy, Spain and Algeria. For the most part he lived in Paris, but he also exhibited in London from 1849. He was elected A.N.W.S. in that year and N.W.S. in 1879. He published twenty lithographs of Paris in 1839, and in 1855 he was awarded the Legion of Honour in recognition of the important part which he played in encouraging French watercolour painting.

Examples: B.M.; V.A.M.; Fitzwilliam; Williamson A.G., Birkenhead; City A.G., Manchester; N.G., Scotland; Newport A.G.; Luxembourg, Paris.
Bibliography: *Walpole Soc.*, II, 1913. *Connoisseur*, LXXXVII, 1931.

WYLLIE, Charles William　　　　1859 (London) – 1923 (London)
The brother of W.L. Wyllie (q.v.), he studied at Leigh's and the R.A. Schools and painted landscapes, coastal and genre subjects. He exhibited from 1872 and was elected to the R.B.A. in 1886. He lived in London and painted on the Channel coasts, on the Thames and in Venice.

Examples: B.M.

WYLLIE, William Lionel, R.A., R.I.
　　　　　　　　　　　　　1851 (London) – 1931 (London)
The half-brother of L.P. Smythe (q.v.) and the brother of C.W. Wyllie (q.v.), he was a marine painter who began to sketch as a boy at Wimereux on the French coast. He studied at Heatherley's and the R.A. Schools and also studied the history and method of shipbuilding to help him with his paintings. At seventeen he exhibited for the first time at the Academy, and he was elected A.R.A. and R.A. in 1889 and 1907. He was also a member of the R.I. In his twenties he worked as a maritime illustrator for the *Graphic*. He painted historical naval subjects, the life of the Thames and docks, the contemporary Navy and yachting and dinghy sailing. He was primarily a watercolourist, being able to sketch under the most difficult conditions, but he also painted in oil, was an accomplished etcher, and he illustrated a number of books.

He was the father of HAROLD WYLLIE (b.1880), also a marine painter.

Examples: B.M.; Bridport A.G.; Towner Gall., Eastbourne; Fitzwilliam; Glasgow A.G.; Greenwich; Maidstone Mus.; City A.G., Manchester.
Bibliography: *A.J.*, 1889.

WYNFIELD, David Wilkie　　　　1837　　　 – 1887
The great-nephew of D. Wilkie (q.v.), he was intended for the Church, but became a genre and history painter. He studied at Leigh's and exhibited from 1859. He was a founder of the 'St. John's Wood Clique' and was a photographer.

WYNNE, Rev. Dr.
An amateur Irish draughtsman who provided drawings of Irish castles and abbeys for Grose's *Antiquities of Ireland*, 1794.

An H. WYNNE was painting topographical views in Cheshire in 1799 and an R.W. WYNNE exhibited London views from 1801 to 1814.

YARD, Charles
A Dublin landscape and marine painter who exhibited at the R.H.A. between 1845 and 1856, and at the S.B.A. between 1848 and 1857. He was twice a candidate for the N.W.S., in 1850, when he was living near Winchester, and in 1857, when he had returned to Dublin.

YATES, Gideon
A topographer who was working from 1803 to 1815, and who was living in Lancaster in 1811. He does not appear to be the same person as the London G. YATES who painted a well-known series of views of London bridges between 1827 and 1837. There are examples of the work of the latter in the B.M.; Bishopsgate Inst.; the Guildhall Lib.; and the British Lib.

YATES, Lieutenant Thomas 1765 – 1796 (London)
An amateur artist and engraver who exhibited a series of naval battles from 1788 to 1794. He was killed in a quarrel.

Examples: B.M.; Greenwich.

YEAMES, William Frederick, R.A.
** 1835 (Taganrog) – 1918 (Teignmouth)**
The son of the British Consul in Taganrog, South Russia, with whom he travelled in Italy between the ages of seven and nine. On the death of his father, the family returned to Russia. He studied in Dresden at the age of thirteen and was brought to London in 1848, where he took lessons from G. Scharf (q.v.) and attended University College. After further lessons from J.S. Westmacott he went to Florence and Rome, remaining in Italy, except for a three month visit to England in 1856, until 1858, when he settled in London. He exhibited from 1859 and was elected A.R.A. and R.A. in 1867 and 1878, and was appointed Librarian to the R.A. and Curator of the Painted Hall at Greenwich. He was also an examiner at South Kensington and a member of the St. John's Wood Clique. His wife was a niece of Wilkie.

Examples: V.A.M.
Bibliography: M.H. Smith: *Art and Anecdotes: Recollections of W.F.Y.*, 1927. *A.J.*, 1874. *Connoisseur*, LXII, 1922.

YEOMAN, Annabelle
A pupil of F. Towne (q.v.) who was working in 1798.

YGLESIAS, Vincent Philip 1845 – 1911 (London)
The son of a Spaniard from Santander who had settled in England, Yglesias painted landscapes in oil and watercolour. He worked in Fitzroy St., London until his marriage in 1887 and thereafter at his home in St. John's Wood. He exhibited at the R.A. from 1874 and was elected a member of the R.B.A. in 1888. His watercolour style is loose, and he can be faulted on his drawing, but he has an effective sense of atmosphere.

YORKE, Hon. Eliot Thomas 1805 – 1885
The son of Admiral Sir J.S. Yorke (q.v.) and brother of the 4th Earl of Hardwicke, he was M.P. for Cambridgeshire from 1854 to 1865. He painted landscapes in the manner of his teacher, de Wint.

Illustrated: G.T. Lowth: *The Wanderer in Western France*, 1863.

YORKE, Admiral Hon. Sir Joseph Sydney
** 1768 – 1831 (Stokes Bay)**
The son of Lord Chancellor Hardwicke, he entered the Navy in 1780 and served under Sir Charles Douglas on a voyage to the West Indies, being present at the battle of Dominica. He was with Douglas again in Halifax in 1784 and was also on the Newfoundland station in 1788. In 1790 he was in the Channel, and he was promoted captain in 1793 and rear-admiral in 1810, when he was knighted. In 1811 he fought at Lisbon. He was promoted admiral in 1830, and after his retirement he lived in Southampton. Naturally, he painted marine subjects.

Examples: Greenwich.

YOUNG, J T 1790 – 1822
An amateur painter of landscapes and architectural subjects in oil and watercolour. He exhibited in London from 1811 to 1822 and lived in Southampton. He was possibly a relation of T.P. Young (q.v.).

YOUNG, Robert Clouston, R.S.W.
** 1860 (Glasgow) – 1929 (Glasgow)**
A lithographer who made a large number of watercolour views of the Clyde. He was elected R.S.W. in 1901.

Examples: Glasgow A.G.

YOUNG, Tobias P – 1824
A Southampton painter of rustic and woodland scenes, somewhat in the manner of Varley. He was also a scenery painter and is said to have worked at Lord Barrymore's private theatre.

Examples: V.A.M.

YOUNGMAN, Annie Mary, R.I.
** 1859 (Saffron Walden) – 1919 (London)**
The daughter and pupil of J.M. Youngman (q.v.), she was a flower and landscape painter. She studied at the R.A. Schools, where she was awarded silver medals, and she exhibited from 1877. She was a member of the Society of Lady Artists and was elected R.I. in 1887. At that date she was living in Notting Hill.

Examples: Aberdeen A.G.

YOUNGMAN, John Mallows 1817 – 1899
A landscape painter and etcher who exhibited from 1834 and attended Sass's School in 1836. He worked as a bookseller in Saffron Walden before settling in London. He was elected A.N.W.S. in 1841 but resigned in 1864. He published a number of etchings of Richmond.

ZIEGLER, Henry Bryan 1798 (London) — 1874 (Ludlow)
A painter of landscapes, portraits and rustic subjects who was a
pupil of J. Varley and studied at the R.A. Schools at a very early
age. He was extremely successful as a drawing master, his pupils
including Queen Adelaide, Prince George of Cambridge and Prince
Edward of Saxe-Weimar. He painted in many parts of the British
Isles and accompanied the Duke of Rutland on a voyage to Norway.
Towards the end of his life he concentrated on watercolour
portraits.

Examples: B.M.; Fitzwilliam.

ZOBEL, James George 1792 — 1879
The son of a table decorator to George III, Zobel settled in Norwich
in about 1819 and worked there as a glass stainer for much of his
life. Fairly late in his career he took up watercolour painting,
producing careful studies of old Norwich houses. He is sometimes
better than his obituary suggests: 'Although no particular artistic
merit can be claimed for his drawings, they are characterised
nevertheless by great truthfulness of delineation.' He is sometimes
stated to have made sand pictures.

Examples: B.M.

ZUCCARELLI, Francesco, R.A.
 1702 (Pitigliano, Tuscany) — 1788 (Florence)
A landscape painter who studied in Florence and Rome, travelled in
Germany, Holland and France and then spent five years in England
in the 1740s working as a scene painter at the Opera House. He
returned to England in 1752 and was a Foundation Member of the
R.A. in 1768. He retired to Florence with a considerable fortune in
1773, but was ruined by the dissolution of a monastery in which he
had invested his savings and was forced to continue painting. His
English works, which had a considerable influence, included
Shakespearian subjects and Thames views as well as typical romantic
landscapes. Many are in body-colour, and some are signed with a
monogram or a gourd motif, and they gained considerable
popularity through the engravings of Woollett, Byrne and
Bartolozzi.

Examples: B.M.; V.A.M.; Maidstone Mus.
Bibliography: A. Ross: *F.Z.*

ZUCCHI, Antonio Pietro, A.R.A.
 1726 (Venice) — 1795 (Rome)
In 1754 he accompanied R. Adam (q.v.) and Charles Louis
Clerisseau on their tour of Italy and Dalmatia. Adam invited him to
England in 1766 and employed him as a decorator on many of his
houses. He was elected A.R.A. in 1770 but returned to Italy eleven
years later on his marriage to A. Kauffmann (q.v.). His drawings are
usually heavily executed in brown wash with white heightening.
Very occasionally he used touches of colour. His subjects, both
architecture and figures, are invariably classical in composition and
handling.

Examples: B.M.; Fitzwilliam.

Appendix

APPENDIX

PUPILS OF HENRY BRIGHT

The following published list was found bound into Glyde's *Ipswich Parishes,* vol. IV, St. Margarets, p. 52.

A LIST of a few of the distinguished Pupils Mr. H. BRIGHT had the honour to instruct in Painting and Water Colour Drawing during twenty years of his Practice in London.

Her Imperial Highness the Grand Duchess Maria of Russia
The Countess Potocski
The Most Noble the Marquis of Granby (present Duke of Rutland)
Lord Dungarvan
The late Rt. Hon. the Marchioness of Bath
Sir Denham Norreys
Miss Norreys
Lord Charles Thynne
The Ladies Bagot
Miss Colville
The Hon. Miss Foulis
Captain Fitzhugh
The Rev. Hindes Groome of Earl Soham
Lieut. Colonel Turner, Scots Fusileer Guards
Miss Strood
The Ladies Georgianna and Elizabeth Campbell
The Hon. Mrs. George Campbell
The Lady Ann Cooke, of Holkham
Mrs. Spencer Stanhope
Miss Gertrude Sloane Stanley
The Hon. Lady Wm. Middleton, Shrubland
The Hon. Lady Augusta Talbot
Miss Talbot
The late Sir Hesketh Fleetwood, Bart.
The late Rt. Hon. the Countess of Burlington
Miss Archdeckne, now the Hon. Lady Huntingfield
Mrs. Archdeckne of Glevering Hall
Miss Pocklington
Miss Barr
The late Lady Rendlesham
Miss Thellusson
Miss Weddell
Monsr Jules Dubois of Paris
Herr Richardt of Berlin
Miss Hayter, daughter of the late Sir George Hayter, Historical Painter to the Queen
Miss Pitt of Petworth
The Misses Hawkins, Bignor Park, Sussex
The late Lady Anson and Miss Anson, Grundisburgh Hall
The Misses Barlow of Burgh Rectory
Miss Peel (daughter of the late Sir Robert) now the Hon. Viscountess Villiers

Captain Courtney Boyle, R.N.
Colonel Daguiller, Granadier Guards
Colonel Snell, Scots Fusileer Guards
Captain Davis
The Hon. Elliot Yorke
Edward Harper, Esq., Barrister at law
Mrs. Edward Harper
The Rev. and Mrs. Croft
Sir George Lee, Bart.
The late Lord Charles Townsend
The Hon. Lady Horton
Miss Horton
The Hon. Miss Jervis, (daughter of the late Earl of St. Vincent) now Mrs. Dyce Sombre
Don Peddrorenna of the Spanish Embassy
Colonel Copeland
Richard Williams, Esq., of Ransoms, Bankers, London
Arthur Fuller, Esq., Banker, London
The late Mrs. Francis Cunningham of Lowestoft Vicarage
The Misses French, daughters of the late Dr. French, Cambridge
The Rev. T.J. Judkin
The Hon. Lady Catherine Harcourt
Colonel Harcourt
The Hon. Lady Charlotte Deninston
The Lady Francis Cole
Miss Cole
The Earl of Enniskillin
Miss Woods
Miss Norman
The Lady George Wombwell
The Hon. Lady Belhaven
John Martin, Esq.
The Hon. the Ladies Butler, of Kellkenny Castle, Ireland
The late Mr. Munro, of Hamilton Place, and Novar, Scotland
Lieut. Steward
The Hon. Miss Parker
The Captain Steward
The Lady Wheatley
Miss Wheatley
The Misses Hotham, Dennington Rectory
The Rt. Hon. the Countess of Chesterfield
The Hon. Miss Forrester
Sir Frederick Trench, Bart.
The Hon. Miss Rice Trevor
Sir Walter James, Bart.
The late Lady Manners of Yoxford
Miss Anderton

Miss Rosa Teesdale
John Middleton, Esq.
John Hardy, Esq.
The late Lady Harland
Miss Crabtree of Halesworth
Miss Lynn of Woodbridge
The Misses Nicholson of Ufford
The Hon. Lady Charles Burrell

The Hon. Lady Hastings
The Rt. Hon. the Marchioness of Londonderry
The Rt. Hon. the Countess Stanhope
The late Rt. Hon. the Countess of Ellesmere
The Hon. Mrs. Grey
Miss Sheriff of Southwold
The Misses Allcard
Mrs. Dawson

PUPILS OF PETER DE WINT

Taken from a de Wint sketchbook in the V.A.M.

Alston, Miss
Anson, Mrs. G.
*Baites, Miss?
Bruce, Lady M.
*Corbett, Miss D.
Douglas, the Misses
Fludyer, Miss
Fludyer, Miss L.
Ganfeon, (?Gaujean) Mrs.
Leveson Gower, the Ladies
Gray, the Misses
Jones, Miss
Legge, Lady H.
Long, Miss

Long, Miss Sydney? (probably Tylney)
Lowther, Lady M.
Markham, Mr.
Pechell, Miss
Pemberton, Miss M.
*Plymouth, Lady
*Pocock, Mr.
Powys, the Hon. Misses
Raikes, Miss
Sheldon, Miss E.
Spencer Stanhope, the Misses
Stanhope, Miss J.D.
Stuart, Miss
Thynne, Lady E.
Windsor, Lady H.
*Yorke, the Ladies

*Taken from a companion volume not in the Museum.

Family Trees

THE PROBABLE FAMILY TREE OF THE ALKENS.

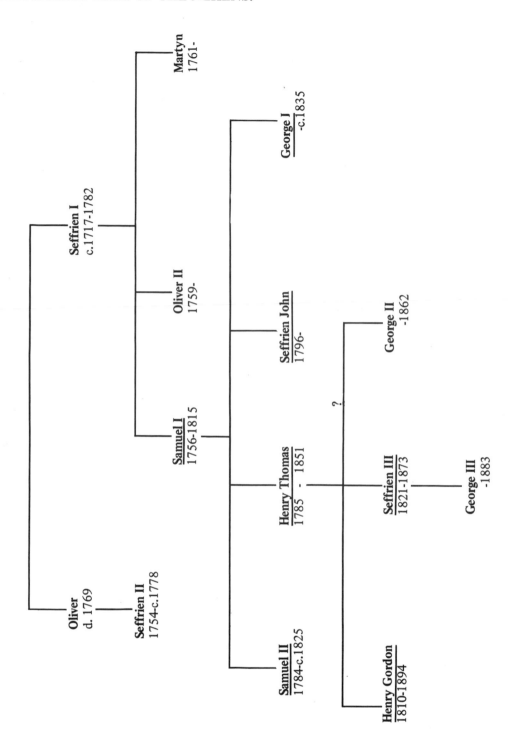

Oliver
d. 1769

Seffrien II
1754-c.1778

Seffrien I
c.1717-1782

Martyn
1761-

Oliver II
1759-

George I
-c.1835

Samuel I
1756-1815

Seffrien John
1796-

George II
-1862

Samuel II
1784-c.1825

Henry Thomas
1785 - 1851

Seffrien III
1821-1873

George III
-1883

?

Henry Gordon
1810-1894

N.B. Any or all of the family who are not underlined, may have painted.

294

Known artists underlined

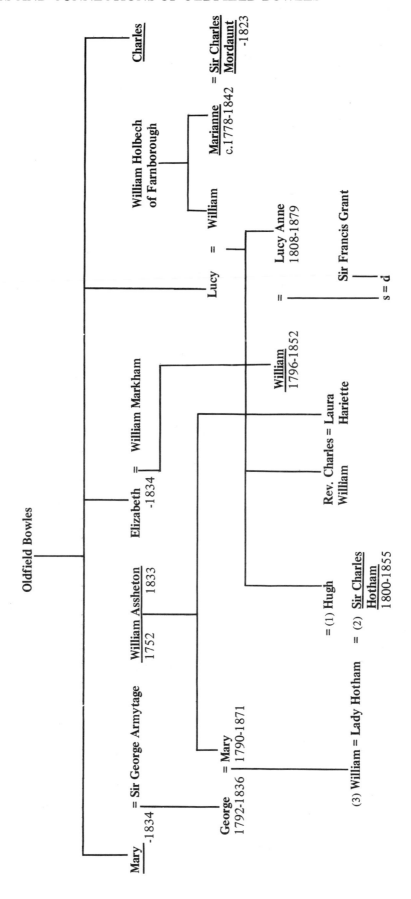

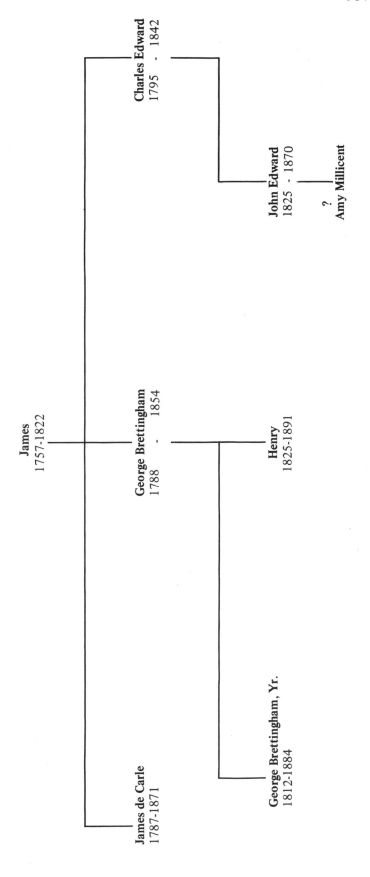

James
1757-1822

James de Carle
1787-1871

George Brettingham
1788 - 1854

George Brettingham, Yr.
1812-1884

Henry
1825-1891

Charles Edward
1795 - 1842

John Edward
1825 - 1870

?
Amy Millicent

THE VARLEYS

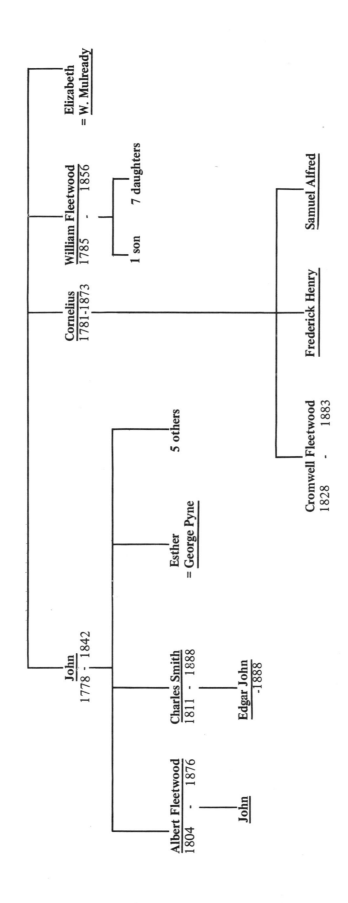

She did not go once but many times, backwards and forwards to the well...